2004
ARTIST'S & GRAPHIC DESIGNER'S MARKET®

WHERE & HOW TO SELL YOUR ILLUSTRATIONS, FINE ART, GRAPHIC DESIGN & CARTOONS

EDITOR
MARY COX

ASSISTANT EDITOR
MONA MICHAEL

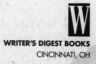

WRITER'S DIGEST BOOKS
CINCINNATI, OH

If you are an editor, art director, creative director, art publisher or gallery director and would like to be considered for a listing in the next edition of *Artist's & Graphic Designer's Market*, send your request for a questionnaire to *Artist's & Graphic Designer's Market*–QR, 4700 East Galbraith Road, Cincinnati OH 45236, or e-mail artdesign@fwpubs.com.

Managing Editor, Writer's Digest Books: Alice Pope
Editorial Director, Writer's Digest Books: Barbara Kuroff

Writer's Market website: www.WritersMarket.com
Writer's Digest Books website: www.WritersDigest.com

International Standard Serial Number 1075-0894
International Standard Book Number 1-58297-184-6

Cover illustration by Mick Wiggins

Attention Booksellers: This is an annual directory of F&W Publications. Return deadline for this edition is December 31, 2004.

contents at a glance

Contents

© Carrie Wild

Page 36

RESOURCES

© 2000 Sophisticated Games Ltd.

From the Editor

Picturing Your Sweet Success

Imagine arriving home from a morning of errands balancing an armful of groceries and art supplies. You plop your keys on the counter and press "play" on the answering machine. As you struggle to rearrange the broccoli so the milk fits in the fridge, two messages from friends barely register. But when you hear "I'm calling from New York," you spin around, (dropping two oranges in the process) and listen intently as the voice continues "We'd like you to illustrate an upcoming cover and 10 illustrations. Give our art director a call, OK?"

Sipping your morning cup of coffee, you check your e-mail, weeding through several spams, until you notice a reply from a gallery you contacted months ago. Subject: Art show. The message reads "We're thinking about you for a one-person show. Does June fit in with your schedule?"

You're at the gym striding on a treadmill when your cell phone rings. You fish it out of your gym bag in time to hear a voice say, "Just getting back to you about that syndication contract for your comic strip. We think we can negotiate the terms you want."

Do any of these scenarios make you smile? Congratulations, you've just used a very powerful tool—visualization. Visualization is a technique practiced by Olympic skaters, golf pros, tennis and basketball champions. Athletes have long been aware that picturing the outcome of your hard work is indeed powerful. It not only provides incentive to keep going, it energizes you and helps you stay focused. As a visual artist, you should be a natural for this technique. With your creativity it just might prove easier for you than for most athletes.

So as you read the listings in this year's edition of *Artist's & Graphic Designer's Market*, picture what it will be like to work with some of the contact people in the listings. Visualize creating and mailing promotional samples. Imagine hearing back from art directors and gallery dealers and providing the art they need.

Visualization is powerful. But as athletes know, it's just part of the equation. Hard work combined with the right information is crucial. While the hard work is up to you, we've squeezed a lot of essential information into this edition. We've brought you lots of listings, ideas, articles, tips and more. Our special guest is John Howe, the artist who visualized Tolkien's unforgettable characters, and inspired Gandalf's famous pointed hat for the Tolkien movies. See page 14 for this inspirational interview. Also paying visits are three *AGDM* readers who share their successes and strategies on pages 35-40. Whether you hope to market your work as a comic strip, book jacket, CD packaging or postage stamp, there's plenty here to keep you motivated and moving in new directions.

So until next year, add a five-minute visualization session to your daily routine and see what happens. And, oh yes, have fun creating, marketing and selling your work!

Mary Cox

Mary Cox
artdesign@fwpubs.com

P.S. Be sure to fill out our reader survey on page 41. You just might win a free book!

Quick-Start Guide to Selling Your Work

Just launching your freelance art career? Don't know quite where to begin?

You've come to the right place! Your first step will be finding out about your potential clients and customers—who they are, and how you can find them. That's what this book is all about. We provide the names and addresses of art buyers along with plenty of marketing tips. You provide the hard work and stick-to-itiveness necessary to hang in there until the momentum kicks in.

If you are picking up this book for the first time, you might not know quite how to start using it. Your first impulse might be to flip through and quickly make a mailing list, submitting to everyone with hopes that someone might like your work. Resist that urge. As a wise person once said, "Luck favors the prepared mind." Read on and find out what you'll need to know before you jump in.

What you'll find in this book

In focus groups artists have told us *Artist's & Graphic Designer's Market* can be overwhelming at first. Don't worry, it's really not that difficult to navigate. Here's how.

The book is divided into five parts:
1. Business, marketing and self-promotion articles
2. Section introductions
3. Listings of companies and galleries
4. Insider Reports
5. Indexes

Listings: the heart of this book

Beyond this section, the book is further divided into market sections, from Greeting Card companies to Record Labels (See Table of Contents for complete list). Each section begins with an introduction with tips and marketing advice to help you break in.

Listings are the life's blood of this book. In a nutshell listings are names, addresses and contact information for places that buy or commission artwork, along with a description of the type of art they need.

What are Insider Reports?

Insider Reports are interviews with artists and experts from the art world. They give you a richer understanding of the marketplace. Reading them gives you an important edge over artists who skip them. Insider Reports are listed in the Table of Contents under "Markets."

HOW AGDM "WORKS"

Following the instructions in the listings, we suggest you send samples of your work (not originals) to a dozen (or more) targeted listings. The more listings you send to, the greater your chances. Establish a tracking system to keep track of who you submit your work to and send follow-up mailings to your target markets at least twice a year.

How to read listings

Each listing contains a description of the artwork and/or services it prefers. The information often reveals how much freelance artwork they use, whether computer skills are needed, and which software programs are preferred.

In some sections, additional subheads help you identify potential markets. Magazine listings specify needs for cartoons and illustrations. Galleries specify media and style.

Editorial comments, denoted by bullets (•), give you extra information about markets, such as company awards, mergers and insight into a listing's staff or procedures.

It takes a while to get accustomed to the layout and language in the listings. In the beginning, you will encounter some terms and symbols that might be unfamiliar to you. Refer to the Glossary on page 644 to help you with terms you don't understand.

Listings are often preceded by symbols, which help lead the way to new listings **N** , mailing address changes ✓ and other information. When you encounter these symbols, refer to the inside flap of this book for a complete list of their meanings.

Working with listings

1. **Read the entire listing to decide whether to submit your samples.** Do NOT use this book simply as a mailing list of names and addresses. Reading listings helps you narrow your mailing list and send the kind of submissions those listed here want.

2. **Read the description of the company or gallery in the first paragraph of the listing.** Then jump to the **Needs** heading to find out what type of artwork the listing prefers. Is it the type of artwork you create? This is the first step to narrowing your target market. You should only send your samples to listings that need the kind of work you create.

3. **Send appropriate submissions.** It seems like common sense to research what kind of samples a listing wants before sending off just any artwork you have on hand. But believe it or not, some artists skip this step. Many art directors have pulled their listings due to artists sending inappropriate submissions. Look under the **First Contact & Terms** heading to find out how to contact the listing. Some companies and publishers are very picky about what kind of samples they like to see; others are more flexible.

 What's an inappropriate submission? I'll give you an example. Suppose you want to be a children's book illustrator. Don't send your sample of puppies and kittens to *Business Law Today* magazine. They would rather see law related subjects. If you don't like to draw legal subjects, use the Niche Marketing index to find listings that take children's illustrations. You'd be surprised how many illustrators waste their postage sending the wrong samples. And boy, does that alienate art directors. Make sure all your mailings are *appropriate* ones.

4. **Consider your competition.** Under the **Needs** heading, compare the number of freelancers who contact the listing with the number they actually work with. You'll have a better chance with listings that use a lot of artwork or work with many artists.

5. **Look for what they pay.** In most sections, you can find this information under **First Contact & Terms**. Book publishers list pay rates under headings pertaining to the type of work you do, such as **Text Illustration** or **Book Design**.

 At first, try not to be too picky about how much a listing pays. After you have a couple of assignments under your belt, you might decide to only send samples to medium- or high-paying markets.

6. **Be sure to read the "tips!"** Artists say the information within the **Tips** helps them get a feel for what a company might be like to work for.

These steps are just the beginning. As you become accustomed to reading listings, you will think of more ways to mine this book for your best clients. Some of our readers tell us they peruse listings to find the speed at which a magazine pays its freelancers. In publishing, it's

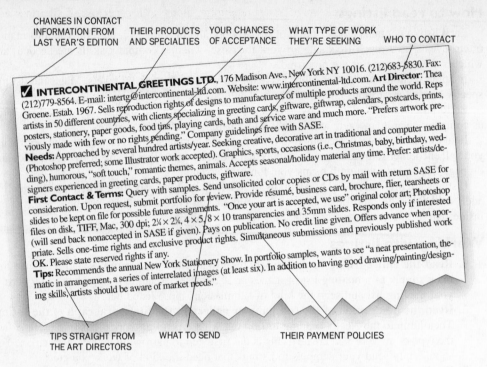

CHANGES IN CONTACT INFORMATION FROM LAST YEAR'S EDITION — THEIR PRODUCTS AND SPECIALTIES — YOUR CHANCES OF ACCEPTANCE — WHAT TYPE OF WORK THEY'RE SEEKING — WHO TO CONTACT

☑ **INTERCONTINENTAL GREETINGS LTD.**, 176 Madison Ave., New York NY 10016. (212)683-5830. Fax: (212)779-8564. E-mail: intertg@intercontinental-ltd.com. Website: www.intercontinental-ltd.com. **Art Director**: Thea Groene. Estab. 1967. Sells reproduction rights of designs to manufacturers of multiple products around the world. Reps artists in 50 different countries, with clients specializing in greeting cards, giftware, giftwrap, calendars, postcards, prints, posters, stationery, paper goods, food tins, playing cards, bath and service ware and much more. "Prefers artwork previously made with few or no rights pending." Company guidelines free with SASE.
Needs: Approached by several hundred artists/year. Seeking creative, decorative art in traditional and computer media (Photoshop preferred; some Illustrator work accepted). Graphics, sports, occasions (i.e., Christmas, baby, birthday, wedding), humorous, "soft touch," romantic themes, animals. Accepts seasonal/holiday material any time. Prefer: artists/designers experienced in greeting cards, paper products, giftware.
First Contact & Terms: Query with samples. Send unsolicited color copies or CDs by mail with return SASE for consideration. Upon request, submit portfolio for review. Provide résumé, business card, brochure, flier, tearsheets or slides to be kept on file for possible future assignments. "Once your art is accepted, we use" original color art; Photoshop files on disk, TIFF, Mac, 300 dpi; 2¼ × 2¼, 4 × 5, 8 × 10 transparencies and 35mm slides. Responds only if interested (will send back nonaccepted in SASE if given). Pays on publication. No credit line given. Offers advance when apropriate. Sells one-time rights and exclusive product rights. Simultaneous submissions and previously published work OK. Please state reserved rights if any.
Tips: Recommends the annual New York Stationery Show. In portfolio samples, wants to see "a neat presentation, thematic in arrangement, a series of interrelated images (at least six). In addition to having good drawing/painting/designing skills, artists should be aware of market needs."

TIPS STRAIGHT FROM THE ART DIRECTORS — WHAT TO SEND — THEIR PAYMENT POLICIES

often a long wait until an edition or book is actually published, but if you are paid on "acceptance" you'll get a check reasonably quick.

When looking for galleries, savvy artists often check to see how many square feet of space is available and what hours the gallery is open. These details all factor in when narrowing down your search for target markets.

Pay attention to copyright information

It's also important to consider what **rights** listings buy. It is preferable to work with listings that buy first or one-time rights. If you see a listing that buys "all rights," be aware you may be giving up the right to sell that particular artwork in the future.

Look for specialties and niche markets

In the Advertising, Design and Related Markets section, we tell what kind of clients an ad agency has within the first paragraph of the listing. If you hope to design restaurant menus, for example, target agencies that have restaurants for clients. But if you don't like to draw food-related illustration and prefer illustrating people, you might target ad agencies whose clients are hospitals or financial institutions. If you like to draw cars, look for agencies with clients in the automotive industry, and so on. Many book publishers specialize, too. Look for a publisher who specializes in children's books if that's the type of work you'd like to do. **The Niche Marketing Index** on page 647 lists possible opportunities for specialization.

Read listings for ideas

You'd be surprised how many artists found new niches they hadn't thought of by browsing the listings. One greeting card artist read about a company that produces mugs. A lightbulb went

off. Now this artist has added mugs to her repertoire, along with paper plates, figurines and rubber stamps—all because she browsed the listings for ideas!

Sending out samples

Once you narrow down some target markets, the next step is sending them samples of your work. As you create your samples and submission packets, be aware your package or postcard has to look professional. It must be up to the standards art directors and gallery dealers expect. Be sure to look at the samples sent out by other artists on pages 22, 23 and 24. Make sure your samples rise to that standard of professionalism.

New year, new listings

Use this book for one year. Highlight listings, make notes in the margins, fill it full of Post-it notes. In September of the year 2004, our next edition—the 2005 *Artist's & Graphic Designer's Market*—starts arriving in bookstores. By then, we'll have collected hundreds of new listings and changes in contact information. It is a career investment to buy the new edition every year. (And it's deductible! See page 10.)

Join a professional organization

Artists who have the most success using this book are those who take the time to read the articles and Insider Reports to learn about the bigger picture. In our Insider Reports, you'll learn what has worked for other artists and what kind of work impresses art directors and gallery dealers.

You'll find out how joining professional organizations such as the **Graphic Artists Guild (G.A.G.)** or the **American Institute of Graphic Arts (AIGA)** can jump start your career. You'll find out the importance of reading trade magazines such as *HOW*, *Print* and *Greetings etc.* to learn more about the industries you hope to approach. You'll learn about trade shows, portfolio days, websites, art reps, shipping, billing, working with vendors, networking, self-promotion and hundreds of other details it would take years to find out about on your own. Perhaps most importantly, you'll read about how successful artists overcame rejection through persistence.

Hang in there!

Being professional doesn't happen overnight. It's a gradual process. I would venture to say that only after two or three years of using each successive year's edition of this book will you have garnered enough information and experience to be a true professional in your field. So if you really want to be a professional artist, hang in there. Before long, you'll feel that heady feeling that comes from selling your work or seeing your illustrations on a greeting card or in a magazine. If you really want it and you're willing to work for it, it *will* happen.

The Art of Business: Simple Systems for Staying on Track

A career as an artist or illustrator involves much more than just painting or drawing. Successful artists must also become small business owners who know their way around an invoice or a contract. Though business seems the antithesus of art, never fear. If you bring your creativity to the business aspects of your work you will come up with some pretty nifty ideas for keeping your business on track. The most important rule of all is to find a system that works for you and stick with it!

YOUR DAILY RECORD-KEEPING SYSTEM

Every artist needs to keep a daily record of art-making and marketing activities. Before you do anything else, visit an office supply store and pick out the following items (or your own variations of these items.) Keep it simple so you can remember your system and use it on "automatic pilot" whenever you make a business transaction.

What you'll need:

- A packet of colorful file folders.
- A notebook to serve as a log or journal to keep track of your daily art-making and art marketing activities.
- A small pocket notebook to keep in your car to track mileage and gas expenses.

How to start your system

- Designate a permanent location in your studio or home office for two file folders and your notebook.
- Label one red file folder "Expenses."
- Label one green file folder "Income."
- Write in your daily log book: Today's date _____ "Started business system."

Every time you purchase anything for your business, such as envelopes or art supplies, place the receipt in your red "Expenses" folder. When you receive payment for an assignment or painting, photocopy the check or place the receipt in your green "Income" folder.

That's all there is to it. By the way, if you purchase any of the suggested supplies at the store, place your receipt in the "Expenses" folder. Congratulations! You've already begun to use your record-keeping system!

"Job jackets" keep assignments on track

Whether you are an illustrator or fine artist, you should devise a system for keeping track of assignments and artworks. Most illustrators assign job numbers to each assignment they receive and create a "job jacket" or file folders for each job. Some file these folders by client name; others keep folders in numerical order. The important thing is to keep all correspondence for each assignment in a spot where you can easily find it. If you are a fine artist, try painter Bert Small's system below.

Pricing illustration and design

One of the hardest things to master is what to charge. It's difficult to make blanket statements on this topic. Every slice of the market is somewhat different. Nevertheless, there is one recurring

A simple tracking system for fine artists

At any one time, I may have three paintings in one gallery, four in another, one entered in a competition and two submitted to a local art show. To keep track of my paintings, I devised a simple system:

As soon as I finish a painting, I make an index card detailing its title, image size, price and any pertinent comments. I then number each card, starting with the year painted, followed by its place in sequence (i.e. 03-001, 03-002, etc.). I then file it in front of a 3 × 5 index card box— the kind containing alphabet files—in a section marked "Paintings on Hand."

When I send a painting to a gallery or show, I move its index card into section B: "Location of Paintings," which consists of the alphabet files. I file the cards under the letter of the alphabet that will identify where I've sent the painting (i.e. S for Seagull Art Gallery or F for Federation of Painters.) When the paintings are returned, I put the cards back in section A: "Paintings on Hand." If any paintings were sold, I pull their index cards; put a red dot on them; note any details of the sale (i.e., Sold by Gallery "X" on "date" for "price.") and if possible, the name and address of the buyer. I then file the cards in section C: "Paintings Sold."

In addition to the card file, I keep a master list of my work, including the title of each painting with sequence number and details, in a journal and on computer file. I also keep a three-ring binder with slides of all of my paintings for reference.

—Bert Small

This tip originally appeared in *Watercolor Magic*.

pattern: hourly rates are generally only paid to designers working inhouse on a client's equipment. Freelance illustrators working out of their own studios are almost always paid a flat fee or an advance against royalties.

If you don't know what to charge, begin by devising an hourly rate, taking into consideration the cost of materials and overhead and what you think your time is worth. If you are a designer, determine what the average salary would be for a full-time employee doing the same job. Then estimate how many hours the job will take and quote a flat fee based on these calculations. *Setting the Right Price for Your Design & Illustration*, by Barbara Ganim (North Light Books), includes easy-to-use worksheets to help you set prices for 33 kinds of projects.

There is a distinct difference between giving the client a job estimate and a job quotation. An estimate is a ballpark figure of what the job will cost, but is subject to change. A quotation is a set fee which, once agreed upon, is pretty much set in stone. Make sure the client understands which you are negotiating. Estimates are often used as a preliminary step in itemizing costs for a combination of design services such as concepting, typesetting and printing. Flat quotations are usually used by illustrators, as there are fewer factors involved in arriving at fees.

For recommended fees for different services, refer to the *Graphic Artist's Guild's Handbook of Pricing & Ethical Guidelines*. Many artists' organizations have hotlines you can call to find out standard payment for the job you're doing.

As you set fees, certain stipulations call for higher rates. Consider these bargaining points:

- **Usage (rights).** The more rights bought, the more you can charge. For example, if the client asks for a "buyout" (to buy all rights), you can charge more, because by relinquishing all rights to future use of your work you will be losing out on resale potential.
- **Turnaround time**. If you are asked to turn the job around quickly, charge more.
- **Budget**. Don't be afraid to ask a project's budget before offering a quote. You won't want to charge $500 for a print ad illustration if the ad agency has a budget of $40,000 for that ad. If the budget is that big, ask for higher payment.
- **Reputation**. The more well-known you are, the more you can charge. As you become established, periodically raise your rates (in small steps) and see what happens.

A simple system for pricing your fine art

There are no hard and fast rules for pricing your fine artwork. Most artists and galleries base prices on market value—what the buying public is currently paying for similar work. Learn the market value by visiting galleries and checking prices of works similar to yours. When you are starting out don't compare your prices to established artists, but to emerging talent in your region. Consider these when determining price:

Medium. Oils and acrylics cost more than watercolors by the same artist. Price paintings higher than drawings.

Expense of materials. Charge more for work done on expensive paper than for work of a similar size on a lesser grade paper.

Size. Though a large work isn't necessarily better than a small one, as a rule of thumb you can charge more for the larger work.

Scarcity. Charge more for one-of-a-kind works like paintings and drawings, than for limited editions such as lithographs and woodcuts.

Status of artist. Established artists can charge more than lesser-known artists.

Status of gallery. It may not be fair, but prestigious galleries can charge higher prices.

Region. Works usually sell for more in larger cities like New York and Chicago.

Gallery commission. The gallery will charge from 30 to 50 percent commission. Your cut must cover the cost of materials, studio space, taxes and perhaps shipping and insurance, and enough extra to make a profit. If materials for a painting cost $25; matting, framing cost $37; and you spent five hours working on it, make sure you get at least the cost of material and labor back before the gallery takes their share. Once you set your price, stick to the same price structure wherever you show your work. A $500 painting by you should cost $500 whether it is bought in a gallery or directly from you. To do otherwise is not fair to the gallery and devalues your work.

As you establish a reputation, begin to raise your prices—but do so cautiously. Each time you "graduate" to a new price level, it becomes more difficult to come back down.

What goes in a contract?

Contracts are simply business tools to make sure everyone is in agreement. Ask for one any time you enter into a business agreement. Be sure to arrange for the specifics in writing, or provide your own. A letter stating the terms of agreement signed by both parties can serve as an informal contract. Several excellent books such as *The Artist's Friendly Legal Guide* (North Light Books) provide sample contracts you can copy, and *Business and Legal Forms for Illustrators*, by Tad Crawford (Allworth Press) contain negotiation checklists and tear-out forms. The sample contracts in these books cover practically any situation you might run into.

The items specified in your contract will vary according to the market you are dealing with and the complexity of the project. Nevertheless, here are some basic points you'll want to cover:

Commercial contracts

- **A description of the service you are providing**.
- **Deadlines for finished work**.
- **Rights sold**.
- **Your fee**. Hourly rate, flat fee or royalty.
- **Kill fee**. Compensatory payment received by you if the project is cancelled.
- **Changes fees**. Penalty fees to be paid by the client for last-minute changes.
- **Advances**. Any funds paid to you before you begin working on the project.
- **Payment schedule**. When and how often you will be paid for the assignment.

- **Statement regarding return of original art**. Unless you are doing work for hire, your artwork should always be returned to you.

Gallery contracts

- **Terms of acquisition or representation**. Will the work be handled on consignment? What is the gallery's commission?
- **Nature of the show(s)**. Will the work be exhibited in group or solo shows or both?
- **Time frames**. At what point will the gallery return unsold works to you? When will the contract cease to be in effect? If a work is sold, when will you be paid?
- **Promotion**. Who will coordinate and pay for promotion? What does promotion entail? Who pays for printing and mailing of invitations? If costs are shared, what is the breakdown?
- **Insurance**. Will the gallery insure the work while it is being exhibited?
- **Shipping**. Who will pay for shipping costs to and from the gallery?
- **Geographic restrictions**. If you sign with this gallery, will you relinquish the rights to show your work elsewhere in a specified area? If so, what are the boundaries of this area?

How to send invoices

If you are a designer or illustrator, you will be responsible for sending invoices for your services. Clients generally will not issue checks without them. Illustrators are generally paid in full either upon receipt of illustration or on publication. So mail or fax an invoice as soon as you've completed the assignment. Most graphic designers arrange to be paid in thirds, billing the first third before starting the project, the second after the client approves the initial roughs, and the third upon completion of the project.

Standard invoice forms allow you to itemize your services. The more you spell out the charges, the easier it will be for your clients to understand what they are paying for. Most freelancers charge extra for changes made after approval of the initial layout. Keep a separate form for change orders and attach it to your invoice.

If you are an illustrator, your invoice can be much simpler, as you'll generally be charging a flat fee. It's helpful, in determining your quoted fee, to itemize charges according to time, materials and expenses (the client need not see this itemization—it is for your own purposes).

Most businesses require your social security number or tax ID number before they can cut a check, so include this information in your bill. Be sure to put a due date on each invoice; include the phrase "payable within 30 days" (or other preferred time frame) directly on your invoice. Most freelancers ask for payment within 10-30 days.

Sample invoices are featured in *The Designer's Commonsense Business Book*, by Barbara Ganim (North Light Books) and *Business and Legal Forms for Illustrators* and *Business and Legal Forms for Graphic Designers*, by Tad Crawford (Allworth Press).

If you are working with a gallery, you will not need to send invoices. The gallery should send you a check each time one of your pieces is sold (generally within 30 days). To ensure that you are paid promptly, call the gallery periodically to touch base. Let the director or business manager know that you are keeping an eye on your work. When selling work independently of a gallery, give receipts to buyers and keep copies for your records.

Take advantage of tax deductions

You have the right to deduct legitimate business expenses from your taxable income. Art supplies, studio rent, printing costs, and other business expenses are deductible against your gross art-related income. It is imperative to seek the help of an accountant or tax preparation service in filing your return. In the event your deductions exceed profits, the loss will lower your taxable income from other sources.

To guard against taxpayers fraudulently claiming hobby expenses as business losses, the IRS

requires taxpayers demonstrate a "profit motive." As a general rule, you must show a profit three out of five years to retain a business status. If you are audited, the burden of proof will be on you to demonstrate your work is a business and not a hobby.

The nine criteria the IRS uses to distinguish a business from a hobby are: the manner in which you conduct your business, expertise, amount of time and effort put into your work, expectation of future profits, success in similar ventures, history of profit and losses, amount of occasional profits, financial status, and element of personal pleasure or recreation. If the IRS rules that you paint for pure enjoyment rather than profit, they will consider you a hobbyist. Complete and accurate records will demonstrate to the IRS that you take your business seriously.

Even if you are a "hobbyist," you can deduct expenses such as supplies on a Schedule A, but you can only take art-related deductions equal to art-related income. If you sold two $500 paintings, you can deduct expenses such as art supplies, art books, and seminars only up to $1,000. Itemize deductions only if your total itemized deductions exceed your standard deduction. You will not be allowed to deduct a loss from other sources of income.

How to fill out a Schedule C

To deduct business expenses, you or your accountant will fill out a 1040 tax form (not 1040EZ) and prepare a Schedule C. Schedule C is a separate form used to calculate profit or loss from your business. The income (or loss) from Schedule C is then reported on the 1040 form. In regard to business expenses, the standard deduction does not come into play as it would for a hobbyist. The total of your business expenses need not exceed the standard deduction.

There is a shorter form called Schedule C-EZ for self-employed people in service industries. It can be applicable to illustrators and designers who have receipts of $25,000 or less and

Are you eligible for a home office deduction?

If you freelance fulltime from your home and devote a separate area to your business, you may qualify for a home office deduction. If eligible you can deduct a percentage of your rent and utilities, expenses such as office supplies and business-related telephone calls.

The IRS does not allow deductions if the space is used for reasons other than business. A studio or office in your home must meet three criteria:

- The space must be used exclusively for your business.
- The space must be used regularly as a place of business.
- The space must be your principle place of business.

The IRS might question a home office deduction if you are employed fulltime elsewhere and freelance from home. If you do claim a home office, the area must be clearly divided from your living area. A desk in your bedroom will not qualify. To figure out the percentage of your home used for business, divide the total square footage of your home by the total square footage of your office. This will give you a percentage to work with when figuring deductions. If the home office is ten percent of the square footage of your home, deduct ten percent of expenses such as rent, heat and air conditioning.

The total home office deduction cannot exceed the gross income you derive from its business use. You cannot take a net business loss resulting from a home office deduction. Your business must be profitable three out of five years. Otherwise, you will be classified as a hobbyist and will not be entitled to this deduction.

Consult a tax advisor before attempting to take this deduction, since its interpretations frequently change.

For additional information, refer to IRS Publication 587, Business Use of Your Home, which can be ordered at www.irs.ustreas.gov or by calling (800)829-3676.

deductible expenses of $2,000 or less. Check with your accountant to see if you qualify.

Deductible expenses include advertising costs, brochures, business cards, professional group dues, subscriptions to trade journals and arts magazines, legal and professional services, leased office equipment, office supplies, business travel expenses, etc. Your accountant can give you a list of all 100 percent and 50 percent deductible expenses (such as entertainment).

As a self-employed "sole proprieter" there is no employer regularly taking tax out of your paycheck. Your accountant will help you put money away to meet your tax obligations and may advise you to estimate your tax and file quarterly returns.

Your accountant also will be knowledgeable about another annual tax called the Social Security Self-Employment tax. You must pay this tax if your net freelance income is $400 or more.

The fees of tax professionals are relatively low, and they are deductible. To find a good accountant, ask colleagues for recommendations, look for advertisements in trade publications or ask your local Small Business Association. And don't forget to deduct the cost of this book.

Whenever possible, retain your independent contractor status

Some clients automatically classify freelancers as employees and require them to file Form W-4. If you are placed on employee status, you may be entitled to certain benefits, but a portion of your earnings will be withheld by the client until the end of the tax year, and you could forfeit certain deductions. In short, you may end up taking home less than you would if you were classified as an independent contractor.

The IRS uses a list of 20 factors to determine whether a person should be classified as an independent contractor or an employee. This list can be found in the IRS Publication 937. Note, however, that your client will be the first to decide how you will be classified.

Report all income to Uncle Sam

Don't be tempted to sell artwork without reporting it on your income tax. You may think this saves money, but it can do real damage to your career and credibility—even if you are never audited by the IRS. Unless you report your income, the IRS will not categorize you as a professional, and you won't be able to deduct expenses. And don't think you won't get caught if you neglect to report income. If you bill any client in excess of $600, the IRS requires the client to provide you with a form 1099 at the end of the year. Your client must send one copy to the IRS and a copy to you to attach to your income tax return. Likewise, if you pay a freelancer over $600, you must issue a 1099 form. This procedure is one way the IRS cuts down on unreported income.

Register with the state sales tax department

Most states require a two to seven percent sales tax on artwork you sell directly from your studio or at art fairs or on work created for a client. You must register with the state sales tax department, which will issue you a sales permit or a resale number, and send you appropriate forms and instructions for collecting the tax. Getting a sales permit usually involves filling out a form and paying a small fee. Reporting sales tax is a relatively simple procedure. Record all sales taxes on invoices and in your sales journal. Every three months, total the taxes collected and send it to the state sales tax department.

In most states, if you sell to a customer outside of your sales tax area, you do not have to collect sales tax. However, this may not hold true for your state. You may also need a business license or permit. Call your state tax office to find out what is required.

Save money on art supply sales tax

As long as you have the above sales permit number, you can buy art supplies without paying sales tax. You will probably have to fill out a tax-exempt form with your permit number at the sales desk where you buy materials. The reason you do not have to pay sales tax on art supplies

is that sales tax is only charged on the final product. However, you must then add the cost of materials into the cost of your finished painting or the final artwork for your client. Keep all receipts in case of a tax audit. If the state discovers that you have not collected sales tax, you will be liable for tax and penalties.

If you sell all your work through galleries, they will charge sales tax, but you still need a tax exempt number to get a tax exemption on supplies.

Some states claim "creativity" is a non-taxable service, while others view it as a product and therefore taxable. Be certain you understand the sales tax laws to avoid being held liable for uncollected money at tax time. Write to your state auditor for sales tax information.

For More Information

Most IRS offices have walk-in centers open year-round and offer over 90 free IRS publications to help taxpayers. Some helpful booklets include Publication 334—Tax Guide for Small Business; Publication 505—Tax Withholding and Estimated Tax; and Publication 533—Self Employment Tax. Order by phone at (800)829-3676. There's plenty of great advice on the Internet, too. Check out the official IRS website: www.irs.gov. Fun graphics lead you to information, and you can even download tax forms.

If you don't have access to the Web, the booklet that comes with your tax return forms contains addresses of regional Forms Distribution Centers you can write to for information. The U.S. Small Business Administration offers seminars and publications to help you launch your business. Check out their extensive website at www.sba.gov. Arts organizations hold many workshops covering business management, often including detailed tax information. Inquire at your local arts council, arts organization or university to see if a workshop is scheduled. S.C.O.R.E. (the Service Corp of Retired Executives) offers free business counseling via e-mail at their website at www.score.org.

Save money on postage

When you send out postcard samples or invitations to openings, you can save big bucks by mailing bulk. Fine artists should send submissions via first class mail for quicker service and better handling. Package flat work between heavy cardboard or foam core, or roll it in a cardboard tube. Include your business card or a label with your name and address on the outside of the packaging material in case the outer wrapper becomes separated from the inner packing in transit.

Protect larger works—particularly those that are matted or framed—with a strong outer surface, such as laminated cardboard, masonite or light plywood. Wrap the work in polyfoam, heavy cloth or bubble wrap and cushion it against the outer container with spacers to keep from moving. Whenever possible, ship work before it is glassed. If the glass breaks en route, it may destroy your original image. If you are shipping large framed work, contact a museum in your area for more suggestions on packaging.

The U.S. Postal Service will not automatically insure your work, but you can purchase up to $600 worth of coverage. Artworks exceeding this value should be sent by registered mail. Certified packages travel a little slower, but are easier to track.

Consider special services offered by the post office, such as Priority Mail, Express Mail Next Day Service and Special Delivery. For overnight delivery, check to see which air freight services are available in your area. Federal Express automatically insures packages for $100 and will ship art valued up to $500. Their 24-hour computer tracking system enables you to locate your package at any time.

UPS automatically insures work for $100, but you can purchase additional insurance for work

valued as high as $25,000 for items shipped by air (there is no limit for items sent on the ground). UPS cannot guarantee arrival dates but will track lost packages. It also offers Two-Day Blue Label Air Service within the U.S. and Next Day Service in specific zip code zones.

Before sending any original work, make sure you have a copy (photostat, photocopy, slide or transparency) in your files. Always make a quick address check by phone before putting your package in the mail.

Send us your business tips!

If you've discovered a business strategy we've missed, please write to *Artist's & Graphic Designer's Market*, 4700 East Galbraith Road, Cincinnati OH 45236 or e-mail us at artdesign@ fwpubs.com. A free copy of the 2005 edition goes to the best five suggestions.

The Magic of John Howe: Tolkien Artist, a World Apart

BY MONA MICHAEL

The second son of a farming family, John Howe grew up in rural southwestern Canada. Though he had no formal training in those days, he began drawing at a very young age—improvising in science class, doing sketches of "microscopic water organisms" for his fellow classmates at 50 cents a shot. He first thought he wanted to be a sign painter— painting billboards—but later discovered book cover illustration and began collecting hoards of paperbacks from used bookstores.

John Howe

No longer selling sketches for change, the illustrator who began his fame with a few spots in a Tolkien calendar in 1987 is now considered one of the premier Tolkien artists. With countless book covers and gallery exhibitions to his name, Howe worked alongside the famed Alan Lee as conceptual artist for *The Lord of the Rings* movies. He even has his own book now. *Myth & Magic*, the first compilation of his work, was published by HarperCollins UK in March 2003. All this hasn't gone to his head though. Howe remembers his beginnings. He credits *Artist's Market* (a previous version of *Artist's & Graphic Designer's Market*) with helping him get started with his career and answers questions from admirers and young artists daily on his website www.john-howe.com.

You talk about copying book covers on your website. Does that fall into the "draw all the time" advice you give aspiring artists?

I'm a firm believer that people, when they are quite young, should not be afraid of being obsessed with things. The deeper you throw yourself into copying someone else's work, the faster you get through it and identify the elements which may eventually become part of your own way of approaching things.

There seems to be a self-consciousness about copying things as a student. But that seems to me to be rather strange, because what's wrong with that? It's a tradition that's been going on for millennia. You're trying to understand another's work and the only way to understand is to try to do it. I must've copied millions of things when I was in my teens.

And you understand things from copying that you don't get from other types of more structured training?

Yes. Because what are you looking for in all this? You're looking for yourself somewhere. You've identified something that you think you can use. You need to try it and you need to make it your own. Imagine a road. You see a section of it way up ahead—because someone else has been drawing for ages and they're professionals with all these techniques and gimmicks and gadgets. You get a glimpse long before you could get there by cutting through the woods yourself.

MONA MICHAEL *is assistant editor of* Artist's & Graphic Designer's Market, Children's Writer's & Illustrator's Market *and freelances as a writing consultant.*

There's nothing shameful about it—it certainly is useful. Once you've understood it, you may realize it does not correspond to your aspirations; but now it's behind you and you can forge on. The quicker you do that, the quicker you evacuate it from your system and move ahead. Holding back out of some notion of originality at any cost will simply slow your progress.

What led to your decision to go to art school?

I had some money from high school that I could only spend on tuition. I wanted to go to art school anyway—that seemed to be quite natural. We grew up on a farm, my brother and I. My brother was the one who was going to pick up farming when my dad quit. It was never in the cards for me, because I was the second one in line and had always drawn pictures. So my parents were very encouraging.

I had a very good friend who had the *Writer's Market*. In there was the ad for the *Artist's Market* and I thought "Oooh that sounds interesting." Obviously, I wasn't ready to start writing to editors in New York. But in there were all these schools with all the addresses. So I wrote off to a half a dozen of them and then chose one.

I was looking for every clue I could get. It was very gratifying to see all of these categories and to realize how many there were. To think, "My goodness—what a large world of illustration and creativity."

In a previous interview you said you learned at art school that "as long as the sketch is not received, it is not finished."

I think that's really a property that's inherent in illustration. It's a communication media. You can illustrate your heart out but there's not much point if it's not going somewhere for someone. It's not just a question of expressing things. I do believe that much of the illustration is actually not in the illustration itself; it's in the person who looks at it.

On your website, you say a lot of your early commissions were nightmares. How did you get those early commissions?

I was very young, just out of art school working for my first commissions. And obviously at that point you take anything that's offered because you're so relieved to get something. You're more likely to find yourself in a situation where you're just not the right person for the job. Thank goodness I don't need to do that kind of thing too often now. I work very poorly in those conditions.

Can you describe any valuable lessons you learned from those jobs?

To persevere. And never to scorn the people you're working for. This is something that seems a little more prevalent in advertising, where you hear more "clients are idiots" and "the people we're selling this stupid product to are all jerks." There is a feeling of superiority towards the people you're exploiting in a certain sense, which I think is very bad. In my mind illustration is a slightly more sincere undertaking. It's that you've accepted a job, you accept the parameters that are given to you—it's a book cover, it has to be done by such and such a date—there is a story that you have to respect—which is going to be in the book, behind the cover. And that's what it's all about.

What enabled you to leave that type of work for the art you enjoy?

Well, I'd like to think I've improved a bit over the years—I hope so anyway. And it takes an incredibly long time to establish a reputation, either good or bad. It took me a while to get back in touch with the English speaking world— because living in continental Europe, I wasn't able to go and see editors in New York and London regularly, to say the least.

You have to do a lot of footwork, before your work does it for you. So, before people see your covers and books in shops regularly, you need to do your self-promotion yourself, rather

than having all these products do it for you without lifting a finger. So there is a lot of running around involved.

What are some specific things that you did as far as self-promotion when you were establishing yourself?

We used to go regularly to the Children's Book Fair in Bologna, Italy. It's one of the world's biggest and is specifically oriented towards children's book illustration. Otherwise, I sent off portfolios with slides and photocopies and all sorts of things to all kinds of people.

What's your opinion on samples? What's best to send?

It's very hard to judge what you should send. To really sum it up and to oversimplify it, you have two choices: either you are one of these lucky people who has a large palette of things you can do—I know illustrators who can do 10 different styles and work with equal happiness in black and white and color and stylized, realistic, cartoony or whatever—or, you're like the rest of us lot who just do one thing and not much else. It's a little harder then, because it may take you ages to find the first editor who thinks that what you do corresponds to what he wants to publish.

But it is very hard to judge WHO is a good editor for what you do. Because the tendency is to go and see a book at a bookshop and think "oh that's great—that's just the kind of subject I love—I'll go and see them." But there's no point because the book is already done and they may not do another book like that for 10 years, if at all.

Also, so many art students make this terrifying mistake of sending a lot of very boring academic schoolwork—beautifully framed and matted and there's nothing worse. This is your personality. You are trying to make them understand who you are not necessarily what you do. When you're just out of art school or still in art school, what you do may not yet represent who you are.

But once again, once you get anything published—anywhere—it's a brick in the wall you're trying to build. So, what you send is very important.

What has your experience been as far as book cover illustrations? Have you had clashes with art directors, marketing departments—changing/altering/putting big text in places you think they shouldn't?

I have. Usually I accept changes. There's quite a strict protocol involved in all this. The starting point is a fairly tight sketch. I do mine in black & white, never in color.

In theory, once the sketch has been okayed, clearly defined elements of the sketch should not change. But there may be things in the finished picture which are not how they imagined. Then the editor may come back and say, "can you fix this please?" or "can you redo that?" And occasionally you get something wrong; you misread the text and put black hair on someone who has blonde and things like that, for example—but that's fine. I'm not always very happy to revisit an illustration, but that's part of the job.

Of the book covers you've done (other than Tolkien), how did you prepare?

The most difficult part is when you read a text and it just doesn't give you a picture. Quite often you don't even get a text—you just get a cover brief. I've done jobs where you have the format, sometimes not even the final title, and the editor's comments on what he'd like to see. Maybe— or you just have nothing but a title and you go ahead and do something that feels appropriate. It's quite common in an industry run by sales meetings and publishing schedules. Occasionally writer and illustrator will deliver their work at the same time.

John Howe has depicted Gandalf, the great Wizard, countless times for books, games and when working on the team that created the look for *The Lord of the Rings* motion pictures. This sketch portrays Gandalf on his return to Hobbiton.

How do you handle rights for your covers? How do you use sub-rights?

Basically—this is only for book covers—the editor purchases the right to use that illustration for a book. He can reprint the same book for a million years if he wants, but he can't put that cover on a different book without your permission. You are allowed to resell that cover for a different book to a different publisher. It's never a fortune—and you would be wise to not sell it to a competing editor for a similar book in the same country. For example, if I do a cover for an English editor, I'm happy to resell it in Germany, Greece, wherever. The original remains your property.

For Tolkien it's a bit special—because although I theoretically have the right to sell Tolkien related material to other editors—I don't. I go back to HarperCollins and ask what they think of it and quite often they refuse because the covers are quite intimately tied to the books. It's a bit of a gray area; so I prefer to abide by their decisions.

The Lord of the Rings series of board games is your first experience with game illustration. What are the similarities/differences between game illustration and other kinds of illustration?

There are graphic differences because it's quite cluttered. The illustrations had to accomodate massive amounts of playing squares and text. So it meant doing something tone on tone with only a very small area where you could really let the contrast come to the front. There were also a great number of cards. It's hard to slow down and treat them properly, as illustrations rather than just whacking them out. You tend to imagine all the cards at once and then it's hard to keep your concentration on any one when you're doing it.

Is there anything you wish someone had told you in the early days of your career?

Lots of things, though they're not things that you're apt to listen to when you're starting out. It is your living, after all. You must never undersell yourself. It's very difficult when you've been

contacted by an editor and you're trying to figure out how much you should ask for the job and they say, "Well what do you want, what's your fee?" You may be so happy to have the job initially and you don't want to scare them off by being too expensive. On the other hand, you can't expect the same fees as someone more well known. This is why agents are so useful. Agents can talk about money without getting embarrassed.

You said, "Drawing must seek for interest not admiration, because admiration wears quickly." Do you think this philosophy is responsible for your success?

Well, I'd like to think so. I'm not a big fan of these artists who basically take a body-building magazine or an issue of *Playboy* and put a dragon behind the girl and make it into a piece of art. I loved that when I was a kid, because it is a question of admiration, you admire the technique and all the gloss. You're basically blown away by how well done it is. But it's all on the surface. It doesn't matter if something is technically quite flashy. That's not where the interest is. I really believe there is a strong value to narrative painting that goes much deeper than appearances.

I think you've either got something to say or you don't. And if you have not a terrible amount to say but a really flashy technique, that's fine. You can get away with that sort of thing for ages and it will appeal to adolescent boys at 18, but it may not have the depth to carry it through into something a little more serious and a little deeper.

Did you have any reservations about *The Lord of the Rings* movies?

Yes, for a quarter of a second or so! I was so embarrassed when they phoned up because I didn't have a clue who Peter Jackson was. I couldn't just ask on the phone, "excuse me—how many movies have you made?" So it was really quite a leap into deep water. But there were no risks involved, because the whole family went down to New Zealand. With such an opportunity, if it doesn't work out you just come back.

Gandalf in his trademark hat and cloak as depicted by John Howe. This particular image is part of The Lord of the Rings Boardgame, produced by Sophisticated Games.

© 2000 Sophisticated Games Ltd.

What was it like suddenly being surrounded by all these people entrenched in Tolkien world creation?

It was great. It was very strange. New Zealand is already a world apart; while it's culturally American, English, European, it's geographically so far away that you feel a bit out of touch. And then we were working away in this other parallel world—Middle Earth—and it was quite disorienting but enormous fun. Added to that was the enormous privilege of meeting Alan Lee. After years of wanting to one day meet him, here we were working in the same office.

There was a real spirit there—people who worked on the project consistently say this—a real Fellowship of interest and enthusiasm, knowing that there's not going to be a remake of this film in our lifetimes. You know that it is something special. But that doesn't mean there's something intrinsic which will make it work; you still have to work hard. We worked 10 to12 hours a day—drawing straight—which is unimaginably difficult. But there was a real momentum behind it all. You carry part of it and part of you is carried by it.

Direct Mail Workshop: Proven Methods for Promoting Your Work

So you're ready to launch your freelance art or gallery career. How do you let people know about your talent? One way is by introducing yourself to them by sending promotional samples. Samples are your most important sales tool so put a lot of thought into what you send. Your ultimate success depends largely on the impression they make.

We divided this article into three sections, so whether you are a fine artist, illustrator or designer, check the appropriate heading for guidelines. Read individual listings and section introductions thoroughly for more specific instructions.

As you read the listings, you'll see the term SASE, short for self-addressed, stamped envelope. Enclose a SASE with your submissions if you want your material returned. If you send postcards or tearsheets, no return envelope is necessary. Many art directors this year specify they only want nonreturnable samples. More and more, busy art directors do not have time to return samples, even with SASEs. So read listings carefully and save stamps!

Illustrators and cartoonists

You will have several choices when submitting to magazines, book publishers and other illustration and cartoon markets. Many freelancers send a cover letter and one or two samples in initial mailings. Others prefer a simple postcard showing their illustrations. Here are a few of your options:

Postcard. Choose one (or more) of your illustrations or cartoons that is representative of your style, then have the image printed on postcards. Have your name, address and phone number printed on the front of the postcard, or in the return address corner. Somewhere on the card should be printed the word "Illustrator" or "Cartoonist." If you use one or two colors you can keep the cost below $200. Art directors like postcards because they are easy to file or tack on a bulletin board. If the art director likes what she sees, she can always call you for more samples.

Promotional sheet. If you want to show more of your work, you can opt for an 8×12 color or black and white photocopy of your work. If you send 8×12 photocopies or tearsheets, do not fold them in thirds. It is more professional to send them flat, not folded, in a 9×12 envelope, along with a typed query letter, preferably on your own professional stationery.

Tearsheets. After you complete assignments, acquire copies of any printed pages on which your illustrations appear. Tearsheets impress art directors because they are proof that you are experienced and have met deadlines on previous projects.

Photographs. Some illustrators have been successful sending photographs, but printed or photocopied samples are preferred by most art directors. It is probably not practical or effective to send slides.

Query or cover letter. A query letter is a nice way to introduce yourself to an art director for the first time. One or two paragraphs stating you are available for freelance work is all you need. Include your phone number, samples or tearsheets.

E-mail submissions. E-mail is another great way to introduce your work to potential clients. When sending e-mails provide a link to your website or attach files of your best work. Humorous illustrators and cartoonists should follow the same guidelines as illustrators when submitting to publishers, greeting card companies, ad agencies and design firms. Professional-looking photo-

copies work well when submitting multiple cartoons to magazines. When submitting to syndicates, refer to the introduction for that section on page 512.

Designers and computer artists

Plan and create your submission package as if it were a paying assignment from a client. Your submission piece should show your skill as a designer. Include one or both of the following:

Cover letter. This is your opportunity to show you can design a beautiful, simple logo or letterhead for your own business card, stationery and envelopes. Have these all-important pieces printed on excellent quality bond paper. Then write a simple cover letter stating your experience and skills.

Sample. Your sample can be a copy of an assignment you have done for another client, or a clever self-promotional piece. Design a great piece to show off your capabilities. For ideas and inspiration, browse through *Fresh Ideas in Promotion 2*, by Betsy Newberry and *Creative Self-Promotion on a Limited Budget*, by Sally Prince Davis (North Light Books).

Stand out from the crowd

You may only have a few seconds to grab art directors' attention as they make their way through the "slush" pile (an industry term for unsolicited submissions). Make yourself stand out in simple, effective ways:

Tie in your query letter with your sample. When sending an initial mailing to a potential client, include a query letter of introduction with your sample. Type it on a great-looking letterhead of your own design. Make your sample tie in with your query letter by repeating a design element from your sample onto your letterhead. List some of your past clients within your letter.

Send artful invoices. After you complete assignments, a well-designed invoice (with one of your illustrations or designs strategically placed on it, of course) will make you look professional and help art directors remember you (and hopefully, think of you for another assignment!)

Follow up with seasonal promotions. Many illustrators regularly send out holiday-themed promo cards. Holiday promotions build relationships while reminding past and potential clients of your services.

It's a good idea to get out your calendar at the beginning of each year and plan some special promos for the year's holidays.

Are portfolios necessary?

You do not need to send a portfolio when you first contact a market. But after buyers see your samples they may want to see more, so have a portfolio ready to show.

Many successful illustrators started their careers by making appointments to show their portfolios. But it is often enough for art directors to see your samples.

Some markets in this book have drop-off policies, accepting portfolios one or two days a week. You will not be present for the review and can pick up the work a few days later, after they've had a chance to look at it. Since things can get lost, include only duplicates that can be insured at a reasonable cost. Only show originals when you can be present for the review. Label your portfolio with your name, address and phone number.

Portfolio pointers

The overall appearance of your portfolio affects your professional presentation. It need not be made of high-grade leather to leave a good impression. Neatness and careful organization are essential whether you are using a three-ring binder or a leather case. The most popular portfolios are simulated leather with puncture-proof sides that allow the inclusion of loose samples. Choose a size that can be handled easily. Avoid the large, "student" size books which are too big to fit easily on an art director's desk. Most artists choose 11×14 or 18×24. If you are a fine artist and your work is too large for a portfolio, bring your slides and a few small samples.

All of Robert Pizzo's samples have one crucial thing in common. They are instantly recognizable as a Pizzo image no matter what subject matter is portrayed. Pizzo makes sure when designing each of his promo pieces, his "brand" comes across loud and clear. How does he do this? By having not only a signature style, but also a consistent format for his name and contact information. He also uses a consistent color palette which helps jog art directors' memories about his work. As in this sample, Pizzo often incorporates one of his past assignments to further demonstrate that he's an experienced professional.

- Don't include everything you've done in your portfolio. Select only your best work and choose pieces germane to the company or gallery you are approaching. If you're showing your book to an ad agency, for example, don't include greeting card illustrations.
- In reviewing portfolios, art directors look for consistency of style and skill. They sometimes like to see work in different stages (roughs, comps and finished pieces) to see the progression of ideas and how you handle certain problems.
- When presenting your portfolio, allow your work to speak for itself. It's best to keep explanations to a minimum and be available for questions if asked. Prepare for the review by taking along notes on each piece. If the buyer asks a question, take the opportunity to talk a little bit about the piece in question. Mention the budget, time frame and any problems you faced and solved. If you are a fine artist, talk about how the piece fits into the evolution of a concept, and how it relates to other pieces you've shown.
- Don't ever walk out of a portfolio review without leaving the buyer a business card or sample to remember you by. A few weeks after your review, follow up by sending a small promo postcard or other sample as a reminder.

Business cards are one of the most important investments for artists. There are so many occasions to hand them out—openings, meetings, weddings. You'll be amazed at how useful they are, and at the callbacks you get. You can also include them in mailings. The most effective include an image of the artist's work right on the card, along with name address, phone number, e-mail and website.

Chris Trevas
1434 Crimson Way
Walled Lake, MI 48390
248•669•2032
chris@christrevas.com

TREVAS
ILLUSTRATION
WWW.CHRIS TREVAS.COM

© Chris Trevas

GUIDELINES FOR FINE ARTISTS

Send a 9×12 envelope containing material galleries request in their listings. Usually that means a query letter, slides and résumé, but check each listing. Some galleries like to see more. Here's an overview of the various components you can include:

- **Slides.** Send 8-12 slides of similar work in a plastic slide sleeve (available at art supply stores). To protect slides from being damaged, insert slide sheets between two pieces of cardboard. Ideally, slides should be taken by a professional photographer, but if you must take your own slides, refer to *The Quick & Easy Guide to Photographing Your Artwork*, by Roger Saddington (North Light Books). Label each slide with your name, the title of the work, media, and dimensions of the work and an arrow indicating the top of the slide. Include a list of titles and suggested prices they can refer to as they review slides. Make sure the list is in the same order as the slides. Type your name, address and phone number at the top of the list. Don't send a variety of unrelated work. Send work that shows one style or direction.
- **Query letter or cover letter.** Type one or two paragraphs expressing your interest in showing at the gallery, and include a date and time when you will follow up.
- **Résumé or bio.** Your résumé should concentrate on your art-related experience. List any shows your work has been included in and the dates. A bio is a paragraph describing where you were born, your education, the work you do and where you have shown in the past.

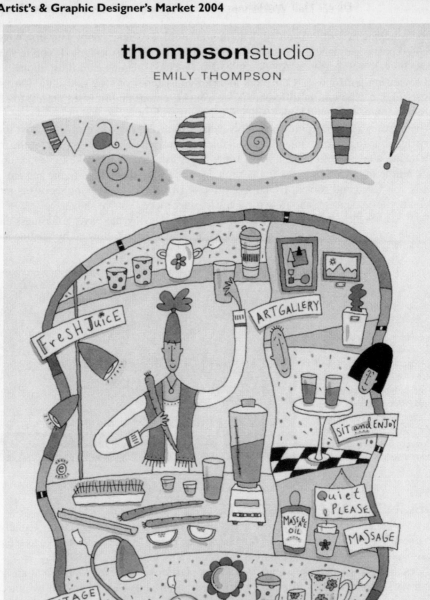

Emily Thompson showcases her identifiable style in postcard mailings to potential clients. She sticks to a color palette which helps "brand" her illustration identity. Using the name "thompson studio" also sets her apart and adds a professional note to her whimsical style. She often adds words to her illustrations in her own lettering style, so she makes sure to show this aspect in each sample she sends.

- **Artist's statement.** Some galleries require a short statement about your work and the themes you are exploring. Your statement should show you have a sense of vision. It should also explain what you hope to convey in your work.
- **Portfolios.** Gallery directors sometimes ask to see your portfolio, but they can usually judge from your slides whether your work would be appropriate for their galleries. Never visit a gallery to show your portfolio without first setting up an appointment.
- **SASE.** If you need material back, don't forget to include a SASE.

What You Should Know About Copyright

As creator of your artwork, you have certain inherent rights over your work and can control how each one of your artworks is used, until you sell your rights to someone else. The legal term for these rights is called **copyright**. Technically, any original artwork you produce is automatically copyrighted as soon as you put it in tangible form.

To be automatically copyrighted, your artwork must fall within these guidelines:

- **It must be your *original* creation.** It cannot be a *copy* of somebody else's work.
- **It must be "pictorial, graphic or sculptural."** Utilitarian objects, such as lamps or toasters, are not covered, although you can copyright an illustration featured on a lamp or toaster.
- **It must be fixed in "any tangible medium, now known or later developed."** Your work, or at least a representation of a planned work, must be created in or on a medium you can see or touch, such as paper, canvas, clay, a sketch pad, or even a website. It can't just be an idea in your head. An idea cannot be copyrighted.

Copyright lasts for your lifetime plus seventy years

Copyright is *exclusive*. When you create a work, the rights automatically belong to you and nobody else but you until you sell those rights to someone else.

In October 1998, Congress passed the Sonny Bono Copyright Term Extension Act, which extended the term of U.S. copyright protection. Works of art created on or after January 1978 are protected for your lifetime plus 70 years.

The artist's bundle of rights

One of the most important things you need to know about copyright is that it is not just a *singular* right. It is a *bundle* of rights you enjoy as creator of your artwork. Let's take a look at the five major categories in your bundle of rights and examine them individually:

- **Reproduction right.** You have the right to make copies of the original work.
- **Modification right.** You have the right to create derivative works based on the original work.
- **Distribution rights.** You have the right to sell, rent or lease copies of your work.
- **Public performance right.** The right to play, recite or otherwise perform a work. (This right is more applicable to written or musical art forms than visual art.)
- **Public display right.** You have the right to display your work in a public place.

This bundle of rights can be divided up in a number of ways, so that you can sell all or part of any of those exclusive rights to one or more parties. The system of selling parts of your copyright bundle is sometimes referred to as **"divisible" copyright**. Just as a land owner could divide up his property and sell it to many different people, the artist can divide up his rights to an artwork and sell portions of those rights to different buyers.

Divisible copyright: divide and conquer

Why is this so important? Because dividing up your bundle and selling parts of it to different buyers will help you get the most payment from each of your artworks. For any one of your

artworks, you can sell your entire bundle of rights at one time (not advisable!) or divide and sell each bundle pertaining to that work into smaller portions and make more money as a result. You can grant one party the right to use your work on a greeting card and sell another party the right to print that same work on T-shirts.

Clients tend to use legal jargon to specify the rights they want to buy. The terms below are commonly used in contracts to specify portions of your bundle of rights. Some terms are vague or general, such as "all rights;" others are more specific, such as "first North American rights." Make sure you know what each term means.

Divisible copyright terms

- **One-time rights.** Your client buys the right to use or publish your artwork or illustration on a one-time basis. One fee is paid for one use. Most magazine and bookcover assignments fall under this category.
- **First rights.** This is almost the same as purchase of one-time rights, except that the buyer is also paying for the privilege of being the first to use your image. He may use it only once unless the other rights are negotiated.

 Sometimes first rights can be further broken down geographically when a contract is drawn up. The buyer might ask to buy **first North American rights,** meaning he would have the right to be the first to publish the work in North America.
- **Exclusive rights.** This guarantees the buyer's exclusive right to use the artwork in his particular market or for a particular product. Exclusive rights are frequently negotiated by greeting card and gift companies. One company might purchase the exclusive right to use your work as a greeting card, leaving you free to sell the exclusive rights to produce the image on a mug to another company.
- **Promotion rights.** These rights allow a publisher to use an artwork for promotion of a publication in which the artwork appeared. For example, if *The New Yorker* bought promotional rights to your cartoon, they could also use it in a direct mail promotion.
- **Electronic rights.** These rights allow a buyer to place your work on electronic media such as websites. Often these rights are requested with print rights.
- **Work for hire.** Under the Copyright Act of 1976, section 101, a "work for hire" is defined as "(1) a work prepared by an employee within the scope of his or her employment; or (2) a work . . . specially ordered or commissioned for use as a contribution to a collective, as part of a motion picture or audiovisual work or as a supplementary work . . . if the parties expressly agree in a written instrument signed by them that the work shall be considered a work made for hire." When the agreement is "work for hire" you surrender all rights to the image and can never resell that particular image again. If you agree to the terms, make sure the money you receive makes it well worth the arrangement.
- **All rights.** Again, be very aware that this phrase means you will relinquish your right to a specific artwork. Before agreeing to the terms, make sure this is an arrangement you can live with. At the very least, arrange for the contract to expire after a specified date. Terms for all rights—including time period for usage and compensation—should be confirmed in a written agreement with the client.

Since legally your artwork is your property, when you create an illustration for a magazine you are, in effect, temporarily "leasing" your work to the client for publication. Chances are you'll never hear an art director ask to lease or license your illustration, and he may not even realize he is leasing, not buying your work. But most art directors know that once the magazine is published, the art director has no further claims to your work and the rights revert back to you. If the art director wants to use your work a second or third time, he must ask permission and negotiate with you to determine any additional fees you want to charge. You are free to take that same artwork and sell it to another buyer.

However, had the art director bought "all rights," you could not legally offer that same image to another client. If you agreed to create the artwork as "work for hire," you relinquished your rights entirely.

What licensing agents know

The practice of leasing parts or groups of an artist's bundle of rights is often referred to as **"licensing,"** because (legally) the artist is granting someone a "license" to use his work for a limited time for a specific reason. As licensing agents have come to realize, it is the exclusivity of the rights and the ability to divide and sell them that make them valuable. Knowing exactly what rights you own, which you can sell, (and in what combinations) will help you negotiate with your clients.

Don't sell conflicting rights to different clients

You also have to make sure the rights you sell to one client don't conflict with any of the rights sold to other clients. For example, you can't sell the exclusive right to use your image on greeting cards to two separate greeting card companies. You *can* sell the exclusive greeting card rights to one card company and the exclusive rights to use your artwork on mugs to a separate gift company. It's always good to get such agreements in writing and to let both companies know your work will appear on other products.

When to use the Copyright © and credit lines

A copyright notice consists of the word "Copyright" or its symbol ©, the year the work was created or first published, and the full name of the copyright owner. It should be placed where it can easily be seen, on the front or back of an illustration or artwork. It's also common to print your copyright notice on slide mounts or onto labels on the back of photographs.

Under today's laws, placing the copyright symbol on your work isn't absolutely necessary to claim copyright infringement and take a plagiarist to court if he steals your work. If you browse through magazines, you will often see the illustrator's name in small print near the illustration, *without* the Copyright ©. This is common practice in the magazine industry. Even though the © is not printed, the illustrator still owns the copyright unless the magazine purchased all rights to the work. Just make sure the art director gives you a credit line near the illustration.

Usually you will not see the artist's name or credit line alongside advertisements for products. Advertising agencies often purchase all rights to the work for a specified time. They usually pay the artist generously for this privilege and spell out the terms clearly in the artist's contract.

How to register a copyright

To register your work with the U.S. Copyright Office, call the Copyright Form Hotline at (202) 707-9100 and ask for package 115 and circulars 40 and 40A. Cartoonists should ask for package 111 and circular 44. You can also write to the Copyright Office, Library of Congress, Washington DC 20559, Attn: Information Publications, Section LM0455.

You can also download forms from the Copyright Office website at http://loc.gov/copyright. Whether you call or write, they will send you a package containing Form VA (for visual artists). Registering your work costs $30.

After you fill out the form, return it to the Copyright Office with a check or money order for $30, a deposit copy or copies of the work and a cover letter explaining your request. For almost all artistic work, deposits consist of transparencies (35mm or $2\frac{1}{4} \times 2\frac{1}{4}$) or photographic prints (preferably 8×10). Send one copy for unpublished works; two copies for published works.

You can register an entire collection of your work rather than one work at a time. That way you will only have to pay one $30 fee for an unlimited number of works. For example if you have created a hundred works since 2000, you can send a copyright form VA to register "the

collected work of Jane Smith, 2000-2002." But you will have to send either slides or photocopies of each of those works.

Why register?

It seems like a lot of time and trouble to send in the paperwork to register copyrights for all your artworks. It may not be necessary or worth it to you to register every artwork you create. After all, a work is copyrighted the moment it's created anyway, right?

The benefits of registering are basically to give you additional clout in case an infringement occurs and you decide to take the offender to court. Without a copyright registration, it probably wouldn't be economically feasible to file suit, because you'd be only entitled to your damages and the infringer's profits, which might not equal the cost of litigating the case. Had works been registered with the U.S. Copyright office it would be easier to prove your case and get reimbursed for your court costs.

Likewise, the big advantage of using the copyright © also comes when and if you ever have to take an infringer to court. Since the copyright © is the most clear warning to potential plagiarizers, it is easier to collect damages if the © is in plain sight.

Register works you fear are likely to be plagiarized with the U.S. Copyright Office before or shortly after they have been exhibited or published. That way, if anyone uses your work without permission, you can take action.

Deal swiftly with plagiarists

If you suspect your work has been plagiarized and you have not already registered it with the Copyright Office, register it immediately. You have to wait until it is registered before you can take legal action against the infringer.

Before taking the matter to court, however, your first course of action might be a well-phrased letter from your lawyer telling the offender to "cease and desist" using your work, because you have a registered copyright. Such a warning (especially if printed on your lawyer's letterhead) is often enough to get the offender to stop using your work.

Don't sell your rights too cheaply

Recently a controversy has been raging about whether or not artists should sell the rights to their work to stock illustration agencies. Many illustrators strongly believe selling rights to stock agencies hurts the illustration profession. They say artists who deal with stock agencies, especially those who sell royalty free art, are giving up the rights to their work too cheaply.

Another pressing copyright concern is the issue of electronic rights. As technology makes it easier to download images, it is more important than ever for artists to protect their work against infringement.

Log on to www.theispot.com and discuss copyright issues with your fellow artists. Join organizations that crusade for artists' rights, such as the Graphic Artist's Guild (GAG) or The American Institute of Graphic Arts (AIGA). Volunteer Lawyers for the Arts is a national network of lawyers who volunteer free legal services to artists who can't afford legal advice. A quick search of the web will help you locate a branch in your state. Most branches offer workshops and consultations.

Stamp Design: Get Your Artwork on Everyone's Mail

BY WAYNE L. YOUNGBLOOD

If the idea of having your artwork reproduced thousands, if not millions of times and seen and used by individuals all over the world appeals to you, then you may wish to consider entering the world of stamp design. This difficult, but gratifying field will present you with challenges not faced with many other types of illustration, but can pay off in more ways than one.

Stamps are used for many purposes, including paying postage for letters and raising revenue for various forms of taxation or charities. Other stamps are released mostly for their interest to collectors. In each case, those responsible for stamp designs want them attractive, well-executed and, usually, difficult to counterfeit.

Overview of the market

Postage stamps are broken down into two main categories; definitives, which are usually small-format (often one-inch square) workhorse stamps, and commemoratives, which are slightly larger in format and generally honor a person, place or event. The workhorse stamps are so labeled because they are the most common form of stamp encountered, such as the ubiquitous Flag stamps. They are printed in quantities of several hundred million or more at a time and are often reprinted as needed. Commemoratives, on the other hand, are more limited in printing and distribution and frequently have a single printing of a mere 20 to 300 million stamps.

If you are interested in stamp design you should have a strong basic knowledge of printing processes, such as line-engraved intaglio, photogravure and offset lithography, as the final printing process frequently determines the most effective media and style for a stamp.

As an artist residing in North America, you have several choices of potential stamp design markets. These include the United States Postal Service, Inter-Governmental Philatelic Corporation, Unicover Corporation, the Federal Duck Stamp Office, and numerous state fish and wildlife offices.

United States Postal Service

The USPS, which creates all stamps and postal items for the United States, produces more than 100 different stamp designs per year and works with numerous artists in many different styles. The ideas for these stamps are distilled by the Citizens' Stamp Advisory Committee from more than 25,000 submitted annually. CSAC is a 14-member committee chosen by the Postmaster General. The committee is made up of artists, historians, stamp collectors and others with a special interest in stamps or stamp design. The process for stamp selection is very different from that of design selection, although both functions are handled by CSAC.

Once a stamp subject is selected (USPS generally works at least 2-3 years ahead), the concept is turned over to design coordinators who work towards finding the most appropriate artist and medium for the stamp. Once an artist is identified, the design coordinators communicate the specifications of the stamp in question, which often dictates the medium used. An artist then submits preliminary sketches to be approved or refined.

WAYNE L. YOUNGBLOOD *is editor of* Stamp Collector *magazine. To learn even more about the world of stamps visit www.stampcollector.net.*

Nicholas Gaetano's dramatic portrait of Ayn Rand, author of *The Fountainhead* and *Atlas Shrugged*, was part of the United States Postal Service's Literary Arts stamp series. The series included images of 16 authors, including F. Scott Fitzgerald and Zora Neale Hurston. Gaetano, who is known for his art deco style, created several versions of the proposed stamp. Ultimately, the vertical stamp design was chosen.

Once the basic design has been approved, the artist is then charged with the task of providing a finished stamp design to CSAC. When the final artwork is approved it is sent to one of several printing contractors that produce stamps for the USPS. Most U.S. stamps are now printed by offset lithography, allowing the artist a great deal of freedom in terms of color and design. Nonetheless, designing postage stamps is a difficult task.

According to Terry McCaffrey, who is manager of stamp development, USPS is "trying to break molds and find unique and fresh styles of art. Successful stamp design is particularly difficult," says McCaffrey, "because the artwork has to be strong enough to work effectively when reduced and reproduced at postage stamp size." Indeed, most designs created for postage stamps range somewhere between two and four times the size of the finished stamp. This can mean working somewhere between 2 inches by 2 inches and 4 inches by 6 inches on average, either with traditional media or on the computer. Thus, a finished stamp design must be complex enough to communicate an event or concept, yet simple enough to be reproduced small, while leaving enough space for necessary text and the denomination, or value.

USPS typically works with a regular stable of artists that have proven themselves, but is always open to new talent, although the postal agency does not accept unsolicited artwork. Assignments are given, based on set criteria and fees are set at $5,000 per finished accepted design. A $1,500 fee also is paid for requested finished stamp designs that are not used. The USPS buys all rights to finished artwork and all preliminary versions as well, but the prestige of having your artwork reproduced anywhere between 25 million and 350 million times can do wonders for your career. If you wish to be considered for a stamp design assignment, you should request a copy of the Creating U.S. Postage Stamps, brochure, available from:

U.S. Postal Service
Stamp Development
ATTN: Stamp Design
475 L'Enfant Plaza SW, Room 5670
Washington, DC 20260-2437

More information about CSAC and the stamp selection process may be found on the USPS website at: www.usps.com/communications/organization/csac.htm.

Inter-Governmental Philatelic Agency

Inter-Governmental Philatelic Agency designs and produces postage stamps for numerous countries worldwide, ranging from Israel to St. Vincent. The company, which also has a strong interest in creating stamps for collectors, produces hundreds of different stamps per year and works with 75-100 different artists per year.

"We have seen work from many great graphic artists who can't work on stamps," according to Mordechai Friedman, director of the art and production department for IGPC. "Stamp design is very challenging, due to its small size." Designs used by IGPC range from single designs to large continuous works that span several stamps, and much of the artwork used is highly representational.

While IGPC prefers to work with artists located in the New York Metropolitan area (and only by assignment), the firm is open to queries from artists from all over who feel they can offer solid design skills. Friedman stresses, however, that interested artists should be not only conversant with different traditional media, but should have strong computer design skills as well.

If you are interested in working with IGPC, you should first send samples to the Art Dept., IGPC, 460 W. 34th St., 10th Floor, New York, NY 10001. If interested, the art director will contact you for a portfolio review. Full contact information and requirements for IGPC are found elsewhere in this volume.

Unicover

Another firm that offers an incredible array of opportunities for the artist is the Unicover Corporation, of Cheyenne, WY. Unicover represents, designs and produces stamps for several countries, including the Marshall Islands. In addition, the firm produces many cachets (special illustrated envelopes for collectors), duck stamps for other countries and numerous stamp collecting-related products. Unicover also is responsible for product design for other firms in need of artwork, such as the Royal Mint, Audubon Society and the Wildlife Federation (each of which produces stamp-like seals).

According to Unicover President Jim Helzer, "Some of the best artists we've used have come out of the blue. We prefer to develop long-term relationships with our artists," Helzer continued, "but we are always interested in refreshing our stable of artists. We've worked with some artists for more than 25 years." During that time Unicover has commissioned 12,000-13,000 original works of art. All work is done by assignment.

If you submit portfolio examples to Unicover, you may have them returned if you wish, according to Helzer, after copies are made for reference. If the company is interested, it will respond with a letter confirming that copies of your artwork have been placed in a prospective artists file. Unlike many firms, Helzer stresses, "Unicover actively uses these files when making assignments." This means that rather than having your information disappear into a black hole, you may eventually receive an assignment, which, if successfully completed, may well be the first of many.

Unicover works with more than 50 different artists each year to create an average of 300-500 pieces of artwork. The firm not only buys all rights, but the originals as well. Although Helzer was hesitant to set a fee range, the firm frequently pays $1,000-5,000 per finished work and more for large series.

The artwork used for most Unicover projects is generally representational work (often watercolor or acrylic) that commemorates specific events. Helzer also states that the firm is using more computer art and is always open to photography.

If you wish to contact Unicover Corp., samples should be sent to the Unicover Corporation, Department A2, 1 Unicover Center, Cheyenne, WY 82008-0001.

Federal Duck Stamp Office

The Federal Duck Stamp Office produces only one stamp per year, but has successfully launched or boosted the careers of many wildlife artists. Although there is no fee paid per se, the financial benefits of winning are substantial, as are the public relations opportunities.

In this case, the stamp design selection is done through open competition. The winner not only has his or her artwork used for the following year's federal duck stamp, but also retains the copyright. This is important, since prints are made and sold on behalf of the artist each year, providing a healthy income.

Interested artists must enter their artwork, usually between July 1 and August 31 each year, to be judged usually in November. There is a $100 entry fee, and all entries must have an image size of $7'' \times 10''$. All art must be original and must be biologically correct for the species represented.

Each year's judging team is composed of artists, duck stamp experts and wildlife conservationists and is aided by stamp production specialists and marine biologists. Each judge may serve only once in his or her lifetime.

For a full listing of duck stamp contest regulations and guidelines, go to http://duckstamps.fws .gov (and click on Federal Duck Stamp Contest Regulations), or write to the Federal Duck Stamp Contest, U.S. Dept. of the Interior, 1849 C St. NW, Suite 2058, Washington, DC 20240.

In addition to the federal duck stamp contest, many states feature their own contests for stamp designs for duck, goose, trout and other wildlife revenue stamps. Information may be located on the internet or by writing to the state wildlife office of each state.

If you are contemplating creating artwork for stamps, you may well wish to obtain a reduction glass to help you design more effectively. A reduction glass, available through many art supply stores, resembles a magnifying glass. However, it reduces a 4-inch by 6-inch image to stamp size so you will be able to see whether you are communicating your concept effectively in miniature. Good luck!

Artist's & Graphic Designer's Market Success Stories

BY DONYA DICKERSON

If you have a copy of this book, it likely means two things: You are an artist or graphic designer, and you want to sell your work. Perhaps you are a seasoned artist looking for new markets. Or maybe you are thinking about sending your work out for the first time. Either way, congratulations. You have done what a lot of people never have—you have taken the first step necessary to achieve your dream.

Nevertheless, sending out your work can seem like a daunting task. There are a more than 2,000 listings in this book. But that's good news for you. That means more opportunities and more markets that might be interested in the type of work you do.

The three artists in this article—Carrie Wild, Joanna Miller, and Steve Stanley—were probably overwhelmed the first time they decided to send out their work. Nevertheless, they buckled down and sent out mailings—and all with tremendous success. As you read about them, learn how they got started, how they attracted the attention of markets, and how they launched their careers as artists. And finally, take inspiration from them! They've done it—so can you.

CARRIE WILD

If Carrie Wild could offer one piece of advice to other artists, it would be to read. "There are so many helpful, clearly written resources," says Wild. "They are all full of information on the business of being an artist." When she decided to start sending out her delicate ink and watercolor illustrations, she used *Artist's and Graphic Designer's Market* and *Children's Writer's & Illustrator's Market* as her main sources of information.

Wild read through the listing in sections she was interested in, specifically greeting card companies, book publishers, magazines, posters and prints, and record labels. But that was just the first step. She also targeted her listings very carefully. According to Wild, "I checked out the companies' websites. This step helped me decide if the company's 'look' was right for my style of work. I then sent out approximately 250 postcards printed with a favorite image of mine to those who had made it onto my new mailing list."

Responses to her mailing came almost immediately. "Some places sent letters or e-mails requesting additional samples, so I sent out returnable mini-portfolios that I had made specifically for this purpose. Some publishers sent letters stating that they didn't have projects available at the moment, but that they would keep my sample on file. In returning a mini-portfolio, one senior editor from a large children's publishing company included a handwritten note asking

DONYA DICKERSON *is an Associate Editor at McGraw-Hill books, specializing in business and career titles. She's a previous editor for Writer's Digest Books and was editor for three editions of* Guide to Literary Agents.

© Carrie Wild

Carrie Wild showcases her distinctive style on her promotional materials. She came up with a name—Wildworks—and designed a brand identity to unify all her promotions.

that I please continue to send samples. It was very heartening to find that people were interested in my work."

As she continued to submit her work, Wild carefully considered what types of companies would be most interested in her unique style. "I usually draw things from the natural world (plants, animals, and insects). Some of my illustrations are geared towards children and picture quirky or whimsical animals. I think my style is well suited for the greeting card industry, and I have had the most success with this industry so far." She has licensed to greeting card companies such as Sunrise Greetings/InterArt Distribution and Allport Editions—companies she found in *AGDM*.

Wild, who calls her illustration business Wildworks, has also had success selling originals and prints through local galleries. This accomplishment was made through a willingness to try new types of work and be open to new ways of marketing her work. "A couple of years ago," she explains, "I decided to have some giclée prints made of my work to sell at a local art fair. When I got to the printer's to view the proofs, she was looking through my work with another client, who was also having some work done. It turned out that this client owned a local gallery, was very interested in my work, and asked if I would be interested in signing with him. I hadn't even planned on approaching galleries—it seemed too daunting in the face of everything else I was trying to do. But I investigated this gallery and found them to be well established and reputable and consigned five paintings with them—all of which sold immediately. So I've discovered that even if sometimes I feel like I'm struggling in the market, I keep taking small steps and trying new things, because as long as you keep moving, you're moving forward."

Wild's final piece of advice to artists: "Be persistent! A person can be the most talented artist out there, but if they don't work at promoting their art, they won't get anywhere. It's important to establish a regular mailing schedule and promote your work whenever you can, wherever you can. We all have dry spells, but it's so important to keep working at it. I would much rather work hard

than just give up in discouragement, spending the rest of my life wondering about what could have been." And Wild has every intention of following her own advice in the future. "I am really interested in illustrating for children, but this seems to be a tougher market to break into for me. I plan to continue targeting publishers with mailings specially designed for this niche."

JOANNA MILLER

After the birth of her son, Joanna Miller decided to put her free-lance design career on hold. Nevertheless, she continued to purchase *Artist's & Graphic Designer's Market* to look for new markets and to read the articles, keeping the information she learned in the back of her head. For example, one year she read about an artist who had been successful contacting art directors via e-mail instead of by traditional mailers. "The idea really struck with me," says Miller.

When her husband Eric lost his job as a technology manager, Miller knew she needed to return to freelancing to make ends meet. "I remembered reading about that artist and decided to do the same thing. I created an online portfolio and began e-mailing art directors. That is how I contacted Pitspopany Press." The art director at this small press specializing in children's books for the Jewish market expressed a great interest in her work and hired her to illustrate *The Brass Serpent*, a children's picture book written by Caldecott honoree Eric Kimmel. Miller believes small presses are a great opportunity for someone trying to break into book illustration. "The advantage of a small press is that they are usually more open to first-time book artists and love a diversity of style."

In addition to finding her book publisher through *AGDM*, Miller also used it to find a market

Joanna Miller was very excited when she got the assignment to illustrate *The Brass Serpent*, a book written by Caldecott winner and beloved children's book author, Eric Kimmel.

for her postal design work. She discovered a listing for IGPC and contacted its art director Jennifer Newman. "I arranged to meet with her and show her my portfolio," explains Miller. "Although I didn't have any experience in postal design, she was willing to give me a chance. Over time, I was allowed not only to explore both traditional and nontraditional forms of illustration but also to employ my graphic design and pre-press skills." She now has over 300 stamp issue designs, including stamps for Disney's *A Bug's Life*, Orchids of the World for Micronesia, and an Elle Macpherson commemorative issue stamp for Antigua. "One of the highlights of my career," says Miller, "was when David Letterman showed the Elle Macpherson stamps on his show." For more information on breaking into the stamp market, see page 31.

When contacting any art director, Miller recommends that artists take a personal approach. "A postcard of an artist's work will only be filed away. The artist needs to summon the courage to call him directly and make an appointment to meet in person. Something about that eye-to-eye contact is invaluable. It is also important to follow up with a note of some sort or a thank-you card. Every chance to make contact beyond the initial meeting will only boost an artist's image."

And above all, Miller believes a professional portfolio is key to impressing an art director. "When you make the initial person-to-person contact with the art director, make sure your portfolio is in perfect condition. Art directors don't care to see an artist lugging around canvases. They only care how a piece looks in reproduction. Color photocopies or high-quality printouts work very well. A portfolio should consist of anywhere from 12 to 15 exceptional examples of your work. These examples should be presented in a neatly bound professional portfolio." For an example of an electronic portfolio, check out Miller's website: www.dreamscapestudio.com.

For Miller, her husband's job loss turned out to be a blessing in disguise. Together they run Dreamscape Studios, and Miller has branched out by selling her work into several new markets, including Cadmus Communications, the Westhampton Playhouse, the Brooklyn Community Center, and Stop & Shop. In addition, his job had been in the vicinity of the World Trade Center, and he would have been there on September 11. They both count themselves very lucky.

STEVE STANLEY

Steve Stanley used *Artist's & Graphic Designer's Market* to launch his career in the world of illustrating licensed cartoon characters. His first step for breaking into this coveted market was researching the listings. "What I did," says Stanley, "was find companies who had a licensing program and submitted work to them. Out of 25 promo packs I sent out back in 1996, I ended up with 5 good contacts. These companies kept me busy for nearly five years."

Sherry Manufacturing was one of those five companies he developed a long-term working relationship with. A leading screen printer, Sherry Manufacturing is licensed by several major companies—including the Walt Disney Company, Warner Bros., Nickelodeon, Peanuts, and King Features—to make souvenir apparel. "I worked for them consistently for nearly five years," says Stanley. "I'm still in contact with the art director, Kenny Oliver, and he and his family have even been to my house."

Stanley also submitted a promotional package to The Hamilton Collection, a leading producer of limited-edition collectibles that is now owned by Bradford. "Within two weeks, I got a call from the art liaison. I ended up creating ten plates for them, mostly Star Trek and Looney Tunes."

Any illustrator who wants to do licensed cartoon work must adhere to strict guidelines set forth by the company who owns the copyright to the characters. "Disney is king of keeping its

Steve Stanley's work, such as this *Star Trek* montage, has been reproduced on book jackets, trading cards, posters, t-shirts and various popular licensed merchandise.

characters on model," explains Stanley. "They have a quality level that is very high, and they want all of their artists to adhere to specific standards. If a drawing is a tad bit off, they'll resubmit it for corrections—again and again."

Other companies aren't as fastidious. "Looney Tunes is more forgiving with poses of Taz, Tweety, or Bugs. They realize that all artists need to do to stay on model is borrow from various style guide poses. The style guide is a studio-produced line art drawing book that the licenser provides to all licensees. If you need a pose of Taz bouncing a basketball, you can usually find one in the style guide. Or you can even take a style guide head from one pose and a torso, arm or leg from another pose, redraw it, and still remain on model."

Stanley's work with cartoon illustration allowed him to build a strong portfolio (available on www.stanleyart.com) that he used to break into other markets, including DC Comics, Kenner Toys, Applause, Muscle Mag International, World Championship Wrestling, WOW Magazine,

and Nascar. Yet even with this much experience under belt, he uses *AGDM* to find new markets. "I'm working on a new promotion and anticipate mailing out 100 or so packages-all from contacts I found in *AGDM*."

Send us your success stories!

Do you have a success story to report—assignments you've received from the listings in *Artist's & Graphic Designer's Market*? Please drop us a line along with copies of work you sold to a listing. E-mail to artdesign@fwpubs.com or mail to Success Stories c/o *Artist's & Graphic Designer's Market*, 4700 East Galbraith Rd. Cincinnati OH 45236. You could be featured in a future article.

ENTER OUR DRAWING
FOR A FREE COPY OF THE NEXT EDITION

Reader Survey: Tell us about yourself!

1. **How often do you purchase** *Artist's & Graphic Designer's Market?*

_____ every year _____ every other year

_____ This is my first edition.

_____ other: _____

2. **Describe yourself and your artwork—and how you use** *AGDM.*

3. **What do you like best about** *AGDM?*

Name: _____

Address: _____

City _____ State _____ Zip _____

Phone: _____ e-mail _____

Website: _____

Fax to Mary Cox, (513)531-2686 or mail to *Artist's & Graphic Designer's Market*, 4700 East Galbraith Road, Cincinnati, OH 45236, or e-mail artdesign@fwpubs.com. Respond by March 30, 2004. **Twenty names will be drawn from respondents to receive free copies of the next edition.**

The Markets

Greeting Cards, Gifts & Products

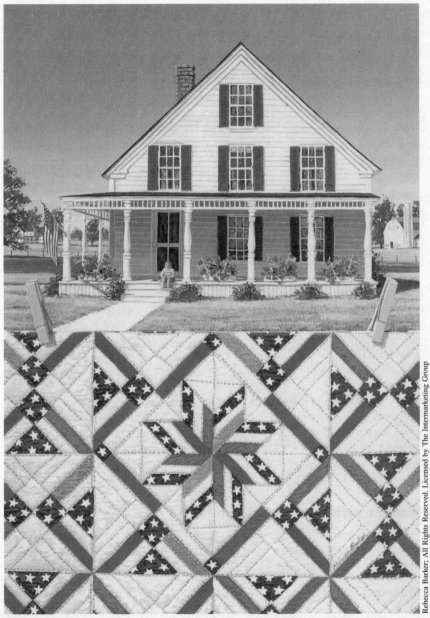

Rebecca Barker speaks of her paintings as "quiltscapes" because quilts are featured prominently in her compositions. In the past six years, she has created hundreds of original artworks that have been reproduced as prints, puzzles, calendars, greeting cards, notepaper, coasters and other products. The licensing company, Intermarketing Group, has helped her reach these outlets with her work.

The following pages offer dozens of opportunities whether you're an illustrator, graphic designer, painter, sculptor, calligrapher, or cartoonist. The businesses in this section need images for all kinds of products: greeting cards, paper plates, napkins, banners, shopping bags, T-shirts, school supplies, personal checks, calendars—you name it. We've included manufacturers of everyday items, like mugs, as well as companies looking for fine art for limited edition collectibles.

THE BEST WAY TO ENTER THE MARKET

1. Read the listings carefully to learn exactly what products each company makes and the specific styles and subject matter they use.
2. Visit stores. Browse store shelves to see what's out there. Take a notebook and jot down the types of cards and products you see. If you want to illustrate greeting cards, familiarize yourself with the various categories of cards and note which images tend to appear again and again in each category.
3. Track down trends. Pay attention to the larger trends in society. Society's move toward diversity, openness and acceptance, is reflected in the cards we buy. There has also been a return to patriotism. Fads such as reality TV, as well as popular celebrities often show up in images on cards and gifts. Trends can also be spotted in movies, national magazines and on websites.

WHAT TO SUBMIT

- Do NOT send originals. Companies want to see photographs, photocopies, printed samples, computer printouts, slides or tearsheets.
- Before you make copies of your sample, render the original artwork in watercolor or gouache in the standard industry size, $4\frac{5}{8} \times 7\frac{1}{2}$ inches.
- Artwork should be upbeat, brightly colored, and appropriate to one of the major categories or niches popular in the industry.
- When creating greeting card art, leave some space at the top or bottom of the artwork, because cards often feature lettering there. Check stores to see how much space to leave. It is not necessary to add lettering, because companies often prefer to use staff artists to create lettering.
- Have color photocopies or slides made of your completed artwork (see listings for specific instructions).
- Make sure each sample is labeled with your name, address and phone number.
- Send three to five appropriate samples of your work to the contact person named in the listing. Include a brief (one to two paragraph) cover letter with your initial mailing.
- Enclose a self-addressed stamped envelope if you need your samples back.
- Within six months, follow up with another mailing to the same listings and additional companies you have researched.

Submitting to gift & product companies

Send samples similar to those you would send to greeting card companies, only don't be concerned with leaving room at the top of the artwork for a greeting. Some companies prefer you send postcard samples or color photocopies. Check the listings for specifics.

Payment and royalties

Most card and product companies pay set fees or royalty rates for design and illustration. What has recently become negotiable, however, is rights. In the past, card companies almost always purchased full rights to work, but now some are willing to negotiate for other arrangements, such as greeting card rights only. If the company has ancillary plans in mind for your

work (calendars, stationery, party supplies or toys), they will probably want to buy all rights. In such cases, you may be able to bargain for higher payment.

Don't overlook the collectibles market

Limited edition collectibles—everything from Dale Earnhardt collector plates to *Wizard of Oz* ornaments—appeal to a wide audience and are a lucrative niche for artists. To do well in this field, you have to be flexible enough to take suggestions. Companies test market to find out which images will sell the best, so they will guide you in the creative process. For a collectible plate, for example, your work must fit into a circular format or you'll be asked to extend the painting out to the edge of the plate.

Popular themes for collectibles include patriotic images, Native American, wildlife, animals (especially kittens and puppies), children, religious (including madonnas and angels), stuffed animals, dolls, TV nostalgia, gardening, culinary and sports images.

E-cards

If you are at all familiar with the Internet, you know that electronic greeting cards are everywhere. Many can be sent for free, but they drive people to websites so they are a big bonus for websites to offer visitors. The most popular e-cards are animated, and there is an increasing need for artists who can animate their own designs for the web, using Flash animation. To look at the range in electronic greeting cards, visit a few sites, such as www.amazon.com; www.bluemountain.com; www.barnesandnoble.com and do a few web searches. Companies often post their design needs on their websites.

KURT S. ADLER INC., 1107 Broadway, New York NY 10010. (212)924-0900. Fax: (212)807-0575. E-mail: Adlers@kurtadler.com. Website: Kurtadler.com. **President:** Howard Adler. Estab. 1946. Produces collectible figurines, decorations, gifts, ornaments. Manufacturer and importer of Christmas ornaments and giftware products.
Needs: Prefers freelancers with experience in giftware. Considers all media. Will consider all styles appropriate for Christmas ornaments and giftware. Produces material for Christmas, Easter, Halloween.
First Contact & Terms: Send query letter with brochure, photocopies, photographs. Responds within 1 month. Will contact for portfolio review if interested. Payment negotiable.
Tips: "We rely on freelance designers to give our line a fresh, new approach and innovative new ideas."

ADVANCE CELLOCARD CO., INC., 2203 Lively Blvd., Elk Grove Village IL 60007-5209. (847)437-0220. **President:** Ron Ward. Estab. 1960. Produces greeting cards.
Needs: Considers watercolor, acrylic, oil and colored pencil. Art guidelines for SASE with first-class postage. Produces material for Valentine's Day, Mother's Day, Father's Day, Easter, graduation, birthdays and everyday.
First Contact & Terms: Send query letter with brochure and SASE. Accepts disk submissions compatible with Mac formatted Illustrator 5.5, Photoshop 3.0 or Power Mac QuarkXPress 3.0. Samples not filed are returned by SASE. Responds in weeks. Originals are not returned. Pays average flat fee of $75-150/design. Buys all rights.
Tips: "Send letter of introduction, and samples or photostats of artwork."

ALASKA MOMMA, INC., 303 Fifth Ave., New York NY 10016. (212)679-4404. Fax: (212)696-1340. E-mail: licensing@alaskamomma.com. **President, licensing:** Shirley Henschel. "We are a licensing company representing artists, illustrators, designers and established characters. We ourselves do not buy artwork. We act as a licensing agent for the artist. We license artwork and design concepts such as wildlife, florals, art deco and tropical to toy, clothing, giftware, textiles, stationery and housewares manufacturers and publishers."
Needs: "We are looking for people whose work can be developed into dimensional products. An artist must have a distinctive and unique style that a manufacturer can't get from his own art department. We need art that can be applied to products such as posters, cards, puzzles, albums, bath accessories, figurines, calendars, etc. No cartoon art, no abstract art, no b&w art."
First Contact & Terms: "Artists may submit work in any form as long as it is a fair representation of

Increasing Your Odds in a Changing Market

When it comes to getting a handle on what art directors are looking for, Linda King Davey has experience on both sides of the fence. She spent 10 years at Paramount Cards as a creative planner, humor manager and creative director. Then she served as creative vice president at Marian Heath for five years. Now she's working as a freelance illustrator, editor and art director. Here, she gives her observations on how to increase your salability in a changing market:

1. Art directors are less inclined to make assignments and more likely to purchase finished art submitted on speculation. Due to increased belt tightening, greeting card companies have fewer in-house artists, or else they've eliminated them entirely. This is good news for freelancers. More companies are buying freelance versus internally generated art.

2. The ability to do various styles of illustration was once thought to increase an artist's marketability, but having multiple styles in your portfolio is not as highly regarded these days and can possibly be a drawback. Art directors want to identify an artist with one specific look.

3. In recent years, consumer acceptance of contemporary looks has grown. The demand for creative, unique and innovative techniques is great.

4. Art directors typically have difficulty finding designs for specific categories, such as Wedding Congratulations, First Communion, Graduation, and so on. You may want to consider doing speculative designs in these areas.

5. Create designs that utilize popular greeting card finishes, like foil, emboss, glitter and virko (raised, plastic coating). Art directors will appreciate having these processes considered as an integral part of the design.

6. When sending a portfolio, make it clear what you want returned and what the art director can keep on file. Always include samples or photocopies that can be kept on file with your name, phone and e-mail address on each piece.

—Cindy Duesing

their style." Prefers to see several multiple color samples in a mailable size. No originals. "We are interested in artists whose work is suitable for a licensing program. We do not want to see b&w art drawings. What we need to see are transparencies or color photographs or color photocopies of finished art. We need to see a consistent style in a fairly extensive package of art. Otherwise, we don't really have a feeling for what the artist can do. The artist should think about products and determine if the submitted material is suitable for licensed product. Please send SASE so the samples can be returned. We work on royalties that run from 5-10% from our licensees. We require an advance against royalties from all customers. Earned royalties depend on whether the products sell."

Tips: "Publishers of greeting cards and paper products have become interested in more traditional and conservative styles. There is less of a market for novelty and cartoon art. We need artists more than ever as we especially need fresh talent in a difficult market. Look at product! Know what companies are willing to license."

ALEF JUDAICA, INC., 8440 Warner Dr., Culver City CA 90232. (310)202-0024. Fax: (310)202-0940. E-mail: alefjud@aol.com. **President:** Guy Orner. Estab. 1979. Manufacturer and distributor of a full line of Judaica, including menorahs, Kiddush cups, greeting cards, giftwrap, tableware, etc.

Greeting Card Basics

- The Greeting Card Industry is also called the "Social Expressions" industry.
- Women buy 85 to 90 percent of all cards.
- The average person receives eight birthday cards a year.
- **Seasonal cards** express greetings for holidays, like Christmas, Easter or Valentine's Day.
- **Everyday cards** express non-holiday sentiments. The "everyday" category includes get well cards, thank you cards, sympathy cards, and a growing number of person-to-person greetings. There are cards of encouragement that say "Hang in there!" and cards to congratulate couples on staying together, or even getting divorced! There are cards from "the gang at the office" and cards to beloved pets. Check the rows and rows of cards in store racks to note the many "everyday" occasion.
- **Birthday cards** are the most popular everyday cards, accounting for 60% of sales of everyday cards.
- Categories are further broken down into the following areas: **traditional**, **humorous** and "**alternative**" cards. "Alternative" cards feature quirky, sophisticated or offbeat humor.
- According to the Greeting card association, the most popular card-sending holidays are, in order:

 1. Christmas
 2. Valentine's Day
 3. Mother's Day
 4. Father's Day
 5. Graduation
 6. Thanksgiving
 7. Halloween
 8. St. Patrick's Day
 9. Jewish New Year
 10. Hannukkah
 11. Grandparent's Day
 12. Sweetest Day
 13. Passover
 14. Secretary's Day
 15. National Boss's Day
 16. April Fool's Day
 17. Nurses' Day

For More Information

Greetings Etc. www.greetingsmagazine.com is the official publication of the Greeting Card Association www.greetingcard.org. Subscriptions are reasonably priced. To subscribe call (973)252-0100.

Party & Paper is a trade magazine focusing on the party niche. Visit their website at http://www.partypaper.com for industry news and subscription information.

The National Stationery Show, the "main event" of the greeting card industry, is held each May at New York City's Jacob K. Javits Center. Log on to www.nationalstationeryshow.com to learn more about that important event. Other industry events are held across the country each year. For upcoming trade show dates, check Greetings Etc. or Party & Paper.

Needs: Approached by 15 freelancers/year. Works with 10 freelancers/year. Buys 75-100 freelance designs and illustrations/year. Prefers local freelancers with experience. Works on assignment only. Uses freelancers for new designs in Judaica gifts (menorahs, etc.) and ceramic Judaica. Also for calligraphy, pasteup and mechanicals. All designs should be upper scale Judaica.

First Contact & Terms: Mail brochure, photographs of final art samples. Art director will contact artist for portfolio review if interested, or portfolios may be dropped off every Friday. Sometimes requests work on spec before assigning a job. Pays $300 for illustration/design; pays royalties of 10%. Considers buying second rights (reprint rights) to previously published work.

ALLPORT EDITIONS, 2337 NW York, Portland OR 97210-2112. (503)223-7268. Fax: (503)223-9182. E-mail: info@allport.com. Website: www.allport.com. **Contact:** Creative Director. Estab. 1983. Produces

greeting cards and stationery. Specializes in greeting cards: fine art, humor, some photography, florals, animals and collage.

Needs: Approached by 100 freelancers/year. Works with 10 freelancers/year. Buys 40 freelance designs and illustrations/year. Art guidelines available on website. Uses freelancers mainly for art for cards. Also for final art. Prefers art scaleable to card size. Produces material for all holidays and seasons, birthdays and everyday. Submit seasonal material 1 year in advance.

First Contact & Terms: Illustrators and cartoonists send query letter with photocopies, photographs, photostats, tearsheets and SASE. Accepts submissions on disk compatible with PC-formatted EPS files with PC Preview or Quark document. Samples are filed or returned by SASE. Responds in 3 months. Portfolio review not required. Rights purchased vary according to project. Pays for illustration by the project. Finds freelancers through artists' submissions and stationery show in New York.

Tips: "Get my attention on the envelope."

AMBERLEY GREETING CARD CO., 11510 Goldcoast Dr., Cincinnati OH 45249-1695. (513)489-2775. Fax: (513)489-2857. Website: www.amberleygreeting.com. **Contact:** Dan Cronstein. Estab. 1966. Produces greeting cards. "We are a multi-line company directed toward all ages. We publish conventional as well as humorous cards."

Needs: Approached by 20 freelancers/year. Works with 10 freelancers/year. Buys 250 illustrations/year. Works on assignment only. Considers any media.

First Contact & Terms: Send query letter with nonreturnable sample or color photocopies. Calligraphers send photocopies of lettering styles. Samples are filed. Responds only if interested. Pays illustration flat fee $75-125; pays calligraphy flat fee $20-30. Buys all rights.

Tips: "Send appropriate materials. Go to a card store or supermarket and study the greeting cards. Look at what makes card art different than a lot of other illustration. Caption room, cliché scenes, "cute" animals, colors, etc. Research publishers and send appropriate art! I wish artists would not send a greeting card publisher art that looks unlike any card they've ever seen on display anywhere."

☑ **AMCAL, INC.,** 2500 Bisso Lane, Suite 200, Concord CA 94520. (925)689-9930. Fax: (925)689-0108. Website: www.amcalart.com. Publishes calendars, notecards, Christmas cards and other book and stationery items. "Markets to a broad distribution channel, including better gifts, book, department stores, larger chains throughout U.S. Some sales to Europe, Canada and Japan. We look for illustration and design that can be used many ways—calendars, note cards, address books and more, so we can develop a collection. We license art that appeals to a widely female audience." No gag humor or cartoons.

Needs: Prefers work in horizontal format. Art guidelines for SASE with first-class postage, on our website or "you can call and request."

First Contact & Terms: Illustrators send query letter with brochure, résumé, photographs, SASE, slides, tearsheets and transparencies. Include a SASE for return of submission. Responds within 6 weeks. Will contact artist for portfolio review if interested. Pays for illustration by the project, advance against royalty.

Tips: "Research what is selling and what's not. Go to gift shows and visit lots of stationery stores. Read all the trade magazines. Talk to store owners."

AMERICAN GREETINGS CORPORATION, One American Rd., Cleveland OH 44144. (216)252-7300. E-mail: jim.hicks@amgreetings.com. Website: www.amgreetings.com. **Director of Creative Recruitment:** James E. Hicks. Estab. 1906. Produces greeting cards, stationery, calendars, paper tableware products, giftwrap and ornaments—"a complete line of social expressions products."

Needs: Prefers artists with experience in illustration, decorative design and calligraphy. Usually works from a list of 100 active freelancers. Guidelines available for SASE.

First Contact & Terms: Send query letter with résumé. "Do not send samples." Pays $200 and up based on complexity of design. Does not offer royalties.

Tips: "Get a BFA in Graphic Design with a strong emphasis on typography."

AMERICAN TRADITIONAL STENCILS, 442 First New Hampshire Turnpike, Northwood NH 03261. (603)942-8100. Fax: (603)942-8919. E-mail: judy@americantraditional.com. Website: www.americantraditional.com. **Owner:** Judith Barker. Estab. 1970. Manufacturer of brass, platinum and laser cut stencils. Clients: retail craft, art and gift shops. Current clients include Michael's Arts & Crafts, Old Sturbridge and Pfaltzgraph Co., JoAnn's Fabrics and some Ben Franklin stores.

Needs: Approached by 1-2 freelancers/year. Works with 1 freelance illustrator/year. Assigns 2 freelance jobs/year. Prefers freelancers with experience in graphics. Art guidelines not available. Works on assign-

ment only. Uses freelancers mainly for stencils. Also for ad illustration and product design. Prefers b&w camera-ready art.

First Contact & Terms: Send query letter with brochure showing art style and photocopies. Samples are filed or are returned. Responds in 2 weeks. Call for appointment to show portfolio of roughs, original/final art and b&w tearsheets. Pays for design by the hour, $8.50-20; by the project, $15-150. Pays for illustration by the hour, $10-15. Rights purchased vary according to project.

Tips: "Join the Society of Craft Designers—great way to portfolio designs for the craft industry. Try juried art and craft shows—great way to see if your art sells."

AMSCAN INC., 80 Grasslands Rd., Elmsford NY 10523. (914)345-2020. Fax: (914)345-8431. **Art Director:** Laurie Cole. Estab. 1954. Designs and manufactures paper party goods. Extensive line includes paper tableware, invitations, giftwrap and bags, decorations. Complete range of party themes for all ages, all seasons and all holidays. Features a gift line which includes baby hard and soft goods, wedding giftware, and home decorative and tabletop products. Seasonal giftware also included.

Needs: "Ever-expanding department with incredible appetite for fresh design and illustration. Subject matter varies from baby, juvenile, floral, type-driven and graphics. Designing is accomplished both in the traditional way by hand (i.e., painting) or on the computer using a variety of programs like FreeHand, Illustrator, Painter and Photoshop."

First Contact & Terms: "Send samples or copies of artwork to show us range of illustration styles. If artwork is appropriate, we will pursue." Pays by the project $300-3,500 for illustration and design.

APPLEJACK LICENSING INTERNATIONAL, Box 1527, Historic Route 7A, Manchester Center VT 05255. (802)362-3662. Fax: (802)362-0370. E-mail: paulw@applejackart.com. Website: www.applejackart .com. **Contact:** Paul Wheeler, vice president. (Division Applejack Art Partners) or Michael Katz, vice president, poster companies. Licenses art for balloons, bookmarks, calendars, CD-ROMs, collectible figurines, decorative housewares, decorations, games, giftbags, gifts, giftwrap, greeting cards, limited edition plates, mugs, ornaments, paper tableware, party supplies, personal checks, posters, prints, school supplies, stationery, T-shirts, textiles, toys, wallpaper, etc.

Needs: Extensive artwork for use on wide cross section of product categories. Looking for variety of styles and subject matter. Art guidelines free for SASE with first class postage. Considers all media and all styles. Prefers final art under 24×36, but not required. Produces material for all holidays. Submit seasonal material 6 months in advance.

First Contact & Terms: Designers send brochure, photocopies, photographs, slides, tearsheets, transparencies, CD ROM and SASE. Illustrators send query letter with photocopies, photographs, photostats, transparencies, tearsheets, résumé and SASE. Send follow-up postcard every 3 months. No e-mail submissions. Accepts disk submissions compatible with Photoshop, Quark or Illustrator. Samples are filed or returned by SASE. Responds in 1 month. Will contact artist for portfolio review if interested. Portfolio should include color final art, photographs, photostats, roughs, slides, tearsheets.

AR-EN PARTY PRINTERS, INC., 3775 W. Arthur, Lincolnwood IL 60712. (847)673-7390. Fax: (847)673-7379. E-mail: info@ar-en.net. Website: ar-en.net. **Owner:** Gary Morrison. Estab. 1978. Produces stationery and paper tableware products. Makes personalized party accessories for weddings and all other affairs and special events.

Needs: Works with 2 freelancers/year. Buys 10 freelance designs and illustrations/year. Art guidelines not available. Works on assignment only. Uses freelancers mainly for new designs. Also for calligraphy. Looking for contemporary and stylish designs, especially b&w line art, no grey scale, to use for hot stamping dyes. Prefers small (2×2) format.

First Contact & Terms: Send query letter with brochure, résumé and SASE. Samples are filed or returned by SASE if requested by artist. Responds in 2 weeks. Company will contact artist for portfolio review if interested. Rights purchased vary according to project. Pays by the hour, $60 minimum; by the project, $1,000 minimum.

Tips: "My best new ideas always evolve from something I see that turns me on. Do you have an idea/style that you love? Market it. Someone out there needs it."

ART LICENSING INTERNATIONAL, 1532 US 41 ByPass S, #272, Venice FL 34293. (941)966-8912. Fax: (941)966-8914. E-mail: artlicensing@comcast.net. Website: www.artlicensinginc.com. **Contact:** Michael Woodward, president. Produces calendars, decorative housewares, gifts, greeting cards, jigsaw puzzles, party supplies, stationery and textiles.

● Please see listing in Artists' Reps section.

ARTFUL GREETINGS, P.O. Box 52428, Durham NC 27717. (919)598-7599. Fax: (919)598-8909. E-mail: myw@artfulgreetings.com. Website: www.artfulgreetings.com. **Vice President of Operations:** Marian WhittedAlderman. Estab. 1990. Produces bookmarks, greeting cards, T-shirts and prints. Specializes in multicultural subject matter, all ages.
Needs: Approached by 200 freelancers/year. Works with 10 freelancers/year. Buys 20 freelance designs and illustrations/year. No b&w art. Pastel chalk media does not reproduce as bright enough color for us. Uses freelancers mainly for cards. Considers bright color art, no photographs. Looking for art depicting people of all races. Prefers a multiple of 2 sizes: 5×7 and 5½×8. Produces material for Christmas, Mother's Day, Father's Day, graduation, Kwanzaa, Valentine's Day, birthdays, everyday, sympathy, get well, romantic, thank you, woman-to-woman and multicultural. Submit seasonal material 1 year in advance.
First Contact & Terms: Designers send photocopies, SASE, slides, transparencies (call first). Illustrators send photocopies (call first). Samples are filed. Artist should follow up with call or letter after initial query. Will contact for portfolio review of color slides and transparencies if interested. Negotiates rights purchased. Pays for illustration by the project $50-100. Finds freelancers through word of mouth, NY Stationery Show.
Tips: "Don't sell your one, recognizable style to all the multicultural card companies."

N ARTVISIONS, 12117 SE 26th St., Bellevue WA 98005-4118. E-mail: art@artvisions.com. Website: www.artvisions.com. **Owner:** Neil Miller. Estab. 1993. Markets include publishers, publishers of limited edition prints, calendars, home decor, stationary, note cards and greeting cards, posters, and manufacturers of giftware, home furnishings, textiles, puzzles and games.
Handles: Fine art licensing for listed markets. See extensive listing in Artists' Reps section.

N BALLOON WHOLESALERS INTERNATIONAL, 5733 E. Shields Ave., Fresno CA 93727-7822. (209)294-2170. Fax: (209)294-1800. **Marketing Director:** Carrie Estrada. Estab. 1983. Manufacturer of balloons for adults and children.
Needs: Approached by 2-3 freelance artists/year. Uses 1-2 freelance artists mainly for balloon and gift design. Prefers bright, contemporary, upbeat styles. Also uses freelance artists for P-O-P displays, package and header card displays.
First Contact & Terms: Send query letter with brochure showing art style or résumé, tearsheets, photostats, photographs and SASE. Samples are filed or are returned by SASE only if requested by artist. Responds in 6 weeks. Request portfolio review in original query. Art Director will contact artist for portfolio review if interested. Portfolio should include roughs, photostats, tearsheets and dummies. Requests work on spec before assigning a job. Rights purchased vary according to project.

N BARTON-COTTON INC., 1405 Parker Rd., Baltimore MD 21227. (410)247-4800. Fax: (410)247-3681. E-mail: carol.bell@bartoncotton.com. **Contact:** Carol Bell, art buyer. Licensing: Carol White. Produces religious greeting cards, commercial all-occasion, Christmas cards, wildlife designs and spring note cards. Licenses wildlife art, photography, traditional Christmas art for notecards, Christmas cards, calendars and all-occasion cards.
Needs: Buys 150-200 freelance illustrations/year. Submit seasonal work any time. Free art guidelines for SASE with first-class postage and sample cards; specify area of interest (religious, Christmas, spring, etc.).
First Contact & Terms: Send query letter with résumé, tearsheets, photocopies or slides. Submit full-color work only (watercolor, gouache, pastel, oil and acrylic). Previously published work and simultaneous submissions accepted. Responds in 1 month. Pays by the project, $300-2,500 for illustration and design. Also needs calligraphy, package/product design, pays $500-3,000. **Pays on acceptance.**
Tips: "Good draftsmanship is a must. Spend some time studying current market trends in the greeting-card industry. There is an increased need for creative ways to paint traditional Christmas scenes with up-to-date styles and techniques."

☑ FREDERICK BECK ORIGINALS, 51 Bartlett Ave., Pittsfield MA 01201. (413)443-0973. Fax: (413)445-5014. **Art Director:** Mark Brown. Estab. 1953. Produces silk screen printed Christmas cards, traditional to contemporary.
● This company is under the same umbrella as Editions Limited and Gene Bliley Stationery. One submission will be seen by all companies, so there is no need to send three mailings. Frederick Beck and Editions Limited designs are a little more high end than Gene Bliley designs. The cards are sold through stationery and party stores, where the customer browses through thick binders to order

cards, stationery or invitations imprinted with customer's name. Though some of the same cards are repeated or rotated each year, all companies are always looking for fresh images. Frederick Beck and Gene Bliley's sales offices are still in North Hollywood, CA, but art director works from Pittsfield office.

BEPUZZLED/UNIVERSITY GAMES, 2030 Harrison St., San Francisco CA 94110. (415)503-1600. Fax: (415)503-0085. **Creative Services Manager:** Susan King. Estab. 1986. Produces games and puzzles for children and adults. "Bepuzzled mystery jigsaw games challenge players to solve an original whodunit thriller by matching clues in the mystery with visual clues revealed in the puzzle."
Needs: Works with 20 freelance artists/year. Buys 20-40 designs and illustrations/year. Prefers local artists with experience in children's book and adult book illustration. Uses freelancers mainly for box cover art, puzzle images and character portraits. All illustrations are done to spec. Considers many media.
First Contact & Terms: Send query letter with brochure, résumé, tearsheets or other nonreturnable samples. Samples are filed. Art director will contact artist for portfolio review if interested. Portfolio should include original/final art and photographs. Original artwork is returned at the job's completion. Sometimes requests work on spec before assigning a job. Pays by the project, $300-3,000. Finds artists through word of mouth, magazines, submissions, sourcebooks, agents, galleries, reps, etc.

BERGQUIST IMPORTS, INC., 1412 Hwy. 33 S., Cloquet MN 55720. (218)879-3343. Fax: (218)879-0010. E-mail: bbergqu106@aol.com. Website: www.bergquistimports.com. **President:** Barry Bergquist. Estab. 1948. Produces paper napkins, mugs and tile. Wholesaler of mugs, decorator tile, plates and dinnerware.
Needs: Approached by 5 freelancers/year. Works with 5 freelancers/year. Buys 50 designs and illustrations/year. Prefers freelancers with experience in Scandinavian and wildlife designs. Works on assignment only. Also uses freelancers for calligraphy. Produces material for Christmas, Valentine's Day and everyday. Submit seasonal material 6-8 months in advance.
First Contact & Terms: Send query letter with brochure, tearsheets and photographs. Samples are not filed and are returned. Responds in 2 months. Request portfolio review in original query. Artist should follow up with a letter after initial query. Portfolio should include roughs, color tearsheets and photographs. Rights purchased vary according to project. Originals are returned at job's completion. Requests work on spec before assigning a job. Pays by the project, $50-300; average flat fee of $100 for illustration/design; or royalties of 5%. Finds artists through word of mouth, submissions/self-promotions and art fairs.

GENE BLILEY STATIONERY, 51 Bartlett Ave., Pittsfield MA 01201-0989. (413)443-0973. Fax: (413)445-5014. **Art Director:** Mark Brown. General Manager: Gary Lainer. Sales Manager: Ron Pardo. Estab. 1967. Produces stationery, family-oriented birth announcements and invitations for most events and Christmas cards.
 • This company also owns Editions Limited and Frederick Beck Originals. One submission will be seen by all companies. See listing for Editions Limited/Frederick Beck.

BLOOMIN' FLOWER CARDS, 4734 Pearl St., Boulder CO 80301. (800)894-9185. Fax: (303)545-5273. E-mail: cards@bloomin.com. **President:** Don Martin. Estab. 1995. Produces greeting cards, stationery and gift tags—all embedded with seeds.
Needs: Approached by 15-25 freelancers/year. Works with 5-10 freelancers/year. Buys 5-10 freelance designs and illustrations/year. Art guidelines available. Uses freelancers mainly for card images. Considers all media. Looking for florals, garden scenes, holiday florals, birds, and butterflies—bright colors, no photography. Produces material for Christmas, Easter, Mother's Day, Father's Day, Valentine's Day, Earth Day, birthdays, everyday, get well, romantic and thank you. Submit seasonal material 8 months in advance.
First Contact & Terms: Designers send query letter with slides, transparencies, photocopies, photographs and SASE. Illustrators send postcard sample of work, photocopies and photographs or e-mail. Samples are filed or returned with letter if not interested. Responds if interested. Portfolio review not required. Rights purchased vary according to project. Pays royalties for design. Pays by the project or

N MARKETS NEW TO THIS EDITION

royalties for illustration. Finds freelancers through word of mouth, submissions, and local artists' guild.

N **BLUE MOUNTAIN ARTS**, Art Dept. AM, P.O. Box 1007, Boulder CO 80306. (303)417-6513. Fax: (303)447-0939. E-mail: jkauflin@sps.com. Website: www.spsstudios.com. **Contact:** Jody Kauflin, art director. Estab. 1970. Produces books, bookmarks, calendars, greeting cards, mugs and prints. Specializes in handmade looking greeting cards, calendars and books with inspirational or whimsical messages accompanied by colorful hand-painted illustrations.

Needs: Art guidelines free with SASE and first-class postage or on website. Uses freelancers mainly for hand-painted illustrations. Considers all media. Product categories include alternative cards, alternative/humor, conventional, cute, inspirational and teen. Produces material for all holidays and seasons, baby congrats, birthday, congratulations, everyday, get-well/sympathy, graduation, woman-to-woman, weddings/anniversary. Submit seasonal material 10 months in advance. Art size should be 5×7 vertical format for greeting cards.

First Contact & Terms: Send query letter with photocopies, photographs, SASE and tearsheets. Send no more than 5 illustrations initially. No phone calls, faxes or e-mails. Samples are filed or are returned by SASE. Responds in 1 month. Portfolio not required. Buys all rights. Pays freelancers flat rate; $150-250/illustration if chosen. Finds freelancers through artists' submissions and word-of-mouth.

Tips: "We are an innovative company, always looking for fresh and unique art styles to accompany our sensitive or whimsical messages. We strive for a hand-made look. We love color! We don't want photography! We don't want slick computer art! Do in-store research to get a feel for the look and content of our products. We want illustrations for printed cards, NOT E-CARDS! We want to see illustrations that fit with our existing looks and we also want fresh, new and exciting styles. Remember that people buy cards for what they say. The illustration is a beautiful backdrop for the message."

☑ BLUE SKY PUBLISHING, 6595 Odell Place, Suite C, Boulder CO 80301. (303)530-4654. Website: www.blueskypublishing.net. **Contact:** Helen McRae. Estab. 1989. Produces greeting cards. "At Blue Sky Publishing, we are committed to producing contemporary fine art greeting cards that communicate reverence for nature and all creatures of the earth, that express the powerful life-affirming themes of love, nurturing and healing, and that share different cultural perspectives and traditions, while maintaining the integrity of our artists' work."

● Only considers submissions from January through end of April. Art director says they are happy with current artists but are looking for new phogographers. Uses new artists only occasionally.

Needs: Approached by 500 freelancers/year. Works with 3 freelancers/year. Licenses 80 fine art pieces/year. Works with freelancers from all over US. Prefers freelancers with experience in fine art media: oils, oil pastels, acrylics, calligraphy, vibrant watercolor and fine art photography. Art guidelines available for SASE. "We primarily license existing pieces of art or photography. We rarely commission work." Looking for colorful, contemporary images with strong emotional impact. Art guidelines for SASE with first-class postage. Produces cards for all occasions. Submit seasonal material 1 year in advance.

First Contact & Terms: Send query letter with SASE, slides or transparencies. Samples are filed or returned if SASE is provided. Responds in 4 months if interested. Transparencies are returned at job's completion. Pays royalties of 3% with a $150 advance against royalties. Buys greeting-card rights for 5 years (standard contract; sometimes negotiated).

Tips: "We're interested in seeing artwork with strong emotional impact. Holiday cards are what we produce in biggest volume. We are looking for joyful images, cards dealing with relationships, especially between men and women, with pets, with Mother Nature and folk art. Vibrant colors are important."

THE BRADFORD EXCHANGE, 9333 Milwaukee Ave., Niles IL 60714. (847)581-8217. Fax: (847)581-8770. E-mail: bgartist@bradfordexchange.com. **Artist Relations:** Suzanne Quigley. Estab. 1973. Produces and markets collectible plates. "Bradford produces limited edition collectors plates featuring various artists' work which is reproduced on the porcelain surface. Each series of 6-8 plates is centered around a concept, rendered by one artist, and marketed internationally."

Needs: Approached by thousands of freelancers/year. Works with approximately 100 freelancers/year. Prefers artists with experience in rendering painterly, realistic, "finished" scenes; best mediums are oil and acrylic. Art guidelines by calling (847)581-8671. Uses freelancers for all work including border designs, sculpture. Considers oils, watercolor, acrylic and sculpture. Traditional representational style is best, depicting scenes of children, pets, wildlife, homes, religious subjects, fantasy art, florals or songbirds in idealized settings. Produces material for all occasions. Submit seasonal material 6-9 months in advance.

First Contact & Terms: Designers send a duplicate of 10-20 35mm slides, color references or samples

of work you have done along with a résumé and additional information. Please do not send original work, or items that are one of a kind. Samples are filed and are not returned. Art Director will contact artist only if interested. Pays by project. Pays royalties. Rights purchased vary according to project.

N **T** **CAN CREATIONS, INC.**, Box 8576, Pembroke Pines FL 33084. (954)581-3312. **President:** Judy Rappoport. Estab. 1984. Manufacturer of Cello wrap.
Needs: Approached by 8-10 freelance artists/year. Works with 2-3 freelance designers/year. Assigns 5 freelance jobs/year. Prefers local artists only. Works on assignment only. Uses freelance artists mainly for "design work for cello wrap." Also uses artists for advertising design, illustration and layout; brochure design; posters; signage; magazine illustration and layout. "We are not looking for illustrators at the present time. Most designs we need are graphic and we also need designs which are geared toward trends in the gift industry."
First Contact & Terms: Send query letter with tearsheets and photostats. Samples are not filed and are returned by SASE only if requested by artist. Responds in 2 weeks. Call or write to schedule an appointment to show a portfolio, which should include roughs and b&w tearsheets and photostats. Pays for design by the project, $75 minimum. Pays for illustration by the project, $150 minimum. Considers client's budget and how work will be used when establishing payment. Negotiates rights purchased.
Tips: "We are looking for simple designs geared to a high end market."

N **CANETTI DESIGN GROUP INC.**, P.O. Box 57, Pleasantville NY 10570. (914)238-3159. Fax: (914)238-0106. E-mail: desngrp@aol.com. **Marketing Vice President:** M. Berger. Estab. 1982. Produces greeting cards, stationery, games/toys and product design.
Needs: Approached by 50 freelancers/year. Works with 10 freelancers/year. Works on assignment only. Uses freelancers mainly for illustration/computer. Also for calligraphy and mechanicals. Considers all media. Looking for contemporary style. Needs computer-literate freelancers for illustration and production. 80% of freelance work demands knowledge of Illustrator, Photoshop, FreeHand, Form 2/Strata.
First Contact & Terms: Send postcard-size sample of work and query letter with brochure. Samples are not filed. Portfolio review not required. Buys all rights. Originals are not returned. Pays by the hour. Finds artists through agents, sourcebooks, magazines, word of mouth and artists' submissions.

N **CARAVAN INTERNATIONAL, INC.**, P.O. Box 768, Colleyville TX 76034. (800)442-0036. Fax: (800)984-6810. Website: www.caravancards.com. **President:** Dale E. Byars. Estab. 1985. Produces book-marks, gifts, magnets, multicultural greeting cards, stationery, T-shirts.
Needs: Art guidelines available. Uses artists/freelancers mainly for new images. Also for calligraphy, P-O-P. Looking for Celtic, Hispanic, African-American, Farsi, French, German, Native American, oriental, multicultural. 10% of freelance work demands computer skills. Produces material for Christmas, Rosh Hashana, Kwanzaa, Hanukkah, New Year, birthdays and everyday. Submit seasonal material 4 months in advance, and all others by July 15.
First Contact & Terms: Send query letter with photocopies, slides and transparencies. Samples are filed or returned by SASE. Responds within 3 months. Will contact artist for portfolio review or slides and transparencies if interested. Rights purchased vary according to project. Pays by the project $50-350; royalties of 2-5% for licensed sales.

CARDMAKERS, Box 236, High Bridge Rd., Lyme NH 03768. Phone/fax: (603)795-4422. Fax: (603)795-4222. Website: www.cardmakers.com. **Principal:** Peter Diebold. Estab. 1978. Produces greeting cards. "We produce special cards for special interests and greeting cards for businesses—primarily Christmas. We have now expanded our Christmas line to include 'photo mount' designs, added designs to our everyday line for stockbrokers and have recently launched a new everyday line for boaters."
Needs: Approached by more than 300 freelancers/year. Works with 5-10 freelancers/year. Buys 20-40 designs and illustrations/year. Prefers professional-caliber artists. Art guidelines available on website or for SASE with first-class postage. Please do not e-mail us for same. Works on assignment only. Uses freelancers mainly for greeting card design, calligraphy and mechanicals. Also for paste-up. Considers all media. "We market 5×7 cards designed to appeal to individual's specific interest—boating, building, cycling, stocks and bonds, etc." Prefers an upscale look. Submit seasonal ideas 6-9 months in advance.
First Contact & Terms: Designers send query letter with SASE and brief sample of work. Illustrators send postcard sample or query letter with brief sample of work. "One good sample of work is enough for us. A return postcard with boxes to check off is wonderful. Phone calls are out; fax is a bad idea." Samples are filed or are returned by SASE. Responds only if interested unless with SASE. Portfolio review not

Susan Drawbaugh created this amusing portrayal of Rudolph the red-nosed reindeer as Santa Claus for Cardmakers, a Lyme, New Hampshire, company whose specialty is greeting cards for businesses.

required. Pays flat fee of $100-300 depending on many variables. Rights purchased vary according to project. Interested in buying second rights (reprint rights) to previously published work, if not previously used for greeting cards. Finds artists through word of mouth, exhibitions and *Artist's & Graphic Designer's Market* submissions.

Tips: "We like to see new work in the early part of the year. It's important that you show us samples *before* requesting submission requirements. Getting published and gaining experience should be the main objective of freelancers entering the field. We favor fresh talent (but do also feature seasoned talent). PLEASE be patient waiting to hear from us! Make sure your work is equal to or better than that which is commonly found in use presently. Go to a large greeting card store. If you think you're as good or better than the artists there, continue!"

CAROLE JOY CREATIONS, INC., 6 Production Dr., #1, Brookfield CT 06804. Fax: (203)740-4495. Website: www.carolejoy.com. **President:** Carole Gellineau. Estab. 1986. Produces greeting cards. Specializes in cards, notes and invitations for people who share an African heritage.

Needs: Approached by 200 freelancers/year. Works with 5-10 freelancers/year. Buys 100 freelance designs, illustrations and calligraphy/year. Prefers artists "who are thoroughly familiar with, educated in and sensitive to the African-American culture." Works on assignment only. Uses freelancers mainly for greeting card art. Also for calligraphy. Considers full color only. Looking for realistic, traditional, Afrocentric, colorful and upbeat style. Prefers 11 × 14. 20% freelance design work demands knowledge of Illustrator, Photoshop and QuarkXPress. Also produces material for Christmas, Easter, Mother's Day, Father's Day, graduation, Kwanzaa, Valentine's Day, birthdays and everyday. Also for sympathy, get well, romantic, thank you, serious illness and multicultural cards. Submit seasonal material 1 year in advance.

First Contact & Terms: Send query letter with brochure, photocopies, photographs and SASE. No phone calls or slides. No e-mail addresses. Responds to street address only. Calligraphers send samples and compensation requirements. Samples are not filed and are returned with SASE only. Responds only if interested. Portfolio review not required. Buys all rights. Pays for illustration by the project.

Tips: "Excellent illustration skills are necessary and designs should be appropriate for African-American

social expression. Writers should send verse that is appropriate for greeting cards and avoid lengthy, personal experiences. Verse and art should be uplifting."

CASE STATIONERY CO., INC., 179 Saw Mill River Rd., Yonkers NY 10701-6616. (914)965-5100. Fax: (914)965-2362. E-mail: case@casestationery.com. Website: www.casestationery.com. **President:** Jerome Sudnow. Vice President: Joyce Blackwood. Estab. 1954. Produces stationery, notes, memo pads and tins for mass merchandisers in stationery and housewares departments.
Needs: Approached by 10 freelancers/year. Buys 50 designs from freelancers/year. Works on assignment only. Buys design and/or illustration mainly for stationery products. Uses freelancers for mechanicals and ideas. Produces materials for Christmas; submit 6 months in advance. Likes to see youthful and traditional styles, as well as English and French country themes. 10% of freelance work requires computer skills.
First Contact & Terms: Send query letter with résumé and tearsheets, photostats, photocopies, slides and photographs. Samples not filed are returned. Responds ASAP. Call or write for appointment to show a portfolio. Original artwork is not returned. Pays by the project. Buys first rights or one-time rights.
Tips: "Find out what we do. Get to know us. We are creative and know how to sell a product."

H. GEORGE CASPARI, INC., 116 E. 27th St., New York NY 10016. (212)685-9798. **Contact:** Lucille Andriola. Publishes greeting cards, Christmas cards, invitations, giftwrap and paper napkins. "The line maintains a very traditional theme."
Needs: Buys 80-100 illustrations/year. Prefers watercolor, gouache, acrylics and other color media. Produces seasonal material for Christmas, Mother's Day, Father's Day, Easter and Valentine's Day. Also for life events such as moving, new house, wedding, birthday, graduation, baby, get well, sympathy.
First Contact & Terms: Send samples to Lucille Andriola to review. Prefers unpublished original illustrations, slides or transparencies. Art director will contact artist for portfolio review if interested. **Pays on acceptance**; negotiable. Pays flat fee of $400 for design. Finds artists through word of mouth, magazines, submissions/self-promotions, sourcebooks, agents, visiting artist's exhibitions, art fairs and artists' reps.
Tips: "Caspari and many other small companies rely on freelance artists to give the line a fresh, overall style rather than relying on one artist. We feel this is a strong point of our company. Please do not send verses."

CEDCO PUBLISHING CO., 100 Pelican Way., San Rafael CA 94901. E-mail: licensing@cedco.com. Website: www.cedco.com. **Contact:** Licensing Department. Estab. 1982. Produces 200 upscale calendars and books.
Needs: Approached by 500 freelancers/year. Art guidelines on website. "We never give assignment work." Uses freelancers mainly for stock material and ideas. "We use either 35mm slides or 4×5s of the work."
First Contact & Terms: "No phone calls accepted." Send query letter with nonreturnable photocopies and tearsheets. Samples are filed. Also send list of places where your work has been published. Responds only if interested. To show portfolio, mail thumbnails and b&w photostats, tearsheets and photographs or e-mail JPEG file. Original artwork is returned at the job's completion. Pays by the project. Buys one-time rights. Interested in buying second rights (reprint rights) to previously published work. Finds artists through art fairs and licensing agents.
Tips: "Full calendar ideas encouraged!"

■ ✦ **CENTRIC CORP.,** 6712 Melrose Ave., Los Angeles CA 90038. (323)936-2100. Fax: (323)936-2101. E-mail: centric@juno.com. Website: www.centriccorp.com. **President:** Sammy Okdot. Estab. 1986. Produces fashion watches, clocks, mugs, frames, pens and T-shirts for ages 13-60.
Needs: Approached by 40 freelancers/year. Works with 6-7 freelancers/year. Buys approximately 100 designs and illustrations/year. Prefers local freelancers only. Works on assignment only. Uses freelancers mainly for watch and clock dials, frames and mug designs, T-shirts, pens and packaging. Also for mechanicals and web design. Considers mainly graphics, computer graphics, cartoons, pen & ink, photography. 95% of freelance work demands knowledge of QuarkXPress, Illustrator, Photoshop.
First Contact & Terms: Send postcard sample or query letter with appropriate samples. Accepts submissions on disk. Samples are filed if interested. Responds only if interested. Originals are returned at job's completion. Also needs package/product designers, pay rate negotiable. Requests work on spec before assigning a job. Pays by the project. Pays royalties of 1-10% for design. Rights purchased vary according to project. Finds artists through submissions/self-promotions, sourcebooks, agents and artists' reps.
Tips: "Show your range on a postcard addressed personally to the target person. Be flexible, easy to work with. The World Wide Web is making it easier to work with artists in other locations."

N **CITY MERCHANDISE INC.**, 241 41st St., P.O. Box 320081, Brooklyn NY 11232. (718)832-2931. Fax: (718)832-2939. E-mail: citymdse@aol.com. **Executive Assistant:** Martina Santoli. Produces calendars, collectible figurines, gifts, mugs, souvenirs of New York.
Needs: Works with 6-10 freelancers/year. Buys 50-100 freelance designs and illustrations/year. "We buy sculptures for our casting business." Prefers freelancers with experience in graphic design. Works on assignment only. Uses freelancers for most projects. Considers all media. 50% of design and 80% of illustration demand knowledge of Photoshop, QuarkXPress, Illustrator. Does not produce holiday material.
First Contact & Terms: Designers send query letter with brochure, photocopies, résumé. Illustrators and/or cartoonists send postcard sample of work only. Sculptors send résumé and copies of their work. Samples are filed. Include SASE for return of samples. Responds in 2 weeks. Portfolios required for sculptors only if interested in artist's work. Buys all rights. Pays by project.

CLARKE AMERICAN, P.O. Box 460, San Antonio TX 78292-0460. (210)697-1375. Fax: (210)558-7045. E-mail: linda_m_roothame@clarkeamerican.com. Website: www.clarkeamerican.com. **Senior Product Development Manager:** Linda Roothame. Estab. 1874. Produces checks and other products and services sold through financial institutions. "We're a national printer seeking original works for check series, consisting of five, three, or one scene. Looking for a variety of themes, media, and subjects for a wide market appeal."
Needs: Uses freelancers mainly for illustration and design of personal checks. Considers all media and a range of styles. Prefers art twice standard check size.
First Contact & Terms: Send postcard sample or query letter with brochure and résumé. "Indicate whether the work is available; do not send original art." Samples are filed and are not returned. Responds only if interested. Rights purchased vary according to project. Payment for illustration varies by the project.
Tips: "Keep red and black in the illustration to a minimum for image processing."

N **CLASSIC OILS**, Box 33, Flushing NY 11367. (914)806-7704. **Contact:** Roy Sicular. Estab. 1978. Produces greeting cards and posters. "I publish scenes of New York City—watercolor, collages, b&w."
Needs: Approached by 5 freelancers/year. Works with 0-1 freelancer/year. Buys 0-1 freelance design and illustration/year. Considers all media.
First Contact & Terms: Send query letter with photocopies. Samples are not filed and are returned. Responds only if interested. Portfolio review not required. Originals are returned at job's completion. Pays $100-300 for reproduction rights. Buys reprint rights.

CLEO, INC., 4025 Viscount Ave., Memphis TN 38118. (901)369-6657. Fax: (901)369-6376. E-mail: cpatat@cleowrap.com. Website: www.cleowrap.com. **Senior Director of Creative Resources:** Claude Patat. Estab. 1953. Produces giftwrap and gift bags. "Cleo is the world's largest Christmas giftwrap manufacturer. Other product categories include some seasonal product. Mass market for all age groups."
Needs: Approached by 25 freelancers/year. Works with 40-50 freelancers/year. Buys more than 200 freelance designs and illustrations/year. Uses freelancers mainly for giftwrap and gift bags (designs). Also for calligraphy. Considers most any media. Looking for fresh, imaginative as well as classic quality designs for Christmas. 30″ repeat for giftwrap. Art guidelines available. Submit seasonal material at least a year in advance.
First Contact & Terms: Send query letter with slides, SASE, photocopies, transparencies and speculative art. Accepts submissions on disk. Samples are filed if interested or returned by SASE if requested by artist. Responds only if interested. Rights purchased vary according to project; usually buys all rights. Pays flat fee. Also needs package/product designers, pay rate negotiable. Finds artists through agents, sourcebooks, magazines, word of mouth and submissions.
Tips: "Understand the needs of the particular market to which you submit your work."

COMSTOCK CARDS, INC., 600 S. Rock Blvd., Suite 15, Reno NV 89502. (775)856-9400. Fax: (775)856-9406. E-mail: submissions@comstockcards.com. Website: www.comstockcards.com. **Production Manager:** Cindy Thomas. Estab. 1987. Produces greeting cards, notepads and invitations. Styles include alternative and adult humor, outrageous, shocking and contemporary themes; specializes in fat, age and funny situations. No animals or landscapes. Target market predominately professional females, ages 25-55.
Needs: Approached by 250-350 freelancers/year. Works with 30-35 freelancers/year. "Especially seeking artists able to produce outrageous adult-oriented cartoons." Uses freelancers mainly for cartoon greeting cards. Art guidelines for SASE with first-class postage. No verse or prose. Gaglines must be brief. Prefers

5×7 final art. Produces material for all occasions. Submit holiday concepts 11 months in advance.

First Contact & Terms: Send query letter with SASE, tearsheets or photocopies. Samples are not usually filed and are returned by SASE if requested. Responds only if interested. Portfolio review not required. Originals are not returned. Pays royalties of 5%. Pays by project, $50-150 minimum; may negotiate other arrangements. Buys all rights.

Tips: "Make submissions outrageous and fun—no prose or poems. Outrageous humor is what we look for—risque OK, mild risque best."

COURAGE CENTER, 3915 Golden Valley Rd., Golden Valley MN 55422. (888)413-3323. E-mail: artsearch@courage.org. Website: www.couragecards.org. **Art and Production Manager:** Laura Brooks. Estab. 1970. "Courage Cards are holiday cards that are produced to support the programs of Courage Center, a nonprofit provider of rehabilitation services that helps people with disabilities live more independently."

Needs: In search of holiday art themes including: traditional, winter, nostalgic, religious, ethnic and world peace designs. Features artists with disabilities, but all artists are encouraged to enter the annual Courage Card Art Search. Art guidelines available on company's website.

First Contact & Terms: Call or e-mail name and address to receive Art Search guidelines, which are mailed January for the March 31 entry deadline. Artist retains ownership of the art. Pays $350 licensing fee in addition to nationwide recognition through distribution of more than 500,000 catalogs and promotional pieces, Internet, TV, radio and print advertising.

Tips: "Do not send originals. We prefer that entries arrive as a result of the Art Search. The Selection Committee chooses art that will reproduce well as a card—colorful contemporary and traditional images for holiday greetings. Participation in the Courage Cards Art Search is a wonderful way to share your talents and help people live more independently."

CREATIF LICENSING, 31 Old Town Crossing, Mount Kisco NY 10549. (914)241-6211. E-mail: info@creatifusa.com. Website: www.creatifusa.com. **President and Licensing Manager:** Paul Cohen. Estab. 1975. "Creatif is a licensing agency that represents artists and concept people." Licenses art for commercial applications for consumer products in gift stationery and home furnishings industry.

Needs: Looking for unique art styles and/or concepts that are applicable to multiple products and categories.

First Contact & Terms: Send query letter with brochure, photocopies, photographs, SASE and tearsheets. Does not accept e-mail attachments but will review website links. Responds in 2 months. Samples are returned with SASE. Creatif will obtain licensing agreements on behalf of the artists, negotiate and manage the licensing programs and pay royalties. Artists are responsible for filing all copyright and trademark. Requires exclusive representation of artists.

Tips: "We are looking to license talented and committed artists. Be aware of current trends and design with specific products in mind."

N ☤ CREEGAN CO., INC., dba The Creegan Animation Factory, 510 Washington St., Steubenville OH 43952. (740)283-3708. Fax: (740)283-4117. E-mail: creegans@weir.net. Website: www.creegans.com. **President:** Dr. G. Creegan. Estab. 1961. "The Creegan Company designs and manufactures animated characters, costume characters and life-size audio animatronic air-driven characters. All products are custom made from beginning to end."

Needs: Approached by 10-30 freelance artists/year. Works with 3 freelancers/year. Prefers local artists with experience in sculpting, latex, oil paint, molding, etc. Artists sometimes work on assignment basis. Uses freelancers mainly for design comps. Also for mechanicals. Produces material for all holidays and seasons, Christmas, Valentine's Day, Easter, Thanksgiving, Halloween and everyday. Submit seasonal material 3 months in advance.

First Contact & Terms: Send query letter with résumé and non-returnable photos or other samples. Samples are filed. Write for appointment to show portfolio of final art, photographs. Originals returned. Rights purchased vary according to project.

SUZANNE CRUISE CREATIVE SERVICES, INC., 7199 W. 98th Terrace, #110, Overland Park KS 66212. (913)648-2190. Fax: (913)648-2110. E-mail: artagent@cruisecreative.com. Website: www.cruisecreative.com. **President:** Suzanne Cruise. Estab. 1990. "Sells and licenses art for calendars, craft papers, decorative housewares, fabric giftbags, gifts, giftwrap, greeting cards, home decor, keychains, mugs, ornaments, prints, rubber stamps, stickers, tabletop, and textiles. "We are a full-service licensing agency, as

well as a full-service creative agency representing licensed artists and freelance artists. Our services include, but are not limited to, screening manufacturers for quality and distribution, negotiating rights, overseeing contracts and payments, sending artists' samples to manufacturers for review, and exhibiting artists' work at major trade shows annually."

Needs: Seeks established and emerging artists with distinctive styles suitable for the ever-changing consumer market. Looking for artists that manufacturers cannot find in their own art staff or in the freelance market, or who have a style that has the potential to become a classic license. "We represent a wide variety of freelance artists, and a few select licensed artists, offering their work to manufacturers of goods such as gifts, textiles, home furnishings, clothing, book publishing, social expression, puzzles, rubber stamps, etc. We look for art that has popular appeal. It can be traditional, whimsical, cute, humorous, seasonal or everyday, as long as it is not 'dated'."

First Contact & Terms: Send query letter with color photocopies, tearsheets or samples. No originals. Samples are returned only if accompanied by SASE. Responds only if interested. Portfolio required. Request portfolio review in original query.

Tips: "Walk a few trade shows and familiarize yourself with the industries you want your work to be in. Attend a few of the panel discussions that are put on during the shows to get to know the business a little better."

CRYSTAL CREATIVE PRODUCTS, INC., 3120 S. Verity Pkwy., Middletown OH 45044-7490. (513)423-0731. Fax: (513)423-0516. Website: www.crystalcreative.com. **Art Director:** Karen Wagers. Estab. 1894. Produces gift bags, printed giftwrapping tissues and decorative accessories. "Crystal produces a broad range of giftwrapping items for the mass market. We especially emphasize our upscale gift bags with coordinating specialty tissues and giftwrap. Our product line encompasses all age groups in both Christmas and all occasion themes."

Needs: Approached by 200 freelancers/year. Works with 500 freelancers/year. Buys over 200 freelance designs and illustrations/year. Prefers freelancers with experience in greeting cards or giftwrap markets. Works on assignment and "we also purchase reproduction rights to existing artwork." Uses freelancers mainly for gift bag and tissue repeat design. Also for calligraphy, mechanicals (computer only), b&w line illustration and local freelancers for design and production. 100% of design and 10% of illustration require knowledge of QuarkXPress, Illustrator, FreeHand, PageMaker and Photoshop. Produces seasonal material for Christmas, Valentine's Day, Easter, Hanukkah, Halloween, birthdays and everyday. "We need a variety of styles from contemporary to traditional—florals, geometric, country, whimsical, juvenile, upscale, etc."

First Contact & Terms: Send query letter with 10 or more color examples (not original art) and SASE. Submit samples anytime. Samples are filed or returned by SASE. Responds in 1 month. Company will contact artist for portfolio review if interested. Originals returned depending on rights purchased. Pays by project, $400-1,200. Negotiates rights purchased.

Tips: "Send a packet of samples of what you do best. We'll keep your work on file if it has potential for us, and return it if it doesn't. No phone calls please. Study the illustration work currently being applied to the product you are interested in (in the marketplace). Be sure your style and subjects are appropriate before sending. Pay attention to trends. Garden themes are still strong. Angels are still important—especially at Christmas and in non-traditional handlings. Old-fashioned roses are growing in popularity and there is an increasing interest in pets. Photographic images and typographic solutions are also increasing."

CURRENT, INC., 1005 E. Woodmen Rd., Colorado Springs CO 80920. (719)594-4100. Fax: (719)531-2564. Website: www.currentcatalog.com. **Creative Business Manager:** Dana Grignano. Estab. 1950. Produces bookmarks, calendars, collectible plates, decorative housewares, decorations, giftbags, gifts, giftwrap, greeting cards, mugs, ornaments, school supplies, stationery, T-shirts. Specializes in seasonal and everyday social expressions products.

Needs: Works with hundreds of freelancers/year. Buys 700 freelance designs and illustrations/year. Prefers freelancers with experience in greeting cards and textile industries. Uses freelancers mainly for cards, wraps, calendars, gifts, calligraphy. Considers all media. Product categories include business, conventional, cute, cute/religious, juvenile, religious, teen. Freelancers should be familiar with Photoshop, Illustrator and

SASE MEANS SELF-ADDRESSED, STAMPED ENVELOPE. Send SASEs when requesting return of your samples.

FreeHand. Produces material for all holidays and seasons and everyday. Submit seasonal material year-round.

First Contact & Terms: Send query letter with photocopies, tearsheets, brochure and photographs. Samples are filed. Responds only if interested. Will contact artist for portfolio review if interested. Buys all rights. Pays by the project; $50-500. Finds freelancers through agents, artists' submissions, sourcebooks.

Tips: "Review web or catalog prior to sending work."

DECORCAL, INC., 2477 Merrick Rd., Bellmore NY 11710. (516)221-7200 or (800)645-9868. Fax: (516)221-7229. E-mail: decorcal1@aol.com. **President:** Walt Harris. Produces decorative, instant stained glass, sports and wildlife decals, as well as custom decals.

Needs: Buys 50 designs and illustrations from freelancers/year. Uses freelancers mainly for greeting cards and decals; also for P-O-P displays. Prefers watercolor.

First Contact & Terms: Send query letter with brochure showing art style or résumé and photographs. Samples not filed are returned. Art director will contact artist for portfolio review if interested. Portfolio should include final reproduction/product and photostats. Originals are not returned. Sometimes requests work on spec before assigning a job. Pays by project. Buys all rights. Finds artists through word of mouth, magazines, submissions/self-promotions, sourcebooks, agents, visiting artists' exhibitions, art fairs and artists' reps.

Tips: "We predict a steady market for the field."

DESIGN DESIGN, INC., P.O. Box 2266, Grand Rapids MI 49501. (616)774-2448. Fax: (616)774-4020. **Creative Director:** Tom Vituj. Produces humorous and traditional fine art greeting cards, stationery, magnets, sticky notes, giftwrap/tissue and paper plates/napkins.

Needs: Uses freelancers for all of the above products. Considers most media. Produces cards for everyday and all holidays. Submit seasonal material 1 year in advance.

First Contact & Terms: Send query letter with appropriate samples and SASE. Samples are not filed and are returned by SASE if requested by artist. To show portfolio, send color copies, photographs or slides. Do not send originals. Pays various royalties per product development.

DESIGNER GREETINGS, INC., Box 140729, Staten Island NY 10314. (718)981-7700. Fax: (718)981-0151. Website: www.designergreetings.com. **Art Director:** Fern Gimbelman. Produces all types of greeting cards. Produces alternative, general, informal, inspirational, contemporary, juvenile and studio cards and giftwrap.

Needs: Works with 16 freelancers/year. Buys 250-300 designs and illustrations/year. Art guidelines free for SAE with first-class postage or on website. Works on assignment only both traditionally and digitally. Also uses artists for airbrushing and pen & ink. No specific size required. Produces material for all seasons; submit seasonal material 6 months in advance. Also needs package/product design and web design.

First Contact & Terms: Send query letter with tearsheets, photocopies or other samples. Samples are filed or are returned only if requested. Responds in 2 months. Appointments to show portfolio are only made after seeing style of artwork. Originals are not returned. Pays flat fee. Buys all greeting card rights. Artist guidelines on website.

Tips: "We are willing to look at any work through traditional mail (photocopies, etc.). Appointments are given after I personally speak with the artist (by phone)."

DIMENSIONS, INC., 1801 N 12th St., Reading PA 19604. (610)939-9900. Fax: (610)939-9666. E-mail: pam.keller@dimensions-crafts.com. Website: www.dimensions-crafts.com. **Designer Relations Coordinator:** Pamela Keller. Produces craft kits and leaflets, including but not limited to needlework, stained glass, paint-by-number, iron-on transfer, printed felt projects. "We are a craft manufacturer with emphasis on sophisticated artwork and talented designers. Products include needlecraft kits and leaflets, paint-by-number, wearable art crafts, baby products. Primary market is adult women but children's crafts also included."

Needs: Approached by 50-100 freelancers/year. Works with 200 freelancers/year. Develops more than 400 freelance designs and illustrations/year. Uses freelancers mainly for the original artwork for each product. Art guidelines for SASE with first-class postage. In-house art staff adapts for needlecraft. Considers all media. Looking for fine art, realistic representation, good composition, more complex designs than some greeting card art; fairly tight illustration with good definition; also whimsical, fun characters. Produces material for Christmas; Easter; Halloween; everyday; birth, wedding and anniversary records. Majority of products are everyday decorative designs for the home.

First Contact & Terms: Send cover letter with color brochure, tearsheets, photographs or photocopies. Samples are filed "if artwork has potential for our market." Samples are returned by SASE only if requested by artist. Responds in 1 month. Portfolio review not required. Originals are returned at job's completion. Pays by project, royalties of 2-5%; sometimes purchases outright. Finds artists through magazines, trade shows, word of mouth, licensors/reps.

Tips: "Current popular subjects in our industry: florals, country/folk art, garden themes, ocean themes, celestial, Southwest/Native American, Victorian, juvenile/baby and whimsical."

☑ **DLM STUDIO**, 2563 Princeton Rd., Cleveland Heights OH 44118. (216)721-4444. Fax: (216)721-6878. E-mail: pat@dlmstudio.com. Website: www.dlmstudio.com. **Vice President:** Pat Walker. Estab. 1984. Produces fabrics/packaging/wallpaper. Specializes in wallcovering, border and mural design, entire package with fabrics, also ultra-wide "mural" borders. Also licenses artwork for wall murals.

Needs: Approached by 40-80 freelancers/year. Works with 20-40 freelancers/year. Buys hundreds of freelance designs and illustrations/year. Art guidelines free for SASE with first-class postage. Works on assignment and some licensing. Uses freelancers mainly for designs, color work. Looking for traditional, country, floral, texture, woven, menswear, children's and novelty styles. 50% of freelance design work demands computer skills. Wallcovering CAD experience a plus. Produces material for everyday.

First Contact & Terms: Illustrators send query letter with photocopies, examples of work, résumé and SASE. Accepts disk submissions compatible with Illustrator or Photoshop files (Mac), SyQuest, Jaz or Zip. Samples are filed or returned by SASE on request. Responds in 1 month. Request portfolio review of color photographs and slides in original query, follow-up with letter after initial query. Rights purchased vary according to project. Pays by the project, $500-1,500, "but it varies." Finds freelancers through agents and local ads, word of mouth.

Tips: "Send great samples, especially traditional patterns. Novelty and special interest also strong, and digital files are very helpful. Study the market closely; do very detailed artwork."

☑ **EDITIONS LIMITED/FREDERICK BECK**, 51 Bartlett Ave., Pittsfield MA 01201. (413)443-0973. Fax: (413)445-5014. E-mail: mark@chatsworthcollection.com. Website: www.chatsworthcollection.com. **Art Director:** Mark Brown. Estab. 1958. Produces holiday greeting cards, personalized and box stock and stationery.

● Editions Limited joined forces with Frederick Beck Originals. The company also runs Gene Bliley Stationery. See editorial comment under Frederick Beck Originals for further information. Mark Brown is the art director for all three divisions.

Needs: Approached by 100 freelancers/year. Works with 20 freelancers/year. Buys 50-100 freelance designs and illustrations/year. Prefers freelancers with experience in silkscreen. Art guidelines available. Uses freelancers mainly for silkscreen greeting cards. Also for separations and design. Considers offset, silkscreen, thermography, foil stamp. Looking for traditional holiday, a little whimsy, contemporary designs. Size varies. Produces material for Christmas, graduation, Hannukkah, New Year, Rosh Hashanah and Valentine's Day. Submit seasonal material 15 months in advance.

First Contact & Terms: Designers send query letter with brochure, photocopies, photographs, résumé, tearsheets. Samples are filed. Responds in 1 month. Will contact artist for portfolio review of b&w, color, final art, photographs, photostats, roughs if interested. Buys all rights. Pays $150-300/design. Finds freelancers through word of mouth, past history.

☒ **EISENHART WALLCOVERINGS CO.**, 400 Pine St., Hanover PA 17331. (717)632-8024. Fax: (717)632-0288. Website: www.eisenwalls.com. **Design Center Administrator:** Gina Shaw. Licensing: JoAnn Berwager. Estab. 1940. Produces custom and residential wallpaper, borders, murals and coordinating fabrics. Licenses various types of artwork for wall coverings. Manufactures and imports residential and architectural wallcovering under the Ashford House®, Eisenhart® and Color Tree® collections.

Needs: Works with 10-20 freelancers/year. Buys 50-100 freelance designs and illustrations/year. Prefers freelancers with experience in wallcovering design, experience with Photoshop helpful. Uses freelancers mainly for wallpaper design/color. Also for P-O-P. Looking for traditional as well as novelty designs.

First Contact & Terms: Designers should contact by e-mail. Illustrators send query letter with color copies. Samples are filed. Samples are returned by SASE if requested. Responds in 2 weeks. Artist should contact after 2 weeks. Will contact for portfolio review if interested. Buys all rights. Pays by design, varies. Finds freelancers through artists' submissions.

KRISTIN ELLIOTT, INC., 6 Opportunity Way, Newburyport MA 01950. (978)526-7126. Fax: (978)526-1013. E-mail: kedesignstudio@aol.com. Website: www.kristinelliott.com. **Creative Director:** Barbara Elliott. Publishes greeting cards and stationery products.

Needs: Works with 25 freelance artists/year. Uses illustrations and graphic design. Prefers watercolor and gouache. Produces Christmas and everyday stationery products, including boxed notes, imprintables and photo cards.

First Contact & Terms: Send published samples, color copies, slides, tearsheets or photos. Include SASE for return of materials. Payment negotiable.

Tips: Crisp, clean colors preferred. "Show prospective clients a full range of art styles in a professional presentation."

N ENCORE STUDIOS, INC., 17 Industrial West, Clifton NJ 07012. (800)526-0497. Phone/fax: (973)472-3005. E-mail: encore17@aol.com. Website: www.encorestudios.com. Estab. 1979. Produces personalized wedding, bar/bat mitzvah, party and engraved invitations, birth announcements, stationery, Christmas and Chanukah cards and Jewish New Year.

Needs: Approached by 50-75 freelance designers/year. Works with 20 freelancers/year. Prefers freelancers with experience in creating concepts for holiday cards, invitations, announcements and stationery. "We are interested in designs for any category in our line. Looking for unique type layouts, textile designs and initial monograms for stationery and weddings, holiday logos, flowers for our wedding line, Hebrew monograms for our bar/bat mitzvah line, religious art for Bar/Bat Mitzvah and Chanukah." Considers b&w or full-color art. Looking for "elegant, graphic, sophisticated contemporary designs." 20% of freelance work demands knowledge of Macintosh: QuarkXPress, Illustrator, Photoshop. Submit seasonal material all year.

First Contact & Terms: Send query letter with brochure, résumé, SASE, tearsheets, photographs, photocopies or slides. Samples are filed or are returned by SASE if requested by artist. Responds in 2 weeks only if interested. Write for appointment to show portfolio, or mail appropriate materials. Portfolio should include roughs, finished art samples, b&w photographs or slides. Pays by the project. Negotiates rights purchased.

ENESCO GROUP INC., 225 Windsor Dr., Itasca IL 60143-1225. (630)875-5300. Fax: (630)875-5350. Website: www.enesco.com. **Contact:** New Submissions/Licensing. Producer and importer of fine gifts and collectibles, such as resin, porcelain bisque and earthenware figurines, plates, hanging ornaments, bells, picture frames, decorative housewares. Clients: gift stores, card shops and department stores.

Needs: Works with multiple freelance artists/year. Prefers artists with experience in gift product and packaging development. Uses freelancers for rendering, illustration and sculpture. 50% of freelance work demands knowledge of Photoshop, QuarkXPress or Illustrator.

First Contact & Terms: Send query letter with résumé, tearsheets and/or photographs. Samples are filed or are returned. Responds in 2 weeks. Pays by the project.

Tips: "Contact by mail only. It is better to send samples and/or photocopies of work instead of original art. All will be reviewed by Senior Creative Director, Executive Vice President and Licensing Director. If your talent is a good match to Enesco's product development, we will contact you to discuss further arrangements. Please do not send slides. Have a well thought-out concept that relates to gift products before mailing your submissions."

EQUITY MARKETING, INC., 6330 San Vicente, Los Angeles CA 90048. (323)932-4300. Website: www.equity-marketing.com. **Studio Assistant:** Nanette Castillo. Specializes in design, development and production of promotional, toy and gift items, especially licensed properties from the entertainment industry. Clients include Tyco, Applause, Avanti and Ringling Bros. and worldwide licensing relationships with Disney, Warner Bros., 20th Century Fox and Lucas Film.

Needs: Needs product designers, sculptors, packaging and display designers, graphic designers and illustrators. Prefers local freelancers only with whimsical and cartoon styles. Products are typically targeted at children. Works on assignment only.

First Contact & Terms: Send résumé and nonreturnable samples. Will contact for portfolio review if interested. Rights purchased vary according to project. Pays for design by the project, $50-1,200. Pays for illustration by the project, $75-3,000. Finds artists through word of mouth, network of design community, agents/reps.

Tips: "Gift items will need to be simply made, priced right and of quality design to compete with low prices at discount houses."

N EXECUTIVE GREETINGS, 1025 Post & Paddock St., Grand Prairie TX 75050-1140. (972)641-4911. Fax: (817)545-6235. E-mail: bjordan@nstar.net. Website: www.executive-greetings.com. **Creative Director:** Barbara Jordan. Estab. 1967. Produces calendars, greeting cards, stationery, posters, memo pads, advertising specialties. Specializes in Christmas, everyday, dental, healthcare greeting cards and postcards, and calendars for businesses and professionals.

Needs: Approached by 5-10 freelancers/year. Art guidelines available free for SASE. Works with 10-15 freelancers/year. Buys 200-300 freelance designs and illustrations/year. Prefers freelancers with experience in greeting cards. Works on assignment only. Uses freelancers mainly for illustration, calligraphy, lettering, humorous writing, cartoons. Prefers traditional Christmas and contemporary and conservative cartoons. Some design work demands knowledge of Photoshop, Illustrator, QuarkXPress. Produces material for Christmas, Halloween, Thanksgiving, birthdays, everyday.

First Contact & Terms: Designers send brochure, résumé, tearsheets. Illustrators and cartoonists send tearsheets. After introductory mailing, send follow-up postcard sample every 6 months. Calligraphers send photocopies of their work. Accepts Mac-compatible disk submissions. Samples are filed or returned. Buys one-time or all rights. Pays for illustration by the project, $250-500. Finds freelancers through agents, other professional contacts, submissions and recommendations.

N FAIRCHILD ART/FAIRCHILD PHOENIX, 1601 Archdale Dr., Charlotte NC 28210. (704)525-6369. **Owner/President:** Marilynn Fairchild. Estab. 1985. Produces fine art greeting cards, stationery, posters and art prints.

Needs: Approached by 10-15 artists/year. Works with 1 or 2 artists/year. Buys 10-20 designs and illustrations/year. Prefers "quality fine artists." Uses freelancers mainly "when artwork is needed to complement our present product line." Considers all media. Prefers "work which is proportionate to 25×38 or 23×35 printing sheets; also sizes useful for printing 2-up, 4-up or 10-up on these size sheets." Produces material for birthdays and everyday. Submit 1 year before holiday. 10-25% of freelance works demands knowledge of FreeHand, Illustrator or CorelArt. Prefers quality fine art.

First Contact & Terms: Send query letter with brochure, résumé, tearsheets, photographs or photocopies. Samples are filed or are not returned. Responds only if interested. Write for appointment to show portfolio, or mail finished art samples, b&w and color photostats, tearsheets and photographs. Pays flat fee for illustration/design, $100-300; or by the hour, $15 minimum. Rights purchased vary according to project.

Tips: This company looks for professionalism in its freelancers.

FENTON ART GLASS COMPANY, 700 Elizabeth St., Williamstown WV 26187. (304)375-6122. Fax: (304)375-7833. E-mail: AskFenton@FentonArtGlass.com. Website: www.Fentonartglass.com. **Design Director:** Nancy Fenton. Estab. 1905. Produces collectible figurines, gifts. Largest manufacturer of handmade colored glass in the US.

• Design Director Nancy Fenton says this company rarely uses freelancers because they have their own staff of artisans. "Glass molds aren't very forgiving," says Fenton. Consequently it's a difficult medium to work with. There have been exceptions. "We were really taken with Linda Higdon's work," says Fenton, who worked with Higdon on a line of historical dresses.

Needs: Uses freelancers mainly for sculpture and ceramic projects that can be translated into glass collectibles. Considers clay, ceramics, porcelain figurines. Looking for traditional artwork appealing to collectibles market.

First Contact & Terms: Send query letter with brochure, photocopies, photographs, résumé and SASE. Samples are filed. Responds only if interested. Negotiates rights purchased. Pays for design by the project; negotiable.

FIDDLER'S ELBOW, Fiddler's Elbow Rd., Middle Falls NY 12848. (518)692-9665. Fax: (518)692-9186. E-mail: info@thetoyworks.com. Website: www.fiddlerselbow.com. **Art and Licensing Coordinator:** John Gunther. Estab. 1974. Produces decorative housewares, gifts, pillows, totes, soft sculpture, flags and doormats.

Needs: Works with 5 freelancers/year. Art guidelines available free for SASE. Buys 50 freelance designs and illustrations/year. Uses freelancers mainly for design and illustration. Looking for traditional, floral, adult contemporary. 50% of freelance design demands knowledge of Photoshop, Illustrator and QuarkXPress, however computer knowledge is not a must. Produces material for everyday home decor.

First Contact & Terms: Designers and illustrators send query letter with photostats, résumé, photocopies, photographs. Accepts disk submissions compatible with Postscript. Samples are filed or returned. Responds in 4 months. No phone calls! Portfolio review not required. Rights purchased vary according to project.

Pays for design by the project; $400-1,000; pays for illustration by the project, $400-1,200.

Tips: When approaching a manufacturer, send color comps or prototypes with the type of art you create. It is much easier for manufacturers to understand your art if they see it on their product.

FISHER-PRICE, 636 Girard Ave., E. Aurora NY 14052. (716)687-3983. Fax: (716)687-5281. Website: www.fisherprice.com. **Manager, Product Art:** Henry Schmidt. Estab. 1931. Manufacturer of toys and other children's products.

Needs: Approached by 10-15 freelance artists/year. Works with 25-30 freelance illustrators and sculptors and 15-20 freelance graphic designers/year. Assigns 100-150 jobs to freelancers/year. Prefers artists with experience in children's style illustration and graphics. Works on assignment only. Uses freelancers mainly for product decoration (label art). Prefers all media and styles except loose watercolor. Also uses sculptors. 25% of work demands knowledge of FreeHand, Illustrator, Photoshop.

• This company has two separate art departments: Advertising and Packaging, which does catalogs and promotional materials; and Product Art, which designs decorations for actual toys. Be sure to specify your intent when submitting material for consideration. Art director told *AGDM* he has been receiving more e-mail and disk samples. He says it's a convenient way for him or his staff to look at work.

First Contact & Terms: Send query letter with samples showing art style or slides, photographs and transparencies. Samples are filed. Responds only if interested. Call to schedule an appointment to show a portfolio. Portfolio should include original, final art and color photographs and transparencies. Pays for design and illustration by the hour, $25-50. Buys all rights.

FOTOFOLIO, INC., 561 Broadway, New York NY 10012. (212)226-0923. Fax: (212)226-0072. E-mail: submissions@fotofolio.com. Website: www.fotofolio.com. Estab. 1976. Produces greeting cards, calendars, posters, T-shirts, postcards and a line of products for children including a photographic book, Keith Haring coloring books and notecards.

Needs: Buys 5-60 freelance designs and illustrations/year. Reproduces existing works. Primarily interested in photography. Produces material for Christmas, Valentine's Day, birthday and everyday. Submit seasonal material 8 months in advance. Art guidelines for SASE with first-class postage.

First Contact & Terms: Send query letter with SASE c/o Editorial Dept. Samples are filed or are returned by SASE if requested by artist. Editorial Coordinator will contact artist for portfolio review if interested. Originals are returned at job's completion. Pays by the project, 7½-15% royalties. Rights purchased vary according to project. Finds artists through word of mouth, magazines, submissions/self-promotions, sourcebooks, agents, visiting artist's exhibitions, art fairs and artists' reps.

Tips: "When submitting materials, present a variety of your work (no more than 40 images) rather than one subject/genre."

THE FRANKLIN MINT, Franklin Center PA 19091-0001. (610)459-7975. Fax:(610)459-6463. Website: www.franklinmint.com. **Artist Relations Manager:** Cathy La Spada. Estab. 1964. Direct response marketing of high-quality collectibles. Produces collectible porcelain plates, prints, porcelain and coldcast sculpture, figurines, fashion and traditional jewelry, ornaments, precision diecast model cars, luxury board games, engineered products, heirloom dolls and plush, home decor items and unique gifts. Clients: general public worldwide, proprietary houselist of 8 million collectors and 55 owned-and-operated retail stores. Markets products in countries worldwide, including: USA, Canada, United Kingdom and Japan.

Needs: Approached by 3,000 freelance artists/year. Contracts 500 artists/sculptors per year to work on 7,000-8,000 projects. Uses freelancers mainly for illustration and sculpture. Considers all media. Considers all styles. 80% of freelance design and 50% of illustration demand knowledge of PageMaker, FreeHand, Photoshop, Illustrator, QuarkXPress and 3D Studio Eclipse (2D). Accepts work in SGI format. Produces material for Christmas and everyday.

First Contact & Terms: Send query letter, résumé, SASE and samples (clear, professional full-color photographs, transparencies, slides, greeting cards and/or brochures and tearsheets). Sculptors send photographic portfolios. Do not send original artwork. Samples are filed or returned by SASE. Responds in 2 months. Portfolio review required for illustrators and sculptors. Company gives feedback on all portfolios submitted. Payment varies.

Tips: "In search of artists and sculptors capable of producing high quality work. Those willing to take art direction and to make revisions of their work are encouraged to submit their portfolios."

N **FREEDOM GREETINGS**, 774 American Dr. Bensalem PA 19020. (215)604-0300. Send submissions to **Creative Director** Plesh Creative Group, Inc., 75 West St., Walpole MA 02081. (508)668-1224.

Estab. 1969. Publisher of everyday and seasonal cards, including alternative card lines such as Cappuccino, Cheers, One-to-One and others.

Needs: Approached by over 100 freelancers/year. Buys over 1,000 designs/year. Prefers freelancers with social expression industry experience. Interested in all styles and ranges, including but not limited to: traditional, whimsical, humorous and sophisticated.

First Contact & Terms: Send query letter with résumé, SASE, photocopies, photostats or transparencies. Do not send original art. Allow 1 month for reply and return of material via SASE. Works on assignment basis. Pays by project or flat fee. Artwork is bought outright, including all rights.

Tips: "We will work closely with selected artists in developing designs that satisfy our styling and product needs."

N GAGNÉ WALLCOVERING, INC., 1771 N. Hercules Ave., Clearwater FL 33765. (727)461-1812. Fax: (727)447-6277. Contact: Trish Kennedy, art director. Estab. 1977. Produces wall murals and wallpaper. Specializes in residential and commercial wallcoverings, borders and murals encompassing a broad range of styles and themes for all age groups.

Needs: Approached by 12-20 freelancers/year. Works with 20 freelancers/year. Buys 150 freelance designs and/or illustrations/year. Considers oils, watercolors, pastels, colored pencil, gouache, acrylic—just about anything two dimensional. Artists should check current wallcovering collections to see the most common techniques and media used.

First Contact & Terms: Send brochure, color photocopies, photographs, slides, tearsheets, actual painted or printed sample of artist's hand if possible. Samples are filed. Responds only if interested. Portfolio not required. "We usually buy all rights to a design, but occasionally consider other arrangements." Pays freelancers by the project $500-1,200. Finds freelancers through magazines, licensing agencies, trade shows and word-of-mouth.

Tips: "We are usually looking for traditional florals, country/folkart, juvenile and novelty designs. We do many borders and are always interested in fine representational art. Panoramic borders and murals are also a special interest. Be aware of interior design trends, both in style and color. Visit a wallcovering store and see what is currently being sold. Send us a few samples of your best quality, well painted, detailed work."

GALISON BOOKS/MUDPUPPY PRESS, 28 W. 44th St., New York NY 10036. (212)354-8840. Fax: (212)391-4037. E-mail: Lorena@galison.com. Website: www.galison.com. **Creative Director:** Lorena Siminovich. Estab. 1978. Produces boxed greeting cards, puzzles, address books and specialty journals. Many projects are done in collaboration with museums around the world.

Needs: Works with 10-15 freelancers/year. Buys 20 designs and illustrations/year. Works on assignment only. Uses freelancers mainly for illustration. Considers all media. Also produces material for Christmas and New Year. Submit seasonal material 1 year in advance. 100% of design and 5% of illustration demand knowledge of QuarkXPress.

First Contact & Terms: Send postcard sample, photocopies, résumé and tearsheets (no unsolicited original artwork) and SASE. Accepts submissions on disk compatible with Photoshop, Illustrator or Quark-XPress (but not preferred). Samples are filed. Responds only if interested. Request portfolio review in original query. Creative Director will contact artist for portfolio review if interested. Portfolio should include color photostats, slides, tearsheets and dummies. Originals are returned at job's completion. Pays by project. Rights purchased vary according to project. Finds artists through word of mouth, magazines and artists' reps.

Tips: "Looking for great presentation and artwork we think will sell and be competitive within the gift market."

GALLANT GREETINGS CORP., P.O. Box 308, Franklin Park IL 60131. (847)671-6500. Fax: (847)671-5900. E-mail: sales@gallantgreetings.com. Website: www.gallantgreetings.com. **Vice President Product Development:** Joan Lackouitz. Estab. 1966. Creator and publisher of seasonal and everyday greeting cards.

First Contact & Terms: Samples are not filed or returned. Responds only if interested.

GALLERY GRAPHICS, INC., P.O. Box 502, Noel MO 64854. (417)475-6191. Fax: (417)475-3542. E-mail: info@gallerygraphics. Website: gallerygraphics.com. **Art Director:** Laura Auffet. Estab. 1979. Produces bookmarks, calendars, gifts, greeting cards, stationery, prints, notepads, notecards. Gift company specializing primarily in nostalgic, country and other contemporary designs.

Needs: Approached by 100 freelancers/year. Works with 10 freelancers/year. Buys 100 freelance illustrations/year. Art guidelines free for SASE with first-class postage. Uses freelancers mainly for illustration. Considers any 2-dimensional media. Looking for country, teddy bears, florals, traditional. Prefers 16×20 maximum. Produces material for Christmas, Valentine's Day, birthdays, sympathy, get well, thank you. Submit seasonal material 8 months in advance.

First Contact & Terms: Accepts printed samples or Photoshop files. Send TIFF or EPS files. Samples are filed or returned by SASE. Will contact artist for portfolio review of color photographs, photostats, slides, tearsheets, transparencies if interested. Payment negotiable. Finds freelancers through submissions and word of mouth.

Tips: ``Be flexible and open to suggestions.''

C.R. GIBSON, CREATIVE PAPERS, 404 BNA Drive, Building 200, Suite 600, Nashville TN 37217. (615)724-2900. Fax: (615)391-3166. **Vice President of Creative:** Ann Cummings. Producer of stationery and gift products, baby, kitchen and wedding collections. Specializes in baby, children, feminine, floral, wedding and kitchen-related subjects, as well as holiday designs. 85-90% require freelance illustration; 50% require freelance design. Gift catalog free by request.

Needs: Approached by 200-300 freelance artists/year. Works with 30-50 illustrators and 10-30 designers/year. Assigns 30-50 design and 30-50 illustration jobs/year. Uses freelancers mainly for covers, borders and cards. 50% of freelance work demands knowledge of QuarkXPress, FreeHand and Illustrator. Works on assignment only.

First Contact & Terms: Send query letter with brochure, résumé, tearsheets and photocopies. Samples are filed or are returned. Responds only if interested. Request portfolio review in original query. Portfolio should include thumbnails, finished art samples, color tearsheets and photographs. Return of original artwork contingent on contract. Sometimes requests work on spec before assigning a job. Interested in buying second rights (reprint rights) to previously published work. ``Payment varies due to complexity and deadlines.'' Finds artists through word of mouth, magazines, artists' submissions/self-promotion, sourcebooks, agents, visiting artist's exhibitions, art fairs and artists' reps.

Tips: ``The majority of our mechanical art is executed on the computer with discs and laser runouts given to the engraver. Please give a professional presentation of your work.''

GLITTERWRAP, INC., 701 Ford Rd., Rockaway NJ 07866. (973)625-4200, ext. 1265. Fax: (973)625-0399. **Creative Director:** Melissa Camacho. Estab. 1987. Produces giftwrap, gift totes and allied accessories. Also photo albums, diaries and stationery items for all ages–party and special occasion market.

Needs: Approached by 50-100 freelance artists/year. Works with 10-15 artists/year. Buys 10-30 designs and illustrations/year. Art guidelines available. Prefers artists with experience in textile design who are knowledgeable in repeat patterns or surface, or designers who have experience with the gift industry. Uses freelancers mainly for occasional on-site Mac production at hourly rate of $15-25. Freelance work demands knowledge of QuarkXPress, Illustrator and Photoshop. Considers many styles and mediums. Style varies with season and year. Consider trends and designs already in line, as well as up and coming motifs in gift market. Produces material for baby, wedding and shower, florals, masculine, Christmas, graduation, birthdays, Valentine's Day, Hanukkah and everyday. Submit seasonal material 6-8 months in advance.

First Contact & Terms: Send query letter with brochure, tearsheets, or color copies of work. Do not send original art, photographs, transparencies or oversized samples. Samples are not returned. Responds in 3 weeks. ``To request our submission guidelines send SASE with request letter. To request catalogs send 11×14 SASE with $3.50 postage. Catalogs are given out on a limited basis.'' Rights purchased vary according to project.

Tips: ``Giftwrap generally follows the fashion industry lead with respect to color and design. Adult birthday and baby shower/birth are fast-growing categories. There is a need for good/fresh/fun typographic birthday general designs in both adult and juvenile categories.''

⊠ GODZ FRUITFUL KIDZ™, 31441 Santa Margarita Pkwy., Suite A, #353. RSM CA 92688. (949)459-6013 or (949)459-2678 Estab. 2003. **Contact:** Jacqueline Shires, creative director/publisher. Estab. 2003. Produces apparel, aprons, caps, T-shirts, visors, etc. Produces a line of cartoon characters called Godz Fruitful Kidz™. Specializes in religious Christian market targeting children birth-12 years.

Needs: Works with 4-12 freelancers/year. Buys 4-12 freelance illustrations/year. Prefers freelancers with experience in T-shirt design. Art guidelines free with SASE and first-class postage. Uses freelancers mainly for animation, calligraphy and font design. Considers pen & ink, calligraphy, computer illustration. Product categories include cute/religious, juvenile and religious. Produces material for Christmas, Easter, Father's

Day, Grandparent's Day, Mother's Day, Valentine's Day. Submit seasonal material 6 months in advance. Art size should be 11×17 maximum—allow for $1\frac{1}{2}''$ border around final art.

First Contact & Terms: Send postcard sample or query letter with photocopies, photographs, résumé, SASE and tearsheets. Send follow-up postcard every 3-6 months. Samples are filed for up to 6 months. Samples are not returned. Responds only if interested. Company will contact artist for portfolio review if interested. Portfolio should include b&w finished art, photographs and tearsheets. Buys rights for aprons, apparel, caps, T-shirts, visors, etc. Rights purchased vary according to project. Pays freelancers by the project $20-250 or royalties of 5-10%. Finds freelancers through artists' submissions, art shows, fairs and word-of-mouth.

Tips: "Know the type of linework needed for silkscreening. Understand the types of designs that would appeal to young children—fun, comical, cute, whimsical."

N. GOES LITHOGRAPHING COMPANY SINCE 1879, 42 W. 61st St., Chicago IL 60621-3999. (773)684-6700. Fax: (773)684-2065. E-mail: goeslitho@ameritech.net. Website: www.goeslitho.com. **Contact:** Linda Goes. Estab. 1879. Produces stationery/letterheads to sell to printers and office product stores.

Needs: Approached by 5-10 freelance artists/year. Works with 2-3 freelance artists/year. Buys 4-30 freelance designs and illustrations/year. Art guidelines for SASE with first-class postage. Uses freelance artists mainly for designing holiday letterheads. Considers pen & ink, color, acrylic, watercolor. Prefers final art 17×22, CMYX color compatible. Produces material for Christmas and Thanksgiving.

First Contact & Terms: "I will send examples for your ideas." Samples are not filed and are returned by SASE. Responds in 1-2 months. Pays $100-200 on final acceptance. Buys first rights and reprint rights.

Tips: "Keep your art fresh and be aggressive with submissions."

GRAHAM & BROWN, 3 Corporate Dr., Cranbury NJ 08512. (609)395-9200. Fax: (609)395-9676. E-mail: atopper@grahambrownusa.com. Website: www.grahambrown.com. **President:** Bill Woods. Estab. 1946. Produces residential wallpaper and borders.

Needs: Prefers freelancers with experience in wallpaper. Uses freelancers mainly for designs. Also for artwork. Looking for traditional, floral and country styles. Produces material for everyday.

First Contact & Terms: Designers send query letter with photographs. Illustrators send postcard sample of work only to the attention of Andrea Topper. Samples are filed or returned. Responds only if interested. Buys all rights. For illustration pays a variable flat fee. Finds freelancers through shows (Surtex, etc.).

GREAT ARROW GRAPHICS, 2495 Main St., Suite 457, Buffalo NY 14214. (716)836-0408. Fax: (716)836-0702. E-mail: design@greatarrow.com. Website: www.greatarrow.com. **Art Director:** Lisa Samar. Estab. 1981. Produces greeting cards and stationery. "We produce silkscreened greeting cards—seasonal and everyday—to a high-end design-conscious market."

Needs: Approached by 150 freelancers/year. Works with 75 freelancers/year. Buys 350-500 images/year. Send or call for art guidelines. Prefers freelancers with experience in hand-separated art. Uses freelancers mainly for greeting card design. Considers all 2-dimensional media. Looking for sophisticated, classic, contemporary or cutting edge styles. Requires knowledge of QuarkXPress, Illustrator or Photoshop. Produces material for all holidays and seasons. Submit seasonal material 1 year in advance.

First Contact & Terms: Send query letter with photocopies. Accepts submissions on disk compatible with QuarkXPress, Illustrator or Photoshop. Samples are filed or returned if requested. Responds in 1 month. Art director will contact artist for portfolio review if interested. Portfolio should include color roughs, final art, photographs and transparencies. Originals are returned at job's completion. Pays royalties of 5% of net sales. Rights purchased vary according to project.

Tips: "We are interested in artists familiar with the assets and limitations of screenprinting, but we are always looking for fun new ideas and are willing to give help and guidance in the silkscreen process. Be original—be complete with ideas—don't be afraid to be different . . . forget the trends . . . do what you want. Make your work as complete as possible at first submission. The National Stationery Show in New York City is a great place to make contacts."

NEED HELP? For tips on finding markets and understanding listings, see our Quick-Start Guide in the front of this book.

HALLMARK CARDS, INC., P.O. Box 419580, Drop 216, Kansas City MO 64141-6580. Website: www.hallmark.com. Estab. 1931.

• Because of Hallmark's large creative staff of fulltime employees and their established base of freelance talent capable of fulfilling their product needs, they do not accept unsolicited freelance submissions.

HAMPSHIRE PEWTER COMPANY, 43 Mill St., Box 1570, Wolfeboro NH 03894-1570. (603)569-4944. Fax: (603)569-4524. E-mail: gifts@hampshirepewter.com. Website: www.hpewter.com. **President:** Bob Steele. Estab. 1974. Manufacturer of handcast pewter tableware, accessories and Christmas ornaments. Clients: jewelry stores, department stores, executive gift buyers, tabletop and pewter specialty stores, churches and private consumers.

Needs: Works with 3-4 freelance artists/year. "Prefers New-England based artists." Works on assignment only. Uses freelancers mainly for illustration and models. Also for brochure and catalog design, product design, illustration on product and model-making.

First Contact & Terms: Send query letter with photocopies. Samples are not filed and are returned only if requested. Call for appointment to show portfolio, or mail b&w roughs and photographs. Pays for design and sculpture by the hour or project. Considers complexity of project, client's budget and rights purchased when determining payment. Buys all rights.

Tips: "Inform us of your capabilities. For artists who are seeking a manufacturing source, we will be happy to bid on manufacturing of designs under private license to the artists, all of whose design rights are protected. If we commission a project, we intend to have exclusive rights to the designs by contract as defined in the Copyright Law, and we intend to protect those rights."

MARIAN HEATH GREETING CARDS, INC., 9 Kendrick Rd., Wareham MA 02571. (508)291-0766. Fax: (508)295-5992. E-mail: marianheath@marianheath.com. Website: www.marianheath.com. **Art Director:** Molly DelMastro. Estab. 1950. Produces giftbags, giftwrap, greeting cards and stationery. Greeting card company supporting independent card and gift shop retailers. Product: greeting cards, notecards, stationery, ancillary products.

Needs: Approached by 100 freelancers/year. Works with 35-45 freelancers/year. Buys 1,200 freelance designs and illustrations/year. Prefers freelancers with experience in social expression. Art guidelines free for SASE with first-class postage or e-mail requesting guidelines. Uses freelancers mainly for greeting cards. Considers all media and styles. Generally $5\frac{1}{4} \times 7\frac{1}{4}$ unless otherwise directed. Will accept various sizes due to digital production, manipulation. 30% of freelance design and illustration work demands knowledge of Photoshop, Illustrator, QuarkXPress. Produces material for all holidays and seasons and everyday. Submit seasonal material 1 year in advance.

First Contact & Terms: Designers send query letter with photocopies, résumé and SASE. OK to send slides, tearsheets and transparencies if necessary. Illustrators send query letter with photocopies, résumé, tearsheets and SASE. Accepts Mac-formatted EPS disk submissions. Samples are filed or returned by SASE. Responds within 1 month. Will contact artist for portfolio review of color, final art, slides, tearsheets and transparencies. Pays for illustration by the project; flat fee; varies per project. Finds freelancers through agents, artist's rep, artist submission, licensing and design houses.

HIGH RANGE DESIGNS, P.O. Box 346, Victor ID 83455-0346. E-mail: hmiller@highrangedesigns .com. **President:** Hondo Miller. Estab. 1989. Produces T-shirts. "We produce screen-printed garments for recreational sport-oriented markets and resort markets, which includes national parks. Subject matter includes, but is not limited to, skiing, climbing, hiking, biking, fly fishing, mountains, out-of-doors, nature, canoeing and river rafting, Native American, wildlife and humorous sayings that are text only or a combination of text and art. Our resort market customers are men, women and kids looking to buy a souvenir of their vacation experience or activity. People want to identify with the message and/or the art on the T-shirt."

• According to High Range Graphics' art guidelines, it is easiest to break into HRG with designs related to fly fishing, downhill skiing, snowboarding or river rafting. The guidelines suggest that your first submission cover one or more of these topics. The art guidelines for this company are detailed and include suggestions on where to place design on the garment.

Needs: Approached by 20 freelancers/year. Works with 3-8 freelancers/year. Buys 10-20 designs and illustration/year. Prefers artists with experience in screen printing. Uses freelancers mainly for T-shirt ideas, artwork and color separations.

First Contact & Terms: Send query letter with résumé, SASE and photocopies. Accepts submissions

on disk compatible with FreeHand 8.0 and Illustrator 8.0. Samples are filed or are returned by SASE if requested by artist. Responds in 6 months. Company will contact artist for portfolio review if interested. Portfolio should include b&w thumbnails, roughs and final art. Originals are returned at job's completion. Pays by the project, licensing fee of $300 in addition to royalties of 5% based on actual sales. Buys garment rights.

Tips: "Familiarize yourself with screen printing and T-shirt art that sells. Must have knowledge of color separations process. We look for creative design styles and interesting color applications. Artists need to be able to incorporate the colors of the garments as part of their design thinking, as well as utilize the screen-printing medium to produce interesting effects and textures. However, sometimes simple is best. Four-color process will be considered if highly marketable. Be willing to work with us on design changes to get the most marketable product. Know the industry. Art that works on paper will not necessarily work on garments. No cartoons please."

N: HOME INTERIORS & GIFTS, 1649 Frankford Rd. W., Carrollton TX 75007. (972)695-1000. Fax: (972)695-1062. **Art Director:** Robbin Allen. Estab. 1957. Produces decorative framed art in volume to public by way of shows in the home. "H.I.& G. is a direct sales company. We sell nationwide with over 71,000 consultants in our sales force. We work with artists to design products for our new product line yearly. We work with some publishers now, but wish to work with more artists on a direct basis."

Needs: Approached by 75 freelance artists/year. Works with 25-30 freelancers/year. "We carry approximately 500-600 items in our line yearly." Prefers artists with knowledge of current colors and the decorative art market. "We give suggestions, but we do not dictate exacts. We would prefer the artists express themselves through their individual style. We will make correction changes that will enhance each piece for our line." Uses freelance artists mainly for artwork to be framed (oil and watercolor work mostly). Also for calligraphy. Considers oil, watercolor, acrylic, pen & ink, pastels, mixed media. "We sell to middle America for the most part. Our art needs to be traditional with a sense of wholesomeness to it. For example: a hunter with dog, but no gun. We sell Victorian, country, landscapes, still life, wildlife. Art that tells a story. We also sell a mild contemporary." Produces material for Father's Day, Halloween, Christmas, Easter, graduation, Thanksgiving, Mother's Day. Submit seasonal material 10 months in advance.

First Contact & Terms: Send query letter with résumé, SASE, photographs, slides and transparencies. Samples are filed or are returned by SASE. Art director will contact artist for portfolio review if interested. Portfolio should include color slides, photographs. Requests work on spec before assigning a job. Pays royalties. Royalties are discussed on an individual basis. Buys reprint rights. Finds artists through word of mouth, magazines, submissions, sourcebooks and visiting artist's exhibitions.

Tips: "This is a great opportunity for the artist who is willing to learn our market. Paint for women because women are our customers. Paintings need softness in form—not rugged and massive/strong or super dark. Jewel tones are great for us. Study Monét—good colors there. Our art demands are unique. The artist will work with our design department to stay current with our needs."

N: HURLIMANN ARMSTRONG STUDIOS, Box 1246, Menlo Park CA 94026. (650)594-1876. Fax: (650)594-9211. E-mail: hascards@aol.com. **Managing General Partner:** Mary Ann Hurlimann. Estab. 1987. Produces mugs.

Needs: Approached by 60 freelance artists/year. Art guidelines free for SASE with first-class postage. Works with 2 freelancers/year. Buys 5 designs/year. Considers watercolor, oil and acrylic. No photography or cartoons. Prefers rich color, clear images, no abstracts.

First Contact & Terms: Send query letter with slides. Samples are filed. Art director will contact artist for portfolio review if interested. Originals are returned at job's completion. Requests work on spec before assigning a job. Pays by the project, $100-300. Buys all rights.

Tips: "Send good quality slides of your work. We are attracted to a strong sense of individual style and technical competence. Avoid trying to be cute in your letter. Keep it simple and professional."

IGPC, 460 W. 34th St., 10th Floor, New York NY 10001. (212)629-7979. Fax: (212)629-3350. Website: www.igpc.net. **Art Director:** Mordechai Friedman. Agent to foreign governments. "We produce postage stamps and related items on behalf of 40 different foreign governments."

Needs: Approached by 50 freelance artists/year. Works with 75-100 freelance illustrators and designers/ year. Assigns several hundred jobs to freelancers/year. Prefers artists within metropolitan New York or tri-state area. Must have excellent design and composition skills and a working knowledge of graphic design (mechanicals). Artwork must be focused and alive (4-color) and reproducible to stamp size (usually 4 times up). Works on assignment only. Uses artists for postage stamp art. Prefers airbrush, acrylic and

gouache (some watercolor and oil OK). Must have reasonable knowledge of Photoshop and Quark.
First Contact & Terms: Send samples showing illustrative skills. Doesn't need to be precious high quality. Color copies are fine. Responds in 5 weeks. Art Director will contact artist for portfolio review if interested. Portfolio should contain "4-color illustrations of realistic, tight flora, fauna, technical subjects, autos or ships. Also include reduced samples of original artwork." Sometimes requests work on spec before assigning a job. Pays by the project, $1,000-4,000. Consider government allowance per project when establishing payment.
Tips: "Artists considering working with IGPC must have excellent drawing abilities in general or specific topics, i.e., flora, fauna, transport, famous people, etc.; sufficient design skills to arrange for and position type; the ability to create artwork that will reduce to postage stamp size and still hold up with clarity and perfection. Familiarity with printing process and print call-outs a plus. Generally, the work we require is realistic art. In some cases, we supply the basic layout and reference material; however, we appreciate an artist who knows where to find references and can present new and interesting concepts. Initial contact should be made by phone for appointment."

THE IMAGINATION ASSOCIATION, P.O. Box 1780, Lake Dallas TX 75065-1780. (940)498-3308. Fax: (940)498-1596. E-mail: ellice@funnyaprons.com. Website: www.funnyaprons.com. **Creative Director:** Ellice Lovelady. Estab. 1992. Produces greeting cards, T-shirts, mugs, aprons and magnets. "We started as a freelance design firm and are established with several major greeting card and t-shirt companies that have produced our work. Our primary focus is now on our subdivision, The Funny Apron Company, that manufactures humorous culinary themed aprons and t-shirts for the gourmet marketplace."
Needs: Works with 12 freelancers/year. Artists must be fax accessible and able to work on fast turnaround. Guidelines free for SAE with first-class postage. Uses freelancers for everything. Considers all media. "We're open to a variety of styles." 100% of freelance work DEMANDS knowledge of Illustrator, Corel Draw, or programs with ability to electronically send vector-based artwork. (Photoshop alone is not sufficient.) Produces material for all holidays and seasons. Submit seasonal material 18 months in advance.
First Contact & Terms: Send query letter with brochure, photographs, SASE and photocopies. Samples are filed or returned by SASE if requested by artist. Company will contact artist for portfolio review if interested. Portfolio should include final art, photographs or any material to give indication of range of artist's style. Negotiates rights and payment terms. Originals are returned at job's completion. Finds artists via word of mouth from other freelancers or referrals from publishers.
Tips: Looking for artist "with a style we feel we can work with and a professional attitude. Understand that sometimes our publishers and manufacturers require several revisions before final art, and all under tight deadlines. Be persistent! Stay true to your creative vision and don't give up!"

N ⊞ IMPERIAL HOME DECOR GROUP, 23645 Mercantile Rd., Cleveland OH 44122. (216)378-5200. Website: www.ihdg.com. **Contact:** Nancy Cerne. Produces wallpaper.
Needs: Works with 20-50 freelancers/year. Prefers local designers/illustrators with experience in wallpaper. Art guidelines available. Product categories include conventional, country, juvenile and teen. 5% of freelance work demands knowledge of Photoshop.
First Contact & Terms: Send brochure, photocopies and photographs. Samples are filed. Responds only if interested. Company will contact artist for portfolio review of color, finished art, original art, photographs, transparencies if interested. Buys rights for wallpaper and/or all rights. Pays freelancers by the project. Finds freelancers through agents, artists' submissions and word-of-mouth.

⊞ INCOLAY STUDIOS INCORPORATED, 520 Library St., San Fernando CA 91344. Fax: (818)365-9599. **Art Director:** Shari Bright. Estab. 1966. Manufacturer. "Basically we reproduce antiques in Incolay Stone, all handcrafted here at the studio. There were marvelous sculptors in that era, but we believe we have the talent right here in the U.S. today and want to reproduce living American artists' work."
 ● Art director told *AGDM* that hummingbirds and cats are popular subjects in decorative art, as are angels, cherubs, endangered species and artwork featuring the family, including babies.
Needs: Prefers local artists with experience in carving bas relief. Uses freelance artists mainly for carvings. Also uses artists for product design and model making.
First Contact & Terms: Send query letter with résumé, or "call and discuss; 1-800-INCOLAY." Samples not filed are returned. Responds in 1 month. Call for appointment to show portfolio. Pays 5% of net. Negotiates rights purchased.

Tips: "Let people know that you are available and want work. Do the best you can. Discuss the concept and see if it is right for 'your talent.'"

☑ **INSPIRATIONS UNLIMITED**, P.O. Box 5097, Crestine CA 92325. (909)338-6758 or (800)337-6758. Fax: (909)338-2907. **Owner:** John Wiedefeld. Estab. 1983. Produces greeting cards, gift enclosures, note cards and stationery.

Needs: Approached by 15 freelancers/year. Works with 4 freelancers/year. Buys 48 freelance designs and illustrations/year. Uses freelancers mainly for greeting cards. Will consider all media, all styles. Prefers 5×7 vertical only. Produces material for Christmas, Mother's Day, graduation, Valentine's Day, birthdays, everyday, sympathy, get well, romantic, thank you, serious illness. Submit seasonal material 1 year in advance.

First Contact & Terms: Designers and illustrators send photocopies and photographs. Samples are filed and are not returned. Responds in 1 week. Company will contact artist for portfolio review if interested. Buys reprint rights; rights purchased vary according to project. Pays $100/piece of art. Also needs calligraphers, pays $25/hour. Finds freelancers through artists' submissions, art galleries and shows.

Tips: "Send color copies of your artwork for review with a self-addressed envelope."

INTERCONTINENTAL GREETINGS LTD., 176 Madison Ave., New York NY 10016. (212)683-5830. Fax: (212)779-8564. E-mail: intertg@intercontinental-ltd.com. Website: www.intercontinental-ltd.com. **Art Director:** Thea Groene. Estab. 1967. Sells reproduction rights of designs to manufacturers of multiple products around the world. Reps artists in 50 different countries, with clients specializing in greeting cards, giftware, giftwrap, calendars, postcards, prints, posters, stationery, paper goods, food tins, playing cards, bath and service ware and much more. "Prefers artwork previously made with few or no rights pending." Company guidelines free with SASE.

Needs: Approached by several hundred artists/year. Seeking creative decorative art in traditional and computer media (Photoshop preferred; some Illustrator work accepted). Graphics, sports, occasions (i.e., Christmas, baby, birthday, wedding), humorous, "soft touch," romantic themes, animals. Accepts seasonal/holiday material any time. Prefer: artists/designers experienced in greeting cards, paper products, giftware.

First Contact & Terms: Query with samples. Send unsolicited color copies or CDs by mail with return SASE for consideration. Upon request, submit portfolio for review. Provide résumé, business card, brochure, flier, tearsheets or slides to be kept on file for possible future assignments. "Once your art is accepted, we use" original color art; Photoshop files on disk, TIFF, Mac, 300 dpi; 2¼×2¼, 4×5, 8×10 transparencies and 35mm slides. Responds only if interested (will send back nonaccepted in SASE if given). Pays on publication. No credit line given. Offers advance when appropriate. Sells one-time rights and exclusive product rights. Simultaneous submissions and previously published work OK. Please state reserved rights if any.

Tips: Recommends the annual New York Stationery Show. In portfolio samples, wants to see "a neat presentation, thematic in arrangement, a series of interrelated images (at least six). In addition to having good drawing/painting/designing skills, artists should be aware of market needs."

THE INTERMARKETING GROUP, 29 Holt Rd., Amherst NH 03031. (603)672-0499. **President, licensing:** Linda L. Gerson. Estab. 1985. Licensing agent for all categories of consumer goods including greeting cards, stationery, calendars, posters, paper tableware products, tabletop, dinnerware, giftwrap, eurobags, giftware, toys, needle crafts. The Intermarketing Group is a full service art licensing agency representing artists' works for licensing with companies in consumer goods products, including the home furnishings, paper product, greeting card, giftware, toy, housewares, needlecraft and apparel industries.

Needs: Approached by 100 freelancers/year. Works with 6 freelancers/year. Licenses work as developed by clients. Prefers freelancers with experience in full-color illustration. Uses freelancers mainly for tabletop, cards, giftware, calendars, paper tableware, toys, bookmarks, needlecraft, apparel, housewares. Will consider all media forms. "My firm generally represents highly illustrated works and illustrations for direct product applications. All works are themed." Prefers 5×7 or 8×10 final art. Produces material for all holidays and seasons and everyday. Submit seasonal material 6 months in advance.

First Contact & Terms: Send query letter with brochure, tearsheets, résumé, slides, SASE or color copies. Samples are not filed and are returned by SASE. Responds in 3 weeks. Originals are returned at job's completion. Requests work on spec before assigning a job. Pays royalties of 2-7% plus advance against royalties. Buys all rights. Considers buying second rights (reprint rights) to previously published work. Finds new artists "mostly by referrals and via artist submissions. I do review trade magazines, attend art shows and other exhibits to locate suitable clients."

Tips: "Companies today seem to be leaning towards a fresh look in the art approach. Companies are selective in their licenses. A well-organized presentation is very helpful. Be aware of the market. See what is selling in stores and focus on specific products that would incorporate your art well. Get educated on market conditions and trends."

N KALAN LP, 97 S. Union Ave., Lansdowne PA 19050. (610)623-1900. Fax: (610)623-0366. E-mail: kalanart@pond.com. **Art Director:** Chris Wiemer. Estab. 1973. Produces giftbags, greeting cards, school supplies, stationery and novelty items such as keyrings, mouse pads, shot glasses and magnets.
Needs: Approached by 50-80 freelancers/year. Buys 10 freelance designs and illustrations/year. Art guidelines are available. Uses freelancers mainly for fresh ideas, illustration and design. Considers all media and styles. 80% of freelance design and 50% of illustration demands knowledge of Photoshop 4 and Illustrator 7. Produces material for major holidays such as Christmas, Mother's Day, Valentine's Day; plus birthdays and everyday. Submit seasonal material 9-10 months in advance.
First Contact & Terms: Designers send query letter with photocopies, photostats and résumé. Illustrators and cartoonists send query letter with photocopies and résumé. Accepts disk submissions compatible with Illustrator 7 or Photoshop 4.0. Send EPS files. Samples are filed. Responds in 1 month if interested in artist's work. Will contact artist for portfolio review of final art if interested. Buys first rights. Pays by the project, $75 and up. Finds freelancers through submissions and newspaper ads.

N KENZIG KARDS, INC., 2300 Julia Goldbach Ave., Ronkonkoma NY 11779-6317. (631)737-1584. Fax: (631)737-8341. E-mail: kenzigkards@aol.com. **Contact:** Jerry Kenzig, President. Estab. 1999. Produces greeting cards and stationery. Specializes in greeting cards (seasonal and everyday) for a high-end design conscious market (all ages).
Needs: Approached by 50 freelancers/year. Works with 3 freelancers/year. Prefers local designers/illustrators, however, we will consider freelancers working anywhere in US. Art guidelines free with SAE and first-class postage. Uses freelancers mainly for greeting cards/design and calligraphy. Considers watercolor, colored pencils; most media. Product categories include alternative/humor, business and cute. Produces material for baby congrats, birthday, cards for pets, Christmas, congratulations, everyday, get-well/sympathy, Valentine's Day and wedding/anniversary. Submit seasonal material 6 months in advance. Art size should be 5×7 or 5¾×5¾ square. 20% of freelance work demands knowledge of Illustrator, QuarkXPress and Photoshop.
First Contact & Terms: Send query letter with brochure, résumé and tearsheets. After introductory mailing, send follow-up postcard sample every 6 months. Samples are filed. Responds in 2 weeks. Company will contact artist for portfolio review if interested. Portfolio should include color, original art, roughs and tearsheets. Buys one-time rights and reprint rights for cards and mugs. Negotiates rights purchased. Pays freelancers by the project, $150-350; royalties (subject to negotiation). Finds freelancers through industry contacts (Kenzig Kards, Inc. is a regular member of the Greeting Card Association [GCA]), artist's submissions and word-of-mouth.
Tips: "We are open to new ideas and different approaches within our niche (i.e. dog- and cat-themed designs, watercolor florals, etc.) Looking for bright colors and cute, whimsical art. Floral designs require crisp colors."

KID STUFF, University Blvd. at Essex Entrance, Building 2704 B-1, P.O. Box 19235, Topeka KS 66619-0235. (785)862-3707. Fax: (785)862-1424. E-mail: chad@kidstuff.com. Website: www.kidstuff.com. **Contact:** Chad Stewart, creative director. Estab. 1982. Produces collectible figurines, toys, kids' meal sacks and cartons for restaurants worldwide.
Needs: Approached by 8 freelancers/year. Works with 6 freelancers/year. Buys 10 freelance designs and illustrations/year. Works on assignment only. Uses freelancers mainly for illustration and sculpting toys. Considers all media. Looking for humorous, child-related styles. Freelance illustrators should be familiar with Photoshop, Illustrator, FreeHand and QuarkXPress. Produces material for Christmas, Easter, Halloween, Thanksgiving, Valentine's Day and everyday. Submit seasonal material 3 months in advance.
First Contact & Terms: Illustrators and cartoonists send query letter with photocopies or e-mail JPEG files. Sculptors, calligraphers send photocopies. Samples are filed or returned by SASE. Responds only if interested. Portfolio review not required. Pays by the project, $250-2,000 for illustration. Finds freelancers through word of mouth and artists' submissions.

KOEHLER COMPANIES, 8758 Woodcliff Rd., Bloomington MN 55438. (952)830-9050. Fax: (952)830-9051. E-mail: bob@koehlercompanies.com. Website: koehlercompanies.com. **President:** Bob

Koehler. Estab. 1988. Manufactures wall decor, plaques, clocks and mirrors; artprints laminated to wood. Clients: gift-based and home decor mail order catalog companies. Clients include: Wireless, Signals, Seasons, Paragon and Potpourri.

Needs: Works with 10 established artists; 8 mid-career artists and 10 emerging artist/year. Considers oil, acrylic, watercolor, mixed media, pastels and pen & ink. Preferred themes and styles: humorous, Celtic, inspirational, pet (cats and dogs), golf, fishing.

First Contact & Terms: Send query letter with brochure, photocopies or photographs, résumé and tearsheets. Samples are not filed and are returned by SASE. Company will contact artist for portfolio review if interested. Pays royalties or negotiates payment. Does not offer an advance. Rights purchased vary according to project. Also works with freelance designers. Finds artists through word of mouth.

THE LANG COMPANIES, Lang Graphics; Main Street Press; Bookmark; R.A. Lang Card Co.; Lang Candles; Lang Books and Lang & Wise, 514 Wells St., Delafield WI 53018. (262)646-3399. Website: www.lang.com. **Product Development Coordinator:** Yvonne Groenevelt (product development and art submissions). Licensing: Robert Lang. Estab. 1982. Produces high quality linen-embossed greeting cards, stationery, calendars, candles, boxes, giftbags, and earthenware.

Needs: Approached by 300 freelance artists/year. Art guidelines available free for SASE. Works with 40 freelance artists/year. Uses freelancers mainly for card and calendar illustrations. Considers all media. Looking for traditional and non-abstract country, folk and fine art styles. Produces material for Christmas, birthdays and everyday. Submit seasonal material 6 months in advance.

First Contact & Terms: Send query letter with SASE and brochure, tearsheets, photostats, photographs, slides, photocopies or transparencies. Samples are filed or are returned by SASE if requested by artist. Responds in 6 weeks. Pays royalties based on net wholesale sales. Rights purchased vary according to project.

Tips: "Research the company and submit a compatible piece of art. Be patient awaiting a response. A phone call often rushes the review, and work may not be seriously considered."

LEADER PAPER PRODUCTS/PAPER ADVENTURES, 901 S. Fifth St., Milwaukee WI 53204. (414)383-0414. Fax: (414)383-0760. E-mail: nicole.e@paperadventures.com. Website: www.paperadventures.com. Art Director: Nicole Eversgerd. Estab. 1901. Produces stationery, imprintables; scrapbook and paper crafting. Specializes in stationery, patterned papers and related paper products.

Needs: Approached by 50 freelancers/year. Works with 20 freelancers/year. Buys or licenses 150 freelance illustrations and design pieces/year. Prefers freelancers with experience in illustration/fine art, stationery design/surface design. Art guidelines available. Works on assignment only. Considers any medium that can be scanned. Also looking for designers for advertising and package design.

First Contact & Terms: Freelancers send or e-mail query letter with nonreturnable color samples and bio. Send follow-up postcard or call every 3 months. Accepts Mac-compatible disk and e-mail submissions. Samples are filed. Will contact artist for more samples and to discuss project. Pays for illustration by the project, $300 and up. Also considers licensing for complete product lines. Finds freelancers through tradeshows and *Artist's & Graphic Designer's Market.*

Tips: "Send lots of samples, showing your best neat and cleanest work with a clear concept. Be flexible."

LEGACY PUBLISHING GROUP, P.O. Box 299, Clinton MA 01510. (800)322-3866 or (978)368-8711. Fax: (978)368-7867. Website: legacypublishinggroup.com. **Contact:** Art Department. Produces bookmarks, calendars, gifts, Christmas and seasonal cards and stationery pads. Specializes in journals, note cards, address and recipe books, coasters, placemats, magnets, book marks, albums, calendars and grocery pads.

Needs: Works with 8-10 freelancers/year. Buys 25-30 freelance designs and illustrations/year. Prefers traditional art. Art guidelines available for SASE. Works on assignment only. Uses freelancers mainly for original art for product line. Considers all color media. Looking for traditional, contemporary, garden themes and Christmas. Produces material for Christmas, everyday (note cards) and cards for teachers.

First Contact & Terms: Illustrators send query letter with photocopies, photographs, résumé, tearsheets, SASE and any good reproduction or color copy. We accept work compatible with Adobe or QuarkXPress plus color copies. Samples are filed. Responds in 2 weeks. Company will contact artist for portfolio review if interested. Portfolio should include color photographs, slides, tearsheets and printed reproductions. Buys all rights. Pays for illustration by the project, $600-1,000. Finds freelancers through word of mouth and artists' submissions.

Tips: "Get work out to as many potential buyers—*Artist's & Graphic Designer's Market* is a good source. Initially, plan on spending 80% of your time on self-promotion."

▣ **THE LEMON TREE STATIONERY CORP.**, 95 Mahan St., West Babylon NY 11704. (631)253-2840. Fax: (631)253-3369. Website: www.lemontreestationery.com. **Contact:** Lucy Mleczko. Estab. 1969. Produces birth announcements, Bar Mitzvah and Bat Mitzvah invitations and wedding invitations.
Needs: Buys 100-200 pieces of calligraphy/year. Prefers local designers. Works on assignment only. Uses Mac designers. Also for calligraphy, mechanicals, paste-up, P-O-P. Looking for traditional, contemporary. 50% of freelance work demands knowledge of Photoshop, QuarkXPress, Illustrator.
First Contact & Terms: Send query letter with résumé. Calligraphers send photocopies of work. Samples are not filed and are not returned. Responds only if interested. Company will contact artist for portfolio review of final art, photostats, thumbnails if interested. Pays for design by the project. Pays flat fee for calligraphy.
Tips: "Look around at competitors' work to get a feeling of the type of art they use."

LIFE GREETINGS, P.O. Box 468, Little Compton RI 02837. (401)635-4918. **Editor:** Kathy Brennan. Estab. 1973. Produces greeting cards. Religious, inspirational greetings.
Needs: Approached by 25 freelancers/year. Works with 5 freelancers/year. Uses freelancers mainly for greeting card illustration. Also for calligraphy. Considers all media but prefers pen & ink and pencil. Prefers 4½×6¼—no bleeds. Produces material for Christmas, religious/liturgical events, baptism, first communion, confirmation, ordination, etc.
First Contact & Terms: Send query letter with photocopies. Samples are filed or returned by SASE if requested by artist. Responds only if interested. Portfolio review not required. Originals are not returned. Pays by the project. **"We pay on acceptance."** Finds artists through submissions.

▣ **THE LOLO COMPANY**, 6755 Mira Mesa Blvd., Suite 123-410, San Diego, CA 92121. (800) 760-9930. Fax: (800)234-6540. E-mail: products@lolofun.com. Website: www.lolofun.com. **Creative Director:** Robert C. Paul. Estab. 1995. Publishes board games. Prefers humorous work. Uses freelancers mainly for product design and packaging. Recent games include "Don't Make Me Laugh," "Don't Make Me Laugh, Jr,." "Strange But True" and "Roh-Szam-Bo."
Needs: Approached by 1 illustrator and 1 designer/year. Works with 1 illustrator and 1 designer/year. Prefers local illustrators. 100% of freelance design and illustration demands knowledge of Illustrator, Photoshop and QuarkXPress.
First Contact & Terms: Preferred submission package is self-promotional postcard sample. Send 5 printed samples or photographs. Accepts disk submissions in Windows format; send via Zip as EPS. Samples are filed. Will contact artist for portfolio review if interested. Portfolios should include artwork of characters in sequence, color photocopies, photographs, transparencies of final art and roughs. Rights purchased vary according to project. Finds freelancers through word of mouth and Internet.

LPG GREETINGS, INC., 4000 Porett Dr., Gurnee IL 60031. (847)244-4414. Fax: (847)244-0188. E-mail: judy@lpggreetings.com. Website: www.lpggreetings.com. **Creative Director:** Judy Cecchi. Estab. 1992. Produces greeting cards. Specializes in boxed Christmas cards.
Needs: Approached by 50-100 freelancers/year. Works with 20 freelancers/year. Buys 70 freelance designs and illustrations/year. Art guidelines free for SASE with first-class postage. Uses freelancers mainly for original artwork for Christmas cards. Considers any media. Looking for traditional and humorous Christmas. Greeting cards can be vertical or horizontal; 5×7 or 6×8. Usually prefers 5×7. Produces material for Christmas. Submit seasonal material 1 year in advance.
First Contact & Terms: Send query letter with photocopies. Samples are filed if interested or returned by SASE. Portfolio review not required. Will contact artist for portfolio if interested. Rights purchased vary according to project. Pays for design by the project. For illustration pays flat fee. Finds freelancers through word of mouth and artists' submissions. Please do not send unsolicited samples via e-mail; they will not be considered.
Tips: "Be creative with fresh new ideas."

LUNT SILVERSMITHS, 298 Federal St., P.O. Box 1010, Greenfield MA 01302-1010. (413)774-2774. Fax: (413)774-4393. E-mail: design@lunt-silversmiths.com. Website: www.lunt-silversmiths.com. **Director of Design:** Carl F. Romboletti Jr. Estab. 1902. Produces collectible figurines, gifts, Christmas ornaments, flatware, babyware, tabletop products, sterling and steel flatware.

Needs: Approached by 1-2 freelancers/year. Works with 1-5 freelancers/year. Contracts 35 product models/ year. Prefers freelancers with experience in tabletop product, model-making. Uses freelancers mainly for model-making and prototypes. Also for mechanicals. Considers clay, plastaline, resins, hard models. Looking for traditional, florals, sentimental, contemporary. 25% of freelance design work demands knowledge of Photoshop, Illustrator, AutoCad. Produces material for all holidays and seasons, Christmas, Valentine's Day, everyday.

First Contact & Terms: Designers and sculptors should send query letter with brochure, photocopies, photographs, résumé. Sculptors should also send résumé and photos. Accepts disk submissions created in Photoshop. Samples are filed or returned by SASE. Responds in 1 week only if interested. Will contact for portfolio review if interested. Portfolio should include photographs, photostats, slides. Rights purchased vary according to project. Pays for design, illustration and sculpture according to project.

MADISON PARK GREETINGS, 1407 11th Ave., Seattle WA 98122-3901. (206)324-5711. Fax: (206)324-5822. E-mail: karinar@madpark.com. Website: www.madisonparkgreetings.com. **Art Director:** Karina Rostek. Estab. 1977. Produces greeting cards, stationery, notepads, frames.

Needs: Approached by 250 freelancers/year. Works with 15 freelancers/year. Buys 200 freelance designs and illustrations/year. Art guidelines available free for SASE. Works on assignment only. Uses freelancers mainly for greeting cards. Also for calligraphy, reflective art. Considers all paper-related media. Produces material for Christmas, Easter, Mother's Day, Father's Day, graduation, New Year, Valentine's Day, birthdays, everyday, sympathy, get well, anniversary, baby congratulations, wedding, thank you, expecting, friendship. "We are interested in floral and whimsical imagery, as well as humor." Submit seasonal material 10 months in advance.

First Contact & Terms: Designers send photocopies, slides, transparencies. Illustrators send postcard sample or photocopies. Accepts submissions on disk. Send EPS files. "Good samples are filed; rest are returned." Please enclose SASE. Company will contact artist for portfolio review of color, final art, roughs if interested. Rights purchased and royalty vary according to project.

S.A. MAXWELL CO., 935 Campus Dr., Mundelein IL 60060. (847)932-3700. Fax: (847)932-3799. **Contact:** Jaima Brown, design director. Estab. 1851. Produces wallpaper. Specializes in traditional wallpaper for mostly mass market, some upper end product.

Needs: Approached by 10 freelancers/year. Works with 6 freelancers/year. Buys 60 freelance designs and/ or illustrations/year. Prefers freelancers with experience in wallpaper and different painting techniques who are good with illustrators with good painting skills. Uses freelancers mainly for paintings in repeat for specific types of printing. Considers guoache, oils, acrylics, crackling etc. Product categories include traditional design. 20-30% of freelance work demands knowledge of Illustrator, Photoshop, AVA color and design experience.

First Contact & Terms: Send photocopies, résumé, artwork examples. Accepts e-mail submissions with link to website. Prefers Windows-compatible, JPEG files. Samples are returned if not filed. Responds only if interested. Company will contact artist for portfolio review if interested. Portfolio should include original art. Buys all rights. Pays freelancers by the project. Finds freelancers through word-of-mouth.

Tips: "Artists need to have repeat experience and to be good at drawing skills and be able to produce a variety of styles of painting techniques from oils to gouache to doing murals."

FRANCES MEYER, INC., P.O. Box 3088, Savannah GA 31402-3088. (912)748-5252. Fax: (800)545-8378. E-mail: creative@francesmeyer.com. Website: www.francesmeyer.com. **Contact:** Creative Director. Estab. 1979. Produces scrapbooking products, stickers and stationery.

Needs: Works with 5-6 freelance artists/year. Art guidelines available free for SASE. Commissions 100 freelance illustrations and designs/year. Works on assignment only. "Most of our artists work in either watercolor or acrylic. We are open, however, to artists who work in other media." Looking for "everything

FOR EXPLANATIONS OF THESE SYMBOLS,
SEE THE INSIDE FRONT AND BACK COVERS OF THIS BOOK.

from upscale and sophisticated adult theme-oriented paper items, to fun, youthful designs for birth announcements, baby and youth products. Diversity of style, originality of work, as well as technical skills are a few of our basic needs." Produces material for Christmas, graduation, Thanksgiving (fall), New Year's, Halloween, birthdays, everyday, weddings, showers, new baby, etc. Submit seasonal material 6-12 months in advance.

First Contact & Terms: Send query letter with tearsheets, slides, SASE, photocopies, transparencies (no originals) and "as much information as is necessary to show diversity of style and creativity." "No response or return of samples by Frances Meyer, Inc. *without* SASE!" Responds in 3 months. Company will contact artist for portfolio review if interested. Originals are returned at job's completion. Pays royalty (varies).

Tips: "Generally, we are looking to work with a few talented and committed artists for an extended period of time. We do not 'clean out' our line on an annual basis just to introduce new product. If an item sells, it will remain in the line. Punctuality concerning deadlines is a necessity."

MILLIMAC LICENSING CO., 188 Michael Way, Santa Clara CA 95051. (408)984-0700. Fax: (408)984-7456. E-mail: clamkinman@attbi.com. Website: www.clamkinman.com. **Owner:** Bruce Ingrassia. Estab. 1978. Produces collectible figurines, mugs, T-shirts and textiles. Produces a line of cartoon characters called the Clamkin® Family directed towards "children and adults young at heart."

Needs: Approached by 10 freelancers/year. Works with 2-3 freelancers/year. Buys 30-40 freelance designs and illustrations/year. Prefers freelancers with experience in cartooning. Works on assignment only. Uses freelancers mainly for line art, color separation, Mac computer assignments. Considers computer, pen & ink. Looking for humorous, clever, "off the wall," cute animals. 50% of freelance design/illustration demands knowledge of Photoshop, Illustrator, FreeHand (pencil roughs OK). "Computer must be Mac." Produces material for everyday.

First Contact & Terms: Designers/cartoonists send query letter with photocopies. Sculptors send photos of work. Accepts disk submissions compatible with Mac Adobe Illustrator files. Samples are filed. Will contact artist for portfolio review if interested. Rights purchased and pay rates vary according to project. Finds freelancers through submissions. "I also find a lot of talent around town—at fairs, art shows, carnivals, students—I'm always on the lookout."

Tips: "Get a computer—learn Adobe Illustrator, Photoshop. Be clever, creative, open minded and responsible and never give up. Quitters never get there."

MIXEDBLESSING, P.O. Box 97212, Raleigh NC 27624-7212. (919)847-7944. Fax: (919)847-6429. E-mail: mixbless@aol.com. Website: www.mixedblessing.com. **President:** Elise Okrend. Licensing: Philip Okrend. Estab. 1990. Produces interfaith greeting cards combining Jewish and Christian as well as multicultural images for all ages. Licenses holiday artwork for wrapping paper, tote bags, clothing, paper goods.

Needs: Approached by 10 freelance artists/year. Works with 10 freelancers/year. Buys 20 designs and illustrations/year. Provides samples of preferred styles upon request. Works on assignment only. Uses freelancers mainly for card illustration. Considers watercolor, pen & ink and pastel. Prefers final art 5×7. Produces material for Christmas and Hanukkah. Submit seasonal material 10 months in advance.

First Contact & Terms: Send query letter with brochure, photocopies, photographs and SASE. Samples are filed. Responds only if interested. Artist should follow up with letter after initial query. Originals are returned at job's completion. Sometimes requests work on spec before assigning a job. Pays flat fee of $125-500 for illustration/design. Buys all rights. Finds artists through visiting art schools.

Tips: "I see growth ahead for the industry. Go to and participate in the National Stationery Show."

NAPCO MARKETING, 7800 Bayberry Rd., Jacksonville FL 32256-6893. (904)737-8500. Fax: (904)737-9526. E-mail: napco@leading.com. **Art Director:** John Skinner. Estab. 1940. NAPCO Marketing supplies floral, garden and home interior markets with middle to high-end products. Clients: wholesale.

● NAPCO Marketing has a higher-end look for their floral market products.

Needs: Works with 15 freelance illustrators and designers/year. 50% of work done on a freelance basis. No restrictions on artists for design and concept. Art guidelines available for SASE with first-class postage. Works on assignment only. Uses freelancers mainly for mechanicals and product design. "Need artists that are highly skilled in illustration for three-dimensional products.

First Contact & Terms: Designers send query letter with brochure, résumé, photocopies, photographs, SASE, tearsheets and "any samples we can keep on file." Illustrators send brochure, résumé, photocopies, photographs and SASE. If work is in clay, send photographs. Samples are filed or returned by SASE. Responds in 2 weeks. Artist should follow up with letter after initial query. Portfolio should include samples

which show a full range of illustration style. Sometimes requests work on spec before assigning a job. Pays for design by the project, $50-500. Pays by the project for illustration, $50-2,000. Pays $15/hour for mechanicals. Buys all rights. Considers buying second rights (reprint rights) to previously published work. Finds artists through word of mouth and self-promotions.

Tips: "We are very selective in choosing new people. We need artists that are familiar with three-dimensional giftware and floral containers. We now produce dolls and seasonal giftware. Our market is expanding and so are our needs for qualified artists."

NCE, New Creative Enterprises, Inc., 401 Milford Pkwy., Milford OH 45150. (800)435-1000. Fax: (513)965-3696. Website: www.ncegifts.com. **Contact:** Terry Lee. Estab. 1979. Produces low-medium priced giftware and decorative accessories. "We sell a wide variety of items ranging from home decor to decorative flags. Our typical retail-level buyer is female, age 30-50."

Needs: Approached by 5-10 freelancers/year. Works with 2-5 freelancers/year. Buys 10-50 designs and illustrations/year. Prefers freelancers with experience in textiles. Most often needs ink or marker illustration. Seeks heart-warming and whimsical designs and illustrations using popular (Santa, Easter Bunny, etc.) or unique characters. Final art must be mailable size. Needs computer-literate freelancers for design, illustration and production. 50% of freelance work demands knowledge of Illustrator. Produces material for Christmas, Valentine's Day, Easter, Thanksgiving and Halloween. Submit seasonal material 1 year in advance.

First Contact & Terms: Send query letter with tearsheets, photographs, photocopies, photostats, slides and transparencies. Samples are filed and are returned by SASE if requested by artist. Responds in 1 week. Director will contact artists for portfolio review if interested. Portfolio should include thumbnails, roughs, finished art samples, b&w and color tearsheets, photographs, slides and dummies. Originals are returned at job's completion. Rights purchased vary according to project.

Tips: "If you want the artwork back please send a SASE with it."

NEW DECO, INC., 23123 Sunfield Dr., Boca Raton FL 33433. (800)543-3326. Fax: (561)488-9743. E-mail: newdeco@mindspring.com. Website: newdeco.com. **President:** Brad Hugh Morris. Estab. 1984. Produces greeting cards, posters, fine art prints and original paintings.

Needs: Approached by 50-100 artists/year. Works with 5-10 freelancers/year. Buys 8-10 designs and 5-10 illustrations/year. Uses artwork for original paintings, limited edition graphics, greeting cards, giftwrap, calendars, paper tableware, poster prints, etc. Licenses artwork for posters and prints.

First Contact & Terms: Send query letter with brochure, résumé, tearsheets, slides and SASE. Samples not filed are returned by SASE. Responds in 10 days only if interested. To show portfolio, mail color slides. Originals are returned at job's completion. Pays royalties of 5-10%. Negotiates rights purchased.

Tips: "Do not send original art at first."

🔲 N-M LETTERS, INC., 125 Esten Ave., Pawtucket RI 02860. (401)247-7651. Fax: (401)245-3182. E-mail: nmltrs@earthlink.net. **President:** Judy Mintzer. Estab. 1982. Produces announcements and invitations.

Needs: Approached by 2-5 freelancers/year. Works with 2 freelancers/year. Prefers local artists only. Works on assignment only. Produces material for births, weddings and Bar/Bat Mitzvahs. Submit seasonal material 6 months in advance.

First Contact & Terms: Send query letter with résumé. Responds in 1 month only if interested. Call for appointment to show portfolio of b&w roughs. Original artwork is not returned. Pays by the project.

NOBLE WORKS, 123 Grand St., P.O. Box 1275, Hoboken NJ 07030. (201)420-0095. Fax: (201)420-0679. Website: www.nobleworksinc.com. **Contact:** Art Department. Estab. 1981. Produces greeting cards, notepads, gift bags and gift products. Produces "modern cards for modern people." Trend oriented, hip urban greeting cards.

Needs: Approached by 100-200 freelancers/year. Works with 50 freelancers/year. Buys 250 freelance designs and illustrations/year. Prefers freelancers with experience in illustration. Art guidelines on website or available for SASE with first-class postage. We purchase "secondary rights" to illustration. Considers illustration, electronic art. Looking for humorous, "off-the-wall" adult contemporary and editorial illustration. Produces material for Christmas, Mother's Day, Father's Day, graduation, Halloween, Valentine's Day, birthdays, thank you, anniversary, get well, astrology, sympathy, etc. Submit seasonal material 18 months in advance.

First Contact & Terms: Designers send query letter with photocopies, SASE, slides, tearsheets, transparencies. Illustrators and cartoonists send query letter with photocopies, tearsheets, SASE. After introductory mailing send follow-up postcard sample every 8 months. Accepts submissions on Zip disk compatible with Mac QuarkXPress 4.0, Photoshop 5.0 or Illustrator 8.0. Samples are filed. Responds in 6 months. Buys reprint rights. Pays for design and illustration by the project. Finds freelancers through sourcebooks, illustration annuals, referrals.
Tips: "As a manufacturer must know the market niche its product falls into, so too must a freelancer."

NORTHERN CARDS, 5694 Ambler Dr., Mississauga, ON L4W 2K9 Canada. (905)625-4944. Fax: (905)625-5995. E-mail: ggarbacki@northerncards.com. Website: northerncards.com. **Product Coordinator:** Greg Garbacki. Estab. 1992. Produces 4 brands of greeting cards.
Needs: Approached by 200 freelancers/year. Works with 25 freelancers/year. Buys 75 freelance designs and illustrations/year. Uses freelancers for "camera-ready artwork and lettering." Art guidelines for SASE with first-class postage. Looking for traditional, sentimental, floral and humorous styles. Prefers $5\frac{1}{2} \times 7\frac{3}{4}$ or 5×7. Produces material for Christmas, Easter, Mother's Day, Father's Day, graduation, Valentine's Day, birthdays and everyday. Also sympathy, get well, someone special, thank you, friendship, new baby, goodbye and sorry. Submit seasonal material 6 months in advance.
First Contact & Terms: Designers send query letter with brochure, photocopies, slides, résumé and SASE. Illustrators and cartoonists send photocopies, tearsheets, résumé and SASE. Lettering artists send samples. Samples are filed or returned by SASE. Responds only if interested. Pays flat fee, $200 (CDN). Finds freelancers through newspaper ads, gallery shows and Internet.
Tips: "Research your field and the company you're submitting to. Send appropriate work only."

NOTES & QUERIES, 9003A Yellow Brick Rd., Baltimore MD 21237. (410)682-6102. Fax: (410)682-5397. E-mail: vanessa@nandq.com. Website: www.nandq.com. **Sales Coordinator:** Vanessa Harnik. Estab. 1981. Produces greeting cards, stationery, journals, paper tableware products and giftwrap. Products feature contemporary art.
Needs: Approached by 30-50 freelancers/year. Works with 3-10 freelancers/year. Art guidelines available "pending our interest." Produces material for special projects only.
First Contact & Terms: Send query letter with photographs, slides, SASE, photocopies, transparencies, "whatever you prefer." Samples are filed or returned by SASE as requested by artist. Responds in 1 month. Artist should follow up with call and/or letter after initial query. Portfolio should include thumbnails, roughs, photostats or transparencies. Rights purchased or 5-7% royalties paid; varies according to project.
Tips: "Review what we do before submitting. Make sure we're appropriate for you."

THE NOTEWORTHY COMPANY, 100 Church St., Amsterdam NY 12010. (518)842-2660. Fax: (800)866-8317. **Contact:** Larry Rallo, vice president sales & marketing. Estab. 1954. Produces bags and coloring books. Advertising specialty manufacturer selling to distributors with clients in the health, real estate, banking and retail fields.
Needs: Buys 25 illustrations/year. Prefers freelancers with experience in designing for flexographic printing. Works on assignment only. Uses freelancers mainly for stock bag art and coloring book themes.
First Contact & Terms: Send query letter with brochure, résumé, samples and SASE. Samples are filed. Pays $200 for bag design.

NOVO CARD PUBLISHERS INC., 3630 W. Pratt Ave., Lincolnwood IL 60712. (847)763-0077. Fax: (847)763-0022. E-mail: art@novocard.net. Website: www.novocard.net. Estab. 1927. Produces all categories of greeting cards.
Needs: Approached by 200 freelancers/year. Works with 30 freelancers/year. Buys 300 or 400 pieces/year from freelance artists. Art guidelines free for SASE with first-class postage. Uses freelancers mainly for illustration and text. Also for calligraphy. Considers all media. Prefers crop size: $5 \times 7\frac{3}{4}$, bleed $5\frac{1}{4} \times 8$. Knowledge of Photoshop, Illustrator and QuarkXPress helpful. Produces material for all holidays and seasons and everyday. Submit seasonal material 8 months in advance.
First Contact & Terms: Designers send brochure, photocopies, photographs and SASE. Illustrators and cartoonists send photocopies, photographs, tearsheets and SASE. Calligraphers send b&w copies. Accepts disk submissions compatible with Macintosh QuarkXPress 4.0 and Windows 95. Art samples are not filed and are returned by SASE only. Written samples retained on file for future assignment with writer's permission. Responds in 2 months. Pays for design and illustration by the project, $75-200.

NRN DESIGNS, INC., 5142 Argosy Dr., Huntington Beach CA 92649. (714)898-6363. Fax: (714)898-0015. Website: www.NRNDesigns.com. **Art Director:** Linda Braun. Scrapbooking Art Director: Katey Franceschini. Estab. 1984. Produces calendars, high-end stationery and scrapbooking items including stickers.
> • This company is no longer producing greeting cards.

Needs: Looking for freelance artists with innovative ideas and formats for invitations and scrapbooking products. Works on assignment only. Produces stickers and other material for Christmas, Easter, graduation, Halloween, Hanukkah, New Year, Thanksgiving, Valentine's Day, birthdays, everyday, (sympathy, get well, etc.). Submit seasonal material 1 year in advance.

First Contact & Terms: Send photocopies or other nonreturnable samples. Responds only if interested. Portfolios required from designers. Company will contact artist for portfolio review if interested. Rights purchased vary according to project. Pays for design by the project.

OATMEAL STUDIOS, Box 138, Rochester VT 05767. (802)767-3171. Fax: (802)767-9890. **Creative Director:** Helene Lehrer. Estab. 1979. Publishes humorous greeting cards and notepads, creative ideas for everyday cards and holidays.

Needs: Approached by approximately 300 freelancers/year. Buys 100-150 freelance designs and illustrations/year. Art guidelines for SASE with first-class postage. Considers all media. Produces seasonal material for Christmas, Mother's Day, Father's Day, Easter, Valentine's Day and Hanukkah. Submit art year round for all major holidays.

First Contact & Terms: Send query letter with slides, roughs, printed pieces or brochure/flyer to be kept on file; write for artists' guidelines. "If brochure/flyer is not available, we ask to keep one slide or printed piece; color or b&w photocopies also acceptable for our files." Samples returned by SASE. Responds in 6 weeks. No portfolio reviews. Sometimes requests work on spec before assigning a job. Negotiates payment.

Tips: "We're looking for exciting and creative, humorous (not cutesy) illustrations and single panel cartoons. If you can write copy and have a humorous cartoon style all your own, send us your ideas! We do accept work without copy too. Our seasonal card line includes traditional illustrations, so we do have a need for non-humorous illustrations as well."

OFFRAY, Rt. 24 Box 601, Chester NJ 07930. (908)879-3604. Fax: (908)879-8588. E-mail: jgaul@offray. com. **Contact:** Jean Gaul, design manager. Estab. 1900. Produces ribbons. "We're a ribbon company—for ribbon designs we look to the textile design studios and textile-oriented people; children's designs, craft motifs, fabric trend designs, floral designs, Christmas designs, bridal ideas, etc. Our range of needs is wide, so we need various looks."

Needs: Approached by 8-10 freelancers/year. Works with 5-6 freelancers/year. Buys 40-50 freelance designs and illustrations/year. Artists must be able to work from pencils to finish, various styles—work is small and tight. Works on assignment only. Uses freelancers mainly for printed artwork on ribbons. Looking for artists able to translate a trend or design idea into a 1½ to 2-inch space on a ribbon. Produces material for Christmas, everyday. Submit seasonal material 6 months in advance.

First Contact & Terms: Send postcard sample or query letter with résumé or call. Samples are filed. Responds only if interested. Portfolio should include color final art. Rights purchased vary according to project. Pays by the project, $200-300 for design.

■■ **ONTARIO FEDERATION OF ANGLERS AND HUNTERS**, P.O. Box 2800, Peterborough, ON K9J 8L5 Canada. (705)748-6324. Fax: (705)748-9577. Website: www.ofah.org. **Graphic Designer:** Deborah Carew. Estab. 1928. Produces calendars, greeting cards, limited edition prints. "We are a nonprofit, conservation organization who publishes a high quality wildlife art calendar and a series of four Christmas cards each year. We also commission two paintings per year that we produce in limited edition prints."

Needs: Approached by 60 freelancers/year. Works with 6-12 freelancers/year. Buys 12 freelance designs and illustrations/year. Prefers wildlife artists. Art guidelines free for SAE with first-class postage, e-mail or on website. Uses freelancers mainly for calendar/cards. Considers any media that gives realistic style. "We find talent through a yearly wildlife art calendar contest. Our criteria is specific to the wildlife art market with a slant towards hunting and fishing activities. We can only consider North American species found in Ontario. We welcome scenes involving sportsmen and women in the outdoors. Also sporting dogs. All art must be fine art quality, realistic, full color, with backgrounds. Any medium that gives these results is acceptable. No illustrative or fantasy-type work please. Look to successful wildlife artists like

Robert Bateman or Michael Sieve for the style we're seeking." Prefers minimum 8½×11 final art. Produces material for Christmas, wildlife art cards, i.e. no wording required.
First Contact & Terms: Contact through contest only please. Samples are filed or returned. Responds following contest. Portfolio review not required. Buys one-time rights. Pays $150/calendar piece plus extras.

P.S. GREETINGS, INC., 5730 N. Tripp Ave., Chicago IL 60646. Website: www.psgreetings.com. **Contact:** Design Director. Manufacturer of boxed greeting and counter cards.
Needs: Receives submissions from 300-400 freelance artists/year. Artists' guidelines are posted on website, or send SASE. Works with 50-100 artists/year on greeting card designs. Prefers illustrations be 5×7¾ with ⅛″ bleeds cropped. Publishes greeting cards for everyday and holidays. 20% of work demands knowledge of QuarkXPress, Illustrator and Photoshop.
First Contact & Terms: All requests as well as submissions must be accompanied by SASE. Samples will *not* be returned without SASE! Responds in 1 month. Pays flat fee. Buys exclusive worldwide rights for greeting cards and stationery.
Tips: "Our line includes a whole spectrum: from everyday needs (florals, scenics, feminine, masculine, humorous, cute) to every major holiday (from New Year's to Thanksgiving) with an extensive Christmas line as well. We continue to grow every year and are always looking for innovative talent."

PAINTED HEARTS & FRIENDS, 1222 N. Fair Oaks Ave., Pasadena CA 91103. (626)798-3633. Fax: (626)296-8890. E-mail: ines@paintedhearts.com. Website: www.paintedhearts.com. **Contact:** David Mekelburg. President: Susan Kinney. Estab. 1988. Produces greeting cards, stationery, invitations and notecards.
 • This company also needs freelancers who can write verse. If you can wear this hat, you'll have an added edge.
Needs: Approached by 75 freelance artists/year. Works with 6 freelancers/year. Art guidelines free for SASE with first-class postage or by e-mail. Works on assignment only. Uses freelancers mainly for design. Produces material for all holidays and seasons, birthdays and everyday. Submit seasonal material 1 year in advance.
First Contact & Terms: Send art submissions Attn: David Mekelburg, send writer's submissions Attn: Richard Crawford or use e-mail. Send query letter with résumé, SASE and color photocopies. Samples are returned with SASE. Responds only if interested. Write for appointment to show portfolio, which should include original and published work. Rights purchased vary according to project. Originals returned at job's completion. Pays flat fee of $150-300 for illustration. Pays royalties of 5%.
Tips: "Familiarize yourself with our card line." This company is seeking "young artists (in spirit!) looking to develop a line of cards. We're looking for work that is compatible but adds to our look, which is bright, clean watercolors. We need images that go beyond just florals to illustrate and express the occasion."

PAPER MAGIC GROUP INC., 401 Adams Ave., Scranton PA 18510. (570)961-3863. Fax: (570)348-8389. **Creative Director for Winter Division:** Peg Cohan. Estab. 1984. Produces greeting cards, stickers, vinyl wall decorations, 3-D paper decorations. "We are publishing seasonal cards and decorations for the mass market. We use a wide variety of design styles."
Needs: Works with 60 freelance artists/year. Prefers artists with experience in greeting cards. Work is by assignment or send submissions on spec. Designs products for Christmas and Valentine's Day. All submissions for Easter, Halloween and school market should be addressed to the Minneapolis office at 100 N. Sixth St., Suite 899C, Minneapolis MN 55403. (612)673-9202. Fax: (612)673-9120. Also uses freelancers for lettering and art direction.
First Contact & Terms: Send query letter with résumé, samples and SASE to the attention of Lisa Spencer. Color photocopies are acceptable samples. Samples are filed or are returned by SASE only if requested by artist. Responds in 2 months. Originals not returned. Pays by the project, $350-2,000 average. Buys all rights.
Tips: "Please, experienced illustrators only."

PAPERPRODUCTS DESIGN U.S. INC., 60 Galli Dr., Suite 1, Novato CA 94949. (415)883-1888. Fax: (415)883-1999. E-mail: carol@paperproductdesign.com. **President:** Carol Florsheim. Estab. 1990. Produces paper napkins, plates, designer tissue, giftbags and giftwrap. Specializes in high-end design, fashionable designs.
Needs: Approached by 20-30 freelancers/year. Buys multiple freelance designs and illustrations/year. Artists do not need to write for guidelines. They may send samples to the attention of Carol Florsheim at

any time. Uses freelancers mainly for designer paper napkins. Looking for very stylized/clean designs and illustrations. Prefers 6½ × 6½. Produces seasonal and everyday material. Submit seasonal material 9 months in advance.

First Contact & Terms: Designers send brochure, photocopies, photographs, tearsheets. Samples are not filed and are returned if requested with SASE. Responds in 6 weeks. Request portfolio review of color, final art, photostats in original query. Rights purchased vary according to project. Pays for design and illustration by the project in advances and royalties. Finds freelancers through agents, *Workbook*.

Tips: "Shop the stores, study decorative accessories, fashion clothing. Read European magazines. We are design house."

☑ 🏛 **PAPILLON INTERNATIONAL GIFTWARE INC.,** P.O. Box 640056, Atlanta GA 30364-0056. Phone/fax: (404)684-7144. **President:** Michael King. Estab. 1987. Produces decorative accessories, home furnishings and Christmas ornaments. "Our product mix includes figurines, decorative accessories, Christmas ornaments and other decor such as night lights."

Needs: Approached by 20 freelance artists/year. Works with 4-6 freelancers/year. Buys 30-40 designs and illustrations/year. Prefers local artists only. Works on assignment only. "We are looking for illustrations appealing to classic and refined tastes for our Christmas decor." Prefers 10 × 14. Produces material for Christmas, Valentine's Day, Thanksgiving and Halloween. Submit seasonal material 1 year in advance.

First Contact & Terms: Send query letter with appropriate materials such as tearsheets, photographs, photocopies, slides and SASE. Samples are filed and are returned by SASE if requested by artist. Responds in 2 months. To show portfolio, mail roughs, color slides and tearsheets. Originals returned at job's completion. Pays by the project, $400 average. Negotiates rights purchased.

PARAMOUNT CARDS INC., 400 Pine St., Pawtucket RI 02860. (401)726-0800, ext. 2240. Fax: (401)727-3890. E-mail: cdesousa@paramountcards.com. Website: www.paramountcards.com. **Contact:** Art Coordinator. Estab. 1906. Publishes greeting cards. "We produce an extensive line of seasonal and everyday greeting cards which range from very traditional to whimsical to humorous. Almost all artwork is assigned."

Needs: Works with 50-80 freelancers/year. Uses freelancers mainly for finished art. Also for calligraphy. Considers watercolor, gouache, airbrush and acrylic. Prefers 5½ × 8⁵⁄₁₆. Produces material for all holidays and seasons. Submit seasonal holiday material 1 year in advance.

First Contact & Terms: Send query letter, résumé, SASE (important), photocopies and printed card samples. Samples are filed only if interested, or returned by SASE if requested by artist. Responds in 1 month if interested. Company will contact artist for portfolio review if interested. Portfolio should include photostats, tearsheets and card samples. Buys all rights. Originals are not returned. Pays by the project, $200-450. Finds artists through word of mouth and submissions.

Tips: "Send a complete, professional package. Only include your best work—you don't want us to remember you from one bad piece. Always include SASE with proper postage and *never* send original art—color photocopies are enough for us to see what you can do. No phone calls please."

🄽 **PATTERN PEOPLE, INC.,** 10 Floyd Rd., Derry NH 03038. (603)432-7180. **President:** Janice M. Copeland. Estab. 1988. Design studio servicing various manufacturers of consumer products. Designs wallcoverings, textiles and home furnishings.

Needs: Approached by 5 freelancers/year. Works with 2 freelance designers/year. Prefers freelancers with professional experience in various media. Uses freelancers mainly for original finished artwork in repeat. "We use all styles but they must be professional." Special needs are "floral (both traditional and contemporary), textural (faux finishes, new woven looks, etc.) and geometric (mainly new wave contemporary)."

First Contact & Terms: Send query letter with photocopies and transparencies. Samples are filed. Art Director will contact artist for portfolio review if interested. Portfolio should include original/final art and color samples. Sometimes requests work on spec before assigning a job. Pays for design by the project, $100-1,000. Buys all rights. Finds artists through sourcebooks and other artists.

PICKARD CHINA, 782 Pickard Ave., Antioch IL 60002. (847)395-3800. Website: www.pickardchina. com. **President:** Eben C. Morgan, Jr.. Estab. 1893. Manufacturer of fine china dinnerware. Clients: upscale specialty stores and department stores. Current clients include Cartier, Marshall Field's and Gump's.

Needs: Assigns 2-3 jobs to freelance designers/year. Prefers designers for china pattern development with experience in home furnishings. Tabletop experience is a plus but not required.

First Contact & Terms: Send query letter with résumé and color photographs, tearsheets, slides or

transparencies showing art styles. Samples are filed or are returned if requested. Art Director will contact artist for portfolio review if interested. Negotiates rights purchased. May purchase designs outright, work on royalty basis (usually 2%) or negotiate non-refundable advance against royalties.

MARC POLISH ASSOCIATES, P.O. Box 3434, Margate NJ 08402. (609)823-7661. E-mail: sedonamax @aol.com. **President:** Marc Polish. Estab. 1972. Produces T-shirts and sweatshirts. "We specialize in printed T-shirts and sweatshirts. Our market is the gift and mail order industry, resort shops and college bookstores."

Needs: Works with 6 freelancers/year. Designs must be convertible to screenprinting. Produces material for Christmas, Valentine's Day, Mother's Day, Father's Day, Hanukkah, graduation, Halloween, birthdays and everyday.

First Contact & Terms: Send query letter with brochure, tearsheets, photographs, photocopies, photostats and slides. Samples are filed or are returned. Responds in 2 weeks. To show portfolio, mail anything to show concept. Originals returned at job's completion. Pays royalties of 6-10%. Negotiates rights purchased.

Tips: "We like to laugh. Humor sells. See what is selling in the local mall or department store. Submit anything suitable for T-shirts. Do not give up. No idea is a bad idea. It sometimes might have to be changed slightly to fit into a marketplace."

THE POPCORN FACTORY, 13970 W. Laurel Dr., Lake Forest IL 60045. E-mail: abromley@thepop cornfactory.com. Website: www.thepopcornfactory.com. **Director of Merchandising:** Ann Bromley. Estab. 1979. Manufacturer of popcorn packed in exclusive designed cans and other gift items sold via catalog for Christmas, Halloween, Valentine's Day, Easter and year-round gift giving needs.

Needs: Works with 6 freelance artists/year. Assigns up to 20 freelance jobs/year. Works on assignment only. Art guidelines available. Uses freelancers mainly for cover illustration and design. Occasionally uses artists for advertising, brochure and catalog design and illustration. 100% of freelance catalog work requires knowledge of QuarkXPress and Photoshop.

First Contact & Terms: Send query letter with photocopies, photographs or tearsheets. Samples are filed. Responds in 1 month. Write for appointment to show portfolio, or mail finished art samples and photographs. Pays for design by the hour, $50 minimum. Pays for catalog design by the page. Pays for illustration by project, $250-2,000. Considers complexity of project, skill and experience of artist, and turnaround time when establishing payment. Buys all rights.

Tips: "Send classic illustration, graphic designs or a mix of photography/illustration. We can work from b&w concepts—then develop to full 4-color when selected. *Do not send art samples via e-mail*."

PORTAL PUBLICATIONS, LTD., 201 Alameda del Prado, Suite 200, Novato CA 94949. (415)884-6200. E-mail: artsub@portalpub.com. Website: www.portalpub.com. **Vice President of Publishing:** Pamela Prince. Estab. 1954. Produces calendars, cards, stationery, posters and prints. "All Portal products are image-driven, with emphasis on unique styles of photography and illustration. All age groups are covered in each product category, although the prime market is female, ages 18 to 45."

Needs: Approached by more than 1,000 freelancers (includes photographers and illustrators)/year. Freelance designs and illustrations purchased per year varies, more than 12 calligraphy projects/year. Prefers freelancers with experience in "our product categories." Art guidelines free for SASE with first-class postage or via website. Works on assignment only. Uses freelancers mainly for primary image, photoshop work and calligraphy. Considers any media. Looking for "beautiful, charming, provocative, humorous images of all kinds." 90% of freelance design demands knowledge of the most recent versions of Illustrator and QuarkXPress. Submit seasonal material 12 months in advance.

First Contact & Terms: Send query letter with photocopies and SASE and follow-up postcard every 6 months. Prefers color copies to disk submissions. Samples are filed or returned by SASE. Responds only if interested. Will contact for portfolio review of b&w, color and final art if interested. Rights purchased vary according to project.

Tips: "Send color copies of your work that we can keep in our files—also, know our product lines."

PORTERFIELD'S FINE ART LICENSING, 5 Mountain Rd., Concord NH 03301-5479. (800)660-8345 or (603)228-1864. Fax: (603)228-1888. E-mail: information@porterfieldsfineart.com. Website: www. porterfieldsfineart.com. **President:** Lance J. Klass. Licenses representational, Americana, and many other subjects. "We're a full-service licensing agency." Estab. 1994. Functions as a full-service licensing representative for individual artists wishing to find publishers or licensees. "We have one of the fastest growing art licensing agencies in North America, as well as the largest and best-known art licensing site on the

Internet. Stop by our site for more information about how to become a Porterfield's artist and have us represent you and your work for licenses in wall and home decor, collectibles, giftware and many other types of products."

Needs: Approached by more than 600 freelancers/year. Licenses many designs and illustrations/year. Prefers representational artists "who can create beautiful pieces of art that people want to look at and look at and look at." Art guidelines listed on its Internet site. Considers existing works first. Considers any media—oil, pastel, watercolor, acrylics. "We want artists who have exceptional talent and who would like to have their art and their talents introduced to the broad public." Particularly seeking country folk Americana artists.

First Contact & Terms: Send query letter with tearsheets, photographs, SASE, photocopies. Samples are filed or returned by SASE. Responds in 1 month. Will contact for portfolio review if interested. Portfolio should include tearsheets or photographs. Rights purchased vary. Pays royalties for licensed works.

Tips: "We are impressed first and foremost by level of ability, even if the subject matter is not something we would use. Thus a demonstration of competence is the first step; hopefully the second would be that demonstration using subject matter that we feel would be marketable. We work with artists to help them with the composition of their pieces for particular media. We treat artists well, and actively represent them to potential licensees. Instead of trying to reinvent the wheel yourself and contact everyone 'cold,' get a licensing agent or rep whose particular abilities complement your art. We specialize in the application of art to collectibles, giftware, home decor and accessories, wall decor, and also to print media such as cards, stationery, calendars, prints, lithographs and even fabrics. Other licensing reps and companies specialize in cartoons, book illustrations, etc.—the trick is to find the right rep whom you feel you can work with, who really loves your art whatever it is, and whose specific contacts and abilities can help further your art in the marketplace."

PORTFOLIO GRAPHICS, INC., P.O. Box 17437, Salt Lake City UT 84117. (801)266-4844. Fax: (801)263-1076. E-mail: info@portfoliographics.com. Website: www.nygs.com. **Creative Directors:** Kent Barton and Ray Morrison. Estab. 1986. Produces greeting cards, fine art posters, prints, limited editions. Fine art publisher and distributor world-wide. Clients include frame shops, galleries, gift stores and distributors.

• Portfolio Graphics also has a listing in the Posters & Prints section of this book.

Needs: Approached by 200-300 freelancers/year. Works with 30 freelancers/year. Buys 50 freelance designs and illustrations/year. Considers all media. "Open to large variety of styles." Produces material for Christmas, everyday, birthday, sympathy, get well, anniversary, thank you and friendship.

First Contact & Terms: Illustrators send résumé, slides, tearsheets, SASE. "Slides are best. Do not send originals." Samples are filed "if interested" or returned by SASE. Responds in 3 months. Negotiates rights purchased. Pays 10% royalties. Finds artists through galleries, word of mouth, submissions, art shows and exhibits.

Tips: "Open to a variety of submissions, but most of our artists sell originals as fine art home or office decor. Keep fresh, unique, creative."

THE PRINTERY HOUSE OF CONCEPTION ABBEY, P.O. Box 12, 37112 State Hwy. VV, Conception MO 64433. (660)944-3110. Fax: (660)944-3116. E-mail: art@printeryhouse.org. Website: www.printer yhouse.org. **Art Director:** Brother Michael Marcotte, O.S.B. Estab. 1950. Publishes religious greeting cards. Licenses art for greeting cards and wall prints. Specializes in religious Christmas and all-occasion themes for people interested in religious, yet contemporary, expressions of faith. "Our card designs are meant to touch the heart. They feature strong graphics, calligraphy and other appropriate styles."

Needs: Approached by 75 freelancers/year. Works with 25 freelancers/year. Art guidelines available on website or for SASE with first-class postage. Uses freelancers for product illustration. Prefers acrylic, pastel, oil, watercolor, line drawings and classical and contemporary calligraphy. Looking for dignified styles and solid religious themes. Produces seasonal material for Christmas and Easter "as well as the usual birthday, get well, sympathy, thank you, etc. cards of a religious nature. Creative general message cards are also needed." Digital work is accepted in Photoshop or Illustrator format.

First Contact & Terms: Send query letter with résumé, photocopies, photographs, SASE, slides or tearsheets. Calligraphers send any printed or finished work. Non-returnable samples preferred—or else samples with SASE. Accepts disk submissions compatible with Photoshop or Illustrator. Send TIFF or EPS files. Responds usually within 3 weeks. To show portfolio, mail appropriate materials only after query has been answered. "In general, we continue to work with artists once we have accepted their work." Pays flat fee of $250-400 for illustration/design, and $50-150 for calligraphy. Usually buys exclusive reproduc-

tion rights for a specified format; occasionally buys complete reproduction rights.

Tips: "Remember our specific purpose of publishing greeting cards with a definite Christian/religious dimension but not piously religious. It must be good quality artwork. We sell mostly via catalogs so artwork has to reduce well for catalog."

 PRISMATIX, INC., 324 Railroad Ave., Hackensack NJ 07601. (201)525-2800 or (800)222-9662. Fax: (201)525-2828. E-mail: prsmatix@optonline.net. **Vice President:** Miriam Salomon. Estab. 1977. Produces novelty humor programs. "We manufacture screen-printed novelties to be sold in the retail market."

Needs: Works with 3-4 freelancers/year. Buys 100 freelance designs and illustrations/year. Works on assignment only. 90% of freelance work demands computer skills.

First Contact & Terms: Send query letter with brochure, résumé. Samples are filed. Responds only if interested. Portfolio should include color thumbnails, roughs, final art. Payment negotiable.

PRIZM INC., P.O. Box 1106, Manhattan KS 66505-1106. (785)776-1613. Fax: (785)776-6550. E-mail: michele@pipka.com. **President of Product Development:** Michele Johnson. Produces collectible figurines, decorative housewares, gifts, limited edition plates, ornaments. Manufacturer of exclusive collectible figurine line.

Needs: Approached by 20 freelancers/year. Art guidelines free for SASE with first-class postage. Works on assignment only. Uses freelancers mainly for figurines, home decor items. Also for calligraphy. Considers all media. Looking for traditional, old world style, sentimental, folkart. Produces material for Christmas, Mother's Day, everyday. Submit seasonal material 1 year in advance.

First Contact & Terms: Send query letter with photocopies, résumé, SASE, slides, tearsheets. Samples are filed. Responds in 2 months if SASE is included. Will contact for portfolio review of color, final art, slides. Rights purchased vary according to project. Pays royalties plus payment advance; negotiable. Finds freelancers through artist submissions, decorative painting industry.

Tips: "People seem to be more family oriented—therefore more wholesome and positive images are important. We are interested in looking for new artists and lines to develop. Send a few copies of your work with a concept."

PRUDENT PUBLISHING, 65 Challenger Rd., Ridgefield Park NJ 07660. (201)641-7900. Fax: (201)641-9356. **Marketing:** Marian Francesco. Estab. 1928. Produces greeting cards. Specializes in business/corporate all-occasion and holiday cards.

Needs: Buys calligraphy. Art guidelines available. Uses freelancers mainly for card design, illustrations and calligraphy. Considers traditional media. Prefers no cartoons or cute illustrations. Prefers $5\frac{1}{2} \times 7\frac{1}{8}$ horizontal format (or proportionate to those numbers). Produces material for Christmas, Thanksgiving, birthdays, everyday, sympathy, get well and thank you.

First Contact & Terms: Designers, illustrators and calligraphers send query letter with brochure, photostats, photocopies, tearsheets. Samples are filed or returned by SASE if requested. Responds ASAP. Portfolio review not required. Buys all rights. No royalty or licensing arrangements. Payment is negotiable. Finds freelancers through artist's submissions, magazines, sourcebooks, agents and word of mouth.

Tips: "No cartoons."

RAINBOW CREATIONS, INC., 216 Industrial Dr., Ridgeland MS 39157. (601)856-2158. Fax: (601)856-5809. E-mail: walls@netdoor.com. Website: rainbowcreations.net. **President:** Steve Thomas. Estab. 1976. Produces wallpaper.

Needs: Approached by 10 freelancers/year. Works with 5 freelancers/year. Buys 45 freelance designs and illustrations/year. Prefers freelancers with experience in Illustrator, Photoshop. Art guidelines available on individual project basis. Works on assignment only. Uses freelancers mainly for images that are enlarged into murals. Also for setting designs in repeat. Considers Mac and hand-painted media. 50% of freelance design work demands knowledge of Photoshop and Illustrator. Produces material for everyday.

First Contact & Terms: Designers send query letter with photocopies, photographs and résumé. "We

 A CHECKMARK PRECEDING A LISTING indicates a change in the mailing address since the 2003 edition.

will accept disk submissions if compatible with Illustrator 5.0." Samples are returned. Responds in 7 days. Buys all rights. Pays for design and illustration by the project. Payment based on the complexity of design.
Tips: "Especially interested in paintings that are appealing to 3-9 year age group."

RECO INTERNATIONAL CORPORATION, Collector's Division, Box 951, 138 Haven Ave., Port Washington NY 11050. (516)767-2400. Fax: (516)767-2409. E-mail: hreich@reco.com. Website: www.rec o.com. Manufacturer/distributor of limited editions, collector's plates, 3-dimensional plaques, lithographs and figurines. Sells through retail stores and direct marketing firms.
Needs: Works with freelance and contract artists. Uses freelancers under contract for plate and figurine design, home decor and giftware. Prefers romantic and realistic styles.
First Contact & Terms: Send query letter and brochure to be filed. Write for appointment to show portfolio. Art director will contact artist for portfolio review if interested. Negotiates payment. Considers buying second rights (reprint rights) to previously published work or royalties.
Tips: "Have several portfolios available. We are very interested in new artists. We go to shows and galleries, and receive recommendations from artists we work with."

RECYCLED PAPER GREETINGS INC., 3636 N. Broadway, Chicago IL 60613. (773)348-6410. Fax: (773)281-1697. Website: www.recycledpapergreetings.com. **Art Directors:** Gretchen Hoffman, John LeMoine. Publishes greeting cards and adhesive notes.
Needs: Buys 1,000-2,000 freelance designs and illustrations. Considers b&w line art and color—"no real restrictions." Looking for "great ideas done in your own style with messages that reflect your own slant on the world." Prefers 5×7 vertical format for cards. "Our primary interest is greeting cards." Produces seasonal material for all major and minor holidays including Jewish holidays. Submit seasonal material 18 months in advance; everyday cards are reviewed throughout the year.
First Contact & Terms: Send SASE to the Art Department or view website for artist's guidelines. "Please do not send slides or tearsheets. We're looking for work done specifically for greeting cards."Responds in 2 months. Portfolio review not required. Originals returned at job's completion. Sometimes requests work on spec before assigning a job. Pays average flat fee of $250 for illustration/design with copy. Some royalty contracts. Buys card rights.
Tips: "Remember that a greeting card is primarily a message sent from one person to another. The art must catch the customer's attention, and the words must deliver what the front promises. We are looking for unique points of view and manners of expression. Our artists must be able to work with a minimum of direction and meet deadlines. There is a renewed interest in the use of recycled paper—we have been the industry leader in this for almost three decades."

RED FARM STUDIO, 1135 Roosevelt Ave., P.O. Box 347, Pawtucket RI 02862-0347. (401)728-9300. Fax: (401)728-0350. Contact: Creative Director. Estab. 1955. Produces greeting cards and stationery from original watercolor art. Also produces coloring books and paintable sets. Specializes in nautical and contemporary themes. Uses freelancers for greeting cards, notes, Christmas cards. Considers watercolor artwork for cards, notes and stationery; b&w linework and tonal pencil drawings for coloring books and paintable sets. Looking for accurate, detailed, realistic work, though some looser watercolor styles are also acceptable. Produces material for Christmas and everyday occasions. Also interested in traditional, realistic artwork for religious line: Christmas, Easter, Mother's and Father's Day and everyday subjects, including realistic portrait and figure work, such as the Madonna and Child.
First Contact & Terms: First send query letter and #10 SASE to request art guidelines. Submit printed samples, transparencies, color copies or photographs with a SASE. Samples not filed are returned by SASE. Art director will contact artist for portfolio review if interested. Pays flat fee of $250-350 for card or note illustration/design, or pays by project, $250-1000. Buys all rights. "No photography, please."
Tips: "We are interested in clean, bright and fun work. Our guidelines will help to explain our needs."

REEDPRODUCTIONS, 100 Ebbtide Ave., Suite 100, Sausalito CA 94965. (415)331-2694. Fax: (415)331-3690. E-mail: reedpro@earthlink.net. **Owner/Art Director:** Susie Reed. Estab. 1978. Produces general stationery and gift items including greeting cards, magnets and address books. Special emphasis on nature.
Needs: Approached by 20 freelancers/year. Works with few freelancers/year. Art guidelines are not available. Prefers local freelancers with experience. Works on assignment only. Artwork used for paper and gift novelty items. Also for computer graphics. Prefers color or b&w photo realist illustrations of nature images.
First Contact & Terms: Send query letter with brochure or résumé, tearsheets, photocopies or slides

and SASE. Samples are filed or are returned by SASE. Art Director will contact artist for portfolio review if interested. Portfolio should include color or b&w final art, final reproduction/product, slides, tearsheets and photographs. Originals are returned at job's completion. Payment negotiated at time of purchase. Considers buying second rights (reprint rights) to previously published work.

RENAISSANCE GREETING CARDS, Box 845, Springvale ME 04083. (207)324-4153. Fax: (207)324-9564. E-mail: talktous@rencards.com. Website: www.rencards.com. **Art Director:** Jennifer Stockless. Estab. 1977. Publishes greeting cards; "current approaches" to all-occasion cards and seasonal cards. "We're an alternative card company with a unique variety of cards for all ages, situations and occasions."

Needs: Approached by 500-600 artists/year. Buys 300 illustrations/year. Occasionally buys calligraphy. Art guidelines on website and available free for SASE with first-class postage. Full-color illustrations only. Produces materials for all holidays and seasons and everyday. Submit art 18 months in advance for fall and Christmas material; approximately 1 year in advance for other holidays.

First Contact & Terms: Send query letter with SASE. To show portfolio, mail color copies, tearsheets, slides or transparencies. Packaging with sufficient postage to return materials should be included in the submission. Responds in 2 months. Originals are returned to artist at job's completion. Sometimes requests work on spec before assigning a job. Pays for design by the project, $150-300 advance on royalties or flat fee, negotiable. Also needs calligraphers, pay rate negotiable. Finds artists mostly through submissions/ self-promotions.

Tips: "Do some 'in store' research first to get familiar with a company's product/look in order to decide if your work is a good fit. It can take a lot of patience to find the right company or situation. Especially interested in trendy styles as well as humorous and whimsical illustration. Start by requesting guidelines, and then send a small (10-12) sampling of 'best' work, preferably color copies or slides (with SASE for return). Indicate if the work shown is available or only samples. We're doing more designs with special effects like die-cutting and embossing. We're also starting to use more computer-generated art and electronic images."

RIGHTS INTERNATIONAL GROUP, 463 First St. #3C, Hoboken NJ 07030. (201)239-8118. Fax: (201)222-0694. E-mail: rhazaga@rightsinternational.com. Website: www.rightsinternational.com. **Contact:** Robert Hazaga. Estab. 1996. Agency for cross licensing. Licenses images for manufacturers of giftware, stationery, posters, home furnishing.
 ● This company also has a listing in the Posters & Prints section.

Needs: Approached by 50 freelancers/year. Uses freelancers mainly for creative, decorative art for the commercial and designer market. Also for textile art. Considers oil, acrylic, watercolor, mixed media, pastels and photography.

First Contact & Terms: Send brochure, photocopies, photographs, SASE, slides, tearsheets or transparencies. Accepts disk submissions compatible with PC format. Responds in 1 month. Will contact for portfolio review if interested. Negotiates rights purchased and payment.

RITE LITE LTD./THE JACOB ROSENTHAL JUDAICA-COLLECTION, 333 Stanley Ave., Brooklyn NY 11207. (718)498-1700. Fax: (718)498-1251. E-mail: ritelite@aol.com. **President:** Alex Rosenthal. Estab. 1948. Manufacturer and distributor of a full range of Judaica ranging from mass-market commercial goods, such as decorative housewares, to exclusive numbered pieces, such as limited edition plates. Clients: department stores, galleries, gift shops, museum shops and jewelry stores.
 ● Company is looking for new menorah, mezuzah, children's Judaica, Passover and matza plate designs.

Needs: Approached by 15 freelancers/year. Works with 4 freelancers/year. Art guidelines not available. Works on assignment only. Uses freelancers mainly for new designs for Judaic giftware. Must be familiar with Jewish ceremonial objects or design. Prefers ceramic, brass and glass. Also uses artists for brochure and catalog design, illustration and layout mechanicals, P-O-P and product design. 25% of freelance work requires knowledge of Illustrator and Photoshop. Produces material for Hannukah, Passover, Hasharah. Submit seasonal material 1 year in advance.

First Contact & Terms: Designers send query letter with brochure or résumé and photographs. Illustrators send photocopies. Do not send originals. Samples are filed. Responds in 1 month only if interested. Portfolio review not required. Art Director will contact for portfolio review if interested. Portfolio should include color tearsheets, photographs and slides. Pays flat fee of $500/design or royalties of 5-6%. Buys all rights. "Works on a royalty basis." Finds artists through word of mouth.

Tips: "Be open to the desires of the consumers. Don't force your preconceived notions on them through the manufacturers. Know that there is one retail price, one wholesale price and one distributor price."

ROCKSHOTS GREETING CARDS, 20 Vandam St., 4th Floor, New York NY 10013-1274. (212)243-9661. Fax: (212)604-9060. **Editor:** Bob Vesce. Estab. 1979. Produces calendars, giftbags, giftwrap, greeting cards, mugs. "Rockshots is an outrageous, sometimes adult, always hilarious card company. Our themes are sex, birthdays, sex, holiday, sex, all occasion and sex. Our images are mainly photographic, but we also seek out cartoonists and illustrators."

Needs: Approached by 10-20 freelancers/year. Works with 5-6 freelancers/year. Buys 10 freelance designs and illustrations/year. Art guidelines free for SASE with first-class postage. "We like a line that has many different facets to it, encompassing a wide range of looks and styles. We are outrageous, adult, witty, off-the-wall, contemporary and sometimes shocking." Prefers any size that can be scaled on a greeting card size to 5 inches by 7 inches. 10% of freelance illustration demands computer skills. Produces material for Christmas, New Year, Valentine's Day, birthdays, everyday, get well, woman to woman ("some male bashing allowed") and all adult themes.

First Contact & Terms: Illustrators and/or cartoonists send photocopies, photographs and photostats. Samples are filed. Responds only if interested. Portfolio review not required. Buys first rights. Pays per image.

Tips: "As far as trends go in the greeting card industry, we've noticed that 'retro' refuses to die. Vintage looking cards and images still sell very well. People find comfort in the nostalgic look of yesterday. Sex also is a huge seller. Rockshots is looking for illustrators that can come up with something a little out of mainstream. Our look is outrageous, witty, adult and sometimes shocking. Our range of style starts at cute and whimsical and runs the gamut all the way to totally wacky and unbelievable. Rockshot cards definitely stand out from the competition. For our line of illustrations, we look for a style that can convey a message, whether through a detailed elaborate colorful piece of art or a simple 'gesture' drawing. Characters work well, such as the ever-present wisecracking granny to the nerdy 'everyman' guy. It's always good to mix sex and humor, as sex always sells. As you can guess, we do not shy away from much. Be creative, be imaginative, be funny, but most of all, be different."

ROMAN, INC., 555 Lawrence Ave., Roselle IL 60172. (630)529-3000. Fax: (630)529-1121. Website: www.roman.com. **Vice President:** Julie Puntch. Estab. 1963. Produces collectible figurines, decorative housewares, decorations, gifts, limited edition plates, ornaments. Specializes in collectibles and giftware to celebrate special occasions.

Needs: Approached by 25-30 freelancers/year. Works with 3-5 freelancers/year. Uses freelancers mainly for graphic packaging design, illustration. Also for a variety of services. Considers variety of media. Looking for traditional-based design. Roman also has an inspirational niche. 80% of freelance design and illustration demands knowledge of Photoshop, QuarkXPress, Illustrator. Produces material for Christmas, Mother's Day, graduation, Thanksgiving, birthdays, everyday. Submit seasonal material 1 year in advance.

First Contact & Terms: Send query letter with photocopies. Samples are filed or returned by SASE. Responds in 2 months if artist requests a reply. Portfolio review not required. Pays by the project, varies. Finds freelancers through word of mouth, artists' submissions.

RUBBERSTAMPEDE, 2550 Pellisier Place, Whittier CA 90601. (562)695-7969. Fax: (800)546-6888. **Senior Marketing Manager:** Olive Choa. Design Manager: Grace Taormina. Estab. 1978. Produces art and novelty rubber stamps, kits, glitter pens, ink pads.

Needs: Approached by 30 freelance artists/year. Works with 10-20 freelance artists/year. Buys 200-300 freelance designs and illustrations/year. Uses freelance artists for calligraphy, P-O-P displays, and original art for rubber stamps. Considers pen & ink. Looks for whimsical, feminine style and fashion trends. Produces seasonal material: Christmas, Valentine's Day, Easter, Hanukkah, Thanksgiving, Halloween, birthdays and everyday (includes wedding, baby, travel, and other life events). Submit seasonal material 6 months in advance.

First Contact & Terms: Send nonreturnable samples. Samples are filed. Responds only if interested. Pays by the hour, $15-50; by the project, $50-1,000. Rights purchased vary according to project. Originals are not returned.

[N] RUSS BERRIE AND COMPANY, 111 Bauer Dr., Oakland NJ 07436. (800)631-8465. **Director Paper Goods:** Angelica Urra. Produces greeting cards, bookmarks and calendars. Manufacturer of impulse gifts for all age groups.

• This company is no longer taking unsolicited submissions.

SEABROOK WALLCOVERINGS, INC., 1325 Farmville Rd., Memphis TN 38122. (901)320-3500. Fax: (901)320-3675. **Director of Product Development:** Suzanne Ashley. Estab. 1910. Developer and distributor of wallcovering and coordinating fabric for all age groups and styles.
Needs: Approached by 10-15 freelancers/year. Works with approximately 6 freelancers/year. Buys approximately 200 freelance designs and illustrations/year. Prefers freelancers with experience in wall coverings. Works on assignment only. Uses freelancers mainly for designing and styling wallcovering collections. Considers gouache, oil, watercolor, etc. Prefers 20½ × 20½. Produces material for everyday, residential.
First Contact & Terms: Designers send query letter with color photocopies, photographs, résumé, slides, transparencies and sample of artists' "hand." Illustrators send query letter with color photocopies, photographs and résumé. Samples are filed or returned. Responds in 2 weeks. Company will contact artist for portfolio review of final art, roughs, transparencies and color copies if interested. Buys all rights. Pays for design by the project. Finds freelancers through word of mouth, submissions, trade shows.
Tips: "Attend trade shows pertaining to trends in wall covering. Be familiar with wallcovering design repeats."

SECOND NATURE, LTD., 10 Malton Rd., London, W105UP England. (020)8960-0212. Fax: (020)8960-8700. E-mail: rods@secondnature.co.uk. Website: www.secondnature.co.uk. **Contact:** Rod Schragger. Greeting card publisher specializing in unique 3-D/handmade cards and special finishes.
Needs: Prefers interesting new contemporary but commercial styles. Also calligraphy and web design. Art guidelines available. Produces material for Christmas, Valentine's Day, Mother's Day and Father's Day. Submit seasonal material 19 months in advance.
First Contact & Terms: Send query letter with samples showing art style. Samples not filed are returned only if requested by artist. Responds in 2 months. Originals are not returned at job's completion. Pays flat fee.
Tips: "We are interested in all forms of paper engineering or anything fresh and innovative."

PAULA SKENE DESIGNS, 1250 45th St., Suite 240, Emeryville CA 94608. (510)654-3510. Fax: (510)654-3496. E-mail: paulaskenedesi@aol.com. **Contact:** Paula Skene, owner/president. Specializes in all types of cards and graphic design as well as foil stamping and embossing. "We do not use any cartoon art. We only use excellent illustration or fine art."
Needs: Works with 1-2 freelancers/year. Works on assignment only. Produces material for all holidays and seasons, everyday.
First Contact & Terms: Designers send tearsheets and photocopies. Illustrators send samples. Samples are returned. Responds in 1 week. Company will contact artist for portfolio review of b&w, color final art if interested. Buys all rights. Pays for design and illustration by the project.

SOURIRE, P.O. Box 1659, Old Chelsea Station, New York NY 10011. (718)573-4624. Fax: (718)455-8898. E-mail: greetings@cardsorbust.com. Website: www.cardsorbust.com. **Contact:** Submissions. Estab. 1998. Produces giftbags, giftwrap/wrapping paper, greeting cards, stationery, T-shirts. Specializes in handcrafted, multicultural, humorous, and alternative themes for holidays and occasions. Target market is metropolitan men and women between ages 20 and 60.
Needs: Approached by 50 freelancers/year. Buys 20 freelance designs and/or illustrations/year. Art guidelines free with SASE and first-class postage. Uses freelancers mainly for graphics, paintings, illustrations. Considers all media. Product categories include African-American, alternative/humor, cute, multicultural, handcrafted. Produces material for all holidays and seasons. Submit seasonal material 6 months in advance.
First Contact & Terms: Send query letter and postcard sample with brochure, photocopies, SASE, tearsheets, URL. Samples are filed. If they are not filed, samples are returned by SASE. Responds in 3 months. Portfolio not required. Rights purchased vary according to project. Pays freelancers by the project, royalties or flat fee. Finds freelancers through artists' submissions and word-of-mouth.

SPARROW & JACOBS, 6701 Concord Park Dr., Houston TX 77040. (713)744-7800. Fax: (713)744-8799. **Contact:** Merchandise Coordinator. (713)744-8796. Fax: (713)744-8799. E-mail: sparrow@gabp.com. Estab. 1986. Produces calendars, greeting cards, postcards and other products for the real estate, insurance and wellness industries.
Needs: Buys up to 100 freelance designs and illustrations/year including illustrations for postcards and greeting cards and calligraphy. Considers all media. Looking for new product ideas featuring residential

front doors, flowers, landscapes, animals, holiday themes and much more. "Our products range from, but are not limited to humorous illustrations and comical cartoons to classical drawings and unique paintings." Produces material for Christmas, Easter, Mother's Day, Father's Day, Halloween, New Year, Thanksgiving, Valentine's Day, birthdays, everyday, time change. Submit seasonal material 1 year in advance.

First Contact & Terms: Send query letter with color photocopies, photographs or tearsheets. We also accept e-mail submissions of low-resolution images or Mac-compatible disk submissions. If sending slides, do not send originals. We are not responsible for slides lost or damaged in the mail. Samples are filed or returned in your SASE.

SPENCER GIFTS, INC., subsidiary of Vivendi Universal, 6826 Black Horse Pike, Egg Harbor Twp. NJ 08234-4197. (609)645-5526. Fax: (609)645-5751. E-mail: james.stevenson@spencergifts.com. Website: wwwspencergifts.com. **Creative Director:** James Stevenson. Licensing: Carl Franke, new product art director. Estab. 1965. Retail gift chain located in approximately 750 stores in 43 states including Hawaii and Canada. Includes 120 new retail chain stores named "DAPY" (upscaled unique gift items), "GLOW" stores, SPIRIT Halloween stores and Universal Studio stores.

- Products offered by store chain include posters, T-shirts, games, mugs, novelty items, cards, 14k jewelry, neon art, novelty stationery. Art director says Spencer's is moving into a lot of different product lines, such as custom lava lights and Halloween costumes and products. Visit a store if you can to get a sense of what they offer.

Needs: Assigns 10-15 freelance jobs/year. Prefers artists with professional experience in advertising design. Uses artists for illustration (hard line art, fashion illustration, airbrush). Also needs product and fashion photography (primarily jewelry), as well as stock photography. Uses a lot of freelance computer art. 50% of freelance work demands knowledge of FreeHand, Illustrator, Photoshop and QuarkXPress. Also needs color separators, production and packaging people. "You don't necessarily have to be local for freelance production."

First Contact & Terms: Send postcard sample or query letter with *nonreturnable* brochure, résumé and photocopies, including phone number where you can be reached during business hours. Accepts submissions on disk. Art director will contact artist for portfolio review if interested. Will contact only upon job need. Considers buying second rights (reprint rights) to previously published work. Finds artists through sourcebooks.

Tips: "Become proficient in as many computer programs as possible."

STOTTER & NORSE, 1000 Second St., Plainfield NJ 07063. (908)754-6330. Fax: (908)757-5241. E-mail: sales@stotternorse.com. Website: www.stotternorse.com. **V.P. Sales:** Larry Speichler. Estab. 1979. Produces barware, serveware, placemats and a broad range of tabletop products.

Needs: Buys 20 designs and illustrations/year. Art guidelines not available. Works on assignment only. Uses freelancers mainly for product design. Seeking trendy styles. Final art should be actual size. Produces material for all seasons. Submit seasonal material 6 months in advance.

First Contact and Terms: Send query letter with brochure and résumé. Samples are filed. Responds in 1 month or does not reply, in which case the artist should call. Call for appointment to show portfolio. Negotiates rights purchased. Originals returned at job's completion if requested. Pays flat fee and royalties; negotiable.

SUNRISE PUBLICATIONS INC., Box 4699, Bloomington IN 47402. (812)336-9900. Fax: (812)336-8712. E-mail: info@interart.com. Website: www.interart.com. **Contact:** Art Review Committee. Estab. 1974. Produces greeting cards, posters, writing papers, gift packaging and related products.

Needs: See art guidelines on website. Uses freelancers mainly for greeting card illustration. Also for calligraphy, lettering and product design. Considers any medium. Looking for "highly detailed, highly rendered illustration, but will consider a range of styles." Also looking for photography, humor concepts and surface design. Produces material for all holidays and seasons and everyday. Reviews seasonal material year-round.

First Contact & Terms: Send query letter with SASE, tearsheets, photographs, photocopies, photostats, slides and/or transparencies—maximum 20 images. Samples are not filed and are returned by SASE. Responds in 6 months. Art Director will contact artist for portfolio review if interested. Portfolio should include color tearsheets, photographs and/or slides (duplicate slides or transparencies, please; *not* originals). Originals are returned at job's completion. Negotiates rights purchased. Considers buying second rights (reprint rights) to previously published work.

Tips: Look carefully at the market/industry in which you want to market your work. Look at the competition!

☑ **SUNSHINE ART STUDIOS, INC.**, 270 Main St., Agawan MA 01001. (413)525-5599. Website: sunshinecards.com. **Contact:** Debbie Fuller, graphics director. Estab. 1921. Produces greeting cards, stationery, calendars and giftwrap that are sold in own catalog, appealing to all age groups.
Needs: Works with 50 freelance artists/year. Buys 100 freelance designs and illustrations/year. Prefers artists with experience in greeting cards. Art guidelines available for SASE with first-class postage. Works on assignment only. Uses freelancers for greeting cards, giftwrap, stationery and gift items. Also for calligraphy. Considers all media. Looking for traditional or humorous look. Prefers art $4\frac{1}{2} \times 6\frac{1}{2}$ or 5×7. Produces material for Christmas, Easter, birthdays and everyday. Submit seasonal material 6-8 months in advance.
First Contact & Terms: Send query letter with brochure, résumé, SASE, tearsheets and slides. Samples are filed or are returned by SASE if requested by artist. Responds only if interested. Portfolio should include finished art samples and color tearsheets and slides. Originals not returned. Pays by the project, $250-400. Pays $25-75/piece for calligraphy and lettering. Buys all rights.

A SWITCH IN ART, Gerald F. Prenderville, Inc., P.O. Box 246, Monmouth Beach NJ 07750. (732)389-4912. Fax: (732)389-4913. E-mail: aswitchinart@aol.com. **President:** G.F. Prenderville. Estab. 1979. Produces decorative switch plates. "We produce decorative switch plates featuring all types of designs including cats, animals, flowers, kiddies/baby designs, birds, etc. We sell to better gift shops, museums, hospitals, specialty stores with large following in mail order catalogs."
Needs: Approached by 4-5 freelancers/year. Works with 2-3 freelancers/year. Buys 10-20 designs and illustrations/year. Prefers artists with experience in card industry and cat rendering. Seeks cats and wildlife art. Prefers 8×10 or 10×12. Submit seasonal material 6 months in advance.
First Contact & Terms: Send query letter with brochure, tearsheets and photostats. Samples are filed and are returned. Responds in 5 weeks. Pays by the project, $75-150. Interested in buying second rights (reprint rights) to previously published artwork. Finds artists mostly through word of mouth.
Tips: "Be willing to accept your work in a different and creative form that has been very successful. We seek to go vertical in our design offering to insure continuity. We are very easy to work with and flexible. Cats have a huge following among consumers but designs must be realistic."

SYRACUSE CULTURAL WORKERS, Box 6367, Syracuse NY 13217. (315)474-1132. Fax: (315)475-1277. E-mail: studio@syrculturalworkers.org. Website: www.syrculturalworkers.org. **Art Director:** Karen Kerney. Estab. 1982. Syracuse Cultural Workers publishes and distributes peace and justice resources through their Tools For Change catalog. Produces posters, notecards, postcards, greeting cards, T-shirts and calendars that are feminist, progressive, radical, multicultural, lesbian/gay allied, racially inclusive and honoring of elders and children.
 • SCW is specifically seeking artwork celebrating diverstiy, people's history and community building. Themes include environment, positive parenting, positive gay and lesbian images, multiculturalism and cross-cultural adoption.
Needs: Approached by many freelancers/year. Works with 50 freelancers/year. Buys 40-50 freelance fine art images and illustrations/year. Considers all media (in slide form). Art guidelines available on website or free for SASE with first-class postage. Looking for progressive, feminist, liberating, vital, people- and earth-centered themes. "December and January are major art selection months."
First Contact & Terms: Send query letter with slides, brochures, photocopies, photographs, SASE, tearsheets and transparencies. Samples are filed or returned by SASE. Responds in 1 month with SASE. Will contact for portfolio review if interested. Buys one-time rights. Pays flat fee of $85-450; royalties of 4-6% gross sales. Finds artists through word of mouth, its own artist list and submissions.
Tips: "Please do NOT send original art or slides. Rather, send photocopies, printed samples or duplicate slides. Also, one postcard sample is not enough for us to judge whether your work is right for us. We'd like to see at least three or four different images. Include return postage if you would like your artwork/slides returned."

▓ **TALICOR, INC.**, 14175 Telephone Ave., Suite A, Chino CA 91710. (909)517-0076. E-mail: webmaster@talicor.com. Website: www.talicor.com. **President:** Lew Herndon. Estab. 1971. Manufacturer and distributor of educational and entertainment games and toys. Clients: chain toy stores, department stores, specialty stores and Christian bookstores.

Needs: Works with 4-6 freelance illustrators and designers/year. Prefers local freelancers. Works on assignment only. Uses freelancers mainly for game design. Also for advertising, brochure and catalog design, illustration and layout; product design; illustration on product; P-O-P displays; posters and magazine design.
First Contact & Terms: Send query letter with brochure. Samples are not filed and are returned only if requested. Responds only if interested. Call or write for appointment to show portfolio. Pays for design and illustration by the project, $100-3,000. Negotiates rights purchased.

☑ **TJ'S CHRISTMAS**, 14855 W. 95th St., Lenexa KS 66215. (913)888-8338. Fax: (913)888-8350. E-mail: mitch@imitchell.com. Website: www.imitchell.com. **Creative Coordinator:** Edward Mitchell. Estab. 1983. Produces figurines, decorative accessories, ornaments and other Christmas adornments. Primarily manufactures and imports Christmas ornaments, figurines and accessories. Also deals in some Halloween, Thanksgiving, gardening and everyday home decor items. Clients: higher-end floral, garden, gift and department stores.
Needs: Uses freelancers mainly for unique and innovative designs. Considers most media. "Our products are often nostalgic, bringing back childhood memories. They also should bring a smile to your face. We are looking for traditional designs that fit with our motto, 'Cherish the Memories.' " Produces material for Christmas, Halloween, Thanksgiving and everyday. Submit seasonal material 18 months in advance.
First Contact & Terms: Send query letter with résumé, SASE and photographs. Will accept work on disk. Portfolios may be dropped off Monday-Friday. Samples are not filed and are returned by SASE. Responds in 1 month. Negotiates rights purchased. Pays advance on royalties of 5%. Terms are negotiated. Finds freelancers through magazines, word of mouth and artist's reps.
Tips: "Continually search for new and creative ideas. Sometimes silly, cute ideas turn into the best sellers (i.e., sad melting snowmen with a sign saying 'I Miss Snow.') Watch for trends (such as increasing number of baby boomers that are retiring.) Try to target the trends you see. Think from the viewpoint of a consumer walking around a small gift store."

▓ **VAGABOND CREATIONS INC.**, 2560 Lance Dr., Dayton OH 45409. (937)298-1124. **Art Director:** George F. Stanley, Jr. Publishes stationery and greeting cards with contemporary humor. 99% of artwork used in the line is provided by staff artists working with the company.
 ● Vagabond Creations Inc. now publishes a line of coloring books.
Needs: Works with 3 freelancers/year. Buys 12 finished illustrations/year. Prefers local freelancers. Seeking line drawings, washes and color separations. Material should fit in standard-size envelope.
First Contact & Terms: Query. Samples are returned by SASE. Responds in 2 weeks. Submit Christmas, Valentine's Day, everyday and graduation material at any time. Originals are returned only upon request. Payment negotiated.
Tips: "Important! Currently we are *not* looking for additional freelance artists because we are very satisfied with the work submitted by those individuals working directly with us. We do not in any way wish to offer false hope to anyone, but it would be foolish on our part not to give consideration. Our current artists are very experienced and have been associated with us in some cases for over 30 years."

WANDA WALLACE ASSOCIATES, 323 E. Plymouth, Suite 2, Inglewood CA 90302. (310)419-0376. Fax: (310)419-0382. Website: www.wandawallace.com. **President:** Wanda. Estab. 1980. Produces greeting cards and posters for general public appeal. "We produce black art prints, posters, originals and other media."
Needs: Approached by 10-12 freelance artists/year. Works with varying number of freelance artists/year. Buys varying number of designs and illustrations/year from freelance artists. Prefers artists with experience in black/ethnic art subjects. Uses freelance artists mainly for production of originals and some guest appearances. Considers all media. Produces material for Christmas. Submit seasonal material 4-6 months in advance.
First Contact & Terms: Send query letter with any visual aid. Some samples are filed. Policy varies regarding answering queries and submissions. Call or write to schedule an appointment to show a portfolio. Rights purchased vary according to project. Art education instruction is available. Pays by the project.

WARNER PRESS, INC., 1200 E. Fifth St., Anderson IN 46018. (765)644-7721. **Creative Director:** John Silvey. Estab. 1884. Produces church bulletins and church supplies such as postcards and children's materials. Warner Press is the publication board of the Church of God. "We produce products for the Christian market. Our main market is the Christian bookstore. We provide products for all ages."
Needs: Approached by 50 freelancers/year. Works with 15-20 freelancers/year. Buys 300 freelance designs

and illustrations/year. Works on assignment only. Uses freelancers for all products, coloring books. Also for calligraphy. "We use local Macintosh artists with own equipment capable of handling 40 megabyte files in Photoshop, FreeHand and QuarkXPress." Considers all media and photography. Looking for bright florals, sensitive still lifes, landscapes, wildlife, birds, seascapes; all handled with bright or airy pastel colors. 100% of production work demands knowledge of QuarkXPress, Illustrator or Photoshop. Produces material for Father's Day, Mother's Day, Christmas, Easter, graduation and everyday. Submit seasonal material 18 months in advance.

First Contact & Terms: Send query letter with brochure, tearsheets and photocopies. Samples are filed and are returned if SASE included. Creative manager will contact artist for portfolio review if interested. Portfolio should include b&w and color final art, tearsheets, photographs and transparencies. Originals are not returned. Pays by the project, $250-350. Pays for calligraphy pieces by the project. Buys all rights (occasionally varies).

Tips: "Subject matter must be appropriate for Christian market. Most of our art purchases are for children's material. We prefer palettes of bright colors as well as clean, pretty pastels."

WHITEGATE FEATURES SYNDICATE, 71 Faunce Dr., Providence RI 02906. (401)274-2149. **Contact:** Eve Green.

• This syndicate is looking for fine artists and illustrators. See their listing in Syndicates for more information about their needs.

CAROL WILSON FINE ARTS, INC., Box 17394, Portland OR 97217. (503)261-1860. **Contact:** Gary Spector. Estab. 1983. Produces greeting cards and fine stationery products.

Needs: Romantic floral and nostalgic images. "We look for artists with high levels of training, creativity and ability."

First Contact & Terms: Write or call for art guidelines. No original artwork on initial inquiry. Samples not filed are returned by SASE.

Tips: "We are seeing an increased interest in romantic fine arts cards and very elegant products featuring foil, embossing and die-cuts."

Magazines

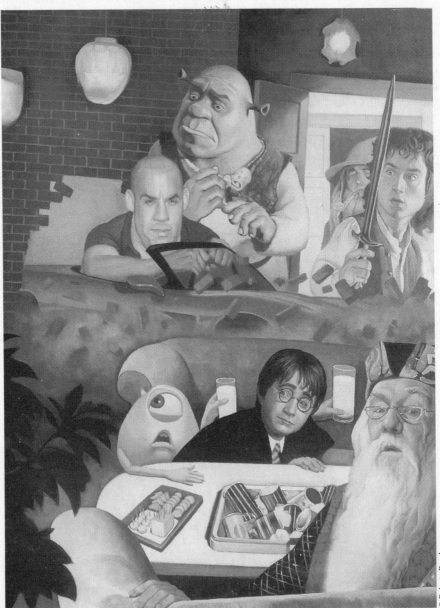

From Harry Potter to Vin Diesel to Monsters Inc.'s Mike, Roberto Parada lampoons all the stars, real and animated, in his painterly caricature style. This illustration is a tour de force and really shows just how talented and versatile Parada is—and why he's so popular with magazines like *Premiere*.

The magazine market is one of the largest markets for freelancers—and perhaps the easiest to break into if your work has a distinct style. There are hundreds of magazines in need of freelance illustrators. Art directors look for the best visual element to hook readers into articles. A whimsical illustration can set the tone for a humorous article, for example, or an edgy caricature of movie stars in boxing gloves might work for an article describing conflicts within a film's cast. Flip through a dozen magazines in your local drugstore and you will quickly see that each illustration conveys the tone and content of articles while fitting in with the magazine's "personality." Read the interview with Aeve Baldwin of *Relix* on page 166 for more insights on how magazines work with artists.

TARGET YOUR MARKETS

Read each listing carefully. Within each listing are valuable clues. Knowing how many artists approach each magazine will help you understand how stiff your competition is. (At first, you might do better submitting to art directors who aren't swamped with submissions.) Look at the preferred subject matter to make sure your artwork fits the magazine's needs. Note the submission requirements and develop a mailing list of markets you want to approach.

Visit newsstands and bookstores. Look for magazines not listed in *Artist's & Graphic Designer's Market*. Check the cover and interior. If illustrations are used, flip to the masthead (usually a box in one of the beginning pages) and note the art director's name. The circulation figure is relevant too. As a rule of thumb, the higher the circulation the higher the art director's budget. When art directors have a good budget, they tend to hire more illustrators and pay higher fees. Look at the illustrations and check the illustrator's name in the credit line in small print to the side of the illustration. Notice which illustrators are used often in the publications you wish to work with. You will notice that each illustrator they chose has a very definite style. After you have studied the illustrations in dozens of magazines, you will understand what types of illustrations are marketable.

CREATE A PROMO SAMPLE

Focus on one or two *consistent* styles to present to art directors in sample mailings. See if you can come up with a style that is different from every other illustrator's style, if only slightly. No matter how versatile you may be, limit styles you market to one or two. That way, you'll be more memorable to art directors. Pick a style or styles you enjoy and can work quickly in. Art directors don't like surprises. If your sample shows a line drawing, they expect you to work in that style when they give you an assignment. Look on pages 22-24 for some examples of good promotional pieces.

MORE MARKETING TIPS

- **Don't overlook trade magazines and regional publications.** While they may not be as glamorous as national consumer magazines, some trade and regional publications are just as lavishly produced. Most pay fairly well and the competition is not as fierce. Until you can get some of the higher circulation magazines to notice you, take assignments from smaller magazines, too. Alternative weeklies are great markets as well. Despite their modest payment, there are many advantages. You learn how to communicate with art directors, develop your signature style and learn how to work quickly to meet deadlines. Once the assignments are done, the tearsheets become valuable samples to send to other magazines.
- **Develop a spot illustration style in addition to your regular style.** "Spots"—illustrations that are half-page or smaller—are used in magazine layouts as interesting visual cues to lead readers through large articles, or to make filler articles more appealing. Though the fee for one spot is less than for a full layout, art directors often assign five or six spots within the same issue to the same artist. Because spots are small in size, they must be all

the more compelling. So send art directors a sample showing several power-packed small pieces along with your regular style.

- **Invest in a fax machine, e-mail and graphics software**. Art directors like to work with illustrators with fax machines and e-mail, because they can quickly fax or e-mail a layout with a suggestion. The artist can send back a preliminary sketch or "rough" the art director can OK. Also they will appreciate it if you can e-mail TIFF, EPS or JPEG files of your work.
- **Get your work into competition annuals and sourcebooks.** The term "sourcebook" refers to the creative directories published annually showcasing the work of freelancers. Art directors consult these publications when looking for new styles. If an art director uses creative directories, we often include that information in the listings to help you understand your competition. Some directories like *Black Book*, *The American Showcase* and *RSVP* carry paid advertisements costing several thousand dollars per page. Other annuals, like the *Print Regional Design Annual* or *Communication Art Illustration Annual* feature award winners of various competitions. An entry fee and some great work can put your work in a competition directory and in front of art directors across the country.
- **Consider hiring a rep.** If after working successfully on several assignments you decide to make magazine illustration your career, consider hiring an artists' representative to market your work for you. (See the Artists' Reps section, page 616.)

For More Information

- A great source for new magazine leads is in the business section of your local library. Ask the librarian to point out the business and consumer editions of the *Standard Rate and Data Service (SRDS)* and *Bacon's Magazine Directory*. These huge directories list thousands of magazines and will give you an idea of the magnitude of magazines published today. Another good source is a yearly directory called *Samir Husni's Guide to New Consumer Magazines* also available in the business section of the public library. Also read *Folio* magazine to find out about new magazine launches and redesigns.

- Each year the Society of Publication Designers sponsors a juried competition called, appropriately, SPOTS. The winners are featured in a prestigious exhibition. For information about the annual competition, contact the Society of Publication Designers at (212)983-8585 or visit their website at www.spd.org.

- Networking with fellow artists and art directors will help you find additional success strategies. The Graphic Artist's Guild, The American Institute of Graphic Artists (AIGA), your city's Art Director's Club or branch of the Society of Illustrators, holds lectures and networking functions. Attend one event sponsored by each organization in your city to find a group you are comfortable with. Then join and become an active member.

AD ASTRA, 600 Pennsylvania Ave. SE, Suite 201, Washington DC 20003-4316. (202)543-1900. Fax: (202)546-4189. E-mail: adastra@nss.org. Website: www.nss.org/. **Editor-in-Chief:** Frank Sietzen, Jr. Estab. 1989. Bimonthly feature magazine popularizing and advancing space exploration and development for the general public interested in all aspects of the space program.
Illustration: Works with 40 freelancers/year. Uses freelancers for magazine illustration. Buys 10 illustrations/year. "We are looking for original artwork on space themes, either conceptual or representing specific designs, events, etc." Prefers acrylics, then oils and collage.
Design: Needs freelancers for multimedia design. 100% of freelance work requires knowledge of Photoshop, QuarkXPress and Illustrator.

First Contact & Terms: Illustrators: Send postcard sample or slides. "Color slides are best." Designers send query letter with brochure and photographs. Samples not filed are returned by SASE. Responds in 6 weeks. Pays $100-300 color, cover; $25-100 color, inside. "We do commission original art from time to time." Fees are for one-time reproduction of existing artwork. Considers rights purchased when establishing payment. Pays designers by the project.

Tips: "Show a set of slides showing planetary art, spacecraft and people working in space. I do not want to see 'science-fiction' art. Label each slide with name and phone number. Understand the freelance assignments are usually made far in advance of magazine deadline."

ADVENTURE CYCLIST, 150 E. Pine St, Missoula MT 59802. (406)721-1776. Fax: (406)721-8754. E-mail: gsiple@adventurecycling.org. Website: www.adventurecycling.org. **Art Director:** Greg Siple. Estab. 1974. Published 9 times/year. A journal of adventure travel by bicycle. Circ. 30,000. Originals returned at job's completion. Sample copies available.

Illustration: Buys 1 illustration/issue. Has featured illustrations by Margie Fullmer, Ludmilla Tomova and Kelly Sutherland. Works on assignment only.

First Contact & Terms: Illustrators: Send printed samples. Samples are filed. Publication will contact artist for portfolio review if interested. Pays on publication, $50-350. Buys one-time rights.

✔ **ADVOCATE, PKA'S PUBLICATION**, 1881 Co. Rt. 2, Prattsville NY 12468. (518)299-3103. **Art Editor:** C.J. Karlie. Estab. 1987. Bimonthly b&w literary tabloid. "*Advocate* provides aspiring artists, writers and photographers the opportunity to see their works published and to receive byline credit toward a professional portfolio so as to promote careers in the arts." Circ. 12,000. "Good quality photocopy or stat of work is acceptable as a submission." Sample copies available for $4. Art guidelines for SASE with first-class postage.

• The Gaited Horse Association Newsletter is published within the pages of *Advocate, PKA's Publication*.

Cartoons: Open to all formats except color washes.

Illustration: Buys 10-15 illustrations/issue. Considers pen & ink, charcoal, linoleum-cut, woodcut, lithograph, pencil or photos, "either b&w or color prints (no slides). We are especially looking for horse-related art and other animals." Also needs editorial and entertainment illustration.

First Contact & Terms: Cartoonists: Send query letter with SASE and submissions for publication. Illustrators: Send query letter with SASE and photos of artwork (b&w or color prints only). No simultaneous submissions. Samples are not filed and are returned by SASE. Portfolio review not required. Responds in 6 weeks. Buys first rights. Pays cartoonists/illustrators in contributor's copies. Finds artists through submissions and from knowing artists and their friends.

Tips: "No postcards are acceptable. Many artists send us postcards to review their work. They are not looked at. Artwork should be sent in an envelope with a SASE."

■ ✦ **AKC GAZETTE**, 260 Madison Ave., 4th Floor, New York NY 10016. (212)696-8370. Fax: (212)696-8299. Website: www.akc.org. **Creative Director:** Tilly Grassa. Estab. 1889. Monthly consumer magazine about "breeding, showing, and training pure-bred dogs." Circ. 58,000. Sample copy available for 9×12 SASE.

Illustration: Approached by 200-300 illustrators/year. Buys 6-12 illustrations/issue. Has featured illustrations by Pam Tanzey and Chet Jezierski. Assigns 20% of illustrations to new and emerging illustrators. Considers all media. 25% of freelance illustration demands knowledge of Photoshop, Illustrator, FreeHand and QuarkXPress.

Design: Needs freelancers for design, production and multimedia projects. Prefers local designers with experience in QuarkXPress, Photoshop and Illustrator. 100% of freelance work demands knowledge of Photoshop, Illustrator and QuarkXPress.

First Contact & Terms: Illustrators: Send query letter with printed samples, photocopies and tearsheets. Send follow-up postcard every 6 months. Designers: Send query letter with printed samples, photocopies, tearsheets and résumé. Accepts Mac platform submissions—compatible with QuarkXPress (latest revision). Send EPS or TIFF files at a high resolution (300 dpi). Samples are filed. Responds only if interested. Rights purchased vary according to project. Pays on publication; $500-1,000 for color cover; $50-150 for b&w, $150-800 for color inside. Pays $75-300 for color spots. Finds illustrators through artist's submissions.

Tips: "Although our magazine is dog-oriented and a knowledge of dogs is preferable, it is not required. Creativity is still key."

ALASKA MAGAZINE, 619 E. Shipcreek Ave., Suite 329, Anchorage AK 99501-1677. (907)272-6070. Fax: (907)258-5360. **Art Director:** Tim Blum. Assistant Art Director: Michelle Kennedy. Estab. 1935. Monthly 4-color regional consumer magazine featuring Alaskan issues, stories and profiles exclusively. Circ. 200,000.

Illustration: Approached by 200 illustrators/year. Buys 1-4 illustration/issue. Has featured illustrations by Bob Crofut, Chris Ware, Victor Juhaz, Bob Parsons. Features humorous and realistic illustrations. On assignment only. Assigns 50% to new and emerging illustrators. 50% of freelance illustration demands knowledge of Illustrator, Photoshop and QuarkXPress.

First Contact & Terms: Send postcard or other nonreturnable samples. Accepts Mac-compatible disk submissions. Samples are not returned. Responds only if interested. Will contact artist for portfolio review if interested. Buys first North American serial rights and electronic rights or rights purchased vary according to project. Pays on publication. Pays illustrators $125-300 for color inside; $400-600 for 2-page spreads; $125 for spots.

Tips: "We work with illustrators who grasp the visual in a story quickly and can create quality pieces on tight deadlines."

ALL ANIMALS, 2100 L St. NW, Washington DC 20037-1525. (202)452-1100. Fax: (301)258-3082. E-mail: allanimals@hsus.org. Website: www.hsus.org. **Creative Director:** Paula Jaworski. Estab. 1954. Quarterly 4-color magazine focusing on The Humane Society news and animal protection issues. Circ. 450,000. Accepts previously published artwork. Originals are returned at job's completion. Art guidelines not available.

Illustration: Occasionally buys illustrations. Works on assignment only. Features natural history, realistic and spot illustration. Assigns 20% of illustrations to well-known or "name" illustrators; 80% to experienced, but not well-known illustrators. Themes vary. Send query letter with samples. Samples are filed or returned. Responds in 1 month. To show a portfolio, mail appropriate materials. Portfolio should include printed samples, b&w and color tearsheets and slides. Buys one-time rights and reprint rights. **Pays on acceptance**; $300-500 for b&w inside; $300-500 for color inside; $300-600 for 2-page spreads; $75-150 for spots.

AMERICA, 106 W. 56th St., New York NY 10019. (212)581-4640. Fax: (212)399-3596. Website: www.am ericamagazine.org. **Associate Editor:** James Martin. Estab. 1904. Weekly Catholic national magazine sponsored by US Jesuits. Circ. 46,000. Sample copies for #10 SASE with first-class postage.

Illustration: Buys 3-5 illustrations/issue. Has featured illustrations by Michael O'Neill McGrath, William Hart McNichols, Tim Foley, Stephanie Dalton Cowan. Features realistic illustration and spot illustration. Assigns 45% of illustrations to new and emerging illustrators. Considers all media.

First Contact & Terms: Illustrators: Send query letter with printed samples and tearsheets. Buys first rights. Pays on publication; $300 for color cover; $75 for b&w inside; $150 for color inside.

Tips: "We look for illustrators who can do imaginative work for religious, educational or topical articles. We will discuss the article with the artist and usually need finished work in two to three weeks. A fast turnaround is extremely valuable."

⚏ AMERICAN BANKER, 1 State St. Plaza, 26th Floor, New York NY 10004. (212)803-8229. Fax: (212)843-9628. E-mail: deborah.fogel@thomsonmedia.com. Website: americanbanker.com. **Contact:** Debbie Fogel, director of editorial design and production. Estab. 1865. Financial services daily newspaper specializing in banking, insurance/investments products, mortgages and credit. Circ. 14,000. Guidelines not available.

Illustration: Approached by 250 illustrators/year. Buys 10 illustrations/year. Features spot illustrations. Prefers business. Prefers fine art with thick heavy brush strokes, and strong vibrant colors. Assigns 1% to new and emerging illustrators.

First Contact & Terms: Send postcard sample with samples. After introductory mailing, send follow-up postcard every 3 months. Samples are filed. Does not reply. Portfolio not required. **Pays on acceptance.** Buys electronic rights, one-time rights. Finds freelancers through word-of-mouth.

Tips: "Please don't call, simply send in samples of your work and if we need you, we will contact you."

⚏ AMERICAN BANKERS ASSOCIATION-BANKING JOURNAL, 345 Hudson St., New York NY 10014. (212)620-7256. Fax: (212)633-0675. E-mail: wwilliams@sbpub.com. Website: www.banking. com/aba. **Creative Director:** Wendy Williams. Associate Creative Director: Phil Desiere. Estab. 1908. 4-color; contemporary design. Emphasizes banking for middle and upper level banking executives and man-

agers. Monthly. Circ. 42,000. Accepts previously published material. Returns original artwork after publication.

Illustration: Buys 4-5 illustrations/issue from freelancers. Features charts & graphs, computer, humorous and spot illustration. Assigns 20% of illustrations to new and emerging illustrators. Themes relate to stories, primarily financial, from the banking industry's point of view; styles vary, realistic, surreal. Uses full-color illustrations. Works on assignment only.

First Contact & Terms: Illustrators: Send finance-related postcard sample and follow-up samples every few months. To send a portfolio, send query letter with brochure and tearsheets, promotional samples or photographs. Negotiates rights purchased. **Pays on acceptance**; $250-950 for color cover; $250-450 for color inside; $250-450 for spots.

Tips: Must have experience illustrating for business or financial publications.

N AMERICAN DEMOGRAPHICS, 470 Park Ave. S., 7th Floor, New York NY 10016-6819. (917)545-3607. Fax: (917)981-2929. Website: www.demographics.com. **Art Director:** Tammy Morton-Fernandez. Estab. 1979. Monthly trade journal covering consumer trends. Circ. 42,000. Sample copies available.

Illustration: Approached by 300 illustrators/year. Buys 2-3 illustrations/issue. Considers all media. Knowledge of Photoshop 3, Illustrator 5.5 helpful, but not required.

First Contact & Terms: Illustrators: Send postcard sample. Designers: Send query letter with tearsheets. Accepts disk submissions. Samples are filed and not returned. Will contact for portfolio review if interested and should include color tearsheets. Buys one-time rights. **Pays on acceptance**.

THE AMERICAN GARDENER, 7931 E. Boulevard Dr., Alexandria VA 22308. (703)768-5700. Fax: (703)768-7533. E-mail: editor@ahs.org. Website: www.ahs.org. **Editor:** David J. Ellis. Managing Editor: Mary Yee. Estab. 1922. Consumer magazine for advanced and amateur gardeners and horticultural professionals who are members of the American Horticultural Society. Bimonthly, 4-color magazine, "very clean and open, fairly long features." Circ. 25,000. Accepts previously published artwork. Original artwork is returned at job's completion. Sample copies for $5.

Illustration: Buys 6-10 illustrations/year from freelancers. Works on assignment only. "Botanical accuracy is important for some assignments. All media used; digital media welcome."

First Contact & Terms: Illustrators: Send query letter with résumé, tearsheets, slides and photocopies. Samples are filed. "We will call artist if their style matches our need." To show a portfolio, mail b&w and color tearsheets and slides. Buys one-time rights. Pays $150-300 color, inside; on publication.

Tips: "As a nonprofit we have a low budget, but offer interesting subject matter, good display and welcome input from artists."

AMERICAN LIBRARIES, 50 E. Huron St., Chicago IL 60611-2795. (312)280-4216. Fax: (312)440-0901. E-mail: americanlibraries@ala.org. Website: www.ala.org. **Editor:** Leonard Kniffel. Estab. 1907. Monthly professional 4-color journal of the American Library Association for its members, providing independent coverage of news and major developments in and related to the library field. Circ. 58,000. Original artwork returned at job's completion if requested. Sample copy $6. Art guidelines available with SASE and first-class postage.

Cartoons: Approached by 15 cartoonists/year. Buys no more than 1 cartoon/issue. Themes related to libraries only.

Illustration: Approached by 20 illustrators/year. Buys 1-2 illustrations/issue. Assigns 25% of illustrations to new and emerging illustrators. Works on assignment only.

First Contact & Terms: Cartoonists: Send query letter with brochure and finished cartoons. Illustrators: Send query letter with brochure, tearsheets and résumé. Samples are filed. Does not respond to submissions. To show a portfolio, mail tearsheets, photographs and photocopies. Portfolio should include broad sampling of typical work with tearsheets of both b&w and color. Buys first rights. **Pays on acceptance**. Pays cartoonists $35-50 for b&w. Pays illustrators $75-150 for b&w and $250-300 for color, cover; $75-150 for b&w and $150-250 for color, inside.

Tips: "I suggest inquirer go to a library and take a look at the magazine first." Sees trend toward "more contemporary look, simpler, more classical, returning to fewer elements."

THE AMERICAN SPECTATOR, 3220 N St. NW (PMB 175), Washington DC 20007-2829. (202)659-7922. Fax: (202)659-7923. Website: www.spectator.org. **Contact:** Artwork Dept. Monthly political, conservative, newsworthy literary magazine. "We cover political topics, human interest items and

book reviews." Circ. 60,000. Original artwork returned after publication. Sample copies available; art guidelines not available.

Illustration: Uses 3-5 illustrations/issue. Interested in "realism with a comic twist." Works on assignment only. Has featured illustrations by Dan Adel, Jack Davis, Phillipe Weisbecker and Blair Drawson. Features caricatures of celebrities and politicians; humorous and realistic illustration; informational graphics; spot illustration. Prefers pen & ink, watercolor, acrylic, colored pencil, oil and pastel.

First Contact & Terms: Illustrators: Samples are filed or returned by SASE. Reports back on future assignment possibilities. Provide résumé, brochure and tearsheets to be kept on file for future assignments. No portfolio reviews. Responds in 2 weeks. Buys first North American serial rights. Pays on publication; $1,200-2,000 for color cover; $150-1,750 for color inside; $1,000-2,000 for 2-page spreads.

ANALOG, 475 Park Ave. S., New York NY 10016. (212)686-7188. Fax: (212)686-7414. **Senior Art Director:** Victoria Green. Associate Art Director: June Levine. All submissions should be sent to June Levine, associate art director. Estab. 1930. Monthly consumer magazine. Circ. 80,000 Art guidelines free for #10 SASE with first-class postage.

Cartoons: Prefers single panel cartoons.

Illustration: Buys 8 illustrations/issue. Prefers science fiction, hardware, robots, aliens and creatures. Considers all media.

First Contact & Terms: Cartoonists: Send query letter with photocopies and/or tearsheets and SASE. Samples are not filed and are returned by SASE. Illustrators: Send query letter with printed samples or tearsheets and SASE. Send follow-up postcard sample every 4 months. Accepts disk submissions compatible with QuarkXPress 7.5/version 3.3. Send EPS files. Files samples of interest, others are returned by SASE. Responds only if interested. "No phone calls." Portfolios may be dropped off every Tuesday and should include b&w and color tearsheets and transparencies. "No original art please, especially oversized." Buys one-time rights. **Pays on acceptance**. Pays cartoonists $35 minimum for b&w cartoons. Pays illustrators $1,200 for color cover; $125 minimum for b&w inside; $35-50 for spots. Finds illustrators through *Black Book, LA Workbook, American Showcase* and other reference books.

ANGELS ON EARTH MAGAZINE, 16 E. 34th St., New York NY 10016. (212)251-8126. Fax: (212)684-1311. Website: www.guideposts.org. **Director of Art & Design:** Francesca Messina. Associate Art Director: Donald Partyka. Estab. 1995. Bimonthly magazine featuring true stories of angel encounters and angelic behavior. Circ. 1,000,000. Art guidelines posted on website.

• Also publishes *Guideposts*, a monthly magazine, which did not respond to our request for updated information this year.

Illustration: Approached by 500 illustrators/year. Buys 5-10 illustrations/issue. Has featured illustrations by Kinuko Craft, Gary Kelley, Rafal Olbinski. Features computer, whimsical, reportorial, humorous, conceptual, realistic and spot illustration. Assigns 40% of illustrations to well-known or "name" illustrators; 40% to experienced but not well-known illustrators; 20% to new and emerging illustrators. Prefers conceptual/realistic, "soft" styles. Considers all media.

First Contact & Terms: Illustrators: Please send nonreturnable promotional materials, slides or tearsheets. Accepts disk submissions compatible with Photoshop, Illustrator. Samples are filed. Send *only* nonreturnable samples. Art director will contact artist for portfolio review of color slides and transparencies if interested. Rights purchased vary. **Pays on acceptance**; $500-2,500 for color cover; $500-2,000 2-page spreads; $300-500 for spots. For more informtion, see website. Finds artists through reps, *American Showcase, Society of Illustrators Annual*, submissions and artist's websites.

Tips: "Please study our magazine and be familiar with the content presented."

ANTHOLOGY, P.O. Box 4411, Mesa AZ 85211-4411. Phone/fax: (602)461-8200. E-mail: info@anthology.org. Website: www.anthology.org. **Contact:** Ann Loring, art editor. Executive Editor: Sharon Skinner. Estab. 1991. Bimonthly b&w literary magazine featuring poetry, prose and artwork. Circ. 2,000. Sample copies for $3.95. Art guidelines free for #10 SASE with first-class postage.

Illustration: Approached by 40-50 illustrators/year. Acquires 6-10 illustrations/issue. Has featured illustrations by Ed Fillmore, Curtis Broadway, Ronit Glazer and Roxell Edward Karr. Features humorous, realistic and spot illustrations of sci-fi, fantasy objects. Prefers b&w ink. Assigns 100% of illustrations to new and emerging illustrators. 100% of freelance illustration demands knowledge of PageMaker or Corel Draw.

First Contact & Terms: Illustrators: Send query letter with photocopies and SASE. Accepts Window-compatible disk submissions. Send TIFF, BMP, PCX or GIF files. Samples are not filed, returned by SASE.

Responds in 3 months. Buys one-time rights. Pays in complimentary copies and ad space. Finds illustrators through word of mouth.

Tips: "Illustration is a valuable yet overlooked area for many literary magazines. The best chance illustrators have is to show the publication how their work will enrich its pages."

AOPA PILOT, 421 Aviation Way, Frederick MD 21701-4798. (301)695-2371. Fax: (301)695-2381. E-mail: mike.kline@aopa.org. Website: www.aopa.org. **Art Director:** Michael Kline. Associate Art Director: Adrienne Rosone. Estab. 1958. Monthly 4-color trade publication for the members of the Aircraft Owners and Pilots Association. The world's largest aviation magazine. Circ. 350,000. Sample copies free for 8½×11 SASE.

Illustration: Approached by 50 illustrators/year. Buys 3 illustrations/issue. Has featured illustrations by Jack Pardue, Byron Gin. Features charts & graphs, informational graphics, realistic, computer, aviation-related illustration. Prefers variety of styles ranging from technical to soft and moody. Assigns 25% of illustrations to new and emerging illustrators. 10% of freelance illustration demands knowledge of Illustrator, Photoshop, FreeHand or 3-D programs.

First Contact & Terms: Illustrators: Send postcard or other nonreturnable samples, such as photocopies and tearsheets. Accepts Mac-compatible disk submissions. Send EPS files. Samples are filed and are not returned. Will contact artist for portfolio review if interested. Rights purchased vary according to project; negotiable. **Pays on acceptance.** Finds illustrators through agents, sourcebooks, online services and samples.

Tips: "We are looking to increase our stable of freelancers. Looking for a variety of styles and experience."

AQUARIUM FISH MAGAZINE, P.O. Box 6050, Mission Viejo CA 92690. (949)855-8822. Fax: (949)855-3045. E-mail: aquariumfish@fancypubs.com. Website: www.aquariumfish.com. **Editor:** Russ Case. Estab. 1988. Monthly magazine covering fresh and marine aquariums and garden ponds. Photo guidelines for SASE with first-class postage.

Cartoons: Approached by 30 cartoonists/year. Themes should relate to aquariums and ponds.

First Contact & Terms: Cartoonists: Send query letter with finished cartoon samples. Samples are filed. Buys one-time rights. Pays $35 for b&w.

AREA DEVELOPMENT MAGAZINE, 400 Post Ave., New York NY 11590-2267. (516)338-0900. Fax: (516)338-0100. Website: www.areadevelopment.com. **Art Director:** Marta Sivakoff. Estab. 1965. Monthly trade journal regarding economic development and site selection issues. Circ. 45,000.

Illustration: Approached by 60 illustrators/year. Buys 3-4 illustrations/year. Features charts & graphs; informational graphics; realistic, medical and computer illustration. Assigns 20% of illustration to experienced, but not well-known illustrators. Prefers business/corporate themes with strong conceptual ideas. Considers all media. 50% of freelance illustration demands knowledge of Photoshop, Illustrator and QuarkXPress.

First Contact & Terms: Illustrators: Send postcard sample. Accepts disk submissions compatible with QuarkXPress 4.0 for the Mac. Send EPS, TIFF files. Art director will contact artist for portfolio review of b&w, color tearsheets if interested. Rights purchased vary according to project. Pays on publication; $500-1,200 for color cover.

Tips: "Must have corporate understanding and strong conceptual ideas. We address the decision-makers' needs by presenting their perspectives. Create a varied amount of subjects (business, retail, money concepts). Mail color self-promotions with more than one illustration."

ARMY MAGAZINE, 2425 Wilson Blvd., Arlington VA 22201. (703)841-4300. Website: www.ausa.org. **Art Director:** Patty Zukerowski. Estab. 1950. Monthly trade journal dealing with current and historical military affairs. Also covers military doctrine, theory, technology and current affairs from a military perspective. Circ. 115,000. Originals returned at job's completion. Sample copies available for $2.25. Art guidelines available.

Cartoons: Approached by 5 cartoonists/year. Buys 1 cartoon/issue. Prefers military, political and humorous cartoons; single or double panel, b&w washes and line drawings with gaglines.

Illustration: Approached by 1 illustrator/year. Buys 1 illustration/issue. Works on assignment only. Prefers military, historical or political themes. Considers pen & ink, airbrush, acrylic, marker, charcoal and mixed media. "Can accept artwork done with Illustrator or Photoshop for Macintosh."

First Contact & Terms: Cartoonists: Send query letter with brochure and finished cartoons. Responds to the artist only if interested. Illustrators: Send query letter with brochure, résumé, tearsheets, photocopies

and photostats. Samples are filed or are returned by SASE if requested by artist. Publication will contact artist for portfolio review if interested. Portfolio should include b&w and color tearsheets, photocopies and photographs. Buys one-time rights. Pays on publication. Pays cartoonists $50 for b&w. Pays illustrators $300 minimum for b&w cover; $500 minimum for color cover; $50 for b&w inside; $75 for color inside; $35-50 for spots.

ARTHRITIS TODAY MAGAZINE, 1330 W. Peachtree St., Atlanta GA 30309-2858. (404)872-7100. Fax: (404)872-9559. **Creative Director:** Audrey Graham. Art Director: Susan Siracusa. Estab. 1987. Bi-monthly consumer magazine. "*Arthritis Today* is the official magazine of the Arthritis Foundation. The award-winning publication is more than the most comprehensive and reliable source of information about arthritis research, care and treatment. It is a magazine for the whole person—from their lifestyles to their relationships. It is written both for people with arthritis and those who care about them." Circ. 700,000. Originals returned at job's completion. Sample copies available. 20% of freelance work demands knowledge of Illustrator, QuarkXPress or Photoshop.
Illustration: Approached by over 100 illustrators/year. Buys 5-10 illustrations/issue. Works on assignment only; stock images used in addition to original art.
First Contact & Terms: Illustrators: Send query letter with brochure, tearsheets, photostats, slides (optional) and transparencies (optional). Samples are filed. Publication will contact artist for portfolio review if interested. Portfolio should include color tearsheets, photostats, photocopies, final art and photographs. Buys first time North American serial rights. Other usage negotiated. **Pays on acceptance.** Finds artists through sourcebooks, Internet, other publications, word of mouth, submissions.
Tips: "No limits on areas of the magazine open to freelancers. Two-three departments, each issue use spot illustrations. Submit tearsheets for consideration. No cartoons."

THE ARTIST'S MAGAZINE, 4700 E. Galbraith Rd., Cincinnati OH 45236. E-mail: tamedit@fwpubs.com. **Art Director:** Daniel Pessell. Monthly 4-color magazine emphasizing the techniques of working artists for the serious beginning, amateur and professional artist. Circ. 200,000. Occasionally accepts previously published material. Returns original artwork after publication. Sample copy $4.99 US, $7.99 Canadian or international; remit in US funds.
 • Sponsors annual contest. Send SASE for more information. Also publishes a quarterly magazine called *Artist's Sketchbook*.
Cartoons: Buys 3-4 cartoons/year. Must be related to art and artists.
Illustration: Buys 2-3 illustrations/year. Has featured illustrations by: Susan Blubaugh, Sean Kane, Jamie Hogan, Steve Dininno, Kathryn Adams. Features humorous and realistic illustration. Works on assignment only.
First Contact & Terms: Cartoonists: Contact: Cartoon Editor. Send query letter with brochure, photocopies, photographs and tearsheets to be kept on file. Prefers photostats or tearsheets as samples. Samples not filed are returned by SASE. Buys first rights. **Pays on acceptance**. Pays cartoonists $65 on acceptance for first-time rights. Pays illustrators $350-1,000 for color inside; $100-500 for spots.
Tips: "Research past issues of publication and send samples that fit the subject matter and style of target publication."

ART:MAG, P.O. Box 70896, Las Vegas NV 89170-0896. (702)734-8121. E-mail: magman@iopener.net. **Art Director:** Peter Magliocco. Contributing Artist-at-Large: Bill Chown. Art Editor: "The Mag Man." Estab. 1984. Yearly b&w small press literary arts zine. Circ. 100. Art guidelines for #10 SASE with first-class postage.
Cartoons: Approached by 5-10 cartoonists/year. Buys 5 cartoons/year. Prefers single panel, political, humorous and satirical b&w line drawings.
Illustration: Approached by 5-10 illustrators/year. Buys 3-5 illustrations/year. Has featured illustrations by Amanda Rehagen, Carrie Christian, Dan Buck. Features caricatures of celebrities and politicians and spot illustrations. Preferred subjects: art, literature and politics. Prefers realism, hip, culturally literate collages and b&w line drawings. Assigns 30% of illustrations to new and emerging illustrators.
First Contact & Terms: Cartoonists: Send query letter with b&w photocopies, samples, tearsheets and SASE. Samples are filed. Rights purchased vary according to project. Illustrators: Send query letter with photocopies, SASE. Responds in 3 months. Portfolio review not required. Buys one-time rights. Pays on publication. Pays cartoonists/illustrators 1 contributor's copy. Finds illustrators through magazines, word of mouth.
Tips: "*Art:Mag* is basically for new or amateur artists with unique vision and iconoclastic abilities whose

work is unacceptable to slick mainstream magazines. Don't be conventional, be idea-oriented."

N 🔲 ASCENT MAGAZINE, 837 Rue Gilford, Montreal QC H2J 1P1 Canada. (514)499-3999. Fax: (514)499-3904. E-mail: info@ascentmagazine.com. Website: www.ascentmagazine.com. **Contact:** Joe Oilmann, designer. Estab. 1999. Quarterly consumer magazine focusing on the personal, transformational and spiritual aspects of yoga. Circ. 6,000. Sample copies are available for $5. Art guidelines available on website or e-mail design@ascentmagazine.com.
Illustration: Approached by 20-40 illustrators/year. Prefers b&w. Assigns 80% to new and emerging illustrators. 80% of freelance illustration demands knowledge of Illustrator, InDesign and Photoshop.
First Contact & Terms: Send postcard sample or query letter with b&w photocopies, samples, URL. Accepts e-mail submissions with link to website or image file. Prefers Mac-compatible, TIFF files. Samples are filed. Responds in 2 months. Company will contact artist for portfolio review if interested. Portfolio should include b&w and color, finished art, photographs and tearsheets. Pays illustrators $300-800 for color cover; $50-300 for b&w inside; $150-500 for 2-page spreads. Pays on publication. Buys first rights, electronic rights. Finds freelancers through agents, artists' submissions, magazines and word-of-mouth.
Tips: "Please be familiar with our magazine. Be open to working with specifications we want (artistic and technical.)"

ISAAC ASIMOV'S SCIENCE FICTION MAGAZINE, 475 Park Ave. S., New York NY 10016. (212)686-7188. Fax: (212)686-7414. **Senior Art Director:** Victoria Green. All submissions should be sent to June Levine, associate art director. Estab. 1977. Monthly b&w with 4-color cover magazine of science fiction and fantasy. Circ. 61,000. Accepts previously published artwork. Original artwork returned at job's completion. Art guidelines available for #10 SASE with first-class postage.
Cartoons: Approached by 20 cartoonists/year. Buys 10 cartoons/year. Two covers commissioned/year. The rest are second time rights or stock images. Prefers single panel, b&w washes or line drawings with and without gagline. Address cartoons to Brian Bieniowski, editor.
Illustration: No longer buys interior illustration.
First Contact & Terms: Cartoonists: Send query letter with finished cartoons, photocopies and SASE. Send query letter with printed samples, photocopies and/or tearsheets and SASE. Accepts disk submissions compatible with QuarkXPress 7.5 version 3.3. Send EPS files. Accepts illustrations done with Illustrator and Photoshop. Samples are filed or returned by SASE. Responds only if interested. Portfolios may be dropped off every Tuesday and should include b&w and color tearsheets. Buys one-time and reprint rights. **Pays on acceptance**. Pays cartoonists $35 minimum. Pays illustrators $600-1,200 for color cover.
Tips: No comic book artists. Realistic work only, with science fiction/fantasy themes. Show characters with a background environment.

N ASPCA ANIMAL WATCH, 424 E. 92nd St., New York NY 10128. **Contact:** Samarra Khaja, creative director. Estab. 1960. Quarterly company magazine. Circ. 398,000. Accepts previously published artwork. Original artwork returned at job's completion.
Illustration: Buys 10-12 illustrations/issue. Considers all media.
First Contact & Terms: No phone calls please. Illustrators: Send nonreturnable samples. Samples are filed. Responds when needed. Rights purchased vary. Pays on publication; rates are commensurate with nonprofit marketplace.

ASSOCIATION OF BREWERS, P.O. Box 1679, Boulder CO 80306. Website: www.beertown.org. **Magazine Art Director:** Dave Harford. Estab. 1978. "Our nonprofit organization hires illustrators for two magazines, *Zymurgy* and *The New Brewer*, each published bimonthly. *Zymurgy* is a journal of the American Homebrewers Association. The goal of the AHA division is to promote public awareness and appreciation of the quality and variety of beer through education, research and the collection and dissemination of information." Circ. 10,000 "*The New Brewer* is a journal of the Institute for Brewing Studies. The goal of the IBS division is to serve as a forum for the technical aspects of brewing and to seek ways to help maintain quality in the production and distribution of beer." Circ. 3,000.
Illustration: Approached by 50 illustrators/year. Buys 3-6 illustrations/year. Prefers beer and homebrewing themes. Considers all media.
Design: Prefers local design freelancers only with experience in Photoshop, QuarkXPress, Illustrator.
First Contact & Terms: Illustrators: Send postcard sample or query letter with printed samples, photo-copies, tearsheets; follow-up sample every 3 months. Accepts disk submissions with EPS, TIFF or JPEG files. "We prefer samples we can keep." No originals accepted; samples are filed. Responds only if

interested. Art director will contact artist for portfolio review of b&w, color, final art, photographs, photostats, roughs, slides, tearsheets, thumbnails, transparencies; whatever media best represents art. Buys onetime rights. **Pays 60 day net on acceptance**. Pays illustrators $700-800 for color cover; $200-300 for b&w inside; $200-400 for color. Pays $150-300 for spots. Finds artists through agents, sourcebooks (Society of Illustrators, *Graphis*, *Print*, *Colorado Creative*), mags, word of mouth, submissions. Designers: Send query letter with printed samples, photocopies, tearsheets.

Tips: "Keep sending promotional material for our files. Anything beer-related for subject matter is a plus. We look at all styles."

ASSOCIATION OF COLLEGE UNIONS INTERNATIONAL, One City Centre, 120 W. Seventh St., Suite 200, Bloomington IN 47404-3925. (812)855-8550. Fax: (812)855-0162. Website: www.acui web.org. **Contact:** Andrea Langerveld. Estab. 1914. Professional higher education association magazine covering "multicultural issues, creating community on campus, union and activities programming, managing staff, union operation, professional development and student development."

● Also publishes hardcover and trade paperback originals. See listing in the Book Publishers section for more information.

Illustration: Works on assignment only. Considers all kinds of illustration.

Design: Needs designers for production.

First Contact & Terms: Illustrators: Designers: Send query letter with résumé, photocopies, tearsheets, photographs, websites or color transparencies of college student union activities. Designers: Send query letter with résumé and samples. Samples are filed. Responds only if interested. Negotiates rights purchased. Pays by project.

Tips: "We are a volunteer-driven association. Most people submit work on that basis. We are on a limited budget."

AUTHORSHIP, 3140 S. Peoria, #295, Aurora CO 80014. (303)841-0246. Fax: (303)841-2607. **Executive Director:** Sandy Whelchel. Estab. 1937. Bimonthly magazine. "Our publication is for our 3,000 members, and is cover-to-cover about writing."

First Contact & Terms: Cartoonists: Samples are returned. Responds in 4 months. Buys first North American serial and reprint rights. **Pays on acceptance**. Pays cartoonists $25 minimum for b&w. Illustrators: Accepts disk submissions. Send TIFF or JPEG files.

Tips: "We only take cartoons slanted to writers."

BABYBUG, 315 Fifth St., Peru IL 61354-0300. (815)223-2520. Fax: (815)224-6675. **Art Director:** Suzanne Beck. Estab. 1994. Magazine published every six weeks "for children six months to two years." Circ. 44,588. Sample copy for $4.95 plus 10% of total order ($4 minimum) for shipping and handling; art guidelines for SASE.

Illustration: Approached by about 85 illustrators/month. Buys 23 illustrations/issue. Considers all media.

First Contact & Terms: Illustrators: Send query letter with printed samples, photocopies and tearsheets. Samples are filed or returned if postage is sent. Responds in 45 days. Buys all rights. Pays 45 days after acceptance. Pays $500 minimum for color cover; $250 minimum per page inside. Finds illustrators through agents, *Creative Black Book*, magazines, word of mouth, artist's submissions and printed children's books.

BALLOON LIFE MAGAZINE, 2336 47th Ave. SW, Seattle WA 98116-2331. (206)935-3649. Fax: (206)935-3326. E-mail: tom@balloonlife.com. Website: www.balloonlife.com. **Editor:** Tom Hamilton. Estab. 1985. Monthly 4-color magazine emphasizing the sport of ballooning. "Contains current news, feature articles, a calendar and more. Audience is sport balloon enthusiasts." Circ. 4,000. Accepts previously published material. Original artwork returned after publication. Sample copy for SASE with 8 first-class stamps. Art guidelines for SASE with first-class postage.

● Only cartoons and sketches directly related to gas balloons or hot air ballooning are considered by *Balloon Life*.

Cartoons: Approached by 20-30 cartoonists/year. Buys 1-2 cartoons/issue. Seeks gag, editorial or political cartoons, caricatures and humorous illustrations. Prefers single panel b&w line drawings with or without gaglines.

Illustration: Approached by 10-20 illustrators/year. Buys 1-3 illustrations/year. Has featured illustrations by Charles Goll. Features humorous illustration; informational graphics; spot illustration. Needs computer-literate illustrators familiar with PageMaker, Illustrator, Photoshop, Colorit, Pixol Paint Professional and FreeHand.

First Contact & Terms: Cartoonists: Send query letter with samples, roughs and finished cartoons. Illustrators: Send postcard sample or query letter with business card and samples. Accepts submissions on disk compatible with Macintosh files. Send EPS files. Samples are filed or returned. Responds in 1 month. Will contact for portfolio review if interested. Buys all rights. Pays on publication. Pays cartoonists $25 for b&w and $25-40 for color. Pays illustrators $50 for b&w or color cover; $25 for b&w inside; $25-40 for color inside.

Tips: "Know what a modern hot air balloon looks like! Too many cartoons reach us that are technically unacceptable."

BARTENDER MAGAZINE, Box 158, Liberty Corner NJ 07938-0158. (908)766-6006. Fax: (908)766-6607. E-mail: barmag@aol.com. Website: www.bartender.com. **Editor:** Jackie Foley. Art Director: Erica DeWitte. Estab. 1979. Quarterly 4-color trade journal emphasizing restaurants, taverns, bars, bartenders, bar managers, owners, etc. Circ. 150,000.

Cartoons: Approached by 10 cartoonists/year. Buys 3 cartoons/issue. Prefers bar themes; single panel.

Illustration: Approached by 5 illustrators/year. Buys 1 illustration/issue. Works on assignment only. Prefers bar themes. Considers any media.

Design: Needs computer-literate designers familiar with QuarkXPress and Illustrator.

First Contact & Terms: Cartoonists: Send query letter with finished cartoons. Buys first rights. Illustrators: Send query letter with brochure. Samples are filed. Negotiates rights purchased. Pays on publication. Pays cartoonists $50 for b&w and $100 for color inside. Pays illustrators $500 for color cover.

◼◼ ◼◼ **BC OUTDOORS, HUNTING AND SHOOTING**, 1080 Howe St., Suite 900, Vancouver, BC V6Z-2T1 Canada. (604)606-4644. Fax: (604)687-1925. 4-color magazine, emphasizing fishing, hunting, camping, wildlife/conservation in British Columbia. Published 2 times/year. Circ. 30,000. Original artwork returned after publication unless bought outright.

Illustration: Approached by more than 10 illustrators/year. Has featured illustrations by Ian Forbes and Brad Nickason. Buys 4-6 illustrations/year. Prefers local artists. Interested in outdoors, wildlife (BC species only) and activities as stories require. Format: b&w line drawings and washes for inside and color washes for inside.

First Contact & Terms: Works on assignment only. Samples returned by SAE (nonresidents include IRC). Reports back on future assignment possibilities. Arrange personal appointment to show portfolio or send samples of style. Subject matter and the art's quality must fit with publication. Buys first North American serial rights or all rights on a work-for-hire basis. Pays on publication; $40 minimum for spots.

Tips: "Send us material on fishing and hunting. We generally just send back non-related work."

THE BEAR DELUXE, P.O. Box 10342, Portland OR 97296. (503)242-1047. Fax: (503)243-2645. E-mail: bear@orlo.org. Website: www.orlo.org. **Contact:** Thomas Cobb, art director. Editor-in-Chief: Tom Webb. Estab. 1993. Quarterly 4-color, b&w consumer magazine emphasizing environmental writing and visual art. Circ. 19,000. Sample copies free for $3. Art guidelines for SASE with first-class postage.

Cartoons: Approached by 50 cartoonists/year. Buys 5 cartoons/issue. Prefers work related to environmental, outdoor, media, arts. Prefers single panel, political, humorous, b&w line drawings.

Illustration: Approached by 50 illustrators/year. Has featured illustrations by Matt Wuerker, Ed Fella, Eunice Moyle and Ben Rosenberg. Caricature of politicians, charts & graphs, natural history and spot illustration. Assigns 30% of illustrations to new and emerging illustrators. 30% of freelance illustration demands knowledge of Illustrator, Photoshop and FreeHand.

First Contact & Terms: Cartoonists: Send query letter with b&w photocopies and SASE. Samples are filed or returned by SASE. Responds in 4 months. Illustrators: Send postcard sample and nonreturnable samples. Accepts Mac-compatible disk submissions. Send EPS or Tiff files. Samples are filed or returned by SASE. Responds only if interested. Portfolios may be dropped off by appointment. Buys first rights. Pays on publication. Pays cartoonists $10-50 for b&w. Pays illustrators $200 b&w or color cover; $15-75

MARKET CONDITIONS are constantly changing! If you're still using this book and it is 2005 or later, buy the newest edition of *Artist's & Graphic Designer's Market* at your favorite bookstore or order directly from Writer's Digest Books (1-800-448-0915).

for b&w or color inside; $15-75 for 2-page spreads; $20 for spots. Finds illustrators through word of mouth, gallery visits and promotional samples.

Tips: We are actively seeking new illustrators and visual artists, and encourage people to send samples. Most of our work (besides cartoons) is assigned out as editorial illustration or independent art. Indicate whether an assignment is possible for you. Indicate your fastest turn-around time. We sometimes need people who can work with 2-3 week turn-around or faster.

⊠ BELLA, 21061 S. Western Ave., Torrance CA 90501-1711. (310)533-2400. Fax: (310)533-2504. Website: www.nailsmag.com. **Art Director:** Liza Samala. Estab. 1983. Bimonthly 4-color trade journal; "seeks to educate readers on new techniques and products, nail anatomy and health, customer relations, chemical safety, salon sanitation and business." Circ. 57,000. Originals can be returned at job's completion. Sample copies available. Art guidelines vary. Needs computer-literate freelancers for design, illustration and production. 100% of freelance work demands knowledge of QuarkXPress, Illustrator or Photoshop.
 • See listing for *Nails*.
Illustration: Buys 3 illustrations/issue. Works on assignment only. Needs editorial and technical illustration; charts and story art. Prefers "fashion-oriented styles." Interested in all media.
First Contact & Terms: Illustrators: Send query letter with brochure and tearsheets. Samples are filed. Responds in 1 month or artist should follow-up with call. Call for an appointment to show a portfolio of tearsheets and transparencies. Buys all rights. **Pays on acceptance**; $200-500 (depending on size of job) for b&w and color inside. Finds artists through self-promotion and word of mouth.

⊠ BIRD WATCHER'S DIGEST, Box 110, Marietta OH 45750. (740)373-5285. Fax: (740)373-8443. E-mail: editor@birdwatchersdigest.com. Website: www.birdwatchersdigest.com. **Editor:** William H. Thompson III. Bimonthly magazine covering birds and bird watching for "bird watchers and birders (backyard and field; veteran and novice)." Circ. 90,000. Art guidelines available on website or free for SASE. Previously published material OK. Original work returned after publication. Sample copy $3.99.
Illustration: Buys 1-2 illustrations/issue. Has featured illustrations by: Julie Zickefoose, Tom Hirata, Kevin Pope and Jim Turanchik. Assigns 15% of illustrations to new and emerging illustrators.
First Contact & Terms: Illustrators: Send samples or tearsheets. Responds in 2 months. Buys one-time rights. Pays $50 minimum for b&w; $100 minimum for color.

☑ BITCH: FEMINIST RESPONSE TO POP CULTURE, 1611 Telegraph Ave., Suite 515, Oakland CA 94612. (510)625-9390. Fax: (510)625-9717. E-mail: briar@bitchmagazine.com. Website: www.bitchm agazine.com. **Art Director:** Briar Levit. Estab. 1996. Four times yearly b&w magazine. "We examine popular culture in all its forms for women and feminists of all ages." Circ. 40,000.
Illustration: Approached by 300 illustrators/year. Buys 3-7 illustrations/issue. Has featured illustrations by Andi Zeisler, Hugh D'Andrade, Pamela Hobbs, Isabel Samaras and Pam Purser. Features caricatures of celebrities, conceptual, fashion and humorous illustration. Work on assignment only. Prefers b&w ink drawings and photo collage. Assigns 90% of illustrations to experienced, but not well-known, illustrators; 8% to new and emerging illustrators; 2% to well-known or "name" illustrators.
First Contact & Terms: Illustrators: Send postcard sample, nonreturnable samples. Accepts Mac-compatible disk submissions. Samples are filed and are not returned. Will contact artist for portfolio review if interested. "We now are able to pay, but not much at all." Finds illustrators through magazines and word of mouth.
Tips: "We have a couple of illustrators we work with generally, but are open to others. Our circulation has been doubling annually, and we are distributed internationally. Read our magazine and send something we might like."

BLACK ENTERPRISE, 130 Fifth Ave., 10th Floor, New York NY 10011-4306. (212)242-8000. Website: www.blackenterprise.com. **Contact:** Terence K. Saulsby, art director. Estab. 1970. Monthly 4-color consumer magazine targeting African-Americans and emphasizing personal finance, careers and entrepreneurship. Circ. 450,000.
Illustration: Approached by over 100 illustrators/year. Buys 10 illustrations/issue. Has featured illustrations by Ray Alma, Cecil G. Rice, Peter Fasolino. Features humorous and spot illustrations, charts & graphs, computer illustration on business subjects. Assigns 10% of illustrations to new and emerging illustrators. 50% of freelance illustration demands knowledge of Illustrator and Photoshop.
First Contact & Terms: Illustrators: Send postcard sample. Samples are filed. After introductory mailing, send follow-up postcard every 3 months. Responds only if interested. Portfolios may be dropped off

Monday-Friday and should include color finished, original art and tearsheets. Buys first rights. **Pays on acceptance**; $200-800 for color inside; $800-1,000 for 2-page spreads. Finds illustrators through agents, artist's submissions and *Directory of Illustration.*

N BLACK WARRIOR REVIEW, Box 862936, University of Alabama, Tuscaloosa AL 35486. (205)348-4518. Website: webdelsol.com/bwr. **Editor:** Dan Kaplan. Biannual literary magazine publishing contemporary poetry, fiction and nonfiction by new and established writers. Circ. 2,000. Accepts previously published artwork. Original artwork is returned at job's completion. Sample copy $8.
Illustration: Considers color and b&w photography, pen & ink, watercolor, acrylic, oil, collage and marker for cover and inside portfolio.
First Contact & Terms: Illustrators: Send postcard sample. Pays on publication; $150 for b&w or color cover; payment for portfolios varies.
Tips: "Check out a recent issue."

☑ THE B'NAI B'RITH IJM, 2020 K. St. NW, 7th Floor, Washington DC 20006. (202)857-6646. Fax: (202)857-2781. E-mail: jbaugher@bnaibrith.org. Website: www.bbinet.org. **Contact:** Jennifer Baugher, art director. Editor: Elana Harris. Estab. 1886. Specialized magazine published 4 times a year, focusing on matters of general Jewish interest. Circ. 100,000. Originals returned at job's completion. Sample copies available for $2; art guidelines for SASE with first-class postage.
Illustration: Approached by 100 illustrators/year. Buys 1-2 illustrations/issue. Works on assignment only. Considers pen & ink, airbrush, colored pencil, mixed media, watercolor, acrylic, oil, pastel, collage, marker, charcoal.
First Contact & Terms: Illustrators: Send query letter with brochure and SASE. Samples are filed. Responds only if interested. Request portfolio review in original query. Portfolio should include final art, color, tearsheets and published work. Buys one-time rights. Pays on publication; $50 for b&w cover; $400 maximum for color cover; $50 for b&w inside; $100 maximum for color inside. Finds artists through word of mouth and submissions.
Tips: "Have a strong and varied portfolio reflecting a high degree of professionalism. Illustrations should reflect a proficiency in conceptualizing art—not just rendering. Will not be held responsible for unsolicited material."

BODY & SOUL, 42 Pleasant St., Watertown MA 02472. (617)926-0200, ext. 338. Website: www.bodyand soulmag.com. **Art Director:** Carolynn Decillo. Emphasizes alternative life-styles, holistic health, ecology, personal growth, human potential, planetary survival. Bimonthly. Circ. 190,000. Accepts previously published material and simultaneous submissions. Originals are returned after publication by request. Sample copy $3.
Illustration: Buys 60-90 illustrations/year. Works on assignment only.
First Contact & Terms: Illustrators: Send tearsheets, slides or promo pieces. Samples returned by SASE if not kept on file. Portfolio may be dropped off. Pays $1,000 for color cover; $400 for color inside.
Tips: Finds artists through sourcebooks and reps. "I prefer to see tearsheets or printed samples."

N BOTH SIDES NOW, 10547 State Hwy. 110 N., Tyler TX 75704-3731. (903)592-4263. E-mail: bothsidesnow@prodigy.net. Website: www.bothsidesnow.com. **Editor/Publisher:** Elihu Edelson. Zine emphasizing the New Age "for people seeking holistic alternatives in spirituality, life-style, and politics." Irregular (4 times/year), photocopied publication. Circ. 200. Accepts previously published material. Original artwork returned by SASE. Sample copy $2.
Cartoons: Buys various number of cartoons/issue. Prefers fantasy, political satire, religion and exposés of hypocrisy as themes. Prefers single or multi panel b&w line drawings.
Illustration: Buys variable amount of illustrations/issue. Prefers fantasy, surrealism, spirituality and realism as themes. Black & white only.
First Contact & Terms: Cartoonists: Send query letter with good photocopies. Illustrators: Send query letter with résumé and photocopies. Samples not filed are returned by SASE. Responds in 3 months. Pays cartoonists/illustrators on publication in copies and subscription.
Tips: "Pay close attention to listing. Do not send color or angst-laden downers, please."

BOW & ARROW HUNTING MAGAZINE, 265 S. Anita Dr., #120, Orange CA 92868-3343. (714)939-9991. Fax: (714)939-9909. E-mail: editorial@bowandarrowhunting.com. Website: www.bowand arrowhunting.com. **Editor:** Joe Bell. Advertising Director: Larry Schultz. Emphasizes the sport of bowhun-

ting. Published 9 times per year. Art guidelines free for SASE with first-class postage. Original artwork returned after publication.

Cartoons: Buys occasional cartoon. Prefers single panel, with gag line; b&w line drawings.

Illustration: Buys 2-6 illustrations/issue; all from freelancers. Has featured illustrations by Tes Jolly and Cisco Monthay. Assigns 25% of illustrations to new and emerging illustrators. Prefers live animals/game as themes.

First Contact & Terms: Cartoonists: Send finished cartoons. Illustrators: Send samples. Prefers photographs or original work as samples. Especially looks for perspective, unique or accurate use of color and shading, and an ability to clearly express a thought, emotion or event. Samples returned by SASE. Responds in 2 months. Portfolio review not required. Buys first rights. Pays on publication; $500 for color cover; $100 for color inside; $50-100 for b&w inside.

[N] BOYS' QUEST, P.O. Box 227, Bluffton OH 45817. (419)358-4610. Website: www.boysquest.com. **Assistant Editor:** Diane Winebar. Estab. 1995. Bimonthly consumer magazine "geared for elementary boys." Circ. 10,000. Sample copies $4 each; art guidelines for SASE with first-class postage.

Cartoons: Buys 1-3 cartoons/issue. Prefers wholesome children themes. Prefers: single or double panel, humorous, b&w line drawings with gagline.

Illustration: Approached by 100 illustrators/year. Buys 6 illustrations/issue. Has featured illustrations by Chris Sabatino, Gail Roth and Pamela Harden. Features humorous illustration; realistic and spot illustration. Assigns 40% of illustrations to new and emerging illustrators. Prefers childhood themes. Considers all media.

First Contact & Terms: Cartoonists: Send finished cartoons. Illustrators: Send query letter with printed samples. Samples are filed or returned by SASE. Responds in 2 months. To arrange portfolio review of b&w work, artist should follow-up with call or letter after initial query. Buys first rights. Pays on publication. Pays cartoonists $5-25 for b&w. Pays illustrators $200-250 for color cover; $25-35 for b&w inside; $50-70 for 2-page spreads; $10-25 for spots. Finds illustrators through artist's submissions.

Tips: "Read our magazine. Send in a few samples of work in pen & ink. Everything revolves around a theme; the theme list is available with SASE."

BUILDINGS MAGAZINE, 615 Fifth St. SE, Cedar Rapids IA 52406-1888. (319)364-6167. Fax: (319)364-4278. E-mail: elisa-geneser@stamats.com. Website: www.buildings.com. **Art Director:** Elisa Geneser. Estab. 1906. Monthly trade magazine featuring "information related to current approaches, technologies and products involved in large commercial facilities." Circ. 57,000. Original artwork returned at job's completion.

Illustration: Works on assignment only. Has featured illustrations by Jonathan Macagba, Pamela Harden, James Henry and Jeffrey Scott. Features informational graphics; computer and spot illustration. Assigns 50% of illustrations to new and emerging illustrators. Considers all media, themes and styles.

Design: 60% of freelance work demands knowledge of Photoshop, Illustrator.

First Contact & Terms: Illustrators: Send postcard sample. Designers: Send query letter with brochure, photocopies and tearsheets. Accepts submissions on disk compatible with Macintosh. Will contact for portfolio review if interested. Portfolio should include thumbnails, b&w/color tearsheets. Rights purchased vary. **Pays on acceptance.** Pays illustrators $250-500 for b&w, $500-1,500 for color cover; $50-200 for b&w inside; $100-350 for color inside; $30-100 for spots. Pays designers by the project. Finds artists through recommendations and submissions.

Tips: "Send postcards with samples of your work printed on them. Show us a variety of work (styles), if available. Send only artwork that follows our subject matter: commercial buildings, products and processes, and facility management."

[N] BUSINESS & COMMERCIAL AVIATION, (Division of the McGraw-Hill Companies), 4 International Dr., Rye Brook NY 10573. (914)939-0300. E-mail: Williamgarvey@aviationnow.com. **Art Direction:** Ringston Media. Monthly technical publication for corporate pilots and owners of business aircraft. 4-color; "contemporary design." Circ. 55,000.

Illustration: Works with 12 illustrators/year. Buys 12 editorial and technical illustrations/year. Uses artists mainly for editorials and some covers. Especially needs full-page and spot art of a business-aviation nature. "We generally only use artists with a fairly realistic style. This is a serious business publication—graphically conservative. Need artists who can work on short deadline time." 70% of freelance work demands knowledge of Photoshop, Illustrator, QuarkXPress and FreeHand.

First Contact & Terms: Illustrators: Query with samples and SASE. Responds in 1 month. Photocopies

OK. Buys all rights, but may reassign rights to artist after publication. Negotiates payment. **Pays on acceptance**; $400 for color; $175-250 for spots.

BUSINESS LAW TODAY, 750 N. Lake Shore Dr., 8th Floor, Chicago IL 60611-4403. (312)988-6122. Fax: (312)988-6081. E-mail: tedhamsj@staff.abanet.org. Website: www.abanet.org. **Art Director:** Jill Tedhams. Estab. 1992. Bimonthly magazine covering business law. Circ. 56,000. Art guidelines not available.
Cartoons: Buys 20-24 cartoons/year. Prefers business law and business lawyers themes. Prefers single panel, humorous, b&w line drawings with gaglines.
Illustration: Buys 6-9 illustrations/issue. Has featured illustrations by Tim Lee, Henry Kosinski and Jim Starr. Features humorous, realistic and computer illustrations. Assigns 10% of illustrations to new and emerging illustrators. Prefers editorial illustration. Considers all media. 10% of freelance illustration demands knowledge of Photoshop, Illustrator and QuarkXPress.
First Contact & Terms: Cartoonists: Send photocopies and SASE to the attention of Ray DeLong. Samples are not filed and are returned by SASE. Responds in several days. Illustrators: "We will accept work compatible with QuarkXPress version 4.04. Send EPS or TIFF files." Samples are filed and are not returned. Responds only if interested. Buys one-time rights. Pays on publication. Pays cartoonists $150 minimum for b&w. Pays illustrators $850 for color cover; $520 for b&w inside, $650 for color inside; $175 for b&w spots.
Tips: "Although our payment may not be the highest, accepting jobs from us could lead to other projects, since we produce many publications at the ABA. Sending samples (three to four pieces) works best to get a sense of your style; that way I can keep them on file."

⧉ CANADIAN DIMENSION (CD), 91 Albert St., Room 2-B, Winnipeg, MB R3R 1G5 Canada. (204)957-1519. Fax: (204)943-4617. E-mail: info@canadiandimension.mb.ca. Website: www.canadiandimension.mb.ca. **Office Manager:** Kevin Matthews. Estab. 1963. Bimonthly consumer magazine published "by, for and about activists in the struggle for a better world, covering women's issues, aboriginal issues, the enrivonment, labour, etc." Circ. 3,100. Accepts previously published artwork. Originals returned at job's completion. Sample copies available for $2. Art guidelines available for SASE with first-class postage.
Illustrators: Approached by 20 illustrators/year. Has featured illustrations by Kenneth Vincent, Darcy Muenchrath and Stephen King. Buys 10 illustrations/year.
First Contact & Terms: Illustrators: Send query letter with brochure and SASE. Samples are filed or returned by SASE if requested by artist. Publication will contact artist for portfolio review if interested. Buys one-time rights. Pays on publication; $100 for b&w cover; $50 for b&w inside and spots. Finds artists through word of mouth and artists' submissions. E-mail inquiries, samples or URLs welcome.

⧉ ⧉ CANADIAN GARDENING, 340 Ferrier St., Suite 210, Markham, ON L3R 2Z5 Canada. (905)475-8440. Fax: (905)475-9246. Website: www.canadiangardening.com. **Art Director:** Bonnie Summerfeldt. Estab. 1990. Special interest magazine published 8 times/year. "A down-to-earth, indispensable magazine for Canadians who love to garden." Circ. 152,000.
Illustration: Approached by 50 illustrators/year. Prefers using Canadian artists. Buys 2 illustrations/issue. Considers all media. 50% of freelance illustration demands knowledge of Photoshop, Illustrator and QuarkXPress.
First Contact & Terms: Illustrators: Send query letter with tearsheets. Accepts disk submissions compatible with Slide Show, QuarkXPress, Illustrator or Photoshop (Mac). Samples are filed and are not returned. Responds only if interested. Artist should follow up. Buys first rights. Pays within 45 days, $50-600 (CDN) for color inside. Pays $50-250 (CDN) for spots.
Tips: Likes work that is "earthy and hip."

⧉ ⧉ CANADIAN HOME WORKSHOP, 340 Ferrier St., Suite 210, Markham ON L3R 2Z5 Canada. (905)475-8440. Fax: (905)475-9246. Website: www.canadianhomeworkshop.com. **Contact:** Amy McCleverty, art director. Estab. 1977. "The Do-it-Yourself" magazine published 10 times/year, which "includes instructions and plans for woodworking projects and step-by-step home improvement articles along with tips from the pros." Circ. 120,000. Sample copies are available on request. Art guidelines available
Illustration: Approached by several freelancers each year. Buys 20 illustrations/year. Has featured illustrations by Jason Schneider, Paul Perreault and Len Churchill. Features computer, humorous, realistic and spot illustration. Assigns 10% of illustrations to new and emerging illustrators. 90% of freelance illustration demands knowledge of Illustrator, Photoshop and QuarkXPress.
First Contact & Terms: Send postcard sample or query letter with brochure, photocopies, photographs,

samples and tearsheets. Send follow-up postcard every 6 months. Accepts e-mail submissions with link to website or image file. Prefers Mac-compatible TIFF, JPEG, GIF or EPS files. Samples are filed and not returned. Responds only if interested. Company will contact for portfolio review if interested. Portfolio should include color finished art, photographs and tearsheets. Pays illustrators $150-800 for color inside; $600-1,200 for 2-page spreads. **Pays on acceptance.** Buys first rights, electronic rights. Finds freelancers through agents, artists' submissions and word-of-mouth.

CAREER FOCUS, 7300 W. 110th St., 7th Floor, Overland Park KS 66210-2330. (913)317-2888. E-mail: careerfocus@neli.net. Website: www.neli.net/publications. **Contact:** Executive Editor. Estab. 1985. Bimonthly educational, career development magazine. "A motivational periodical designed for Black and Hispanic college graduates who seek career development information." Circ. 250,000. Accepts previously published artwork. Originals are returned at job's completion. Sample copies and art guidelines for SASE with first-class postage.
 • *Career Focus* is published by CPG Communications Inc. (Career Publishing Group) which also publishes *Direct Aim*, *College Preview*, *Focus Kansas City* and *First Opportunity*. These magazines have similar needs for illustration as *Career Focus*.
Illustration: Buys 1 illustration/issue.
First Contact & Terms: Illustrators: Send query letter with samples as attachments via e-mail. Any correspondence should be conducted via e-mail. Samples are filed. Responds only if interested. Buys one-time rights. Pays on publication; $20 for b&w, $25 for color.

N THE CAROLINA QUARTERLY, Greenlaw Hall CB 3520, University of North Carolina, Chapel Hill NC 27599-3520. (919)962-0204. Fax: (919)962-3520. E-mail: cquarter@unc.edu. Website: www.unc.edu/depts/cqonline. **Contact:** Art Editor. Estab. 1948. Quarterly literary magazine featuring contemporary fiction, poetry, reviews, creative nonfiction, interviews and artwork by established and emerging artists. Circ. 800. Send only clear copies of artwork. Sample copy $5 (includes postage and handling). Art guidelines for SASE with first-class postage and on website.
Cartoons: Approached by 50 cartoonists/year. Buys 0-3 cartoons/year. Prefers literary, single panel, humorous or b&w drawings.
Illustration: Approached by 100 illustrators/year. Buys 3-15 illustrations/year. Features caricatures of celebrities/politicians, realistic illustration, humorous illustration, spot illustration, computer illustration. Prefers b&w line drawings, though open to other. Assigns 70% of illustrations to new and emerging illustrators.
First Contact & Terms: Cartoonists/Illustrators: After introductory mailing, send follow-up postcard sample every year. Samples are filed unless return is requested and SASE included. If they are not filed, samples are returned by SASE only. When response is requested, responds in 6 months. Company will contact artist for portfolio review if interested. Pays cartoonists/illustrators maximum $50 for any image or sequence of images. Pays on publication. Rights purchased vary according to project. Finds freelancers through word-of-mouth and artists' submissions.
Tips: "Bold, spare images often work best in our format. Look at a recent issue to get a clear idea of content and design."

CAT FANCY, Fancy Publications, Inc., Box 6050, Mission Viejo CA 92690. (949)855-8822. E-mail: query@catfancy.com. Website: www.catfancy.com. **Contact:** Bridget Johnson, editor. Monthly 4-color magazine for cat owners, breeders and fanciers; contemporary, colorful and conservative. Readers are interested in all phases of cat ownership. Circ. 303,000. No simultaneous submissions. Sample copy $5.50; artist's guidelines for SASE.
Cartoons: Buys 4 cartoons/year. Seeks single, double and multipanel with gagline. Should be simple, upbeat and reflect love for and enjoyment of cats. Central character should be a cat.
Illustration: Needs editorial, medical and technical illustration and images of cats.
First Contact & Terms: Cartoonists: Send query letter with photostats or photocopies as samples and SASE. Illustrators: Send query letter with brochure, high-quality photocopies (preferably color), SASE and tearsheets. Article illustrations assigned. Portfolio review not required. Responds in 3 months. Buys first rights. Pays on publication. Pays cartoonists $35 for b&w line drawings.
Pays illustrators $20-35 for spots; $20-100 for b&w; $50-300 for color insides; more for packages of multiple illustrations.
Tips: "Seeking creative and innovative illustrators that lend a modern feel to our magazine. Please review a sample copy of the magazine before submitting your work to us."

CATHOLIC FORESTER, Box 3012, Naperville IL 60566-7012. (630)983-4900. E-mail: cofpr@aol.com. Website: catholicforester.com. Fax: (800)811-2140. **Contact:** Art Director. Estab. 1883. "We are a fraternal insurance company but use general-interest articles, art and photos. Audience is middle-class, many small town as well as big-city readers, patriotic, Catholic and traditionally conservative." National quarterly 4-color magazine. Circ. under 100,000. Accepts previously published material. Sample copy for 9×12 SASE with 3 first-class stamps.
Cartoons: Buys less than 2 cartoons/year from freelancers. Considers "anything *funny* but it must be clean." Prefers single panel with gagline or strip; b&w line drawings.
Illustration: Buys and commissions editorial illustration.
First Contact & Terms: Cartoonists: Material returned by SASE. Responds in about 2 months. Illustrators: Will contact for portfolio review if interested. Requests work on spec before assigning job. Buys one-time rights, North American serial rights or reprint rights. Pays on publication. Pays cartoonists $30 for b&w. Pays illustrators $30-100 for b&w, $75-300 for color inside.
Tips: "Know the audience you're drawing for—always read the article and don't be afraid to ask questions. Pick the art director's brain for ideas and be timely."

N CATS & KITTENS, Pet Publishing Inc., 7-L Dundas Circle, Greensboro NC 27407. (336)292-4047. Fax: (336)292-4272. E-mail: rdavis@petpublishing.com. Website: www.catsandkittens.com. **Executive Director:** Rita Davis. Bimonthly, 4-color, consumer magazine about cats including breed profiles, medical reports, training advice, cats at work, cat collectibles and cat stories. Circ. 75,000. Art guidelines free for #10 SASE with first-class postage.
Illustration: Features realistic illustrations. Prefers watercolor, pen & ink, acrylics and color pencil. Assigns illustrations to experienced, but not well-known illustrators; and to new and emerging illustrators.
First Contact & Terms: Illustrators: Send postcard sample. Send query letter with printed samples, photocopies, SASE and tearsheets. Accepts Windows-compatible, disk submissions. Send EPS files at 266 dpi. Portfolio review not required. Pays on publication; $50 maximum for b&w, $50 maximum for color inside.
Tips: "Need artists with ability to produce illustrations for specific story on short notice."

CED, P.O. Box 266007, Highlands Ranch CO 80163-6007. (303)470-4800. Fax: (303)470-4890. E-mail: druth@reedbusiness.com. Website: cedmagazine.com. **Art Director:** Don Ruth. Estab. 1978. Monthly trade journal dealing with "the engineering aspects of the technology in Cable TV. We try to publish both views on subjects." Circ. 22,815. Accepts previously published work. Original artwork not returned at job's completion. Sample copies and art guidelines available.
Illustration: Buys 1 illustration/issue. Works on assignment only. Features caricatures of celebrities; realistic illustration; charts & graphs; informational graphics and computer illustrations. Assigns 10% of illustrations to new and emerging illustrators. Prefers cable TV-industry themes. Considers watercolor, airbrush, acrylic, colored pencil, oil, charcoal, mixed media, pastel, computer disk through Photoshop, Illustrator or FreeHand.
First Contact & Terms: Contact only through artist rep. Samples are filed. Call for appointment to show portfolio. Portfolio should include final art, b&w/color tearsheets, photostats, photographs and slides. Rights purchased vary according to project. **Pays on acceptance.** Pays illustrators $400-800 for color cover; $125-400 for b&w and color inside; $250-500 for 2-page spreads; $75-175 for spots.
Tips: "Be persistent; come in person if possible. Be willing to change in mid course; be willing to have finished work rejected. Make sure you can draw and work fast."

N ⊕ CHALICE PRESS AND CHRISTIAN BOARD OF PUBLICATIONS, P.O. Box 179, St. Louis MO 63166. (314)231-8500. Fax: (314)231-8524. Website: www.chalicepress.com. Estab. 1997. Circulation: 2,000. Publishes *Masters of Role Playing Magazine*. Art guidelines available free for 4×9 SASE with 1 first-class stamp or can be viewed on website.
Illustration: Works with 6-30 freelance illustrators/year. Assigns 1-6 freelance design jobs; 6 cover illustration jobs and 6-30 text illustration jobs/year. Prefers local illustrators with experience in fantasy and science fiction illustration. Prefered styles and themes are: Japanimation, Gothic-punk, horror, science fiction, fantasy, humor, cyberpunk, Gothic and mythology. Uses freelancers mainly for interior illustration.
First Contact & Terms: Send query letter with résumé, business card, SASE, printed samples or photocopies. Requests 15-25 samples. Samples are filed and not returned. Will contact artist for portfolio review if interested. Portfolio should include artwork of characters in sequence, b&w photographs of final art. This magazine publisher pays in copies of magazine (usually a minimum of 5 copies) plus free advertising

space to promote your website or artwork. Rights purchased vary according to project. Finds freelancers through online contacts, submission guidelines requests, friends and existing illustrators.

Tips: "We specialize in giving talented new artists and illustrators an opportunity to exhibit their abilities."

CHARLOTTE MAGAZINE, 127 W. Worthington Ave., Suite 208, Charlotte NC 28203-4474. (704)335.7181. Fax: (704)335-3757. E-mail: ErinPotter@abartapub.com. Website: www.charlottemag. com. **Art Director:** Erin Potter. Associate Art Directors: Kristin Allen and Chris Goeller. Estab. 1995. Monthly 4-color, city-based consumer magazine for the Charlotte and surrounding areas. Circ. 28,000. Sample copies free for #10 SAE with first-class postage.

Illustration: Approached by many illustrators/year. Buys 1-5 illustrations/issue. Has featured illustrations by Jack Unruh, Sally Wern Conport, Vivienne Flesher, Stephen Verriest, Ishmael Roldan. Features caricatures of celebrities and politicians; computer illustration; humorous illustration; natural history, realistic and spot illustration. Prefers wide range of media/conceptual styles. Assigns 20% of illustrations to new and emerging illustrators.

First Contact & Terms: Illustrators: Send postcard sample and follow-up postcard every 6 months. Send non-returnable samples. Accepts e-mail submissions. Send EPS or TIFF files. Samples are filed. Responds only if interested. Portfolio review not required. Finds illustrators through artist promotional samples and sourcebooks.

Tips: "We are looking for diverse and unique approaches to illustration. Highly creative and conceptual styles are greatly needed. If you are trying to get your name out there we are a great avenue for you."

CHESAPEAKE BAY MAGAZINE, 1819 Bay Ridge Ave., Annapolis MD 21403. (410)263-2662. Fax: (410)267-6924. E-mail: kashley@cbmmag.net. Website: www.cbmmag.net. **Art Director:** Karen Ashley. Estab. 1972. Monthly 4-color magazine focusing on the boating environment of the Chesapeake Bay— including its history, people, places and ecology. Circ. 45,000. Original artwork returned after publication upon request. Sample copies free for SASE with first-class postage. Art guidelines available. "Please call."

Cartoons: Approached by 12 cartoonists/year. Prefers single panel, b&w washes and line drawings with gagline. Cartoons or nautical and fishing humor are appropriate to the Chesapeake environment.

Illustration: Approached by 12 illustrators/year. Buys 2-3 technical and editorial illustrations/issue. Has featured illustrations by Jim Paterson, Kim Harroll, Jan Adkins, Tamzin C. Biles and Marcy Ramsey. Assigns 50% of illustrations to new and emerging illustrators. Considers pen & ink, watercolor, collage, acrylic, marker, colored pencil, oil, charcoal, mixed media and pastel. Usually prefers watercolor or oil for 4-color editorial illustration. "Style and tone are determined by the artist after he/she reads the story."

First Contact & Terms: Cartoonists: Send query letter with finished cartoons. Illustrators: Send query letter with résumé, tearsheets and photographs. Samples are filed. Make sure to include contact information on each sample. Responds only if interested. Publication will contact artist for portfolio review if interested. Portfolio should include "anything you've got." No b&w photocopies. Buys one-time rights. "Price decided when contracted." Pays cartoonists $50 for b&w. Pays illustrators $100-300 (for ¼ page or spot illustrations) up to $1,200 (for spreads) for color inside.

Tips: "Our magazine design is relaxed, fun, oriented toward people having fun on the water. Style seems to be loosening up. Boating interests remain the same. But for the Chesapeake Bay—water quality and the environment are more important to our readers now than in the past. Colors brighter. We like to see samples that show the artist can draw boats and understands our market environment. Send tearsheets or call for an interview—we're always looking. Artist should have some familiarity with the appearance of different types of boats, boating gear and equipment."

N CHESS LIFE, 3054 US Rt. 9W, New Windsor NY 12553. (914)562-8350. **Senior Art Director:** Jami Anson. Estab. 1939. Official publication of the United States Chess Federation. Contains news of major chess events with special emphasis on American players, plus columns of instruction, general features, historical articles, personality profiles, cartoons, quizzes, humor and short stories. Monthly b&w with 4-color cover. Design is "text-heavy with chess games." Circ. 90,000. Accepts previously published material and simultaneous submissions. Sample copy for SASE with 6 first-class stamps; art guidelines for SASE with first-class postage.

- Also publishes children's magazine, *School Mates* (once/year). Every other month the children get *Chess Life Now*. Same submission guidelines apply.

Cartoons: Approached by 200-250 cartoonists/year. Buys 60-75 cartoons/year. All cartoons must be chess related. Prefers single panel with gagline; b&w line drawings.

Illustration: Approached by 100-150 illustrators/year. Works with 4-5 illustrators/year from freelancers.

Buys 8-10 illustrations/year. Uses artists mainly for covers and cartoons. All must have a chess motif; uses some humorous and occasionally cartoon-style illustrations. "We use mainly b&w." Works on assignment, but will also consider unsolicited work.

First Contact & Terms: Cartoonists: Send query letter with brochure showing art style. Material kept on file or returned by SASE. Illustrators: Send query letter with photostats or original work for b&w; slides for color, or tearsheets to be kept on file. Responds in 2 months. Call to schedule an appointment to show a portfolio, which should include roughs, original/final art, final reproduction/product and tearsheets. Negotiates rights purchased. Pays on publication. Pays cartoonists $25, b&w; $40, color. Pays illustrators $150, b&w cover; $300, color cover; $25, b&w inside; $40, color inside.

Tips: "Include a wide range in your portfolio."

CHILDREN'S PLAYMATE, Children's Better Health Institute, 1100 Waterway Blvd., Box 567, Indianapolis IN 46206. (317)636-8881. Fax: (317)684-8094. Website: www.childrensplaymatemag.org. **Art Director:** Rob Falco. 4-color magazine for ages 6-8. Special emphasis on entertaining fiction, games, activities, fitness, health, nutrition and sports. Published 6 times/year. Original art becomes property of the magazine and will not be returned. Sample copy $1.25.

 • Also publishes *Child Life*, *Humpty Dumpty's Magazine*, *Jack and Jill* and *Turtle Magazine*.

Illustration: Uses 8-12 illustrations/issue; buys 6-8 from freelancers. Interested in editorial, medical, stylized, humorous or realistic themes; also food, nature and health. Considers pen & ink, airbrush, charcoal/pencil, colored pencil, watercolor, acrylic, oil, pastel, collage, multimedia and computer illustration. Works on assignment only.

First Contact & Terms: Illustrators: Send sample of style; include illustrations of children, families, animals—targeted to children. Provide brochure, tearsheet, stats or good photocopies of sample art to be kept on file. Samples returned by SASE if not filed. Artist should follow up with call or letter. Also considers b&w camera-ready art for puzzles, such as dot-to-dot, hidden pictures, crosswords, etc. Buys all rights on a work-for-hire basis. Payment varies. Pays $275 for color cover; up to $155 for color and $90 for b&w inside, per page. Finds artists through artists' submissions/self-promotions.

Tips: "Become familiar with our magazine before sending anything. Don't send just two or three samples. I need to see a minimum of eight pieces to determine that the artist fits our needs. Looking for samples displaying the artist's ability to interpret text, especially in fiction for ages 6-8. Illustrators must be able to do their own layout with a minimum of direction."

CHRISTIAN HOME & SCHOOL, 3350 E. Paris Ave. SE, Grand Rapids MI 49512. (616)957-1070. Fax: (616)957-5022. E-mail: rogers@csionline.org. Website: www.CSIonline.org/csi/chs. **Senior Editor:** Roger W. Schmurr. Emphasizes current, crucial issues affecting the Christian home for parents who support Christian education. 4-color magazine; 4-color cover; published 6 times/year. Circ. 66,000. Sample copy for 9×12 SASE with 4 first-class stamps; art guidelines for SASE with first-class postage.

Cartoons: Prefers family and school themes.

Illustration: Buys approximately 2 illustrations/issue. Has featured illustrations by Patrick Kelley, Rich Bishop and Pete Sutton. Features humorous, realistic, computer and spot illustration. Assigns 75% of illustrations to experienced, but not well-known illustrators; 25% to new and emerging illustrators. Prefers pen & ink, charcoal/pencil, colored pencil, watercolor, collage, marker and mixed media. Prefers family or school life themes. Works on assignment only.

First Contact & Terms: Illustrators: Send query letter with résumé, tearsheets, photocopies or photographs. Show a representative sampling of work. Samples returned by SASE, or "send one or two samples art director can keep on file." Will contact if interested in portfolio review. Buys first rights. Pays on publication. Pays cartoonists $50 for b&w. Pays illustrators $250 for 4-color full-page inside; $75-125 for spots. Finds most artists through references, portfolio reviews, samples received through the mail and artist reps.

☑ **CHRISTIAN READER**, 465 Gundersen Dr., Carol Stream IL 60188. (630)260-6200. Fax: (630)260-0114. Website: www.ChristianReader.net. **Contact:** Phil Marcelo, designer. Estab. 1963. Bimonthly general interest magazine. "Stories of faith, hope and God's love." Circ. 175,000. Accepts previously published artwork. Originals returned at job's completion.

Illustration: Works on assignment only. Has featured illustrations by Rex Bohn, Ron Mazellan and Donna Kae Nelson. Features humorous, realistic and spot illustration. Prefers family, home and church life. Considers all media.

First Contact & Terms: Illustrators: Samples are filed. Responds only if interested. To show a portfolio, mail appropriate materials. Buys one-time rights.

Tips: "Send samples of your best work, in your best subject and best medium. We're interested in fresh and new approaches to traditional subjects and values."

N. CHRISTIAN RESEARCH JOURNAL, 30162 Tomas, Rancho Santa Margarita CA 92688-2124. (949)858-6100. Fax: (949)858-6111. E-mail: response@equip.org. Website: www.equip.org. **Contact:** Melanie Cogdil, managing editor. Estab. 1987. Quarterly religion and theology journal that probes "today's religious movements, promoting doctrinal discernment and critical thinking, and providing reason for Christian faith and ethics." Circ. 35,000. Art guidelines not available.

Cartoons: Prefers humorous cartoons.

Illustration: Has featured illustrations by Tom Fluharty, Phillip Burke, Tim O'Brian. Features caricatures of celebrities/politicians, humorous illustration, realistic illustrations of men and women and related to subjects of articles. Assigns 70% of illustrations to new and emerging illustrators.

First Contact & Terms: Cartoonists/illustrators send postcard sample. Accepts e-mail submissions with link to website. Prefers JPEG files. Samples are not filed but are returned. Responds only if interested. Company will contact artist for portfolio review if interested. Pays on completion of assignment. Buys first rights. Finds freelancers through artists' submissions, word-of-mouth and sourcebooks.

N. THE CHURCH HERALD, 4500 60th St. SE, Grand Rapids MI 49512-9642. (616)698-7071. Fax: (616)698-6606. E-mail: chherald@aol.com. Estab. 1837. Monthly magazine. "The official denominational magazine of the Reformed Church in America." Circ. 110,000. Accepts previously published artwork. Originals returned at job's completion. Sample copies available for $2. Open to computer-literate freelancers for illustration.

Illustration: Buys up to 2 illustrations/issue. Works on assignment only. Considers pen & ink, watercolor, collage, marker and pastel.

First Contact & Terms: Illustrators: Send postcard sample with brochure. Accepts disk submissions compatible with Illustrator 5.0 or Photoshop 3.0. Send EPS files. Also may submit via e-mail. Samples are filed. Responds to the artist only if interested. Portfolio review not required. Buys one-time rights. Pays on publication; $300 for color cover; $75 for b&w, $125 for color inside.

CICADA, Box 300, Peru IL 61354. Website: www.cicadamag.com. **Senior Art Editor:** Ron McCutchan. Estab. 1998. Bimonthly literary magazine for young adults (senior high-early college). Limited illustration (spots and half-pages). Black & white interior with full-color cover. Circ. 12,500. Original artwork returned after publication. Sample copy $7.95 plus 10% of total order ($4 minimum) for shipping and handling; art guidelines available on website or for SASE with first-class postage.

Illustration: Works with 30-40 illustrators a year. Buys 120 illustrations/year. Has featured illustrations by Erik Blegvad, Victor Ambrus, Ted Rall and Whitney Sherman. Has a strong need for good figurative art with teen appeal, but also uses looser/more graphic/conceptual styles. Works on assignment only.

First Contact & Terms: Illustrators: Send query letter and 4-6 samples to be kept on file "if I like it." Prefers photocopies and tearsheets as samples. Samples not kept on file are returned by SASE only. Responds in 6 weeks. Pays 45 days from receipt of final art; $750 for color cover, $50-150 for b&w inside. Buys all rights.

CINCINNATI CITYBEAT, 811 Race St., Cincinnati OH 45202. (513)665-4700. Fax: (513)665-4369. Website: www.citybeat.com. **Art Director:** Sean Hughes. Estab. 1994. Weekly alternative newspaper emphasizing issues, arts and events. Circ. 50,000.

- Please research alternative weeklies before contacting this art director. He reports receiving far too many inappropriate submissions.

Cartoons: Approached by 30 cartoonists/year. Buys 1 cartoon/year.

Illustration: Buys 1-3 illustrations/issue. Has featured illustrations by Ryan Greis, Woodrow J. Hinton III and Steven Verriest. Features caricatures of celebrities and politicians, computer and humorous illustration. Prefers work with a lot of contrast. Assigns 40% of illustrations to new and emerging illustrators. 10% of freelance illustration demands knowledge of Illustrator, Photoshop, FreeHand, QuarkXPress.

First Contact & Terms: Cartoonists: Send query letter with samples. Illustrators: Send postcard sample or query letter with printed samples and follow-up postcard every 4 months. Accepts Mac-compatible disk submissions. Send EPS, TIFF or PDF files. Samples are filed. Responds in 2 weeks only if interested. Buys one-time rights. Pays on publication. Pays cartoonists $10-100 for b&w, $30-100 for cartoons, $10-

35 for comic strips. Pays illustrators $75-150 for b&w cover, $150-250 for color cover; $10-50 for b&w inside, $50-75 for color inside, $75-150 for 2-page spreads. Finds illustrators through word of mouth and artist samples.

N CINEFANTASTIQUE, P.O. Box 34425, Los Angeles CA 90034-0425. (708)366-5566. Fax: (708)366-1441. **Editor-in-Chief:** David O. Williams. Monthly magazine emphasizing science fiction, horror and fantasy films for "devotees of 'films of the imagination.' " Circ. 105,000. Original artwork not returned. Sample copy $8.
Illustration: Uses 1-2 illustrations/issue. Interested in "dynamic, powerful styles, though not limited to a particular look." Works on assignment only.
First Contact & Terms: Illustrators: Send query letter with résumé, brochure and samples of style to be kept on file. Samples not returned. Responds in 1 month. Buys all rights. Pays on publication; $150 maximum for inside b&w line drawings and washes; $600 maximum for cover color washes; $150 maximum for inside color washes.

CIRCLE K MAGAZINE, 3636 Woodview Trace, Indianapolis IN 46268. (317)875-8755. Fax: (317)879-0204. Website: www.circlek.org. **Art Director:** Laura Houser. Estab. 1968. Kiwanis International's youth magazine for college-age students emphasizing service, leadership, etc. Published 5 times/year. Circ. 12,000. Originals and sample copies returned to artist at job's completion.
● This organization also publishes *Kiwanis* magazine and *Keynoter*.
Illustration: Approached by more than 30 illustrators/year. Buys 1-2 illustrations/issue. Works on assignment only. Needs editorial illustration. "We look for variety."
First Contact & Terms: Send query letter with photocopies, photographs, tearsheets and SASE. Samples are filed. Will contact for portfolio review if interested. Portfolio should include tearsheets and slides. **Pays on acceptance**; $100 for b&w cover; $250 for color cover; $50 for b&w inside; $150 for color inside.

N CITY & SHORE MAGAZINE, 200 E. Las Olas Blvd., Ft. Lauderdale FL 33026. (954)356-4685. Fax: (954)356-4612. E-mail: mgauert@sun-sentinel.com. Website: cityandshore.com. **Contact:** Greg Caramante, art director. Estab. 2000. Bimonthly "lifestyle magazine published for readers in South Florida." Circ. 38,000. Sample copies available for $4.95.
Illustration: Features caricatures of celebrities/politicians; fashion, humorous and spot illustrations. Freelance artists should be familiar with QuarkXPress.
First Contact & Terms: Accepts e-mail submissions with image file.

CLARETIAN PUBLICATIONS, 205 W. Monroe, Chicago IL 60606. (312)236-8682. Fax: (312)236-8207. **Art Director:** Tom Wright. Estab. 1960. Monthly magazine "covering the Catholic family experience and social justice." Circ. 40,000. Sample copies and art guidelines available.
Illustration: Approached by 20 illustrators/year. Buys 6 illustrations/issue. Considers all media.
First Contact & Terms: Illustrators: Send postcard sample or send query letter with printed samples and photocopies. Accepts disk submissions compatible with EPS or TIFF on 10 Mega Zip disks or CDs. Samples are filed. Responds only if interested. Art director will contact artist for portfolio review if interested. Negotiates rights purchased. **Pays on acceptance;** $100-400 for color inside.
Tips: "We like to employ humor in our illustrations and often use clichés with a twist and appreciate getting art in digital form."

CLEANING BUSINESS, Box 1273, Seattle WA 98111. (206)622-4241. Fax: (206)622-6876. E-mail: wgriffin@cleaningconsultants.com. Website: www.cleaningconsultants.com. **Publisher:** Bill Griffin. Submissions Editor: Jeff Warner. Monthly magazine with technical, management and human relations emphasis for self-employed cleaning and maintenance service contractors and workers. Circ. 6,000. Prefers to purchase all rights. Simultaneous submissions OK "if sent to noncompeting publications." Original artwork returned after publication if requested by SASE. Sample copy $3.
Cartoons: Buys 1-2 cartoons/issue. Must be relevant to magazine's readership. Prefers b&w line drawings.
Illustration: Buys approximately 12 illustrations/year including some humorous and cartoon-style illustrations.
First Contact & Terms: Illustrators: Send query letter with samples. "*Don't* send samples unless they relate specifically to our market." Samples returned by SASE. Buys first publication rights. Responds only if interested. Pays for illustration by project $3-15. Pays on publication.
Tips: "Our budget is extremely limited. Those who require high fees are really wasting their time. We

are interested in people with talent and ability who seek exposure and publication. Our readership is people who work for and own businesses in the cleaning industry, such as maid services; janitorial contractors; carpet, upholstery and drapery cleaners; fire, odor and water damage restoration contractors; etc. If you have material relevant to this specific audience, we would definitely be interested in hearing from you. We are also looking for books, games, videos, software, books, jokes and reports related to the cleaning industry."

THE CLERGY JOURNAL, 6160 Carmen Ave. E., Inver Grove Heights MN 55076-4420. (800)328-0200. Fax: (888)852-5524. Website: www.joinhands.com. **Assistant Editor:** Sharilyn Figueroa. Magazine for professional clergy and church business administrators; 2-color with 4-color cover. Monthly (except June, August and December). Circ. 10,000. Original artwork returned after publication if requested.
 • This publication is one of many published by Logos Productions and Woodlake Books.
Cartoons: Buys 4 single panel cartoons/issue from freelancers on religious themes.
First Contact & Terms: Cartoonists: Send SASE. Responds in 1 month. Pays $25 on publication.

CLEVELAND MAGAZINE, Dept. AGDM, 1422 Euclid Ave., Suite 730, Cleveland OH 44115. (216)771-2833. Fax: (216)781-6318. E-mail: sluzewski@clevelandmagazine.com. **Contact:** Gary Sluzewski. Monthly city magazine, b&w with 4-color cover, emphasizing local news and information. Circ. 45,000.
Illustration: Approached by 100 illustrators/year. Buys 3-4 editorial illustrations/issue on assigned themes. Sometimes uses humorous illustrations. 40% of freelance work demands knowledge of QuarkXPress, FreeHand or Photoshop.
First Contact & Terms: Illustrators: Send postcard sample with brochure or tearsheets. Accepts disk submissions. Please include application software. Call or write for appointment to show portfolio of printed samples, final reproduction/product, color tearsheets and photographs. Pays $100-700 for color cover; $75-300 for b&w inside; $150-400 for color inside; $75-350 for spots.
Tips: "Artists are used on the basis of talent. We use many talented college graduates just starting out in the field. We do not publish gag cartoons but do print editorial illustrations with a humorous twist. Full-page editorial illustrations usually deal with local politics, personalities and stories of general interest. Generally, we are seeing more intelligent solutions to illustration problems and better techniques. The economy has drastically affected our budgets; we pick up existing work as well as commissioning illustrations."

COBBLESTONE, DISCOVER AMERICAN HISTORY, Cobblestone Publishing, Inc., 30 Grove St., Suite C, Peterborough NH 03458. (603)924-7209. Fax: (603)924-7380. E-mail: anndillon@yahoo.com. Website: www.cobblestonepub.com. **Art Director:** Ann Dillon. Monthly magazine emphasizing American history; features nonfiction, supplemental nonfiction, fiction, biographies, plays, activities and poetry for children ages 8-14. Circ. 38,000. Accepts previously published material and simultaneous submissions. Sample copy $4.95 with 8×10 SASE; art guidelines on website. Material must relate to theme of issue; subjects and topics published in guidelines for SASE. Freelance work demands knowledge of Illustrator, Photoshop and QuarkXPress..
 • Other magazines published by Cobblestone include *Calliope* (world history), *Dig* (archaeology for kids), *Faces* (cultural anthropology), *Footsteps* (African American history), *Odyssey* (science), all for kids ages 8-15, and *Appleseeds* (social studies), for ages 7-9.
Illustration: Buys 2-5 illustrations/issue. Prefers historical theme as it pertains to a specific feature. Works on assignment only. Has featured illustrations by Annette Cate, Beth Stover, David Kooharian. Features caricatures of celebrities and politicians, humorous, realistic illustration, informational graphics, computer and spot illustration. Assigns 15% of illustrations to new and emerging illustrators.
First Contact & Terms: Illustrators: Send query letter with brochure, résumé, business card and b&w photocopies or tearsheets to be kept on file or returned by SASE. Write for appointment to show portfolio. Buys all rights. Pays on publication; $20-125 for b&w inside; $40-225 for color inside. Artists should request illustration guidelines.
Tips: "Study issues of the magazine for style used. Send samples and update samples once or twice a year to help keep your name and work fresh in our minds. Send nonreturnable samples we can keep on file—we're always interested in widening our horizons."

COMMONWEAL, 475 Riverside Dr., Room 405, New York NY 10115. (212)662-4200. E-mail: tiina@commonwealmagazine.org. Website: www.commonwealmagazine.org. **Editor:** Paul Baumann. Business

Manager: Paul Q. Kane. Estab. 1924. Public affairs journal. "Journal of opinion edited by Catholic lay people concerning public affairs, religion, literature and all the arts"; b&w with 4-color cover. Biweekly. Circ. 20,000. Original artwork is returned at the job's completion. Sample copies for SASE with first-class postage. Guidelines for SASE with first-class postage.

Cartoons: Approached by 20-40 cartoonists/year. Buys 3-4 cartoons/issue from freelancers. Prefers simple lines and high-contrast styles. Prefers single panel, with or without gagline; b&w line drawings.

Illustration: Approached by 20 illustrators/year. Buys 3-4 illustrations/issue, 60/year from freelancers. Has featured illustrations by Baloo. Assigns 10% of illustrations to new and emerging illustrators. Prefers high-contrast illustrations that "speak for themselves." Prefers pen & ink and marker.

First Contact & Terms: Cartoonists: Send query letter with finished cartoons. Illustrators: Send query letter with tearsheets, photographs, SASE and photocopies. Samples are filed or returned by SASE if requested by artist. Responds in 2 weeks. To show a portfolio, mail b&w tearsheets, photographs and photocopies. Buys non-exclusive rights. Pays cartoonists $15 for b&w. Pays illustrators $15 for b&w inside on publication.

Tips: "Be familiar with publication before mailing submissions."

N COMMUNICATION WORLD, One Hallidie Plaza, Suite 600, San Francisco CA 94102. (415)544-4700. E-mail: naomi@iabc.com. Website: www.iabc.com/cw. **Contact:** Naomi Mendelstein, senior editor. Emphasizes communication, public relations for members of International Association of Business Communicators: corporate and nonprofit businesses, hospitals, government communicators, universities, etc. who produce internal and external publications, press releases, annual reports and customer magazines. Published 6 times/year. Circ. 18,000. Accepts previously published material. Original artwork returned after publication. Art guidelines available for SASE with first-class postage.

Cartoons: Approached by 6-10 cartoonists/year. Buys 3 cartoons/year. Considers public relations, entrepreneurship, teleconference, editing, writing, international communication and publication themes. Prefers single panel with gagline; b&w line drawings or washes.

Illustration: Approached by 20-30 illustrators/year. Buys 6-8 illustrations/issue. Features humorous and realistic illustration; informational graphics; computer and spot illustration. Assigns 35% to new and emerging illustrators. Theme and style are compatible to individual article.

First Contact & Terms: Cartoonists/Illustrators: Send query letter with samples to be kept on file. To show a portfolio, write or call for appointment. Accepts tearsheets, photocopies or photographs as samples. Samples not filed are returned only if requested. Responds in 1 year only if interested. Negotiates rights purchased. Pays on publication. Pays cartoonists $25-50, b&w. Pays illustrators $300 for b&w cover; $200-500 for color cover; $200 for b&w or color inside; $350 for 2-page spreads; $200 for spots.

Tips: Sees trend toward "more sophistication, better quality, less garish, glitzy—subdued, use of subtle humor."

COMMUNITY BANKER, 900 19th St. NW, Washington DC 20006. (202)857-3100. Fax: (202)857-5581. E-mail: jbock@acbankers.org. Website: www.americascommunitybankers.com. **Art Director:** Jon C. Bock. Estab. 1993. Monthly trade journal targeting senior executives of high tech community banks. Circ. 12,000. Accepts previously published artwork. Originals returned at job's completion.

Illustration: Approached by 200 illustrators/year. Buys 2 illustrations/issue. Has featured illustrations by Kevin Rechin, Jay Montgomery and Matthew Trueman. Features humorous illustration, informational graphics, spot illustrations, computer illustration. Preferred subjects: business subjects. Prefers pen & ink with color wash, bright colors, painterly. Works on assignment only.

First Contact & Terms: Illustrators: Send query letter, nonreturnable postcard samples and tearsheets. Accepts Mac-compatible disk submissions. Send TIFF files. Samples are filed. Responds only if interested. "Artists should be patient and continue to update our files with future mailings. We will contact artist when the right story comes along." Publication will contact artist for portfolio review if interested. Portfolio should include mostly finished work, some sketches. Buys first North American serial rights. Pays on publication; $1,200-2,000 for color cover; $800-1,200 for color inside; $250-300 for spots. Finds artists primarily through word of mouth and sourcebooks—*Directory of Illustration* and *Illustration Work Book*.

Tips: "Looking for: high tech/technology in banking; quick turnaround; and new approaches to illustration."

CONFRONTATION: A LITERARY JOURNAL, English Department, C.W. Post, Long Island University, Brookville NY 11548. (516)299-2720. Fax: (516)299-2735. **Editor:** Martin Tucker. Estab. 1968. Semiannual literary magazine devoted to the short story and poem, for a literate audience open to all forms,

new and traditional. Circ. 2,000. Sample copies available for $3. 20% of freelance work demands computer skills.

• *Confrontation* has won a long list of honors and awards from CCLM (now the Council of Literary Magazines and Presses) and NEA grants.

Illustration: Approached by 10-15 illustrators/year. Buys 2-3 illustrations/issue. Works on assignment only. Considers pen & ink and collage.

First Contact & Terms: Illustrators: Send query letter with SASE and photocopies. Samples are not filed and are returned by SASE. Responds in 2 months only if interested. Rights purchased vary according to project. Pays on publication; $50-100 for b&w, $100-250 for color cover; $25-50 for b&w, $50-75 for color inside; $25-75 for spots.

CONSERVATORY OF AMERICAN LETTERS, Box 298, Thomaston ME 04861. (207)354-0998. **Editor:** Bob Olmsted. Estab. 1982. Quarterly Northwoods Journal, a magazine for writers emphasizing literature for literate and cultured adults. Original artwork returned after publication.

Illustration: Approached by 30-50 illustrators/year.

First Contact & Terms: "Very little illustration used. Find out what is coming up, then send something appropriate. Unsolicited 'blind' portfolios are of little help." Portfolio review not required. Buys first rights, one-time rights. **Pays on acceptance**. Pays cartoonists $5 for b&w cartoons. Pays illustrators $5 for b&w cover; $30 for color cover; $5 for b&w inside; $30 for color inside.

[N] CONSTRUCTION EQUIPMENT OPERATION AND MAINTENANCE, Construction Publications, Inc., Box 1689, Cedar Rapids IA 52406. (319)366-1597. E-mail: ckparks@constpub.com. **Editor-in-Chief:** C.K. Parks. Estab. 1948. Bimonthly b&w tabloid with 4-color cover. Concerns heavy construction and industrial equipment for contractors, machine operators, mechanics and local government officials involved with construction. Circ. 67,000. Original artwork not returned after publication. Free sample copy.

Cartoons: Buys 8-10 cartoons/issue. Interested in themes "related to heavy construction industry" or "cartoons that make contractors and their employees 'look good' and feel good about themselves"; single panel.

First Contact & Terms: Cartoonists: Send finished cartoons and SASE. Responds in 2 weeks. Buys all rights, but may reassign rights to artist after publication. Pays $25 for b&w. Reserves right to rewrite captions.

[N] CONSUMERS DIGEST, 8001 N. Lincoln Ave., 6th Floor, Skokie IL 60077. (847)763-9200. Fax: (847)763-0200. **Art Director:** Lori Weber. Estab. 1961. Frequency: Bimonthly consumer magazine offering "practical advice, specific recommendations, and evaluations to help people spend wisely." Circ. 800,000. Art guidelines available.

Illustration: 75% of freelance illustration demands knowledge of FreeHand, Photoshop, Illustrator.

First Contact & Terms: Illustrators: Send postcard sample or query letter with printed samples, tearsheets. Accepts disk submissions compatible with Macintosh System 8.0. Samples are filed or are returned by SASE. Responds only if interested. Portfolio dropoffs are departmentally reviewed on the second Monday of each month and returned in the same week. Buys first rights. **Pays on acceptance**, $400 minimum for b&w inside; $300-1,000 for color inside; $300-400 for spots. Finds illustrators through *American Showcase* and *Workbook*, submissions and other magazines.

COOK COMMUNICATIONS MINISTRIES, 4050 Lee Vance View, Colorado Springs CO 80918-7100. (719)536-0100. Website: www.cookministries.com. **Art Director:** Paul Segsworth. Publisher of teaching booklets, books, take home papers for Christian market, "all age groups." Art guidelines available for SASE with first-class postage only. No samples returned without SASE.

Illustration: Buys about 10 full-color illustrations/month. Has featured illustrations by Richard Williams, Chuck Hamrick, Ron Diciani. Assigns 5% of illustrations to new and emerging illustrators. Features realistic illustration; Bible illustration; computer and spot illustration.

First Contact & Terms: Illustrators: Send tearsheets, color photocopies of previously published work; include self-promo pieces. No samples returned unless requested and accompanied by SASE. Work on assignment only. **Pays on acceptance**; $400-700 for color cover; $150-250 for b&w inside; $250-400 for color inside; $500-800 for 2-page spreads; $50-75 for spots. Considers complexity of project, skill and experience of artist and turnaround time when establishing payment. Buys all rights.

Tips: "We do not buy illustrations or cartoons on speculation. Do *not* send book proposals. We welcome those just beginning their careers, but it helps if the samples are presented in a neat and professional

manner. Our deadlines are generous but must be met. Fresh, dynamic, the highest of quality is our goal; art that appeals to preschoolers to senior citizens; realistic to humorous, all media."

[N] COPING WITH CANCER, P.O. Box 682268, Franklin TN 37068. (615)790-2400. Fax: (615)794-0179. **Editor:** Kay Thomas. Estab. 1987. *"Coping with Cancer* is a bimonthly, nationally-distributed consumer magazine dedicated to providing the latest oncology news and information of greatest interest and use to its readers. Readers are cancer survivors, their loved ones, support group leaders, oncologists, oncology nurses and other allied health professionals. The style is very conversational and, considering its sometimes technical subject matter, quite comprehensive to the layman. The tone is upbeat and generally positive, clever and even humorous when appropriate, and very credible." Circ. 80,000. Accepts previously published artwork. Originals returned at job's completion. Sample copy available for $3. Art guidelines for SASE with first-class postage.
 • All writers and artists who contribute to this publication volunteer their services without pay for the benefit of cancer patients, their loved ones and caregivers.

COSMOPOLITAN, The Hearst Corp., 224 W. 57th St., New York NY 10019-3299. (212)649-3570. Fax: (212)307-6563. Website: www.cosmopolitan.com. **Art Director:** John Lanuza. Associate Art Director: Theresa Izzilo. Designer: John Hansen. Estab. 1886. Monthly 4-color consumer magazine for contemporary women covering a broad range of topics including beauty, health, fitness, fashion, relationships and careers. Circ. 2,592,887
Illustration: Approached by 300 illustrators/year. Buys 10-12 illustrations/issue. Has featured illustrations by Marcin Baranski and Aimee Levy. Features beauty, well, humorous and spot illustration. Preferred subjects: women and couples. Prefers trendy fashion palette. Assigns 5% of illustrations to new and emerging illustrators.
First Contact & Terms: Illustrators: Send postcard sample and follow-up postcard every 4 months. Samples are filed. Responds only if interested. Buys first North American serial rights. **Pays on acceptance**; $1,000 minimum for 2-page spreads; $450-650 for spots. Finds illustrators through sourcebooks and artists promotional samples.

[N] COUNTRY FOLK MAGAZINE, HCC 77 Box 608, Pittsburg MO 65724. E-mail: salaki@countryfolkmag.com. Website: www.countryfolkmag.com. **Managing Editor:** Susan Salaki. Estab. 1994. Magazine "capturing the history of the Ozark region of Missouri." Circ. 5,000. Sample copies available for $4.25. Art guidelines available for SASE with first-class postage or on our website.
Cartoons: Buys 1 cartoon/issue. All cartoons should reflect the theme of "Life in the Ozarks" or "country life." Prefers single panel b&w line drawings with gagline.
First Contact & Terms: Cartoonists: Send photocopies only. Responds in 1 week. Pays up to $5 for quality cartoons.
Tips: "Most of the work we publish is written by older men and women their parents and grandparents about how the Ozark region was settled in the people—not hillbillies. Cartoons should reflect that difference. We never anyone or any type of person."

THE COVENANT COMPANION, 5101 N. Francisco Ave., Chica (773)784-4366. E-mail: communication@covchurch.org. Website: w Meyer. Managing Editor: Jane K. Swanson-Nystrom. Art Director: Da zine with 4-color cover emphasizing Christian life and faith. Circ. for SASE. Original artwork returned after publication if requeste PageMaker and CorelDraw. Art guidelines available.
Illustration: Uses b&w drawings or photos about Easter, Adver ment only. Write or submit art 10 weeks in advance of season.
First Contact & Terms: Illustrators: Send query letter with transparencies and SASE. Responds "within a reasonable tim color cover; $25 for b&w, $50 for color inside. More photos
Tips: "We usually have some rotating file, if we are inte Submit copies/photos, etc. which we can hold on file."

CRAFTS 'N THINGS, 2400 Devon, Suite 375, Des Pl (847)635-6311. Website: www.craftideas.com. **President an**

General crafting magazine published 10 times yearly. Circ. 305,000. Originals returned at job's completion. Sample copies available. Art guidelines for SASE with first-class postage.

- *Crafts 'n Things* is a "how to" magazine for crafters. The magazine is open to crafters submitting designs and step-by-step instruction for projects such as Christmas ornaments, cross-stitched pillows, stuffed animals and quilts. They do not buy cartoons and illustrations. This publisher also publishes other craft titles including *Cross Stitcher* and *Pack-O-Fun*.

Design: Needs freelancers for design.

First Contact & Terms: Designers: Send query letter with photographs. Pays by project $50-300. Finds artists through submissions.

Tips: "Our designers work freelance. Send us photos of your *original* craft designs with clear instructions. Skill level should be beginning to intermediate. We concentrate on general crafts and needlework. Call or write for submission guidelines."

CRICKET, Box 300, Peru IL 61354-0300. Website: www.cricketmag.com. **Senior Art Director:** Ron McCutchan. Estab. 1973. Monthly magazine emphasizes children's literature for children ages 10-14. Design is fairly basic and illustration-driven; full-color with 2 basic text styles. Circ. 75,000. Original artwork returned after publication. Sample copy $4.95 plus 10% of total order ($4 minimum) for shipping and handling; art guidelines available on website or for SASE with first-class postage.

Cartoons: "We rarely run cartoons."

Illustration: Approached by 800-1,000 illustrators/year. Works with 75 illustrators/year. Buys 600 illustrations/year. Has featured illustrations by Trina Schart Hyman, Kevin Hawkes and Deborah Nourse Lattimore. Assigns 25% to new and emerging illustrators. Uses artists mainly for cover and interior illustration. Prefers realistic styles (animal or human figure), but "we're also looking for humorous, folkloric and nontraditional styles." Works on assignment only.

First Contact & Terms: Illustrators: Send query letter with SASE and samples to be kept on file, "if I like it." Prefers photocopies and tearsheets as samples. Samples not kept on file are returned by SASE. Responds in 6 weeks. Does not want to see "overly slick, cute commercial art (i.e., licensed characters and overly sentimental greeting cards)." Buys all rights. Pays 45 days from receipt of final art; $750 for color cover; $50-150 for b&w inside; $75-250 for color inside; $250-350 for 2-page spreads; $50-75 for spots.

Tips: "We are trying to focus *Cricket* at a slightly older, preteen market. Therefore we are looking for art that is less sweet and more edgy and funky. Since a large proportion of the stories we publish involve people, particularly children, *please* try to include several samples with *faces* and full figures in an initial submission (that is, if you are an artist who can draw the human figure comfortably). It's also helpful to remember that most children's publishers need artists who can draw children from many different racial and ethnic backgrounds. Know how to draw the human figure from all angles, in every position. Send samples that tell a story (even if there is no story); art should be intriguing."

DAIRY GOAT JOURNAL, W11564 Hwy. 64, Withee WI 54488. (715)785-7979. Fax: (715)785-7414. E-mail: csymag@tds.net. Website: www.sheepmagazine.net. **Contact:** Anne-marie Tucker. Estab. 1923. Monthly trade publication covering dairy goats. Circ. 8,000. Accepts previously published work. Sample copies available.

- See also listing for *Sheep! Magazine*.

oons: Approached by 20 cartoonists/year. Buys 2-8 cartoons/issue. Will consider all styles and Prefers single panel.

ion: Approached by 20 illustrators/year. Buys 10-30 illustrations/year. Features charts and graphs, ustration, informational graphics, realistic illustration, medical illustration and spot illustrations. ignment only.

& Terms: Illustrators: Send query letter with appropriate samples. Samples are returned. eks. **Pays on acceptance**. Pays cartoonists $15-25. Pays illustrators $50-150 for color inside. Buys first rights or all rights.

TRY, Box 2714, Bismark ND 58502. (701)255-3031. Fax: (701)255-5038. E-mail: er: Bill Mitzel. Estab. 1979. *Dakota Country* is a monthly hunting and fishing North and South Dakota. Features stories on all game animals and fish and t, b&w and 2-color with 4-color cover, feature layout. Circ. 13,200. Accepts riginal artwork is returned after publication. Sample copies for $2; art s postage.

Cartoons: Likes to buy cartoons in volume. Prefers outdoor themes, hunting and fishing. Prefers multiple or single cartoon panels with gagline; b&w line drawings.

Illustration: Features humorous and realistic illustration of the outdoors. Portfolio review not required.

First Contact & Terms: Cartoonists: Send query letter with samples of style. Samples not filed are returned by SASE. Responds to queries/submissions within 2 weeks. Negotiates rights purchased. **Pays on acceptance**. Pays cartoonists $10-20, b&w. Pays illustrators $20-25 for b&w inside; $12-30 for spots.

Tips: "Always need good-quality hunting and fishing line art and cartoons."

DAKOTA OUTDOORS, P.O. Box 669, Pierre SD 57501-0669. (605)224-7301. Fax: (605)224-9210. **Editor:** Kevin Hipple. Managing Editor: Rachel Engbrecht. Estab. 1978. Monthly outdoor magazine covering hunting, fishing and outdoor pursuits in the Dakotas. Circ. 7,500. Accepts previously published artwork. Original artwork is returned at job's completion. Sample copies and art guidelines for SASE with first-class postage.

Cartoons: Approached by 10 cartoonists/year. Buys 1-2 cartoons/issue. Prefers outdoor, hunting and fishing themes. Prefers cartoons with gagline.

Illustration: Approached by 2-10 illustrators/year. Buys 1 illustration/issue. Features spot illustration. Prefers outdoor, hunting/fishing themes, depictions of animals and fish native to the Dakotas. Prefers pen & ink. Accepts submissions on disk compatible with Macintosh in Illustrator, FreeHand and Photoshop. Send TIFF, EPS and PICT files.

First Contact & Terms: Cartoonists: Send query letter with appropriate samples and SASE. Illustrators: Send postcard sample or query letter with tearsheets, SASE and copies of line drawings. Samples are not filed and are returned by SASE. Responds in 2 months. To show a portfolio, mail "high-quality line art drawings." Rights purchased vary according to project. Pays on publication. Pays cartoonists $5 for b&w. Pays illustrators $5-50 for b&w inside; $5-25 for spots.

Tips: "We especially need line-art renderings of fish, such as the walleye."

DELAWARE TODAY MAGAZINE, 3301 Lancaster Pike, Suite 5C, Wilmington DE 19805-1436. Phone/fax: (302)656-1809. E-mail: kcarter@delawaretoday.com. Website: www.delawaretoday.com. **Creative Director:** Kelly Carter. Monthly 4-color magazine emphasizing regional interest in and around Delaware. Features general interest, historical, humorous, interview/profile, personal experience and travel articles. "The stories we have are about people and happenings in and around Delaware. Our audience is middle-aged (40-45) people with incomes around $79,000, mostly educated. We try to be trendy in a conservative state." Circ. 25,000. Needs computer-literate freelancers for illustration.

Cartoons: Works on assignment only.

Illustration: Buys approximately 3-4 illustrations/issue. Has featured illustrations by Nancy Harrison, Charles Stubbs and Paine Proffit. "I'm looking for different styles and techniques of editorial illustration!" Works on assignment only. Open to all styles.

First Contact & Terms: Cartoonists: Do not send gaglines. Do not send folders of pre-drawn cartoons. Illustrators: Send postcard sample. "Will accept work compatible with QuarkXPress 7.5/version 4.0. Send EPS or TIFF files (RGB)." Send printed color promos. Samples are filed. Responds only if interested. Publication will contact artist for portfolio review if interested. Portfolio should include printed samples, color or b&w tearsheets, and final reproduction/product. Pays on publication; $200-400 for cover; $100-150 for inside. Buys first rights or one-time rights. Finds artists through submissions and self-promotions.

Tips: "Be conceptual, consistent and flexible."

DELICIOUS LIVING MAGAZINE, (formerly *Delicious! Magazine*), 1401 Pearl St., Boulder CO 80302. (303)939-8440. Fax: (303)440-8884. E-mail: delicious@newhope.com. Website: www.deliciouslivingmag.com. **Art Director:** MVicki Hopewell. Designer: Julie Kruse. Estab. 1984. Monthly magazine distributed through natural food stores focusing on health, natural living, alternative healing. Circ. 400,000 guaranteed. Sample copies available.

Illustration: Approached by hundreds of illustrators/year. Buys approximately 1 illustration/issue. Prefers positive, healing-related and organic themes. Considers acrylic, collage, color washed, mixed media, pastel. 30% of illustration demands knowledge of Photoshop and Illustrator.

Design: Needs freelancers for design, production. Prefers local designers with experience in QuarkXPress, Illustrator, Photoshop and magazines/publishing. 100% of freelance work demands knowledge of Photoshop, Illustrator, QuarkXPress.

First Contact & Terms: Illustrators: Send postcard sample, query letter with printed samples, tearsheets. Send follow-up postcard sample every 6 months. Designers: Send query letter with printed samples, photo-

copies, tearsheets and résumé. Accepts disk submissions compatible with QuarkXPress 3.32 (EPS or TIFF files). Samples are filed and are not returned. Art director will contact artist for portfolio review of color, final art, photographs, photostats, tearsheets, transparencies, color copies. Rights purchased vary according to project. **Pays on acceptance**. Pays illustrators $1,000 maximum for color cover; $250-700 for color inside; $250 for spots. Finds illustrators through *Showcase Illustration*, SIS, magazines and artist's submissions.

Tips: "We like our people and designs to have a positive and upbeat outlook. Illustrators must be able to illustrate complex health articles well and have great concepts with single focus images."

✔ **DERMASCOPE**, Geneva Corporation, 2611 N. Belt Line Rd., Suite 101, Sunnyvale TX 75182. (972)226-2309. Fax: (972)226-2339. Website: www.dermascope.com. **Graphic Artist:** Sandra Bedd. Estab. 1978. Monthly magazine/trade journal, 128-page magazine for aestheticians, plastic surgeons and stylists. Circ. 15,000. Sample copies and art guidelines available.

Illustration: Approached by 5 illustrators/year. Prefers illustrations of "how-to" demonstrations. Considers all media. 100% of freelance illustration demands knowledge of Photoshop, Illustrator, QuarkXPress, Fractil Painter.

First Contact & Terms: Accepts disk submissions. Samples are not filed. Responds only if interested. Rights purchased vary according to project. Pays on publication.

DISCOVERIES, 6401 The Paseo, Kansas City MO 64131. (816)333-7000. Fax: (816)333-4439. E-mail: khendrixson@nazarene.org. **Editor:** Virginia L. Folsom. Estab. 1974. Weekly 4-color story paper; "for 8-10 year olds of the Church of the Nazarene and other holiness denominations. Material is based on everyday situations with Christian principles applied." Circ. 40,000. Originals are not returned at job's completion. Sample copies and guidelines for SASE with first-class postage.

Cartoons: Approached by 15 cartoonists/year. Buys 52 cartoons/year. "Cartoons need to be humor for children—not about them." Spot cartoons only. Prefers artwork with children and animals; single panel.

First Contact & Terms: Cartoonists: Send finished cartoons. Samples not filed are returned by SASE. Responds in 2 months. Buys all rights. Pays $15 for b&w.

Tips: No "fantasy or science fiction situations or children in situations not normally associated with Christian attitudes or actions."

DIVERSION MAGAZINE, 1790 Broadway, 6th Floor, New York NY 10019-1412. (212)969-7500. Fax: (212)969-7557. Website: diversion.com. **Cartoon Editor:** Shari Hartford. Estab. 1976. Monthly travel and lifestyle magazine for physicians. Circ. 176,000. Art guidelines available free with SASE.

Cartoons: Approached by 50 cartoonists/year. Buys 10 cartoons/year. Prefers travel, food/wine, sports, lifestyle, family, animals, technology, art and design, performing arts, gardening. Prefers single panel, humorous, b&w line drawings, with or without gaglines.

First Contact & Terms: "SASE must be included or cartoons will be discarded." Samples are not filed and are returned by SASE. Responds in 5 days. Buys first North American serial rights. **Pays on acceptance**; $100.

THE EAST BAY MONTHLY, 1301 59th St., Emeryville CA 94608. (510)658-9811. Fax: (510)658-9902. E-mail: artdirector@themonthly.com. **Art Director:** Andreas Jones. Estab. 1970. Consumer monthly tabloid; b&w with 4-color cover. Editorial features are general interests (art, entertainment, business owner profiles) for an upscale audience. Circ. 80,000. Accepts previously published artwork. Originals returned at job's completion. Art guidelines for SASE with first-class postage. Sample copy and guidelines for SASE with 5 oz. first-class postage. No nature or architectural illustrations. 100% of freelance design work demands knowledge of PageMaker, QuarkXPress, Macromedia FreeHand, Illustrator, Photoshop.

Cartoons: Approached by 75-100 cartoonists/year. Buys 3 cartoons/issue. Prefers single panel, b&w line drawings; "any style, extreme humor."

Illustration: Approached by 150-200 illustrators/year. Buys 2 illustrations/issue. Prefers pen & ink, watercolor, acrylic, colored pencil, oil, charcoal, mixed media and pastel.

Design: Needs freelancers for design and production. 100% of freelance design requires knowledge of PageMaker, Macromedia FreeHand, Photoshop, QuarkXPress and Illustrator.

First Contact & Terms: Cartoonists: Send query letter with finished cartoons. Illustrators: Send postcard sample or query letter with tearsheets and photocopies. Designers: Send query letter with résumé, photocopies or tearsheets. Accepts submissions on disk, Mac compatible with Macromedia FreeHand, Illustrator, Photoshop, PageMaker or QuarkXPress. Samples are filed or returned by SASE. Responds only if inter-

ested. Write for appointment to show portfolio of thumbnails, roughs, b&w tearsheets and slides. Buys one-time rights. Pays cartoonists $35 for b&w. Pays illustrators $100-200 for b&w inside; $25-50 for spots. Pays 15 days after publication. Pays for design by project.

ELECTRICAL APPARATUS, Barks Publications, Inc., 400 N. Michigan Ave., Suite 900, Chicago IL 60611-4198. (312)321-9440. Fax: (312)321-1288. E-mail: eamagazine@aol.com. Website: www.eamagazi ne.com. **Senior Editor:** Kevin Jones. Estab. 1948. Monthly 4-color trade journal emphasizing industrial electrical/mechanical maintenance. Circ. 16,000. Art guidelines available free for SASE. Original artwork not returned at job's completion. Sample copy $4.
Cartoons: Approached by several cartoonists/year. Buys 3-4 cartoons/issue. Has featured illustrations by Joe Buresch, James Estes, Bernie White and Mark Ziemann. Assigns 25% of illustrations to new and emerging illustrators. Prefers themes relevant to magazine content; with gagline. "Captions are typeset in our style."
Illustration: "We have staff artists, so there is little opportunity for freelance illustrators, but we are always glad to hear from anyone who believes he or she has something relevant to contribute."
First Contact & Terms: Cartoonists: Send query letter with roughs and finished cartoons. "Anything we don't use is returned." Responds in 3 weeks. Buys all rights. Pays $15-20 for b&w and color.
Tips: "Pay attention to the magazine's editorial focus."

ENVIRONMENT, 1319 18th St. NW, Washington DC 20036-1802. (202)296-6267, ext. 237. Fax: (202)296-5149. E-mail: env@heldref.org. Website: www.heldref.org. **Editorial Assistant:** Ellen Fast. Estab. 1958. Emphasizes national and international environmental and scientific issues. Readers range from "high school students and college undergrads to scientists, business, and government leaders and college and university professors." 4-color magazine with "relatively conservative" design. Published 10 times/year. Circ. 7,500. Original artwork returned after publication. Sample copy $9.60.
Cartoons: Buys 2-3 cartoons/year. Receives 5 submissions/week. Interested in single panel line drawings or b&w washes with or without gagline.
First Contact & Terms: Cartoonists: Send finished cartoons and SASE. Responds in 2 months. Buys first North American serial rights. Pays on publication; $50 for b&w cartoon.
Tips: "Regarding cartoons, we prefer witty or wry comments on the impact of humankind on the environment. Stay away from slapstick humor.'

⊞ EUROPE, MAGAZINE OF THE EUROPEAN UNION, 2300 M St. NW, 3rd Floor, Washington DC 20037. (202)862-9555. Fax: (212)429-1766. Website: www.eurunion.org. **Editor-in-Chief:** Robert J. Guttman. Emphasizes European affairs, US-European relations—particularly economics, politics and culture; 4-color. Readers are business professionals, academics, government officials and consumers. Published 10 times/year. Circ. 65,000. Free sample copy.
Cartoons: Occasionally uses cartoons, mostly from a cartoon service. "The magazine publishes articles on US-European relations in economics, trade, business, industry, politics, energy, inflation, etc." Considers single panel b&w line drawings or b&w washes with or without gagline.
Illustration: Uses 3-5 illustrations/issue. "We look for economic graphs, tables, charts and story-related statistical artwork"; b&w line drawings and washes for inside. 30% of freelance work demands knowledge of PageMaker and QuarkXPress.
First Contact & Terms: Cartoonists: Send résumé, SASE, plus finished cartoons and/or samples. Buys one-time rights. Illustrators: Send résumé, SASE and photocopies of style. Responds in 1 month. To show a portfolio, mail printed samples. Buys all rights on a work-for-hire basis. Pays on publication. Pays cartoonists $25 on publication.

⊞ ✦ EVENT, Douglas College, Box 2503, New Westminster, BC V3L 5B2 Canada. (604)527-5293. E-mail: event@douglas.bc.ca. Website: event.douglas.bc.ca. **Editor:** Cathy Stonehouse. Assistant Editor: Ian Cockfield. Estab. 1971. For "those interested in literature and writing"; b&w with 4- or 2-color cover. Published 3 times/year. Circ. 1,300. Art guidelines available free for SASE (Canadian postage/IRCs only). Slides/negatives of artwork returned after publication. Sample back issue for $5. Current issue for $8.
Illustration: Buys approximately 3 illustrations/year. Has featured illustrations by Sharalee Regehr, Michael Downs and Jesus Romeo Galdámez. Assigns 50% of illustrations to new and emerging illustrators. Uses freelancers mainly for covers. "Interested in drawings and prints, b&w line drawings, photographs and lithographs for cover, and thematic or stylistic series of 3 works. SASE (Canadian postage or IRCs).
First Contact & Terms: Reponse time varies; generally 4 months. Buys first North American serial

rights. Pays on publication, $150 for color cover, 2 free copies plus 10 extra covers.

FASHION ACCESSORIES, P.O. BOX 859, Mahwah NJ 07430. (201)684-9222. Fax: (201)684-9228. **Publisher:** Sam Mendelson. Estab. 1951. Monthly trade journal; tabloid; emphasizing costume jewelry and accessories. Publishes both 4-color and b&w. Circ. 9,500. Accepts previously published artwork. Original artwork is returned to the artist at the job's completion. Sample copies for $3.
Illustration: Works on assignment only. Needs editorial illustration. Prefers mixed media. Freelance work demands knowledge of QuarkXPress.
First Contact & Terms: Illustrators: Send query letter with brochure and photocopies. Samples are filed. Responds in 1 month. Portfolio review not required. Rights purchased vary according to project. **Pays on acceptance**; $50-100 for b&w cover; $100-150 for color cover; $50-100 for b&w inside; $100-150 for color inside.

FAULTLINE, Department of English and Comparative Literature, UC Irvine, Irvine CA 92697-2650. E-mail: faultline@uci.edu. Website: www.humanities.uci.edu/faultline. **Creative Director:** Lorene Delany Ullman (2002-03 rotating director).
 ● Even though this is not a paying market, this high-quality literary magazine would be an excellent place for fine artists to gain exposure. Postcard samples with a website address are the best way to show us your work.

FIFTY SOMETHING MAGAZINE, 1168 Beachview, Willoughby OH 44094. (216)951-2468. **Editor:** Linda L. Lindeman-DeCarlo. Estab. 1990. Quarterly magazine; 4-color. "We cater to the fifty-plus age group with upbeat information, feature stories, travel, romance, finance and nostalgia." Circ. 25,000. Accepts previously published artwork. Original artwork is returned at the job's completion. Sample copies for SASE, 10×12, with $1.37 postage.
Cartoons: Approached by 50 cartoonists/year. Buys 3 cartoons/issue. Prefers funny issues on aging. Prefers single panel b&w line drawings with gagline.
Illustration: Approached by 50 illustrators/year. Buys 2 illustrations/issue. Prefers old-fashioned, nostalgia. Considers all media.
First Contact & Terms: Cartoonists: Send query letter with brochure, roughs and finished cartoons. Illustrators: Send query letter with brochure, photographs, photostats, slides and transparencies. Samples are filed. Responds only if interested. To show a portfolio, mail thumbnails, printed samples, b&w photographs, slides and photocopies. Buys one-time rights. Pays on publication. Pays cartoonists $10, b&w and color. Pays illustrators $25 for b&w, $100 for color cover; $25 for b&w, $75 for color inside.

☑ **FILIPINAS MAGAZINE**, 1486 Huntington Ave., Suite 300, South San Francisco CA 94080. (650)872-8657. Fax: (650)872-8651. E-mail: r.virata@filipinasmag.com. Website: www.filipinasmag.com. **Art Director:** Raymond Virata. Estab. 1992. Monthly magazine "covering issues of interest to Filipino Americans and Filipino immigrants." Circ. 30,000. Sample copies free for 9×12 SASE and $1.70. Contact Art Director for information.
Cartoons: Buys 1 cartoon/issue. Prefers work related to Filipino/Filipino-American experience. Prefers single panel, humorous, b&w washes and line drawings with or without gagline.
Illustration: Approached by 5 illustrators/year. Buys 1-3 illustrations/issue. Considers all media.
First Contact & Terms: Cartoonists: Send query letter with photocopies. Illustrators: Send query letter with photocopies. Accepts disk submissions compatible with Mac, QuarkXPress 4.1, Photoshop 6, Illustrator 7, include any attached image files (TIFF or EPS) or fonts. Samples are filed. Responds only if interested. Pays on publication. Pays cartoonists $25 minimum. Pays illustrators $100 minimum for cover; $25 minimum for inside. Buys all rights.
Tips: "Read our magazine."

THE FINAL EDITION, Box 294, Rhododendron OR 97049. (503)622-4798. **Publisher:** Michael P. Jones. Estab. 1985. Monthly b&w investigative journal that deals "with a variety of subjects—environment, wildlife, crime, etc. for professional and blue collar people who want in-depth reporting." Circ. 1,500. Accepts previously published material. Original artwork is returned after publication. Art guidelines for #10 SASE with 1 first-class stamp. 50% of freelance work demands computer skills.
Cartoons: Buys 1-18 cartoons/issue. Prefers single, double, multipanel, b&w line drawings, b&w or color washes with or without gagline.
Illustration: Buys 10 illustrations/issue. Works with 29 illustrators/year. Prefers editorial, technical and

medical illustration in pen & ink, airbrush, pencil, marker, calligraphy and computer illustration.

Design: Needs freelancers for design and production. 50% of freelance work demands computer skills.

First Contact & Terms: Cartoonists: Send query letter with samples of style, roughs or finished cartoons. Illustrators: Send query letter with brochure showing art style or résumé and tearsheets, transparencies, photocopies, slides or photographs. Designers: Send brochure, résumé, photocopies, photographs, SASE, slides, tearsheets or transparencies. Samples not filed are returned by SASE. Responds in 2 months, "depending upon work load." Cannot return phone calls because of large volume. Request portfolio review in original query. Portfolio should include thumbnails, roughs, printed samples, final reproduction/product, color or b&w tearsheets, photostats and photographs. Acquires one-time rights. Pays cartoonists/illustrators in copies. Finds artists primarily through sourcebooks and also through word of mouth.

Tips: "We are really looking for artists who can sketch covered wagons, pioneers, Native Americans and mountain men. Everything is acceptable just as long as it doesn't advocate sex and violence and destroying our environment. We are looking for illustrators who can illustrate in black & white. Pen and ink is a plus. We want to work with an illustrator who wants to be published. Due to the great many requests we are receiving each day, illustrators should include a SASE for a timely response."

FIRST FOR WOMEN, 270 Sylvan Ave., Englewood Cliffs NJ 07632. (201)569-6699. Fax: (201)569-6264. Website: www.ffwmarket.com. **Art Director:** Lisa Vibronek. Estab. 1988. Mass market consumer magazine for the younger woman published every 3 weeks. Circ. 1.4 million. Originals returned at job's completion. Sample copies and art guidelines not available.

Cartoons: Buys 10 cartoons/issue. Prefers women's issues. Prefers humorous cartoons; single panel b&w washes and line drawings.

Illustration: Approached by 100 illustrators/year. Buys 1 illustration/issue. Works on assignment only. Preferred themes are humorous, sophisticated women's issues. Considers all media.

First Contact & Terms: Cartoonists: Send query letter with photocopies. Illustrators: Send query letter with any sample or promo we can keep. Samples are filed. Responds only if interested. Publication will contact artist for portfolio review if interested. Buys one-time rights. **Pays on acceptance**. Pays cartoonists $150 for b&w. Pays illustrators $200 for b&w, $300 for color inside. Finds artists through promo mailers and sourcebooks.

Tips: Uses humorous or conceptual illustration for articles where photography won't work. "Use the mail—no phone calls please."

FIRST HAND MAGAZINE, P.O. Box 1314, Teaneck NJ 07666. (201)836-9177. Fax: (201)836-5055. Estab. 1980. Monthly consumer magazine emphasizing gay erotica. Circ. 60,000. Sample copies available for $5. Art guidelines for SASE with first-class postage.

Cartoons: Approached by 10 cartoonists/year. Buys 5 cartoons/issue. Prefers gay male themes—erotica; humorous; single panel b&w line drawings with gagline.

Illustration: Approached by 30 illustrators/year. Buys 12 illustrations/issue. Prefers gay male erotica. Considers pen & ink, airbrush, marker, colored pencil and charcoal.

First Contact & Terms: Cartoonists: Send query letter with finished cartoons. Illustrators: Send query letter with photostats. Samples are not filed and are returned by SASE. Responds in 6 weeks. Portfolio review not required. Buys all rights. Pays on publication. Pays cartoonists $20 for b&w. Pays illustrators $50 for b&w inside.

FOODSERVICE AND HOSPITALITY, Kostuch Publications Limited, 23 Lesmill Rd., #101, Don Mills, ON M3B 3P6 Canada. (416)447-0888. Fax: (416)447-5333. E-mail: mhewis@foodservice.ca. Website: www.foodserviceworld.com. **Senior Designer:** Michael Hewis. Estab. 1973. Monthly business magazine for foodservice industry/operators. Circ. 25,000. Sample copies available. Art guidelines available.

 • Also publishes *Hotel Executive Magazine*.

Illustration: Approached by 30 illustrators/year. Buys 1 illustration/issue. Prefers serious/businessy/stylized art for *Hotel Executive Magazine*; casual free and fun style for *Foodservice and Hospitality*. Considers all media.

First Contact & Terms: Illustrators: Send query letter with printed samples and tearsheets or postcards. Samples are filed. Responds only if interested. Art director will contact artist for portfolio review of final art and tearsheets if interested. Portfolios may be dropped off every Monday and Tuesday. Buys one-time rights. Pays on publication; $500 minimum for color cover; $300 minimum for color inside. Finds illustrators through sourcebooks, word of mouth, artist's submissions.

FOODSERVICE DIRECTOR MAGAZINE, 770 Broadway, 4th Floor, New York NY 10003-1789. (646)654-7407. Fax: (646)654-7410. Website: www.fsdmag.com. **Contact:** Kathleen McCann. Estab. 1988. Monthly 4-color trade publication covering cafeteria-style food in colleges, schools, hospitals, prisons, airlines, business and industry. Circ. 45,000.

Illustration: Approached by 75 illustrators/year. Buys 1-2 illustrations/issue. Features humorous illustration, informational graphics, spot illustrations of food and kitchen art and business subjects. Prefers solid colors that reproduce well. No neon. Assigns 50% of illustration to new and emerging illustrators. 10% of freelance illustration demands knowledge of Illustrator, Photoshop, FreeHand, QuarkXPress.

First Contact & Terms: Illustrators: Send postcard or other nonreturnable samples or query letter with photocopies. Send follow-up postcard every 6 months. Accepts Mac-compatible disk submissions. Send EPS or TIFF files. Samples are filed. Will contact artist for portfolio review if interested. Pays on publication; $350-550 for color inside; $150 for spots. Finds illustrators through samples, sourcebooks.

N FORBES MAGAZINE, 60 Fifth Ave., New York NY 10011. (212)620-2200. E-mail: bmansfield@forbes.com. **Art Director:** Robert Mansfield. Five associate art directors. Established 1917. Biweekly business magazine read by company executives and those who are interested in business and investing. Circ. 785,000. Art guidelines not available.

Illustration: Assigns 20% of illustrations to new and emerging illustrators.

First Contact & Terms: "Assignments are made by one of the art directors. We do not use, nor are we liable for ideas or work that a Forbes art director didn't assign. We prefer contemporary illustrations that are lucid and convey an unmistakable idea, with wit and intelligence. No cartoons please. Illustration art must be rendered on a material and size that can be separated on a drum scanner or submitted digitally. We are prepared to receive art on zip, scitex, CD, floppy disk, or downloaded via e-mail. Discuss the specifications and the fee before you accept the assignment. **Pays on acceptance** whether reproduced or not. Pays up to $3,000 for a cover assignment and an average of $450 to $700 for an inside illustration depending on complexity, time and the printed space rate. Dropping a portfolio off is encouraged. Deliver portfolios by 11 a.m. and plan to leave your portfolio for a few hours or overnight. Call first, to make sure an art director is available. Address the label to the attention of the Forbes Art Department and individual you want to reach. Attach your name and local phone number to the outside of the portfolio. Include a note stating when you need it. Robin Regensberg, the art traffic coordinator, will make every effort to call you to arrange for your pickup. Samples: Do not mail original artwork. Send printed samples, scanned samples or photocopies of samples. Include enough samples as you can spare in a portfolio for each person on our staff. If interested, we'll file them. Otherwise they are discarded. Samples are returned only if requested."

Tips: "Look at the magazine to determine if your style and thinking are suitable. The art director and associate art directors are listed on the masthead, located within the first ten pages of an issue. The art directors make assignments for illustration. However, it is important that you include Robert Mansfield in your mailings and portfolio review. We get a large number of requests for portfolio reviews, and many mailed promotions daily. This may explain why, when you follow up with a call we may not be able to acknowledge receipt of your samples. If the work is memorable and we think we can use your style, we'll file samples for future consideration."

N FUGUE LITERARY MAGAZINE, 200 Brink Hall, University of Idaho, Moscow ID 83843. (208)885-6156. E-mail: fugue02@hotmail.com. Estab. 1990. Biannual literary magazine. Circ. 500. Sample copies available for $6. Art guidelines available with SASE.

Illustration: Approached by 10 illustrators/year. Buys 1-2 illustrations/year. Has featured illustrations by Sarah Wichlucz, Cori Flowers. Features graphic art. Prefers any color scheme; preferably paintings (in slide form). Freelance illustration demands knowledge of PageMaker and Photoshop.

First Contact & Terms: Cartoonists/Illustrators: Send query letter with b&w photocopies, photographs, résumé, SASE and slides. Accepts e-mail submissions with link to website. Prefers Windows-compatible, TIFF or JPEG files. Samples are not filed but are returned by SASE. Responds in 4 months. Company will contact artist for portfolio review if interested. Portfolio should include b&w original art, photographs, slides and thumbnails. **Pays on acceptance.** Buys first North American serial rights.

GAME & FISH, 2250 Newmarket Pkwy., Suite 110, Marietta GA 30067. (770)953-9222. Fax: (770)933-9510. Website: www.gameandfish.about.com. **Graphic Artist:** Allen Hansen. Estab. 1975. Monthly b&w with 4-color cover. Circ. 575,000 for 30 state-specific magazines. Original artwork is returned after publication. Sample copies available.

Illustration: Approached by 50 illustrators/year. Buys illustrations mainly for spots and feature spreads. Buys 1-5 illustrations/issue. Considers pen & ink, watercolor, acrylic and oil.

First Contact & Terms: Illustrators: Send query letter with photocopies. "We look for an artist's ability to realistically depict North American game animals and game fish or hunting and fishing scenes." Samples are filed or returned only if requested. Responds only if interested. Portfolio review not required. Buys first rights. Pays 2½ months prior to publication; $25 minimum for b&w inside; $75-100 for color inside.

Tips: "We do not publish cartoons, but we do use some cartoon-like illustrations which we assign to artists to accompany specific humor stories. Send us some samples of your work, showing as broad a range as possible, and let us hold on to them for future reference. Being willing to complete an assigned illustration in a 4-6 week period and providing what we request will make you a candidate for working with us."

GEORGIA MAGAZINE, P.O. Box 1707, Tucker GA 30085-1707. (770)270-6950. Fax: (770)270-6995. E-mail: ann.orowski@georgiaemc.com. **Editor:** Ann Orowski. Estab. 1945. Monthly consumer magazine promoting electric co-ops (largest read publication by Georgians for Georgians). Circ. 438,000 members.

Cartoons: Approached by 10 cartoonists/year. Buys 2 cartoons/year. Prefers electric industry theme. Prefers single panel, humorous, b&w washes and line drawings.

Illustration: Approached by 10 illustrators/year. Prefers electric industry theme. Considers all media. 50% of freelance illustration demands knowledge of Illustrator and QuarkXPress.

Design: Uses freelancers for design and production. Prefers local designers with magazine experience. 80% of design demands knowledge of Photoshop, Illustrator and QuarkXPress.

First Contact & Terms: Cartoonists: Send query letter with photocopies. Samples are filed and not returned. Illustrators: Send postcard sample or query letter with photocopies. Designers: Send query letter with printed samples and photocopies. Accepts disk submissions compatible with QuarkXPress 7.5. Samples are filed or returned by SASE. Responds in 1 month if interested. Rights purchased vary according to project. **Pays on acceptance.** Pays cartoonists $50 for b&w, $50-100 for color. Pays illustrators $50-100 for b&w, $50-200 for color. Finds illustrators through word of mouth and artist's submissions.

GIFTWARE NEWS, 20 W. Kinzie, 12th Floor, Chicago IL 60610. (312)849-2220. Fax: (312)849-2174. Website: www.giftwarenews.com. **Art Director:** Bob Page. Monthly magazine "of gifts, collectibles, stationery, gift baskets, tabletop and home accessories." Circ. 33,500. Sample copies available.

Design: Needs freelancers for design, production, multimedia projects and Internet, possible CD production. Prefers designers with experience in magazine design. 100% of work demands knowledge of Photoshop 7.0, Illustrator 10 and QuarkXPress 4.0.

First Contact & Terms: Designers: Send query letter with printed samples.

GIRLFRIENDS MAGAZINE, 3415 Cesar Chavez, #101, San Francisco CA 94110. (415)648-9464. Fax: (415)648-4705. E-mail: ethan@girlfriendsmag.com. Website: www.girlsfriendsmag.com. **Art Director:** Ethan Duran. Estab. 1994. Monthly lesbian magazine. Circ. 30,000. Sample copies available for $4.95. Art guidelines for #10 SASE with first-class postage.

Illustration: Approached by 50 illustrators/year. Buys 3-4 illustrations/issue. Features caricatures of celebrities and realistic, computer and spot illustration. Assigns 40% of illustrations to new and emerging illustrators. Prefers any style. Considers all media. 10% of freelance illustration demands knowledge of Illustrator, QuarkXPress.

First Contact & Terms: Illustrators: Send query letter with printed samples, tearsheets, résumé, SASE and color copies. Accepts disk submissions compatible with QuarkXPress (JPEG files). Samples are filed or returned by SASE on request. Responds in 2 months. To show portfolio, artist should follow-up with call and/or letter after initial query. Portfolio should include color, final art, tearsheets, transparencies. Rights purchased vary according to project. Pays on publication; $50-200 for color inside; $150-300 for 2-page spreads; $50-75 for spots. Finds illustrators through word of mouth and submissions.

Tips: "Read the magazine first; we like colorful work; ability to turn around in two weeks."

CARTOON markets are listed in the Cartoon Index located within the Niche Marketing Index at the back of this book.

GIRLS' LIFE, 4517 Hartford Rd., Baltimore MD 21214-3122. (410)426-9600. Fax: (410)254-0991. Website: www.girlslife.com. **Art Director:** Chun Kim. Estab. 1994. Bimonthly consumer magazine for 8- to 15-year-old girls. Originals sometimes returned at job's completion. Sample copies available for $5 on back order or on newsstands. Art guidelines not available. Sometimes needs computer literate freelancers for illustration. 20% of freelance work demands computer knowledge of Illustrator, QuarkXPress or Photoshop. Circ. 315,905.

Illustration: Prefers anything pertaining to girls 8-15 years-old. Assigns 60% of illustrations to experienced, but not well-known illustrators; 10% to new and emerging illustrators. Considers pen & ink, watercolor, airbrush, acrylic and mixed media.

First Contact & Terms: Illustrators: Send query letter with SASE, tearsheets, photographs, photocopies, photostats, slides and transparencies. Samples are filed or are returned by SASE if requested by artist. Publication will contact artist for portfolio review if interested. Portfolio should include tearsheets, slides, photostats, photocopies, final art and photographs. Buys first rights. Pays on publication. Finds artists through artists' submissions.

Tips: "Send work pertaining to our market."

[N] GLASS FACTORY DIRECTORY, Box 2267, Hempstead NY 11557. (516)481-2188. E-mail: manager@glassfactorydir.com. Website: www.glassfactorydir.com. **Manager:** Liz Scott. Annual listing of glass manufacturers in US, Canada and Mexico.

Cartoons: Receives an average of 1 submission/week. Buys 5-10 cartoons/issue. Cartoons should pertain to glass manufacturing (flat glass, fiberglass, bottles and containers; no mirrors). Prefers single and multiple panel b&w line drawings with gagline. Prefers roughs or finished cartoons. "We do not assign illustrations. We buy from submissions only."

First Contact & Terms: Send SASE. Responds in 3 months. Buys all rights. **Pays on acceptance**; $25.

Tips: "Learn about making glass of all kinds. We rarely buy broken glass jokes. There *are* women working in glass plants. Glassblowing is overdone. What about flat glass, autoglass, bottles, fiberglass?"

GOLF ILLUSTRATED, 15115 S. 76th East Ave., Bixby OK 74008-4114. (918)366-6191. Fax: (918)366-6512. Website: www.Golfillustrated.com. **Managing Editor:** Jason Sowards. Art Director: Burt McCall. Estab. 1914. Golf lifestyle magazine published 4 times/year with instruction, travel, equipment reviews and more. Circ. 150,000. Sample copies free for 9×11 SASE and 6 first-class stamps. Art guidelines available for #10 SASE with first-class postage.

Cartoons: Approached by 25 cartoonists/year. Prefers golf. Prefers single panel, b&w washes or line drawings.

Illustration: Approached by 50 illustrators/year. Buys 10 illustrations/issue. Prefers instructional, detailed figures, course renderings. Considers all media. 30% of freelance illustration demands knowledge of Photoshop, Illustrator and QuarkXPress.

First Contact & Terms: Cartoonists: Send photocopies. Illustrators: Send query letter with photocopies, SASE and tearsheets. Accepts disk submissions. Samples are filed. Responds in 1 month. Portfolios may be dropped off Monday-Friday. Buys first North American serial and reprint rights. **Pays on acceptance**. Pays cartoonists $50 minimum for b&w. Pays illustrators $100-200 for b&w, $250-400 for color inside. Finds illustrators through sourcebooks, magazines, word of mouth and submissions.

Tips: "Read our magazine. We need fast workers with quick turnaround."

[✓] THE GOLFER, 551 Fifth Ave., Suite 3010, New York NY 10176. (212)867-7070. Fax: (212)867-8550. E-mail: thegolfer@walrus.com. Website: www.emeraldtee.com. **Art Director:** Andrea Darif. Estab. 1994. 6 times/year "sophisticated golf magazine with an emphasis on travel and lifestyle. Circ. 254,865.

Illustration: Approached by 200 illustrators/year. Buys 6 illustrations/issue. Considers all media.

First Contact & Terms: Illustrators: Send postcard sample. "We will accept work compatible with QuarkXPress 3.3. Send EPS files." Samples are not filed and are not returned. Responds only if interested. Rights purchased vary according to project. Pays on publication. Payment to be negotiated.

Tips: "I like sophisticated, edgy, imaginative work. We're looking for people to interpret sport, not draw a picture of someone hitting a ball."

[N] [✠] GRAND RAPIDS MAGAZINE, Gemini Publications, 549 Ottawa Ave., Grand Rapids MI 49503. (616)459-4545. **Editor:** Carole Valade. Monthly for greater Grand Rapids residents. Circ. 20,000. Original artwork returned after publication. Local artists only.

Cartoons: Buys 2-3 cartoons/issue. Prefers Michigan, Western Michigan, Lake Michigan, city, issue, consumer/household, fashion, lifestyle, fitness and travel themes.

Illustration: Buys 2-3 illustrations/issue. Prefers Michigan, Western Michigan, Lake Michigan, city, issue, consumer/household, fashion, lifestyle, fitness and travel themes.

First Contact & Terms: Cartoonists: Send query letter with samples. Illustrators: Send query letter with samples. Samples not filed are returned by SASE. Responds in 1 month. To show a portfolio, mail printed samples and final reproduction/product or call for an appointment. Buys all rights. Pays on publication. Pays cartoonists $35-50 for b&w. Pays illustrators $200 minimum for color cover; $40 minimum for b&w inside; $40 minimum for color inside.

Tips: "Particular interest in those who are able to capture the urban lifestyle."

☑ **GRAPHIC ARTS MONTHLY**, 360 Park Ave. S., 15th Floor, New York NY 10010. (646)746-7321. Fax: (646)746-7489. E-mail: rlevy@cahners.com. Website: www.gammag.com/. **Creative Director:** Rani Levy. Estab. 1930. Monthly 4-color trade magazine for management and production personnel in commercial and specialty printing plants and allied crafts. Design is "direct, crisp and modern." Circ. 70,000. Accepts previously published artwork. Originals returned at job's completion. Needs computer-literate freelancers for illustration.

Illustration: Approached by 150 illustrators/year. Buys 6 illustrations/issue. Works on assignment only. Considers all media, including computer.

First Contact & Terms: Illustrators: Send postcard-sized sample to be filed. No phone calls please. Accepts disk submissions compatible with Photoshop, Illustrator or JPEG files. Will contact for portfolio review if interested. Portfolio should include final art, photographs, tearsheets. Buys one-time and reprint rights. **Pays on acceptance**; $750-1200 for color cover; $250-350 for color inside; $250 for spots. Finds artists through submissions.

GREENPRINTS, P.O. Box 1355, Fairview NC 28730. (828)628-1902. Website: www.greenprints.com. **Editor:** Pat Stone. Estab. 1990. Quarterly magazine "that covers the personal, not the how-to, side of gardening." Circ. 13,000. Sample copy for $5; art guidelines available on website or free for #10 SASE with first-class postage.

Illustration: Approached by 46 illustrators/year. Works with 15 illustrators/issue. Has featured illustrations by Claudia McGehee, P. Savage, Marilynne Roach and Jean Jenkins. Assigns 50% of illustrations to new and emerging illustrators. Prefers plants and people. Considers b&w only.

First Contact & Terms: Illustrators: Send query letter with photocopies, SASE and tearsheets. Samples accepted by US mail only. Accepts e-mail queries without attachments. Samples are filed or returned by SASE. Responds in 2 months. Buys first North American serial rights. Pays on publication; $250 maximum for color cover; $100-125 for b&w inside; $25 for spots. Finds illustrators through word of mouth, artist's submissions.

Tips: "Read our magazine and study the style of art we use. Can you do both plants and people? Can you interpret as well as illustrate a story?"

GUITAR PLAYER, 2800 Campus Dr., San Mateo CA 94403. (650)513-4400. Fax: (650)513-4661. Website: www.guitarplayer.com. **Art Director:** Alexandra Zeigler. Estab. 1975. Monthly 4-color magazine focusing on technique, artist interviews, etc. Circ. 150,000. Original artwork is returned at job's completion. Sample copies and art guidelines not available.

Illustration: Approached by 15-20 illustrators/week. Buys 5 illustrations/year. Works on assignment only. Features caricature of celebrities; realistic, computer and spot illustration. Assigns 33% of illustrations to new and emerging illustrators. Prefers conceptual, "outside, not safe" themes and styles. Considers pen & ink, watercolor, collage, airbrush, computer based, acrylic, mixed media and pastel.

First Contact & Terms: Illustrators: Send query letter with brochure, tearsheets, photographs, photocopies, photostats, slides and transparencies. Accepts disk submissions compatible with Mac. Samples are filed. Responds only if interested. Will contact for portfolio review if interested. Buys first rights. Pays on publication; $200-400 for color inside; $400-600 for 2-page spreads; $200-300 for spots.

GULF COAST MEDIA, 886 110th Ave. N., Suite 5, Naples FL 34108. (239)591-3431. Fax: (239)591-3938. Website: www.gulfcoastmedia.com. **Art Director:** Tracy Kiernan. Estab. 1989. Publishes chamber's annuals promoting area tourism as well as books; 4-color and b&w; design varies. Accepts previously published artwork. Originals are returned at job's completion.

Illustration: Works on assignment only; usage of illustration depends on client. Needs editorial illustration,

maps and charts. Preferred themes depend on subject; watercolor, collage, airbrush, acrylic, marker, color pencil, mixed media.

First Contact & Terms: Illustrators: Send postcard or query letter with tearsheets, photographs and/or photocopies. Samples are filed. Responds only if interested. Publication will contact artist for portfolio review if interested. Portfolio should include roughs and original/final art. Buys first rights, one-time rights or reprint rights. Pays on publication; $250 for b&w, $250 for color, cover; $35 for b&w, $250 for color, inside; $50 for color spot art.

Tips: "Our magazine publishing is restricted to contract publications, such as Chamber of Commerce publications, playbills, collateral materials. All of our work is located in Florida, mostly southwest Florida, therefore everything we use will have a local theme."

GULFSHORE LIFE MAGAZINE, 9051 Tamiami Trail N., Suite 202, Naples FL 34108. (941)594-9980. Fax: (941)594-9986. Website: www.gulfshorelife.com. **Contact:** Creative Director. Estab. 1970. "Monthly 4-color magazine emphasizing life-style of southwest Florida for an affluent, sophisticated audience, traditional design." Circ. 30,000. Accepts previously published material. Original artwork returned after publication. Sample copy for $3.95. Art guidelines for SASE with first-class postage.

Illustration: Approached by 15-20 illustrators/year. Buys 1 illustration/issue. Prefers watercolor, collage, airbrush, acrylic, mixed media and pastel. Digital is OK.

Design: Needs freelancers for design. Freelance work demands knowledge of Photoshop, QuarkXPress or Illustrator.

First Contact & Terms: Illustrators: Send postcard sample or query letter with brochure, résumé, tearsheets, photostats and photocopies. Designers: Send query letter with résumé and tearsheets. Accepts disk submissions compatible with Illustrator or QuarkXPress. Samples not filed are returned by SASE. Responds only if interested. Write to schedule appointment to show a portfolio, which should include thumbnails, printed samples, final/reproduction/product and tearsheets. Negotiates rights purchased. Buys one-time rights. Pays on publication. Pays illustrators $500-1000 for color cover; $100-350 for b&w inside; $150-500 for color inside. $100-200 for spots. Pays designers by the project or by the hour. Needs technical illustration. Needs freelancers familiar with Illustrator, Photoshop or QuarkXPress.

HADASSAH MAGAZINE, 50 W. 58th St., New York NY 10019. (212)451-6289. Fax: (212)451-6257. E-mail: egoldberg@hadassah.org. Website: www.hadassah.org. **Art Director:** Jodie Rossi. Estab. 1914. Consumer magazine. *Hadassah Magazine* is a monthly magazine chiefly of and for Jewish interests—both here and in Israel. Circ. 340,000.

Cartoons: Buys 3-5 freelance cartoons/year. Preferred themes include the Middle East/Israel, domestic Jewish themes and issues.

Illustration: Approached by 50 freelance illustrators/year. Works on assignment only. Features humorous, realistic, computer and spot illustration. Prefers themes of health, news, Jewish/family, Israeli issues, holidays.

First Contact & Terms: Cartoonists: Send query letter with sample cartoons. Send postcard sample or query letter with tearsheets. Samples are filed or are returned by SASE. Write for appointment to show portfolio of original/final art, tearsheets and slides. Buys first rights. Pays on publication. Pays $50, b&w; $100, color. Pays illustrators $400-600 for color cover; $100-200 for b&w inside; $200-250 for color inside; $75-100 for spots.

HARDWOOD MATTERS, National Hardwood Lumber Association, P.O. Box 34518, Memphis TN 38184-0518. (901)377-1818. Fax: (901)382-6419. Website: www.natlhardwood.org. **Editor:** Tim Bullard. Estab. 1989. Bimonthly magazine for trade association. Publication covers "forest products industry, government affairs and environmental issues. Audience is forest products members, Congress, natural resource users. Our magazine is pro-resource use, *no preservationist slant* (we fight to be able to use our private property and natural resources)." Accepts previously published artwork. Art guidelines not available.

• This publication buys one cartoon/issue at $20 (b&w). Send query letter with finished cartoons (single, double or multi-panel).

Illustration: Buys 6 illustrations/year. Prefers forestry, environment, legislative, legal themes. Considers pen & ink.

First Contact & Terms: Illustrators: Send query letter with résumé, photocopies of pen & ink work. Rights purchased vary according to project. Pays up to $200 for b&w inside.

Tips: "Our publication covers all aspects of the forest industry, and we consider ourselves good stewards

of the land and manage our forestlands in a responsible, sustainable way—submissions should follow this guideline."

HARPER'S MAGAZINE, 666 Broadway, 11th Floor, New York NY 10012. (212)420-5720. Fax: (212)228-5889. **Art Director:** Stacey D. Clarkson. Estab. 1850. Monthly 4-color literary magazine covering fiction, criticism, essays, social commentary and humor.
Illustration: Approached by 250 illustrators/year. Buys 5-10 illustrations/issue. Has featured illustrations by Steve Brodner, Ralph Steadman, Polly Becker, Edmund Guy, Mark Ulriksen, Victoria Kann, Peter de Seve. Features intelligent concept-oriented illustration. Preferred subjects: literary, artistic, social, fiction-related. Prefers intelligent, original thought and imagery in any media. Assigns 25% of illustrations to new and emerging illustrators. 10% of freelance illustration demands knowledge of Photoshop.
First Contact & Terms: Illustrators: Send nonreturnable samples. Accepts Mac-compatible disk submissions. Samples are filed and are not returned. Will contact artist for portfolio review if interested. Portfolios may be dropped off for review; call first to schedule. Buys first North American serial rights. Pays on publication; $250-300 for b&w inside; $400-1,000 for color inside; $400 for spots. Finds illustrators through samples, annuals, reps, other publications.
Tips: "Intelligence, originality and beauty in execution are what we seek. A wide range of styles is appropriate; what counts most is content."

N **☀** **HAWAII MAGAZINE**, 1210 Auahi St., #231, Honolulu HI 96814. (808)589-1515. Fax: (808)589-1616. E-mail: hawaii@fancypubs.com. **Editor:** John Hollon. Estab. 1984. Bimonthly "written for and directed to the frequent visitor and residents who travel frequently among the Hawaiian Islands. We try to encourage people to discover the vast natural beauty of these Islands." Circ. 90,000. Original artwork is returned after publication. Sample copies $3.95.
● Editor told *AGDM* he prefers artists who are familiar with Hawaii, so "please don't send samples unless you live in Hawaii."
Illustration: Buys illustrations mainly for spots and feature spreads. Buys 1-2 illustrations/issue. Works on assignment only. Considers pen & ink, airbrush, watercolor, acrylic, oil, charcoal pencil and calligraphy.
First Contact & Terms: Illustrators: Send postcard samples. Samples are not filed and are returned. Reports back about queries/submissions within 1 month. To show a portfolio mail printed samples and tearsheets. Buys first rights.

N **HEALTH FORUM INC.**, 1 N. Franklin, 28th Floor, Chicago IL 60601. (312)893-6888. **Art Directors:** Cheri Kusek (*Trustee*); Jennifer Hornberger (*Health Facilities Management* and *Health Forum Journal*); Susan Edge-Gumbel (*Materials Management & Healthcare*); Chuck Lazar (*Hospitals & Health Networks*). Estab. 1936. Publishes several trade journals for healthcare executive administrators and health networks. Affiliated with the American Hospital Association. Circ. 25,000. Accepts previously published artwork. Originals are returned at job's completion.
● This company publishes 5 different magazines; *Trustee, Health Facilities Management, Health Forum Journal, Materials Management & Healthcare*, and *Hospitals and Health Networks*.
Illustration: Approached by 25-30 illustrators/year. Buys 3-5 illustrations/issue. Works on assignment only. Has featured illustrations by Tana Powell and Whitney Sherman. Features charts & graphs; computer illustration. Assigns 15% of illustrations to new and emerging illustrators. Preferred styles vary, usually abstract and painterly; watercolor, collage, acrylic, oil and mixed media.
First Contact & Terms: Send nonreturnable samples such as postcards, query letter with SASE, tearsheets or photocopies. Samples are filed and returned by SASE if requested by artist. Responds only if interested. Buys one-time rights. **Pays on acceptance**; $1,000-1,600 for color cover; $500-800 for color inside; $200-500 for spots.

HEARTLAND BOATING MAGAZINE, 319 N. 4th St., #650, St. Louis MO 63102. (314)241-4310. Fax: (314)241-4207. Website: www.Heartlandboating.com. **Art Director:** John R. Cassady II. Estab. 1989. Specialty magazine published 9 times per year devoted to power (cruisers, houseboats) and sail boating enthusiasts throughout middle America. The content is both humorous and informative and reflects "the challenge, joy and excitement of boating on America's inland waterways." Circ. 16,000. Originals are returned at job's completion. Sample copies available for $5. Art guidelines for SASE with first-class postage.
Cartoons: Buys cartoons occasionally. Prefers boating; single panel without gaglines.

Illustration: Buys 1-2 illustrations/issue. Works on assignment only. Prefers boating-related themes. Considers pen & ink.

First Contact & Terms: Cartoonists: Send query letter with roughs. Illustrators: Send postcard sample or query letter with SASE, photocopies and tearsheets. Accepts disk submissions compatible with Illustrator 5.0. Send EPS files. Samples are filed or returned by SASE. Responds in 2 months. Portfolio review not required. Negotiates rights purchased. Pays on publication. Pay is negotiated. Finds artists through submissions.

HEARTLAND USA, 100 W. Putnam Ave., Greenwich CT 06830-5342. (203)622-3456. Fax: (203)863-7296. E-mail: husaedit@ustnet.com. **Editor:** Brad Pearson. Creative Director: Elaine Mester. Estab. 1991. Bimonthly 4-color magazine. Audience is composed of blue-collar men with a passion for hunting, fishing and the great outdoors. Circ. 1.2 million. Accepts previously published artwork. Originals are returned at job's completion. Sample copies for SASE with first-class postage.

Cartoons: Approached by 60 cartoonists/year. Buys 1-2 cartoons/issue. Preferred themes are blue-collar life-style, "simple style, light humor, nothing political or controversial"; single panel, b&w line drawings and washes with or without gagline.

Illustration: Approached by 36 illustrators/year. Buys 2 illustrations/issue. Preferred themes are blue-collar lifestyle. Prefers flexible board.

First Contact & Terms: Cartoonists: Send query letter with roughs. Illustrators: Send query letter with tearsheets. Samples are filed. Responds in 1 month. Call for appointment to show portfolio of printed samples, tearsheets and slides. Rights purchased vary according to project. Pays on publication. Pays $150 for b&w. Pays illustrators $150 for b&w or color.

N. HEAVY METAL MAGAZINE, 100 N. Village Rd., Suite 12, Rookville Center NY 11570. Website: www.metaltv.com. **Contact:** Submissions. Estab. 1977. Consumer magazine. "*Heavy Metal* is the oldest illustrated fantasy magazine in U.S. history."

• See listing in Book Publishers section.

HIGHLIGHTS FOR CHILDREN, 803 Church St., Honesdale PA 18431. (570)253-1080. Fax: (570)251-7847. Website: www.highlights.com. **Art Director:** Janet Moir McCaffrey. Cartoon Editor: Rich Wallace. Monthly 4-color magazine for ages 2-12. Circ. 3 million. Art guidelines for SASE with first-class postage.

Cartoons: Receives 20 submissions/week. Buys 2-4 cartoons/issue. Interested in upbeat, positive cartoons involving children, family life or animals; single or multiple panel. "One flaw in many submissions is that the concept or vocabulary is too adult, or that the experience necessary for its appreciation is beyond our readers. Frequently, a wordless self-explanatory cartoon is best."

Illustration: Buys 30 illustrations/issue. Works on assignment only. Prefers "realistic and stylized work; upbeat, fun, more graphic than cartoon." Pen & ink, colored pencil, watercolor, marker, cut paper and mixed media are all acceptable. Discourages work in fluorescent colors.

First Contact & Terms: Cartoonists: Send roughs or finished cartoons and SASE. Illustrators: Send query letter with photocopies, SASE and tearsheets. Samples to be kept on file. Responds in 10 weeks. Buys all rights on a work-for-hire basis. **Pays on acceptance**. Pays cartoonists $20-40 for line drawings. Pays illustrators $1,025 for color front and back covers; $50-600 for color inside. "We are always looking for good hidden pictures. We require a picture that is interesting in itself and has the objects well-hidden. Usually an artist submits pencil sketches. In no case do we pay for any preliminaries to the final hidden pictures." Hidden Pictures should be submitted to Jody Taylor.

Tips: "We have a wide variety of needs, so I would prefer to see a representative sample of an illustrator's style."

ALFRED HITCHCOCK MAGAZINE, 475 Park Ave. S., 11th Floor, New York NY 10016. (212)686-7188. Fax: (212)686-7414. **Contact:** June Levine, associate art director. Estab. 1956. Monthly b&w magazine with 4-color cover emphasizing mystery fiction. Circ. 202,470. Accepts previously published artwork. Original artwork returned at job's completion. Art guidelines available for #10 SASE with first-class postage.

Illustration: Approached by 300 illustrators/year. Buys 8-10 illustrations/issue. Prefers semi-realistic, realistic style. Works on assignment only. Considers pen & ink. Send query letter with printed samples, photocopies and/or tearsheets and SASE.

First Contact & Terms: Illustrators: Send follow-up postcard sample every 3 months. Samples are filed

or returned by SASE. Responds only if interested. "No phone calls." Portfolios may be dropped off every Tuesday and should include b&w and color tearsheets. "No original art please." Rights purchased vary according to project. **Pays on acceptance**; $1,000-1,200 for color cover; $100 for b&w inside; $35-50 for spots. Finds artists through submissions drop-offs, RSVP.

Tips: "No close-up or montages. Show characters within a background environment."

HONOLULU MAGAZINE, 1000 Bishop St., Honolulu HI 96813. (808)537-9500. Fax: (808)537-6455. E-mail: jaysonh@pacificbasin.net. Website: www.honlulumagazine.com. **Art Director:** Jayson Harper. "Monthly 4-color city/regional magazine reporting on current affairs and issues, people profiles, lifestyle. Readership is generally upper income (based on subscription). Circ. 33,000. Contemporary, clean, colorful and reader-friendly" design. Original artwork is returned after publication. Sample copies for SASE with first-class postage. Art guidelines available free for SASE.

Illustration: Buys illustrations mainly for spots and feature spreads. Buys 2-6 illustrations/issue. Has featured illustrations by Rob Barber, Dean Hayashi and Charlie Pedrina. Assigns 10% of illustrations to new and emerging illustrators. Works on assignment only. Considers any media but not pencil work.

First Contact & Terms: Illustrators: Send postcard or published sample showing art style. Looks for local subjects, conceptual abilities for abstract subjects (editorial approach)—likes a variety of techniques. Knowledge of Hawaii a must. Samples are filed or are returned only if requested with a SASE. Responds only if interested. Write to schedule an appointment to show a portfolio which should include original/final art and color and b&w tearsheets. Buys first rights or one-time rights. Pays 60 days after publication; $300-500 for cover; $100-350 for inside; $75-150 for spots. Finds artists through word of mouth, magazines, submissions, attending art exhibitions.

Tips: "Needs both feature and department illustration—best way to break in is with small spot illustration. Prefers art on Zip disk or e-mail. Friendly and professional attitude is a must. Be a very good conceptual artist, professional, fast, and, of course, a sense of humor."

HOPSCOTCH, The Magazine for Girls, Box 164, Bluffton OH 45817. (419)358-4610. Fax: (419)358-5027. Website: www.hopscotchmagazine.com. **Contact:** Marilyn Edwards. Estab. 1989. A bimonthly magazine for girls between the ages of 6 and 12; 2-color with 4-color cover; 52 pp.; 7×9 saddle-stapled. Circ. 15,000. Original artwork returned at job's completion. Sample copies available for $4. Art guidelines for SASE with first-class postage. 20% of freelance work demands computer skills.

● Also publishes *Boys' Quest*, www.boysquest.com and *Fun For Kidz*, www.funforkidz.com.

Illustration: Approached by 200-300 illustrators/year. Buys 6-7 freelance illustrations/issue. Has featured illustrations by Chris Sabatino, Pamela Harden and Donna Catanese. Features humorous, realistic and spot illustration. Assigns 40% of illustrations to new and emerging illustrators. Artists work mostly on assignment. Needs story illustration. Prefers traditional and humor; pen & ink.

First Contact & Terms: Illustrators: Send query letter with photocopies of pen & ink samples. Samples are filed. Responds in 2 months. Buys first rights and reprint rights. **Pays on acceptance**; $200-250 for color cover; $25-35 for b&w inside; $50-70 for 2-page spreads; $10-25 for spots.

Tips: "Read our magazine. Send a few samples of work in pen and ink. Everything revolves around a theme. Our theme list is available with SASE."

HORSE ILLUSTRATED, P.O. Box 6050, Mission Viejo CA 92690. (949)855-8822. E-mail: horseillustrated@fancypubs.com. Website: www.horseillustratedmagazine.com. **Managing Editor:** Elizabeth Moyer. Editor: Moira C. Harris. Estab. 1976. Monthly consumer magazine providing "information for responsible horse owners." Circ. 220,000. Originals are returned after job's completion. Art guidelines free for SASE with first-class postage.

Cartoons: Approached by 200 cartoonists/year. Buys 1 or 2 cartoons/issue. Prefers satire on horse ownership ("without the trite clichés"); single panel b&w line drawings with gagline.

Illustration: Approached by 60 illustrators/year. Buys 1 illustration/issue. Prefers realistic, mature line art, pen & ink spot illustrations of horses. Assigns 10% of illustrations to new and emerging illustrators. Considers pen & ink.

First Contact & Terms: Cartoonists: Send query letter with brochure, roughs and finished cartoons. Illustrators: Send query letter with SASE and photographs. Samples are not filed and are returned by SASE. Responds in 6 weeks. Portfolio review not required. Buys first rights or one-time rights. Pays on publication. Pays cartoonists $40 for b&w. Finds artists through submissions.

Tips: "We only use spot illustrations for breed directory and classified sections. We do not use much, but if your artwork is within our guidelines, we usually do repeat business. *Horse Illustrated* needs illustrators

who know equine anatomy, as well as human anatomy with insight into the horse world."

⊡ HORTICULTURE MAGAZINE, 98 N. Washington St., Boston MA 02114. (617)742-5600. Fax: (617)367-6364. E-mail: edit@hortmag.com. Website: www.hortmag.com. **Contact:** Linda Golon, art director. Estab. 1904. Monthly magazine for all levels of gardeners (beginners, intermediate, highly skilled). "*Horticulture* strives to inspire and instruct avid gardeners of every level." Circ. 300,000. Originals are returned at job's completion. Art guidelines are available.

Illustration: Approached by 75 freelance illustrators/year. Buys 10 illustrations/issue. Works on assignment only. Features realistic illustration; informational graphics; spot illustration. Assigns 20% of illustrations to new and emerging illustrators. Prefers tight botanicals; garden scenes with a natural sense to the clustering of plants; people; hands and "how-to" illustrations. Considers all media.

First Contact & Terms: Illustrators: Send query letter with brochure, résumé, SASE, tearsheets, slides. Samples are filed or returned by SASE. Publication will contact artist for portfolio review if interested. Buys one-time rights. Pays 1 month after project completed. Payment depends on complexity of piece; $800-1,200 for 2-page spreads; $150-250 for spots. Finds artists through word of mouth, magazines, artists' submissions/self-promotions, sourcebooks, artists' agents and reps, attending art exhibitions.

Tips: "I always go through sourcebooks and request portfolio materials if a person's work seems appropriate and is impressive."

HR MAGAZINE, 1800 Duke St., Alexandria VA 22314. (703)548-3440. Fax: (703)548-9140. E-mail: eabsher@shrm.org. Website: www.shrm.org. **Art Director:** Eva Absher. Estab. 1948. Monthly trade journal dedicated to the field of human resource management. Circ. 165,000.

Illustration: Approached by 70 illustrators/year. Buys 6-8 illustrations/issue. Prefers people, management and stylized art. Considers all media.

First Contact & Terms: Illustrators: Send query letter with printed samples. Accepts disk submissions. Illustrations can be attached to e-mails. *HR Magazine* is Macintosh based. Samples are filed. Art director will contact artist for portfolio review if interested. Rights purchased vary according to project. Requires artist to send invoice. Pays within 30 days. Pays $700-2,500 for color cover; $200-1,800 for color inside. Finds illustrators through sourcebooks, magazines, word of mouth and artist's submissions.

HUMPTY DUMPTY'S MAGAZINE, Children's Better Health Institute, Box 567, Indianapolis IN 46206. (317)636-8881. Fax: (317)684-8094. Website: www.humptydumptymag.org. **Art Director:** Rob Falco. A health-oriented children's magazine for ages 4-7; 4-color; simple and direct design. Published 6 times/year. Circ. 264,000. Originals are not returned at job's completion. Sample copies available for $1.25; art guidelines for SASE with first-class postage.

• Also publishes *Child Life, Children's Digest, Children's Playmate, Jack and Jill, Turtle Magazine* and *U.S. Kids, A Weekly Reader Magazine.*

Illustration: Approached by 300-400 illustrators/year. Buys 10-15 illustrations/issue. Has featured illustrations by John Nez, Kathryn Mitter, Alan MacBain, David Helton and Patti Goodnow. Features humorous, realistic, medical, computer and spot illustration. Assigns 10% of illustrations to new and emerging illustrators. Works on assignment only. Preferred styles are mostly cartoon and some realism. Considers any media as long as finish is done on scannable (bendable) surface.

First Contact & Terms: Illustrators: Send query letter with photocopies, tearsheets and SASE. Samples are filed and are not returned. Responds only if interested. To show a portfolio, mail color tearsheets, digital files (Mac), photostats, photographs and photocopies. Buys all rights. Pays on publication; $275 for color cover; $35-90 for b&w inside; $70-155 for color inside; $210-310 for 2-page spreads; $35-80 for spots; additional payment for digital pre-separated imagery: $35 full; $15 half; $10 spot.

Tips: "Please review our publications to see if your style is a match for our needs. Then you may send us very consistent styles of your abilities, along with a comment card and SASE for return."

HUSTLER LEG WORLD, 8484 Wilshire Blvd., Suite 900, Beverly Hills CA 90211. (323)651-5400. E-mail: legworld@lfp.com. **Art Director:** Ed Donato. Estab. 1997. Monthy magazine "which contains fiction and nonfiction; sometimes serious, often humorous. Sex is the main topic but any sensational subject is possible." Circ. 90,000. Originals returned at job's completion. Sample copies available for $12.

Illustration: Approached by 15 illustrators/year. Buys 2 illustrations/issue. Works on assignment only. Prefers foot, leg and stocking fetishes as themes. Considers all media.

First Contact & Terms: Illustrators: Send query letter with tearsheets, photographs and photocopies. Samples are filed. Artist should follow up with call and/or letter after initial query. Publication will contact

artist for portfolio review if interested. Porfolio should include b&w and color slides and final art. Buys all rights. **Pays on acceptance**; $500 for full page color inside. Finds artists through word of mouth, mailers and submissions.

Tips: "We use artists from all over the country, with diverse styles, from realistic to abstract. Must be able to deal with adult subject matter and have no reservations concerning explicit sexual images. We want to show these subjects in new and interesting ways."

HUSTLER'S BARELY LEGAL, 8484 Wilshire Blvd., Suite 900, Beverly Hills CA 90211. (323)651-5400. **Art Director:** Elizabeth Keating. Estab. 1993. Monthy magazine "which contains fiction and nonfiction; sometimes serious, often humorous. Sex is the main topic but any sensational subject is possible." Circ. 90,000. Originals returned at job's completion. Sample copies available for $6.

Illustration: Approached by 15 illustrators/year. Buys 3 illustrations/issue. Works on assignment only. Prefers sex/eroticism as themes. Considers all media.

First Contact & Terms: Illustrators: Send query letter with tearsheets, photographs and photocopies. Samples are filed. Artist should follow up with call and/or letter after initial query. Publication will contact artist for portfolio review if interested. Porfolio should include b&w and color slides and final art. Buys all rights. **Pays on acceptance**; $500 for full page color inside. Finds artists through word of mouth, mailers and submissions.

Tips: "We use artists from all over the country, with diverse styles, from realistic to abstract. Must be able to deal with adult subject matter and have no reservations concerning explicit sexual images. We want to show these subjects in new and interesting ways."

HX MAGAZINE, 230 W. 17th St., 8th Floor, New York NY 10011. (212)352-3535. Fax: (212)252-3596. E-mail: hx@hx.com. Website: www.hx.com. **Art Director:** Chris Hawkins. Weekly magazine "covering gay and lesbian general interest, entertainment and nightlife in New York City." Circ. 40,000.

Cartoons: Approached by 5 cartoonists/year. Buys 1 cartoon/issue. Prefers gay and/or lesbian themes. Prefers multiple panel, humorous b&w line drawings with gagline.

Illustration: Approached by 10 illustrators/year. Number of illustrations purchased/issue varies. Prefers gay and/or lesbian themes. Considers all media.

First Contact & Terms: Cartoonists: Send query letter with photocopies. Illustrators: Send query letter with photocopies. Samples are filed and are not returned. Responds only if interested. Art director will contact artist for portfolio review of b&w and color if interested. Rights purchased vary according to project. Pays on publication. Payment varies. Finds illustrators through submissions.

Tips: "Read and be familiar with our magazine. Our style is very specific."

IDEALS MAGAZINE, a division of Guideposts, 535 Metroplex Dr., Suite 250, Nashville TN 37211. (615)333-0478. Fax: (615)781-1447. Website: www.idealspublications.com. **Editor:** Michelle Burke. Art Director: Eve DeGrie. Estab. 1944. 4-color bimonthly seasonal general interest magazine featuring poetry and family articles. Circ. 200,000. Accepts previously published material. Sample copy $4. Art guidelines free with #10 SASE with first-class postage.

Illustration: Approached by 100 freelancers/year. Buys 8 illustrations/issue. Features realistic and spot illustration of children, families and pets. Uses freelancers mainly for flowers, plant life, wildlife, realistic people illustrations and botanical (flower) spot art. Prefers seasonal themes. Prefers watercolors. Assigns 90% of illustrations to experienced, but not well-known illustrators; 10% to new and emerging illustrators. "We are not interested in computer generated art. Must *look* as hand-drawn as possible."

First Contact & Terms: Illustrators: Send nonreturnable samples or tearsheets. Samples are filed. Responds only if interested. Do not send originals. Prefers to buy artwork outright. Pays on publication; payment negotiable.

Tips: "In submissions, target our needs as far as style is concerned, but show representative subject matter. Artists should be familiar with our magazine before submitting samples of work."

IEEE SPECTRUM, 3 Park Ave., 17th Floor, New York NY 10016-5902. (212)419-7568. Fax: (212)419-7570. Website: www.spectrum.ieee.org. **Contact:** Mark Montgomery, senior art director. Estab. 1963. Monthly nonprofit trade magazine serving electrical and electronics engineers worldwide. Circ. 320,000.

Illustration: Buys 7 illustrations/issue. Has featured illustrations by John Hersey, David Plunkert, Gene Grief, Mick Wiggins. Features caricatures of celebrities/politicians, charts & graphs, computer illustration, informational graphics, natural history illustration, realistic illustration and spot illustration. Preferred subjects: business, politics, science. Assigns 25% to new and emerging illustrators. Considers all media.

Mark Montgomery, Senior Art Director at *IEEE Spectrum*, assigned illustrator J.D. King to enliven a dry, complicated article about computers. "I thought the subject was so dry it needed some humor and spontaneity," said Montgomery. King's style, with the simple, bold shapes, and childlike cartoony characters fit the bill. King, who is represented by Gerald & Cullen Rapp, says it took a long time to develop his signature style.

First Contact & Terms: Illustrators: Send postcard sample or query letter with printed samples and tearsheets. Designers: Send query letter with tearsheets. Samples are filed and are not returned. Responds only if interested. Art director will contact artist for portfolio review if interested. Portfolio should include color, final art and tearsheets. Buys first rights and one year's use on website. **Pays on acceptance**; $1,700 minimum for cover; $450 minimum for inside. Finds illustrators through Graphic Artist Guild book, *American Showcase*, *Workbook*.

Design: Needs freelancers for design and multimedia. Local design freelancers only. 100% of freelance work demands knowledge of Photoshop, Illustrator, QuarkXPress and Quark Publishing System, as well as prior publishing experience.

Tips: "As our subject matter is varied, *Spectrum* uses a variety of illustrators. Read our magazine before sending samples"

INSIDE, 2100 Arch St., Philadelphia PA 19103. (215)832-0745. **Editor:** Robert Leiter. Estab. 1979. Quarterly. Circ. 60,000. Original artwork returned after publication.

Illustration: Buys several illustrations/issue from freelancers. Has featured illustrations by: Sam Maitin, David Noyes, Robert Grossman. Assigns 25% of work to new and emerging illustrators. Prefers color and b&w drawings. Works on assignment only.

First Contact & Terms: Illustrators: Send samples and tearsheets to be kept on file. Samples not kept on file are not returned. Call for appointment to show portfolio. Responds only if interested. Buys first rights. Pays on publication; minimum $500 for color cover; minimum $350 for b&w and color inside. Prefers to see sketches.

Tips: Finds artists through artists' promotional pieces, attending art exhibitions, artists' requests to show portfolio. "We like illustrations that are bold, edgy and hip. We are currently redesigning the magazine for a younger market (25-40 year olds)."

ISLANDS, Dept. AM, 6309 Carpinteria Ave., Carpinteria CA 93140-4728. (805)745-7100. Fax: (805)745-7102. **Art Director:** Albert Chiang. Estab. 1981. Bimonthly magazine of "international travel exclusively about islands." 4-color with contemporary design. Circ. 225,000. Original artwork returned after publication. Sample copies available. Art guidelines for SASE with first-class postage. 100% of freelance work demands knowledge of QuarkXPress, FreeHand, Illustrator and Photoshop.
Illustration: Approached by 20-30 illustrators/year. Buys 3-4 illustrations/issue. Needs editorial illustration. No theme or style preferred. Considers all media.
First Contact & Terms: Illustrators: Send query letter with brochure, tearsheets, photographs and slides. "We prefer samples of previously published tearsheets." Samples are filed. Responds only if interested. Write for appointment to show portfolio or mail printed samples and color tearsheets. Buys first rights or one-time rights. **Pays on acceptance**; $500-750 for color cover; $100-400 per image inside.
Tips: A common mistake freelancers make is that "they show too much, not focused enough. Specialize!" Notices "no real stylistic trends, but desktop publishing is affecting everything in terms of how a magazine is produced."

☑ **JACKSONVILLE**, 534 Lancaster St., Jacksonville FL 32204. (904)358-8330. E-mail: info@jacksonvillemag.com. Website: www.jacksonvillemag.com. **Creative Director:** Bronie Massey. Estab. 1983. City/regional lifestyle magazine covering Florida's First Coast. 12 times/yearly with 2 supplements. Circ. 25,000. Originals returned at job's completion. Sample copies available for $5 (includes postage).
Illustration: Approached by 50 illustrators/year. Buys 1 illustration every 6 months. Has featured illustrations by Robert McMullen, Jennifer Kalis and Liz Burns. Assigns 75% of illustrations to local experienced but not well-known illustrators; 25% to new and emerging illustrators. Prefers editorial illustration with topical themes and sophisticated style.
First Contact & Terms: Illustrators: Send tearsheets. Will accept computer-generated illustrations compatible with Macintosh programs: Illustrator and Photoshop. Samples are filed and are returned by SASE if requested. Publication will contact artist for portfolio review if interested. Portfolio should include b&w and color tearsheets and slides. Buys one-time rights. Pays on publication; $600 for color cover; $150-400 for inside depending on scope.

☑ **JAPANOPHILE**, P.O. Box 7977, 921 W. Washington St., Suite 2, Ann Arbor MI 48107. (734)930-1553. Fax: (734)930-9968. E-mail: japanophile@aol.com. Website: www.Japanophile.com. **Editor and Publisher:** Susan Aitken. Associate Editors: Madeleine Vala and Jason Bredle. Quarterly emphasizing bonsai, haiku, sports, cultural events, etc. for educated audience interested in Japanese culture. Circ. 1,000. Accepts previously published material. Original artwork returned at job's completion. Sample copy $7; art guidelines for SASE.
Cartoons: Approached by 7-8 cartoonists/year. Buys 1 cartoon/issue. Prefers single panel b&w line drawings with gagline.
Illustration: Buys 1-5 illustrations/issue. Has featured illustrations by Bob Rogers. Assigns 50% of illustrations to new and emerging illustrators. Needs humorous editorial illustration. "Will publish 2-color designs, especially for cover." Prefers sumie or line drawings.
Design: Needs freelancers for design.
First Contact & Terms: Cartoonists: Send finished cartoons. Illustrators: Send postcard sample to be kept on file if interested. Samples returned only if requested with SASE. Responds only if interested. Buys first-time rights. Pays on publication. Pays cartoonists $20-50 for b&w. Pays illustrators $20-50 for b&w cover, b&w inside and spots. Pays designers by the project, $20-50. Designers: Send query letter with brochure, photocopies, SASE, résumé.
Tips: Would like cartoon series on American foibles when confronted with Japanese culture. "Read the magazine. Tell us what you think it needs. Material that displays a unique insight into Japanese-American cultural relations draws our attention. We have redesigned our magazine and format and are looking for artists who can help us continue to improve our look."

☑ **JEMS, Journal of Emergency Medical Services**, 525 B St., Suite 1900, San Diego CA 92101. (800)266-5367. E-mail: keri.losavio@jems.com. Website: www.jems.com. **Senior Editor:** Keri Losavio. Estab. 1980. Monthly trade journal aimed at paramedics/paramedic instructors. Circ. 45,000. Accepts

previously published artwork. Originals returned at job's completion. Sample copies available. Art guidelines for SASE. 95% of freelance work demands knowledge of QuarkXPress, Illustrator and Photoshop.
Illustration: Approached by 240 illustrators/year. Has featured illustrations by Brook Wainwright, Chris Murphy and Shayne Davidson. Buys 2-6 illustrations/issue. Works on assignment only. Prefers medical as well as general editorial illustration. Considers pen & ink, airbrush, colored pencil, mixed media, collage, watercolor, acrylic, oil and marker.
First Contact & Terms: Illustrators: Send postcard sample or query letter with photocopies. Accepts disk submissions compatible with most current versions of Illustrator or Photoshop. Samples are filed and are not returned. Portfolio review not required. Publication will contact artist for portfolio review of final art, tearsheets and printed samples if interested. Rights purchased vary according to project. Pays on publication. Pays $150-400 for color, $10-25 for b&w inside; $25 for spots. Finds artists through directories, agents, direct mail campaigns.
Tips: "Review magazine samples before submitting. We have had the most mutual success with illustrators who can complete work within one to two weeks and send finals in computer format. We use black & white and four-color medical illustrations on a regular basis."

JEWISH ACTION, 11 Broadway, New York NY 10004. (212)613-8146. Fax: (212)613-0646. E-mail: ja@ou.org. Website: www.ou.org. **Editor:** Nechama Carmel. Art Director: Ed Hamway. Estab. 1986. Quarterly magazine "published by Orthodox Union for members and subscribers. Orthodox Jewish contemporary issues." Circ. 25,000. Sample copies available for 9×12 SASE and $1.75 postage or can be seen on website.
Cartoons: Approached by 2 cartoonists/year. Prefers themes relevant to Jewish issues. Prefers single, double or multiple panel, political, humorous b&w washes and line drawings with or without gaglines.
Illustration: Approached by 4-5 illustrators. Considers all media. Assigns 50% of illustrations to experienced, but not well-known illustrators; 50% to new and emerging illustrators. Knowledge of Photoshop, Illustrator and QuarkXPress "not absolutely necessary, but preferred."
Design: Needs freelancers for design and production. Prefers local design freelancers only.
First Contact & Terms: Cartoonists: Send query letter with photocopies and SASE. Illlustrators: Send query letter with photocopies and SASE. Accepts disk submissions. Prefer QuarkXPress TIFF or EPS files. Can send ZIP disk. Samples are not filed and are not returned. Responds only if interested. Art director will contact artist for portfolio review of photographs if interested. Buys one-time rights. Pays within 6 weeks of publication. Pays cartoonists $20-50 for b&w. Pays illustrators $25-75 for b&w, $50-300 for color cover; $50-200 for b&w, $25-150 for color inside. Finds illustrators through submissions.
Tips: Looking for "sensitivity to Orthodox Jewish traditions and symbols."

JOURNAL OF ACCOUNTANCY, AICPA, Harborside 201 Plaza III, Jersey City NJ 07311. (201)938-3450. **Art Director:** Jeryl Ann Costello. Monthly 4-color magazine emphasizing accounting for certified public accountants; corporate/business format. Circ. 360,000. Accepts previously published artwork. Original artwork returned after publication.
Illustration: Approached by 200 illustrators/year. Buys 2-6 illustrations/issue. Prefers business, finance and law themes. Accepts mixed media, then pen & ink, airbrush, colored pencil, watercolor, acrylic, oil, pastel and digital. Works on assignment only. 35% of freelance work demands knowledge of Illustrator, QuarkXPress and FreeHand.
First Contact & Terms: Illustrators: Send query letter with brochure showing art style. Samples not filed are returned by SASE. Portfolio should include printed samples, color and b&w tearsheets. Buys first rights. Pays on publication; $1,200 for color cover; $200-600 for color (depending on size) inside. Finds artists through submissions/self-promotions, sourcebooks and magazines.
Tips: "I look for indications that an artist can turn the ordinary into something extraordinary, whether it be through concept or style. In addition to illustrators, I also hire freelancers to do charts and graphs. In portfolios, I like to see tearsheets showing how the art and editorial worked together."

JOURNAL OF ASIAN MARTIAL ARTS, 821 W. 24th St., Erie PA 16502-2523. (814)455-9517. Fax: (814)455-2726. E-mail: info@goviamedia.com. Website: www.goviamedia.com. **Publisher:** Michael A. DeMarco. Estab. 1991. Quarterly journal covering all historical and cultural aspects of Asian martial arts. Interdisciplinary approach. College-level audience. Circ. 12,000. Accepts previously published artwork. Sample copies available for $10. Art guidelines for SASE with first-class postage.
Illustration: Buys 60 illustrations/issue. Has featured illustrations by Oscar Ratti, Tony LaMotta and Michael Lane. Features realistic and medical illustration. Assigns 10% of illustrations to new and emerging

illustrators. Prefers b&w wash; brush-like Oriental style; line. Considers pen & ink, watercolor, collage, airbrush, marker and charcoal.

First Contact & Terms: Illustrators: Send query letter with brochure, résumé, SASE and photocopies. Accepts disk submissions compatible with PageMaker, QuarkXPress and Illustrator. Samples are filed. Responds in 6 weels. Publication will contact artist for portfolio review if interested. Portfolio should include b&w roughs, photocopies and final art. Buys first rights and reprint rights. Pays on publication; $100-300 for color cover; $10-100 for b&w inside; $100-150 for 2-page spreads.

Tips: "Usually artists hear about or see our journal. We can be found in bookstores, libraries, or in listings of publications. Areas most open to freelancers are illustrations of historic warriors, weapons, castles, battles—any subject dealing with the martial arts of Asia. If artists appreciate aspects of Asian martial arts and/or Asian culture, we would appreciate seeing their work and discuss the possibilities of collaboration."

JUDICATURE, 180 N. Michigan Ave., Suite 600, Chicago IL 60601-7401. E-mail: drichert@ajs.org. Website: www.ajs.org. **Contact:** David Richert. Estab. 1917. Journal of the American Judicature Society. 4-color bimonthly publication. Circ. 8,000. Accepts previously published material and computer illustration. Original artwork returned after publication. Sample copy for SASE with $1.47 postage; art guidelines not available.

Cartoons: Approached by 10 cartoonists/year. Buys 1-2 cartoons/issue. Interested in "sophisticated humor revealing a familiarity with legal issues, the courts and the administration of justice."

Illustration: Approached by 20 illustrators/year. Buys 1-2 illustrations/issue. Has featured illustrations by Estelle Carol, Mary Chaney, Jerry Warshaw and Richard Laurent. Features humorous and realistic illustration; charts & graphs; computer and spot illustration. Works on assignment only. Interested in styles from "realism to light humor." Prefers subjects related to court organization, operations and personnel. Freelance work demands knowledge of PageMaker and FreeHand.

Design: Needs freelancers for design. 100% of freelance work demands knowledge of PageMaker and FreeHand.

First Contact & Terms: Cartoonists: Send query letter with samples of style and SASE. Responds in 2 weeks. Illustrators: Send query letter, SASE, photocopies, tearsheets or brochure showing art style. Publication will contact artist for portfolio review if interested. Portfolio should include roughs and printed samples. Wants to see "black & white and color, along with the title and synopsis of editorial material the illustration accompanied." Buys one-time rights. Negotiates payment. Pays cartoonists $35 for unsolicited b&w cartoons. Pays illustrators $250-375 for 2-, 3- or 4-color cover; $250 for b&w full page, $175 for b&w half page inside; $75-100 for spots. Pays designers by the project.

Tips: "Show a variety of samples, including printed pieces and roughs."

KALEIDOSCOPE: Exploring the Experience of Disability through Literature and the Fine Arts, 701 S. Main St., Akron OH 44311-1019. (330)762-9755. E-mail: mshiplett@udsakron.org. Website: www.udsakron.org. **Senior Editor:** Gail Willmott. Estab. 1979. Black & white with 4-color cover. Semiannual. "Elegant, straightforward design. Explores the experiences of disability through lens of the creative arts. Specifically seeking work by artists with disabilities. Work by artists without disabilities must have a disability focus." Circ. 1,500. Accepts previously published artwork. Sample copy $6; art guidelines for SASE with first-class postage.

Illustration: Freelance art occasionally used with fiction pieces. More interested in publishing art that stands on its own as the focal point of an article. Approached by 15-20 artists/year. Has featured illustrations by Dennis J. Brizendine, Deborah Vidaver Cohen and Sandy Palmer. Features humorous, realistic and spot illustration.

First Contact & Terms: Illustrators: Send query letter with résumé, photocopies, photographs, SASE and slides. Do not send originals. Prefers high contrast, b&w glossy photos, but will also review color photos or 35mm slides. Include sufficient postage for return of work. Samples are not filed. Publication will contact artist for portfolio review if interested. Acceptance or rejection may take up to a year. Pays $25-100 for color covers; $10-25 for b&w or color insides. Rights return to artist upon publication. Finds artists through submissions/self-promotions and word of mouth.

Tips: "Inquire about future themes of upcoming issues. Considers all mediums, from pastels to acrylics to sculpture. Must be high-quality art."

☑ **KALLIOPE, a journal of women's literature and art**, 11901 Beach Blvd., Jacksonville FL 32246. (904)646-2346. Website: www.fccj.org/kalliope. **Editor:** Mary Sue Koeppel. Estab. 1978. Literary b&w biannual which publishes an average of 27 pages of art by women in each issue. "Publishes poetry, fiction,

reviews, and visual art by women and about women's concerns; high-quality art reproductions; visually interesting design." Circ. 1,600. Accepts previously published "fine" artwork. Original artwork is returned at the job's completion. Sample copy for $7. Art guidelines available for SASE with first-class postage.
Cartoons: Approached by 1 cartoonist/year. Has featured art by Aimee Young Jackson, Kathy Keler, Lise Metzger. Topics should relate to women's issues.
Illustration: Approached by 35 fine artists/year. Buys 27 photos of fine art/issue. Looking for "excellence in fine visual art by women (nothing pornographic)."
First Contact & Terms: Cartoonists: Send query letter with roughs. Illustrators: Send query letter with résumé, SASE, photographs (b&w glossies) and artist's statement (50-75 words). Samples are not filed and are returned by SASE. Responds in 2 months. Rights acquired vary according to project. Pays 1 year subscription or 2 complimentary copies for b&w cover or inside.
Tips: "Please study recent issues of *Kalliope*."

N ✠ KANSAS CITY MAGAZINE, 118 Southwest Blvd., Suite 600, Kansas City MO 64108. (816)421-4111. Fax: (816)221-8350. **Contact:** Jennifer Tanous, art director. Estab. 1994. Monthly lifestyle-oriented magazine, celebrating living in Kansas City. "We try to look at things from a little different angle (for added interest) and show the city through the eyes of the people." Circ. 27,000. Sample copies available for #10 SASE with first-class postage. Art guidelines not available.
Illustration: Approached by 100-200 illustrators/year. Buys 3-5 illustrations/issue. Works on assignment only. Prefers conceptual editorial style. Considers all media. 25% of freelance illustration demands knowledge of Illustrator and Photoshop.
Design: Needs freelancers for design and production. Prefers local freelancers only. 100% of freelance work demands knowledge of Photoshop, Illustrator and QuarkXPress.
First Contact & Terms: Illustrators: Send postcard-size sample or query letter with tearsheets, photocopies and printed samples. Designers: Send query letter with printed samples, photocopies, SASE and tearsheets. Accepts disk submissions compatible with Macintosh files (EPS, TIFF, Photoshop, etc.). Samples are filed. Will contact artist for portfolio review if interested. Portfolio should include final art, photographs, tearsheets, photocopies and photostats. Buys reprint rights. **Pays on acceptance**; $500-800 for color cover; $50-200 for b&w, $150-300 for color inside. Pays $50-150 for spots. Finds artists through sourcebooks, word of mouth, submissions.
Tips: "We have a high quality, clean, cultural, creative format. Look at magazine before you submit."

N KASHRUS MAGAZINE—The Periodical for the Kosher Consumer, Box 204, Brooklyn NY 11204. (718)336-8544. Fax: (718)336-8550. Website: www.kashrus.com. **Editor:** Rabbi Yosef Wikler. Estab. 1980. Bimonthly magazine with 4-color cover which updates consumer and trade on issues involving the kosher food industry, especially mislabeling, new products and food technology. Circ. 10,000. Accepts previously published artwork. Original artwork is returned after publication. Sample copy $2; art guidelines not available.
Cartoons: Buys 2 cartoons/issue. Accepts color for cover or special pages. Seeks "kosher food and Jewish humor."
Illustration: Buys illustrations mainly for covers. Works on assignment only. Has featured illustrations by R. Keith Rugg and Theresa McCracken. Features humorous, realistic and spot illustration. Assigns 30% of illustrations to new and emerging illustrators. Prefers pen & ink.
First Contact & Terms: Send query letter with photocopies. Responds in 7 days. Request portfolio review in original query. Portfolio should include tearsheets and photostats. Pays cartoonists $25-35 for b&w; payment is negotiated by project. Pays illustrators $100-200 for color cover; $25-75 for b&w inside; $75-150 for color inside; $25-35 for spots. Finds artists through submissions and self-promotions.
Tips: "Send general food or Jewish food- and travel-related material. Do not send off-color material."

KEYNOTER, Kiwanis International, 3636 Woodview Trace, Indianapolis IN 46268. (317)875-8755. **Executive Editor:** Amy Wiser. Art Director: Laura Houser. Official publication of Key Club International, nonprofit high school service organization. 4-color; "contemporary design for mature teenage audience." Published 7 times/year. Circ. 170,000. Previously published, photocopied and simultaneous submissions OK. Original artwork returned after publication. Free sample copy with SASE and 65¢ postage.
Illustration: Buys 3 editorial illustrations/issue. Works on assignment only.
First Contact & Terms: Include SASE. Responds in 2 weeks. "Freelancers should call our Production and Art Department for interview." Buys first rights. **Pays on receipt of invoice**; $500 for b&w, $1,000 for color cover; $200 for b&w, $700 for color, inside.

KIPLINGER'S PERSONAL FINANCE, 1729 H St. NW, Washington DC 20006. (202)887-6416. Fax: (202)331-1206. E-mail: ccurrie@kiplinger.com. Website: www.kiplinger.com. **Art Director:** Cynthia L. Currie. Estab. 1947. A monthly 4-color magazine covering personal finance issues including investing, saving, housing, cars, health, retirement, taxes and insurance. Circ. 1 million. Originals are returned at job's completion.

Illustration: Approached by 350 illustrators/year. Buys 10-15 illustrations/issue. Works on assignment only. Has featured illustrations by Gregory Manchess, Tim Bower, Edwin Fotheringham. Features computer, humorous, conceptual editorial and spot illustration. Prefers business subjects. Assigns 10% of illustrations to new and emerging illustrators. Looking for original conceptual art. Interested in editorial illustration in new styles, including computer illustration.

First Contact & Terms: Illustration: Send postcard samples. Accepts Mac-compatible disk submissions. Samples are filed or returned by SASE if requested by artist. Publication will contact artist for portfolio review if interested. Portfolio should include tearsheets. Buys one-time rights. Pays on publication; $400-1,200 for color inside; $250-500 for spots. Finds illustrators through reps, online, magazines, *Workbook* and award books.

Tips: "Send us high-caliber original work that shows creative solutions to common themes. Send postcards regularly. If they're good, they'll get noticed. A fresh technique, combined with a thought-out image will intrigue art directors and readers alike. We strive to have a balance of seriousness and wit throughout."

KIWANIS, 3636 Woodview Trace, Indianapolis IN 46268. (317)875-8755. Fax: (317)879-0204. E-mail: kiwanismail@kiwanis.org. **Managing Editor:** Jack Brockley. Art Director: Laura Houser. Estab. 1918. 4-color magazine emphasizing civic and social betterment, business, education and domestic affairs for business and professional persons. Published 10 times/year. Original artwork returned after publication by request. Art guidelines available for SASE with first-class postage.

Illustration: Buys 0-2 illustrations/issue. Assigns themes that correspond to themes of articles. Works on assignment only. Keeps material on file after in-person contact with artist.

First Contact & Terms: Illustration: Include SASE. Responds in 2 weeks. To show a portfolio, mail appropriate materials (out of town/state) or call or write for appointment. Portfolio should include roughs, printed samples, final reproduction/product, color and b&w tearsheets, photostats and photographs. Buys first rights. **Pays on acceptance**; $600-1,000 for cover; $400-800 for inside; $50-75 for spots. Finds artists through talent sourcebooks, references/word-of-mouth and portfolio reviews.

Tips: "We deal direct—no reps. Have plenty of samples, particularly those that can be left with us. Too many student or unassigned illustrations in many portfolios."

LADYBUG, the Magazine for Young Children, Box 300, Peru IL 61354. **Art Director:** Suzanne Beck. Estab. 1990. Monthly 4-color magazine emphasizing children's literature and activities for children, ages 2-6. Design is "geared toward maximum legibility of text and basically art-driven." Circ. 140,000. Accepts previously published material. Original artwork returned after publication. Sample copy $4.95 plus 10% of total order ($4 minimum) for shipping and handling; art guidelines for SASE with first class postage.

Illustration: Approached by 600-700 illustrators/year. Works with 40 illustrators/year. Buys 200 illustrations/year. Has featured illustrations by Rosemary Wells, Tomie de Paola and Diane de Groat. Uses artists mainly for cover and interior illustration. Prefers realistic styles (animal, wildlife or human figure); occasionally accepts caricature. Works on assignment only.

First Contact & Terms: Illustrators: Send query letter with photocopies, photographs and tearsheets to be kept on file, "if I like it." Prefers photocopies and tearsheets as samples. Samples are returned by SASE if requested. Publication will contact artist for portfolio review if interested. Portfolio should show a strong personal style and include "several pieces that show an ability to tell a continuing story or narrative." Does not want to see "overly slick, cute commercial art (i.e., licensed characters and overly sentimental greeting cards)." Buys all rights. **Pays 45 days after acceptance**; $750 for color cover; $250 for color full page; $100 for color, $50 for b&w spots.

Tips: "Has a need for artists who can accurately and attractively illustrate the movements for finger-rhymes and songs and basic informative features on nature and 'the world around you.' Multi-ethnic portrayal is also a *very* important factor in the art for *Ladybug*."

LAW PRACTICE MANAGEMENT, 24476 N. Echo Lake Rd., Hawthorn Woods IL 60047-9039. (847)550-9790. Fax: (847)550-9794. Website: www.abanet.org/lpm. **Art Director:** Mark Feldman, Feldman Communications, Inc. E-mail: mark@feldcomm.com. 4-color trade journal for the practicing lawyer

about "the business of practicing law." Estab. 1975. Published 8 times/year. Circ. 20,833.

Illustration: Uses cover and inside feature illustrations. Uses all media, including computer graphics. Mostly 4-color artwork.

First Contact & Terms: Illustrators: Send postcard sample or query letter with samples. Pays on publication. Very interested in high quality, previously published works. Pay rates: $200-350/illustration. Original works negotiable. Cartoons very rarely used.

Tips: "There's an increasing need for artwork to illustrate high-tech articles on technology in the law office. (We have two or more such articles each issue.) We're especially interested in computer graphics for such articles. Recently redesigned to use more illustration on covers and with features. Topics focus on management, marketing, communications and technology."

N ✷ ✲ LETHBRIDGE LIVING MAGAZINE, Box 22005, Henderson Post Office, Lethbridge AB T1K 2W4 Canada. (403)329-1008. Fax: (403)329-0268. **Contact:** Martin Oordt, owner/editor. Estab. 1994. Quarterly consumer magazine that features people and their lives in Southwestern Alberta. Circ. 15,000. Sample copies available on request. Art guidelines available.

Cartoons: Approached by 1 cartoonist/year. Buys 4-6 cartoons/year. Prefers illustration of stories. Prefers single panel, humorous color washes.

Illustration: Approached by 2 illustrators/year. Buys 4-6 illustrations/year. Features humorous illustration, spot illustrations, literary. Features illustrations of children, families, men, women, teens. Assigns 15% to new and emerging illustrators. Freelance artists should be familiar with Illustrator, InDesign, Photoshop and QuarkXPress.

First Contact & Terms: Cartoonists/illustrators: Send query letter with photocopies, photographs, résumé (color only). After introductory mailing, send follow-up postcard sample every 6 months. Accepts e-mail submissions with image file. Prefers Mac-compatible, TIFF files. Samples are not filed but are returned by e-mail or SASE. Responds in 2 weeks. Portfolio should include color roughs. Pays cartoonists/ illustrators $75 minimum for color cartoons. Pays on publication. Buys electronic rights. Finds freelancers through artists' submissions.

Tips: "It will be a challenge to fit into our magazine as we're very locale oriented."

LISTEN MAGAZINE, 55 W. Oak Ridge Dr., Hagerstown MD 21740. (301)393-4010. E-mail: listen@hea lthconnection.org. **Editor:** Anita Jacobs. Monthly magazine (September-May) for teens with specific aim to educate against alcohol, tobacco and other drugs and to encourage positive life choices. Circ. 30,000. Accepts previously published artwork. Originals returned at job's completion. Sample copies available for $1. Art guidelines for SASE with first-class postage.

Cartoons: Buys occasional cartoons. Prefers single panel b&w washes and line drawings.

Illustration: Approached by 50 illustrators/year. Buys 6 illustrations/issue. Has featured illustrations by Perry Stewart and Rick Thomson. Works on assignment only. Considers all media.

First Contact & Terms: Cartoonists: Send query letter with brochure and roughs. Illustrators: Send postcard sample or query letter with brochure, résumé and tearsheets. Accepts submissions on disk. Samples are filed or are returned by SASE. Responds only if interested. Publication will contact artist for portfolio review if interested. Buys reprint rights. **Pays on acceptance**. No longer uses illustrations for covers.

THE LOOKOUT, 8121 Hamilton Ave., Cincinnati OH 45231. (513)931-4050. Fax: (513)931-0950. E-mail: lookout@standardpub.com. Website: www.standardpub.com. **Administrative Assistant:** Sheryl Overstreet. Weekly 4-color magazine for conservative Christian adults and young adults. Circ. 100,000. Sample copy available for $1.

Cartoons: Prefers cartoons on family life and religious/church life; mostly single panel. Has featured illustrations by Dik Lapine, Steve Phelps and Jonny Hawkins.

Illustration: Prefers humorous, stylish illustrations featuring Christian families.

First Contact & Terms: Cartoonists: Send photocopies of cartoons. Illustrators: Send postcard or other nonreturnable samples. Pays cartoonists $50 for b&w.

Tips: Do not send e-mail submissions.

LYNX EYE, 542 Mitchell Dr., Los Osos CA 93402. (805)528-8146. Fax: (805)528-7876. E-mail: pamccull y@aol.com. **Co-Editor:** Pam McCully. Estab. 1994. Quarterly b&w literary magazine. Circ. 500.

Cartoons: Approached by 100 cartoonists/year. Buys 10 cartoons/year. Prefers sophisticated humor. Prefers single panel, political and humorous b&w washes or line drawings.

Illustration: Approached by 100 illustrators/year. Buys 20 illustrations/issue. Has featured illustrations

by Wayne Hogan, Greg Kidd and Michael Greenstein. Features humorous, natural history, realistic or spot illustrations. Prefers b&w work that stands alone as a piece of art—does not illustrate story/poem. Assigns 100% of illustrations to new and emerging illustrators, as well as to experienced, but not well-known illustrators.

First Contact & Terms: Cartoonists: Send b&w photocopies and SASE. Illustrators: Send query letter with photocopies and SASE. Samples are not filed and are returned by SASE. Responds in 3 months. Will contact artist for portfolio review if interested. Buys first North American serial rights. **Pays on acceptance**. Pays $10 for b&w plus 3 copies.

Tips: "We are always in need of artwork. Please note that your work is considered an individual piece of art and does not illustrate a story or poem."

MAD MAGAZINE, 1700 Broadway, New York NY 10019. (212)506-4850. Fax: (212)506-4848. Website: www.madmag.com. **Art Director:** Sam Viviano. Associate Art Director: Nadina Simon. Assistant Art Director: Patricia Dwyer. Monthly irreverent humor, parody and satire magazine. Estab. 1952. Circ. 250,000.

Illustration: Approached by 300 illustrators/year. Works with 50 illustrators/year. Has featured illustrations by Jack Davis, Paul Coker, Tom Bunk. Features humor, realism, caricature.

First Contact & Terms: Illustrators: Send query letter with tearsheets and SASE. Samples are filed. Portfolios may be dropped off every Wednesday and can be picked up same day 4:30-5:00 p.m. Buys all rights. Pays $2,500-3,200 for color cover; $400-725 for inside. Finds illustrators through direct mail, sourcebooks (all).

Design: Uses local freelancers for design infrequently. 100% of freelance design demands knowledge of Illustrator, Photoshop and QuarkXPress.

Tips: "Know what we do! *MAD* is very specific. Everyone wants to work for *MAD*, but few are right for what *MAD* needs! Understand reproduction process, as well as 'give-and-take' between artist and client."

MAIN LINE TODAY, 4699 W. Chester Pike, Newtown Business Center, Newtown Square PA 19703. (610)325-4630. Fax: (610)325-4636. **Art Director:** Ingrid Hansen-Lynch. Estab. 1996. Monthly consumer magazine providing quality information to the Main Line and western surburbs of Philadelphia. Sample copies for #10 SASE with first-class postage.

Illustration: Approached by 100 illustrators/year. Buys 3-5 illustrations/issue. Considers acrylic, charcoal, collage, color washed, mixed media, oil, pastel and watercolor.

First Contact & Terms: Send postcard sample or query letter with printed samples and tearsheets. Send follow-up postcard sample every 3-4 months. Samples are filed and are not returned. Responds only if interested. Buys one-time and reprint rights. Pays on publication; $400 maximum for color cover; $125-250 for b&w inside; $125-250 for color inside. Pays $125 for spots. Finds illustrators by word of mouth and submissions.

MANAGED CARE, 780 Township Line Rd., Yardley PA 19067. (267)685-2788. Fax: (267)685-2966. Website: www.managedcaremag.com. **Art Director:** Philip Denlinger. Estab. 1992. Monthly trade publication for healthcare executives. Circ. 60,000.

Illustration: Approached by 50 illustrators/year. Buys 3 illustrations/issue. Has featured illustrations by Theo Rudnak, David Wilcox, Gary Overacre, Roger Hill. Features informational graphics, realistic and spot illustration. Prefers business subjects. Assignments for illustrations divided equally between well-known or name illustrators; experienced, but not well-known, illustrators; and new and emerging illustrators.

First Contact & Terms: Send postcard sample. Samples are filed. Will contact artist for portfolio review if interested. Rights purchased vary according to project. **Pays on acceptance**; $1,500-2,000 for color cover; $250-750 for color inside; $450 for spots. Finds illustrators through *American Showcase* and postcards.

MASSAGE MAGAZINE, 200 7th Ave. #240, Santa Cruz CA 95062-4628. (831)477-1176. Fax: (831)477-2918. Website: www.massagemag.com. **Art Director:** Karen Menehan. Estab. 1986. Bimonthly trade magazine for practitioners and their clients in the therapeutic massage and allied healing arts and sciences (acupuncture, aromatherapy, chiropractic, etc.) Circ. 45,000. Art guidelines not available.

Illlustration: Not approached by enough illustrators/year. Buys 6-10 illustrations/year. Features medical illustration representing mind/body/spirit healing. Assigns 100% of illustrations to experienced, but not well-known illustrators. Themes or style range from full color spiritually-moving to business-like line art. Considers all media. All art must be scanable.

First Contact & Terms: Send postcard sample and query letter with printed samples or photocopies. Accepts disk-submitted artwork done in Freehand or Photoshop for use in QuarkXPress 4.0. Responds only if interested. Rights purchased vary according to project. Pays on publication; $75-200 for inside color illustration. Finds illustrators through word of mouth and artist's submissions.

Tips: "I'm looking for quick, talented artists, with an interest in the healing arts and sciences."

MB MEDIA, (formerly *Magical Blend*), 133½ Broadway, Chico CA 95928. (530)893-9037. Fax: (530)893-9076. E-mail: artdept@magicalblend.com. Website: www.magicalblend.com. **Art Director:** René Schmidt. Estab. 1980. Bimonthly 4-color magazine emphasizing spiritual exploration, transformation and visionary arts; eclectic design. Circ. 100,000. Original artwork returned after publication. Sample copy $5; art guidelines by SASE.

Illustration: Works with 20 illustrators/year. Uses 65 illustrations/year. Has featured illustrations by Gage Taylor and Alex Grey. Assigns 10% of illustrations to new and emerging illustrators. Also publishes portfolios on individual or group of artists each issue. "We keep samples on file and work by editorial fit according to the artists style and content. We prefer eye-friendly and well executed color work. We look for pieces with a positive, inspiring, uplifting feeling."

First Contact & Terms: Illustrators: Send photographs, slides and SASE. Responds in 6 months if interested. Buys first North American serial rights. Pays in copies, subscriptions, and possibly ad space. Will print contact information with artwork if desired by artist.

Tips: "We want work that is energetic and thoughtful that has a hopeful outlook on the future. Our page size is 8×10¾. We like to print quality art by people who have talent, but don't fit into any category and are usually unpublished. Have technical skill, be unique, show a range of styles; don't expect to get rich from us, 'cuz we sure aren't! Be persistent."

METRO PULSE, 505 Market St., Suite 300, Knoxville TN 37902. (865)522-5399, ext. 21. Fax: (865)522-2955. E-mail: james@metropulse.com. Website: www.metropulse.com. **Art Director:** Martha Shepp-Jones. Estab. 1985. Weekly, 4-color, b&w, alternative news magazine for Knoxville, TN. Circ. 30,000.

Illustration: Approached by 150. Buys 2 illustrations/issue. Features humorous, spot, computer and editorial illustrations. Subject matter varies. Assigns 20% of illustrations to new and emerging illustrators. 10% of freelance illustration demands knowledge of Photoshop. No real need for computer knowledge, but it's helpful to send work digitally.

First Contact & Terms: Illustrators: Send postcard sample or tearsheets. Accepts Mac-compatible disk submissions. Send JPEG, TIFF files. Samples are filed and are not returned. Responds only if interested. Portfolio review not required. Will contact artist for portfolio review if interested. Buys first rights or one-time rights. Pays on publication. Need approval/sketch stage before finished art is purchased. Kill fee is half of normal fee. Pays illustrators $200-400 for b&w cover; $200-400 for color cover; $50-150 for b&w inside; $50-150 for color inside. Finds illustrators through magazines and promo samples.

Tips: "We look for editorial illustrators with a unique style; we never use realistic styles. I'm mostly looking for savvy interpretors of editorial content."

MICHIGAN OUT OF DOORS, Box 30235, Lansing MI 48909. (517)371-1041. Fax: (517)371-1505. E-mail: magazine@mucc.org. Website: www.mucc.org. **Contact:** Dennis C. Knickerbocker. 4-color magazine emphasizing outdoor recreation, especially hunting and fishing, conservation and environmental affairs. Circ. 100,000. "Conventional" design. Art guidelines available free for SASE. Sample copy $3.50.

Illustration: "Following the various hunting and fishing seasons we have a limited need for illustration material; we consider submissions 6-8 months in advance." Has featured illustrations by Ed Sutton and Nick Van Frankenhuyzen. Assigns 10% of illustrations to new and emerging illustrators.

First Contact & Terms: Responds as soon as possible. **Pays on acceptance**; $30 for pen & ink illustrations in a vertical treatment.

MICROSOFT CERTIFIED PROFESSIONAL MAGAZINE, 9121 Oakdale Ave., Suite 101, Chatsworth CA 91311. (818)734-1520. Fax: (818)734-1526. E-mail: mseibert@101com.com. Website: www.mcpmag.com. **Art Director:** Michele Seibert. Estab. 1993. Monthly 4-color trade publication for Windows NT/2000 professionals. Circ. 125,000.

Illustration: Approached by 1-2 illustrators/year. Features charts & graphs, informational graphics, spot illustrations and computer illustration of business subjects. Has featured illustrations by Bob Daly and Mark Betcher. Assigns 50% of illustrations to experienced, but not well-known illustrators; 50% to new and emerging illustrators.

First Contact & Terms: Accepts Mac-compatible disk submissions. Samples are filed. Responds in 1 month. Portfolio review not required. Buys all rights. Pays $500 for spots.

Tips: Art director looks for "something unique or different—the wierder, the better."

MID-AMERICAN REVIEW, English Dept., Bowling Green State University, Bowling Green OH 43403. (419)372-2725. Website: www.bgsu.edu/midamericanreview. **Contact:** Editor-in-Chief. Estab. 1980. Twice yearly literary magazine publishing "the best contemporary poetry, fiction, essays, and work in translation we can find. Each issue includes poems in their original language and in English." Circ. 700. Originals are returned at job's completion. Sample copies available for $5.

Illustration: Approached by 10-20 illustrators/year. Buys 1 illustration/issue.

First Contact & Terms: Send query letter with brochure, SASE, tearsheets, photographs and photocopies. Samples are filed or are returned by SASE if requested by artist. Responds in 3 months. Buys first rights. Pays on publication. Pays $50 when funding permits. Also pays in copies, up to 20.

Tips: "*MAR* only publishes artwork on its cover. We like to use the same artist for one volume (two issues). We are looking for full-color artwork for a front-to-back, full bleed effect. Visit our website!"

MODERN DRUMMER, 12 Old Bridge Rd., Cedar Grove NJ 07009. (201)239-4140. **Editor-in-Chief:** Ronald Spagnardi. Art Director: Scott Bienstock. Monthly magazine for drummers, "all ages and levels of playing ability with varied interests within the field of drumming." Circ. 103,000. Previously published work OK. Original artwork returned after publication. Sample copy for $4.99.

Cartoons: Buys 10-12 cartoons/year. Interested in drumming themes; single and double panel. Prefers finished cartoons or roughs.

First Contact & Terms: Include SASE. Responds in 3 weeks. Buys first North American serial rights. Pays on publication; $100.

Tips: "We want strictly drummer-oriented gags."

☑ **MODERN PLASTICS**, 110 William St., 11th Floor, New York NY 10038. (212)621-4653. Fax: (212)621-4685. Website: www.modplas.com. **Art Director:** Larry E. Matthews. Monthly trade journal emphasizing technical articles for manufacturers of plastic parts and machinery; 4-color with contemporary design. Circ. 65,000 domestic, 35,000 international. 20% of freelance work demands knowledge of Illustrator, QuarkXPress or FreeHand.

Illustration: Works with 4 illustrators/year. Buys 6 illustrations/year. Prefers airbrush, computer and conceptual art. Works on assignment only.

First Contact & Terms: Illustrators: Send brochure. Samples are filed. Does not reply. Call for appointment to show a portfolio of tearsheets, photographs, slides, color and b&w. Buys all rights. **Pays on acceptance**; $800-1,000 for color cover; $200-250 for color inside.

Tips: "I get a lot of stuff that is way off track—aliens, guys with heads cut off, etc. We need technical and computer graphics that's appropriate."

N **MOM GUESS WHAT NEWSPAPER**, 1725 L St., Sacramento CA 95814. (916)441-6397. E-mail: info@mgwnews.com. Website: www.mgwnews.com. **Publisher/Editor:** Linda Birner. Estab. 1978. Weekly newspaper "for gays/lesbians." Circ. 21,000. Sample copies for 10×13 SASE and 4 first-class stamps. Art guidelines for #10 SASE with first-class postage.

Cartoons: Approached by 15 cartoonists/year. Buys 5 cartoons/issue. Prefers gay/lesbian themes. Prefers single and multiple panel political, humorous b&w line drawings with gagline.
Pays cartoonists $5-50 for b&w.

Illustration: Approached by 10 illustrators/year. Buys 3 illustrations/issue. Has featured illustrations by Andy Markley and Tim Brown. Features caricatures of celebrities; humorous, realistic and spot illustration. Assigns 50% of illustration to new and emerging illustrators. Prefers gay/lesbian themes. Considers pen & ink. 50% of freelance illustration demands knowledge of PageMaker.

Design: Needs freelancers for design and production. Prefers local design freelancers. 100% of freelance work demands knowledge of PageMaker 6.5, QuarkXPress, Photoshop, Freehand, InDesign.

First Contact & Terms: Cartoonists: Send query letter with photocopies and SASE. Illustrators: Send query letter with photocopies. Send query letter with photocopies, phone art director. Art director will contact artist for portfolio review of b&w photostats if interested. Rights purchased vary according to project. Pays on publication; $100 for b&w or color cover; $10-100 for b&w or color inside; $300 for 2-page spreads; $25 for spots. Finds illustrators through word or mouth and artist's submissions.

Tips: "Send us copies of your ideas that relate to gays/lesbians issues, serious and humorous."

⊞ **MONTANA MAGAZINE**, P.O. Box 5630, Helena MT 59604. (406)443-2842. Fax: (406)443-5480. Website: www.montanamagazine.com. **Editor:** Beverly R. Magley. Estab. 1970. Bimonthly magazine covering Montana recreation, history, people, wildlife. Geared to Montanans. Circ. 40,000.

Illustration: Approached by 15-20 illustrators/year. Buys 1-2 illustrations/year. Prefers outdoors. Considers all media. Knowledge of Quark, Photoshop, Illustrator helpful but not required. Send query letter with photocopies. Accepts disk submissions combatible with Quark.

First Contact & Terms: Illustrators: Send EPS files. Samples are filed and are not returned. Buys one-time rights. Pays on publication; $35-50 for b&w; $50-125 for color. Pays $35-50 for spots. Finds illustrators through submissions, word of mouth.

Tips: "We work with local artists usually because of convenience and turnaround." No cartoons.

☑ **MOTHERING MAGAZINE**, % Linda Johnson, 1532-A Paseo de Peralta, Santa Fe NM 87501. (505)989-8460. Website: www.mothering.com. **Contact:** Linda Johnson, designer. Estab. 1976. Consumer magazine focusing on natural family living, and natural/alternative practices in parenting. Circ. 75,000. Sample copies and art guidelines available.

• This magazine is art directed by Swell Design, an outside design firm.

Illustration: Knowledge of Photoshop 5, QuarkXPress 4.1 helpful, but not required. Send query letter and/or postcard sample. We will accept work compatible with QuarkXPress 4.1 for Power Mac.

First Contact & Terms: Illustrators: Send EPS files. Samples are filed. Responds only if interested. Buys first rights. Pays on publication; $500 maximum for cover; $275-450 for inside. Payment for spots depends on size. Finds illustrators through submissions, sourcebooks, magazines, word of mouth.

Tips: "Become familiar with tone and subject matter (mothers and babies) of our magazine."

🅽 **MOTORING ROAD**®, P.O. Box M, Franklin MA 02038. (508)528-6211. Fax: (508)528-6211. **Contact:** Jay Kruza, editor. Estab. 2001. Bimonthly trade publication of automotive news affecting New England dealers, bodyshops, garages, mechanics and gas stations. Circ. 11,000. Sample copies available with SASE.

Cartoons: Buys 24 cartoons/year. Prefers positive or corrective styles/themes. Prefers single panel, humorous, b&w washes and drawings.

Illustration: Buys 6-12 illustrations/year. Features caricatures of celebrities/politicians, charts & graphs, computer illustration and informational graphics. Assigns 50% to new and emerging illustrators.

🔲 **MUSCLEMAG INTERNATIONAL**, 5775 McLaughlin Rd., Mississauga, ON L5R 3P7 Canada. (905)507-3545. **Contact:** Robert Kennedy. Estab. 1974. Monthly consumer magazine. Magazine emphasizes bodybuilding for men and women. Circ. 300,000. Originals returned at job's completion. Sample copies available for $5; art guidelines not available.

Cartoons: "We are interested in acquiring a cartoonist to produce one full-page cartoon each month.

Illustration: Approached by 200 illustrators/year. Buys 130 illustrations/year. Has featured illustrations by Eric Blais and Gino Edwards. Features caricatures of celebrities; charts & graphs; humorous, medical and computer illustrations. Assigns 20% of illustrations to new and emerging illustrators. Prefers bodybuilding themes. Considers all media.

First Contact & Terms: Cartoonists: Send photocopy of your work." Illustrators: Send query letter with photocopies. Samples are filed. Responds in 1 month. Portfolio review not required. Buys all rights. **Pays on acceptance**. Pays cartoonists $50-100. Pays illustrators $100-150 for b&w inside; $250-1,000 for color inside. "Higher pay for high-quality work." Finds artists through "submissions from artists who see our magazine."

Tips: Needs line drawings of bodybuilders exercising. "Study the publication: work to improve by studying others. Don't send out poor quality stuff. It wastes editor's time."

MUSHING, P.O. Box 149, Ester AK 99725-0149. (907)479-0454. Fax: (907)479-3137. E-mail: editor@m ushing.com. Website: www.mushing.com. **Publisher:** Todd Hoener. Estab. 1988. Bimonthly "year-round, international magazine for all dog-powered sports, from sledding to skijoring to weight pulling to carting to packing. We seek to educate and entertain." Circ. 10,000. Photo/art originals are returned at job's completion. Sample copies available for $5. Art guidelines available upon request.

Cartoons: Approached by 20 cartoonists/year. Buys up to 1 cartoon/issue. Prefers humorous cartoons; single panel b&w line drawings with gagline.

Illustration: Approached by 20 illustrators/year. Buys 0-1 illustrations/issue. Prefers simple; healthy,

happy sled dogs; some silhouettes. Considers pen & ink and charcoal. Send query letter with SASE and photocopies. Accepts disk submissions if Mac compatible.

First Contact & Terms: Cartoonists: Send query letter with roughs. Illustrators: Send EPS or TIFF files with hardcopy. Samples are returned by SASE if requested by artist. Prefers to keep copies of possibilities on file and use as needed. Responds in 6 months. Portfolio review not required. Buys first rights and reprint rights. Pays on publication. Pays cartoonists $25 for b&w and color. Pays illustrators $150 for color cover; $25 for b&w and color inside; $25 for spots. Finds artists through submissions.

Tips: "Be familiar with sled dogs and sled dog sports. We're most open to using freelance illustrations with articles on dog behavior, adventure stories, health and nutrition. Illustrations should be faithful and/ or accurate to the sport. Cartoons should be faithful and tasteful (e.g., not inhumane to dogs)."

MY FRIEND, The Catholic Magazine for Kids, 50 St. Paul's Ave., Boston MA 02130-3491. (617)522-8911. Fax: (617)541-9805. E-mail: design@pauline.org. Website: www.myfriendmagazine.org. **Graphic Design Dept. Director of Operations:** Sister Helen Rita Lane, fsp. Estab. 1979. Monthly Catholic magazine for kids, 4-color cover, containing information, entertainment, and Christian information for young people ages 6-12. Circ. 11,000. Originals returned at job's completion. Sample copies free for 9 × 12 SASE with first-class postage; art guidelines available for SASE with $1.29 postage.

Illustration: Approached by 60 illustrators/year. Buys 6 illustrations/issue; 60/year. Works on assignment only. Has featured illustrations by Mary Rojas, Chris Ware, Larry Nolte, and Bob Berry. Features realistic illustration; informational graphics; spot illustration. Assigns 10% of illustrations to new and emerging illustrators. Prefers humorous, realistic portrayals of children. Considers pen & ink, watercolor, airbrush, acrylic, marker, colored pencil, oil, charcoal, mixed media and pastel.

Design: Needs freelancers for design, production and multimedia projects. Design demands knowledge of PageMaker, Illustrator and Photoshop.

First Contact & Terms: Illustrators: Send query letter with résumé, SASE, tearsheets, photocopies. Designers: Send query letter with résumé, photocopies and tearsheets. Accepts disk submissions compatible with Windows/Mac OS, PageMaker 6.5, Illustrator, Photoshop. Send TIFF or EPS files. Samples are filed or are returned by SASE if requested by artist. Responds within 2 months only if interested. Portfolio review not required. Rights purchased vary according to project. Pays on publication; $175 for color 2-page spread; $125 for color single page spread, $75 for color half page. Pays designers by project.

THE MYSTERY REVIEW, P.O. Box 233, Colborne, ON K0K 1S0 Canada. (613)475-4440. Fax: (613)475-3400. E-mail: mystrev@reach.net. Website: www.TheMysteryReview.com. **Editor:** Barbara Davey. Estab. 1992. Quarterly literary magazine "for mystery readers." Circ. 6,000.

Illustration: Send query letter with photocopies and SASE. Asks that disk submissions be compatible with PageMaker 6.0 version for Windows."

First Contact & Terms: Illustrators: Samples are filed. Responds only if interested. Negotiates rights purchased. Pays on publication; $50 maximum for b&w cover; $20 maximum for b&w inside. Finds illustrators through artist's submissions.

Tips: "Take a look at our magazine—it's in bookstores."

NA'AMAT WOMAN, 350 Fifth Ave., Suite 4700, New York NY 10118. (212)563-5222. Fax: (212)563-5710. E-mail: judith@naamat.org. **Editor:** Judith Sokoloff. Estab. 1926. Jewish women's magazine published 4 times yearly, covering a wide variety of topics that are of interest to the Jewish community, affiliated with NA'AMAT USA (a nonprofit organization). Originals are returned at job's completion. Sample copies available for $1.

Cartoons: Approached by 5 cartoonists/year. Buys 4-5 cartoons/year. Prefers political cartoons; single panel b&w line drawings.

Illustration: Approached by 20 illustrators/year. Buys 1-3 illustrations/issue. Has featured illustrations by Julie Delton, Miriam Katin and Ilene Winn-Lederer. Works on assignment only. Considers pen & ink, collage, marker and charcoal.

First Contact & Terms: Cartoonists: Send query letter with brochure and finished cartoons. Illustrators: Send query letter with tearsheets. Samples are filed or are returned by SASE if requested by artist. Responds to the artist only if interested. Publication will contact artist for portfolio review if interested. Portfolio should include b&w tearsheets and final art. Rights purchased vary according to project. Pays on publication. Pays cartoonists $50 for b&w.

Pays illustrators $150-200 for b&w cover; $50-75 for b&w inside. Finds artists through sourcebooks, publications, word of mouth, submissions.

Tips: "Give us a try! We're small, but nice."

NAILS, 21061 S. Western Ave., Torrance CA 90501-1711. (310)533-2400. Fax: (310)533-2504. Website: www.nailsmag.com. **Art Director:** Liza Samala. Estab. 1983. Monthly (*Nails*) and bimonthly (*Bella*) 4-color trade journals; "seeks to educate readers on new techniques and products, nail anatomy and health, customer relations, chemical safety, salon sanitation and business." Circ. 57,000. Originals can be returned at job's completion. Sample copies available. Art guidelines vary. Needs computer-literate freelancers for design, illustration and production. 100% of freelance work demands knowledge of QuarkXPress, Illustrator or Photoshop.
Illustration: Buys 3 illustrations/issue. Works on assignment only. Needs editorial and technical illustration; charts and story art. Prefers "fashion-oriented styles." Interested in all media.
First Contact & Terms: Illustrators: Send query letter with brochure and tearsheets. Samples are filed. Responds in 1 month or artist should follow-up with call. Call for an appointment to show a portfolio of tearsheets and transparencies. Buys all rights. **Pays on acceptance**; $200-500 (depending on size of job) for b&w and color inside. Finds artists through self-promotion and word of mouth.

THE NATION, 33 Irving Pl., 8th Floor, New York NY 10003. (212)209-5400. Fax: (212)982-9000. Production-ext. 5421. E-mail: sbrower@printmag.com. Website: www.thenation.com. **Art Director:** Steven Brower. Estab. 1865. A weekly journal of "left/liberal political opinion, covering national and international affairs, literature and culture." Circ. 100,000. Originals are returned after publication upon request. Sample copies available. Art guidelines not available.
● *The Nation*'s art director works out of his design studio at Steven Brower Design. You can send samples to *The Nation* and they will be forwarded. Steven is also A.D. for *Print*.
Illustration: Approached by 50 illustrators/year. Buys 3-4 illustrations/issue. Works with 25 illustrators/year. Has featured illustrations by Robert Grossman, Luba Lukora, Igor Kopelnitsky and Karen Caldecott. Buys illustrations mainly for spots and feature spreads. Works on assignment only. Considers pen & ink, airbrush, mixed media and charcoal pencil; b&w only.
First Contact & Terms: Illustrators: Send query letter with tearsheets and photocopies. "On top of a defined style, artist must have a strong and original political sensibility." Samples are filed or are returned by SASE. Responds only if interested. Buys first rights. Pays $75-125 for b&w inside; $150 for color inside.

▣ **NATIONAL GEOGRAPHIC**, 17th and M Streets NW, Washington DC 20036. (202)857-7000. Website: www.nationalgeographic.com. **Art Director:** Chris Sloan. Estab. 1888. Monthly. Circ. 9 million. Original artwork returned 1 year after publication, but *National Geographic* owns the copyright.
● *National Geographic* receives up to 30 inquiries a day from freelancers. They report most are not appropriate to their needs. Please make sure you have studied several issues before you submit. They have a roster of artists they work with on a regular basis, and it's difficult to break in, but if they like your samples they will file them for consideration for future assignments.
Illustration: Works with 20 illustrators/year. Contracts 50 illustrations/year. Interested in "full-color renderings of historical and scientific subjects. Nothing that can be photographed is illustrated by artwork. No decorative, design material. We want scientific geological cut-aways, maps, historical paintings, prehistoric scenes." Works on assignment only.
First Contact & Terms: Illustrators: Send color copies, postcards, tearsheets, proofs or other appropriate samples. Art director will contact for portfolio review if interested. Samples are returned by SASE. **Pays on acceptance**; varies according to project.
Tips: "Do your homework before submitting to any magazine. We only use historical and scientific illustrations, ones that are very informative and very accurate. No decorative, abstract, or portraits."

NATIONAL REVIEW, 215 Lexington Ave., New York NY 10016. (212)679-7330. Website: www.nationalreview.com. **Art Director:** Luba Myts. Emphasizes world events from a conservative viewpoint; bimonthly b&w with 4-color cover, design is "straight forward—the creativity comes out in the illustrations used." Originals are returned after publication. Uses freelancers mainly for illustrations of articles and book reviews, also covers. Circ. 162,091.
Cartoons: Buys 6 cartoons/issue. Interested in "light political, social commentary on the conservative side."
Illustration: Buys 6-7 illustrations/issue. Especially needs b&w ink illustration, portraits of political figures and conceptual editorial art (b&w line plus halftone work). "I look for a strong graphic style; well-

developed ideas and well-executed drawings." Style of Tim Bower, Jennifer Lawson, Janet Ham/
Nahigian. Works on assignment only.
First Contact & Terms: Cartoonists: Send appropriate samples and SASE. Responds in 2 week/
tors: Send query letter with brochure showing art style or tearsheets and photocopies. No sampl/
Responds to future assignment possibilities. Call for an appointment to show portfolio of fir/
reproduction/product and b&w tearsheets. Include SASE. Buys first North American serial rights. Pays /
publication. Pays cartoonists $50 for b&w. Pays illustrators $100 for b&w inside; $750 for color cover.
Tips: "Tearsheets and mailers are helpful in remembering an artist's work. Artists ought to make sure
their work is professional in quality, idea and execution. Recent printed samples alongside originals help.
Changes in art and design in our field include fine art influence and use of more halftone illustration." A
common mistake freelancers make in presenting their work is "not having a distinct style, i.e., they have
a cross sample of too many different approaches to rendering their work. This leaves me questioning what
kind of artwork I am going to get when I assign a piece."

NATURE CONSERVANCY, 4245 N. Fairfax Dr., #100, Arlington VA 22203-1606. Fax: (703)841-
9692. E-mail: mrowe@tnc.org. Website: www.nature.org. **Art Director:** Miya Su Rowe. Estab. 1951.
Quarterly membership magazine of nonprofit conservation organization. "The intent of the magazine is to
educate readers about broad conservation issues as well as to inform them about the Conservancy's specific
accomplishments. The magazine is achievement-oriented without glossing over problems, creating a gener-
ally positive tone. The magazine is rooted in the Conservancy's work and should be lively, engaging and
readable by a lay audience." Sample copies available.
Illustration: Approached by 100 illustrators/year. Buys 1-5 illustrations/issue. Considers all media. 10%
of freelance illustration demands knowledge of Photoshop and/or Illustrator.
First Contact & Terms: Illustrators: Send query letter with photocopies and tearsheets. Samples are
sometimes filed and are not returned. Responds only if interested. Rights purchased vary according to
project. **Pays on acceptance**. Payment varies. Finds illustrators through sourcebooks, magazines and sub-
missions.

NERVE COWBOY, P.O. Box 4973, Austin TX 78765-4973. **Editors:** Joseph Shields and Jerry Hagins.
Art Director: Mary Gallo. Estab. 1995. Biannual b&w literary journal of poetry, short fiction and b&w
artwork. Sample copies for $5 postpaid. Art guidelines free for #10 SASE with first-class postage.
Illustration: Approached by 200 illustrators/year. Buys work from 10 illustrators/issue. Has featured
illustrations by Amanda Rehagen, Jill Goodman and Johnny Hawkins. Features unusual illustration and
creative b&w images. Prefers b&w. "Color will be considered if a b&w half-tone can reasonably be created
from the piece." Assigns 40% of illustrations to new and emerging illustrators.
First Contact & Terms: Illustrators: Send printed samples, photocopies with a SASE. Samples are
returned by SASE. Responds in 3 months. Portfolio review not required. Buys first North American serial
rights. Pays on publication; 3 copies of issue in which art appears on cover; or 1 copy if art appears inside.
Tips: "We are always looking for new artists with an unusual view of the world."

NEVADA, 401 N. Carson St., #100, Carson City NV 89701. (775)687-0600. Fax: (775)687-6159. Website:
www.nevadamagazine.com. Estab. 1936. Bimonthly magazine "founded to promote tourism in Nevada."
Features Nevada artists, history, recreation, photography, gaming. Traditional, 3-column layout with large
(coffee table type) 4-color photos. Circ. 80,000. Accepts previously published artwork. Originals are re-
turned to artist at job's completion. Sample copies for $3.50. Art guidelines available.
Illustration: Approached by 25 illustrators/year. Buys 2 illustrations/issue. Works on assignment only.
First Contact & Terms: Illustrators: Send query letter with brochure, résumé and slides. Samples are
filed. Responds in 2 months. To show portfolio, mail 20 slides and bio. Buys one-time rights. Pays $35
minimum for inside illustrations.

N: NEW LETTERS, University House, 5101 Rockhill Rd., University of Missouri, Kansas City MO
64110. (816)235-1168. Fax: (816)235-2611. E-mail: newletters@umkc.edu. Website: www.umkc.edu/news
letters. **Contact:** Robert Stewart, editor. Quarterly "innovative" literary magazine with an international
scope; b&w with 2-color cover.
Illustration: Has featured illustrations by Charlie Podrebarac, Charles Barsotti, Lucy Masterman, Eliza-
beth Layton. Uses camera-ready spot drawings, line drawings and washes; "any medium that will translate
well to the 6×9 b&w printed page." Preferred subjects: business, politics, issues of writing and humorous
illustrations. Also needs cover designs.

First Contact & Terms: Submit art. Must include SASE for return of work. Responds in 2 months. Buys all rights. Pays cartoonists $5-15 for b&w. Pays illustrators $5-20 for b&w cover.

Tips: "Artwork does not necessarily need to relate to content, but it does need to be skillful, provocative, unique and memorable."

☑ **NEW MOON: THE MAGAZINE FOR GIRLS AND THEIR DREAMS**, 34 E. Superior St., #200, Duluth MN 55802. (218)728-5507. Fax: (218)728-0314. E-mail: girl@newmoon.org. Website: www. newmoon.org. **Managing Editor:** Deb Mylin. Estab. 1992. Bimonthly 4-color cover, 2-color inside consumer magazine. Circ. 30,000. Sample copies are $6.50.

Illustration: Buys 3-4 illustrations/issue. Has featured illustrations by Neverne Covington, Tricia Tusa, Julie Paschkis, Amanda Harvey. Features realistic illustrations, informational graphics and spot illustrations of children, women and girls. Prefers b&w, ink. Assigns 30% of illustrations to new and emerging illustrators.

First Contact & Terms: Illustrators: Send postcard sample or other nonreturnable samples. Final work can be submitted on disk or as original artwork. Send EPS files at 300 dpi or greater, hi-res. Samples are filed. Responds only if interested. Portfolio review not required. Buys one-time rights. Pays on publication; $400 maximum for color cover; $75 maximum for b&w inside. Finds illustrators through *Illustration Workbook*, samples and *PictureBook*.

Tips: "Be very familiar with the magazine and our mission. We are a magazine for girls ages 8-14 and look for illustrators who portray people of all different shapes, sizes, and ethnicities in their work. Women cover artists only. Men and women are welcome to submit black & white samples for inside. Send a 9×11 SASE for cover art guidelines."

Ⓝ THE NEW PHYSICIAN, 1902 Association Dr., Reston VA 20191. (703)620-6600, ext. 246. **Art Director:** Julie Cherry. For physicians-in-training; concerns primary medical care, political and social issues relating to medicine; 4-color, contemporary design. Published 9 times/year. Circ. 28,000. Original artwork returned after publication. Buys one-time rights. Pays on publication.

Illustration: Approached by 200-300 illustrators/year. Buys 3 illustrations/issue from freelancers.

First Contact & Terms: Illustrators: Samples are filed. Submit samples of style. Accepts disk submissions compatible with QuarkXPress 4.0, Illustrator 8, Photoshop 6. Send EPS files. Responds in 2 months. Buys one-time rights. Pays $900-1,100 for color cover; $275 minimum for inside.

the new renaissance, 26 Heath Rd., Apt. 11, Arlington MA 02174-3645. E-mail: umichaud@gwi.net. **Editor:** Louise T. Reynolds. Co-editor/Art Editor: Michal Anne Kuchauki. Estab. 1968. Biannual (spring and fall) magazine emphasizing literature, arts and opinion for "the general, literate public"; b&w with 4-color cover, 6×9. Circ. 1,400. Originals are only returned after publication if SASE is enclosed. Sample copy available for $6.50. Recent issue $11.50 add $1.50 foreign.

Cartoons: Approached by 35-45 freelance artists/year. Cartoons used only every 4-5 issues, not every issue.

Illustration: Buys 6-8 illustrations/issue from freelancers and "occasional supplementary artwork (2-4 pages)" mainly on assignment. Has featured illustrations by Phoebe McKay and Barry Nolan. Features expressive, realistic illustrations and symbolism. Assigns 25% or more illustrations to new and emerging illustrators.

First Contact & Terms: Illustrators: Send résumé, samples, photos and SASE. DO NOT send postcards. Responds in 4 months. Publication will contact artist for portfolio review if interested, "but only if artist has enclosed SASE." Portfolio should include roughs, b&w photographs and SASE. Buys one-time rights. Pays after publication. Pays $15-30 for b&w plus 1 copy. Pays illustrators $25-30 for b&w inside; $18-25 for drop-in art.

Tips: "Buy a back issue to see if your work fits in with our mission. We like realistic or symbolic, expressionistic interpretations. Only interested in b&w. We want artists who understand a 'quality' (or 'serious' or 'literary') piece of fiction. Study our past illustrations. We are receiving work that is appropriate for a newsletter, newsprint, or alternative-press magazines, but not for us. We will consider only work that is submitted with a SASE."

NEW WRITER'S MAGAZINE, Box 5976, Sarasota FL 34277. Phone/fax: (941)953-7903. E-mail: newriters@aol.com. Website: www.newriters.com. **Editor/Publisher:** George J. Haborak. Estab. 1986. Bimonthly b&w magazine. Forum "where all writers can exchange thoughts, ideas and their own writing. It is focused on the needs of the aspiring or new writer." Rarely accepts previously published artwork.

Original artwork returned after publication if requested. Sample copies for $3; art guidelines for SASE with first-class postage.

Cartoons: Approached by 15 cartoonists/year. Buys 1-3 cartoons/issue. Features spot illustration. Assigns 80% of illustrations to new and emerging illustrators. Prefers cartoons "that reflect the joys or frustrations of being a writer/author"; single panel b&w line drawings with gagline.

Illustration: Buys 1 illustration/issue. Works on assignment only. Prefers line drawings. Considers watercolor, mixed media, colored pencil and pastel.

First Contact & Terms: Cartoonists: Send query letter with samples of style. Illustrators: Send postcard sample. Samples are filed or returned if requested by SASE. Responds in 1 month. To show portfolio, mail tearsheets. Buys first rights or negotiates rights purchased. Pays on publication. Pays cartoonists $10 for b&w. Pays illustrators $10 for spots. Payment negotiated.

N NEW YORK ACADEMY OF SCIENCES UPDATE, 2 E. 63rd St., New York NY 10021. Fax: (212)838-5226. E-mail: dvanatta@nyas.org. Website: www.nyas.org. **Contact:** Dan Van Atta, manager, print communications. Estab. 2001. Newsletter of science and health related articles for members of nonprofit New York Academy of Sciences. Circ. 25,000. Sample copies are available with SASE. Guidelines not available.

Illustration: Buys 4-5 illustrations/year. Features science/health related charts & graphs, computer illustration, informational graphics, realistic illustration, medical illustration, spot illustrations. Assigns 2% of illustration to new and emerging illustrators. 80% of freelance illustration demands knowledge of QuarkXPress, Photoshop.

First Contact & Terms: Send query letter with photographs, résumé, SASE and slides. Accepts e-mail submissions with TIFF image file. Samples are not filed but returned by SASE. Responds only if interested. Company will contact artist for portfolio review if interested. Pays illustrators $600 maximum. Pays on publication. Buys electronic rights, reprint rights. Rights purchased vary according to project. Finds freelancers through sourcebooks and word-of-mouth.

Tips: "We are nonprofit, working on tight budgets, and rarely purchase original illustrations. We sometimes receive works by well-known illustrators—such as Marshall Arisman, little at or no cost to the Academy. We sometimes purchase medical illustrations or stock photography that relates to or creates added interest in articles on various developments in science and medicine."

THE NEW YORKER, 4 Times Square, New York NY 10036. (212)286-5400. Fax: (212)286-5445. E-mail (cartoons): toon@cartoonbank.com. Website: www.cartoonbank.com. Emphasizes news analysis and lifestyle features.

Cartoons: Buys b&w cartoons. Receives 3,000 cartoons/week. Cartoon editor is Bob Mankoff, who also runs Cartoon Bank, a stock cartoon agency that features *New Yorker* cartoons.

Illustration: All illustrations are commissioned. Portfolios may be dropped off Wednesdays between 10-6 and picked up on Thursdays.

First Contact & Terms: Cartoonists: Accepts unsolicited submissions only by mail. Reviews unsolicited submissions every 1-2 weeks. Photocopies only. Strict standards regarding style, technique, plausibility of drawing. Especially looks for originality. Pays $575 minimum for cartoons. Contact cartoon editor. Illustrators: Mail samples, no originals. "Because of volume of submissions we are unable to respond to all submissions." No calls please. Emphasis on portraiture. Contact illustration department.

Tips: "Familiarize yourself with *The New Yorker*."

NEWSWEEK, 251 W. 57th St., 15th Floor, New York NY 10019. (212)445-4000. Website: www.newsweek.com. **Art Directors:** Amid Capeci and Alexander Ha. Assistant Managing Editor/Design: Lynn Staley. Weekly news magazine. Circ. 3,180,000. Has featured illustrations by Daniel Adel and Zohar Lozar.

Illustration: Prefers illustrations or situations in national and international news.

First Contact & Terms: Illustrators: Send postcard samples or other nonreturnable samples. Portfolios may be dropped off at front desk Tuesday or Wednesday from 9 to 5. Call ahead.

N NORTH AMERICAN HUNTER/NORTH AMERICAN FISHERMAN, 12301 Whitewater Dr., #260, Minnetonka MN 55343-4103. (952)936-9333. Fax: (952)352-7001. Website: www.huntingclub.com. **Art Director:** Mark Simpson. Estab. 1978 (*N.A. Hunter*) and 1988 (*N.A. Fisherman*). Bimonthly consumer magazines. *North American Hunter* and *Fisherman* are the official publications of the North American Hunting Club and the North American Fishing Club. Circ. 700,000 and 500,000. Accepts previously published artwork. Originals are returned at job's completion. Sample copies available. Art guidelines for

SASE with first-class postage. Needs computer-literate freelancers for illustration. 20% of freelance work demands computer knowledge of Illustrator, QuarkXPress, Photoshop or FreeHand.

• This publisher also publishes *Cooking Pleasures* (circ. 300,000) and *Gardening How-to* (circ. 500,000).

Cartoons: Approached by 20 cartoonists/year. Buys 3 cartoons/issue. Prefers humorous work portraying outdoorsmen in positive image; single panel b&w washes and line drawings with or without gagline.

Illustration: Approached by 40 illustrators/year. Buys 3 illustrations/issue. Prefers illustrations that portray wildlife and hunting and fishing in an accurate and positive manner. Considers pen & ink, watercolor, airbrush, acrylic, colored pencil, oil, charcoal, mixed media and pastel.

First Contact & Terms: Cartoonists: Send query letter with brochure. Illustrators: Send query letter with brochure, tearsheets, résumé, photographs and slides. Samples are filed. Does not reply. Portfolio review not required. Rights purchased vary according to project. **Pays on acceptance**.

THE NORTH AMERICAN REVIEW, University of Northern Iowa, Cedar Falls IA 50614. (319)273-6455. Fax: (319)273-4326. E-mail: nar@2edu. Website: webdelsol.com/NorthAmReview/NAR/. **Art Directors:** Osie L. Johnson, Jr. and Gary Kelly. Estab. 1815. "General interest bimonthly, especially known for fiction (twice winner of National Magazine Award for fiction)." Accepts previously published work. Original artwork returned at job's completion. "Sample copies can be purchased on newsstand or examined in libraries."

• The NAR is the oldest literary magazine in America, and continues to be one of the most respected. It's known for the creativity and excellence of its illustration and layouts.

Illustration: Approached by 500 freelance artists/year. Buys 15 freelance illustrations/issue. Artists primarily work on assignment. Looks for "well-designed illustrations in any style. We prefer to use b&w media for illustrations reproduced in b&w and color for those reproduced in color. We prefer camera ready line art for spot illustrations."

First Contact & Terms: Illustrators: Send postcard samples, color photocopies or other nonreturnable samples. Please send no more than 5 pieces. Samples are filed if of interest or returned by SASE if requested by artist. Responds to the artist only if interested. No portfolio reviews. Buys one-time rights. Contributors receive 2 copies of the issue. Pays on publication $300 for color cover plus 50 tearsheets of cover only; $10 for b&w inside spot illustrations; $65 for b&w large illustration. No color inside.

Tips: "Send b&w photocopies of spot illustrations (printed size about 2×2). For the most part, our color covers and major b&w inside illustrations are obtained by direct assignment from illustrators we contact, e.g., Gary Kelley, Osie Johnson, Chris Payne, Skip Liepke and others. Write for guidelines for annual cover competition."

NORTH CAROLINA LITERARY REVIEW, English Dept., East Carolina University, Greenville NC 27858-4353. E-mail: bauerm@mail.ecu.edu. **Editor:** Margaret Bauer. Estab. 1992. Annual literary magazine of art, literature, culture having to do with NC. Circ. 500. Samples available for $10 and $15; art guidelines for SASE with first-class postage or e-mail address. NC artists/art only.

Illustration: Considers all media.

First Contact & Terms: Illustrators: Send postcard sample or send query letter with printed samples, SASE and tearsheets. Send follow-up postcard sample every 2 months. Samples are not filed and are returned by SASE. Responds in 2 months. Art director will contact artist for portfolio review of b&w, color slides and transparencies if interested. Rights purchased vary according to projects. Pays on publication; $100-250 for cover; $50-250 for inside. Pays $25 for spots. Finds illustrators through magazines and word of mouth.

Tips: "Read our magazine."

THE NORTHERN LOGGER & TIMBER PROCESSOR, Northeastern Loggers Association, Inc., Box 69, Old Forge NY 13420. (315)369-3078. **Editor:** Eric A. Johnson. Trade publication ($8\frac{1}{2} \times 11$) with an emphasis on education. Focuses on methods, machinery and manufacturing as related to forestry. For loggers, timberland managers and processors of primary forest products. Monthly b&w with 4-color cover. Circ. 13,000. Previously published material OK. Free sample copy and guidelines available.

Cartoons: Buys 1 cartoon/issue. Receives 1 submission/week. Interested in "any cartoons involving forest industry situations."

First Contact & Terms: Cartoonists: Send finished cartoons with SASE. Responds in 1 week. **Pays on acceptance**. Pays cartoonists $20 for b&w line drawings. Pays $20 for b&w cover.

Tips: "Keep it simple and pertinent to the subjects we cover. Also, keep in mind that on-the-job safety is an issue we like to promote."

NOTRE DAME MAGAZINE, 535 Grace Hall, Notre Dame IN 46556. (574)631-4630. Website: www.N D.EDU/~NDMAG. **Art Director:** Don Nelson. Estab. 1971. Quarterly 4-color university magazine that publishes essays on cultural, spiritual and ethical topics, as well as news of the university for Notre Dame alumni and friends. Circ. 155,000. Accepts previously published artwork. Original artwork returned after publication.

Illustration: Approached by 40 illustrators/year. Buys 5-8 illustrations/issue. Has featured illustrations by Steve Madson, Joe Ciardiello, Mark Fisher and Terry Lacy. Assigns 10% of illustrations to new and emerging illustrators. Works on assignment only. Tearsheets, photographs, slides, brochures and photocopies OK for samples. Samples are returned by SASE if requested. "Don't send submissions—only tearsheets or samples." Buys first rights.

Tips: "Looking for noncommercial style editorial art by accomplished, experienced editorial artists. Conceptual imagery that reflects the artist's awareness of fine art ideas and methods is the kind of thing we use. Sports action illustrations not used. Cartoons not used. Create images that can communicate ideas."

◼ NOVA EXPRESS, P.O. Box 27231, Austin TX 78755. E-mail: lawrence@io.com. Website: www.io. com/~lawrence/nova.html. **Editor:** Lawrence Person. Estab. 1987. B&w literary zine featuring cutting-edge science fiction, fantasy, horror and slipstream. Circ. 550.

Illustration: Approached by 75 illustrators/year. Buys 10-15 illustrations/issue. Has featured illustrations by GAK, Tim Powers, Angela Mark, Steven Sanders, Michael Csontos, Cathy Burburuz, Bill D. Fountain, Phil Yeh, Keith Burdak. Features science fiction, fantasy, horror, spot illustrations. Requires b&w. Assigns 50% of illustrations to experienced, but not well-known illustrators; 50% to new and emerging illustrators.

First Contact & Terms: Illustrators: Send nonreturnable samples. Accepts CD-ROM submissions. Samples are filed. Responds in 3 months. Portfolio review not required. Buys one-time rights. Pays on publication in copies and subscription only. Finds illustrators online.

Tips: "We only publish artwork connected to the SF/F/H metagenre (though sometimes we find abstract or futuristic designs useable). However, we do not want clichéd SF/F themes (i.e., Gernsbackian rocket ships, unicorns, elves, or any other generic fantasy or horror). Solid work and originality are always welcome. We only use b&w illustrations, so don't send color samples. Though not a paying market, *Nova Express* is widely read and well regarded by genre professionals. Note: *Nova Express* will only do two more print issues before moving to the web."

NOW AND THEN, Box 70556 ETSU, Johnson City TN 37614-1707. (423)439-5348. Fax: (423)439-6340. E-mail: fischman@etsu.edu. Website: cass.etsu.edu/n&t/. **Editor:** Jane Harris Woodside. Managing Editor: Nancy Fischman. Estab. 1984. Magazine covering Appalachian issues and arts, published 3 times a year. Circ. 1,000. Accepts previously published artwork. Originals are returned at job's completion. Sample copies available for $7. Art guidelines free for SASE with first class postage or on website.

Cartoons: Approached by 5 cartoonists/year. Prefers Appalachia issues, political and humorous cartoons; b&w washes and line drawings.

Illustration: Approached by 3 illustrators/year. Buys 1-2 illustrations/issue. Has featured illustrations by Nancy Jane Earnest, David M. Simon and Anthony Feathers. Features natural history; humorous, realistic, computer and spot illustration. Assigns 100% of illustrations to experienced, but not well-known illustrators. Prefers Appalachia, any style. Considers b&w or 2- or 4-color pen & ink, collage, airbrush, marker and charcoal. Freelancers should be familiar with FreeHand, PageMaker or Photoshop.

First Contact & Terms: Cartoonists: Send query letter with brochure, roughs and finished cartoons. Illustrators: Send query letter with brochure, SASE and photocopies. Samples are filed or will be returned by SASE if requested by artist. Responds in 6 months. Publication will contact artist for portfolio review if interested. Portfolio should include b&w tearsheets, slides, final art and photographs. Buys one-time rights. Pays on publication. Pays cartoonists $25 for b&w. Pays illustrators $50-100 for color cover; $25 maximum for b&w inside.

Tips: "We have special theme issues. Illustrations have to have something to do with theme. Write for guidelines, see the website, enclose SASE."

🏵 NURSEWEEK, 1156-C Aster Ave., Sunnyvale CA 94086. (408)249-5877. Fax: (408)249-8204. E-mail: youngk@nurseweek.com. Website: www.nurseweek.com. **Creative Director:** Young Kim. "*Nurseweek* is a biweekly 4-color tabloid mailed free to registered nurses nationwide. Combined circulation of

all publications is over 1 million. Biweekly to every RN nationwide. *Nurseweek* provides readers with nursing-related news and features that encourage and enable them to excel in their work and that enhance the profession's image by highlighting the many diverse contributions nurses make. In order to provide a complete and useful package, the publication's article mix includes late-breaking news stories, news features with analysis (including in-depth bimonthly special reports), interviews with industry leaders and achievers, continuing education articles, career option pieces (Spotlight, Entrepreneur) and reader dialogue (Letters, Commentary, First Person)." Sample copy $3. Art guidelines not available. Needs computer-literate freelancers for production. 90% of freelance work demands knowledge of Quark, PhotoShop, Illustrator, Adobe Acrobat, CorelDraw.

Illustration: Approached by 10 illustrators/year. Buys 1 illustration/year. Prefers pen & ink, watercolor, airbrush, marker, colored pencil, mixed media and pastel. Needs medical illustration.

Design: Needs freelancers for design. 90% of design demands knowledge of Photoshop 4.0, QuarkXPress 4.0. Prefers local freelancers. Send query letter with brochure, résumé, SASE and tearsheets.

First Contact & Terms: Illustrators: Send query letter with brochure, tearsheets, photographs, photocopies, photostats, slides and transparencies. Samples are not filed and are returned by SASE if requested by artist. Publication will contact artist for portfolio review if interested. Portfolio should include final art samples, photographs. Buys all rights. Pays on publication; $150 for b&w, $250 for color cover; $100 for b&w, $175 for color inside. Finds artists through sourcebooks.

N NUTRITION HEALTH REVIEW, Box #406, Haverford PA 19041. (610)896-1853. Fax: (610)896-1857. **Contact:** A. Rifkin, publisher. Estab. 1975. Quarterly newspaper covering nutrition, health, and medical information for the consumer. Sample copies available for $3. Art guidelines available.

Cartoons: Prefers single panel, humorous, b&w drawings.

Illustration: Features b&w humorous, medical and spot illustrations pertaining to health.

First Contact & Terms: Cartoonists/Illustrators: Send query letter with b&w photocopies. After introductory mailing, send follow-up postcard every 3-6 months. Samples are filed or returned by SASE. Responds in 6 months. Company will contact artist for portfolio review if interested. Pays cartoonists $20 maximum for b&w. Pays illustrators $200 maximum for b&w cover; $20 maximum for b&w inside. **Pays on acceptance.** Buys first rights, one-time rights, reprint rights. Finds freelancers through agents, artists' submissions, sourcebooks.

✓ OFF OUR BACKS, a woman's news journal, 2337B 18th St. NW, Washington DC 20009. (202)234-8072. Fax (202)234-8092. E-mail: offourbacks@compuserve.com. Website: www.offourbacks.o rg. **Office Coordinator:** Jennie Ruby. Collective Member: Karla Mantilla. Estab. 1970. Monthly feminist news journal; magazine format; covers women's issues and the feminist movement. Circ. 10,000. Accepts previously published artwork. Original artwork is returned at the job's completion. Sample copies available; art guidelines free for SASE with first-class postage.

Cartoons: Approached by 6 freelance cartoonists/year. Buys 2 freelance cartoons/issue. Prefers political, feminist themes.

Illustration: Approached by 20 freelance illustrators/year. Prefers feminist, political themes. Considers pen & ink.

First Contact & Terms: Cartoonists: Send query letter with roughs. Responds to the artist if interested within 2 months. Illustrators: Send query letter with photocopies. Samples are filed. Responds to the artist only if interested. To show a portfolio, mail appropriate materials.

Tips: "Ask for a sample copy. Preference given to feminist, woman-centered, multicultural line drawings."

N ▓ THE OFFICER, 201 N. Washington St., Alexandria VA 22314. (703)549-2311. Website: www.m oaa.org. **Creative Director:** M.L. Woychik. Estab. 1945. Four-color magazine for retired and active duty military officers of the uniformed services; concerns current military/political affairs; recent military history, especially Vietnam and Korea; holiday anecdotes; travel; human interest; humor; hobbies; second-career job opportunities and military family lifestyle.

Illustration: Works with 9-10 illustrators/year. Buys 15-20 illustrations/year. Buys illustrations on assigned themes. (Generally uses Washington DC area artists.) Uses freelancers mainly for features and covers.

First Contact & Terms: Send samples.

Tips: "We look for artists who can take a concept and amplify it editorially."

✓ OHIO MAGAZINE, 1422 Euclid Ave., Cleveland OH 44115. (216)771-2833 or (800)210-7293. Fax: (216)781-6318. Website: www.ohiomagazine.com. **Art Director:** Rob McGar. 12 issues/year emphasizing

traveling in Ohio. Circ. 95,000. Previously published work OK. Original artwork returned after publication. Sample copy $2.50; art guidelines not available.

Illustration: Approached by 70 illustrators/year. Buys 2 illustrations/issue. Works on assignment only. Has featured illustrations by David and Amy Butler and Chris O'Leary. Features charts & graphs; informational graphics; spot illustrations. Assigns 10% of illustrations to new and emerging illustrators. Considers pen & ink, watercolor, collage, acrylic, marker, colored pencil, oil, mixed media and pastel. 20% of freelance work demands knowledge of Illustrator, QuarkXPress, Photoshop or FreeHand.

Design: Needs freelancers for design and production. 100% of freelance work demands knowledge of Photoshop and QuarkXPress.

First Contact & Terms: Illustrators: Send postcard sample or brochure, SASE, tearsheets and slides. Designers: Send query letter with tearsheets and slides. Accepts disk submissions. Send Mac EPS files. Samples are filed or are returned by SASE. Responds in 1 month. Request portfolio review in original query. Portfolio should include b&w and color tearsheets, slides, photostats, photocopies and final art. Buys one-time rights. **Pays on acceptance**; $250-500 for color cover; $50-400 for b&w inside; $50-500 for color inside; $100-800 for 2-page spreads; $50-125 for spots. Finds artists through submissions and gallery shows.

Tips: "Please take time to look at the magazine if possible before submitting."

OKLAHOMA TODAY MAGAZINE, 15 N. Robinson, Suite 100, Oklahoma City OK 73102-5403. (405)521-2496. Fax: (405)522-4588. Website: www.oklahomatoday.com. **Editor:** Louisa McCune. Estab. 1956. Bimonthly regional, upscale consumer magazine focusing on all things that define Oklahoma and interest Oklahomans. Circ. 50,000. Accepts previously published artwork. Originals are returned at job's completion. Sample copies available with a SASE.

Illustration: Approached by 24 illustrators/year. Buys 5-10 illustrations/year. Has featured illustrations by Rob Silvers, Tim Jossel, Steven Walker and Cecil Adams. Features caricatures of celebrities; natural history; realistic and spot illustration. Assigns 10% of illustrations to new and emerging illustrators. Considers pen & ink, watercolor, collage, airbrush, acrylic, marker, colored pencil, oil, charcoal and pastel. 20% of freelance work demands knowledge of PageMaker, Illustrator and Photoshop.

First Contact & Terms: Illustrators: Send query letter with brochure, résumé, SASE, tearsheets and slides. Samples are filed. Responds in days if interested; months if not. Portfolio review required if interested in artist's work. Portfolio should include b&w and color thumbnails, tearsheets and slides. Buys one-time rights. Pays $200-500 for b&w cover; $200-750 for color cover; $50-500 for b&w inside; $75-750 for color inside. Finds artists through sourcebooks, other publications, word of mouth, submissions and artist reps.

Tips: Illustrations to accompany short stories and features are most open to freelancers. "Read the magazine. Be willing to accept low fees at the beginning."

N **ON OUR BACKS**, 3415 Ceasar Chavez, #101 San Francisco CA 94110-2351. (415)648-9464. Fax: (415)648-4705. E-mail: staff@onourbacksmag.com. Website: www.onourbacksmag.com. **Contact:** Ethan Duran, art director. Estab. 1984. A b&w with 4-color cover bimonthly magazine, covering lesbian sexuality. "One of our specialties is lesbian erotic photography." Accepts previously published artwork. Originals are returned at job's completion upon request with SASE. Submission guidelines available. Needs computer-literate freelancers for design and production. 10% of freelance work demands knowledge of PageMaker, FreeHand, Photoshop or Quark.

Cartoons: Needs lesbian/sex humor. "We will accept a variety of styles."

First Contact & Terms: Illustrators: Send query letter with photocopies. Samples are filed or are returned by SASE. Publication will contact artist for portfolio review if interested. Rights purchased vary according to project. Pays cartoonists $25 for b&w. Pays 30 days after publication. Pays illustrators $30 for b&w inside. Finds artists through artists' submissions/self-promotion, sourcebooks, artists' agents and reps, attending art exhibitions, other publications, press releases and public listings.

Tips: "Lesbian sex photography is a pioneer effort, and we are constantly trying to enlarge our scope and possibilties. We explore a variety of sexual styles; and nudity, per se, is not necessarily the focus. An erotic,

THE MULTIMEDIA INDEX preceding the General Index in the back of this book lists markets seeking freelancers with multimedia, animation and CD-ROM skills.

and often emotional interpretation is. In general, we want a diversity of lesbians and intriguing themes that touch on our gay experience in a sexy and convincing manner."

THE OPTIMIST, 4494 Lindell Blvd., St. Louis MO 63108-2404. (314)371-6000. Fax: (314)371-6006. E-mail: walkera@optimist.org. Website: www.optimist.org. **Graphic Designer:** Andrea Walker. 4-color magazine with 4-color cover that emphasizes activities relating to Optimist clubs in US and Canada (civic-service clubs). "Magazine is mailed to all members of Optimist clubs. Average age is 42; most are management level with some college education." Circ. 120,000. Sample copy for SASE; art guidelines not available.
Cartoons: Buys 2 or 3 cartoons/issue. Has featured cartoons by Martin Bucella, Randy Glasbergen, Randy Bisson. Assigns 25% of cartoons to new and emerging cartoonists. Prefers themes of general interest: family-orientation, sports, kids, civic clubs. Prefers color single panel with gagline. No washes.
First Contact & Terms: Illustrators: Send query letter with samples. Send art on a disk if possible (Macintosh compatible). Submissions returned by SASE. Responds in 1 week. Buys one-time rights. **Pays on acceptance**; $30 for b&w or color.
Tips: "Send clear cartoon submissions, not poorly photocopied copies."

OREGON CATHOLIC PRESS, 5536 NE Hassalo, Portland OR 97213-3638. (503)281-1191. Fax: (503)282-3486. E-mail: jeang@ocp.org. Website: www.ocp.org/. **Art Director:** Jean Germano. Estab. 1988. Quarterly liturgical music planner in both Spanish and English with articles, photos and illustrations specifically for but not exclusive to the Roman Catholic market.
● See *OCP*'s listing in the Book Publishers section to learn about this publisher's products and needs.
Illustration: Approached by 10 illustrators/year. Buys 20 illustrations/issue. Has featured illustrations by John August Swanson and Steve Erspamer. Assigns 50% of illustrations to new and emerging illustrators.
First Contact & Terms: Illustrators: Send query letter with printed samples, photocopies, SASE. Samples are filed or returned by SASE. Responds in 2 weeks. Portfolio review not required. Rights purchased vary according to project. **Pays on acceptance**; $100-250 for color cover; $30-50 for b&w spot art or photo.

Ⓝ OREGON QUARTERLY, 5228 University of Oregon, Eugene OR 97403-5228. (541)346-5048. Fax: (541)346-5571. E-mail: quarterly@oregon.uoregon.edu. Website: www.darkwing.uoregon.edu/~oql. **Editor:** Guy Maynard. Estab. 1919. Quarterly 4-color alumni magazine. "The Northwest perspective. Regional issues and events as addressed by UO faculty members and alumni." Circ. 91,000. Accepts previously published artwork. Originals are returned at job's completion. Sample copies available for SASE with first-class postage.
Illustration: Approached by 25 illustrators/year. Buys 1 illustration/issue. Prefers story-related themes and styles. Interested in all media.
First Contact & Terms: Illustrators: Send query letter with résumé, SASE and tearsheets. Samples are filed unless accompanied by SASE. Responds only if interested. Buys one-time rights. Portfolio review not required. **Pays on acceptance**; $250 for b&w, $500 for color cover; $100 for b&w, $250 for color inside; $100 for spots.
Tips: "Send postcard, not portfolio."

OREGON RIVER WATCH, Box 294, Rhododendron OR 97049. (503)622-4798. **Editor:** Michael P. Jones. Estab. 1985. Quarterly b&w books published in volumes emphasizing "fisheries, fishing, camping, rafting, environment, wildlife, hiking, recreation, tourism, mountain and wilderness scenes and everything that can be related to Oregon's waterways. Down-home pleasant look, not polished, but practical—the '60s still live on." Circ. 2,000. Accepts previously published material. Original artwork returned after publication. Art guidelines for SASE with first-class postage.
Cartoons: Approached by 400 cartoonists/year. Buys 1-25 cartoons/issue. Cartoons need to be straightforward, about fish and wildlife/environmental/outdoor-related topics. Prefers single, double or multiple panel b&w line drawings, b&w or color washes with or without gagline.
Illustration: Approached by 600 illustrators/year. Works with 100 illustrators/year. Buys 225 illustrations/year. Needs editorial, humorous and technical illustration related to the environment. "We need b&w pen & ink sketches. We look for artists who are not afraid to be creative, rather than those who merely go along with trends."
Design: Needs freelancers for design and production.
First Contact & Terms: Cartoonists: Send query letter with SASE, samples of style, roughs or finished

cartoons. Illustrators: Send query letter with brochure, résumé, photocopies, SASE, slides, tearsheets and transparencies. "Include enough to show me your true style." Designers: Send brochure, photocopies, SASE, tearsheets, résumé, photographs, slides and transparencies. Samples not filed are returned by SASE. Responds in 2 months. Buys one-time rights. Pays in copies. 20% of freelance work demands computer skills.

Tips: "Freelancers must be patient. We have a lot of projects going on at once but cannot always find an immediate need for a freelancer's talent. Being pushy doesn't help. I want to see examples of the artist's expanding horizons, as well as their limitations. Make it really easy for us to contact you. Remember, we get flooded with letters and will respond faster to those with a SASE."

ORGANIC GARDENING, 22 E. Second St., Emmaus PA 18098. E-mail: brian.goddard@rodale.com. Website: www.organicgardening.com. **Art Director:** Brian Goddard. Magazine emphasizing gardening; 4-color; "uncluttered design." Published 6 times/year. Circ. 600,000. Usually buys first publication rights. Sample copies available only with SASE.

Illustration: Buys 10 illustrations/issue. Works on assignment only.

First Contact & Terms: Illustrators: Send tearsheets. Samples are filed or are returned by SASE only. Occasionally needs technical illustration. Buys first rights or one-time rights.

Tips: "Our emphasis is 'how-to' gardening; therefore illustrators with experience in the field will have a greater chance of being published. Detailed and fine rendering quality is essential."

OUR SUNDAY VISITOR, 200 Noll Plaza, Huntington IN 46750. (260)356-8400. Fax: (260)356-8472. Website: www.osv.com. **Art Director:** Eric Schoening. Estab. 1912. Weekly magazine which focuses on Catholicism. Audience is mostly older, conservative; adheres to the teachings of the magisterium of the church. Circ. 85,000. Accepts previously published artwork. Originals are returned at job's completion. Sample copies available. Art guidelines not available.

Illustration: Approached by 25-30 illustrators/year. Buys 100 illustrations/year. Works on assignment only. Preferred themes are religious and social issues. Considers pen & ink, watercolor, collage, airbrush, acrylic, marker, colored pencil, oil, charcoal, mixed media and pastel.

First Contact & Terms: Illustrators: Send query letter with photographs. Samples are filed. Portfolio review not required. Buys first rights. Pays on publication; $250 for b&w, $400 for color cover; $150 for b&w, $250 for color inside.

OUTDOOR CANADA MAGAZINE, 340 Ferrier St., Suite 210, Markham, ON L3R 2Z5 Canada. Website: www.outdoorcanada.ca. **Art Director:** Robert Biron. 4-color magazine for Canadian anglers and hunters, enthusiasts and their families. Stories on fishing, hunting and wildlife. Readers are 81% male. Publishes 8 regular issues/year. Circ. 95,000. Art guidelines are available.

Illustration: Approached by 12-15 illustrators/year. Buys approximately 10 drawings/issue. Has featured illustrations by Malcolm Cullen, Stephen MacEachren and Jerzy Kolatch. Features humorous, computer and spot illustration. Assigns 90% to experienced, but not well-known illustrators; 10% to new and emerging illustrators. Uses freelancers mainly for illustrating features and columns. Uses pen & ink, acrylic, oil and pastel.

Design: Needs freelancers for multimedia. 20% of freelance work demands knowledge of Photoshop, Illustrator and QuarkXPress.

First Contact & Terms: Illustrators: Send postcard sample, brochure and tearsheets. Designers: Send brochure, tearsheets and postcards. Accepts disk submissions compatible with Illustrator 7.0. Send EPS, TIFF and PICT files. Buys first rights. Pays illustrators $150-300 for b&w inside, $100-500 for color inside; $500-700 for 2-page spreads; $150-300 for spots. Pays designers by the project. Artists should show a representative sampling of their work. Finds most artists through references/word of mouth.

Tips: "Meet our deadlines and our budget. Know our product. Fishing and hunting knowledge an asset."

OUTDOOR LIFE MAGAZINE, Dept. AGDM, 2 Park Ave., New York NY 10016-5604. (212)779-5000. Fax: (212)779-5366. Website: www.outdoorlife.com. **Art Director:** James M. Keleher. Assistant Art Directors: Margaret McKenna and Jason Beckstead. Estab. 1897. Monthly magazine geared toward hunting, fishing and outdoor activities. Circ. 900,000. Original artwork is returned at job's completion. Sample copies not available.

Illustration: Works on assignment only.

First Contact & Terms: Illustrators: Send nonreturnable postcard samples, tearsheets or brochures. Samples are filed. Rights purchased vary according to project. **Pays on acceptance.**

OUTER DARKNESS (Where Nightmares Roam Unleashed), 1312 N. Delaware Place, Tulsa OK 74110. (918)832-1246. E-mail: odmagazine@aol.com. **Editor:** Dennis Kirk. Estab. 1994. Quarterly digest/zine of horror and science fiction, poetry and art. Circ. 500. Sample copy for $3.95. Sample illustrations free for 6×9 SASE and 2 first-class stamps. Art guidelines free for #10 SASE with first-class postage.
Cartoons: Approached by 15-20 cartoonists/year. Buys 15 cartoons/year. Prefers horror/science fiction slant, but not necessary. Prefers single panel, humorous, b&w line drawings.
Illustration: Approached by 30-40 illustrators/year. Buys 5-7 illustrations/issue. Has featured illustrations by Allen Koszowski, Jeff Ward, Terry Campbell, Steve Rader. Features realistic science fiction and horror illustrations. Prefers b&w, pen & ink drawings. Assigns 20% of illustrations to new and emerging illustrators.
First Contact & Terms: Cartoonists: Send query letter with b&w photocopies, samples, SASE. Samples are returned. Illustrators: Send query letter with photocopies, SASE. Responds in 2 weeks. Buys one-time rights. Pays on publication in contributor's copies. Finds illustrators through magazines and submissions.
Tips: "Send samples of your work, along with a cover letter. Let me know a little about yourself. I enjoy learning about artists interested in *Outer Darkness*. *Outer Darkness* is continuing to grow at an incredible rate. It's presently stocked in two out-of-state bookstores, and I'm working to get it into more. The latest issue of OD features a full color cover, and I hope to publish more such issues in the future. Outer darkness is quickly moving through the ranks."

OXYGEN, 5775 Mclaughlin Rd., Mississauga, ON L5R P37 Canada. (905)507-3545. Fax: (905)507-2372. Website: www.emusclemag.com. **Art Director:** Robert Kennedy. Estab. 1997. Bimonthly consumer magazine. "Oxygen is a magazine devoted entirely to women's fitness, health and physique." Circ. 300,000.
Illustration: Buys 6-10 illustrations/issue. Has featured illustrations by Erik Blais, Ted Hammond and Lauren Sanders. Features caricatures of celebrities; charts & graphs; computer and realistic illustrations. Assigns 15% of illustrations to new and emerging illustrators. Prefers loose illustration, full color. Considers acrylic, airbrush, charcoal, collage, color washed, colored pencil, mixed media, pastel and watercolor. 50% of freelance illustration demands knowledge of Photoshop and QuarkXPress.
First Contact & Terms: Illustrators: Send query letter with photocopies and tearsheets. Samples are filed and are not returned. Responds in 21 days. Buys all rights. **Pays on acceptance**; $1,000-2,000 for b&w and color cover; $50-500 for b&w and color inside; $100-1,000 for 2-page spreads. Finds illustrators through word of mouth and submissions.
Tips: "Artists should have a working knowledge of women's fitness. Study the magazine. It is incredible the amount of work that is sent that doesn't begin to relate to the magazine."

PACIFIC PRESS PUBLISHING ASSOCIATION, 1350 North Kings Rd., Nampa ID 83687. (208)465-2500. **Art Designers, Books:** Michelle Petz and Dennis Ferree. Art Director, Advertising: Tim Larson. Art Designer, Textbooks: Eucaris Galicia. Art Designer, Spanish and French Magazines: Ariel Fuentealba. Art Designer, *Signs of the Times*: Merwin Stewart. Estab. 1875. Book and magazine publisher. Specializes in Christian lifestyles and Christian outreach.
 • This association publishes magazines and books. Also see *Signs of the Times* listing for needs.

PACIFIC YACHTING MAGAZINE, 1080 Howe St., Suite 900, Vancouver, BC V6Z 2T1 Canada. (604)606-4644. Fax: (604)687-1925. E-mail: editorial@pacificyachting.net. Website: www.pacificyachting.com. **Editor:** Peter A. Robson. Estab. 1968. Monthly 4-color magazine focused on boating on the West Coast of Canada. Power/sail cruising only. Circ. 25,000. Accepts previously published artwork. Original artwork returned at job's completion. Sample copies available for $4.95 cover price. Art guidelines not available.
Cartoons: Approached by 12-20 cartoonists/year. Buys 1 illustration or cartoon/issue. Boating themes only; single panel b&w line drawings.
Illustration: Approached by 25 illustrators/year. Buys 4-6 illustrations/year. Has featured illustrations by Dave Alavoine, Roger Jackson and Tom Shardlow. Boating themes only. Considers pen & ink, watercolor, airbrush, acrylic, colored pencil, oil and charcoal.
First Contact & Terms: Cartoonists: Send query letter with brochure and roughs. Responds in 1 month. Illustrators: Send query letter with brochure. Samples are filed or are returned by SASE if requested by artist. Responds in 2 weeks only if interested. Call for appointment to show portfolio of appropriate samples related to boating on the West Coast. Buys one-time rights. Pays on publication. Pays cartoonists $25-50 for b&w.

Pays illustrators $300 for color cover; $50-100 for b&w inside; $100-150 for color inside; $25-50 for spots.
Tips: "Know boats and how to draw them correctly. Know and love my magazine."

PAINT HORSE JOURNAL, Box 961023, Fort Worth TX 76161-0023. (817)834-2742. E-mail: dstreeter @apha.com. Website: www.painthorsejournal.com. **Art Director:** Paul Zinn. Monthly 4-color official publication of breed registry of Paint horses for people who raise, breed and show Paint horses. Circ. 34,000. Original artwork returned after publication if requested. Sample copy for $3; artist's guidelines for SASE.
Illustration: Approached by 25-30 illustrators/year. Receives 4-5 illustrations/week. Buys a few illustrations each issue.
First Contact & Terms: Illustrators: Send business card and samples to be kept on file. Prefers snapshots of original art or photostats as samples. Samples returned by SASE if not filed. Responds in 1 month. Buys first rights on cover art, but would like to be able to use small, filler art many times. Payment varies by project.
Tips: "No matter what style of art you use—you must include Paint horses with conformation acceptable (to the APHA). As horses are becoming more streamlined—as in race-bred Paints, the older style of horse seems outdated. Horses of Arabian-type conformation or with unnatural markings are incorrect. Action art and performance events are very nice to have."

PALO ALTO WEEKLY, 703 High St., Palo Alto CA 94301. (415)326-8210. E-mail: chubenthal@pa weekly.com. Website: www.paloaltoonline.com. **Design Director:** Carol Hubenthal. Estab. 1979. Semiweekly newspaper. Circ. 45,000. Accepts previously published artwork. Originals returned at job's completion. Sample copies available.
Illustration: Buys 20-30 illustrations/year. Works on assignment only. Considers all media.
First Contact & Terms: Illustrators: Send query letter with brochure, résumé, SASE, tearsheets, photographs, photocopies, photostats, slides and transparencies. Samples are filed. Publication will contact artist for portfolio review if interested. Pays on publication; $200 for color cover; $100 for b&w inside, $125 for color inside.
Tips: Most often uses freelance illustration for covers and cover story, especially special section covers such as restaurant guides. "We call for artists' work in our classified ad section when we need some fresh work to look at. We work exclusively with local artists."

PARADE MAGAZINE, 711 Third Ave., New York NY 10017. (212)450-7000. Fax: (212)450-7284. E-mail: ira_yoffe@parade.com. **Creative Director:** Ira Yoffe. Photo Editor: Miriam White-Lorentzen. Art Director: Nick Torello. Weekly emphasizing general interest subjects. Circ. 40 million (readership is 76 million). Original artwork returned after publication. Sample copy and art guidelines available. Art guidelines for SASE with first-class postage.
Illustration: Uses varied number of illustrations/issue. Works on assignment only.
Design: Needs freelancers for design. 100% of freelance work demands knowledge of Photoshop, Illustrator, QuarkXPress. Prefers local freelancers.
First Contact & Terms: Illustrators: Send query letter with brochure, résumé, business card and tearsheets to be kept on file. Designers: Send query letter with résumé. Call or write for appointment to show portfolio. Responds only if interested. Buys first rights, occasionally all rights. Pays for design by the project, by the day or by the hour depending on assignment.
Tips: "Provide a good balance of work."

PC MAGAZINE, Ziff-Davis Media, 28 E. 28th St., 11th Floor, New York NY 10016. (212)503-3500. **Art Director:** Dean Markadakis. Deputy Art Director: Lisa Kelsey. Associate Art Directors: Ann Greenfield and Cynthia Rhett. Estab. 1983. Bimonthly consumer magazine featuring comparative lab-based reviews of current PC hardware and software. Circ. 1.2 million. Sample copies available.
Illustration: Approached by 100 illustrators/year. Buys 10-20 illustrations/issue. Considers all media.
First Contact & Terms: Illustrators: Send postcard sample and/or printed samples, photocopies, tearsheets. Accepts Zip disk, CD or e-mail submissions. Samples are filed. Portfolios may be dropped on Wednesday and should include tearsheets and transparencies; art department keeps for one week to review. **Pays on acceptance.** Payment negotiable for cover and inside; $350 for spots.

PENNSYLVANIA LAWYER, Pennsylvania Bar Association, 100 South St., Harrisburg PA 17108-0186. (717)238-6715. E-mail: editor@pabar.org. Website: www.pabar.org. **Editor:** Geoff Yuda. Bimonthly asso-

ciation magazine "featuring nuts and bolts articles and features of interest to lawyers." Circ. 30,000. Sample copies for #10 SASE with first-class postage. Art guidelines available.

Illustration: Approached by 30 illustrators/year. Buys 12 illustrations/year. Considers all media.

First Contact & Terms: Illustrators: Send query letter with samples. Samples are filed or returned by SASE. Art director will contact artist for portfolio review if interested. Negotiates rights purchased. **Pays on acceptance**; $185-600 for color cover; $100 for inside. Pays $25-50 for spots. Finds illustrators through word of mouth and artists' submissions.

Tips: "Artists must be able to interpret legal subjects. Art must have fresh, contemporary look. Read articles you are illustrating, provide three or more roughs in timely fashion."

PERSIMMON HILL, Published by the National Cowboy and Western Heritage Museum, 1700 NE 63rd St., Oklahoma City OK 73111. (405)478-6404. Fax: (405)478-4714. E-mail: editor@nationalmuseum.org. Website: www.nationalcowboymuseum.org. **Director of Publications:** M.J. Van Deventer. Estab. 1970. Quarterly 4-color journal of western heritage "focusing on both historical and contemporary themes. It features nonfiction articles on notable persons connected with pioneering the American West; art, rodeo, cowboys, floral and animal life; or other phenomena of the West of today or yesterday. Lively articles, well written, for a popular audience. Contemporary design follows style of *Architectural Digest* and *European Travel and Life*." Circ. 15,000. Original artwork returned after publication. Sample copy for $10.50.

Illustration: Fine art only.

First Contact & Terms: Send query letter with tearsheets, SASE, slides and transparencies. Samples are filed or returned by SASE if requested. Publication will contact artist for portfolio review if interested. Portfolio should include original/final art, photographs or slides. Buys first rights. Requests work on spec before assigning job. Payment varies. Finds artists through word of mouth and submissions.

Tips: "We are a museum publication. Most illustrations are used to accompany articles. Work with our writers, or suggest illustrations to the editor that can be the basis for a freelance article or a companion story. More interest in the West means we have to provide more contemporary photographs and articles about what people in the West are doing today. Study the magazine first—at least four issues."

PHI DELTA KAPPAN, Box 789, Bloomington IN 47402. (812)339-1156. Fax: (812)339-0018. Website: www.pdkintl.org/kappan/khpsubmi.htm. **Design Director:** Carol Bucheri. Emphasizes issues, policy, research findings and opinions in the field of education. For members of the educational organization Phi Delta Kappa and subscribers. Black & white with 4-color cover and "conservative, classic design." Published 10 times/year. Circ. 100,000. Include SASE. Responds in 2 months. "We return illustrations and cartoons after publication." Sample copy for $5.50 plus $3 S&H. "The journal is available in most public and college libraries."

Cartoons: Approached by over 100 cartoonists/year. Looks for "finely drawn cartoons, with attention to the fact that we live in a multi-racial, multi-ethnic world."

Illustration: Approached by over 100 illustrators/year. Uses 1 4-color cover and spread/issue. Features serious conceptual art; humorous, realistic, computer and spot illustraion. Prefers style of John Berry, Brenda Grannan and Jem Sullivan. Most illustrations depict some aspect of the education process (from pre-kindergarten to university level), often including human figures.

First Contact & Terms: Illustrators: Send postcard sample. Samples returned by SASE. "We can accept computer illustrations that are Mac formatted (EPS or TIFF files. Photoshop 6.0 or Illustrator 9.0)." Buys one-time print and electronic rights. Payment varies.

Tips: "We look for artists who can create a finely crafted image that holds up when translated onto the printed page. Our journal is edited for readers with master's or doctoral degrees, so we look for illustrators who can take abstract concepts and make them visual, often through the use of metaphor. Submission specifications online."

☑ **PHILADELPHIA WEEKLY**, 1500 Sansom St., 3rd Floor, Philadelphia PA 19102-2800. (215)563-7400. Fax: (215)563-0620. E-mail: jcox@philadelphiaweekly.com. Website: wwwphiladelphiaweekly.com. **Art Director:** Jeffrey Cox. Estab. 1971. Alternative, weekly, 4-color, b&w, tabloid focusing on news and opinion and arts and culture. Circ. 123,200.

Cartoons: Approached by 25 cartoonists/year. Buys 0-1 cartoon/issue. Prefers single panel, multiple panel, political, humorous, b&w washes, b&w line drawings.

Illustration: Approached by scores of illustrators/year. Buys 3-5 illustrations/issue. Has featured illustrations by Brian Biggs, Jay Bevenour, James McHugh. Features caricatures of celebrities and politicians; humorous, realistic and spot illustrations. Prefers realism but considers wide range of styles.

First Contact & Terms: Cartoonists: Send query letter with b&w photocopies. Illustrators: Send postcard sample or query letter with printed samples and photocopies. Send non-returnable samples. Samples are filed and are not returned. Responds only if interested. Buys one-time rights. Pays on publication; $300 for color cover; $75-150 for b&w inside; $100-250 for color inside; $75 for spots. Finds illustrators through promotional samples.

PLANNING, American Planning Association, 122 S. Michigan Ave., Suite 1600, Chicago IL 60603. (312)431-9100. **Editor and Publisher:** Sylvia Lewis. Art Director: Richard Sessions. Monthly 4-color magazine for urban and regional planners interested in land use, housing, transportation and the environment. Circ. 35,000. Previously published work OK. Original artwork returned after publication, upon request. Free sample copy and artist's guidelines available. "Enclose $1 in postage for sample magazine—stamps only, no cash or checks, please."
Cartoons: Buys 2 cartoons/year on the environment, city/regional planning, energy, garbage, transportation, housing, power plants, agriculture and land use. Prefers single panel with gaglines ("provide outside of cartoon body if possible").
Illustration: Buys 20 illustrations/year on the environment, city/regional planning, energy, garbage, transportation, housing, power plants, agriculture and land use.
First Contact & Terms: Cartoonists: Include SASE. Illustrators: Send samples of style we can keep on file. If you want a response, enclose SASE. Responds in 2 weeks. Buys all rights. Pays on publication. Pays cartoonists $50 minimum for b&w line drawings. Pays illustrators $250 maximum for b&w cover drawings; $100 minimum for b&w line drawings inside.
Tips: "Don't send portfolio. No corny cartoons. Don't try to figure out what's funny to planners. All attempts seen so far are way off base. Your best chance is to send samples of any type of illustration—cartoons or other—that we can keep on file. If we like your style we will commission work from you."

PLAYBOY MAGAZINE, 680 N. Lakeshore Dr., Chicago IL 60611. (312)751-8000. Website: www.playboy.com. **Art Director:** Tom Staebler. Estab. 1952. Monthly magazine. Circ. 3.5 million. Originals returned at job's completion. Sample copies available.
Cartoons: Playboy Enterprises Inc., Cartoon Dept., 730 Fifth Ave., New York NY 10019.
Illustration: Approached by 700 illustrators/year. Buys 30 illustrations/issue. Prefers "uncommercial looking" artwork. Considers all media.
First Contact & Terms: Illustrators: Send postcard sample or query letter with slides and photocopies or other appropriate sample. Does not accept originals. Samples are filed or returned. Responds in 2 weeks. Buys all rights. **Pays on acceptance**; $1,200/page; $2,000/spread; $250 for spots.
Tips: "No phone calls, only formal submissions of five pieces."

POCKETS, Box 340004, 1908 Grand Ave., Nashville TN 37203-0004. (615)340-7333. Fax: (615)340-7267. E-mail: pockets@upperroom.org. Website: www.pockets.org. **Editor:** Janet R. Knight. Devotional magazine for children 6-12. 4-color with some 2-color. Monthly except January/February. Circ. 100,000. Accepts previously published material. Original artwork returned after publication. Sample copy for 9×12 or larger SASE with 4 first-class stamps.
Illustration: Approached by 50-60 illustrators/year. Features humorous, realistic, computer and spot illustration. Assigns 15% of illustrations to new and emerging illustrators. Uses variety of styles; 4-color, 2-color, flapped art appropriate for children. Realistic, fable and cartoon styles.
First Contact & Terms: Illustrators: Send postcard sample, brochure, photocopies, SASE and tearsheets. No fax submissions accepted. Also open to more unusual art forms: cut paper, embroidery, etc. Samples not filed are returned by SASE. "No response without SASE." Responds only if interested. Buys one-time or reprint rights. **Pays on acceptance**; $600 flat fee for 4-color covers; $50-250 for b&w inside, $75-350 for color inside.
Tips: "Decisions made in consultation with out-of-house designer. Send samples to our designer: Chris Schechner, 408 Inglewood Dr., Richardson, TX 75080."

THE PORTLAND REVIEW, P.O. BOX 347, Portland OR 97207. (503)725-4533. Fax: (503)725-5860. E-mail: review@vanguard.vg.pdx.edu. Website: www.portlandreview.org. **Contact:** Rebecca Rich Goldweber, editor. Estab. 1954. Quarterly student-run arts journal. Circ. 1,000. Sample copies available for $6. Art guidelines available free with SASE or on website.
Illustration: Approached by 50 illustrators/year. We don't pay contributors. Features humorous and natural history illustration.

First Contact & Terms: Cartoonists/Illustrators: Send postcard sample or query letter with b&w photocopies and SASE. Accepts e-mail submissions with link to website or with image file. Prefers Mac-compatible. Samples are not filed and not returned. Responds in 2 months. Portfolio not required.

POTPOURRI, A Magazine of the Literary Arts, P.O. Box 8278, Prairie Village KS 66208-0278. (913)642-1503. Fax: (913)642-3128. E-mail: potpourpub@aol.com. Website: www.potpourri.org. **Art Director:** Alberta J. Daw. Estab. 1989. Quarterly literary magazine featuring short stories, poetry, essays on arts, illustrations. Circ. 3,000. Art guidelines free for SASE with first-class postage. Sample copy for $4.95.
Illustration: Approached by 20 illustrators/year. Buys 10-12 illustrations/issue. Has featured illustrations by Wendy Born Hollender, M. Keating, E. Reeve, A. Olsen, T. Devine, D.J. Baker, D. Transue, S. Chapman, W. Philips, M. Larson, D. McMillion. Features caricatures of literary celebrities, computer and realistic illustrations. Prefers pen & ink. Assigns 20% of illustrations to new and emerging illustrators.
First Contact & Terms: Illustrators: Send query letter with printed samples, photocopies and SASE. Samples are filed. Responds in 3 months. Portfolio review not required. Buys one-time and reprint rights. Pays on publication, in copies. Finds illustrators through sourcebooks, artists' samples, word of mouth.
Tips: "*Potpourri* seeks original illustrations for its short stories. Also open to submissions for cover illustration of well-known literary persons. Prefer clean, crisp black & white illustrations and quick turnaround. *Potpourri* has completed its 14th year of publication and offers artists an opportunity for international circulation/exposure. The illustration should catch the reader's eye and imagination to make her stop and read the story."

PRAIRIE JOURNAL TRUST, P.O. Box 61203 Brentwood P.O., Calgary, AB T2L 2K6 Canada. E-mail: prairiejournal@yahoo.com. Website: www.geocities.com/prairiejournal. **Contact:** Editor (by mail). Estab. 1983. Biannual literary magazine. Circ. 600. Sample copies available for $6; art guidelines on website.
Illustration: Approached by 25 illustrators/year. Buys 6 illustrations/year. Has featured illustrations by Hubert Lacey, Rita Diebolt, Lucie Chan. Considers artistic/experimental b&w line drawings or screened print.
First Contact & Terms: Illustrators: Send postcard sample or query letter with b&w photocopies. Samples are filed. Responds only if interested. Portfolio review not required. Acquires one-time rights. Pays $50 maximum (Canadian) for b&w cover and $25 maximum for inside drawings. Pays on publication. Finds freelancers through unsolicited submissions and queries.
Tips: "We are looking for black & white line drawings easily reproducable and camera-ready copy. Never send originals through the mail."

PRAIRIE SCHOONER, 201 Andrews Hall, University of Nebraska, Lincoln NE 68588-0334. (402)472-0911. Fax: (402)472-9771. E-mail: kgrey2@unl.edu. Website: www.unl:edu/schooner/psmain.htm. **Contact:** Kelly Grey, managing editor. Estab. 1926. Quarterly b&w literary magazine with 2-color cover. "*Prairie Schooner*, now in its 77th year of continuous publication, is called 'one of the top literary magazines in America' by *Literary Magazine Review*. Each of the four issues contains short stories, poetry, book reviews, personal essays, interviews or some mix of these genres. Contributors are both established and beginning writers. Readers live in all states in the U.S. and in most countries outside the U.S." Circ. 3,200. Original artwork is returned after publication. "We rarely have the space or funds to reproduce artwork in the magazine but hope to do more in the future." Sample copies for $5.
Illustration: Approached by 5-10 illustrators/year. Uses freelancers mainly for cover art.
First Contact & Terms: "Before submitting, artist should be familiar with our cover and format, 6×9, black and one color or b&w, vertical images work best; artist should look at previous issues of *Prairie Schooner*. Portfolio review not required. We are rarely able to pay for artwork; have paid $50 to $100."
Tips: Finds artists through word of mouth. "We're trying for some four-color covers."

PREMIERE MAGAZINE, 1633 Broadway, 41st Floor, New York NY 10019. (212)767-6000. Fax: (212)767-5450. Website: www.premiermag.com. **Art Director:** Richard Baker. Estab. 1987. "Monthly popular culture magazine about movies and the movie industry in the U.S. and the world. Of interest to both a general audience and people involved in the film business." Circ. 612,952. Original artwork is returned after publication.
Illustration: Approached by 250 illustrators/year. Works with 150 illustrators/year. Buys 3-4 spot illustrations/issue. Buys illustrations mainly for spots. Has featured illustrations by Dan Adel, Brian Briggs, Anita Kunz and Roberto Parada. Works on assignment only. Considers all styles depending on needs.

First Contact & Terms: Illustrators: Send query letter with tearsheets, photostats and photocopies. Samples are filed. Samples not filed are returned by SASE. Reports back about queries/submissions only if interested. Drop-offs Monday through Friday, and pick-ups the following day. Buys first rights or one-time rights. Pays $350 for b&w, $375-1,200 for color inside.

☑ ☷ **THE PRESBYTERIAN RECORD**, 50 Wynford Dr., Toronto ON M3C 1J7 Canada. (416)441-1111. E-mail: pcrecord@presbyterian.ca. Website: www.presbyterian.ca/record. **Production and Design:** Tim Faller. Published 11 times/year. Deals with family-oriented religious themes. Circ. 50,000. Original artwork returned after publication. Simultaneous submissions and previously published work OK. Free sample copy and artists' guidelines for SASE with first-class postage.
Cartoons: Approached by 12 cartoonists/year. Buys 1-2 cartoons/issue. Interested in some theme or connection to religion.
Illustration: Approached by 6 illustrators/year. Buys 1 illustration/year on religion. Has featured illustrations by Ed Schnurr, Claudio Ghirardo and Chrissie Wysotski. Features humorous, realistic and spot illustration. Assigns 50% of illustrations to new and emerging illustrators. "We are interested in excellent color artwork for cover." Any line style acceptable—should reproduce well on newsprint. Works on assignment only.
First Contact & Terms: Cartoonists: Send roughs and SAE (nonresidents include IRC). Illustrators: Send query letter with brochure showing art style or tearsheets, photocopies and photographs. Will accept computer illustrations compatible with QuarkXPress 4.1, Illustrator 8.0, Photoshop 6.0. Samples returned by SAE (nonresidents include IRC). Responds in 1 month. To show a portfolio, mail final art and color and b&w tearsheets. Buys all rights on a work-for-hire basis. Pays on publication. Pays cartoonists $25-50 for b&w. Pays illustrators $50-100 for b&w cover; $100-300 for color cover; $25-80 for b&w inside; $25-60 for spots.
Tips: "We don't want any 'cute' samples (in cartoons). Prefer some theological insight in cartoons; some comment on religious trends and practices."

PRESBYTERIANS TODAY, 100 Witherspoon St., Louisville KY 40202. (502)569-5637. Fax: (502)569-8632. E-mail: today@pcusa.org. Website: www.pcusa.org/today. **Art Director:** Linda Crittenden. Estab. 1830. 4-color; official church magazine emphasizing Presbyterian news and informative and inspirational features. Publishes 10 issues year. Circ. 62,000. Originals are returned after publication if requested. Some feature illustrations may appear on website. Sample copies for SASE with first-class postage.
Cartoons: Approached by 20-30 cartoonists/year. Buys 1-2 freelance cartoons/issue. Prefers general religious material; single panel.
Illustration: Approached by more than 50 illustrators/year. Buys 2-3 illustrations/issue, 30 illustrations/year from freelancers. Works on assignment only. Media varies according to need.
First Contact & Terms: Cartoonists: Send roughs and/or finished cartoons. Responds in 1 month. Rights purchased vary according to project. Illustrators: Send query letter with tearsheets. Samples are filed and not returned. Responds only if interested. Buys one-time rights. Pays cartoonists $25, b&w. Pays illustrators $150-350, cover; $80-250, inside.

☑ **PRINT MAGAZINE**, 116 E. 27th St., 6th Floor, New York NY 10016. (646)742-0800. Fax: (646)742-9211. E-mail: sbrower@printmag.com. www.printmag.com. **Art Director:** Steven Brower. Estab. 1990. Bimonthly professional magazine for "art directors, designers and anybody else interested in graphic design." Circ. 55,000. Art guidelines available.
Illustration: Knowledge of Illustrator and QuarkXPress helpful but not required.
First Contact & Terms: Illustrators: Send postcard sample, printed samples and tearsheets. Sample are filed. Responds only if interested. Art director will contact artist for portfolio review if interested. Portfolios may be dropped off every Monday, Tuesday, Wednesday, Thursday and Friday. Buys first rights. Pays on publication. Finds illustrators through agents, sourcebooks, word of mouth and artist's submissions.
Tips: "Read the magazine—we show art and design and don't buy and commission much, but it does happen."

PROCEEDINGS, U.S. Naval Institute, 291 Wood Rd., Annapolis MD 21402-5035. (410)268-6110. Fax: (410)269-7940. Website: www.navalinstitute.org. **Art Director:** LeAnn Bauer. Monthly 4-color magazine emphasizing naval and maritime subjects. "*Proceedings* is an independent forum for the sea services." Design is clean, uncluttered layout, "sophisticated." Circ. 110,000. Accepts previously published material. Sample copies and art guidelines available.

Cartoons: Buys 23 cartoons/year from freelancers. Prefers cartoons assigned to tie in with editorial topics.
Illustration: Buys 1 illustration/issue. Works on assignment only. Has featured illustrations by Tom Freeman, R.G. Smith and Eric Smith. Features humorous and realistic illustration; charts & graphs; informational graphics; computer and spot illustration. Needs editorial and technical illustration. "We like a variety of styles if possible. Do excellent illustrations and meet the requirement for military appeal." Prefers illustrations assigned to tie in with editorial topics.
First Contact & Terms: Cartoonists: Send query letter with samples of style to be kept on file. Illustrators: Send query letter with printed samples, tearsheets or photocopies. Accepts submissions on disk (call production manager for details). Samples are filed or are returned only if requested by artist. Responds only if interested. Publication will contact artist for portfolio review if interested. Negotiates rights purchased. Sometimes requests work on spec before assigning job. Pays cartoonists $25-50 for b&w, $50 for color. Pays illustrators $50 for b&w inside, $50-75 for color inside; $150-200 for color cover; $25 minimum for spots. "Contact us first to see what our needs are."

PROGRESSIVE RENTALS, 1504 Robin Hood Trail, Austin TX 78703. (512)794-0095. Fax: (512)794-0097. E-mail: nferguson@apro-rto.com. Website: www.aprovision.org. **Art Director:** Neil Ferguson. Estab. 1983. Bimonthly association publication for members of the Association of Progressive Rental Organizations, the national association of the rental-purchase industry. Circ. 5,000. Sample copies free for catalog-size SASE with first-class postage.
Illustration: Buys 3-4 illustrations/issue. Has featured illustrations by Barry Fitzgerald, Aletha Reppel, A.J. Garces, Edd Patton and Jane Marinsky. Features computer and conceptual illustration. Assigns 15% of illustrations to new and emerging illustrators. Prefers cutting edge; nothing realistic; strong editorial qualities. Considers all media. "Accepts computer-based illustrations (Photoshop, Illustrator).
First Contact & Terms: Illustrators: Send postcard sample, query letter with printed samples, photocopies or tearsheets. Accepts disk submissions. (Must be Photoshop-accessable EPS high-resolution [300 dpi] files or Illustrator files.) Samples are filed or returned by SASE. Responds in 1 month if interested. Rights purchased vary according to project. Pays on publication; $300-400 for color cover; $200-300 for b&w, $250-350 for color inside; $75-125 for spots. Finds illustrators mostly through artist's submissions; some from other magazines.
Tips: "Illustrators who work for us must have a strong conceptual ability—that is, they must be able to illustrate for editorial articles dealing with business/management issues. We are looking for cutting-edge styles and unique approaches to illustration. I am willing to work with new, lesser-known illustrators."

THE PROGRESSIVE, 409 E. Main St., Madison WI 53703. (608)257-4626. Website: www.progressive.org. **Art Director:** Nick Jehlen. Estab. 1909. Monthly b&w plus 4-color cover. Circ. 50,000. Originals returned at job's completion. Free sample copy and art guidelines.
Illustration: Works with 50 illustrators/year. Buys 10 b&w illustrations/issue. Features humorous and political illustration. Has featured illustrations by Luba Lukova, Alex Nabaum and Seymour Chwast. Assigns 30% of illustrations to new and emerging illustrators. Needs editorial illustration that is "original, smart and bold." Works on assignment only.
First Contact & Terms: Illustrators: Send query letter with tearsheets and/or photocopies. Samples returned by SASE. Responds in 6 weeks. Portfolio review not required. Pays $800 for b&w and color cover; $250 for b&w line or tone drawings/paintings/collage inside. Buys first rights. Do not send original art. Send samples, postcards or photocopies and appropriate postage for materials to be returned.
Tips: Check out a copy of the magazine to see what kinds of art we've published in the past. A free sample copy is available by visiting our website.

PROTOONER, P.O. Box 2270, Daly City CA 94017-2270. Phone/fax: (650)755-4827. E-mail: protooner @earthlink.net. Website: www.protooner.lookscool.com. **Editor:** Joyce Miller. Art Director: Ladd A. Miller. Estab. 1995. Monthly trade journal for the professional cartoonist and gagwriter. Circ. 925. Sample copy $6 U.S., $9 foreign. Art guidelines for #10 SASE with first-class postage.
Cartoons: Approached by tons of cartoonists/year. Buys 5 cartoons/issue. Prefers good visual humorous impact. Prefers single panel, humorous, b&w line drawings, with or without gaglines.
Illustration: Approached by 6-12 illustrators/year. Buys 3 illustrations/issue. Has featured illustrations by Walt Klis, Chris Kemp, Art McCourt, Chris Patterson and Bob Votjko. Assigns 20% of illustrations to new and emerging illustrators. Features humorous illustration; informational graphics; spot illustration. Prefers humorous, original. Avoid vulgarity. Considers pen & ink. 50% of freelance illustration demands computer knowledge. Query for programs.

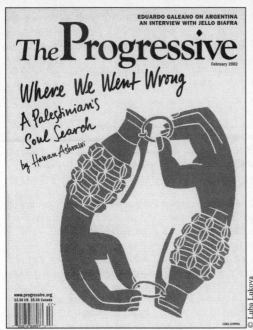

EDUARDO GALEANO ON ARGENTINA
AN INTERVIEW WITH JELLO BIAFRA

The Progressive
February 2002

Where We Went Wrong
A Palestinian's
Soul Search
by Hanan Ashrawi

www.progressive.org
$3.50 US $5.50 Canada

© Luba Lukova

© Sterling Hundley

The Progressive, a monthly political magazine published out of Madison WI, features some of today's most important illustrators. Seymour Chwast, Peter Kuper, David Wheeler, Ted Rall, Luba Lukova and Sterling Hundley. Art director Nick Jehlen fills the publication with powerful art to accompany the magazine's often controversial content. The portrait of Danny Glover by Sterling Hundley, right, accompanied an interview with the actor. The powerfully graphic cover, above, was created by Luba Lukova.

First Contact & Terms: Cartoonists: Send query letter with roughs, SASE, tearsheets. Illustrators: Send query letter with printed samples and SASE. Samples are filed. Responds in 1 month. Buys reprint rights. **Pays on acceptance**. Pays cartoonists $25-35 for b&w cartoons; $15 cover/spots. Pays illustrators $20-30 for b&w cover. Pay for spots varies according to assignment.
Tips: "Pay attention to the magazine slant and SASE a must! Study sample copy before submitting. Request guidelines. Don't mail artwork not properly slanted!"

PSYCHOLOGY TODAY, 49 E. 21st St., 11th Floor, New York NY 10010. (212)260-7210. Fax: (212)260-7566. Website: www.psychologytoday.com. **Art Director:** Philippe Garnier. Estab. 1991. Bimonthly consumer magazine for professionals and academics, men and women. Circ. 350,000. Accepts previously published artwork. Originals returned at job's completion.
Illustration: Approached by 250 illustrators/year. Buys 5 illustrations/issue. Works on assignment only. Prefers psychological, humorous, interpersonal studies. Considers all media. Needs editorial, technical and medical illustration. 20% of freelance work demands knowledge of QuarkXPress or Photoshop.
First Contact & Terms: Illustrators: Send query letter with brochure, photostats and photocopies. Samples are filed and are not returned. Responds only if interested. Buys one-time rights. Pays on publication; $200-500 for color inside; $50-350 for spots; cover negotiable.

PUBLIC CITIZEN NEWS, 1600 20th St., NW, Washington DC 20009. (202)588-1000. Fax: (202)588-7799. E-mail: jvinson@citizen.org. Website: www.citizen.org. **Editor:** Jeff Vinson. Bimonthly magazine emphasizing consumer issues for the membership of Public Citizen, a group founded by Ralph Nader in 1971. Circ. 100,000. Accepts previously published material. Sample copy available for 9 × 12 SASE with first-class postage.

Illustration: Buys up to 2 illustrations/issue. Assigns 33% of illustrations to new and emerging illustrators. Prefers contemporary styles in pen & ink.

First Contact & Terms: Illustrators: Send query letter with samples to be kept on file. Samples not filed are returned by SASE. Buys first rights or one-time rights. Pays on publication. Payment negotiable.

Tips: "Send several keepable samples that show a range of styles and the ability to conceptualize. Want cartoons that lampoon policies and politicians, especially on the far right of the political spectrum. Magazine was redesigned into a newspaper format in 1998."

QUEEN OF ALL HEARTS, Monfort Missionaries, 26 S. Saxon Ave., Bay Shore NY 11706-8993. (631)665-0726. Fax: (631)665-4349. E-mail: montfort@optonline.net. Website: www.montfortmissionaries .com. **Managing Editor:** Rev. Roger Charest. Estab. 1950. Bimonthly Roman Catholic magazine on Marian theology and spirituality. Circ. 2,500. Accepts previously published artwork. Sample copy available.

Illustration: Buys 1 or 2 illustrations/issue. Works on assignment only. Prefers religious. Considers pen & ink and charcoal.

First Contact & Terms: Illustrators: Send postcard samples. Samples are not filed and are returned by SASE if requested by artist. Buys one-time rights. **Pays on acceptance**; $50 minimum for b&w inside.

Tips: Area most open to freelancers is illustration for short stories. "Be familiar with our publication."

RANGER RICK, 1100 Wildlife Center Dr., Reston VA 20190. (703)438-6000. Website: www.nwf.org. **Art Director:** Donna D. Miller. Monthly 4-color children's magazine focusing on wildlife and conversation. Circ. 500,000. Art guidelines are free for #10 SASE with first-class postage.

Illustration: Approached by 100-200 illustrators/year. Buys 4-6 illustrations/issue. Has featured illustrations by Danielle Jones, Jack Desrocher, John Dawson and Dave Clegg. Features computer, humorous, natural science and realistic illustrations. Preferred subjects: children, wildlife and natural world. Assigns 1% of illustrations to new and emerging illustrators. 50% of freelance illustration demands knowledge of Illustrator, Photoshop.

First Contact & Terms: Illustrators: Send query letter with printed samples, photocopies and SASE. Accepts Mac-compatible disk submissions. Samples are filed or returned by SASE. Responds in 3 months. Will contact artist for portfolio review if interested. Buys one-time rights. Pays on publication; $50-250 for b&w inside; $150-800 for color inside; $1,000-2,000 for 2-page spreads; $350-450 for spots. Finds illustrators through promotional samples, books and other magazines.

Tips: "Looking for new artists to draw animals using Illustrator, Photoshop and other computer drawing programs. Please read our magazine before submitting."

REDBOOK MAGAZINE, Redbook Art Dept., 224 W. 57th St., 6th Floor, New York NY 10019-3212. (212)649-2000. Website: www.redbookmag.com. **Contact:** Joanna Farrinond, associate art director. Monthly magazine "geared to married women ages 24-39 with young children and busy lives interested in fashion, food, beauty, health, etc." Circ. 7 million. Accepts previously published artwork. Original artwork returned after publication with additional tearsheet if requested.

Illustration: Buys 3-7 illustrations/issue. Illustrations can be in any medium. Accepts fashion illustrations for fashion page.

First Contact & Terms: Send quarterly postcard. Art director will contact for more samples if interested. Portfolio drop off any day, pick up 2 days later. Buys reprint rights or negotiates rights.

Tips: "We are absolutely open to seeing new stuff, but look at the magazine before you send anything, we might not be right for you. Generally, illustrations should look new, of the moment, fresh, intelligent and feminine. Keep in mind that our average reader is 30 years old, pretty, stylish (but not too 'fashion-y.') We do a lot of health pieces and many times artists don't think of health when sending samples to us—so keep that in mind too."

REFORM JUDAISM, 633 Third Ave., 6th Floor, New York NY 10017-6778. (212)650-4240. **Managing Editor:** Joy Weinberg. Estab. 1972. Quarterly magazine. "The official magazine of the Reform Jewish movement. It covers developments within the movement and interprets world events and Jewish tradition from a Reform perspective." Circ. 310,000. Accepts previously published artwork. Originals returned at job's completion. Sample copies available for $3.50.

Cartoons: Prefers political themes tying into editorial coverage.

Illustration: Buys 8-10 illustrations/issue. Works on assignment. 10% of freelance work demands computer skills.

First Contact & Terms: Cartoonists: Send query letter with finished cartoons. Illustrators: Send query

letter with brochure, résumé, SASE and tearsheets. Samples are filed. Responds in 1 month. Publication will contact artist for portfolio review if interested. Portfolio should include tearsheets, slides and final art. Rights purchased vary according to project. **Pays on acceptance**; varies according to project. Finds artists through sourcebooks and artists' submissions.

N RELIX MAGAZINE, 180 Varick St., 4th Floor, New York NY 10014. (646)230-0100. Website: www.relix.com. **Contact:** Publisher. Estab. 1974. Bimonthly consumer magazine emphasizing independent music and the jamband scene. Circ. 100,000.
Cartoons: Approached by 50 cartoonists/year. Prefers music-related humorous cartoons, single or multiple panel b&w line drawings.
Illustration: Approached by 100 illustrators/year. Buys multiple illustrations/issue. Prefers color illustrations about alternative lifestyle, concerts, touring, hippies, and the jamband scene. Considers pen & ink, airbrush and marker.
First Contact & Terms: Cartoonists: Send query letter with finished cartoons. Illustrators: Send query letter with SASE and photocopies. Samples are not filed and are returned by SASE if requested by artist. Responds to the artist only if interested. Portfolio review not required. Buys all rights. Pays on publication. Pays $25-75 for b&w, $100-150 for color. Pays illustrators $75-150 for b&w, $100-200 for color cover; $15-75 for b&w inside; $15-25 for spots. Finds artists through word of mouth.
Tips: "Not looking for any skeleton artwork. Artwork should be happy, trippy, humorous, and not dark or gory."

☑ THE REPORTER, Women's American ORT, 250 Park Ave. S., Suite 600, New York NY 10003. (212)505-7700. Fax: (212)674-3057. Website: www.waort.org. **Contact:** Dana Asher. Estab. 1966. Biannual organization magazine for Jewish women emphasizing Jewish and women's issues, lifestyle, education. *The Reporter* is the magazine of Women's American ORT, a membership organization supporting a worldwide network of technical and vocational schools. Circ. 60,000. Original artwork returned at job's completion. Sample copies for SASE with first-class postage.
Illustration: Buys 4-8 illustrations/issue. Works on assignment only. Prefers contemporary art. Considers pen & ink, mixed media, watercolor, acrylic, oil, charcoal, airbrush, collage and marker.
First Contact & Terms: Illustrators: Send postcard sample or query letter with brochure, SASE and photographs. Samples are filed. Responds to the artist only if interested. Rights purchased vary according to project. Pays on publication; $150 and up, depending on work.

RHODE ISLAND MONTHLY, 280 Kinsley Ave., Providence RI 02903-4161. (401)421-2552. Fax: (401)277-8080. **Art Director:** Ellen Dessloch. Estab. 1988. Monthly 4-color magazine which focuses on life in Rhode Island. Provides the reader with in-depth reporting, service and entertainment features and dining and calendar listings. Circ. 40,000. Accepts previously published artwork. Art guidelines not available.
 • Also publishes a bride magazine and tourism-related publications.
Illustration: Approached by 200 freelance illustrators/year. Buys 2-4 illustrations/issue. Works on assignment. Considers all media.
First Contact & Terms: Illustrators: Send self-promotion postcards or samples. Samples are filed and not returned. Buys one-time rights. Pays on publication; $250 minimum for color inside, depending on the job. Pays $600-1,000 for features. Finds artists through submissions/self-promotions and sourcebooks.
Tips: "Although we use a lot of photography, we are using more illustration, especially smaller, spot or quarter-page illustrations for our columns in the front of the magazine. If we see a postcard we like, we'll log on to the illustrator's website to see more work."

▤ RICHMOND MAGAZINE, 2100 W. Broad St., Suite 105, Richmond VA 23220. (804)355-0111. Fax: (804)355-5442. E-mail: gwenrd@richmag.com. Website: www.richmag.com. **Art Director:** Steve Hedberg. Estab. 1980. Monthly 4-color regional consumer magazine focusing on Richmond lifestyles. Circ. 25,000. Art guidelines free for #10 SASE with first-class postage.
Cartoons: Approached by 20 cartoonists/year. Buys 5-10 cartoons/year. Prefers humorous, witty, Richmond-related, single panel, humorous color washes. Responds only if interested.
Illustration: Approached by 30 illustrators/year Buys 1-2 illustrations/issue. Has featured illustrations by Kelly Alder, Kerry Talbott, Joel Priddy. Features humorous, realistic, conceptional, medical and spot illustrations. Assigns 25% of illustrations to new and emerging illustrators uses Virginia-based illustrators only.

Follow-up is key to magazine assignments

Managing editor Aeve Baldwin insisted on a complete redesign of music monthly *Relix* magazine when she took the job just over two years ago. These days *Relix* is 100 pages of full-color that focuses on live music and alternative lifestyles. Before the redesign, the magazine was completely black and white and the art "was all sort-of Grateful Dead related—there were a lot of skeletons and roses, and I'm really not a fan of skeletons at all," says Baldwin.

While most of the art published in *Relix* is music related, as the magazine delves further into lifestyle topics its need for other types of art is increasing. For example, a recent issue featured an article about home-brewing beer. *Relix* staffers felt the subject matter didn't lend itself to photos—"So we hired an illustrator and he did this really cute drawing of these elfy-looking guys brewing up beer in the kitchen and it looked great," says Baldwin.

How did Baldwin find A.J. Mitchell, the illustrator who created her "elfy guys" brewing beer? She looked through her files—where she keeps all samples, websites and anything else she gets from artists. "When we're thinking about illustrations we just pull out the file, start going through it, find someone who would fit the article perfectly and then we contact that person."

Even now, a series of postcards by artist Coulter Young sits in her files, waiting for the perfect article. Young sent *Relix* a series of postcards of "five different musicians—like Bruce Springsteen, Bob Dylan, Jerry Garcia. They were immediately recognizable, and there was something very distinctive about them at the same time," says Baldwin. She emphasizes that just because an artist doesn't hear from her right away does not mean she's not interested. Many times, she's just waiting for the right article or subject to come up. "We haven't used him [Young] yet, but I thought 'Wow, that would make a great cover one day for the magazine.' "

Ever since illustrator Coulter Young started sending his promo cards to *Relix* many months ago, Aeve Baldwin just knew she wanted to use his portraits. He has sent promo cards of musicians from Mick Jagger to Ani DiFranco to Ricky Scaggs (whose likeness appears here.) No doubt Baldwin will use the illustrator's talent soon. She's just waiting for the right assignment. To see more of Young's work, visit www.coulteryoung.com.

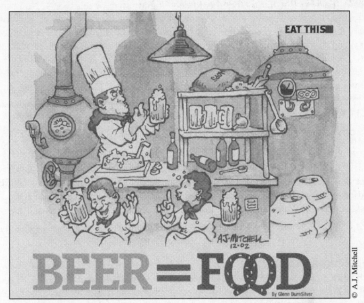

For an article on homebrewing, Aeve Baldwin wanted something a little humorous or whimsical to liven up the article. She contacted A.J. Mitchell, whose promotional postcards had caught her eye. What resulted was this layout. Some features work well with photographs, but others need an illustration, says Baldwin. It's the art director's job to know the difference, and to decide whether to assign either an illustration or photograph.

Surprisingly, Baldwin notes that the only issue she encounters with artists is lack of follow-up. "I mean they send us material, or maybe an e-mail that points us to a website and we keep all that information on file, but they almost never follow up." A phone call or e-mail (after a reasonable amount of time) to check on your submission here might actually be welcome. "Then we can say, 'Hey we think your work might be right for the magazine,' or 'No, we really don't see any future with you at *Relix* at all'," says Baldwin. Artists should also send follow-up postcards every six months or so to keep their work fresh in editors' minds.

The point is that sending a postcard sample really can't hurt—no matter what sort of art you do (except skeletons or roses of course!). Baldwin says she wants to "encourage illustrators to keep contacting us—send us their website information and samples of their art. We don't know any illustrators really—so that's how we select people."
—*Mona Michael*

First Contact & Terms: Cartoonists/Illustrators: Send postcard sample or query letter with photocopies, tearsheets or other nonreturnable samples. Send follow-up postcard every 3 months. Send EPS files. Samples are not returned. Will contact artist for portfolio review if interested. Pays on publication. Pays $150-350 for color cover; $100-300 for color inside. Buys one-time rights. Finds illustrators through promo samples, word of mouth, regional sourcebooks.
Tips: "Be dependable, on time and have strong concepts."

N RISK MANAGEMENT, 655 Third Ave., 2nd Floor, New York NY 10017. (212)286-9292. **Art Director:** Cate Behringer. Emphasizes the risk management and insurance fields; 4-color. Monthly. Circ. 11,600.

Illustration: Buys 3-5 freelance illustrations/issue. Uses artists for covers, 4-color inside and spots. Works on assignment only.

First Contact & Terms: Illustrators: Send card showing art style or tearsheets. No drop-off policy. To show a portfolio, mail tearsheets, postcards or send website address. Printed pieces as samples only. Samples are returned only if requested. Buys one-time rights. Needs conceptual illustration. Needs computer-literate freelancers for illustration and production. 75% of freelance work demands computer literacy in Illustrator, Photoshop.

Tips: When reviewing an artist's work, looks for "strong concepts, creativity and craftsmanship. Our current design uses both illustration and photography."

RIVER CITY, English Dept., University of Memphis, Memphis TN 38152. (901)678-4591. E-mail: _rivercity@memphis.edu. Website: www.people.memphis.edu/~rivercity. **Contact:** Dr. Mary Leader, editor-in-chief. Estab. 1975. Biannual literary magazine. Publishes poetry, fiction, essays and artwork. Circ. 3,000. Sample copies available for $7. Art guidelines available with SASE on website.

Illustration: Buys 12 illustrations/year. Prefers paintings, drawings, sketches, photography.

First Contact & Terms: Illustrators: Send slides. Samples are filed or returned by SASE. Responds in 3 months. Portfolios not required. "Payment is publication of work, two copies of issue featuring work and one-year subscription." Pays on publication. Buys first North American serial rights. Finds freelancers through artists' submissions.

Tips: "We are a small literary journal featuring 4-6 artists per issue. Visit website."

THE ROANOKER MAGAZINE, P.O. Box 21535, Roanoke VA 24018. (540)989-6138. E-mail: art@leisurepublishing.com. Website: www.theroanoker.com. **Art Director:** William Alexander. Production Director: Patty Jackson. Estab. 1974. Bimonthly general interest magazine for the city of Roanoke, Virginia and the Roanoke valley. Circ. 10,000. Originals are returned. Art guidelines not available.

Illustration: Approached by 20-25 freelance illustrators/year. Buys 2-5 illustrations/year. Works on assignment only.

First Contact & Terms: Illustrators: Send query letter with brochure, tearsheets and photocopies. Samples are filed. Responds only if interested. No portfolio reviews. Buys one-time rights. Pays on publication; $100 for b&w or color cover; $75 for b&w or color inside.

Tips: "Please *do not* call or send any material that needs to be returned."

ROBB REPORT, 29160 Heathercliff Rd., Suite 200, Malibu CA 90265. (310)589-7700. Fax: (310)589-7701. **Design Director:** Russ Rocknak. Monthly 4-color consumer magazine "for the luxury lifestyle, featuring exotic cars, investment, entrepreneur, boats, etc." Circ. 150,000. Accepts previously published artwork. Original artwork is returned at job's completion. Sample copies not available; art guidelines for SASE with first-class postage.

ROLLING STONE MAGAZINE, 1290 Avenue of the Americas, 2nd Floor, New York NY 10104-0298. (212)484-1616. Fax: (212)484-1664. Website: www.rollingstone.com. **Art Director:** Andy Cowles. Senior Art Director: Kory Kennedy. Deputy Art Director: Devin Pedzwater. Estab. 1967. Bimonthly magazine. Circ. 1.4 million. Originals returned at job's completion. 100% of freelance design work demands knowledge of Illustrator, QuarkXPress and Photoshop. (Computer skills not necessary for illustrators.) Art guidelines on website.

Illustration: Approached by "tons" of illustrators/year. Buys approximately 4 illustrations/issue. Works on assignment only. Considers all media.

First Contact & Terms: Illustrators: Send postcard sample and/or query letter with tearsheets, photocopies or any appropriate sample. Samples are filed. Does not reply. Portfolios may be dropped off every Tuesday before noon and should include final art and tearsheets. Portfolios may be picked back up on Friday afternoon. Publication will contact artist for portfolio review if interested. Buys first and one-time rights. **Pays on acceptance**; payment for cover and inside illustration varies; pays $300-500 for spots. Finds artists through word of mouth, *American Illustration*, *Communication Arts*, mailed samples and drop-offs.

ROOM OF ONE'S OWN, Box 46160, Station D, Vancouver, BC V6J 5G5 Canada. E-mail: info@roommagazine.com. Website: www.roommagazine.com. **Contact:** Editor. Estab. 1975. Quarterly literary journal. Emphasizes feminist literature for women and libraries. Circ. 1,000. Original artwork

returned after publication if requested. Sample copy for $7; art guidelines for SASE (nonresidents include 3 IRCs).

Illustration: Buys 3-5 illustrations/issue from freelancers. Prefers good realistic illustrations of women and b&w line drawings. Prefers pen & ink, then charcoal/pencil and collage.

First Contact & Terms: Illustrators: Send photographs, slides or original work as samples to be kept on file. Samples not kept on file are returned by SAE (nonresidents include IRC). Responds in 6 months. Buys first rights. Pays cartoonists $25 minimum for b&w and color. Pays illustrators $25-50, b&w, color. Pays on publication.

THE ROTARIAN, 1560 Sherman Ave., Evanston IL 60201-4818. (847)866-3000. Fax: (847)866-9732. E-mail: rotarian@rotaryintl.org. Website: www.rotary.org. Managing Editor: Janice Chambers. **Contact:** D. Lawrence, creative director. Estab. 1911. Monthly 4-color publication emphasizing general interest, business and management articles. The official magazine of Rotary International, a service organization for business and professional men and women, their families and other subscribers. Circ. 510,000. Accepts previously published artwork. Sample copy and editorial fact sheet available.

Cartoons: Buys 5-8 cartoons/year. Interested in general themes with emphasis on business, sports and animals. Avoid topics of sex, national origin, politics.

Illustration: "Rarely purchase illustrations. Primarily purchase photography."

First Contact & Terms: Cartoonists: Send query letter to Cartoon Editor, Charles Pratt, with brochure showing art style. Illustrators: Send query letter to art director with photocopies or brochure showing art style. To show portfolio, artist should follow-up with a call or letter after initial query. Portfolio should include original/final art, final reproduction/product, color and photographs. Responds in 2 weeks. Sometimes requests work on spec before assigning job. Buys all rights. **Pays on acceptance.** Pays cartoonists $100. Illustrator payment negotiable, depending on size, medium, etc.; $800-1,000 for color cover; $75-150 for b&w inside; $200-700 for color inside.

RURAL HERITAGE, Dept AGDM, 281 Dean Ridge Lane, Gainesboro TN 38562-5039. (931)268-0655. E-mail: editor@ruralheritage.com. Website: www.ruralheritage.com. **Editor:** Gail Damerow. Estab. 1976. Bimonthly farm magazine "published in support of modern-day farming and logging with draft animals (horses, mules, oxen)." Circ. 6,700. Sample copy for $8 postpaid; art guidelines not available.

• Editor stresses the importance of submitting cartoons that deal only with farming and logging using draft animals.

Cartoons: Approached by "not nearly enough" cartoonists who understand our subject. Buys 2 or more cartoons/issue. Prefers bold, clean, minimalistic draft animals and their relationship with the teamster. "No unrelated cartoons!" Prefers single panel, humorous, b&w line drawings with or without gagline.

First Contact & Terms: Cartoonists: Send query letter with finished cartoons and SASE. Samples accepted by US mail only. Samples are not filed (unless we plan to use them—then we keep them on file until used) and are returned by SASE. Responds in 2 months. Buys first North American serial rights or all rights rarely. Pays on publication; $10 for one-time rights; $20 for all rights.

Tips: "Know draft animals (horses, mules, oxen, etc.) well enough to recognize humorous situations intrinsic to their use or that arise in their relationship to the teamster. Our best contributors read *Rural Heritage* and get their ideas from the publication's content."

☑ SACRAMENTO MAGAZINE, 706 56th St., Sacramento CA 95819. (916)452-6200. Fax: (916)498-6061. Website: www.sacmag.com. **Art Director:** Debbie Hurst. Estab. 1975. Monthly consumer lifestyle magazine with emphasis on home and garden, women, health features and stories of local interest. Circ. 20,000. Accepts previously published artwork. Originals returned to artist at job's completion. Sample copies available.

Illustration: Approached by 100 illustrators/year. Buys 5 illustrations/year. Works on assignment only. Considers pen & ink, collage, airbrush, acrylic, colored pencil, oil, marker and pastel.

First Contact & Terms: Illustrators: Send postcard sample. Accepts disk submissions. Send EPS files. Samples are filed and are not returned. Publication will contact artist for portfolio review if interested. Portfolio should include b&w and color tearsheets and final art. Buys one-time rights. Pays on publication; $300-400 for color cover; $200-500 for b&w or color inside; $100-200 for spots. Finds artists through submissions.

Tips: Sections most open to freelancers are departments and some feature stories.

Ⓝ SACRAMENTO NEWS & REVIEW, Chico Community Publishing, 1015 20th St., Sacramento CA 95814. (916)498-1234. Fax: (916)498-7930. E-mail: andread@newsreview.com. Website: www.newsre

view.com. **Art Director:** Andrea Diaz. Estab. 1989. "An award-winning black & white with 4-color cover alternative newsweekly for the Sacramento area. We combine a commitment to investigative and interpretive journalism with coverage of our area's growing arts and entertainment scene." Circ. 90,000. Occasionally accepts previously published artwork. Originals returned at job's completion. Art guidelines not available.

● Also publishes issues in Chico, CA and Reno, NV.

Illustration: Approached by 50 illustrators/year. Buys 1 illustration/issue. Works on assignment only. Features caricatures of celebrities and politicans; humorous, realistic, computer and spot illustrations. Assigns 50% of illustrations to new and emerging illustrators. For cover art, needs themes that reflect content.

First Contact & Terms: Illustrators: Send postcard sample or query letter with photocopies, photographs, SASE, slides and tearsheets. Accepts disk submissions compatible with Photoshop. Samples are filed. Publication will contact artist for portfolio review if interested. Portfolio should include tearsheets, slides, photocopies, photographs or Mac floppy disk. Buys first rights. **Pays on acceptance**; $75-150 for b&w cover; $150-300 for color cover; $20-75 for b&w inside; $10-40 for spots. Finds artists through submissions.

Tips: "Looking for colorful, progressive styles that jump off the page. Have a dramatic and unique style . . . not traditional or common."

SALES & MARKETING MANAGEMENT MAGAZINE, 770 Broadway., New York NY 10003. (646)654-7608. Fax: (646)654-7616. E-mail: abass@salesandmarketing.com. Website: www.salesandmark eting.com. **Contact:** Andrew Bass, art director. Monthly trade magazine providing a much needed community for sales and marketing executives to get information on how to do their jobs with colleagues and receive exclusive research and tools that will help advance their careers. Circ. 65,000. Sample copies available on request (depending on availability).

Illustration: Approached by 250-350 illustrators/year. Buys over 1,200 illustrations/year. Has featured illustrations by Douglas Fraser, Murray Kimber, Chris Sickels. Features charts & graphs, humorous, realistic and spot illustrations. Prefers business subjects. 5% of freelance illustration demands knowledge of Illustrator or Photoshop.

First Contact & Terms: Illustrators: Send query letter with samples. Accepts Mac-compatible JPEG or EPS files, or link to website. Samples are filed. Will contact artist for portfolio review if interested. Portfolio should include photographs, slides and tearsheets. Buys first North American serial rights or one-time rights. Pays illustrators $1,000-1,500 for b&w cover; $1,500-2,000 for color cover; $250-950 for b&w inside; $450-1,000 for color inside; 1,200-1,650 for 2-page spreads. Finds illustrators through agents, artists' submissions, *WorkBook*, *Art Pick*, *American Showcase* and word-of-mouth.

SALT WATER SPORTSMAN, 263 Summer St., Boston MA 02210. (617)303-3660. Fax: (617)303-3661. Website: www.saltwatersportsman.com. **Art Director:** Chris Powers. Estab. 1939. Monthly consumer magazine describing the how-to and where-to of salt water sport fishing in the US, Caribbean and Central America. Circ. 140,000. Accepts previously published artwork. Originals returned at job's completion. Sample copies for 8½×11 SASE and 6 first-class stamps. Art guidelines available for SASE with first-class postage.

Illustration: Buys 4-5 illustrations/issue. Works on assignment only. Considers pen & ink, watercolor, acrylic, charcoal and electronic art files.

Design: Needs freelancers for design. 10% of freelance work demands knowledge of Photoshop, Illustrator, QuarkXPress.

First Contact & Terms: Illustrators: Send query letter with tearsheets, photocopies, SASE and transparencies. Designers: Send query letter with photocopies, SASE, tearsheets, transparencies. Samples are not filed and are returned by SASE if requested by artist. Publication will contact artist for portfolio review if interested. Portfolio should include b&w and color tearsheets and final art. Buys first rights. **Pays on acceptance**. Pays illustrators $500-1,000 for color cover; $50 for b&w inside; $100 for color inside. Pays designers by the project. Finds artists mostly through submissions.

Tips: Areas most open to freelancers are how-to, semi-technical drawings for instructional features and

NICHE MARKETING INDEX, identifying Cartoons, Children's Illustration, Licensing, Medical Illustration, Mugs, Religious Art, Science Fiction/Fantasy Art, Sport Art, T-Shirts, Textiles, Wildlife Art and other categories, is located in the back of this book.

columns; occasional artwork to represent fishing action or scenes. "Look the magazine over carefully to see the kind of art we run—focus on these styles."

☑ **SAN FRANCISCO BAY GUARDIAN**, 135 Mississippi St., San Francisco CA 94103. (415)255-3100. Website: www.sfbg.com. **Art Director:** Victor Krummenacher. For "a young, liberal, well-educated audience." Circ. 157,000. Weekly newspaper; tabloid format, b&w with 4-color cover, "progressive design." Art guidelines not available.

Illustration: Has featured illustrations by Mark Matcho, John Veland, Barbara Pollack, Gabrielle Drinard and Gus D'Angelo. Features caricatures of politicans; humorous, realistic and spot illustration. Assigns 30% of illustrations to new and emerging illustrators. Weekly assignments given to local artists. Subjects include political and feature subjects. Preferred styles include contemporary, painterly and graphic line—pen and woodcut. "We like intense and we like fun." Artists who exemplify desired style include Tom Tommorow and George Rieman.

Design: 100% of freelance work demands knowledge of Photoshop, Illustrator, QuarkXPress. Prefers diversified talent.

First Contact & Terms: Designers: Send query letter with photocopies, photographs and tearsheets. Pays illustrators on publication; $300-315 for b&w and color cover; $34-100 for b&w inside; $75-150 for color inside; $100-250 for 2-page spreads; $34-100 for spots. Pays for design by the project.

Tips: "Please submit samples and letter before calling. Turnaround time is generally short, so long-distance artists generally will not work out." Advises freelancers to "have awesome work—but be modest."

SANTA BARBARA MAGAZINE, 25 E. De La Guerra St., Santa Barbara CA 93101-2217. (805)965-5999. Fax: (805)965-7627. **Art Director:** Alisa Baur. Estab. 1975. Bimonthly 4-color magazine with classic design emphasizing Santa Barbara culture and community. Circ. 32,500. Original artwork returned after publication if requested. Sample copy for $3.50.

Illustration: Approached by 20 illustrators/year. Works with 2-3 illustrators/year. Buys about 1-3 illustrations/year. Uses freelance artwork mainly for departments. Works on assignment only.

First Contact & Terms: Send postcard, tearsheets or photocopies. To show a portfolio, mail b&w and color art, final reproduction/product and tearsheets; will contact if interested. Buys first rights. **Pays on acceptance**; approximately $275 for color cover; $175 for color inside. "Payment varies."

Tips: "Be familiar with our magazine."

☑ **THE SATURDAY EVENING POST**, 1100 Waterway Blvd., Indianapolis IN 46202. (317)634-1100. Fax: (317)637-0126. E-mail: Satevepst@aol.com. Website: www.satevepost.org. Estab. 1728. Preventative health magazine with a general interest slant. Published 6 times/year. Circ. 400,000. Sample copy $5.

Cartoons: Cartoon Editor: Steven Pettinga. Buys about 30 cartoons/issue. Uses freelance artwork mainly for humorous fiction. Prefers single panel with gaglines. Receives 100 batches of cartoons/week. "We look for cartoons with neat line or tone art. The content should be in good taste, suitable for a general-interest, family magazine. It must not be offensive while remaining entertaining. Review our guidelines online and then review recent issues. Political, violent or sexist cartoons are not used. Need all topics, but particularly medical, health, travel and financial."

Illustration: Art Director: Chris Wilhoite. Uses average of 3 illustrations/issue. Send query letter with brochure showing art style or résumé and samples. To show a portfolio, mail final art. Buys all rights, "generally. All ideas, sketchwork and illustrative art are handled through commissions only and thereby controlled by art direction. Do not send original material (drawings, paintings, etc.) or 'facsimiles of' that you wish returned." Cannot assume any responsibility for loss or damage.

First Contact & Terms: Cartoonists: SASE. Illustrators: "If you wish to show your artistic capabilities, please send nonreturnable, expendable/sampler material (slides, tearsheets, photocopies, etc.)." Responds in 2 months. Pays on publication. Pays cartoonists $125 for b&w line drawings and washes, no pre-screened art. Pays illustrators $1,000 for color cover; $175 for b&w, $450 for color inside.

Tips: "Send samples of work published in other publications. Do not send racy or too new wave looks. Have a look at the magazine. It's clear that 50 percent of the new artists submitting material have not looked at the magazine."

SCIENCE NEWS, 1719 N St. NW, Washington DC 20036. (202)785-2255. Fax: (202)659-0365. Website: wwwsciencenews.org. **Art Director:** Eric Roell. Weekly magazine emphasizing all sciences for teachers, students and scientists. Circ. 220,000. Accepts previously published material. Original artwork returned after publication. Sample copy for SASE with 42¢ postage.

Illustration: Buys 6 illustrations/year. Prefers realistic style, scientific themes; uses some cartoon-style illustrations. Works on assignment only.

First Contact & Terms: Illustrators: Send query letter with photostats or photocopies to be kept on file. Samples returned by SASE. Responds only if interested. Buys one-time rights. Write for appointment to show portfolio of original/final art. **Pays on acceptance**; $50-800; $50 for spots.

SCRAP, 1325 G St. N.W., Suite 1000, Washington DC 20005-3104. (202)662-8547. Fax: (202)626-0947. E-mail: kentkiser@scrap.org. Website: www.scrap.org. **Editor:** Kent Kiser. Estab. 1987. Bimonthly 4-color trade publication that covers all aspects of the scrap recycling industry. Circ. 7,000.

Cartoons: "We run single-panel cartoons that focus on the recycling theme/business."

Illustration: Approached by 100 illustrators/year. Buys 0-2 illustrations/issue. Features realistic illustrations, business/industrial/corporate illustrations and international/financial illustrations. Prefered subjects: business subjects. Assigns 10% of illustrations to new and emerging illustrators.

First Contact & Terms: Illustrators: Send postcard sample. Samples are filed. Responds in 2 weeks. Portfolio review not required. Buys first North American serial rights. **Pays on acceptance**; $1,200-2,000 for color cover; $300-1,000 for color inside. Finds illustrators through creative sourcebook, mailed submissions, referrals from other editors, and "direct calls to artists whose work I see and like."

Tips: "We're always open to new talent and different styles. Our main requirement is the ability and willingness to take direction and make changes if necessary. No prima donnas, please. Send a postcard to let us see what you can do."

N SCREEN ACTOR, 5757 Wilshire Blvd., Los Angeles CA 90036. (323)954-1600. **Acting National Director of Communication:** Ilyanne Morden Kichauen. Estab. 1934. Quarterly trade journal; magazine format. Covering issues of concern to performers. Circ. 120,000.

SEA MAGAZINE, Box 17782 Cowan, Irvine CA 92614. **Art Director:** Julie Hogan. Estab. 1908. Monthly 4-color magazine emphasizing recreational boating for owners or users of recreational powerboats, primarily for cruising and general recreation; some interest in boating competition; regionally oriented to 13 Western states. Circ. 55,000. Accepts previously published artwork. Return of original artwork depends upon terms of purchase. Sample copy for SASE with first-class postage.

● Also needs freelancers fluent in Quark and Photoshop for production.

Illustration: Approached by 20 illustators/year. Buys 10 illustrations/year mainly for editorial. Considers airbrush, watercolor, acrylic and calligraphy.

First Contact & Terms: Illustrators: Send query letter with brochure showing art style. Samples are returned only if requested. Publication will contact artist for portfolio review if interested. Portfolio should include tearsheets and cover letter indicating price range. Negotiates rights purchased. Pays on publication; $50 for b&w; $250 for color inside (negotiable).

Tips: "We will accept students for portfolio review with an eye to obtaining quality art at a reasonable price. We will help start career for illustrators and hope that they will remain loyal to our publication."

SEATTLE WEEKLY, 1008 Western Ave., Suite 300, Seattle WA 98104. (206)623-0500. Fax: (206)467-4338. E-mail: ksteichen@seattleweekly.com. Website: www.seattleweekly.com. **Contact:** Art Director. Estab. 1975. Weekly consumer magazine; tabloid format; news with emphasis on local and national issues and arts events. Circ. 35,000. Accepts previously published artwork. Original artwork can be returned at job's completion; "but you can come and get them if you're local." Sample copies available for SASE with first-class postage. Art guidelines not available.

Illustration: Approached by 30-50 freelance illustrators/year. Buys 3 freelance illustrations/issue. Works on assignment only. Prefers "sophisticated themes and styles, usually b&w." Considers pen & ink, charcoal, mixed media and scratchboard.

First Contact & Terms: Illustrators: Send query letter with tearsheets and photocopies. Samples are filed and are not returned. Does not reply, in which case the artists should "revise work and try again." To show a portfolio, mail b&w and color photocopies; "always leave us something to file." Buys first rights. Pays on publication; $200-250 for color cover; $60-75 for b&w inside.

Tips: "Give us a sample we won't forget. A really beautiful mailer might even end up on our wall, and when we assign an illustration, you won't be forgotten. All artists used must sign contract. Feel free to e-mail for a copy."

SEEK, 8121 Hamilton Ave., Cincinnati OH 45231. (513)931-4050, ext. 365. **Contact:** Eileen H. Wilmoth, senior editor. Emphasizes religion/faith. Readers are young adult to middle-aged adults who attend church

and Bible classes. Quarterly in weekly issues. Circ. 45,000. Sample copy and art guidelines for SASE with first-class postage.

Cartoons: Approached by 6 cartoonists/year. Buys 8-10 cartoons/year. Buys "church or Bible themes—contemporary situations of applied Christianity." Prefers single panel b&w line drawings with gagline. Has featured illustrations by Chuck Perry and Julie Riley.

First Contact & Terms: Cartoonists: Send finished cartoons, photocopies and photographs. Include SASE. Illustrators: Send b&w 8 × 10 glossy photographs. Responds in 4 months. Buys first North American serial rights. **Pays on acceptance**; $30.

☑ **SHEEP! MAGAZINE**, W11564 Hwy. 64, Withee WI 54498. (715)785-7979. Fax: (715)785-7414. E-mail: csymag@tds.net. Website: www.sheepmagazine.net. **Contact:** Anne-marie Tucker. Estab. 1980. A bimonthly publication covering sheep, wool and woolcrafts. Circ. 5,000. Accepts previously published work.

Cartoons: Approached by 30 cartoonists/year. Buys 5 cartoons/year. Considers all themes and styles. Prefers single panel with gagline.

Illustration: Approached by 10 illustrators/year. Buys 5 illustrations/year; no inside color. Considers pen & ink. Features charts & graphs, computer illustration, informational graphics, realistic, medical and spot illustrations. All art should be sheep related.

First Contact & Terms: Cartoonists: Send query letter with brochure and finished cartoons. Illustrators: Send query letter with brochure, SASE and tearsheets. To show a portfolio, mail thumbnails and b&w tearsheets. Buys first rights or all rights. **Pays on acceptance**. Pays cartoonists $5-15 for b&w. Pays illustrators $75 minimum for b&w.

Tips: "Demonstrate creativity and quality work."

SIGNS OF THE TIMES, 1350 N. King's Rd., Nampa ID 83687. (208)465-2592. E-mail: merste@pacificp ress.com. Website: www.pacificpress.com. **Art Director:** Merwin Stewart. A monthly Seventh-day Adventist 4-color publication that examines contemporary issues such as health, finances, diet, family issues, exercise, child development, spiritual growth and end-time events. "We attempt to show that Biblical principles are relevant to everyone." Circ. 200,000. Art guidelines available for SASE with first-class postage.

• They accept illustrations in electronic form provided to their ftp site by prior arrangement, or sent as e-mail attachments.

Illustration: Buys 6-10 illustrations/issue. Works on assignment only. Has featured illustrations by Ron Bell, Darren Thompson, Consuelo Udave and Lars Justinen. Features realistic illustration. Assigns 10% of illustrations to new and emerging illustrators. Prefers contemporary "realistic, stylistic, or humorous styles (but not cartoons)." Considers any media.

First Contact & Terms: Send postcard sample, brochure, photographs, tearsheets or transparencies. Samples are not returned. "Tearsheets or color photos (prints) are best, although color slides are acceptable." Publication will contact artist for more samples of work if interested. Buys first-time North American publication rights. **Pays on acceptance** (30 days); $800 for color cover; $100-300 for b&w inside; $300-700 for color inside. Fees negotiable depending on needs and placement, size, etc. in magazine. Finds artists through submissions, sourcebooks, and sometimes by referral from other art directors.

Tips: "Most of the magazine illustrations feature people. Approximately 20 visual images (photography as well as artwork) are acquired for the production of each issue, half in black & white, half in color, and the customary working time frame is 3 weeks. Quality artwork and timely delivery are mandatory for continued assignments. It is customary for us to work with highly skilled and dependable illustrators for many years." Advice for artists: "Invest in a good art school education, learn from working professionals within an internship, and draw from your surroundings at every opportunity. Get to know lots of people in the field where you want to market your work, and consistently provide samples of your work so they'll remember you. Then relax and enjoy the adventure of being creative."

THE SILHOUETTE, 940 Second St., Portsmouth OH 45662. (740)351-3689. E-mail: brichards @shawnee.edu. Estab. 1985. Biannual color literary magazine. Circ. 2,000. Poetry journal for ages 18-60; audience is mostly college students and professors. Accepts previously published artwork.

Illustration: Publishes 24 illustrations/issue. Restricted to Scioto County residents only.

First Contact & Terms: Call or e-mail for submission information.

SKILLSUSA CHAMPIONS, (formerly *SkillsUSA Professional*), 14001 James Monroe Hwy., Box 3000, Leesburg VA 20177. (703)777-8810. Fax: (703)777-8999. E-mail: tomhall@skillsusa. Website: www.skills

usa.org. **Editor:** Tom Hall. Estab. 1965. Four-color quarterly magazine. "*SkillsUSA Champions* is primarily a features magazine that provides motivational content by focusing on successful members. SkillsUSA-VICA is an organization of 266,000 students and teachers in technical, skilled and service careers. Circ. 270,000. Accepts previously published artwork. Originals returned at job's completion (if requested). Sample copies available.

Illustration: Approached by 4 illustrators/year. Works on assignment only. Prefers positive, youthful, innovative, action-oriented images. Considers pen & ink, watercolor, collage, airbrush and acrylic.

Design: Needs freelancers for design. 100% freelance work demands knowledge of PageMaker 7.0 and FreeHand 5.0.

First Contact & Terms: Illustrators: Send postcard sample. Designers: Send query letter with brochure. Accepts disks compatible with FreeHand 5.0, Illustrator 10 and PageMaker 7.0. Send FreeHand and EPS files. Samples are filed. Portfolio should include printed samples, b&w and color tearsheets and photographs. Rights purchased vary according to project. **Pays on acceptance**. Pays illustrators $200-300 for color; $100-300 for spots. Pays designers by the project.

Tips: "Send samples or a brochure. These will be kept on file until illustrations are needed. Don't call! Fast turnaround helpful. Due to the unique nature of our audience, most illustrations are not re-usable; we prefer to keep art."

SKIPPING STONES, P.O. Box 3939, Eugene OR 97403-0939. (541)342-4956. E-mail: editor@Skipping Stones.org. Website: www.SkippingStones.org. **Editor:** Arun Toké. Estab. 1988. Bimonthly b&w (with 4-color cover) consumer magazine. International nonprofit multicultural and nature education magazine for today's youth. Circ. 2,500. Art guidelines are free for SASE with first-class postage. Sample copy available for $5.

Cartoons: Prefers multicultural, social issues, nature/ecology themes. Requests b&w washes and line drawings. Featured cartoons by Lindy Wojcicki of Florida. Prefers cartoons by youth under age 19.

Illustration: Approached by 100 illustrators/year. Buys 10-20 illustrations/year. Has featured illustrations by Greg Acuna, Vidushi Avrati Bhatnagar, India; Inna Svjatova, Russia; Jon Bush, US. Features humorous illustration, informational graphics, natural history and realistic, authentic, illustrations. Preferred subjects: children and teens. Prefers pen & ink. Assigns 80% of work to new and emerging illustrators.

First Contact & Terms: Cartoonists: Send b&w photocopies and SASE. Illustrators: Send nonreturnable photocopies and SASE. Samples are filed or returned by SASE. Responds in 3 months if interested. Portfolio review not required. Buys first rights, reprint rights. Pays on publication 1-5 copies. Finds illustrators through word of mouth, artists promo samples.

Tips: "We are a gentle, non-glossy, ad-free magazine not afraid to tackle hard issues. We are looking for work that challenges the mind, charms the spirit, warms the heart; handmade, non-violent, global, for youth 8-15 with multicultural/nature content. Please, no aliens or unicorns. We are especially seeking work by young artists under 19 years of age! People of color and international artists are especially encouraged."

SMALL BUSINESS TIMES AND EMPLOYMENT TIMES, 1123 N. Water St., Milwaukee WI 53202. (414)277-8181. Fax: (414)277-8191. Website: www.biztimes.com. **Art Director:** Shelly Paul. Estab. 1995. Biweekly newspaper/magazine business-to-business publication for southeast Wisconsin.

Illustration: Approached by 80 illustrators/year. Uses 3-5 illustrations/issue. Has featured illustrations by Brad Hamann, Fedrico Jordan, Michael Waraska. Features charts & graphs, computer, humorous illustration, informational graphics, realistic and b&w spot illustrations. Prefers business subjects in simpler styles that reproduce well on newsprint. Assigns 75% of work to new and emerging illustrators.

First Contact & Terms: Illustrators: Send postcard sample and follow-up postcard every year. Accepts Mac-compatible disk submissions. Send EPS or TIFF files. Will contact artist for portfolio review if interested. Buys one-time rights. Pays illustrators $200-400 for color cover; $80-100 for inside. **Pays on acceptance**.

Tips: "Conceptual work wanted! Audience is business men and women in southeast Wisconsin. Need ideas relative to today's business issues/concerns. One to two week turnaround."

THE SMALL POND MAGAZINE OF LITERATURE, Box 664, Stratford CT 06615. **Editor:** Napoleon St. Cyr. Estab. 1964. Emphasizes poetry and short prose. Readers are people who enjoy literature—primarily college-educated. Usually b&w or 2-color cover with "simple, clean design." Published 3 times/year. Circ. 300. Sample copy for $4; art guidelines for SASE.

Illustration: Receives 50-75 illustrations/year. Acquires 1-3 illustrations/issue. Assigns 80% of work to new and emerging illustrators. Has featured illustrations by Matthew Morgaine, Tom Herzberg and Jackie

Peterson. Features spot illustrations. Uses freelance artwork mainly for covers and spots. Prefers "line drawings (inside and on cover) which generally relate to natural settings, but have used abstract work completely unrelated. Fewer wildlife drawings and more unrelated-to-wildlife material."

First Contact & Terms: Illustrators: Send query letter with finished art or production-quality photocopies, 2×3 minimum, 8×11 maximum. Include SASE. Publication will contact artist for portfolio review if interested. Pays 2 copies of issue in which work appears. Buys copyright in copyright convention countries. Finds artists through submissions.

Tips: "Need cover artwork, but inquire first or send for sample copy." Especially looks for "smooth clean lines, original movements, an overall impact. Don't send a heavy portfolio, but rather four to six black & white representative samples with SASE. Don't send your life history and/or a long sheet of credits. DO NOT send a postcard with a beautiful work in full color. Black & white and 3-5 pieces, no postcards. Work samples are worth a thousand words." Advice to artists: "Peruse listings in *Artist's & Graphic Designer's Market* for wants and needs of various publications."

SMART MONEY, 1755 Broadway, 2nd Floor, New York NY 10019. (212)830-9200. Fax: (212)830-9245. Website: www.smartmoney.com. **Art Director:** Gretchen Smelter. Estab. 1992. Monthly consumer magazine. Circ. 760,369. Originals returned at job's completion. Sample copies available.

Illustration: Approached by 200-300 illustrators/year. Buys 10 illustrations/issue. Works on assignment only. Considers pen & ink, airbrush, colored pencil, mixed media, collage, charcoal, watercolor, acrylic, oil, pastel and digital.

First Contact & Terms: Illustrators: Send postcard-size sample. Samples are filed. Publication will contact artist for portfolio review if interested. Portfolio should include tearsheets and photocopies. Buys first and one-time rights. Pays 30 days from invoice; $1,500 for color cover; $400-700 for spots. Finds artists through sourcebooks and submissions.

N SOAP OPERA DIGEST, 261 Madison Ave., 10th Floor, New York NY 10016-2303. (212)716-2700. **Design Creative:** Virginia Bassett. Estab. 1976. Emphasizes soap opera and prime-time drama synopses and news. Weekly. Circ. 2 million. Accepts previously published material. Returns original artwork after publication upon request. Sample copy available for SASE.

Tips: "Review the magazine before submitting work."

N SOAP OPERA WEEKLY, 261 Madison Ave., New York NY 10016. (212)716-8400. **Art Director:** Susan Ryan. Estab. 1989. Weekly 4-color consumer magazine; tabloid format. Circ. 600,000-700,000. Original artwork returned at job's completion.

Illustration: Approached by 50 freelance illustrators/year. Works on assignment only.

First Contact & Terms: Illustrators: Send query letter with brochure and soap-related samples. Samples are filed. Request portfolio review in original query. Publication will contact artist for portfolio review if interested. Portfolio should include original/final art. Buys first rights. **Pays on acceptance**; $2,000 for color cover; $750 for color, full page.

SOLIDARITY MAGAZINE, Published by United Auto Workers, 8000 E. Jefferson, Detroit MI 48214. (313)926-5291. Fax: (313)331-1520. E-mail: uawsolidarity@uaw.net. Website: www.uaw.org. **Editor:** Larry Gabriel. Four-color magazine for "1.3 million member trade union representing U.S., Canadian and Puerto Rican workers in auto, aerospace, agricultural-implement, public employment and other areas." Contemporary design.

Cartoons: Carries "labor/political" cartoons. Payment varies.

Illustration: Works with 10-12 illustrators/year for posters and magazine illustrations. Interested in graphic designs of publications, topical art for magazine covers with liberal-labor political slant. Looks for "ability to grasp our editorial slant."

First Contact & Terms: Illustrators: Send postcard sample or tearsheets and SASE. Samples are filed. Pays $500-600 for color cover; $200-300 for b&w inside; $300-450 for color inside. Graphic Artists Guild members only.

SOUTHERN ACCENTS MAGAZINE, 2100 Lakeshore Dr., Birmingham AL 35209. (205)445-6000. Fax: (445)877-6990. Website: www.southernaccents.com. **Art Director:** Ann M. Carothers. Estab. 1977. Bimonthly consumer magazine emphasizing fine Southern interiors and gardens. Circ. 400,000.

 • Also publishes *Coastal Living*.

Illustration: Buys 25 illustrations/year. Considers color washes, colored pencil and watercolor.

First Contact & Terms: Illustrators: Send postcard sample. Samples are returned. Responds only if interested. Art director will contact artist for portfolio of final art, photographs, slides and tearsheets if interested. Rights purchased vary according to project. Pays on publication; $100-800 for color inside. Finds artists through magazines, sourcebooks and submissions.

N: SOUTHWEST ART, #1440, 5444 Westheimer, Houston TX 77056. (713)296-7900. Fax: (713)850-1314. E-mail: southwestart@southwestart.com. Website: www.southwestart.com. **Editor-in-Chief:** Kristin Bucher. Estab. 1971. Monthly consumer magazine for art collectors interested in the representational fine arts west of the Mississippi River. The editorial core of *Southwest Art* is interviews with contemporary artists complemented by articles that explore the historical context of western American art. Columns focus on changing events in western art museums, galleries and auction houses, along with reviewing past trends and activities in the marketplace. Circ. 60,000. Original transparencies returned at job's completion. Sample copies and art guidelines available.
First Contact & Terms: Does not use cartoons or illustrations, but features the work of fine artists. Send query letter with 35mm slides for possible feature or interview.

SPIDER, P.O. Box 300, Peru IL 61354. **Art Director:** Anthony Jacobson. Estab. 1994. Monthly magazine "for children 6 to 9 years old. Literary emphasis, but also include activities, crafts, recipes and games." Circ. 95,000. Sample copies available; art guidelines for SASE with first-class postage.
Illustration: Approached by 800-1,000 illustrators/year. Buys 30-35 illustrations/issue. Has featured illustrations by Floyd Cooper, Jon Goodell and David Small. Features humorous and realistic illustration. Assigns 25% of illustrations to new and emerging illustrators. Prefers art featuring children and animals, both realistic and whimsical styles. Considers all media.
First Contact & Terms: Send query letter with printed samples, photocopies, SASE and tearsheets. Send follow-up every 4 months. Samples are filed or are returned by SASE. Responds in 6 weeks. Buys all rights. Pays 45 days after acceptance; $750 minimum for cover; $150-250 for color inside. Pays $50-150 for spots. Finds illustrators through artists who've published work in the children's field (books/magazines); artist's submissions.
Tips: "Read our magazine, include samples showing children and animals and put your name, address and phone number on every sample. It's helpful to include pieces that take the same character(s) through several actions/emotional states. It's also helpful to remember that most children's publishers need artists who can draw children from many different racial and ethnic backgrounds."

N: SPRING HILL REVIEW, P.O. Box 621, Brush Prairie WA 98606. (360)892-1178. E-mail: springhillreview@aol.com. **Contact:** Lucy SR Austen, editor. Estab. 2001. Monthly alternative newspaper/literary magazine of Northwest culture—a mixture of art, poetry, fiction, essays, book and movie reviews, and current regional issues. Circ. 5,000. Sample copies available for $2. Art guidelines free with SASE or by e-mail.
Cartoons: Buys 10-12 cartoons/year. Prefers cartoons without sexist or ethnic humor. Prefers single panel, political, humorous, b&w washes, drawings.
Illustration: "We buy artwork—preferably b&w drawings, paintings, photographs, prints, photos of sculpture/collage/etc. Often used as cover art and run with a note on the artist and the work (or sometimes with a full article on or interview with the artist). May be submitted in JPEG by e-mail, or hard copy with SASE."
First Contact & Terms: Cartoonists: Send postcard sample or query letter with SASE. Artists: Send query letter with photographs, SASE, URL. Accepts e-mail submissions with link to website or image file. Prefers Windows-compatible, JPEG files. Samples are filed. Responds in 2 months (SASE required if hard copy). Request portfolio review in original query. Artist should follow up with letter or e-mail after initial query. Portfolio should include b&w, finished art, original art, photographs. Pays cartoonists $10. Pays artists $10-15 for b&w cover; $30 maximum for 2-page spreads. Pays within 3 months of publication. Buys first rights, reprint rights. Finds freelancers through artists' submissions, galleries, word-of-mouth.
Tips: "Artists—don't do cute small animal pictures. We use a wide variety of media and styles, both representational and abstract. Cartoonists: no humor perpetrating sexist or racist stereotypes."

STONE SOUP, The Magazine by Young Writers and Artists, P.O. Box 83, Santa Cruz CA 95063. (831)426-5557. E-mail: editor@stonesoup.com. Website: www.stonesoup.com. **Editor:** Gerry Mandel. Bi-monthly 4-color magazine with "simple and conservative design" emphasizing writing and art by children. Features adventure, ethnic, experimental, fantasy, humorous and science fiction articles. "We only publish

writing and art by children through age 13. We look for artwork that reveals that the artist is closely observing his or her world." Circ. 20,000. Sample copies available for $4. Art guidelines for SASE with first-class postage.

Illustration: Buys 12 illustrations/issue. Prefers complete and detailed scenes from real life. All art must be by children ages 8-13.

First Contact & Terms: Illustrators: Send query letter with photocopies. Samples are filed or are returned by SASE. Responds in 1 month. Buys all rights. Pays on publication; $75 for color cover; $25 for color inside; $25 for spots.

THE STRAIN, 11702 Webercrest, Houston TX 77048. (713)733-0338. **Articles Editor:** Alicia Adler. Estab. 1987. Monthly literary magazine and interactive arts publication. "The purpose of our publication is to encourage the interaction between diverse fields in the arts and (in some cases) science." Circ. 1,000. Accepts previously published artwork. Original artwork is returned to the artist at the job's completion. Sample copy for $5 plus 9×12 SAE and 7 first-class stamps.

Illustration: Buys 2-10 illustrations/issue. "We look for works that inspire creation in other arts."

First Contact & Terms: Cartoonists: Send photocopies of finished cartoons with SASE. Samples not filed are returned by SASE. Responds in 2 years on submissions. Buys one-time rights or negotiates rights purchased. Illustrators: Send work that is complete in any format. Samples are filed "if we think there's a chance we'll use them." Those not filed are returned by SASE. Publication will contact artist for portfolio review if interested. Portfolio should include final art or photographs. Negotiates rights purchased. Pays on publication; $10 for b&w, $5 for color cover; $10 for b&w inside; $5 for color inside.

STRATEGIC FINANCE, 10 Paragon Dr., Montvale NJ 07645. (800)638-4427. Website: www.imanet. org and www.strategicfinancemag.com. **Editorial Director:** Kathy Williams. Art Director: Mary Zisk. Production Manager: Lisa Nasuta. Estab. 1919. Monthly 4-color with a 3-column design emphasizing management accounting for management accountants, controllers, chief financial officers, chief accountants and treasurers. Circ. 80,000. Accepts simultaneous submissions. Originals are returned after publication.

Illustration: Approached by 6 illustrators/year. Buys 10 illustrations/issue.

First Contact & Terms: Illustrators: Send nonreturnable postcard samples. Prefers financial accounting themes.

STUDENT LAWYER, 750 N. Lake Shore Dr., Chicago IL 60611. (312)988-6042. E-mail: kulcm@staff.a banet.org. **Art Director:** Mary Anne Kulchawik. Estab. 1972. Trade journal, 4-color, emphasizing legal education and social/legal issues. "*Student Lawyer* is a legal affairs magazine published by the Law Student Division of the American Bar Association. It is not a legal journal. It is a features magazine, competing for a share of law students' limited spare time—so the articles we publish must be informative, lively, good reads. We have no interest whatsoever in anything that resembles a footnoted, academic article. We are interested in professional and legal education issues, sociolegal phenomena, legal career features, and profiles of lawyers who are making an impact on the profession." Monthly (September-May). Circ. 35,000. Original artwork is returned to the artist after publication.

Illustration: Approached by 20 illustrators/year. Buys 8 illustrations/issue. Has featured illustrations by Sean Kane, Jim Starr, Slug Signorino, Ken Wilson and Charles Stubbs. Features realistic, computer and spot illustration. Assigns 50% of illustrations to experienced, but not well-known illustrators; 50% to new and emerging illustrators. Needs editorial illustration with an "innovative, intelligent style." Works on assignment only. Needs computer-literate freelancers for illustration.

First Contact & Terms: Send postcard sample, brochure, tearsheets and printed sheet with a variety of art images (include name and phone number). Samples are filed. Call for appointment to show portfolio of final art and tearsheets. Buys one-time rights. **Pays on acceptance**; $500-800 for color cover; $450-650 for color inside; $150-350 for spots.

Tips: "In your samples show a variety of styles with an emphasis on editorial work."

☒ ☒ SUB-TERRAIN MAGAZINE, Anvil Press, 6 W. 17th Ave. (Rear), Vancouver BC V5Y 1Z4 Canada. (604)876-8710. Fax: (604)879-2667. E-mail: subter@portal.ca. Website: www.anvilpress.com. **Managing Editor:** Brian Kaufman. Estab. 1988. Quarterly b&w literary magazine featuring contemporary literature of all genres. Art guidelines for SASE with first-class postage.

Cartoons: Prefers single panel cartoons.

Illustration: Assigns 50% of illustrations to new and emerging illustrators.

First Contact & Terms: Send query letter with photocopies. Samples are filed. Responds in 6 months.

Portfolio review not required. Buys first rights, first North American serial rights, one-time rights or reprints rights. Pays in copies, except for covers; price negotiable.

Tips: "Take the time to look at an issue of the magazine to get an idea of what work we use."

☑ **TAMPA BAY MAGAZINE**, 2531 Landmark Dr., Clearwater FL 33761. (727)791-4800. **Editor:** Aaron Fodiman. Estab. 1986. Bimonthly local lifestyle magazine with upscale readership. Circ. 40,000. Accepts previously published artwork. Sample copy available for $4.50. Art guidelines not available.

Cartoons: Approached by 30 cartoonists/year. Buys 6 cartoons/issue. Prefers single panel color washes with gagline.

Illustration: Approached by 100 illustrators/year. Buys 5 illustrations/issue. Prefers happy, stylish themes. Considers watercolor, collage, airbrush, acrylic, marker, colored pencil, oil and mixed media.

First Contact & Terms: Cartoonists: Send query letter with finished cartoon samples. Illustrators: Send query letter with photographs and transparencies. Samples are not filed and are returned by SASE if requested. To show a portfolio, mail color tearsheets, slides, photocopies, finished samples and photographs. Buys one-time rights. Pays on publication. Pays cartoonists $15 for b&w, $20 for color. Pays illustrators $150 for color cover; $75 for color inside.

T&D MAGAZINE, (formerly *Training & Development Magazine*), 1640 King St., Box 1443, Alexandria VA 22313-2043. (703)683-8146. Fax: (703)548-2383. E-mail: ljones@astd.org. **Art Director:** Elizabeth Z. Jones. Estab. 1945. Monthly trade journal that covers training and development in all fields of business. Circ. 40,000. Accepts previously published artwork. Original artwork is returned at job's completion. Art guidelines not available.

Illustration: Approached by 20 freelance illustrators/year. Buys 5-7 freelance illustrations/issue. Works on assignment only. Has featured illustrations by Alison Seiffer, James Yang and Riccardo Stampatori. Features humorous, realistic, computer and spot illustration. Assigns 10% of work to new and emerging illustrators. Prefers sophisticated business style. Considers collage, pen & ink, airbrush, acrylic, oil, mixed media, pastel.

First Contact & Terms: Illustrators: Send postcard sample. Accepts disks compatible with Illustrator 9, FreeHand 5.0, Photoshop 5. Send EPS, JPEG or TIFF files. Use 4-color (process) settings only. Samples are filed. Responds to the artist only if interested. Write for appointment to show portfolio of tearsheets, slides. Buys one-time rights or reprint rights. Pays on publication; $700-1,200 for color cover; $350 for b&w inside; $350-800 for color inside; $800-1,000 for 2-page spreads; $100-300 for spots.

Tips: "Send more than one image if possible. Do not keep sending the same image. Try to tailor your samples to the art director's needs if possible."

TECHNICAL ANALYSIS OF STOCKS & COMMODITIES, 4757 California Ave. SW, Seattle WA 98116-4499. (206)938-0570. Fax: (206)938-1307. E-mail: cmorrison@traders.com. Website: www.Traders .com. **Art Director:** Christine Morrison. Estab. 1982. Monthly traders' magazine for stocks, bonds, futures, commodities, options, mutual funds. Circ. 66,000. Accepts previously published artwork. Sample copies available for $5. Art guidelines on website.

 • This magazine has received several awards including the Step by Step Design Annual, American Illustration IX, Society of American Illustration New York. They also publish *Working Money*, a general interest financial magazine (has similar cartoon and illustration needs).

Cartoons: Approached by 10 cartoonists/year. Buys 1 cartoon/issue. Prefers humorous cartoons, single panel b&w line drawings with gagline.

Illustration: Approached by 100 illustrators/year. Buys 6 illustrations/issue. Works on assignment only. Features humorous, realistic, computer (occasionally) and spot illustrations.

First Contact & Terms: Cartoonists: Send query letter with finished cartoons. Illustrators: Send brochure, tearsheets, photographs, photocopies, photostats, slides. Accepts disk submissions compatible with any Adobe products on TIFF or EPS files. Samples are filed and are not returned. Publication will contact artist for portfolio review if interested. Portfolio should include b&w and color tearsheets, slides, photostats, photocopies, final art and photographs. Buys one-time rights and reprint rights. Pays on publication. Pays cartoonists $35 for b&w. Pays illustrators $135-350 for color cover; $165-213 for color inside; $105-133 for b&w inside.

Tips: "Looking for creative, imaginative and conceptual types of illustration that relate to the article's concepts. Also caricatures with market charts and computers. Send a few copies of black & white and color work with cover letter—if I'm interested I will call."

TEXAS PARKS & WILDLIFE, 3000 S. IH 35, Suite 120, Austin TX 78704-6536. (512)912-7000. Fax: (512)707-1913. Website: www.tpwmagazine.com. **Art Director:** Mark Mahorsky. Estab. 1942. Monthly magazine "containing information on state parks, wildlife conservation, hunting and fishing, environmental awareness." Circ. 180,000. Sample copies for #10 SASE with first-class postage.

Illustration: 100% of freelance illustration demands knowledge of QuarkXPress.

First Contact & Terms: Illustrators: Send postcard sample. Samples are not filed and are not returned. Responds only if interested. Buys one-time rights. Pays on publication; negotiable. Finds illustrators through magazines, word of mouth, artist's submissions.

Tips: "Read our magazine."

THEDAMU ARTS MAGAZINE, 30 Josephine, 3rd Floor, Detroit MI 48202-1810. (313)871-3333. E-mail: davidrambeau@hotmail.com. Website: www.pbfmp,com. **Publisher:** David Rambeau. Estab. 1970. Annual b&w "general adult multi-disciplinary afro-centric urban arts magazine." Circ. 1,000. Accepts previously published graphic artwork "for our covers and our website." Send copies only. Sample copies and art guidelines available via e-mail.

Cartoons: Approached by 5-10 cartoonists/year. "We do special cartoon issues featuring a single artist like a comic book (40-80, 8×11 horizontal drawings) with adult, urban, contemporary themes with a storyline that can be used or transferred to video and would fill seven tab pages and a cover." Prefers b&w graphics or color line drawings.

Design: Needs freelancers for design, production and multimedia projects.

First Contact & Terms: "Prefers correspondence be made by e-mail." Cartoonists: Send query letter with 3-6 story cartoons. Illustrators: Send résumé, photocopies, SASE; "whatever the illustrator is happy with." Prefers e-mail submissions. Payment negotiable; usually copies. Designers: Send query letter with photocopies and SASE. Pays by the project; negotiable. Responds in 2 weeks only if interested. Buys one-time rights usually, but rights purchased sometimes vary according to project. Pays cartoonists $25 for b&w and color. Finds artists through word of mouth and other magazines.

Tips: "We're the first or second step on the publishing ladder for artists and writers. Submit same work to others also. Be ready to negotiate. I see even more computer-based magazines ahead. More small (500-1,000 copies) magazines given computer advances, linkages with video, particularly with respect to cartoons. Be ready to accept copies to distribute. Do cover graphics and story cartoons. Be computer literate. Be persistent. Be self-critical. Be ready to fit the format."

THOMSON MEDICAL ECONOMICS, Five Paragon Dr., Montvale NJ 07645. (201)358-7695. **Art Coordinator:** Sindi Price. Estab. 1909. Publishes 22 health related publications and several annuals. Interested in all media, including electronic and traditional illustrations. Accepts previously published material. Originals are returned at job's completion. Uses freelance artists for "all editorial illustration in the magazines."

Cartoons: Prefers general humor topics: workspace, family, seasonal; also medically related themes. Prefers single panel b&w drawings and washes with gagline.

Illustration: Prefers all media including 3-D illustration. Needs editorial and medical illustration that varies, "but is mostly on the conservative side." Works on assignment only.

First Contact & Terms: Cartoonists: Submissions accepted twice a year—in January and July. Send unpublished cartoons only with SASE to Liz O'Brien, cartoon editor. Pays $150. Buys first world publication rights. Illustrators: Send samples to Sindi Price. Samples are filed. Responds only if interested. Write for portfolio review. Buys one-time rights. Pays $1,000-1,500 for color cover; $200-600 for b&w, $250-800 for color inside.

TIME, 1271 Avenue of the Americas, Rockefeller Center, New York NY 10020-1393. (212)522-4769. Fax: (212)522-0637. Website: www.time.com. **Art Director:** Arthur Hochstein. Deputy Art Directors: Cynthia Hoffman and D.W. Pine. Estab. 1923. Weekly magazine covering breaking news, national and world affairs, business news, societal and lifestyle issues, culture and entertainment. Circ. 4,096,000.

Illustration: Considers all media. Send postcard sample, printed samples, photocopies or other appropriate samples.

First Contact & Terms: Illustrators: Accepts disk submissions. Samples are filed. Responds only if interested. Portfolios may be dropped off every Tuesday between 11 and 1. They may be picked up the following day, Wednesday, between 11 and 1. Buys first North American serial rights. Payment is negotiable. Finds artists through sourcebooks and illustration annuals.

TODAY'S PARENT, 269 Richmond St. West, Toronto, ON M5V 1X1, Canada. (416)596-8680. Fax: (416)596-1991. Website: www.todaysparent.com. **Acting Art Director:** Joann Martin. Monthly parenting magazine. Circ. 175,000. Sample copies available.

Illustration: Send query letter with printed samples, photocopies or tearsheets.

First Contact & Terms: Illustrators: Send follow-up postcard sample every year. Portfolios may be dropped off on Mondays and picked up on Tuesdays. Accepts disk submissions. Art director will contact artist for portfolio review of b&w and color photographs, slides, tearsheets and transparencies if interested. Buys first rights. **Pays on acceptance**, $100-300 for b&w and $250-800 for color inside. Pays $400 for spots. Finds illustrators through magazines, submissions and word of mouth.

Tips: Looks for "good conceptual skills and skill at sketching children and parents."

TOLE WORLD, 1041 Shary Circle, Concord CA 94518-2407. (925)671-9852. Fax: (925)671-0692. E-mail: syarmolich@egw.com. Website: www.toleworld.com. **Editor:** Sandra Yarmolich. Estab. 1977. Bi-monthly 4-color magazine with creative designs for decorative painters. "*Tole* incorporates all forms of craft painting including folk art. Manuscripts on techniques encouraged." Circ. 90,000. Accepts previously published artwork. Original artwork returned after publication. Sample copies available; art guidelines available for SASE with first-class postage.

Illustrations: Buys illustrations mainly for step-by-step project articles. Buys 8-10 illustrations/issue. Prefers acrylics and oils. Considers alkyds, pen & ink, mixed media, colored pencil, watercolor and pastels. Needs editorial and technical illustration.

First Contact & Terms: Illustrators: Send query letter with photographs. Samples are not filed and are returned. Responds within 2 months. Pay is negotiable.

Tips: "Submissions should be neat, evocative and well-balanced in color scheme with traditional themes, though style can be modern."

TRAINING MAGAZINE, Helping People and Business Succeed, 50 S. Ninth St., Minneapolis MN 55402-3118. (612)333-0471. Fax: (612)333-6526. Website: www.trainingmag.com. **Art Director:** Michele Schmidt. Estab. 1964. Monthly 4-color trade journal covering job-related training and education in business and industry, both theory and practice. Audience: training directors, personnel managers, sales and data processing managers, general managers, etc. Circ. 51,000. Sample copies for SASE with first-class postage.

Illustration: Buys a few illustrations/year. Works on assignment only. Prefers themes that relate directly to business and training. Styles are varied. Considers pen & ink, airbrush, mixed media, watercolor, acrylic, oil, pastel and collage.

First Contact & Terms: Illustrators: Send postcard sample, tearsheets or photocopies. Accepts disk submissions. Samples are filed. Responds to the artist only if interested. Buys first rights or one-time rights. **Pays on acceptance**. Pays illustrators $1,500-2,000 for color cover; $800-1,200 for color inside; $100 for spots.

Tips: "Show a wide variety of work in different media and with different subject matter. Good renditions of people are extremely important."

TRAVEL & LEISURE, Dept. AM, 1120 Sixth Ave., 10th Floor, New York NY 10036-6700. (212)382-5600. Fax: (212)382-5877. Website: www.travelandleisure.com. **Contact:** Luke Layman, creative director. Art Director: Emily Crawford. Associate Art Director: Rob Hewitt. Senior Designer: Tom Alberty. Monthly magazine emphasizing travel, resorts, dining and entertainment. Circ. 1 million. Original artwork returned after publication. Art guidelines for SASE.

Illustration: Approached by 250-350 illustrators/year. Buys 1-15 illustrations/issue. Interested in travel and leisure-related themes. "Illustrators are selected by excellence and relevance to the subject." Works on assignment only.

First Contact & Terms: Provide samples and business card to be kept on file for future assignment. Responds only if interested.

Tips: No cartoons.

TRAVEL NATURALLY, (formerly Naturally Magazine), P.O. Box 317, Newfoundland NJ 07435. (973)697-3552. Fax: (973)697-8313. E-mail: naturally@internaturally.com. Website: www.internaturally.com. **Publisher/Editor:** Bernard Loibl. Director of Operations: Cheryl Hanenberg. Estab. 1981. Quarterly magazine covering family nudism/naturism and nudist resorts and travel. Circ. 35,000. Sample copies for $7.50 and $4.25 postage; art guidelines for #10 SASE with first-class postage.

Cartoons: Approached by 10 cartoonists/year. Buys approximately 3 cartoons/issue. Prefers nudism/naturism.

Illustration: Approached by 10 illustrators/year. Buys approximately 3 illustrations/issue. Prefers nudism/naturism. Considers all media. 20% of freelance illustration demands knowledge of Corel Draw.

First Contact & Terms: Cartoonists: Send query letter with finished cartoons. Illustrators: Contact only through artists' rep. Accepts all digital formats or hard copies. Samples are filed. Responds only if interested. Buys one-time rights. Pays on publication. Pays cartoonists $15-70. Pays illustrators $200 for cover; $70/page inside. Fractional pages or fillers are prorated.

TREASURY & RISK MANAGEMENT MAGAZINE, 52 Vanderbilt Ave., Suite 514, New York NY 10017. (212)557-7480. Fax: (212)557-7653. E-mail: hdevine@treasuryandrisk.com. Website: www.treasuryandrisk.com. **Contact:** Heather Devine, creative director. Monthly trade publication for financial/CFO-treasurers. Circ. 50,000. Sample copies available on request.

Illustration: Buys 45-55 illustrations/year. Features business computer illustration, humorous illustration and spot illustrations. Prefers electronic media. Assigns 25% of illustrations to new and emerging illustrators. Freelance artists should be familiar with Illustrator and Photoshop.

First Contact & Terms: Illustrators: Send postcard sample. After introductory mailing, send follow-up postcard sample every 3 months. Accepts e-mail submissions with link to website and image file. Prefers Mac-compatible, JPEG files for samples. Responds only if interested. Company will contact artist for portfolio review if interested. Portfolio should include color and tearsheets. Pays illustrators $1,000-1,200 for color cover; $400 for spot; $500 for ½ page color inside; $650 for full page; $800 for spread. Buys first rights, one-time rights, reprint rights and all rights. Finds freelancers through agents, artists' submissions, magazines and word-of-mouth.

TRIQUARTERLY, 2020 Ridge Ave., Northwestern University, Evanston IL 60208-4302. (847)491-3490. Fax: (847)467-2096. Website: www.triquarterly.nwu.edu. **Editor:** Susan Firestone Hahn. Estab. 1964. *TriQuarterly* literary magazine is "dedicated to publishing writing and graphics which are fresh, adventurous, artistically challenging and never predictable." Circ. 5,000. Originals returned at job's completion.

Illustration: Approached by 10-20 illustrators/year. Considers only work that can be reproduced in b&w as line art or screen for pages; all media; 4-color for cover.

First Contact & Terms: Illustrators: Send query letter with SASE, tearsheets, photographs or photocopies. Samples are filed or are returned in 3 months (if SASE is supplied). Publication will contact artist if interested. Buys first rights. Pays on publication; $300 for b&w/color cover; $20 for b&w inside.

TRUE WEST MAGAZINE, P.O. Box 8008, Cave Creek AZ 85327. (480)575-1881. Fax: (480)575-1903. E-mail: editor@truewestmagazine.com. Website: www.truewestmagazine.com. **Executive Editor:** Bob Boze Bell. Monthly color magazine emphasizing American Western history from 1800 to 1920. For a primarily rural and suburban audience, middle-age and older, interested in Old West history, horses, cowboys, art, clothing and all things Western. Circ. 90,000. Original artwork returned after publication. Sample copy for $5 plus $2.50 postage; art guidelines on website.

• Cartoons must have a Western theme.

Cartoons: Approached by 10-20 cartoonists/year. Buys 2-3 cartoon/issue. Prefers western history theme. Prefers humorous cartoons, single or multiple panel.

Illustration: Occasionally buys illustrations. Has featured illustrations by Gary Zaboly, Bob Bose Bell, Sparky Moore and Jack Jackson. Assigns 80% of illustrations to well-known or "name" illustrators; 10% to experienced, but not well-known illustrators; 10% to new and emerging illustrators. "Inside illustrations are usually, but not always, pen & ink line drawings; covers are Western paintings." 10% of freelance illustration demands knowledge of Photoshop, Illustrator and QuarkXPress.

First Contact & Terms: Cartoonists/Illustrators: Send query letter with photocopies to be kept on file; "We return anything on request. For inside illustrations, we want samples of artist's line drawings. For covers, we need to see full-color transparencies." Responds in 2 weeks if interested. Publication will contact artist for portfolio review if interested. Buys first rights, one-time rights. Pays cartoonists $25-75 for b&w cartoons. Pays illustrators $500-1,000 for color cover; $50-150 for b&w inside; $50-250 for spots.

TURTLE MAGAZINE, For Preschool Kids, Children's Better Health Institute, 1100 Waterway Blvd., Box 567, Indianapolis IN 46202. (317)636-8881. Website: www.turtlemag.org. **Art Director:** Bart Rivers. Estab. 1979. Emphasizes health, nutrition, exercise and safety for children 2-5 years. Published 6 times/

year; 4-color. Circ. 343,923. Original artwork not returned after publication. Sample copy for $1.75; art guidelines for SASE with first-class postage. Needs computer-literate freelancers familiar with Macromedia FreeHand and Photoshop for illustrations.

 • Also publishes *Child Life*, *Children's Digest*, *Children's Playmate*, *US Kids*, *Humpty Dumpty's Magazine* and *Jack and Jill*.

Illustration: Approached by 100 illustrators/year. Works with 20 illustrators/year. Buys 15-30 illustrations/ issue. Interested in "stylized, humorous, realistic and cartooned themes; also nature and health." Works on assignment only.

First Contact & Terms: Illustrators: Send query letter with good photocopies and tearsheets. Accepts disk submissions. Samples are filed or are returned by SASE. Responds only if interested. Portfolio review not required. Buys all rights. Pays on publication; $275 for color cover; $35-90 for b&w inside; $70-155 for color inside; $35-70 for spots. Finds most artists through samples received in mail.

Tips: "Familiarize yourself with our magazine and other children's publications before you submit any samples. The samples you send should demonstrate your ability to support a story with illustration."

TV GUIDE, 1211 Sixth Ave., New York NY 10036. (212)852-7500. Fax: (212)852-7470. Website: www.tv guide.com. **Art Director:** Theresa Griggs. Estab. 1953. Weekly consumer magazine for television viewers. Circ. 11,000,000. Has featured illustrations by Mike Tofanelli and Toni Persiani.

Illustration: Approached by 200 illustrators/year. Buys 50 illustrations/year. Considers all media.

First Contact & Terms: Illustrators: Send postcard sample. Samples are filed. Art director will contact artist for portfolio review of color tearsheets if interested. Negotiates rights purchased. **Pays on acceptance**; $1,500-4,000 for color cover; $1,000-2,000 for full page color inside; $200-500 for spots. Finds artists through sourcebooks, magazines, word of mouth, submissions.

UNMUZZLED OX, 105 Hudson St., New York NY 10013. (212)226-7170. Fax: (718)448-3395. E-mail: MAndreOX@aol.com. **Editor:** Michael Andre. Emphasizes poetry, stories, some visual arts (graphics, drawings, photos) for poets, writers, artists, musicians and interested others; b&w with 2-color cover and "classy" design. Circ. varies depending on format (5,000-20,000). Return of original artwork after publication "depends on work—artist should send SASE." Sample copy for $14 (book quality paperback form).

Illustration: Uses "several" illustrations/issue. Themes vary according to issue.

First Contact & Terms: Cartoonists: Send query letter with copies. No payment for cartoons. Illustrators: Send query letter and "anything you care to send" to be kept on file for possible future assignments. Responds in 10 weeks.

Tips: Magazine readers and contributors are "highly sophisticated and educated"; artwork should be geared to this market. "Really, *Ox* is part of New York art world. We publish art, not 'illustration.' "

UTNE READER, 1624 Harmon Place, Suite 330, Minneapolis MN 55403. (612)338-5040. Fax: (612)338-6043. Website: www.utne.com. **Art Director:** Kristi Anderson. Assistant Art Director: Jessica Coulter. Estab. 1984. Bimonthly digest featuring articles and reviews from the best of alternative media; independently published magazines, newsletters, books, journals and websites. Topics covered include national and international news, history, art, music, literature, science, education, economics and psychology. Circ. 250,000.

 • *Utne Reader* seeks to present a lively diversity of illustration and photography "voices." We welcome artistic samples which exhibit a talent for interpreting editorial content.

Illustration: Buys 10-15 illustrations per issue. Buys 60-day North American rights. Finds artists through submissions, annuals and sourcebooks.

First Contact & Terms: Illustrators: Send single-sided postcards, color or b&w photocopies, printed agency/rep samples, or small posters. We are unlikely to give an assignment based on only one sample, and we strongly prefer that you send several samples in one package rather than single pieces in separate mailings. Clearly mark your full name, address, phone number, fax number, and e-mail address on everything you send. Do not send electronic disks, e-mails with attachments or references to websites. Do not send original artwork of any kind. Samples cannot be returned.

N 🗲 VALLUM, P.O. Box 48003, Montreal, QC H2V 4S8 Canada. E-mail: vallummag@sympatico.ca. Website: www.vallummag.com. **Contact:** Joshua Auerbach or Eleni Auerbach, editors. Estab. 2001. Literary/fine arts magazine published twice/yearly. Publishes exciting interplay of poets and artists. Circ. 1,800. Sample copies available for $7. Art guidelines free with SASE or on website.

Cartoons: Prefers intelligent humor.

Illustration: Buys 15 illustrations/year. Has featured illustrations by Charles Weiss, Chris Conroy. Prefers art that is interesting visually, contemporary and fresh. Uses color for cover, inside of magazine uses b&w or color.

First Contact & Terms: Cartoonists/illustrators send postcard sample or query letter with brochure, photographs, résumé, samples. After introductory mailing, send follow-up postcard every 6 months. Samples are not filed but are returned by SASE. Responds in 5 months. Payment varies. Pays on publication. Buys first North American rights.

VANITY FAIR, 4 Times Square, 22nd Floor, New York NY 10036. (212)286-8180. Fax: (212)286-6707. E-mail: vfmail@vf.com. Website: www.vanityfair.com. **Deputy Art Director:** Julie Weiss. Design Director: David Harris. Estab. 1983. Monthly consumer magazine. Circ. 1.1 million. Does not use previously published artwork. Original artwork returned at job's completion. 100% of freelance design work demands knowledge of QuarkXPress and Photoshop.

Illustration: Approached by "hundreds" of illustrators/year. Buys 3-4 illustrations/issue. Works on assignment only. "Mostly uses artists under contract."

N VARBUSINESS, 600 Community Dr., Manhasset NY 11030. (516)562-5000. E-mail: varbizart@cmp.com. Website: www.varbusiness.com. **Senior Art Director:** Scott Gormely. Estab. 1985. Emphasizes computer business, for and about value added resellers. Biweekly 4-color magazine with an "innovative, contemporary, progressive, very creative" design. Circ. 107,000. Original artwork is returned to the artist after publication. Art guidelines not available.

Illustration: Approached by more than 100 illustrators/year. Works with 30-50 illustrators/year. Buys 150 illustrations/year. Needs editorial illustrations. Open to all styles. Uses artists mainly for covers, full and single page spreads and spots. Works on assignment only. Prefers "digitally compiled, technically conceptual oriented art (all sorts of media)."

Design: Also needs freelancers for design. 100% of design demands knowledge of Photoshop 4.0 and QuarkXPress 3.31.

First Contact & Terms: Illustrators: Send postcard sample or query letter with tearsheets. Accepts e-mail submissions. Samples are filed. Responds only if interested. Call or write for appointment to show portfolio, which should include tearsheets, final reproduction/product and slides. Buys one-time rights. Pays on publication. Pays $1,000-1,500 for b&w cover; $1,500-2,500 for color cover; $500-850 for b&w inside; $750-1,000 for color inside; pays $300-600 for spots.

Tips: "Show printed pieces or suitable color reproductions. Concepts should be imaginative, not literal. Sense of humor sometimes important."

VEGETARIAN JOURNAL, P.O. Box 1463, Baltimore MD 21203-1463. (410)366-8343. E-mail: vrg@vrg.org. Website: www.vrg.org. **Editor:** Debra Wasserman. Estab. 1982. Bimonthly nonprofit vegetarian magazine that examines the health, ecological and ethical aspects of vegetarianism. "Highly educated audience including health professionals." Circ. 27,000. Accepts previously published artwork. Originals returned at job's completion upon request. Sample copies available for $3.

Cartoons: Approached by 4 cartoonists/year. Buys 1 cartoon/issue. Prefers humorous cartoons with an obvious vegetarian theme; single panel b&w line drawings.

Illustration: Approached by 20 illustrators/year. Buys 6 illustrations/issue. Works on assignment only. Prefers strict vegetarian food scenes (no animal products). Considers pen & ink, watercolor, collage, charcoal and mixed media.

First Contact & Terms: Cartoonists: Send query letter with roughs. Illustrators: Send query letter with photostats. Samples are not filed and are returned by SASE if requested by artist. Responds in 2 weeks. Portfolio review not required. Rights purchased vary according to project. **Pays on acceptance**. Pays cartoonists $25 for b&w. Pays illustrators $25-50 for b&w/color inside. Finds artists through word of mouth and job listings in art schools.

Tips: Areas most open to freelancers are recipe section and feature articles. "Review magazine first to learn our style. Send query letter with photocopy sample of line drawings of food."

VIM & VIGOR, 1010 E. Missouri Ave., Phoenix AZ 85014. (602)395-5850. Fax: (602)395-5853. **Senior Art Director:** Susan Knight. Creative Director: Randi Karabin. Estab. 1985. Quarterly consumer magazine focusing on health. Circ. 1.2 million Originals returned at job's completion. Sample copies available. Art guidelines available.

• The company publishes many other titles as well.

Illustration: Approached by 100 illustrators/year. Buys 10 illustrations/issue. Works on assignment only. Considers mixed media, collage, charcoal, acrylic, oil, pastel and computer.
First Contact & Terms: Illustrators: Send postcard sample with tearsheets and online portfolio/website information. Accepts disk submissions. Samples are filed. Rights purchased vary according to project. **Pays on acceptance**. Finds artists through agents, web sourcebooks, word of mouth and submissions.

WASHINGTON CITY PAPER, 2390 Champlain St. N.W., Washington DC 20009. (202)332-2100. Fax: (202)332-8500. E-mail: mail@washcp.com. Website: www.washingtoncitypaper.com. **Art Director:** Jandos Rothstein. Estab. 1980. Weekly tabloid "distributed free in DC and vicinity. We focus on investigative reportage, arts, and general interest stories with a local slant." Circ. 95,000. Art guidelines not available.
Cartoons: Only accepts weekly features, no spots or op-ed style work.
Illustration: Approached by 100-200 illustrators/year. Buys 2-8 illustrations/issue. Has featured illustrations by Michael Kupperman, Peter Kuper, Greg Heuston, Joe Rocco, Marcos Sorensen and Robert Meganck. Features caricatures of politicians; humorous illustration; informational graphics; computer and spot illustration. Considers all media, if the results do well in b&w.
First Contact & Terms: Illustrators: Send query letter with printed samples, photocopies or tearsheets. We occasionally accept Mac-compatible files. Art director will contact artist for portfolio review of b&w, final art, tearsheets if interested. Buys first-rights. Pays on publication which is usually pretty quick. Pays cartoonists $25 minimum for b&w. Pays illustrators $150 minimum for b&w cover; $220 minimum for color cover; $85 minimum for inside. Finds illustrators mostly through submissions.
Tips: "We are a good place for freelance illustrators, we use a wide variety of styles, and we're willing to work with beginning illustrators. We like illustrators who are good on concept and can work fast if needed. We don't use over polished 'clip art' styles. We also avoid cliché DC imagery such as the capitol and monuments. We strongly recommend that interested illustrators send samples by mail rather than e-mail or URLs."

N WASHINGTON FLYER MAGAZINE, % The Magazine Group, 1707 L St. NW, Suite 300, Washington DC 20036-4218. (202)331-9393. Website: www.fly2dc.com. **Art Director:** Sylvia Gashi. Estab. 1989. Bimonthly 4-color consumer magazine. "In-airport publication focusing on travel, transportation, trade and communications for frequent business and pleasure travelers." Circ. 180,000. Accepts previously published artwork. Original artwork is returned to the artist at the job's completion. Sample copies available. Art guidelines not available. Needs computer-literate freelancers for illustration. 20% of freelance work demands knowledge of QuarkXPress, FreeHand or Illustrator.
Illustration: Approached by 100 illustrators/year. Needs editorial illustration—"clear, upbeat, sometimes serious, positive, bright." Works on assignment only. Considers all media.
First Contact & Terms: Illustrators: Send query letter with brochure, tearsheets, photostats, photographs, slides, SASE, photocopies and transparencies. Samples are filed. Publication will contact artist for portfolio review if interested. Portfolio should include color tearsheets, photostats, photographs, slides and color photocopies. Buys reprint rights or all rights. **Pays on acceptance**; $600 for color cover; $250 for color inside.
Tips: "We are very interested in reprint rights."

N WASHINGTONIAN MAGAZINE, 1828 L St., NW, Suite 200, Washington DC 20036. (202)296-3600. E-mail: ecrowson@washingtonian.com. Website: www.washingtonian.com. **Contact:** Eileen Crowson, associate design director. Assistant Design Director: Bill Thompson. Estab. 1965. Monthly 4-color consumer lifestyle and service magazine. Circ. 185,000. Sample copies free for #10 SASE with first-class postage.
Illustration: Approached by 200 illustrators/year. Buys 7-10 illustrations/issue. Has featured illustrations by Pat Oliphant, Chris Tayne and Richard Thompson. Features caricatures of celebrities, caricatures of politicians, humorous illustration, realistic illustrations, spot illustrations, computer illustrations and photo collage. Preferred subjects: men, women and creative humorous illustration. Assigns 20% of illustrations to new and emerging illustrators. 20% of freelance illustration demands knowledge of Photoshop.
First Contact & Terms: Illustrators: Send postcard sample and follow-up postcard every 6 months. Send nonreturnable samples. Send query letter with tearsheets. Accepts Mac-compatible submissions. Send EPS or TIFF files. Samples are filed or returned by SASE. Responds only if interested. Will contact artist for portfolio review if interested. Buys first rights. **Pays on acceptance**; $900-1,200 for color cover; $200-800 for b&w, $400-900 for color inside; $900-1,200 for 2-page spreads; $400 for spots. Finds illustrators through magazines, word of mouth, promotional samples, sourcebooks.

Tips: "We like caricatures that are fun, not mean and ugly. Want a well-developed sense of color, not just primaries."

N WEEKLY ALIBI, 2118 Central Ave. SE, PMB 151, Albuquerque NM 87106-4004. (505)346-0660. Fax: (505)256-9651. E-mail: alibi@alibi.com. Website: www.Alibi.com. **Art Director:** Tom Nayder. Estab. 1992. Small, 4-color, alternative, weekly newspaper/tabloid focusing on local news, music and the arts. Circ. 50,000. Sample copies free for 10 × 13 SAE and 4 first-class stamps. Art guidelines for #10 SAE with first-class postage.

Cartoons: Approached by 30 cartoonists/year. Buys 10 cartoons/issue. Prefers strange, humorous and clean styles. Prefers single panel, double panel, multiple panel, political, humorous, b&w line drawings.

Illustration: Approached by 50 illustrators/year. Buys 3-7 illustrations/issue. Has featured illustrations by Lloyd Dangle, Tony Millionair, Brian Biggs and Sean Tejaratchi. Features caricatures of politicians; humorous, realistic, spot illustration; charts & graphs; and informational graphics. Prefers "anything that looks good on newsprint." Assigns 20% of work to new and emerging illustrators.

First Contact & Terms: Cartoonists: Send query letter with b&w photocopies. Illustrators: Accepts Mac-compatible disk submissions. Send TIFF files. Samples are filed. Responds only if interested. Will contact artist for portfolio review if interested. Responds only if interested. Rights purchased vary according to project. Pays on publication. Pays cartoonists $5-20 for b&w; $10-20 for comic strips. Pays illustrators $150-200 for b&w cover; $150-200 for color cover; $10-20 for b&w inside; $15-25 for color inside; $25 for spots. Finds illustrators through artists' submissions/artists' websites.

Tips: "Send finished art. We get a ton of unfinished pencil drawings that usually get thrown out!"

N WEEKLY READER, Weekly Reader Corp., 200 First Stamford Place, Stamford CT 06912. (203)705-3500. Website: www.weeklyreader.com. **Contact:** Amy Gery. Estab. 1928. Educational periodicals, posters and books. *Weekly Reader* teaches the news to kids pre-K through high school. The philosophy is to connect students to the world. Publications are 4-color. Accepts previously published artwork. Original artwork is returned at job's completion. Sample copies are available.

Illustration: Needs editorial and technical illustration. Style should be "contemporary and age-level appropriate for the juvenile audience." Buys more than 50/week. Works on assignment only. Uses computer and reflective art.

First Contact & Terms: Illustrators: Send brochure, tearsheets, SASE and photocopies. Samples are filed or are returned by SASE if requested by artist. Payment is usually made within 3 weeks of receiving the invoice. Finds artists through artists' submissions/self-promotions, sourcebooks, agents and reps. Some periodicals need quick turnarounds.

Tips: "Our primary focus is the children's and young adult marketplace. Art should reflect creativity and knowledge of audience's needs. Our budgets are tight, and we have very little flexibility in our rates. We need artists who can work with our budgets. Avoid using fluorescent dyes. Use clear, bright colors. Work on flexible board."

N WILDLIFE ART, P.O. Box 22439, Eagan MN 55337. (952)736-1020. Fax: (952)732-1030. **Publisher:** Robert Koenke. Estab. 1982. Bimonthly 4-color trade journal with award-winning design. Many two-page color art spreads. "The largest magazine in wildlife art originals, prints, duck stamps, artist interviews and industry information." Circ. 35,000. Accepts previously published artwork. Original artwork returned to artist at job's completion. Sample copy for $6.95; art guidelines for SASE with first-class postage.

Illustration: Approached by 100 illustrators/year. Works on assignment only. Prefers nature and animal themes. Considers pen & ink and charcoal.

First Contact & Terms: Illustrators: Send postcard sample or query letter. Accepts disk submissions compatible with Mac—QuarkXPress, Illustrator and Photoshop. Send EPS files. Samples are not filed and are returned by SASE if requested by artist. Responds in 2 months. To show a portfolio, mail color tearsheets, slides and photocopies. Buys first rights. "We do not pay artists for illustration in publication material."

Tips: "Interested wildlife artists should send SASE, three to seven clearly-marked slides or transparencies, short biography and be patient!

N WIRE JOURNAL INTERNATIONAL, 1570 Boston Post Rd., Guilford CT 06437-2312. (203)453-2777. Fax: (203)453-8384. Website: www.wirenet.org. **Contact:** Art Director. Emphasizes the wire industry worldwide, members of Wire Association International, industry suppliers, manufacturers, research/devel-

opers, engineers, etc. Monthly 4-color. Circ. 15,000. Design is "professional, technical and conservative." Original artwork not returned after publication. Free sample copy and art guidelines.
Illustration: Illustrations are "used infrequently." Works on assignment only.
First Contact & Terms: Illustrators: Provide samples, business card and tearsheets to be kept on file for possible assignments. To submit a portfolio, call for appointment. Responds "as soon as possible." Buys all rights. Payment is negotiable; on publication.
Tips: "Show practical artwork that relates to industrial needs; and avoid bringing samples of surrealism, for example. Also, show a variety of techniques—and know something about who we are and the industry we serve."

WISCONSIN REVIEW, 800 Algoma Blvd., University of Wisconsin-Oshkosh, Oshkosh WI 54901. (920)424-2267. E-mail: wireview@yahoo.com. **Contact:** Art Editor. Triquarterly review emphasizing literature (poetry, short fiction, reviews). Black & white with 4-color cover. Circ. 2,000. Accepts previously published artwork. Original artwork returned after publication "if requested." Sample copy for $4; art guidelines available; for SASE with first-class postage.
Illustration: Uses 5-10 illustrations/issue. Has featured illustrations by Kurt Zivlonghi and Simone Bonde. Assigns 75% of illustrations to new and emerging illustrators. "Cover submissions can be color, size 5½×8½ or smaller or slides. Submissions for inside must be b&w, size 5½×8½ or smaller unless artist allows reduction of a larger size submission.
First Contact & Terms: Illustrators: Send postcard sample, SASE and slides with updated address and phone number to be kept on file for possible future assignments. Send query letter with roughs, finished art or samples of style. Samples returned by SASE. Responds in 5 months. Pays in 2 contributor's copies.

WISCONSIN TRAILS, P.O. Box 317, BlackEarth WI 53515. (608)767-8000. **Creative Director:** Kathie Campbell. 4-color publication concerning travel, recreation, history, industry and personalities in Wisconsin. Published 6 times/year. Circ. 35,000. Previously published and photocopied submissions OK. Art guidelines for SASE.
Illustration: Buys 6 illustrations/year. "Art work is done on assignment, to illustrate specific articles. All articles deal with Wisconsin. We allow artists considerable stylistic latitude."
First Contact & Terms: Illustrators: Send postcard samples or query letter with brochure, photocopies, SASE, tearsheets, résumé, photographs, slides and transparencies. Samples kept on file for future assignments. Indicate artist's favorite topics; name, address and phone number. Include SASE. Publication will contact artist for portfolio review if interested. Buys one-time rights on a work-for-hire basis. Pays on publication; $50-150 for b&w inside; $50-400 color inside. Finds artists through magazines, submissions/self-promotions, artists' agents and reps and attending art exhibitions.
Tips: "Keep samples coming of new work."

WORKBENCH, August Home Publishing, Inc., 2200 Grand Ave., Des Moines IA 50312. (515)282-7000. Website: www.workbenchmagazine.com. **Art Director:** Robert Foss. Estab. 1957. Bimonthly 4-color magazine for woodworking and home improvement enthusiasts. Circ. 550,000. 100% of freelance work demands knowledge of Illustrator or QuarkXPress on PC or Macintosh.
Illustration: Works with 10 illustrators/year. Buys 50 illustrations/year. Artists with experience in the area of technical drawings, especially house plans, exploded views of furniture construction, power tool and appliance cutaways, should send SASE for sample copy and art guidelines. Style of Eugene Thompson, Don Mannes and Mario Ferro.
First Contact & Terms: Illustrators: Send query letter with nonreturnable samples. Publication will contact artist for portfolio review if interested. Sometimes requests work on spec before assigning job. Pays $50-1,200 for full color.

WORKFORCE, 245 Fischer Ave., B-2, Costa Mesa CA 92626-4537. (714)751-1883. Fax: (714)751-4106. Website: www.workforce.com. **Art Director:** Douglas R. Deay. Production Director: Laura Brunell. Estab. 1922. Monthly trade journal for human resource business executives. Circ. 36,000. Sample copies available in libraries.
Illustration: Approached by 100 illustrators/year. Buys 3-4 illustrations/issue. Prefers business themes. Considers all media. 40% of freelance illustration demands knowledge of Photoshop, QuarkXPress and Illustrator. Send postcard sample. Send follow-up postcard sample every 3 months. Samples are filed and are not returned. Does not reply, artist should call. Art director will contact for portfolio review if interested. Rights purchased vary according to project. **Pays on acceptance**; $350-500 for color cover; $100-400 for

b&w and/or color inside; $75-150 for spots. Finds artists through agents, sourcebooks such as *LA Workbook*, magazines, word of mouth and submissions.
Tips: "Read our magazine."

WY'EAST HISTORICAL JOURNAL, P.O. Box 294, Rhododendron OR 97049. (503)622-4798. Fax: (503)622-4798. **Publisher:** Michael P. Jones. Estab. 1994. Quarterly historical journal. "Our readers love history and nature, and this is what we are about. Subjects include America, Indians, fur trade, Oregon Trail, etc., with a focus on the Pacific Northwest." Circ. 2,500. Accepts previously published artwork. Originals returned at job's completion if accompanied by SASE. Sample copies $10. Art guidelines for SASE with first-class postage. 50% of freelance work demands computer skills.
Cartoons: Approached by 50 cartoonists/year. Buys 6 cartoons/issue. Prefers Northwest Indians, Oregon Trail, wildlife; single panel.
Illustration: Approached by 100 illustrators/year. Buys 10 illustrations/issue. Prefers Northwest Indians, Oregon Trail, fur trade, wildlife. Considers pen & ink, airbrush and charcoal.
Design: Needs freelancers for design and production. 50% of freelance work demands computer skills.
First Contact & Terms: Cartoonists: Send query letter with brochure, roughs and finished cartoons. Buys reprint rights. Illustrators/Designers: Send query letter with brochure, résumé, SASE, tearsheets, photographs, photocopies, slides and transparencies. Samples are filed or are returned by SASE if requested by artist. Responds in 2 weeks. Publication will contact artist for portfolio review if interested. Portfolio should include b&w and color thumbnails, tearsheets, slides, roughs, photostats, photocopies, final art and photographs. Buys first rights. Pays in copies. Finds artists through submissions, sourcebooks and word of mouth.
Tips: Uses freelancers for "feature articles in need of illustrations. However, we will consider doing a feature on the artist's work. Artists find us. Send us a good selection of your samples, even if they are not what we are looking for. Once we see what you can do, we will give an assignment. We are specifically seeking illustrators who know how to make black & white illustrations come alive."

☑ **YACHTING MAGAZINE**, 18 Marshall St., Suite 114, South Norwalk CT 06854-2237. (203)299-5900. Fax: (203)299-5901. Website: www.yachtingnet.com. **Art Director:** Rana Bernhardt. Estab. 1907. Monthly magazine "with emphasis on high-end power and sail vessels. Gear and how-to also included." Circ. 132,000. Art guidelines not available.
Illustration: Approached by 75 illustrators/year. Buys 4-5 illustrations/issue. Features humorous illustration; charts & graphs; informational graphics; computer and spot illustration. Assigns 100% of illustrations to experienced, but not well-known illustrators. Prefers tech drawings. Considers all media. 30% of freelance illustration demands knowledge of Photoshop, Illustrator and QuarkXPress, all late versions.
Design: Needs freelancers for design, production and multimedia projects, rarely. Prefers designers with experience in production. 100% of freelance work demands knowledge of Photoshop, Illustrator and QuarkXPress.
First Contact & Terms: Illustrators: Send postcard sample. Send follow-up postcard samle every 3 months. Designers: Send query letter with printed samples and tearsheets. Accepts disk submissions compatible with QuarkXPress 7.5/version 3.3 send EPS files. Files accepted on CD and ZIP. Samples are filed and are not returned. Responds only if interested. Art director will contact artist for portfolio review of b&w, color tearsheets if interested. Buys first rights. Pays on publication; $250-450 for color inside; $450-600 for 2-page spreads; $150-350 for spots.
Tips: "Read the magazine. I like clean, professional work done quickly and with little supervision. Have a presentable portfolio. Our subject is pretty slim, but we can see potential."

☑ **YM**, Dept. AM, 15 E. 26th St., New York NY 10010. (646)758-0555. Fax: (646)758-0808. **Art Director:** Amy Demas. Deputy Art Director: Karmen Lizzul. A fashion magazine for teen girls between the ages of 14-21. Twelve issues. Circ. 2,276,939. Original artwork returned at job's completion. Sample copies available.
Illustration: Buys 1-2 illustrations/issue. Buys 12-36 illustrations/year. Prefers funny, whimsical illustra-

N MARKETS NEW TO THIS EDITION

tions related to girl/guy problems, horoscopes and dreams. Considers watercolor, collage, acrylic, colored pencil, oil, charcoal, mixed media, pastel.

First Contact & Terms: Samples are filed or not filed (depending on quality). Samples are not returned. Responds to the artist only if interested. Buys one-time rights. **Pays on acceptance** or publication. Offers one half of original fee as kill fee.

N **🖼** **YO! YOUTH OUTLOOK MAGAZINE**, 275 Ninth St., San Francisco CA 94103. (415)503-4170. Fax: (415)503-0970. E-mail: christine@youthoutlook.org. Website: www.youthoutlook.org. **Contact:** Christine Wong, art director. Estab. 1990. Consumer magazine published 10 times/year by and for youth ages 14-24 in the San Francisco Bay Area. *Yo! Magazine* is published by the nonprofit Pacific News Service, and distributed free to classrooms in the 9-county area. Circ. 20,000. Sample copies available with SASE. Art guidelines available.

Illustration: Approached by 50-75 illustrators/year. Buys 50 illustrations/year. Has featured illustrations by Rob Sato, Joe To, Ninette Lewis, Josué Rojas. Features caricatures of celebrities/politicians, fashion illustration, realistic illustration, computer illustration and spot illustrations of families, men, women and teens. Prefers any media that reproduces well in b&w. Assigns 100% of illustrations to new and emerging illustrators. 50% of freelance illustration demands knowledge of scanning and e-mailing images.

First Contact & Terms: Illustrators: Send query letter with b&w and/or color photocopies. After introductory mailing, send follow-up postcard every 6 months. Accepts e-mail submissions with link to website or with image file. Prefers Mac-compatible, JPEG, GIF lo-res small files in one e-mail only. Samples are filed if appropriate or returned by SASE. Responds only if interested. Request portfolio review in original query. Portfolio should include b&w and finished art. Pays illustrators $300 for color cover; $75-100 for b&w inside; $200-250 for 2-page spreads. **Pays on acceptance.** Buys first rights, electronic rights. Finds freelancers through artists' submissions, job postings at local art schools.

Tips: "Please apply if you are between the ages of 14-24 **only. Do not** apply if you are age 25 or older. In your query letter, include your age. We look for art that is narrative, can communicate ideas and emotions, and portrays young people of diverse backgrounds in nonstereotypical ways. People of color and women strongly encouraged. Check out our website or request a sample issue. Local young artists may come to weekly Wednesday editorial meetings 4:30-5:30 p.m.; bring your samples or portfolio. Please call ahead and speak with art director first."

Posters & Prints

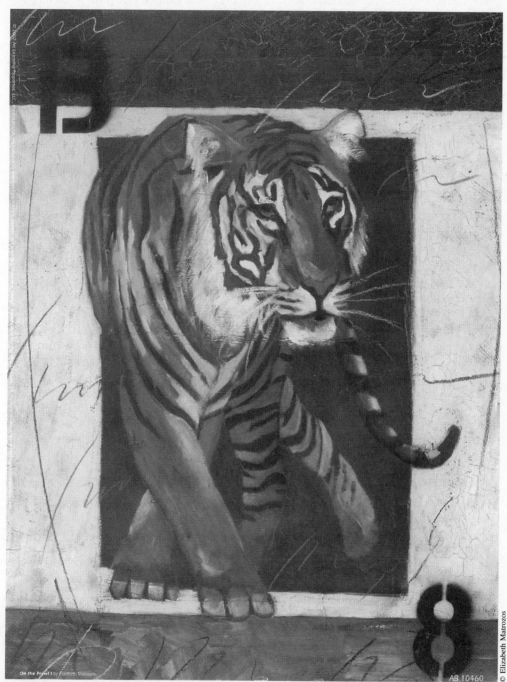

On the Prowl I, by Elizabeth Matrozos, originated with a series of paintings by the artist featuring animals incorporating abstract and typographic elements. The print series was published by Rights International Group.

This section lists art publishers and distributors who can publish and market your work as prints. It is important to understand the difference between the terms "publisher" and "distributor" before you begin your research. Art *publishers* work with you to publish a piece of your work in print form. Art *distributors* assist you in marketing a pre-existing poster or print. Some companies function as both publisher and distributor. Look in the first paragraph of each listing to determine if the company is a publisher, distributor or both.

RESEARCH THE MARKET

Some listings in this section are **fine art presses**, others are more commercial. Read the listings carefully to determine if they create editions for the fine art market or for the **decorative market**. Visit galleries, frame shops, furniture stores and other retail outlets that carry prints to see where your art fits in. You may also want to visit designer showrooms and interior decoration outlets.

To further research this market, check each publisher's website or send for each publisher's catalog. Some publishers will not send their catalogs because they are too expensive, but you can often ask to see one at a local poster shop, print gallery, upscale furniture store or frame shop. Examine the colors in the catalogs to make sure the quality is high.

What to send

To approach a publisher, send a brief query letter, a short bio, a list of galleries that represent your work and five to ten slides or whatever samples they specify in their listing. It helps to send printed pieces or tearsheets as samples, as these show publishers that your work reproduces well and that you have some understanding of the publication process. Most publishers will accept digital submissions via e-mail or CD.

Signing and numbering your editions

Before you enter the print arena, follow the standard method of signing and numbering your editions. You can observe how this is done by visiting galleries and museums and talking to fellow artists.

If you are creating a limited edition, with a specific set number of prints, all prints are numbered, such as 35/100. The largest number is the total number of prints in the edition; the smaller number is the number of the print. Some artists hold out 10% as artist's proofs and number them separately with AP after the number (such as 5/100 AP). Many artists sign and number their prints in pencil.

Types of prints

Original prints. Original prints may be woodcuts, engravings, linocuts, mezzotints, etchings, lithographs or serigraphs. What distinguishes them is that they are produced by hand by the artist (and consequently often referred to as hand-pulled prints). In a true original print the work is created specifically to be a print. Each print is considered an original because the artist creates the artwork directly on the plate, woodblock, etching stone or screen. Original prints are sold through specialized print galleries, frame shops and high-end decorating outlets, as well as fine art galleries.

Offset reproductions and posters. Offset reproductions, also known as posters and image prints, are reproduced by photochemical means. Since plates used in offset reproductions do not wear out, there are no physical limits on the number of prints made. Quantities, however, may still be limited by the publisher in order to add value to the edition.

Giclée prints. As the new color-copier technology matures, inkjet fine art prints, also called giclée prints, are gaining popularity. Iris prints, images that are scanned into a computer and output on oversized printers, are even showing up in museum collections.

YOUR PUBLISHING OPTIONS

1. Working with a commercial poster manufacturer or art publisher. If you don't mind creating commercial images, and following current trends, the decorative market can be quite lucrative. On the other hand, if you work with a fine art publisher, you will have more control over the final image.

2. Working with a fine art press. Fine art presses differ from commercial presses in that press operators work side by side with you to create the edition every step of the way, sharing their experience and knowledge of the printing process. You may be charged a fee for the time your work is on the press and for the expert advice of the printer.

3. Working at a co-op press. Instead of approaching an art publisher you can learn to make your own hand-pulled original prints—such as lithographs, monoprints, etchings or silkscreens. If there is a co-op press in your city, you can rent time on a press and create your own editions. It is rewarding to learn printing skills and have the hands-on experience. You also gain total control of your work. The drawback is you have to market your images yourself by approaching galleries, distributors and other clients.

4. Self-publishing with a printing company. Several national printing concerns advertise heavily in artists' magazines, encouraging artists to publish their own work. If you are a savvy marketer, who understands the ins and outs of trade shows and direct marketing, this is a viable option. However it takes a large investment up front. You could end up with a thousand prints taking up space in your basement, or if you are a good marketer you could end up selling them all and making a much larger profit than if you had gone through an art publisher or poster company.

5. Marketing through distributors. If you choose the self-publishing route, but don't have the resources to market your prints, distributors will market your work in exchange for a percentage of sales. Distributors have connections with all kinds of outlets like retail stores, print galleries, framers, college bookstores and museum shops.

Canvas transfers. Canvas transfers are becoming increasingly popular. Instead of, and often in addition to, printing an image on paper, the publisher transfers your image onto canvas so the work has the look and feel of a painting. Some publishers market limited editions of 750 prints on paper, along with a smaller edition of 100 of the same work on canvas. The edition on paper might sell for $150 per print, while the canvas transfer would be priced higher, perhaps selling for $395.

Pricing criteria for limited editions and posters

Because original prints are always sold in limited editions, they command higher prices than posters, which are not numbered. Since plates for original prints are made by hand, and as a result can only withstand a certain amount of use, the number of prints pulled is limited by the number of impressions that can be made before the plate wears out. Some publishers impose their own limits on the number of impressions to increase a print's value. These limits may be set as high as 700 to 1,000 impressions, but some prints are limited to just 250 to 500, making them highly prized by collectors.

A few publishers buy work outright for a flat fee, but most pay on a royalty basis. Royalties for handpulled prints are usually based on retail price and range from 5 to 20 percent, while percentages for posters and offset reproductions are lower (from 2½ to 5 percent) and are based on the wholesale price. Be aware that some publishers may hold back royalties to cover promotion and production costs. This is not uncommon.

Prices for prints vary widely depending on the quantity available; the artist's reputation; the

popularity of the image; the quality of the paper, ink and printing process. Since prices for posters are lower than for original prints, publishers tend to select images with high-volume sales potential.

Negotiating your contract

As in other business transactions, ask for a contract and make sure you understand and agree to all the terms before you sign. Make sure you approve the size, printing method, paper, number of images to be produced and royalties. Other things to watch for include insurance terms, marketing plans, and a guarantee of a credit line or copyright notice.

Always retain ownership of your original work. Work out an arrangement in which you're selling publication rights only. You'll also want to sell rights only for a limited period of time. That way you can sell the image later as a reprint, or license it for other use (for example as a calendar or note card). If you are a perfectionist about color, make sure your contract gives you final approval of your print. Stipulate that you'd like to inspect a press proof prior to the print run.

MORE INDUSTRY TIPS

Find a niche. Consider working within a specialized subject matter. Prints with Civil War themes, for example, are avidly collected by Civil War enthusiasts. But to appeal to Civil War buffs, every detail, from weapons and foliage in battlefields, to uniform buttons, must be historically accurate. Signed limited editions are usually created in a print run of 950 or so and can average about $175-200; artist's proofs sell from between $195-250, with canvas transfers selling for $400-500. The original paintings from which images are taken often sell for thousands of dollars to avid collectors.

Sport art is another lucrative niche. There's a growing trend toward portraying sports figures from football, basketball, racing (both sports car and horse racing) in prints which include both the artist's and the athlete's signatures. Movie stars and musicians from the 1940s and 50s (such as James Dean, Marilyn Monroe and Elvis) are also cult favorites.

Work in a series. It is easier to market a series of small prints exploring a single theme than to market single images. A series of similar prints works well in long hospital corridors, office meeting rooms or restaurants. Also marketable are "paired" images. Hotels often purchase two similar prints for each of their rooms.

Study trends. If you hope to get published by a commercial art publisher or poster company, your work will have a greater chance of acceptance if you use popular colors and themes.

Attend trade shows. Many artists say it's the best way to research the market and make contacts. Increasingly it has become an important venue for self-published artists to market their work. Decor Expo is held each year in four cities, Atlanta, New York, Orlando and Los Angeles. For more information call (888)608-5300 or visit www.decor_expo.com.

Insider Tips

☑ Read industry publications, such as *Decor* magazine and *Art Business News* to get a sense of what sells.

☑ To find out what trade shows are coming up in your area, check the event calendars in industry trade publications. Many shows, such as the Decor Expo, coincide with annual stationery or gift shows, so if you work in both the print and greeting card markets, be sure to take that into consideration. Remember, traveling to trade shows is a deductible business expense, so don't forget to save your receipts!

☑ Consult *Business and Legal Forms for Fine Artists* by Tad Crawford (Allworth Press) for sample contracts.

ACTION IMAGES INC., 7101 N. Ridgeway, Lincolnwood IL 60712. (847)763-9700. Fax: (847)763-9701. E-mail: actionim@aol.com. Website: www.actionimagesinc.com. **President:** Tom Green. Estab. 1989. Art publisher of sport art. Publishes limited edition prints, open edition posters as well as direct printing on canvas. Specializes in sport art prints for events such as the Super Bowl, World Series, Final Four, Indy 500 and NASCAR. Clients include galleries, distributors, sales promotion agencies. Current clients include E&J Gallo Winery, Duracell Battery, CocaCola, AllSport.

Needs: Seeking sport art for posters and as promotional material for sporting events. Considers all media. Artists represented include Ken Call, Konrad Hack and Alan Studt. Approached by approximately 25 artists/year. Publishes the work of 1 emerging artist/year.

First Contact & Terms: Send query letter with slides or color prints and SASE. Accepts submissions on disk compatible with Mac. Send EPS files. Samples are filed. Responds only if interested. If interested in samples, will ask to see more of artist's work. Pays flat fee: $1,000-2,000. Buys exclusive reproduction rights. Often acquires original painting. Provides insurance while work is at firm and outbound in-transit insurance. Promotional services vary depending on project. Also needs designers. Prefers designers who own Macs. Designers send query letter and samples. Finds artists through recommendations from other artists, word of mouth and submissions.

Tips: "The trend seems to be moving away from superrealism toward more Impressionistic work. We like to work with artists who are knowledgable about the pre-press process. Sometimes artists don't understand that the colors they create in their studios will not reproduce the exact way they envision them. Greens are tough to reproduce accurately. When you finish an artwork, have a photographer shoot it and get a color print. You'll be surprised how the colors come out. For example, if you use dayglow colors, they will not show up well in the cromalin. When we hire an artist to create a piece, we need to know the cromalin print will come back with accurate colors. This can only occur when the artist understands how colors reproduce and plans his colors so the final version shows the intended color."

ALEXANDRE ENTERPRISES, P.O. Box 34, Upper Marlboro MD 20773. (301)627-5170. Fax: (301)627-5106. **Artistic Director:** Walter Mussienko. Estab. 1972. Art publisher and distributor. Publishes and distributes handpulled originals, limited editions and originals. Clients: retail art galleries, collectors and corporate accounts.

Needs: Seeking creative and decorative art for the serious collector and designer market. Considers oil, watercolor, acrylic, pastel, ink, mixed media, original etchings and colored pencil. Prefers landscapes, wildlife, abstraction, realism and impressionism. Artists represented include Cantin and Gantner. Editions created by collaborating with the artist. Approached by 30 artists/year. Publishes the work of 2 emerging artists/year. Distributes the work of 2-4 emerging artists/year.

First Contact & Terms: Send query letter with résumé, tearsheets and photographs. Samples are filed. Responds in 6 weeks only if interested. Call to schedule an appointment to show a portfolio or mail photographs and original pencil sketches. Payment method is negotiated: consignment and/or direct purchase. Offers an advance when appropriate. Negotiates rights purchased. Provides promotion, a written contract and shipping from firm.

Tips: "Artist must be properly trained in the basic and fundamental principles of art and have knowledge of art history. Have work examined by art instructors before attempting to market your work."

ARNOLD ART STORE & GALLERY, 210 Thames St., Newport RI 02840. (401)847-2273. (800)352-2234. Fax: (401)848-0156. E-mail: info@arnoldart.com. Website: arnoldart.com. **Owner:** Bill Rommel. Estab. 1870. Poster company, art publisher, distributor, gallery specializing in marine art. Publishes/distributes limited and unlimited edition, fine art prints, offset reproduction and posters.

Needs: Seeking creative, fashionable, decorative art for the serious collector, commercial and designer markets. Considers oil, acrylic, watercolor, mixed media, pastel, pen & ink, sculpture. Prefers sailing images—Americas Cup or other racing images. Artists represented include Kathy Bray, Thomas Buechner and James DeWitt. Editions created by working from an existing painting. Approached by 100 artists/year. Publishes/distributes the work of 10-15 established artists/year.

First Contact & Terms: Send query letter with 4-5 photographs. Samples are filed or returned by SASE. Call to arrange portfolio review. Pays flat fee, royalties or consignment. Negotiates rights purchased; rights purchased vary according to project. Provides advertising and promotion. Finds artists through word of mouth.

HERBERT ARNOT, INC., 250 W. 57th St., New York NY 10107. (212)245-8287. Website: www.arnotart.com. **President:** Peter Arnot. Vice President: Vicki Arnot. Art dealer of original oil paintings. Clients: galleries, design firms.

International print publisher favors artists with unique vision

Art in Motion, one of the world's largest publishers of print reproduction, presides over the well-trafficked intersection between fine art and retail. Established in 1985, the Canadian-based publisher supplies stunning open edition prints and decorative products to every industry imaginable in over 70 countries. Museums, upscale department stores, restaurants, hotels, and exclusive interior design studios from Chicago to Tokyo are among the clients served. Keeping a staff of 500, Art In Motion has helped hundreds of artists break into the commercial art exchange and as Promotions Specialist Anita Kirk contends, the name speaks for itself on textiles, stationery and wall décor everywhere.

As fine art printers and publishers sprout up frequently, how does an artist choose the appropriate one to query? Also, with other competing publishers chaperoned by an excellent reputation such as Winn Devon Art Group, Wild Apple, and Bruce McGaw Graphics, among others, how does Art In Motion manage to stand out?

Here, Kirk discusses the company's values, the world's hunger for beautiful imagery and the importance of an artist's individual vision, whether an artist happens to be a student or a staple in the most exclusive gallery.

What does Art In Motion look for specifically when choosing art to publish?
We look for artwork with some element of commercial appeal. We also look for exciting new imagery with a fresh idea or interpretation on popular themes such as floral, still life, landscape, and botanicals in wonderful color and texture. For the open edition print market, the work needs to fit into a person's home, an international hotel chain or restaurant. We are interested in all artists whether they are self-taught or have formal training. Many successful published artists have never shown their work in a gallery; others are represented in the world's finest.

Do you scout at galleries, on the Web, or use art directories in your search for talent?
Art In Motion has built a reputation as an artist's company. Many artists submit their work after browsing our catalog in a store, after seeing our collection at a trade show or they may respond to an article in a trade magazine. However, it is our reputation of treating artists with respect, fairness, honesty, and loyalty that draws many artists to submit their work for consideration. We encourage artists to look at our website to get a sense of the styles of artwork we publish.

How do you decide which artwork to publish?
In order to remain at the forefront of trend development, our art directors immerse themselves in fashion, style and the arts. This research often elicits new ideas or sparks a new theme that can be translated into artwork. Imagery that is selected for publication will generally be in line with home decor trends. For example, when Asian is a strong theme in furniture, wall decor will naturally follow.

Are there any particular subjects or themes that are rather difficult to market in today's commercial art exchange?
Artwork featuring religion, politics, nudity, or violence does not translate into our markets.

Does Art In Motion keep records on the works of art sold and the customers the items are sold to? What are the benefits of logging this information?
Like most companies, we keep accurate customer records. This allows us to develop reports to tell us what our top-selling images are. We can also break these numbers down by continent, country or region.

Who are some of your top-selling artists?
Kathryn White, who is originally from England, finds the Old World to be an endless source for themes, light, concepts, colors, design, and decorative elements, which she celebrates in her art. Her current work fuses contemporary materials and traditional methods, with the use of mixed media and textural finishes.

Another artist is Emily Adams, who loves experimenting with the subtleties of color and texture, captures a juxtaposition of modern and Old World elements. Her artistic perspective encourages her to view subjects in a fresh and creative manner, enabling her to interpret a simple object with a unique and often whimsical approach. Whether she depicts florals or an object found on one of her many adventures, it is always rendered with soft brushstrokes and a varied palette.

Saffron Blooms by Ivo and *café au lait* by Emily Adams are two best selling prints published by Art in Motion.

Finally, Ivo, who was born in Kustendil, Bulgaria, studied mural and monumental painting at the Nicolai Pavlovich Academy of Fine Arts in Sofia. Having immigrated to Canada via New-foundland in 1990, Ivo continues to create spontaneous works of art inspired by the relation-ship between the outer presence and the inner life of his paintings. He has been commissioned to create splendid murals across Japan, Canada, Bermuda, and the United States. His works are admired in private collections around the world, and he regularly exhibits his paintings in high profile public spaces.

Unlike many publishers, you published unlimited, rather than limited editions. Could you explain why you've chosen that route?
Our specialty is the open-edition print market. By not limiting the number of prints we produce, we can continue selling an artist's work to our international customer base for many years. This allows for greater market penetration and increased revenue for our artists.

How often do you request promotional appearances from artists?
We occasionally have an artist attend a show for an artist signing. We tend to promote our artists more broadly and to a larger audience through targeted advertising and public relations campaigns both nationally and internationally.

You have welcomed artists whose work is miles apart in terms of subject matter, style and audience—from Clifford Bailey's figurative art to Janet Hampton's classic garden landscapes. It seems those two artists are at opposite ends of the spectrum in terms of style. Is there an "Art in Motion" style-something all your artists have in common?
We sell our artwork in 72 countries and have collections that appeal to all ages, all cultures and individual tastes. It is always thrilling to walk through cities and towns throughout the world and see our artists' work in gift stores, hotels, restaurants, and galleries. Whether it is in a hotel in Paris, a restaurant in Australia or a gallery in San Francisco, people love exquisite art and our collection appeals to their senses of style. What they all have in common includes amazing talent, inspiring ideas and a passion for their work.
—*Candi Lace*

To find out more about Art in Motion visit their website at www.artinmotion.com

Needs: Seeking creative and decorative art for the serious collector and designer market. Considers oil and acrylic paintings. Has wide range of themes and styles—"mostly traditional/impressionistic, not ab-stract." Artists represented include Raymond Campbell, Christian Nesvadba, Gerhard Nesvadba and Lucien Delarue. Distributes the work of 250 artists/year.
First Contact & Terms: Send query letter with brochure, résumé, business card, slides or photographs to be kept on file. Samples are filed or are returned by SASE. Responds in 1 month. Portfolios may be dropped off every Monday-Friday or mailed. Provides promotion.
Tips: "Artist should be professional."

ART EMOTION CORP., 1758 S. Edgar, Palatine IL 60067. (847)397-9300. E-mail: gperez@artcom.com. **President:** Gerard V. Perez. Estab. 1977. Art publisher and distributor. Publishes and distributes limited editions. Clients: corporate/residential designers, consultants and retail galleries.
Needs: Seeking decorative art. Considers oil, watercolor, acrylic, pastel and mixed media. Prefers represen-tational, traditional and impressionistic styles. Artists represented include Garcia, Johnson and Sullivan.

Editions created by working from an existing painting. Approached by 50-75 artists/year. Publishes and distributes the work of 2-5 artists/year.

First Contact & Terms: Send query letter with slides or photographs. "Supply a SASE if you want materials returned to you." Samples are filed. Does not necessarily reply. Pays royalties of 10%.

Tips: "Send visuals first."

THE ART GROUP, 146-150 Royal College St., London NW1 OTA England. 0207 428 1700. Fax: 0207 428 1705. Website: www.artgroup.com. **Contact:** Research Dept. Rights Director. Fine art card and poster publisher/distributor handling posters for framers, galleries, museums, department stores and gift shops. Current clients include IKEA, Habitat, Pier One.

Needs: Considers all media and broad subject matter. Fine art contemporary; digitally created artwork. Publishes the work of 100-200 mid-career and 200-400 established artists/year. Distributes the work of more than 2,000 artists/year.

First Contact & Terms: Send query letter with brochure, photostats, photographs, photocopies, slides and transparencies. Samples are filed or are returned. Responds in 1 month. Publisher/Distributor will contact artists for portfolio review if interested.

Tips: "Send only relevant samples of work. Visit poster and card shops to understand the market a little more before submitting ideas. Be clear and precise."

ART IN MOTION, 2000 Brigatine Dr., Coquitlam, BC V3K 7B5 Canada. (800)663-1308 or (604)525-3900. Fax: (877)525-6166. E-mail: artdirector@artinmotion.com. Website: www.artinmotion.com. **President:** Garry Peters. Artist Relations: Jessica Gibson. Fine art publisher, distributor and framer. Publishes, licenses and distributes open edition reproductions. Licenses all types of artwork for all industries including wallpaper, fabric, stationary and calendars. Clients: galleries, high-end retailers, designers, distributors world wide and picture frame manufacturers.

Needs: "Our collection of imagery reflects today's interior decorating tastes; and we publish a wide variety of techniques. View our collection online before submitting. However, we are always interested in new looks, directions, and design concepts." Considers oil and mixed media.

First Contact & Terms: Please send slides, photographs and transparencies or e-mail digital files. Samples are filed or are returned. "Artists that are selected for publication can look forward to regular income from royalties (paid on a monthly basis); an arrangement that does not affect sales or originals in any way, allowing you to carry on business as you have always done with galleries and other outlets; additional royalty opportunities from licensing your images; worldwide exposure through advertising, publicity and marketing support; representation at over 70 North American and international trade shows each year; commitment to protecting your intellectual property rights (artist maintains copyright at all times); coverage of all costs, including reproduction, insurance and courier charges."

Tips: "We are a world leader in fine art publishing with distribution in over 72 countries. The publishing process utilizes the latest technology and state-of-the-art printing equipment, and uses the finest inks and papers available. Artist input and participation are highly valued and encouraged at all times. We warmly welcome artist inquiries."

ARTEFFECT DESIGNS & LICENSING, (formerly ArtEffects Designs & Licensing Inc.), P.O. Box 1090, Dewey AZ 86327. (928)632-0530. Fax: (928)632-9052. **Manager:** William F. Cupp. Product development, art licensing and representation of European publishers.

Needs: Seeking creative, decorative art for the commercial and designer markets. Considers oil, acrylic, mixed media. Interested in all types of design. Artists represented include James Demmick, Judy Kaufman, Wendy Stevenson, Timothy Easton, Gideon and Christian Baron. Editions created by working from an existing painting.

First Contact & Terms: Send brochure, photographs, SASE, slides. "Must have SASE or will not return." Responds only if interested. Company will contact artist for portfolio review of transparencies if interested. Pays flat fee or royalties. No advance. Rights purchased vary according to project. Provides advertising and representation at international trade shows.

ARTHUR'S INTERNATIONAL, 2613 High Range Dr., Las Vegas NV 89134. **President:** Marvin C. Arthur. Estab. 1959. Art distributor handling original oil paintings primarily. Publishes and distributes limited and unlimited edition prints. Clients: galleries, corporate and private collectors, etc.

Needs: Seeking creative art for the serious collector. Considers all types of original work. Artists represented include Wayne Takazono, Wayne Stuart Shilson, Paul J. Lopez, Ray Shry-Ock and Casimir Gradom-

ski. Editions created by collaborating with the artist or by working from an existing painting. Purchases have been made in pen & ink, charcoal, pencil, tempera, watercolor, acrylic, oil, gouache and pastel. "All paintings should be realistic to view, though may be expressed in various manners."

First Contact & Terms: Send brochure, slides or photographs to be kept on file; no originals unless requested. Artist biographies appreciated. Samples not filed are returned by SASE. Normally responds within 1 week. "We pay a flat fee to purchase the original. Payment made within 5 days. Then we pay 30% of our net profit made on reproductions. The reproduction royalty is paid after we are paid. We automatically raise artist's flat fee as demand increases."

Tips: "Do not send any original paintings unless we have requested them. Having a track record is nice, but it is not a requirement."

☑ **ARTS UNIQ' INC.**, 2299 Summerfield Rd., Box 305, Cookeville TN 38506. (615)526-3491 or (800)223-5020. Fax: (615)528-8904. E-mail: CarrieW@artsuniq.com. Website: www.artsuniq.com. **Contact:** Carrie Wallen. Licensing: Carol White. Estab. 1985. Art publisher. Publishes limited and open editions. Licenses a variety of artwork for cards, throws, figurines, etc. Clients: art galleries, gift shops, furniture stores and department stores.

Needs: Seeking creative and decorative art for the designer market. Considers all media. Artists represented include D. Morgan, Jack Terry, Judy Gibson and Carolyn Wright. Editions created by collaborating with the artist or by working from an existing painting.

First Contact & Terms: Send query letter with slides or photographs. Samples are filed or are returned by request. Responds in 2 months. Pays royalties monthly. Requires exclusive representation rights. Provides promotion, framing and shipping from firm.

ARTVISIONS, 12117 SE 26th St., Bellevue WA 98005-4118. E-mail: ART@artvisions.com. Website: www.artvisions.com. **President:** Neil Miller. Estab. 1993. Markets include publishers of limited edition prints, calendars, home decor, stationery, note cards & greeting cards, posters, and manufacturers of giftware, home furnishings, textiles, puzzles and games. See complete listing in Artists' Reps section.

N **ASHLAND ART**, 1005 Highland Ave., Ashland KY 41102. Phone/fax: (606)325-1816. **Contact:** Bob Coffey, owner. Estab. 1974. Art publisher, distributor. Publishes/distributes hand-pulled originals, monoprints, monotypes, original art. Clients: art consultants, corporate curators, decorators, distributors, frame shops, galleries.

Needs: Seeking decorative art for the commercial and designer markets. Considers acrylic, mixed media, oil, watercolor, serography, etchings. Editions created by collaborating with the artist; and working with the needs of the customer. Approached by over 25 artists/year. Publishes work of 6-8 emerging artists/year. Distributes the work of over 60 emerging artists/year.

First Contact & Terms: Send photographs, slides and transparencies. Samples are not filed but are returned. Responds in 2 weeks. Portfolios not required. Request portfolio review in original query. Company will contact artist for portfolio review if interested. Portfolio should include color art, in whatever presentation is easiest for artist. Pays on consignment basis: firm receives variable commission. No advance. Rights purchased vary according to project. Requires regional exclusive representation of artist. Provides insurance while work is at firm, shipping from our firm, all sales expenses. Finds artists through artist's submissions, referrals.

N **BANKS FINE ART**, 1231 Dragon St., Dallas TX 75207. (214)352-1811. Fax: (214)352-6360. E-mail: bob@banksfineart.com. Website: www.banksfineart.com. **Owner:** Bob Banks. Estab. 1980. Distributor, gallery of original oil paintings. Clients: galleries, decorators.

Needs: Seeking decorative, traditional and impressionistic art for the serious collector and the commercial market. Considers oil, acrylic. Prefers traditional and impressionistic styles. Artists represented include Joe Sambataro, Jan Bain and Marcia Banks. Approached by 100 artists/year. Publishes/distributes the work of 2 emerging artists/year.

First Contact & Terms: Send photographs. Samples are returned by SASE. Responds in 1 week. Offers advance. Rights purchased vary according to project. Provides advertising, in-transit insurance, insurance while work is at firm, promotion, shipping from firm, written contract.

Tips: Needs Paris and Italy street scenes. Advises artists entering the poster and print fields to attend Art Expo, the industry's largest trade event, held in New York City every spring. Also recommends reading *Art Business News*.

☑ **BENTLEY PUBLISHING GROUP**, Box 5551, 1410-J Lesnick Lane, Walnut Creek CA 94597. (925)935-3186. Fax: (925)935-0213. E-mail: alp@bentleypublishinggroup.com. Website: www.bentleypub lishinggroup.com. **Director:** Mary Sher. Product Development Coordinator: Jan Weiss. Estab. 1986. Art publisher of open and limited editions of offset reproductions and canvas replicas; also agency for licensing of artists' images worldwide. Licenses florals, teddy bear, landscapes, wildlife and Christmas images to appear on puzzles, tapestry products, doormats, stitchery kits, giftbags, greeting cards, mugs, tiles, wall coverings, resin and porcelain figurines, waterglobes and various other gift items. Clients: framers, galleries, distributors and framed picture manufacturers.
Needs: Seeking decorative fine art for the designer, residential and commercial markets. Considers oil, watercolor, acrylic, pastel, mixed media and photography. Artists represented include Sherry Strickland, Lisa Chesaux and Andre Renoux. Editions created by collaborating with the artist or by working from an existing painting. Approached by 1,000 artists/year.
First Contact & Terms: Submit JPEG images via e-mail or send query letter with brochure showing art style or résumé, advertisements, slides and photographs. Samples are filed or are returned by SASE if requested by artist. Responds in 6 weeks. Pays royalties of 10% net sales for prints monthly plus 50 artist proofs of each edition. Pays 50% monies received from licensing. Obtains all reproduction rights. Usually requires exclusive representation of artist. Provides national trade magazine promotion, a written contract, worldwide agent representation, 5 annual trade show presentations, insurance while work is at firm and shipping from firm.
Tips: "Feel free to call and request guidelines. Bentley House is looking for experienced artists, with images of universal appeal."

BERKSHIRE ORIGINALS, 2 Prospect Hill, Stockbridge MA 01263. (413)298-3691. Fax: (413)298-1293. E-mail: trumbull@marian.org. Website: www.marian.org. **Program Planner:** Alice Trumbull. Estab. 1991. Art publisher and distributor of offset reproductions and greeting cards.
Needs: Seeking creative art for the commercial market. Considers oil, watercolor, acrylic, pastel and pen & ink. Prefers religious themes, but also considers florals, holiday and nature scenes, line art and border art.
First Contact & Terms: Send query letter with brochure showing art style or other art samples. Samples are filed or are returned by SASE if requested by artist. Responds in 1 month. Write for appointment to show portfolio of slides, color tearsheets, transparencies, original/final art and photographs. Pays flat fee; $50-500. Buys all rights.
Tips: "Good draftsmanship is a must, particularly with figures and faces. Colors must be harmonious and clearly executed."

BERNARD FINE ART, P.O. Box 1528, Historic Rt. 7A, Manchester Center VT 05255. (802)362-0373. Fax: (802)362-1082. E-mail: Michael@applejackart.com. Website: www.applejackart.com. **Managing Director:** Michael Katz. Art publisher. Publishes open edition prints and posters. Clients: picture frame manufacturers, distributors, manufacturers, galleries and frame shops.
 ● This company is a division of Applejack Art Partners, along with the high-end poster lines Hope Street Editions and Rose Selavy of Vermont, as well as Pineapple Publishing, which features over 75 Norman Rockwell images.
Needs: Seeking creative, fashionable and decorative art for commercial and designer markets. Considers oil, watercolor, acrylic, pastel, mixed media and printmaking (all forms). Art guidelines free for SASE with first-class postage. Editions created by collaborating with the artist or by working from an existing painting. Artists represented include Erin Dertner, Kevin Daniel, Bill Bell, Shelly Rasche, John Zaccheo, Robin Betterly and Michael Harrison. Approached by hundreds of artists/year. Publishes the work of 8-10 emerging, 10-15 mid-career and 100-200 established artists.
First Contact and Terms: Send query letter with brochure showing art style and/or résumé, tearsheets, photostats, photocopies, slides, photographs or transparencies. Samples are returned by SASE. Responds only if interested. Call or write for appointment to show portfolio of thumbnails, roughs, original/final art,

MARKET CONDITIONS are constantly changing! If you're still using this book and it is 2005 or later, buy the newest edition of *Artist's & Graphic Designer's Market* at your favorite bookstore or order directly from Writer's Digest Books (1-800-448-0915).

b&w and color photostats, tearsheets, photographs, slides and transparencies. Pays royalty. Offers an advance when appropriate. Buys all rights. Usually requires exclusive representation of artist. Provides in-transit insurance, insurance while work is at firm, promotion, shipping from firm and a written contract. Finds artists through submissions, sourcebooks, agents, art shows, galleries and word of mouth.

Tips: "We look for subjects with a universal appeal. Some subjects that would be appropriate are landscapes, still lifes, wildlife, religious themes and florals. Please send enough examples of your work so we can see a true representation of style and technique."

THE BILLIARD LIBRARY CO., 1570 Seabright Ave., Long Beach CA 90813. (562)437-5413. Fax: (562)436-8817. E-mail: info@billiardlibrary.com. **Creative Director:** Darian Baskin. Estab. 1973. Art publisher. Publishes unlimited and limited editions and offset reproductions. Clients: galleries, frame shops, decorators. Current clients include Deck the Walls, Prints Plus, Adventure Shops.

Needs: Seeking creative, fashionable and decorative art for the commercial and designer markets. Considers oil, watercolor, mixed media, pastel, sculpture and acrylic. Artists represented include George Bloomfield, Dave Harrington and Lance Slaton. Approached by 100 artists/year. Publishes and distributes the work of 1-3 emerging, 1-3 mid-career and 1-2 established artists/year. Also uses freelancers for design. Prefers local designers only.

First Contact & Terms: Send query letter with slides, photocopies, résumé, photostats, transparencies, tearsheets and photographs. Samples are filed and not returned. Responds only if interested. Publisher/Distributor will contact artists for portfolio review if interested. Pays royalties of 10%. Negotiates rights purchased. Provides promotion, advertising and a written contract. Finds artists through submissions, word of mouth and sourcebooks.

Tips: "The Billiard Library Co. publishes and distributes artwork of all media relating to the sport of pool and billiards. Themes and styles of any type are reviewed with an eye towards how the image will appeal to a general audience of enthusiasts. We are experiencing an increasing interest in nostalgic pieces, especially oils. Will also review any image relating to bowling or darts."

N TOM BINDER FINE ARTS, 825 Wilshire Blvd., #708, Santa Monica CA 90401. (310)822-1080. Fax: (310)822-1580. E-mail: info@artman.net. Website: www.artman.net. **Owner:** Tom Binder. Wholesaler of handpulled originals, limited editions and fine art prints. Clients: galleries and collectors.

Needs: Seeking art for the commercial market. Considers acrylic, mixed media, giclee and pop art. Artists represented include Alexander Chen, John Stango and Leo Posillico. Editions created by working from an existing painting.

First Contact & Terms: Send brochure, photographs, photostats, slides, transparencies and tearsheets. Accepts disk submissions if compatible with Illustrator 5.0. Samples are not filed and are returned by SASE. Does not reply; artist should contact. Offers advance when appropriate. Rights purchased vary according to project. Provides shipping. Finds artists through art fairs and World Wide Web.

N BON ART & ARTIQUE, divisions of Art Resources International Ltd., 281 Fields Lane, Brewster NY 10509. (845)277-8888 or (800)228-2989. Fax: (845)277-8602. E-mail: randy@fineartpublishers.com. Website: www.fineartpublishers.com. **Vice President:** Robin E. Bonnist. Estab. 1980. Art publisher. Publishes unlimited edition offset lithographs and posters. Does not distribute previously published work. Clients: galleries, department stores, distributors, framers worldwide.

Needs: Seeking creative and decorative art for the commercial market. Considers oil, acrylic, giclée, watercolor and mixed media. Art guidelines free for SASE with first-class postage. Artists represented include Martin Wiscombe, Mid Gordon, Tina Chaden, Nicky Boehme, Jennifer Wiley, Claudine Hellmuth, Diane Knott, Joseph Kiley, Brenda Walton, Gretchen Shannon, Craig Biggs. Editions created by collaborating with the artist. Approached by hundreds of artists/year. Publishes the work of 15 emerging, 10 mid-career and 10 established artists/year.

First Contact & Terms: E-mail or send query letter with photocopies, photographs, tearsheets, slides and photographs to be kept on file. Samples returned by SASE only if requested. Portfolio review not required. Prefers to see slides or transparencies initially as samples, then reviews originals. Responds in 2 months. Appointments arranged only after work has been sent with SASE. Negotiates payment. Offers advance in some cases. Requires exclusive representation for prints/posters during period of contract. Provides advertising, in-transit insurance, insurance while work is at publisher, shipping from firm, promotion and a written contract. Artist owns original work. Finds artists through art and trade shows, magazines and submissions.

Tips: "Please submit decorative, fine quality artwork. We prefer to work with artists who are creative, professional and open to art direction."

CANADIAN ART PRINTS INC., 110-6311 Westminster Hwy., Richmond, BC V7C 4V4 Canada. (800)663-1166 or (604)276-4551. Fax: (604)276-4552. E-mail: sales@canadianartprints.com. Website: ww w.canadianartprints.com. **Creative Director:** Niki Krieger. Artists Relations: Danielle Worsley and Teesa Martin. Estab. 1965. Art publisher/distributor. Publishes or distributes unlimited edition, fine art prints, posters and art cards. Clients: galleries, decorators, frame shops, distributors, corporate curators, museum shops, giftshops and manufacturing framers. Licenses all subjects of open editions for wallpaper, writing paper, placemats, books, etc.
Needs: Seeking fashionable and decorative art for the commercial and designer markets. Considers oil, acrylic, watercolor, mixed media, pastel. Prefers representational florals, landscapes, marine, decorative, and street scenes. Artists represented include Linda Thompson, Jae Dougall, Philip Craig, Joyce Kamikura, Kiff Holland, Victor Santos, Dubravko Raos, Don Li-Leger, Michael O'Toole and Will Rafuse. Editions created by collaborating with the artist and working from an existing painting. Approached by 300-400 artists/year. Publishes/distributes the work of more than 150 artists/year.
First Contact & Terms: Send query letter with photographs, SASE, slides, tearsheets, transparencies. Samples are not filed and are returned by SASE. Responds in 1 month. Will contact artist for portfolio review of photographs, slides or transparencies if interested. Pays range of royalties. Buys reprint rights or negotiates rights purchased. Provides advertising, in-transit insurance, insurance while work is at firm, promotion, shipping and contract. Finds artists through art exhibitions, art fairs, word of mouth, art reps, submissions.
Tips: "Keep up with trends by following decorating magazines."

CARMEL FINE ART PRODUCTIONS, LTD., 21 Stocker Rd., Verona NJ 07044. (800)951-1950. Fax: (973)571-1768. E-mail: carmelfineart@comcast.net. Website: carmelprod.com. **Vice President Sales:** Louise Perrin. Estab. 1995. Art publisher/distributor. Publishes/distributes originals, limited and open edition fine art prints. Clients: galleries, corporate curators, distributors, frame shops, decorators.
Needs: Seeking creative art for the serious collector, commercial and designer markets. Considers oil, acrylic, pastel. Prefers family-friendly abstract and figurative images. Artists represented include William Calhoun, Jon Jones and Anthony Armstrong. Editions created by collaborating with the artist and working from an existing painting. Approached by 10-20 artists/year. Publishes the work of 2-3 emerging, 1 mid-career and 2-3 established artists/year.
First Contact & Terms: Send query letter with brochure, photographs. Samples are filed. Responds in 1 month. Will contact artist for portfolio review of final art, roughs if interested. Rights purchased vary according to project. Provides advertising, promotion, shipping from firm and contract. Finds artists through established networks.
Tips: "Be true to your creative callings and keep the faith."

CARPENTREE, INC., 2724 N. Sheridan, Tulsa OK 74115. (918)582-3600. Fax: (918)587-4329. Website: www.carpentree.com. **Contact:** Marj Miller, product development. Estab. 1976. Wholesale framed art manufacturer. Publishes and/or distributes limited edition, posters, unlimited edition. Clients: decorators, frame shops, galleries, gift shops and museum shops.
Needs: Seeking decorative art for the commercial market. Considers acrylic, mixed media, oil, pastel, pen & ink, sculpture, watercolor and photography. Prefers traditional, family-oriented, Biblical themes, landscapes. Editions created by collaborating with the artist and by working from an existing painting. Approached by 50 artists/year.
First Contact & Terms: Send photographs, SASE and tearsheets. Accepts e-mail submissions with link to website and image file. Prefers Windows-compatible, JPEG files. Samples are not filed, returned by SASE. Responds in 2 months. Portfolio not required. Negotiates payment. No advance. Negotiates rights purchased. Requires exclusive regional representation of artist. Provides advertising, promotion and written contract. Finds artists through art exhibits/fairs and artist's submissions.

CAVALIER GRAPHICS, 17197 Old Jefferson, Prairieville LA 70769. (225)673-4612. Fax: (225)673-9503. E-mail: support@cavaliergraphics.com. Website: www.cavaliergraphics.com. **Partner:** Al Cavalier. Estab. 1991. Poster company, art publisher and distributor. Publishes/distributes limited edition, unlimited edition, offset reproduction and posters. Clients: galleries, frame shops and distributors. "We have about 1,000 clients in over 40 states."

Needs: Seeking creative, fashionable and decorative art for the commercial and designer market. Considers oil, acrylic, watercolor and mixed media. Prefers decorative, floral, southern genre. Editions created by collaborating with the artist and working from an existing painting. Approached by 20-40 artists/year.

First Contact & Terms: Send query letter with brochure, photographs and tearsheets. Samples are not filed and are returned by SASE. Responds in 3 weeks. Company will contact artist for portfolio review if interested. Portfolio should include color, final art, photographs and tearsheets. Pays royalties and negotiates payment or pays in merchandise. Rights purchased vary according to project. Provides advertising. Finds artists through art exhibition, art fairs, word of mouth and artists' submissions.

Tips: "Be aware of current color trends. Work in a series."

CHALK & VERMILION FINE ARTS, 55 Old Post Rd., #2, Greenwich CT 06831. (203)869-9500. Fax: (203)869-9520. E-mail: mail@chalk-vermilion.com. **Contact:** Pam Ferraro. Estab. 1976. Art publisher. Publishes original paintings, handpulled serigraphs and lithographs, posters, limited editions and offset reproductions. Clients: 4,000 galleries worldwide.

Needs: Publishes decorative art for the serious collector and the commercial market. Considers oil, mixed media, acrylic and sculpture. Artists represented include Thomas McKnight, Bruce Ricker and Fanny Brennan. Editions created by collaboration. Approached by 350 artists/year.

First Contact & Terms: Send query letter with résumé and slides or photographs. Samples are filed or are returned by SASE if requested by artist. Responds in 3 months. Publisher will contact artist for portfolio review if interested. Payment "varies with artist, generally fees and royalties." Offers advance. Negotiates rights purchased. Prefers exclusive representation of artist. Provides advertising, in-transit insurance, promotion, shipping to and from firm, insurance while work is at firm and written contract. Finds artists through exhibitions, trade publications, catalogs, submissions.

CIRRUS EDITIONS, 542 S. Alameda St., Los Angeles CA 90013. (213)680-3473. Fax: (213)680-0930. E-mail: cirrus@cirrusgallery.com. Website: www.cirrusgallery.com. **President:** Jean R. Milant. Produces limited edition handpulled originals. Clients: museums, galleries and private collectors.

Needs: Seeking contemporary paintings and sculpture. Prefers abstract, conceptual work. Artists represented include Lari Pittman, Joan Nelson, John Millei, Charles C. Hill and Bruce Nauman. Publishes and distributes the work of 6 emerging, 2 mid-career and 1 established artists/year.

First Contact & Terms: Prefers slides as samples. Samples are returned by SASE.

CLASSIC COLLECTIONS FINE ART, 1 Bridge St., Irvington NY 10533. (914)591-4500. Fax: (914)591-4828. **Acquisition Manager:** Larry Tolchin. Estab. 1990. Art publisher. Publishes unlimited editions and offset reproductions. Clients: galleries, interior designers, hotels. Licenses florals, landscapes, animals for kitchen/bathroom.

Needs: Seeking decorative art for the commercial and designer markets. Considers oil, acrylic, watercolor, mixed media and pastel. Prefers landscapes, still lifes, florals. Artists represented include Harrison Rucker, Henrietta Milan, Sid Willis, Charles Zhan and Henry Peeters. Editions created by collaborating with the artist and by working with existing painting. Approached by 100 artists/year. Publishes the work of 6 emerging, 6 mid-career and 6 established artists/year.

First Contact & Terms: Send slides and transparencies. Samples are filed. Responds in 3 months. Company will contact artist for portfolio review if interested. Offers advance when appropriate. Buys first and reprint rights. Provides advertising, insurance while work is at firm and written contract. Finds artists through art exhibitions, fairs and competitions.

THE COLONIAL ART CO., 1336 NW First St., Oklahoma City OK 73106. (405)232-5233. Fax: (405)232-6607. E-mail: colonialart@msn.com. **Owner:** Willard Johnson. Estab. 1919. Publisher and distributor of offset reproductions for galleries. Clients: retail and wholesale. Current clients include Osburns, Grayhorse and Burlington.

Needs: Artists represented include Felix Cole, Dennis Martin, John Walch and Leonard McMurry. Publishes the work of 2-3 emerging, 2-3 mid-career and 3-4 established artists/year. Distributes the work of 10-20 emerging, 30-40 mid-career and hundreds of established artists/year. Prefers realism and expressionism—emotional work.

First Contact & Terms: Send sample prints. Samples not filed are returned only if requested by artist. Publisher/distributor will contact artist for portfolio review if interested. Pays negotiated flat fee or royalties, or on a consignment basis (firm receives 33% commission). Offers an advance when appropriate. Does not

require exclusive representation of the artist. Considers buying second rights (reprint rights) to previously published work.

Tips: "The current trend in art publishing is an emphasis on quality."

N̲ COLVILLE PUBLISHING, 2909 Oregon Ct., #B2, Torrance CA 90503. (310)618-3700. Fax: (310)618-3710. **Contact:** Peter Iwasaki, president. Licensing: Vicky Verg. Estab. 1982. Art publisher. Publishes fine art prints, hand-pulled originals, limited edition, offset reproduction, posters, unlimited edition. Clients: art galleries, dealers and designers.

Needs: Seeking creative art for the serious collector. Considers oil on canvas. Considering high end product licensing only. Prefers impressionism and American Realism. Artists represented include John Powell, Daniel Gerhartz and Don Hatfield. Publishes and distributes the work of a varying number of emerging artists/year.

First Contact & Terms: Send query letter with résumé, slides, photographs, transparencies, biography and SASE. Samples are not filed. Responds in 1 month. To show a portfolio, mail appropriate materials. Payment method and advances are negotiated. Prefers exclusive representation of artist. Provides in-transit insurance, insurance while work is at firm, promotion, shipping to and from firm and a written contract.

Tips: "Establish a unique style, look or concept before looking to be published."

CRAZY HORSE PRINTS, 23026 N. Main St., Prairie View IL 60069. (847)634-0963. **Owner:** Margaret Becker. Estab. 1976. Art publisher and gallery. Publishes limited editions, offset reproductions and greeting cards. Clients: Native American art collectors.

Needs: "We publish only Indian authored subjects." Considers oil, pen & ink and acrylic. Prefers nature themes. Editions created by working from an existing painting. Approached by 10 artists/year. Publishes the work of 2 and distributes the work of 20 established artists/year.

First Contact & Terms: Send résumé and photographs. Samples are filed. Responds only if interested. Portfolio review not required. Publisher will contact artist for portfolio review if interested. Portfolio should include photographs and bio. Pays flat fee: $250-1,500 or royalties of 5%. Offers advance when appropriate. Buys all rights. Provides promotion and written contract. Finds artists through art shows and submissions.

CREATIF LICENSING CORP., 31 Old Town Crossing, Mount Kisco NY 10549-4030. (914)241-6211. E-mail: creatiflic@aol.com. Website: members.aol.com/creatiflic. Estab. 1975. Art licensing agency. Clients: manufacturers of gifts, stationery, toys and home furnishings.

 • Creatif posts submission guidelines on its web page.

N̲ CUPPS OF CHICAGO, INC., 831 Oakton St., Elk Grove IL 60007. (847)593-5655. Fax: (847)593-5550. **President:** Gregory Cupp. Estab. 1967. Art publisher and distributor of limited and open editions, offset reproductions and posters. Clients: galleries, frame shops, designers and home shows.

 • Pay attention to contemporary/popular colors when creating work for this design-oriented market.

Needs: Seeking creative and decorative art for the commercial and designer markets. Also needs freelance designers. Artists represented include Gloria Rose and Rob Woodrum. Editions created by collaborating with the artist or by working from an existing painting. Considers oil and acrylic paintings in "almost any style—only criterion is that it must be well done." Prefers individual works of art. Approached by 150-200 artists/year. Publishes and distributes the work of 25-50 emerging artists/year.

First Contact & Terms: Send query letter with résumé, photographs, photocopies and tearsheets. Samples are filed or are returned by SASE if requested. Responds only if interested. Company will contact artist for portfolio review of color photographs if interested. Negotiates payment. Rights purchased vary according to project. Provides advertising, promotion, shipping from firm, insurance while work is at firm.

Tips: This distributor sees a trend toward traditional and the other end of the spectrum—contemporary.

DARE TO MOVE, Dept. AGDM, 12932 SE Kent-Kangley Rd. #007, Kent WA 98031. (253)639-4493. Fax: (253)630-1865. E-mail: daretomove@aol.com. Website: www.daretomove.com. **President:** Steve W. Sherman. Estab. 1987. Art publisher, distributor. Publishes/distributes limited editions, unlimited editions, canvas transfers, fine art prints, offset reproductions. Licenses aviation and marine art for puzzles, note cards, book marks, coasters etc. Clients: art galleries, aviation museums, frame shops and interior decorators.

 • This company has expanded from aviation-related artwork to work encompassing most civil service areas. Steve Sherman likes to work with artists who have been painting for 10-20 years. He

usually starts off distributing self-published prints. If prints sell well, he will work with artist to publish new editions.

Needs: Seeking naval, marine, firefighter, civil service and aviation-related art for the serious collector and commercial market. Considers oil and acrylic. Artists represented include John Young, Ross Buckland, Mike Machat, James Dietz, Jack Fellows, William Ryan, Patrick Haskett. Editions created by collaborating with the artist or working from an existing painting. Approached by 15-20 artists/year. Publishes the work of 1 emerging, 2-3 mid-career and established artists/year. Distributes the work of 9 emerging and 2-3 established artists/year.

First Contact & Terms: Send query letter with photographs, slides, tearsheets and transparencies. Samples are filed or sometimes returned by SASE. Artist should follow up with call. Portfolio should include color photographs, transparencies and final art. Pays royalties of 20% commission of wholesale price. Buys one-time or reprint rights. Provides advertising, in-transit insurance, insurance while work is at firm, promotion, shipping from firm and written contract.

Tips: "Present your best work—professionally."

DAUPHIN ISLAND ART CENTER, 1406 Cadillac Ave., Box 699, Dauphin Island AL 36528. Phone/fax: (800)861-5701. E-mail: photography@dauphinislandartcenter.com. Websites: www.dauphinislandartcenter.com and/or www.nickcolquitt.com. **Owner:** Nick Colquitt. Estab. 1984. Wholesale producer and distributor of marine and nautical decorative art. Clients: West, Gulf and eastern coastline retailers.

Needs: Approached by 12-14 freelance artists/year. Works with 8-10 freelance artists/year. Prefers local artists with experience in marine and nautical themes. Uses freelancers mainly for wholesale items to be retailed. Also for advertising, brochure and catalog illustration, and design. 1% of projects require freelance design.

First Contact & Terms: Send query letter with brochure and samples. Samples not filed are returned only if requested by artist. Responds in 3 weeks. To show portfolio, mail final reproduction/product. Pays for design and illustration by the finished piece. Considers skill and experience of artist and "retailability" when establishing payment. Negotiates rights purchased.

Tips: Advises artists to attend any of the Art Expo events, especially those held in Atlanta Merchandise Mart. Dauphin Island Art Center offers weekend seminar/workshops year-round on subject of making and marketing any graphic art. Every inquiry is answered promptly.

DECORATIVE EXPRESSIONS, INC., 3595 Clearview Place, Atlanta GA 30340. (770)457-8008. Fax: (770)457-8018. **President:** Robert Harris. Estab. 1984. Distributor. Distributes original oils. Clients: galleries, designers, antique dealers.

Needs: Seeking creative and decorative art for the designer market. Styles range from traditional to contemporary to impressionistic. Artists represented include Javier Mulio and Giner Bueno. Approached by 6 artists/year. Distributes the work of 2-6 emerging, 2-4 mid-career and 10-20 established artists/year.

First Contact & Terms: Send photographs. Samples are returned by SASE if requested by artist. Responds only if interested. Portfolios may be dropped off every Monday. Portfolio should include final art and photographs. Negotiates payment. Offers advance when appropriate. Negotiates rights purchased. Requires exclusive representation of artist. Provides advertising, in-transit insurance, promotion and distribution through sale force and trade shows. Finds artists through word of mouth, exhibitions, travel.

Tips: "The design market is major source for placing art. We seek art that appeals to designers."

DELJOU ART GROUP, INC., 1630 Huber St., Atlanta GA 30318. (404)350-7190. Fax: (404)350-7195. E-mail: submit@deljouartgroup.com. **Contact:** Art Director. Estab. 1980. Art publisher, distributor and gallery of limited editions (maximum 250 prints), handpulled originals, monoprints/monotypes, sculpture, fine art photography, fine art prints and paintings on paper and canvas. Clients: galleries, designers, corporate buyers and architects. Current clients include Coca Cola, Xerox, Exxon, Marriott Hotels, General Electric, Charter Hospitals, AT&T and more than 3,000 galleries worldwide, "forming a strong network throughout the world."

Needs: Seeking creative, fine and decorative art for the designer market and serious collectors. Considers oil, acrylic, pastel, sculpture and mixed media. Artists represented include Yunessi Alterra, Ivan Reyes, Mindeli, Sanford Wakeman, Niri Vessali, Lee White, Alexa Kelemen, Bika, Kamy, Babak Emanuel, Craig Alan, Roya Azim, Jian Chang, Elya DeChino, Antonio Dojer and Mia Stone. Editions created by collaborating with the artist. Approached by 300 artists/year. Publishes the work of 10 emerging, 20 mid-career artists/year and 20 established artists/year.

First Contact & Terms: Send query letter with photographs, slides, brochure, photocopies, tearsheets,

SASE and transparencies. Samples not filed are returned only by SASE. Responds in 6 months. Will contact artist for portfolio review if interested. Payment method is negotiated. Offers an advance when appropriate. Negotiates rights purchased. Requires exclusive representation. Provides promotion, a written contract and advertising. Finds artists through visiting galleries, art fairs, word of mouth, World Wide Web, art reps, submissions, art competitions and sourcebooks. Pays highest royalties in the industry.

Tips: "We need landscape artists, monoprint artists, strong figurative artists, sophisticated abstracts and soft-edge abstracts. We are also beginning to publish sculptures and are interested in seeing slides of such. We have had a record year in sales and have recently relocated again into a brand new gallery, framing and studio complex. We also have the largest gallery in the country. We are starting a new poster company this year and need images for its catalogue as well."

☑ **DENVER ART COMPANY, INC.**, 7009 S. Fillmore Court, Centennial CO 80122. (303)773-6250. Fax: (303)773-6199. **President:** Debbrah Courtney. Estab. 1984. Publishes/distributes handpulled originals, monoprints, monotypes, original acrylic on canvas/paper. Clients: galleries, designers, architects, distributors, corporate curators.

Needs: Seeking creative art for the serious collector, commercial and designer markets. Considers oil, acrylic, watercolor, mixed media, pastel, pen & ink. Prefers abstract-contemporary, figurative styles. Artists represented include Mary Mackay, Elaine Martin, William Marlowe, Kate McGuinness, Madeleine O'Connell, Susana Richter, Mary Beth Thorngren, Janus Thorpe, Sarah Van Beckum, Chris Welsh, Phillip Jaeger. Editions created by collaborating with the artist or by working from an existing painting. Publishes work by 2 emerging, 2 mid-career, 10 established artist/year. Distributes work by 7 emerging, 1 mid-career, 1 established artist/year.

First Contact & Terms: Send photographs, résumé, tearsheets. Samples are filed or returned. Responds in 2 weeks. Company will contact artist for portfolio review of color photographs if interested. Pays on consignment basis: firm receives 50% commission. Negotiates rights purchased. Representation negotiable. Provides advertising, in-transit insurance, insurance while work is at firm, promotion, shipping from firm, written contract. Finds artists through trade shows, Art Expo-New York, art publications.

Tips: "Study—read trade publications and attend trade shows."

DIRECTIONAL PUBLISHING, INC., 2812 Commerce Square E., Birmingham AL 35210. (205)951-1965. Fax: (205)951-3250. E-mail: custsvc@directionalart.com. Website: directionalart.com. **President:** David Nichols. Art Director: Tony Murray. Estab. 1986. Art publisher. Publishes limited and unlimited editions and offset reproductions. Clients: galleries, frame shops and picture manufacturers. Licenses: decorative stationery, rugs, home products.

Needs: Seeking decorative art for the designer market. Considers oil, watercolor, acrylic and pastel. Prefers casual designs in keeping with today's interiors. Artists represented include A. Kamelhair, H. Brown, R. Lewis, L. Brewer, S. Cairns, N. Strailey, D. Swartzendruber, D. Nichols, M.B. Zeitz and N. Raborn. Editions created by working from an existing painting. Approached by 50 artists/year. Publishes and distributes the work of 5-10 emerging, 5-10 mid-career and 3-5 established artists/year.

First Contact & Terms: Send query letter with slides and photographs or digital disc. Samples are not filed and are returned by SASE. Responds in 3 months. Pays royalties. Buys all rights. Provides in-transit insurance, insurance while work is at firm, promotion, shipping from firm and written contract.

Tips: "Always include SASE. Do not follow up with phone calls. All work published is first of all *decorative*. The application of artist designed borders to artwork can sometimes greatly improve the decorative presentation. We follow trends in the furniture/accessories market. Aged and antiqued looks are currently popular—be creative! Check out what's being sold in home stores for trends and colors."

DODO GRAPHICS, INC., 145 Cornelia St., P.O. Box 585, Plattsburgh NY 12901. (518)561-7294. Fax: (518)561-6720. **Manager:** Frank How. Art publisher of offset reproductions, posters and etchings for galleries and frame shops.

Needs: Considers pastel, watercolor, tempera, mixed media, airbrush and photographs. Prefers contemporary themes and styles. Prefers individual works of art, 16×20 maximum. Publishes the work of 5 artists/year.

First Contact & Terms: Send query letter with brochure showing art style or photographs and slides. Samples are filed or are returned by SASE. Responds in 3 months. Write for appointment to show portfolio of original/final art and slides. Payment method is negotiated. Offers an advance when appropriate. Buys all rights. Requires exclusive representation of the artist. Provides written contract.

Tips: "Do not send any originals unless agreed upon by publisher."

N DOLICE GRAPHICS, 163 Third Ave., Suite 321, New York NY 10003. (212)529-2025. Fax: (212)260-9217. E-mail: tech-man@erols.com. **Contact:** Joe Dolice, publisher. Estab. 1968. Art publisher. Publishes fine art prints, limited edition, offset reproduction, unlimited edition. Clients: architects, corporate curators, decorators, distributors, frame shops, galleries, gift shops and museum shops. Current clients include: Bloomingdale's (Federated Dept. Stores).

Needs: Seeking decorative, representational, antiquarian "type" art for the commercial and designer markets. Considers acrylic, mixed media, pastel, pen & ink, prints (intaglio, etc.) and watercolor. Prefers traditional, decorative, antiquarian type. Editions created by collaborating with the artist and working from an existing painting. Approached by 12-20 artists/year.

First Contact & Terms: Send query letter with color photocopies, photographs, résumé, SASE, slides and transparencies. Samples are returned by SASE or not returned. Responds only if interested. Company will contact artist for portfolio review if interested. Negotiates payment. Buys all rights on contract work. Rights purchased vary according to project. Provides promotion and written contract. Finds artists through art reps and artist's submissions.

Tips: "We publish replicas of antiquarian type art prints for decorative arts markets, and will commission artists to create "works for hire" in the style of pre-century artists, and occasionally to color black & white engravings, etchings, etc. Artists interested should be well schooled and accomplished in traditional painting and printmaking techniques, and should be able to show samples of this type of work if we contact them."

N EDELMAN FINE ARTS, LTD., 141 W. 20th St., Third Floor, New York NY 10011-3601. (646)336-6610. E-mail: artprices@aol.com. Website: www.hheatheredelmangallery.com. **Vice President:** H. Heather Edelman. Art distributor of original acrylic and oil paintings. "Additional company distributes works of art on paper, sculptures, blown glass, tapestry, and unique objects de Art." Clients: galleries, dealers, consultants, interior designers and furniture stores worldwide.

● The mainstream art market is demanding traditional work with great attention to detail. Impressionism is still in vogue but with a cutting edge to it, with strong colors; Madonna & Child old world, high quality landscapes; woman and woman and children in all techniques needed. Abstracts with an image.

Needs: Seeking creative and decorative art for the serious collector and designer markets. Considers oil and acrylic paintings, watercolor, sculpture and mixed media. Artists represented include Marc Chagall, Joan Miro and Pablo Picasso. Distributes the work of 150 emerging, 70 mid-career and 150 established artists.

First Contact & Terms: Send six 3×5 photos of your best work (no slides), résumé, tearsheets. Samples are filed. Call before dropping off portfolios. Portfolio should include bio, exhibition history, price of work, photographs and/or original/final art and photographs. Reports as soon as possible. Pays royalties of 40% on works on consignment basis, 20% commission for trade sales; 50/50 retail. Buys all rights. Provides in-transit insurance, insurance while work is at firm, promotion and shipping from firm.

Tips: "Know what's salable and available in the marketplace."

EDITIONS LIMITED GALLERIES, INC., 4090 Halleck St., Emeryville CA 94608. (510)923-9770. Fax: (510)923-9777. Website: www.editionslimited.com. **Director:** Todd Haile. Art publisher and distributor of limited edition graphics and fine art posters. Clients: contract framers, galleries, framing stores, art consultants and interior designers.

Needs: Seeking art for the original and designer markets. Considers oil, acrylic and watercolor painting, monoprint, monotype, photography and mixed media. Prefers landscape, floral and abstract imagery. Editions created by collaborating with the artist or by working from existing works.

First Contact & Terms: Send query letter with résumé, slides and photographs or JPEG files (8″ maximum at 72 dpi) via e-mail at website. Samples are filed or are returned by SASE. Responds in 2 months. Publisher/distributor will contact artist for portfolio review if interested. Payment method is negotiated. Negotiates rights purchased.

Tips: "We deal both nationally and internationally, so we need art with wide appeal. When sending slides or photos, send at least six so we can get an overview of your work. We publish artists, not just images."

ENCORE GRAPHICS & FINE ART, P.O. Box 812, Madison AL 35758. (800)248-9240. E-mail: encore @randenterprises.com. Website: www.egart.com. **President:** J. Rand, Jr. Estab. 1995. Poster company, art publisher, distributor. Publishes/distributes limited edition, unlimited edition, fine art prints, offset reproduction, posters. Clients: galleries, frame shops, distributors.

Needs: Creative art for the serious collector. Considers all media. Prefers African American and abstract.

Art guidelines available on company's website. Artists represented include Greg Gamble, Buck Brown, Mario Robinson, Lori Goodwin, Wyndall Coleman, T.H. Waldman, John Will Davis, Burl Washington, Henry Battle, Cisco Davis, Delbert Iron-Cloud, Gary Thomas and John Moore. All Buffalo Soldier Prints. Editions created by working from an existing painting. Approached by 15 artists/year. Publishes the work of 3 emerging artists, 1 mid-career artist/year. Distributes the work of 3 emerging, 2 mid-career and 3 established artists/year.

First Contact & Terms: Send photocopies, photographs, résumé, tearsheets. Samples are filed. Responds only if interested. Company will contact artist for portfolio review of color, photographs, tearsheets if interested. Negotiates payment. Offers advance when appropriate. Requires exclusive representation of artist. Provides advertising, in-transit insurance, insurance while work is at firm, promotion, shipping from firm, written contract. Finds artists through the World Wide Web and art exhibits.

Tips: "Prints of African-Americans with religious themes or children are popular now. Paint from the heart."

FAIRFIELD ART PUBLISHING, 625 Broadway, 4th Floor, New York NY 10012. (212)677-2559. Fax: (212)677-2253. **Vice President:** Peter Lowenkron. Estab. 1996. Art publisher. Publishes posters, unlimited editions and offset reproductions. Clients: galleries, frame shops, museum shops, decorators, corporate curators, giftshops.

Needs: Decorative art for the designer and commercial markets. Considers collage, oil, watercolor, pastel, pen & ink, acrylic. Artists represented include Daniel Pollera, Roger Vilarchao, Yves Poinsot.

First Contact & Terms: Send query letter with slides and brochure. Samples are returned by SASE if requested by artist. Responds only if interested. Pays flat fee, $400-2,500 maximum, or royalties of 7-15%. Offers advance when appropriate. Rights purchased vary according to project. Interested in buying second rights (reprint rights) to previously published artwork.

Tips: "If you don't think you're excellent, wait until you have something excellent. Posters are a utility, they go somewhere specific, so images I use fit somewhere—over the couch, kitchen, etc."

[N] FLYING COLORS, INC., 4117 W. Jefferson Blvd., Los Angeles CA 90016. (323)732-9994. Fax: (323)731-0969. E-mail: joe@flying-colors.net. Website: www.flying-colors.net. **Art Director:** Lyle Siwkewich. Estab. 1993. Poster company and art publisher. Publishes unlimited edition, fine art prints, posters. Clients: galleries, frame shops, distributors, museum shops, giftshops, mail order, end-users, retailers, chains, direct mail.

Needs: Seeking decorative art for the commercial market. Considers oil, acrylic, watercolor, mixed media, pastel. Prefers multicultural, religious, inspirational wildlife, Amish, country, scenics, stilllife, American culture. Also needs freelancers for design. Prefers designers who own Mac computers. Artists represented include Greg Gorman, Deidre Madsen. Editions created by collaborating with the artist or by working from an existing painting. Approached by 200 artists/year. Publishes the work of 20 emerging, 5-10 mid-career, 1-2 established artists/year.

First Contact & Terms: May contact via e-mail or send photocopies, photographs, SASE, slides, transparencies. Accepts disk submissions if compatible with SyQuest, Dat, Jazzy, ZIP, QuarkXPress, Illustrator, Photoshop or FreeHand. Samples are filed or returned by SASE. Responds only if interested. Artist should follow-up with call to show portfolio. Portfolio should include color, photographs, roughs, slides, transparencies. Negotiates payment. Offers advance when appropriate. Negotiates rights purchased, all rights preferred. Provides advertising, promotion, written contract. Finds artists through attending art exhibitions, art fairs, word of mouth, artists' submissions, clients, local advertisements.

Tips: "Ethnic and inspirational/religious art is very strong. Watch the furniture industry. Come up with themes, sketches and series of at least two pieces. Art has to work on 8×10, 16×20, 22×28, 24×36, greeting cards and other possible mediums."

[N] FRONT LINE ART PUBLISHING, 165 Chub Ave., Lyndhurst NJ 07071. (201)842-8500. Fax: (201)842-8546. **Creative Director:** Rachael Cronin. Estab. 1981. Publisher of posters, prints, offset reproductions and limited editions. Clients: galleries, frame shops, gift shops and corporate curators.

NEED HELP? For tips on finding markets and understanding listings, see our Quick-Start Guide in the front of this book.

Needs: Seeking creative and decorative art reflecting popular trends for the commercial and designer markets. Also needs freelancers for design. Considers oil, acrylic, pastel, pen & ink, watercolor and mixed media. Prefers contemporary interpretations of landscapes, seascapes, florals, abstracts and African-American subjects. Artists represented include Hannum, Graves, Van Dyke and Cacalono. Editions created by working from an existing painting or by collaborating with the artist. Approached by 300 artists/year. Publishes the work of 40 artists/year.

First Contact & Terms: Send query letter with brochure, photocopies, photographs, tearsheets and slides. Samples not filed are returned by SASE. Responds in 1 month if interested. Company will contact artist for portfolio review of photographs and slides if interested. Payment method is negotiated; royalty based contracts. Requires exclusive representation of the artist. Provides advertising, promotion, written contract and insurance while work is at firm.

Tips: "Front Line Art Publishing is looking for artists who are flexible and willing to work to develop art that meets the specific needs of the print and poster marketplace. We actively seek out new art and artists on an ongoing basis."

G.C.W.A.P. INC., 12075 Marina Loop, W. Yellowstone MT 59758. (406)646-9551. Fax: (406)646-9552. E-mail: GCWAP@wyellowstone.com. **Executive Vice President:** Jack Carter. Estab. 1980. Publishes limited edition art. Clients: galleries and individuals.

Needs: Seeking art for the serious collector and commercial market. Considers oil and pastel. Prefers western, wildlife and train themes. Artists represented include Gary Carter, Arlene Hooker Fay, Jim Norton. Editions created by collaborating with the artist. Approached by 10-20 artists/year. Publishes/distributes the work of 3 established artists/year.

First Contact & Terms: Send query letter with photographs, résumé and transparencies. Samples are returned. Responds in 1 month. Company will contact artists for portfolio review if interested. Negotiates payment. Buys reprint rights. Requires exclusive representation of artist. Provides advertising.

GALAXY OF GRAPHICS, LTD., 460 W. 34th St., New York NY 10001. (212)947-8989. Fax: (212)629-4317. E-mail: aakgog@aol.com. **Art Directors:** Colleen Buchweitz and Christine Pratti. Estab. 1983. Art publisher and distributor of unlimited editions. Licensing handled by Colleen Buchweitz. Clients: galleries, distributors, and picture frame manufacturers.

Needs: Seeking creative, fashionable and decorative art for the commerical market. Artists represented include Richard Henson, Betsy Brown, John Butler, Charlene Olson, Ros Oesterle, Joyce Combs, Christa Kieffer, Ruane Manning and Carol Robinson. Editions created by collaborating with the artist or by working from an existing painting. Considers any media. "Any currently popular and generally accepted themes." Art guidelines free for SASE with first-class postage. Approached by several hundred artists/year. Publishes and distributes the work of 20 emerging and 20 mid-career and established artists/year.

First Contact & Terms: Send query letter with résumé, tearsheets, slides, photographs and transparencies. Samples are not filed and are returned by SASE. Responds in 2 weeks. Call for appointment to show portfolio. Pays royalties of 10%. Offers advance. Buys rights only for prints and posters. Provides insurance while material is in-house and while in transit from publisher to artist/photographer. Provides written contract to each artist.

Tips: "There is a trend of strong jewel-tone colors and spice-tone colors. African-American art very needed."

✔ **ROBERT GALITZ FINE ART & ACCENT ART**, (formerly Robert Galitz Fine Art), 166 Hilltop Lane, Sleepy Hollow IL 60118-1816. (847)426-8842. Fax: (847)426-8846. **Owner:** Robert Galitz. Estab. 1986. Distributor of fine art prints, handpulled originals, limited editions, monoprints, monotypes and sculpture. Clients: architects and galleries.

● See also listing in Galleries.

Needs: Seeking creative, decorative art for the commercial and designer markets. Considers acrylic, mixed media, oil, sculpture and watercolor.

First Contact & Terms: Send query letter with brochure, SASE, slides and photographs. Samples are not filed and are returned by SASE. Responds in 1 month. Company will contact artist for portfolio review if interested. Pays flat fee. No advance. Rights purchased vary according to project. Finds artists through art fairs and submissions.

N GALLERIA FINE ARTS & GRAPHICS, 7305 Edgewater Dr., Unit D, Oakland CA 94621. (510)553-0228. Fax: (510)553-9130. **Director:** Thomas Leung. Estab. 1985. Art publisher/distributor. Pub-

lishes/distributes limited editions, open editions, canvas transfers, fine art prints, offset reproductions, posters.

Needs: Seeking creative, decorative art for the serious collector and the commercial market. Considers oil, acrylic, watercolor. Editions created by collaborating with the artist or by working from an existing painting. Approached by 50 artists/year.

First Contact & Terms: Send query letter with photographs. Samples are filed. Responds only if interested. Company will contact artist for portfolio review of color photographs, slides, transparencies if interested. Negotiates payment. Buy all rights. Requires exclusive representation of artist. Provides advertising, in-transit insurance, insurance while work is at firm, promotion, shipping to and from our firm, written contract.

Tips: "Color/composition/subject are important."

N GALLERY GRAPHICS, 2400 S. Hwy. 59, P.O. Box 502, Noel MO 64854. (417)475-6191. Fax: (417)475-3542. E-mail: info@gallerygraphics.com. Website: www.gallerygraphics.com. **Contact:** Mimi Badgerow. Estab. 1980. Wholesale producer and distributor of prints, cards, sachets, stationery, calendars, framed art, stickers. Clients: frame shops, craft shops, florists, pharmacies and gift shops.

Needs: Seeking art with nostalgic look, country, Victorian, children, angels, florals, landscapes, animals—nothing too abstract or non-representational. Considers oil, watercolor, mixed media, pastel and pen & ink. 10% of editions created by collaborating with artist. 90% created by working from an existing painting. Artists include Barbara Mock, Glynda Turley and Mary Hughes.

First Contact & Terms: Send query letter with brochure showing art style and tearsheets. Designers send photographs, photocopies and tearsheets. Accepts disk submissions compatible with IBM or Mac. Samples are filed or are returned by SASE. Responds in 2 months. To show portfolio, mail finished art samples, color tearsheets. Can buy all rights or pay royalties of 5%. Provides insurance while work is at firm, promotion and a written contract.

Tips: "I wish artists would submit artwork on different subjects and styles. Some artists do certain subjects particularly well, but you don't know if they can do other subjects. Don't concentrate on just one area—do others as well. Don't limit yourself, or you could be missing out on some great opportunities. Paint the world you live in."

☑ GANGO EDITIONS, INC., (formerly Gango Editions), 351 NW 12th Ave., Portland OR 97209. (503)223-9694. Fax: (503)223-0925. E-mail: info@gangoeditions.com. Website: www.gangoeditions.com. **Contact:** Jackie Gango, art director. Estab. 1977. Art publisher/distributor. Publishes/distributes offset reproduction and posters. Clients: architects, decorators, distributors, frame and gift shops, and galleries.

Needs: Seeking decorative art for the commercial and designer markets. Considers oil, watercolor, acrylic, pastel, mixed media. Prefers art that follows current trends and colors. Artists represented include Amy Melious and Pamela Gladding. Editions created by working from an existing painting or work and by collaborating with the artist. Publishes and distributes the work of 70 emerging artists/year.

First Contact & Terms: Send query letter with slides, SASE, tearsheets, transparencies and/or photographs. E-mail submissions accepted with link to website or image file. Prefers Windows-compatible JPEG files. Samples returned by SASE. Artist is contacted by mail. Responds in 6 weeks. Company will contact artist for portfolio review if interested. Portfolio should include b&w and color finished, original art, photographs, slides or transparencies. Pays royalties of 10%. Requires exclusive representation of artist. Buys first rights and reprint rights. Provides advertising, in-transit insurance, insurance while work is at firm, promotion, shipping from our firm and written contract. Finds artists through art exhibits/fairs, art reps, artist's submissions, Internet and word of mouth.

Tips: "We require work that can be done in pairs. Artist may submit a single but must have a mate available if piece is selected. To be a pair the works must both be horizontal or vertical. Palette must be the same. Perspective the same. Content must coordinate."

GEME ART INC., 209 W. Sixth St., Vancouver WA 98660. (360)693-7772. Fax: (360)695-9795. **Art Director:** Merilee Will. Estab. 1966. Art publisher. Publishes fine art prints and reproductions in unlimited and limited editions. Clients: galleries, frame shops, art museums. Licenses designs.

Needs: Considers oil, acrylic, watercolor and mixed media. "We use a variety of styles from realistic to whimsical, catering to "Mid-America art market." Artists represented include Lois Thayer, Crystal Skelley, Steve Nelson.

First Contact & Terms: Send color slides, photos or brochure. Include SASE. Publisher will contact artist

for portfolio review if interested. Simultaneous submissions OK. Payment on a royalty basis. Purchases all rights. Provides promotion, shipping from publisher and contract.
Tips: "We have added new sizes and more artists to our lines since last year."

⬛ GHAWACO INTERNATIONAL INC., P.O. Box 8365, Station T, Ottawa, ON K1G 3H8 Canada. (613)293-1011 or (888)769-ARTS. Fax: (613)824-0842 or (888)769-5505. E-mail: buyart@ghawaco.com. Website: www.ghawaco.com. **Product Development:** Dr. Kwasi Nyarko. Estab. 1994. Art publisher and distributor. Publishes/distributes limited edition, unlimited edition, canvas transfers and offset reproduction. Clients: museum shops, galleries, gift shops, frame shops, distributors, bookstores and other buyers.
Needs: Seeking contemporary ethnic art. Considers oil and acrylic. Prefers artwork telling the stories of peoples of the world. Emphasis on under-represented groups such as African and Aboriginal. Artists represented include Wisdom Kudowor, Ablade Glover, Kofi Agorsor, A.K. Duah, Oumarou Traoré. Editions created working from an existing painting. Publishes work of 1 emerging artist/year. Also needs freelancers for design.
First Contact & Terms: Send query letter with brochure, photographs, résumé and SASE. Samples are filed. Responds only if interested. Request portfolio review in original query. Company will contact artist for portfolio review if interested. Portfolio should include final art, photographs and slides. Pays royalties of up to 30% (net). Consignment basis: firm receives 50% commission or negotiates payment. Offers no advance. Negotiates rights purchased. Requires exclusive representation of artist. Provides advertising, insurance while work is at firm, promotion, shipping from our firm and written contract. Finds artists through referrals, word of mouth and art fairs.
Tips: "To create good works that are always trendy, do theme-based compositions. Artists should know what they want to achieve in both the long and short term. Overall theme of artist must contribute to the global melting pot of styles."

⬛ GLEEDSVILLE ART PUBLISHERS, 5 W. Loudoun St., Leesburg VA 20175. (703)771-8055. Fax: (703)771-0225. E-mail: buyart@gleedsvilleart.com. Website: www.gleedsvilleart.com. **Contact:** Lawrence J. Thomas, president. Estab. 1999. Art publisher and gallery. Publishes and/or distributes fine art prints and limited edition. Clients: decorators, distributors, frame shops and galleries.
Needs: Seeking decorative art for the serious collector, commercial and designer markets. Considers acrylic, mixed media, oil, pastel, pen & ink and watercolor. Prefers impressionist, landscapes, figuratives, city scenes, realistic and whimsical. Artists represented include Lillian D. August, Anthony Andrews and Julie Lea. Editions created by collaborating with the artist.
First Contact & Terms: Send photographs, slides, tearsheets, transparencies and URL. Accepts e-mail submissions with link to website. Prefers Windows-compatible, JPEG files. Samples are filed or returned. Responds in 3 months. Company will contact artist for portfolio review if interested. Portfolio should include original art, slides, tearsheets, thumbnails and transparencies. Pays royalties. Negotiates rights purchased. Requires exclusive representation of artist. Provides advertising, insurance while work is at firm, promotion, shipping from our firm and written contract. Finds artists through art competitions, art exhibits/fairs, artist's submissions and word-of-mouth.

GRAPHIQUE DE FRANCE, 9 State St., Woburn MA 01801. (781)935-3405. Fax: (781)935-5145. E-mail: artworksubmissions@graphiquedefrance.com. Website: www.graphiquedefrance.com. **Contact:** Licensing Department. Estab. 1979. Manufacturer of fine art, photographic and illustrative greeting cards, notecard gift boxes, posters and calendars. Clients: galleries, foreign distributors, museum shops, high end retailers, book trade, museum shops.
First Contact & Terms: Artwork may be submitted in the form of slides, transparencies or high-quality photocopies. Please do not send original artwork. Please allow 2 months for response. SASE is required for any submitted material to be returned.
Tips: "It's best not to insist on speaking with someone at a targeted company prior to submitting work. Let the art speak for itself and follow up a few weeks after submitting."

RAYMOND L. GREENBERG ART PUBLISHING, 42 Leone Lane, Chester NY 10918. (845)469-6699. Fax: (845)469-5955. E-mail: art@raymondlgreenberg.com. Website: raymondlgreenberg.com. **Owner:** Ray Greenberg. Licensing: Ray Greenberg. Estab. 1995. Art publisher. Publishes unlimited edition fine art prints for major framers and plaque manufacturers. Licenses inspirational, ethnic, Victorian, kitchen and bath artwork for prints for wall decor. Clients include Crystal Art Galleries, North American Art.
Needs: Seeking decorative artwork in popular styles for the commercial and mass markets. Considers oil,

acrylic, watercolor, mixed media, pastel and pen & ink. Prefers inspirational, ethnic, Victorian, nostalgic, country, floral and religious themes. Art guidelines free for SASE with first-class postage. Artists represented include Barbara Lanza, David Tobey, Diane Viera, Robert Daley and Marilyn Rea. Editions created by collaborating with the artist and/or working from an existing painting. Approached by 35 artists/year. Publishes 7 emerging, 13 mid-career and 5 established artists/year.

First Contact & Terms: Send query letter with photographs, slides, SASE; "any good, accurate representation of your work." Samples are filed or returned by SASE. Responds in 6 weeks. Company will contact artist for portfolio review if interested. Pays flat fee: $50-200 or royalties of 5-7%. Offers advance against royalties when appropriate. Buys all rights. Prefers exclusive representation. Provides insurance, promotion, shipping from firm and contract. Finds artists through word-of-mouth.

Tips: "Versatile artists who are willing to paint for the market can do very well with us. Be flexible and patient."

THE GREENWICH WORKSHOP, INC., One Greenwich Place, Shelton CT 06484. Website: www.greenwichworkshop.com. **Contact:** Artist Selection Committee. Art publisher and gallery. Publishes limited and open editions, offset productions, fine art lithographs, serigraphs, canvas reproductions and fine art porcelains and books. Clients: independent galleries in US, Canada and United Kingdom.

Needs: Seeking creative, fashionable and decorative art for the serious collector, commercial and designer markets. Considers oil, watercolor, mixed media, pastel and acrylic. Considers all but abstract. Artists represented include James C. Christensen, Howard Terpning, James Reynolds, James Bama, Bev Doolittle, Scott Gustafson, Braldt Bralds. Editions created by collaborating with the artist or by working from an existing painting. Approached by 100 artists/year. Publishes the work of 4-5 emerging, 15 mid-career and 25 established artists. Distributes the work of 4-5 emerging, 15 mid-career and 25 established artists/year.

First Contact & Terms: Send query letter with brochure, slides, photographs, SASE and transparencies. Samples are not filed and are returned by SASE. Responds in 3 months. Publisher will contact artist for portfolio review if interested. Portfolio should include final art, tearsheets, photographs, slides and transparencies. Pays royalties. No advance. Rights purchased vary according to project. Requires exclusive representation of artist. Provides advertising, insurance while work is at firm, promotion, shipping to and from firm, and written contract. Finds artists through art exhibits, submissions and word of mouth.

GUILDHALL, INC., Dept. AM, P.O. Box 136550, Fort Worth TX 76136. (800)356-6733. Fax: (817)236-0015. E-mail: westart@guildhall.com. Website: www.guildhall.com/artprints. **President:** John M. Thompson III. Art publisher/distributor of limited and unlimited editions, offset reproductions and handpulled originals for galleries, decorators, offices and department stores. Current clients include over 500 galleries and collectors nationwide.

Needs: Seeking creative art for the serious and commercial collector and designer market. Considers pen & ink, oil, acrylic, watercolor, and bronze and stone sculptures. Prefers historical Native American, Western, equine, wildlife, landscapes and religious themes. Prefers individual works of art. Artists represented include Wayne Baize, Jack Hines and Ralph Wall. Editions created by collaborating with the artist and by working from an existing painting. Approached by 150 artists/year. Also for design. 15% of projects require freelance design.

First Contact & Terms: Send query letter with résumé, tearsheets, photographs, slides and 4×5 transparencies, preferably cowboy art in photos or printouts. Samples are not filed and are returned only if requested. Responds in 1 month. Call or write for appointment to show portfolio, or mail thumbnails, color and b&w tearsheets, slides and 4×5 transparencies. Pays $200-15,000 flat fee; 10-20% royalties; 35% commission on consignment; or payment method is negotiated. Negotiates rights purchased. Requires exclusive representation for contract artists. Provides insurance while work is at firm, promotion, shipping from firm and written contract.

Tips: "The new technologies in printing are changing the nature of publishing. Self-publishing artists have flooded the print market. Many artists are being told to print themselves. Most of them, in order to sell their work, have to price it very low. In many markets this has caused a glut. Some art would be best served if it was only one of a kind. There is no substitute for scarcity and quality."

HADDAD'S FINE ARTS INC., 3855 E. Miraloma Ave., Anaheim CA 92806. (714)996-2100. Website: www.haddadsfinearts.com. **President:** Paula Haddad. Art Director: Beth Hedstrom. Estab. 1953. Art publisher and distributor. Produces unlimited edition offset reproductions and posters. Clients: galleries, art stores, museum stores and manufacturers. Sells to the trade only—no retail.

Needs: Seeking creative and decorative art for the commercial and designer markets. Prefers traditional,

realism with contemporary flair; unframed individual works and pairs; all media including photography. Editions created by collaborating with the artist or by working from an existing painting. Approached by 200-300 artists/year. Publishes the work of 10-15 emerging artists/year. Also uses freelancers for design. 20% of projects require freelance design. Design demands knowledge of QuarkXPress and Illustrator.

First Contact & Terms: Illustrators should send query letter with brochure, transparencies, slides, photos representative of work for publication consideration. Include SASE. Designers send query letter explaining skills. Responds in 3 months. Publisher/distributor will contact artist for portfolio review if interested. Portfolio should include slides, roughs, final art, transparencies. Pays royalties quarterly, 10% of base net price. Rights purchased vary according to project. Provides advertising and written contract.

HADLEY HOUSE PUBLISHING, 11300 Hampshire Ave. S., Bloomington MN 55438. (952)943-8474. Fax: (952)943-8098. Website: www.hadleylicensing.com. or www.hadleyhouse.com. **Director of Art Publishing:** Lisa Laliberte Belak. Licensing: Gary Schmidt Estab. 1974. Art publisher, distributor and 30 retail galleries. Publishes and distributes canvas transfers, fine art prints, limited and unlimited editions, offset reproductions and posters. Licenses all types of flat art. Clients: wholesale and retail.

Needs: Seeking artwork with creative artistic expression and decorative appeal. Considers oil, watercolor, acrylic, pastel and mixed media. Prefers wildlife, florals, landscapes, figurative and nostalgic Americana themes and styles. Art guidelines free for SASE with first-class postage. Artists represented include Nancy Howe, Steve Hamrick, Cha Ilyong, Sueellen Ross, Larry Chandler, Collin Bogle, Lee Bogle, Adele Earnshaw and Bruce Miller. Editions created by collaborating with artist and by working from an existing painting. Approached by 200-300 artists/year. Publishes the work of 3-4 emerging, 15 mid-career and 8 established artists/year. Distributes the work of 1 emerging and 4 mid-career artists/year.

First Contact & Terms: Send query letter with brochure showing art style or résumé and tearsheets, slides, photographs and transparencies. Samples are filed or are returned. Responds in 2 months. Call for appointment to show portfolio of slides, original final art and transparencies. Pays royalties. Requires exclusive representation of artist and/or art. Provides insurance while work is at firm, promotion, shipping from firm, a written contract and advertising through dealer showcase.

Tips: "Build a market for your originals by affiliating with an art gallery or two. Never give away your copyrights! When you can no longer satisfy the overwhelming demand for your originals . . . *that* is when you can hope for success in the reproduction market."

[N] [✍] HEARTSTRINGS CREATIVE PUBLISHING LTD., 409-244 Wallace Ave., Toronto, ON M6H 1V7 Canada. (416)532-3922. Fax: (416)532-6351. E-mail: posters@heartstringscreative.com. **President:** Peter Pesic. Estab. 1975. Art publisher and distributor. Publishes/distributes canvas transfers and offset reproductions. Clients: galleries, frame shops, distributors and giftshops.

Needs: Seeking creative and decorative art for the commercial market. Prefers home decor that is warm and color sensitive. Looking for landscape, wildlife, seascape, sentimental-figurative, floral and contemporary mixed media utilizing architectural elements. Editions created by collaborating with the artist. Approached by 15-20 artists/year. Publishes work of 6 emerging, 3 mid-career and 2 established artists/year. Distributes the work of 6 emerging, 3 mid-career and 2 established artists/year. Also needs freelancers for design. Prefers designers who own a Mac computer.

First Contact & Terms: Send query letter with photocopies, photographs, slides and transparencies. Accepts disk submissions compatible with Mac and Power Mac. Samples are filed or returned by SASE. Responds in 3 weeks. Company will contact artist for portfolio review if interested. Payment of royalties is negotiable. Offers advance when appropriate. Rights purchased vary according to project. Requires exclusive representation of artist. Provides advertising, insurance while work is at firm, promotion and written contract. Finds artists through art exhibitions, art fairs, word of mouth and artists' submissions.

Tips: "Wildlife is selling well. Be aware of current color trends. Work in a series."

[N] HOOF PRINTS, 13849 N. 200E, Alexandria IN 46001. (765)724-7004. Fax: (765)724-4632. Website: www.hoofprints.com. Estab. 1991. Mail order art retailer and wholesaler. Handles handpulled originals, limited and unlimited editions, offset reproductions, posters and engravings. Clients: individuals, galleries, tack shops and pet stores.

Needs: Considers only existing horse, dog, fox and cat prints.

First Contact & Terms: Send brochure, tearsheets, photographs and samples. Samples are filed. Will contact artist for portfolio review if interested. Pays per print. No advance. Provides advertising and shipping from firm. Finds artists through sourcebooks, magazine ads, word of mouth.

IMAGE CONNECTION, 456 Penn St., Yeadon PA 19050. (610)626-7770. Fax: (610)626-2778. E-mail: imageco@earthlink.net. Website: www.imageconnection.biz. **Art Coordinator:** Helen Casale. Estab. 1988. Publishes and distributes limited editions and posters. Represents several European publishers.

Needs: Seeking fashionable and decorative art for the commercial market. Considers oil, pen & ink, watercolor, acrylic, pastel and mixed media. Prefers contemporary and popular themes, realistic and abstract. Prefers contemporary realistic and abstract art. Editions created by collaborating with the artist and by working from an existing painting. Approached by 200 artists/year.

First Contact & Terms: Send query letter with brochure showing art style or résumé, slides, photocopies, photographs, tearsheets and transparencies. Accepts e-mail submissions with link to website or Mac-compatible image file. Samples are not filed and are returned by SASE. Responds in 2 months. Company will contact artist for portfolio review if interested. Portfolio should include b&w and color finished, original art, photographs, slides, tearsheets and transparencies. Payment method is negotiated. Offers advance when appropriate. Negotiates rights purchased. Requires exclusive representation of artist for product. Finds artists through art competitions, exhibits/fairs, reps, submissions, Internet, sourcebooks and word-of-mouth.

IMCON, 68 Greene St., Oxford NY 13830. (607)843-5130. E-mail: imcon@mkl.com. **President:** Fred Dankert. Estab. 1986. Fine art printer of handpulled originals. "We invented the waterless litho plate, and we make our own inks." Clients: galleries, distributors.

Needs: Seeking creative art for the serious collector. Editions created by collaborating with the artist "who must produce image on my plate. Artist given proper instruction."

First Contact & Terms: Call or send query letter with résumé, photographs and transparencies.

Tips: "Artists should be willing to work with me to produce original prints. We do *not* reproduce; we create new images. Artists should have market experience."

IMPACT IMAGES, 4919 Windplay Dr., El Dorado Hills CA 95762. (916)933-4700. Fax: (916)933-4717. **Owner:** Benny Wilkins. Estab. 1975. Publishes unlimited edition posters. Clients: frame shops, museum and gift shops. Current clients inlcude Impulse Designs, Image Conscious, Prints Plus, Summit Art Inc. and Deck the Walls. Licences art posters.

Needs: Seeking traditional and contemporary artwork. Considers oils, acrylics, pastels, watercolors, mixed media. Prefers contemporary, original themes, humor, fantasy, autos, animals, children, western, country, floral, golf, angels, inspirational, aviation, ethnic, wildlife and suitable poster subject matter. Prefers individual works of art. "Interested in licensed subject matter." Artists represented include Jonnie Chardon, Dan McMannis and Beatrix Potter. Publishes the work of 5 emerging, 25 mid-career and 15 established artists/ year.

First Contact & Terms: Send query letter with brochure, tearsheets, photographs, slides and transparencies. Samples are not filed and are returned by SASE. Responds in 1 month. Payment method is negotiated. Offers an advance when appropriate. Negotiates rights purchased. Does not require exclusive representation of the aritst. Provides written contract. Finds artists through art fairs, word of mouth and submissions.

Tips: "We usually publish 16×20 and 8×10 formats so we need artwork that can be cropped to these dimensions. We do not require exclusive rights to an image so the artist is free to sell images for other uses."

N̲ INSPIRATIONART & SCRIPTURE, INC., P.O. Box 5550, Cedar Rapids IA 52406. (319)365-4350. Fax: (319)861-2103. E-mail: charles@inspirationart.com. Website: www.inspirationart.com. **Creative Director:** Charles R. Edwards. Estab. 1993 (incorporated 1996). Produces Christian poster prints. "We create and produce jumbo-sized (24×36) posters targeted at pre-teens (10-14), teens (15-18) and young adults (18-30). A Christian message is contained in every poster. Some are fine art and some are very commercial. We prefer very contemporary images."

Needs: Approached by 150-200 freelance artist/year. Works with 10-15 freelancers/year. Buys 10-15 designs, photos, illustrations/year. Christian art only. Uses freelance artists for posters. Considers all media. Looking for "something contemporary or unusual that appeals to teens or young adults and communicates a Christian message." Art guidelines available for SASE with first-class postage. Catalog available for $3.

First Contact & Terms: Send query letter with photographs, slides, SASE or transparencies. Accepts submissions on disk (call first). Samples are filed or are returned by SASE. Responds in 6 months. Company will contact artist for portfolio review if interested. Portfolio should include color roughs, final art, photographs and transparencies. "We need to see the artist's range. It is acceptable to submit 'secular' work, but we also need to see work that is Christian-inspired." Originals are returned at job's completion. Pays

by the project, $50-250. Pays royalties of 5% "only if the artist has a body of work that we are interested in purchasing in the future." Rights purchased vary according to project.

Tips: "The better the quality of the submission, the better we are able to determine if the work is suitable for our use (slides are best). The more complete the submission (e.g., design, art layout, scripture, copy), the more likely we are to see how it may fit into our poster line. We do accept traditional work, but are looking for work that is more commercial and hip (think MTV with values). A poster needs to contain a Christian message that is relevant to teen and young adult issues and beliefs. Understand what we publish before submitting work. Artists can either purchase a catalog for $3 or visit our website to see what it is that we do. We are not simply looking for beautiful art, but rather we are looking for art that communicates a specific scriptural passage."

INTERCONTINENTAL GREETINGS LTD., 176 Madison Ave., New York NY 10016. (212)683-5380. Fax: (212)779-8564. Website: www.intercontinental-ltd.com. **Art Director:** Thea Groene. Estab. 1967. Sells reproduction rights of design to publisher/manufacturers. Handles offset reproductions, greeting cards, stationery and gift items. Clients: paper product, gift tin, ceramic and textile manufacturers. Current clients include: Franklin Mint, Scandecor, Verkerke, Simon Elvin, others in Europe, Latin America, Japan and Asia.

Needs: Seeking creative, fashionable and decorative art for the commercial and designer markets. Considers oil, watercolor, mixed media, pastel, acrylic, computer and photos. Approached by several hundred artists/year. Publishes the work of 30 emerging, 100 mid-career and 100 established artists/year. Also needs freelance design (not necessarily designers). 100% of freelance design demands knowledge of Photoshop, Illustrator and Painter. Prefers designers experienced in greeting cards, paper products and giftware.

First Contact & Terms: Send query letter with brochure, tearsheets, slides, photographs, photocopies and transparencies or CDs. Samples are filed or returned by SASE if requested by artist. Artist should follow-up with call. Portfolio should include color final art, photographs and slides. Pays flat fee, $30-500, or royalties of 20%. Offers advance when appropriate. Rights purchased vary according to project. Requires exclusive representation of artist, "but only on the artwork we represent." Provides promotion, shipping to firm and written contract. Finds artists through attending art exhibitions, word of mouth, sourcebooks or other publications and submissions. Company guidelines are free with SASE.

Tips: Recommends New York Stationery Show held annually. "In addition to having good painting/designing skills, artists should be aware of market needs."

☑ ⊕ **INTERNATIONAL GRAPHICS GMBH.**, Junkersring 11, 76344, Eggenstein Germany. 011(49)721-978-0688. Fax: (49)721-978-0651. E-mail: LW@ig-team.de. Website: www.international-graphics.de. **President:** Lawrence Walmsley. Publishing Assistant: Evelyne Dennler. Estab. 1983. Poster company/art publisher/distributor. Publishes/distributes limited edition monoprints, monotypes, offset reproduction, posters, original paintings and silkscreens. Clients: galleries, framers, department stores, gift shops, card shops and distributors. Current clients include: Windsor Art, Intercontinental Art and Balangier.

Needs: Seeking creative, fashionable and decorative art for the commercial and designer markets. Also seeking Americana art for our gallery clients. Considers oil, acrylic, watercolor, mixed media, pastel. Prefers landscapes, florals, still lifes. Art guidelines free for SASE with first-class postage. Artists represented include Christian Choisy, Benevolenza and Mansart. Editions created by working from an existing painting. Approached by 100-150 artists/year. Publishes the work of 4-5 emerging artists/year. Distributes the work of 40-50 emerging artists/year.

First Contact & Terms: Send query letter with brochure, photocopies, photographs, photostats, résumé, slides, tearsheets. Accepts disk submissions in Mac or Windows. Samples are filed and returned. Responds in 2 months. Will contact artist for portfolio review if interested. Negotiates payment on basis of per piece sold arrangement. Offers advance when appropriate. Buys first rights. Provides advertising, promotion, shipping from our firm and contract. Also work with freelance designers. Prefers local designers only. Finds artists through exhibitions, word of mouth, submissions.

Tips: "Pastel landscapes and still life pictures are good at the moment. Earthtones are popular—especially lighter shades."

N 🔳 **ISLAND ART**, 6687 Mirah Rd., Saanichton, BC V8M 1Z4 Canada. (250)652-5181. Fax: (250)652-2711. E-mail: islandart@islandart.com. Website: www.islandart.com. **President:** Myron D. Arndt. Estab. 1985. Art publisher and distributor. Publishes and distributes limited and unlimited editions, offset reproductions, posters and art cards. Clients: galleries, department stores, distributors, gift shops. Current clients include: Disney, Host-Marriott, Ben Franklin.

Needs: Seeking creative and decorative art for the serious collector, commercial and designer markets. Considers oil, watercolor and acrylic. Prefers lifestyle themes/Pacific Northwest. Also needs designers. 10% of products require freelance design and demand knowledge of Photoshop. Art guidelines available on company's website. Artists represented include Sue Coleman and Lissa Calvert. Editions created by working from an existing painting. Approached by 100 artists/year. Publishes the work of 2 emerging artists/year. Distributes the work of 4 emerging artists/year.

First Contact & Terms: Send résumé, tearsheets, slides and photographs. Designers send photographs, slides or transparencies (do not send originals). Accepts submissions on disk compatible with Photoshop. Send EPS of TIFF files. Samples are not filed and are returned by SASE if requested by artist. Responds in 3 months. Publisher/distributor will contact artist for portfolio review if interested. Portfolio should include color roughs, final art, slides and 4×5 transparencies. Pays royalties of 5-10%. Offers advance when appropriate. Buys reprint rights. Requires exclusive representation of artist. Provides insurance while work is at firm, promotion, shipping from firm, written contract, trade fair representation and Internet service. Finds artists through art fairs, referrals and submissions.

Tips: "Provide a body of work along a certain theme to show a fully developed style that can be built upon. We are influenced by our market demands. Please ask for our submission guidelines before sending work on spec."

LESLI ART, INC., Box 6693, Woodland Hills CA 91365. (818)999-9228. E-mail: artlesli@aol.com. **President:** Stan Shevrin. Estab. 1965. Artist agent handling paintings for art galleries and the trade.

Needs Considers oil paintings and acrylic paintings. Prefers realism and impressionism—figures costumed with narrative content, landscapes, still lifes and florals. Works with 20 artists/year.

First Contact & Terms: To show portfolio, mail slides or color photographs. Samples not filed are returned by SASE. Responds in 1 month. Payment method is negotiated. Offers an advance. Provides national distribution, promotion and written contract.

Tips: "Considers only those artists who are serious about having their work exhibited in important galleries throughout the United States and Europe."

✔ **LESLIE LEVY FINE ART PUBLISHING, INC.**, 7137 Main St., Scottsdale AZ 85251. (480)947-2925. Fax: (480)945-1518. E-mail: leslevy@ix.netcom.com. Website: www.leslielevy.com. **President:** Leslie Levy. Estab. 1976. Art publisher of posters. "Our publishing customers are mainly frame shops, galleries, designers, framed art manufacturers, distributors and department stores. Currently works with over 10,000 clients."

Needs Seeking creative and decorative art for the residential, hospitality, health care, commercial and designer markets. Artists represented include: Steve Hanks, Doug Oliver, Robert Striffolino, Kent Wallis, Cyrus Afsary, Raymond Knaub, Terry Isaac, June Carey, Peter Van Dusen, Mary DeLoyht-Arendt, and many others. Considers oil, acrylic, pastel, watercolor, tempera and mixed media. Prefers art depicting florals, landscapes, wildlife, semiabstract, Americana and figurative works. Approached by hundreds of artists/year.

First Contact & Terms: Send query letter with résumé, slides or photos and SASE. Samples are returned by SASE. "Portfolio will not be seen unless interest is generated by the materials sent in advance." Please do not send limited editions, transparencies or original works. Pays royalties quarterly based on wholesale price. Insists on acquiring reprint rights for posters. Requires exclusive representation of the artist. Provides advertising, promotion, written contract and insurance while work is at firm. "Please, don't call us. After we review your materials, we will contact you or return materials within 2 months."

Tips: "We are looking for floral, figurative, landscapes, wildlife, semiabstract art. Please, if you are a beginner, do not go through the time and expense of sending materials."

 LIPMAN PUBLISHING, 76 Roxborough St. W., Toronto, ON M5R 1T8 Canada. (800)561-4260. Fax: (416)967-4731. E-mail: lipman@passport.ca. **Owner:** Louise Lipman. Estab. 1976. Art publisher.

● **SPECIAL COMMENTS** within listings by the editor of *Artist's & Graphic Designer's Market* are set off by a bullet.

Publishes unlimited editions, offset reproductions and posters. Clients: wholesale framers, distributors, hospitality. Current clients include: Pier One, Bombay, Spiegel.

Needs: Seeking decorative art for the commercial and designer markets. Considers all 2-dimensional media. Prefers garden, kitchen, landscape, floral themes. Art guidelines available. Artists represented include William Buffett, Jim Harrington, Anna Pugh and Donald Farnsworth. Editions created by collaborating with the artist or by working from an existing painting.

First Contact & Terms: Send slides, photographs, photocopies or any low-cost facsimile. Samples are filed and not returned. Responds in a few weeks. Publisher will contact artist for portfolio review if interested. Portfolio should include color thumbnails, photographs and slides. Pays royalties of 10%. Negotiates rights purchased. Requires exclusive representation of artist. Provides advertising, promotion and written contract.

Tips: "There's a trend to small pictures of garden-, kitchen-, and bathroom-related material. Be willing to take direction."

LOLA LTD./LT'EE, 1817 Egret St. SW, S. Brunswick Islands, Ocean Isle NC 28470. (910)754-8002. E-mail: jumpjive@37.com. **Owner:** Lola Jackson. Distributor of limited editions, offset reproductions, unlimited editions, handpulled originals, antique prints and etchings. Clients: art galleries, architects, picture frame shops, interior designers, major furniture and department stores, industry and antique gallery dealers.
- This distributor also carries antique prints, etchings and original art on paper and is interested in buying/selling to trade.

Needs: Seeking creative and decorative art for the commercial and designer markets. "Handpulled graphics are our main area." Also considers oil, acrylic, pastel, watercolor, tempera or mixed media. Prefers unframed series, up to 30×40 maximum. Artists represented include Buffet, White, Brent, Jackson, Mohn, Baily, Carlson, Coleman. Approached by 100 artists/year. Publishes the work of 5 emerging, 5 mid-career and 5 established artists/year. Distributes the work of 40 emerging, 40 mid-career and 5 established artists/year.

First Contact & Terms: Send query letter with sample. Samples are filed or are returned only if requested. Responds in 2 weeks. Payment method is negotiated. "Our standard commission is 50% less 50% off retail." Offers an advance when appropriate. Provides insurance while work is at firm, shipping from firm and written contract.

Tips: "We find we cannot sell b&w only; red, orange and yellow are also hard to sell unless included in abstract subjects. Best colors: emerald, mauve, blues and gem tones. Leave wide margins on prints. Send all samples before end of May each year as our main sales are targeted for summer. We do a lot of business with birds, botanicals, boats and shells—anything nautical."

LYNESE OCTOBRE, INC., P.O. Box 5002, Clearwater FL 33758. (727)789-2800. Fax: (727)724-8352. E-mail: jerry@lyneseoctobre.com. Website: www.lyneseoctobre.com. **President:** Jerry Emmons. Estab. 1982. Distributor. Distributes unlimited editions, offset reproductions and posters. Clients: picture framers and gift shops.

Needs: Seeking fashionable and decorative art for the commercial and designer markets. Considers oil, watercolor, mixed media, pastel, pen & ink and acrylic. Artists represented include Neil Adamson, AWS, NWS, FWS; Roger Isphording, Betsy Monroe, Paul Brendt, Sherry Vintson, Jean Grastorf. Approached by 50 artists/year.

First Contact & Terms: Send brochure, tearsheets, photographs and photocopies. Samples are sometimes filed or are returned. Responds in 1 month. Distributor will contact artist for portfolio review if interested. Portfolio should include final art, photographs and transparencies. Negotiates payment. No advance. Rights purchased vary according to project. Provides written contract.

Tips: Recommends artists attend decor expo shows. "The trend is toward quality, color-oriented regional works."

SEYMOUR MANN, INC., 230 Fifth Ave., Suite 910, New York NY 10001. (212)683-7262. Fax: (212)213-4920. E-mail: smanninc@aol.com. Website: www.seymourmann.com. Manufacturer.

Needs: Seeking fashionable and decorative art for the serious collector and the commercial and designer markets. Also needs freelancers for design. 15% of products require freelance design. Considers watercolor, mixed media, pastel, pen & ink and 3-D forms. Editions created by collaborating with the artist. Approached by "many" artists/year. Publishes the work of 2-3 emerging, 2-3 mid-career and 4-5 established artists/year.

Tips: "Focus on commercial end purpose of art."

N **M** **MAPLE LEAF PRODUCTIONS**, 391 Steelcase Rd. W, Unit 24, Markham, ON L3R 3V9 Canada. (905)940-9229. Fax: (905)940-9761. E-mail: ssillcox@ca.inter.net. Website: www.mapleleafproductions.com. **Contact:** Scott Sillcox, president. Estab. 1993. Art publisher. Publishes sports art (historical), limited edition, posters, unlimited edition. Clients: distributors, frame shops, gift shops and museum shops.
Needs: Considers watercolor. Please see our website for the theme and style. Artists represented include Tino Paolini, Nola McConnan, Bill Band. Editions created provide the artist with source material. Approached by 5 artists/year. Publishes/distributes 1 emerging artist/year.
First Contact & Terms: Send e-mail. Accepts e-mail submissions with link to website. Prefers TIFF, JPEG, GIF, EPS. Responds in 1 week. Negotiates payment. Offers advance when appropriate. Buys all rights. Provides written contract. Finds artists through word-of-mouth.
Tips: "We require highly detailed watercolor artists, especially those with an understanding of sports and the human body. Attention to small details is a must."

MARLBORO FINE ART & PUBLISHING, LTD., 10 Gristmill Rd., Howell NJ 07731. Phone/fax: (732)901-5732. E-mail: charlin15@aol.com. Website: www.art-websites.com/mfa. Estab. 1996. Art publisher/distributor. Publishes/distributes limited and unlimited edition offset reproductions and posters. Clients: galleries, decorators, frame shops, distributors, architects, corporate curators, museum shops, giftshops. Current clients include: Charray Art, Creative Energies, James Lawrence, Inc.
Needs: Publishes/distributes creative, fashionable and decorative art for the commercial market. Considers acrylic, watercolor, mixed media, pastel, pen & ink. Prefers multicultural themes; specializes in African-American themes. Artists represented include Anthony Armstrong, Khalil Bey, Hosa Anderson, Harry Davis, William Buffett, Alex Corbbrey, Mario A. Robinson, Ophie Lawrence, James Ghetters, Jr. and Ruth Williams. Editions created by collaborating with the artist and working from an existing painting. Approached by 15-20 artists/year. Publishes 1-2 emerging, 2 established artists/year. Distributes the work of 5-10 emerging, 5 mid-career artists/year.
First Contact & Terms: Send query letter with brochure, photocopies, photographs, photostats, slides, transparencies. Samples are not filed and are returned. Responds in days. Will contact artist for portfolio review if interested. Royalties paid monthly. Offers advance when appropriate. Rights purchased vary according to project. Provides advertising, promotion, shipping from firm and contract. Finds artists through the web, trade publications.
Tips: "Do your own thing if it feels right, go for it! You could be the next trendsetter."

BRUCE MCGAW GRAPHICS, INC., 389 W. Nyack Rd., West Nyack NY 10994. (845)353-8600. Fax: (845)353-3155. E-mail: acquisitions@bmcgaw.com. Website: www.bmcgaw.com. **Acquisitions:** Martin Lawlor. Clients: poster shops, galleries, I.D., frame shops.
 • Bruce McGaw publishes nearly 300 images per year.
Needs: Artists represented include Diane Romanello, Romero Britto, David Doss, Ray Hendershot, Jacques Lamy, Bob Timberlake, Robert Bateman, Michael Kahn, Albert Swayhoover, William Mangum and P.G. Gravele. Other important fine art poster licenses include Disney, Andy Warhol, MOMA, New York and others. Publishes the work of 30 emerging and 30 established artists/year.
First Contact & Terms: Send slides, transparencies or any other visual material that shows the work in the best light. "We review all types of 2-dimensional art with no limitation on media or subject. Review period is 1 month, after which time we will contact you with our decision. If you wish the material to be returned, enclose a SASE. If forwarding material electronically, send easily opened JPEG files for initial review consideration only. 10-15 JPEGs are preferred. Referrals to artists' websites will not be addressed." Contractual terms are discussed if work is accepted for publication." Forward 20-60 examples—we look for a body of work from which to publish.
Tips: "Simplicity is very important in today's market (yet there still needs to be 'a story' to the image). Form and palette are critical to our decision process. We have a tremendous need for decorative pieces, especially new abstracts, landscapes and florals. Decorative still life images are very popular, whether painted or photographed, and much needed as well. There are a lot of prints and posters being published into the marketplace these days. Market your best material! There are a number of important shows—the largest American shows being Art Expo, New York (March), Galeria, New York (March), and the Atlanta A.B.C. Show (September). Review our catalog at your neighborhood gallery or poster shop or visit our website before submitting. Send your best."

N **METALART STUDIOS, INC.**, 202 Roosevelt Rd., Valparaiso IN 46383. (219)465-5188. Fax: (219)548-0145. E-mail: metalartstudios@worldnet.att.net. **Contact:** Heather McGill, managing partner.

Estab. 1979. Photoengraver of metal etchings. Publishes metal etchings/reproductions. Clients: architects, decorators, frame shops, gift shops, museum shops. Current clients include: Accent Chicago, City of Chicago Store, Chicago Architecture Foundation.

Needs: Seeking decorative art for the commercial market. Considers pen & ink, line art illustrations. Prefers cityscapes, architectural renderings (cities, university); line art illustrations of automobiles, motorcycles, railroad, still life, animal etc. Artists represented include William Carr Olendorf. Editions created by collaborating with the artist, by working from an existing painting.

First Contact & Terms: Send brochure, photocopies, photographs, slides, tearsheets, transparencies, URL. Accepts e-mail submissions with image file. Prefers Windows-compatible, JPEG files. Samples are filed. Responds in 1 week. Company will contact artist for portfolio review if interested. Negotiates payment. Offers advance when appropriate. Buys reprint rights—in metal only, rights purchased vary according to project. Requires exclusive representation of artist in metal only. Provides promotion and written contract. Finds artists through artist's submissions.

Tips: "Line art illustrations are reproduced in zinc or copper; shading and color wash cannot be reproduced."

MILL POND PRESS COMPANIES, 310 Center Court, Venice FL 34292-3500. (800)535-0331. Fax: (941)497-6026. E-mail: millpondPD@worldnet.att.net. Website: www.millpond.com. **Public Relations Director:** Ellen Collard. Licensing: Angela Sauro. Estab. 1973. Publishes limited editions, unlimited edition, offset reproduction and giclees. Divisions include Mill Pond Press, Loren Editions, Visions of Faith and Mill Pond Licensing. Clients: galleries, frameshops and specialty shops, Christian book stores, licensees. Licenses various genre on a range of products.

Needs: Seeking creative, fashionable, decorative art. Open to all styles. Considers oil, acrylic, watercolor and mixed media. Prefers wildlife, spiritual, figurative and nostalgic. Artists represented include Robert Bateman, Carl Brenders, Peter Ellenshaw, Nita Engle, Luke Buck, Paco Young and Maynard Reece. Editions created by collaborating with the artist or by working from an existing painting. Approached by 400-500 artists/year. Publishes the work of 4-5 emerging, 5-10 mid-career and 15-20 established artists/year.

First Contact & Terms: Send query letter with photographs, résumé, SASE, slides, transparencies and description of artwork. Samples are not filed and are returned by SASE. Responds in 1 year. Company will contact artist for portfolio review if interested. Pays royalties. Rights purchased vary according to project. Requires exclusive representation of artist. Provides advertising, in-transit insurance, insurance while work is at firm, promotion, shipping to and from firm and written contract. Finds artists through art exhibitions, submissions and word of mouth.

Tips: "We continue to expand the genre published. Inspirational art has been part of expansion. Realism is our base but we are open to looking at all art."

MODARES ART PUBLISHING, 2305 Louisiana Ave. N, Golden Valley MN 55427. (800)896-0965. Fax: (763)513-1357. Website: gallery394.com. **President:** Mike Modares. Estab. 1993. Art publisher, distributor. Publishes/distributes limited edition, unlimited edition, canvas transfers, monoprints, monotypes, offset reproduction and posters. Clients: galleries, decorators, frame shops, distributors, architects, corporate curators, museum shops and giftshops.

Needs: Seeking creative and decorative art for the commercial and designer market. Considers oil, acrylic, watercolor mixed media and pastel. Prefers realism and impressionism. Artists represented include Jim Hansel, Derk Hansen and Michael Schofield. Editions created by collaborating with the artist or working from an existing painting. Approached by 10-50 artists/year. Distributes the work of 10-30 emerging artists/year. Also needs freelancers for design.

First Contact & Terms: Send query letter with brochure, photographs, photostats, slides and transparencies. Samples are not filed and are returned. Responds in 5 days. Portfolio may be dropped off every Monday, Tuesday and Wednesday. Artist should follow up with a call. Portfolio should include color, final art, photographs, photostats, thumbnails. Payment negotiated. Offers advance when appropriate. Buys one-time rights and all rights. Sometimes requires exclusive representation of artist. Provide advertising, in-transit insurance, insurance while work is at firm, promotion, shipping from our firm and written contract. Finds artists through attending art exhibitions, art fairs and word of mouth.

MORIAH PUBLISHING, INC., 23500 Mercantile Rd., Unit B, Beechwood OH 44122. (216)595-3131. Fax: (216)595-3140. E-mail: rouven@moriahpublishing.com. Website: www.moriahpublishing.com. **Contact:** Rouven R. Cyncynatus. Estab. 1989. Art publisher and distributor of limited editions. Licenses wildlife and nature on all formats. Clients: wildlife art galleries.

Needs: Seeking artwork for the serious collector. Editions created by working from an existing painting. Approached by 100 artists/year. Publishes the work of 6 and distributes the work of 15 emerging artists/year. Publishes and distributes the work of 10 mid-career artists/year. Publishes the work of 30 and distributes the work of 10 established artists/year.

First Contact & Terms: Send query letter with brochure showing art style, slides, photocopies, résumé, photostats, transparencies, tearsheets and photographs. Responds in 2 months. Write for appointment to show portfolio or mail appropriate materials: rough, b&w, color photostats, slides, tearsheets, transparencies and photographs. Pays royalties. No advance. Buys reprint rights. Requires exclusive representation of artist. Provides in-transit insurance, promotion, shipping to and from firm, insurance while work is at firm, and a written contract.

Tips: "Artists should be honest, patient, courteous, be themselves, and make good art."

☑ **MUNSON GRAPHICS**, 1209 Parkway Dr., Suite A, Santa Fe NM 87507. (505)424-4112. Fax: (505)424-6338. E-mail: michael@munsongraphics.com. Website: www.munsongraphics.com. **President:** Michael Munson. Estab. 1997. Poster company, art publisher and distributor. Publishes/distributes limited edition, fine art prints and posters. Clients: galleries, museum shops, gift shops and frame shops.

Needs: Seeking creative art for the serious collector and commercial market. Considers oil, acrylic, watercolor and pastel. Artists represented include O'Keeffe, Baumann, Nieto, Abeyta. Editions created by working from an existing painting. Approached by 75 artists/year. Publishes work of 3-5 emerging, 3-5 mid-career and 3-5 established artists/year. Distributes the work of 5-10 emerging, 5-10 mid-career and 5-10 established artists/year.

First Contact & Terms: Send query letter with slides, SASE and transparencies. Samples are not filed and are returned by SASE. Responds in 1 month. Company will contact artist for portfolio review if interested. Negotiates payment. Offers advance. Rights purchased vary according to project. Provides written contract. Finds artists through art exhibitions, art fairs, word of mouth and artists' submissions.

[N] **MUSEUM EDITIONS WEST**, 4130 Del Rey Ave., Marina Del Rey CA 90292. (310)822-2558. Fax: (310)822-3508. E-mail: jordanarts@aol.com. **Director:** Grace Yu. Poster company, distributor, gallery. Distributes unlimited editions, canvas transfers, posters. Clients: galleries, decorators, frame shops, distributors, architects, corporate curators, museum shops, giftshops. Current clients include: San Francisco Modern Art Museum and The National Gallery, etc.

Needs: Seeking creative, fashionable art for the commercial and designer markets. Considers oil, acrylic, watercolor, pastel. Prefers landscape, floral, abstract. Artists represented include John Botzy and Carson Gladson. Editions created by working from an existing painting. Approached by 150 artists/year. Publishes/distributes the work of 5 mid-career and 20 established artists/year. Also needs freelancers for design.

First Contact & Terms: Send query letter with brochure, photocopies, photographs, résumé, SASE, slides, tearsheets, transparencies. Samples are not filed and are returned by SASE. Responds in 3 months. Company will contact artist for portfolio review of photographs, slides, tearsheets and transparencies if interested. Pays royalties of 8-10%. Offers advance when appropriate. Rights purchased vary according to project. Provides advertising, insurance while work is at firm, promotion, shipping from firm, written contract. Finds artists through art exhibitions, art fairs, word of mouth, submissions.

Tips: "Look at our existing catalog for samples."

[N] **MUSEUM MASTERS INTERNATIONAL**, 26 E. 64th St., New York NY 10021. (212)759-0777. **President:** Marilyn Goldberg. Distributor handling limited editions, posters, tapestry and sculpture for galleries, museums and gift boutiques. Current clients include the Boutique/Galeria Picasso in Barcelona, Spain and The Hakone Museum in Japan.

Needs: Seeking artwork with decorative appeal for the designer market. Considers oil, acrylic, pastel, watercolor and mixed media. Prefers individual works of art in unframed series. Also reproduces art images on boutique product. Artists represented include Pablo Picasso and Ichiro Tsuruta. Editions created by collaborating with the artist. Approached by 100 artists/year. Publishes and distributes the work of 3 emerging, mid-career and established artists/year.

First Contact & Terms: Send query letter with résumé, brochures and samples. Samples are filed or returned. Call or write for appointment to show portfolio or mail slides and transparencies. Payment method is negotiated. Offers advance when appropriate. Negotiates rights purchased. Exclusive representation is not required. Provides insurance while work is at firm, shipping to firm and a written contract.

NEW YORK GRAPHIC SOCIETY, 129 Glover Ave., Norwalk CT 06850. (203)661-2400. Website: www.nygs.com. **Publisher:** Richard Fleischmann. President: Owen Hickey. Estab. 1925. Publisher of offset

reproductions, posters, unlimited edition. Clients: galleries, frame shops and museums shops. Current clients include Deck The Walls, Artistry, Prints Plus.

Needs: Considers oil, acrylic, pastel, watercolor, mixed media and colored pencil drawings. Publishes reproductions, posters. Artists represented include Dan Campanelli, Doug Brozu. Publishes and distributes the work of numerous emerging artists/year. Art guidelines free with SASE. Response to submissions in 90 days.

First Contact & Terms: Send query letter with transparencies or photographs. All submissions returned to artists by SASE after review. Pays royalties of 10%. Offers advance. Buys all print reproduction rights. Provides in-transit insurance from firm to artist, insurance while work is at firm, promotion, shipping from firm and a written contract; provides insurance for art if requested. Finds artists through submissions/self promotions, magazines, visiting art galleries, art fairs and shows.

Tips: "We publish a broad variety of styles and themes. We actively seek all sorts of fine decorative art."

NORTHLAND POSTER COLLECTIVE, Dept. AM, 1613 E. Lake St., Minneapolis MN 55407. (612)721-2273. Website: www.northlandposter.com. **Manager:** Ricardo Levins Morales. Estab. 1979. Art publisher and distributor of handpulled originals, unlimited editions, posters and offset reproductions. Clients: mail order customers, teachers, bookstores, galleries, unions.

Needs: "Our posters reflect themes of social justice and cultural affirmation, history, peace." Artists represented include Ralph Fasanella, Frank Escalet, Christine Wong, Beatriz Aurora, Betty La Duke, Ricardo Levins Morales and Lee Hoover. Editions created by collaborating with the artist or by working from an existing painting.

First Contact & Terms: Send query letter with tearsheets, slides and photographs. Samples are filed or are returned by SASE. Responds in months; if does not report back, the artist should write or call to inquire. Write for appointment to show portfolio. Payment method is negotiated. Offers an advance when appropriate. Negotiates rights purchased. Contracts vary but artist always retains ownership of artwork. Provides promotion and a written contract.

Tips: "We distribute work that we publish as well as pieces already printed. We print screen prints inhouse and publish one to four offset posters per year."

Ⓝ NORZ GRAPHICA, (207)985-6134. Fax: (207)985-7633. E-mail: crew@norsgear.com. **Publisher:** Alexander Bridge. Estab. 1989. Art publisher/distributor. Publishes and distributes limited and unlimited editions, posters, offset reproductions and stationery. Clients: framers, galleries.

Needs: Seeking creative art for the commercial market. Specializes in rowing, sailing and sporting art. Considers oil, watercolor, mixed media, pen & ink, acrylic and b&w photography. Artists and photographers represented include John Gable, David Foster and Amy Wilton. Editions created by collaborating with the artist. Approached by 300 artists/year. Publishes and distributes the work of 4 mid-career artists and photographers and 3 established artists/year. Send 35mm slides.

Tips: "Persist in your work to succeed!"

NOTTINGHAM FINE ART, P.O. Box 309, Chester NH 03036-0309. (603)887-7089. Fax: (603)887-2447. E-mail: robert@artandgift.com. Website: www.artandgift.com. **President:** Robert R. Lemelin. Estab. 1992. Art publisher, distributor. Publishes/distributes handpulled originals, limited editions, fine art prints, monoprints, monotypes, offset and digital reproductions. Clients: galleries, frame shops, architects.

Needs: Seeking creative, fashionable, decorative art for the serious collector. Considers oil, acrylic, watercolor, mixed media, pastel. Prefers sporting, landscape, floral, creative, musical and lifestyle themes. Artists represented include Roger Blum, Barbie Tidwell, Cristina Martuccelli, Monique Parry and Ronald Parry. Editions created by collaborating with the artist or by working from an existing painting. Approached by 60 artists/year.

First Contact & Terms: Send query letter with brochure, photographs, slides. Samples are filed or returned by SASE. Responds in 2 months. Company will contact artist for portfolio review of color photographs, slides and transparencies if interested. Pays in royalties. Rights purchased vary according to project. Requires exclusive representation of artist. Provides advertising, insurance while work is at firm, promotion, shipping from firm, written contract. Finds artists through art fairs, submissions and referrals from existing customers.

Tips: "If you don't have a marketing plan developed or $5,000 you don't need, don't self-publish. We look for artists with consistent quality and a feeling to their work."

NOVA MEDIA INC., 1724 N. State, Big Rapids MI 49307. (231)796-4637. E-mail: trund@nov.com. Website: www.nov.com. **Editor:** Tom Rundquist. Licensing: Arne Flores. Estab. 1981. Poster company,

art publisher, distributor. Publishes/distributes limited editions, unlimited editions, fine art prints, posters, e-prints. Current clients: various galleries. Licenses e-prints.

Needs: Seeking creative art for the serious collector. Considers oil, acrylic. Prefers expressionism, impressionism, abstract. Editions created by collaborating with the artist or by working from an existing painting. Approached by 14 artists/year. Publishes/distributes the work of 2 emerging, 2 mid-career and 1 established artists/year. Artists represented include Jill Everest Fonner. Also needs freelancers for design. Prefers local designers.

First Contact & Terms: Send query letter with photographs, résumé, SASE, slides, tearsheets. Samples are returned by SASE. Responds in 2 weeks. Request portfolio review in original query. Company will contact artist for portfolio review of color photographs, slides, tearsheets if interested. Pays royalties of 10% or negotiates payment. No advance. Rights purchased vary according to project. Provides promotion.

Tips: Predicts colors will be brighter in the industry. "Focus on companies that sell your style."

OLD WORLD PRINTS, LTD., 2601 Floyd Ave., Richmond VA 23220-4305. (804)213-0600. Fax: (804)213-0700. E-mail: kwurdeman@yahoo.com. Website: oldworldprintsltd.com. **President:** John Wurdeman. Vice President Art Acceptance: Kathy Wurdeman. Licensing: John Wurdeman. Estab. 1973. Art publisher and distributor of open-edition, hand-printed reproductions of antique engravings as well as all subject matter of color printed art. Clients: retail galleries, frame shops and manufacturers, hotels, and fund raisers.

● Old World Prints reports the top-selling art in their 10,000-piece collection includes botanical and decorative prints.

Needs: Seeking traditional and decorative art for the commercial and designer markets. Specializes in handpainted prints. Considers "b&w (pen & ink or engraved) art which can stand by itself or be hand painted by our artists or originating artist." Prefers traditional, representational, decorative work. Editions created by collaborating with the artist. Distributes the work of more than 1,000 artists. "Also seeking golf, coffee, tea, and exotic floral images."

First Contact & Terms: Send query letter with brochure showing art style or résumé and tearsheets and slides. Samples are filed. Responds in 6 weeks. Write for appointment to show portfolio of photographs, slides and transparencies. Pays flat fee of $100/piece and royalties of 10% of profit. Offers an advance when appropriate. Negotiates rights purchased. Provides in-transit insurance, insurance while work is at firm, promotion, shipping from firm and a written contract. Finds artists through word of mouth.

Tips: "We are a specialty art publisher, the largest of our kind in the world. We are actively seeking artists to publish and will consider all forms of art."

✅ **OPUS ONE PUBLISHING**, 129 Glover Ave., Norwach CT 06850. (203)847-2000. Fax: (203)846-2105. **Contact:** Owen F. Hickey. Estab. 1970. Art Publisher. Publishes fine art prints.

Needs: Seeking creative, fashionable and decorative art for the commercial and designer markets. Considers all media. Art guidelines free for SASE with first-class postage. Artists represented include Kate Frieman, Jack Roberts, Jean Richardson, Richard Franklin, Lee White. Approached by 100 artists/year. Publishes the work of 20% emerging, 20% mid-career and 60% established artists.

First Contact & Terms: Send brochure, tearsheets, slides, photographs, photocopies, transparencies. Samples are not filed and are returned. Responds in 1 month. Artist should follow up with call after initial query. Portfolio should include final art, slides, transparencies. Pays royalties of 10%. Rights purchased vary according to project.

Tips: "Please attend the Art Expo New York City trade show."

🔲 **PALOMA EDITIONS**, 2290 Enrico Fermi Dr., Suite 16, San Diego CA 92154. (619)671-0153. E-mail: customerservice@palomaeditions.com **Publisher:** Kim A. Butler. Art publisher/distributor of limited and unlimited editions, fine art prints, offset reproductions and posters. Specializes in African-American art. Clients include galleries, specialty shops, retail chains, framers, distributors, museum shops.

Needs: Seeking creative and decorative art for the commercial and designer market. Considers all media. Prefers African-American art. Artists represented include Albert Fennell, Raven Williamson, Tod Hanskin Fredericks. Editions created by working from existing painting. Approached by hundreds of artists/year. Publishes the work of 4 emerging artists/year. Distributes the work of 10 emerging artists/year.

First Contact & Terms: Send query letter with brochure, photocopies, photographs, tearsheets and/or transparencies or JPEGs. Samples are returned by SASE, only if requested. Responds in 2 months, only if interested. Publisher will contact for portfolio review of color final art, photographs, tearsheets and transparencies if interested. Payment negotiable, royalties vary. Offers advance when appropriate. Negoti-

ates rights purchased. Requires exclusive representation of artist. Provides advertising, promotion, shipping and written contract. Also needs designers. Prefers designers who own IBM PCs. Freelance designers should be experienced in QuarkXPress, Photoshop, FreeHand. Finds artists through art shows, magazines and referrals.

Tips: "African-American art is hot! Read the trade magazines and watch the furniture and fashion industry. Keep in mind that your work must appeal to a wide audience. It is helpful if fine artists also have basic design skills so they can present their artwork complete with border treatments. We advertise in *Decor*, *Art Business News*, *Art Trends*. See ads for examples of what we choose to publish."

PANACHE EDITIONS LTD, 234 Dennis Lane, Glencoe IL 60022. (847)835-1574. E-mail: artofrunning @aol.com. Website: www.artofrunning.com. **President:** Donna MacLeod. Estab. 1981. Art publisher and distributor of offset reproductions and posters. Clients: galleries, frame shops, domestic and international distributors. Current clients are mostly individual collectors.

Needs: Considers acrylic, pastel, watercolor and mixed media. "Looking for contemporary compositions in soft pastel color palettes; also renderings of children on beach, in park, etc." Artists represented include Bart Forbes, Peter Eastwood and Carolyn Anderson. Prefers individual works of art and unframed series. Publishes and distrubutes work of 1-2 emerging, 2-3 mid-career and 1-2 established artists/year.

First Contact & Terms: Send query letter with brochure showing art style or photographs, photocopies and transparencies. Samples are filed. Responds only if interested. To show portfolio, mail roughs and final reproduction/product. Pays royalties of 10%. Negotiates rights purchased. Requires exclusive representation of artist. Provides in-transit insurance, insurance while work is at firm, promotion, shipping to and from firm and written contract.

Tips: "We are looking for artists who have not previously been published [in the poster market] with a strong sense of current color palettes. We want to see a range of style and coloration. Looking for a unique and fine art approach to collegiate type events, i.e., Saturday afternoon football games, Founders Day celebrations, homecomings, etc. We do not want illustrative work but rather an impressionistic style that captures the tradition and heritage of one's university. We are very interested in artists who can render figures."

N MARK PATSFALL GRAPHICS, INC., 1312 Clay St., Cincinnati OH 45202. (513)241-3232. E-mail: mpginc@iac.net. Website: www.patsfallgraphics.com. **Contact:** Mark Patsfall, owner. Estab. 1981. Art publisher and contract printer. Publishes fine art prints, hand-pulled originals, limited edition. Clients: architects, corporate curators, decorators, galleries and museum print curators.

Needs: Seeking art for the serious collector. Prefers conceptual/contemporary. Artists represented include Name June Paik, Kay Rosen, Bill Allen, Bern Porter. Editions created by collaborating with the artist. Approached by 1-10 artists/year. Publishes the work of 2-3 emerging artists/year.

First Contact & Terms: Contact only through artist rep. Accepts e-mail submissions with image file. Prefers Mac-compatible JPEG files. Responds in 1 week. Negotiates payment. Negotiates rights purchased. Services provided depend on contract. Finds artists through art reps, galleries and word-of-mouth.

N ⊕ PGM ART WORLD, Carl-von-Linde-Str. 33, 85738 Garching Germany. (01149)89-320-02-170. Fax: (01149)89-320-02-270. E-mail: info@pgm-art-world.com. Website: www.pgm-art-world.de. **General Manager:** Andrea Kuborn. Estab. 1995. (German office established 1969.) International fine art publisher, distributor, gallery. Publishes/distributes limited and unlimited edition, offset reproductions, posters. Clients: world-wide supplier of galleries, framers, distributors, decorators.

● This publisher's main office is in Germany. PGM publishes more than 300 images and distributes more than 6,000 images in Europe and Asia. The company also operates three galleries in Munich.

Needs: Seeking creative, fashionable and decorative art for the commercial and designer markets. Considers oil, acrylic, watercolor, mixed media, pastel, pen & ink. Considers any well accomplished work of any theme or style. Artists represented include Renato Casaro, Diane French-Gaugush, Leslie Hunt, Patricia

NICHE MARKETING INDEX, identifying Cartoons, Children's Illustration, Licensing, Medical Illustration, Mugs, Religious Art, Science Fiction/Fantasy Art, Sport Art, T-Shirts, Textiles, Wildlife Art and other categories is located in the back of this book.

Nix, Nina Nolte. Editions created by working from an existing painting. Approached by 100 artists/year. Publishes the work of 25 artists/year.

First Contact & Terms: Send query letter with photographs, résumé, SASE, slides, transparencies. Samples are not filed and are returned by SASE. Responds in 3 months. Will contact artist for portfolio review if interested. Pays royalties; negotiable. Does not require exclusive representation of artist. Provides advertising, promotion, written contract.

Tips: "Get as much exposure as possible! Advises artists to attend ABC shows, Art Expo and Galeria for exposure. Advises artists to read *Art World News* and *Art Trends*. The world wide web is very important (like a gallery online)."

PORTAL PUBLICATIONS, LTD., 201 Alameda del Prado, Suite 200, Novato CA 94949. (415)884-6200. **Vice President, Publishing:** Pamela Prince. Estab. 1954. Poster company and art publisher. Publishes art prints, posters, blank and greeted cards, stationery and calendars.
 • See listing in Greeting Cards, Gifts & Products section.

PORTER DESIGN—EDITIONS PORTER, The Old Estate Yard, Newton St. Loe, Bath, Somerset BA2 9BR, England. (01144)1225-874250. Fax: (01144)1225-874251. E-mail: Mary@porter-design.com. Website: www.porter-design.com. US Address: 38 Anacapa St., Santa Barbara CA 93101. (805)568-5433. (805)568-5435. **Partners:** Henry Porter, Mary Porter. Estab. 1985. Publishes limited and unlimited editions and offset productions and hand-colored reproductions. Clients: international distributors, interior designers and hotel contract art suppliers. Current clients include Devon Editions, Top Art, Harrods and Bruce McGaw.

Needs: Seeking fashionable and decorative art for the designer market. Considers watercolor. Prefers 16th-19th century traditional styles. Artists represented include Victor Postolle, Joseph Hooker and Adrien Chancel. Editions created by working from an existing painting. Approached by 10 artists/year. Publishes and distributes the work of 10-20 established artists/year.

First Contact & Terms: Send query letter with brochure showing art style or résumé and photographs. Accepts disk submissions compatible with QuarkXPress on Mac. Samples are filed or are returned. Responds only if interested. To show portfolio, mail photographs. Pays flat fee or royalties. Offers an advance when appropriate. Negotiates rights purchased.

PORTFOLIO GRAPHICS, INC., P.O. Box 17437, Salt Lake City UT 84117. (801)266-4844. E-mail: info@portfoliographics.com. Website: www.nygs.com. **Creative Directors:** Kent Barton and Ray Morrison. Estab. 1986. Publishes and distributes unlimited editions and posters. Clients: galleries, designers, poster distributors (worldwide) and framers. Licensing: All artwork is available for license for large variety of products. Portfolio Graphics works with a large licensing firm who represents all of their imagery.

Needs: Seeking creative, fashionable and decorative art for commercial and designer markets. Considers oil, watercolor, acrylic, pastel, mixed media and photography. Publishes 80-100 new works/year. Editions created by working from an existing painting or transparency.

First Contact & Terms: Send query letter with résumé, biography, slides and photographs. Samples are not filed. Responds in 3 months. To show portfolio, mail slides, transparencies, tearsheets, and photographs with SASE. (Material will not be returned without an enclosed SASE.) Pays royalties of 10%. Provides promotion and a written contract.

Tips: "We find artists through galleries, magazines, art exhibits, submissions. We're looking for a variety of artists and styles/subjects."

POSNER FINE ART, 13234 Fiji Way, Suite G, Marina Del Rey CA 90292. (310)318-8622. Fax: (310)578-8501. E-mail: posart1@aol.net. Website: posnergallery.com. **Director:** Judith Posner. Associate Director: Roberta Kerr. Estab. 1994. Art distributor and gallery. Distributes fine art prints, monoprints, sculpture and paintings. Clients: galleries, frame shops, distributors, architects, corporate curators, museum shops. Current clients include: Renaissance Hollywood Hotel, Adler Realty, Royal Specialty.

Needs: Seeking creative art for the serious collector and commercial market. Considers oil, acrylic, watercolor, mixed media, sculpture. Prefers very contemporary style. Artists represented include Robert Indiana, Greg Gummersall and Susan Veneable. Editions created by collaborating with the artist. Approached by hundreds of artists/year. Distributes the work of 5-10 emerging, 5 mid-career and 200 established artists/year. Art guidelines free for SASE with first-class postage.

First Contact & Terms: Send slides. "Must enclose self-addressed stamped return envelope." Samples are filed or returned. Responds in a few weeks. Pays on consignment basis: firm receives 50% commission.

Buys one-time rights. Provides advertising, promotion, insurance while work is at firm. Finds artists through art fairs, word of mouth, submissions, attending exhibitions, art reps.

Tips: "Know color trends of design market. Look for dealer with same style in gallery." Send consistent work.

POSTER PORTERS, P.O. Box 9241, Seattle WA 98109-9241. (206)286-0818. Fax: (206)286-0820. E-mail: posterporters@compuserve.com. Website: www.posterporters.com. **Marketing Director:** Mark Simard. Art rep/publisher/distributor/gift wholesaler. Publishes/distributes limited and unlimited edition, posters and art T-shirts. Clients: galleries, decorators, frame shops, distributors, corporate curators, museum shops, giftshops. Current clients include: Prints Plus, W.H. Smith, Smithsonian, Nordstrom.

Needs: Publishes/distributes creative art for regional commercial and designer markets. Considers oil, watercolor, pastel. Prefers regional, art. Artists represented include Beth Logan, Carolin Oltman, Jean Casterline, M.J. Johnson. Art guidelines free for SASE with first-class postage. Editions created by collaborating with the artist, working from an existing painting. Approached by 144 artists/year. Publishes the work of 2 emerging, 2 mid-career and 1 established artist/year. or Distributes the work of 50 emerging, 25 mid-career, 20 established artists/year.

First Contact & Terms: Send photocopies, SASE, tearsheets. Accepts disk submissions. Samples are filed or returned by SASE. Will contact artist for Friday portfolio drop off. Pays flat fee: $225-500; royalties of 5%. Offers advance when appropriate. Buys all rights. Provides advertising, promotion, contract. Also works with freelance designers. Prefers local designers only. Finds artists through exhibition, art fairs, art reps, submissions.

Tips: "Be aware of what is going on in the interior design sector. Be able to take criticism. Be more flexible."

POSTERS INTERNATIONAL, 1200 Castlefield Ave., Toronto, ON M6B 1G2 Canada. (416)789-7156. Fax: (416)789-7159. E-mail: karen@postersinternational.net. Website: www.postersinternational.net. **President:** Esther Cohen. Artist submissions to: Creative Director Karen McElroy. Licensing: Richie Cohen. Estab. 1976. Poster company, art publisher. Publishes fine art posters. Licenses for gift and stationery markets. Clients: galleries, decorators, distributors, hotels, restaurants etc., in U.S., Canada and International. Current clients include: Holiday Inn and Bank of Nova Scotia.

Needs: Seeking creative, fashionable art for the commercial market. Considers oil, acrylic, watercolor, mixed media, b&w and color photography. Prefers landscapes, florals, abstracts, photography, vintage, collage and tropical imagery. Artists represented include Patricia George, Scott Steele and Shojaei. Editions created by collaborating with the artist or by working from an existing painting. Approached by 100 artists/year. Art guidelines free for SASE with first-class postage or IRC.

First Contact & Terms: Send query letter with brochure, photographs, slides, transparencies. "No originals please!" Samples are filed or returned by SASE. Responds in 2 months. Company will contact artist for portfolio review of photographs, photostats, slides, tearsheets, thumbnails, transparencies if interested. Pays flat fee or royalties of 10%. Offers advance when appropriate. Rights purchased vary according to project. Provides advertising, promotion, shipping from firm, written contract. Finds artists through art fairs, art reps, submissions.

Tips: "Be aware of current color trends and always work in a series of two or more. Visit poster shops to see what's popular before submitting artwork."

PRESTIGE ART INC., 3909 W. Howard St., Skokie IL 60076. (847)679-2555. E-mail: prestige@prestige art.com. Website: www.prestigeart.com. **President:** Louis Schutz. Estab. 1960. Publisher/distributor/art gallery. Represents a combination of 18th and 19th century work and contemporary material. Publishes and distributes handpulled originals, limited and unlimited editions, canvas transfers, fine art prints, offset reproductions, posters, sculpture. Licenses artwork for note cards, puzzles, album covers and posters. Clients: galleries, decorators, architects, corporate curators.

 ● Company president Louis Shutz does consultation for new artists on publishing and licensing their art in various media.

Needs: Seeking creative and decorative art. Considers oil, acrylic, mixed media, sculpture, glass. Prefers figurative art, impressionism, surrealism/fantasy, photo realism. Artists represented include Jean-Paul Avisse. Editions created by collaborating with the artist or by working from an existing painting. Approached by 15 artists/year. Publishes the work of 2 emerging artists/year. Distributes the work of 5 emerging artists/year.

First Contact & Terms: Send query letter with résumé and tearsheets, photostats, slides, photographs

and transparencies. Accepts IBM compatible disk submissions. Samples are not filed and are returned by SASE. Responds only if interested. Company will contact artist for portfolio review of tearsheets if interested. Pays flat fee. Offers an advance when appropriate. Rights purchased vary according to project. Provides insurance in-transit and while work is at firm, advertising, promotion, shipping from firm and written contract.

Tips: "Be professional. People are seeking better quality, lower-sized editions, fewer numbers per edition—1/100 instead of 1/750."

PRIME ART PRODUCTS, 5772 N. Ocean Shore Blvd., Palm Coast FL 32137. Phone/fax: (386)445-6057. **Owner:** Dee Abraham. Estab. 1990. Art publisher, distributor. Publishes/distributes limited editions, unlimited editions, fine art prints, offset reproductions. Clients include: galleries, specialty giftshops, interior design and home accessory stores.

Needs: Seeking art for the commercial and designer markets. Considers oil, acrylic, watercolor. Prefers realistic shore birds and beach scenes. Artists represented include Robert Binks, James Harris, Keith Martin Johns, Christi Mathews, Art LaMay and Barbara Klein Craig. Editions created by collaborating with the artist or by working from an existing painting. Approached by 30 artists/year. Publishes the work of 1-2 emerging artists/year. Distributes the work of many emerging and 4 established artists/year.

First Contact & Terms: Send photographs, SASE and tearsheets. Samples are filed or returned by SASE. Responds in 5 days. Company will contact artist for portfolio review if interested. Negotiates payment per signature. Offers advance when appropriate. Rights purchased vary according to project. Finds artists through submissions and small art shows.

THE PRINTS AND THE PAPER, 106 Walnut St., Montclair NJ 07042. (973)746-6800. Fax: (973)746-6801. Estab. 1996. Distributor of handpulled originals, limited and unlimited edition antiques and reproduced illustration, prints, hand colored etchings and offset reproduction. Clients: galleries, decorators, frame shops, giftshops.

Needs: Seeking reproductions of decorative art. Considers watercolor, pen & ink. Prefers illustration geared toward children; also florals. Artists represented include Helga Hislop, Raymond Hughes, Dorothy Wheeler, Arthur Rackham, Richard Doyle.

First Contact & Terms: Send query letter with SASE, slides. Samples are filed or returned by SASE. Will contact artist for portfolio review of slides if interested. Negotiates payment. Rights purchased vary according to project. Finds artists through art exhibitions, word of mouth.

Tips: "We are a young company (8 years). We have not established all guidelines. We are attempting to establish a reputation for having quality illustration which covers a broad range."

PROGRESSIVE EDITIONS, 37 Sherbourne St., Toronto, ON M5A 2P6 Canada. (416)860-0983. Fax: (416)367-2724. E-mail: info@progressiveeditions.com. Website: www.progressiveeditions.com. **President:** Mike Havers. General Manager: Tom Shacklady. Estab. 1982. Art publisher. Publishes handpulled originals, limited edition fine art prints and monoprints. Clients: galleries, decorators, frame shops, distributors.

Needs: Seeking creative and decorative art for the serious collector and designer market. Considers oil, acrylic, watercolor, mixed media, pastel. Prefers figurative, abstract, landscape and still lifes. Artists represented include Emilija Pasagic, Doug Edwards, Marsha Hammel. Editions created by working from an existing painting. Approached by 100 artists/year. Publishes the work of 4 emerging artists/year. Distributes the work of 10 emerging artists/year.

First Contact & Terms: Send query letter with photographs, slides. Samples are not filed and are returned. Responds in 1 month. Will contact artist for portfolio review if interested. Negotiates payment. Offers advance when appropriate. Negotiates rights purchased. Requires exclusive representation of artist. Provides advertising, in-transit insurance, insurance while work is at firm, promotion, shipping and contract. Finds artists through exhibition, art fairs, word of mouth, art reps, sourcebooks, submissions, competitions.

Tips: "Develop organizational skills."

RIGHTS INTERNATIONAL GROUP, 463 First St., #3C, Hoboken NJ 07030. (201)239-8118. Fax: (201)222-0694. E-mail: info@rightsinternational.com. Website: www.rightsinternational.com. **Contact:** Robert Hazaga. Estab. 1996. Agency for cross licensing. Represents artists for licensing into publishing, stationery, posters, prints, calendars, giftware, home furnishing. Clients: giftware, stationery, posters, prints, calendars, wallcoverings and home decor publishers.

● This company is also listed in the Greeting Card, Gifts & Products section.

Needs: Seeking creative, decorative art for the commercial and designer markets. Also looking for country/Americana with a new fresh interpretation of country with more of a cottage influence. Think Martha Stewrat, *Country Living* magazine; globaly-inspired artwork. Considers all media. Prefers commercial style. Artists represented include Forest Michaels, Susan Hayes and Susan Osborne. Approached by 50 artists/year.

First Contact & Terms: Send brochure, photocopies, photographs, SASE, slides, tearsheets, transparencies, jpgs, CD-ROM. Accepts disk submissions compatible with PC Platform. Samples are not filed and are returned by SASE. Responds in 2 weeks. Company will contact artist for portfolio review if interested. Negotiates payment.

Tips: "Check our website for trend, color and style forecasts!"

RINEHART FINE ARTS, INC., a member of Bentley Publishing Group, 250 W. 57th St., Suite 2202A, New York NY 10107. (212)399-8958. Fax: (212)399-8964. E-mail: hwrinehart@aol.com. Website: www.bentleypublishinggroup.com. Poster publisher. President: Harriet Rinehart. Licenses 2D artwork for posters. Clients include galleries, decorators, frame shops, corporate curators, museum shops, gift shops and substantial overseas distribution.

Needs: Seeking creative, fashionable and decorative art. Considers oil, acrylic, watercolor, mixed media, pastel and pen & ink. Artists represented include Howard Behrens, Thomas McKnight, Tadashi Asoma, André Bourrié. Editions created by collaborating with the artist or working from an existing painting. Approached by 30-40 artists/year. Publishes the work of 10 emerging artists/year.

First Contact & Terms: Send query letter with photographs, SASE, slides, tearsheets, transparencies or "whatever the artist has which represents artist." Samples are not filed. Responds in 3 months. Portfolio review not required. Pays royalties of 8-10%. Rights purchased vary according to project. Provides advertising, promotion, written contract and substantial overseas exposure.

Tips: "Read *Home Furnishings News*. Work in a series. Attend trade shows."

N SALEM GRAPHICS, INC., P.O. Box 15134, Winston-Salem NC 27113. (910)727-0659. **Contact:** Blades Elliott, vice president. Estab. 1981. Art publisher/distributor. Publishes/distributes canvas transfers, fine art prints, hand-pulled originals, limited edition, offset reproduction, unlimited edition.

Needs: Seeking decorative art for the serious collector, commercial and designer markets. Prefers landscapes, seascapes, coastal scenes and florals. Artists represented include Phillip Philbeck, Amy Youngblood, Larry Burge.

First Contact & Terms: Send query letter with slides or photographs and SASE. Publisher will contact for portfolio review if interested. Buys reprint rights. Requires exclusive representation of artist. Provides advertising, in-transit insurance and insurance while work is at firm, promotion and written contract.

☑ SCAFA ART PUBLISHING CO. INC., 276 Fifth Ave., Suite 205, New York NY 10001. Website: www.scafaart.com. **Art Coordinator and licensing:** Elaine Citron. Produces open edition offset reproductions. Clients: framers, commercial art trade and manufacturers worldwide. Licenses florals, still lifes, landscapes, animals, religious, etc. for placemats, puzzles, textiles, furniture, cassette/CD covers.

Needs: Seeking decorative art for the wall decor market. Considers unframed decorative paintings, posters, photos and drawings. Prefers pairs and series. Artists represented include T.C. Chiu, Jack Sorenson, Kay Lamb Shannon and Marianne Caroselli. Editions created by collaborating with the artist and by working from a pre-determined subject. Approached by 100 artists/year. Publishes and distributes the work of dozens of artists/year. "We work constantly with our established artists, but are always on the lookout for something new."

First Contact & Terms: Send query letter first with slides or photos and SASE. Responds in about 1 month. Pays $200-350 flat fee for some accepted pieces. Royalty arrangements with advance against 5-10% royalty is standard. Buys only reproduction rights. Provides written contract. Artist maintains ownership of original art. Requires exclusive publication rights to all accepted work.

Tips: "Do not limit your submission. We are interested in seeing your full potential. Please be patient. All inquiries will be answered."

SCHIFTAN INC., 1300 Steel Rd. W, Suite 4, Morrisville PA 19067. (215)428-2900 or (800)255-5004. Fax: (215)295-2345. E-mail: schiftan@erols.com. Website: www.schiftan.com. **President:** Harvey S. Cohen. Estab. 1903. Art publisher, distributor. Publishes/distributes unlimited editions, fine art prints, offset reproductions, posters and hand-colored prints. Clients: galleries, decorators, frame shops, architects, wholesale framers to the furniture industry.

Needs: Seeking fashionable, decorative art for the commercial market. Considers watercolor, mixed media. Prefers traditional, landscapes, botanicals, wildlife, Victorian. Editions created by collaborating with the artist. Approached by 15-20 artists/year. Also needs freelancers for design.

First Contact & Terms: Send query letter with transparencies. Samples are not filed and are returned. Responds in 1 week. Company will contact artist for portfolio review of final art, roughs, transparencies if interested. Pays flat fee or royalties. Offers advance when appropriate. Negotiates rights purchased. Provides advertising, written contract. Finds artists through art exhibitions, art fairs, submissions.

SCHLUMBERGER GALLERY, P.O. Box 2864, Santa Rosa CA 95405. (707)544-8356. Fax: (707)538-1953. E-mail: sande@schlumberger.org. **Owner:** Sande Schlumberger. Estab. 1986. Art publisher, distributor and gallery. Publishes and distributes limited editions, posters, original paintings and sculpture. Clients: collectors, designers, distributors, museums, galleries, film and television set designers. Current clients include: Bank of America Collection, Fairmont Hotel, Editions Ltd., Sonoma Cutter Vineyards, Dr. Robert Jarvis Collection and Sparks Collection.

Needs: Seeking decorative art for the serious collector and the designer market. Prefers trompe l'oeil, realist, architectural, figure, portrait. Artists represented include Charles Giulioli, Deborah Deichler, Susan Van Camden, Aurore Carnero, Borislav Satijnac, Robert Hughes, Fletcher Smith and Tom Palmore. Editions created by collaborating with the artist or by working from an existing painting. Approached by 50 artists/year.

First Contact & Terms: Send query letter with tearsheets and photographs. Samples are not filed and are returned by SASE if requested by artist. Publisher/Distributor will contact artist for portfolio review if interested. Portfolio should include color photographs and transparencies. Negotiates payment. Offers advance when appropriate. Rights purchased vary according to project. Provides advertising, in-transit insurance, insurance while work is at firm, promotion, shipping to and from firm, written contract and shows. Finds artists through exhibits, referrals, submissions and "pure blind luck."

Tips: "Strive for quality, clarity, clean lines and light, even if the style is impressionistic. Bring spirit into your images. It translates!"

ROSE SELAVY OF VERMONT, Division of Applejack Art Partners, P.O. Box 1528, Historic Rt. 7A, Manchester Center VT 05255. (802)362-0373. Fax: (802)362-1082. E-mail: michael@applejackart.com. Website: www.applejackart.com. Publishes/distributes unlimited edition fine art prints. Clients: galleries, decorators, frame shops, distributors, architects, corporate curators, museum shops and giftshops.

Needs: Seeking decorative art for the serious collector, commercial and designer markets. Considers oil, acrylic, watercolor, mixed media, pastel and pen & ink. Prefers folk art, antique, traditional and Botanical. Artists represented include Susan Clickner and Valorie Evers Wenk. Editions created by collaborating with the artist or by working from an existing painting.

First Contact & Terms: Send query letter with brochure, photocopies, photographs, slides and tearsheets. Samples are not filed and are returned by SASE. Responds only if interested. Company will contact artist for portfolio review if interested. Negotiates payment. Offers advance when appropriate. Rights purchased vary according to project. Usually requires exclusive representation of artist. Provides promotion and written contract. Also needs freelancers for design. Finds artists through art exhibitions and art fairs.

SIDE ROADS PUBLICATIONS, 177 NE 39th St., Miami FL 33137. (305)438-8828. Fax: (305)576-0551. E-mail: sideropub@aol.com. Website: www.sideroadspub.com. Estab. 1998. Art publisher and distributor of originals and handpulled limited edition serigraphs. Clients: galleries, decorators and frame shops.

Needs: Seeking creative art for the commercial market. Considers oil, acrylic, mixed media and sculpture. Open to all themes and styles. Artists represented include Clemens Briels. Editions created by working from an existing painting.

First Contact & Terms: Send query letter with brochure, photographs, résumé, slides and SASE. Samples are filed or returned by SASE. Company will contact artist for portfolio review if interested. Payment on consignment basis. Rights purchased vary according to project. Requires exclusive representation of artist. Provides advertising and promotion. Finds artists through art exhibitions and artists' submissions.

N SIGNATURE SERIES BY ANGEL GRAPHICS, 903 W. Broadway, P.O. Box 530, Fairfield IA 52556. (515)472-5481. Fax: (515)472-7353. E-mail: sales@angelgraphics.net. Website: www.angelgraphic sinc.com. **Project Manager:** Sheryll Ryan. Estab. 1996. Art publisher. Publishes fine art prints. Clients include ABC, LTD, National Wildlife.

Needs: Needs all types of currently popular subjects. Artists represented include Roger Bock, Gail Rain. Art guidelines available for SASE with first-class postage. Best trends include "den art" (golf, sports etc.), Hispanic subjects (churches, slice of life); African-American (especially religious content and leisure); gardens, florals, fruit; whimsical folk art; tropical, nostalgic. Needs high quality, detailed art work, both realistic and stylized. Uses 100-150 new images/year. "We follow trends in the art world."
First Contact & Terms: Send photographs, SASE and duplicate slides. Do not send originals. E-mail images or provide your web address. Pays flat fee or royalties. Competitive pricing and terms.
Tips: "Include expected contract terms in cover letter. Send $3 for current catalog or $10 for catalog and 22×28 print sample."

SIPAN LLC, 300 Glenwood Ave., Raleigh NC 27603. Phone/fax: (919)833-2535. **Member:** Owen Walker III. Estab. 1994. Art publisher. Publishes handpulled originals. Clients: galleries and frame shops.
Needs: Seeking art for the serious collector and the commercial market. Considers oil, acrylic, watercolor. Prefers traditional themes. Artists represented include Altino Villasante. Editions created by collaborating with the artist. Approached by 5 artists/year. Publishes/distributes the work of 1 emerging artist/year.
First Contact & Terms: Send photographs, SASE and transparencies. Samples are not filed and are returned by SASE. Responds in 2 weeks. Company will contact artist for portfolio review of color final art if interested. Negotiates payment. Offers advance when appropriate. Buys all rights. Requires exclusive representation of artist. Provides advertising, in-transit insurance, insurance while work is at firm, promotion, written contract.

🌐 **SJATIN PUBLISHING & LICENSING B.V.**, (formerly Sjatin BV), P.O. Box 4028, 5950 AA Belfeld/Holland. 31 77 475 1965. Fax: 31774 475 1965. E-mail: art@sjatin.nl. Website: www.sjatin.nl. **President:** Inge Colbers. Estab. 1977. Art publisher. Publishes handpulled originals, limited editions, fine art prints. Licenses romantic art to appear on placemats, notecards, stationery, photo albums, posters, puzzles and gifts. Clients: furniture stores, department stores. Current clients include: Karstadt (Germany), Prints Plus (USA).
 • Sjatin actively promotes worldwide distribution for artists they sign.
Needs: Seeking decorative art for the commercial market. Considers oil, acrylic, watercolor, mixed media, pastel. Prefers romantic themes, florals, landscapes/garden scenes, women. Artists represented include Willem Haenraets, Peter Motz, Reint Withaar. Editions created by collaborating with the artist or by working from an existing painting. Approached by 50 artists/year. "We work with 20 artists only, but publish a very wide range from cards to oversized prints and we sell copyrights."
First Contact & Terms: Send brochure and photographs. Responds only if interested. Company will contact artist for portfolio review of color photographs (slides) if interested. Negotiates payment. Offers advance when appropriate. Buys all rights. Provides advertising, promotion, shipping from firm and written contract (if requested).
Tips: "Follow the trends in interior decoration; look at the furniture and colors. I receive so many artworks that are beautiful and very artistic, but are not commercial enough for reproduction. I need designs which appeal to many many people, worldwide such as flowers, gardens, interiors and kitchen scenes. I do not wish to receive graphic art. Artists entering the poster/print field should attend the I.S.F. Show in Birmingham, Great Britain or the ABC show in Atlanta."

SOHO GRAPHIC ARTS WORKSHOP, 433 W. Broadway, Suite 5, New York NY 10012. (212)966-7292. **Director:** Xavier H. Rivera. Estab. 1977. Art publisher, distributor and gallery. Publishes and distributes limited editions.
Needs: Seeking art for the serious collector. Considers prints. Editions created by collaborating with the artist or working from an existing painting. Approached by 10-15 artists/year.
First Contact & Terms: Send résumé. Responds in 2 weeks. Artist should follow-up with letter after initial query. Portfolio should include slides and 35mm transparencies. Negotiates payment. No advance. Buys first rights. Provides written contract.

🌐 **JACQUES SOUSSANA GRAPHICS**, 37 Pierre Koenig St., Jerusalem 91041 Israel. Phone: 972-2-6782678. Fax: 972-2-6782426. E-mail: jsgraphics@soussanart.com. Website: www.soussanart.com. Estab. 1973. Art publisher. Publishes handpulled originals, limited editions, sculpture. Clients: galleries, decorators, frame shops, distributors, architects. Current clients include: Royal Beach Hotel, Moriah Gallery, London Contemporary Art.
Needs: Seeking decorative art for the serious collector and designer market. Considers oil, watercolor

and sculpture. Artists represented include Zina Roitman, Nachum Gutman and Moshe Castel. Editions created by collaborating with the artist. Approached by 20 artists/year. Publishes/distributes the work of 5 emerging artists/year.

First Contact & Terms: Send query letter with brochure, slides. To show portfolio, artist should follow up with letter after initial query. Portfolio should include color photographs.

SPORT'EN ART, R.R. #3, Box 17, Sullivan IL 61951-1058. (217)797-6770. Fax: (217)797-6482. E-mail: sportart@moultrie.com. Large publisher/distributor of limited edition prints and posters featuring outdoor wildlife spsorts (i.e. hunting and fishing) images. **Contact:** Dan Harshman.

First Contact & Terms: Send query letter with slides and SASE. Publisher will contact for portfolio review if interested.

SPORTS ART INC, Dept. AM, N. 1675 Powers Lake Rd., Powers Lake WI 53159. (800)552-4430. Fax: (262)279-9830. E-mail: ggg-golfgifts@elknet.net. Website: www.golfgiftsandart.com. **President:** Dean Chudy. Estab. 1989. Art publisher and distributor of limited and unlimited editions, offset reproductions and posters. Clients: over 2,000 active art galleries, frame shops and specialty markets.

Needs: Seeking artwork with creative artistic expression for the serious collector and the designer market. Considers oil, watercolor, acrylic, pastel, pen & ink and mixed media. Prefers sports themes. Artists represented include Ken Call and Brent Hayes. Editions created by collaborating with the artist or working from an existing painting. Approached by 150 artists/year. Distributes the work of 30 emerging, 60 mid-career and 30 established artists/year.

First Contact & Terms: Send query letter with brochure showing art style or résumé, tearsheets, SASE, slides and photographs. Accepts submissions on disk. Samples are filed or returned by SASE if requested by artist. To show a portfolio, mail thumbnails, slides and photographs. Pays royalties of 10%. Offers an advance when appropriate. Negotiates rights purchased. Sometimes requires exclusive representation of the artist. Provides promotion and shipping from firm.

Tips: "We are interested in generic sports art that captures the essence of the sport as opposed to specific personalities."

SULIER ART PUBLISHING AND DESIGN RESOURCE NETWORK, 111 Conn Terrace, Lexington KY 40508-3205. (859)223-3272. Fax: (859)296-0650. E-mail: info@NeilSulier.com. Website: www.Homeplaceproducts.com. Estab. 1969. **Art Director:** Neil Sulier. Art publisher and distributor. Publishes and distributes handpulled originals, limited and unlimited editions, posters, offset reproductions and originals. Clients: designers.

Needs: Seeking creative, fashionable and decorative art for the serious collector and the commercial and designer markets. Considers oil, watercolor, mixed media, pastel and acrylic. Prefers impressionist. Artists represented include Judith Webb, Neil Sulier, Eva Macie, Neil Davidson, William Zappone, Zoltan Szabo, Henry Faulconer, Mariana McDonald. Editions created by collaborating with the artist or by working from an existing painting. Approached by 20 artists/year. Publishes the work of 5 emerging, 30 mid-career and 6 established artists/year. Distributes the work of 5 emerging artists/year.

First Contact & Terms: Send query letter with brochure, slides, photocopies, résumé, photostats, transparencies, tearsheets and photographs. Samples are filed or are returned. Responds only if interested. Request portfolio review in original query. Artist should follow up with call. Publisher will contact artist for portfolio review if interested. Portfolio should include slides, tearsheets, final art and photographs. Pays royalties of 10%, on consignment basis or negotiates payment. Offers advance when appropriate. Negotiates rights purchased (usually one-time or all rights). Provides in-transit insurance, promotion, shipping to and from firm, insurance while work is at firm and written contract.

SUN DANCE GRAPHICS & NORTHWEST PUBLISHING, 9580 Delegates Dr., Orlando FL 32837. (407)240-1091. Fax: (407)240-1951. E-mail: sales@northwestpublishing.com and sales@sundance graphics.com. Website: northwestpublishing.com. **Art Director:** Kathy Anish. Estab. 1996. Publishes art prints.

Needs: Approached by 300 freelancers/year. Works with 50 freelancers/year. Buys 200 freelance designs and illustrations/year. Art guidelines free for SASE with first-class postage. Works on assignment only. Looking for high-end art. 20% of freelance design work demands knowledge of Photoshop, Illustrator and QuarkXPress.

First Contact & Terms: Designers send brochure photocopies, photographs, photostats, tearsheets and SASE. "No original art please." Samples are filed or returned by SASE. Responds in 6 weeks. Company

will contact artists for portfolio review if interested. Portfolio should include color final art, slides, tearsheets and transparencies. Rights purchased vary according to project. Pays "either royalties or a flat fee. The artist may choose." Finds freelancers through SURTEX, word of mouth and art societies.
Tips: "Read the trade magazines, *GSB*, *G&D*, *GN*, *Decor* and *Greetings Today*."

SYRACUSE CULTURAL WORKERS, P.O. Box 6367, Syracuse NY 13217. (315)474-1132. Fax (315)475-1277. E-mail: scwart@dreamscape.com. Website: www.syrculturalworkers.org. **Art Director:** Karen Kerney. Produces posters, notecards, postcards, greeting cards, T-shirts and calendars that are feminist, multicultural, lesbian/gay allied, racially inclusive and honor elders and children.
Needs: Art guidelines free for SASE with first-class postage and also available on company's website.
First Contact & Terms: Pays flat fee, $85-400; royalties of 6% of gross sales.

JOHN SZOKE EDITIONS, 591 Broadway, 3rd Floor, New York NY 10012-3232. (212)219-8300. Fax: (212)966-3064. E-mail: info@johnszokeeditions.com. Website: www.johnszokeeditions.com or www.jame srizzi.com. **Director:** John Szoke. Produces limited edition handpulled originals for galleries, museums and private collectors. Deals with modern masters Picasso, Chagall . . . and contemporary artists Rauschenberg, Chuck Close, Louise Bourgeois, Frankenthaler . . .
 • This prestigious publisher works with many of the biggest names in contemporary art. He is constantly offering new editions, but is not considering new artists at the present time. See his website for a look at limited edition prints by well-known artists.
Needs: Artists represented include James Rizzi, Janet Fish, Peter Milton, Richard Haas and others.

 TELE GRAPHICS, 153 E. Lake Brantley Dr., Longwood FL 32779. **President:** Ron Rybak. Art publisher/distributor handling original mixed media and handpulled originals. Clients: galleries, picture framers, interior designers and regional distributors.
Needs: Seeking decorative art for the serious collector. Artists represented include Beverly Crawford, Diane Lacom, Joy Broe and W.E. Coombs. Editions created by collaborating with the artist or by working from an existing painting. Approached by 30-40 artists/year. Publishes the work of 1-4 emerging artists/year.
First Contact & Terms: Send query letter with résumé and samples. Samples are not filed and are returned only if requested. Responds in 1 month. Call or write for appointment to show portfolio of original/final art. Pays by the project. Considers skill and experience of artist and rights purchased when establishing payment. Offers advance. Negotiates rights purchased. Requires exclusive representation. Provide promotions, shipping from firm and written contract.
Tips: "Be prepared to show as many varied examples of work as possible. Show transparencies or slides plus photographs in a consistent style. We are not interested in seeing only one or two pieces."

BRUCE TELEKY INC., 625 Broadway, 4th Floor, New York, NY 10012. (800)835-3539 or (212)677-2559. Fax: (212)677-2253. Publisher/Distributor. **President:** Bruce Teleky. Clients include galleries, manufacturers and other distributors.
Needs: Works from existing art to create open edition posters or works with artist to create limited editions. Artists represented include Romare Bearden, Faith Ringgold, Joseph Reboli. Prefers depictions of African-American, Carribean scenes or African themes.
First Contact & Terms: Send query letter with slides, transparencies, postcard or other appropriate samples and SASE. Publisher will contact artist for portfolio review if interested. Payment negotiable.

ULTIMATE LITHO, 42 Leome Lane, Chester NY 10918. (875)469-6699. E-mail: info@ultimatelitho .com. Website: www.ultimatelitho.com. **Contact:** Ray Greenberg, owner. Estab. 1995. Art publisher. Pub-

lishes and/or distributes fine art prints, offset reproduction, posters and unlimited edition. Clients: distributors.

Needs: Seeking decorative art for the commercial and designer markets; figurative art for wall decor. Considers acrylic, mixed media, oil, pastel, watercolor. Artists represented include Jason DeLancey, Shelley Jackson, Laura Lotusco. Approached by 150 artists/year. Publishes work of 3-5 emerging artists/year.

First Contact & Terms: Send query letter with brochure, photocopies, photographs, résumé, SASE, slides, tearsheets, transparencies. Samples are returned by SASE. Responds only if interested. Company will contact artist for portfolio review if interested. Portfolio should include color photographs, slides, tearsheets, transparencies, any good representation of the broadest range of styles and subjects the artist has done. Pays flat fee or advance against royalties. Offers advance when appropriate. Rights purchased vary according to project. Provides advertising, insurance while work is at firm, promotion, shipping from our firm, written contract. Finds artists through art exhibits/fairs, art reps, artist's submissions, Internet, word-of-mouth.

UMOJA FINE ARTS, 16250 Northland Dr., Suite 104, Southfield MI 48075. (800)469-8701. Fax: (248)552-0035. E-mail: info@umojafinearts.com. Website: www.umojafinearts.com. Estab. 1995. Art publisher and distributor specializing in African-American posters, graphics, painting and sculpture. **President:** Ian Grant.

Needs: Seeking fine art and decorative images and sculpture for the serious collector as well as the commercial market. Artists include Lazarus Bain, Jeff Clark, Joe Dobbins, Marcus Glenn, David Haygood, Annie Lee, Jimi Claybrooks, Joe Dobbins Sr., Ivan Stewart. Editions created by collaborating with the artist. Approached by 40-50 artists/year. Publishes the work of 1-2 emerging, 1-2 mid-career and 1 established artists/year. Distributes the work of 2-3 emerging, 2-3 mid-career and 2 established artists/year.

First Contact & Terms: Send query letter with slides and SASE. Samples are filed. Responds only if interested in 1 month. Publisher will contact for portfolio review if interested. Buys all rights. Requires exclusive representation of artist. Provides advertising, insurance while work is at firm and written contract.

WANDA WALLACE ASSOCIATES, 323 E. Plymouth, Suite #2, Inglewood CA 90306-0436. (310)419-0376. Fax: (310)419-0382. Website: www.wandawallace.com. **President:** Wanda Wallace. Estab. 1980. Art publisher, distributor, gallery and consultant for corporations, businesses and residential. Publishes handpulled originals, limited and unlimited editions, canvas transfers, fine art prints, monotypes, posters and sculpture. Clients: decorators, galleries, distributors.

• This company operates a nonprofit organization called Wanda Wallace Foundation that educates children through utilizing art and creative focus.

Needs: Seeking art by and depicting African-Americans. Considers oil, acrylic, watercolor, mixed media, pastel, pen & ink and sculpture. Prefers traditional, modern and abstract styles. Artists represented include Alex Beaujour, Dexter, Aziz, Momogu Ceesay, Charles Bibbs, Betty Biggs, Tina Allen, Adrian Won Shue. Editions created by collaborating with the artist or by working from an existing painting. Approached by 100 artists/year. Publishes/distributes the work of 10 emerging, 7 mid-career and 3 established artists/year.

First Contact & Terms: Send query letter with brochure, photocopies, photographs, tearsheets and transparencies. Samples are filed and are not returned. Responds only if interested. Company will contact artist for portfolio review of color, final art, photographs and transparencies. Pays on consignment basis: firm receives 50% commission or negotiates payment. Offers advance when appropriate. Buys all rights. Requires exclusive representation of artist. Provides advertising, promotion, shipping from firm and written contract.

Tips: "African-American art is very well received. Depictions that sell best are art by black artists. Be creative, it shows in your art. Have no restraints. Educational instruction available."

WHITEGATE FEATURES SYNDICATE, 71 Faunce Dr., Providence RI 02906. (401)274-2149. Website: www.whitegatefeatures.com. **Talent Manager:** Eve Green.

• This syndicate is looking for fine artists and illustrators. See listing in Syndicates section for information on their needs.

First Contact & Terms: "Please send (nonreturnable) slides or photostats of fine arts works. We will call if a project suits your work." Pays royalties of 50% if used to illustrate for newspaper or books.

Tips: "We also work with collectors of fine art and we are starting a division that will represent artists to galleries."

N WILD ART GROUP, 31630 Sierra Verde Rd., Homeland CA 92548. (800)669-1368. Fax: (888)219-2710. E-mail: sales@WildArtGroup.com. Website: www.WildArtGroup.com. Art Publisher/Distributor/

Framer. Publishes lithographs, canvas transfers, serigraphs, giclée printing, digital photography and offset/digital printing.

Needs: Seeking fine art for serious collectors and decorative art for the commercial market. Considers all media. Artists represented include Gamboa, Joan Sanford, Ediciones Selina, Annie Lee, Terry Wilson and Merryl Jaye.

First Contact & Terms: Send query letter with slides, transparencies or other appropriate samples and SASE. Will accept submissions on disk or CD-ROM. Publisher will contact artist for portfolio review if interested.

WILD WINGS LLC, (formerly Wild Wings Inc.), S. Highway 61, Lake City MN 55041. (651)345-5355. Fax: (651)345-2981. Website: www.wildwings.com. **Vice President:** Sara Koller. Estab. 1968. Art publisher, distributor and gallery. Publishes and distributes limited editions and offset reproductions. Clients: retail and wholesale.

Needs: Seeking artwork for the commercial market. Considers oil, watercolor, mixed media, pastel and acrylic. Prefers wildlife. Artists represented include David Maass, Lee Kromschroeder, Ron Van Gilder, Robert Abbett, Michael Sieve and Persis Clayton Weirs. Editions created by working from an existing painting. Approached by 300 artists/year. Publishes the work of 36 artists/year. Distributes the work of numerous emerging artists/year.

First Contact & Terms: Send query letter with slides and résumé. Samples are filed and held for 6 months then returned. Responds in 3 weeks if uninterested or 6 months if interested. Publisher will contact artist for portfolio review if interested. Pays royalties for prints. Accepts original art on consignment and takes 40% commission. No advance. Buys first-rights or reprint rights. Requires exclusive representation of artist. Provides in-transit insurance, promotion, shipping to and from firm, insurance while work is at firm and a written contract.

WINN DEVON ART GROUP, 6015 Sixth Ave. S., Seattle WA 98108. (206)763-9544. Fax: (206)762-1389. **Contact:** Karen Schweitzer, creative director. Estab. 1976. Art publisher. Publishes open and limited editions, offset reproductions, giclees and serigraphs. Clients: mostly trade, designer, decorators, galleries, retail frame shops. Current clients include: Pier 1, Z Gallerie, Intercontinental Art, Chamton International, Bombay Co.

Needs: Seeking decorative art for the designer market. Considers oil, watercolor, mixed media, pastel, pen & ink and acrylic. Artists represented include Buffet, Lourenco, Jardine, Hall, Goerschner, Schaar. Current clients include: Lourenco, Romeu, Shrack, Bernsen/Tunick, Tomao. Editions created by working from an existing painting. Approached by 300-400 artists/year. Publishes and distributes the work of 0-3 emerging, 3-8 mid-career and 8-10 established artists/year.

First Contact & Terms: Send query letter with brochure, slides, photocopies, résumé, photostats, transparencies, tearsheets or photographs. Samples are returned by SASE if requested by artist. Responds in 4-6 weeks. Publisher will contact artist for portfolio review if interested. Portfolio should include "whatever is appropriate to communicate the artist's talents." Pay varies. Rights purchased vary according to project. Provides written contract. Finds artists through attending art exhibitions, agents, sourcebooks, publications, submissions.

Tips: Advises artists to attend Art Expo New York City, ABC Atlanta. "I would advise artists to attend just to see what is selling and being shown, but keep in mind that this is not a good time to approach publishers/exhibitors with your artwork."

Book Publishers

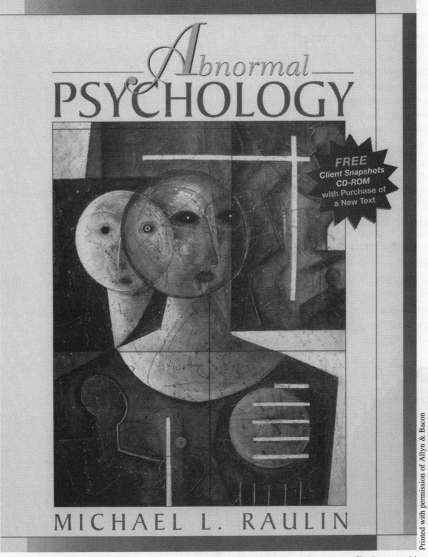

Printed with permission of Allyn & Bacon

Art Director Susan Brown of Allyn and Bacon thought Noma Bliss's acrylic painting *Shadows* would set the perfect tone for a psychology textbook. Bliss's figures are highly psychological and metaphorical: the figures here could represent introspection or relationship issues, depending on what the viewer brings to the artwork. Bliss got this job through researching potential markets in *Artist's & Graphic Designer's Market*. "I sent Allyn and Bacon a postcard with my website and they called me," says Bliss. "The publisher used about seventeen images for opening chapters in the book." To see more of Bliss's intriguing work, visit her website, www.nomaartist.com.

While not as easy to break into as the magazine market, book publishing is an excellent market to specialize in. The artwork you create for book covers must grab readers' attention and make them want to pick up the book. Secondly, it must show at a glance what type of book it is and who it is meant to appeal to. In addition, the cover has to include basic information such as title, the author's name, the publisher's name, blurbs and price.

Book interiors are also important. The page layouts you design direct readers through the text and illustrators create artwork to complement the story. This is particularly important in children's books and textbooks. Many publishing companies hire freelance designers with computer skills to design interiors on a contract basis. Look within each listing for the subheading Book Design to find the number of jobs assigned each year, and how much is paid per project.

Finding your best markets

The first paragraph of each listing describes the types of books each publisher specializes in. This may seem obvious, but submit only to publishers who specialize in the type of book you want to illustrate or design. There's no use submitting to a publisher of literary fiction if you want to illustrate for children's picture books.

The publishers in this section are just the tip of the iceberg. You can find additional publishers by visiting bookstores and libraries and looking at covers and interior art. When you find covers you admire, write down the name of the books' publishers in a notebook. If the publisher is not listed in *Artist's & Graphic Designer's Market*, go to your public library and ask to look at a copy of *Literary Market Place*, also called *LMP*, published annually by Information Today, Inc. The cost of this large directory is prohibitive to most freelancers, but you should become familiar with it if you plan to work in the industry. Though it won't tell you how to submit to each publisher, it does give art directors' names.

How to submit

Send one to five nonreturnable samples along with a brief letter. Never send originals. Most art directors prefer samples 8½×11 or smaller that can fit in file drawers. Bulky submissions are considered a nuisance. After sending your initial introductory mailing, you should follow-up with postcard samples every few months to keep your name in front of art directors. If you have an e-mail account and can send TIFF or JPEG files, check the publishers' preferences and see if they will accept submission via e-mail.

PUBLISHING TERMS TO KNOW

Mass market paperbacks are sold in supermarkets, newsstands, drugstores, etc. They include romance novels, diet books, mysteries and paperbacks by popular authors like Stephen King.
Trade books are the hardcovers and paperbacks found only in bookstores and libraries. The paperbacks are larger than those on the mass market racks. They are printed on higher quality paper, and often feature matte-paper jackets.
Textbooks feature plenty of illustrations, photographs, and charts to explain their subjects.
Small press books are produced by small, independent publishers. Many are literary or scholarly in theme, and often feature fine art on the cover.
Backlist titles or **reprints** refer to publishers' titles from past seasons that continue to sell year after year. These books are often updated and republished with freshly designed covers to keep them up-to-date and attractive to readers.

Getting paid

Payment for design and illustration varies depending on the size of the publisher, the type of project and the rights bought. Most publishers pay on a per-project basis, although some publish-

ers of highly illustrated books (such as children's books) pay an advance plus royalties. A few very small presses may only pay in copies.

Children's book illustration

Working in children's books requires a specific set of skills. You must be able to draw the same characters in a variety of action poses and situations. Like other publishers, many children's publishers are expanding their product lines to include multimedia projects. While a number of children's publishers are listed in this book, *Children's Writer's & Illustrator's Market*, published by Writer's Digest Books (800)448-0915, is an invaluable resource if you enter this field. You can order this essential book on www.writersdigest.com/store/books.asp.

> ### For More Information
>
> If you decide to focus on book publishing, become familiar with *Publishers Weekly*, the trade magazine of the industry. Its website, www.publishersweekly.com will keep you abreast of new imprints, publishers that plan to increase their title selection, and the names of new art directors. You should also look for articles on book illustration and design in *HOW*, *Print* and other graphic design magazines. *Jackets Required: An Illustrated History of American Book Jacket Design, 1920-1950*, by Steven Heller and Seymour Chwast (Chronicle Books), offers nearly 300 examples of book jackets.

AACE INTERNATIONAL, 209 Prairie Ave., Suite 100, Morgantown WV 26501. (304)296-8444. Fax: (304)291-5728. E-mail: nkinderknecht@compuserve.com. Website: aacei.org. **Contact:** Noah Kinderknecht, graphic designer/editor. Estab. 1958. Publishes trade paperback originals and reprints and textbooks. Specializes in engineering and project management books. Titles include: *Cost Engineering* journal. Catalog available.
Needs: 100% of freelance design demands knowledge of QuarkXPress. 100% of freelance illustration demands knowledge of Photoshop, Illustrator and QuarkXPress.
First Contact & Terms: Designers send query letter with résumé and slides.
Book Design: Assigns 1-2 freelance design jobs/year.
Text Illustration: Assigns 1-2 freelance illustration jobs/year.

A&B PUBLISHERS GROUP, 1000 Atlantic Ave., Brooklyn NY 11238. (718)783-7808. Fax: (718)783-7267. **Production Manager:** Maxwell Taylor. Estab. 1992. Publishes trade paperback originals, calendars and reprints. Types of books include comic books, cookbooks, history, juvenile, preschool, reference, self-help and young adult. Specializes in history. Publishes 10 titles/year. Recent titles include: *Nutrition Made Simple* and *What They Never Told You in History Class*, *Vol. I and II*. 70% require freelance illustration; 25% require freelance design. Catalog available.
Needs: Approached by 60 illustrators and 32 designers/year. Works with 12 illustrators and 6 designers/ year. Prefers local illustrators experienced in airbrush and computer graphics. Uses freelancers mainly for "book covers and insides." 85% of freelance design demands knowledge of Photoshop, Illustrator and QuarkXPress. 60% of freelance design demands knowledge of Photoshop, Illustrator, QuarkXPress and Painter. 20% of titles require freelance art direction.
First Contact & Terms: Designers send query letter with photocopies. Illustrators send postcard sample, photocopies, printed samples or tearsheets. Send follow-up postcard sample every 4 months. Accepts disk submissions from designers compatible with QuarkXPress, Photoshop and Illustrator. Send EPS and TIFF files. Samples are filed. Portfolio review required. Portfolio should include artwork portraying children, animals, perspective, anatomy and transparencies. Rights purchased vary according to project.
Book Design: Assigns 14 freelance design jobs/year. Pays by the hour, $15-65 and also a flat fee.
Jackets/Covers: Assigns 14 freelance design jobs and 20 illustration jobs/year. Pays by the project, $250-1,200. Prefers "computer generated titles, pen & ink and watercolor or airbrush for finish."

Text Illustration: Assigns 11 freelance illustration jobs/year. Pays by the hour, $8-25 or by the project $800-2,400 maximum. Prefers "airbrush or watercolor that is realistic or childlike, appealing to young school-age children." Finds freelancers through word of mouth, submissions, NYC school of design.
Tips: "I look for artists who are knowledgeable about press and printing systems—from how color reproduces to how best to utilize color for different presses."

N HARRY N. ABRAMS, INC., 100 Fifth Ave., New York NY 10011. (212)206-7715. Website: www.abramsbooks.com. **Contact:** Michael Walsh, creative director. Estab. 1951. Company publishes hardcover originals, trade paperback originals and reprints. Types of books include fine art and illustrated books. Publishes 150 titles/year. 60% require freelance design. Visit website for art submission guidelines.
Needs: Uses freelance designers to design complete books including jackets and sales materials. Uses illustrators mainly for maps and occasional text illustration. 90% of freelance design and 50% of illustration demands knowledge of Illustrator, QuarkXPress and Photoshop. Works on assignment only.
First Contact & Terms: Send query letter with résumé, tearsheets, photocopies. Accepts disk submissions or supply web address. Samples are filed "if work is appropriate." Samples are returned by SASE if requested by artist. Art Director will contact artist for portfolio review if interested. Portfolio should include printed samples, tearsheets and/or photocopies. Originals are returned at job's completion, with published product. Finds artists through word of mouth, submissions, attending art exhibitions and seeing published work.
Book Design: Assigns several freelance design jobs/year. Pays by the project.

N ACROPOLIS BOOKS, INC., 8601 Dunwoody Pl., Suite 303, Atlantic GA 30350. (770)643-1118. Fax: (770)643-1170. E-mail: acropolisbooks@mindspring.com. Website: www.acropolisbooks.com. **Vice President Operations:** Christine Lindsay. Imprints include Awakening. Publishes hardcover originals and reprints, trade paperback originals and reprints. Types of books include mysticism and spiritual. Specializes in books of higher consciousness. Publishes 4 titles/year. Recent titles include: *Seek ye First*, by Joel Goldsmith; and *Spiritual Discernmenta: The Healing Consciousness*, by Robert Rabbin. 30% require freelance design. Catalog available.
Needs: Approached by 7 illustrators and 5 designers/year. Works with 2-3 illustrators and 2-3 designers/year. Knowledge of Photoshop and QuarkXPress useful in freelance illustration and design.
First Contact & Terms: Designers send brochure and résumé. Illustrators send query letter with photocopies and résumé. Samples are filed. Responds in 2 months. Will contact artist for portfolio review if interested. Buys all rights.
Book Design: Assigns 3-4 freelance design jobs/year. Pays by the project.
Jackets/Covers: Assigns 3-4 freelance design jobs/year. Pays by the project.
Tips: "We are looking for people who are familiar with our company and understand our focus."

ADAMS MEDIA CORPORATION 57 Littlefield St., Avon MA 02322. (508)427-7100. Fax: (508)427-6790. E-mail: pbeatrice@adamsmedia.com. Website: www.adamsmedia.com. **Art Director:** Paul Beatrice. Estab. 1980. Company publishes hardcover originals, trade paperback originals and reprints. Types of books include biography, business, gardening, pet care, cookbooks, history, humor, instructional, New Age, nonfiction, reference, self-help and travel. Specializes in business and careers. Publishes 100 titles/year. 15% require freelance illustration. Recent titles include: *The Postage Stamp Garden Book*, *Test Your Cat's Psychic Powers*, and *The Everything Cover Letter Book*. Book catalog free by request.
Needs: Works with 8 freelance illustrators and 7-10 designers/year. Buys less than 100 freelance illustrations/year. Uses freelancers mainly for jacket/cover illustration, text illustration and jacket/cover design. 100% of freelance work demands computer skills. Freelancers should be familiar with QuarkXPress 4.1 and Photoshop.
First Contact & Terms: Send postcard sample of work. Samples are filed. Art director will contact artist for portfolio review if interested. Portfolio should include tearsheets. Rights purchased vary according to project, but usually buys all rights.
Jackets/Covers: Assigns 50 freelance design jobs/year. Pays by the project, $700-1,500.
Text Illustration: Assigns 30 freelance illustration jobs/year.

N AFRICA WORLD PRESS, INC., 541 W. Ingham Ave., Suite B, Trenton NJ 08638. (609)695-3200. Fax: (609)844-0198. E-mail: africawpress@nyo.com. **Art Director:** Linda Nickens. Estab. 1984. Publishes hardcover and trade paperback originals. Types of books include biography, preschool, juvenile, young adult and history. Specializes in any and all subjects that appeal to an Afrocentric market. Publishes 50

titles/year. Titles include: *Blacks Before America*, by Mark Hyman; and *Too Much Schooling Too Little Education*, by Mwalimu J. Shujaa. 60% require freelance illustration; 10% require freelance design. Book catalog available by request. Approached by 50-100 freelancers/year. Works with 5-10 illustrators and 4 designers/year. Buys 50-75 illustrations/year. Prefers artists with experience in 4-color separation and IBM-compatible PageMaker. Uses freelancers mainly for book illustration. Also for jacket/cover design and illustration. Uses designers for typesetting and formatting.

Needs: "We look for freelancers who have access to or own their own computer for design and illustration purposes but are still familiar and proficient in creating mechanicals, mock-ups and new ideas by hand." 50% of freelance work demands knowledge of PageMaker 5.0, CorelDraw 4.0 and Word Perfect 6.0. Works on assignment only.

First Contact & Terms: Send query letter with brochure, tearsheets, photostats, bio, résumé, SASE, photocopies and transparencies. Samples are filed or are returned by SASE if requested by artist. Responds in 6 weeks. Write for appointment to show portfolio, or mail b&w and color photostats, tearsheets and 8½×11 transparencies. Rights purchased vary according to project. Originals are returned at job's completion if artist provides SASE and instructions.

Book Design: Assigns 100 freelance design jobs/year. Pays by the project.

Jackets/Covers: Assigns 100 freelance design and 50-75 illustration jobs/year. Prefers 2- or 4-color process covers. Pays by the project.

Text Illustration: Assigns 25 illustration jobs/year. Prefers "boards and film with proper registration and color specification." Pays by the project.

Tips: "Artists should have a working knowledge of the Windows 3.1 platform of the IBM computer; be familiar with the four-color process (CMYK) mixtures and changes (5-100%) and how to manipulate them mechanically as well as on the computer; have a working knowledge of typefaces and styles, the ability to design them in an appealing manner; swift turn around time on projects from preliminary through the manipulation of changes and a clear understanding of African-centered thinking, using it to promote and professionally market books and other cultural items creatively. Work should be colorful, eyecatching and controversial."

ALLYN AND BACON, INC., 75 Arlington St., Suite 300, Boston MA 02116. (617)848-6000. Fax: (617)455-1378. E-mail: Linda.Knowles@ablongman.com. Website: www.ablongman.com. **Art Director:** Linda Knowles. Publishes more than 300 hardcover and paperback textbooks/year. 60% require freelance cover designs. Subject areas include education, psychology and sociology, political science, theater, music and public speaking. Recent titles include: *Electronic Media, Psychology, Foundations of Education.*

Needs: Designers must be strong in book cover design and contemporary type treatment. 50% of freelance work demands knowledge of Illustrator, Photoshop and FreeHand.

Jackets/Covers: Assigns 100 design jobs and 2-3 illustration jobs/year. Pays for design by the project, $500-1,000. Pays for illustration by the project, $500-1,000. Prefers sophisticated, abstract style in pen & ink, airbrush, charcoal/pencil, watercolor, acrylic, oil, collage and calligraphy.

Tips: "Keep stylistically and technically up to date. Learn *not* to over-design: read instructions and ask questions. Introductory letter must state experience and include at least photocopies of your work. If I like what I see, and you can stay on budget, you'll probably get an assignment. Being pushy closes the door. We primarily use designers based in the Boston area."

AMERICAN JUDICATURE SOCIETY, 180 N. Michigan, Suite 600, Chicago IL 60601-7401. (312)558-6900, ext. 119. Fax: (312)558-9175. E-mail: drichert@ajs.org. Website: www.ajs.org. **Editor:** David Richert. Estab. 1913. Publishes journals and books. Specializes in courts, judges and administration of justice. Publishes 5 titles/year. 75% requires freelance illustration. Catalog available free for SASE.

Needs: Approached by 20 illustrators and 6 designers/year. Works with 3-4 illustrators and 1 designer/year. Prefers local designers. Uses freelancers mainly for illustration. 100% of freelance design demands knowledge of PageMaker, FreeHand, Photoshop and Illustrator. 10% of freelance illustration demands knowledge of PageMaker, FreeHand, Photoshop and Illustrator.

First Contact & Terms: Designers send query letter with photocopies. Illustrators send query letter with photocopies and tearsheets. Send follow-up postcard every 3 months. Samples are not filed and are returned by SASE. Responds in 1 month. Will contact artist for portfolio review of photocopies, roughs and tearsheets if interested. Buys one-time rights.

Book Design: Assigns 1-2 freelance design jobs/year. Pays by the project, $500-1,000.

Text Illustration: Assigns 10 freelance illustration jobs/year. Pays by the project, $75-375.

✓ AMHERST MEDIA, INC., 155 Rano St., Suite 300, Buffalo NY 14207. (716)874-4450. Fax: (716)874-4508. Website: www.AmherstMedia.com. **Publisher:** Craig Alesse. Estab. 1974. Company publishes trade paperback originals. Types of books include instructional and reference. Specializes in photography, how-to. Publishes 30 titles/year. Recent titles include: *Portrait Photographer's Handbook* and *Creating World Class Photography*. 20% require freelance illustration; 80% require freelance design. Book catalog free for 9 × 12 SAE with 3 first-class stamps.

Needs: Approached by 12 freelancers/year. Works with 3 freelance illustrators and 3 designers/year. Uses freelance artists mainly for illustration and cover design. Also for jacket/cover illustration and design and book design. 80% of freelance work demands knowledge of QuarkXPress or Photoshop. Works on assignment only.

First Contact & Terms: Send brochure, résumé and photographs. Samples are filed. Responds only if interested. Art director will contact artist for portfolio review if interested. Portfolio should include slides. Rights purchased vary according to project. Originals are returned at job's completion. Finds artists through word of mouth.

Book Design: Assigns 12 freelance design jobs/year. Pays for design by the hour $25 minimum; by the project $2,000.

Jackets/Covers: Assigns 12 freelance design and 4 illustration jobs/year. Pays $200-1200. Prefers computer illustration (QuarkXPress/Photoshop).

Text Illustration: Assigns 12 freelance illustration jobs/year. Pays by the project. Prefers computer illustration (QuarkXPress).

ANDREWS McMEEL PUBLISHING, 4520 Main, Kansas City MO 64111-7701. (816)932-6600. Fax: (816)932-6781. E-mail: tlynch@amuniversal.com. Website: www.amuniversal.com/amp. **Art Director:** Tim Lynch. Estab. 1972. Publishes hardcover originals and reprints; trade paperback originals and reprints. Types of books include humor, instructional, nonfiction, reference, self help. Specializes in cartoon/humor books. Publishes 200 titles/year. Recent titles include: *Blue Day Book*, *The Millionaire Mind* and *The Last Editor*. 10% requires freelance illustration; 80% requires freelance design.

Needs: Approached by 100 illustrators and 10 designers/year. Works with 15 illustrators and 25 designers/year. Prefers freelancers experienced in book jacket design. 100% of freelance design demands knowledge of Illustrator, Photoshop, QuarkXPress. 100% of freelance illustration demands knowledge of traditional art skills: printing, watercolor, etc.

First Contact & Terms: Designers send query letter with printed samples. Illustrators send query letter with printed samples or contact through artists' rep. Samples are filed and not returned. Responds only if interested. Portfolio review not required. Rights purchased vary according to project. Finds freelancers mostly through sourcebooks and samples sent in by freelancers.

Book Design: Assigns 60 freelance design jobs/year. Pays by the project, $600-3,000.

Jackets/Covers: Assigns 60 freelance design jobs and 20 illustration jobs/year. Pays for design $600-3,000.

Tips: "We want designers who can read a manuscript and design a concept for the best possible cover. Communicate well and be flexible with design."

✓ ⚑ ANTARCTIC PRESS, 7272 Wurzbach, Suite 204, San Antonio TX 78240. (210)614-0396. Fax: (210)614-5029. E-mail: ap_submissions@juno.com or apcog@hotmail.com. Website: www.antarctic-press.com. **Contact:** Rod Espinosa, submissions editor. Estab. 1985. Publishes CD ROMs, mass market paperback originals and reprints, trade paperback originals and reprints. Types of books include adventure, comic books, fantasy, humor, juvenile fiction. Specializes in comic books. Publishes 18 titles/year. Recent titles include: *Ninja High School*, *Gold Digger*, *Twilight X*. 50% requires freelance illustration. Book catalog free with 9 × 12 SASE ($3 postage).

Needs: Approached by 60-80 illustrators/year. Works with 12 illustrators/year. Prefers local illustrators. 100% of freelance illustration demands knowledge of FreeHand and Photoshop.

First Contact & Terms: Send query letter or postcard sample with brochure and photocopies. Accepts e-mail submissions from illustrators. Prefers Mac-compatible, Windows-compatible, TIFF, JPEG files. Samples are filed or returned by SASE. Portfolios may be dropped off every Monday-Friday. Portfolio should include b&w, color finished art. Buys first rights. Rights purchased vary according to project. Finds freelancers through anthologies we publish, artist's submissionis, Internet, word-of-mouth.

Text Illustration: Negotiated.

Tips: "You must love comics and be proficient in doing sequential art."

⬛ APPALACHIAN MOUNTAIN CLUB BOOKS, 5 Joy St., Boston MA 02108. (617)523-0636. Fax: (617)523-0722. E-mail: amcbooks@amcinfo.org. Website: www.outdoors.org. **Production:** Belinda Thresher. Estab. 1876. Publishes trade paperback originals and reprints. Types of books include adventure, instructional, nonfiction, travel and children's nature books. Specializes in hiking guidebooks. Publishes 7-10 titles/year. Recent titles include: *Northeastern Wilds* and *Women on High*. 5% requires freelance illustration; 100% requires freelance design. Book catalog free for #10 SAE with 1 first-class stamp.
Needs: Approached by 5 illustrators and 2 designers/year. Works with 1 illustrator and 2 designers/year. Prefers local freelancers experienced in book design. 100% of freelance design demands knowledge of FreeHand, Photoshop, QuarkXPress. 100% of freelance illustration demands knowledge of FreeHand, Illustrator.
First Contact & Terms: Designers send postcard sample or query letter with photocopies. Illustrators send postcard sample. Accepts Mac-compatible disk submissions. Samples are not filed and are not returned. Will contact artist for portfolio review of book dummy, photocopies, photographs, tearsheets, thumbnails if interested. Negotiates rights purchased. Finds freelancers through professional recommendation (word of mouth).
Book Design: Assigns 10-12 freelance design jobs/year. Pays for design by the project, $1,200-1,500.
Jackets/Covers: Assigns 10-12 freelance design jobs and 1 illustration job/year. Pays for design by the project.

ARJUNA LIBRARY PRESS, 1025 Garner St., D, Space 18, Colorado Springs CO 80905-1774. Website: www.poetry.com or www.ephotograph.com. **Executive Director:** Count Prof. Joseph A. Uphoff, Jr. Estab. 1979. Company publishes trade paperback originals and monographs. Types of books include experimental fiction, fantasy, horror, nonfiction and science fiction. Specializes in experimental surrealism and differential metamathematics. Publishes 1 or more titles/year. Recent titles include: *The Promethean and Epimethean Continuum of Art*, by Professor Shlomo Giora Shoham; *Thoughtful Fragments*, by Ryan Jackson. 100% require freelance illustration. Book catalog available for $1.
Needs: Approached by 1-2 freelancers/year. Works with 1-2 freelance illustrators/year. Buys 1-2 freelance illustrations/year. Uses freelancers for jacket/cover and text illustration.
First Contact & Terms: Send query letter with brochure, résumé, SASE, tearsheets, slides, photographs and photocopies. Samples are filed. Responds if interested. Portfolio review not required. Originals are not returned.
Book Design: Pays contributor's copy and "royalties by agreement if work becomes profitable."
Jackets/Covers: Pays contributor's copy and "royalties by agreement if work becomes profitable."
Text Illustration: Pays contributor's copy and "royalties by agreement if work becomes profitable."
Tips: "Although color illustrations are needed for dust jackets and paperback covers, because of the printing cost, most interior book illustrations are black and white. It is a valuable skill to be able to make a color image with strong values of contrast that will transcribe positively into black and white. In terms of publishing and computer processing, art has become information. There is yet an art that presents the manifestation of the object as being a quality. This applies to sculpture, ancient relics, and anything with similar material value. These things should be treated with respect; curatorial values will always be important. Also, the proliferation of design that has become the Internet is often very confusing to look at or read. A good design can be very complex if its elegance includes a lucid way to focus on information content."

ART DIRECTION BOOK CO. INC., 456 Glenbrook Rd., Glenbrook CT 06906. (203)353-1441. Fax: (203)353-1371. **Contact:** Karyn Mugmon, production manager. Publishes hardcover and paperback originals on advertising design and photography. Publishes 10-12 titles/year. Titles include disks of *Scan This Book* and *Most Happy Clip Art*; book and disk of *101 Absolutely Superb Icons* and *American Corporate Identity #11*. Book catalog free on request.
Needs: Works with 2-4 freelance designers/year. Uses freelancers mainly for graphic design.
First Contact & Terms: Send query letter to be filed and arrange to show portfolio of 4-10 tearsheets. Portfolios may be dropped off Monday-Friday. Samples returned by SASE. Buys first rights. Originals are returned to artist at job's completion. Advertising design must be contemporary. Finds artists through word of mouth.
Book Design: Assigns 8 freelance design jobs/year. Pays $350 maximum.
Jackets/Covers: Assigns 8 freelance design jobs/year. Pays $350 maximum.

ARTIST'S & GRAPHIC DESIGNER'S MARKET, Writer's Digest Books, 4700 East Galbraith Rd., Cincinnati OH 45236. E-mail: artdesign@fwpubs.com. **Editor:** Mary Cox. Annual directory of markets for designers, illustrators and fine artists. Buys one-time rights.
Needs: Buys 35-45 illustrations/year. "I need examples of art that have been sold to the listings in *Artist's & Graphic Designer's Market*. Look through this book for examples. The art must have been freelanced; it cannot have been done as staff work. Include the name of the listing that purchased or exhibited the work, what the art was used for and, if possible, the payment you received. Bear in mind that interior art is reproduced in black and white, so the higher the contrast, the better. I also need to see promo cards, business cards and tearsheets."
First Contact & Terms: Send printed piece, photographs or tearsheets. "Since *Artist's & Graphic Designer's Market* is published only once a year, submissions are kept on file for the upcoming edition until selections are made. Material is then returned by SASE if requested." Pays $75 to holder of reproduction rights and free copy of *Artist's & Graphic Designer's Market* when published.

N **ASSOCIATION OF COLLEGE UNIONS INTERNATIONAL**, One City Centre, 120 W. Seventh St., Suite 200, Bloomington IN 47404-3925. (812)855-8550. Fax: (812)855-0162. E-mail: acui@india na.edu. Website: www.acuiweb.org. Estab. 1914. Professional education association. Publishes hardcover and trade paperback originals. Specializes in multicultural issues, creating community on campus, union and activities programming, managing staff, union operations, and professional and student development.
 ● This association also publishes a magazine, *The Bulletin*. Note that most illustration and design is accepted on a volunteer basis. This is a good market if you're just looking to build or expand your portfolio.
Needs: "We are a volunteer-driven association. Most people submit work on that basis." Uses freelancers mainly for illustration. Works on assignment only.
First Contact & Terms: Send query letter with tearsheets. Samples are filed. Responds to the artist only if interested. Negotiates rights purchased. Originals are returned at job's completion.
Book Design: Assigns 2 freelance design jobs/year.
Tips: Looking for color transparencies of college student union activities.

ATHENEUM BOOKS FOR YOUNG READERS, 1230 Avenue of the Americas, New York NY 10020. (212)698-4381. Fax: (212)698-2798. E-mail: kristin.smith@simonandschuster.com. Website: www.simons ayskids.com. **Contact:** Art Director. Imprint of Simon & Schuster Children's Publishing Division. Imprint publishes hardcover originals, picture books for young kids, nonfiction for ages 8-12 and novels for middle-grade and young adults. Types of books include biography, historical fiction, history, nonfiction. Publishes 60 titles/year. Recent titles include: *Olivia Saves the Circus*, by Ian Falconer; and *Zeely*, by Virginia Hamilton. 100% requires freelance illustration. Book catalog free by request.
Needs: Approached by hundreds of freelance artists/year. Works with 40-60 freelance illustrators/year. Buys 40 freelance illustrations/year. "We are interested in artists of varying media and are trying to cultivate those with a fresh look appropriate to each title."
First Contact & Terms: Send postcard sample of work or send query letter with tearsheets, résumé and photocopies. Samples are filed. Portfolios may be dropped off every Tuesday between 9 a.m. and 4:30 p.m. Art Director will contact artist for portfolio review if interested. Portfolio should include final art if appropriate, tearsheets, and folded and gathered sheets from any picture books you've had published. Rights purchased vary according to project. Originals are returned at job's completion. Finds artists through submissions, magazines ("I look for interesting editorial illustrators"), word of mouth.
Jackets/Covers: Assigns 20 freelance illustration jobs/year. Pays by the project, $1,200-1,800. "I am not interested in generic young adult illustrators."
Text Illustration: Pays by the project, $500-2,000.

ATLAS GAMES, P.O. Box 131233, Roseville MN 55113-1233. (651)638-0077. Fax: (651)638-0084. E-mail: info@atlas-games.com. Website: www.atlas-games.com. **Art Director:** Scott Reeves. Publishes roleplaying game books, game/trading cards and board games. Main style/genre of games: fantasy, horror, historical (medieval). Uses freelance artists mainly for b&w interior illustrations. Publishes 12 titles or products/year. Game/product lines include: *Unknown Armies*, *Ars Magica*, *Penumbra*, and *Feng Shui*. 100% requires freelance illustration; 5% requires freelance design. Request art guidelines by mail or on website.
Needs: Approached by 100 illustrators and 10 designers/year. Works with 6 illustrators and 1 designer/year. 100% of freelance design demands knowledge of Photoshop and QuarkXPress.

First Contact & Terms: Illustrators send 6-12 printed samples, photocopies, photographs or tearsheets. Samples are filed. Responds in 2 months. Will contact artist for portfolio review if interested. Negotiates rights purchased. Finds freelancers through submissions and referrals.
Visual Design: Assigns 1 freelance design job/year.
Book Covers/Posters/Cards: Assigns 4 illustration jobs/year. Pays $200-300 for cover art. Pays for design by the project, $100-300.
Text Illustration: Assigns 20 freelance text illustration jobs/year. Pays by the full page, $40-50. Pays by the half page, $20-25.
Tips: "Please include a SASE."

AUGSBURG FORTRESS PUBLISHERS, Box 1209, 100 S. Fifth St., Suite 700, Minneapolis MN 55402. (612)330-3300. Website: www.augsburgfortress.org. **Contact:** Director of Design, Marketing Services. Publishes hard cover and paperback Protestant/Lutheran books (90 titles/year), religious education materials, audiovisual resources, periodicals. Recent titles include: *Ecotheraphy*, by Howard Clinebell; and *Thistle*, by Walter Wangerin.
Needs: Uses freelancers for advertising layout, design, illustration and circulars and catalog cover design. Freelancers should be familiar with QuarkXPress 4.1, Photoshop 5.5 and Illustrator 8.01.
First Contact & Terms: "Majority, but not all, of our freelancers are local." Works on assignment only. Responds on future assignment possibilities in 2 months. Call, write or send brochure, disk, flier, tearsheet, good photocopies and 35mm transparencies; if artist is not willing to have samples filed, they are returned by SASE. Buys all rights on a work-for-hire basis. May require designers to supply overlays on color work.
Jackets/Covers: Uses designers primarily for cover design. Pays by the project, $600-900. Prefers covers on disk using QuarkXPress.
Text Illustration: Negotiates pay for 1-, 2- and 4-color. Generally pays by the project, $25-500.
Tips: Be knowledgeable "of company product and the somewhat conservative contemporary Christian market."

AVALANCHE PRESS, LTD., P.O. Box 100852, Birmingham AL 35210-0852. (205)957-0017. Fax: (205)957-0016. E-mail: avlchpress@aol.com. Website: www.avalanchepress.com. **Production Manager:** Peggy Gordon. Estab. 1993. Publishes roleplaying game books, game/trading cards, posters/calendars and board games. Main style/genre of games: science fiction, fantasy, humor, Victorian, historical, military and mythology. Uses freelance artists for "most everything." Publishes 40 titles or products/year. Game/product lines include: The *Epic* line of historical role playing games. 10% requires freelance illustration.
Needs: Approached by 50 illustrators and 150 designers/year. Works with 4 illustrators and 1 designer/year. Prefers local illustrators. Prefers freelancers experienced in professional publishing. 20% of freelance design demands knowledge of Illustrator. 30% of freelance illustration demands knowledge of QuarkXPress.
First Contact & Terms: Send query letter with résumé and SASE. Send printed samples. Samples are not filed and are not returned. Will contact artist for portfolio review if interested. Buys all rights.
Visual Design: Assigns 8-12 freelance design projects/year. Pays by the project.
Book Covers/Posters/Cards: Assigns 10-12 illustration jobs/year. Pays by the project.
Tips: "We need people who want to work with us and have done their homework. Study our product lines and do not send us blanket, mass-mailed queries. We really mean this—mail-merge inquiries land in the circular file."

AVATAR PRESS, 9 Triumph Dr., Urbana IL 61802. Fax: (217)384-2216. E-mail: submissions@avatar press.net. Website: www.avatarpress.com. **Contact:** William A. Christenson, editor-in-chief. Publishes trade paperback originals. Types of books include comic book fiction. Publishes 50 titles/year. Recent titles include: *The Courtyard*, by Alan Moore; *Scars*, by Warren Ellis and Jason Burrows; *Shi: Pandora's Box #1*, by Robert Lugibihl and Juan Jose Ryp. Book catalog available on website.
 ● See this company's website before submitting.
First Contact & Terms: Illustrators send query letter with tearsheets, samples "showcasing all your abilities and panel to panel continuity." Accepts Zip disk or CD submissions from colorists. Prefers Windows-compatible, CMYK mode at size 6.875×10.5 at 600 dpi. Responds only if interested. Company will contact artist for portfolio review if interested.
Tips: "Avatar Press is always looking for quality creator-owned projects. The ideal submission will include

an overview of the story, a detailed plot synopsis, sample script pages, and sample art pages (panel to panel continuity)."

BAEN BOOKS, P.O. Box 1188, Wake Forest NC 27588. (919)570-1640. Fax: (919)570-1644. Website: www.baen.com. **Publisher:** Jim Baen. Editor: Toni Weisskopf. Estab. 1983. Publishes science fiction and fantasy. Publishes 60-70 titles/year. Titles include: *War of Honor* and *Lord Darcy*. 75% requires freelance illustration; 80% requires freelance design. Book catalog free on request.
First Contact & Terms: Approached by 500 freelancers/year. Works with 10 freelance illustrators and 3 designers/year. 50% of work demands computer skills. Designers send query letter with résumé, color photocopies, tearsheets (color only) and SASE. Illustrators send query letter with color photocopies, SASE, slides and tearsheets. Samples are filed. Originals are returned to artist at job's completion. Buys exclusive North American book rights.
Jackets/Covers: Assigns 64 freelance design and 64 illustration jobs/year. Pays by the project—$200 minimum, design; $1,000 minimum, illustration.
Tips: Wants to see samples within science fiction, fantasy genre only. "Do not send black & white illustrations or surreal art. Please do not waste our time and your postage with postcards. Serious submissions only."

BANDANNA BOOKS, 1212 Punta Gorda St., Suite 13, Santa Barbara CA 93103. Phone/fax: (805)899-2145. E-mail: bandanna@cox.net. Website: www.bandannacollege.com. **Publisher:** Sasha Newborn. Estab. 1981. Publishes nonfiction trade paperback originals and reprints. Types of books include classics and self-help books for college freshmen. Publishes 3 titles/year. Recent titles include: *Benigna Machiavelli*, by Charlotte Perkins Gilman; *Italian for Opera Lovers*; and *Don't Panic: The Procrastinator's Guide to Writing an Effective Term Paper*, by Steven Posusta.
 • Bandanna Books focuses on college freshmen, their teachers, their parents—with special interest in distance learning, independent study, writing and learning disabilities.
Needs: Approached by 150 freelancers/year. Uses illustrators mainly for b&w woodblock or scratchboard and pen & ink art. Also for cover and text illustration.
First Contact & Terms: Send postcard sample or query letter with samples. Samples are filed and are returned by SASE only if requested. Responds in 2 months if interested. Originals are not returned. To show portfolio, mail thumbnails and sample work. Considers project's budget when establishing payment.
Jackets/Covers: Pays by the project, $50-200.
Text Illustration: Pays by the project, $50-200. Prefers b&w.
Tips: "Include at least five samples in your submission. Make sure samples are generally related to our topics published. We're interested in work that is innovative without being bizarre, quality without looking too 'slick' or commercial. Simplicity is important. We are not interested in New Age or fantasy work. Book illustration does not have to be center stage; some of the finest work blends into the page or is ornamental."

BARBOUR PUBLISHING, 1810 Barbour Dr., P.O. Box 719, Uhrichsville OH 44683. (740)922-6045, ext. 125. Fax: (740)922-5948. E-mail: rmartins@barbourbooks.com. Website: www.barbourbooks.com. **Creative Director:** Robyn Martins. Estab. 1981. Publishes hardcover, trade paperback and mass market paperback originals and reprints. Types of books include general Christian contemporary and Christian romance, self help, young adult, reference and Christian children's books. Specializes in short, easy-to-read Christian bargain books. Publishes 150 titles/year. 60% require freelance illustration.
Needs: Prefers freelancers with experience in people illustration and photorealistic styles. Uses freelancers mainly for fiction romance jacket/cover illustration. Works on assignment only.
First Contact & Terms: Send query letter with photocopies or tearsheets and SASE. Accepts Mac disk submissions compatible with Illustrator 6.0 and Photoshop. Buys all rights. Originals are returned. Finds artists through word of mouth, recommendations, sample submissions and placing ads.
Jackets/Covers: Assigns 10 freelance design and 90 illustration jobs/year. Pays by the project, $450-750.
Tips: "Submit a great illustration of people suitable for a romance cover or youth cover in a photorealistic style. I am also looking for great background illustrations, such as florals and textures. As a publisher of bargain books, I am looking for top-quality art on a tight budget."

BEAVER POND PUBLISHING, P.O. Box 224, Greenville PA 16125. (724)588-3492. Fax: (724)588-2486. E-mail: ojay@zoominternet. Website: www.bookblender.com. **Owner:** Rich Faler. Estab. 1988. Subsidy publisher and publisher of trade paperback originals and reprints and how-to booklets. Types of books

include instructional and adventure. Specializes in outdoor topics. Publishes 20 titles/year. Recent titles include: *Allegheny Angler*, by John Busch Jr.; and *Crow Shooting Secrets II*, by Dick Mermon. 20% require freelance illustration. Book catalog free by request.

Needs: Approached by 6 freelance artists/year. Works with 3 illustrators/year. Buys 50 illustrations/year. Prefers artists with experience in outdoor activities and animals. Uses freelancers mainly for book covers and text illustration. Works on assignment only.

First Contact & Terms: Send query letter with tearsheets and/or photocopies. Samples are filed. Responds only if interested. To show portfolio, mail appropriate materials: thumbnails, b&w photocopies. Rights purchased vary according to project. Originals are returned at job's completion (if all rights not purchased).

Jackets/Covers: Assigns 3-4 illustration jobs/year. Pays for covers as package with text art. Prefers pen & ink line art.

Text Illustration: Assigns 3-4 jobs/year. Pays by the project, $100 (booklets)-$1,600 (books). Prefers pen & ink line art.

Tips: "Show an understanding of animal anatomy. We want accurate work."

BEDFORD/ST. MARTIN'S, 75 Arlington St., Boston MA 02116. (617)399-4000. Fax: (617)350-7544. Website: www.bedfordstmartins.com. **Advertising Assistant Manager:** Jill Chmelko. Promotions Manager: Thomas Macy. Creative Supervisors: Hope Tompkins and Pelle Cass. Estab. 1981. Publishes college textbooks in English, history and communications. Publishes 40 titles/year. Recent titles include: *A Writer's Reference*, Fifth Edition; *The Bedford Handbook*, Sixth Edition; and *The American Promise* Second Edition. Books have "contemporary, classic design." 5% require freelance illustration; 90% require freelance design.

Needs: Approached by 25 freelance artists/year. Works with 2-4 illustrators and 6-8 designers/year. Buys 2-4 illustrations/year. Prefers artists with experience in book publishing. Uses freelancers mainly for cover and brochure design. Also for jacket/cover and text illustration and book and catalog design. 75% of design work demands knowledge of Adobe Illustrator, QuarkXPress and Adobe Photoshop.

First Contact & Terms: Send query letter with brochure, tearsheets and SASE. Samples are filed or are returned by SASE if requested by artist. Responds only if interested. Request portfolio review in original query. Art director or promotions manager will contact artists for portfolio review if interested. Portfolio should include roughs, original/final art, color photostats and tearsheets. Interested in buying second rights (reprint rights) to previously published work. Originals are returned at job's completion.

Jackets/Covers: Assigns 40 design jobs and 2-4 illustration jobs/year. Pays by the project. Finds artists through magazines, self-promotion and sourcebooks. Contact: Donna Dennison.

Tips: "Regarding book cover illustrations, we're usually interested in buying reprint rights for artistic abstracts or contemporary, multicultural scenes and images of writers and writing-related scenes (i.e. desks with typewriters, paper, open books, people reading, etc.)."

BENTLEY PUBLISHERS, (formerly Robert Bentley Publishers), 1734 Massachusetts Ave., Cambridge MA 02138-1804. (617)547-4170. Fax: (617)876-9235. E-mail: Sales@BentleyPublishers.com. Website: www.bentleypublishers.com. **Publisher:** Michael Bentley. Publishes hardcover originals and reprints and trade paperback originals—reference books. Specializes in automotive technology and automotive how-to. Publishes 20 titles/year. Titles include: *Jeep Owner's Bible*, *Unbeatable BMW* and *Zora Arkus-Duntov: The Legend Behind Corvette*. 50% require freelance illustration; 50% require freelance design and layout. Book catalog for 9×12 SAE.

Needs: Works with 5-10 illustrators and 15-20 designers/year. Buys 1,000 illustrations/year. Prefers artists with "technical illustration background, although a down-to-earth, user-friendly style is welcome." Uses freelancers for jacket/cover illustration and design, text illustration, book design, page layout, direct mail and catalog design. Also for multimedia projects. 100% of design work requires computer skills. Works on assignment only.

First Contact & Terms: Send query letter with résumé, SASE, tearsheets and photocopies. Accepts disk submissions. Samples are filed. Responds in 5 weeks. To show portfolio, mail thumbnails, roughs and b&w tearsheets and photographs. Buys all rights. Originals are not returned.

Book Design: Assigns 10-15 freelance design and 20-25 illustration jobs/year. Pays by the project.

Jackets/Covers: Pays by the project.

Text Illustration: Prefers Illustrator files.

Tips: "Send us photocopies of your line artwork and résumé."

BETHLEHEM BOOKS, 10194 Garfield St., S, Bathgate ND 58216. (701)265-3725. Fax: (701)265-3716. E-mail: inquiry@bethlehembooks.com. Website: www.bethlehembooks.com. **Contact:** Jack Sharpe, publisher. Estab. 1993. Publishes hardcover originals, trade paperback originals and reprints. Types of books include adventure, biography, history, juvenile and young adult. Specializes in children's books. Publishes 5-10 titles/year. Recent titles include: *Galen and the Gateway to Medicine*. Catalog available.
Needs: Approached by 25 illustrators/year. Works with 4 illustrators/year. Prefers freelancers experienced in b&w line drawings. Uses freelancers mainly for covers and book illustrations.
First Contact & Terms: Illustrators send postcard sample or query letter with photocopies. Accepts disk submissions from illustrators compatible with IBM, prefers TIFFs or QuarkXPress 3.32 files. Samples are filed. Will contact artist for portfolio review if interested. Portfolio should include artwork portraying people in action. Negotiates rights purchased.
Jackets/Covers: Assigns 2 freelance illustration jobs/year. Pays by the project, $800-1,000. Prefers oil or watercolor.
Text Illustration: Assigns 2 freelance illustration jobs/year. Pays by the project, $100-2,000. Prefers pen and ink. Finds freelancers through books and word of mouth.
Tips: "Artists should be able to produce life-like characters that fit the story line."

BINARY ARTS CORP., 1321 Cameron St., Alexandria VA 22314. (703)549-4999. Fax: (703)549-6210. E-mail: swagner@puzzles.com. Website: www.puzzles.com. **Director of Product Design and Development:** Steve Wagner. Estab. 1985. Publishes board games, grid games and puzzles. Main style/genre of games: humor and education. Uses freelance artists mainly for illustration. Publishes 7-15 titles or products/year. Game/product lines include: *Grid Games*, *Kinetics*, *Peg Puzzles* and *Thinking Games*. 100% requires freelance illustration; 50% requires freelance design.
Needs: Approached by 20 illustrators and 20 designers/year. Works with 5 illustrators and 3 designers/year. Sometimes prefers local illustrators. Prefers freelancers experienced in Illustrator, Quark. 100% of freelance design demands knowledge of Illustrator, Photoshop and QuarkXPress. 100% of freelance illustration demands knowledge of Illustrator.
First Contact & Terms: Send self-promotion postcard sample and follow-up postcard. Illustrators send 10-20 printed samples and tearsheet. Samples are filed. Responds only if interested. Will contact artist for portfolio review if interested. Buys all rights. Finds freelancers through referrals, *Black Book*, etc.
Visual Design: Assigns 20 freelance design jobs/year.
Posters/Cards: Assigns 5 freelance design jobs and 5 illustration jobs/year. Pays for illustration by the project.

BLOOMSBURY CHILDREN'S BOOKS, 175 Fifth Ave., #712. New York NY 10010. (212)674-5151, ext. 243. Website: www.bloomsbury.com/usa. **Contact:** Julie Romeis, assistant. Estab. 2001. Publishes children's hardcover originals and reprints, trade paperback and reprints. Types of books include children's picture books, fantasy, humor, juvenile and young adult fiction. Publishes 50 titles/year. Recent titles include: *No Trouble At All*, *Five Little Fiends*. 100% requires freelance design; 100% requires freelance illustration. Book catalog not available.
Needs: Works with 10 designers and 20 illustrators/year. Prefers local designers. 100% of freelance design work demands knowledge of Illustrator, QuarkXPress and Photoshop.
First Contact & Terms: Designers send postcard sample or query letter with brochure, résumé, tearsheets. Illustrators send postcard sample or query letter with brochure, photocopies and SASE. After introductory mailing, send follow-up postcard sample every 6 months. Samples are filed or returned by SASE. Responds only if interested. Company will contact artist for potfolio review if interested. Portfolio should include color finished art and tearsheets. Buys all rights. Finds freelancers through word-of-mouth.
Jackets/Covers: Assigns 2 freelance cover illustration jobs/year.

BLUEWOOD BOOKS, 38 South B St., Suite 202, San Mateo CA 94401. (650)548-0754. Fax: (650)548-0654. E-mail: bluewoodb@aol.com. **Director:** Richard Michaels. Estab. 1990. Publishes trade paperback originals. Types of books include biography, history, nonfiction and young adult. Publishes 4-10 titles/year. Titles include: *True Stories of Baseball's Hall of Famers*, *100 Scientists Who Shaped World History* and *American Politics in the 20th Century*. 100% require freelance illustration; 75% require freelance design. Catalog not available.
Needs: Works with 5 illustrators and 3 designers/year. Prefers local freelancers experienced in realistic, b&w line illustration and book design. Uses freelancers mainly for illustration and design. 80-100% of freelance design demands knowledge of Photoshop, Illustrator and QuarkXPress. 80-100% of freelance

illustration demands knowledge of FreeHand, Photoshop, Illustrator and QuarkXPress.
First Contact & Terms: Designers send query letter with brochure, photocopies, résumé, SASE and tearsheets. Illustrators send query letter with photocopies, résumé, SASE and tearsheets. Samples are filed. Responds only if interested. Will contact artist for portfolio review of photocopies, photographs, roughs, slides, tearsheets, thumbnails and transparencies if interested. Buys all rights.
Book Design: Assigns 4-10 freelance design jobs/year. Pays by the hour or project.
Jackets/Covers: Pays by the project, $150-200 for color.
Text Illustration: Assigns 4-10 freelance illustration jobs/year. Pays $15-30 for each b&w illustration. Finds freelancers through submissions.

BROADMAN & HOLMAN PUBLISHERS 127 Ninth Ave. N., Nashville TN 37234. (615)251-5825. Website: www.broadmanholman.com. **Contact:** Greg Pope, creative director. Estab. 1891. Religious publishing house. Publishes 104 titles/year. Types of books include children's picture books, mainstream fiction, reference, romance, self-help, young adult fiction; biography, coffee table books, history, instructional, preschool, religious, textbooks, home school educational curricula nonfiction. 20% of titles require freelance illustration. Recent titles include: *Spiritual Readership*, *My Happy Heart* and *Summer With a Smile*. Books have contemporary look. Book catalog free on request.
Needs: Works with 10 freelance illustrators and 15 freelance designers/year. Artist must be experienced, professional. Works on assignment only. 100% of titles require freelance art direction.
First Contact & Terms: Send query letter and samples to be kept on file. Bio is helpful. Call or write for appointment to show portfolio. Send slides, tearsheets, postcards or photocopies; "samples *cannot* be returned." Responds only if interested. Pays for illustration by the project, $250-1,500. Negotiates rights purchased.
Book Design: Pays by the project, $500-1,000.
Jackets/Covers: "100% of our cover designs are now done on computer." Pays by the project, $1,500-5,000
Text Illustration: Pays by the project, $150 and up.
Tips: "We are looking for computer-literate experienced book designers with extensive knowledge of biblical themes." Looks for "the ability to illustrate scenes with multiple figures, to accurately illustrate people of all ages, including young children and babies, and to illustrate detailed scenes described in text."

■ ☷ **THE BUREAU FOR AT-RISK YOUTH**, A Guidance Channel Company, 135 Dupont St., P.O. Box 760, Plainview NY 11803-0760. (800)999-6884. Fax: (800)262-1886. E-mail: info@guidancechannel. com. Website: www.at-risk.com. **Editor-in-Chief:** Sally Germain. Estab. 1991. Publishes CD-ROMs, booklets, pamphlets, posters, video programs, curriculum and educational resources for educators, counselors, children, parents and others who work with youth. Publishes 20-50 titles/year. Titles include: *Express Yourself Poster Series*, by Kathleen Bishop; *YouthLink Mentoring Program* and *You're the Boss Lifeskills & Entrepreneurship Program*. 30% requires freelance illustrations; 75% requires freelance design. Free Catalog of Resources available with $1.70 in stamps.
Needs: Works with 4 illustrators/year and 6 designers/year. Prefers local designers/illustrators, but not required. Prefers freelancers experienced in educational/youth materials. Freelance design demands knowledge of Photoshop and QuarkXPress. Illustration demands knowledge of Illustrator, Photoshop and QuarkXPress.
First Contact & Terms: Send query letter with photocopies and SASE. Accepts Mac-compatible disk submissions. Send EPS files. Samples are filed. Responds only if interested; will return materials if SASE sent and requested. Portfolio review not required intially. Rights purchased vary according to project. Finds freelancers through word of mouth and networking.
Jackets/Covers: Payment either by hour or by project, but depends on specific project.

■ **CACTUS GAME DESIGN, INC.**, 751 Tusquittee St., Hayesville, NC 28904. (828)389-1536. Fax: (828)389-1534. E-mail: cactusrob@aol.com. Website: www.cactusgamedesign.com. **Art Director:** Doug Gray. Estab. 1995. Publishes comic books, game/trading cards, posters/calendars, CD-ROM/online games and board games. Main style/genre of games: science fiction, fantasy and Biblical. Uses freelance artists mainly for illustration. Publishes 2-3 titles or products/year. *Outburst: Bible Edition, Redemption 2nd Edition, Gil's Bible Jumble*. 100% requires freelance illustration; 25% requires freelance design.
Needs: Approached by 50 illustrators and 5 designers/year. Works with 20 illustrators and 1 designer/year. Prefers freelancers experienced in fantasy and Biblical art. 100% of freelance design demands knowledge of Corel Draw, Photoshop and QuarkXPress.

First Contact & Terms: Send query letter with résumé and photocopies. Accepts disk submissions in Windows or Mac format. Send via CD, floppy disk, Zip as TIFF, GIF or JPEG files. Samples are filed. Responds only if interested. Portfolio review not required. Rights purchased vary according to project. Finds freelancers through submission packets and word of mouth.
Visual Design: Assigns 100-150 freelance design jobs/year. Pays for design by the hour, $20.
Book Covers/Posters/Cards: Pays for illustration by the project, $25-250. "Artist must be aware of special art needs associated with Christian retail environment."
Tips: "We like colorful action shots."

CARTWHEEL BOOKS, Imprint of Scholastic, Inc., 555 Broadway, New York NY 10012-3999. (212)343-6100. Fax: (212)343-4444. Website: www.scholastic.com. **Art Director:** Richard Deas. Estab. 1990. Publishes mass market and trade paperback originals. Types of books include children's picture books, instructional, juvenile, preschool, novelty books. Specializes in books for very young children. Publishes 100 titles/year. Titles include: *I Spy*, by Jean Marzollo and Walter Wick. 100% requires freelance illustration; 25% requires freelance design; 5% requires freelance art direction. Book catalog available for SASE with first-class stamps.
Needs: Approached by 500 illustrators and 50 designers/year. Works with 75 illustrators, 5 designers and 3 art directors/year. Prefers local designers. 100% of freelance design demands knowledge of QuarkXPress.
First Contact & Terms: Designers send query letter with printed samples, photocopies, SASE. Illustrators send postcard sample or query letter with printed samples, photocopies and follow-up postcard every 2 months. Samples are filed. Responds in 1 month. Will contact artist for portfolio review of artwork portraying children and animals, artwork of characters in sequence, tearsheets if interested. Rights purchased vary according to project. Finds freelancers through submissions on file, reps.
Book Design: Assigns 10 freelance design and 2 art direction projects/year. Pays for design by the hour, $30-50; art direction by the hour, $35-50.
Text Illustration: Assigns 200 freelance illustration jobs/year. Pays by the project, $500-10,000.
Tips: "I need to see cute fuzzy animals, young, lively kids, and/or clear depictions of objects, vehicles and machinery."

MARSHALL CAVENDISH, 99 White Plains Rd., Tarrytown NY 10591. (914)332-8888. Fax: (914)332-1888. Website: www.marshallcavendish.com. **Art Director:** Anahid Hamparian. Imprints include Benchmark Books and Cavendish Children's Books. Publishes hardcover originals. Types of books include children's picture books, young adult and juvenile. Publishes 24 titles/year. Recent titles include: *A Place to Sleep*, *Jack Quack*, *The Boy Who Was Generous With Salt* and *Borderlands*. 80% requires freelance illustration.
Needs: Uses freelancers mainly for illustration.
First Contact & Terms: Send photocopies and/or printed samples. Samples are filed. Will contact artist for portfolio review of artwork portraying children, adults, animals, artwork of characters in sequence, book dummy, photocopies. Negotiates rights purchased. Finds freelancers mostly through agents.
Jacket/Covers: Assigns 5 illustration jobs/year. Pays by the project; negotiable.
Text Illustration: Assigns 10 freelance jobs/year. Pays by the project; offers royalty.

CELO VALLEY BOOKS, 160 Ohle Rd., Burnsville NC 28714. **Production Manager:** Diana Donovan. Estab. 1987. Publishes hardcover originals and trade paperback originals. Types of books include biography, juvenile, mainstream fiction and nonfiction. Publishes 3-5 titles/year. Recent titles include: *Quaker Profiles*. 5% require freelance illustration.
Needs: Approached by 5 illustrators/year. Works with 1 illustrator every 3 years. Prefers local illustrators. Uses freelancers mainly for working with authors during book design stage.
First Contact & Terms: Illustrators send query letter with photocopies. Send follow-up postcard every year. Samples are filed. Responds only if interested. Negotiates rights purchased.
Jackets/Covers: Assigns 1 freelance job every 3 years or so. Payment negotiable. Finds freelancers mostly through word of mouth.
Tips: "Artist should be able to work with authors to fit ideas to production."

THE CENTER FOR WESTERN STUDIES, Box 727, Augustana College, Sioux Falls SD 57197. (605)274-4007. Website: inst.augie.edu/CWS/. **Publications Director:** Harry F. Thompson. Estab. 1970. Publishes hardcover originals and trade paperback originals and reprints. Types of books include western history. Specializes in history and cultures of the Northern Plains, especially Plains Indians, such as the

Sioux and Cheyenne. Publishes 1-2 titles/year. Recent titles include: *Soldier, Settler, Sioux: Fort Ridgeley and the Minnesota River Valley*; and *The Lizard Speaks: Essays on the Writings of Frederick Manfred*. 25% require freelance design. Books are conservative, scholarly and documentary. Book catalog free by request.

Needs: Approached by 1-2 freelancers/year. Works with 1-2 freelance designers and 1-2 illustrators/year. Uses freelancers mainly for cover design. Also for book design and text illustration. Works on assignment only.

First Contact & Terms: Send query letter with résumé, SASE and photocopies. Request portfolio review in original query. Responds only if interested. Portfolio should include roughs and final art. Sometimes requests work on spec before assigning a job. Rights purchased vary according to project. Originals are not returned. Finds illustrators and designers through word of mouth and submissions/self promotion.

Book Design: Assigns 1-2 freelance design jobs/year. Pays by the project, $500-750.

Jackets/Covers: Assigns 1-2 freelance design jobs/year. Pays by the project, $250-500.

Text Illustration: Pays by the project, $100-500.

Tips: "We are a small house, and publishing is only one of our functions, so we usually rely on the work of graphic artists with whom we have contracted previously. Send samples."

CENTERSTREAM PUBLISHING, P.O. Box 17878, Anaheim Hills CA 92807. (714)779-9390. E-mail: centerstrm@aol.com. **Production:** Ron Middlebrook. Estab. 1978. Publishes audio tapes and hardcover originals. Types of books include history, self-help, music history and instruction. Publishes 10-20 titles/year. Recent titles include: *Orange Blossom Boys*, *Cowboy Guitars*, *Diatonic Harmonica Workbook*, *Doug Dillard Banjo Book*. 100% requires freelance illustration. Book catalog free for 6×9 SAE with 2 first-class stamps.

Needs: Approached by 12 illustrators/year. Works with 3 illustrators/year.

First Contact & Terms: Illustrators send postcard sample or tearsheets. Accepts Mac-compatible disk submissions. Samples are not filed and are returned by SASE. Responds only if interested. Buys all rights, or rights purchased vary according to project.

Tips: "Publishing is a quick way to make a slow buck."

CHARIOT VICTOR PUBLISHING, Cook Communication Ministries, 4050 Lee Vance View, Colorado Springs CO 80918-7100. (719)536-0100. **Creative Director:** Randy Maid. Estab. late 1800s. Imprints include Chariot Publishing, Victor Publishing, Lion Publishing and Rainfall Educational Toys. Imprint publishes hardcover and trade paperback originals and mass market paperback originals. Also toys. Types of books include contemporary and historical fiction, mystery, self-help, religious, juvenile, some teen and preschool. Publishes 100-150 titles/year. Recent titles include: *Gifts from God* and *Kids Hope*. 100% require freelance illustration; 60% require freelance design.

Needs: Approached by dozens of freelance artists/year. Works with 150 freelance illustrators and 30 freelance designers/year. Buys 1,050-1,200 freelance illustrations/year. Prefers artists with experience in children's publishing and/or packaging. Uses freelance artists mainly for covers, educational products and picture books. Also uses freelance artists for and text illustration, jacket/cover and book design. 50% of design work demands knowledge of Illustrator, QuarkXPress, Photoshop or FreeHand. Works on assignment only.

First Contact & Terms: Send postcard sample or query letter with résumé, tearsheets and photocopies. "Only send samples you want me to keep." Samples are not returned. Responds only if interested. Artist should follow up with call. Rights purchased vary according to project. Originals are "usually" returned at the job's completion. Finds artists through submissions and word of mouth.

Book Design: Assigns 40 freelance design jobs/year.

Jackets/Covers: Assigns 100 freelance design/illustration jobs/year. Pays by the project, $300-2,000. Prefers computer design for comps, realistic illustration for fiction, cartoon or simplified styles for children's.

Text Illustration: Assigns 225 freelance illustration jobs/year. Pays by the project, $2,000-5,000 buyout

 A CHECKMARK PRECEDING A LISTING indicates a change in the mailing address since the 2003 edition.

for 32-page picture books. "Sometimes we offer royalty agreement." Prefers from simplistic, children's styles to realistic.

Tips: "First-time assignments are frequently available as we are always looking for a fresh look. However, our larger 'A' projects usually are assigned to those who we've worked with in the past."

CHARLESBRIDGE PUBLISHING, 85 Main St., Watertown MA 02472. E-mail: tradeeditorial@charlesbridge.com. Website: www.charlesbridge.com. Estab. 1980. Publishes hardcover and softcover children's trade picture books: nonfiction and a small fiction line. Publishes 25 titles/year. Recent titles include: *First Year Letters*, by Julie Danneberg; and *The Deep-Sea Floor*, by Sneed B. Collard III. Books are "realistic art picture books depicting people, outdoor places and animals."

Needs: Works with 5-10 freelance illustrators/year. "Specializes in detailed, color realism, although other styles are gladly reviewed."

First Contact & Terms: Send résumé, tearsheets and photocopies. Samples not filed are returned by SASE. Responds only if interested. Originals are not returned. Considers complexity of project and project's budget when establishing payment. Buys all rights.

Text Illustration: Assigns 5-10 jobs/year. Pays by the project: flat fee or royalty with advance.

CHILDREN'S BOOK PRESS, 2211 Mission St.,San Francisco CA 94110. (415)821-3080. Fax: (415)821-3081. E-mail: childrensbookpress@childrensbookpress.org. Website: www.childrensbookpress.org. Estab. 1975. Publishes hardcover originals and trade paperback reprints. Types of books: juvenile picture books only. Specializes in multicultural. Publishes 3 titles/year. Recent titles include: *Bears Make Rock Soup*, *A Movie and My Pillow*, *My Diary From Here to There*, *Soledad Sigh-Sighs*. 100% requires freelance illustration and design. Catalog free for 9×6 SASE with 57¢ first-class stamps.

Needs: Approached by 1,000 illustrators and 20 designers/year. Works with 2 illustrators and 2 designers/year. Prefers local designers experienced in QuarkXPress (designers) and previous children's picture book experience (illustrators). Uses freelancers for 32-page picture book design. 100% of freelance design demands knowledge of Photoshop, Illustrator and QuarkXPress.

First Contact & Terms: Designers send query letter with brochure, photocopies, résumé, bio, SASE and tearsheets. Illustrators send postcard sample or query letter with photocopies, photographs, printed samples, résumé, SASE and tearsheets. Responds in 6 months if interested or if SASE is included. Will contact artist for portfolio review if interested. Buys all rights.

Book Design: Assigns 2 freelance design jobs/year. Pays by the project.

Text Illustration: Assigns 2 freelance illustration jobs/year. Pays royalty.

Tips: "We look for a multicultural experience. We are especially interested in the use of bright colors and non-traditional instructive approach."

CHILDSWORK/CHILDSPLAY, LLC, The Guidance Channel, 135 Dupont St., Plainview NY 11803-0760. (516)349-5520, ext. 351. Fax: (516)349-5521. E-mail: karens@guidancechannel.com. Website: childswork.com. **Editor:** Karen Schader. Estab. 1985. Types of books include children's picture books, instructional, juvenile, nonfiction, psychological/therapeutic books, games and counseling tools. Publishes 12-15 titles/year. Recent titles include: *No More Arguments* and *Healing Games*. 100% requires freelance illustration; 100% requires freelance design. Product catalog for 4 first-class stamps.

Needs: Works with 6-8 illustrators and 2-4 designers/year. Prefers local illustrators. Prefers local designers. Freelance design demands knowledge of Illustrator, Photoshop, QuarkXPress. Freelance illustrations demands knowledge of Illustrator, Photoshop, QuarkXPress.

First Contact & Terms: Designer send query letter with photocopies, SASE. Illustrators send query letter with photocopies, SASE. Send EPS or TIFF files. Samples are filed or returned by SASE. Responds only if interested. Portfolio review not required. Will contact artist for portfolio review if interested. Buys all rights. Finds freelancers through referral, recommendations, submission packets.

Book Design: Assigns 12-15 freelance design jobs/year.

Jackets/Covers: Assigns 6-8 freelance design jobs and 6-8 illustration jobs/year. Pays for design by the project.

Text Illustration: Prefers freelancers experienced in children's educational/psychological materials.

Tips: "Freelancers should be flexible and responsive to our needs, with commitment to meet deadlines and, if needed, be available during business hours. We use a wide range of styles, from cartoonish to realistic."

CHRONICLE BOOKS, 85 Second St., 6th Floor, San Francisco CA 94105. Website: www.chroniclebooks.com. **Creative Director:** Michael Carabetta. Estab. 1976. Company publishes high quality, affordably

priced hardcover and trade paperback originals and reprints. Types of books include cookbooks, art, design, architecture, contemporary fiction, travel guides, gardening and humor. Publishes approximately 150 titles/year. Recent best-selling titles include the *Griffin & Sabine* trilogy, by Nick Bantock, *Worst Case Scenario Survival Handbooks* and *Extreme Dinosaurs*. Book catalog free on request (call 1-800-722-6657).

● Chronicle has a separate children's book division and a gift division, which produces blank greeting cards, calendars, address books, journals and the like.

Needs: Approached by hundreds of freelancers/year. Works with 15-20 illustrators and 30-40 designers/year. Uses artists for cover and interior design and illustration. 99% of design work demands knowledge of PageMaker, QuarkXPress, FreeHand, Illustrator or Photoshop; "mostly QuarkXPress—software is up to discretion of designer." Works on assignment only.

First Contact & Terms: Send query letter with tearsheets, color photocopies or printed samples no larger than 8½×11. Samples are filed or are returned by SASE. Responds only if interested. Art Director will contact artist for portfolio review if interested. Portfolio should include thumbnails, roughs, final art, photostats, tearsheets, slides, tearsheets and transparencies. Buys all rights. Originals are returned at job's completion. Finds artists through submissions, *Communication Arts* and sourcebooks.

Book Design: Assigns 30-50 freelance design jobs/year. Pays by the project; $750-1200 for covers; varying rates for book design depending on page count.

Jackets/Covers: Assigns 30 freelance design and 30 illustration jobs/year. Pays by the project.

Text Illustration: Assigns 25 freelance illustration jobs/year. Pays by the project.

Tips: "Please write instead of calling; don't send original material."

CIRCLET PRESS, INC., 1770 Massachusetts Ave., #278, Cambridge MA 02140. (617)864-0492. Fax: (617)864-0663. E-mail: circlet-info@circlet.com. Website: www.circlet.com. **Publisher:** Cecilia Tan. Estab. 1992. Company publishes trade paperback originals. Types of books include erotica, erotic science fiction and fantasy. Publishes 8-10 titles/year. Recent titles include: *Nymph*, by Francesca Lia Block; *Through A Brazen Mirror*, by Delia Sherman; and *Sex Noir*, by Jamie Joy Gato. 100% require freelance illustration. Book catalog free for business size SAE with 1 first-class stamp.

Needs: Approached by 300-500 freelancers/year. Works with 4-5 freelance illustrators/year. Uses freelancers for cover art. Needs computer-literate freelancers for illustration. 100% of freelance work demands knowledge of QuarkXPress or Photoshop. Works on assignment only. 10% of titles require freelance art direction.

First Contact & Terms: Send e-mail with attachments, pitching an idea for specific upcoming books. List of upcoming books available for 37¢ SASE or on website. Ask for "Artists Guidelines." Samples are discarded. Responds only if interested. Portfolio review not required. Buys one-time rights or reprint rights. Originals are returned at job's completion. Finds artists through art shows at science fiction conventions and submission samples. "I need to see human figures well-executed with sensual emotion. No tentacles or gore! Photographs, painting, computer composites all welcomed. We use much more photography these days."

Book Design: Assigns 2-4 freelance design jobs/year. Pays by the project, $15-100.

Jackets/Covers: Assigns 2-4 freelance illustration jobs/year. Pays by the project, $100-200. Now using 4-color and halftones.

Tips: "I have not bought and art from a physical submission in five years. It has all been via e-mail. Follow the instructions in this listing: Don't send me color samples on slides. I have no way to view them. Any jacket and book design experience is also helpful. I prefer to see a pitch idea for a cover aimed at a specific title, a way we can use an image that is already available to fit a theme. The artists I have hired in the past 3 years have come to me through the Internet by e-mailing JPEG or GIF files of samples in response to the guidelines on our website. The style that works best for us is photographic collage and post-modern."

✓ CLARION BOOKS, 215 Park Ave. S., 10th Floor, New York NY 10003. (212)420-5800. Website: www.hmco.com. **Art Director:** Joann Hill. Imprint of Houghton Mifflin Company. Imprint publishes hardcover originals and trade paperback reprints. Specializes in picture books, chapter books, middle grade novels and nonfiction, including historical and animal behavior. Publishes 60 titles/year. 90% requires freelance illustration. Book catalog free for SASE.

● *The Three Pigs*, by David Weisner was awarded the 2002 Caldecott Medal. *A Single Shard*, by Linda Sue Park was awarded the 2002 Newbery Medal.

Needs: Approached by "countless" freelancers. Works with 48 freelance illustrators/year. Uses freelancers mainly for picture books and novel jackets. Also for jacket/cover and text illustration.

First Contact & Terms: Send query letter with tearsheets and photocopies. Samples are filed "if suitable to our needs." Responds only if interested. Portfolios may be dropped off every Monday. Art Director will contact artist for portfolio review if interested. Rights purchased vary according to project. Originals are returned at job's completion.

Text Illustration: Assigns 48 freelance illustration jobs/year. Pays by the project.

Tips: "Be familiar with the type of books we publish before submitting. Send a SASE for a catalog or look at our books in the bookstore. Send us children's book-related samples."

N **✦** **CLEIS PRESS**, P.O. Box 14684, San Francisco CA 94114. (415)575-4700. Fax: (415)575-4705. E-mail: fdelacoste@cleispress.com. Website: www.cleispress.com. **Art Director:** Frederique Delacoste. Estab. 1979. Publishes trade paperback originals and reprints. Types of books include comic books, experimental and mainstream fiction, nonfiction and self-help. Specializes in lesbian/gay. Publishes 18 titles/year. Titles include: *Sexually Speaking: Collected Sex Writings*, by Gore Vidal. 100% requires freelance design. Book catalog free for SAE with 2 first-class stamps.

Needs: Works with 4 designers/year. Prefers local illustrators. Freelance design demands knowledge of Illustrator, Photoshop, QuarkXPress.

First Contact & Terms: Designers send postcard sample and follow-up postcard every 6 months or query letter with photocopies. Illustrators send postcard sample or query letter with printed samples, photocopies. Accepts Mac-compatible disk submissions. Send EPS or TIFF files. Samples are filed and are not returned. Will contact artist for portfolio review if interested.

Book Design: Assigns 17 freelance design jobs/year. Pays for design by the project, $500.

Jackets/Covers: Pays for design by the project, $500.

N **CONTEMPORARY BOOKS** Parent company: McGraw-Hill. 1 Prudential Plaza, 130 E. Randolph St., Suite 900, Chicago IL 60601. (312)233-7500. **Contact:** Art Department. Estab. 1961. Book publisher. Publishes hardcover and trade paperback originals, audio tapes, CD-ROMs, textbooks and trade paperpack reprints. Types of books include instructional, juvenile, nonfiction, sports, parenting, fitness, business, foreign language, reference and self-help. 20-25% requires freelance illustration; 20-30% requires freelance design. Book catalog not available.

Needs: Approached by 75 illustrators and 20 designers/year. Works with 10 illustrators and 15 designers/year. Prefers freelancers experienced in book/editorial illustration or design. 100% of design demands knowledge of Illustrator, Photoshop and QuarkXPress. 40% of illustration demands knowledge of Photoshop, Illustrator.

First Contact & Terms: Designers send query letter with printed samples, photocopies, SASE and tearsheets. Illustrators send postcard sample or query letter with printed samples, photocopies, SASE and tearsheets. Accepts Mac-compatible disk submissions. Send EPS files. Samples are filed and are not returned. Responds only if interested. Will contact artist for portfolio review if interested. Rights purchased vary according to project. Finds artists through samples, sourcebooks and annuals, *Workbook*, *Showcase*, *Illustrators* and *Directory of Illustration*.

Book Design: Assigns 80-120 freelance design jobs/year. Pays by the project.

Jackets/Covers: Assigns 30 cover designs and 30 inside cover designs/year. Pays by the project.

Text Illustration: Assigns 30 freelance jobs/year. Pays by the project.

Tips: "We publish a wide variety of nonfiction titles and textbooks. We welcome promotional samples in editorial (not too commercial) styles. We keep samples on file."

✦ **COUNCIL FOR EXCEPTIONAL CHILDREN**, 1110 N. Glebe Rd., Suite 300, Arlington VA 22201-5704. (703)620-3660. Fax: (703)620-2521. E-mail: cecpubs@cec.sped.org. Website: www.cec.sped.org. **Senior Director for Publications:** Kathleen McLane. Estab. 1922. Publishes audio and videotapes, CD-ROMs, paperback originals. Specializes in professional development/instruction. Recent titles include: *IEP Team Guide* and *Adapting Instructional Material for the Inclusive Classroom*. Publishes 10 titles/year. Book catalog available.

Needs: Prefers local illustrators, designers and art directors. Prefers freelancers experienced in education. Some freelance illustration demands knowledge of PageMaker, QuarkXPress.

First Contact & Terms: Send query letter with printed samples, SASE. Accepts Windows-compatible disk submissions or TIFF files. Samples are not filed and are returned by SASE. Will contact artist for portfolio review showing book dummy and roughs if interested. Buys all rights.

N **COUNCIL FOR INDIAN EDUCATION**, 2032 Woody Dr., Billings MT 59102. (406)652-7598. Fax: (406)248-3465. E-mail: hapcie@aol.com. **Editor:** Hap Gilliland. Estab. 1970. Publishes trade paper-

MOUNTAIN PRESS PUBLISHING CO., P.O. Box 2399, Missoula MT 59806. (406)728-1900. Fax: (406)728-1635. E-mail: info@mtnpress.com. Website: www.mountain-press.com. **Editor:** Kathleen Ort. Production Design: Jean Nuckolls. Estab. 1960s. Company publishes trade paperback originals and reprints; some hardcover originals and reprints. Types of books include western history, geology, natural history/nature. Specializes in geology, natural history, history, horses, western topics. Publishes 20 titles/year. Recent titles include: *From Angels to Hellcats: Legendary Texas Women*, regional photographic field guides. Book catalog free by request.

Needs: Approached by 100 freelance artists/year. Works with 5-10 freelance illustrators/year. Buys 5-10 freelance illustrations/year. Prefers artists with experience in book illustration and design, book cover illustration. Uses freelance artists for jacket/cover illustration, text illustration and maps. 100% of design work demands knowledge of PageMaker, FreeHand or Illustrator. Works on assignment only.

First Contact & Terms: Send query letter with résumé, SASE and any samples. Samples are filed or are returned by SASE. Responds only if interested. Project editor will contact artist for portfolio review if interested. Buys one-time rights or reprint rights depending on project. Originals are returned at job's completion. Finds artists through submissions, word of mouth, sourcebooks and other publications.

Book Design: Pays by the project.

Jackets/Covers: Assigns 0-1 freelance design and 3-6 freelance illustration jobs/year. Pays by the project.

Text Illustration: Assigns 0-1 freelance illustration jobs/year. Pays by the project. Prefers b&w: pen & ink, scratchboard, ink wash, pencil.

Tips: First-time assignments are usually book cover/jacket illustration or map drafting; text illustration projects are given to "proven" freelancers.

NBM PUBLISHING CO., 555 Eighth Ave., Suite 1202, New York NY 10018. (212)643-5407. Fax: (212)643-1545. Website: www.nbmpub.com. **Publisher:** Terry Nantier. Publishes graphic novels for an audience of 18-34 year olds. Types of books include adventure, fantasy, mystery, science fiction, horror and social parodies. Recent titles include: *A Treasury of Victorian Murder* and *Boneyard*. Circ. 5,000-10,000.

- Not accepting submissions unless for graphic novels. Publisher reports too many inappropriate submissions from artists who "don't pay attention." Check their website before submitting, so you're sure that your art is appropriate for them.

N THOMAS NELSON PUBLISHERS, Nelson Publishing Group, P.O. Box 141000, Nashville TN 37214-1000. **Contact:** Art Director. Estab. 1798. Book publisher. Publishes hardcover and trade paperback originals and reprints. Types of books include contemporary, experimental and historical fiction; mystery; juvenile; young adult; reference; self-help; humor; and inspirational. Specializes in Christian living, apologetics and fiction. Publishes 150-200 titles/year. Recent titles include: *Success God's Way*; and *Prayer: My Soul's Adventure with God*, by Robert Schuller. 20-30% require freelance illustration; 90% require freelance design. Book catalog available by request.

Needs: Approached by 10-30 artists/year. Works with 6-8 freelance illustrators and 4-6 freelance designers/year. Buys 15-20 freelance illustrations/year. Prefers artists with experience in full-color illustration, computer graphics and realism. Uses freelance artists mainly for cover illustration. Also uses freelance artists for jacket/cover design. Works on assignment only. 100% of design and 25% of illustration demand knowledge of QuarkXPress, Illustrator, Photoshop, FreeHand (Mac only).

First Contact & Terms: Designers send query letter with brochure, SASE, tearsheets, photographs, slides and photocopies. Illustrators send postcard sample or query letter with photocopies, photographs, SASE, slides, tearsheets and transparencies. Accepts disk submissions compatible with Mac QuarkXPress or Abobe Photoshop. Samples are filed or are returned by SASE if requested by artist. Responds to the artist only if interested. Call to schedule an appointment to show a portfolio. Portfolio should include roughs, color photostats, tearsheets, photographs and slides. Rights purchased vary according to project. Originals returned to artist at job's completion unless negotiated otherwise.

Jackets/Covers: Assigns 25-30 freelance design and 15-20 freelance illustration jobs/year. Prefers various media, including airbrush, acrylic, ink and multimedia. No pastels or abstract art." Pays for design by the project, $600-1,500; illustration fees vary by project.

Tips: "Request a catalog and see if your style fits our materials. I want to see new ideas, but there are some styles of illustration that just don't fit who we are. I don't have a great deal of time to spend looking through art submissions, but those artists who catch my eye are usually hired soon after."

[N:] **NEW ENGLAND COMICS (NEC PRESS)**, P.O. 690346, Quincy MA 02269. Website: www.new englandcomics.com. Types of books include comic books and games. Recent titles include: *The Tick*. Book catalog available on website.

Needs: Pencillers and inkers. Is not currently interested in new stories.

First Contact & Terms: Send SASE and 2 pages of pencil or ink drawings derived from the script posted on website. Responds in 2 weeks (with SASE only).

Tips: Visit website for submissions script. Do not submit original characters or stories. Do not call.

THE NEW ENGLAND PRESS, Box 575, Shelburne VT 05482. (802) 863-2520. Fax: (802)863-1510. E-mail: nep@together.net. Website: www.nepress.com. **Managing Editor:** Christopher A. Bray. Special-izes in paperback originals on regional New England subjects and nature. Publishes 6-8 titles/year. Recent titles include: *Rum Runners & Revenuers: Prohibition in Vermont*, *Green Mountain Boys of Summer: Vermonters in the Big Leagues*, and *Spanning Time: Vermont's Covered Bridges*. 50% require freelance illustration. Books have "traditional, New England flavor."

First Contact & Terms: Approached by 50 freelance artists/year. Works with 2-3 illustrators and 1-2 designers/year. Send query letter with photocopies and tearsheets. Samples are filed. Responds only if interested. Considers complexity of project, skill and experience of artist, project's budget and turnaround time when establishing payment. Negotiates rights purchased. Originals not usually returned to artist at job's completion, but negotiable.

Book Design: Assigns 1-2 jobs/year. Payment varies.

Jackets/Covers: Assigns 2-4 illustration jobs/year. Payment varies.

Text Illustration: Assigns 2-4 jobs/year. Payment varies.

Tips: Send a query letter with your work, which should be "generally representational, but also folk-style and humorous; nothing cute."

[✓] **NORTHLAND PUBLISHING**, 2900 Fort Valley Rd., Flagstaff AZ 86002-1389. (928)774-5251. Fax: (928)774-0592. E-mail: lois@northlandpub.com. Website: www.northlandpub.com. **Art Director:** David Jenney. Estab. 1958. Company publishes hardcover and trade paperback originals. Types of books include western, natural history, Native American art, cookbooks and children's picture books. Publishes 25 titles/year. Recent titles include: *Fiesta Mexicali* and *Arizona's Greatest Golf Courses*. 50% requires freelance illustration; 25% requires freelance design. Art guidelines on website.

● Rising Moon is Northland's children's imprint.

Needs: Approached by 1,000 freelancers/year. Works with 5-12 freelance illustrators and 2-4 book design-ers/year. Prefers freelancers with experience in illustrating children's titles. Uses freelancers mainly for children's books. 100% of freelance design work demands knowledge of Illustrator, QuarkXPress or Photo-shop. Works on assignment only.

First Contact & Terms: Send query letter with résumé, SASE, tearsheets, slides and transparencies. Samples are filed or are returned by SASE if requested by artist. Will contact artist for portfolio review if interested. Portfolio should include color tearsheets and transparencies. Rights purchased vary according to project. Originals are returned at job's completion. Finds artists mostly through submissions.

Book Design: Assigns 2-4 freelance design jobs/year. Pays by the project, $500-4,500.

Jackets/Covers: No jacket/cover art needed.

Text Illustration: Assigns 5-12 freelance illustration jobs/year. Pays by the project, $1,000-10,000. Royal-ties are preferred—gives cash advances against royalties.

Tips: "Creative presentation and promotional pieces filed."

NORTHWESTERN PRODUCTS, INC., 2855 Anthony Lane S, Suite 225, Minneapolis MN 55413. (612)617-1600. Fax: (612)617-1691. **Creative Director:** Tonya Gunn. Types of products include framed art and inspirational gifts. Produces 300 products/year. 100% requires freelance illustration and design.

Needs: Approached by 30 freelancers/year. Works with 20 freelance illustrators/year. Uses freelancers for illustrations of landscape and still lifes.

First Contact & Terms: Send query letter with brochure, tearsheets, photographs and photocopies. Samples are filed by artist. Art director will contact artist for portfolio review if interested. Portfolio should include 4-color photographs and dummies. Sometimes requests work on spec before assigning a job. Nonexclusive rights purchased.

Product Design: Assigns 20 freelance design jobs/year. Pays by the project. Any medium may be used.

NORTHWOODS PRESS, P.O. Box 298, Thomaston ME 04561. Division of the Conservatory of Ameri-can Letters. Website: www.americanletters.org. **Editor:** Robert Olmsted. Estab. 1972. Specializes in hard-

cover and paperback originals of poetry. Publishes approximately 6 titles/year. Titles include *Aesop's Eagles*. 10% require freelance illustration. Book catalog for SASE.

• The Conservatory of American Letters now publishes the *Northwoods Journal*, a quarterly literary magazine. They're seeking cartoons and line art and pay cash on acceptance. Get guidelines from website.

Needs: Approached by 40-50 freelance artists/year. Works with 1-2 illustrators/year. Uses freelance artists mainly for cover illustration. Rarely uses freelance artists for text illustration.

First Contact & Terms: Send query letter to be kept on file. Art Director will contact artist for portfolio review if interested. Sometimes requests work on spec before assigning a job. Considers complexity of project, skill and experience of artist, project's budget, turnaround time and rights purchased when establishing payment. Buys one-time rights and occasionally all rights. Originals are returned at job's completion.

Book Design: Pays by the project, $10-100.

Jackets/Covers: Assigns 2-3 design jobs and 4-5 illustration jobs/year. Pays by the project, $10-100.

Text Illustration: Pays by the project, $5-20.

Tips: Portfolio should include "art suitable for book covers—contemporary, usually realistic."

N NORTHWORD PRESS, 18705 Lake Dr. E, Chanhassen MN 55317. (952)936-4700. Fax: (952)932-0386. Website: www.northwordpress.com. **Contact:** Aimee Jackson, executive editor. Estab. 1984. Book publisher; imprint of Creative Publishing International, Inc. Publishes hardcover originals and reprints and trade paperback originals and reprints. Types of books include children's nonfiction and picture book fiction, adult coffee table books, natural histories and nature guides. Specializes in nature, wildlife and environmental. Publishes about 25 titles/year. Recent titles include: Children's: *Anna's Table*, *Everything Dog*; Adult: *To the Top, Bill Fortney's Great Photography Workshop*. 30% require freelance illustration; 20% require freelance design.

Needs: Works with 5 illustrators and 5 designers/year. "We commission packages of 30-40 illustrations for 3-4 titles/year, with covers. Most books are illustrated with photos." Prefers artists with experience in wildlife art. Uses freelancers mainly for illustration. Works on assignment only.

First Contact & Terms: Send query letter with brochure, SASE, tearsheets, photographs, photocopies, photostats, slides and transparencies. "No originals, and make sure they fit in standard-size folders." Samples are filed or are returned by SASE. Responds only if interested. "I prefer samples mailed and will call to contact the artist if I want to see a portfolio." Negotiates rights purchased. Originals returned at job's completion "unless we purchase all rights."

Jackets/Covers: Assigns 5-7 cover illustrations/year.

Text Illustration: Assigns 5-7 illustration jobs/year. Pays by the project, $50-2,000. Any medium accepted.

Tips: "Must be serious and realistic art; no cartoons."

NOVALIS PUBLISHING, INC., 49 Front St. E., 2nd Floor, Toronto, ON M53 1B3 Canada. (416)363-3303. Fax: (416)363-9409. E-mail: novalis@interlog.com. Website: www.novalis.ca. **Managing Editor:** Anne Louise Mahoney. Estab. 1936. Publishes hardcover, mass market and trade paperback originals and textbooks. Primarily religious. Publishes at least 30 titles/year. 100% requires freelance illustration; 25% requires freelance design; and 25% require freelance art direction. Free book catalog available.

Needs: Approached by 4 illustrators and 4 designers/year. Works with 3-5 illustrators and 2-4 designers/year. Prefers local freelancers experienced in graphic design and production. 100% of freelance work demands knowledge of Illustrator, Photoshop, PageMaker, PageMaker, QuarkXPress.

First Contact & Terms: Send postcard sample or query letter with printed samples, photocopies, tearsheets. Samples are filed or returned on request. Will contact artist for portfolio review if interested. Rights purchased vary according to project; negotiable.

Book Design: Assigns 10-20 freelance design and 2-5 art direction projects/year. Pays for design by the hour, $25-40.

Jackets/Covers: Assigns 5-10 freelance design and 2-5 illustration jobs/year. Prefers b&w, ink, woodcuts, linocuts, varied styles. Pays for design by the project, $100-800, depending on project. Pays for illustration by the project, $100-800, depending on project. Pays for illustration by the project, $100-600.

Text Illustration: Assigns 2-10 freelance illustration jobs/year. Pays by the project, $100 minimum, depending on project.

Tips: "We look for dynamic design incorporating art and traditional, non-traditional, folk etc. with spiritual, religious, Gospel, biblical themes—mostly Judeo-Christian."

OCTAMERON PRESS, 1900 Mount Vernon Ave., Alexandria VA 22301. Website: www.octameron.com. **Editorial Director:** Karen Stokstod. Estab. 1976. Specializes in paperbacks—college financial and college admission guides. Publishes 10-15 titles/year. Titles include *College Match* and *The Winning Edge*.
Needs: Approached by 25 freelancers/year. Works with 1-2 freelancers/year. Works on assignment only.
First Contact & Terms: Send query letter with brochure showing art style or résumé and photocopies. Samples not filed are returned if SASE included. Considers complexity of project and project's budget when establishing payment. Rights purchased vary according to project.
Jackets/Covers: Works with 1-2 designers and illustators/year on 15 different projects. Pays by the project, $500-1,000.
Text Illustration: Works with variable number of artists/year. Pays by the project, $35-75. Prefers line drawings to photographs.
Tips: "The look of the books we publish is friendly! We prefer humorous illustrations."

ORCHARD BOOKS, Scholastic, 557 Broadway, New York NY 10012. (212)343-4490. Fax: (212)343-4890. Website: www.scholastic.com. Book publisher. **Art Director:** David Saylor. Estab. 1987. Publishes hardcover and paperback children's books. Specializes in picture books and novels for children and young adults. Publishes 20-30 titles/year. Recent titles include: *Talkin About Bessi*, by Nikki Grimes, illustrated by E.B. Lewis. 100% require freelance illustration; 25% require freelance design. Book catalog free for SAE with 2 first-class stamps.
Needs: Works with 50 illustrators/year. Works on assignment only. 5% of titles require freelance art direction.
First Contact & Terms: Designers send brochure and/or photocopies. Illustrators send samples, photocopies and/or tearsheets. Samples are filed or are returned by SASE only if requested. Responds to queries/submissions only if interested. Portfolios may be dropped off on Mondays and are returned the same day. Originals returned to artist at job's completion. Considers complexity of project, skill and experience of artist and project's budget when establishing payment.
Book Design: Assigns 15 freelance design jobs/year. Pays by the project, $650 minimum.
Jackets/Covers: Assigns 20 freelance design jobs/year. Pays by the project, $650 minimum.
Text Illustration: Assigns 5 freelance jobs/year. Pays by the project, minimum $2,000 advance against royalties.
Tips: "Send a great portfolio."

OREGON CATHOLIC PRESS, 5536 NE Hassalo, Portland OR 97213-3638. (503)281-1191. Fax: (503)282-3486. E-mail: jeang@ocp.org. Website: ocp.org/. **Art Director:** Jean Germano. Division estab. 1997. Types of books include religious and liturgical books specifically for, but not exclusively to, the Roman Catholic market. Publishes 2-5 titles/year. 30% requires freelance illustration. Book catalog available for 9×12 SAE with first-class stamps.
 ● Oregon Catholic Press (OCP Publications) is a nonprofit publishing company, producing music and liturgical publications used in parishes throughout the United States, Canada, England and Australia. This publisher also has listings in the Magazine and Record Labels sections.
Tips: "I am always looking for appropriate art for our projects. We tend to use work already created on a one-time-use basis, as opposed to commissioned pieces. I look for tasteful, not overtly religious art."

THE OVERLOOK PRESS, 141 Wooster St., New York NY 10012. (212)673-2210. Fax: (212)673-2296. Website: www.overlookpress.com. **Contact:** Art Director. Estab. 1970. Book publisher. Publishes hardcover originals. Types of books include contemporary and experimental fiction, health/fitness, history, fine art and children's books. Publishes 90 titles/year. Recent titles include: *Right Ho, Jeeves*, by P.G. Wodehouse. 60% require freelance illustration; 40% require freelance design. Book catalog for SASE.
Needs: Approached by 10 freelance artists/year. Works with 4 freelance illustrators and 4 freelance designers/year. Buys 5 freelance illustrations/year. Prefers local artists only. Uses freelance artists mainly for jackets. Works on assignment only.
First Contact & Terms: Send query letter with printed samples or other non-returnable material. Samples are filed. To show a portfolio, mail tearsheets and slides. Buys one-time rights. Originals returned to artist at job's completion.
Jackets/Covers: Assigns 10 freelance design jobs/year. Pays by the project, $250-350.

THE OVERMOUNTAIN PRESS, Sabre Industries, Inc., P.O. Box 1261, Johnson City TN 37605. (423)926-2691. Fax: (423)929-2464. E-mail: beth@overmtn.com. Website: www.overmtn.com. **Senior**

Editor: Elizabeth L. Wright. Estab. 1970. Publishes hardcover and trade paperback originals and reprints. Types of books include biography, children's picture books, cookbooks, history and nonfiction. Specializes in regional nonfiction (Appalachian). Publishes 40 titles/year. Recent titles include: *Lost Heritage*, *Our Living Heritage*, *Ten Friends* and *The Book of Kings: A History of Bristol TN/VA's Founding Family*. 20% requires freelance illustration. Book catalog free for 3 first-class stamps.

- The Overmountain Press has recently begun publishing southern mysteries under a new imprint—Silver Dagger Mysteries.

Needs: Approached by 10 illustrators/year. Works with 3 illustrators/year. Prefers local illustrators, designers and art directors. Prefers freelancers experienced in children's picture books. 100% of freelance design and illustration demands knowledge of Photoshop and QuarkXPress.

First Contact & Terms: Illustrators send query letter with printed samples. Samples are filed. Will contact artist for portfolio review including artwork and photocopies portraying children/kids' subjects if interested. Rights purchased vary according to project.

Jackets/Covers: Assigns 5-10 illustration jobs/year. Considers any medium and/or style. Pays by the project, royalty only, no advance. Prefers children's book illustrators.

Text Illustration: Assigns 2 freelance illustration jobs/year. Pays by the project, royalty only. Considers any style, medium, color scheme or type of work.

Tips: "We are starting a file of children's book illustrators. At this time we are not 'hiring' freelance illustrators. We are collecting names, addresses, numbers and samples of those who would be interested in having an author contact them about illustration."

RICHARD C. OWEN PUBLICATIONS INC., P.O. Box 585, Katonah NY 10536. (914)232-3903. Fax: (914)232-3977. Website: www.rcowen.com. **Art Director:** Janice Boland. Estab. 1986. Company publishes children's books. Types of books include juvenile fiction and nonfiction. Specializes in books for 5-, 6- and 7-year-olds. Publishes 15-20 titles/year. Recent titles include: *I Went to the Beach*, *Cool*, *So Sleepy*, *Bedtime*, *Sea Lights*, *Mama Cut My Hair* and *The Author on My Street* and *My Little Brother Ben*. 100% require freelance illustration.

- "Focusing on adding nonfiction for young children on subjects such as history, geography, social studies, science and technology."

Needs: Approached by 200 freelancers/year. Works with 20-40 freelance illustrators/year. Prefers freelancers with focus on children's books who can create consistency of character from page to page in an appealing setting. Needs illustrators who can illustrate human characters and figures in an appropriate and appealing manner to young children. Uses freelancers for jacket/cover and text illustration. Works on assignment only.

First Contact & Terms: Send samples of work (color brochure, tearsheets and photocopies). Samples are filed. Art director will contact artist if interested and has a suitable project available. Buys all rights. Original illustrations are returned at job's completion.

Text Illustration: Assigns 20-40 freelance illustration jobs/year. Pays by the project, $1,000 for a full book; $25-100 for spot illustrations.

Tips: "Show adequate number and only best samples of work. Send work in full color, but target the needs of the individual publisher. Send color copies of work—no slides. Be willing to work with the art director. All our books have a trade book look. No odd, distorted figures. Our readers are 5-8 years old. Try to create worlds that will captivate them."

OXFORD UNIVERSITY PRESS, English as a Second Language (ESL), 198 Madison Ave., 9th Floor, New York NY 10016. E-mail: jun@oup-usa.org. Website: www.oup-usa.org. **Senior Art Editor:** Jodi Waxman. Chartered by Oxford University. Estab. 1478. Specializes in fully illustrated, not-for-profit, contemporary textbooks emphasizing English as a second language for children and adults. Also produces wall charts, picture cards, CDs and cassettes. Recent titles include: *American Headway*, *English Time* and various Oxford Picture Dictionaries.

Needs: Approached by 1,000 freelance artists/year. Works with 100 illustrators and 8 designers/year. Uses freelancers mainly for interior illustrations of exercises. Also uses freelance artists for jacket/cover illustration and design. Some need for computer-literate freelancers for illustration. 20% of freelance work demands knowledge of QuarkXPress or Illustrator. Works on assignment only.

First Contact & Terms: Send query letter with brochure, tearsheets, photostats, slides or photographs. Samples are filed. Art Buyer will contact artist for portfolio review if interested. Artists work from detailed specs. Considers complexity of project, skill and experience of artist and project's budget when establishing payment. Artist retains copyright. Originals are returned at job's completion. Finds artists through submis-

sions, artist catalogs such as *Showcase*, *Guild Book*, etc. occasionally from work seen in magazines and newspapers, other illustrators.

Jackets/Covers: Pays by the project.

Text Illustration: Assigns 500 jobs/year. Uses black line, half-tone and 4-color work in styles ranging from cartoon to realistic. Greatest need is for natural, contemporary figures from all ethnic groups, in action and interaction. Pays for text illustration by the project, $45/spot, $2,500 maximum/full page.

Tips: "Please wait for us to call you. You may send new samples to update your file at any time. We would like to see more natural, contemporary, nonwhite people from freelance artists. Art needs to be fairly realistic and cheerful."

N PARENTING PRESS, INC., 11065 Fifth Ave. NE, #F, Seattle WA 9825. (206)364-2900. Fax: (206)364-0702. E-mail: office@ParentingPress.com. Website: www.ParentingPress.com. **Contact:** Carolyn Threadgill, publisher. Estab. 1979. Publishes trade paperback originals and hardcover originals. Types of books include nonfiction; instruction and parenting fiction. Specializes in parenting and social skill building books for children. Recent titles include: *The Way I Feel*, *Family Matters*, *Please Don't Call My Mother*. 100% requires freelance design; 100% requires freelance illustration. Book catalog free on request.

Needs: Approached by 10 designers/year and 100 illustrators/year. Works with 2 designers/year. Prefers local designers. 100% of freelance design work demands knowledge of PageMaker, Photoshop and QuarkXPress.

First Contact & Terms: Send query letter with brochure, SASE, postcard sample with photocopies, photographs and tearsheets. After introductory mailing, send follow-up postcard sample every 6 months. Accepts e-mail submissions. Prefers Windows-compatible, TIFF, JPEG files. Samples returned by SASE if not filed. Responds only if interested. Company will contact artist for portfolio review if interested. Portfolio should include b&w or color tearsheets. Rights purchased vary according to project.

Jackets/Covers: Assigns 4 freelance cover illustrations/year. Pays for illustration by the project $300-1,000. Prefers appealing human character-realistic or moderately stylized.

Text Illustration: Assigns 3 freelance illustration jobs/year. Pays by the project or shared royalty with author.

Tips: "Be willing to supply 2-4 roughs before finished art."

** PAULINE BOOKS & MEDIA**, 50 St. Pauls Ave., Boston MA 02130-3491. (617)522-8911. Fax: (617)541-9805. E-mail: design@pauline.org. Website: www.pauline.org. **Art Director:** Sr. Helen Rita Lane. Estab. 1932. Book publisher. "We also publish a children's magazine and produce audio and video cassettes." Publishes hardcover and trade paperback originals and reprints and textbooks. Also electronic books and software. Types of books include instructional, biography, preschool, juvenile, young adult, reference, history, self-help, prayer and religious. Specializes in religious topics. Publishes 20 titles/year. Art guidelines available. Sample copies for SASE with first-class postage.

Needs: Approached by 50 freelancers/year. Works with 10-20 freelance illustrators/year. Also needs freelancers for multimedia projects. 65% of freelance work demands knowledge of PageMaker, Illustrator, Photoshop, etc.

First Contact & Terms: Send query letter with résumé, SASE, tearsheets and photocopies. Accepts disk submissions compatible with Windows 95, Mac. Send EPS, TIFF, GIF or TARGA files. Samples are filed or are returned by SASE. Responds in 3 months only if interested. Rights purchased vary according to project. Originals are returned at job's completion.

Jackets/Covers: Assigns 1-2 freelance illustration jobs/year. Pays by the project.

Text Illustration: Assigns 3-10 freelance illustration jobs/year. Pays by the project.

** PAULIST PRESS**, 997 Macarthur Blvd., Mahwah NJ 07430. (201)825-7300. Fax: (201)825-8345. Website: www.paulistpress.com. **Managing Editor:** Paul McMahon. Estab. 1869. Company publishes hardcover and trade paperback originals and textbooks. Types of books include biography, juvenile and religious. Specializes in academic and pastoral theology. Publishes 95 titles/year. Recent titles include: *The Voice*, *Father Mychal Judge*, *The Voice of the Irish*, *Navigating New Terrain*. 5% requires freelance illustration; 5% requires freelance design.

 ● Paulist Press recently began to distribute a general trade imprint HiddenSpring. Books in this imprint "help readers seek the spiritual."

Needs: Works with 10-12 freelance illustrators and 15-20 designers/year. Prefers local freelancers. Uses freelancers for juvenile titles, jacket/cover and text illustration. 10% of freelance work demands knowledge of QuarkXPress. Works on assignment only.

First Contact & Terms: Send query letter with brochure, résumé and tearsheets. Samples are filed. Responds only if interested. Portfolio review not required. Negotiates rights purchased. Originals are returned at job's completion if requested.

Book Design: Assigns 10-12 freelance design jobs/year.

Jackets/Covers: Assigns 80 freelance design jobs/year. Pays by the project, $400-800.

Text Illustration: Assigns 3-4 freelance illustration jobs/year. Pays by the project.

PEACHTREE PUBLISHERS, 1700 Chattahoochee Ave., Atlanta GA 30318. (404)876-8761. Fax: (404)875-2578. E-mail: hello@peachtree-online.com. Website: www.peachtree-online.com. **Art Director:** Loraine Joyner. Production Manager: Melanie McMahon. Estab. 1977. Publishes hardcover and trade paperback originals. Types of books include children's picture books, young adults fiction, juvenile, preschool, self-help, travel, young adult. Specializes in children's and young adult titles. Publishes 20-24 titles/year. Recent titles include: *Little Rabbit Lost*, *Grandma U*, *Hey Daddy*. 100% requires freelance illustration. Call for catalog.

Needs: Approached by 750 illustrators/year. Works with 10 illustrators. Prefers fine art painterly style in children's and young adult books. "If possible, send samples that show your ability to depict subjects or characters in a consistent manner."

First Contact & Terms: Illustrators send query letter with photocopies, SASE, tearsheets. "Prefer not to receive samples from designers." Accepts Mac-compatible disk submissions but not preferred. Samples are returned by SASE. Responds only if interested. Will contact artist for portfolio review if interested. Rights purchased vary according to project. Finds freelancers through submission packets, agents and sourcebooks, including *Directory of Illustration* and *Picturebook*.

Jackets/Covers: Assigns 18-20 illustration jobs/year. Prefers acrylic, watercolor, or a mixed media on flexible material. Pays for design by the project.

Text Illustration: Assigns 4-6 freelance illustration jobs/year. Pays by the project.

Tips: "We are an independent, high-quality house with a limited number of new titles per season, therefore each book must be a jewel. We expect the illustrator to bring creative insights which expand the readers' understanding of the storyline through visual clues not necessarily expressed within the text itself."

PEARSON TECHNOLOGY GROUP, 201 W. 103rd St., Indianapolis IN 46290. (317)581-3500. Website: www.pearsonptg.com. **Operations Specialist:** Phyllis Gault. Imprints include Que, New Riders, Sams, Alpha and Brady Games. Company publishes instructional computer books and general reference books. Publishes 500 titles/year. 5-10% requires freelance illustration; 3-5% requires freelance design.

Needs: Approached by 100 freelancers/year. Works with more than 10 freelance illustrators and 10 designers/year. Buys 50 freelance illustrations/year. Uses freelancers for jacket/cover illustration and design, text illustration, direct mail and book design. 50% of freelance work demands knowledge of QuarkXPress, Illustrator and Photoshop. Finds artists through agents, sourcebooks, word of mouth, submissions and attending art exhibitions.

First Contact & Terms: Send query letter with brochure, tearsheets, photostats, résumé, photographs, slides, photocopies or transparencies. Samples are filed or returned by SASE if requested by artist. Art Director will contact artist for portfolio review if interested. Portfolio should include final art, photographs, photostats, roughs, slides, tearsheets and transparencies. Rights purchased vary according to project.

Book Design: Assigns 10 freelance design jobs/year. Pays by the project, $1,000-4,000.

Jackets/Covers: Assigns 10 freelance design and more than 10 illustration jobs/year. Pays by the project, $1,000-3,000.

Text Illustration: Pays by the project.

PELICAN PUBLISHING CO., Box 3110, Gretna LA 70054. (504)368-1175. Fax: (504)368-1195. E-mail: production@pelicanpub.com. Website: www.pelicanpub.com. **Contact:** Production Manager. Publishes hardcover and paperback originals and reprints. Publishes 70 titles/year. Types of books include travel guides, cookbooks, business/motivational, architecture, golfing, history and children's books. Books

MARKET CONDITIONS are constantly changing! If you're still using this book and it is 2005 or later, buy the newest edition of *Artist's & Graphic Designer's Market* at your favorite bookstore or order directly from Writer's Digest Books (1-800-448-0915).

have a "high-quality, conservative and detail-oriented" look. Recent titles include: *Della Ray, Majesty of St. Charles*, by Shawn O'Hisser.

Needs: Approached by 200 freelancers/year. Works with 20 freelance illustrators/year. Uses freelancers for illustration and multimedia projects. Works on assignment only. 100% of design and 50% of illustration demand knowledge of QuarkXPress, Photoshop 4.0, Illustrator 4.0.

First Contact & Terms: Designers send photocopies, photographs, SASE, slides and tearsheets. Illustrators send postcard sample or query letter with photocopies, SASE, slides and tearsheets. Samples are not returned. Responds on future assignment possibilities. Buys all rights. Originals are not returned.

Book Design: Pays by the project, $500 minimum.

Jackets/Covers: Pays by the project, $150-500.

Text Illustration: Pays by the project, $50-250.

Tips: "Show your versatility. We want to see realistic detail and color samples."

PENGUIN BOOKS, 375 Hudson St., New York NY 10014. (212)366-2000. Website: www.penguinputnam.com. **Art Director:** Paul Buckley. Publishes hardcover and trade paperback originals.

Needs: Works with 100-200 freelance illustrators and 100-200 freelance designers/year. Uses freelancers mainly for jackets, catalogs, etc.

First Contact & Terms: Send query letter with tearsheets, photocopies and SASE. Rights purchased vary according to project.

Book Design: Pays by the project; amount varies.

Jackets/Covers: Pays by the project; amount varies.

N. PENNY-FARTHING PRESS, INC., 10370 Richmond Ave., Suite 980, Houston TX 77042. E-mail: corp@pfpress.com. Website: www.pfpress.com. **Contact:** Submissions Editor. Publishes hardcover and trade paperback originals. Types of books include adventure, children's picture books, comic books, fantasy, juvenile, science fiction, young adult fiction. Specializes in comics and graphic novels. Recent titles include: *The Loch Part III*, *The Victorian: Act II*, *Self-Immolation*. Book catalog available on website.

Needs: Pencillers: Send "3-5 pencilled pages showing story-telling skills and versatility. Do not include dialogue or narrative boxes." Inkers: Send at least 3-5 samples (full-sized and reduced to letter-sized) showing interior work. "include copies of the pencils." Illustrators send color photocopies. "Please do not send oversized copies." Samples are returned by SASE ONLY. Responds in several months.

Tips: "Do not send originals. Electronic submissions will not be accepted. Do not call."

PERFECTION LEARNING CORPORATION, COVER-TO-COVER, 10520 New York Ave., Des Moines IA 50322-3775. (515)278-0133, ext. 209. Fax: (515)278-2980. E-mail: rmesser@plconline.com. Website: www.perfectionlearning.com. **Art Director:** Randy Messer. Senior Designer: Deb Bell. Estab. 1927. Publishes hardcover originals and reprints, mass market paperback originals and reprints, educational resources, trade paperback originals and reprints, high general interest/low reading level, multicultural, nature, science, social issues, sports. Specializes in high general interest/low reading level and Lit-based teacher resources. Publishes 100 titles/year. Recent titles: *American Justice II*, *The Secret Room, the Message, the Promise, and How Pigs Figure in*, *River of Ice*, *Orcas—High Seas Supermen*. All 5 titles have been nominated for ALA Quick Picks. 50% requires freelance illustration.

• Perfection Learning Corporation has had several books nominated for awards including *Iditarod*, nominated for a Golden Kite award and *Don't Bug Me*, nominated for an ALA-YALSA award.

Needs: Approached by 70 illustrators and 10-20 designers/year. Works with 30-40 illustrators/year. Prefers local designers and art directors. Prefers freelancers experienced in cover illustration and interior spot—4-color and b&w. 100% of freelance design demands knowledge of QuarkXPress.

First Contact & Terms: Illustrators send postcard or query letter with printed samples, photocopies, SASE, tearsheets. Accepts Mac-compatible disk submissions. Send EPS. Samples are filed or returned by SASE. Responds only if interested. Portfolio review not required. Rights purchased vary according to project. Finds freelancers through tearsheet submissions, illustration annuals, phone calls, artists' reps.

Jackets/Covers: Assigns 40-50 freelance illustration jobs/year. Pays for illustration by the project, $750-1,750, depending on project. Prefers illustrators with conceptual ability.

Text Illustration: Assigns 40-50 freelance illustration jobs/year. Pays by the project. Prefers freelancers who are able to draw multicultural children and good human anatomy.

Tips: "We look for good conceptual skills, good anatomy, good use of color. Our materials are sold through schools for classroom use—they need to meet educational standards."

☑ **PETER PAUPER PRESS, INC.**, 202 Mamaroneck Ave., Suite 400, White Plains NY 10601-5387. (914)681-0144. Fax: (914)681-0389. E-mail: pauperp@aol.com. **Contact:** Creative Director. Estab. 1928. Company publishes hardcover small format illustrated gift books and photo albums. Specializes in friendship, love, celebrations, holidays. Publishes 40-50 titles/year. Recent titles include: *Love Is a Beautiful Thing* and *A Friend for All Seasons*. 100% require freelance illustration; 100% require freelance design.

Needs: Approached by 75-100 freelancers/year. Works with 15-20 freelance illustrators and 3-5 designers/year. Uses freelancers for jacket/cover and text illustration. 100% of freelance design demands knowledge of QuarkXPress. Works on assignment only.

First Contact & Terms: Send query letter with brochure, résumé, SASE, photographs, tearsheets or photocopies. Samples are filed or are returned by SASE. Responds in 1 month with SASE. Art Director will contact artist for portfolio review if interested. Portfolio should include book dummy, final art, photographs and photostats. Rights purchased vary according to project. Originals are returned at job's completion. Finds artists through submissions, gift and card shows.

Book Design: Assigns 65 freelance design jobs/year. Pays by the project, $500-2,500.

Jackets/Covers: Assigns 65 freelance design and 40 illustration jobs/year. Pays by the project, $800-1,200.

Text Illustration: Assigns 65 freelance illustration jobs/year. Pays by the project, $1,000-2,800.

Tips: "Knowledge of the type of product we publish is extremely helpful in sorting out artists whose work will click for us. We are most likely to have a need for up-beat works."

ℕ PIPPIN PRESS, 229 E. 85th St., Gracie Station Box 1347, New York NY 10028. (212)288-4920. Fax: (732)225-1562. **Publisher/Editor-in-Chief:** Barbara Francis. Estab. 1987. Company publishes hardcover juvenile originals. Publishes 4-6 titles/year. Recent titles include: *Abigail's Drums*, *The Spinner's Daughter* and *The Sounds of Summer*. 100% require freelance illustration; 100% require freelance design. Book catalog free for SAE with 2 first-class stamps.

Needs: Approached by 50-75 freelance artists/year. Works with 6 freelance illustrators and 2 designers/year. Prefers artists with experience in juvenile books for ages 4-10. Uses freelance artists mainly for book illustration. Also uses freelance artists for jacket/cover illustration and design and book design.

First Contact & Terms: Send query letter with résumé, tearsheets, photocopies. Samples are filed "if they are good" and are not returned. Responds in 2 weeks. Portfolio should include selective copies of samples and thumbnails. Buys all rights. Originals are returned at job's completion.

Book Design: Assigns 3-4 freelance design jobs/year.

Text Illustration: All text illustration assigned to freelance artists.

Tips: Finds artists "through exhibits of illustration and looking at recently published books in libraries and bookstores. Aspiring illustrators should be well-acquainted with work of leading children's book artists. Visit children's rooms at local libraries to examine these books. Prepare a sketchbook showing animals and children in a variety of action drawings (running, jumping, sitting, etc.) and with a variety of facial expressions. Create scenes perhaps by illustrating a well-known fairytale. Know why you want to illustrate children's books."

PLAYERS PRESS, Box 1132, Studio City CA 91614. **Associate Editor:** Jean Sommers. Specializes in plays and performing arts books. Recent titles include: *Principles of Stage Combat*, *Theater Management* and *The American Musical Theatre*.

Needs: Works with 3-15 freelance illustrators and 1-3 designers/year. Uses freelancers mainly for play covers. Also for text illustration. Works on assignment only.

First Contact & Terms: Send query letter with brochure showing art style or résumé and samples. Samples are filed or are returned by SASE. Request portfolio review in original query. Art director will contact artist for portfolio review if interested. Portfolio should include thumbnails, final reproduction/product, tearsheets, photographs and "as much information as possible." Sometimes requests work on spec before assigning a job. Buys all rights. Considers buying second rights (reprint rights) to previously published work, depending on usage. "For costume books this is possible."

Book Design: Pays by the project, rate varies.

Jackets/Covers: Pays by the project, rate varies.

Text Illustration: Pays by the project, rate varies.

Tips: "Supply what is asked for in the listing and don't waste our time with calls and unnecessary cards. We usually select from those who submit samples of their work which we keep on file. Keep a permanent address so you can be reached."

N P&R PUBLISHING, P.O. 817, Phillipsburg NJ 08865. (908)454-0505. Fax: (908)859-2390. E-mail: dawn@prpbooks.com. Website: www.prpbooks.com. **Contact:** Dawn Premako, art director. Estab. 1930. Publishes trade paperback and hardcover originals and reprints. Types of books include religious nonfiction. Specializes in confessional publications. Publishes 40 titles/year. Recent titles include: *Addictions—A Banquet in the Grave*, *No Other God*, *A Response to Open Theism*, *Duncan's War*. 100% requires freelance design; 100% requires freelance illustration. Book catalog free with 9×12 SASE.

Needs: Approached by 3 designers and 3 illustrators/year. Works with 4 designers and 3 illustrators/year. 100% of freelance design work demands knowledge of FreeHand, Illustrator, QuarkXPress, Photoshop.

First Contact & Terms: Designers/Illustrators send query letter with résumé, tearsheets and samples. After introductory mailing, send follow-up postcard sample every 6 months. Responds only if interested. Company will contact artist for portfolio review if interested. Portfolio should include b&w and color finished art, photographs, tearsheets and thumbnails. Negotiates rights purchased. Finds freelancers through artist's submissions and word-of-mouth.

Jackets/Covers: Assigns 2 freelance cover illustration jobs/year. Prefers color, oils/acrylics. Pays for illustration by the project. Prefers children's literature.

Text Illustration: Assigns 2 freelance illustration jobs/year. Pays by the project.

Tips: "Send letters of recommendation."

N PRE-EMPTIVE PRODUCTS, DEVELOPING HEARTS SYSTEMS, 2048 Elm St., Stratford CT 06615. (203)378-6725. Fax: (203)380-0456. E-mail: berquist@ntplx.net. **President:** Tom Berquist. Estab. 1985. Publishes children's picture books. Recent titles include: *Bonding with Baby Developmental Book*.

Needs: Approached by 15-20 freelancers/year. Works with 3-5 freelancers/year. Buys 20-30 freelance designs and illustrations/year. Considers art, acrylic and watercolor. Looking especially for short, wordless books for infants.

First Contact & Terms: Designers and cartoonists send query letter with photocopies. Samples are filed and are not returned. Responds only if interested. Rights purchased vary according to project. Pays royalties of 3-5% for original art. Finds freelancers through word of mouth.

PRENTICE HALL COLLEGE DIVISION, Pearson Education, 445 Hutchinson Ave., 4th Floor, Columbus OH 43235. (614)841-3700. Fax: (614)841-3645. Website: www.prenhall.com. **Design Coordinator:** Diane Lorenzo. Specializes in college textbooks in education and technology. Publishes 300 titles/year. Recent titles include: *Exceptional Children*, by Heward; and *Electronics Fundamentals*, by Floyd.

Needs: Approached by 25-40 designers/freelancers/year. Works with 15 freelance designers/illustrators/year. Uses freelancers mainly for cover textbook design. 100% of freelance design and 70% of illustration demand knowledge of QuarkXPress 4.0, Illustrator 9.0 and Photoshop 6.0.

First Contact & Terms: Send query letter with résumé and tearsheets; sample text designs on CD in Mac format. Accepts submissions on CD in Mac files only (not PC) in software versions stated above. Samples are filed and portfolios are returned. Responds in 30 days. Rights purchased vary according to project. Originals are returned at job's completion.

Book Design: Pays by the project, $500-2,500.

Text Illustration: Assigns 20 text designs/year.

Tips: "Send a style that works well with our particular disciplines. All text designs are produced electronically, but the textbook should be appealing to the student-reader."

PROLINGUA ASSOCIATES, P.O. Box 1348, Brattleboro VT 05302-1348. (802)257-7779. Fax: (802)257-5117. E-mail: prolingu@sover.net. Website: www.prolinguaAssociates.com. **President:** Arthur A. Burrows. Estab. 1980. Company publishes textbooks. Specializes in language textbooks. Publishes 3-8 titles/year. Recent titles include: *Writing Strategies* and *Dictations and Discussions*. Most require freelance illustration. Book catalog free by request.

Needs: Approached by 10 freelance artists/year. Works with 2-3 freelance illustrators/year. Uses freelance artists mainly for pedagogical illustrations of various kinds. Also uses freelance artists for jacket/cover and text illustration. Works on assignment only.

First Contact & Terms: Send postcard sample and/or query letter with brochure, photocopies and photographs. Samples are filed. Responds in 1 month. Portfolio review not required. Buys all rights. Originals are returned at job's completion if requested. Finds artists through word of mouth and submissions.

Text Illustration: Assigns 5 freelance illustration jobs/year. Pays by the project, $200-1,200.

PULSE-FINGER PRESS, Box 488, Yellow Springs OH 45387. **Contact:** Orion Roche or Raphaello Farnese. Publishes hardbound and paperback fiction, poetry and drama. Publishes 5-10 titles/year.
Needs: Prefers local freelancers. Works on assignment only. Uses freelancers for advertising design and illustration. Pays $25 minimum for direct mail promos.
First Contact & Terms: Send query letter. "We can't use unsolicited material. Inquiries without SASE will not be acknowledged." Responds in 6 weeks; responds on future assignment possibilities. Samples returned by SASE. Send résumé to be kept on file. Artist supplies overlays for all color artwork. Buys first serial and reprint rights. Originals are returned at job's completion.
Jackets/Covers: "Must be suitable to the book involved; artist must familiarize himself with text. We tend to use modernist/abstract designs. Try to keep it simple, emphasizing the thematic material of the book." **Pays on acceptance**; $25-100 for b&w jackets.
Tips: "We do most of our work in-house; otherwise, we recruit from the rich array of talent in the colleges and universities in our area. We've used the same people—as necessary—for years; so it's very difficult to break into our line-ups. We're receptive, but our needs are so limited as to preclude much of a market."

PUSSYWILLOW, 1212 Punta Gorda St., #13, Santa Barbara CA 93103. Phone/fax: (805)899-2145. E-mail: bandanna@cox.net. **Contact:** Briar Newborn, publisher. Estab. 2002. Publishes fiction and poetry trade paperback originals and reprints. Types of books include erotic classics mainly in translation for the connoisseur or collector. Recent titles include *Wife of Bath*, *Aretino's Sonnetti Lussuriosi*. Target audience is mature adults of both sexes. No porn, yes erotica.
Needs: Sensual suggestive art pieces in any genre.
First Contact & Terms: Send samples for our files, not originals. Responds in 2 months only if interested.
Jackets/Covers: Pays at least $200.
Text Illustration: Pays by the project.
Tips: "We're more likely to commission pieces than to buy originals. Show us what you can do. Send samples we can keep on file."

G.P. PUTNAM'S SONS, PHILOMEL BOOKS, 345 Hudson St., 14th Floor, New York NY 10014-3657. (212)366-2000. Website: www.penguin.com. **Art Director, Children's Books:** Cecilia Yung. Publishes hardcover juvenile books. Publishes 60 titles/year. Free catalog available.
Needs: Illustration on assignment only.
First Contact & Terms: Provide flier, tearsheet, brochure and photocopy or stat to be kept on file for possible future assignments. Samples are returned by SASE only. "We take drop-offs on Tuesday mornings before noon and return them to the front desk after 4 p.m. the same day. Please call Carrie Fucile, (212)366-2000 in advance with the date you want to drop of your portfolio. Do not send samples via e-mail. We do not review websites or CDs."
Jackets/Covers: "Uses full-color paintings, realistic painterly style."
Text Illustration: "Uses a wide cross section of styles for story and picture books."

QUITE SPECIFIC MEDIA GROUP LTD., 7373 Pyramid Place, Hollywood CA 90046. (323)851-5797. Fax: (323)851-5798. Website: www.quitespecificmedia.com. **Contact:** Ralph Pine. Estab. 1967. Publishes hardcover originals and reprints, trade paperback reprints and textbooks. Specializes in costume, fashion, theater and performing arts books. Publishes 12 titles/year. Recent titles include: *The Medieval Tailor's Assistant*. 10% requires freelance illustration; 60% requires freelance design.
• Imprints of Quite Specific Media Group Ltd. include Drama Publishers, Costume & Fashion Press, By Design Press, Entertainment Pro and Jade Rabbit.
Needs: Works with 2-3 freelance designers/year. Uses freelancers mainly for jackets/covers. Also for book, direct mail and catalog design and text illustration. Works on assignment only.
First Contact & Terms: Send query letter with brochure and tearsheets. Samples are filed. Responds to the artist only if interested. Rights purchased vary according to project. Originals not returned. Pays by the project.

RADIO COMIX, PMB 117, 11765 West Ave., San Antonio TX 78216. E-mail: radiocomix@aol.com. Website: www.radiocomix.com. **Contact:** Will Allison. Types of books include fantasy, science fiction, American manga, animal/anthropomorphic, independent or adults only fiction. Recent titles include: *Milk! #3* (adults only), *Mangaphile*, *The Collected Skunkworks* (adults only). Book catalog on website.
First Contact & Terms: Send photocopies (no larger than 8½×11), digital submissions (Zip disk or CD but must be accompanied by photocopies). Prefers TIFF files, 400 dpi minimum. Samples are not filed

or returned. Responds as soon as possible. Company will contact artist for portfolio review if interested.
Tips: "All published work is creator-owned. Visit website to see what submissions we are currently looking for." No superheroes.

RAINBOW BOOKS, INC., P.O. Box 430, Highland City FL 33846-0430. (863)648-4420. Fax: (863)647-5951. E-mail: RBIbooks@aol.com. **Media Buyer:** Betsy A. Lampe. Estab. 1979. Company publishes hardcover and trade paperback originals. Types of books include instruction, adventure, biography, travel, self-help, religious, mystery, reference, history and cookbooks. Specializes in nonfiction, self help and how-to. Publishes 20 titles/year. Recent titles include: *How to Handle Bullies and Teasers and Other Meanies* and *Medical School Is Murder*.
Needs: Approached by hundreds of freelance artists/year. Works with 5 illustrators/year. Prefers freelancers with experience in book-cover design and line illustration. Uses freelancers for jacket/cover illustration and design and text illustration. Needs computer-literate freelancers for design, illustration and production. 90% of freelance work demands knowledge of draw or design programs. Works on assignment only.
First Contact & Terms: Send brief query, tearsheets, photographs and book covers or jackets. Samples are not returned. Responds in 2 weeks. Art director will contact artist for portfolio review if interested. Portfolio should include b&w and color tearsheets, photographs and book covers or jackets. Rights purchased vary according to project. Originals are returned at job's completion.
Jackets/Covers: Assigns 10 freelance illustration jobs/year. Pays by the project, $250-1,000.
Text Illustration: Pays by the project. Prefers pen & ink or electronic illustration.
Tips: "Nothing Betsy Lampe receives goes to waste. After consideration for Rainbow Books, Inc., artists/designers are listed free in her newsletter (Publisher's Report), which goes out to over 500 independent presses (weekly). Then, samples are taken to the art department of a local school to show students how professional artists/designers market their work. Send samples (never originals), be truthful about the amount of time needed to complete a project, learn to use the computer. Study the competition (when doing book covers), don't try to write cover copy, learn the publishing business (attend small press seminars, read books, go online, make friends with the local sales reps of major book manufacturers). Pass along what you learn. Do not query via e-mail attachment."

N RAINBOW PUBLISHERS, P.O. Box 261129, San Diego CA 92196. (858)668-3260. Fax: (858)668-3328. E-mail: rbbooks@earthlink.net. **Creative Director:** Sue Miley. Estab. 1979. Publishes trade paperback originals. Types of books include religious books, reproducible Sunday School books for children ages 2-12 and Bible teaching books for children and adults. Publishes 20 titles/year. Titles include: *Favorite Bible Children*, *Make It Take It Crafts*, *Worship Bulletins for Kids*, *Cut, Color & Paste*, *God's Girls*, *Gotta Have God* and *God and Me*. Book catalog for SASE with 2 first-class stamps.
Needs: Approached by hundreds of illustrators and 50 designers/year. Works with 5-10 illustrators and 5-10 designers/year. 100% of freelance design and illustration demands knowledge of Illustrator, Photoshop and QuarkXPress.
First Contact & Terms: Send query letter with printed samples, SASE and tearsheets. Samples are filed or returned by SASE. Responds only if interested. Will contact artist for portfolio review if interested. Finds freelancers through samples sent and personal referrals.
Book Design: Assigns 25 freelance design jobs/year. Pays for design by the project, $350 minimum. Pays for art direction by the project, $350 minimum.
Jackets/Covers: Assigns 25 freelance design jobs and 25 illustration jobs/year. "Prefers computer generated-high energy style with bright colors appealing to kids." Pays for design and illustration by the project, $350 minimum. "Prefers designers/illustrators with some Biblical knowledge."
Text Illustration: Assigns 50 freelance illustration jobs/year. Pays by the project, $450 minimum. "Prefers black & white line art, preferably computer generated with limited detail yet fun."
Tips: "We look for illustrators and designers who have some Biblical knowledge and excel in working with a fun, colorful, high-energy style that will appeal to kids and parents alike. Designers must be well versed in Quark, Illustrator and Photoshop, know how to visually market to kids and have wonderful conceptual ideas!"

☑ RANDOM HOUSE CHILDREN'S BOOK GROUP, 1745 Broadway, New York NY 10019. (212)782-9000. Fax: (212)782-9698. Website: www.randomhouse.com/kids. **Art Director:** Jan Gerardi. Specializes in hardcover and mass market paperback originals and reprints. Publishes 250 titles/year. Titles include: *Wiggle Waggle Fun* and *Junie B. First Grader (at last!)*. 100% require freelance illustration.
Needs: Works with 100-150 freelancers/year. Works on assignment only.

First Contact & Terms: Send query letter with résumé, tearsheets and printed samples, photostats; no originals. Samples are filed. Negotiates rights purchased.
Book Design: Assigns 5 freelance design jobs/year. Pays by the project.
Text Illustration: Assigns 150 illustration jobs/year. Pays by the project.

■ **RANDOM HOUSE VALUE PUBLISHING**, 1745 Broadway, New York NY 10019. (212)782-9000. **Contact:** Art Director. Imprint of Random House, Inc. Other imprints include Wings, Testament, Gramercy and Crescent. Imprint publishes hardcover, trade paperback and reprints, and trade paperback originals. Types of books include adventure, coffee table books, cookbooks, children's books, fantasy, historical fiction, history, horror, humor, instructional, mainstream fiction, New Age, nonfiction, reference, religious, romance, science fiction, self-help, travel and western. Specializes in contemporary authors' work. Recent titles include work by John Saul, Mary Higgins Clark, Tom Wolfe, Dave Barry, Stephen King, Rita Mae Brown and Michael Chrichton (all omnibuses). 80% requires freelance illustration; 50% requires freelance design.
Needs: Approached by 50 freelancers/year. Works with 20 freelance illustrators and 20 designers/year. Uses freelancers mainly for jacket/cover illustration and design for fiction and romance titles. 100% of design and 50% of illustration demands knowledge of Illustrator, QuarkXPress, Photoshop and FreeHand. Works on assignment only.
First Contact & Terms: Designers send résumé and tearsheets. Illustrators send postcard sample, brochure, résumé and tearsheets. Samples are filed. Request portfolio review in original query. Art Director will contact artist for portfolio review if interested. Portfolio should include tearsheets. Buys first rights. Originals are returned at job's completion. Finds artists through *American Showcase*, *Workbook*, *The Creative Illustration Book*, artist's reps.
Book Design: Pays by the project.
Jackets/Covers: Assigns 50 freelance design and 20 illustration jobs/year. Pays by the project, $500-1,500.
Tips: "Study the product to make sure styles are similar to what we have done: new, fresh, etc."

READ'N RUN BOOKS, imprint of Crumb Elbow, Box 294, Rhododendron OR 97049. (503)622-4798. **Publisher:** Michael P. Jones. Estab. 1985. Specializes in fiction, history, environment and wildlife books for children through adults. "Books for people who do not have time to read lengthy books." Publishes 60 titles/year. Recent titles include: *Sir Dominick's Bargain*, by J. Sheridan LeFanu. "Our books, printed in b&w or sepia, are both hardbound and softbound, and are not slick looking. They are home-grown-looking books that people love." Accepts previously published material. Art guidelines for #10 SASE.
• Read 'N Run is an imprint of Crumb Elbow publishing. See listing for other imprints.
Needs: Works with 55 freelance illustrators and 10 designers/year. Prefers pen & ink, airbrush, charcoal/pencil, markers, calligraphy and computer illustration. Uses freelancers mainly for illustrating books. Also for jacket/cover, direct mail, book and catalog design. 50% of freelance work demands computer skills.
First Contact & Terms: Send query letter with brochure, tearsheets, photocopies and SASE. Samples not filed are returned by SASE. Request portfolio review in original query. Art Director will contact artist for portfolio review if interested. Artist should follow up after initial query. Portfolio should include thumbnails, roughs, final reproduction/product, color and b&w tearsheets, photostats and photographs. Will not respond to postcards. Buys one-time rights. Interested in buying second rights (reprint rights) to previously published material. Originals are returned at job's completion. Pays in copies, on publication.
Book Design: Assigns 20 freelance design jobs/year.
Jackets/Covers: Assigns 20 freelance design and 30 illustration jobs/year. Pays $75-250 or in published copies.
Text Illustration: Assigns 70 freelance illustration jobs/year. Pays by the project, $75-250.
Tips: "Generally, the artists find us by submitting samples—lots of them, I hope. We will not return phone calls. We will be publishing short-length cookbooks. I want to see a lot of illustrations showing a variety of styles. There is little that I don't want to see. We have a tremendous need for illustrations on the Oregon Trail (i.e., oxen-drawn covered wagons, pioneers, mountain men, fur trappers, etc.) and illustrations depicting the traditional way of life of Plains Indians and those of the North Pacific Coast and Columbia River with emphasis on mythology and legends. Pen & ink is coming back stronger than ever! Be versatile with your work. We will also evaluate your style and may utilize your work through another imprint that is under us, or even through our 'Wy-East Historical Journal.' "

■ **RED DEER PRESS**, Room 813, MacKimmie Library Tower, 2500 University Dr., NW, Calgary, AB T2N 1N4 Canada. (403)220-4334. Fax: (403)210-8191. E-mail: rdp@ucalgary.ca. **Managing Editor:**

Dennis Johnson. Estab. 1975. Book publisher. Publishes hardcover and trade paperback originals. Types of books include contemporary and mainstream fiction, fantasy, biography, preschool, juvenile, young adult, humor and cookbooks. Specializes in contemporary adult and juvenile fiction, picture books and natural history for children. Recent titles include: *The Saturday Appaloosa* and *Waiting for the Sun*. 100% require freelance illustration; 30% require freelance design. Book catalog available for SASE with Canadian postage.

Needs: Approached by 50-75 freelance artists/year. Works with 10-12 freelance illustrators and 2-3 freelance designers/year. Buys 50 freelance illustrations/year. Prefers artists with experience in book and cover illustration. Also uses freelance artists for jacket/cover and book design and text illustration. Works on assignment only.

First Contact & Terms: Send query letter with résumé, tearsheets, photographs and slides. Samples are filed. To show a portfolio, mail b&w slides and dummies. Rights purchased vary according to project. Originals returned at job's completion.

Book Design: Assigns 3-4 design and 6-8 illustration jobs/year. Pays by the project.

Jackets/Covers: Assigns 6-8 design and 10-12 illustration jobs/year. Pays by the project, $300-1,000 CDN.

Text Illustration: Assigns 3-4 design and 4-6 illustration jobs/year. Pays by the project. May pay advance on royalties.

Tips: Looks for freelancers with a proven track record and knowledge of Red Deer Press. "Send a quality portfolio, preferably with samples of book projects completed."

RED WHEEL/WEISER, (Publishers of RedWheel, Weiser Books and Conari Press), 368 Congress St., 4th Floor, Boston MA 02210. (617)542-1324. Fax: (617)482-9676. E-mail: kfivel@redwheelweiser.com. Website: www.redwheelweiser.com. **Contact:** Kathleen Wilson Fivel, art director. Specializes in hardcover and paperback originals, reprints and trade publications: Red Wheel: spunky self-help; Weiser Books: metaphysics/oriental philosophy/esoterical; Conari Press: self-help/inspirational. Publishes 24 titles/year.

Needs: Freelancers for jacket/cover design and illustration.

First Contact & Terms: Designers send query letter with résumé, photocopies and tearsheets. Illustrators send query letter with photocopies, photographs, SASE and tearsheets. "We can use art or photos. I want to see samples I can keep." Samples are filed or are returned by SASE only if requested by artist. Responds in 1 month only if interested. Originals are returned to artist at job's completion. To show portfolio, mail tearsheets, color photocopies or slides. Considers complexity of project, skill and experience of artist, project's budget, turnaround time and rights purchased when establishing payment. Buys one-time nonexclusive rights. Finds most artists through references/word-of-mouth, portfolio reviews and samples received through the mail.

Jackets/Covers: Assigns 20 design jobs/year. Prefers airbrush, watercolor, acrylic and oil. Pays by the project, $100-500.

Tips: "Send me color copies of work—something we can keep in our files. Stay in touch with phone numbers. Sometimes we get good material but then can't use it because we can't find the photographer or artist! We're interested in buying art that we use to create a cover, or in artists with professional experience with cover design—who can work from inception of design to researching/creating image to type design. We work in a purely electronic format and prefer digitally generated artwork or scans. Do not send us drawings of witches, goblins and demons, for that is not what our field is about. You should know something about us before you send materials."

RIVER CITY PUBLISHING, 1719 Mulberry St., Montgomery AL 36106. Estab. 1991. Small press. Publishes hardcover and trade paperback originals. Types of books include biography, history, coffee table books, illustrated histories, novels and travel. Specializes in Americana, history, natural history. Publishes 4 titles/year. Recent titles include: *Speaks the Nightbird*, by Robert McCammon; *Nobody's Hero*, by Paul Hamphill; and *Cloud Cuckoo Land*, by Lisa Borders.

ROWMAN & LITTLEFIELD PUBLISHERS, INC., Parent company: University Press of America, 4720 Boston Way, Suite A, Lanham MD 20706. (301)731-9534. Fax: (301)459-3464. E-mail: ghenry@univ press.com. Website: www.rowmanlittlefield.com. **Art Director:** Giséle Byrd Henry. Estab. 1975. Publishes hardcover originals and reprints, textbooks, trade paperback originals and reprints. Types of books include biography, history, nonfiction, reference, self help, textbooks. Specializes in nonfiction trade. Publishes 250 titles/year. Recent titles include: *Orphans of Islam*. 100% of titles require freelance design. Does not use freelance illustrations. Book catalog not available.

Needs: Approached by 10 designers/year. Works with 20 designers/year. Prefers freelancers experienced in typographic design, Photoshop special effects. 100% of freelance design demands knowledge of Photoshop and QuarkXPress.

First Contact & Terms: Designers send query letter with printed samples, photocopies, tearsheets, SASE. Accepts Mac-compatible disk submissions. Send TIFF files. Samples are filed or returned by SASE. Responds only if interested. Portfolio review not required. Buys all rights. Finds freelancers through submission packets and word of mouth.

Jackets/Covers: Assigns 150 freelance design jobs/year. Prefers postmodern, cutting-edge design and layering, filters and special Photoshop effects. Pays for design by the project $500-1,100. Prefers interesting "on the edge" typography. Must be experienced book jacket designer.

Tips: "All our designers must work on a Mac platform, and all files imported into Quark. Proper file set up is essential. Looking for cutting edge trade nonfiction designers who are creative and fluent in all special effect software."

SCHOLARLY RESOURCES INC., 104 Greenhill Ave., Wilmington DE 19805-1897. (302)654-7713. Fax: (302)654-3871. E-mail: tmoyer@scholarly.com. Website: www.scholarly.com. **Marketing Manager:** Toni Moyer. Estab. 1972. Publishes textbooks and trade paperback originals. Types of books include American history, Latin American studies, military history and reference books. Publishes 40 titles/year. Recent titles include: *World War II on the Web: A Guide to the Very Best Sites*, *Gotham at War: New York City, 1860-1865* and *Indians, Oil, and Politics: A Recent History of Ecuador*. 60% requires freelance illustration; 80% requires freelance design. Book catalog free.

Needs: Works with 3 illustrators and 8 designers/year. Prefers freelancers experienced in book design. 100% of freelance design demands knowledge of PageMaker and QuarkXPress.

First Contact & Terms: Designers and illustrators send query letter with printed samples, photocopies, tearsheets and SASE. Accepts Mac-compatible disk submissions. Samples are filed. Responds only if interested. Will contact artist for portfolio review if interested. Buys all rights. Finds freelancers through submission packets and networking events.

Book Design: Assigns 12 freelance design jobs/year. Pays by the project, $400-800.

Jackets/Covers: Assigns 30 freelance design jobs/year. Pays by the project, $1,000-1,500.

SCHOLASTIC INC., 557 Broadway, New York NY 10012. Website: www.scholastic.com. **Creative Director:** David Saylor. Specializes in paperback originals of young adult, biography, classics, historical and contemporary teen. Publishes 750 titles/year. Recent titles include: *The Three Questions* and *When Marian Sang*. 80% require freelance illustration. Books have "a mass-market look for kids."

● David Saylor is in charge of all imprints, from mass market to high end. Publisher uses digital work only for mass market titles. All other imprints prefer traditional media such as watercolors and pastels.

Needs: Approached by 100 freelancers/year. Works with 75 freelance illustrators and 2 designers/year. Prefers local freelancers with experience. Also for jacket/cover illustration and design and book design. 40% of illustration demand knowledge of QuarkXPress, Illustrator, Photoshop.

First Contact & Terms: Illustrators send postcard sample or tearsheets. Samples are filed or are returned only if requested, with SASE. Art Director will contact artist for portfolio review if interested. Considers complexity of project and skill and experience of artist when establishing payment. Originals are returned at job's completion. Finds artists through word of mouth, *American Showcase*, *RSVP* and Society of Illustrators.

Book Design: Pays by the project, $2,000 and up.

Jackets/Covers: Assigns 200 freelance illustration jobs/year. Pays by the project, $2,000-5,000.

Text Illustration: Pays by the project, $1,500 minimum.

Tips: "Illustrators should research the publisher. Go into a bookstore and look at the books. Gear what you send according to what you see is being used. It is particularly helpful when illustrators include on their postcard a checklist of phrases, such as 'Please keep mailing samples' or 'No, your work is not for us.' That way, we can prevent the artists who we don't want from wasting postage and we can encourage those we'd like to work with."

SCHOLASTIC LIBRARY PUBLISHING, 90 Sherman Turnpike, Danbury CT 06810. Parent company of imprints Children's Press, Franklin Watts, Grolier and Grolier Online.

● Scholastic Library Publishing specializes in children's nonfiction, reference an online reference.

[N] [T] SCHOOL GUIDE PUBLICATIONS, 210 North Ave., New Rochelle NY 10801. (800)433-7771. Fax: (914)632-3412. E-mail: info@schoolguides.com. Website: www.schoolguides.com. **Art Director:** Melvin Harris. Assistant Art Director: Tory Ridder. Estab. 1935. Types of books include reference and educational directories. Specializes in college recruiting publications. Recent titles include: *School Guide*, *Graduate School Guide*, *College Transfer Guide*, *Armed Services Veterans Education Guide* and *College Conference Manual*. 25% requires freelance illustration; 75% requires freelance design.

Needs: Approached by 10 illustrators and 10 designers/year. Prefers local freelancers. Prefers freelancers experienced in book cover and brochure design. 100% of freelance design and illustration demands knowledge of Illustrator, Photoshop, QuarkXPress.

First Contact & Terms: Send query letter with printed samples. Accepts Mac-compatible disk submissions. Send EPS files. Samples are filed. Responds only if interested. Will contact artist for portfolio review if interested. Rights purchased vary according to project. Finds freelancers through word of mouth.

Book Design: Assigns 4 freelance design and 4 art direction projects/year.

Jackets/Covers: Assigns 8 freelance design jobs/year.

Tips: "We look for an artist/designer to create a consistent look for our publications and marketing brochures."

17TH STREET PRODUCTIONS, Division of Alloy, 151 W. 26th St., 11th Floor, New York NY 10001. (212)244-4307. **Contact:** Sandy Demarco, art director. Independent book producer/packager. Publishes mass market paperback originals. Publishes mainstream fiction, juvenile, young adult, self-help and humor. Publishes 125 titles/year. Recent titles include: *Roswell High*, *Sweet Valley High*, *Sweet Valley Twins* series, *Summer* series and *Bonechillers* series. 80% require freelance illustration; 25% require freelance design. Book catalog not available.

Needs: Approached by 50 freelance artists/year. Works with 20 freelance illustrators and 5 freelance designers/year. Only uses artists with experience in mass market illustration or design. Uses freelance artists mainly for jacket/cover illustration and design. Also uses freelance artists for book design. Works on assignment only.

First Contact & Terms: Send query letter with résumé, SASE, tearsheets, photographs and photocopies. Samples are filed or returned by SASE if requested by artist. Responds to the artist only if interested. To show portfolio, mail original/final art, slides dummies, tearsheets and transparencies. Sometimes requests work on spec before assigning a job. Rights purchased vary according to project. Originals are returned at job's completion.

Jackets/Covers: Assigns 10 freelance design and 50-75 freelance illustration jobs/year. Only criteria for media and style is that they reproduce well.

Tips: "Know the market and have the professional skills to deliver what is requested on time. Book publishing is becoming very competitive. Everyone seems to place a great deal of importance on the cover design as that affects a book's sell through in the book stores."

SIMON & SCHUSTER, Division of Viacom, 1230 Avenue of the Americas, New York NY 10020. (212)698-7000. Fax: (212)698-7007. Website: www.simonsays.com. **Art Director:** Michael Accordino. Imprints include Pocket Books, Minstrel and Archway. Company publishes hardcover, trade paperback and mass market paperback originals, reprints and textbooks. Types of books include juvenile, preschool, romance, self-help, young adult and many others. Specializes in young adult, romance and self help. 95% require freelance illustration; 80% require freelance design.

Needs: Works with 50 freelance illustrators and 5 designers/year. Prefers freelancers with experience working with models and taking direction well. Uses freelancers for hand lettering, jacket/cover illustration and design and book design. 100% of design and 75% of illustration demand knowledge of Illustrator and Photoshop. Works on assignment only.

First Contact & Terms: Send query letter with tearsheets. Accepts disk submissions. Samples are filed and are not returned. Responds only if interested. Portfolios may be dropped off every Monday and Wednesday and should include tearsheets. Buys all rights. Originals are returned at job's completion.

Text Illustration: Assigns 50 freelance illustration jobs/year.

SIMON & SCHUSTER CHILDREN'S PUBLISHING, 1230 Avenue of the Americas, 4th Floor, New York NY 10020. (212)698-7000. Website: www.simonsays.com. **Vice President/Creative Director:** Lee Wade. Imprints include Alladin, Atheneum, McElderry, Simon & Schuster Books for Young Readers, Simon Pulse, Simon Spotlight. Imprint publishes hardcover originals and reprints. Types of books include

picture books, nonfiction and young adult. Publishes 80 titles/year. 100% require freelance illustration; 1% require freelance design.

• Simon & Schuster's Children's Publishing division has many different imprints each with a unique specialty; and each with its own art director. Imprints include Simon Spotlight (Art Director Chani Yammer), Simon Pulse (Art Director Russell Gordon), Books for Young Readers (Dan Potash), Alladin (Debbie Sfetsios) and McElderry (Ann Bobco).

Needs: Approached by 200 freelancers/year. Works with 40 freelance illustrators and 2-3 designers/year. Uses freelancers mainly for jackets and picture books. 100% of design work demands knowledge of Illustrator, QuarkXPress and Photoshop. Works on assignment only.

First Contact & Terms: Designers send query letter with résumé and photocopies. Illustrators send postcard sample or other nonreturnable samples. Accepts disk submissions. Art Director will contact artist for portfolio review if interested. Portfolio should include original art, photographs and transparencies. Originals are returned at job's completion. Finds artists through submissions, agents, scouting in nontraditional juvenile areas such as painters, editorial artists.

Jackets/Covers: Assigns 20 freelance illustration jobs/year. Pays by the project, $800-2,000. "We use full range of media: collage, photo, oil, watercolor, etc."

Text Illustration: Assigns 30 freelance illustration jobs/year. Pays by the project.

N ☘ ☗ SOMERVILLE HOUSE INC., 24 Dinnick Crescent, Toronto, ON M4N 1L5 Canada. (416)489-7769. E-mail: somer@sympatico.ca. Website: www.sombooks.com. **Creative Director:** Jane Somerville. Estab. 2000. Publishes mass market and trade paperback originals. Types of books include juvenile. Titles include: *The Titanic Book and Submersible Model*, *Toe Tapper*, and *Plant-a-Page: Grow a Butterfly Garden*. 100% requires freelance illustration, design and art direction. Book catalog free for sufficient Canadian postage, or visit website.

First Contact & Terms: Designers send postcard sample and follow-up postcard every year. Illustrators send query letter with printed samples, photocopies and tearsheets. Samples are filed. Responds only if interested. Will contact artist for portfolio review if interested. Rights purchased vary according to project. Finds freelancers through design community and various publications.

Book Design: Assigns 4 freelance design and 4 freelance art direction projects/year. Pays by the project.

Jackets/Covers: Assigns 4 freelance design and 4 illustration jobs/year.

Text Illustration: Assigns 4 freelance illustration jobs/year. Pays by the project.

SOURCEBOOKS, INC., 1935 Brookdale Rd., Suite 139, Naperville IL 60563. (630)961-3900. Fax: (630)961-2168. Estab. 1987. Company publishes hardcover and trade paperback originals and ancillary items. Types of books include humor, New Age, nonfiction, fiction, preschool, reference, self-help and gift books. Specializes in business books and gift books. Publishes 150 titles/year. Recent titles include: *Poetry Speaks*, *Conscious Cuisine*, *The Last Noel*. Book catalog free for SAE with $2.86 postage.

Needs: Uses freelancers mainly for ancillary items, journals, jacket/cover design and illustration, text illustration, direct mail, book and catalog design. 100% of design and 25% of illustration demand knowledge of QuarkXPress 4.0, Photoshop 5.0 and Illustrator 8.0. Works on assignment only.

First Contact & Terms: Designers send query letter with photocopies. Illustrators send postcard sample. Accepts disk submissions compatible with Illustrator 8.0, Photoshop 5.0. Send EPS files. Responds only if interested. Request portfolio review in original query. Negotiates rights purchased.

Book Design: Pays by the project.

Jackets/Covers: Pays by the project.

Text Illustration: Pays by the project.

Tips: "We have expanded our list tremendously and are, thus, looking for a lot more artwork. We have terrific distribution in retail outlets and are looking to provide more great-looking material."

THE SPEECH BIN, INC., 1965 25th Ave., Vero Beach FL 32960. (561)770-0007. Fax: (561)770-0006. Website: www.speechbin.com. **Senior Editor:** Jan J. Binney. Estab. 1984. Publishes textbooks and educational games and workbooks for children and adults. Specializes in tests and materials for treatment

NEED HELP? For tips on finding markets and understanding listings, see our Quick-Start Guide in the front of this book.

of individuals with all communication disorders. Publishes 20-25 titles/year. Recent titles include: *I Can Say R*, *I Can Say S*, *R & L Stories Galore*. 50% require freelance illustration; 50% require freelance design. Book catalog available for 8½×11 SAE with $1.48 postage.

Needs: Works with 8-10 freelance illustrators and 2-4 designers/year. Buys 1,000 illustrations/year. Work must be suitable for handicapped children and adults. Uses freelancers mainly for instructional materials, cover designs, gameboards, stickers. Also for jacket/cover and text illustration. Occasionally uses freelancers for catalog design projects. Works on assignment only.

First Contact & Terms: Send query letter with SASE, tearsheets and photocopies. Samples are filed or are returned by SASE if requested by artist. Responds to the artist only if interested. Do not send portfolio; query only. Usually buys all rights. Considers buying second rights (reprint rights) to previously published work. Finds artists through "word of mouth, our authors and submissions by artists."

Book Design: Pays by the project.

Jackets/Covers: Assigns 10-12 freelance design jobs and 10-12 illustration jobs/year. Pays by the project.

Text Illustration: Assigns 6-10 freelance illustration jobs/year. Prefers b&w line drawings. Pays by the project.

SPINSTERS INK BOOKS, P.O. Box 22005, Denver CO 80222. (303)762-7284. Fax: (303)761-5284. E-mail: spinster@spinsters-ink.com. Website: www.spinsters-ink.com. **Production Manager:** Grant Dunmire. Editorial Director: Sharon Silvas. Corporate Communications Manager: Nina Miranda. Estab. 1978. Company publishes trade paperback originals and reprints. Types of books include contemporary fiction, mystery, biography, young women, reference, history of women, humor and feminist. Specializes in "fiction and nonfiction that deals with significant issues in women's lives from a feminist perspective." Publishes 12 titles/year. Recent titles include: *Voices of the Soft-Bellied Warrior*, by Mary Saracind (memoir); *Look Me in the Eye: Old Women, Aging, & Ageism (nonfiction new expanded edition)*. 50% require freelance illustration; 100% require freelance design. Book catalog free by request.

Needs: Approached by 24 freelancers/year. Works with 6-8 freelance illustrators and 6-8 freelance designers/year. Buys 10-14 freelance illustrations/year. Prefers artists with experience in "portraying positive images of women's diversity." Uses freelance artists for jacket/cover illustration and design, book and catalog design. 100% of freelance work demands knowledge of Illustrator, Photoshop, QuarkXPress or InDesign. Works on assignment only.

First Contact & Terms: Designers send query letter with résumé. Illustrators send postcard sample with photocopies and SASE. Accepts submissions on disk compatible with QuarkXPress or InDesign. Samples are filed or are returned by SASE if requested by artist. Responds in 6 weeks. Art Director will contact artist for portfolio review if interested. Portfolio should include b&w and color thumbnails, final art and photographs. Buys first rights. Originals are returned at job's completion. Finds artists through word of mouth and submissions.

Jackets/Covers: Assigns 14 freelance design and 14 freelance illustration jobs/year. Pays by the project, $200-1,000. Prefers "original art with appropriate type treatment, b&w to 4-color. Often the entire cover is computer-generated, with scanned image. Our production department produces the entire book, including cover, electronically."

Text Illustration: Assigns 0-6 freelance illustrations/year. Pays by the project, $75-150. Prefers "b&w line drawings or type treatment that can be converted electronically. We create the interior of books completely using desktop publishing technology on the Macintosh."

Tips: "We're always looking for freelancers who have experience portraying images of diverse women, and who have current technological experience on the computer."

N STAR PUBLISHING, Box 68, Belmont CA 94002. (650)591-3505. Fax: (650)591-3898. E-mail: mail@starpublishing.com. Website: www.starpublishing.com. **Publisher:** Stuart Hoffman. Estab. 1978. Specializes in original paperbacks and textbooks on science, art, business. Publishes 12 titles/year. 33% require freelance illustration. Titles include *Microbiology Techniques*.

STARBURST PUBLISHERS, P.O. Box 4123, Lancaster PA 17604. (717)293-0939. Fax: (717)293-1945. E-mail: editorial@starburstpublishers.com. **Publisher:** David Robie. Senior Editor: Deb Strubel. Estab. 1982. Publishes hardcover originals and trade paperback originals and reprints. Types of books include contemporary and historical fiction, celebrity biography, self help, cookbooks and other nonfiction. Specializes in inspirational and general nonfiction. Publishes 10-12 titles/year. Recent titles include: *Acts: God's Word for the Biblically Inept*. 50% require freelance design; 50% require freelance illustration. Books

contain strong, vibrant graphics or realistic pen & ink drawings. Book catalog available for SAE with 4 first-class stamps.

Needs: Works with 3 freelance illustrators and designers/year. Buys 10 illustrations/year. Prefers artists with experience in publishing and knowledge of mechanical layout. Uses freelancers mainly for jacket/ cover design and illustration. Works on assignment only.

First Contact & Terms: Send query letter with tearsheets or samples. Samples are filed or are returned by SASE. Art Director will contact artist for portfolio review if interested. Sometimes requests work on spec before assigning a job. Buys all rights. Considers buying second rights (reprint rights) to previously published artwork. Originals are not returned.

Book Design: Assigns 5-7 freelance design jobs/year. Pays by the project, $200 minimum.

Jackets/Cover: Assigns 10-12 freelance jobs/year. Pays by the project, $200 minimum.

Text Illustration: Assigns 15 illustration jobs/year. Pays by the project, $200 minimum.

STEMMER HOUSE PUBLISHERS, INC., 2627 Caves Rd., Owings Mills MD 21117. (410)363-3690. Fax: (410)363-8459. E-mail: stemmerhouse@comcast.net. Website: www.stemmer.com. **President:** Barbara Holdridge. Specializes in hardcover and paperback nonfiction, art books, gardening books, and design resource originals. Publishes 10 titles/year. Recent titles include: *William Morris Patterns & Designs* and *Medieval Floral Designs*. Books are "well illustrated." 10% requires freelance design; 75% requires freelance illustration.

Needs: Approached by more than 200 freelancers/year. Works with 4 freelance illustrators and 1 designer/ year. Works on assignment only.

First Contact & Terms: Designers send query letter with brochure, tearsheets, SASE, photocopies. Illustrators send postcard sample or query letter with brochure, photocopies, photographs, SASE, slides and tearsheets. Do not send original work. Material not filed is returned by SASE. Call or write for appointment to show portfolio. Responds in 6 weeks. Works on assignment only. Originals are returned to artist at job's completion on request. Negotiates rights purchased.

Book Design: Assigns 1 freelance design and 2 illustration projects/year. Pays by the project, $300-2,000.

Jackets/Covers: Assigns 4 freelance design jobs/year. Prefers paintings. Pays by the project, $300-1,000.

Text Illustration: Assigns 3 freelance jobs/year. Prefers full-color artwork for text illustrations. Pays by the project on a royalty basis.

Tips: Looks for "draftmanship, flexibility, realism, understanding of the printing process." Books are "rich in design quality and color, stylized while retaining realism; not airbrushed. We prefer non-computer. Review our books. No picture book illustrations considered currently."

SWAMP PRESS, 15 Warwick Ave., Northfield MA 01360. **Owner:** Ed Rayher. Estab. 1977. Publishes trade paperback originals. Types of books include poetry. Specializes in limited letterpress editions. Publishes 2 titles/year. Recent titles include: *Scripture of Venus* and *Tightrope*. 75% requires freelance illustration. Book catalog not available.

Needs: Approached by 10 illustrators/year. Works with 2 illustrators/year. Prefers freelancers experienced in single and 2-color woodblock/linocut illustration.

First Contact & Terms: Illustrators send query letter with photocopies and SASE. Accepts Mac-compatible disk submissions. Samples are filed or returned by SASE. Responds in 2 months. Rights purchased vary according to project.

Jackets/Covers: Pays for illustration by the project, $20-50.

Text Illustration: Assigns 2 freelance illustration jobs/year. Pays by the project, $20-50 plus copies. Prefers knowledge of letterpress.

Tips: "We are a small publisher of limited edition letterpress printed and hand-bound poetry books. We use fine papers, archival materials and original art."

JEREMY P. TARCHER, INC., 375 Hudson St., New York NY 10014. (212)366-2000. **Art Director:** David Walker. Estab. 1970s. Imprint of Penguin. Imprint publishes hardcover and trade paperback originals and trade paperback reprints. Types of books include instructional, New Age, adult contemporary and self-help. Publishes 45-50 titles/year. Recent titles include: *The End of Work*, by Jeremy Riskin; *The Artist's Way*, by Julia Cameron; and *The New Drawing on the Right Side of the Brain*, by Betty Edwards. 30% require freelance illustration; 30% require freelance design.

Needs: Approached by 10 freelancers/year. Works with 10-12 freelance illustrators and 4-5 designers/ year. Works only with artist reps. Uses jacket/cover illustration. 50% of freelance work demands knowledge of QuarkXPress. Works on assignment only.

First Contact & Terms: Send postcard sample of work or send query letter with brochure, tearsheets and photocopies. Samples are filed. Art Director will contact artist for portfolio review if interested. Portfolio should include book dummy, final art, photographs, roughs, tearsheets and transparencies. Buys first rights or one-time rights. Originals are returned at job's completion. Finds artists through sourcebooks, *Communication Arts*, word of mouth, submissions.

Book Design: Assigns 4-5 freelance design jobs/year. Pays by the project, $800-1,000.

Jackets/Covers: Assigns 4-5 freelance design and 10-12 freelance illustration jobs/year. Pays by the project, $950-1,100.

Text Illustration: Assigns 1 freelance illustration job/year. Pays by the project, $100-500.

TECHNICAL ANALYSIS, INC., 4757 California Ave. SW, Seattle WA 98116-4499. (206)938-0570. Fax: (206)938-1307. Website: www.traders.com. **Art Director:** Christine Morrison. Estab. 1982. Magazine, books and software producer. Publishes trade paperback reprints and magazines. Types of books include instruction, reference, self-help and financial. Specializes in stocks, options, futures and mutual funds. Publishes 3 titles/year. Recent titles include: *Charting the Stock Market*. Books look "technical, but creative; original graphics are used to illustrate the main ideas." 100% requires freelance illustration; 10% requires freelance design.

Needs: Approached by 100 freelance artists/year. Works with 20 freelance illustrators/year. Buys 100 freelance illustrations/year. Uses freelance artists for magazine illustration. Also uses freelance artists for text illustration and direct mail design. Works on assignment only.

First Contact & Terms: Send query letter with tearsheets, photographs or photocopies. Samples are filed. Will contact for possible assignment if interested. Buys first rights or reprint rights. Most originals are returned to artist at job's completion.

Book Design: Assigns 5 freelance design, 100 freelance illustration jobs/year. Pays by project, $30-230.

Jackets/Covers: Assigns 1 freelance design, 15 freelance illustration jobs/year. Pays by project $30-230.

Text Illustration: Assigns 5 freelance design and 100 freelance illustration jobs/year. Pays by the hour, $50-90; by the project, $100-140.

TEHABI BOOKS, INC., 4920 Carroll Canyon Rd., Suite 200, San Diego CA 92121. (858)450-9100. Fax: (858)450-9146. E-mail: nancy@tehabi.com. Website: www.tehabi.com. **Editorial Director:** Nancy Cash. Art Director: Curt Boyer. Senior Art Director: Josie Delker. Estab. 1992. Publishes softcover, hardcover, trade. Specializes in design and production of large-format, visual books. Works hand-in-hand with publishers, corporations, institutions and nonprofit organizations to identify, develop, produce and market high-quality visual books for the international market place. Produces lifestyle/gift books; institutional books; corporate-sponsored books and CD-ROMs. Publishes 12 titles/year. Recent titles include: *Titanic, Legacy of the World's Greatest Ocean Liner*, by Susan Wels; *Hooked: America's Passion for Bass Fishing*; and *Cleopatra's Palace*.

Needs: Approached by 50 freelancers/year. Works with 75-100 freelance photographers and illustrators/year. Freelancers should be familiar with PageMaker, Illustrator, QuarkXPress, Photoshop, FreeHand and 3-D programs. Works on assignment only. 3% of titles require freelance art direction.

First Contact & Terms: Send query letter with résumé, samples. "Give a follow-up call." Rights purchased vary according to project. Finds artists through sourcebooks, publications and submissions.

Text Illustration: Pays by the project, $100-10,000.

THISTLEDOWN PRESS LTD., 633 Main St., Saskatoon, SK S7H 0J8 Canada. (306)244-1722. Fax: (306)244-1762. E-mail: tdpress@shaw.ca. Website: www.thistledown.sk.ca. **Director, Production:** Allan Forrie. Estab. 1975. Publishes trade and mass market paperback originals. Types of books include contemporary and experimental fiction, juvenile, young adult and poetry. Specializes in poetry creative and young adult fiction. Publishes 10-12 titles/year. Titles include *Filling the Belly*, by Tara Manuel; *Four Wheel Drift*, by Mel Dagg.

Needs: Approached by 25 freelancers/year. Works with 8-10 freelance illustrators/year. Prefers local, Canadian freelancers. Uses freelancers for jacket/cover illustration. Uses only Canadian artists and illustrators for its title covers. Works on assignment only.

First Contact & Terms: Designers send query letter with résumé and photocopies. Illustrators send postcard samples. Samples are filed or are returned by SASE. Responds to the artist only if interested. Call for appointment to show portfolio of original/final art, tearsheets, photographs, slides and transparencies. Buys one-time rights.

Jackets/Covers: Assigns 10-12 illustration jobs/year. Prefers painting or drawing, "but we have used

tapestry—abstract or expressionist to representational." Also uses 10% computer illustration. Pays by the project, $250-600.

Tips: "Look at our books and send appropriate material. More young adult and adolescent titles are being published, requiring original cover illustration and cover design. New technology (Illustrator, Photoshop) has slightly altered our cover design concepts."

TOP COW, Imprint of Image Comics, 10350 Santa Monica Blvd., #100, Los Angeles CA 90025. E-mail: submissions@topcow.com. Website: www.topcow.com. **Contact:** Submissions Editor. Types of books include comic books. Recent titles include: *Darkness #1*, *Witchblade #60*, *Battle of the Planets #4*. Book catalog available on website.

First Contact & Terms: Send photocopies, résumé. It's best to include Top Cow characters. Show "3-4 pages of good storytelling using sequential panels." Accepts e-mail submissions from illustrators. Prefers JPEG files (under 500k). Samples not filed and not returned. Responds only if interested.

Tips: "Include only your best work. Show your grasp of dynamic anatomy, ability to draw all types of people, faces and expressions. Show your grasp of perspective. Show us detailed background."

TRIUMPH BOOKS, 601 LaSalle St., Suite 500, Chicago IL 60605. (312)939-3330. Fax: (312)663-3557. E-mail: triumphbks@aol.com. Estab. 1990. Publishes hardcover originals and reprints, trade paperback originals and reprints. Types of books include biography, coffee table books, humor, instructional, reference, sports. Specializes in sports titles. Publishes 50 titles/year. 5% requires freelance illustration; 60% requires freelance design. Book catalog free for SAE with 2 first-class stamps.

Needs: Approached by 5 illustrators and 5 designers/year. Works with 2 illustrators and 8 designers/year. Prefers freelancers experienced in book design. 100% of freelance design demands knowledge of Photoshop, PageMaker, QuarkXPress.

First Contact & Terms: Send query letter with printed samples, SASE. Accepts Mac-compatible disk submissions. Send TIFF files. Samples are filed or returned by SASE. Will contact artist for portfolio review if interested. Buys all rights. Finds freelancers through word of mouth, organizations (Chicago Women in Publishing), submission packets.

Book Design: Assigns 20 freelance design jobs/year. Pays for design by the project.

Jackets/Covers: Assigns 30 freelance design and 2 illustration jobs/year. Pays for design by the project. Prefers simple, easy-to-read, in-your-face cover treatment.

Tips: "Most of our interior design requires a fast turnaround. We do mostly one-color work with occasional two-color and four-color jobs. We like a simple, professional design."

TYNDALE HOUSE PUBLISHERS, INC., 351 Executive Dr., Carol Stream IL 60188. (630)668-8300. E-mail: talinda_laubach@tyndale.com. Website: www.tyndale.com. **Art Buyer:** Talinda M. Laubach. Vice President, Production: Joan Major. Specializes in hardcover and paperback originals as well as children's books on "Christian beliefs and their effect on everyday life." Publishes 200 titles/year. 50% require freelance illustration. Books have "high quality innovative design and illustration." Recent titles include: *Desecration* and *Bringing Up Boys*.

Needs: Approached by 50-75 freelance artists/year. Works with 30-40 illustrators and cartoonists/year.

First Contact & Terms: Send query letter, tearsheets and/or slides. Samples are filed or are returned by SASE. Responds only if interested. Considers complexity of project, skill and experience of artist, project's budget and rights purchased when establishing payment. Negotiates rights purchased. Originals are returned at job's completion except for series logos.

Jackets/Covers: Assigns 40 illustration jobs/year. Prefers progressive but friendly style. Pays by the project.

Text Illustration: Assigns 10 jobs/year. Prefers progressive but friendly style. Pays by the project.

Tips: "Only show your best work. We are looking for illustrators who can tell a story with their work and who can draw the human figure in action when appropriate." A common mistake is "neglecting to make follow-up calls. Be able to leave sample(s). Be available; by friendly phone reminders, sending occasional samples. Schedule yourself wisely, rather than missing a deadline."

ULTIMATE SPORTS FORCE, 2444 Wilshire Blvd., Suite 414, Santa Monica CA 90403. (310)829-9590. E-mail: info@ultimatesportsforce.com. Website: www.ultimatesportforce.com. **Contact:** Art Submissions. Publishes comic books fiction (sports only). Recent titles include: *Two Minute Warning*, *Gridiron Giants*, *The Mailman*. Book catalog available on website.

First Contact & Terms: Send photocopies (8½×11 only), résumé, URL, 6-8 sample storytelling pages

with your name, address, phone number and e-mail address on each page of your submission. Samples not filed and not returned. Responds only if interested.

Tips: "Sample pages must feature popular, recognizable comic book characters in the discipline you plan on working in (line art, colors); must feature your ability to capture likenesses of popular athletes set in a game situation. Unsolicited original writing materials/ideas characters will be immediately destroyed. Do not send pin-ups or originals. Please do not call."

THE UNIVERSITY OF ALABAMA PRESS, Box 870380, Tuscaloosa AL 35487-0380. (205)348-5180 or (205)348-1571. Fax: (205)348-9201. E-mail: rcook@uapress.ua.edu. Website: www.uapress.ua.edu. **Production Manager:** Rick Cook. Designer: Michelle Myatt Quinn. Specializes in hardcover and paperback originals and reprints of academic titles. Publishes 55 titles/year. Recent titles include: *Whiskey Man*, by Howell Raines; *Traces of Gold*, by Nicolas S. Witschi; and *Mark Twain in the Margins*, by Joe B. Fulton. 5% requires freelance design.

Needs: Works with 1-2 freelancers/year. Requires book design experience, preferably with university press work. Works on assignment only. 100% of freelance design demands knowledge of PageMaker 6.5, Photoshop 5.0, QuarkXPress and Illustrator.

First Contact & Terms: Send query letter with résumé, tearsheets and slides. Accepts disk submissions if compatible with Macintosh versions of above programs, provided that a hard copy that is color accurate is also included. Samples not filed are returned only if requested. Responds in a few days. To show portfolio, mail tearsheets, final reproduction/product and slides. Considers project's budget when establishing payment. Buys all rights. Originals are not returned.

Book Design: Assigns several freelance jobs/year. Pays by the project, $600 minimum.

Jackets/Covers: Assigns 5-6 freelance design jobs/year. Pays by the project, $600 minimum.

Tips: Has a limited freelance budget. "We often need artwork that is abstract or vague rather than very pointed or focused on an obvious idea. For book design, our requirements are that they be classy and, for the most part, conservative."

■ **UNIVERSITY OF PENNSYLVANIA PRESS**, 4200 Pine St., Philadelphia PA 19104-4011. (215)898-6261. Fax: (215)898-0404. E-mail: cgross@pobox.upenn.edu. Website: www.upenn.edu/pennpress/. **Design Director:** John Hubbard. Estab. 1920. Publishes audio tapes, CD-ROMs and hardcover originals. Types of books include biography, history, nonfiction, landscape architecture, art history, anthropology, literature and regional history. Publishes 70 titles/year. Recent titles include: *Bootleggers and Smuthounds* and *Red Planet*. 90% requires freelance design. Book catalog free for 8½×11 SASE with 5 first-class stamps.

Needs: Works with 7 designers/year. 100% of freelance work demands knowledge of Illustrator, Photoshop, FreeHand and QuarkXPress.

First Contact & Terms: Designers send query letter with photocopies. Illustrators send postcard sample. Accepts Mac-compatible disk submissions. Samples are not filed and are returned. Will contact artist for portfolio review if interested. Portfolio should include book dummy and photocopies. Rights purchased vary according to project. Finds freelancers through submission packets and word of mouth.

Book Design: Assigns 10 freelance design jobs/year. Pays by the project, $600-1,000.

Jackets/Covers: Assigns 60 freelance design jobs/year. Pays by the project, $500-1,000.

VOYAGEUR PRESS, 123 N. Second St., Stillwater MN 55082-5002. (651)430-2210. Fax: (651)430-2211. E-mail: books@voyageurpress.com. Website: www.voyageurpress.com. **Editorial Director:** Michael Dregni. Pre-Press Director: Andrea Rud. Estab. 1973. Book publisher. Publishes hardcover and trade paperback originals. Types of books include Americana, collectibles, travel, cookbooks, natural history and regional. Specializes in natural history, travel and regional subjects. Publishes 50 titles/year. Recent titles include: *Every Quilt Tells a Story* and *The Last Big Cats*. 10% require freelance illustration; 10% require freelance design. Book catalog free by request.

Needs: Approached by 100 freelance artists/year. Works with 2-5 freelance illustrators and 2-5 freelance designers/year. Prefers artists with experience in maps and book and cover design. Uses freelance artists mainly for cover and book design. Also uses freelance artists for jacket/cover illustration and direct mail and catalog design. 100% of design requires computer skills. Works on assignment only.

First Contact & Terms: Send postcard sample and/or query letter with brochure, photocopies, SASE and tearsheets, list of credits and nonreturnable samples of work that need not be returned. Samples are filed. Responds to the artist only if interested. "We do not review portfolios unless we have a specific

project in mind. In that case, we'll contact artists for a portfolio review." Usually buys first rights. Originals returned at job's completion.

Book Design: Assigns 2-5 freelance design jobs and 2-5 freelance illustration jobs/year.

Jackets/Covers: Assigns 2-5 freelance design and 2-5 freelance illustration jobs/year.

Text Illustration: Assigns 2-5 freelance design and 2-5 design illustration jobs/year.

Tips: "We use more book designers than artists or illustrators, since most of our books are illustrated with photographs."

☑ **WARNER BOOKS INC.**, imprint of AOL Time Warner Book Group, 1271 Avenue of the Americas, 9th Floor, New York NY 10020. (212)522-7200. Website: www.twbookmark.com. **Vice President and Creative Director of Warner Books:** Jackie Meyer. Publishes mass market paperbacks and adult trade hardcovers and paperbacks. Publishes 300 titles/year. Recent titles include: *Find Me*, by Rosie O'Donnell; *The Millionaires*, by Brad Meltzer; and *Cancer Schmancer*, by Fran Drescher. 20% requires freelance design; 80% requires freelance illustration.

 • Others in the department are Diane Luger and Flamur Tonuzi. Send them mailers for their files as well.

Needs: Approached by 500 freelancers/year. Works with 75 freelance illustrators and photographers/year. Uses freelancers mainly for illustration and handlettering. Works on assignment only.

First Contact & Terms: Do not call for appointment or portfolio review. Mail samples only. Send non-returnable brochure or tearsheets and photocopies. Samples are filed. Art Director will contact artist for portfolio review if interested. Negotiates rights purchased. Considers buying second rights (reprint rights) to previously published work. Originals are returned at job's completion (artist must pick up). "Check for most recent titles in bookstores." Finds artists through books, mailers, parties, lectures, judging and colleagues.

Jackets/Covers: Pays for design and illustration by the project. Uses all styles of jacket illustrations.

Tips: Industry trends include "graphic photography and stylized art." Looks for "photorealistic style with imaginative and original design and use of eye-catching color variations. Artists shouldn't talk too much. Good design and art should speak for themselves."

☒ **WATERBROOK PRESS**, Random House, 2375 Telstar Dr., Suite 160, Colorado Springs CO 80920. (719)264-9404. Fax: (719)590-8977. E-mail: jthamilton@randomhouse.com. Website: www.waterbrookpress.com. **Contact:** John Hamilton, art director. Estab. 1997. Publishes audio tapes, hardcover, mass market paperback and trade paperback originals. Types of books include romance, science fiction, western, young adult fiction; biography, coffee table books, religious, self-help nonfiction. Specializes in Christian titles. Publishes 60 titles/year. Recent titles include *Thorn in My Heart*, *Winner Take All*, *Bad Girls of the Bible*. 30% requires freelance design; 10% requires freelance illustration. Book catalog free on request.

Needs: Approached by 10 designers and 100 illustrators/year. Works with 4 designers and 2 illustrators/year. 90% of freelance design work demands knowledge of Illustrator, QuarkXPress and Photoshop.

First Contact & Terms: Designer/Illustrators send postcard sample with brochure, tearsheets. After introductory mailing, send follow-up postcard sample every 3 months. Samples are filed and not returned. Portfolio not required. Buys one-time rights, first North American serial rights. Finds freelancers through artist's submissions, Internet.

Jackets/Covers: Assigns 2 freelance cover illustration jobs/year. Pays for illustration by the project $600-1,000.

Text Illustration: Assigns 4 freelance illustration jobs/year. Pays by the project $200-3,000.

☒ **WEBB RESEARCH GROUP PUBLISHERS**, Box 314, Medford OR 97501. (541)664-5205. Website: www.pnwbooks.com. **Owner:** Bert Webber. Estab. 1979. Publishes hardcover and trade paperback originals. Types of books include biography, reference, history and travel. Specializes in the history and development of the Pacific Northwest and the Oregon Trail and selected areas of WWII in the Pacific. Recent titles include: *Dredging for Gold*, by Bert Webber; and *Top Secret*, by James Martin Davis and Bert Webber. 5% require freelance illustration. Book catalog for SAE with 2 first-class stamps.

Needs: Approached by more than 30 freelancers/year, "most artists waste their and our time." Uses freelancers for localizing travel maps and doing sketches of Oregon Trail scenes. Also for jacket/cover and text illustration. Works on assignment only.

First Contact & Terms: Send query letter with SASE and photocopied samples of the artists' Oregon Trail subjects. "We will look only at subjects in which we are interested—Oregon history, development and Oregon Trail. No wildlife or scenics." Samples are not filed and are only returned by SASE if requested

by artist. Responds to the artist only if interested and SASE is received. Portfolios are not reviewed. Rights purchased vary according to project. Originals often returned at job's completion.

Jackets/Covers: Assigns about 10 freelance design jobs/year. Payment negotiated.

Text Illustration: Assigns 6 freelance illustration jobs/year. Payment negotiated.

Tips: "Freelancers negatively impress us because they do not review our specifications and send samples unrelated to what we do. We do not want to see 'concept' examples of what some freelancer thinks is 'great stuff.' If the subject is not in our required subject areas, do not waste samples or postage or our time with unwanted heavy mailings. We, by policy do not, will not, will never, respond to postal card inquiries. Most fail to send SASE thus submissions go into the trashcan, never looked at, for the first thing we consider with unsolicited material is if there is a SASE. Time is valuable for artists and for us. Let's not waste it."

N ✍ WEIGL EDUCATIONAL PUBLISHERS LIMITED., 6325 Tenth St. SE, Calgary, AB T2H 2Z9 Canada. (403)233-7747. Fax: (403)233-7769. E-mail: info@weigl.com. Website: www.weigl.com. **Contact:** Managing Editor. Estab. 1979. Textbook and library series publisher catering to juvenile and young adult audience. Specializes in social studies, science-environmental, life skills, multicultural American and Canadian focus. Publishes over 100 titles/year. Titles include *The Love of Sports*, *A Guide to American States*, *20th Century USA*. Book catalog free by request.

Needs: Approached by 300 freelancers/year. Uses freelancers only during peak periods. Prefers freelancers with experience in children's text illustration in line art/watercolor. Uses freelancers mainly for text illustration or design. Also for direct mail design. Freelancers should be familiar with QuarkXPress 5.0, Illustrator 10.0 and Photoshop 7.0.

First Contact & Terms: Send résumé for initial review prior to selection for interview. Limited freelance opportunities. Graphic designers required on site. Extremely limited need for illustrators. Samples are returned by SASE if requested by artist. Responds to the artist only if interested. Write for appointment to show portfolio of original/final art (small), b&w photostats, tearsheets and photographs. Rights purchased vary according to project.

Text Illustration: Pays on project basis, depending on job. Prefers line art and watercolor appropriate for elementary and secondary school students.

WHITE MANE PUBLISHING COMPANY, INC., 63 W. Burd St., P.O. Box 708, Shippensburg PA 17257. (717)532-2237. Fax: (717)532-6110. **Vice President:** Harold Collier. Estab. 1987. Publishes hardcover originals and reprints, trade paperback originals and reprints. Types of books include biography, history, juvenile, nonfiction, religious, self-help and young adult. Publishes 70 titles/year. 10% requires freelance illustration; 50% requires freelance design. Book catalog free with SASE.

Needs: Works with 2-8 illustrators and 2 designers/year.

First Contact & Terms: Illustrators and designers send query letter with printed samples. Samples are filed. Responds only if interested. Will contact artist for portfolio review if interested. Rights purchased vary according to project. Finds freelancers through submission packets and postcards.

Jackets/Covers: Assigns 10 freelance design jobs and 2 illustration jobs/year. Pays for design by the project.

Tips: Uses art for covers, mainly—primarily historical scenes.

ALBERT WHITMAN & COMPANY, 6340 Oakton, Morton Grove IL 60053-2723. **Editor:** Kathleen Tucker. Art Director: Carol Gildar. Specializes in hardcover original juvenile fiction and nonfiction—many picture books for young children. Publishes 25 titles/year. Recent titles include: *Mabella the Clever*, by Margaret Read MacDonal; and *Bravery Soup*, by Maryann Cocca-Leffle. 100% requires freelance illustration. Books need "a young look—we market to preschoolers and children in grades 1-3."

Needs: Prefers working with artists who have experience illustrating juvenile trade books. Works on assignment only.

First Contact & Terms: Illustrators send postcard sample and tearsheets. "One sample is not enough. We need at least three. Do *not* send original art through the mail." Accepts disk submissions. Samples are not returned. Responds "if we have a project that seems right for the artist. We like to see evidence that an artist can show the same children and adults in a variety of moods, poses and environments." Rights purchased vary. Original work returned at job's completion.

Cover/Text Illustration: Cover assignment is usually part of text illustration assignment. Assigns 2-3 covers per year. Prefers realistic and semi-realistic art. Pays by flat fee for covers; royalties for picture books.

Tips: Especially looks for "an artist's ability to draw people, especially children and the ability to set an appropriate mood for the story."

WILLIAMSON PUBLISHING, P.O. Box 185, Charlotte VT 05445. (802)425-2102. E-mail: jean@williamsonbooks.com. Website: www.williamsonbooks.com. **Editorial Director:** Susan Williamson. Production Manager: Dana Pierson. Estab. 1983. Publishes trade paperback originals. Types of books include children's nonfiction (science, history, the arts), creative play, early learning, preschool and educational. Specializes in children's active hands-on learning. Publishes 15 titles/year. Recent titles include: *The Lewis & Clark Expedition*, *Awesome Ocean Science*, *Kid's Easy Bike Repair*. Book catalog free for 8½×11 SASE with 6 first-class stamps.

Needs: Approached by 200 illustrators and 10 designers/year. Works with 15 illustrators and 8 designers/year. 100% of freelance design demands computer skills. "We especially need illustrators with a vibrant black & white style—and with a sense of humor evident in illustrations." All illustrations must be provided in scanned, electronic form.

First Contact & Terms: "Please do not e-mail large files to us. We prefer receiving postcards with references to your websites. We really will look if we are interested." Designers send query letter with brochure, photocopies, résumé, SASE. Illustrators send postcard sample and/or query letter. Designers send query letter with brochure, photocopies, résumé, SASE. Illustrators send postcard sample and/or query letter with photocopies, résumé and SASE. Samples are filed. Responds only if interested.

Book Design: Pays for design and illustration by the project.

Tips: "We are actively seeking freelance illustrators and book designers to support our growing team. We are looking for mostly black & white and some 2-color illustration—step-by-step how-to (always done with personality as opposed to technical drawings). Go to the library and look up several of our books in our four series. You'll immediately see what we're all about. Then do a few samples for us. If we're excited about your work, you'll definitely hear from us. We always need designers who are interested in a non-traditional approach to kids' book design. Our books are award-winners and design and illustration are key elements to our books' phenomenal success."

WILSHIRE BOOK CO., 12015 Sherman Rd., North Hollywood CA 91605. (818)765-8579. E-mail: mpowers@mpowers.com. Website: www.mpowers.com. **President:** Melvin Powers. Company publishes trade paperback originals and reprints. Types of books include internet marketing, humor, instructional, New Age, psychology, self-help, inspirational and other types of nonfiction. Publishes 25 titles/year. Titles include: *Think Like a Winner!*, *The Princess Who Believed in Fairy Tales* and *The Knight in Rusty Armor*. 100% require freelance design. Catalog for SASE with first-class stamps.

Needs: Uses freelancers mainly for book covers, to design cover plus type. Also for direct mail design. "We need graphic design ready to give to printer. Computer cover designs are fine."

First Contact & Terms: Send query letter with fee schedule, tearsheets, photostats, photocopies (copies of previous book covers). Portfolio may be dropped off every Monday-Friday. Portfolio should include book dummy, slides, tearsheets, transparencies. Buys first, reprint or one-time rights. Interested in buying second rights (reprint rights) to previously published work. Negotiates payment.

Book Design: Assigns 25 freelance design jobs/year.

Jackets/Covers: Assigns 25 cover jobs/year.

■ **WINDSTORM CREATIVE**, 7419 Ebbert Dr. SE, Port Orchard WA 98367. (360)769-7174. Website: www.windstormcreative.com. **Senior Editor:** Ms. Cris Newport. Publishes books, CD-ROMs, internet guides. Trade paperback. Children's books as well as illustrated novels for adults. Genre work as well as general fiction. Recent titles: *Surprise for Ray*, *Miss Panda in China*, *Yen Shei and The American Bonsai* and *Roses & Thorns: Beauty & the Beast Retold*.

Needs: Prefers freelancers. Must provide references and résumé.

First Contact & Terms: See webpage for guidelines. Portfolios submitted without SASE are not reviewed. Does not respond to postcards without return postage. Keep portfolios on file. After receiving guidelines, artists should respond within 30 days with portfolio sample and SASE as well as agreement to guidelines in writing. MUST be able to work on a schedule and meet deadlines. Must be willing to revise and work closely with art director. Artists paid on royalty and retain originals of their own work.

WIZARDS OF THE COAST, P.O. Box 707, Renton WA 98057-0707. (425)204-7289. Website: www.wizards.com. **Attn:** Artist Submissions. Estab. 1990.
 ● Because of large stable of artists, very few new artists are being given assignments.

Needs: Prefers freelancers with experience in fantasy art. Art guidelines available for SASE or on website. Works on assignment only. Uses freelancers mainly for cards, posters, books. Considers all media. Looking for fantasy, science fiction portraiture art. 100% of design demands knowledge of Photoshop, Illustrator, FreeHand, QuarkXPress. 30% of illustration demands computer skills.

First Contact & Terms: Illustrators send query letter with 6-10 non-returnable full color or b&w pieces. Accepts submissions on disk. "We do not accept original artwork." Will contact for portfolio review if interested. Portfolios should include color, finished art or b&w pieces, photographs and tearsheets. Rights purchased vary according to project. Pays for design by the project, $300 minimum. Payment for illustration and sculpture depends on project. Finds freelancers through conventions, submissions and referrals.

Tips: "Remember who your audience is. Not everyone does 'babe' art."

✔ **WRIGHT GROUP-McGRAW HILL**, Parent company: McGraw Hill Companies. 1 Prudential Plaza, 130 E. Randolph St., Suite 400, Chicago IL 60601. (312)233-6600. Website: www.wrightgroup.com. **Contact:** Vickie Tripp, Amy Krupp, design managers. Publishes educational children's books. Types of books include children's picture books, history, nonfiction, preschool, educational reading materials. Specializes in education pre K-8. Publishes 150 titles/year. 100% requires freelance illustration; 5% requires freelance design.

Needs: Approached by 100 illustrators and 10 designers/year. Works with 50 illustrators and 2 designers/year. Prefers local designers and art directors. Prefers freelancers experienced in children's book production. 100% of freelance design demands knowledge of Photoshop, FreeHand, QuarkXPress.

First Contact & Terms: Send query letter with printed samples, color photocopies and follow-up postcard every 6 months. Samples are filed or returned. Will contact artist for portfolio review if interested. Buys all rights. Finds freelancers through submission packets, agents, sourcebooks, word of mouth.

Book Design: Assigns 2 freelance design and 2 freelance art direction projects/year. Pays for design by the hour, $30-35.

Text Illustration: Assigns 150 freelance illustration jobs/year. Pays by the project, $3,000-3,800.

Tips: "Illustrators will have fun and enjoy working on our books, knowing the end result will help children learn to love to read."

■ **XICAT INTERACTIVE INC.**, 800 E. Broward, Suite 700, Ft. Lauderdale FL 33301. (954)522-3900, ext. 206. Fax: (954)522-0280. E-mail: jlinn@xicat.com. Website: www.xicat.com. **Art Director:** John Linn. Estab. 1990. Produces software and games for all major platforms. Produces flight sims, action, adventure and strategy titles. Recent releases: *Motor Trend Presents*, *Lotus Challenge*, *Blackstone*, *Metal Dungeon*, *Choplifter-Crisis Shield*.

Needs: Produces 30 releases/year. Works with 2 freelancers/year. Prefers local or national freelancers who own Mac/IBM computers with experience in packaging and high-end design. "Interns are welcome as well." Uses freelancers for packaging design for software i.e. game boxes. 90% of freelance design and illustration demands knowledge of Illustrator, QuarkXPress, Photoshop, FreeHand, 3D Studio Max and Adobe Premier.

First Contact & Terms: Send or e-mail postcard sample and/or query letter with résumé. Accepts disk submissions in IBM format (Zip, 3.5″, CD). Samples are filed. Responds in 30 days. Will contact for portfolio review if interested. Portfolio should include b&w, color, final art, slides, thumbnails, transparencies or CD-ROM. Pays by the hour, $100-150 depending on complexity. Buys all rights. Finds artists through local art college like International Fine Arts College in Miami or the Art Institute of Fort Lauderdale.

Tips: "Don't stop; continue networking yourself, your ideas. Don't take no for an answer! I look for flawless work, with a not-so-conservative style. Prefer wild, flashy, distorted, fun designs."

YE GALLEON PRESS, Box 287, Fairfield WA 99012. (509)283-2422. Estab. 1937. Publishes hardcover and paperback originals and reprints. Types of books include rare Western history, Indian material, antiquarian shipwreck and old whaling accounts, and town and area histories. Publishes 20 titles/year. 10% requires freelance illustration. Book catalog on request.

First Contact & Terms: Works with 2 freelance illustrators/year. Query with samples and SASE. No advance. Pays promised fee for unused assigned work. Buys book rights.

◤◢ **ZAPP STUDIO**, 338 St. Antoine St. E., 3rd Floor, Montreal, QC H2Y 1A3 Canada. (514)954-1441. Fax: (514)954-1443. E-mail: dianem@tormont.ca. **Art Director:** Diane Mineau. Estab. 1986. Company publishes hardcover originals and reprints. Specializes in children's books. Publishes 40 titles/year. Recent

titles include: *Human Body Puzzle Book* (boxed set with 16 blocks, poster, stickers, activity book and trivia cards); *Fun World Atlas*; flash-card sets; *Math in a Flash* and *Preschool Fun!*. 50% requires freelance illustration; 30% requires freelance design.

Needs: Approached by 60 freelance illustrators/year. Works with 15 freelance illustrators and 3 designers/year. Prefers freelancers with experience in children's publications. Uses freelancers for illustration and book design. 50% of freelance work demands knowledge of Illustrator, QuarkXPress and Photoshop. Works on assignment only.

First Contact & Terms: Send postcard sample or query letter with brochure, résumé, photographs, SASE, tearsheets and photocopies. Accepts disk submissions compatible with Illustrator 8.0 and Photoshop 5.5. Send EPS files. Samples are filed and are not returned. Responds in 1 month. Art Director will contact artist for portfolio review if interested. Portfolio should include book dummy, final art or transparencies. Buys first rights. Does not pay royalties. Originals are not returned. Finds artists through sourcebooks, word of mouth, submissions and attending art exhibitions.

Tips: "Our studio's major publications are children's books focusing on 3-7 year age group."

Galleries

© Jose Pelaez

Woodcut is the medium of choice for José Peláez, a Cuban-born engraver, photographer and poet residing in San Juan, Puerto Rico. *El Regreso de Claudia* has a story behind it, says Peláez. "When a couple of turtle doves nested in a palm tree in our back yard, my older daughter, who is an animal lover, rescued one of their young that had fallen from the nest. She kept the little bird in the house, feeding her until she grew fat and healthy. The bird, whom she named Claudia, used to fly to the top of our heads whenever we entered a room. At the time I was working on a series of reinterpretations of African masks, so I combined both things into one piece and voila." Peláez's gallery, Galerias Prinardi, is listed for the first time this edition on page 505. To see more of Peláez's work visit www.prinardi.com.

Whether you are just now deciding to approach galleries or you're comtemplating branching out into other cities, this section offers lots of opportunities. You don't have to move to New York City to find a gallery. The easiest galleries to try first are the ones closest to you.

The majority of galleries will be happy to take a look at your slides if you make an appointment or mail your slides to them. If they feel your artwork doesn't fit their gallery, most will steer you toward a more appropriate one.

A few guidelines

- **Never walk into a gallery without an appointment, expecting to show your work to the gallery director**. When we ask gallery directors for pet peeves they always discuss the talented newcomer walking into the gallery with paintings in hand. Send a polished package of about 8 to 12 neatly labeled, mounted duplicate slides of your work submitted in plastic slide sheet format (refer to the listings for more specific information on each gallery's preferred submission method). Do not send original slides, as you will need them to reproduce later. Send a SASE, but realize you may not get your packet returned.
- **Seek out galleries that show the type of work you create.** Each gallery has a specific "slant" or mission. Read the interview with gallery dealer John Cram in this section for tips on finding the right one for you.
- **Visit as many galleries as you can.** Browse for a while and see what type of work they sell. Do you like the work? Is it similar to yours in quality and style? What about the staff? Are they friendly and professional? Do they seem to know about the artists the gallery handles? Do they have convenient hours? When submitting to galleries outside your city, if you can't manage a personal visit before you submit, read the listing carefully to make sure you understand what type of work is shown in that gallery and get a feel for what the space is like. Ask a friend or relative who lives in that city to check out the gallery for you.
- **Attend openings.** You'll have a chance to network and observe how the best galleries promote their artists. Sign each gallery's guest book or ask to be placed on galleries' mailing lists. That's also one good way to make sure the gallery sends out professional mailings to prospective collectors.

Showing in multiple galleries

Most successful artists show in several galleries. Once you have achieved representation on a local level, you are ready to broaden your scope by querying galleries in other cities. You may decide to concentrate on galleries in surrounding states, becoming a "regional" artist. Some artists like to have an East Coast and a West Coast gallery.

If you plan to sell work from your studio, or from a website or other galleries, be upfront with your gallery. Work out a commission arrangement you can all live with and everybody wins.

Pricing your fine art

A common question of beginning artists is "What do I charge for my paintings?" There are no hard and fast rules. The better known you become, the more collectors will pay for your work. Though you should never underprice your work, you must take into consideration what people are willing to pay. Also keep in mind that you must charge the same amount for a painting sold in a gallery as you would for work sold from your studio.

Juried shows, competitions and other outlets

It may take months, maybe years, before you find a gallery to represent you. But don't worry, there are plenty of other venues to show in until you are accepted in a commercial gallery. If

Types of Galleries

As you search for the perfect gallery, it's important to understand the different types of spaces and how they operate. The route you choose depends on your needs, the type of work you do, your long term goals, and the audience you're trying to reach.

Retail or commercial galleries. The goal of the retail gallery is to sell and promote artists while turning a profit. Retail galleries take a commission of 40 to 50 percent of all sales.

Co-op galleries. Co-ops exist to sell and promote artists' work, but they are run by artists. Members exhibit their own work in exchange for a fee, which covers the gallery's overhead. Some co-ops also take a small commission of 20 to 30 percent to cover expenses. Members share the responsibilities of gallery-sitting, sales, housekeeping and maintenance.

Rental galleries. The gallery makes its profit primarily through renting space to artists and consequently may not take a commission on sales (or will take only a very small commission). Some rental spaces provide publicity for artists, while others do not. Showing in this type of gallery is risky. Rental galleries are sometimes thought of as "vanity galleries" and, consequently they do not have the credibility other galleries enjoy.

Nonprofit galleries. Nonprofit spaces will provide you with an opportunity to sell work and gain publicity, but will not market your work aggressively, because their goals are not necessarily sales-oriented. Nonprofits normally take a small commission of 20 to 30 percent.

Museums. Though major museums generally show work by established artists, many small museums are open to emerging artists.

Art consultancies. Generally, art consultants act as liasions between fine artists and buyers. Most take a commission on sales (as would a gallery). Some maintain small gallery spaces and show work to clients by appointment.

you get involved with your local art community, attend openings, read the arts section of your local paper, you'll see there are hundreds of opportunities.

Enter group shows and competitions every chance you get. Go to the art department of your local library and check out the bulletin board, then ask the librarian to steer you to magazines like *Art Calendar* (www.artcalendar.com), that list "calls to artists" and other opportunities to exhibit your work. Subscribe to the *Art Deadlines List*, available in hard copy or online versions (www.artdeadlineslist.com). Join a co-op gallery and show your work in a space run by artists for artists.

Another opportunity to show your work is through local restaurants and retail shops that show the work of local artists. Ask the manager how you can show your work. Become an active member in an arts group. It's important to get to know your fellow artists. And since art groups often mount exhibitions of their members' work you'll have a way to show your work until you find a gallery to represent you.

For More Information

To develop a sense of various galleries and how to approach them, look to the myriad of art publications that contain reviews and articles. A few such publications are ARTnews, Art in America and regional publications such as ARTweek (West Coast), Southwest Art, dialogue and Art New England. Lists of galleries can be found in Art in America's Guide to Galleries and Art Now. The Artist's Magazine, Art Papers and Art Calendar are invaluable resources for artists and feature dozens of helpful articles about dealing with galleries.

Alabama

N THE ATCHISON GALLERY, 2847 Culver Rd., Birmingham AL 35223. (205)871-6233. **Director:** Larry Atchinson. Retail gallery and art consultancy. Estab. 1974. Represents 35 emerging, mid-career and a few established artists/year. Exhibited artists include Bruno Zupan and Cynthia Knapp. Sponsors 12 shows/year. Average display time 1 month. Open all year; Monday-Friday, 9:30-5; Saturday, 10-2. Located in the Mountain Brook Village; 2,000 sq. ft.; open ceiling, large open spaces. 25-30% of space for special exhibitions; 75% of space for gallery artists. Clientele: upscale, residential and corporate. 70-75% private collectors, 25-30% corporate collectors. Overall price range: $600-15,000; most work sold at $1,800-3,500 (except for exclusive pieces, Dine's, Warhols, etc.)

Media: Considers all media except fiber, paper and pen & ink. Considers engravings, lithographs and etchings. Most frequently exhibits oil-acrylic, mixed media and pastel.

Style: Exhibits: expressionism, painterly abstraction, minimalism, impressionism, photorealism and realism. Genres include florals, landscapes and figurative work. Prefers: painterly abstraction, impressionism and realism/figurative.

Terms: Accepts work on consignment (50% commission). Retail price set by both the gallery and artist. Gallery provides insurance, promotion and contract; shipping costs are shared. Prefers artwork unframed.

Submissions: Most artists are full-time professionals. Send query letter with résumé, bio and artist's statement with slides, brochure, photographs and/or reviews. Write for appointment to show portfolio of photographs, slides and transparencies. Responds in 1 month. Files résumé, slides, bio, photographs, artist statement and brochure. Finds artists through referrals by other artists, submissions, visiting exhibits, reviewing art journals/magazines.

CORPORATE ART SOURCE, 2960-F Zelda Rd., Montgomery AL 36106. (334)271-3772. E-mail: casjb@mindspring.com. Website: casgallery.com. **Owner:** Jean Belt. Consultant: Keven Belt. Retail gallery and art consultancy. Estab. 1985. Interested in mid-career and established artists. "I don't represent artists, but keep a slide bank to draw from as resources." Exhibited artists include: Beau Redmond and Dale Kenington. Open Monday-Friday, 10-5. Located in exclusive shopping center; 1,000 sq. ft. Clientele: corporate upscale, local. 25% private collectors, 75% corporate collectors. Overall price range: $100-50,000. Most work sold at $2,500.

Media: Considers all media and all types of prints. Most frequently exhibits oil/acrylic paintings on canvas, glass, prints, pastel and watercolor. Also interested in sculpture.

Style: Exhibits expressionism, neo-expressionism, pattern painting, color field, geometric, abstraction, postmodernism, painterly abstraction, impressionism and realism. Genres include landscapes, abstract and architectural work.

Terms: Artwork is accepted on consignment (50% commission). Retail price set by artist. Gallery provides insurance. Prefers artwork unframed.

Submissions: Send query letter with résumé, slides or photographs and SASE. Call for appointment to show portfolio of slides and photographs. Responds in 6 weeks.

Tips: "Always send several photos (or slides) of your work. An artist who sends a letter and one photo and says 'write for more info' gets trashed. We don't have time to respond unless we feel strongly about the work—and that takes more than one sample."

N EASTERN SHORE ART CENTER, 401 Oak St., Fairhope AL 36532. (251)928-2228. E-mail: esac@mindspring.com. **Executive Director:** Robin Fitzhugh. Museum. Estab. 1957. Exhibits emerging, mid-career and established artists. Average display time 1 month. Open all year. Located downtown; 8,000 sq. ft. of galleries.

• Artists applying to Eastern Shore should expect to wait at least a year for exhibits.

Media: Considers all media and prints.

Style: Exhibits all styles and genres.

Terms: Accepts works on consignment (25% commission). Retail price set by artist. Gallery provides insurance, promotion and contract. Prefers artwork framed.

Submissions: Send query letter with résumé and slides. Write for appointment to show portfolio of originals and slides.

Tips: "Conservative, realistic art is appreciated more and sells better."

N FAYETTE ART MUSEUM, 530 N. Temple Ave., Fayette AL 35555. (205)932-8727. Fax: (205)932-8788. **Director:** Jack Black. Museum. Estab. 1969. Exhibits the work of emerging, mid-career and estab-

lished artists. Open all year; Monday-Friday, 9-4 and by appointment outside regular hours. Located downtown Fayette Civic Center; 16,500 sq. ft. Six galleries devoted to folk art.

Media: Considers all media and all types of prints. Most frequently exhibits oil, watercolor and mixed media.

Style: Exhibits expressionism, primitivism, painterly abstraction, minimalism, postmodern works, impressionism, realism and hard-edge geometric abstraction. Genres include landscapes, florals, Americana, wildlife, portraits and figurative work.

Terms: Shipping costs negotiable. Prefers artwork framed.

Submissions: Send query letter with résumé, brochure and photographs. Write for appointment to show portfolio of photographs. Files possible exhibit material.

Tips: "Do not send expensive mailings (slides, etc.) before calling to find out if we are interested. We want to expand collection. Top priority is folk art from established artists."

LEON LOARD GALLERY OF FINE ARTS, 2781 Zelda Rd., Montgomery AL 36106. (334)272-0077. Fax: (334)270-0150. E-mail: leonloardgallery1_1@juno.com. **Gallery Director:** Betty Richardson. Retail gallery. Estab. 1989. Represents about 70 emerging, mid-career and established artists/year. Exhibited artists include Paige Harvey, Barbara Reed, Cheryl McClure, McCreery Jordan and Pete Beckman. Sponsors 4 shows/year. Average display time 3 months. Open all year; Monday-Friday, 10-4; weekends by appointment. Located in upscale suburb; cloth walls. 45% of space for special exhibitions; 45% of space for gallery artists. Clientele: local community—many return clients. 80% private collectors, 20% corporate collectors. Overall price range: $100-75,000; most work sold at $500-5,000.

Media: Considers oil, acrylic, watercolor, pastel, pen & ink, drawing, mixed media, collage, paper, sculpture, ceramics, fiber and glass. Most frequently exhibits oil on canvas, acrylic on canvas and watercolor on paper.

Style: Exhibits all styles and all genres. Prefers impressionism, realism and abstract.

Terms: Accepts work on consignment. Retail price set by the gallery and the artist. Gallery provides insurance, promotion and contract. Shipping costs are shared. Prefers artwork unframed.

Submissions: Send query letter with résumé, slides, bio and photographs. Portfolio should include photographs and slides. Responds in 2 weeks. Files bios and slides.

N: RENAISSANCE GALLERY, INC., 431 Main Ave., Northport AL 35476. (205)752-4422. **Owners:** Judy Buckley and Kathy Groshong. Retail gallery. Estab. 1994. Represents 25 emerging, mid-career and established artists/year. Exhibited artists include: Elayne Goodman and John Kelley. Sponsors 12 shows/year. Average display time 6 months. Open all year; Monday-Saturday, 11-4:30. Located in downtown historical district; 1,000 sq. ft.; historic southern building. 25% of space for special exhibitions; 75% of space for gallery artists. Clientele: tourists and local community. 95% private collectors; 5% corporate collectors. Overall price range: $65-3,000; most work sold at $300-900.

Media: Considers oil, acrylic, watercolor, pastel, pen & ink, mixed media, sculpture; types of prints include woodcuts and monoprints. No mass produced reproductions. Most frequently exhibits oil, acrylic and watercolor.

Style: Exhibits: painterly abstraction, impressionism, photorealism, realism, imagism and folk-whimsical. Genres include florals, portraits, landscapes, Americana and figurative work. Prefers: realism, imagism and abstract.

Terms: Accepts work on consignment (50% commission). Retail price set by the artist. Gallery provides promotion; shipping costs are shared. Prefers artwork framed. "We are not a frame shop."

Submissions: Prefers only painting, pottery and sculpture. Send query letter with slides or photographs. Write for appointment to show portfolio of photographs and sample work. Responds only if interested within 1 month. Files artists slides/photographs, returned if postage included. Finds artists through referrals by gallery artists.

Tips: "Do your homework. See the gallery before approaching. Make an appointment to discuss your work. Be open to suggestions, not defensive. Send or bring decent photos. Have work that is actually available, not already given away or sold. Don't bring in your first three works. You should be comfortable with what you are doing, past the experimental stage. You should have already produced many works of art (zillions!) before approaching galleries."

N: UNIVERSITY OF ALABAMA AT BIRMINGHAM VISUAL ARTS GALLERY, 900 13th St. S, Birmingham AL 35294-1260. (205)934-4941. Fax: (205)975-2836. **Director and Curator:** Brett M. Levine. Nonprofit university gallery. Estab. 1972. Represents emerging, mid-career and established artists.

Sponsors 10-12 exhibits/year. Average display time 3-4 weeks. Open Monday-Thursday, 11-6; Friday, 11-5; Saturday, 1-5. Closed Sundays and holidays. Located on first floor of Humanities Building, a classroom and office building, 2 rooms with a total of 2,000 sq. ft. and 222 running feet. Clients include local community, students and tourists.

Media: Considers all media except craft. Considers all types of prints.

Style: Considers all styles and genres.

Making Contact & Terms: Gallery provides insurance and promotion. Accepted work should be framed.

Submissions: Write to arrange a personal interview to show portfolio of slides. Send query letter with artist's statement, bio, brochure, photographs, résumé, reviews, SASE and slides. Returns material with SASE.

N: MARCIA WEBER/ART OBJECTS, INC., 1050 Woodley Rd., Montgomery AL 36106. (334)262-5349. Fax: (334)567-0060. E-mail: weberart@mindspring.com. Website: www.marciaweberartobjects.com. **Owner:** Marcia Weber. Retail, wholesale gallery. Estab. 1991. Represents 21 emerging, mid-career and established artists/year. Exhibited artists include: Woodie Long, Jimmie Lee Sudduth. Sponsors 6 shows/year. Open all year except July by appointment only. Located in Old Cloverdale near downtown in older building with hardwood floors in section of town with big trees and gardens. 100% of space for gallery artists. Clientele: tourists, upscale. 90% private collectors, 10% corporate collectors. Overall price range: $300-20,000; most work sold at $300-4,000.

● This gallery owner specializes in the work of self-taught, folk, or outsider artists. Many artists shown generally "live down dirt roads without phones," so a support person first contacts the gallery for them. Marcia Weber moves the gallery to New York's Soho district 3 weeks each winter and routinely shows in the Atlanta area.

Media: Considers all media except prints. Must be original one-of-a-kind works of art. Most frequently exhibits acrylic, oil, found metals, found objects and enamel paint.

Style: Exhibits genuine contemporary folk/outsider art, self-taught art and some Southern antique original works.

Terms: Accepts work on consignment (variable commission) or buys outright. Gallery provides insurance, promotion and contract if consignment is involved. Prefers artwork unframed so the gallery can frame it.

Submissions: Folk/outsider artists usually do not contact dealers. If they have a support person or helper, who might write or call, send query letter with photographs, artist's statement. Call or write for appointment to show portfolio of photographs, original material. Finds artists through word of mouth, other artists and "serious collectors of folk art who want to help an artist get in touch with me." Gallery also accepts consignments from collectors.

Tips: "An artist is not a folk artist or an outsider artist just because their work resembles folk art. They have to *be* folks who began creating art without exposure to fine art to create folk art. Outsider artists live in their own world outside the mainstream and create art. Academic training in art excludes artists from this genre. Prefers artists committed to full-time creating."

Alaska

N: ALASKA STATE MUSEUM, 395 Whittier St., Juneau AK 99801-1718. (907)465-2901. Fax: (907)465-2976. E-mail: bruce_kato@eed.state.ak.us. Website: museums.state.ak.us. **Curator of Exhibitions:** Mark Daughhetee. Museum. Estab. 1900. Approached by 40 artists/year; exhibits 4 emerging, mid-career and established artists. Sponsors 10 exhibits/year. Average display time 6-10 weeks. Downtown location—3 galleries exhibiting temporary exhibitions.

Media: Considers all media. Most frequently exhibits painting, photography and mixed media. Considers engravings, etchings, linocuts, lithographs, mezzotints, serigraphs and woodcuts.

Style: Considers all styles.

Submissions: Write to arrange a personal interview to show portfolio of slides. Returns material with SASE. Finds artists through submissions and portfolio reviews.

DECKER/MORRIS GALLERY, 621 W. Sixth Ave., Anchorage AK 99501-2127. (907)272-1489. Fax: (907)272-5395. **Managers:** Don Decker and Julie Decker. Retail gallery. Estab. 1994. Interested in emerging, mid-career and established artists. Represents 50 artists. Sponsors 15 solo and group shows/year. Average display time 4 weeks. Clientele: 90% private collectors, 10% corporate clients. Overall price range: $100-5,000; most work sold at $500-1,000.

Media: Considers oil, acrylic, watercolor, pastel, mixed media, collage, works on paper, sculpture, ceramic, craft, fiber, glass and all original handpulled prints. Most frequently exhibits oil, mixed media and all types of craft.

Style: Exhibits all styles. "We have no pre-conceived notions as to what an artist should produce." Specializes in original works by artists from Alaska and the Pacific Northwest. "We are a primary source of high-quality crafts in the state of Alaska. We continue to generate a high percentage of our sales from jewelry and ceramics, small wood boxes and bowls and paper/fiber pieces. We push the edge to avante garde."

Terms: Accepts work on consignment (50% commission). Retail price set by artist. Exclusive area representation preferred. Gallery provides insurance, promotion.

Submissions: Send letter of introduction with résumé, slides, bio and SASE.

Tips: Impressed by "high quality ideas/craftsmanship—good slides."

Arizona

N ◼ **ARIZONA STATE UNIVERSITY ART MUSEUM**, Nelson Fine Arts Center and Ceramics Research Center, Arizona State University, Tempe AZ 85287-2911. (480)965-2787. Website: asuartmuseum .asu.edu. **Director:** Marilyn Zeitlin. Museum. Estab. 1950. Presents mid-career, established and emerging artists. Sponsors 12 shows/year. Average display time 2 months. Open all year. Located downtown Tempe ASU campus. Nelson Fine Arts Center features award-winning architecture, designed by Antoine Predock. "The Ceramics Research Center, located just next to the main museum, features open storage of our 3,000 works plus collection and rotating exhibitions. The museum also presents an annual short film and video festival."

Media: Considers all media. Greatest interests are contemporary art, crafts, video, and work by Latin American and Latin artists.

Submissions: "Interested artists should submit slides to the director or curators."

Tips: "With the University cutbacks, the museum has scaled back the number of exhibitions and extended the average show's length. We are always looking for exciting exhibitions that are also inexpensive to mount."

ARTISIMO ARTSPACE, 4333 N. Scottsdale Rd., Scottsdale AZ 85251. (480)949-0433. Fax: (480)994-0959. E-mail: artisimo@earthlink.net. Website: www.artisimogallery.com. Contact: Amy Wenk, director. For-profit gallery. Estab. 1991. Approached by 30 artists/year. Represents 20 emerging, mid-career and established artists. Exhibited artists include: Carolyn Gareis (mixed media), Scott R. Smith (airbrush on canvas). Sponsors 3 exhibits/year. Average display time 5 weeks. Open all year; Thursday-Saturday, 10-4. Closed August. Clients include local community, upscale, designers, corporations, restaurants. Overall price range: $200-4,000; most work sold at $1,500.

Media: Considers all media and all types of prints.

Style: Exhibits: geometric abstraction and painterly abstraction. Genres include figurative work, florals, landscapes and abstract.

Terms: Artwork is accepted on consignment and there is a 50% commission. Retail price set by the artist. Gallery provides insurance and promotion. Requires exclusive representation locally.

Submissions: Send query letter with artist's statement, bio, photographs, résumé and SASE. Returns material with SASE. Responds in 3 weeks. Files slides and bios. Finds artists through word of mouth, submissions, portfolio reviews, art exhibits, art fairs and referrals by other artists.

Tips: Good quality slides or photos.

N **JOAN CAWLEY GALLERY, LTD.**, 7135 E. Main St., Scottsdale AZ 85251. (602)947-3548. Fax: (602)947-7255. E-mail: karinc@jcgltd.com. Website: www.jcgltd.com. **President:** Kevin P. Cawley. Director: Karin Cawley. Retail gallery and print publisher. Estab. 1974. Represents 20 emerging, mid-career and established artists/year. Exhibited artists include: Carol Grigg, Adin Shade. Sponsors 5-10 shows/year. Average display time 2-3 weeks. Open all year; Monday-Saturday, 10-5; Thursday, 7-9. Located in art district, center of Scottsdale; 2,730 sq. ft. (about 2,000 for exhibiting); high ceilings, glass frontage and interesting areas divided by walls. 50% of space for special exhibitions; 75% of space for gallery artists. Clientele: tourists, locals. 90% private collectors. Overall price range: $100-12,000; most work sold at $3,500-5,000.

● Joan Cawley also runs an art licensing company—Joan Cawley Licensing, 1410 W. 14th St., Suite 101, Tempe AZ 85281. (800)835-0075. Fax: (602)858-0363.

Media: Considers all media except fabric or cast paper; all graphics. Most frequently exhibits acrylic on canvas, watercolor, pastels and chine colle.

Style: Exhibits expressionism, painterly abstraction, impressionism. Exhibits all genres. Prefers Southwestern and contemporary landscapes, figurative, wildlife.

Terms: Accepts work on consignment (50% commission.) Gallery provides promotion and contract; shipping costs are shared. Prefers artwork framed.

Submissions: Prefers artists from west of Mississippi. Send query letter with bio and at least 12 slides or photos. Call or write for appointment to show portfolio of photographs, slides or transparencies. Responds as soon as possible.

Tips: "We are a contemporary gallery in the midst of traditional Western galleries. We are interested in seeing new work always." Advises artists approaching galleries to "check out the direction the gallery is going regarding subject matter and media. Also always make an appointment to meet with the gallery personnel. We always ask for a minimum of five to six paintings on hand. If the artist sells for the gallery, we want more, but a beginning is about six paintings."

☒ THE CULTURAL EXCHANGE GALLERY, 4235 N. Marshall Way, Scottsdale AZ 85251. (480)941-0900. Fax: (480)941-0814. Retail gallery and art consultancy. Exhibits the work of 100s of mid-career and established artists/year. Exhibited artists include Christopher Pelley and Sandy Skoglund. Average display time 1 month. Open all year; Monday-Friday, 9-5; Thursday evenings, 7-9; Saturday, 10-5; Sunday, 12-4. Located downtown; 7,500 sq. ft. "Have vast array of artwork from the 1900s to contemporary." Clientele: upscale, local and tourists. 75% private collectors, 25% corporate collectors. Overall price range: $100-150,000; most work sold at $3,000-7,000.

Media: Considers all media except weavings and tapestry. Considers all types of prints except posters. Most frequently exhibits oils/acrylics, bronze and pastels/lithos and photography.

Style: Exhibits expressionism, neo-expressionism, painterly abstraction, conceptualism, minimalism, color field, postmodern works, photorealism, hard-edge geometric abstraction, realism and imagism. Exhibits all genres.

Terms: Artwork is accepted on consignment and there is a 40% commission (from clients not artists). Retail price set by the gallery. Gallery provides insurance, promotion and contract; shipping costs are shared.

Submissions: Accepts consignments from private and corporate clients. Represent contemporary artists.

ELEVEN EAST ASHLAND INDEPENDENT ART SPACE, 11 E. Ashland, Phoenix AZ 85004. (602)257-8543. Fax: (602)257-8543. **Contact:** David Cook. Estab. 1986. Represents emerging, mid-career and established artists. Exhibited artists include Erastes Cinaedi, Frank Mell, Ron Crawford and Mark Dolce. Sponsors 1 juried, 1 invitational and 6 solo and mixed group shows/year. Average display time 2 months. Located in "two-story old farm house in central Phoenix, off Central Ave." Overall price range: $100-5,000; most artwork sold at $100-800.

● An anniversary exhibition is held every year in April and is open to national artists. Work must be submitted by the end of February. Work will be for sale, and considered for permanent collection and traveling exhibition.

Media: Considers all media and all types of prints. Most frequently exhibits photography, painting, mixed media and sculpture.

Style: Exhibits all styles, preferably conceptualism, minimalism and neo-expressionism.

Terms: Accepts work on consignment (25% commission); rental fee for space covers 2 months. Retail price set by artist. Artist pays for shipping.

Submissions: Accepts proposal in person or by mail to schedule shows 6 months in advance. Send query letter with résumé, brochure, business card, 3-5 slides, photographs, bio and SASE. Call or write for appointment to show portfolio of slides and photographs. Be sure to follow through with proposal format. Responds only if interested within 1 month. Samples are filed or returned if not accepted or under consideration.

Tips: "Be active and enthusiastic."

ETHERTON GALLERY, 135 S. Sixth Ave., Tucson AZ 85701. (520)624-7370. Fax: (520)792-4569. Second location: 4419 N. Campbell Ave., Tucson AZ 85718. (520)615-1441. Fax: (520)615.1151. E-mail: ethertongallery@mindspring.com. **Contact:** Terry Etherton. Retail gallery and art consultancy. Specializes

in vintage and contemporary photography. Estab. 1981. Represents 50+ emerging, mid-career and established artists. Exhibited artists include Holly Roberts, Kate Breakey, James G. Davis and Mark Klett. Sponsors 12 shows/year. Average display time 5 weeks. Open from September to June. Located "downtown; 3,000 sq. ft.; in historic building—wood floors, 16' ceilings." 75% of space for special exhibitions; 10% of space for gallery artists. Clientele: 50% private collectors, 25% corporate collectors, 25% museums. Overall price range: $100-50,000; most work sold at $500-2,000.

Media: Considers oil, acrylic, drawing, mixed media, collage, sculpture, ceramic, all types of photography, original handpulled prints, woodcuts, wood engravings, linocuts, engravings, mezzotints, etchings and lithographs. Most frequently exhibits photography, painting and sculpture.

Style: Exhibits expressionism, neo-expressionism, primitivism, postmodern works. Genres include landscapes, portraits and figurative work. Prefers expressionism, primitive/folk and post-modern. Interested in seeing work that is "cutting-edge, contemporary, issue-oriented, political."

Terms: Accepts work on consignment (50% commission). Buys outright for 50% of retail price (net 30 days). Retail price set by gallery and artist. Gallery provides insurance and promotion; shipping costs are shared. Prefers framed artwork.

Submissions: Only "cutting-edge contemporary—no decorator art." No "unprepared, incomplete works or too wide a range—not specific enough." Send résumé, brochure, disk, slides, photographs, reviews, bio and SASE. Call or write to schedule an appointment to show a portfolio, which should include slides. Responds in 6 weeks only if interested. Files slides, résumés and reviews.

Tips: "Become familiar with the style of our gallery and with contemporary art scene in general."

N **THE SCOTTSDALE MUSEUM OF CONTEMPORARY ART**, 7380 E. Second St., Scottsdale AZ 85251. (480)874-4610, Fax: (480)874-4655. Website: www.ScottsdaleArts.org. **Contact:** Susan Krane, director. Museum. Approached by 30-50 artists/year. "As a unique educational institution, the Scottsdale Museum of Contemporary Art will collect, preserve, interpret and exhibit works of modern and contemporary art, architecture and design. By presenting innovative, challenging and culturally diverse exhibitions, publications and interdisciplinary programs on issues os social and cultural relevance, SMoCA seeks to promote intellectual inquiry and scholarship, inspire creative excellence and deepen an understanding of the contemporary visual environment in which we live." Sponsors 15-20 exhibits/year. Average display time 10 weeks. Open Tuesday, Wednesday, Friday, Saturday, 10-5; Thursday, 10-8; Sunday, 12-5. Closed Monday. Located in downtown Scottsdale; more than 20,000 sq. ft. of exhibition space. Clients include local community, students, tourists and upscale.

Media: Considers all media.

Style: Considers works of contemporary art, architecture and design.

Submissions: Send query letter with artist's statement, bio, photocopies, résumé, reviews and SASE. Returns material with SASE. Responds in 3 weeks.

Tips: Make your submission clear and concise. Fully identify all slides. All submission material, such as artist's statement and slide labels should be typed, not handwritten.

TEMPLE BETH ISRAEL SYLVIA PLOTKIN JUDAICA MUSEUM/CONTEMPORARY ARTS GALLERY, 10460 N. 56th St., Scottsdale AZ 85253. (480)951-0323. Fax: (480)951-7150. E-mail: museum @templebethisrael.org. **Director:** Pamela S. Levin. Museum. Estab. 1997. Represents 75 emerging, mid-career and established artists. Exhibited artists include Robert Lipnich and Elizabeth Mears. Clients include local community, tourists and upscale. Overall price range: $50-5,000; most work sold at $500.

Media: Considers all media. Most frequently exhibits craft, glass and ceramics. Considers all types of prints.

Styles: Considers all styles. Genre: Judaica.

Making Contact & Terms: Artwork is accepted on consignment and there is a 40% commission. Retail price set by the artist. Gallery provides insurance and promotion. Accepted work should be framed. Prefers only Judaica.

Submissions: Call to arrange a personal interview to show portfolio. Send query letter with bio, brochure, photocopies, photographs, résumé, reviews, slides. Returns material with SASE. Responds in 1 month.

N **VANIER FINE ART, LTD.**, 7106 E. Main St., Scottsdale AZ 85251. (480)946-7507. Fax: (602)945-2448. E-mail: RandolphRhoton@vanierart.com. Website: www.vanier.roberts.com. **Contact:** Randolph Rhoton or Jerre Lynn. Retail gallery. Estab. 1994. Represents 50 emerging, mid-career and established artists/year. Sponsors 7 shows/year. Average display time 1 month. Open all year; Monday-Saturday, 10-5; Thursday, 7-9 pm. Located in Old Town (downtown) Scottsdale; 6,500 sq. ft.; multi-levels, multiple

rooms, 25 foot ceilings. Clientele: tourists, upscale, local. 90% private collectors, 10% corporate collectors. Overall price range: $500-295,000; most work sold at $2,000-10,000.

Media: Considers oil, pen & ink, drawing, sculpture, watercolor, mixed media, pastel, acrylic, paper, ceramics, glass, collage and photography. Most frequently exhibits oil.

Style: Exhibits: photorealism, color field, conceptualism, expressionism, geometric abstraction, surrealism and realism. Most frequently exhibits painterly abstraction, geometric and impressionism. Exhibits all genres. Prefers landscape, florals and portrait.

Terms: Accepts work on consignment (50% commission). Retail price set by the artist in conjunction with gallery. Gallery provides insurance, promotion and contract; shipping costs are shared. Prefers artwork framed.

Submissions: Send query letter with résumé, brochure, business card, slides, photographs, reviews, artist's statement, bio, SASE and price list. Write for appointment to show portfolio of photographs and slides. Responds in 3 weeks. Finds artists through out of town (state) shows, referrals by other artists, national publications.

Tips: "Initial impressions are important. Don't waste my time until it is evident with an extensive CV and gallery exhibition record that your career is established."

WILDE-MEYER GALLERY, 4142 North Marshall Way, Scottsdale AZ 85251. (602)945-2323. Fax: (602)941-0362. **Co-owner:** Betty Wilde. Retail/wholesale gallery and art consultancy. Estab. 1983. Represents/exhibits 40 emerging, mid-career and established artists/year. Exhibited artists include Linda Carter-Holman and Jacqueline Rochester. Sponsors 5-6 shows/year. Average display time 1-12 months rotating. Open all year; Monday-Saturday, 9-6; Sunday, 12-4. Located in downtown Scottsdale in the heart of Art Walk; 3,000 sq. ft.; 20% of space for special exhibitions; 80% of space for gallery artists. Clientele: upscale tourists: local community. 90% private collectors, 10% corporate collectors. Overall price range: $500-45,000; most work sold at $1,500-7,000.

Media: Considers all media and all types of prints. Most frequently exhibits original oil/canvas, mixed media and originals on paper.

Style: Exhibits primitivism, painterly abstraction, figurative, landscapes, all styles. All genres. Prefers contemporary artwork.

Terms: Accepts work on consignment (50% commission). Retail price set by gallery and artist. Insurance and promotion shared 50/50 by artist and gallery. Artist pays for shipping costs.

Submissions: Send query letter with résumé, slides, bio, photographs, SASE, business card, reviews and prices. Write for appointment to show portfolio of photographs, slides, bio and prices. Responds only if interested within 6 weeks. Files all material if interested. Finds artists through word of mouth, referrals by artists and artists' submissions.

Tips: "Just do it."

RIVA YARES GALLERY, 3625 Bishop Lane, Scottsdale AZ 85251. (480)947-3251. Fax: (480)947-4251. E-mail: art@rivayaresgallery.com. Website: www.rivayaresgallery.com. Second gallery at 123 Grant Ave., Santa Fe NM 87501. (505)984-0330. Retail gallery. Estab. 1963. Represents 30-40 emerging, mid-career and established artists/year. Exhibited artists include: Rodolfo Morales and Esteban Vicente. Sponsors 12-16 shows/year. Average display time 3-6 weeks. Open all year; Tuesday-Saturday, 10-5; Sunday by appointment. Located in downtown area; 8,000 sq. ft.; national design award architecture; international artists. 50% of space for special exhibitions; 50% of space for gallery artists. Clientele: collectors. 90% private collectors; 10% corporate collectors. Overall price range: $1,000-1,000,000; most work sold at $20,000-50,000.

Media: Considers all media except craft and fiber and all types of prints. Most frequently exhibits paintings (all media), sculpture and drawings.

Style: Exhibits expressionism, photorealism, neo-expressionism, minimalism, pattern painting, color field, hard-edge geometric abstraction, painterly abstraction, realism, surrealism and imagism. Prefers abstract expressionistic painting and sculpture, surrealistic sculpture and modern schools' painting and sculpture.

Terms: Accepts work on consignment (50% commission). Retail price set by the artist. Gallery provides insurance, promotion and contract; gallery pays for shipping from gallery; artist pays for shipping to gallery. Prefers artwork framed.

Submissions: Not accepting new artists at this time.

Tips: "Few artists take the time to understand the nature of a gallery and if their work even applies."

Arkansas

N⃞ AMERICAN ART GALLERY, 724 Central Ave., Hot Springs National Park AR 71901. (501)624-0550. E-mail: amerart@ipa.net. Website: 411web.com/A/americanartgallery/. Retail gallery. Estab. 1990. Represents 22 emerging, mid-career and established artists. Exhibited artists include Jimmie Tucek and Jimmie Leach. Sponsors 12 shows/year. Average display time 1 month. Open all year. Located downtown; 4,000 sq. ft.; 40% of space for special exhibitions. Clientele: private, corporate and the general public. 85% private collectors, 15% corporate collectors. Overall price range: $50-12,000; most work sold at $350-800.
Media: Considers oil, acrylic, watercolor, pastel, pen & ink, sculpture, ceramic, photography, original handpulled prints, woodcuts, wood engravings, lithographs and offset reproductions. Most frequently exhibits oil, wood sculpture and watercolor.
Style: Exhibits all styles and genres. Prefers realistic, abstract and impressionistic styles; wildlife, landscapes and floral subjects.
Terms: Accepts work on consignment (40% commission). Retail price set by gallery and the artist. Gallery provides promotion and contract; artist pays for shipping. Offers customer discounts and payment by installments. Prefers artwork framed.
Submissions: Prefers Arkansas artists, but shows 5-6 others yearly. Send query letter with résumé, 8-12 slides, bio and SASE. Call or write for appointment to show portfolio of originals and slides. Responds in 6 weeks. Files copy of résumé and bio. Finds artists through agents, by visiting exhibitions, word of mouth, various art publications and sourcebooks, submissions/self promotions and art collectors' referrals.
Tips: "We have doubled our floor space and have two floors, which allows us to separate the feature artist from the regular artist. We have also upscaled the quality of artwork exhibited. Our new gallery is located between two other galleries. It's a growing art scene in Hot Springs. We prefer artists have an appointment, not just pop in."

N⃞ ARKANSAS STATE UNIVERSITY FINE ARTS CENTER GALLERY, P.O. Drawer 1920, State University AR 72467. (870)972-3050. E-mail: csteele@astate.edu. Website: www.clt.astate.edu/finearts/art_exhibitions.htm. **Chair, Department of Art:** Curtis Steele. University—Art Department Gallery. Estab. 1968. Represents/exhibits 3-4 emerging, mid-career and established artists/year. Sponsors 3-4 shows/year. Average display time 1 month. Open fall, winter and spring; Monday-Friday, 10-4. Located on university campus; 1,600 sq. ft.; 60% of time devoted to special exhibitions; 40% to faculty and student work. Clientele: students/community.
Media: Considers all media. Considers all types of prints. Most frequently exhibits painting, sculpture and photography.
Style: Exhibits conceptualism, photorealism, neo-expressionism, minimalism, hard-edge geometric abstraction, painterly abstraction, postmodern works, realism, impressionism and pop. "No preference except quality and creativity."
Terms: Exhibition space only; artist responsible for sales. Retail price set by the artist. Gallery provides insurance, promotion and contract; shipping costs are shared. Prefers artwork framed.
Submissions: Send query letter with résumé, slides and SASE. Portfolio should include photographs, transparencies and slides. Responds only if interested within 2 months. Files résumé. Finds artists through call for artists published in regional and national art journals.
Tips: "Show us 20 slides of your best work. Don't overload us with lots of collateral materials (reprints of reviews, articles, etc.). Make your vita as clear as possible."

N⃞ ⊞ ARTISTS WORKSHOP, 810 Central Ave., Hot Springs AR 71913. (501)623-6401. Website: www.artistsworkshopgallery.com. **Chairman:** Sue Shields. Cooperative gallery. Estab. 1990. Represents 35 emerging, mid-career and established artists/year. Sponsors 12 shows/year. Average display time 2 months. Open all year; Monday-Saturday, 10-4. Located in historic district; approximately 920 sq. ft.; in historic building. 10% of space for special exhibitions; 90% of space for gallery artists. Clientele: primarily tourist, some local. 100% private collectors. Overall price range: $12-4,500; most work sold at $100-800.
Media: Considers all media and all types of prints.
Style: Exhibits: painterly abstraction, impressionism, photorealism and realism. Exhibits all genres.
Terms: Co-op membership fee plus donation of time (15% commission). Retail price set by the artist.

Gallery provides promotion; artist pays for shipping. Prefers framed artwork.

Submissions: Accepts only artists from Arkansas. Send query letter with bio and SASE. Call or write for appointment to show examples of work brought to co-op membership meeting (held once/month). Does not reply. Artist should attend monthly meetings. Finds artists through word of mouth, referrals by other artists, visiting art fairs and exhibitions and submissions.

[N] EILEEN'S GALLERY OF FINE ARTS, 10720 N. Rodney Parham, Little Rock AR 72212. (501)223-0667. **Owner:** Eileen Lindemann. Retail gallery. Estab. 1987. Represents 30 emerging and mid-career artists/year. Exhibited artists include: Robert Moore and Dale Terbush. Sponsors 2 shows/year. Average display time 6 months. Open all year; Tuesday-Saturday, 10-5. Located west Little Rock; 1,800 sq. ft. 100% of space for gallery artists. Clientele: local (statewide) and upscale. 95% private collectors; 5% corporate collectors. Overall price range: $300-15,000; most work sold at $1,500-3,500.

Media: Considers oil, acrylic, watercolor and sculpture. Most frequently exhibits oils, well executed acrylics and wood and marble sculpture.

Style: Exhibits: impressionism, photorealism and realism. Genres include florals, landscapes Americana and figurative work. Prefers: florals, figuratives and landscapes.

Terms: Accepts work on consignment (40% commission). Retail price set by the artist. Gallery provides promotion and contract for out-of-state artists; shipping costs are shared. "If the artist is out of state, the gallery will provide frames."

Submissions: Prefers only canvas. Send query letter with bio and photographs. Call or write for appointment to show portfolio of photographs and information on shows, other galleries and years in profession. Responds ASAP. Artist should send stamped return envelope. Finds artists through word-of-mouth, my excellent reputation, visiting galleries in travel, requests by my clients for interest in special artists.

Tips: "Artists should not send unrequested work or walk in uninvited and take up my time before they know I'm interested."

[N] HERR-CHAMBLISS FINE ARTS, P.O. Box 2840, Hot Springs AR 71914. (501)624-7188. **Director:** Malinda Herr-Chambliss. Corporate art consultant. Estab. 1988. Represents emerging, mid-career and established artists. Overall price range: $50-24,000.

● This art consultant formerly ran a retail gallery for 12 years. She now works exclusively with corporate and private clients as an art consultant.

Media: Considers oil, acrylic, watercolor, pastel, pen & ink, drawings, mixed media, sculpture, fiber, glass, etchings, charcoal and large scale work.

Style: Exhibits all styles, specializing in Italian contemporary art.

Terms: "Negotiation is part of acceptance of work; generally commission is 40%." Gallery provides insurance, promotion and contract (depends on negotiations); artist pays for shipping to and from gallery. Prefers artwork framed.

Submissions: Prefers painting and sculpture of regional, national and international artists. Send query letter with résumé, slides, bio, brochure, photographs, SASE, business card and reviews. Do not send any materials that are irreplaceable. Write for appointment to show portfolio of originals, slides, photographs and transparencies. Responds in 6 weeks.

Tips: "When mailing your submission to galleries, make your presentation succinct, neat and limited. Consider how you would review the information if you received it. Respect the art gallery owner's position—realizing the burdens that face them each day—help the gallery help you and your career by providing support in their requests to you. Slides should include the date, title, medium, size, and directional information. Also, résumé should show the number of one-person shows, educational background, group shows, list of articles (as well as enclosure of articles). The neater the presentation, the greater chance the dealer can glean important information quickly. Put yourself behind the dealer's desk, and include what you would like to have for review."

[N] LEONARD FINE ARTS, 520 Central Ave., Hot Springs AR 71901. (501)623-9847. Fax: (501)623-8957. E-mail: brian@leonardfinearts.com. Website: www.leonardfinearts.com. Retail gallery. Estab. 2003. Represents/exhibits 15 established artists/year. Interested in seeing the work of emerging artists. Exhibited artists include Benini, Galardini and Cunningham. Sponsors 12 shows/year. Average display time 1 month. Open daily and during Hot Springs Gallery Walks and by appointment. Located on historic Central Avenue; 5,000 sq. ft.; housed in 1886 brick structure restored in 1988 according to National Historic Preservation Guidelines. Clientele: tourists, upscale, community and students. 90% private collectors, 10% corporate collectors.

Media: Considers all media except prints. Most frequently exhibits painting, sculpture, drawing/photography.
Style: Exhibits contemporary Italian masters.
Tips: Considers "individual style and quality" when choosing artists.

California

THE ART COLLECTOR, 4151 Taylor St., San Diego CA 92110. (619)299-3232. Fax: (619)299-8709.
Contact: Janet Disraeli. Retail gallery and art consultancy. Estab. 1972. Represents emerging, mid-career and established artists. Exhibited artists include Susan Singleton and Reed Cardwell. Average display time 1 month. Open all year; Monday-Friday. 1,000 sq. ft.; 100% of space for gallery artists. Clientele: upscale, business, decorators. 50% private collectors, 50% corporate collectors. Overall price range: $175-10,000; most work sold at $450-1,000.
Media: Considers all media and all types of prints. Most frequently exhibits paintings, sculpture, monoprints.
Style: Exhibits all styles. Genres include all genres, especially florals, landscapes and figurative work. Prefers abstract, semi-realistic and realistic.
Terms: Artwork is accepted on consignment and there is a 50% commission. Retail price set by the artist. Gallery provides insurance. Gallery pays for shipping from gallery. Artist pays for shipping to gallery. Prefers artwork unframed.
Submissions: Accepts artists from United States only. Send query letter with résumé and slides. Call for appointment to show portfolio of slides. Responds in 2 weeks. Files slides, biographies, information about artist's work.
Tips: Finds artists through artist's submissions and referrals.

ART SOURCE LA INC., Southern California Corporate Office, 2801 Ocean Park Blvd., PMB 7, Santa Monica CA 90405. (310)452-4411. Fax: (310)452-0300. E-mail: info@artsourcela.com. Website: www.artsourcela.com. **Contact:** Francine Ellman, president Southern California Corporate Office. Estab. 1980.
 • Art Source LA also has offices at the following locations: Northern California Office, 177 Webster St. PMB 311, Monterey CA 93940. (831)375-9904. Fax: (831)375-4141. E-mail: aylssaw@artsource la.com; East Coast Office, 3 Blue Hosta Way, Rockville MD 20850. (301)610-9900. Fax: (301)610-9904. E-mail: bonniek@artsourcela.com. A midwest office will open soon in Chicago. All submissions should be sent to the Southern California Corporate Office.
Media: Considers fine art in all media, including works on canvas, paper, sculpture, giclee and a broad array of accessories handmade by American artists. Also sells photography, works on paper and sculpture. Considers all types of prints.
Terms: Artwork is accepted on consignment, and there is a 50% commission. No geographic restrictions.
Submissions: "Submit a minimum of 20 slides, photographs or inkjet prints (laser copies not acceptable), clearly labeled with name, date, title of work; plus résumé, catalogs, brochures, pricelist and SASE. E-mail submissions accepted; but not as good as slides, etc." Responds in 2 months.
Tips: "Be professional when submitting visuals. Remember—first impressions can be critical! Submit a body of work that is consistent and of the highest quality. Work should be in excellent condition and already photographed for your records. Framing does not enhance presentation to the client."

N ATHENAEUM MUSIC AND ARTS LIBRARY, 1008 Wall St., La Jolla CA 92037-4419. (858)454-5872. **Director:** Erika Torri. Nonprofit gallery. Estab. 1899. Represents/exhibits emerging, mid-career and established artists. Exhibited artists include Ming Mur-Ray, Italo Scanga and Mauro Staccioli. Sponsors 8 exhibitions/year. Average display time 2 months. Open all year; Tuesday-Saturday, 10-5:30; Wednesday 10-8:30. Located downtown La Jolla. An original 1921 building designed by architect William Templeton Johnson: 12-foot high wood beam ceilings, casement windows, Spanish-Italianate architecture. 100% of space for special exhibitions. Clientele: tourists, upscale, local community, students and Athenaeum members. 100% private collectors. Overall price range: $100-1,000; most work sold at $100-500.
Media: Considers all media. Considers all types of prints. Most frequently exhibits painting, multi-media and book art.
Style: Exhibits all styles. Genres include florals, portraits, landscapes and figurative work.
Terms: Artwork is accepted on consignment, and there is a 25% commission. Retail price set by the artist. Gallery provides insurance and promotion; shipping costs are shared. Prefers artwork framed.

Submissions: Artists must be considered and accepted by the art committee. Send query letter with slides, bio, SASE and reviews. Write for appointment to show portfolio of photographs, slides and transparencies. Responds in 2 months. Files slide and bio only if there is initial interest in artist's work.
Tips: Finds artists through word of mouth and referrals.

N. TOM BINDER FINE ARTS, 825 Wilshire Blvd., #708, Santa Monica CA 90401. (310)822-1080. Fax: (310)822-1580. E-mail: info@artman.net. Website: www.artman.net. For profit gallery. Exhibits established artists. Also has location in Marina Del Rey. Clients include local community, tourists and upscale. Overall price range: $200-2,000.
• Tom Binder Fine Arts also has a listing in the Poster & Prints section of this book.
Media: Considers all media; types of prints include etchings, lithographs, posters and serigraphs.
Style: Considers all styles and genres.
Making Contact & Terms: Artwork accepted on consignment or bought outright. Retail price set by the gallery. Gallery provides insurance. Accepted work should be mounted.
Submissions: Write to arrange a personal interview to show portfolio. Returns material with SASE. Responds in 2 weeks.

N. Y CHI GALLERY, P.O. Box 5152, Berkeley CA 94705. (510)832-4244. Fax: (510)841-1974. E-mail: info@chigallery.com. Website: www.chigallery.com. **Contact:** Corinne Innis, director. For-profit gallery, art consultancy. Estab. 2000. Represents mid-career and established artists. Exhibited artists include: Carol Brighton, mixed media on handmade paper; Jeanette Madden, mixed media. Chi Gallery began as a small art gallery in downtown Oakland, California. After two and a half years the gallery was transformed from a storefront to a virtual gallery on the Internet. Clients include local community. 5% of sales are to corporate collectors. Most work sold at $1,200.
Media: Considers acrylic, mixed media, paper, pastel, pen & ink, watercolor. Most frequently exhibits mixed media, acrylic, oil. Considers etchings, linocuts and lithographs.
Style: Exhibits: color field, expressionism, geometric abstraction, impressionism, minimalism, postmodernism, painterly abstraction. Most frequently exhibits color field, postmodernism, painterly abstraction.
Terms: There is a co-op membership $20 fee/month. There is a 30% commission. Accepts only artists from: Bay Area (Oakland, Berkeley, San Francisco).
Submissions: Call or write to arrange personal interview to show portfolio of photographs, slides. Send query letter with artist's statement, bio, brochure, business card, photocopies, photographs, résumé, reviews, SASE, slides. Returns material with SASE. Responds to queries only if interested within 1 month. Files slides, artist's statement and résumé. Finds artists through art fairs, art exhibits, portfolio reviews.
Tips: To make your gallery submissions professional, be sure to have your "slides properly labeled, include SASE, cover letter, slide list, artist statement and résumé."

CONTEMPORARY CENTER, 2630 W. Sepulveda Blvd., Torrance CA 90505. (310)539-1933. Fax: (310)539-0724. **Director:** Sharon Fowler. Retail gallery. Estab. 1953. Represents 150 emerging, mid-career and established artists. Exhibited artists include Steve Main, Cheryl Williams. Open all year; Tuesday-Saturday, 10-6; Sunday 12-5; closed Monday. Space is 5,000 sq. ft. "We sell contemporary American crafts along with contemporary production and handmade furniture." Clientele: private collectors, gift seekers, many repeat customers. Overall price range: $20-800; most work sold at $20-200.
Media: Considers paper, sculpture, ceramics, fiber and glass.
Terms: Retail price set by the gallery and the artist.
Submissions: Send query letter with brochure, slides and photographs. Call for appointment to show portfolio of photographs and slides. Responds in 2 weeks. Finds artists through word of mouth and attending craft shows.
Tips: "Be organized with price, product and realistic ship dates."

N. PATRICIA CORREIA GALLERY, 2525 Michigan Ave., Bergamot Station #E2, Santa Monica CA 90404. (310)264-1760. Fax: (310)264-1762. E-mail: correia@earthlink.net. Website: www.correiagallery.com. **Director:** Patricia Correia. Associate Director: Amy Perez. Retail gallery. Estab. 1991. Represents 8 established artists only (at museum level). Exhibited artists include Patssi Valdez and Frank Romero. Sponsors 8 shows/year. Average display time 6 weeks. Open all year. 80% of space for special exhibitions; 20% of space for gallery artists. Clientele: upper middle class. 70% private collectors, 10% corporate collectors, 20% museum collection. Overall price range: $500-100,000; most work sold at $10,000-20,000.
• Located in fashionable Bergamot Station, arts district surrounded by other interesting galleries.

Media: Considers all media.

Style: Exhibits contemporary art.

Terms: Accepts work on consignment (50% commission). Retail price set by gallery and artist. Gallery provides insurance, promotion, contract and shipping costs from gallery.

Submissions: Must be collected by museums.

Tips: "The role as a dealer is different in contemporary time. It is as helpful for the artist to learn how to network with museums, press and the art world, as well as the gallery doing the same. It takes creative marketing on both parts. Please include your résumé, cover letter and slides with dimensions, median and retail price. Visit the gallery first and know their policies."

CUESTA COLLEGE ART GALLERY, P.O. Box 8106, San Luis Obispo CA 93403-8106. (805)546-3202. Fax: (805)546-3904. E-mail: pmckenna@cuesta.edu. Website: academic.cuesta.cc.ca.us/finearts/gall ery.htm. **Contact:** Pamela McKenna, gallery assistant. Nonprofit gallery. Estab. 1965. Exhibits the work of emerging, mid-career and established artists. Exhibited artists include Italo Scanga and JoAnn Callis. Sponsors 5 shows/year. Average display time 4½ weeks. Open all year. Space is 1,300 sq. ft.; 100% of space for special exhibitions. Overall price range: $250-5,000; most work sold at $400-1,200.

Media: Considers all media and all types of prints. Most frequently exhibits painting, sculpture and photography.

Style: Exhibits all styles, mostly contemporary.

Terms: Accepts work on consignment (20% commission). Retail price set by artist. Customer payment by installment available. Gallery provides insurance, promotion and contract; shipping costs are shared. Prefers artwork framed.

Submissions: Send query letter with résumé, slides, bio, brochure, SASE and reviews. Call for appointment to show portfolio. Responds in 6 months. Finds artists mostly by reputation and referrals, sometimes through slides.

Tips: "We have a medium budget, thus cannot pay for extensive installations or shipping. Present your work legibly and simply. Include reviews and/or a coherent statement about the work. Don't be too slick or too sloppy."

DELPHINE GALLERY, 1324 State St., Santa Barbara CA 93101. **Director:** Michael Lepere. Retail gallery and custom frame shop. Estab. 1979. Represents/exhibits 10 mid-career artists/year. Exhibited artists include Jim Leonard, Edwin Brewer and Steve Vessels. Sponsors 8 shows/year. Average display time 4-6 weeks. Open all year; Tuesday-Friday, 10-5; Saturday, 10-3. Located downtown Santa Barbara; 300 sq. ft.; natural light (4th wall is glass). 33% of space for special exhibitions. Clientele: upscale, local community. 40% private collectors, 20% corporate collectors. Overall price range: $1,000-4,500; most work sold at $1,000-3,000.

Media: Considers all media except photography, installation and craft. Considers serigraphs. Most frequently exhibits oil on canvas, acrylic on paper and pastel.

Style: Exhibits conceptualism and painterly abstraction. Includes all genres and landscapes.

Terms: T.B.A.

Submissions: No longer accepting submissions.

N. D5 PROJECTS, 2525 Michigan Ave. Santa Monica CA 90404. (310)315-1937. Fax: (310)315-9688. E-mail: berman@artnet.net. Website: www.robertbermangallery.com. **Contact:** Manager. For profit gallery. Approached by 200 artists/year; exhibits 25 mid-career artists. Sponsors 12 exhibits/year. Average display time 1 month. Open Tuesday-Saturday, 11-6. Closed December 24-January 1 and the last 2 weeks of August. Located in Bergamot Station Art Center in Santa Monica. Clients include local community, students, tourists, and upscale. Overall price range: $600-30,000; most work sold at $4,000.

Media: Considers all media. Most frequently exhibits oil on canvas.

Style: Considers contemporary.

Making Contact & Terms: Artwork is accepted on consignment. Retail price set by the gallery and the artist. Gallery provides insurance and promotion.

Submissions: "We currently accept submissions via e-mail ONLY as URL address or no more than 3 images sent as attachments, JPEG or GIF. All three not to exceed 1.5 MB total. Images exceeding 1.5 MB will not be considered. If we receive slide submissions without a SASE, they will not be considered."

FALKIRK CULTURAL CENTER, 1408 Mission Ave., P.O. Box 151560, San Rafael CA 94915-1560. (415)485-3328. Fax: (415)485-3404. Website: www.falkirkculturalcenter.org. Nonprofit gallery. Es-

tab. 1974. Approached by 500 artists/year. Exhibits 350 emerging, mid-career and established artists. Sponsors 8 exhibits/year. Average display time 2 months. Open Monday-Friday, 10-5; Saturday, 10-1; Thursday til 9. Closed Sundays. Three galleries located on second floor with lots of natural light (UV filtered). National historic place (1888 Victorian) converted to multi-use cultural center. Clients include local community, students, tourists and upscale.

Media: Considers all media and all types of prints. Most frequently exhibits painting, sculpture and works on paper.

Making Contact & Terms: Artwork is accepted on consignment, and there is a 30% commission. Retail price set by the artist. Gallery provides insurance. Prefers only Marin County artists.

Submissions: Marin County and San Francisco Bay Area artists only send artist's statement, bio, résumé and slides. Returns material with SASE. Responds within 3 months.

[N] SHERRY FRUMKIN/SHERRY DUVAL GALLERY, Bergamot Station T-1, 2525 Michigan Ave., Santa Monica CA 90404. (310)453-1850. Fax: (310)453-8370. E-mail: Frumkingal@aol.com. **Director:** Sherry Frumkin. Retail gallery. Estab. 1990. Represents 20 emerging, mid-career and established artists. Interested in seeing the work of emerging artists. Exhibited artists include Ron Pippin, Tanja Rector, Robert Russell. Sponsors 11 shows/year. Average display time 5 weeks. Open all year; Tuesday-Saturday, 10:30-5:30. Located in the Bergamot Station Arts Center; 3,000 sq. ft. in converted warehouse with 16 ft. ceilings, skylights. 25% of space for special exhibitions; 75% of space for gallery artists. Clientele: upscale, creative arts, i.e. directors, actors, producers. 80% private collectors, 20% corporate collectors. Overall price range: $1,000-25,000; most work sold at $2,000-5,000.

Media: Considers oil, acrylic, mixed media, collage, pen & ink, sculpture, ceramic and installation. Most frequently exhibits assemblage sculpture, paintings and photography.

Style: Exhibits expressionism, neo-expressionism, conceptualism, painterly abstraction and postmodern works. Prefers expressionism, painterly abstraction and postmodern.

Terms: Accepts work on consignment (50% commission). Retail price set by gallery and artist. Offers payment by installments. Gallery provides insurance and promotion. Prefers artwork framed.

Submissions: Send query letter with résumé, slides, reviews and SASE. Portfolio review requested if interested in artist's work. Portfolio should include slides and transparencies. Responds in 1 month. Files résumé and slides.

Tips: "Present a coherent body of work, neatly and professionally presented. Follow up, but do not become a nuisance."

[N] GALLERY BERGELLI, 483 Magnolia Ave., Larkspur CA 94939. (415)945-9454. Fax: (415)945-0311. E-mail: rcitelli@bergelli.com. Website: www.gallerybergelli.com. **Contact:** Robin Critelli, owner. For-profit gallery. Estab. 2000. Approached by 200 artists/year; exhibits 15 emerging artists/year. Exhibited artists include Jeff Faust and James Leonard (acrylic painting). Sponsors 8-9 exhibits/year. Average display time 6 weeks. Open all year; Tuesday-Saturday, 10-5; Sunday, 12-5. "We're located in affluent Marin County, just across the Golden Gate Bridge from San Francisco. The Gallery is in the center of town, on the main street of Larkspur, a charming village known for its many fine restaurants. It is spacious and open with 2,500 square feet of exhibition space with large window across the front of the building. Moveable hanging walls (see the home page of our website) give us great flexibility to customize the space to best show the current exhibition." Clients include local community, upscale in the Marin County & Bay Area. Overall price range is $2,000-26,000; most work sold at $4,000-10,000.

Media: Considers acrylic, collage, mixed media, oil, pastel, sculpture. Most frequently exhibits acrylic, oil and sculpture.

Style: Exhibits geometric abstraction, imagism, new-expressionism, painterly abstraction, postmodernism, surrealism. Most frequently exhibits painterly abstraction, imagism and neo-expressionism.

Terms: Artwork is accepted on consignment and there is a 50% commission. Retail price set by the artist with gallery input. Gallery provides insurance and promotion. Accepted work should be matted, stretched, unframed and ready to hang. Requires exclusive representation locally. Artwork evidencing geographic and cultural differences is viewed favorably.

Submissions: Mail portfolio for review or send query letter with artist's statement, bio, brochure, business card, photographs, resume, reviews, SASE and slides. Returns material with SASE. Responds to queries in 1 month. Files material not valuable to the artist (returns slides) that displays artist's work. Finds artists through art exhibits, portfolio reviews, referrals by other artists, submissions and word-of-mouth.

Tips: "Your submission should be about the artwork, the technique, the artist's accomplishments, and

perhaps the artist's source of creativity. Many artist's statements are about the emotions of the artist, which is irrelevant when selling paintings."

GALLERY EIGHT, 7464 Girard Ave., La Jolla CA 92037. (858)454-9781. **Director:** Ruth Newmark. Retail gallery with focus on contemporary crafts. Estab. 1978. Represents 100 emerging and mid-career artists. Interested in seeing the work of emerging artists. Exhibited artists include Philip Moulthrop, Patrick Crab and Karen Massaro. Sponsors 6 shows/year. Average display time 6-8 weeks. Open all year; Monday-Saturday, 10-5. Located downtown; 1,200 sq. ft. 25% of space for special exhibitions; 100% of space for gallery artists. Clientele: upper middle class, mostly 35-60 in age. Overall price range: $5-5,000; most work sold at $25-150.
Media: Considers ceramics, mixed media, sculpture, craft, fiber, glass. Most frequently exhibits ceramics, jewelry, mixed media.
Terms: Accepts work on consignment (50% commission) or buys outright for 50% of retail price (net 30 days). Retail price set by the gallery and the artist. Gallery provides insurance, promotion and shipping costs from gallery; artist pays shipping costs to gallery.
Submissions: Send query letter with résumé, slides, photographs, reviews and SASE. Call or write for appointment to show portfolio of photographs and slides. Responds in 3 weeks. Files "generally only material relating to work by artists shown at gallery." Finds artists by visiting exhibitions, word of mouth, various art publications and sourcebooks, submissions, through agents, and juried fairs.
Tips: "Enclose résumé, cost of item (indicate if retail or wholesale), make appointment."

GREENLEAF GALLERY, 20315 Orchard Rd., Saratoga CA 95070. Phone/fax: (408)867-3277. **Owner:** Janet Greenleaf. Director: Chris Douglas. Collection and art consultancy and advisory. Estab. 1979. Represents 45 to 60 emerging, mid-career and established artists. By appointment only. "Features a great variety of work in diverse styles and media. We have become a resource center for designers and architects, as we will search to find specific work for all clients." Clientele: professionals, collectors and new collectors. 50% private collectors, 50% corporate clients. Prefers "very talented emerging or professional full-time artists—already established." Overall price range: $400-15,000; most artwork sold at $500-8,000.
Media: Considers oil, acrylic, watercolor, pastel, mixed media, collage, works on paper, sculpture, glass, original handpulled prints, lithographs, serigraphs, etchings and monoprints.
Style: Deals in expressionism, neo-expressionism, minimalism, impressionism, realism, abstract work or "whatever I think my clients want—it keeps changing." Traditional, landscapes, florals, wildlife, figurative and still lifes.
Terms: Artwork is accepted on consignment. "The commission varies." Artist pays for shipping or shipping costs are shared.
Submissions: Send query letter, résumé, 6-12 photographs (but slides OK), bio, SASE, reviews and "any other information you wish." Call or write to schedule an appointment for a portfolio review, which should include originals. If does not reply, the artist should call. Files "everything that is not returned. Usually throw out anything over two years old." Finds artists through visiting exhibits, referrals from clients, or artists, submissions and self promotions.
Tips: "Send good photographs with résumé and ask for an appointment. Send to many galleries in different areas. It's not that important to have a large volume of work. I would prefer to know if you are full time working artist and have representation in other galleries."

JUDITH HALE GALLERY, 2890 Grand Ave., P.O. Box 884, Los Olivos CA 93441-0884. (805)688-1222. Fax: (805)688-2342. **Owner:** Judy Hale. Retail gallery. Estab. 1987. Represents 70 mid-career and established artists. Exhibited artists include Dirk Foslien, Howard Carr, Kelly Donovan and Meth Lawson. Sponsors 4 shows/year. Average display time 6 months. Open all year. Located downtown; 2,100 sq. ft.; "the gallery is eclectic and inviting, an old building with six rooms." 20% of space for special exhibitions which are regularly rotated and rehung. Clientele: homeowners, tourists, decorators, collectors. Overall price range: $500-15,000; most work sold at $500-5,000.
 ● This gallery opened a second location next door at 2884 Grand Ave. and connecting sculpture garden. Representing nationally recognized artists. This old building once housed the blacksmith's shop.
Media: Considers oil, acrylic, watercolor, pastel, sculpture, engravings and etchings. Most frequently exhibits watercolor, oil, acrylic and sculpture.
Style: Exhibits impressionism and realism. Genres include landscapes, florals, western and figurative work. Prefers figurative work, western, florals, landscapes, structure. No abstract or expressionistic.

Terms: Accepts work on consignment (40% commission). Retail price set by artist. Offers payment by installments. Gallery arranges reception and promotion; artist pays for shipping. Prefers artwork framed.
Submissions: Send query letter with 10-12 slides, bio, brochure, photographs, business card and reviews. Call for appointment to show portfolio of photographs. Responds in 2 weeks. Files bio, brochure and business card.
Tips: "Create a nice portfolio. See if your work is comparable to what the gallery exhibits. Do not plan your visit when a show is on; make an appointment for future time. I like 'genuine' people who present quality with fair pricing. Rotate artwork in a reasonable time, if unsold. Bring in your best work, not the 'seconds' after the show circuit."

HEARST ART GALLERY, SAINT MARY'S COLLEGE, P.O. Box 5110, Moraga CA 94575. (925)631-4379. Fax: (925)376-5128. Website: http://gallery.stmarys-ca.edu. College gallery. Estab. 1931. Exhibits mid-career and established artists. Exhibited artists include: William Keith (painting). Sponsors 6 exhibits/year. Average display time 5-6 weeks. Open Wednesday-Sunday, 11-4:30; weekends from 11-4:30. Closed major holidays, installation periods. Located on college campus, 1,650 square feet exhibition space. Clients include local community, students and tourists.
Media: Considers all media. Most frequently exhibits paintings, works on paper and sculpture. Considers all types of prints.
Submissions: Send query letter with artist's statement, bio, résumé, SASE and slides. Returns material with SASE. Finds artists through submissions, art exhibits, art fairs, referrals by other artists.

[N] LINCOLN ARTS, 540 F St., Lincoln CA 95648. (916)645-9713. Fax: (916)645-3945. E-mail: lincoln arts@sbcglobal.net. Website: www.lincolnarts.org. **Executive Director:** Claudia Renati. Nonprofit gallery and alternative space area coordinator. Estab. 1986. Represents more than 100 emerging, mid-career and established artists/year. More than 400 members. Sponsors 14 shows/year (9 gallery, 4 alternative and 1 major month-long ceramics exhibition). Average display time 5 weeks. Open all year; Tuesday-Saturday, 10-3. Located in the heart of downtown Lincoln; original Beermanhouse a 1926 bungalow overlooking beautiful Beermann Plaza. "Our annual 'Feats of Clay®' exhibition is held inside the 128-year-old Gladding McBean terra cotta factory." 70% of space for gallery artists. 90% private collectors, 10% corporate collectors. Overall price range: $90-7,000; most work sold at $150-2,000.
Media: Considers all media including linocut prints. Most frequently exhibits ceramics and mixed media.
Style: Exhibits all styles, all genres.
Terms: Accepts work on consignment (35% commission). "Membership donation (min. $35) is encouraged but not required." Retail price set by the artist. Gallery provides promotion; artist pays shipping costs to and from gallery. Prefers artwork framed.
Submissions: Send query letter with résumé, slides or photographs, bio and SASE. Call or write for appointment to show portfolio of originals (if possible) or photographs or slides. Responds in 1 month. Artist should include SASE for return of slides/photos. Files bio, résumé, review notes. "Scheduling is done minimum one year ahead in August for following calendar year. Request prospectus for entry information for Feats of Clay© exhibition." Finds artists through visiting exhibitions, word of mouth, art publications and sourcebooks and submissions.

LIZARDI/HARP GALLERY, P.O. Box 91895, Pasadena CA 91109. (626)791-8123. Fax: (626)791-8887. E-mail: lizardiharp@earthlink.net. Director: Grady Harp. Retail gallery and art consultancy. Estab. 1981. Represents 15 emerging, mid-career and established artists/year. Exhibited artists include Wes Hempel, Robert Peterson, Wim Heldens and William Fogg. Sponsors 9 shows/year. Average display time 1 month. Open all year; Tuesday-Saturday. 80% private collectors, 20% corporate collectors. Overall price range: $900-80,000; most work sold at $2,000-15,000.
Media: Considers oil, acrylic, watercolor, pastel, pen & ink, drawing, mixed media, sculpture, installation, photography, lithographs, and etchings. Most frequently exhibits works on paper and canvas, sculpture, photography.
Style: Exhibits representational art. Genres include landscapes, figurative work—both portraiture and narrative and still life. Prefers figurative, landscapes and experimental.
Terms: Accepts work on consignment (50% commission). Retail price set by the gallery and the artist. Gallery provides insurance, promotion, contract; artist pays shipping costs.
Submissions: Send query letter with artist's statement, résumé, 20 slides, bio, photographs, SASE and reviews. Write for appointment to show portfolio of photographs, slides and transparencies. Responds in 1 month. Files "all interesting applications." Finds artists through studio visits, group shows, submissions.

Tips: "Timelessness of message is a plus (rather than trendy). Our emphasis is on quality or craftsmanship, evidence of originality . . . and maturity of business relationship concept." Artists are encouraged to send an "artist's statement with application and at least one 4×5 or print along with 20 slides. Whenever possible, send images over the Internet via e-mail."

MOCTEZUMA BOOKS & GALLERY, 289 Third Ave., Chula Vista CA 91910-2721. (619)426-1283. Fax: (619)426-0212. E-mail: lisamoctezuma@hotmail.com. Website: www.latambooks.com. **Contact:** Lisa Moctezuma, owner. For-profit gallery. Estab. 1999. Approached by 40 artists/year. Represents 12 emerging, mid-career and established artists. Exhibited artists include: Alberto Blanco (painting, Chinese ink drawings, collage, mixed media) and Norma Michel (painting, mixed media and boxes). Sponsors 8 exhibits/year. Average display time 6 weeks. Open all year; Monday-Saturday, 10-5. Located just south of San Diego, in downtown Chula Vista. The gallery space is approximately 1,000 sq. ft. and is coupled with a bookstore. Clients include local community and upscale. 10% of sales are to corporate collectors. Overall price range: $200-2,000; most work sold at $800.
Media: Considers all media and all types of prints. Most frequently exhibits paper, canvas, watercolor and acrylic.
Style: Considers all styles and genres. Most frequently exhibits painterly abstraction, primitivism realism and conceptualism.
Terms: Artwork is accepted on consignment and there is a 40% commission. Retail price set by the gallery. Gallery provides promotion and contract. Accepted work should be framed. Does not require exclusive representation locally. We focus on established and emerging artists from the San Diego/Tijuana border area, Mexico and the Californias.
Submissions: Mail portfolio for review. Send query letter with artist's statement, bio, photocopies, photographs, résumé, reviews, SASE and slides. Responds in 2 months. Finds artists through word of mouth and referrals by other artists.

JOHN NATSOULAS GALLERY, 521 First St., Davis CA 95616. (530)756-3938. Fax: (530)756-3961. Website: www.natsoulas.com. **Contact:** Director. Retail gallery and art consultancy. Represents 30 artists; emerging and established. Exhibited artists include Roy Deforest and Robert Arneson. Sponsors 10 shows/year. Average display time 6 weeks. Open all year. Located: downtown, 4 blocks from U.C.-Davis; 4,000 sq. ft. 70% of space for special exhibitions. 75% private collectors, 25% corporate collectors. Overall price range: $100-45,000; most work sold at $1,000-15,000.
Media: Considers oil, acrylic, watercolor, pastel, drawing, mixed media, collage, sculpture, ceramic, glass and original handpulled prints. Most frequently exhibits ceramic, oil and mixed media on paper.
Style: Exhibits expressionism, color field, realism, abstract expression and "ceramic funk." Genres include "Bay area figurative work." Prefers figurative, abstract and realist works.
Terms: Artwork is accepted on consignment (50-60% commission). Retail price set by the gallery. Gallery provides insurance and promotion; shipping costs are shared. Prefers artwork framed.
Submissions: Accepts primarily artists from California. Send query letter with SASE and all information available. Write to schedule an appointment to show a portfolio, which should include all pertinent information. Responds in 2 months. Files "only work to be represented."

A NEW LEAF GALLERY/SCULPTURESITE.COM, 1286 Gilman St., Berkeley CA 94706. (510)525-7621. Fax: (510)525-5282. E-mail: info@sculpturesite.com. **Contact:** Staff. Retail gallery. Estab. 1990. Represents 100 emerging, mid-career and established artists. Sponsors 3-6 sculpture shows/year. Average display time 6 months. Open Wednesday-Friday, 10-5; weekends, 11-5. Closed December 23-January 1. Clients include local community and upscale. Overall price range: $1,000-1,000,000; most work sold at $5,000-10,000.
Media: Considers sculpture, mixed media, ceramic and glass. Most frequently exhibits sculpture (considers only sculptural media for outdoors). "No paintings or works on paper, please."
Style: Exhibits only contemporary abstract and abstract figurative.
Terms: Accepts artwork on consignment (40-50% commission). Exclusive area representation required. Retail price set by artist in cooperation with gallery. Gallery provides insurance. Accepted work should be mounted.
Submissions: Write to arrange personal interview to show a small portfolio of photographs, slides, digital images; or mail portfolio of small selection of images in any format; or send e-mail link to your site for review; or send artist's statement, bio, photocopies, photographs, SASE and slides. Responds in 1 month.

Tips: "We suggest artists visit us if possible—this is a unique setting. Sculpturesite.com, our new website, shows a wider range of sculpture than our outdoor gallery can."

▉ ORANGE COUNTY CENTER FOR CONTEMPORARY ART, 117 N. Sycamore St., Santa Ana CA 92701. (714)667-1517. Website: www.occca.org. **Acting Director:** Lloyd Rodgers. Cooperative, nonprofit gallery. Exhibits emerging and mid-career artists. 20 members. Sponsors 12 shows/year. Average display time 1 month. Open all year; Wednesday-Sunday 11-4. 3,000 sq. ft. 25% of time for special exhibitions; 75% of time for gallery artists.
Media: Considers all media.
Terms: Co-op membership fee plus a donation of time. Retail price set by artist.
Submissions: Accepts artists generally in and within 50 miles of Orange County. Send query letter with SASE. Responds in 1 week.
Tips: "This is an artist-run nonprofit. Send SASE for application prospectus. Membership means 20 hours monthly working in and for the gallery and programs; educational outreach; specific theme special exhibitions; hands-on gallery operations and professional career development."

▉ ORLANDO GALLERY, 18376 Ventura Blvd., Tarzana CA 91356. (818)705-5368. E-mail: orlando2 @earthlink.com. Website: venturablvd.com/orlando/. **Co-Directors:** Robert Gino and Don Grant. Retail gallery. Estab. 1958. Represents 30 emerging, mid-career and established artists. Sponsors 22 solo shows/year. Average display time is 1 month. Accepts only California artists. Overall price range: up to $35,000; most artwork sold at $2,500.
Media: Considers oil, acrylic, watercolor, pastel, pen & ink, drawings, mixed media, collage, works on paper, sculpture, ceramic and photography. Most frequently exhibits oil, watercolor and acrylic.
Style: Exhibits painterly abstraction, conceptualism, primitivism, impressionism, photorealism, expressionism, neo-expressionism, realism and surrealism. Genres include landscapes, florals, Americana, figurative work and fantasy illustration. Prefers impressionism, surrealism and realism. Interested in seeing work that is contemporary. Does not want to see decorative art.
Terms: Accepts work on consignment. Retail price set by artist. Offers customer discounts and payment by installments. Exclusive area representation required. Gallery provides insurance and promotion; artist pays for shipping.
Submissions: Send query letter, résumé and 12 or more slides. Portfolio should include slides and transparencies. Finds artists through submissions. Portfolio may be sent by e-mail.
Tips: "Be inventive, creative and be yourself."

▉ PEPPERS ART GALLERY, 1200 E. Colton, P.O. Box 3080, Redlands CA 92373-0999. (909)793-2121 ext. 3660. **Contact:** Terre Hodgson, administrative assistant. Nonprofit university gallery. Estab. 1960s. Represents/exhibits 4-6 mid-career and established California artists/year. Exhibited artists include Greg Kennedy (ceramics). Work for sale. Open fall and spring; Tuesday-Saturday, 1-5; Sunday, 2-5. Closed June, July, August. Located in the city of Redlands; 980 sq. ft.; 12' high walls. 100% of space for special exhibitions. Clientele: local community, students. Overall price range: $1,500-20,000.
Media: Considers all media, all types of prints except posters. Most frequently exhibits sculpture, painting and ceramics.
Style: Exhibits expressionism, neo-expressionism, primitivism, painterly abstraction, postmodern works, realism and imagism.
Terms: Gallery provides insurance and promotion. Prefers artwork framed.
Submissions: Files résumés only. Finds artists through visiting gallerys and referrals.
Tips: "Don't follow trends—be true to yourself."

THE MARY PORTER SESNON GALLERY, Porter College, UCSC, Santa Cruz CA 95064. (831)459-3606. Fax: (831)459-3535. E-mail: lfellows@cats.ucsc.edu. Website: www.arts.ucsc.edu/sesnon. **Director:** Shelby Graham. University gallery, nonprofit. Estab. 1971. Features new and established artists. Sponsors 4-6 shows/year. Average display time 4-6 weeks. Open September-June; Tuesday-Saturday, noon-5. Located on campus; 1,000 sq. ft. 100% of space for changing exhibitions. Clientele: academic and community-based. "We are not a commercial gallery. Visitors interested in purchasing work are put in direct contact with artists."
Media: Considers all media.
Style: Exhibits experimental, conceptually-based work.

Terms: Gallery provides insurance, promotion, shipping costs to and from gallery and occasional publications.

Submissions: Send query letter with résumé, slides, statement, SASE and reviews. Responds only if interested within 6 months. "Material is retained for committee review and returned in SASE."

N SAN DIEGO ART INSTITUTE, House of Charm, Balboa Park 1439 El Prado, San Diego CA 92101-1617. (619)236-0011. Fax: (619)236-1974. E-mail: director@sandiego-art.org. Website: www.sandiego-art.org. **Executive Director:** Timothy J. Field. Membership Associate: Kerstin Robers. Art Director: K.D. Benton. Nonprofit gallery. Estab. 1941. Represents 500 emerging and mid-career member/artists. 2,400 artworks juried into shows each year. Exhibited artists include Sammy Pasto, Alejandro Martinez Pena. Sponsors 12 all-media exhibits/year. Average display time 4-6 weeks. Open Tuesday-Saturday, 10-4; Sunday 12-4. Closed major holidays—all Mondays. 10,000 sq. ft. located in the heart of Balboa Park. Clients include local community, students and tourists. 10% of sales are to corporate collectors. Overall price range $50-2,000. Most work sold at $500.

Media: Considers all media and all types of prints. Most frequently exhibits oil, mixed media and pastel.

Styles: Considers all styles and genres.

Making Contact & Terms: Artwork is accepted on consignment, and there is a 40% commission. Membership fee: $125. Retail price set by the artist. Accepted work should be framed. Work must be hand carried in for each monthly show except for annual international show juried by slides.

Submissions: Request membership packet and information about juried shows. Membership not required for submittal in monthly juried shows, but fee required. Returns material with SASE. Finds artists through word of mouth and referrals by other artists.

Tips: "All work submitted must go through jury process for each monthly exhibition. Work required to be framed in professional manner."

STUDIO 7 FINE ARTS, 77 West Angela St., Pleasanton CA 94566. (925)846-4322. E-mail: jaime@studio7finearts.com. Website: www.studio7finearts.com. **Owners:** Jaime Dowell and Linsey Dowell. Retail gallery. Estab. 1981. Represents/exhibits 40-60 emerging and established artists/year. Sponsors 4-6 shows/year. Average display time 3 weeks. Open all year. Located in historic downtown Pleasanton; 1,800 sq. ft.; excellent lighting from natural and halogen sources. 70% of space for special exhibitions; 70% of space for gallery artists. Clientele: "wonderful, return customers." 99% private collectors, 1% corporate collectors. Overall price range: $100-10,000; most work sold at under $2,000.

Media: Considers oil, acrylic, watercolor, pastel, drawing, mixed media, collage, paper, sculpture, ceramics, fine craft, glass, woodcuts, engravings, lithographs, mezzotints, serigraphs and etchings. Most frequently exhibits oil, acrylic, etching, watercolor, handblown glass, jewelry and ceramics.

Style: Exhibits painterly abstraction and impressionism. Genres include landscapes and figurative work. Prefers landscapes, figurative and abstract.

Terms: Work only on consignment. Retail price set by the artist. Gallery provides promotion and contract and shares in shipping costs.

Submissions: Prefers artists from the Bay Area. Send query letter with résumé, 20-30 slides representing current style and SASE. Call for appointment to show portfolio of originals, slides and transparencies. Responds only if interested within 1 month. Files only accepted artists' slides and résumés (others returned). Finds artists through word of mouth and "my own canvassing."

Tips: "Be prepared! Please come to your appointment with an artist statement, an inventory listing including prices, a résumé, and artwork that is ready for display."

N JILL THAYER GALLERIES AT THE FOX, 1700 20th St., Bakersfield CA 93301-4329. (661)328-9880. Fax: (661)631-9711. E-mail: jill@jillthayer.com. Website: www.jillthayer.com. **Director:** Jill Thayer. For profit gallery. Estab. 1994. Represents 20 emerging, mid-career and established artists. Features 6-8 exhibits/year. Average display time 6 weeks. Open Thursday-Friday, 10-4; Saturday 1-4 or by appointment. Closed holidays. Located at the historic Fox Theater, built in 1930. Thayer renovated the 400 sq. ft. space in 1994. The space features large windows, high ceilings, wood floor and bare wire, solux halogen lighting system. Clients include regional southern California upscale. 50% of sales are to corporate collectors. Overall price range: $250-10,000; most work sold at $1,500.

Media: Considers all media and all types of prints. Exhibits painting, drawing, photography, montage, assemblage, glass.

Style: Color field, conceptualism, expressionism, impressionism, neo-expressionism and painterly abstraction. Most frequently exhibits contemporary, abstract, impressionistic and expressionistic.

Terms: Artwork is accepted on consignment and there is a 50% commission. Artist pays all shipping. Retail price set by the gallery and the artist. Gallery provides promotion and contract. Artist shares cost of mailings and receptions.

Submissions: Send query letter with artist's statement bio, résumé, reviews, SASE and slides. Responds in 1 month if interested. Finds artists through submissions and portfolio reviews.

Tips: "When submitting to galleries, be concise, professional, send up-to-date vitae (listing of exhibitions and education/bio) and a slide sheet."

NATALIE AND JAMES THOMPSON ART GALLERY, School of Art Design, San José State University, San José CA 95192-0089. (408)924-4723. Fax: (408)924-4326. E-mail: jfh@cruzio.com. Website: www.sjsu.edu. **Contact:** Jo Farb Hernandez, director. Nonprofit gallery. Approached by 100 artists/year. Sponsors 6 exhibits/year of emerging, mid-career and established artists. Average display time 1 month. Open all year; Tuesday-Friday, 11-4. Closed semester breaks, summer and weekends. Clients include local community, students and upscale.

Media: Considers all media and all types of prints.

Style: Considers all styles and genres.

Terms: Retail price set by the artist. Gallery provides insurance, transportation and promotion. Accepted work should be framed and/or ready to display. Does not require exclusive representation locally.

Submissions: Send query letter with artist's statement, bio, résumé, reviews, SASE and slides. Returns material with SASE.

N ATELIER RICHARD TULLIS, 1 N. Calle Cesar Chaves, #9, Santa Barbara CA 93103. (805)965-1091. Fax: (805)965-1093. Website: www.tullis-art.com. **Director:** Richard Tullis II. Specializes in collaborations with artists. Exploration of material and image-making on various media. Estab. 1992. Exhibited artists Kirkeby, Millei, Carroll, Haynes, Kaneda, Humphries, Gipe, Tullis, Fierro, Walker, Oulton. Hours by appointment. Located in industrial area; 6,500 sq. ft.; sky lights in saw tooth roof; 27′ ceiling.

Submissions: By invitation.

EDWARD WESTON FINE ART, 10511 Andora Ave., P.O. Box 3098, Chatsworth CA 91313. (818)885-1044. Fax: (818)885-1021. Art consultancy, for profit gallery, rental and wholesale gallery. Estab. 1960. Approached by 50 artists/year. Represents 100 emerging, mid-career and established artists. Exhibited artists include George Barris, George Hurrell, C.S. Bull, Milton Greene and Laszlo Willinger. Sponsors 16 exhibits/year. Average display time 4-6 weeks. Open 7 days a week by appointment. Located in a 2-story 30×60 showroom gallery, office and storage facility. Clients include local community, tourists, upscale and dealers. 5% of sales are to corporate collectors. Overall price range: $50-75,000; most work sold at $1,000.

Media: Considers all media and all types of prints. Most frequently exhibits photography, paintings, sculpture and Picasso ceramics.

Style: Considers all styles. Most frequently exhibits figurative work, landscapes. Considers all genres.

Making Contact & Terms: Artwork is accepted on consignment, and there is a 50% commission. Artwork is bought outright for 10-20% of the retail price; net 30 days. Retail price set by the gallery. Gallery provides contract. Accepted work should be framed and matted. Requires exclusive representation locally.

Submissions: Write to arrange a personal interview to show portfolio of photographs and transparencies. Mail portfolio for review. Send query letter with bio, brochure, business card, photocopies, photographs and reviews. Cannot return material. Responds in 1 month. Files materials if interesting. Finds artists through word of mouth, art exhibits and art fairs.

Tips: "Be thorough and complete."

✓ SYLVIA WHITE GALLERY CONTEMPORARY ARTISTS' SERVICES, (formerly Sylvia White Contemporary Artists' Services), 1013 Pico Blvd, Santa Monica CA 90405. (310)828-6200. E-mail: info@artadvice.com. Website: www.artadvice.com. **Owner:** Sylvia White. Retail gallery, art consultancy and artist's career development services. Estab. 1979. Represents 25 emerging, mid-career and established artists. Interested in seeing work of emerging artists. Exhibited artists include Martin Mull, John White. Sponsors 12 shows/year. Average display time 1 month. Open all year; Tuesday-Friday, 10-5; Saturday by appointment. Located in downtown Santa Monica; 2,000 sq. ft.; 100% of space for special exhibitions. Clientele: upscale. 50% private collectors, 50% corporate collectors. Overall price range: $1,000-10,000; most work sold at $3,000.

• Sylvia White also has representatives in Chicago and San Francisco.

Media: Considers all media, including photography. Most frequently exhibits painting and sculpture.

Style: Exhibits all styles, including painterly abstraction and conceptualism.

Terms: Retail price set by gallery and artist. Gallery provides insurance, promotion and contract. Artist pays for shipping costs.

Submissions: Send query letter with résumé, slides, bio and SASE. Portfolio should include slides.

⊠ WINFIELD GALLERY, P.O. Box 7393, Carmel CA 93921-7393. (831)624-3369. Fax: (831)624-5618. E-mail: chris@winfieldgallery.com. Website: www.winfieldgallery.com. **Contact:** Chris Winfield, director. For-profit gallery. Estab. 1993. Approached by 75 artists/year; exhibits 75 emerging, mid-career and established artists/year. Sponsors 4 exhibits/year. Average display time is 6 weeks. Open all year; Monday-Saturday, 11-5; Sunday, 12-5. Located "in the heart of Carmel on Dolores between Ocean and 7th. The 2,400 square foot gallery with open-beamed ceilings and skylights leads up to a 400 square foot stage of designated exhibition space." Clients include local community, students, tourists, upscale. Overall price range: $300-100,000; most work sold at $2,500.

Media: Considers acrylic, ceramics, drawing, mixed media, oil, sculpture, watercolor. Most frequently exhibits oil painting, sculpture and ceramics.

Style: Considers all styles. Genres include figurative work, florals and landscapes.

Terms: Artwork is accepted on consignment and there is a 50% commission. Retail price set by the artist and the gallery. Gallery provides insurance and contract. Requires exclusive representation locally.

Submissions: Write to arrange personal interview to show portfolio of prints. Send query letter with artist's statement, bio or resume, and SASE. Returns material with SASE. Responds to queries only if interested in 2 months. Finds artist's through portfolio reviews, referrals by other artists, submissions and word-of-mouth.

Tips: "Always include a SASE."

WOMEN'S CENTER ART GALLERY, UCSB, Bldg. 434, Santa Barbara CA 93106. (805)893-3778. Fax: (805)893-3289. E-mail: artforwomen@mail2museum.com. Website: www.sa.ucsb.edu/women'scenter/artgallery/index.html. **Contact:** Nicole DeGuzman, curator. Nonprofit gallery. Estab. 1973. Approached by 200 artists/year. Represents 50 emerging, mid-career and established artists. Exhibited artists include: Bobbi Bennett (photography) and Christa Reyes-Gonzales (acrylic on canvas). Sponsors 4 exhibits/year. Average display time 11 weeks. Open all year; Monday-Friday, 10-8. Closed UCSB campus holidays and weekends. Located in the Women's Center, on the campus of University of California at Santa Barbara. Exhibition space is roughly 1,000 sq. ft. Clients include local community and students. Overall price range: $100-1,000; most work sold at $300.

Media: Considers all media and all types of prints. Most frequently exhibits acrylic, mixed media and photography.

Style: Considers all styles and genres. Most frequently exhibits post modernism, feminist art and abstraction.

Terms: Retail price set by the artist. Gallery provides insurance and promotion. Accepted work should be framed. Does not require exclusive representation locally. Preference given to residents of Santa Barbara County.

Submissions: Mail portfolio for review. Send query letter with artist's statement, bio, photocopies, photographs, résumé, SASE and slides. Returns material with SASE. Responds only if interested within 3 months. Files complete submission material. Finds artists through word of mouth, submissions, portfolio reviews, art exhibits, referrals by other artists, e-mail and promotional calls to artists.

Tips: "Complete your submission thoroughly and include a relevent statement pertaining to the specific exhibit." Emphasize feminist subjects in imagery chosen.

LEE YOUNGMAN GALLERIES, 1316 Lincoln Ave., Calistoga CA 94515. (707)942-0585. Fax: (707)942-6657. E-mail: leeyg@earthlink.net. Website: www.leeyoungmangalleries.com. **Owner:** Ms. Lee Love Youngman. Retail gallery. Estab. 1985. Represents 40 established artists. Exhibited artists include Ralph Love and Paul Youngman. Sponsors 3 shows/year. Average display time 1 month. Open all year. Located downtown; 3,000 sq. ft.; "contemporary decor." Clientele: 100% private collectors. Overall price range: $500-24,000; most artwork sold at $1,000-3,500.

Media: Considers oil, acrylic, watercolor and sculpture. Most frequently exhibits oils, bronzes and alabaster.

Style: Exhibits impressionism and realism. Genres include landscapes, Southwestern, Western and wildlife. Interested in seeing American realism. No abstract art.

Terms: Accepts work on consignment (50% commission). Retail price set by gallery. Customer discounts and payment by installment are available. Gallery provides insurance and promotion. Artist pays for shipping to and from gallery. Prefers framed artwork.

Submissions: Accepts only artists from Western states. "No unsolicited portfolios." Portfolio review requested if interested in artist's work. "The most common mistake artists make is coming on weekends, the busiest time, and expecting full attention." Finds artists through publication, submissions and owner's knowledge.

Tips: "Don't just drop in—make an appointment. No agents."

Los Angeles

ACADEMY GALLERY, 8949 Wilshire Blvd., Beverly Hills CA 90211. (310)247-3000. Fax: (310)247-3610. E-mail: gallery@oscars.org. Website: www.oscars.org. Nonprofit gallery. Estab. 1992. Exhibitions focus on all aspects of the film industry and the filmmaking process. Sponsors 3-5 exhibitions/year. Average display time 3 months. Open all year; Tuesday-Friday, 10-5; weekends 12-6. Gallery begins in building's Grand Lobby and continues on the 4th floor. Total square footage is approx. 2,000. Clients include students, senior citizens, film aficianados and tourists.

Submissions: Call or write to arrange a personal interview to show portfolio of photographs, slides and transparencies. Finds exhibitions through referrals by other artists.

☑ 🎨 **CITY OF LOS ANGELES' CULTURAL AFFAIRS DEPARTMENT SLIDE REGISTRY**, 514 S. Spring St., 5th Floor, Los Angeles CA 90013. (213)473-0637. Fax: (213)473-0656. E-mail: moliver @cad.lacity.org. **Slide Registrar:** Mary E. Oliver. Registry for California artists. Estab. 1985. Represents 1,300 emerging, mid-career and established artists. Permanent resource for artists and consultants.

Media: Considers all media.

Style: Considers all styles and genres.

Terms: Accepts only artists from California. All artists must fill out application to be registered.

Submissions: Call, send query letter or e-mail for application.

🆕 **CRAFT & FOLK ART MUSEUM (CAFAM)**, 5814 Wilshire Blvd., Los Angeles CA 90036. (323)937-4230. Fax: (323)937-5576. **Director:** Peter Tokofsky. Museum. Estab. 1973. Sponsors 3-4 shows/year. Average display time 2-3 months. Open all year; Tuesday-Sunday 11-5; closed Monday. Located on Miracle Mile; features design, contemporary crafts, international folk art.

Media: Considers all media, woodcut and wood engraving. Most frequently exhibits ceramics, found objects, wood, fiber, glass, textiles.

Style: Exhibits all styles, all genres. Prefers culturally specific, craft and folk art.

Submissions: Send query letter with résumé, slides and bio. Write for information. Portfolio should include slides. Finds artists through written submissions, word of mouth and visiting exhibits.

🆕 **DEL MANO GALLERY**, 11981 San Vicente Blvd., W. Los Angeles CA 90049. (310)476-8508. E-mail: gallery@delmano.com. Website: www.delmano.com. **Contact:** Kirsten Muenster, director of exhibitions. Retail gallery. Estab. 1973. Represents more than 300 emerging, mid-career and established artists. Interested in seeing the work of emerging artists working in wood, glass, ceramics, fiber and metals. Gallery deals heavily in turned and sculpted wood, showing work by David Ellsworth, William Hunter and Ron Kent. Gallery hosts approximately 5 exhibitions per year. Average display time 2-6 months. Open Tuesday-Sunday. Gallery located in Brentwood (a scenic corridor). Space is 3,000 sq. ft. 25% of space for special exhibitions; 75% of space for gallery artists. Clientele: professionals and affluent collectors. 20% private collectors, 5% corporate collectors. Overall price range: $50-20,000; most work sold at $250-5,000.

Media: Considers contemporary art in craft media—ceramics, glass, jewelry, wood, fiber. No prints. Most frequently exhibits wood, glass, ceramics, fiber, metal and jewelry.

Style: Exhibits all styles and genres.

Terms: Accepts work on consignment (50% commission) or 30 days net. Retail price set by gallery and artist. Customer discounts and payment by installment are available. 10-mile exclusive area representation required. Gallery provides insurance, promotion and shipping costs from gallery. Prefers artwork framed.

Submissions: Send query letter with résumé, slides, bio and prices. Portfolio should include slides, price list, artist's statement and bio."

DEVORZON GALLERY, 2720 Ellison Dr., Beverly Hills CA 90210-1208. (310)888-0111. Website: www.devorzon@mac.com. **Owner:** Barbara DeVorzon. Private gallery. "We also work in the design trade." Represents emerging and mid-career artists. Exhibited artists include Vasa, John Kennedy, Zdenek Sorf, Fulvia Levi-Bianchi, Enrique Senis Oliver. Average display time varies. Open all year. Located in Beverly Hills; 2,000 sq. ft. 100% of space for special exhibitions. 25% private collectors; 25% corporate collectors; 50% designers. Overall price range: $500-10,000.
Media: Considers oil, acrylic, watercolor, pastel, mixed media and sculpture. Most frequently exhibits oil or acrylic canvases, mixed media or three dimensional sculpture.
Style: Exhibits neo-expressionism, painterly abstraction, conceptualism, color field, realism, photorealism and neo-renaissance. "Original work only!"
Terms: Accepts work on consignment. Retail price set by the gallery. Gallery provides insurance. Artist pays for shipping. Prefers artwork unframed.
Submissions: Call for appointment to show portfolio.

N LA ARTISTS GALLERY, 3222 La Cienega Ave., #301, Culver City CA 90232. (310)841-2738. E-mail: susan100art@yahoo.com. Website: www.laartists.com. **Contact:** Susan Anderson, director. Alternative space. Estab. 2000. Approached by 25 artists/year. Represents 25 mid-career artists. Exhibited artists include: Dan Shupe, Esau Andrade. Gallery not open to walk-ins. Open by appointment. Clients includ upscale dealers, designers, private clients. 10% of sales are to corporate collectors. Overall price range: $1,500-5,000.
Media: Considers collage, oil, sculpture, watercolor. Most frequently exhibits oil on canvas. Considers all types of prints.
Style: Exhibits: neo-expressionism, postmodernism, figurative, contemporary, folk. Most frequently exhibits figurative/contemporary.
Terms: Artwork is accepted on consignment and there is a 10-50% commission. Retail price set by the artist.
Submissions: Write to arrange personal interview to show portfolio of photographs. Mail portfolio for review. Returns material with SASE. Does not reply to queries. File work I can sell.
Tips: "Keep submissions really short and enclose photographs, not slides."

N LA LUZ DE JESUS GALLERY, 4633 Hollywood Blvd., Los Angeles CA 90027. (323)666-7667. Fax: (323)663-0243. E-mail: sales@laluzdejesus.com. Website: www.laluzdejesus.com. **Gallery Manager:** Michel Chenelle. Retail gallery, retail store attached with ethnic/religious and pop culture merchandise. "We provide a space for low-brow/cutting edge and alternative artists to show their work." Estab. 1976. Represents emerging, mid-career and established artists. Exhibited artists include Shag, Joe Coleman, S. Clay Wilson. Sponsors 12 shows/year; "each show ranges from 1 person to large group (as many as 50)." Average display time 3½ weeks. Open all year; Sunday, 12-6; Monday-Wednesday, 11-7; Thursday-Saturday, 11-9. Clientele: "mostly young entertainment biz types, celebrities, studio and record company types, other artists, business people, tourists." 95% private collectors, 5% corporate collectors. Overall price range: $100-10,000; most work sold at $200-2,500.
Media: Considers all media. Considers all types of prints, which are usually shown with paintings and drawings by the same artist. Most frequently exhibits acrylic or oil, pen & ink.
Style: Exhibits alternative, underground, comix-inspired. Prefers alternative/underground/cutting-edge, comix-inspired.
Terms: Accepts work on consignment (50% commission). Retail price set by the gallery and the artist."We ask for an idea of what artist thinks and discuss it." Gallery provides insurance, promotion, contract. Gallery pays shipping costs from gallery, artist pays shipping costs to gallery, buyer pays for shipping if piece goes out of town. Prefers artwork framed.
Submissions: Send query letter with résumé, slides, bio, photographs, SASE, reviews and an idea price range for artist's work. Responds on a quarterly basis. Finds artists through word of mouth (particularly from other artists), artists' submissions, visiting exhibitions.
Tips: "Visit the space before contacting us. If you are out of town, ask a friend to visit and give you an idea. We are a very different gallery."

LOS ANGELES MUNICIPAL ART GALLERY, Barnsdall Art Park, 4804 Hollywood Blvd., Los Angeles CA 90027. **Curators:** Noel Korten and Scott Canty. Nonprofit gallery. Estab. 1971. Interested in

emerging, mid-career and established artists. Sponsors 5 solo and group shows/year. Average display time 2 months. 10,000 sq. ft. Accepts primarily Southern California artists.

Media: Considers oil, acrylic, watercolor, pastel, pen & ink, drawings, contemporary sculpture, ceramic, fiber, photography, craft, mixed media, performance art, video, collage, glass, installation and original handpulled prints.

Style: Exhibits contemporary works only. "We organize and present exhibitions which primarily illustrate the significant developments and achievements of living Southern California artists. The gallery strives to present works of the highest quality in a broad range of media and styles. Programs reflect the diversity of cultural activities in the visual arts in Los Angeles."

Terms: Gallery provides insurance, promotion and contract. This is a curated exhibition space, not a sales gallery.

Submissions: Send query letter, résumé, brochure, slides and photographs. Slides and résumés are filed. Submit slides to Noel Korten.

Tips: "No limits—contemporary only."

N BEN MALTZ GALLERY AT OTIS COLLEGE OF ART & DESIGN, 9045 Lincoln Blvd., Los Angeles CA 90045. (310)665-6905. Fax: (310)665-6908. E-mail: galleryinfo@otis.edu. Website: www.otis. edu. **Gallery Director:** Anne Ayres. Nonprofit gallery. Estab. 1957. Represents emerging and mid-career artists. Sponsors 4-6 exhibits/year. Average display time 1-2 months. Open Tuesday-Saturday, 10-5; weekends 10-5. Closed July-August. Located near Los Angeles International Airport (LAX). Approximately 3,520 sq. ft., wall height 14'. Clients include local community, students, tourists, upscale and artists.

Media: Considers all media and all types of prints. Most frequently exhibits painting, mixed media. Finds artists through word of mouth, art exhibits, referrals by other artists.

Tips: Submit good quality 35mm slides of artwork—with information (name, title, date, media, dimensions) on slide—be patient.

San Francisco

N AUROBORA PRESS, 147 Natoma St., San Francisco CA 94105. (415)546-7880. Fax: (415)546-7881. E-mail: monotype@aurobora.com. Website: www.aurobora.com. **Directors:** Michael Liener. Retail gallery and fine arts press. Invitational Press dedicated to the monoprint and monotype medium. Estab. 1993. Represents/exhibits emerging, mid-career and established artists. Exhibited artists include William T. Wiley, David Ireland, Stephan DeStaebler, Tony Delap. Sponsors 10 shows/year. Average display time 4-6 weeks. Open all year; Monday-Saturday, 11-5. Located south of Market—Yerba Buena; 1,000 sq. ft.; turn of the century firehouse—converted into gallery and press area. Clientele: collectors, tourists and consultants. Overall price range: $1,200-6,000; most work sold at $1,500-4,000.

 • Aurobora Press invites artists each year to spend a period of time in residency working with Master Printers.

Media: Publishes monotypes.

Terms: Retail price set by gallery and artist. Gallery provides promotion.

Submissions: By invitation only.

N CATHARINE CLARK GALLERY, 49 Geary St., #2FL, San Francisco CA 94108-5705. (415)399-1439. Fax: (415)399-0675. E-mail: morphos@cclarkgallery.com. Website: www.cclarkgallery.com. **Owner/Director:** Catharine Clark. Retail gallery. Estab. 1991. Represents 10 emerging and mid-career artists. Curates 5-12 shows/year. Average display time 4-6 weeks. Open all year. Located downtown San Francisco; 3,000 sq. ft., including video project room. 90% of space for special exhibitions. Clientele: 95% private collectors, 5% corporate collectors. Overall price range: $200-300,000; most work sold at $2,000-3,000.

Media: Considers oil, acrylic, mixed media, collage, sculpture, installation, photography, woodcuts, wood engravings, linocuts, engravings, mezzotints, etchings, photography, lithographs and new genres. Most frequently exhibits painting, sculpture, installation and new genres.

Style: Exhibits all styles and genres.

Terms: Accepts work on consignment (50% commission). Retail price set by gallery and artist. Offers customer payment by installments. Gallery provides insurance, promotion and contract; shipping costs are shared. Prefers artwork framed.

Submissions: Send query letter with slides, bio, reviews and SASE in the month of July. Reviews submissions in December and August.

⚑ **EBERT GALLERY**, 49 Geart St., San Francisco CA 94108. (415)296-8405. E-mail: dickebert@spryn et.com. Website: www.ebertgallery.com. **Owner:** Dick Ebert. Retail gallery. Estab. 1989. Represents 24 established artists "from this area." Interested in seeing the work of emerging artists. Sponsors 11-12 shows/year. Average display time 1 month. Open all year; Tuesday-Friday, 10:30-5:30; Saturday, 11-5. Located downtown near bay area; 200 sq. ft.; one room. Clientele: collectors, tourists, art students. 80% private collectors. Overall price range: $500-20,000; most work sold at $500-8,000.
Media: Considers oil, acrylic, watercolor, pastel, pen & ink, drawing, mixed media, collage, paper, sculpture, glass, photography, woodcuts, engravings, mezzotints, etchings and encostic. Most frequently exhibits acrylic, oils and pastels.
Style: Exhibits expressionism, painterly abstraction, impressionism and realism. Genres include landscapes, figurative work, all genres. Prefers landscapes, abstract, realism. "Smaller work to 4×5—no larger."
Terms: Accepts work on consignment (50% commission). Retail price set by the artist. Gallery provides promotion. Shipping costs are shared. Prefers artwork framed.
Submissions: San Francisco Bay Area artists only. Send query letter with résumé and slides. Finds artists through referral by professors or stable artists.
Tips: "You should have several years of practice as an artist before approaching galleries. Enter as many juried shows as possible."

INTERSECTION FOR THE ARTS, 446 Valencia, San Francisco CA 94103. (415)626-2787. E-mail: info@theintersection.org. Website: www.theintersection.org **Program Director:** Kevin B. Chen. Alternative space and nonprofit gallery. Estab. 1965. Exhibits the work of 10 emerging and mid-career artists/year. Sponsors 8 shows/year. Average display time 6 weeks. Open all year. Located in the Mission District of San Francisco; 1,000 sq. ft.; gallery has windows at one end and cement pillars betwen exhibition panels. 100% of space for special exhibitions. Clientele: 100% private collectors.
 ● This gallery supports emerging and mid-career artists who explore experimental ideas and processes. Interdisciplinary, new genre, video performance and installation is encouraged.
Media: Considers oil, pen & ink, acrylic, drawings, watercolor, mixed media, installation, collage, photography, site-specific installation, video installation, original handpulled prints, woodcuts, lithographs, posters, wood engravings, mezzotints, linocuts and etchings.
Style: Exhibits all styles and genres.
Terms: Retail price set by artist. Customer discounts and payment by installment are available. Gallery provides promotion; shipping costs are shared.
Submissions: Send query letter with résumé, 20 slides, reviews, bio, clippings and SASE. Portfolio review not required. Responds within 6 months only if interested and SASE has been included. Files slides.
Tips: "Create proposals which consider the unique circumstances of this location, utilizing the availability of the theater and literary program/resources/audience."

MUSEO ITALOAMERICANO, Fort Mason Center Bldg. C, San Francisco CA 94123. (415)673-2200. Fax: (415)673-2292. E-mail: museo@firstworld.net. Website: www.museoitaloamericano.org. Museum. Estab. 1978. Approached by 80 artists/year. Exhibits 15 emerging, mid-career and established artists/year. Exhibited artists include: Sam Provenzano. Sponsors 7 exhibits/year. Average display time 3-4 months. Open all year; Wednesday-Sunday, 12-5; weekends 12-5. Closed major holidays. Located in the San Francisco Marina District with beautiful view of the Golden Gate Bridge. 3,500 sq. ft. of exhibition space. Clients include local community, students, tourists, upscale and members.
Media: Considers all media and all types of prints. Most frequently exhibits mixed media, paper, photography and oil.
Style: Considers all styles and genres. Most frequently exhibits primitivism realism, geometric abstraction, figurative and conceptualism.
Terms: The museum sells pieces in agreement with the artist, and if it does, it takes 20% of the sale. Gallery provides insurance and promotion. Accepted work should be framed, mounted and matted. Accepts only Italian or Italian-American artists.
Submissions: Call or write to arrange a personal interview to show portfolio of photographs, slides and catalogues. Send query letter with artist's statement, bio, brochure, photography, résumé, reviews, SASE and slides. Returns material with SASE. Responds in 2 months. Files 2 slides and biography and artist's

statement for each artist. Finds artists through word of mouth and submissions.

Tips: Looks for good quality slides; and clarity in writing statements and résumés. "Be concise."

OCTAVIA'S HAZE GALLERY, 498 Hayes St., San Francisco CA 94102. (415)255-6818. Fax: (415)255-6827. E-mail: octaviashaze@mindspring.com. Website: www.octaviashaze.com. **Director:** Sky Alsgaard. For profit gallery. Estab. 1999. Approached by 60 artists/year. Represents 10 emerging and mid-career artists. Exhibited artists include: Tsuchida Yasuhiko and Stanley Mouse. Sponsors 8 exhibits/year. Average display time 45 days. Open all year; Wednesday-Sunday, 12-6; Sunday, 11-5. Closed Christmas through New Years. Clients include local community, tourists and upscale. 13% of sales are to corporate collectors. Overall price range: $200-6,000; most work sold at $600.

Media: Most frequently exhibits glass, paintings (all media) and photography. Considers all types of prints.

Style: Considers all styles. Most frequently exhibits abstract, surrealism and expressionism. Genres include figurative work and landscapes.

Terms: Artwork is accepted on consignment and there is a 50% commission. Retail price set by the gallery. Gallery provides promotion and contract. Accepted work should be framed and matted.

Submissions: Send query letter with artist's statement, résumé, SASE and slides. Returns material with SASE. Responds in 4 months. Finds artists through word of mouth, submissions and art exhibits.

🌑 **SAN FRANCISCO ARTS COMMISSION GALLERY**, 401 Van Ness Ave., San Francisco CA 94102. (415)554-6080. Fax: (415)252-2595. E-mail: natasha.garcia-lomas@sfgov.org. Website: sfac.sfsu.edu/. **Director:** Rupert Jenkins. Gallery Manager: Natasha Garcia-Lomas. Nonprofit municipal gallery; alternative space. Estab. 1983. Exhibits innovative contemporary work by emerging and mid-career artists primarily from the Bay Area region. Sponsors 7 indoor group shows/year. Average display time 5 weeks (indoor); 3 months (outdoor installations). Open all year. Located at the Civic Center; 1,000 sq. ft. across the street from City Hall and in the heart of the city's performing arts complex. 100% of space for special exhibitions. Clientele: cross section of San Francisco/Bay Area including tourists, upscale, local and students. Sales are minimal.

Media: Considers all media. Most frequently exhibits installation, mixed media, sculpture/3-D, painting, photography.

Style: Exhibits all styles. Prefers cutting-edge, contemporary works.

Terms: Accepts artwork on consignment (25% commission). Retail price set by artist. Gallery provides insurance, promotion and contract; artist pays for shipping.

Submissions: Accepts only artists residing in one of nine Bay Area counties. Download gallery guidelines from website. Do not send unsolicited slides.

Tips: "The Art Commission Gallery serves as a forum for exhibitions which reflect the aesthetic and cultural diversity of contemporary art in the Bay Area. Gallery does not promote sale of art, as such, but will handle sale of available work if a visitor wishes to purchase it. Exhibit themes, artists, and selected works are recommended by the gallery director and advisory board to the San Francisco Art Commission for approval. Gallery operates for the benefit of the public as well as the artists. It is not a commercial venue for art."

Colorado

THE BOULDER MUSEUM OF CONTEMPORARY ART, 1750 13th St., Boulder CO 80302. (303)443-2122. Fax: (303)447-1633. E-mail: info@bmoca.org. Website: www.bmoca.org. **Contact:** Exhibitions Committee. Nonprofit museum. Estab. 1972. Exhibits contemporary art and performance. Programs regional, national and international emerging and established artists. 10,000 sq. ft. of exhibition and performance spaces. "Located in a historically landmarked two-story, red-brick building in heart of downtown Boulder."

Media: Considers all media.

Style: Exhibits new art forms in the work of emerging and established artists.

Submissions: Accepts work by invitation only, after materials have been reviewed by Exhibitions Committee. Send query letter, artist statement, résumé, approximately 20 high-quality slides or CD, outline of logistics if installation and SASE. Portfolio review requested if interested in artist's work. Submission review in January. Responds in 6 months. Submissions are filed. Additional materials appropriate to submission are accepted.

☑ 🕮 **BUSINESS OF ART CENTER**, 513 Manitou Ave., Manitou Springs CO 80829. (719)685-1861. Website: www.thebac.org. Nonprofit gallery. Estab. 1988. Approached by 200 emerging, mid-career and established artists/year. Sponsors 40 exhibits/year. Average display time 1 month. Open all year; Tuesday-Saturday, 10-6. Shorter winter hours, please call. Clients include local community, students and upscale. 10% of sales are to corporate collectors.

Media: Considers all media and all types of prints. Most frequently exhibits painting, photography and ceramic.

Style: Considers all styles and genres.

Terms: Artwork is accepted on consignment and there is a 40% commission. Retail price set by the artist. Gallery provides insurance, promotion and contract. Accepted work should be framed. Requires exclusive representation locally. Primary focus on Colorado artists.

Submissions: Write to arrange a personal interview to show portfolio. Send query letter with artist's statement, bio and slides. Returns material with SASE. Finds artists through word of mouth, submissions, portfolio reviews, art exhibits and referrals by other artists.

Tips: Archival quality materials are mandatory to the extent possible in the medium.

🆒 **COGSWELL GALLERY**, 223 Gore Creek Dr., Vail CO 81657. (970)476-1769. Fax: (970)479-1141. E-mail: cogswellgallery@qwest.net. Website: www.ogswellgallery.com. **Contact:** Amy Logan, John Cogswell. Retail gallery. Estab. 1980. Represents 40 emerging, mid-career and established artists. Exhibited artists include Steve Devenyns, Sherry Sander and Jean Richardson. Sponsors 8-10 shows/year. Average display time 3 weeks. Open all year. Located in Creekside Building in Vail; 3,000 sq. ft. 50% of space for special exhibitions. Clientele: American and international, young and active. 80% private collectors, 20% corporate collectors. Overall price range: $100-50,000; most work sold at $1,000-5,000.

Media: Considers oil, sculpture, watercolor, and pastels; engravings, lithographs, giclées and serigraphs. Most frequently exhibits bronze, oil and watercolor.

Style: Exhibits color field and impressionism. Genres include Southwestern, Western, figurative work, wildlife, bronze.

Terms: Accepts work on consignment (50% commission). Retail price set by the artist. Offers customer discounts and payment by installments. Gallery provides insurance and promotion; shipping costs from gallery. Prefers artwork framed.

Submissions: Send query letter with résumé, slides and bio. Call for appointment to show portfolio of slides. Responds only if interested within 1 month.

🆒 🕮 **CORE NEW ART SPACE**, 2045 Larimer St., Denver CO 80205. (303)297-8428. Website: www.corenewartspace.com. **Directors:** Bruce Clark and Dave Griffin. Cooperative, alternative and non-profit gallery. Estab. 1981. Exhibits 30 emerging and mid-career artists. Sponsors 30 solo and 6-10 group shows/year. Average display time: 3 weeks. Open Friday-Sunday. Open all year. Located "in lower downtown, former warehouse area; 3,400 sq. ft." Accepts mostly artists from front range Colorado. Clientele: 97% private collectors; 3% corporate clients. Overall price range: $75-3,000; most work sold at $100-600.

Media: Considers all media. Specializes in cutting edge work. Prefers quality rather than marketability.

Style: Exhibits expressionism, neo-expressionism, painterly abstraction, conceptualism; considers all styles and genres, but especially contemporary and alternative (non-traditional media and approach), including installations.

Terms: Co-op membership fee plus donation of time. Retail price set by artist. Exclusive area representation not required. Also rents loft gallery space to non-members for $125-275/3 week run. Send slides for consideration to gallery attention: Annette Coleman.

Submissions: Send query letter with SASE. Quarterly auditions to show portfolio of originals, slides and photographs. Request membership or supporting member application. "Our gallery gives an opportunity for emerging artists in the metro-Denver area to show their work. We run four to six open juried shows a year. There is an entry fee charged, but no commission is taken on any work sold. The member artists exhibit in a one-person show once a year. Member artists generally work in more avant-garde formats, and the gallery encourages experimentation. Members are chosen by slide review and personal interviews. Due to time commitments we require that they live and work in the area. There is a yearly Associate Members Show." Finds artists through invitations, word of mouth, art publications.

Tips: "We want to see challenging art. If your intention is to manufacture coffee-table and over-the-couch art for suburbia, we are not a good place to start."

🆒 **FIRST PEOPLES GALLERY**, P.O. Box 23259, Parkway Place, Silverthorne CO 80498. (970)513-8038 or (888)663-3900. Fax: (970)513-8053. E-mail: indianart@direcway.com. Website: www.FIRSTPeop

les.net. **Director:** Victoria Torrez Kneemeyer. Retail gallery. Estab. 1992. Represents 30 mid-career and established artists/year. Interested in seeing the work of emerging North American Native and Southwestern artists. Exhibited artists include Bill Mittag, Lisa Fi Field, Pablo Luzardo and Raymond Nordwall. Sponsors 2 shows/year. Average display time 6 weeks. Open all year; Tuesday-Sunday, 11-6. Located in Summit City—Colorado's playground. Space is 2,000 sq. ft. (new construction) in ski resort location. 60% of space for special exhibitions; 40% of space for gallery artists. Clientele: collectors, walk-in traffic, tourists. 30% private collectors, 10% corporate collectors. Overall price range: $100-1,000 (40%), $1,000-15,000 (10%); most work sold at $7,000 (50%).

Media: Considers oil, acrylic, watercolor, pastel, pen & ink, mixed media, sculpture, pottery (coiled, traditional style only) and Cape Dorset Soapstone sculpture. Most frequently exhibits oil and acrylic, watercolors.

Style: Only North American Native fine art paintings. Exhibits expressionism, landscapes, traditional, wildlife and (figurative) realism by several artists, Southwest artists (Art Deco, Kiowa), who work in Santa Fe school, Jalisco and other local styles. Genres includes Southwestern, portraits and figurative work. Prefers expressionism, landscapes, wildlife, traditional styles.

Terms: Accepts work on consignment (40-50% commission) or buys outright for 50% of retail price (net 30 days). Retail price set by the gallery and the artist. Gallery provides insurance, promotion and contract; artist pays shipping costs to gallery. Prefers artwork framed in wood.

Submissions: Accepts only artists native to North America. Send query letter with résumé, slides, bio, brochure, price list, list of exhibitions, business card and reviews. Call for appointment to show portfolio. Responds in 3-4 weeks. Responds if interested within 1 week. Files entire portfolio. Finds artists through exhibits, submissions, publications and Indian markets.

Tips: "Send artist statement, bio and profile describing work and photos/slides. First Peoples Gallery accepts only North American Native art and a minimum of ten pieces."

FORT COLLINS MUSEUM OF CONTEMPORARY ART, 201 S. College Ave., Ft. Collins CO 80524. (970)482-2787. **Executive Director:** Jeanne Schaff. Private nonprofit collecting museum. Estab. 1983. Presents 10 rotating exhibitions/year in two galleries, 1,800 sq. ft. each. Showing the work of emerging and mid-career regional, national and international artists. Open all year; Tuesday-Saturday, 10-6. Located downtown; in 1911 renovated Italian renaissance post office building.

Media: Considers all media.

Style: Exhibits work by living artists with emphasis on new media, form or techniques and work that gives visual expression to contemporary issues.

Submissions: Send 15-20 slides of latest work with résumé and artist's statement with SASE. Slides may be kept for 4 months before responding; if works accepted for exhibition, slides will be kept for promotional and educational purposes. Works may be made available for sale, MOCA keeps 30% commission.

GALLERY M, 2830 E. Third Ave., Denver CO 80206. (303)331-8400. Fax: (303)331-8522. E-mail: newartists@gallerym.com. Website: www.gallery.com. **Contact:** Managing Partner. For-profit gallery. Estab. 1996. Represents emerging, mid-career and established artists. Exhibited artists include: Alfred Elsenstaedt (photography). Average display time 6-12 weeks. Clients include local community, tourists and upscale. Overall price range: $265-??; most work sold at $1,000-5,000.

Media: Considers acrylic, collage, drawing, glass, installation, mixed media, oil, paper, pastel, pen & ink, watercolor, engravings, etchings, linocuts, lithographs, mezzotints, serigraphs, woodcuts, photography and sculpture.

Style: Exhibits: color field, expressionism, geometric abstraction, neo-expressionism, postmodernism, primitivism realism and surrealism. Considers all genres.

Terms: Retail price set by the gallery and the artist. Gallery provides insurance and promotion. Requires exclusive local and regional representation.

Submissions: Write to arrange a personal interview to show portfolio of photographs, slides and transparencies. Mail portfolio for review. Returns materials with SASE. Finds artists through current artists represented, other gallery referral, museum referral and select art exhibits.

WILLIAM HAVU GALLERY, 1040 Cherokee St., Denver CO 80204 (303)893-2360. Fax: (303)893-2813. E-mail: bhavu@mho.net. Website: www.williamhavugallery.com. **Owner:** Bill Havu. Gallery Administrator: Kate Thompson. For-profit gallery. Estab. 1998. Approached by 120 emerging, mid-career and established artists. Exhibits 50 artists. Exhibited artists include: Emilio Lobato, painter and printmaker; Amy Metier, painter. Sponsors 7-8 exhibits/year. Average display time 6-8 weeks. Open all year; Tuesday-

Friday, 10-6; Saturday, 11-5. Closed Sundays, Christmas and New Year's Day. Located in the Golden Triangle Arts District of downtown Denver. The only gallery in Denver designed as a gallery; 3,000 square feet, 18 foot high ceilings, 2 floors of exhibition space; sculpture garden. Clients include local community, students, tourists, upscale, interior designers and art consultants. Overall price range: $250-15,000; most work sold at $1,000-4,000.

Media: Considers acrylic, ceramics, collage, drawing, mixed media, oil, paper, pastel, pen & ink, sculpture and watercolor. Most frequently exhibits painting, prints and ceramic sculpture. Considers etchings, linocuts, lithographs, mezzotints, woodcuts, monotypes, monoprints and silkscreens.

Style: Exhibits: expressionism, geometric abstraction, impressionism, minimalism, postmodernism, surrealism and painterly abstraction. Most frequently exhibits painterly abstraction, impressionism and expressionism.

Terms: Artwork is accepted on consignment and there is a 50% commission. Retail price set by the gallery and the artist. Gallery provides insurance, promotion and contract. Accepted work should be framed. Primarily accepts only artists from Rocky Mountain, Southwestern region.

Submissions: Mail portfolio for review. Send query letter with artist's statement, bio, brochure, résumé, SASE and slides. Returns material with SASE. Responds only if interested within 1 month. Files slides and résumé, if we are interested in the artist. Finds artists through word of mouth, submissions and referrals by other artists.

Tips: Always mail a portfolio packet. We do not accept walk-ins or phone calls to review work. Explore website or visit gallery to make sure work would fit with the gallery's objective. Archival-quality materials play a major role in selling fine art to collectors. We only frame work with archival-quality materials and feel its inclusion in work can "make" the sale.

E.S. LAWRENCE GALLERY, 516 E. Hyman Ave., Aspen CO 81611. (970)920-2922. Fax: (970)920-4072. E-mail: esl@eslawrence.com. Website: www.eslawrence.com. **Director:** Kert Koski. Retail gallery. Estab. 1988. Represents emerging, mid-career and established artists. Exhibited artists include Zvonimir Mihanovic, Leon Bronstein (bronze artist), Pino, Steve Hanks and Chiu Tak Hak. Sponsors 2 shows/year. Open all year; daily 10-10. Located downtown. 100% of space for gallery artists. 95% private collectors, 5% corporate collectors.

• This gallery also has a location in Charleston SC.

Media: Considers oil, acrylic, watercolor, pastel, mixed media, sculpture, glass, lithograph and serigraphs. Most frequently exhibits oil, acrylic, watercolor and bronzes.

Style: Exhibits expressionism, impressionism, photorealism and realism. Genres include landscapes, florals, Americana, figurative work. Prefers photorealism, impressionism, expressionism.

Terms: Accepts artwork on consignment. Retail price set by the gallery and the artist. Gallery provides insurance, promotion and contract; artist pays shipping costs to and from gallery "if not sold." Prefers artwork framed.

Submissions: Send query letter with résumé, slides and photographs. Write for appointment to show portfolio of photographs, slides and reviews. Responds in 1 month. Finds artists through agents, visiting exhibitions, word of mouth, art publications and artists' submissions.

Tips: "We are always willing to look at submissions. We are only interested in originals above $5,000 retail price range. Not interested in graphics."

SANGRE DE CRISTO ARTS CENTER AND BUELL CHILDREN'S MUSEUM, 210 N. Santa Fe Ave., Pueblo CO 81003. (719)295-7200. Fax: (719)295-7230. E-mail: mail@sdc-arts.org. **Curator of Visual Arts:** Jina Pierce. Nonprofit gallery and museum. Estab. 1972. Exhibits emerging, mid-career and established artists. Sponsors 20 shows/year. Average display time 10 weeks. Open all year. Admission $4 adults; $3 children. Located "downtown, right off Interstate I-25"; 16,000 sq. ft.; six galleries, one showing a permanent collection of western art; changing exhibits in the other five. Also a new 12,000 sq. ft. children's museum with changing, interactive exhibits. Clientele: "We serve a 19-county region and attract 200,000 visitors yearly." Overall price range for artwork: $50-100,000; most work sold at $50-2,500.

Media: Considers all media.

Style: Exhibits all styles. Genres include southwestern, regional and contemporary.

Terms: Accepts work on consignment (40% commission). Retail price set by artist. Gallery provides insurance, promotion, contract and shipping costs. Prefers artwork framed.

Submissions: "There are no restrictions, but our exhibits are booked into 2004 right now." Send query letter with slides. Write or call for appointment to show portfolio of slides. Responds in 2 months.

PHILIP J. STEELE GALLERY AT ROCKY MOUNTAIN COLLEGE OF ART & DESIGN, 6875 E. Evans Ave., Denver CO 80224. (303)753-6046. Fax: (303)759-4970. E-mail: lspivak@rmcad.edu. Website: wwwrmcad.edu. **Gallery Director:** Lisa Spivak. Nonprofit college gallery. Estab. 1962. Represents emerging, mid-career and established artists. Sponsors 10-12 shows/year. Exhibited artists include Christo, Jenny Holzer. Average display time 1 month. Open all year; Monday-Friday, 8-6; Saturday, 9-4. Located in southeast Denver; 1,500 sq. ft.; in very prominent location (art college with 450 students enrolled). 100% of space for gallery artists. Clientele: local community, students, faculty.
Media: Considers all media and all types of prints. Most frequently exhibits mixed media, oil/acrylic and work on paper.
Style: Exhibits all styles.
Terms: Artists sell directly to buyer; gallery takes no commission. Retail price set by the artist. Gallery provides insurance and promotion; artist pays shipping costs to and from gallery.
Submissions: Send query letter with résumé, slides, bio, SASE and reviews by April 15 for review for exhibit the following year.
Tips: Impressed by "professional presentation of materials, good-quality slides or catalog."

Connecticut

ALVA GALLERY, 54 State St., New London CT 06320. (860)437-8664. Fax: (860)437-8665. E-mail: Alva@Alvagallery.com. Website: www.alvagallery.com. For-profit gallery. Estab. 1999. Approached by 50 artists/year. Represents 30 emerging, mid-career and established artists. Exhibited artists include: Maureen McCabe (assemblage), Sol LeWitt (prints) and Judith Cotton (paintings). Average display time 6 weeks. Open all year; Tuesday-Saturday, 11-5. Closed between Christmas and New Year and last 2 weeks of August. Clients include local community, tourists and upscale. 5% of sales are to corporate collectors. Overall price range: $250-10,000; most work sold at $1,500.
Media: Considers acrylic, collage, drawing, fiber, glass, mixed media, oil, paper, pastel, pen & ink, sculpture and watercolor. Most frequently exhibits oil, photography and mixed media. Considers all types of prints.
Style: Considers all styles and genres.
Terms: Artwork is accepted on consignment and there is a 50% commission. Retail price set by the artist. Gallery provides insurance and promotion. Does not require exclusive representation locally.
Submissions: Mail portfolio for review. Responds in 2 months. Finds artists through word of mouth, portfolio reviews and referrals by other artists.

ARTWORKS GALLERY, 233 Pearl St., Hartford CT 06103. (860)247-3522. E-mail: artworks.gallery@snet.net. Website: www.artworksgallery.org. **Executive Director:** Colin P. Burke. Cooperative nonprofit gallery. Estab. 1976. Exhibits 200 emerging, mid-career and established artists. Interested in seeing the work of emerging artists. 40 members. Sponsors 13 shows/year. Average display time 1 month. Open Wednesday-Friday, 11-5; Saturday, 12-3. Closed in August. Located in downtown Hartford; 1,300 sq. ft.; large, first floor, store front space. 20% of space for special exhibitions; 80% of space for gallery artists. Clientele: 80% private collectors, 20% corporate collectors. Overall price range: $200-5,000; most work sold at $200-1,000.
Media: Considers all media and all types of prints. Most frequently exhibits paintings, photography and sculpture. No crafts or jewelry.
Style: Exhibits all styles and genres, especially contemporary.
Terms: Co-op membership fee plus a donation of time. There is a 30% commission. Retail price set by artist. Offers customer discounts and payment by installments. Gallery provides insurance, promotion and contract. Artist pays for shipping costs. Prefers artwork framed. Accepts only artists from Connecticut for membership. Accepts artists from New England and New York for juried shows.
Submissions: For membership, send query letter with résumé, slides, bio and $10 application fee. Call for appointment to show portfolio of slides. Responds in 1 month. Finds artists through visiting exhibitions, various art publications and sourcebooks, artists' submissions, art collectors' referrals, but mostly through word of mouth and 2 juried shows/year.

MONA BERMAN FINE ARTS, 78 Lyon St., New Haven CT 06511. (203)562-4720. Fax: (203)787-6855. E-mail: info@monabermanfinearts.com. Website: monabermanfinearts.com. **Director:** Mona Berman. Art consultant. Estab. 1979. Represents 100 emerging and mid-career artists. Exhibited artists include

Tom Hricko, David Dunlop, Pierre Dardignac and S. Wind-Greenbaum. Sponsors 1 show/year. Open all year by appointment. Located near downtown; 1,400 sq. ft. Clientele: 25% private collectors, 75% corporate collectors. Overall price range: $200-20,000; most artwork sold at $500-5,000.

Media: Considers all media except installation. Shows very little sculpture. Considers all limited edition prints except posters and photolithography. Also considers limited and carefully selected high-quality digital media. Most frequently exhibits works on paper, painting, relief and ethnographic arts.

Style: Exhibits most styles. Prefers abstract, landscape and transitional. Little figurative, little still life.

Terms: Accepts work on consignment (50% commission; net 30 days). Retail price is set by gallery and artist. Customer discounts and payment by installment are available. Gallery provides insurance; artist pays for shipping. Prefers artwork unframed.

Submissions: Accepts digital submissions by e-mail and links to websites or send query letter, résumé, CD or "about 20 slides," bio, SASE, reviews and "retail price list—including stated commission." Portfolios are reviewed only after CD or slide submission. Include e-mail address for faster response or responds in 1 month. Slides and reply returned only if SASE is included. Finds artists through word of mouth, art publications and sourcebooks, submissions and self-promotions and other professionals' recommendations.

Tips: "We will not carry artists who list prices on their websites, especially those who do not maintain consistent retail pricing. Please understand that we are not a gallery, although we do a few exhibits. We are primarily art consultants. We continue to be busy selling high-quality art and related services to the corporate, architectural, design and private sectors. Read our listings, then you don't have to call first. A follow-up e-mail is preferrable to a phone call."

N CENTER FOR CONTEMPORARY PUBLISHING, Matthews Park 299 West Ave., Norwalk CT 06850. (203)899-7999. Fax: (203)899-7997. E-mail: contemprints@snet.net. Website: www.norwalk.com/graphicarts. **Contact:** Anthony Kirk, artistic director. Nonprofit gallery and printmaking workshop. Estab. 1995. Approached by 50 artists/year. Represents established artists. Exhibited artists include: Helen Frankenthaler, Wolf Kahn, Gabor Peterdi, Antonio Frasconi and CCP members. Average display time 3 months. Open all year; Monday-Saturday, 9-5. Located in 20×30 space in historic stone building on the grounds of the Lockwood Mathews Mansion Museum. Overall price range: $10-3,000; most work sold at $300-500.

 • The center is gaining international attention for noteworthy exhibitions of world-class prints. Their International Miniature Prints competition attracts 3,000 visitors yearly.

Media: "We exhibit original prints, works on handmade paper and photography." Considers all types of prints.

Style: Considers all styles.

Terms: Artwork is accepted on consignment and there is a 40% commission. Retail price set by the gallery. Gallery provides insurance and promotion. Accepted work should be framed, mounted and matted.

Submissions: Write to arrange a personal interview to show portfolio of photographs and slides. Send query letter with bio, photographs, SASE and slides. Responds in 2 months. Finds artists through word of mouth.

N CONTRACT ART INTERNATIONAL, INC., P.O. Box 520, Essex CT 06426. (860)767-0113. Fax: (860)767-7247. **President:** K. Mac Thames. In business approximately 32 years. "We contract artwork for blue-chip businesses." Represents emerging, mid-career and established artists. Assigns site-specific commissions to artists based on project needs, theme and client preferences. Studio is open all year to corporate art directors, architects and designers. 1,600 sq. ft.. Clientele: 98% commercial. Overall price range: $500-500,000.

Media: Places all types of art mediums.

Terms: Pays for design by the project, negotiable; 50% up front. Rights purchased vary according to project.

Submissions: Send letter of introduction with résumé, slides, bio, brochure, photographs and SASE. If local, write for appointment to present portfolio; otherwise, mail appropriate materials, which should include slides and photographs. "Show us a good range of your talent. Also, we recommend you keep us updated if you've changed styles or media." Responds in 1 week. Files all samples and information in registry library.

Tips: "We exist mainly to art direct commissioned artwork for specific projects."

N FARMINGTON VALLEY ARTS CENTER'S FISHER GALLERY, 25 Arts Center Lane, Avon CT 06001. (860)678-1867, ext. 107. Website: www.fvac.net. **Manager:** Korin Watras. Nonprofit gallery.

Estab. 1972. Exhibits the work of 100 emerging, mid-career and established artists. Also presents gallery talks or workshops by featured artsits through the Center's School of the Arts. Open all year; Wednesday-Saturday, 11-5; Sunday, 12-4; extended hours November-December. Located in Avon Park North just off Route 44; 600 sq. ft.; "in a beautiful 19th-century brownstone factory building once used for manufacturing." Clientele: upscale contemporary craft buyers. Overall price range: $35-500; most work sold at $50-100.

Media: Considers "primarily crafts," also considers some mixed media, works on paper, ceramic, fiber, glass and small size prints. Most frequently exhibits jewelry, ceramics and fiber.

Style: Exhibits contemporary, handmade craft.

Terms: Accepts artwork on consignment (50% commission). Retail price set by the artist. Gallery provides promotion and contract; shipping costs are shared. Requires artwork framed where applicable.

Submissions: Send query letter with résumé, bio, slides, photographs, SASE. Responds only if interested. Files a slide or photo, résumé and brochure.

BILL GOFF, INC., 5 Bridge St., P.O. Box 977, Kent CT 06757-0977. (860)927-1411. Fax: (860)927-1987. Website: goodsportsart.com. **President:** Bill Goff. Estab. 1977. Exhibits, publishes and markets baseball art. 95% private collectors, 5% corporate collectors.

Needs: Baseball subjects for prints. Realism and photorealism. Represents 10 artists; emerging, mid-career and established. Exhibited artists include Andy Jurinko and William Feldman, Bill Purdom, Bill Williams.

First Contact & Terms: Send query letter with bio and photographs. Write to schedule an appointment to show a portfolio, which should include photographs. Responds only if interested within 2 months. Files photos and bios. Accepts work on consignment (50% commission) or buys outright for 50% of retail price. Overall price range: $95-30,000; most work sold at $125-220 (published lithographs). Retail price set by the gallery. Gallery provides insurance and promotion; shipping costs are shared. Prefers artwork unframed.

Tips: "Do not waste our time or your own by sending non-baseball items."

N GREAT HARBOR GALLERY OF FINE ART, 63 Wall St., Madison CT 06443. (203)245-3327. Fax: (203)245-8012. E-mail: grharbart2@aol.com. **Director:** Robert A. Westerlund. For profit gallery. Estab. 1997. Exhibits antique American works of artists listed in *Who Was Who in American Art: 1564-1975* and an occasional living local artist. Exhibited artists include: Tina Waring, (oil, pastel, watercolor) contemporary artist. Sponsors 4 exhibits/year. Average display time 1 month. Open all year; Tuesday-Sunday, 10-5; weekends Saturday, 11-5; Sunday, 12-5. Located in a historic house in Madison. Clients include local community, upscale and Web.

Media: Considers all media except ceramics, glass and craft. Most frequently exhibits oil, watercolor and pastel. Considers all types of prints, antique prints, mainly.

Style: Most frequently exhibits impressionism. Considers all genres.

Terms: Artwork is accepted on consignment or bought outright. Retail price set by the gallery. Accepts only artists from northeastern US.

Submissions: Send query letter with bio, photographs and SASE. Responds in 6 months.

SILVERMINE GUILD GALLERY, 1037 Silvermine Rd., New Canaan CT 06840. (203)966-5617. Fax: (203)972-7236. **Director:** Helen Klisser During. Nonprofit gallery. Estab. 1922. Represents 300 emerging, mid-career and established artists/year. Sponsors 24 shows/year. Average display time 1 month. Open all year; Tuesday-Saturday, 11-5; Sunday, 1-5. 5,000 sq. ft. 95% of space for gallery artists. Clientele: private collectors, corporate collectors. Overall price range: $250-10,000; most work sold at $1,000-2,000.

Media: Considers all media and all types of prints. Most frequently exhibits paintings, sculpture and ceramics.

Style: Exhibits all styles.

Terms: Accepts guild member work on consignment (50% commission). Co-op membership fee plus donation of time (50% commission.) Retail price set by the gallery and the artist. Gallery provides insurance, promotion and contract. Prefers artwork framed.

Submissions: Send query letter.

SMALL SPACE GALLERY, Arts Council of Greater New Haven, 70 Audubon St., New Haven CT 06510. (203)772-2788. Fax: (203)772-2262. E-mail: dhesse.ac@snet.net. Website: www.artscouncil-newhaven.org. **Director:** Debbie House. Alternative space. Estab. 1985. Interested in emerging artists. Sponsors 10 solo and group shows/year. Average display time 1-2 months. Open to Arts Council members

only (Greater New Haven). Arts Council membership costs $35. Artwork price range: $35-3,000.
Media: Considers all media.
Style: Exhibits all styles and genres. "The Small Space Gallery was established to provide our artist members with an opportunity to show their work. Particularly those who were just starting their careers. We're not a traditional gallery, but an alternative art space." Shows are promoted through greater New Haven's only comprehensive arts and entertainment events magazine.
Terms: Arts Council requests 10% donation on sale of each piece. Retail price set by artist. Exclusive area representation not required. Gallery provides insurance (up to $10,000) and promotion.
Submissions: Send query letter with résumé, brochure, slides, photographs and bio. Call or write for appointment to show portfolio of originals, slides, transparencies and photographs. Will reply to all mailings and phone calls.

Delaware

CARSPECKEN SCOTT GALLERY, 1707 N. Lincoln St., Wilmington DE 19806. (302)655-7173. E-mail: carspecken-Scott@aol.com. **Gallery Director:** Toni Vandegrift. Art consultancy, for profit gallery. Also provides museum quality framing. Estab. 1973. Approached by 100 artists/year. Represents 25 mid-career and established artists. Exhibited artists include: Mary Page Evans and Carl Plansky. Sponsors 8 exhibits/year. Average display time 1 month. Open all year; Monday-Friday, 9-5:30; Saturday, 10-3. Clients include local community and upscale. Overall price range: $500-8,000; most work sold at $2,800.
Media: Considers drawing, oil, sculpture and watercolor. Most frequently exhibits oil, acrylic and drawing. Considers engravings, etchings and lithographs.
Style: Exhibits: expressionism, impressionism and painterly abstraction. Most frequently exhibits florals, stilllifes and landscapes.
Terms: Artwork is accepted on consignment and there is a 40% commission. Retail price set by the artist. Gallery provides promotion. Accepted work should be framed. Requires exclusive representation locally.
Submissions: Mail portfolio for review. Send query letter with artist's statement, bio, photographs or slides, résumé, SASE. Returns material with SASE. Responds in 1 month. Finds artists through portfolio reviews, and referrals by other artists.

MICHELLE'S OF DELAWARE, 831 North Market St., Wilmington DE 19801. (302)655-3650. Fax: (302)661-ARTS. **Art Director:** Raymond Bullock. Retail gallery. Estab. 1991. Represents 18 mid-career and established artists/year. May be interested in seeing the work of emerging artists in the future. Exhibited artists include: Ernie Barnes (acrylic) and Verna Hart (oil). Sponsors 8 shows/year. Average display time 1-2 weeks. Open all year; Saturday-Sunday, 11-5 and 1-5 respectively. Located in Market Street Mall (downtown); 2,500 sq. ft. 50% of space for special exhibitions. Clientele: local community. 97% private collectors; 3% corporate collectors. Overall price range: $300-20,000; most work sold at $1,300-1,500.
Media: Considers all media except craft and fiber; considers all types of prints. Most frequently exhibits acrylic, pastel and oil.
Style: Exhibits geometric abstraction and impressionism. Prefers: jazz, landscapes and portraits.
Terms: Retail price set by the artist. Gallery provides insurance and contract; shipping costs are shared. Prefers artwork framed.
Submissions: Send slides. Write for appointment to show portfolio of artwork samples. Responds only if interested within 1 month. Files bio. Finds artists through art trade shows and exhibitions.
Tips: "Use conservation materials to frame work."

District of Columbia

ADDISON/RIPLEY FINE ART, 1670 Wisconsin Ave., NW, Washington DC 20007. (202)338-5180. Fax: (202)338-2341. E-mail: addisonrip@aol.com. Website: www.addisonripleyfineart.com. **Owner:** Christopher Addison. For profit gallery and art consultancy. Estab. 1981. Approached by 100 artists/year. Represents 25 emerging, mid-career and established artists. Exhibited artists include: Wolf Kahn (paintings, pastels). Sponsors 13 exhibits/year. Average display time 6 weeks. Open all year; Tuesday-Saturday, 11-6. Closed end of summer. Upper Georgetown, large, open gallery space that is light filled. Clients include

local community, tourists and upscale. 20% of sales are to corporate collectors. Overall price range: $500-80,000; most work sold at $2,500-5,000.

Media: Considers acrylic, ceramics, collage, drawing, fiber, glass, installation, mixed media, oil, paper, pastel, sculpture and watercolor. Most frequently exhibits oil and acrylic. Considers etchings, linocuts, lithographs, mezzotints, photography and woodcuts.

Style: Considers all styles. Most frequently exhibits painterly abstraction, color field and expressionism. Considers all genres.

Terms: Terms depend on the circumstances. Retail price set by the gallery and the artist. Gallery provides insurance, promotion and contract. Accepted work should be framed, mounted and matted. No restrictions regarding art or artists.

Submissions: Mail portfolio for review. Send query letter with artist's statement, bio, photocopies, résumé and SASE. Returns material with SASE. Responds in 1 month. Call. "Files ones we like." Finds artists through word of mouth, submissions, and referrals by other artists.

Tips: "Submit organized, professional-looking materials."

ALEX GALLERY, 2106 R St. NW, Washington DC 20008. (202)667-2599. E-mail: Alexartint@aol.c om. Website: www.alexgalleries.com. Director: Victor Gaetan. Retail gallery and art consultancy. Estab. 1986. Represents 20 emerging and mid-career artists. Exhibited artists include Willem de Looper, Gunter Grass and Olivier Debre. Sponsors 8 shows/year. Average display time 1 month. Open all year. Located in the heart of a "gallery" neighborhood; "2 floors of beautiful turn-of-the-century townhouse; a lot of exhibit space." Clientele: diverse; international and local. 50% private collectors; 50% corporate collectors. Overall price range: $1,500-60,000.

Media: Considers oil, acrylic, watercolor, pastel, mixed media, collage, sculpture, photography, original handpulled prints, lithographs, linocuts and etchings. Most frequently exhibits painting, sculpture and works on paper.

Style: Exhibits expressionism, abstraction, color field, impressionism and realism; all genres. Prefers abstract and figurative work.

Terms: Accepts artwork on consignment. Retail price set by gallery and artist. Gallery provides insurance, promotion and contract; shipping costs are shared.

Submissions: Send query letter with résumé, slides, bio, SASE and artist's statement. Write for appointment to show portfolio, which should include slides and transparencies. Responds in 2 months.

ATLANTIC GALLERY OF GEORGETOWN, 1055 Thomas Jefferson St. NW, Washington DC 20007. (202)337-2299. Fax: (202)333-4467. E-mail: gallerydc@aol.com. **Director:** Virginia Smith. Retail gallery. Estab. 1976. Represents 10 mid-career and established artists. Exhibited artists include John Stobart, Tim Thompson, John Gable, Frits Goosen and Robert Johnson. Sponsors 5 solo shows/year. Average display time is 2 weeks. Open all year. Located downtown; 700 sq. ft. Clientele: 70% private collectors, 30% corporate clients. Overall price range: $100-20,000; most artwork sold at $300-5,000.

Media: Considers oil, watercolor and limited edition prints.

Style: Exhibits realism and impressionism. Prefers realistic marine art, florals, landscapes and historic narrative leads.

Terms: Accepts work on consignment (40% commission). Retail price set by gallery and artist. Exclusive area representation required. Gallery provides insurance, promotion and contract; artist pays for shipping.

Submissions: Send query letter, résumé and slides. Portfolio should include originals and slides.

BIRD-IN-HAND BOOKSTORE & GALLERY, 323 7th St. SE, Box 15258, Washington DC 20003. (202)543-0744. Fax: (202)547-6424. E-mail: chrisbih@aol.com. **Director:** Christopher Ackerman. Retail gallery. Estab. 1987. Represents 20 emerging artists. Exhibited artists include Dario Scholis, Karen Whitman, Janet Dowling, Darien Payne. Sponsors 6 shows/year. Average display time 6-8 weeks. Located on Capitol Hill at Eastern Market Metro; 300 sq. ft.; space includes small bookstore, art and architecture. "Most of our customers live in the neighborhood." Clientele: 100% private collectors. Overall price range: $40-1,650; most work sold at $50-400.

Media: Considers original handpulled prints, woodcuts, wood engravings, artists' books, linocuts, engravings, etchings. Also considers small paintings. Prefers small prints, works on paper and fabric.

Terms: Accepts work on consignment (40% commission). Retail price set by gallery. Gallery provides insurance, promotion and contract; shipping costs are shared.

Submissions: Send query letter with résumé, 10-12 slides and SASE. Write for appointment to show

portfolio of originals and slides. Interested in seeing tasteful work. Responds in 1 month. Files résumé; slides of accepted artists.

Tips: "The most common mistake artists make in presenting their work is dropping off slides/samples without SASE and without querying first. We suggest a visit to the gallery before submitting slides. We show framed and unframed work of our artists throughout the year as well as at time of individual exhibition. Also, portfolio/slides of work should have a professional presentation, including media, size, mounting, suggested price, and copyright date."

N ROBERT BROWN GALLERY, 2030 R St., NW, Washington DC 20009. (202)483-4383. Fax: (202)483-4288. Website: www.robertbrowngallery.com. **Director:** Robert Brown. Retail gallery. Estab. 1978. Represents emerging, mid-career and established artists. Exhibited artists include Joseph Solman, Oleg Kudryashov. Sponsors 6 shows/year. Average display time 6 weeks. Open all year; Tuesday-Saturday, 12-6. Located in Dupont Circle area; 600 sq. ft.; English basement level on street of townhouse galleries. 100% of space for gallery artists. Clientele: local, national and international. Overall price range: $500-20,000.

Media: Considers oil, acrylic, watercolor, pen & ink, drawing, mixed media, collage, paper, photography, woodcut, engraving, lithograph, wood engraving, mezzotint, serigraphs, linocut and etching. Most frequently exhibits works on paper, prints, paintings.

Style: Exhibits all styles.

Terms: Accepts work on consignment (50% commission). Retail price set by the gallery and the artist by agreement. Gallery provides insurance and promotion. Prefers artwork framed.

Submissions: Send query letter with slides, bio, brochure, SASE and any relevant information. No originals. Write for appointment to show portfolio of originals. "Will return information/slides without delay if SASE provided." Files "only information on artists we decide to show." Finds artists through exhibitions, word of mouth, artist submissions.

DADIAN GALLERY, 4500 Massachusetts Ave. NW, Washington DC 20016. (202)885-8674. Fax: (202)885-8605. E-mail: dsokolove@wesleysem.edu. Website: www.wesleysem.edu/car/dadian.htm. **Curator:** Deborah Sokolove. Nonprofit gallery. Estab. 1989. Approached by 50 artists a year. Exhibits 7-10 emerging, mid-career and established artists. Sponsors 7 exhibits/year. Average display time 2 months. Open Monday-Friday, 11-5. Closed August, December 24-January 1. Gallery is within classroom building of Methodist seminary; 550 sq. ft.; glass front open to foyer, moveable walls for exhibition and design flexibility.

Media: Considers all media and all types of prints. Most frequently exhibits painting, drawing and sculpture.

Style: Considers all styles and genres.

Terms: Artists are requested to make a donation to the Henry Luce III Center for the Arts and Religion at Wesley Theological Seminary from any sales. Gallery provides insurance. Accepted work should be framed. "We look for strong work with a spiritual or religious intention."

Submissions: Send query letter with artist's statement, SASE and slides. Returns material with SASE. Responds only if interested within 1 year. Finds artists through word of mouth, submissions, art exhibits and referrals by other artists.

N DISTRICT OF COLUMBIA ARTS CENTER (DCAC), 2438 18th St. NW, Washington DC 20009. (202)462-7833. Fax: (202)328-7099. E-mail: info@dcartscenter.org. Website: dcartscenter.org. **Executive Director:** B. Stanley. Nonprofit gallery and performance space. Estab. 1989. Exhibits emerging and mid-career artists. Sponsors 7-8 shows/year. Average display time 1-2 months. Open Wednesday-Sunday, 2-7; Friday-Saturday, 2-10; and by appointment. Located "in Adams Morgan, a downtown neighborhood; 132 running exhibition feet in exhibition space and a 52-seat theater." Clientele: all types. Overall price range: $200-10,000; most work sold at $600-1,400.

Media: Considers all media including fine and plastic art. "No crafts." Most frequently exhibits painting, sculpture and photography.

Style: Exhibits all styles. Prefers "innovative, mature and challenging styles."

Terms: Accepts artwork on consignment (30% commission). Artwork only represented while on exhibit. Retail price set by the gallery and artist. Offers payment by installments. Gallery provides promotion and contract; artist pays for shipping. Prefers artwork framed.

Submissions: Send query letter with résumé, slides, bio and SASE. Portfolio review not required. Responds in 4 months. More details are available on website.

Tips: "We strongly suggest the artist be familiar with the gallery's exhibitions and the kind of work we show: strong, challenging pieces that demonstrate technical expertise and exceptional vision. Include SASE if requesting reply and return of slides!"

N: FOUNDRY GALLERY, 9 Hillyer Court NW, Washington DC 20008. (202)387-0203. E-mail: foundr yartists@aol.com. Website: www.foundry_gallery.org. **Director:** Julianne Fuchs-Musgrave. Membership Director: Marcia Mayne. Cooperative gallery and alternative space. Estab. 1971. Sponsors 10-20 solo and 2-3 group shows/year. Average display time 1 month. Interested in emerging artists. Clientele: 80% private collectors; 20% corporate clients. Overall price range: $100-5,000; most work sold at $100-1,000.
Media: Considers oil, acrylic, watercolor, pastel, pen & ink, drawings, mixed media, collage, paper, sculpture, ceramic, fiber, glass, installation, photography, woodcuts, engravings, mezzotints, etchings, pochoir and serigraphs. Most frequently exhibits painting, sculpture, paper and photography.
Style: Exhibits "serious artists in all mediums and styles." Prefers non-objective, expressionism and neo-geometric. "Founded to encourage and promote Washington area artists and to foster friendship with artists and arts groups outside the Washington area. The Foundry Gallery is known in the Washington area for its promotion of contemporary works of art."
Terms: Co-op membership fee plus donation of time required; 30% commission. Retail price set by artist. Offers customer discounts and payment by installments. Exclusive area representation not required. Gallery provides insurance and a promotion contract. Prefers framed artwork.
Submissions: Send query letter with résumé, 20 slides, and SASE. "Local artists drop off actual work." Call or write for appointment to drop off portfolio. Finds artists through submissions.
Tips: "Build up résumé by entering/showing at juried shows. Visit gallery to ascertain where work fits in. Have coherent body of work. Show your very best, strongest work. Present yourself well—clearly label slides. Before approaching us, you should have a minimum of 10 actual, finished works. See website for membership application."

FOXHALL GALLERY, 3301 New Mexico Ave. NW, Washington DC 20016. (202)966-7144. E-mail: foxhallgallery@foxhallgallery.com. Website: www.foxhallgallery.com. **Director:** Jerry Eisley. Retail gallery. Represents emerging and established artists. Sponsors 6 solo and 6 group shows/year. Average display time 3 months. Overall price range: $500-20,000; most artwork sold at $1,500-6,000.
Media: Considers oil, acrylic, watercolor, pastel, sculpture, mixed media, collage and original handpulled prints (small editions).
Style: Exhibits contemporary, abstract, impressionistic, figurative, photorealistic and realistic works and landscapes.
Terms: Accepts work on consignment (50% commission). Retail price set by gallery and artist. Customer discounts and payment by installment are available. Exclusive area representation required. Gallery provides insurance.
Submissions: Send résumé, brochure, slides, photographs and SASE. Call or write for appointment to show portfolio. Finds artists through agents, by visiting exhibitions, word of mouth, various art publications and sourcebooks, artists' submissions, self promotions and art collectors' referrals.
Tips: To show in a gallery artists must have "a complete body of work—at least 30 pieces, participation in a juried show and commitment to their art as a profession."

THE FRASER GALLERY, 1054 31st St., NW, Washington DC 20007. (202)298-6450. Fax: (202)298-6450. E-mail: frasergallery@hotmail.com. Website: www.thefrasergallery.com. **Director:** Catriona Fraser. For profit gallery. Estab. 1996. Approached by 400 artists/year. Represents 40 emerging, mid-career and established artists and sells the work of another 100 artists. Exhibited artists include: David FeBland (oil painting). Sponsors 12 exhibits/year. Average display time 1 month. Open all year; Tuesday-Friday, 12-3; weekends, 12-6. 400 sq. ft. Located in the center of Georgetown, Ind—inside courtyard with 3 other galleries. Clients include local community, tourists, internet browsers and upscale. Overall price range: $200-15,000; most work sold at under $5,000. The Fraser Gallery is charter associate dealer for Southebys.com and member of Art Dealers Association of Greater Washington.
Media: Considers acrylic, drawing, mixed media, oil, paper, pastel, pen & ink, sculpture and watercolor. Most frequently exhibits oil, photography and drawing. Considers engravings, etchings, linocuts, mezzotints and woodcuts.
Style: Most frequently exhibits contemporary realism. Genres include figurative work and surrealism.
Terms: Artwork is accepted on consignment and there is a 50% commission. Retail price set by the artist.

Gallery provides insurance, promotion and contract. Accepted work should be framed. Requires exclusive representation locally.

Submissions: Write to arrange a personal interview to show portfolio of photographs and slides. Send query letter with bio, photographs, résumé, reviews, SASE and slides or CD-ROM with images and résumé. Returns material with SASE. Responds in 3 weeks. Finds artists through submissions, portfolio reviews, art exhibits and art fairs.

Tips: "Research the background of the gallery and apply to galleries that show your style of work. All work should be framed or matted to full museum standards."

GALLERY K, 2010 R St. NW, Washington DC 20009. (202)234-0339. Fax: (202)334-0605. E-mail: galleryk@ix.netcom.com. Website: www.galleryk.com. **Director:** Komei Wachi. Retail gallery. Estab. 1975. Represents 47 emerging, mid-career and established artists. Interested in seeing the work of emerging artists. Exhibited artists include Jody Mussoff and Y. David Chung. Sponsors 10 shows/year. Average display time 1 month. Closed mid July through mid-September; Tuesday-Saturday 11-6. Located in DuPont Circle area; 2,500 sq. ft. Clientele: local. 80% private collectors, 10% corporate collectors; 10% museums. Overall price range: $100-250,000; most work sold at $200-2,000.

Media: Considers oil, pen & ink, paper, acrylic, drawing, sculpture, watercolor, mixed media, ceramic, pastel, collage, photography, woodcuts, wood engravings, linocuts, engravings, mezzotints, etchings, lithographs and serigraphs. Most frequently exhibits oil, acrylic, drawing.

Style: Exhibits realism, surrealism and abstract. Genres include landscapes and figurative work. Prefers surrealism, realism and postmodernism. Kindly look at our website home page.

Terms: Accepts work on consignment (20-50% commission). Retail price set by gallery and artist. Gallery provides insurance, promotion and contract; artist pays for shipping costs. Prefers artwork framed and ready to display.

Submissions: Accepts artists mainly from DC area. Send query letter with résumé, 1 sheet of 25 slides and SASE. Responds in 6 weeks only if SASE enclosed.

Tips: You should have completed about 30-50 works of art before approaching galleries.

JANE HASLEM GALLERY, 2025 Hillyer St. NW, Washington DC 20009-1005. (202)232-4644. Fax: (202)387-0679. E-mail: haslem@artline.com. Website: www.JaneHaslemGallery.com. For-profit gallery. Estab. 1960. Approached by hundreds of artists/year; exhibits 75-100 emerging, mid-career and established artists/year. Exhibited artists include Garry Trudeau (cartoonist), Mark Adams (paintings, prints, tapestry), Nancy McIntyre (prints). Sponsors 6 exhibits/year. Average display time 7 weeks. Open by appointment. Located at DuPont Circle across from Phillips Museum; 2 floors of 1886 building; 3,000 square feet. Clients include local community, students, upscale and collectors worldwide. 5% of sales are to corporate collectors. Overall price range is $30-30,000; most work sold at $500-2,000.

Media: Considers acrylic, collage, drawing, mixed media, oil, paper, pastel, pen & ink, watercolor. Most frequently exhibits prints and works on paper. Considers engravings, etchings, linocuts, lithographs, mezzotints, serigraphs, woodcuts and digital images.

Style: Exhibits expressionism, geometric abstraction, neo-expressionism, pattern painting, painterly abstraction, postmodernism, surrealism. Most frequently exhibits abstraction, realism and geometric. Genres include figurative work, florals and landscapes.

Terms: Artwork is accepted on consignment and there is a 50% commission. Retail price set by the artist and the gallery. Gallery provides promotion and contract. Accepts only artists from the US. Prefers only prints, works on paper and paintings.

Submissions: Artists should contact via e-mail. Returns material with SASE. Responds to queries only if interested in 3 months. Finds artist's through art fairs and exhibits, referrals by other artists and word-of-mouth.

Tips: "100% of our sales are internally generated. We prefer all submissions initially by e-mail."

SPECTRUM GALLERY, 1132 29th St. NW, Washington DC 20007. (202)333-0954. **Contact:** John Blee, director. Retail/cooperative gallery. Estab. 1966. Exhibits the work of 29 mid-career artists. Sponsors 10 solo and 2 group shows/year. Average display time 1 month. Accepts only artists from Washington area. Open year round. Located in Georgetown. Clientele: 80% private collectors, 20% corporate clients. Overall price range: $50-5,000; most artwork sold at $450-1,200.

Media: Considers oil, acrylic, watercolor, pastel, pen & ink, drawings, mixed media, collage, works on paper, sculpture, ceramic, fiber, woodcuts, mezzotints, etchings, lithographs and serigraphs. Most frequently exhibits acrylic, watercolor and oil.

Style: Exhibits impressionism, realism, minimalism, painterly abstraction, pattern painting and hard-edge geometric abstraction. Genres include landscapes, florals, Americana, portraits and figurative work.

Terms: Co-op membership fee plus donation of time; 35% commission. Retail price set by artist. Sometimes offers payment by installment. Exclusive area representation not required. Gallery provides promotion and contract.

Submissions: Artists must live in the Washington area because of the cooperative aspect of the gallery. Bring actual painting at jurying; application forms needed to apply. "Contact gallery for application."

N **STUDIO GALLERY**, 2108 R Street NW, Washington DC 20008. (202)232-8734. E-mail: info@studiogallerydc.com. Website: www.studiogallerydc.com. **Contact:** Lana Lyons. Cooperative and nonprofit gallery. Estab. 1964. Exhibits the work of 30 emerging, mid-career and established local artists. Sponsors 11 shows/year. Average display time 1 month. Guest artists in August. Located downtown in the Dupont Circle area; 550 sq. ft.; "gallery backs onto a courtyard, which is a good display space for exterior sculpture and gives the gallery an open feeling." 5% of space for special exhibitions. Clientele: private collectors, art consultants and corporations. 85% private collectors; 8% corporate collectors. Overall price range: $300-10,000; most work sold at $500-3,000.

Media: Considers glass, oil, acrylic, watercolor, pastel, pen & ink, drawings, mixed media, collage, works on paper, sculpture, ceramic, fiber, original handpulled prints, woodcuts, lithographs, monotypes, linocuts and etchings. Most frequently exhibits oil, acrylic and paper.

Style: Considers all styles. Most frequently exhibits expressionism, conceptualism, geometric abstraction.

Terms: Co-op membership fee plus a donation of time (70% commission).

Submissions: Send query letter with SASE. "Artists must be local—or willing to drive to Washington for monthly meetings and receptions. Artist is informed as to when there is a membership opening and a selection review." Files artist's name, address, telephone.

Tips: "This is a cooperative gallery. Membership is decided by the gallery membership. The director does not determine membership. Ask when the next review for membership is scheduled. Do not send slides. Feel free to ask the director questions about gallery operations. Dupont Circle is an exciting gallery scene with a variety of galleries. First Fridays from 6-8 for all galleries of DuPont Circle." Show this gallery you are a professional by presenting your work "in a portfolio with slides of recent work and a clear résumé."

N **TOUCHSTONE GALLERY**, 406 Seventh St. NW, Washington DC 20004. (202)347-2787. Fax: (202)347-3339. E-mail: info@touchstonegallery.com. Website: www.touchstonegallery.com. **Director:** Camille Mosley-Pasley. Cooperative gallery. Estab. 1976. Interested in emerging, mid-career and established artists. Represents over 30 artists. Sponsors 20 solo, several group shows and 2 juried shows/year. Average display time 1 month. Located in the Seventh Street Gallery District in Penn Quarter; second floor of a building that is home to 5 other art galleries; main exhibition space features 2 solo exhibits; 3 smaller exhibit spaces feature monthly members shows. Two large rooms are available on a rental basis for artists, organizations and dealers. Clientele: 90% private collectors, 10% corporate clients. Overall price range: $100-6,000. Most artwork sold at $400-1,500.

Media: Considers all media. Most frequently exhibits paintings, sculpture, prints, installations and photography.

Style: Exhibits all styles and genres. "We show contemporary art from the Washington DC area."

Terms: Donation of time, monthly fee of $100 and 40% commission. Retail price set by artist. Exclusive area representation not required. Prefers framed artwork.

Submissions: Visit website for new member and juried show information or send query letter requesting prospectus with SASE. Prospective artists are juried by actual work and slides 3 times/year. Artists are juried by actual work at monthly meetings. Artists are juried in by the member artists. A majority of positive votes is required for acceptance. Voting is by secret ballot. The most common mistake artists make in presenting their work is "showing work from each of many varied periods in their careers."

Tips: "Artists who approach a co-op gallery should be aware that acceptance makes them partial owners of the gallery. They should be willing to work for the gallery's success."

N **TROYER GALLERY**, 1710 Connecticut Ave. NW, Washington DC 20009. (202)328-7189. Fax: (202)667-8106. Retail gallery. Estab. 1983. Represents 22 emerging, mid-career and established artists/ year; 30 emerging, mid-career and established photographers. Exhibited artists include: Mindy Weisel and Madalynn Marcus. Sponsors 6 shows/year. Average display time 7 weeks. Open all year except August;

Tuesday-Friday, 11-5; Saturday-12-5. Located on Dupont Circle; 1,000 sq. ft.; townhouse. Overall price range: $500-10,000.

Media: Considers oil, paper, acrylic, sculpture, watercolor, mixed media, pastel, collage and photography. Most frequently exhibits paintings, photography and sculpture.

Style: Exhibits neo-expressionism, painterly abstraction, surrealism, all styles.

Terms: Accepts work on consignment (50% commission). Gallery provides insurance and promotion; artist pays for shipping.

Submissions: Accepts only Mid-Atlantic artists. Send query letter with résumé, slides and bio. Call for appointment to show portfolio of photographs, transparencies and slides. Files slides. Finds artists through word of mouth, referrals by other artists, visiting art fairs and exhibitions and submissions.

N WASHINGTON PRINTMAKERS GALLERY, 1732 Connecticut Ave. NW, Washington DC 20009. (202)332-7757. **Director:** Pamela Hoyle. Cooperative gallery. Estab. 1985. Exhibits 40 emerging and mid-career artists/year. Exhibited artists include Lee Newman, Max-Karl Winkler, Trudi Y. Ludwig and Margaret Adams Parker. Sponsors 12 exhibitions/year. Average display time 1 month. Open all year; Tuesday-Thursday, 12-6; Friday, 12-9; Saturday-Sunday, 12-5. Located downtown in Dupont Circle area. 100% of space for gallery artists. Clientele: varied. 90% private collectors, 10% corporate collectors. Overall price range: $65-1,500; most work sold at $200-400.

Media: Considers all types of original prints, except posters, hand pulled by artist. Most frequently exhibits etchings, lithographs, serigraphs, relief prints.

Style: Considers all styles and genres. Prefers expressionism, abstract, realism.

Terms: Co-op membership fee plus donation of time (35% commission). Retail price set by artist. Gallery provides promotion, pays shipping costs to and from gallery. Purchaser pays shipping costs of work sold.

Submissions: Send query letter. Call for appointment to show portfolio of original prints. Responds in 1 month.

Tips: "There is a monthly jury for prospective new members. Call to find out how to present work. We are especially interested in artists who exhibit a strong propensity for not only the traditional conservative approaches to printmaking, but also the looser, more daring and innovative experimentation in technique."

N ZENITH GALLERY, 413 7th St. NW, Washington DC 20004. (202)783-2963. Fax: (202)783-0050. E-mail: zenithga@erols.com. Website: www.zenithgallery.com. **Contact:** Margery E. Goldberg, owner/director. For-profit gallery. Estab. 1978. Exhibits emerging, mid-career and established artists. Exhibited artists include Gloria Cesal (oil painting), Stephen Hansen (paper mache sculpture). Open Tuesday-Friday, 11-6; Saturday-Sunday, 12-4. Located in the "heart of downtown Washington DC—street level, 2,400 square feet of space, 3 different exhibition rooms." Clients include local community, tourists and upscale. 50% of sales are to corporate collectors. Overall price range: $5,000-10,000

Media: Considers all media.

Terms: Requires exclusive representation locally for solo exhibitions.

Submissions: Mail portfolio for review. Send query letter with artist's statement, bio, brochure, business card, photocopies, photographs, résumé, reviews, SASE, slides. Returns material with SASE. Responds to queries only if interested in 1 year. Finds artist's through art fairs and exhibits, portfolio reviews, referrals by other artists, submissions and word-of-mouth.

Florida

N 🏋 ALBERTSON-PETERSON GALLERY, 329 S. Park Ave., Winter Park FL 32789. (407)628-1258. Fax: (407)647-6928. **Owner:** Judy Albertson. Retail gallery. Estab. 1984. Represents 10-25 emerging, mid-career and established artists/year. "We no longer have a retail space—open by appointment only."

Media: Considers oil, acrylic, watercolor, pastel, mixed media, collage, paper, sculpture, ceramics, craft, fiber, glass, installation, photography, woodcut, engraving, lithograph, wood engraving, mezzotint, serigraphs, linocut and etching. Most frequently exhibits paintings, ceramic, sculpture.

Style: Exhibits all styles. Prefers abstract, contemporary landscape and nonfunctional ceramics.

Terms: Accepts work on consignment (varying commission). Retail price set by the gallery and the artist. Gallery provides insurance, promotion, contract and shipping costs from gallery; artist pays shipping costs to gallery. Prefers artwork unframed.

Submissions: Accepts only artists "exclusive to our area." Send query letter with résumé, slides, bio,

photographs, SASE and reviews. Call or write for appointment to show portfolio of photographs, slides and transparencies. Responds within a month. Finds artists through exhibitions, art publications and artists' submissions.

ALEXANDER FINE ARTS, (813)348-9885. E-mail: chandra@yborart.com. Website: yborart.com. **Owner:** C. Alexander. Art consultancy. Estab. 1993. Represents more than 10 established artists. Exhibited artists include: James Michalopoulos (oil), Victoria Martinez Rodgers (oil) and Daniel Watts (oil). Sponsors 7 exhibits/year. Average display time 6 weeks. Clients include local community and upscale. 30% of sales are to corporate collectors.
Media: Considers original contemporary art—oil, watercolor acrylic, sculpture, mixed media and glass. Most frequently exhibits oil, sculpture and acrylic.
Style: Considers all styles.
Terms: Artwork is accepted on consignment and there is a 50% commission. Retail price set by the gallery. Gallery provides insurance. Accepted work should be in good condition. Requires exclusive representation locally.
Submissions: Contact by e-mail. Returns material with SASE. Files résumé and photos. Finds artists through word of mouth, submissions, art fairs, and referrals by other artists.
Tips: "Be professional."

ART CENTER/SOUTH FLORIDA, 800 Lincoln Rd., Miami Beach FL 33139. (305)674-8278. Fax: (305)674-8772. E-mail: info@artcentersf.org. Website: www.artcentersf.org. Nonprofit gallery. Estab. 1985. Exhibits group shows by emerging artists. Average display time 1 month. Open all year; Monday-Wednesday, 1-10; Thursday-Sunday, 1-11. Clients include local community, students, tourists and upscale. Overall price range: $500-5,000.
Media: Considers all media except craft. Most frequently exhibits painting, sculpture, drawings and installation.
Style: Exhibits: themed group shows, which challenge and advance the knowledge and practice of contemporary arts.
Terms: Retail price set by the artist. Gallery provides insurance and promotion. Gallery receives 10% commission from sales. Accepted work should be ready to install. Does not require exclusive representation locally.
Submissions: Artist sends SASE—we send application which will be reviewed by a panel. Send query letter with SASE. Returns material with SASE. Artists apply with a proposal for an exhibition. It is then reviewed by a panel.

ATLANTIC CENTER FOR THE ARTS, INC., 1414 Arts Center Ave., New Smyrna Beach FL 32168. (386)427-6975. Website: www.atlanticcenterforthearts.org. Nonprofit interdisciplinary, international artists-in-residence program. Estab. 1977. Sponsors 5-6 residencies/year. Located on secluded bayfront—3½ miles from downtown.
 ● This location accepts applications for residencies only, but they also run Harris House of Atlantic Center for the Arts, which accepts Florida artists only for exhibition opportunities. Harris House is located at 214 S. Riverside Dr., New Smyrna Beach FL 32168. (386)423-1753.
Media: Most frequently exhibits paintings/drawings/prints, video installations, sculpture, photographs.
Style: Contemporary.
Terms: Call Harris House for more information.
Submissions: Call Harris House for more information.

N BAKEHOUSE ART COMPLEX, 561 N.W. 32 St., Miami FL 33127. (305)576-2828. E-mail: bacart @stis.net. Website: www.bakehouseartcomplex.org. Alternative space and nonprofit gallery. Estab. 1986. Represents 150 emerging and mid-career artists. 65 tenants, more than 50 associate artists. Sponsors numerous shows and cultural events annually. Average display time 3 weeks. Open all year; daily, 11-5. Office hours: Monday-Friday, 10-4. Located in Design District; 3,200 sq. ft. gallery; 33,000 sq. ft. retro fitted bakery preparation area, 17′ ceilings. Clientele: 80% private collectors, 20% corporate collectors. Overall price range: $500-8,000.
 ● Bakehouse Art Complex is also home to the Diaspora Vibe Gallery.
Media: Considers all media.
Style: Exhibits all styles, all genres.

Terms: Co-op membership fee plus donation of time (20% commission to BAC). Rental fee for studio space; covers 1 month. Retail price set by the artist.

Submissions: Accepts artists to juried membership. Send query letter for application.

Tips: "Don't stop painting, sculpture, etc. while you are seeking representation. Daily work (works-in-progress, studies) evidences a commitment to the profession. Speaking to someone about your work while you are working brings an energy and an urgency that moves the art and the gallery representation relationship forward."

N SETH JASON BEITLER FINE ARTS, 520 SE Fifth Ave., Suite 2501, Ft. Lauderdale FL 33301. (954)832-0414. Fax: (305)933-0939. E-mail: info@sethjason.com. Website: www.sethjason.com. **Contact:** Seth Beitler, owner. For-profit gallery, art consultancy. Estab. 1997. Approached by 300 artists/year. Represents 40 mid-career, established artists. Exhibited artists include Florimond Dufoor, oil paintings; Terje Lundaas, glass sculpture. Sponsors 5 exhibits/year. Average display time 2-3 months. Open Tuesday through Saturday, 12-5. Closed June-August. Located in downtown Ft. Lauderdale, Florida in a 1,000 sq. ft. private showroom. Clients include local community and upscale. 5-10% of sales are to corporate collectors. Overall price range: $2,000-300,000; most work sold at $5,000.

Media: Considers acrylic, glass, mixed media, sculpture, drawing, oil. Most frequently exhibits sculpture, painting, photography. Considers etchings, linocuts, lithographs.

Style: Exhibits: color field, geometric abstraction and painterly abstraction. Most frequently exhibits geometric sculpture, abstract painting, photography. Genres include figurative work and landscapes.

Terms: Artwork is accepted on consignment and there is a 50% commission. Retail price set by the gallery. Gallery provides insurance, promotion and contract. Accepted work should be mounted.

Submissions: Write to arrange personal interview to show portfolio of photographs, slides , transparencies. Send query letter with artist's statement, bio, photographs, résumé, SASE. Returns material with SASE. Responds to queries in 2 months. Files photos, slides, transparencies. Finds artists through art fairs, portfolio reviews, referrals by other artists and word of mouth.

Tips: Send "easy to see photographs. E-mail submissions for quicker response."

BOCA RATON MUSEUM OF ART, 501 Plaza Real, Mizner Park, Boca Raton FL 33432. (561)392-2500. Fax: (561)391-6410. E-mail: info@bocamuseum.org. Website: www.BocaMuseum.org. **Executive Director:** George S. Bolge. Museum. Estab. 1950. Represents established artists. 5,500 members. Exhibits change every 2 months. Open all year; Tuesday, Thursday-Saturday, 10-5; Wednesday and Friday, 10-9; Sunday, 12-5. Located one mile east of I-95 in Mizner Park in Boca Raton; 44,000 sq. ft.; national and international temporary exhibitions and impressive second-floor permanent collection galleries. three galleries—one shows permanent collection, two are for changing exhibitions. 66% of space for special exhibitions.

Media: Considers all media. Exhibits modern masters including Braque, Degas, Demuth, Glackens, Klee, Matisse, Picasso and Seurat; 19th and 20th century photographers; Pre-Columbian and African art.

Submissions: "Contact executive director, in writing."

Tips: "Photographs of work of art should be professionally done if possible. Before approaching museums, an artist should be well-represented in solo exhibitions and museum collections. Their acceptance into a particular museum collection, however, still depends on how well their work fits into that collection's narrative and how well it fits with the goals and collecting policies of that museum."

ALEXANDER BREST MUSEUM/GALLERY, 2800 University Blvd., Jacksonville University, Jacksonville FL 32211. (904)745-7371. Fax: (904)745-7375. E-mail: dlauder@ju.edu. Website: www.dept.ju.edu/art/. **Director:** David Lauderdale. Museum. Estab. 1970. Sponsors group shows of various number of artists. Average display time 6 weeks. Open all year; Monday-Friday, 9-4:30; Saturday, 12-5. "We close 2 weeks at Christmas and University holidays." Located in Jacksonville University, near downtown; 1,600 sq. ft.; 11½ foot ceilings. 50% of space for special exhibitions. "As an educational museum we have few if any sales. We do not purchase work—our collection is through donations."

Media: "We rotate style and media to reflect the curriculum offered at the institution. We only exhibit media that reflect and enhance our teaching curriculum. (As an example we do not teach bronze casting, so we do not seek such artists.)."

Style: Exhibits expressionism, neo-expressionism, primitivism, painterly abstraction, surrealism, all styles, primarily contemporary.

Terms: Retail price set by the artist. Gallery provides insurance and promotion; artist pays shipping costs to and from gallery. "The art work needs to be ready for exhibition in a professional manner."

Submissions: Send query letter with résumé, slides, brochure, business card and reviews. Write for appointment to show portfolio of slides. "Responds fast when not interested. Yes takes longer." Finds artists through visiting exhibitions and submissions.

Tips: "Being professional impresses us. But circumstances also prevent us from exhibiting all artists we are impressed with."

N **CAPITOL COMPLEX EXHIBITION PROGRAM**, Division of Cultural Affairs, The Capitol, Tallahassee FL 32399-0250. (850)245-6470. Fax: (850)245-6492. E-mail: sshaughnessy@mail.dos.state.fl. us. Website: www.dos.state.fl.us. **Arts Administrator:** Sandy Shaughnessy. Exhibition spaces (6 galleries). Represents 20 emerging, mid-career and established artists/year. Sponsors 20 shows/year. Average display time 3 months. Open all year; Monday-Friday, 8-5; Saturday-Sunday, 8:30-4:30. "Exhibition spaces include 22nd Floor Gallery, Cabinet Meeting Room, Judicial Meeting Room, Old Capitol-Gallery, the Florida Supreme Court Rotunda and The Governor's Office Hallway."

Media: Considers all media and all types of prints. Most frequently exhibits oil, watercolor and acrylic.

Style: Exhibits all genres.

Terms: Free exhibit space—artist sells works. Retail price set by the artist. Gallery provides insurance; artist pays for shipping to and from gallery.

Submissions: Accepts only artists from Florida. Send query letter with résumé, 20 slides, artist's statement and bio.

N **CHURCH STREET GALLERY OF CONTEMPORARY ART**, 418 Church St., Orlando FL 32801. (407)835-8822. E-mail: rvbadjet@earthlink.net. Website: www.rvbadjet.com. **Contact:** Robin Van Arsdol, owner. Wholesale gallery. Estab. 1983. Approached by 100 artists/year; exhibits 10 emerging, mid-career and established artists/year. Exhibited artists include Ekathreina Savtchenko (paintings) and Robin VanArsdol (sculpture). Sponsors 25 exhibits/year. Average display time 3 weeks. Closed May 15-September 15. Located 1 block west of Church Street Exchange; 3,000 square foot studio. Clients include local community. Overall price range: $300-15,000; most work sold at $500-1,000.

Media: Considers acrylic, drawing, oil, sculpture. Most frequently exhibits paintings, sculpture and performance/installation.

Style: Exhibits conceptualism, expressionism, minimalism, painterly abstraction, primitivism realism.

Terms: Artwork is accepted on consignment and there is a 50% commission. Retail price of the art set by the gallery and the artist. Gallery provides insurance and promotion. Does not require exclusive representation locally. Owner must "like you and your work" to be represented.

Submissions: Artists should call for first contact, gallery does not reply to queries. Gallery cannot return material.

N **CLAYTON GALLERIES, INC.**, 4105 S. MacDill Ave., Tampa FL 33611. (813)831-3753. Fax: (813)837-8750. **Director:** Cathleen Clayton. Retail gallery. Estab. 1986. Represent 28 emerging and mid-career artists. Exhibited artists include Bruce Marsh and Craig Rubadoux. Sponsors 7 shows/year. Average display time 5-6 weeks. Open all year. Located in the southside of Tampa 1 block from the Bay; 1,400 sq. ft.; "post-modern interior with glass bricked windows, movable walls, center tiled platform." 30% of space for special exhibitions. Clientele: 40% private collectors, 60% corporate collectors. Overall price range: $100-15,000; most artwork sold at $500-2,000.

Media: Considers oil, pen & ink, works on paper, fiber, acrylic, sculpture, glass, watercolor, mixed media, ceramic, pastel, craft, photography, original handpulled prints, woodcuts, wood engravings, engravings, mezzotints, etchings, lithographs, collagraphs and serigraphs. Prefers oil, metal sculpture and mixed media.

Style: Considers neo-expressionism, painterly abstraction, post-modern works, realism and hard-edge geometric abstraction. Genres include landscapes and figurative work. Prefers figurative, abstraction and realism—"realistic, dealing with Florida, in some way figurative."

Terms: Accepts work on consignment (50% commission). Retail price set by gallery and the artist. Gallery provides insurance, promotion and contract; artist pays for shipping. Prefers unframed artwork.

Submissions: Prefers Florida or Southeast artists with M.F.A.s. Send résumé, slides, bio, SASE and reviews. Write to schedule an appointment to show a portfolio, which should include photographs and slides. Responds in 6 months. Files slides and bio, if interested.

Tips: Looking for artist with "professional background i.e., B.A. or M.F.A. in art, awards, media coverage, reviews, collections, etc." A mistake artists make in presenting their work is being "not professional, i.e., no letter of introduction; poor or unlabeled slides; missing or incomplete résumé."

N 🏠 **CULTURAL RESOURCE CENTER METRO-DADE**, 111 NW First St., Miami FL 33128. (305)375-4635. Fax: (305)375-3068. E-mail: culture@miamidade.gov. Website: www.tropiculturemiami.com. **Contact:** Rem Cabrera, chief of cultural development. Alternative space/nonprofit gallery. Estab. 1989. Exhibits south Florida resident artists. Sponsors rotating shows year round. Average display time 1 month. Open all year; Monday-Friday 10-3. Located in Government Center in downtown Miami.
Media: Most frequently exhibits oil, mixed media, photography and sculpture.
Terms: Retail price set by artist. Gallery provides insurance and promotion; artist pays shipping costs. Prefers artwork framed.
Submissions: Accepts only artists from South Florida. Send query letter with résumé, slides, brochure, SASE and reviews. Call for appointment to show portfolio of slides. Responds only if interested within 2 weeks. Files slides, résumés, brochures, photographs.

N **THE DELAND MUSEUM OF ART, INC.**, 600 N. Woodland Blvd., De Land FL 32720-3447. (904)734-4371. **Contact:** Executive Director. Museum. Exhibits the work of established artists. Sponsors 8-10 shows/year. Open all year. Located near downtown; 5,300 sq. ft.; in The Cultural Arts Center; 18' carpeted walls, two gallery areas, including a modern space. Clientele: 85% private collectors, 15% corporate collectors. Overall price range: $100-30,000; most work sold at $300-5,000.
Media: Considers oil, acrylic, watercolor, pastel, works on paper, sculpture, ceramic, woodcuts, wood engravings, engravings and lithographs. Most frequently exhibits painting, sculpture, photographs and prints.
Style: Exhibits contemporary art, the work of Florida artists, expressionism, surrealism, impressionism, realism and photorealism; all genres. Interested in seeing work that is finely crafted and expertly composed, with innovative concepts and professional execution and presentation. Looks for "quality, content, concept at the foundation—any style or content meeting these requirements considered."
Terms: Accepts work on consignment for exhibition period only. Retail price set by artist. Gallery provides insurance, promotion and contract; shipping costs may be shared.
Submissions: Send résumé, slides, bio, brochure, SASE and reviews. Files slides and résumé. Reviews slides twice a year.
Tips: "Artists should have a developed body of artwork and an exhibition history that reflects the artist's commitment to the fine arts. Museum contracts 2-3 years in advance. Label each slide with name, medium, size and date of execution."

N **FLORIDA ART CENTER & GALLERY**, 208 First St. NW, Havana FL 32333. (850)539-1770. E-mail: drdox@juno.com. **Executive Director:** Dr. Kim Doxey. Retail gallery, studio and art school. Estab. 1993. Represents 30 emerging, mid-career and established artists. Interested in seeing the work of emerging artists. Open all year. Located in small, but growing town in north Florida; 2,100 st. ft.; housed in a large renovated 50-year-old building with exposed rafters and beams. Clientele: private collectors. 100% private collectors.
Media: Considers all media and original handpulled prints (a few).
Style: Exhibits all styles, tend toward traditional styles. Genres include landscapes and portraits.
Terms: Accepts work on consignment (45% commission). Retail price set by gallery and artist. Gallery provides insurance, promotion and contract.
Submissions: Send query letter with slides. Call or write for appointment.
Tips: "Prepare a professional presentation for review, (i.e. quality work, good slides, clear, concise and informative backup materials). Include size, medium, price and framed condition of painting. In order to effectively express your creativity and talent, you must be a master of your craft, including finishing and presentation."

✓ **FLORIDA STATE UNIVERSITY MUSEUM OF FINE ARTS**, 250 Fab, corner of Copeland & W. Tennessee St., Tallahassee FL 32306-1140. (850)644-6836. E-mail: apcraig@mailer.fsu.edu. Website: www.mofa.fsu.edu. **Director:** Allys Palladino-Craig. Estab. 1970. Shows work by over 100 artists/year; emerging, mid-career and established. Sponsors 12-22 shows/year. Average display time 3-4 weeks. Located on the university campus; 16,000 sq. ft. 50% of space for special exhibitions.
Media: Considers all media, including electronic imaging and performance art. Most frequently exhibits painting, sculpture and photography.
Style: Exhibits all styles. Prefers contemporary figurative and non-objective painting, sculpture, printmaking, photography.
Terms: "Sales are almost unheard of; the museum takes no commission." Retail price set by the artist.

Museum provides insurance, promotion and shipping costs to and from the museum for invited artists.

Submissions: Send query letter or call for Artist's Proposal Form.

Tips: "The museum offers a yearly competition with an accompanying exhibit and catalog. Artists' slides are kept on file from this competition as a resource for possible inclusion in other shows. Write for prospectus, available late December through January."

[N] FRIZZELL CULTURAL CENTRE GALLERY, 10091 McGregor Blvd., Ft. Myers FL 33919. (239)939-2787. Fax: (239)939-0794. Website: www.artinlee.org. Contact: Exhibition committee. Nonprofit gallery. Estab. 1979. Represents emerging, mid-career and established artists. 800 members. Sponsors 12 shows/year. Average display time 1 month. Open all year; Monday-Friday, 9-5; Saturday, 9-3. Located in Central Lee County—near downtown; 1,400 sq. ft.; high ceiling, open ductwork—ultra modern and airy. Clientele: local to national. 90% private collectors, 10% corporate collectors. Overall price range: $200-100,000; most work sold at $500-5,000.

Media: Considers all media and all types of print. Most frequently exhibits oil, sculpture, watercolor, print, drawing and photography.

Style: Exhibits all styles, all genres.

Terms: Retail price set by the artist. Prefers artwork framed. Only 30% commission.

Submissions: Send query letter with slides, bio and SASE. Write for appointment to show portfolio of photographs and slides. Responds in 3 months. Files "all material unless artist requests slides returned." Finds artists through visiting exhibitions, word of mouth and artists' submissions.

[N] [symbol] BARBARA GILLMAN GALLERY, 3814 NE Miami Court, Miami Beach FL 33137. (305)759-9155. E-mail: bggart@att.net. Website: artnet.com/bgillman.html. **Director:** Barbara Gillman. For profit gallery. Estab. 1960. Approached by 20 artists/year. Represents 20 established artists. Exhibited artists include: Herman Leonard and William Gettlieb. Sponsors 4 exhibits/year. Average display time 2 months. Open all year by appointment. Clients include local community, tourists and upscale. 30% of sales are to corporate collectors. Overall price range: $1,000-20,000; most work sold at $10,000.

Media: Considers painting, sculpture, prints, photography and mixed media. Most frequently exhibits photography, prints, paintings. Considers engravings, etchings, linocuts, lithographs, mezzotints and serigraphs.

Style: See website. Considers all genres.

Terms: Artwork is bought on consignment and there is a 50% commission. Gallery provides promotion. Accepted work should be framed, mounted and matted. Requires exclusive representation locally. Accepts only artists from Florida.

Submissions: Please call for how and what to submit.

[N] GLASS CANVAS GALLERY, INC., 146 Second St., N., St. Petersburg FL 33701. (727)821-6767. Fax: (727)821-1775. Website: www.glasscanvasgallery.com. **President:** Dick Fortune. Retail gallery. Estab. 1992. Represents 350 emerging and established artists. Exhibited artists from US, Canada, Australia, England. Sponsors 6 shows/year. Average display time 6-8 weeks. Open all year; Monday-Friday, 10-6; Saturday, 10-5; Sunday, 12-5.

Media: Considers glass only.

Style: Exhibits color field. Prefers unique, imaginative, contemporary, colorful and unusual.

Terms: Accepts work on consignment and buys at wholesale price (net 30 days). Retail price set by the gallery. Gallery provides insurance, promotion, contract and shipping costs from gallery; artist pays shipping costs to gallery. Prefers artwork framed.

Submissions: Prefers only glass. Send query letter with résumé, brochure, photographs and business card. Call for appointment to show portfolio of photographs. Responds in 2 weeks. Files all material.

Tips: "We look at the pieces themselves (and not the slides) to evaluate the technical expertise prior to making the decision to represent an artist."

KENDALL CAMPUS ART GALLERY, MIAMI-DADE COMMUNITY COLLEGE, 11011 SW 104 St., Miami FL 33176-3393. (305)237-2322. Fax: (305)237-2901. E-mail: Lfontana@MDCC.edu. **Interim Director:** Lilia Fontana. College gallery. Estab. 1970. Represents emerging, mid-career and established artists. Exhibited artists include Komar and Melamid. Sponsors 8 shows/year. Average display time 5 weeks. Open all year except for 2 weeks at Christmas and 3 weeks in August. Located in suburban area, southwest of Miami; 3,000 sq. ft.; "space is totally adaptable to any exhibition." 100% of space for special

exhibitions. Clientele: students, faculty, community and tourists. "Gallery is not primarily for sales, but sales have frequently resulted."

Media: Considers all media, all types of original prints. "No preferred style or media. Selections are made on merit only."

Style: Exhibits all styles and genres.

Terms: "Purchases are made for permanent collection; buyers are directed to artist." Retail price set by artist. Gallery provides insurance and promotion; arrangements for shipping costs vary. Prefers artwork framed.

Submissions: Send query letter with résumé, slides, bio, brochure, SASE, and reviews. Write for appointment to show portfolio of slides. "Artists commonly make the mistake of ignoring this procedure." Files résumés and slides (if required for future review).

Tips: "Present good-quality slides of works which are representative of what will be available for exhibition."

N A LAUREL ART GALLERY, 2112 Crystal Dr., Ft. Myers FL 33907. (941)278-0489. Fax: (941)482-6879. E-mail: alaurelart@cyberstreet.com. Website: www.alaurelart.com. Retail gallery. Estab. 1990. Represents 6 emerging artists/year. Exhibited artists include Ch Vaurina and G. Valtier. Sponsors 2 shows/year. Average display time 6 weeks. Open all year; 11-4. 6,000 sq. ft.. 75% of space for special exhibitions. Clientele: tourists and upscale. 10% private collectors. Overall price range: $1,000-10,000; most work sold at $3,000.

Media: Considers oil and acrylic.

Style: Exhibits: impressionism. Genres include landscapes and still lifes.

Terms: Accepts work on consignment (50% commission). Retail price set by the gallery. Gallery provides promotion; artist pays for shipping.

Submissions: Send résumé, brochure and 12 photographers. Call for appointment to show portfolio of photographs.

Tips: "You should have completed a body of work of approximately 200 works before approaching galleries."

MIAMI ART MUSEUM, 101 W. Flagler St., Miami FL 33130. (305)375-3000. Fax: (305)375-1725. Website: www.miamiartmuseum.org. **Director:** Suzanne Delehanty. Museum. Estab. 1996. Represents emerging, mid-career and established artists. Average display time 3 months. Open all year; Tuesday-Friday, 10-5; Saturday and Sunday, noon-5 pm. Located downtown; cultural complex designed by Philip Johnson. 16,000 sq. ft. for exhibitions.

Media: Considers all media.

Style: Exhibits international art with a particular emphasis on the art of the Western Hemisphere 1940s to the present; large scale traveling exhibitions, retrospective of internationally known artists.

Submissions: Accepts only artists nationally and internationally recognized. Send query letter with résumé, slides, bio, brochure, photographs, SASE and reviews. Responds in 3 months. Finds artists through visiting exhibitions, word of mouth, art publications and artists' submissions.

N MICHAEL MURPHY GALLERY INC., 2722 S. MacDill Ave., Tampa FL 33629. (813)902-1414. Fax: (813)835-5526. E-mail: mmurphy@michaelmurphygallery.com. Website: www.michaelmurphygallery.com. **Contact:** Michael Murphy, owner. For-profit gallery. Estab. 1988. Approached by 100 artists/year; exhibits 35 emerging and mid-career artists/year. Exhibited artists include Marsha Hammel and Peter Pettegrew. Sponsors 6 exhibits/year. Average display time 1 month. Open all year; Monday-Saturday, 10-6. Clients include local community and upscale. 20% of sales are to corporate collectors. Overall price range is $500-15,000; most work sold at less than $1,000.

Media: Considers all media. Most frequently exhibits acrylic, oil and watercolor. Considers all types of prints.

Style: Considers all styles. Most frequently exhibits color field, impressionism and painterly abstraction. Considers all genres.

Terms: Artwork is accepted on consignment and there is a 50% commission. Retail price set by the gallery. Accepted work should be framed. Requires exclusive representation locally.

Submissions: Send query with artist's statement, bio, brochure, business card, photocopies, photographs, résumé, reviews, SASE and slides. Cannot return material. Responds to queries only if interested in 1 month. Files all materials. Finds artist's through art fairs and exhibits, portfolio reviews, referrals by other artists, submissions and word-of-mouth.

NUANCE GALLERIES, 804 S. Dale Mabry, Tampa FL 33609. (813)875-0511. **Owner:** Robert A. Rowen. Retail gallery. Estab. 1981. Represents 70 emerging, mid-career and established artists. Sponsors 3 shows/year. Open all year. 3,000 sq. ft. "We've reduced the size of our gallery to give the client a more personal touch. We have a large extensive front window area."

Media: Specializing in watercolor, original mediums including sculpture.

Style: "Majority of the work we like to see are realistic landscapes, escapism pieces, bold images, bright colors and semitropical subject matter. Our gallery handles quite a selection, and it's hard to put us into any one class."

Terms: Accepts work on consignment (50% commission). Retail price set by gallery and artist. Offers customer discounts and payment by installments. Gallery provides insurance and contract; shipping costs are shared.

Submissions: Send query letter with slides and bio, SASE if want slides/photos returned. Portfolio review requested if interested in artist's work.

Tips: "Be professional; set prices (retail) and stick with them. There are still some artists out there that are not using conservation methods of framing. As far as submissions we would like local artists to come by to see our gallery and get the idea what we represent. Tampa has a healthy growing art scene, and the work has been getting better and better. But as this town gets more educated, it is going to be much harder for up-and-coming artists to emerge."

OPUS 71 GALLERIES, HEADQUARTERS, 1301 Petronia St., Key West FL 33040. (305)294-7381 or (305)295-7454. E-mail: lionxsx@aol.com. **Co-Directors:** Charles Z. Candler III and Gary R. Johnson. Retail and wholesale gallery, alternative space, art consultancy and salon style organization. Estab. 1969. Represents 40 (25-30 on regular basis) emerging, mid-career and established artists/year. By appointment only. Clientele: upscale, local, international and regional. 75% private collectors; 25% corporate collectors. Overall price range: $200-85,000; most work sold at $500-5,000

- This gallery is a division of The Leandros Corporation. Other divisions include The Alexander Project and Opus 71 Art Bank.

Media: Considers oil, acrylic, pastel, pen & ink, drawing, mixed media, collage, sculpture and ceramics; types of prints include woodcuts and wood engravings. Most frequently exhibits oils or acrylic, bronze and marble sculpture and pen & ink or pastel drawings.

Style: Exhibits: expressionism, neo-expressionism, primitivism, painterly abstraction, surrealism, conceptualism, minimalism, color field, postmodern works, impressionism, photorealism, hard-edge geometric abstraction (paintings), realism and imagism. Exhibits all genres. Prefers: figural, objective and nonobjective abstraction and realistic bronzes (sculpture).

Terms: Accepts work on consignment or buys outright. Retail price set by "consulting with the artist initially." Gallery provides insurance (with limitations), promotion and contract; artist pays for shipping to gallery and for any return of work. Prefers artwork framed, unless frame is not appropriate.

Submissions: Telephone call is important. Call for appointment to show portfolio of photographs and actual samples. "We will not look at slides." Responds in 2 weeks. Files résumés, press clippings and some photographs. "Artists approach us from a far flung area. We currently have artists from about 12 states and 4 foreign countries. Most come to us. We approach only a handful of artists annually."

Tips: "Know yourself . . . be yourself . . . ditch the jargon. Quantity of work available not as important as quality and the fact that the presenter is a working artist. We don't want hobbyists."

N ⬛ **P.A.S.T.A. FINE ART (PROFESSIONAL ARTISTS OF ST. AUGUSTINE) GALLERY INC.**, 214 Charlotte St., St. Augustine FL 32084. (904)824-0251. E-mail: jwart479@aol.com. Website: www.staugustinegalleries.com. **President and Director:** Jean W. Treimel. Cooperative nonprofit gallery. Estab. 1984. Represents 18 emerging, mid-career and established artists/year; all artist members. Exhibited artists include Jean W. Treimel. Continuous exhibition of members' work plus a featured artist each month. Average display time 2 months. Open all year; Monday-Friday, 12-4; Saturday and Sunday, 12-5. Located downtown—"South of The Plaza"; 1,250 sq. ft.; a 100-year-old building adjoining a picturesque antique shop and located on a 400-year-old street in our nation's oldest city." 100% of space for gallery artists. Clientele: tourists and visitors. 100% private collectors. "We invite two guest artists for two month exhibitions. Same conditions as full membership."

Overall price range: $10-3,000; most work sold at $10-800.

- This gallery reports that their clients are looking for larger paintings.

Media: Considers oil, acrylic, watercolor, pastel, pen & ink, drawing, mixed media, collage, sculpture,

ceramics, photography, alkyd, serigraphs and mono prints. Most frequently exhibits watercolor, oil and alkyd.

Style: Exhibits expressionism, primitivism, painterly abstraction, impressionism and realism. Genres include landscapes, florals, portraits and figurative work. Prefers impressionism and realism.

Terms: Co-op membership fee (30% commission). Retail price set by the artist. Gallery provides insurance, promotion and contract; artist pays shipping costs to and from gallery.

Submissions: Accepts only artists from Northeast Florida. Work must be no larger than 60 inches. Send query letter with résumé, 5 slides or photographs, bio, brochure, and SASE. Call or write for appointment to show portfolio of originals, photographs and brochures. "New members must meet approval of a committee and sign a 4-month contract with the 1st and 4th month paid in advance." Responds only if interested within 2 weeks. Finds artists through visiting exhibitions, word of mouth, artists' submissions.

Tips: "We can tell when artists are ready for gallery representation by their determination to keep producing and improving regardless of negative sales plus individual expression and consistent good workmanship. They should have up to ten works—large pieces, medium sizes and small pieces—in whatever medium they choose. Every exhibited artwork should have a bio of the artist on the books. A résumé on the backside of each art work is good publicity for the artist and gallery."

PENSACOLA MUSEUM OF ART, 407 S. Jefferson, Pensacola FL 32501. (850)432-6247. Website: www.pensacolamuseumofart.org. **Director:** Maria V. Butler. Nonprofit museum. Estab. 1954. Interested in emerging, mid-career and established artists. Sponsors 18 exhibitions/year. Average display time: 6-8 weeks. Open all year. Located in the historic district; renovated 1906 city jail. Clientele: 90% private collectors; 10% corporate clients. Overall price range: $200-20,000; most work sold at $500-3,000.

• This museum has guidelines for submitting work. Write to Curator of Exhibitions for "Unsolicited Exhibition Policy" guidelines.

Media: Considers all media. Most frequently exhibits painting, sculpture, photography, glass and new-tech (i.e. holography, video art, computer art etc.).

Style: Exhibits neo-expressionism, realism, photorealism, surrealism, minimalism, primitivism, color field, postmodern works, imagism; all styles and genres.

Terms: Retail price set by museum and artist. Exclusive area representation not required. Museum provides insurance and promotion costs.

Submissions: Send query letter with résumé, at least 3 slides, SASE and/or videotape. "A common mistake of artists is making impromptu drop-ins." Files guides and résumé.

Tips: Looks for "skill and expertise and a broad selection of definitive works."

POLK MUSEUM OF ART, 800 E. Palmetto St., Lakeland FL 33801-5529. (863)688-7743. Website: www.PolkMuseumofArt.org. **Contact:** Todd Behrens, curator of art. Museum. Estab. 1966. Approached by 75 artists/year. Sponsors 19 exhibits/year. Open all year; Monday-Friday, 9-5; Saturday, 10-5; Sunday, 1-5. Closed major holidays. Four different galleries of various sizes and configurations. Visitors include local community, students and tourists.

Media: Considers all media. Most frequently exhibits prints, photos and paintings. Considers all types of prints except posters.

Style: Considers all styles. Considers all genres, provided the artistic quality is very high.

Terms: Gallery provides insurance, promotion and contract. Accepted work should be framed.

Submissions: Mail portfolio for review. Send query letter with artist's statement, bio, résumé and SASE. Returns material with SASE. Reviews 2-3 times/year and responds shortly after each review. Files slides and résumé.

RENNER STUDIOS, 4268 SE Rainbows End, Stuart FL 34997, (772)287-1855. Fax: (772)287-0398. E-mail: ron@rennerstudios.com. Website: www.rennerstudios.com. **Gallery Director/Owner:** Ron Renner. Exhibited artists include Simbari, John Zaccheo and Ron Renner. Private gallery and interior design studios. Clientele: upscale. 90% private collectors, 10% corporate collectors. Overall price range: $750-250,000; most work sold at $7,500-10,000.

Media: Considers oil, pen & ink, acrylic, drawing, watercolor, mixed media, pastel, collage, photography, engravings, etchings, lithographs and serigraphs. Most frequently exhibits oil on canvas/linen, acrylic on canvas, serigraphs.

Style: Exhibits expressionism, impressionism, action painting. Genres include Mediterranean seascapes. Prefers abstract expressionism, impressionism and drawings.

Terms: Artwork is accepted on consignment (50% commission). Retail price set by the gallery. Gallery

provides insurance, promotion, contract; shipping costs are shared. Prefers artwork framed.
Submissions: Send query letter with résumé, slides, bio and SASE. Responds only if interested within 3 weeks. Files bio, résumé, photos and slides. Finds artists through submissions and visits to exhibits.
Tips: "Keep producing, develop your style, take good pictures for slides or digital portfolio of your work."

☑ **STETSON UNIVERSITY DUNCAN GALLERY OF ART**, 421 N. Woodland Blvd., Unit 8252, Deland FL 32723-3756. (386)822-7266. Fax: (386)822-7268. E-mail: cnelson@stetson.edu. Website: stetso n.edu/departments/art. **Gallery Director:** Dan Gunderson. Nonprofit university gallery. Approached by 20 artists/year. Represents 8-12 emerging and established artists. Exhibited artists include: Jack Earl (ceramics). Sponsors 7-8 exhibits/year. Average display time 4-6 weeks. Open Sept.-April; Monday-Friday, 10-4; weekends 1-4. Duncan Gallery occasionally sponsors summer exhibitions; call for details. Approximately 2,400 sq. ft. located in a building (Sampson Hall) which houses the Art Department, American Studies Department, and the Modern Language Department at Stetson University. Clients include local community, students, tourists, school groups and elder hostelers.
Media: Considers acrylic, ceramics, drawing, installation, mixed media, oil, pen & ink, sculpture installation. Most frequently exhibits oil/acrylic, sculpture and ceramics.
Style: Most frequently exhibits contemporary.
Terms: 30% of price is returned to gallery. Retail price set by the artist. Gallery provides insurance. Accepted work should be framed, mounted and matted. Does not require exclusive representation locally.
Submissions: Send query letter with artist's statement, bio, letter of proposal, résumé, reviews, SASE and 20 slides. Returns material with SASE. May respond, but artist should contact by phone. Files "whatever is found worthy of an exhibition—even if for future year." Finds artists through word of mouth, submissions, art exhibits, and referrals by other artists.
Tips: Looks for "professional-quality slides. Good letter of proposal."

TERRACE GALLERY, 400 S. Orange Ave., Orlando FL 32801. (407)246-4279. Fax; (407)246-4329. E-mail: public.art@cityoforlando.net. **Contact:** Frank Holt, director. Estab. 1996. Approached by 50 artists/year. Represents 4 emerging, mid-career and established artists. Average display time 3 months. Open all year; Monday-Friday, 8-9; weekends, 12-5. Closed major holidays. Terrace Gallery does not sell art; they showcase various exhibits to the community.
Submissions: Mail portfolio for review. Send query letter with artist's statement, bio, brochure, business card, photocopies, photographs, résumé, reviews, slides, and images that don't have to be sent back. Responds in 1 month. Finds artists through word of mouth, submissions, portfolio reviews, art exhibits, art fairs and referrals by other artists.

▣ **VISUAL ARTS CENTER OF NORTHWEST FLORIDA**, 19 E. Fourth St., Panama City FL 32401. (850)769-4451. Fax: (850)785-9248. E-mail: visualartscenterofnorthwestflorida@comcast.net. **Exhibition Coordinator:** Heather Parker. Museum. Estab. 1988. Approached by 20 artists/year. Exhibits local mid-career and established artists. Exhibited artists include: Don Taylor, watercolor; Roland Hacket, mixed media; Emil Holzhauer, acrylic. Sponsors 10 exhibits/year. Average display time 6 weeks. Open all year; Monday, Wednesday and Friday, 10-4; Tuesday and Thursday, 10-8; Saturday, 1-5. Closed major holidays and Sundays. The center is located in downtown Panama City in a historic building. The center features a large gallery (200 running feet) upstairs and smaller gallery downstairs (80 running feet); also a unique stairwell and gallery available as needed. Clients include local community and tourists. Overall price range: $50-2,000.
Media: Considers all media and all types of prints. Most frequently exhibits oil, watercolor, acrylic, sculpture, pottery and photography.
Style: Considers all styles and genres.
Terms: There is a 30% commission for artwork sold while on exhibit. Retail price set by the artist. Gallery provides promotion and contract. Accepted work should be framed, mounted and matted. Does not require exclusive representation locally.
Submissions: Send query letter with artist's statement, bio, résumé, SASE and slides or photos. Returns material with SASE. Responds only if interested within 4 months. Files artist's statement, bio and résumé. Finds artists through word of mouth, submissions and art exhibits.

▣ ▣ **THE VON LIEBIG ART CENTER**, 585 Park St., Naples FL 34102. (239)262-6517. Fax: (239)262-5404. E-mail: info@naplesartcenter.org. Website: naplesartcenter.org. Full nonprofit contemporary visual arts center with galleries, professional studios, photography lab, resource library and outdoor

festivals. Estab. 1954—new facility 1998. Represents 200 emerging, mid-career and established artists with membership of nearly 1,500. Exhibited artists include: Clyde Butcher, Jim Rosenquist and Jonathan Green. Sponsors 14 exhibits/year. Average display time 6 weeks. Open all year; Monday-Saturday, 10-4. Closed holidays. Located in downtown Naples; 16,000 sq. ft. visual arts facility. Audience includes local community, students, upscale.

Media: Considers original works in all media.

Style: Considers all styles. Most frequently exhibits contemporary American art in all media from 1950 forward.

Terms: Artwork is accepted on consignment and there is a 30% commission. All members' exhibitions are juried. Must be a member to participate. Director selects artists for curated exhibitions. Retail price set by the artist. Gallery provides insurance. Accepted work should be framed. Requires exclusive representation locally. Prefers only Florida artists.

Submissions: Finds artists through word of mouth, juried exhibits, and referrals by other artists and curators.

Tips: "Must have had work exhibited in number of accredited fine art museums included in private, public and corporate collections. Must have received grant awards or fellowships."

Georgia

BRENAU UNIVERSITY GALLERIES, One Centennial Circle, Gainesville GA 30501. (770)534-6263. Fax: (770)538-4599. **Gallery Director:** Jean Westmacott. Nonprofit gallery. Estab. 1980s. Exhibits emerging, mid-career and established artists. Sponsors 7-9 shows/year. Average display time 6-8 weeks. Open all year; Monday-Friday, 10-4; Sunday, 2-5 during exhibit dates. "Please call for Summer hours." Located near downtown; 3,958 sq. ft., 2-3 galleries—the main one in a renovated 1914 neoclassic building, the other in an adjacent renovated Victorian building dating from the 1890s, the third gallery is in the new center for performing arts. 100% of space for special exhibitions. Clientele: tourists, upscale, local community, students. "Although sales do occur as a result of our exhibits, we do not currently take any percentage, except in our invitational exhibitions. Our purpose is primarily educational."

Media: Considers all media.

Style: Exhibits wide range of styles. "We intentionally try to plan a balanced variety of media and styles."

Terms: Retail price set by the artist. Gallery provides insurance and promotion; shipping costs are shared, depending on funding for exhibits. Prefers artwork framed. "Artwork must be framed or otherwise ready to exhibit."

Submissions: Send query letter with résumé, 10-20 slides, photographs and bio. Write for appointment to show portfolio of slides and transparencies. Responds within months if possible. Artist should call to follow up. Files one or two slides or photos with a short résumé or bio if interested. Remaining material returned. Finds artists through referrals, direct viewing of work and inquiries.

Tips: "Be persistent, keep working, be organized and patient. Take good slides and develop a body of work. Galleries are limited by a variety of constraints—time, budgets, location, taste and rejection does not mean your work may not be good; it may not 'fit' for other reasons at the time of your inquiry."

N THE CITY GALLERY AT CHASTAIN, 135 W. Wieuca Rd. NW, Atlanta GA 30342. (404)257-1804. **Contact:** Karen Comer. Nonprofit gallery. Estab. 1979. Represents emerging artists. Sponsors 6 shows/year. Average display time 7-8 weeks. Open all year; Tuesday-Saturday, 1-5. Located in Northwest Atlanta; 2,000 sq. ft.; historical building; old architecture with much character. Clientele: local community, students. Overall price range: $50-10,000.

● For submissions, call or write Karen Comer, City of Atlanta/Gallery Program, Bureau of Cultural Affairs, 675 Ponce de Leon Ave. N.E. Atlanta GA 30308. (404)817-6981. Fax: (404)817-6827. E-mail: kcomer@ci.atlanta.ga.us.

Media: Considers all media except prints. Most frequently exhibits sculpture, painting, mixed media and installation.

Style: Exhibits conceptual and postmodern works. Genres include social or political. Prefers contemporary/alternative.

Terms: Retail price set by the artist. Gallery provides insurance; gallery pays shipping costs.

Submissions: Send query letter with résumé, brochure, slides, photographs, reviews, artist's statement, bio. Call or write for appointment to show portfolio of photographs, slides. Responds in 1 month. Finds artists through word of mouth, referrals by other artists, visiting art fairs and exhibitions, submissions.

N SKOT FOREMAN FINE ART, 315 Peters St. SW, Atlanta GA 30313. (404)222-0440. E-mail: info@skotforeman.com. Website: www.skotforeman.com. **Contact:** Erica Stevens, assistant. For-profit gallery. Estab. 1994. Approached by 1,500-2,000 artists/year; exhibits 30 mid-career and established artists/year. Exhibited artists include Purvis Young (house paint on wood), Chris Dolan (oil/acrylic on canvas). Sponsors 6-8 exhibits/year. Average display time 30-45 days. Open Tuesday-Friday, 11-5; Saturday-Sunday, 12-5. Closed August. Located "in a downtown metropolitan loft district of Atlanta. The 100-year-old historical building features hardwood floors and 18 ft. ceilings." Clients include local community, tourists, upscale and art consultants. 25% of sales are to corporate collectors. Overall price range is $500-50,000; most work sold at $3,000-5,000.

Media: Considers acrylic, collage, drawing, glass, installation, mixed media, oil, paper, pastel, pen & ink, sculpture, watercolor. Most frequently exhibits acrylic, oil and mixed media. Considers engravings, etchings, linocuts, lithographs, mezzotints, posters, serigraphs, woodcuts.

Style: Exhibits expressionism, impressionism, neo-expressionism, painterly abstraction, postmodernism, surrealism. Most frequently exhibits painterly abstraction, neo-expressionism and neo-impressionism. Genres include figurative work, landscapes, portraits and perspective.

Terms: Artwork is accepted on consignment and there is a variable commission. Retail price set by the gallery. Gallery provides insurance, promotion and contract. Requires exclusive representation locally. No outdoor Fair self-representation.

Submissions: Send e-mail with bio and photocopies. Returns material with SASE. Responds to queries only if interested in 3 weeks. Finds artist's through art fairs and exhibits, portfolio reviews, referrals by other artists, submissions and word-of-mouth.

Tips: "Be concise. Not too much verbage-let the art speak on your behalf."

GALERIE TIMOTHY TEW, 309 E. Paces Ferry, #130, Atlanta GA 30305. (404)869-0511. Fax: (404)869-0512. E-mail: info@timothytew.com. Website: www.timothytew.com. For-profit gallery. Estab. 1987. Approached by 2-10 artists/year. Exhibits 27 emerging and established artists. Exhibited artists include: Isabelle Melchior and Kimo Minton. Sponsors 6 exhibits/year. Average display time 4-6 weeks. Open all year; Tuesday-Saturday, 11-5. Clients include local community, upscale and international. 20% of sales are to corporate collectors. Overall price range: $4,000-20,000; most work sold at $4,000-10,000.

Media: Considers drawing, oil and sculpture. Considers etchings.

Style: Exhibits: conceptualism, expressionism and painterly abstraction. Genres include figurative work, florals and portraits.

Terms: Artwork is accepted on consignment and there is a 50% commission. Retail price set by the gallery. Gallery provides insurance and promotion. Accepted work should be mounted. Requires exclusive representation locally.

Submissions: Portfolio should include slides. Mail portfolio for review. Returns material with SASE. Responds in 1 week. Finds artists through word of mouth.

HEAVEN BLUE ROSE CONTEMPORARY GALLERY, "The Contemporary Gallery in Roswell's Historic District." 934 Canton St., Roswell GA 30075. (770)642-7380. Fax: (770)640-7335. E-mail: inquiries@heavenbluerose.com. Website: www.heavenbluerose.com. **Contact:** Catherine Moore or Nan Griffith, partners/owners. Cooperative, for-profit gallery. Estab. 1991. Approached by 8 artists/year. Represents 13 emerging, mid-career and established artists. Exhibited artists include: Jeff Cohen (oils, mixed media and 3D), Dawn Walker (oils, encaustic, mixed media), Ronald Pircio (oils and pastels). Average display time 6 weeks. Open all year; Tuesday-Friday, 11-5:30; Saturday, 11-5:30 and 7-10; Sunday, 1-4. "Located in the Historic District of Roswell GA. Space is small but fantastic energy! Beautifully curated to an overall gallery look. Open, white spaces. Two levels; great reputation." 10% of sales are to corporate collectors. Overall price range: $200-7,000; most work sold at $1,000.

Media: Considers acrylic, collage, drawing, fiber, glass, mixed media, oil, paper, pastel, sculpture, watercolor giclée. Only of works whose originals were shown in gallery first. Also digital art. Most frequently exhibits oils, mixed media and pastel.

Style: Exhibits: color field, conceptualism, expressionism, geometric abstraction, minimalism, neo-expressionism, primitivism realism, surrealism and painterly abstraction. Most frequently exhibits geometric abstraction, neo-expressionism and conceptualism. Considers all genres.

Terms: Artwork is accepted on consignment and there is a 50% commission—3D only. There is a co-op membership fee plus a donation of time. There is a 20% commission. Retail price set by the gallery and the artist. Gallery provides contract. Accepted work should be framed. Requires exclusive representation

insider report

Promoting your work online

Imagine unlimited space and plenty of atmospheric lighting for all your artistic creations, whether they're paintings, sculpture, ceramic pots, prints, or jewelry. Thousands of patrons may view your work on a daily basis, and the exhibition time spans one year. You don't have to claim a long list of previous solo shows in order to display your work. Artists of all levels of experience are encouraged to query, says Allison Wagner, the founder and director of Artcanyon.com, one of the many online galleries and portfolios of fine art.

Allison Wagner

Collectors, agents, gallery owners and the artists whose work is represented on the site know the multi-service site as "the emerging artist marketplace." *Newsweek* rated it one of the greatest websites for anyone affiliated with art, and one buyer says it has revolutionized e-commerce. After all, "where else can you choose from 1,500 relatively inexpensive, quality art objects while seated at your desk?" asks Wagner.

Just as Friday evening gallery strolls, art festivals and auctions are popular cultural and commercial engagements, the online way of doing any kind of business related to art is common practice. Simply key in the word "art" in your favorite search engine, and you'll discover millions of sites to choose from. If your first stop happens to be Artcanyon.com, you discover a whole new jumping off point for marketing and selling your work.

While the main purpose of the company is to enhance the careers of artists, it's evident by the homepage alone that Artcanyon.com also boasts a slew of activities for buyers, gallery owners, interior designers, or browsers who are simply enthusiasts of all things visually remarkable. Artcanyon.com's sophisticated schema provides an enjoyable and lasting experience for visitors because the center of attraction remains on imagery (the week's "hot" home décor, for example). As the site collaborates with 28 partnering galleries exhibiting current shows, as well as inventory not shown in their physical spaces, the imagery on the site is endless.

A painter herself, Wagner's primary goal in establishing the emerging artist marketplace was to break down the barriers between artists and "industrious people." With a degree in art history and experience in business management, she originally envisioned opening a gallery in metro Atlanta. Although the hefty price tag of up to $13,000 monthly may not have existed for such a commercial space in 1999, Wagner decided that high rent was not an option for someone with a tight budget and an ambitious plan. Therefore, she concentrated on the Internet, which at that time scarcely served the needs of visual artists. During the planning stages of Artcanyon.com, Wagner discovered many gallery and auction sites, but she insists Net services in general were not centered on individual artist exposure, professional support and income—three essentials for artists who were striving to enter the commercial world of art. Through direct mail blurbs and e-mail promotions, Artcanyon. com began with just 35 artists. Currently the site represents 150 artists, and recruitment is ongoing.

"Qualifications for selection are based on the quality and originality of the artwork, not on the career or experience of the artist," says Wagner. All disciplines and media are accepted including: painting, drawing, collage, mixed media, sculpture, jewelry, printmaking, signed limited editions, textiles, photography, and pottery. Artists submit up to 15 pieces of work, which undergo a two-week review process from Wagner and two consulting partners. There is no initial fee and no exclusivity rules upon acceptance. Once an artist signs a one-year contract guaranteeing Artcanyon.com will receive 50% commission, she can enjoy an aggressive promotional campaign, which includes a two-week slot on Artcanyon.com's "Who's Hot" column, exposure on "Art Break," the site's weekly e-mail newsletter, and a starter package of personalized promotional materials. New artists may also be recognized on a featured artist's page, along with a direct mail update including the artist's biographical blurb. The direct mail promotion and "Art Break" newsletter reach thousands of potential buyers. And as "expansion of the art market" appears to be Wagner's winning catchphrase, Artcanyon.com also reaches beyond computerized promotion and travels straight to the homes of at least five clients per month. What begins as an initial art consultation session (surveying the walls and interior layout of someone's home to determine matching artwork) may result in a lavish home art party— a one-night art opening to showcase the host's purchases from Artcanyon.com.

One artist who has soaked up the benefits of connecting with Artcanyon.com is Debra Forrester, a self-taught painter from Dahlonega, Georgia. While she has shown her work on several sites, her Artcanyon.com presence brought her multiple sales. "Artcanyon gave me my first boost in morale," says Forrester. "To have Allison and Artcanyon feel my work was good enough to post—and then to have actual sales—was all the inspiration I needed to keep working." Since receiving wide attention from the site's customers for her paintings, Forrester opened up her own studio in Dahlonega.

—*Candi Lace*

Think you're ready to rove The Canyon or other sites that may spur your professional career in art? Read Allison Wagner's tips on page 364.

Read Allison Wagner's tips on page 364.

locally. Accepts only artists from metro Atlanta and local to Roswell GA. We want to promote our local artists. We are all well recognized and/or awarded and/or collected.

Submissions: Call or write to arrange a personal interview to show portfolio of photographs, slides, transparencies or framed work. Send query letter with artist's statement, bio, photographs, résumé and SASE. Returns material with SASE. Responds in 1 month. Files contact information. Finds artists through word of mouth, submissions and referrals by other artists.

Tips: "Framing is very important. Our clients want properly framed pieces. Consistency of work, available inventory, quality and integrity of artist and work are imperative."

THE LOWE GALLERY, 75 Bennett St., Space A-2, Atlanta GA 30309. (404)352-8114. Fax: (404)352-0564. E-mail: info@lowegallery.com. **Director:** Anne Archer Dennington. Retail gallery. Estab. 1989. Exhibits contemporary emerging, mid-career, and internationally recognized artists. Hosts 6-10 exhibits/year. Average display time 6-8 weeks. Open all year; Tuesday-Friday, 10:30-5:30; Saturday, 11-5 and Sunday by appointment. Located uptown (Buckhead); 12,000 sq. ft.; 4 exhibition rooms with a dramatic split level Grand Salon with 30 ft. ceilings and 18 ft. walls. 100% of space for gallery artists. 75% private collectors, 25% corporate collectors. Overall price range: $700-150,000; most work sold at $2,000-15,000.

Media: Considers any 2- or 3-dimensional medium. Most frequently exhibits painting, drawing and sculpture.

Style: Exhibits a wide range of aesthetics from figurative realism to painterly abstraction. Prefers postmodern works with a humanistic/spiritual content.

Five Internet Marketing Tips Every Artist Should Know

1. **Explore user-friendly, advantageous sites only.**
 Many sites run on an extensive database provided by the e-commerce software Intershop. This is evident by how speedy and specific each site's internal search engine is. If the search engine leads you to the wrong place more than twice, this may indicate that the site does not have a good internal search engine, which will make it difficult for consumers to access your work.

2. **Before forwarding any material, inquire about the company's feature opportunities and marketing efforts.**
 Look for site-sponsored auctions and key words that denote buyer participation. Phrases such as "make an offer" or "name your price" point out that the company encourages negotiations, and is not limited to fixed prices.

3. **Query sites that provide an uncomplicated application for submissions.**
 If you are initially required to submit more than a brief biography and more than 15 images, your time may be better spent at another site. Most sites prefer digital images that can be uploaded directly into their database. Do include the actual size, media and style for each work submitted. Don't include your own interpretation of the work or how many hours you spent creating it.

4. **Know the company you are submitting your work to.**
 Inquire how long the company has been in business and search for any press or reviews about their credentials. Also examine contracts closely for policies on exclusivity and any penalties.

5. **A big body of work is better than a limited one.**
 In selecting works to profile on extensive sites such as Artcanyon.com, present a variety of sizes and prices if such a selection exists in your portfolio. After all, within a broad base of over 150 artists, it's helpful to offer a competitive pool of work to choose from.

—Candi Lace

Terms: Artwork is accepted on consignment (50% commission). Retail price set by the gallery. Gallery provides promotion and contract; shipping costs are shared. Prefers artwork framed.
Submissions: Send query letter with résumé, 10-20 slides and SASE. Responds only if interested within 6 weeks. Finds artists through submissions.
Tips: "Put together an organized, logical submission. Do not bring actual pieces into the gallery. Be sure to include a SASE. Show galleries at least one cohesive body of work, could be anywhere between 10-40 pieces."

N **MARY PAULINE GALLERY**, 982 Broad St., Augusta GA 30901. E-mail: mmcdowel@mindspring.com. Website: www.marypaulinegallery.com. **Contact:** Kathy Newton, gallery assistant. For-profit gallery. Estab. 1998. Approached by 10 artists/year; exhibits 20 established artists/year. Exhibited artists Benny Andrews (oil and collage on paper and canvas), Edward Rice (oil on paper, canvas, or board). Average display time 6-8 weeks. Closed Christmas-New Year. Located in downtown Augusta. Clients include local community, students, tourists and upscale. Overall price range: $1,000-70,000; most work sold at $2,500.
Media: Considers acrylic, ceramics, collage, drawing, glass, mixed media, oil, paper, pastel, pen & ink, sculpture, watercolor. Most frequently exhibits painting, drawing and collage.

Style: Most frequently exhibits painterly abstraction, surrealism and expressionism. Genres include Americana, figurative work, florals and landscapes.

Terms: Artwork is accepted on consignment and there is a 50% commission. Retail price of the art set by the gallery. Gallery provides insurance, promotion and contract. Accepted work should be framed. Requires exclusive representation locally. Prefers only Southern artists.

Submissions: Send query letter with artist's statement, bio, brochure, business card, photocopies, photographs, resume, reviews, SASE, slides. Returns material with SASE. Responds to queries in 6 months. Files résumé. Finds artist's through art fairs and exhibits, portfolio reviews, referrals by other artists, submissions and word-of-mouth.

Tips: "Have a good body of work and a résumé that reflects that you are on a career track."

N TRINITY GALLERY, 315 E. Paces Ferry Rd., Atlanta GA 30305. (404)237-0370. Fax: (404)240-0092. E-mail: info@trinitygallery.com. Website: www.trinitygallery.com. **President:** Alan Avery. Retail gallery and corporate sales consultants. Estab. 1983. Represents/exhibits 67 mid-career and established artists and old masters/year. Exhibited artists include Cheryl Warrick, Randall Lagro, Jason Rolf and Russell Whiting. Sponsors 6-8 shows/year. Average display time 6 weeks. Open all year; Tuesday-Friday, 10-6; Saturday, 11-5 and by appointment. Located mid-city; 6,700 sq. ft.; 25-year-old converted restaurant. 50-60% of space for special exhibitions; 40-50% of space for gallery artists. Clientele: upscale, local, regional, national and international. 70% private collectors, 30% corporate collectors. Overall price range: $2,500-100,000; most work sold at $2,500-5,000.

Media: Considers all media and all types of prints. Most frequently exhibits painting, sculpture and work on paper.

Style: Exhibits expressionism, conceptualism, color field, painterly abstraction, postmodern works, realism, impressionism and imagism. Genres include landscapes, Americana and figurative work. Prefers realism, abstract and figurative.

Terms: Artwork is accepted on consignment (negotiable commission), or it is bought outright for a negotiable price. Retail price set by gallery. Gallery pays promotion and contract. Shipping costs are shared. Prefers artwork framed.

Submissions: Send query letter with résumé, at least 20 slides, bio, prices, medium, sizes and SASE. Reviews every 6 weeks. Finds artists through word of mouth, referrals by other artists and artists' submissions.

Tips: "Be as complete and professional as possible in presentation. We provide submittal process sheets listing all items needed for review. Following this sheet is important."

VESPERMANN GLASS GALLERY, 309 E. Paces Ferry Rd., Atlanta GA 30305. (404)266-0102. Fax: (404)266-0190. Website: www.vespermann.com. **Owner:** Seranda Vespermann. Manager: Tracey Lofton. Retail gallery. Estab. 1984. Represents 200 emerging, mid-career and established artists/year. Sponsors 4-5 shows/year. Average display time 1 month. Open all year; Tuesday-Friday, 11-5 and Saturday 12-5. 2,500 sq. ft.; features contemporary art glass. Overall price range: $100-10,000; most work sold at $200-2,000.

Media: Art glass.

Style: Exhibits contemporary.

Terms: Accepts work on consignment (50% commission). Buys outright for 50% of retail price (net 30 days). Retail price set by the gallery and the artist. Gallery provides insurance, promotion and contract; shipping costs are shared.

Submissions: Send query letter with résumé, slides, bio. Write for appointment to show portfolio of photographs, transparencies and slides. Responds only if interested within 2 weeks. Files slides, résumé, bio.

Hawaii

CEDAR STREET GALLERIES, 817 Cedar St., Honolulu HI 96814. (808)589-1580. E-mail: info@CedarStreetGalleries.com. Website: www.cedarstreetgalleries.com. **Contact:** Michael C. Schnack. Art consultancy, for-profit and wholesale gallery. Estab. 1999. Represents 200 and growing emerging, mid-career and established artists. Sponsors 3 exhibits (historical also)/year. Open all year; Monday-Saturday, 10-5; weekends 10-4. Clients include local community, students, tourists and upscale. Overall price range: $100-50,000.

Media: Considers all media; types of prints include engravings, etchings, linocuts, lithographs, mezzotints, serigraphs and woodcuts.

Style: Considers all styles. Genres include florals, landscapes and figurative.

Terms: Artwork is accepted on consignment and there is 1 50% commission. Retail price set by the artist. Accepted work should be framed, mounted and matted. Does not require exclusive representation locally. Accepts only artists from Hawaii.

Submissions: Call or write to arrange a personal interview to show portfolio of photographs.

[N] COAST GALLERIES, Locations in Big Sur, Carmel and Pebble Beach, California, Hana, Hawaii. Mailing address: P.O. Box 22351, Carmel CA 93922. (831)625-8688. Fax: (831)625-8699. E-mail: gary@c oastgalleries.com. Websites: coastgalleries.com, bigsurgallery.com or www.hanacoastgallery.com. **Owner:** Gary Koeppel.

 ● See listing in San Francisco section for information on the galleries' needs and submission policy.

[image] HANA COAST GALLERY, Hotel Hana-Maui, P.O. Box 565, Hana Maui HI 96713. (808)248-8636. Fax: (808)248-7332. E-mail: director@hanacoast.com Website: www.hanacoast.com. **Managing Director:** Patrick Robinson. Retail gallery and art consultancy. Estab. 1990. Represents 78 established artists. Sponsors 12 group shows/year. Average display time 1 month. Open all year. Located in the Hotel Hana-Maui at Hana Ranch; 3,000 sq. ft.; "an elegant ocean-view setting in one of the top small luxury resorts in the world." 20% of space for special exhibitions. Clientele: ranges from very upscale to highway traffic walk-ins. 85% private collectors, 15% corporate collectors. Overall price range: $150-50,000; most work sold at $1,000-6,500.

Media: Considers oil, acrylic, watercolor, pastel, mixed media, collage, works on paper, sculpture, ceramic, craft, fiber, glass, photography, original handpulled prints, engravings, lithographs, pochoir, wood engravings, mezzotints, serigraphs and etchings. Most frequently exhibits oil, watercolor and original prints.

Style: Exhibits expressionism, primitivism, impressionism and realism. Genres include landscapes, florals, portraits, figurative work and Hawaiiana. Prefers landscapes, florals and figurative work. "We also display decorative art and master-level craftwork, particularly turned-wood bowls, blown glass, fiber, bronze sculpture and studio furniture.

Terms: Accepts artwork on consignment (60% commission). Retail price set by gallery and artist. Gallery provides insurance, promotion and shipping costs from gallery. Framed artwork only.

Submissions: Accepts only full-time Hawaii resident artists. Send query letter with résumé, slides, bio, brochure, photographs, SASE and reviews. Write for appointment to show portfolio after query and samples submitted. Portfolio should include originals, photographs, slides and reviews. Responds only if interested within 1 week. If not accepted at time of submission, all materials returned.

Tips: "Know the quality and price level of artwork in our gallery and know that your own art would be companionable with what's being currently shown. Be able to substantiate the prices you ask for your work. We do not offer discounts, so the mutually agreed upon price/value must stand the test of the market."

HONOLULU ACADEMY OF ARTS, 900 S. Beretania St., Honolulu HI 96814. (808)532-8700. Fax: (808)532-8787. E-mail: academypr@honoluluacademy.org. Website: www.honoluluacademy.org. **Director:** Stephen Little, Ph.D. Nonprofit museum. Estab. 1927. Exhibits emerging, mid-career and established Hawaiian artists. Interested in seeing the work of emerging artists. Sponsors 40-50 shows/year. Average display time 6-8 weeks. Open all year; Tuesday-Saturday 10-4:30, Sunday 1-5. Located just outside of downtown area; 40,489 sq. ft. 30% of space for special exhibition. Clientele: general public and art community.

Media: Considers all media. Most frequently exhibits painting, works on paper, sculpture.

Style: Exhibits all styles and genres. Prefers traditional, contemporary and ethnic.

Terms: "On occasion, artwork is for sale." Retail price set by artist. Museum provides insurance and promotion; museum pays for shipping costs. Prefers artwork framed.

Submissions: Exhibits artists of Hawaii. Send query letter with résumé, slides and bio directly to curator(s) of Western and/or Asian art. Curators are: Jennifer Saville, Western art; Julia White, Asian art. Write for appointment to show portfolio of slides, photographs and transparencies. Responds in 3-4 weeks. Files résumés, bio.

Tips: "Be persistent but not obnoxious." Artists should have completed a body of work of 50-100 works before approaching galleries.

MAYOR'S OFFICE OF CULTURE AND THE ARTS, 530 S. King, #404, Honolulu HI 96813. (808)523-4674. Fax: (808)527-5445. E-mail: pradulovic@co.honolulu.hi.us. Website: www.co.honolulu.hi

.us/moca. **Executive Director:** Peter Radulovic. Local government/city hall exhibition areas. Estab. 1965. Exhibits group shows coordinated by local residents. Sponsors 50 shows/year. Average display time 3 weeks. Open all year; Monday-Friday, 7:45-4:30. Located at the civic center in downtown Honolulu; 3 galleries—courtyard (3,850 sq. ft.), lane gallery (873 sq. ft.), 3rd floor (536 sq. ft.); Mediterranean-style building, open interior courtyard. "City does not participate in sales. Artists make arrangements directly with purchaser."
Media: Considers all media and all types of prints. Most frequently exhibits oil/acrylic, photo/print and clay.
Terms: Gallery provides promotion; local artists deliver work to site. Prefers artwork framed.
Submissions: "Local artists are given preference." Send query letter with résumé, slides and bio. Write for appointment to show portfolio of slides. "We maintain an artists' registry for acquisition review for the art in City Buildings Program."
Tips: "Selections of exhibitions are made through an annual application process. Have a theme or vision for exhibit. Plan show at least one year in advance."

RAMSAY MUSEUM, 1128 Smith St., Honolulu HI 96817. (808)537-ARTS. Fax: (808)531-MUSE. E-mail: ramsay@lava.net. Website: www.ramsaymuseum.org. **CEO:** Ramsay. Gallery, museum shop, permanent exhibits and artists' archive documenting over 200 exhibitions including 500 artists of Hawaii. Estab. 1981. Open all year; Monday-Friday, 10-5; Saturday, 10-4. Located in downtown historic district; 5,000 sq. ft.; historic building with courtyard. 25% of space for special exhibitions; 25% of space for gallery artists. 50% of space for permanent collection of Ramsay Quill and Ink originals spanning 50 years. Clientele: 50% tourist, 50% local. 60% private collectors, 40% corporate collectors.
Media: Especially interested in ink.
Style: Exhibits all styles and genres. Currently focusing on the art of tattoo.
Terms: Accepts work on consignment. Retail price set by the artist.
Submissions: Send query letter with résumé, 20 slides, bio, SASE. Write for appointment to show portfolio of original art. Responds only if interested within 1 month. Files all material that may be of future interest. Finds artists through submissions and judging.
Tips: "Keep a record of all artistic endeavors for future book use, and to show your range to prospective commissioners and galleries. Prepare your gallery presentation packet with the same care that you give to your art creations. Quality counts more than quantity. Show samples of current work with an exhibit concept in writing."

VOLCANO ART CENTER GALLERY, P.O. Box 104, Hawaii National Park HI 96718. (808)967-7565. Fax: (808)967-8512. **Gallery Manager:** Fia Mattice. Nonprofit gallery to benefit arts education; nonprofit organization. Estab. 1974. Represents 300 emerging, mid-career and established artists/year. 1,400 member organization. Exhibited artists include Dietrich Varez and Brad Lewis. Sponsors 8 shows/year. Average display time 6 weeks. Open all year; daily 9-5 except Christmas. Located Hawaii Volcanoes National Park; 3,000 sq. ft.; in the historic 1877 Volcano House Hotel. 15% of space for special exhibitions; 85% of space for gallery artists. Clientele: affluent travelers from all over the world. 95% private collectors, 5% corporate collectors. Overall price range: $20-12,000; most work sold at $50-400.
Media: Considers all media, all types of prints. Most frequently exhibits wood, ceramics, glass and 2 dimensional.
Style: Prefers traditional Hawaiian, contemporary Hawaiian and contemporary fine crafts.
Terms: "Artists must become Volcano Art Center members." Accepts work on consignment (50% commission). Retail price set by the gallery. Gallery provides promotion and contract; artist pays shipping costs to gallery.
Submissions: Prefers only work relating to the area or by Hawaiian artists. Call for appointment to show portfolio. Responds only if interested within 1 month. Files "information on artists we represent."

WAILOA CENTER, division of State Parks, Department of Land & Natural Resources State of Hawaii, DLNR P.O. Box 936, Hilo HI 96721. (808)933-0416. Fax: (808)933-0417. E-mail: wailoa@yahoo.com. **Contact:** Codie M. King, director. Nonprofit gallery and museum. Focus is on propagation of Hawaiian culture. Estab. 1968. Represents/exhibits 300 emerging, mid-career and established artists. Interested in seeing work of emerging artists. Sponsors 60 shows/year. Average display time 1 month. Open all year; Monday-Friday, 8-4:30. Located downtown; 10,000 sq. ft.; 3 exhibition areas: main gallery and two local airports. Clientele: tourists, upscale, local community and students. Overall price range: $25-25,000; most work sold at $1,500.

Media: Considers all media and all types of prints. Most frequently exhibits mixed media.

Style: Exhibits all styles. "We cannot sell, but will refer buyer to seller." Gallery provides promotion. Artist pays for shipping costs. Prefers artwork framed.

Submissions: Send query letter with résumé, slides, photographs and reviews. Call for appointment to show portfolio of photographs and slides. Responds in 3 weeks. Finds artists through word of mouth, referrals by other artists, visiting art fairs and exhibitions, submissions.

Tips: "We welcome all artists, and try to place them in the best location for the type of art they have. Drop in and let us review what you have."

Idaho

KNEELAND GALLERY, P.O. Box 2070, Sun Valley ID 83353. (208)726-5512. Fax: (208)726-3490. (800)338-0480. E-mail: art@kneelandgallery.com. **Director:** Carey Molter. Retail gallery, art consultancy. Estab. 1981. Represents 40 emerging, mid-career and established artists/year. Artists include: Ovanes Berberian, Steven Lee Adams, Scott Christensen, Glenna Goodacre, Donna Howell-Sickles, Robert Moore. Sponsors 10 shows/year. Average display time 1 month. Open all year; Monday-Saturday, 10-5. Located downtown; 2,500 sq. ft.; features a range of artists in several exhibition rooms. 50% of space for special exhibitions; 50% of space for gallery artists. Clientele: tourist, seasonal, local, upscale. 95% private collectors, 5% corporate collectors. Overall price range: $200-25,000; most work sold at $1,000-6,000.

Media: Considers all media and all types of prints. Most frequently exhibits oil, acrylic, watercolor.

Style: Genres include landscapes, florals, figurative work. Prefers traditional landscapes-realism, expressionism.

Terms: Accepts work on consignment (50% commission). Retail price set by the artist. Gallery provides insurance, promotion and contract; shipping costs are shared. Prefers artwork framed.

Submissions: Send query letter with résumé, slides, photographs, artists' statement, bio, SASE. Write for appointment to show portfolio of photographs and slides. Responds in 2 months. Files photo samples/business cards. Finds artists through submissions and referrals.

N **POCATELLO ART CENTER GALLERY & SCHOOL,** 444 N. Main, Pocatello ID 83204. (208)232-0970. Nonprofit gallery featuring work of artist/members. Estab. 1970. Represents approximately 60 emerging, mid-career and established artists/year. Approximately 150 members. Exhibited artists include: Barbara Ruffridge, Jerry Younkin, Onita Asbury and Barbara Swanson. Sponsors 10-12 shows/year. Average display time 2 months. Open all year; Monday-Friday, 10-4 (varies occasionally). Located downtown in "Old Town." "We sponsor the 'Sagebrush Arts Fest' each year, usually in September, on the Idaho State University Campus." We hold classes, feature all levels of artists and are a gathering place for artists. Clientele: tourists, local community, students and artists. 100% private collectors. Overall price range: $25-1,000; most work sold at $25-300.

Media: Considers oil, acrylic, watercolor, pastel, pen & ink, drawing, mixed media, collage, paper, sculpture, ceramics, high-end craft, fiber, glass and photography; types of prints include woodcuts, engravings, wood engravings, serigraphs, linocuts and etchings. Most frequently exhibits watercolor, oil and pastel.

Style: Exhibits: Expressionism, neo-expressionism, primitivism, painterly abstraction, surrealism, minimalism, impressionism, photorealism, hard-edge geometric abstraction, realism and imagism. Exhibits all genres. Prefers: impressionism, realism and painterly abstraction.

Terms: Co-op membership fee plus donation of time. Donations-monetary. Retail price set by the artist. Gallery provides promotion; hand delivered works only. Prefers artwork framed.

Submissions: Accepts only artists from Southeast Idaho. Memberships open to all artists and persons interested in the visual arts. Send query letter or visit gallery. Finds artists through word of mouth, referrals by other artists, visiting art fairs and exhibitions.

Tips: "Have work ready to hang."

THE ROLAND GALLERY, Sun Valley Rd. & East Ave., P.O. Box 221, Ketchum ID 83340. (208)726-2333. Fax: (208)726-6266. E-mail: rolandgallery@aol.com. Website: Website: www.rolandgallery.com. **Owner:** Roger Roland. Retail gallery. Estab. 1990. Represents 100 emerging, mid-career and established artists. Sponsors 8 shows/year. Average display time 1 month. Open all year; daily 11-5. 800 sq. ft. 50% of space for special exhibitions; 50% of space for gallery artists. Clientele: 75% private collectors, 25% corporate collectors. Overall price range: $10-10,000; most work sold at $500-1,500.

Media: Considers oil, pen & ink, paper, fiber, acrylic, sculpture, glass, watercolor, mixed media, ceramic,

installation, pastel, collage, craft and photography, engravings, mezzotints, etchings, lithographs. Most frequently exhibits glass, paintings and jewelry.

Style: Considers all styles and genres.

Terms: Accepts work on consignment (50% commission) or buys outright for 50% of the retail price (net 30 days). Retail price set by artist. Gallery provides insurance, promotion, shipping costs from gallery. Prefers artwork framed.

Submissions: Send query letter with résumé, slides, bio, brochure, photographs, SASE, business card and reviews. Write for appointment to show portfolio of photographs, slides and transparencies. Responds only if interested within 2 weeks.

Illinois

ARTCO, INCORPORATED, 3148 RFD, Long Grove IL 60047. (847)438-8420. Fax: (847)438-6464. E-mail: sybiltillman@msn.com. Website: www.e-Artco.com. **President:** Sybil Tillman. Retail and wholesale gallery, art consultancy and artists' agent. Estab. 1970. Represents 60 mid-career and established artists. Interested in seeing the work of emerging artists. Exhibited artists include Ed Paschke and Gary Grotey. Open all year; daily and by appointment. Located "2 blocks outside of downtown Long Grove; 7,200 sq. ft.; unique private setting in lovely estate and heavily wooded area." 50% of space for special exhibitions. Clientele: upper middle income. 65% private collectors, 20% corporate collectors. Overall price range: $500-20,000; most work sold at $2,000-5,000.

Media: Considers paper, sculpture, fiber, glass, original handpulled prints, woodcuts, engravings, pochoir, wood engravings, mezzotints, linocuts, etchings and serigraphs. Most frequently exhibits originals and signed limited editions "with a small number of prints."

Style: Exhibits all styles, including expressionism, abstraction, surrealism, conceptualism, postmodern works, impressionism, photorealism and hard-edge geometric abstraction. All genres. Likes American contemporary and Southwestern styles.

Terms: Accepts artwork on consignment. Retail prices set by gallery. Customer discounts and payment by installment are available. Gallery provides promotion and contract; artist pays for shipping.

Submissions: Send query letter with résumé, slides, transparencies, bio, brochure, photographs, SASE, business card and reviews. Responds in 1 month. Files materials sent. Portfolio review required. Finds artists through agents, by visiting exhibitions, word of mouth, various art publications and sourcebooks, submissions/self-promotions and art collectors' referrals.

Tips: "We prefer established artists but will look at all new art."

FREEPORT ARTS CENTER, 121 N. Harlem Ave., Freeport IL 61032. (815)235-9755. Fax: (815)235-6015. **Director:** Stephen H. Schwartz. Estab. 1975. Interested in emerging, mid-career and established artists. Sponsors 21 solo and group shows/year. Open all year; Tuesdays, 10-6; Wednesday-Sunday, 10-5. Clientele: 30% tourists; 60% local; 10% students. Average display time 7 weeks.

Media: Considers all media and prints.

Style: Exhibits all styles and genres. "We are a regional museum serving Northwest Illinois, Southern Wisconsin and Eastern Iowa. We have extensive permanent collections and 8-9 special exhibits per year representing the broadest possible range of regional and national artistic trends. Some past exhibitions include 'Gifts for the Table,' 'Art in Bloom,' 'Au Naturel: American Wildlife Art,' and 'Midwestern Romanticism.' "

Terms: Gallery provides insurance and promotion; artist pays shipping costs. Prefers artwork framed.

Submissions: Send query letter with résumé, slides, SASE, brochure, photographs and bio. Responds in 4 months. Files résumés.

Tips: "The Exhibition Committee meets three times each year to review the slides submitted."

☑ **NAF GALLERY**, 4444 Oakton, Skokie IL 60076. (847)674-7990. Fax: (847)675-8116. Website: www.nafgallery.com. **Contact:** Harry Hagen. Retail/wholesale gallery and art consultancy. Estab. 1987. Represents/exhibits 60-80 emerging, mid-career and established artists/year. Interested in seeing the work of emerging artists. Exhibited artists include Christana-Sahagian. Sponsors 3-4 shows/year. Average display time 4-6 weeks. Open all year; Monday-Sunday, 10-4. Located on main street of Skokie; 1,500 sq. ft. 80-100% of space for gallery artists. 5-10% private collectors, 5-10% corporate collectors. Overall price range: $50-3,000; most work sold at: $200-2,000.

Media: Considers acrylic, ceramics, mixed media, oil, pastel, sculpture and watercolor. Most frequently exhibits oil, watercolor.
Style: Exhibits expressionism, imagism, impressionism, painterly abstraction, postmodernism, surrealism. Genres include Americana, figurative work, florals, landscapes, portraits, Southwestern and wildlife. Prefers impressionism, abstraction and realism.
Terms: Artwork is accepted on consignment (30% commission). Retail price set by the gallery and the artist. Gallery provides insurance and promotion. Artist pays for shipping costs. Prefers artwork framed.
Submissions: Send query letter with résumé, slides and SASE. Include price and size of artwork. Call or write for appointment to show portfolio of photographs, slides and transparencies. Responds in 2 weeks. Finds artists through word of mouth, referrals by other artists, visiting art fairs and exhibitions, submissions.
Tips: "Be persistent."

N PRESTIGE ART GALLERIES, 3909 W. Howard, Skokie IL 60076. (847)679-2555. E-mail: prestige @prestigeart.com. Website: www.prestigeart.com. **President:** Louis Schutz. Retail gallery. Estab. 1960. Exhibits 100 mid-career and established artists/year. Interested in seeing the work of emerging artists. Exhibited artists include Jean Paul Avisse. Sponsors 4 shows/year. Average display time 4 months. Open all year; Saturday and Sunday, 11-5; Monday-Wednesday, 10-5. Located in a suburb of Chicago; 3,000 sq. ft. 20% of space for special exhibitions; 50% of space for gallery artists. Clientele: professionals. 20% private collectors, 10% corporate collectors. Overall price range: $100-100,000; most work sold at $1,500-2,000.
Media: Considers oil, acrylic, mixed media, paper, sculpture, ceramics, craft, fiber, glass, lithographs and serigraphs. Most frequently exhibits paintings, glass and fiber.
Style: Exhibits surrealism, New Age visionary, impressionism, photorealism and realism. Genres include landscapes, florals, portraits and figurative work. Prefers landscapes, figurative-romantic and floral.
Terms: Accepts work on consignment (50% commission). Retail price set by the gallery and the artist. Gallery provides insurance, promotion and contract; shipping costs are shared. Prefers artwork framed.
Submissions: Send query letter with résumé, slides, bio, SASE and prices/sizes. Call for appointment to show portfolio of photographs. Responds in 2 weeks. "Returns all material if SASE is included."

N WILLIAM & FLORENCE SCHMIDT ART CENTER, Southwestern Illinois College, 2500 Carlyle Ave., Belleville IL 62221. E-mail: libby.reuter@swic.edu. Website: www.swicfoundation.com. **Contact:** Libby Reuter, executive director. Nonprofit gallery. Estab. 2001. Exhibits emerging, mid-career and established artists. Sponsors 10-12 exhibits/year. Average display time 6-8 weeks. Open Tuesday-Saturday, 11-5. Closed during college holidays. Clients include local community, students and tourists.
Media: Considers all media. Most frequently exhibits oil, ceramics, photography. Considers all types of prints.
Style: Considers all styles.
Submissions: Mail portfolio for review. Send query letter with artist's statement, bio and slides. Returns material with SASE. Finds artists through art fairs and exhibits, portfolio reviews, referrals by other artists, submissions and word-of-mouth.

N LAURA A. SPRAGUE ART GALLERY, Joliet Junior College, 1215 Houbolt Rd., Joliet IL 60431-8938. (815)280-2423. **Gallery Director:** Joe B. Milosevich. Nonprofit gallery. Estab. 1978. Interested in emerging and established artists. Sponsors 6-8 solo and group shows/year. Average display time is 3-4 weeks.
Media: Considers all media except performance. Most frequently exhibits painting, drawing and sculpture (all media).
Style: Considers all styles.
Terms: Gallery provides insurance and promotion.
Submissions: Send query letter with résumé, brochure, slides, photographs and SASE. Call or write for appointment to show portfolio of originals and slides. Query letters and résumés are filed.

Chicago

N A.R.C. GALLERY/EDUCATIONAL FOUNDATION, 734 N. Milwaukee Ave., Chicago, IL 60622. (312)733-2787. E-mail: ARCgallery@yahoo.com. Website: www.ARCgallery.org. **President:** Carolyn King. Nonprofit gallery. Estab. 1973. Exhibits emerging, mid-career and established artists. Interested

in seeing the work of emerging artists. 21 members. Exhibited artists include Miriam Schapiro. Average display time 1 month. Closed August. Located in the River West area; 3,500 sq. ft. Clientele: 80% private collectors, 20% corporate collectors. Overall price range $50-40,000; most work sold at $200-4,000.
Media: Considers oil, acrylic, drawings, mixed media, paper, sculpture, ceramics, installation, photography and original handpulled prints. Most frequently exhibits painting, sculpture (installation) and photography.
Style: Exhibits all styles and genres. Prefers postmodern and contemporary work.
Terms: Rental fee for space. Rental fee covers 1 month. Gallery provides promotion; artist pays shipping costs. Prefers work framed.
Submissions: Send query letter with résumé, slides, bio and SASE. Call for deadlines for review. Portfolio should include slides.

✓ JEAN ALBANO GALLERY, 215 W. Superior St., Chicago IL 60610. (312)440-0770. **Director:** Jean Albano Broday. Retail gallery. Estab. 1985. Represents 24 mid-career artists. Somewhat interested in seeing the work of emerging artists. Exhibited artists include Martin Facey and Jim Waid. Average display time 5 weeks. Open all year. Located downtown in River North gallery district; 1,600 sq. ft. 60% of space for special exhibitions; 40% of space for gallery artists. Clientele: 80% private collectors, 20% corporate collectors. Overall price range: $1,000-20,000; most work sold at $2,500-6,000.
Media: Considers oil, acrylic, sculpture and mixed media. Most frequently exhibits mixed media, oil and acrylic. Prefers non-representational, non-figurative and abstract styles.
Terms: Accepts artwork on consignment (50% commission). Retail price set by gallery and artist; shipping costs are shared.
Submissions: Send query letter with résumé, bio, SASE and well-labeled slides: "size, name, title, medium, top, etc." Write for appointment to show portfolio. Responds in 6 weeks. "If interested, gallery will file bio/résumé and selected slides."
Tips: "We look for artists whose work has a special dimension in whatever medium. We are interested in unusual materials and unique techniques."

N ARTEMISIA GALLERY, 700 N. Carpenter, Chicago IL 60622. (312)226-7323. E-mail: info@artemisia.org. Website: www.enteract.com/~artemisi. **Gallery Coordinator:** Tricia Alexander. Cooperative and nonprofit gallery/alternative space run by women artists. Estab. 1973. Sponsors 60 solo shows/year. Average display time 4 weeks. Interested in emerging and established artists. Overall price range: $150-10,000; most work sold at $600-2,500.
Media: Considers all traditional media including craft, installation, performance and new technologies.
Terms: Rental fee for space; rental fee covers 1 month. Retail price set by artist. Exclusive area representation not required. Artist pays for shipping and announcement cards. Gallery does not take commission.
Submissions: Send query letter with résumé, statement, 10 slides, slide sheet and SASE. Portfolios reviewed each month. Responds in 6 weeks. All material is returned if not accepted or under consideration if SASE is included.
Tips: "Send clear, readable slides, labeled and marked 'top' or with red dot in lower left corner."

BALZEKAS MUSEUM OF LITHUANIAN CULTURE ART GALLERY, 6500 S. Pulaski Rd., Chicago IL 60629. (773)582-6500. Fax: (773)582-5133. Museum, museum retail shop, nonprofit gallery and rental gallery. Estab. 1966. Approached by 20 mid-career and established artists/year. Sponsors 8 exhibits/year. Average display time 6 weeks. Open 7 days a week. Closed holidays. Clients include local community, tourists and upscale. 74% of sales are to corporate collectors. Overall price range: $150-6,000; most work sold at $545.
Media: Considers all media and all types of prints.
Style: Considers all styles and genres.
Terms: Artwork is accepted on consignment and there is a 33% commission. Retail price set by the gallery. Gallery provides promotion. Accepted work should be framed.
Submissions: Write to arrange a personal interview to show portfolio. Cannot return material. Responds in 2 months. Finds artists through word of mouth, art exhibits, and referrals by other artists.

N CHIAROSCURO, 700 N. Michigan Ave., Chicago IL 60611. (312)988-9253. Proprietors: Ronna Isaacs and Peggy Wolf. Contemporary retail gallery. Estab. 1987. Represents over 200 emerging artists. Located on Chicago's "Magnificent Mile"; 2,500 sq. ft. on Chicago's main shopping boulevard, Michigan Ave. "Space was designed by award winning architects Himmel & Bonner to show art and contemporary crafts in an innovative way." Overall price range: $30-2,000; most work sold at $50-200.

Media: All 2-dimensional work—mixed media, oil, acrylic; ceramics (both functional and decorative works); sculpture, art furniture, jewelry. "We moved out of Chicago's gallery district to a more 'retail' environment 3 years ago because many galleries were closing. Paintings seemed to stop selling, even at the $500-1,000 range, where functional pieces (i.e. furniture) would sell at that price."

Style: "Generally we exhibit bright contemporary works. Paintings are usually figurative works either traditional oil on canvas or to the very non-traditional layers of mixed-media built on wood frames. Other works are representative of works being done by today's leading contemporary craft artists. We specialize in affordable art for the beginning collector, and are focusing on 'functional works'. We are currently carrying fewer of the 'funky' brightly painted objects—though we still feature them—and have added more metals and objects with 'cleaner' lines."

Terms: Accepts work on consignment (50% commission). Retail price set by gallery and artist. Customer discounts and payment by installment are available. Gallery provides insurance.

Submissions: Send query letter (Attn: Peggy Wolf) with résumé, slides, photographs, price list, bio and SASE. Portfolio review requested if interested in artist's work. All material is returned if not accepted or under consideration. Finds artists through agents, by visiting exhibitions and national craft and gift shows, word of mouth, various art publications and sourcebooks, submissions/self-promotions and art collectors' referrals.

Tips: "Don't be afraid to send photos of anything you're working on. I'm happy to work with the artist, suggest what's selling (at what prices). If it's not right for this gallery, I'll let them know why."

N CHICAGO CENTER FOR THE PRINT & POSTER, 1509 W. Fullerton, Chicago IL 60614. (773)477-1585. Fax: (773)477-1851. E-mail: rkasvin@prints-posters.com. Website: www.prints-posters.com. **Owner/Director:** Richard H. Kasvin. Retail gallery. Estab. 1979. Represents 100 mid-career and established artists/year. Interested in seeing the work of emerging artists. Exhibited artists include Hiratsuka, J. Buck, David Bumbeck, Scott Sandel, Armin Hoffmann and Herbert Leupin. Sponsors 2-3 shows/year. Average display time 6-8 weeks. Open all year; Tuesday-Saturday, 11-7; Sunday, 12-5. Located in Lincoln Park, Chicago; 3,000 sq. ft. "We represent works on paper, Swiss graphics and European vintage posters." 40% of space for special exhibitions; 60% of space for gallery artists. 90% private collectors, 10% corporate collectors. Overall price range: $300-3,000; most work sold at $500-1,300.

Media: Considers mixed media, paper, woodcuts, engravings, lithographs, wood engravings, mezzotints, serigraphs, linocuts, etchings and vintage posters. Most frequently exhibits prints and vintage posters.

Style: Exhibits all styles. Genres include landscapes and figurative work. Prefers abstract, figurative and landscape.

Terms: Accepts work on consignment (50% commission) or buys outright for 40-60% of the retail price (30-60 days). Retail price set by the gallery and the artist. Gallery provides promotion; shipping costs are shared. Prefers artwork unframed.

Submissions: Send query letter with résumé, slides and photographs. Write for appointment to show portfolio of originals, photographs and slides. Files everything. Finds new artists through agents, by visiting exhibitions, word of mouth, art publications and sourcebooks, submissions.

CONTEMPORARY ART WORKSHOP, 542 W. Grant Place, Chicago IL 60614. (773)472-4004. Fax: (773)472-4505. E-mail: info@contemporaryartworkshop.org. Website: www.contemporaryartworkshop.org. **Director:** Lynn Kearney. Nonprofit gallery. Estab. 1949. Interested in emerging and mid-career artists. Average display time is 4½ weeks "if it's a show, otherwise we can show the work for an indefinite period of time." Open Tuesday-Friday, 12:30-5:30; Saturday, 12-5. Clientele: art-conscious public. 75% private collectors, 25% corporate clients. Overall price range: $100-1,000; most artwork sold at $400."

- This gallery also offers studios for sculptors, painters and fine art crafts on a month-to-month arrangement, and open space for sculptors.

Media: Considers oil, acrylic, mixed media, works on paper, sculpture, installations and original handpulled prints. Most frequently exhibits paintings, sculpture and works on paper and fine art furniture.

Style: "Any high-quality work" is considered.

Terms: Accepts work on consignment (33% commission). Retail price set by gallery or artist. "Discounts and payment by installments are seldom and only if approved by the artist in advance." Exclusive area representation not required. Gallery provides insurance and promotion.

Submissions: Send query letter with résumé, slides (a full sheet), artist statement and SASE. Slides and résumé are filed. "First we review slides and then send invitations to bring in a portfolio based on the slides." Finds artists through call for entries in arts papers; visiting local BFA, MFA exhibits; referrals from other artists, collectors.

Tips: "Looks for a professional approach and a fine art school degree (or higher). Artists a long distance from Chicago will probably not be considered."

DIX ART MIX, 2068 N. Leavitt, Chicago IL 60647. Phone/fax: (773)384-5142. Website: www.fota.com. **Director:** Thomas E. Frerk. Retail gallery, alternative space, art consultancy. Estab 1998. Represents 35 emerging artists and 12 consignment artists/year. Exhibited artists include Connie Hinkle, Kevin Orth and Adele Kiel. Sponsors 6 shows/year. Average display time 1 month. Open all year; Wednesday and Saturday evenings; Sunday afternoons by appointment. Clientele: local community—many diverse groups. 90% private collectors, 10% corporate collectors. Overall price range $100-2,000; most work sold at $200-500.
Media: Considers all media and all types of prints. Most frequently exhibits paintings, photography, mixed media, glass, jewelry, pottery, sculpture and consignment art.
Style: Exhibits neoexpressionism, conceptualism, street art, environmental/cultural, painterly abstraction and surrealism. Prefers conceptualism, mixed media, pop art, avant garde.
Terms: Accepts work on consignment (15-25% commissions) and/or rental fee for space. The rental fee covers 1 month; there is a per event price. Prices of artwork set by artist. Gallery provides promotion and contract; artist pays for shipping.
Submissions: Send query letter with résumé, business card, 3 or more slides, photographs, artist's statment, bio and SASE. Call for appointment to show portfolio of photographs and slides. Responds in 1 month. files color photocopies. Finds artists through visiting shows/openings, referrals and word of mouth.

N FINE ARTS BUILDING GALLERY, 410 S. Michigan Ave., #433, Chicago IL 60605-1300. (312)913-0537. Website: www.fabgallery.com. Cooperative for profit gallery. Estab. 1995. Approached by 12 artists/year. Represents 19 mid-career and established artists. Average display time 1 month. Open all year; Wednesday-Saturday, 12-6; weekends, 12-6. Closed Sundays and holidays. Located on 4th floor of historic landmark building; Venetian court (open courtyeard in addition to gallery). Clients include local community, tourists and upscale. 15% of sales are to corporate collectors. Overall price range: $100-15,000; most work sold at $1,500.
Media: Considers acrylic, ceramics, collage, drawing, mixed media, oil, paper, pastel, pen & ink, sculpture and watercolor. Most frequently exhibits paintings on canvas, works on paper, mixed media sculpture. Considers etchings, linocuts, lithographs and monotypes.
Style: Exhibits: color field, geometric abstraction, imagism, pattern painting, surrealism, painterly abstraction and realism. Most frequently exhibits realism, surrealism and painterly abstraction. Considers all genres.
Terms: Artwork is accepted on consignment and there is a 25% commission. There is a co-op membership fee plus a donation of time. There is a 15% commission. There is a rental fee for space. The rental fee covers 1 month. Retail price set by the artist. Gallery provides insurance and promotion. Accepted work should be framed and matted. Does not require exclusive representation locally. Member artists must be from the Chicago area. Guest artists may come from anywhere.
Submissions: Call or write to arrange a personal interview to show portfolio of photographs, slides, and transparencies. Send query letter with artist's statement, bio, brochure, business card, photocopies, photographs, résumé, reviews, SASE and slides. Returns material with SASE. Responds in 2 weeks. Files résumés and artist's statements. Finds artists through word of mouth, submissions, portfolio reviews, art exhibits, and referrals by other artists.
Tips: "Quality of slides and or transparencies or photocopies must be of high quality and correctly represent the artwork! Archival-quality materials play a very important role. Hopefully even if the artist uses 'new materials,' he/she tries to learn about the archival quality of the materials that are used. Materials do not have to be expensive or official art materials."

ROBERT GALITZ FINE ART, 166 Hilltop Court, Sleepy Hollow IL 60118. (847)426-8842. Fax: (847)426-8846. **Owner:** Robert Galitz. Wholesale representation to the trade. Makes portfolio presentations to corporations. Estab. 1986. Represents 40 emerging, mid-career and established artists. Exhibited artists include Marko Spalatin and Jack Willis. Open by appointment. Located in far west suburban Chicago.
Media: Considers oil, acrylic, watercolor, mixed media, collage, ceramic, fiber, original handpulled prints, engravings, lithographs, pochoir, wood engravings, mezzotints, serigraphs and etchings. "Interested in original works on paper."
Style: Exhibits expressionism, painterly abstraction, surrealism, minimalism, impressionism and hard-edge geometric abstraction. Interested in all genres. Prefers landscapes and abstracts.
Terms: Accepts artwork on consignment (variable commission) or artwork is bought outright (25% of

retail price; net 30 days). Retail price set by artist. Customer discounts and payment by installment are available. Gallery provides promotion and shipping costs from gallery. Prefers artwork unframed only.
Submissions: Send query letter with SASE and submission of art. Portfolio review requested if interested in artist's work. Files bio, address and phone.
Tips: "Do your thing and seek representation—don't drop the ball! Keep going—don't give up!"

☑ **GALLERY 400, UNIVERSITY OF ILLINOIS AT CHICAGO**, 1240 W. Harrison (MC033), Chicago IL 60607. (312)996-6114. Fax: (312)355-3444. Website: gallery400.aa.uic.edu. **Director:** Lorelei Stewart. Nonprofit gallery. Estab. 1983. Approached by 500 artists/year. Exhibits 80 emerging and mid-career artists. Exhibited artists include: Öyvind Fahlström and Kristin Lucas. Sponsors 6 exhibits/year. Average display time 4-6 weeks. Open Tuesday-Friday, 10-5; Saturday, 12-5. Closed holiday season. Located in 2,400 sq. ft. former supermarket. Clients include local community, students, tourists and upscale.
Media: Considers drawing, installation, mixed media and sculpture. Most frequently exhibits sculpture, drawing and photography.
Style: Exhibits: conceptualism, minimalism and postmodernism. Most frequently exhibits contemporary conceptually based artwork.
Terms: Gallery provides insurance and promotion.
Submissions: Send query letter with SASE. Returns material with SASE. Responds in 5 months. Files résumé only. Finds artists through word of mouth, art exhibits and referrals by other artists.
Tips: Please check our website for guidelines for proposing an exhibition.

GALLERY 1633, 1633 N. Damen Ave., Chicago IL 60647. (773)384-4441. E-mail: montanaart@att.net. Website: home.att.net/~montanaart. **Director:** Montana Morrison. Consortium of contributing artists. Estab. 1986. Represents/exhibits a number of emerging, mid-career and established artists. Interested in seeing the work of emerging artists. Exhibited artists include painters, printmakers, sculptors, photographers. Sponsors 11 shows/year. Average display time 1 month. Open all year; Friday, 12-9:30; Saturday and Sunday, 12-5. Located in Bucktown; 900 sq. ft.; original tin ceiling, storefront charm. 35% of space for special exhibitions; 65% of space for gallery artists. Clientele: tourists, local community, local artists, "suburban visitors to popular neighborhood." Sells to both private collectors and commercial businesses. Overall price range: $50-5,000; most work sold at $250-500.
Media: Considers all media and types of prints. Most frequently exhibits painting and drawing; ceramics, sculpture and photography.
Style: Exhibits all styles including usable crafts (i.e. tableware). All genres. Montana Morrison shows neo-expressionism, activated minimalism and post modern works.
Terms: Artwork is accepted on consignment, and there is a 25% commission. There is a rental fee for space. Available memberships include "gallery artists" who may show work every month for 1 year; associate gallery artists who show work for 6 months; and guest artists, who show for one month. Retail price set by the artist. Gallery provides promotion and contract. Artist pays for shipping costs. Call for appointment to show portfolio. Artist should call and visit gallery.
Tips: "If you want to be somewhat independent and handle your own work under an 'umbrella' system where artists work together, in whatever way fits each individual—join us."

GALLERY 312, 312 N. May St., Suite 110, Chicago IL 60607. (312)942-2500. Fax: (312)942-0574. E-mail: gall312@megsinet.com. Website: www.gallery312.org. **Program Director:** Paul Brenner. Nonprofit, artist-run venue "committed to the exploration and exhibition of ideas and trends in artmaking relevant to today's world. By focusing on new art forms and emerging artists, and integrating educational strategies, Gallery 312 acts as a local lens for an international community." Sponsors 6 shows/year. Average display time 6 weeks. Open all year; Tuesday-Saturday, 11-5. Located in Fulton/Randolph Market District; 7,200 sq. ft.; 28 ft. ceiling. Gallery is in restored boiler room of large warehouse. 100% of space for special exhibitions. Clientele: "museum-goers," educators, artists, collectors, students. 50% private collectors, 50% corporate collectors. Overall price range: $500-25,000; most work sold at $500-5,000.
Media: Considers and exhibits all media.
Style: Exhibits conceptualism, minimalism, color field, postmodern. Prefers contemporary.
Terms: Accepts work on consignment for exhibition only. Retail price set by artist. Gallery provides insurance, promotion and contract; artist pays for shipping. Prefers paper and photographs framed; canvas etc. unframed.
Submissions: Send query letter with résumé, brochure, business card, slides, photographs, reviews, artists' statement, bio and SASE. Advisory Programming Committee reviews work. Responds in 1 month. Files

catalogs. Finds artists through referrals by other galleries, museums, guest curators and submissions.

HYDE PARK ART CENTER, 5307 S. Hyde Park Blvd., Chicago IL 60615. (773)324-5520. Fax. (773)324-6641. E-mail: info@hydeparkart.org. Website: hydeparkart.org. **Executive Director:** Chuck Thurow. Nonprofit gallery. Estab. 1939. Exhibits emerging artists. Sponsors 8 group shows/year. Average display time is 4-6 weeks. Located in the historic Del Prado building, in a former ballroom. "Primary focus on Chicago area artists not currently affiliated with a retail gallery." Clientele: general public. Overall price range: $100-10,000.
Media: Considers all media. Interested in seeing "innovative, 'cutting edge' work by young artists; also interested in proposals from curators, groups of artists."
Terms: Accepts work "for exhibition only." Retail price set by artist. Sometimes offers payment by installment. Exclusive area representation not required. Gallery provides insurance and contract.
Submissions: Send query letter with résumé, no more than 10 slides and SASE. Will not consider poor slides. "A coherent artist's statement is helpful." Portfolio review not required. Send Attn: Exhibition Coordinator. Finds artists through open calls for slides, curators, visiting exhibitions (especially MFA programs) and artists' submissions. Prefers not to receive phone calls.
Tips: "Do not bring work in person."

ILLINOIS ARTISANS PROGRAM, James R. Thompson Center, 100 W. Randolph St., Chicago IL 60601. (312)814-5321. Fax: (312)814-3891. E-mail: cpatterson@museum.state.il.us. **Director:** Carolyn Patterson. Four retail shops operated by the nonprofit Illinois State Museum Society. Estab. 1985. Represents over 1,500 artists; emerging, mid-career and established. Average display time 6 months. "Accepts only juried artists living in Illinois." Clientele: tourists, conventioneers, business people, Chicagoans. Overall price range: $10-5,000; most artwork sold at $25-100.
Media: Considers all media. "The finest examples in all media by Illinois artists."
Style: Exhibits all styles. "Seeks contemporary, traditional, folk and ethnic arts from all regions of Illinois."
Terms: Accepts work on consignment (50% commission). Retail price set by gallery and artist. Sometimes offers customer discounts. Exclusive area representation not required. Gallery provides promotion and contract.
Submissions: Send résumé and slides. Accepted work is selected by a jury. Résumé and slides are filed. "The finest work can be rejected if slides are not good enough to assess." Portfolio review not required. Finds artists through word of mouth, requests by artists to be represented and by twice-yearly mailings to network of Illinois crafters announcing upcoming jury dates.

ILLINOIS STATE MUSEUM CHICAGO GALLERY, (formerly Illinois Art Gallery), Suite 2-100, 100 W. Randolph, Chicago IL 60601. (312)814-5322. Fax: (312)814-3471. E-mail: jstevens@museum. state.il.us. Website: www.museum.state.il.us. **Assistant Administrator:** Jane Stevens. Museum. Estab. 1985. Exhibits emerging, mid-career and established artists. Sponsors 6-7 shows/year. Average display time 7-8 weeks. Open all year. Located "in the Chicago loop, in the James R. Thompson Center designed by Helmut Jahn." 100% of space for special exhibitions.
Media: All media considered, including installations.
Style: Exhibits all styles and genres, including contemporary and historical work.
Terms: "We exhibit work, do not handle sales." Gallery provides insurance and promotion; artist pays for shipping. Prefers artwork framed.
Submissions: Accepts only artists from Illinois. Send résumé, 10 high quality slides, bio and SASE.

LOYOLA UNIVERSITY CHICAGO, Crown Center Gallery, 6525 N. Sheridan Rd., Chicago IL 60626. (773)508-3811. Fax: (773)508-2282. **Contact:** Fine Arts Department. Nonprofit gallery. Estab. 1983. Approached by more than 100 artists/year. Sponsors 6 exhibits/year. Open all year; Monday-Friday, 10-3. Located on Chicago lakefront adjacent to glass wall overlooking lake and Michigan. Gallery is 85×19 with large lobby and auditorium. Clients include local community, students and upscale.
Media: Considers all media except performance art.
Style: Considers all styles and genres.
Terms: We are nonprofit. Pass sales on to artists. Retail price set by the artist. Gallery provides insurance, promotion and contract. Accepted work should be framed, mounted and matted. Does not require exclusive representation locally. Prefer midwest and international artists.
Submissions: Send query letter with artist's statement, bio, SASE and slides. Returns material with SASE. Responds in 3 months. Finds artists through word of mouth and portfolio reviews.

N̈ LYDON FINE ART, 309 W. Superior St., Chicago IL 60610. (312)943-1133. Fax: (312)943-8090. E-mail: lydonart@earthlink.net. Website: www.lydonfineart.com. **President:** Douglas K. Lydon. Retail gallery. Estab. 1989. Represents contemporary European and American artists. Exhibited artists include Trevor Bell, Bernd Haussmann, Stephen McClymont and Maria Olivieri Quinn. Exhibits 7-8 shows/year. Average display time 1-2 months. Open all year; Tuesday-Sunday, 10-5. Located in River North Gallery District; 3,000 sq. ft.; features several adjoining spaces allowing for varied exhibition. 70% of space for special exhibitions; 30% of space for gallery artists. Clientele: regional and national collectors, major corporate collections. 60% private collectors, 40% corporate collectors. Overall price range: $1,000-25,000; most work sold at $4,000-19,000.
Media: Considers oil, acrylic, sculpture, mixed media, all types of prints. Most frequently exhibits painting.
Style: Exhibits: color field, painterly abstraction, realism. Genres include landscapes. Prefers realism-landscape, abstract painting.
Terms: Accepts work on consignment. Price set by the gallery in consultation with the artists. Gallery provides insurance, promotion and contract; shipping costs are shared. Prefers artwork framed.
Submissions: Send query letter with résumé, slides, reviews, artist's statement, bio, SASE. Send one slide sheet with a full range of work. The majority of which should be current, but include some older pieces to give a sense of where you've come from. Responds in 2 months.

N̈ MASTERS' PORTFOLIO LTD, 4075 S. Dearborn St., Suite 1030, Chicago IL 60605. (312)922-7594. Fax: (312)922-7291. **Contact:** Scott B. Johnson. Art consultancy and private dealer. Estab. 1984. Represents 20 established artists/year. Exhibiting artists from Manet through DeKooning. Sponsors 3 shows/year. Average display time 3 months. Open all year; Tuesday-Friday, 10:30-5:30; Saturday, 10:30-2:30. Located in the Central Business District; 1,400 sq. ft. Clientele: museums, private and corporate collectors. 55% private collectors, 25% corporate collectors.
Media: Considers oil, watercolor, pastel, pen & ink, drawing and sculpture. Most frequently exhibits oil, drawings, photography and watercolor.
Terms: Retail price set by the gallery. Gallery provides promotion and contract. Prefers artwork framed.
Submissions: Send query letter with résumé and slides. Write for appointment to show portfolio of originals and transparencies. Responds only if interested in 1 month.
Tips: Finds artists through visiting exhibitions and word of mouth.

PETER MILLER GALLERY, 118 N. Peoria St., Chicago IL 60607. (312)226-5291. Fax: (312)226-5441. E-mail: info@petermillergallery.com. Website: petermillergallery.com. **Director:** Natalie R. Domchenko. Retail gallery. Estab. 1979. Represents 15 emerging, mid-career and established artists. Sponsors 9 solo and 3 group shows/year. Average display time is 1 month. Clientele: 80% private collectors, 20% corporate clients. Overall price range: $500-30,000; most artwork sold at $5,000 and up.
Media: Considers oil, acrylic, mixed media, collage, sculpture, installations and photography. Most frequently exhibits oil and acrylic on canvas and mixed media.
Style: Exhibits abstraction, conceptual and realism.
Terms: Accepts work on consignment (50% commission). Retail price set by gallery and artist. Exclusive area representation required. Insurance, promotion and contract negotiable.
Submissions: Send a sheet of 20 slides of work done in the past 18 months with a SASE." Slides, show card are filed.

N̈ SUBURBAN FINE ARTS CENTER, 1913 Sheridan Rd., Highland Park IL 60035-2607. (847)432-1888. **Executive Director:** Ann Rosen. Nonprofit gallery. Estab. 1960. Represents "hundreds" of emerging, mid-career and established artists/year. 2,200 members. Sponsors 12 shows/year. Average display time 1 month. Open all year, Monday-Saturday, 9-5. Located downtown, in Highland Park, a suburb of Chicago; 7,000 sq. ft.; spacious, light and airy. 20% of space for special exhibitions; 20% of space for gallery artists. Clientele: vast array. 100% private collectors. Overall price range: $20-30,000; most work sold at $100.
Media: Considers all media and all types of prints. Most frequently exhibits acrylic, watercolor and craft.
Style: Exhibits all styles, all genres. Most frequently exhibits painterly abstraction, expressionism and minimalism.
Terms: Accepts work on consignment (20% commission). Retail price set by the artist. Gallery provides insurance, promotion and contract; artist pays shipping costs to and from gallery. Prefers artwork framed.
Submissions: Send query letter with résumé, slides and bio. Call or write for appointment to show portfolio of slides. Responds in 1 week. Files résumé, bio, artist statement.
Tips: "Prepare slides well, along with well written proposal. Talent counts more than quantity."

UNION STREET GALLERY, 1655 Union Ave., Chicago Heights IL 60411. (708)754-2601. Fax: (708)754-8779. Website: www.unionstreetgallery.org. **Gallery Administrator:** Karen Leluga. Nonprofit gallery. Estab. 1995. Represents more than 100 emerging and mid-career artists. Studio artists include: Renee Klyczek/Nordstrom (acrylic) and Marikay Peter Witlock (graphite/pastels). Sponsors 6 exhibits/year. Average display time 6 weeks. Open all year; Monday-Friday, 10-2 or by appointment. Gallery's studio complex houses emerging, professional artists, creating, teaching, hosting seminars, and curating exhibitions for the state-of-the art gallery. Loft spaces with polished maple floors, tall paned windows, and a 3rd floor view energizes this space for artists and viewers alike. Overall price range: $30-3,000; most work sold at $300-600.
Media: Considers all media and all types of prints.
Style: Considers all styles.
Terms: Artwork is accepted on consignment and there is a 20% commission. Retail price set by the artist. Gallery provides promotion. Accepted work should be framed.
Submissions: To receive prospectus for all juried events, call, write or fax to be added to mailing list. Artists interested in studio space or solo/group exhibitions should contact Union Street to request information packets.

VALE CRAFT GALLERY, 230 W. Superior St., Chicago IL 60610. (312)337-3525. Fax: (312)337-3530. E-mail: peter@valecraftgallery.com. Website: www.valecraftgallery.com. **Owner:** Peter Vale. Retail gallery. Estab. 1992. Represents 100 emerging, mid-career artists/year. Exhibited artists include John Neering and Kathyanne White. Sponsors 6 shows/year. Average display time 2 months. Open all year; Tuesday-Friday, 10:30-5:30; Saturday, 11-5. Located in River North gallery district near downtown; 2,100 sq. ft.; lower level of prominent gallery building; corner location with street-level windows provides great visibility. 40% of space for special exhibitions; 60% of space for gallery artists. Clientele: private collectors, tourists, people looking for gifts, interior designers and art consultants. 50% private collectors, 10% corporate collectors. Overall price range; $50-2,000; most work sold at $100-500.
Media: Considers paper, sculpture, ceramics, craft, fiber, glass, metal, wood and jewelry. Most frequently exhibits fiber wall pieces, jewelry, glass, ceramic sculpture and mixed media.
Style: Exhibits contemporary craft. Prefers decorative, sculptural, colorful, whimsical, figurative, and natural or organic.
Terms: Accepts work on consignment (50% commission). Retail price set by the artist. Gallery provides insurance, promotion, contract and shipping costs from gallery; artist pays shipping costs to gallery.
Submissions: Accepts only artists from US. Only craft media. Send query letter with résumé, 10-20 slides (including slides of details), bio or artist's statement, photographs, record of previous sales, SASE and reviews if available and price list. Call for appointment to show portfolio of originals and photographs. Responds in 2 months. Files résumé (if interested). Finds artists through submissions, art and craft fairs, publishing a call for entries, artists' slide registry and word of mouth.
Tips: "Call ahead to find out if the gallery is interested in showing the particular type of work you do; send professional slides and statement about the work or call for an appointment to show original work. Try to visit the gallery ahead of time or check out the gallery's website to find out if your work fits into the gallery's focus. I would suggest you have completed at least 20 pieces in a body of work before approaching galleries."

SONIA ZAKS GALLERY, 311 W. Superior St., Suite 207, Chicago IL 60610. (312)943-8440. Fax: (312)943-8489. **Director:** Sonia Zaks. Retail gallery. Represents 25 emerging, mid-career and established artists/year. Sponsors 10 solo shows/year. Average display time is 1 month. Overall price range: $500-15,000.
Media: Considers oil, acrylic, watercolor, drawings, sculpture.
Style: Exhibits imagism, surrealism. Genres include figurative work. Specializes in contemporary paintings, works on paper and sculpture. Interested in narrative work.
Terms: Accepts work on consignment. Retail price is set by gallery and artist. Exclusive area representation required. Gallery provides insurance and contract.
Submissions: Send query letter with 20 slides plus SASE.
Tips: "Submit 20 well-worked slides, a SASE and a cover letter."

Indiana

ARTLINK, 437 E. Berry St., Suite 202, Fort Wayne IN 46802-2801. (219)424-7195. Fax: (219)424-8453. E-mail: artlinkfw@juno.com. **Executive Director:** Betty Fishman. Nonprofit gallery. Estab. 1979. Exhibits emerging and mid-career artists. 620 members. Sponsors 18 shows/year, 2 galleries. Average display time

5-6 weeks. Open all year. Located 4 blocks from central downtown, 2 blocks from art museum and theater for performing arts; in same building as a cinema theater, dance group and historical preservation group; 1,600 sq. ft. 100% of space for special exhibitions. Clientele: "upper middle class." Overall price range: $100-500; most artwork sold at $200.

- Publishes a quarterly newsletter, *Genre*, which is distributed to members. Includes features about upcoming shows, profiles of members and other news. Some artwork shown at gallery is reproduced in b&w in newsletter. Send SASE for sample and membership information.

Media: Considers all media, including prints. Prefers work for annual print show and annual photo show, sculpture and painting.

Style: Exhibits expressionism, neo-expressionism, painterly abstraction, conceptualism, color field, post-modern works, photorealism, hard-edge geometric abstraction; all styles and genres. Prefers imagism, abstraction and realism. "Interested in a merging of craft/fine arts resulting in art as fantasy in the form of bas relief, photo/books, all experimental media in nontraditional form.".

Terms: Accepts work on consignment only for exhibitions (35% commission). Retail price set by artist. Gallery provides insurance. Shipping costs are shared. Prefers framed artwork.

Submissions: Send query letter with résumé, no more than 6 slides and SASE. Reviewed by 14-member panel. Responds in 1 month. "Jurying takes place three times per year unless it is for a specific call for entry. A telephone call will give the artist the next jurying date."

Tips: "Call ahead to ask for possibilities for the future and an exhibition schedule for the next two years will be forwarded." Common mistakes artists make in presenting work are "bad slides and sending more than requested—large packages of printed material. Printed catalogues of artist's work without slides are useless." Sees trend of community-wide cooperation by organizations to present art to the community.

N EDITIONS LIMITED GALLERY OF FINE ART, 4040 E. 82nd St., Indianapolis IN 46250-1620. (317)842-1414. **Owner:** John Mallon. Director: Marta Blades. Retail gallery. Represents emerging, mid-career and established artists. Sponsors 4 shows/year. Average display time 1 month. Open all year. Located "north side of Indianapolis; track lighting, exposed ceiling, white walls." Clientele: 60% private collectors, 40% corporate collectors. Overall price range: $100-8,500; most artwork sold at $200-1,200.

Media: Considers oil, acrylic, watercolor, pastel, pen & ink, drawings, mixed media, collage, works on paper, sculpture, ceramics, craft, fiber, glass, photography, original handpulled prints, woodcuts, engravings, mezzotints, etchings, lithographs, pochoir and serigraphs. Most frequently exhibits mixed media, acrylic and pastel.

Style: Exhibits all styles and genres. Prefers abstract, landscapes and still lifes.

Terms: Accepts work on consignment (50% commission). Retail price set by artist. "I do discuss the prices with artist before I set a retail price." Sometimes offers customer discounts and payment by installment. Gallery provides insurance; shipping costs are shared. Prefers artwork unframed.

Submissions: Send query letter with slides, SASE and bio. Portfolio review requested if interested in artist's work. Portfolio should include originals, slides, résumé and bio. Files bios, reviews, slides and photos.

Tips: Does not want to see "hobby art."

N GREATER LAFAYETTE MUSEUM OF ART, 101 S. Ninth St., Lafayette IN 47901. (317)742-1128. E-mail: glma@glmart.org. Website: glma.org. **Executive Director:** Les Reker. Museum. Estab. 1909. Temporary exhibits of American and Indiana art as well as work by emerging, mid-career and established artists from Indiana and the midwest. 1,340 members. Sponsors 5-7 shows/year. Average display time 10 weeks. Located 6 blocks from city center; 3,318 sq. ft.; 4 galleries. Clientele: includes Purdue University faculty, students and residents of Lafayette/West Lafayette and 14 county area.

Style: Exhibits all styles. Genres include landscapes, still life, portraits, abstracts, non-objective and figurative work.

Terms: Accepts some crafts for consignment in gift shop (35% mark-up).

Submissions: Send query letter with résumé, slides, artist's statement and letter of intent.

Tips: "Indiana artists specifically encouraged to apply."

✔ ⚐ HOOSIER SALON PATRONS ASSOCIATION & GALLERY, 714 E. 65th St., Indianapolis IN 46220-1610. (317)253-5340. Fax: (317)259-1817. E-mail: hoosiersalon@iquest.net. Website: www.hoosiersalon.org. Nonprofit gallery. Estab. 1925. Membership of 500 emerging, mid-career and established artists. Sponsors 7 exhibits/year (6 in gallery, 1 juried show each year at the Indiana State Museum). Average display time 1 month. Open Tuesday-Friday, 11-5; Saturday, 11-3. Closed over Christmas week.

Gallery is in the Village of Broad Ripple, Indianapolis as part of a business building. Gallery occupies about 1,800 sq. ft. Clients include local community and tourists. 20% of sales are to corporate collectors. Overall price range: $50-5,000; most work sold at $1,000.

- This gallery opened a new location in 2001 at 507 Church St., New Harmony IN 47631; (812)682-3970.

Media: Considers acrylic, ceramics, collage, drawing, fiber, mixed media, oil, paper, pastel, pen & ink, sculpture, watercolor and hand-pulled prints. Most frequently exhibits oil, watercolor and pastel.

Style: Exhibits: traditional impressionism to abstract. Considers all genres.

Terms: Artwork is accepted on consignment and there is a 33% commission. Retail price set by the artist. Gallery provides insurance and contract. Accepted work must be exhibit ready. Requires membership. Criteria for membership is 1 year's residence in Indiana. Accepts only artists from Indiana (1 year residency). Gallery only shows artists who have been in one Annual Exhibit (show of approx. 200 artists each year).

Submissions: Call or e-mail for membership and Annual Exhibition information. Responds ASAP. We do not keep artists' materials unless they are members. Finds artists through word of mouth, art exhibits and art fairs.

Tips: While not required, all mats, glass etc. need to be archival-quality. Because the Association is widely regarded as exhibiting quality art, artists are generally careful to present their work in the most professional way possible.

INDIANAPOLIS ART CENTER, 820 E. 67th St., Indianapolis IN 46220. (317)255-2464. Fax: (317)254-0486. E-mail: exhibs@indplsartcenter.org. Website: www.indplsartcenter.org. Director of Exhibitions and Artist Services: Julia Moore. Exhibitions Associates: Stephanie Robertson, Susan Watt. Nonprofit art center. Estab. 1934. Prefers emerging artists. Exhibits approximately 100 artists/year. 1,800 members. Sponsors 15-20 shows/year. Average display time 5 weeks. Open Monday-Friday, 9-10; Saturday, 9-3; Sunday, 12-3. Located in urban residential area; 2,560 sq. ft. in 3 galleries; "Progressive and challenging work is the norm!" 100% of space for special exhibitions. Clientele: mostly private. 90% private collectors, 10% corporate collectors. Overall price range: $50-15,000; most work sold at $100-5,000. Also sponsors annual Broad Ripple Art Fair in May.

Media: Considers all media and all types of original prints. Most frequently exhibits painting, sculpture installations and fine crafts.

Style: All styles. Interested in figurative work. "In general, we do not exhibit genre works. We do maintain a referral list, though." Prefers postmodern works, installation works, conceptualism.

Terms: Accepts work on consignment (35% commission). Commission is in effect for 3 months after close of exhibition. Retail price set by artist. Gallery provides insurance, promotion, contract; artist pays for shipping. Prefers artwork framed.

Submissions: "Special consideration for IN, OH, MI, IL, KY artists." Send query letter with résumé, minimum of 20 slides, SASE, reviews and artist's statement. Responds in 6 weeks. Season assembled in January.

Tips: "Research galleries thoroughly—get on their mailing lists, and visit them in person at least twice before sending materials. Find out the 'power structure' of the targeted galleries and use it to your advantage. Most artists need to gain experience exhibiting in smaller or non-profit spaces before approaching a gallery—work needs to be of consistent, dependable quality. Have slides done by a professional if possible. Stick with one style—no scattershot approaches. Have a concrete proposal with installation sketches (if it's never been built). We book two years in advance—plan accordingly. Do not call. Put me on your mailing list one year before sending application so I can be familiar with your work and record—ask to be put on my mailing list so you know the gallery's general approach. It works!"

MIDWEST MUSEUM OF AMERICAN ART, 429 S. Main St., Elkhart IN 46516. Phone/fax: (219)293-6660. **Director:** Jane Burns. Curator: Brian D. Byrn. Museum. Estab. 1978. Represents mid-career and established artists. May be interested in seeing the work of emerging artists in the future. Sponsors 10-12 shows/year. Average display time 4-6 weeks. Open all year; Tuesday-Friday, 11 to 5; Saturday and Sunday, 1-4. Located downtown; 1,000 sq. ft. temporary exhibits; 10,000 sq. ft. total; housed in a renovated neoclassical style bank building; vault gallery. 10% for special exhibitions. Clientele: general public.

Media: Considers all media and all types of prints.

Style: Exhibits all styles, all genres.

Terms: Acquired through donations. Retail price set by the artist "in those cases when art is offered for

sale." Gallery provides insurance, promotion and contract; artist pays shipping costs to and from gallery. Prefers artwork framed.

Submissions: Accepts only art of the Americas, professional artists 18 years or older. Send query letter with résumé, slides, bio, reviews and SASE. Write for appointment to show portfolio of slides. Responds in 6 months. Files résumé, bio, statement. Finds artists through visiting exhibitions, submissions, art publications.

Tips: "Keep portfolio updated. Have your work professionally framed."

SWOPE ART MUSEUM, 25 S. Seventh St., Terre Haute IN 47807-3604. (812)238-1676. Fax: (812)238-1677. E-mail: info@swope.org. Website: www.swope.org. Nonprofit museum. Estab. 1942. Approached by approximately 10 artists/year. Represents 1-3 mid-career and established artists. Average display time 4-6 weeks. Open all year; Tuesday-Friday, 10-5; Thursday, 10-8; weekends 12-5. Closed Mondays and national holidays. Located in downtown Terre Haute in a Renaissance-revival building with art deco interior.

Media: Considers all media except craft. Most frequently exhibits paintings, sculpture, and works on paper. Considers all types of prints except posters.

Style: Exhibits: impressionism, modern and representational. Exhibits permanent collection: representational, Indiana impressionists, regionalism. Genres include Americana, landscapes and Southwestern.

Terms: Accepts only local and regional paintings, sculptures and works on paper for "Wabash Currents," an exhibition that showcases local and regional artists (size and weight are limited because we do not have a freight elevator).

Submissions: Send query letter with artist's statement, brochure, résumé and SASE (if need items returned). Returns material with SASE. Responds in 5 months. Files only what fits the mission statement of the museum for special exhibitions. Finds artists through word of mouth, and annual juried exhibition at the museum.

Tips: "Send only art statement, slides, brochure, résumé. If returnable items are sent, they must have a SASE (with proper postage). Archival-quality materials guarantee a longer life span of artwork, and no viewable damage of artwork in the future they increase the future value of artwork and reduce conservation costs to museums."

Iowa

ARTS FOR LIVING CENTER, P.O. Box 5, Burlington IA 52601-0005. Located at Seventh & Washington. (319)754-8069. Fax: (319)754-4731. **Executive Director:** Lois Rigdon. Nonprofit gallery. Estab. 1974. Exhibits the work of mid-career and established artists. May consider emerging artists. 425 members. Sponsors 10 shows/year. Average display time 3 weeks. Open all year; Tuesday-Friday, 12-5; weekends, 1-4. Located in Heritage Hill Historic District, near downtown; 2,500 sq. ft.; "former sanctuary of 1868 German Methodist church with barrel ceiling, track lights." 35% of space for special exhibitions. Clientele: 80% private collectors, 20% corporate collectors. Overall price range: $25-1,000; most work sold at $75-500.

Media: Considers all media and all types of prints. Most frequently exhibits watercolor, intaglio and sculpture.

Style: Exhibits all styles.

Terms: Accepts work on consignment (25% commission). Retail price set by artist. Gallery provides insurance, promotion and contract; artist pays for shipping. Prefers artwork framed.

Submissions: Send query letter with résumé, slides, bio, brochure, photographs, SASE and reviews. Call or write for appointment to show portfolio of slides and gallery experience verification. Responds in 1 month. Files résumé and photo for reference if interested.

CORNERHOUSE GALLERY AND FRAME, 2753 First Ave. SE, Cedar Rapids IA 52402. (319)365-4348. Fax: (319)365-1707. E-mail: info@cornerhousegallery.com. Website: www.cornerhousegallery.com. **Director:** Janelle McClain. Retail gallery. Estab. 1976. Represents 150 emerging, mid-career and established midwestern artists. Exhibited artists include Fred Basker, Thomas C. Jackson, Ann Royer. Sponsors 3 shows/year. Average display time 1 month. Open all year; Monday-Friday, 9:30-5:30; Saturday, 9:30-4. 3,000 sq. ft.; "converted 1907 house with 3,000 sq. ft. matching addition devoted to framing, gold leafing and gallery." 25% of space for special exhibitions. Clientele: "residential/commercial, growing collectors." 80% private collectors. Overall price range: $200-100,000; most artwork sold at $200-2,000.

Media: Considers oil, acrylic, watercolor, pastel, drawings, mixed media, collage, works on paper, sculpture, ceramic, fiber, glass, original handpulled prints, woodcuts, wood engravings, linocuts, engravings, mezzotints, jewelry, etchings, lithographs and serigraphs. Most frequently exhibits oil, acrylic, original prints and ceramic works.

Style: Exhibits all styles. Genres include florals, landscapes, figurative work. Prefers regionalist/midwestern subject matter. Exhibits only original work—no reproductions.

Terms: Accepts work on consignment (45% commission) or artwork is bought outright for 50% of retail price (net 30 days). Retail price set by artist and gallery. Gallery provides insurance and promotion. Prefers artwork unframed.

Submissions: Prefers only Midwestern artists. Send résumé, 20 slides, photographs and SASE. Portfolio review requested if interested in artist's work. Responds in 1 month. Files résumé and photographs. Finds artists through word of mouth, submissions/self promotions and art collectors' referrals. Do not stop in unannounced.

Tips: "Send a written letter of introduction along with five representative images and retail prices. Ask for a return call and appointment. Once appointment is established, send a minimum of 20 images and résumé so it can be reviewed before appointment. Do not approach a gallery with only a handful of works to your name. I want to see a history of good quality works. I tell artists they should have completed at least 50-100 high quality works with which they are satisfied. An artist also needs to know which works to throw away!"

CSPS, 1103 Third St. SE, Cedar Rapids IA 52401-2305. (319)364-1580. Fax: (319)362-9156. E-mail: legionarts.org. Website: www.legionarts.org. **Artistic Director:** Mel Andringa. Alternative space, nonprofit gallery. Estab. 1991. Approached by 50 artists/year. Exhibits 15 emerging artists. Exhibited artists include: Bill Jordan (photographs), Paco Rosic (spray can murals). Sponsors 15 exhibits/year. Average display time 2 months. Open Wednesday-Sunday, 11-6. Closed June, July and August. Located in south end Cedar Rapids; old Czech meeting hall, 2 large galleries and off-site exhibits; track lights, carpet, ornamental tin ceilings. (65 events a year). Clients include local community. Overall price range: $50-500; most work sold at $200.

Media: Considers all media and all types of prints. Most frequently exhibits painting, mixed media and installation.

Style: Considers all styles. Most frequently exhibits postmodernism, conceptualism and surrealism.

Terms: Artwork is accepted on consignment and there is a 30% commission. Retail price set by the artist. Gallery provides insurance and promotion. Accepted work should be framed. Requires exclusive representation locally.

Submissions: Send query letter with artist's statement, bio, SASE and slides. Responds in 6 months. Files résumé, sample slide and statement. Finds artists through word of mouth, art exhibits and art trade magazines.

GUTHART GALLERY & FRAMING, 506 Clark St., Suite A, Charles City IA 50616. (641)228-5004. **Owner:** John R. Guthart. Retail gallery and art consultancy. Estab. 1992. Represents 12 emerging, mid-career and established artists. Exhibited artists include: John Guthart. Average display time is 2 months. Open all year; Monday-Saturday, 10-5, and by appointment. Located downtown—close to art center and central park. 700 sq. ft. 50% of space for special exhibitions; 50% of space for gallery artists. Clientele: tourists, upscale, local community and students. 80% private collectors, 20% corporate collectors. Overall price range: $25-10,000; most work sold at $200-800.

Media: Considers all media. Considers all types of prints. Most frequently exhibits watercolors, oils and prints.

Style: Exhibits expressionism, primitivism, painterly abstraction, surrealism, postmodernism, impressionism and realism. Exhibits all genres. Prefers florals, wildlife and architectural art.

Terms: Accepts artwork on consignment (30% commission) or buys outright for 50% of retail price (net 30 days). Retail price set by gallery. Gallery provides insurance and promotion. Shipping costs are shared. Prefers artwork framed.

Submissions: Send query letter with résumé, slides and brochure. Write for appointment to show portfolio of photographs and slides. Responds only if interested in 2 weeks. Files résumé, letter and slides. Finds artists through word of mouth, referrals, submissions and visiting art fairs and exhibitions.

KAVANAUGH ART GALLERY, 131 Fifth St., W. Des Moines IA 50265. (515)279-8682. Fax: (515)279-7609. E-mail: kagallery@aol.com. Website: www.kavanaughgallery.com. **Director:** Carole Kavanaugh.

Retail gallery. Estab. 1990. Represents 25 mid-career and established artists/year. May be interested in seeing the work of emerging artists in the future. Exhibited artists include Kati Roberts, Don Hatfield, Dana Brown, Gregory Steele, August Holland, Ming Feng and Larry Guterson. Sponsors 3-4 shows/year. Averge display time 3 months. Open all year; Monday-Saturday, 10-5. Located in Old Town shopping area; 6,000 sq. ft. 70% private collectors, 30% corporate collectors. Overall price range: $300-20,000; most work sold at $800-3,000.

Media: Considers all media and all types of prints. Most frequently exhibits oil, acrylic and pastel.

Style: Exhibits color field, impressionism, realism, florals, portraits, western, wildlife, southwestern, landscapes, Americana and figurative work. Prefers landscapes, florals and western.

Terms: Accepts work on consignment (50% commission). Retail price set by the artist. Gallery provides insurance, promotion and contract. Shipping costs are shared. Prefers artwork unframed.

Submissions: Send query letter with résumé, bio and photographs. Portfolio should include photographs. Responds in 3 weeks. Files bio and photos. Finds artists through word of mouth, referrals by other artists, visiting art fairs and exhibitions, artist's submissions.

Tips: "Get a realistic understanding of the gallery/artist relationship by visiting with directors. Be professional and persistent."

LUTHER COLLEGE GALLERIES, 700 College Dr., Decorah IA 52101. (563)387-1665. Fax: (563)387-1132. E-mail: kammdavi@Luther.edu. Website: galleries.luther.edu. **Gallery Coordinator:** David Kamm. Nonprofit college gallery. Estab. 1989. Approached by 20 artists/year. Represents 12-14 emerging, mid-career and established artists. Sponsors 14-16 exhibits/year. Average display time 4-8 weeks. Open all year; Monday-Friday, 8-5; weekend hours vary. Closed college holidays and summer. Gallery has 4 exhibition spaces; 90-150' wall space; low security, good visibility. Clients include local community, students, tourists and upscale.

Media: Considers all media.

Style: Considers all styles and genres.

Terms: Retail price set by the artist. Gallery provides insurance, promotion and contract. Accepted work should be framed or ready to exhibit.

Submissions: Send query letter with artist's statement, résumé, SASE and slides. Responds only if interested within 6 months. Files résumé and artist's statement. Finds artists through word of mouth, submissions, art exhibits, art fairs, and referrals by other artists.

Tips: "Communicate clearly, and have quality slides and professional résumé (form and content)."

MACNIDER ART MUSEUM, 303 Second St. SE, Mason City IA 50401. (641)421-3666. Website: www.macniderart.org. Nonprofit gallery. Estab. 1966. Exhibits 1-10 emerging, mid-career and established artists. Sponsors 12-20 exhibits/year. Average display time 2 months. Open all year; Tuesday and Thursday, 9-9; Wednesday, Friday and Saturday, 9-5; Sunday, 1-5. Closed Mondays. Large gallery space with track system which we hang works on monofiliment line. Smaller gallery items are hung or mounted. Clients include local community, students, tourists and upscale. Overall price range: $50-2,500; most work sold at $200.

Media: Considers all media and all types of prints.

Style: Considers all styles and genres.

Terms: Artwork is accepted on consignment and there is a 40% commission. Retail price set by the artist. Gallery provides insurance, promotion and contract. Accepted work should be framed. Does not require exclusive representation locally.

Submissions: Mail portfolio for review. Returns material with SASE. Responds only if interested within 3 months. Finds artists through word of mouth, submissions, portfolio reviews, art exhibits, art fairs and referrals by other artists.

Tips: "Exhibition opportunities include exhibition in 2 different gallery spaces, entry into competitive exhibits (1 fine craft exhibit open to Iowa artists and 1 all media open to artists within 100 miles of Mason City Iowa), features in museum shop on consignment, booth space in Festival Art Market in August."

WALNUT STREET GALLERY, 301 SW Walnut St., Ankeny IA 50021. (515)964-9434. Fax: (515)964-9438. E-mail: wsg@dwx.com. Website: www.walnutstreetgallery.com. **Owner:** Drue Wolfe. Retail gallery. Estab. 1982. Represents 50 emerging, mid-career and established artists/year. Exhibited artists include Steve Hanks, Stew Buck, Larry Zach and Terry Redlin. Sponsors 1 show/year. Average display time 6 months. Open all year; Monday-Thursday, 9-7; Friday, 9-5; Saturday, 9-3. Located downtown; 1,500 sq.

ft.; renovated building. 25% of space for special exhibitions. Clientele: local community and suburbs. Overall price range: $100-1,000; most work sold at $250-600.

Media: Considers all media and all types of prints. Most frequently exhibits watercolor, acrylic and oil.

Style: Exhibits: expressionism, impressionism and realism. Genres include florals, wildlife, landscapes and Americana. Prefers: impressionism, realism and expressionism.

Terms: Buys outright for 50% of retail price (net 30 days). Retail price set by the artist. Gallery provides promotion; gallery pays shipping. Prefers artwork unframed.

Submissions: Send query letter with brochure and photographs. Write for appointment to show portfolio of photographs. Responds only if interested within 3 weeks. Files all material. Finds artists through visiting art fairs and recommendations from customers.

Kansas

GALLERY XII, 412 E. Douglas, Suite A, Wichita KS 67202. (316)267-5915. **President:** Doug Billings. Consignment Committee: Judy Dove. Cooperative nonprofit gallery. Estab. 1977. Represents 50 mid-career and established artists/year and 20 members. Average display time 1 month. Open all year; Monday-Saturday, 10-5. Usually open with other galleries for "Final Fridays" gallery tour 7-10 p.m., final Friday of month. Located in historic Old Town which is in the downtown area; 1,300 sq. ft.; historic building. 20% of space for special exhibitions; 80% of space for gallery artists. Clientele: private collectors, corporate collectors, people looking for gifts, tourists. Overall price range: $10-2,000.

Terms: Only accepts 3-D work on consignment (35% commission). Co-op membership screened and limited. Annual exhibition fee, 15% commission and time involved. Artist pays shipping costs to and from gallery.

Submissions: Limited to local artists or those with ties to area. Work juried from slides. "We are a co-op gallery whose members rigorously screen prospective new members."

STRECKER-NELSON GALLERY, 406.5 Poyntz Ave., Manhattan KS 66502. (785)537-2099. E-mail: gallery@kansas.net. Website: www.strecker-nelsongallery.com. **President:** Jay Nelson. Retail gallery. Estab. 1979. Represents 40 emerging and mid-career artists. Exhibited artists include John Gary Brown, Louis Copt, Ann Piper. Sponsors 6 shows/year. Average display time 6 weeks. Open all year; Monday-Saturday, 10-6. Located downtown; 3,000 sq. ft.; upstairs in historic building. 50% of space for special exhibitions; 50% of space for gallery artists. Clientele: university and business. 80% private collectors, 20% corporate collectors. Overall price range: $300-2,000; most work sold at $300-1,000.

Media: Considers all media and all types of prints (no offset reproductions). Most frequently exhibits watercolor, intaglio and oil.

Style: All styles. Genres include landscapes, still life, portraits and figurative work. Prefers landscapes, figurative and architectural subjects.

Terms: Accepts work on consignment (50% commission). Retail price set by artist. Sometimes offers payment by installment. Gallery provides promotion; artist pays for shipping costs. Prefers artwork framed.

Submissions: Send query letter with résumé, slides, reviews, bio and SASE. Write for appointment to show portfolio of slides. Responds in 2 weeks.

Tips: "I look for uniqueness of vision, quality of craftsmanship and realistic pricing. Our gallery specializes in Midwest regionalists with a realistic or naturalistic approach."

TOPEKA & SHAWNEE COUNTY PUBLIC LIBRARY GALLERY/ALICE C. SABATINI GALLERY, 1515 W. Tenth, Topeka KS 66604-1374. (785)580-4516. Fax: (785)580-4496. E-mail: lpeters@tscpl.lib.ks.us. Website: www.tscpl.org. **Gallery Director:** Larry Peters. Nonprofit gallery. Estab. 1976. Exhibits emerging, mid-career and established artists. Sponsors 8-9 shows/year. Average display time 1 month. Open all year; Monday-Saturday, 9-6; Sunday, 12-9. Located 1 mile west of downtown; 2,500 sq. ft.; security, track lighting, plex top cases; recently added five moveable walls. 100% of space for special exhibitions and permanent collections. Overall price range: $150-5,000.

● Larry Peters is scheduled to retire by October 2003.

Media: Considers oil, fiber, acrylic, sculpture, glass, watercolor, mixed media, ceramic, pastel, collage, metal work, woodcuts, wood engravings, linocuts, engravings, mezzotints, etchings, lithographs. Most frequently exhibits ceramic, oil and watercolor.

Style: Exhibits neo-expressionism, painterly abstraction, postmodern works and realism. Prefers painterly abstraction, realism and neo-expressionism.

Terms: Artwork accepted or not accepted after presentation of portfolio/résumé. Retail price set by artist. Gallery provides insurance; artist pays for shipping costs. Prefers artwork framed.
Submissions: Usually accepts only artists from KS, MO, NE, IA, CO, OK. Send query letter with résumé and 12-24 slides. Call or write for appointment to show portfolio of slides. Responds in 2 months. Files résumé. Finds artists through visiting exhibitions, word of mouth and submissions.
Tips: "Find out what each gallery requires from you and what their schedule for reviewing artists' work is. Do not go in unannounced. Have good quality slides—if slides are bad they probably will not be looked at. Have a dozen or more to show continuity within a body of work. Your entire body of work should be at least 50-100 pieces. Competition gets heavier each year. Looks for originality."

EDWIN A. ULRICH MUSEUM OF ART, Wichita State University, 1845 Fairmount, Wichita KS 67260-0046. (978)689-3664. Fax: (978)689-3898. E-mail: david.butler@wichita.edu. Website: www.ulrich .wichita.edu. **Director:** Dr. David Butler. Museum. Estab. 1974. Represents mid-career and established artists. Sponsors 7 shows/year. Average display time 6-8 weeks. Open Monday-Friday, 9-5; Saturday and Sunday, 12-5; closed major holidays. Located on campus; 6,732 sq. ft.; high ceilings, neutral space. 75% of space for special exhibitions.
Media: Considers sculpture, installation, neon-light, new media.
Style: Exhibits conceptualism and new media.
Submissions: Currently not accepting submissions.

☑ **WICHITA ART MUSEUM STORE SALES GALLERY**, 1400 W. Museum Blvd., Wichita KS 67203. (316)268-4975. Fax: (316)268-4980. **Manager/Buyer:** Kevin Bishop. Nonprofit retail and consignment gallery. Estab. 1963. Exhibits 150 emerging and established artists. Average display time is 6 months. 1,228 sq. ft. Accepts only artists from expanded regional areas. Clientele: tourists, residents of city, students. 75% private collectors, 25% corporate clients. Overall price range: $25-2,500; most work sold at $25-800.
Media: Considers sculpture, ceramic, fiber, glass and original handpulled prints.
Terms: Accepts work on consignment (40% commission). Retail price set by artist. Exclusive area representation not required. Gallery provides insurance and contract.
Submissions: Send query letter with résumé. Resumes and brochures are filed.
Tips: "We are constantly looking for and exhibiting new artists. We have a few artists who have been with us for many years, but our goal is to exhibit the emerging artist."

Kentucky

⚑ **CENTRAL BANK GALLERY**, 300 W. Vine St., Lexington KY 40507. (859)253-6161. Fax: (606)253-6069. **Curator:** John Irvin. Nonprofit gallery. Estab. 1985. Interested in seeing the work of emerging artists. Represented more than 1,400 artists in the past 17 years. Exhibited artists include Helen Price Stacy and Catherine Wells. Sponsors 12 shows/year. Average display time 3 weeks. Open all year; Monday-Friday, 9-4:30. Located downtown. 100% of space for special exhibitions. Clientele: local community. 100% private collectors. Overall price range: $100-5,000; most work sold at $350-500.
● Central Bank Gallery considers Kentucky artists only.
Media: Considers all media. Most frequently exhibits oils, watercolor, sculpture.
Style: Exhibits all styles. "Please, no nudes."
Terms: Retail price set by the artist "100% of proceeds go to artist." Gallery provides insurance and promotion; artist pays for shipping.
Submissions: Call or write for appointment.
Tips: "Don't be shy, call me. We pay 100% of the costs involved once the art is delivered."

MAIN AND THIRD FLOOR GALLERIES, Northern Kentucky University, Nunn Dr., Highland Heights KY 41099. (859)572-5148. Fax: (859)572-6501. Gallery Director of Exhibitions and Collections: David Knight. University galleries. Program established 1975. Main gallery and third floor gallery. Represents emerging, mid-career and established artists. Sponsors 10 shows/year. Average display time 1 month. Open Monday-Friday, 9-9 or by appointment; closed major holidays and between Christmas and New Year's. Located in Highland Heights, KY, 8 miles from downtown Cincinnati; 3,000 sq. ft.; two galleries— one small and one large space with movable walls. 100% of space for special exhibitions. 90% private collectors, 10% corporate collectors. Overall price range; $25-50,000; most work sold at $25-2,000.

Media: Considers all media and all types of prints. Most frequently exhibits painting, printmaking and photography.

Style: Exhibits all styles, all genres.

Terms: Proposals are accepted for exhibition. Retail price set by the artist. Gallery provides insurance, promotion and contract; shipping costs are shared. Prefers artwork framed "but we are flexible." Commission rate is 20%.

Submissions: Send query letter with résumé, slides, bio, photographs, SASE and reviews. Write for appointment to show portfolio of originals, photographs and slides. Submissions are accepted in December for following academic school year. Files résumés and bios. Finds artists through agents, visiting exhibitions, word of mouth, art publications, sourcebooks and submissions.

N⃞ UNIVERSITY ART GALLERIES, Murray State University, 604 Fine Arts Bldg., Murray KY 42071-3342. (270)762-3052. Fax: (502)762-3920. **Director:** Jim Bryant. University gallery. Estab. 1971. Represents emerging, mid-career and established artists. Sponsors 8-15 shows/year. Average display time 6 weeks. Open all year; Monday-Friday, 8-5; Saturday-Sunday, 1-4; closed during university holidays. Located on campus, small town; 4,000 sq. ft.; modern multi-level dramatic space. 100% of space for special exhibitions. Clientele: "10,000 visitors per year."

Media: Considers all media and all types of prints.

Style: Exhibits all styles.

Terms: "We supply the patron's name to the artist for direct sales. We take no commission." Retail price set by the artist. Gallery provides insurance, promotion and shipping costs from gallery. Prefers artwork framed.

Submissions: Send query letter with résumé and 10-20 slides. Responds in 1 month.

Tips: "Do good work that *expresses* something."

YEISER ART CENTER INC., 200 Broadway, Paducah KY 42001-0732. (270)442-2453. E-mail: yacenter@bellsouth.net. Website: www.yeiserartcenter.com. **Contact:** Ms. Robin Taffler, executive director. Nonprofit gallery. Estab. 1957. Exhibits emerging, mid-career and established artists. 450 members. Sponsors 8-10 shows/year. Average display time 6-8 weeks. Open all year. Located downtown; 1,800 sq. ft.; "in historic building that was farmer's market." 90% of space for special exhibitions. Clientele: professionals and collectors. 90% private collectors. Overall price range: $200-8,000; most artwork sold at $200-1,000.

Media: Considers all media. Prints considered include original handpulled prints, woodcuts, wood engravings, linocuts, mezzotints, etchings, lithographs and serigraphs.

Style: Exhibits all styles and genres.

Terms: Accepts work on consignment (35% commission). Retail price set by artist. Gallery provides insurance and promotion; shipping costs are shared. Prefers artwork framed.

Submissions: Send résumé, slides, bio, SASE and reviews. Responds in 3 months.

Tips: "Do not call. Give complete information about the work: media, size, date, title, price. Have good-quality slides of work, indicate availability and include artist statement. Presentation of material is important."

N⃞ ⊞ ZEPHYR GALLERY, 610 E. Market St., Louisville KY 40202. (502)585-5646. **Directors:** Patrick Donley, Peggy Sue Howard. Cooperative gallery and art consultancy with regional expertise. Estab. 1987. Exhibits 18 emerging and mid-career artists. Exhibited artists include C. Radtke, K. Malloy, G. Smith, W. Smith, J.P. Begley, J. Kirstein, S. Howerton Leightty. Sponsors 11 shows/year. Average display time 1 month. Open all year. Located downtown; approximately 1,800 sq. ft. Clientele: 25% private collectors, 75% corporate collectors. Most work sold at $200-2,000.

Media: Considers all media. Considers only small edition handpulled print work by the artist. Most frequently exhibits painting, photography and sculpture.

Style: Exhibits individual styles.

Terms: Co-op membership fee plus donation of time (25% commission). Must live within 50-mile radius of Louisville. Prefers artwork framed. No glass.

Submissions: No functional art (jewelry, etc.). Send query letter with résumé and slides. Call for appointment to show portfolio of slides; may request original after slide viewing. Responds in 6 weeks. Files slides, résumés and reviews (if accepted). Submissions accepted on quarterly deadlines of May 20, 2003; August 19, 2003; November 2003 and February 2004 for January 15 and June 15 review.

Tips: "Submit well-organized slides with slide list. Include professional résumé with notable exhibitions."

Louisiana

■ **BATON ROUGE GALLERY, INC.**, 1442 City Park Ave., Baton Rouge LA 70808-1037. (225)383-1470. Fax: (225)336-0943. **Director:** Charles Hunt. Cooperative gallery. Estab. 1966. Exhibits the work of 50 professional artists. 300 members. Sponsors 12 shows/year. Average display time 1 month. Open all year. Located in the City Park Pavilion. Overall price range: $100-10,000; most work sold at $200-600.
 • The gallery hosts a spoken word series featuring literary readings of all genres. We also present special performances including dance, theater and music.
Media: Considers all media. Most frequently exhibits painting, sculpture and glass.
Style: Exhibits all styles and genres.
Terms: Co-op membership fee plus donation of time. Gallery takes 40% commission. Retail price set by artist. Artist pays for shipping. Artwork must be framed.
Submissions: Membership and guest exhibitions are selected by screening committee. Send query letter for application. Call for appointment to show portfolio of slides.
Tips: "The screening committee screens applicants in March and October each year. Call for application to be submitted with portfolio and résumé."

BRUNNER GALLERY, 215 N. Columbia, Covington LA 70433. (985)893-0444. Fax: (985)893-0070. E-mail: BrunnerGal@aol.com. Website: www.brunnergallery.com. **Director:** Robin Hamaker. For-profit gallery. Estab. 1997. Approached by 400 artists/year. Exhibits 45 emerging, mid-career and established artists. Sponsors 10-12 exhibits/year. Average display time 1 month. Open all year; Tuesday-Saturday, 10-5; weekends, 10-5. Closed major holidays. Located 45 minutes from metropolitan New Orleans, one hour from capital of Baton Rouge and Gulf Coast; 2,500 sq. ft. Building designed by Rick Brunner, artist and sculptor and Susan Brunner, designer. Clients include local community, tourists, upscale and professionals. 20% of sales are to corporate collectors. Overall price range: $200-10,000; most work sold at $1,500-3,000.
Media: Considers all media, etchings and monoprints.
Style: Considers all styles and genres. Most frequently exhibits abstraction, expressionism and conceptualism.
Terms: Artwork is accepted on consignment and there is a 50% commission or bought outright for 90-100% of retail price; net 30 days. Retail price set by the gallery and the artist. Gallery provides insurance, promotion and contract. Accepted work should be framed. Requires exclusive representation locally.
Submissions: Photographs and slides. Mail portfolio for review. Send query letter with artist's statement, bio, brochure, business card, photocopies, photographs, résumé, reviews, SASE and slides. Returns material with SASE. Responds in 4 months as committee meets. Keeps on file possible future work. Finds artists through word of mouth, submissions, portfolio reviews, art exhibits, art fairs and referrals by other artists.

CONTEMPORARY ARTS CENTER, 900 Camp, New Orleans LA 70130. (504)528-3805. Fax: (504)528-3828. Website: cacno.org. **Curator of Visual Arts:** David S. Rubin. Alternative space, nonprofit gallery. Estab. 1976. Exhibits emerging, mid-career and established artists. Open all year; Tuesday-Sunday, 11-5; weekends 11-5. Closed Mardi Gras, Christmas and New Year's Day. Located in Central Business District of New Orleans; renovated/converted warehouse. Clients include local community, students, tourists and upscale.
Media: Considers all media and all types of prints. Most frequently exhibits painting, sculpture, installation and photography.
Style: Considers all styles. Exhibits anything contemporary.
Terms: Artwork is accepted on loan for curated exhibitions. Retail price set by the artist. CAC provides insurance and promotion. Accepted work should be framed. Does not require exclusive representation locally. The CAC is not a sales venue, but will refer inquiries. CAC receives 20% on items sold as a result of an exhibition.
Submissions: Send query letter with bio, SASE and slides. Responds in 4 months. Files letter and bio—slides when appropriate. Finds artists through word of mouth, submissions, art exhibits, art fairs, referrals by other artists, professional contacts and periodicals.
Tips: "Use only one slide sheet with proper labels (title, date, medium and dimensions)."

HANSON GALLERY, 229 Royal, New Orleans LA 70130-2226. (504)524-8211. Fax: (504)524-8420. E-mail: info@hansongallery-nola.com. Website: www.hansongallery-nola.com. **Director:** Angela King. For profit gallery. Estab. 1977. Represents 22 emerging, mid-career and established artists. Exhibited artists include: Frederick Hart (sculptor) and Leroy Neiman (all mediums). Sponsors 6 exhibits/year. Average display time ongoing to 3 weeks. Open all year; Monday-Saturday, 10-6; Sunday, 11-5. Closed 3 days for Mardi Gras. Clients include local community, tourists and upscale. Overall price range: $650-100,000; most work sold at $4,000.
Media: Considers acrylic, drawing, oil, pastel, sculpture and watercolor. Most frequently exhibits oil, pastel and acrylic. Considers etchings, lithographs and serigraphs.
Style: Exhibits impressionism, neo-expressionism and surrealism. Considers all styles. Genres include figurative work and landscapes.
Terms: Retail price set by the gallery and the artist. Gallery provides insurance. Requires exclusive representation locally.
Submissions: Write to arrange a personal interview to show portfolio of photographs and slides. Mail portfolio for review. Send query letter with artist's statement, bio, brochure, photographs, résumé, reviews, SASE and slides. Responds in 6 weeks. Finds artists through word of mouth, submissions, art exhibits and art fairs.
Tips: "Archival-quality materials play a major role in selling fine art to collectors."

LE MIEUX GALLERIES, 332 Julia St., New Orleans LA 70130. (504)522-5988. Fax: (504)522-5682. E-mail: mail@lemieuxgalleries.com. Website: www.lemieuxgalleries.com. **Contact:** Christy Wood, Denise Berthiaume. Retail gallery and art consultancy. Estab. 1983. Represents 30 mid-career artists. Exhibited artists include Shirley Rabe Masinter and Alan Gerson. Sponsors 10 shows/year. Average display time 6 months. Open all year. Located in the warehouse district/downtown; 1,400 sq. ft. 20-75% of space for special exhibitions. Clientele: 75% private collectors; 25% corporate clients.
Media: Considers all media; engravings, etchings, linocuts, lithographs, mezzotints, serigraphs, woodcuts. Most frequently exhibits oil, watercolor and drawing.
Style: Exhibits impressionism, neo-expressionism, realism and hard-edge geometric abstraction. Genres include landscapes, florals, wildlife and figurative work. Prefers landscapes, florals and figural/narrative.
Terms: Accepts work on consignment (50% commission). Retail price set by artist. Exclusive area representation required. Gallery provides promotion and contract; artist pays for shipping.
Submissions: Accepts only artists from the Southeast. Send query letter with SASE, bio, brochure, résumé, slides and photographs. Write for appointment to show portfolio of originals. Responds in 3 weeks. All material is returned if not accepted or under consideration.
Tips: "Send information before calling. Give me the time and space I need to view your work and make a decision; you cannot sell me on liking or accepting it; that I decide on my own."

MASUR MUSEUM OF ART, 1400 S. Grand St., Monroe LA 71202. (318)329-2237. Fax: (318)329-2847. E-mail: masur@ci.monroe.la.us. **Director:** Sue Prudhomme. Museum. Estab. 1963. Approached by 500 artists/year. Exhibits 150 emerging, mid-career and established artists. Exhibited artists include: Lin Emery, kinetic aluminum sculpture. Sponsors 8 exhibits/year. Average display time 2 months. Open Tuesday-Thursday, 9-5; Friday-Saturday, 2-5. Closed between exhibitions. Located in historic home. Approximately 400 running feet, 3,000 sq. ft. Clients include local community. 50% of sales are to corporate collectors. Overall price range: $100-12,000; most work sold at $300.
Media: Considers all media and all types of prints. Most frequently exhibits mixed media, acrylic and drawing.
Style: Considers all styles and genres. Most frequently exhibits conceptualism, painterly abstraction, expressionism.
Terms: Artwork is accepted on consignment and there is a 20% commission. Retail price set by the artist. Gallery provides insurance and promotion. Accepted work should be framed. Does not require exclusive representation locally.
Submissions: Send query letter with artist's statement, bio, résumé, reviews, SASE and slides. Returns material with SASE. Responds in 6 months. Finds artists through word of mouth, submissions, art exhibits and referrals by other artists.

N STONE AND PRESS GALLERIES, 238 Chartres St., New Orleans LA 70130. (504)561-8555. Fax: (504)561-5814. **Owner:** Earl Retif. Retail gallery. Estab. 1988. Represents/exhibits 20 mid-career and established artists/year. Interested in seeing the work of emerging artists. Exhibited artists include

Carol Wax and Benton Spruance. Sponsors 9 shows/year. Average display time 1 month. Open all year; Monday-Saturday, 10:30-5:30. Located in historic French Quarter; 1,200 sq. ft.; in historic buildings. 50% of space for special exhibitions; 50% of space for gallery artists. Clientele: collectors nationwide also tourists. 90% private collectors, 10% corporate collectors. Overall price range: $50-10,000; most work sold at $400-900.

Media: Considers all drawing, pastel and all types of prints. Most frequently exhibits mezzotint, etchings and lithograph.

Style: Exhibits realism. Genres include Americana, portraits and figurative work. Prefers American scene of '30s and '40s and contemporary mezzotint.

Terms: Artwork is accepted on consignment (50% commission). Retail price set by the gallery and the artist. Gallery provides insurance, promotion and contract; shipping costs are shared. Prefers artwork unframed.

Submissions: Send query letter with résumé, slides and SASE. Write for appointment to show portfolio of photographs. Responds in 3 weeks.

Tips: Finds artists through word of mouth and referrals of other artists.

TURNER ART CENTER GALLERY, 2911 Centenary Blvd., Shreveport LA 71104. Fax: (318)869-5184. Website: www.centenary.edu/departme/art. **Contact:** Dr. Lisa Nicoletti, gallery director. Nonprofit gallery. Estab. 1990. Approached by 10 artists/year. Exhibits emerging and mid-career artists. Exhibited artists include: Daniel Piersol. Sponsors 5 exhibits/year. Average display time 1 month. Open all year; Monday-Frirday, 10-4. Closed May-August, holiday breaks. Located on a private college campus in an urban area of about 300,000. The gallery is small, but reputable. Clients include local community and students. Overall price range: $50-1,500; most work sold at $200.

Media: Considers all media and all types of prints. Most frequently exhibits photography, installations, drawings and acrylic.

Style: Considers all styles and genres. Most frequently exhibits postmodernism and expressionism.

Terms: Artwork is accepted on consignment and there is a 25% commission. Retail price set by the artist. Gallery provides promotion. Accepted work should be framed. Does not require exclusive representation locally.

Submissions: Mail portfolio for review. Send query letter with slides. Returns material with SASE. Finds artists through word of mouth and submissions.

Maine

N DUCKTRAP BAY TRADING COMPANY, 37 Bayview St., Camden ME 04843. (207)236-9568. Fax: (207)236-6203. E-mail: info@ducktrapbay.com. Website: www.ducktrapbay.com. **Owners:** Tim and Joyce Lawrence. Retail gallery. Estab. 1983. Represents 200 emerging, mid-career and established artists/year. Exhibited artists include: Sandy Scott, Doug Hunt, Yvonne Davis, Beki Killorin, Jim O'Reilly and Gary Eigenberger. Open all year; Monday-Saturday, 9-5, Sunday, 11-4. Located downtown waterfront; 2 floors 3,000 sq. ft. 100% of space for gallery artists. Clientele: tourists, upscale. 70% private collectors, 30% corporate collectors. Overall price range: $250-18,000; most work sold at $250-2,500.

Media: Considers watercolors, oil, acrylic, pastel, pen & ink, drawing, paper, sculpture, bronze and carvings. Types of prints include lithographs. Most frequently exhibits woodcarvings, watercolor, acrylic and bronze.

Style: Exhibits: realism. Genres include nautical, wildlife and landscapes. Prefers: marine and wildlife.

Terms: Accepts work on consignment (40% commission) or buys outright for 50% of the retail price (net 30 days). Retail price set by the artist. Gallery provides insurance and minimal promotion; artist pays for shipping. Prefers artwork framed.

Submissions: Send query letter with 10-20 slides or photographs. Call or write for appointment to show portfolio of photographs. Files all material. Finds artists through word of mouth, referrals by other artists and submissions.

Tips: "Find the right gallery and location for your subject matter. Have at least eight to ten pieces or carvings or three to four bronzes."

N GOLD/SMITH GALLERY, 41 Commercial St., BoothBay Harbor ME 04538. (207)633-6252. Director: Karen Swartsberg. Retail gallery. Estab. 1974. Represents 30 emerging, mid-career and established artists. Exhibited artists include John Vander and John Wissemann. Sponsors 6 shows/year. Average display

time 6 weeks. Open May-December; Monday-Saturday, 10-6; Sunday, 12-5. Located downtown across from the harbor. 1,500 sq. ft.; traditional 19th century house converted to contemporary gallery. 75% of space for special exhibitions; 25% of space for gallery artists. Clientele: residents and visitors. 90% private collectors, 10% corporate collectors. Overall price range: $350-5,000; most work sold at $350-1,500.

- One of 2 Gold/Smith Galleries. The other is in Sugar Loaf; the 2 are not affiliated with each other. Artists creating traditional and representational work should try another gallery. The work shown here is strong, self-assured and abstract.

Media: Considers oil, acrylic, watercolor, pastel, pen & ink, drawing, mixed media, collage, paper, sculpture, photography, woodcuts, engravings, lithographs, wood engravings, mezzotints, serigraphs, linocuts and etchings. Most frequently exhibits acrylic and watercolor.

Style: Exhibits expressionism, painterly abstraction "emphasis on nontraditional work." Prefers expressionist and abstract landscape.

Terms: Commission negotiated. Retail price set by the artist. Gallery provides insurance and promotion; artist pays shipping costs to and from gallery. Prefers artwork framed.

Submissions: No restrictions—emphasis on artists from Maine. Send query letter with slides, bio, photographs, SASE, reviews and retail price. Write for appointment to show portfolio of originals. Responds in 2 weeks. Artist should write the gallery.

Tips: "Present a consistent body of mature work. We need 12 to 20 works of moderate size. The sureness of the hand and the maturity interest of the vision are most important."

N GREENHUT GALLERIES, 146 Middle St., Portland ME 04101. (207)772-2693. E-mail: greenhut@ maine.com. Website: www.greenhutgalleries.com. **Contact:** Peggy Greenhut Golden. Retail gallery. Estab. 1990. Represents/exhibits 20 emerging and mid-career artists/year. Sponsors 12 shows/year. Exhibited artists include: Connie Hayes (oil/canvas), Sarah Knock (oil/canvas). Average display time 3 weeks. Open all year; Monday-Friday, 10-5:30; Saturday, 10-5. Located in downtown-Old Port; 3,000 sq. ft. with neon accents in interior space. 60% of space for special exhibitions. Clientele: tourists and upscale. 55% private collectors, 10% corporate collectors. Overall price range: $500-12,000; most work sold at $600-3,000.

Media: Considers acrylic, paper, pastel, sculpture, drawing, oil, watercolor. Most frequently exhibits oil, watercolor, pastel.

Style: Considers all styles; etchings, lithographs, mezzotints. Genres include figurative work, landscapes, still life, seascape. Prefers landscape, seascape and abstract.

Terms: Artwork is accepted on consignment (50% commission). Retail price set by the gallery and artist. Gallery provides insurance and promotion. Artists pays for shipping costs. Prefers artwork framed (museum quality framing).

Submissions: Accepts only artists from Maine or New England area with Maine connection. Send query letter with slides, reviews, bios and SASE. Call for appointment to show portfolio of slides. Responds in 1 month. Finds artists through word of mouth, referrals by other artists, visiting art shows and exhibitions, and submissions.

Tips: "Visit the gallery and see if you feel your work fits in."

JAMESON GALLERY & FRAME AND THE JAMESON ESTATE COLLECTION, (formerly Jameson Gallery & Frame), 305 Commercial St., Portland ME 04101. (207)772-5522. Fax: (207)774-7648. E-mail: info@jamesongallery.com. **Gallery Director:** Michael Rancourt. Retail gallery, custom framing, restoration, appraisals, consultation. Estab. 1992. Represents 20 emerging, mid-career and established artists/year. Exhibited artists include Tillman Crane, Vincent Vallarino, Alicia Czechowski and Nathaniel Larrabee. Sponsors 6 shows/year. Average display time 3-4 weeks. Open all year; Monday-Saturday, 10-6; Holiday season Monday-Sunday, 10-6. Located on the waterfront in the heart of the shopping district; 4,000 sq. ft. 50% of space for contemporary artists; 25% of space for frame shop; 25% of space for The Jameson Estate Collectin dealing later 19th and early 20th century drawings and photographs. Clientele: local community, tourists, upscale. 80% private collectors, 20% corporate collectors. Overall price range: $500 minimum; most work sold at $1,500-30,000.

Media: Considers all media including woodcuts, engravings, wood engravings, mezzotints, linocuts and lithographs and serigraphs only if gallery carries original work. Most frequently exhibits oil, watercolor and fine woodworking.

Style: Exhibits: impressionism, photorealism, American realism and b&w photography. Genres include florals, landscapes and still life.

Terms: Depends on each contract. Retail price set by the gallery. Gallery provides insurance, promotion

and contract; artist pays for shipping costs. Prefers artwork unframed, but will judge on a case by case basis. Artist may buy framing contract with gallery.

Submissions: Send query letter with résumé, slides, bio, photographs, statement about why they want to show at the gallery and SASE. Gallery will contact for appointment to show portfolio of photographs and sample work.

☑ **THE LIBRARY ART STUDIO**, 1467 Rt. 32 at Munro Brook, Round Pond ME 04564. (207)529-4210. **Contact:** Sally DeLorme Pedrick, owner/director. Art consultancy and gallery. Estab. 1989. Exhibits established artists. Number of exhibits varies each year. Average display time 6 weeks. Open year round by appointment or chance. Located in a small coastal village (Round Pond) on the Pemaquid Peninsula, midcoast Maine. Clients include local community, tourists and upscale. Overall price range: $50-7,500; most work sold at $350.

Media: Considers all media. Most frequently exhibits oil, woodcuts, and mixed media with glass.

Style: Considers all styles. Most frequently exhibits painterly abstraction, expressionism, conceptualism. "Most art is associated with literature, thus *The Library Art Studio*."

Terms: Artwork is accepted on consignment and there is a 30% commission. Retail price set by the artist. Gallery provides promotion. Accepted work should be framed. Does not require exclusive representation locally.

Submissions: Send query letter with SASE and slides. Returns material with SASE. Responds in 1 month.

N **MATHIAS FINE ART**, 10 Mathias Dr., Trevett ME 04571. (207)633-7404. **President:** Cordula Mathias. For profit gallery. Estab. 1992. Approached by 20-30 artists/year. Represents 15-20 emerging, mid-career and established artists. Exhibited artists include: Brenda Bettinson and Mike Culver. Sponsors 6 exhibits/year. Average display time 2 months. Open all year; Wednesday-Sunday, 12-5; and by appointment. Mid-November through mid-May: by appointment only. Located in Mid-Coast area of Maine; 400 sq. ft. combination of natural and artificial lighting. Clients include local community, tourists and upscale. Percentage of sales to corporate collectors varies. Overall price range: $50-25,000; most work sold at $1,200.

Media: Considers acrylic, collage, drawing, original prints, mixed media, oil, paper and pen & ink. Most frequently exhibits painting, drawing and photography. Considers all types of prints except posters.

Style: Considers all styles and genres.

Terms: Artwork is accepted on consignment and there is a 50% commission. Retail price set by the gallery and the artist. Gallery provides promotion and contract. Accepted work should be framed and matted. Requires exclusive representation locally. Prefers paintings or works on paper. Prefers artists who can deliver and pick up.

Submissions: Send query letter with bio, photographs, résumé, reviews, SASE and slides. Returns material with SASE. Responds in 6 weeks. Files CV, artist's statement, visuals if of interest within 6-18 months. Finds artists through word of mouth, submissions, portfolio reviews, art exhibits, and referrals by other artists.

Tips: "Clearly labeled slides or photographs, well organized vita, informative artist's statement. Archival-quality materials are 100% essential in selling fine art to collectors."

N **STEIN GALLERY CONTEMPORARY GLASS**, 195 Middle St., Portland ME 04101. (207)772-9072. E-mail: astein@steinglass.com. Website: www.steinglass.com. Contact: Anne Stein. Retail gallery. Represents 100 emerging, mid-career and established artists. Open all year. Located in "old port" area. 100% of space for gallery artists.

Media: Considers glass and jewelry.

Terms: Retail price set by the artist. Gallery provides insurance and promotion.

Submissions: Send query letter with résumé and slides.

Maryland

ARTEMIS, INC., 4715 Crescent St., Bethesda MD 20816. (301)229-2058. Fax: (301)229-2186. E-mail: sjtropper@aol.com. **Owner:** Sandra Tropper. Retail and wholesale dealership and art consultancy. Represents more than 100 emerging and mid-career artists. Does not sponsor specific shows. Clientele: 40% private collectors, 60% corporate clients. Overall price range: $100-10,000; most artwork sold at $1,000-3,000.

Media: Considers oil, acrylic, watercolor, mixed media, collage, works on paper, sculpture, ceramic, craft, fiber, glass, installations, woodcuts, engravings, mezzotints, etchings, lithographs, pochoir, serigraphs and offset reproductions. Most frequently exhibits prints, contemporary canvases and paper/collage.

Style: Exhibits impressionism, expressionism, realism, minimalism, color field, painterly abstraction, conceptualism and imagism. Genres include landscapes, florals and figurative work. "My goal is to bring together clients (buyers) with artwork they appreciate and can afford. For this reason I am interested in working with many, many artists." Interested in seeing works with a "finished" quality.

Terms: Accepts work on consignment (50% commission). Retail price set by dealer and artist. Exclusive area representation not required. Gallery provides insurance and contract; shipping costs are shared. Prefers unframed artwork.

Submissions: Send query letter with résumé, slides, photographs and SASE. Write to schedule an appointment to show a portfolio, which should include originals, slides, transparencies and photographs. Indicate net and retail prices. Responds only if interested within 1 month. Files slides, photos, résumés and promo material. All material is returned if not accepted or under consideration.

Tips: "Many artists have overestimated the value of their work. Look at your competition's prices."

CREATIVE PARTNERS GALLERY, 4600 E. West Hwy., Suite 120, Bethesda MD 20814. (301)951-9441. Fax: (301)951-9441. Website: www.creativepartnersart.com. **Contact:** Dick Lasner. Cooperative gallery. Estab. 1994. Approached by 8 artists/year. Represents 25 mid-career artists. Exhibited artists include: Ella Tulin and Ann Leonard. Average display time 1 month. Open Tuesday-Friday, 12-6; Saturday, 11-5. Closed month of August, Sundays and Mondays. Located downtown Bethesda MD; suburban center 20 minutes from downtown Washington DC; beautiful open space with large windows 2,000 sq. ft. Clients include local community and tourists. Overall price range: $5-20,000; most work sold at $200.

Media: Considers all media. Most frequently exhibits painting, sculpture and photography. Considers all types of prints.

Style: Considers all styles.

Terms: There is a co-op membership fee plus a donation of time. Retail price set by artist. Gallery provides promotion and contract. Accepted work should be framed and matted. Does not require exclusive representation locally. Accepts only artists from 50 miles of Washington DC.

Submissions: Call or write to arrange a personal interview to show portfolio of photographs, slides and original work. Returns material with SASE. Reviews portfolios January, April and September. Finds artists through word of mouth, submissions, portfolio reviews, and referrals by other artists.

THE FRASER GALLERY, 7700 Wisconsin Ave., Suite E, Bethesda MD 20814. (301)718-9651. Fax: (301)718-9652. E-mail: frasergallery@hotmail.com. Website: www.thefrasergallery.com. **Contact:** Catriona Fraser, director. For-profit gallery. Estab. 1996. Approached by 400 artists/year; represents 25 emerging, mid-career and established artists/year and sells the work of another 100 artists. Exhibited artists include Joyce Tenneson (figurative photography) and David FeBland (oil painting). Average display time 1 month. Open all year; Tuesday-Saturday, 12-6. Located in the center of Bethesda in courtyard next to Discovery Channel HQ. 1,680 square feet. Clients include local community, internet browsers, tourists and upscale. Overall price range: $200 -25,000; most work sold at under $5,000.

● The Fraser Gallery is charter associate dealer for Sothebys.com and member of Art Dealers Association of Greater Washington and Bethesda Chamber of Commerce. See their listing in the Washington D.C. section for their submission requirements.

THE GLASS GALLERY, ongoing display at 4720 Hampden Lane, Bethesda MD 20814. (301)657-3478. **Owner:** Sally Hansen. Retail gallery. Estab. 1981. Sponsors 5 shows/year. Open all year; Monday-Saturday 11-5. Clientele: collectors.

Media: Considers sculpture in glass and monoprints (only if they are by glass sculptors who are represented by The Glass Gallery). Also interested in sculpture in glass incorporated with additional materials (bronze, steel etc.). "Focus is on creativity as well as on ability to handle the material well. The individuality of the artist must be evident."

Terms: Accepts work on consignment. Retail price set by artist. Sometimes offers customer discounts and payment by installment. Gallery provides insurance (while work is in gallery), promotion, contract and shipping costs from gallery.

Submissions: Send query letter with résumé, slides, photographs, reviews, bio and SASE. Portfolio review requested if interested in artist's work.

Tips: Finds artists through visits to exhibitions and professional glass conferences, plus artists' submissions

and keeping up-to-date with promotion of other galleries (show announcements and advertising). "Send good slides with SASE and clear, concise cover letter and/or description of process. Familiarize yourself with the work of gallery displays to evaluate whether the quality of your work meets the standard."

N: MARIN-PRICE GALLERIES, 7022 Wisconsin Ave., Chevy Chase MD 20815. (301)718-0622. **President:** F.J. Marin-Price. Retail/wholesale gallery. Estab. 1992. Represents/exhibits 25 established painters and 4 sculptors/year. Exhibited artists include Joseph Sheppard. Sponsors 24 shows/year. Average display time 3 weeks. Open Monday-Sunday, 11-8. 1,500 sq. ft. 50% of space for special exhibitions. Clientele: upscale. 90% private collectors, 10% corporate collectors. Overall price range: $3,000-25,000; most work sold at 6,000-12,000.
Media: Considers oil, drawing, watercolor and pastel. Most frequently exhibits oil, watercolor and pastels.
Style: Exhibits expressionism, photorealism, neo-expressionism, primitivism, realism and impressionism. Genres include landscapes, florals, Americana and figurative work.
Terms: Retail price set by the gallery and the artist. Gallery provides insurance, promotion and contract. Artist pays for shipping costs. Prefers artwork framed.
Submissions: Prefers only oils. Send query letter with résumé, slides, bio and SASE. Responds in 6 weeks.
Tips: Finds artists through research, from clients visiting studios. "We do well with established artists and totally unknown artists, better than mid-career. If you are just starting out, keep your prices as low as you can tolerate them."

✓ MARLBORO GALLERY, Prince George's Community College, 301 Largo Rd., Largo MD 20774-2199. (301)322-0965. Fax: (301)808-0418. E-mail: tberault@pgcc.edu. Website: academic.pg.cc.md.us/. **Contact:** Thomas A. Berault, curator-director. Nonprofit gallery. Estab. 1976. Interested in emerging, mid-career and established artists. Sponsors 4 solo and 4 group shows/year. Average display time 1 month. Seasons for exhibition: September-May. 2,100 sq. ft. with 10 ft. ceilings and 25 ft. clear story over 50% of space—track lighting (incandescent) and daylight. Clientele: 100% private collectors. Overall price range: $200-10,000; most work sold at $500-700.
Media: Considers all media. Most frequently exhibits acrylics, oils, photographs, watercolors and sculpture.
Style: Exhibits expressionism, neo-expressionism, realism, photorealism, minimalism, primitivism, painterly abstraction, conceptualism and imagism. Exhibits all genres. "We are open to all serious artists and all media. We will consider all proposals without prejudice."
Terms: Accepts artwork on consignment. Retail price set by artist. Exclusive area representation not required. Gallery provides insurance. Artist pays for shipping. Prefers artwork ready for display.
Submissions: Send query letter with résumé, slides, SASE, photographs, artist's statement and bio. Portfolio review requested if interested in artist's work. Portfolio should include slides and photographs. Responds every 6 months. Files résumé, bio and slides. Finds artists through word of mouth, visiting exhibitions and submissions.
Tips: Impressed by originality. "Indicate if you prefer solo shows or will accept inclusion in group show chosen by gallery."

ROMBRO'S ART GALLERY, 1805 St. Paul St., Baltimore MD 21202. (301)962-0451. Retail gallery, rental gallery. Estab. 1984. Represents 3 emerging, mid-career and established artists/year. May be interested in seeing the work of emerging artists in the future. Exhibited artists include Dwight Whitley and Judy Wolpert. Sponsors 4 shows/year. Average display time 3 months. Open all year; Tuesday-Saturday, 9-5; closed August. Located in downtown Baltimore; 3,500 sq. ft. Clientele: upscale, local community. Overall price range: $350-15,000.
Media: Considers oil, acrylic, watercolor, pastel, pen & ink, drawing, mixed media, collage, paper, sculpture and ceramics. Considers all types of prints. Most frequently exhibits oil, pen & ink, lithographs.
Style: Exhibits expressionism, painterly abstraction, color field, postmodern works, hard-edge geometric abstraction. Genres include florals and figurative work. Prefers florals and figurative.
Terms: Accepts work on consignment (50% commission) or buys outright for 35% of the retail price; net 45 days. Rental fee for space ($650). Retail price set by the gallery and the artist. Gallery provides promotion and contract; artist pays for shipping costs to gallery. Prefers artwork framed.
Submissions: Send query letter with résumé, brochure, slides and artist's statement. Write for appointment to show portfolio of slides. Files slides. Finds artists through visiting exhibitions.

✓ STEVEN SCOTT GALLERY, 9169 Reisterstown Rd., Owings Mill MD 21117. (410)752-6218. Website: www.stevenscottgallery.com. **Director:** Steven Scott. Retail gallery. Estab. 1988. Represents 20

mid-career and established artists/year. May be interested in seeing the work of emerging artists in the future. Exhibited artists include Hollis Sigler, Gary Bukovnik. Sponsors 6 shows/year. Average display time 2 months. Open all year; Tuesday-Saturday, 12-6. Located in the suburbs of NW Baltimore; 1,000 sq. ft.; white walls, grey carpet—minimal decor. 80% of space for special exhibitions; 20% of space for gallery artists. 80% private collectors, 20% corporate collectors. Overall price range: $300-15,000; most work sold at $1,000-7,500.

Media: Considers oil, acrylic, watercolor, pastel, pen & ink, drawing, mixed media, collage, paper and photography. Considers all types of prints. Most frequently exhibits oil, prints and drawings.

Style: Exhibits expressionism, neo-expressionism, surrealism, postmodern works, photorealism, realism and imagism. Genres include florals, landscapes and figurative work. Prefers florals, landscapes and figurative.

Terms: Retail price set by the gallery and the artist. Gallery provides insurance, promotion and contract; shipping costs are shared. Prefers artwork unframed.

Submissions: Accepts only artists from US. Send query letter with résumé, brochure, slides, photographs, reviews, bio and SASE. Call for appointment to show portfolio of photographs and slides. Responds in 2 weeks.

Tips: "Don't send slides which are unlike the work we show in the gallery, i.e. abstract or minimal."

VILLA JULIE COLLEGE GALLERY, 1525 Green Spring Valley Rd., Stevenson MD 21153. (410)602-7163. Fax: (410)486-3552. E-mail: dea-dian@mail.vjc.edu. Website: www.vjc.edu. **Contact:** Diane DiSalvo. College/university gallery. Estab. 1997. Approached by many artists/year. Represents numerous emerging, mid-career and established artists. Sponsors 8 exhibits/year. Average display time 6 weeks. Open all year; Monday-Tuesday and Thursday-Friday, 11-5; Wednesday, 11-8; Saturday, 1-4. Located in the Greenspring Valley 5 miles north of downtown Baltimore; beautiful space in renovated academic center. "We do not take commission; if someone is interested in an artwork we send them directly to the artist."

Media: Considers all media and all types of prints except posters. Most frequently exhibits painting, sculpture and photography.

Style: Considers all styles and genres.

Terms: Artwork is accepted on consignment and there is no commission. Retail price set by the artist. Gallery provides insurance. Does not require exclusive representation locally. Accepts only artists from mid-Atlantic, emphasis on Baltimore artists.

Submissions: Write to arrange a personal interview to show portfolio of slides. Send query letter with artist's statement, bio, résumé, reviews, SASE and slides. Returns material with SASE. Responds in 3 months. Files bio, statement, reviews, letter but will return slides. Finds artists through word of mouth, submissions, portfolio reviews, art exhibits, and referrals by other artists.

Tips: "Be clear and concise, and have good slides."

WASHINGTON COUNTY MUSEUM OF FINE ARTS, 91 Key St., P.O. Box 423, Hagerstown MD 21741. (301)739-5727. Fax: (301)745-3741. E-mail: WCMFA@myactv.net. Website: www.washcomuseum. **Curator:** Sandra Strong. Museum. Estab. 1929. Approached by 30 established artists/year. Open all year; Tuesday-Saturday, 10-5; Sunday, 1-5. Closed holidays. Located in western Maryland; facility includes 12 galleries. Overall price range: $300-1,500; most work sold at $800-900.

Media: Considers all media except installation and craft. Most frequently exhibits oil, watercolor and ceramics. Considers all types of prints except posters.

Style: Exhibits: impressionism. Genres include florals, landscapes, portraits and wildlife.

Terms: Sales from exhibits only—30% commission. Retail price set by the artist. Gallery provides insurance. Accepted work should be framed. Does not require exclusive representation locally.

Submissions: Write to arrange a personal interview to show portfolio of photographs and slides. Mail portfolio for review. Returns material with SASE. Responds in 1 month. Finds artists through word of mouth, portfolio reviews, art exhibits, and referrals by other artists.

Massachusetts

ART@NET INTERNATIONAL GALLERY, (617)495-7451 (+ +359 98448132). Fax: (617)495-7049 (+ +359)251-2838. E-mail: Artnetg@Yahoo.com. Website: www.designbg.com. **Director:** Yavor Shopov. For profit gallery, Internet gallery. Estab. 1998. Approached by 150 artists/year. Represents 20 emerging, mid-career and established artists. Exhibited artists include: Nicolas Roerich (paintings)

and Yavor Shopov-Bulgari (photography). Sponsors 15 exhibits/year. Average display time permanent. Open all year; Monday-Sunday, 24 hours. "Internet galleries like ours have a number of unbelievable advantages over physical galleries and work far more efficiently, so they are expanding extremely rapidly and taking over many markets held by conventional galleries for many years. Our gallery exists only in Internet giving us a number of advantages both for our clients and artists. Our expenses are reduced to the absolute minimum, so we charge our artists lowest commission in the branch (only 10%) and offer to our clients lowest prices for the same quality of work. Unlike physical galleries we have over 100 million potential internet clients world-wide and are able to sell in over 150 countries without need to support offices or representatives everywhere. We mount cohesive shows of our artists, which are unlimited in size and may be permanent. Each artist has individual "exhibition space" divided to separate thematic exhibitions along with bio and statement. We are just hosted in the Internet space, otherwise our organization is the same as of a traditional gallery." Clients include collectors and business offices spread world-wide. 30% corporate collectors. Overall price range: $150-50,000.

Media: Considers ceramics, craft, drawing, oil, pastel, pen & ink, sculpture and watercolor. Most frequently exhibits photos, oil and drawing. Considers all types of prints.

Style: Considers expressionism, geometric abstraction, impressionism and surrealism. Most frequently exhibits impressionism, expressionism and surrealism. Considers Americana, figurative work, florals, landscapes and wildlife.

Terms: Artwork is accepted on consignment and there is a 10% commission and a rental fee for space of $1/image per month or $5/images per year (first 6 images are displayed free of rental fee). Retail price set by the gallery or the artist. Gallery provides promotion. Accepted work should be matted. Does not require exclusive representation locally. Every exhibited image will contain your name and copyright as watermark and cannot be printed or illegally used, sold or distributed anywhere.

Submissions: E-mail portfolio for review. E-mail attached scans 900×1200 px (300dpi for prints or 900 dpi for 36mm slides) as JPEG files for IBM computers. "We accept only computer scans, no slides please." E-mail artist's statement, bio, résumé, and scans of the work. Cannot return material. Responds in 6 weeks. Finds artists through submissions, portfolio reviews, art exhibits, art fairs, and referrals by other artists.

Tips: "E-mail us or send a disk or CD with a tightly edited selection of less than 20 scans of your best work. All work must be very appealing and interesting, and must force any person to look over it again and again. Main usage of all works exhibited in our gallery is for limited edition (photos) or original (paintings) wall decoration of offices and homes. Photos must have the quality of paintings. We like to see strong artistic sense of mood, composition, light and color and strong graphic impact or expression of emotions. We exhibit only artistically perfect work in which value will last for decade. We would like to see any quality work facing these requirements on any media, subject or style. No distractive subjects. For us only quality of work is important, so new artists are welcome. Before you send us your work, ask yourself, "who and why will someone buy this work? Is is appropriate and good enough for this purpose?" During the exhibition all photos must be available in signed limited edition museum quality 8×10 or larger matted prints."

BROMFIELD ART GALLERY, 11 Thayer St., Boston MA 02118. (617)451-3605. E-mail: bromfieldartg allery@earthlink.net. Website: www.bromfieldartgallery.com. **Contact:** Laurie Alpert, director of exhibitions. Cooperative gallery. Estab. 1974. Represents 18 emerging and mid-career artists. Exhibited artists include Florence Yoshiko Montgomery, Adam Sherman, George Hancin and Tim Nichols. Sponsors 25 shows/year. Average display time 1 month. Open all year; Wednesday-Saturday 12-5. Located in South End. 50% of space for special exhibitions; 50% of space for gallery artists. Clientele: 70% private collectors, 30% corporate collectors. Overall price range: $300-6,000; most work sold at $300-2,000.

Media: Considers all media and original handpulled prints. Most frequently exhibits paintings, prints, sculpture.

Style: Exhibits all styles and genres.

Terms: Co-op membership fee plus donation of time (gallery charges 40% commission for members, 50% for visiting artists). Retail price set by artist. Offers customer discounts and payment by installments. Gallery provides promotion and contract; artist pays for shipping costs.

Submissions: Send query letter with résumé, slides and SASE. Write for appointment to show portfolio of originals. Responds in 1 month. Files all info on members and visiting artists. Finds artists through word of mouth, various art publications and sourcebooks, submissions/self-promotions and referrals.

N Y **CAPE MUSEUM OF FINE ARTS**, Box 2034, 60 Hope Lane, Dennis MA 02638. (508)385-4477. E-mail: cmfa@capecod.net. Website: www.cmfa.org. **Executive Director:** Donald E. Knaub. Mu-

seum. Estab. 1981, opened to public in 1985. Represents emerging and established artists associated with Cape Cod. Located "on the grounds of the historic Cape Playhouse."

Media: No offset reproductions or posters. Most frequently exhibits original oil, sculpture, watercolor prints.

Style: Exhibits all styles and all genres. "The CMFA provides a year-round schedule of art-related activities and programs for the Cape community: exhibitions, Reel Art Cinema, lectures, bus trips and specially planned events for all ages. The permanent collection of over 1,000 works focuses on art created by Cape artists from 1899 to the present."

Submissions: Send query letter with résumé and slides. Write for appointment to show portfolio, which should include originals. The most common mistakes artists make in presenting their work are "dropping off work unannounced and not including bio, reference materials or phone number." All material is returned if not accepted or under consideration with SASE.

Tips: "We encourage Cape Cod artists to leave with the Museum their résumé and slides so that we can file it in our archives." Wants to see works by "innovators, creators . . . leaders. Museum-quality works. Artist should be organized. Present samples that best represent your abilities and accomplishments."

N CHASE GALLERY, 129 Newbury St., Boston MA 02116-0292. (617)859-7222. Website: www.chase gallery.com. **Director:** Julie Lohnes. Retail gallery. Estab. 1990. Represents 20 mid-career and established artists/year. Exhibited artists include Enrique Santana, Cynthia Packard. Sponsors 11 shows/year. Average display time 1 month. Open all year; Monday-Saturday, 10-6. 1,400 sq. ft. 80% of space for special exhibitions; 20% of space for gallery artists. 95% private collectors, 5% corporate collectors. Overall price range: $500-25,000; most work sold at $2,000-10,000.

Media: Considers oil, acrylic and sculpture. Most frequently exhibits oil paintings, alkyd, acrylic.

Style: Exhibits narrative/representational. Genres include landscapes and figurative work.

Terms: Accepts work on consignment (50% commission). Retail price set by the artist. Gallery provides insurance and promotion; artist pays shipping costs. Prefers artwork framed.

Submissions: Prefers only oil, acrylic, alkyd. Send query letter with résumé, brochure, slides, reviews and SASE. Responds in 1 month. Files cards; "SASE should be provided for return of materials." Finds artists through referrals, submissions.

Tips: "Don't send one or two images—20 slides of recent work should be submitted."

DEPOT SQUARE GALLERY, 1837 Massachusetts Ave., Lexington MA 02420. (781)863-1597. E-mail: depotsquaregallery@aol.com. Website: www.depotsquaregallery.com. **Treasurer:** Natalie Warshawer. Cooperative gallery. Estab. 1981. Represents emerging, mid-career and established artists. 25 members. Exhibited artists include Gracia Dayton, Natalie Warshawer, Carolyn Latanision, Dora Hsiung and Joan Carcia. Sponsors 10 shows/year. Average display time 1 month. Open all year; Tuesday-Saturday, 10-5:30; open Sunday, 12-4, (September-June only). Located downtown; 2,000 sq. ft.; 2 floors—street level and downstairs. 100% of space for gallery artists. 10% private collectors, 10% corporate collectors. Overall price range: $100-3,000; most work sold at $100-500.

Media: Considers oil, acrylic, watercolor, pastel, pen & ink, drawing, mixed media, collage, paper, sculpture, ceramics, fiber, glass, woodcuts, engravings, wood engravings, mezzotints, serigraphs, linocuts and etchings. Most frequently exhibits watercolor, oil and prints.

Style: Exhibits all styles, all genres. Prefers realism, impressionism (depends on makeup of current membership).

Terms: Co-op membership fee plus donation of time (40% commission). Retail price set by the artist. Prefers artwork framed. Do have print bins for works on paper.

Submissions: Accepts only local artists who must attend meetings, help hang shows and work in the gallery. Send query letter with résumé, slides, bio, SASE and reviews. Call for information. Responds in 6 weeks. Files bio and one slide—"if we want to consider artist for future membership." Finds artists through advertising for new members and referrals.

Tips: "The work needs to show a current direction with potential, and it must be professionally presented."

GALLERY NAGA, 67 Newbury St., Boston MA 02116. (617)267-9060. E-mail: mail@gallerynaga.c om. Website: www.gallerynaga.com. **Director:** Arthur Dion. Retail gallery. Estab. 1977. Represents 30 emerging, mid-career and established artists. Exhibited artists include Robert Ferrandini and George Nick. Sponsors 9 shows/year. Average display time 1 month. Open Tuesday-Saturday 10-5:30. Closed August. Located on "the primary street for Boston galleries; 1,500 sq. ft.; housed in an historic neo-gothic church."

Clientele: 90% private collectors, 10% corporate collectors. Overall price range: $500-40,000; most work sold at $2,000-10,000.

Media: Considers oil, acrylic, mixed media, sculpture, photography, studio furniture and monotypes. Most frequently exhibits painting and furniture.

Style: Exhibits expressionism, painterly abstraction, postmodern works and realism. Genres include landscapes, portraits and figurative work. Prefers expressionism, painterly abstraction and realism.

Terms: Accepts work on consignment (50% commission). Retail price set by gallery and artist. Gallery provides insurance and promotion; artist pays for shipping. Prefers artwork framed.

Submissions: "Not seeking submissions of new work at this time."

Tips: "We focus on Boston and New England artists. We exhibit the most significant studio furnituremakers in the country. Become familiar with any gallery to see if your work is appropriate before you make contact."

KAJI ASO STUDIO/GALLERY NATURE AND TEMPTATION, 40 St. Stephen St., Boston MA 02115. (617)247-1719. Fax: (617)247-7564. E-mail: kajiasostudio@rcn.com. **Administrator:** Kate Finnegan. Nonprofit gallery. Estab. 1975. Represents 40-50 emerging, mid-career and established artists. 35-45 members. Exhibited artists include Kaji Aso and Katie Sloss. Sponsors 10 shows/year. Average display time 3 weeks. Open all year by appointment. Located in city's cultural area (near Symphony Hall and Museum of Fine Arts); "intimate and friendly." 30% of space for special exhibitions; 70% of space for gallery artists. Clientele: urban professionals and fellow artists. 80% private collectors, 20% corporate collectors. Overall price range: $150-8,000; most work sold at $150-1,000.

Media: Considers oil, acrylic, watercolor, pastel, pen & ink, drawing, ceramics and etchings. Most frequently exhibits watercolor, oil or acrylic and ceramics.

Style: Exhibits painterly abstraction, impressionism and realism.

Terms: Co-op membership fee plus donation of time (35% commission). Retail price set by the artist. Gallery provides promotion; artist pays shipping costs to and from gallery. Prefers artwork framed.

Submissions: Send query letter with résumé, slides, bio, photographs and SASE. Write for appointment to show portfolio of originals, photographs, slides or transparencies. Does not reply; artist should contact. Files résumé. Finds artists through advertisements in art publications, word of mouth, submissions.

KINGSTON GALLERY, 37 Thayer St., Boston MA 02118. (617)423-4113. Website: www.kingstongallery.com. **Director:** Janet Hansen Kawada. Cooperative gallery. Estab. 1982. Exhibits the work of 19 emerging, mid-career and established artists. Sponsors 11 shows/year. Average display time 1 month. Closed August. Located "in downtown Boston (South End); 1,300 sq. ft.; large, open room with 12 ft. ceiling and smaller center gallery—can accomodate large installation." Overall price range: $100-7,000; most work sold at $600-1,000.

Media: Considers all media. 20% of space for special exhibitions.

Style: Exhibits all styles.

Terms: Co-op membership requires dues plus donation of time. 25% commission charged on sales by members. Retail price set by the artist. Sometimes offers payment by installments. Gallery provides insurance, some promotion and contract. Rental of center gallery by arrangement.

Submissions: Accepts only artists from New England for membership. Artist must fulfill monthly co-op responsibilities. Send query letter with résumé, slides, SASE and "any pertinent information. Slides are reviewed every other month. Gallery will contact artist within 1 month." Does not file material but may ask artist to re-apply in future.

Tips: "Please include thorough, specific information on slides: size, price, etc."

MEAD ART MUSEUM, Amherst College, Amherst MA 01002. (413)542-2335. Fax: (413)542-2117. E-mail: mead@amherst.edu. Website: www.amherst.edu/mead. **Advertising Manager:** Donna M. Abelli. Museum. Exhibits established artists. Sponsors 4 exhibits/year. Average display time 1 month. Open all year; Tuesday-Sunday, 10-4:30. Visitors include local community, students and tourists. Note: Though Mead exhibits, they do not sell art.

Media: Considers all media and all types of prints.

Style: Considers all styles and genres.

Submissions: Mail portfolio for review. Send query letter with bio, résumé, reviews, SASE and slides. Returns material with SASE. Responds only if interested within 1 month. Files résumé and slides.

Tips: "Keep it organized and concise. Slides and reviews are paramount."

R. MICHELSON GALLERIES, 132 Main St., Northampton MA 01060. (413)586-3964. Also 25 S. Pleasant St., Amherst MA 01002. (413)253-2500. E-mail: rm@rmichelson.com. Website: www.rmichelson. com. **Owner:** R. Michelson. Retail gallery. Estab. 1976. Represents 30 emerging, mid-career and established artists/year. Exhibited artists include Barry Moser and Leonard Baskin. Sponsors 6 shows/year. Average display time 1 month. Open all year; Monday-Saturday, 10-6; Sunday, 12-5. Located downtown; Northampton gallery has 3,500 sq. ft.; Amherst gallery has 1,800 sq. ft. 50% of space for special exhibitions. Clientele: 80% private collectors, 20% corporate collectors. Overall price range: $100-75,000; most artwork sold at $1,000-25,000.
Media: Considers all media and all types of prints. Most frequently exhibits oil, egg tempera, watercolor and lithography.
Style: Exhibits impressionism, realism and photorealism. Genres include florals, portraits, wildlife, landscapes, Americana and figurative work.
Terms: Accepts work on consignment (commission varies). Retail price set by gallery and artist. Customer discounts and payment by installment are available. Gallery provides promotion; shipping costs are shared.
Submissions: Prefers Pioneer Valley artists. Send query letter with résumé, slides, bio, brochure and SASE. Write for appointment to show portfolio. Responds in 3 weeks. Files slides.

NIELSEN GALLERY, 179 Newbury St., Boston MA 02116. (617)266-4835. Fax: (617)266-0480. **Owner/Director:** Nina Nielsen. Retail gallery. Estab. 1963. Represents 25 emerging, mid-career and established artists/year. Exhibited artists include Joan Snyder and John Walker. Sponsors 8 shows/year. Average display time 3-5 weeks. Closed in August. Located downtown; 2,500 sq. ft.; brownstone with 2 floors. 100% of space for gallery artists. 80% private collectors, 20% corporate collectors. Overall price range: $1,000-100,000; most work sold at $5,000-20,000.
Media: Considers contemporary painting, sculptures, prints, drawings and mixed media.
Style: Exhibits all styles.
Terms: Retail price set by the gallery and the artist. Gallery provides insurance and promotion.
Submissions: Send query letter with slides. Responds in 2 months. Finds artists through word of mouth, referrals by other artists, visiting art fairs and exhibitions, submissions.

PEPPER GALLERY, 38 Newbury St., Boston MA 02116. (617)236-4497. Fax: (617)236-4497. **Director:** Audrey Pepper. Retail gallery. Estab. 1993. Represents 20 emerging, mid-career and established artists/ year. Exhibited artists include Marja Llanko, Daphne Confar, Judith Belzer, Andrew Nixon, Katy Schneider, Pamela Ellis Hawkes. Sponsors 9 shows/year. Average display time 6 weeks. Open all year; Tuesday-Saturday, 10-5. Located downtown, Back Bay; 700 sq. ft. 80% of space for special exhibitions. Clientele: private collectors, museums, corporate. 70% private collectors, 15% corporate collectors, 15% museum collectors. Overall price range: $600-25,000; most work sold at $1,000-7,000.
Media: Considers oil, watercolor, pastel, drawing, mixed media, glass, woodcuts, engravings, lithographs, mezzotints, etchings and photographs. Most frequently exhibits oil on canvas, lithos/etchings and photographs.
Style: Exhibits contemporary representational paintings, prints, drawings and photographs.
Terms: Accepts work on consignment (50% commission). Retail price set by the gallery and the artist. Gallery provides insurance and contract.
Submissions: Send query letter with résumé, slides, bio, SASE and reviews. Call for appointment to show portfolio of originals, photographs, slides and transparencies. Responds in 2 months. Finds artists through exhibitions, word of mouth, open studios and submissions.

N PIERCE GALLERIES, INC., 721 Main St., Rt. 228, Hingham MA 02043. (781)749-6023. Fax: (781)749-6685. Website: www.piercegalleries.com. **President:** Patricia Jobe Pierce. Director: Marco Apollo. Retail and wholesale gallery, art historians, appraisers and consultancy. Estab. 1968. Represents 12 established artists. May consider emerging artists in the future. Exhibited artists include John Kidroy, Pino Deangelico, Joseph McGurt, Bernard Corey, Stephen Gjerston, Joseph Fontaine, Geetesh and Kahlil Gibran. Sponsors 6 shows/year. Average display time 1 month. Open all year. Hours by appointment only. Located "in historic district on major road; 3,800 sq. ft.; historic building with high ceilings and an elegant ambiance." 100% of space for special exhibits. Overall price range: $1,500-400,000; most work sold at $1,500-100,000.
 ● This gallery has another location at 5 S. Water St., Nantucket MA; (508)228-1789 (summers only).
Media: Considers oil, acrylic, watercolor, pastel, pen & ink, drawings and sculpture. Does not consider prints. Most frequently exhibits oil, acrylic and watercolor.

Style: Exhibits expressionism, neo-expressionism, surrealism, impressionism, realism, photorealism and social realism. All genres and subjects, including landscapes, florals, Americana, western, wildlife and figurative work. Prefers impressionism, expressionism and super realism.

Terms: Often buys artwork outright for 50% of retail price; sometimes accepts on consignment (20-33% commission). Retail price set by artist, generally. Sometimes offers customer discounts and payment by installment. Gallery provides insurance and promotion; contract and shipping costs may be negotiated.

Submissions: Send query letter with résumé, slide sheets of 10 slides and SASE. Gallery will contact if interested for portfolio review. Portfolio should include photos or slides of originals. Responds in 48 hours. Files material of future interest.

Tips: Finds artists through referrals, portfolios/slides "sent to me or I see the work in a show or magazine. I want to see consistent, top quality work and techniques—not a little of this, a little of that. Please supply three prices per work: price to dealer buying outright, price to dealer for consigned work and a retail price. The biggest mistake artists make is that they sell their own work (secretly under the table) and then expect dealers to promote them! If a client can buy art directly from an artist, dealers don't want to handle the work. Artists should have a body of work before approaching galleries. Expand your breadth and show a new vital dimension."

THE NORMAN ROCKWELL MUSEUM, P.O. Box 308, Stockbridge MA 01262. (413)298-4100. Fax: (413)298-4145. E-mail: spunkett@NRM.org. Website: www.nrm.org. **Associate Director for Exhibitions and Programs:** Stephanie Plunkett. Museum. Estab. 1969. Exhibits 2-10 emerging, mid-career and established artists. Exhibited artists include: Maxfield Parrish, Fred Marcellino, and many contemporary illustrators. Sponsors 4 exhibits/year. Average display time 3 months. Open all year; Monday-Sunday, 10-5. Closed Thanksgiving, Christmas and New Years. Located in Stockbridge on 36-acre site bordering the Housatonic River. 11,000 sq. ft. of exhibition and classroom space. Clients include local community, students, tourists, upscale and international.

Media: Considers all media. Most frequently exhibits oil, drawing media and acrylic.

Style: Considers illustration art in all styles and genres.

Terms: Gallery provides insurance, promotion and contract. Requires exclusive representation locally.

Submissions: Send query letter with artist's statement, proposal and visuals. Responds in 3 months. Files proposals, bios and visuals. Finds artists through word of mouth, portfolio reviews, referrals by other artists, publications and research.

N̄ ST. GEORGE GALLERY, 245 Newbury St., Boston MA 02116. E-mail: arts@stgeorgegallery.com. Website: www.stgeorgegallery.com. **Contact:** William St. George. For-profit gallery. Estab. 1999. Approached by 100 artists/year; exhibits 3 emerging and established artists/year. Sponsors 8 exhibits/year. Average display time 45 days. Open all year; Tuesday-Saturday, 11-6; Sunday, 12-6. Located on Newbury St.; 1,800-2,000 square feet. Clients include local community, tourists and upscale. 10% of sales are to corporate collectors. Overall price range: $2,000-15,000; most work sold at $3,500-5,000.

Media: Considers acrylic, collage, drawing, mixed media, oil, pastel, watercolor. Most frequently exhibits oil, acrylics and pastel. Considers giclee prints.

Style: Exhibits expressionism, impressionism and painterly abstraction. Most frequently exhibits expressionism, fauvism and impressionism. Genres include figurative work, florals, horses, landscapes, portraits and swimmers.

Terms: Artwork is accepted on consignment and there is a 50% commission. Retail price of the art set by the artists. Gallery provides promotion and contract. Accepted work should be framed. Does not require exclusive representation locally.

Submissions: Write to arrange personal interview to show portfolio of photographs or send query letter with artist's statement, bio, brochure, business card, photographs, resume, reviews and SASE. Returns material with SASE. Responds to queries in 3 weeks. Files bio and 2-3 photographs. Finds artist's through referrals by other artists and submissions.

Tips: To make your submissions professional use a "covering letter, folder containing your business card in flap slot. Keep your bio, resume and photos with sizes medium and price on one side. Have a separate price list or indicate in letter specs on back of photos. Place publicity stuff on the right (possibly, it's up to you). Use a white or black glossy folder (Staples stores have them.)"

J. TODD GALLERIES, 572 Washington St., Wellesley MA 02482. (781)237-3434. E-mail: jtodd@jtodd. com. Website: www.jtodd.com. **Owner:** Jay Todd. Retail gallery. Estab. 1980. Represents 55 emerging, mid-career and established artists. Sponsors 6 shows/year. Average display time 1 month. Open all year;

Tuesday-Saturday, 10-5:30; Sunday, 1-5 October through April. Closed Sunday, May through September. Located "in Boston's wealthiest suburb"; 4,000 sq. ft.; vast inventory, professionally displayed. 30% of space for special exhibitions; 70% of space for gallery artists. Clientele: residential and corporate. 70% private collectors, 30% corporate collectors. Overall price range: $500-35,000; most work sold at $1,000-10,000.

Media: Considers oil, acrylic, watercolor, pen & ink, drawing, mixed media, woodcuts, engravings, lithographs, wood engravings, mezzotints, serigraphs, linocuts and etchings. Most frequently exhibits oils, woodcuts and etchings

Style: Exhibits primitivism, postmodern works, impressionism and realism. Genres include landscapes, florals, figurative work and still life. Prefers landscapes, figures and still life.

Terms: Accepts work on consignment (negotiable commission). Retail price set by the artist. Gallery provides promotion. Prefers artwork unframed.

Submissions: No abstract work. Send query letter with résumé, slides, bio, photographs and price list. Call or write for appointment to show portfolio of photographs or slides. Responds in 6 weeks. Enclose SASE for return of slides/photos. Files "all that is interesting to us." Finds artists through agents, visiting exhibitions, word of mouth, art publications and sourcebooks and submissions.

Tips: "Give us a minimum of six works that are new and considered to be your BEST. Maximum size: 30″ × 40″."

⟦N⟧ WORCESTER CENTER FOR CRAFTS GALLERIES, 25 Sagamore Rd., Worcester MA 01605. (508)753-8183. Fax: (508)797-5626. E-mail: wcc@worcestercraftcenter.org. Website: www.worcestercraft center.org. **Executive Director:** M. Attwood. Nonprofit rental gallery. Dedicated to promoting artisans and American crafts. Estab. 1856. Has several exhibits throughout the year, including 1 juried, catalogue show and 2 juried craft fairs in May and November. Exhibits student, faculty, visiting artists, regional, national and international artists. Open all year; Monday-Saturday, 10-5. Located at edge of downtown; 2,205 sq. ft. (main gallery); track lighting, security. Overall price range: $20-400; most work sold at $65-100.

Media: Considers all media except paintings and drawings. Most frequently exhibits wood, metal, fiber, ceramics, glass and photography.

Style: Exhibits all styles.

Terms: Artwork is accepted on consignment (40% commission). Retail price set by the artist. Gallery provides insurance, promotion and contract. Shipping costs are shared.

Submissions: Call for appointment to show portfolio of photographs and slides. Responds in 1 month.

Michigan

⟦N⟧ THE ANN ARBOR CENTER/GALLERY SHOP, 117 W. Liberty, Ann Arbor MI 48104. (734)994-8004. Fax: (734)994-3610. E-mail: info@annarborartcenter.org. Website: www.annarborartcenter.org. **Gallery Shop Director:** Millie Rae Webster. Gallery Shop Assistant Directors: Ana Evora, Cindy Marr. Estab. 1978. Represents over 350 artists, primarily Michigan and regional. Gallery Shop purchases support the Art Center's community outreach programs.

• The Ann Arbor Art Center also has exhibition opportunities for Michigan artists in its Exhibition Gallery and Art Consulting Program.

Media: Considers original work in virtually all 2- and 3-dimensional media, including jewelry, prints and etchings, ceramics, glass, fiber, wood, photography and painting.

Style: "The gallery specializes in well-crafted and accessible artwork. Many different styles are represented, including innovative contemporary."

Terms: Accepts work on consignment. Retail price set by artist. Offers member discounts and payment by installments. Exclusive area representation not required. Gallery provides contract; artist pays for shipping.

Submissions: "The Art Center seeks out artists through the exhibition visitation, wholesale and retail craft shows, networking with graduate and undergraduate schools, word-of-mouth, in addition to artist referral and submissions."

⟦N⟧ ART CENTER OF BATTLE CREEK, 265 E. Emmett St., Battle Creek MI 49017. (269)962-9511. **Contact:** Dean Adkins, executive director. Estab. 1948. Represents 150 emerging, mid-career and established artists. 90% private collectors, 10% corporate clients. Exhibition program offered in galleries, usually 3-4 solo shows each year, two artists' competitions, and a number of theme shows. Also offers Michigan Artworks Shop featuring work for sale or rent. Average display time 1-2 months. "Three galleries,

converted from church—handsome high-vaulted ceiling, arches lead into galleries on either side. Welcoming, open atmosphere." Overall price range: $20-1,000; most work sold at $20-300.

Media: Considers oil, acrylic, watercolor, pastel, pen & ink, drawings, mixed media, collage, works on paper, sculpture, ceramic, craft, fiber, glass, photography and original handpulled prints.

Style: Exhibits painterly abstraction, minimalism, impressionism, photorealism, expressionism, neo-expressionism and realism. Genres include landscapes, florals, Americana, portraits and figurative work. Prefers Michigan artists.

Terms: Accepts work on consignment (40% commission). Retail price set by artist. Exclusive area representation not required. Gallery provides insurance, promotion and contract; artist pays for shipping.

Submissions: Michigan artists receive preference. Send query letter, résumé, brochure, slides and SASE. Slides returned; all other material is filed.

Tips: "Contact Art Center before mailing materials. We are working on several theme shows with groupings of artists."

ARTQUOTE INTERNATIONAL, LLC, 6364 Ramwyck Court, West Bloomfield MI 48322. (248)851-6091. Fax: (248)851-6090. E-mail: artquote@BigFoot.com. **Contact:** M. Burnstein. Art consultancy, for-profit, wholesale gallery, corporate art and identity programs. Estab. 1985. Exhibits established artists. Exhibited artists include: Warhol, serigraph; and Bill Mack, sculpture. Clients include local community. 99% of sales are to corporate collectors. Does not sell art at retail prices.

Submissions: Depends on corporate client. Finds artists through word of mouth, art exhibits and art fairs.

ARTS EXTENDED GALLERY, INC., 2966 Woodward Ave., The Art Bldg., Detroit MI 48201. (313)831-0321. Fax: (313)831-0415. **Director:** Dr. C.C. Taylor. Retail, nonprofit gallery, educational 501C3 space art consultancy and appraisals. Estab. 1959. Represents/exhibits many emerging, mid-career and established artists. Exhibited artists include: Michael Kelly Williams, Samuel Hodge, Gil Ashby and Charles McGee. Sponsors 6 shows/year. Average display time 8-10 weeks. Open all year; Wednesday-Saturday, 12-5. Located near Wayne State University; 1,000 sq. ft. Clients include tourists, upscale, local community. 80% of sales are to private collectors, 20% corporate collectors. Overall price range: $150-4,000 up; most work sold at $200-500 (for paintings—craft items are considerably less).

• Gallery also sponsors art classes and exhibits outstanding work produced there.

Media: Considers all media, woodcuts, engravings, linocuts, etchings and monoprints. Most frequently exhibits painting, fibers, photographs and antique African art.

Style: "The work which comes out of the community we serve is varied but rooted in realism, ethnic symbols and traditional designs/patterns with some exceptions."

Terms: Artwork is accepted on consignment, and there is a 45% commission, or artwork is bought outright for 55% of the retail price. Retail price set by the gallery and the artist. Gallery provides insurance, promotion and contract; shipping costs are shared. Prefers artwork framed or ready to install.

Submissions: Send query letter with résumé, slides, photographs and reviews. Call for appointment to show a portfolio of photographs, slides and bio. Responds in 3 weeks. Files biographical materials sent with announcements, catalogs, résumés, visual materials to add to knowledge of local artists, letters, etc.

Tips: "Our work of recruiting local artists is known, and consequently artists beginning to exhibit or seeking to expand are sent to us. Many are sent by relatives and friends who believe that ours would be a logical place to inquire. Study sound technique—there is no easy way or scheme to be successful. Work up to a standard of good craftsmanship and honest vision. Come prepared to show a group of artifacts. Have clearly in mind a willingness to part with work and understand that market moves fairly slowly."

BELIAN ART CENTER, 5980 Rochester Rd., Troy MI 48085. (248)828-1001. Fax: (248)828-1905. E-mail: belianartcenter@aol.com. **Directors:** Garabed or Zabel Belian. Retail gallery and art consultancy. Estab. 1985. Represents 20 emerging, mid-career and established artists/year. Exhibited artists include Reuben Nakian and Edward Avesdisian. Sponsors 3-4 shows/year. Average display time 1 month. Open all year; Monday-Saturday, 12-6. Located in a suburb of Detroit; 2,000 sq. ft.; has outdoor area for pool side receptions; different levels of exhibits. 50% of space for special exhibitions; 50% of space for gallery artists. Clientele: 50-60% local, 30% Metropolitan area 10-20% national. 70-80% private collectors, 10-20% corporate collectors. Overall price range: $1,000-20,000.

Media: Considers oil, acrylic, watercolor, pastel, pen & ink, drawing, mixed media, collage, paper, sculpture, ceramics, installation, photography, woodcuts, engravings, lithographs, wood engravings, mezzotints and serigraphs. Most frequently exhibits oils, sculptures (bronze) and engraving.

Style: Exhibits expressionism, neo-expressionism, primitivism, painterly abstraction, surrealism, conceptu-

alism, minimalism, color field, postmodern works, impressionism, photorealism, hard-edge geometric abstraction, realism and imagism. Includes all genres. Prefers abstraction, realism, mixed.

Terms: Accepts work on consignment (commission varies) or buys outright for varying retail price. Retail price set by the gallery and the artist. Gallery provides insurance and promotion; shipping costs are shared. prefers artwork framed.

Submissions: Send query letter with résumé, 6-12 slides, bio, brochure, photographs and reviews. Call or write for appointment to show portfolio of photographs, slides and transparencies. Responds only if interested within 3 weeks. Finds artists through catalogs, sourcebooks, exhibitions and magazines.

Tips: "Produce good art at an affordable price. Have a complete biography and representative examples of your characteristic style. Have enough art pieces for a viable exhibition, which will also show your artistic merit and ability."

CENTRAL MICHIGAN UNIVERSITY ART GALLERY, Wightman 132, Art Department, Mt. Pleasant MI 48859. (989)774-3800. Fax: (989)774-2278. E-mail: julia.morrisroe@cmich.edu. Website: www.ccf a.cmich.edu/uag/. **Director:** Julia Morrisroe. Nonprofit gallery. Estab. 1970. Approached by 250 artists/year. Represents 40 emerging, mid-career and established artists. Exhibited artists include: Lou Cabeen and Carol Kumata. Sponsors 7 exhibits/year. Average display time 1 month. Open all year; Monday, Tuesday, Thursday and Friday, 10-5; Wednesday, 12-8; Saturday, 12-5. Clients include local community, students and tourists. Overall price range: $200-5,000.

Media: Considers all media and all types of prints. Most frequently exhibits sculpture, painting and photography.

Style: Considers all styles.

Terms: Buyers are referred to the artist. Gallery provides insurance, promotion and contract. Accepted work should be framed. Does not require exclusive representation locally.

Submissions: Write to arrange a personal interview to show portfolio of slides. Mail portfolio for review. Send query letter with artist's statement, bio, résumé, reviews, SASE and slides. Returns material with SASE. Responds only if interested within 2 months. Files résumé, reviews, photocopies and brochure. Finds artists through word of mouth, submissions, portfolio reviews, art exhibits, and referrals by other artists.

■ **DETROIT ARTISTS MARKET**, 4719 Woodward Ave., Detroit MI 48201. (313)832-8540. Fax: (313)832-8543. E-mail: contactus@detroitartistsmarket.org. **Executive Director:** Aaron Timlin. Gallery Manager: Mary Mordi. Nonprofit gallery. Estab. 1932. Exhibits the work of emerging, mid-career and established artists/year; 1,000 members. Sponsors 6-8 shows/year. Average display time 6 weeks. Open Wednesday-Sunday, 11-6. Located in downtown Detroit; 2,600 sq. ft. 85% of space for special exhibitions. Clientele: "extremely diverse client base—varies from individuals to the Detroit Institute of Arts." 95% private collectors; 5% corporate collectors. Overall price range: $200-15,000; most work sold at $100-500.

Media: Considers all media. No posters. Most frequently exhibits multimedia.

Style: All contemporary styles and genres.

Terms: Accepts artwork on consignment (33% commission). Retail price set by the artist. Gallery provides insurance; artist pays for partial shipping.

Tips: "Detroit Artists Market educates the Detroit metropolitan community about the work of emerging and established Detroit and Michigan artists through exhibitions, sales and related programs."

N ✦ **DETROIT REPERTORY THEATRE LOBBY GALLERY**, 13103 Woodrow Wilson, Detroit MI 48238. (313)868-1347. Fax: (313)868-1705. **Gallery Director:** Gilda Snowden. Alternative space, nonprofit gallery, theater gallery. Estab. 1965. Represents emerging, mid-career and established artists. Exhibited artists include Curt Winnega, Marcy Parzych and Jocelyn Rainey. Sponsors 4 shows/year. Average display time 6-10 weeks. Exhibits November through June; Thursday-Friday, 8:30-11:30 pm; Saturday-Sunday, 7:30-10:30. Located in midtown Detroit; 750 sq. ft.; features lobby with a wet bar and kitchen; theatre. 100% of space for special exhibitions. Clientele: theatre patrons. 100% private collectors. Overall price range: $50-500; most work sold at $125-300.

Media: Considers oil, acrylic, watercolor, pastel, pen & ink, drawing, mixed media, collage and paper. "Must be two-dimensional; no facilities for sculpture." Most frequently exhibits painting, photography and drawing.

Style: Exhibits all styles, all genres. Prefers figurative painting, figurative photography and collage.

Terms: "No commission taken by gallery; artist keeps all revenues from sales." Retail price set by the

artist. Gallery provides insurance and promotion (catalog, champagne reception); artist pays shipping costs to and from gallery. Prefers artwork framed.

Submissions: Accepts only artists from Metropolitan Detroit area. Prefers only two dimensional wall work. Artists install their own works. Send query letter with résumé, slides, bio and SASE. Write for appointment to show portfolio of slides, résumé and bio. Responds in 3 months.

Tips: Finds artists through word of mouth and visiting exhibitions.

N̄ FIELD ART STUDIO, 24242 Woodward Ave., Pleasant Ridge MI 48069. (248)399-1320. **Director:** Jerome Feig. Retail gallery and art consultancy. Estab. 1950. Represents 6 mid-career and established artists. Average display time 1 month. Overall price range: $25-3,000; most work sold at $100-800.

Media: Considers watercolor, pastel, pen & ink, mixed media, collage, paper, fiber and original handpulled prints. Specializes in etchings and lithographs.

Style: Exhibits landscapes, florals and figurative work. Genres include aquatints, watercolor and acrylic paintings.

Terms: Accepts work on consignment (40% commission). Retail price set by gallery and artist. Exclusive area representation not required. Gallery provides insurance, promotion and contract; shipping costs are shared.

Submissions: Send query letter, résumé, slides or photographs. Write for appointment to show portfolio of originals and slides. Bio and résumé are filed.

Tips: "We are looking for creativeness in the artists we consider. Do not want to see commercial art. Approach gallery in a businesslike manner."

GALLERY SHOP AND GALLERIES: BIRMINGHAM BLOOMFIELD ART CENTER, 1516 S. Cranbrook Rd., Birmingham MI 48009. (248)644-0866. Fax: (248)644-7904. Nonprofit gallery shop. Estab. 1962. Represents emerging, mid-career and established artists. Sponsors ongoing exhibition. Open all year; Monday-Satuday, 9-5. Suburban location. 100% of space for gallery artists. Clientele: upscale, local. 100% private collectors. Overall price range: $50-2,000.

Media: Considers all media. Most frequently exhibits glass, jewelry, ceramics and 2D work.

Style: Exhibits all styles.

Terms: Accepts work on consignment (40% commission). Retail price set by the artist. Gallery provides promotion and contract; artist pays for shipping costs to gallery.

Submissions: Send query letter with résumé, brochure, slides, photographs, reviews, artist's statement, bio, SASE; "as much information as possible." Files résumé, bio, brochure, photos.

Tips: "We consider the presentation of the work (framing, matting, condition) and the professionalism of the artist."

GRAND RAPIDS ART MUSEUM, 155 Division N, Grand Rapids MI 49503-3154. (616)831-1000. Fax: (616)559-0422. E-mail: pr@gr-artmuseum.org. Website: www.gramonline.org. Museum. Estab. 1910. Exhibits established artists. Sponsors 3 exhibits/year. Average display time 4 months. Open all year; Tuesday-Sunday, 11-6; weekends, 11-6. Located in the heart of downtown Grand Rapids, the Grand Rapids Art Museum presents exhibitions of national caliber and regional distinction. The museum collection spans Renaissance to modern art, with particular strength in 19th and 20th century paintings, parts and drawings. Clients include: local community, students, tourists, upscale.

Media: Considers all media and all types of prints. Most frequently exhibits paintings, prints and drawings.

Style: Considers all styles and genres. Most frequently exhibits impressionist, modern and Renaissance.

ELAINE L. JACOB GALLERY, Wayne State University, 480 W. Hancock, Detroit MI 48202. (313)993-7813. Fax: (313)577-8935. E-mail: ac1370@wayne.edu. Website: www.art.wayne.edu. **Curator of Exhibition:** Sandra Dupret. Nonprofit university gallery. Estab. 1997. Exhibits national and international artists. Approached by 40 artists/year. Sponsors 5 exhibits/year. Average display time 6 weeks. Open Tuesday-Friday, 10-6; Saturdays, 11-5. Closed week between Christmas and the New Year. Call for summer hours. Located in the annex of the Old Main building on campus. The gallery space is roughly 3,000 sq. ft. and is divided between 2 floors. Clients include local community, students, tourists.

Media: Considers all types of media.

Style: Mainly contemporary art exhibited.

Terms: Exhibition only, with occasional sales. Retail price set by the artist. Gallery provides insurance, promotion and contract. Accepted work should be framed, mounted and matted. Does not require exclusive representation locally.

Submissions: Send query letter with artist's statement, bio, brochure, business card, photocopies, photographs, résumé. reviews, SASE and slides. Responds in 2 months. Files slides, curriculum vitae and artist statements.

Tips: "Include organized and pertinent information, professional slides, and a clear and concise artist statement."

N ROBERT L. KIDD GALLERY, 107 Townsend St., Birmingham MI 48009. (248)642-3909. Fax: (248)647-1000. **Director:** Ray Frost Fleming. Retail gallery. Estab. 1976. Represents approximately 125 emerging, mid-career and established artists. Sponsors 8 solo and 3 group shows/year. Average display time is 1 month. Open: Tuesday-Saturday, 10:30-5:30; or by appointment. Clientele: 50% private collectors, 50% corporate clients. Overall price range: $1,000-100,000; most artwork sold at $4,000-20,000.

Media: Considers oil, acrylic, watercolor, pastel, mixed media, works on paper, sculpture, ceramic, fiber and glass. Most frequently exhibits acrylic, oil and sculpture.

Style: Exhibits color field, painterly abstraction, photorealism and realism. "We specialize in original contemporary paintings, sculpture, glass and clay by contemporary American artists."

Terms: Accepts work on consignment. Retail price set by gallery and artist. Exclusive area representation required. Gallery provides insurance and promotion; shipping costs are shared.

Submissions: Send query letter, résumé, slides and SASE.

Tips: Looks for "high-quality technical expertise and a unique and personal conceptual concept. Understand the direction we pursue and contact us with appropriate work."

N RUSSELL KLATT GALLERY, 1467 S. Woodward, Birmingham MI 48009. (810)647-6655. Fax: (810)644-5541. **Director:** Sharon Crane. Retail gallery. Estab. 1987. Represents 100 established artists/year. Interested in seeing the work of emerging artists. Exhibited artists include Henri Plisson, Roy Fairchild, Don Hatfield, Mary Mark, Eng Tay. Open all year; Monday-Friday, 10-6; Saturday, 10-5. Located on Woodward, 4 blocks north of 14 mile on the east side; 800 sq. ft. 100% private collectors. Overall price range: $800-1,500; most work sold at $1,000.

Media: Considers oil, acrylic, watercolor, pastel, ceramics, lithograph, mezzotint, serigraphs, etching and posters. Most frequently exhibits serigraphs, acrylics and oil pastels.

Style: Exhibits painterly abstraction, impressionism and realism. Genres include landscapes, florals and figurative work. Prefers traditional European style oil paintings on canvas.

Terms: Accepts work on consignment (60% commission) or buys outright for 50% of retail price (net 30-60 days). Retail price set by the gallery and the artist. Gallery provides insurance and shipping to gallery; artist pays shipping costs from gallery. Prefers artwork unframed.

Submissions: Send query letter with brochure and photographs. Write for appointment to show portfolio of photographs. Finds artists through visiting exhibitions.

KRASL ART CENTER, 707 Lake Blvd.; St. Joseph MI 49085. (269)983-0271. Fax: (269)983-0275. E-mail: info@krasl.org. Website: www.krasl.org. **Director:** Dar Davis. Retail gallery of a nonprofit arts center. Estab. 1980. Clients include community residents and summer tourists. Sponsors 30 solo and group shows/year. Average display time is 1 month. Interested in emerging and established artists.

Media: Considers oils, acrylics, watercolor, pastels, pen & ink, drawings, mixed media, collage, paper, sculpture, ceramics, crafts, fibers, glass, installations, photography and performance.

Style: Exhibits all styles. "The works we select for exhibitions reflect what's happening in the art world. We display works of local artists as well as major traveling shows from SITES. We sponsor sculpture invitationals and offer holiday shows each December."

Terms: Accepts work on consignment (35% commission). Retail price is set by artist. Sometimes offers customer discounts. Exclusive area representation required. Gallery provides insurance, promotion, shipping and contract.

Submissions: Send query letter, résumé, slides, and SASE. Call for appointment to show portfolio of originals.

JOYCE PETTER GALLERY, 161 Blue Star Highway, Douglas MI 49406. (269)857-7861. Website: www.joycepettergallery.com. **Owner:** Joyce Petter. Retail gallery. Estab. 1973. Represents 50 artists; emerging, mid-career and established. Exhibited artists include Harold Larsen and Fran Larsen. Sponsors group or individual shows each year. Average display time 2 weeks. Open all year. Located on the main corridor connecting the art mecca of Saugatuck and Douglas, Michigan. It is housed in a spacious 1930s building designed by Carl Hoerman, artist and architect. It offers 12,500 sq. ft. of exhibition space. It

includes the main display area, print gallery, sculpture barn and garden. Overall price range: $150-8,000.
Media: Considers oil, acrylic, watercolor, pastel, drawings, mixed media, sculpture, ceramic, glass, original handpulled prints, woodcuts, etchings, lithographs, serigraphs ("anything not mechanically reproduced").
Style: Exhibits painterly abstraction, surrealism, impressionism, realism, hard-edge geometric abstraction and all styles and genres. Prefers landscapes, abstracts, figurative and "art of timeless quality."
Terms: Accepts work on consignment (50% commission). Retail price set by the artist. Gallery provides insurance, promotion, contract and cost for return shipping of work. The artwork should be framed with the exception of prints.
Submissions: Send query letter with résumé and photographs or slides, including dimensions and prices. "It's a mistake not to have visited the gallery to see if the artist's work fits the feeling or culture of the establishment."
Tips: "Art is judged on its timeless quality. We are not interested in the 'cutting edge.' After 30 seasons we continue to maintain relationships with artists who joined at the onset and to take on new artists who exhibit those same traits of career longevity and solid commitment to their art."

PEWABIC POTTERY, 10125 E. Jefferson, Detroit MI 48214. (313)822-0954. Fax: (313)822-6266. E-mail: pewabic@pewabic.com. Website: www.pewabic.com. Historic, nonprofit gallery in ceramics education and fabrication center. Estab. 1903. Represents 80 emerging, mid-career and established artists/year. Sponsors 7 shows/year. Average display time 6-52 weeks. Open all year; Monday-Saturday, 10-6; open 7 days during holiday. Located 3 miles east of downtown Detroit; historic building (1906). 40% of space for special exhibitions; 60% of space for gallery artists. Clients include: tourists, ceramic collectors. 98% of sales are to private collectors, 2% corporate collectors. Overall price range: $15-1,500; most work sold at $50-100.
Media: Considers ceramics, mixed media, ceramic jewelry.
Style: Exhibits utilitarian and sculptural clay.
Terms: Accepts work on consignment (50% commission). Retail price set by the artist. Gallery provides insurance and promotion; shipping costs are shared.
Submissions: Only ceramics. Send query letter with résumé, slides, artist's statement and SASE. Write for appointment to show portfolio of slides. Responds in 3 months. Finds artists through word of mouth, referrals by other artists, visiting art fairs and exhibitions, submissions.
Tips: "Avoid sending poor-quality slides."

SAPER GALLERIES, 433 Albert Ave., East Lansing MI 48823. Phone/fax: (517)351-0815. E-mail: roy@sapergalleries.com. Website: www.sapergalleries.com. **Director:** Roy C. Saper. Retail gallery. Estab. in 1978 as 20th Century Fine Arts; in 1986 designed and built new location and name. Displays the work of 100 artists; mostly mid-career, and artists of significant national prominence. Exhibited artists include: Picasso, Peter Max, Rembrandt. Sponsors 2 shows/year. Average display time 2 months. Open all year. Located downtown; 5,700 sq. ft.; "We were awarded *Decor* magazine's Award of Excellence for gallery design." 50% of space for special exhibitions. Clients include students, professionals, experienced and new collectors. 80% of sales are to private collectors, 20% corporate collectors. Overall price range: $100-100,000; most work sold at $1,000.
Media: Considers oil, acrylic, watercolor, pastel, drawings, mixed media, collage, paper, sculpture, ceramic, craft, glass and original handpulled prints. Considers all types of prints except offset reproductions. Most frequently exhibits intaglio, serigraphy and sculpture. "Must be of highest professional quality."
Style: Exhibits expressionism, painterly abstraction, surrealism, postmodern works, impressionism, realism, photorealism and hard-edge geometric abstraction. Genres include landscapes, florals, southwestern and figurative work. Prefers abstract, landscapes and figurative. Seeking outstanding artists who will continue to produce exceptional work.
Terms: Accepts work on consignment (negotiable commission); or buys outright for negotiated percentage of retail price. Retail price set by the artist. Offers payment by installments. Gallery provides insurance, promotion and contract; shipping costs are shared. Prefers artwork unframed (gallery frames).
Submissions: Send query letter with bio or résumé, brochure and 6-12 slides or photographs and SASE. Call for appointment to show portfolio of originals or photos of any type. Responds in 1 week. Files any material the artist does not need returned. Finds artists mostly through NY Art Expo.
Tips: "Present your very best work to galleries which display works of similar style, quality and media. Must be outstanding, professional quality. Student quality doesn't cut it. Must be great. Be sure to include prices and SASE."

N̄ SWORDS INTO PLOWSHARES, Peace Center and Gallery, 33 E. Adams, Detroit MI 48226. (313)963-7575. Fax: (313)963-2569. E-mail: swordsintoplowshares@prodigy.net. Website: www.swordsin toplowshares.org. **Contact:** Lois White, administrative assistant. Nonprofit gallery. "Our theme is 'World Peace.' " Estab. 1985. Represents 25-30 emerging, mid-career and established artists/year. Sponsors 4-6 shows/year. Average display time 2½ months. Open all year; Tuesday, Thursday, Saturday, 11-3. Located in downtown Detroit in the Theater District; 2,881 sq. ft.; 1 large gallery, 2 small galleries. 100% of space for special exhibitions. Clients include walk-in, church, school and community groups. 100% of sales are to private collectors. Overall price range: $75-6,000; most work sold at $75-700.
Media: Considers all media. Considers all types of prints. "We have a juried show every two years for Ontario and Michigan artists about our theme. The juries make the selection of 2- and 3-dimensional work."
Terms: Accepts work on consignment (35% commission). Retail price set by the artist. Gallery provides insurance and promotion; shipping costs from gallery.
Submissions: Accepts artists primarily from Michigan and Ontario. Send query letter with statement on how other work relates to our theme. Responds in 2 months. Finds artists through lists of Michigan Council of the Arts, Windsor Council of the Arts.

URBAN INSTITUTE FOR CONTEMPORARY ARTS, 41 Sheldon Blvd.,Grand Rapids MI 49503. (616)459-5994. Fax: (616)459-9395. E-mail: jteunis@uica.org. Website: www.uica.org. **Visual Arts Program Manager:** Janet Teunis. Alternative space, nonprofit gallery. Estab. 1977. Approached by 250 artists/ year. Exhibits 20 emerging, mid-career and established artists. "We have three galleries—one for each type." Exhibited artists include: Sally Mann, photography. Sponsors 20 exhibits/year. Average display time 6 weeks. Open Tuesday-Saturday, 12-10; Sunday, 12-7. Closed week of Christmas and New Year's. Clients include local community and students.
Media: Considers all media and all types of prints. Most frequently exhibits mixed media and nontraditional.
Style: Exhibits: conceptualism and postmodernism.
Terms: Gallery provides insurance, promotion and contract.
Submissions: Call to arrange a personal interview to show portfolio. Send query letter with artist's statement, bio, résumé, reviews, SASE and slides. Returns material with SASE. Does not reply. Artist should see website, inquire about specific calls for submissions. Finds artists through submissions.
Tips: "Get submission requirements before sending materials."

Minnesota

N̄ 🖼 ART DOCK INC., 394 Lake Ave. S., Duluth MN 55802. (218)722-1451. E-mail: artdock@qwest .net. **Contact:** Bev L. Johnson. Retail consignment gallery. Estab. 1985. Represents 185 emerging and mid-career artists/year. Exhibited artists include: Cheng Khee Chee and Jay Steinke. Sponsors 4 exhibitions/ year. Average display time 6 months. Open all year; January 1-April 30; Monday-Wednesday and Saturday, 10-6; Thursday-Friday, 10-9; Sunday, 11-5; May 1-December 31, Monday-Friday, 10-9; Saturday, 10-8; Sunday, 11-5. Located downtown-Canal Park, 1,200 sq. ft. historical building. #1 tourist attraction in the state on the shores of Lake Superior. We feature local artists within a 100-mile radius of Duluth. Clientele: 50% local, 50% tourists. 95% private collectors, 5% corporate collectors. Over all price range: $1-5,000; most work sold at $30-75.
Media: Considers acrylic, ceramics, collage, craft, drawing, fiber, glass, mixed media, oil, paper, pastel, pen & ink, sculpture, watercolor, jewelry, wood all types of prints. Most frequently exhibits watercolor, pottery and photographs.
Style: Exhibits: painterly abstraction, photorealism and realism. Genres include regional images.
Terms: Accepts work on consignment (40% commission). Retail price set by the artist. Gallery provides insurance, promotion and contract; artists pays for shipping.
Submissions: Accepts only artists from 100-mile radius of Duluth. Send query letter with photographs, or call for appointment to show portfolio of photographs and slides. Responds in 2 months. Files current artist information. Finds artists through submissions.
Tips: "They should present as if they are selling the work. No portfolio."

N̄ ART OPTIONS GALLERY, 132 E. Superior St., Duluth MN 55802. (218)727-8723. Website: www. artoptions.com. **President:** Sue Pavlatos. Retail gallery. Estab. 1988. Represents 35 mid-career artists/year.

Sponsors 4 shows/year. Average display time 1 month. Open all year; Tuesday-Friday, 10:30-5; Monday and Saturday, 10:30-2. Located downtown. Clients include tourists and local community. 70% of sales are to private collectors, 30% corporate collectors. Overall price range: $50-1,000; most work sold at $300.
Media: Considers all media and all types of prints. Most frequently exhibits watercolor, mixed media and oil.
Style: Exhibits all styles and genres. Prefers: landscape, florals and Americana.
Terms: Accepts work on consignment (40% commission). Retail price set by the artist. Gallery provides insurance and promotion; artist pays for shipping. Prefers artwork framed.
Submissions: Send query letter with résumé, slides and bio. Write for appointment to show portfolio of slides. Responds in 2 weeks. Files bio and résumé. Finds artists through word of mouth.
Tips: "Paint or sculpt as much as you can. Work, work, work. You should have at least 50-100 pieces in your body of work before approaching galleries."

CALLAWAY GALLERIES, INC., 101 SW First Ave., Rochester MN 55902. (507)287-6525. Fax: (507)292-8892. Website: callawaygalleries.yahoo.com. **Owner:** Barbara Callaway. Retail gallery. Estab. 1971. Represents 50+ emerging, mid-career and established artists/year. Average display time 1 month. Open all year; Monday-Friday, 9:30-5:30; Saturday, 10-4. Located downtown; 700 sq. ft. Clientele: tourists and upscale corporate. 30% corporate collectors. Overall price range: $100-4,000; most work sold at $200-1,000.
Media: Considers acrylic, craft, fiber, glass, mixed media, oil, paper, pastel, sculpture and watercolor. Considers all types of prints except numbered photo repros. Most frequently exhibits pastel, mixed media and glass.
Style: Considers all styles. Genres include florals, southwestern, landscapes and figurative work.
Terms: Accepts work on consignment (50% commission) or buys outright for 50% of retail price (net 30 days). Retail price set by the artist. Shipping costs are shared. Prefers artwork unframed.
Submissions: Send query letter with bio, photographs, SASE, reviews and artist's statement. Write for appointment to show portfolio of photographs or slides. Responds in 1 month (if SASE provided). Finds artists through word of mouth, referrals by other artists, visiting art fairs and exhibitions and submissions.
Tips: Send "slides or photos and biographical with SASE."

⌖ EAGLE CREEK GALLERY, 12358 Boone Ave S., Savage, MN 55378. (952)445-3035. **Gallery Director:** Mark Roberts. Estab. 1975. Represents 75-100 emerging, mid-career and established artists. Interested in seeing the work of emerging artists. Open all year. 2,000 sq. ft. 10% of space for special exhibitions; 50% of space for gallery artists. Clientele: private homeowners and corporate. 80% private collectors, 20% corporate collectors. Overall price range $10-1,000; most work sold at $100-500.
Media: Considers oil, acrylic, watercolor, pastel, mixed media, paper, woodcuts, wood engravings, engravings, mezzotints, etching, lithographs, serigraphs and posters. Most frequently exhibits watercolor, serigraphs/lithographs and offset reproductions.
Style: Exhibits painterly abstraction, impressionism and realism. Genres include landscapes and florals.
Terms: Accepts work on consignment (50% commission). Retail price set by artist. Payment by installment. Gallery provides promotion; artist pays for shipping.
Submissions: Send query letter with résumé, slides, bio, photographs, business card, reviews and SASE. Portfolio review requested if interested in artist's work. Files résumé and card. Finds artists through visiting exhibitions, word of mouth and artists' submissions.
Tips: "The mood of our clients has leaned towards quality, colorful artwork that has an uplifting appeal."

ICEBOX QUALITY FRAMING & GALLERY, 2401 Central Ave. NE, Minneapolis MN 55418. (612)788-1790. E-mail: icebox@bitstream.net. Website: www.iceboxminnesota.com. **Fine Art Representative:** Howard Christopherson. Retail gallery and alternative space. Estab. 1988. Represents emerging and mid-career artists. Sponsors 4-7 shows/year. Average display time 1-2 months. Open all year. Intimate, black-walled space.
Media: Considers photography and all fine art with some size limitations.
Style: Exhibits: any thought-provoking artwork.
Terms: "Exhibit expenses and promotional material paid by the artist along with a sliding scale commission." Gallery provides great exposure, mailing list of 1,700 and good promotion.
Submissions: Accepts predominantly Minnesota artists but not exclusively. Send 20 slides, materials for review, letter of interest.
Tips: "Be more interested in the quality and meaning in your artwork than in a way of making money."

☑ **MIKOLS RIVER STUDIO INC.**, 717 Main St. NW, Elk River MN 55330. (763)441-6385. Website: www.mikolsriverstudio.com. **President:** Anthony Mikols. Retail gallery. Estab. 1985. Represents 12 established artists/year. Exhibited artists include: Steve Hanks. Sponsors 2 shows/year. Open all year; 6 days, 9-6. Located in downtown; 2,200 sq. ft. 10% of space for special exhibitions; 50% of space for gallery artists. Overall price range: $230-595.

Media: Considers watercolor, sculpture, acrylic, paper and oil; types of prints include lithographs, posters and seriographs.

Style: Genres include florals, portraits, wildlife, landscapes and western. Prefers: wildlife, florals and portraits.

Terms: Buys outright for 50% of retail price (net on receipt). Retail price set by the gallery. Gallery provides insurance; gallery pays for shipping.

Submissions: Send photographs. Artist's portfolio should include photographs. Responds only if interested within 2 weeks. Files artist's material. Finds artists through word of mouth.

ℕ THE CATHERINE G. MURPHY GALLERY, The College of St. Catherine, 2004 Randolph Ave., St. Paul MN 55105. (612)690-6637. Fax: (612)690-6024. E-mail: kmdaniels@stkate.edu. Website: www.st kate.edu. **Director:** Kathleen M. Daniels. Nonprofit gallery. Estab. 1973. Represents emerging, mid-career and nationally and regionally established artists. "We have a mailing list of 1,000." Sponsors 5 shows/year. Average display time 4-5 weeks. Open September-June; Monday-Friday, 8-8; Saturday, 12-6; Sunday, 12-6. Located in the Visual Arts Building on the college campus of the College of St. Catherines; 1,480 sq. ft.

● This gallery also exhibits historical art and didactic shows of visual significance. Gallery shows 75% women's art since it is an all-women's undergraduate program.

Media: Considers a wide range of media for exhibition.

Style: Exhibits: Considers a wide range of styles.

Terms: Artwork is loaned for the period of the exhibition. Gallery provides insurance. Shipping costs are shared. Prefers artwork framed.

Submissions: Send query letter with artist statement and checklist of slides (title, size, medium, etc.), résumé, slides, bio and SASE. Responds in 6 weeks. Files résumé and cover letters. Serious consideration is given to artists who do group proposals under one inclusive theme.

ℕ NORMANDALE COLLEGE CENTER GALLERY, 9700 France Ave., So., Bloomington MN 55431. (952)481-8121. Fax: (952)487-8130. E-mail: c.mikkelsen.n.cc.us.mn. **Contact:** Chris Mikkelsen. College gallery. Estab. 1975. Exhibits 6 emerging, mid-career and established artists/year. Sponsors 6 shows/year. Average display time 2 months. Open all year. Suburban location; 30 running feet of exhibition space. 100% of space for special exhibitions. Clientele: students, staff and community. Overall price range: $25-750; most artwork sold at $100-200.

Media: Considers all media and all types of prints. Most frequently exhibits watercolor, photography and prints.

Style: Exhibits all styles and genres.

Terms: "We collect 10% as donation to our foundation." Retail price set by artist. Gallery provides insurance, promotion and contract; artist pays for shipping. Prefers framed artwork.

Submissions: "Send query letter; we will send application and info." Portfolio should include slides. Responds in 2 months. Files "our application/résumé."

ℕ NORTH COUNTRY MUSEUM OF ARTS, 301 Court St., P.O. Box 328, Park Rapids MN 56470. (218)732-5237. **Curator/Administrator:** Johanna M. Verbrugghen. Museum. Estab. 1977. Interested in seeing the work of emerging and established artists. 100 members. Sponsors 8 shows/year. Average display time 3 weeks. Open all year; May-October; Tuesday-Sunday, 11-5. Located next to courthouse; 5 rooms in a Victorian building built in 1900 (on Register of Historic Monuments). 50% of space for special exhibitions; 50% of space for gallery artists.

Media: Considers all media and all types of prints. Most frequently exhibits acrylic, watercolor and sculpture.

Style: Exhibits all genres; prefers realism.

Terms: Accepts work on consignment (20% commission). Retail price set by the artist. Artist pays shipping costs to and from gallery. Prefers artwork framed.

Submissions: "Work should be of interest to general public." Send query letter with résumé and 4-6

slides. Portfolio should include photographs and slides. Responds only if interested within 2 months. Finds artists through word of mouth.

OPENING NIGHT FRAMING SERVICES & GALLERY, (formerly Opening Night Gallery), 2836 Lyndale Ave. S., Minneapolis MN 55408-2108. (612)872-2325. Fax: (612)872-2385. E-mail: deen@onframe-art.com. Website: www.onframe-art.com. Rental gallery. Estab. 1974. Approached by 40 artists/year. Exhibits 15 emerging and mid-career artists. Sponsors 4 exhibits/year. Average display time 6-10 weeks. Open all year; Monday, Wednesday and Friday, 8:30-5; Tuesday and Thursday, 8:30-7; Saturday, 10:30-4. Located on a main street the space is approximately 2,500 sq. ft. Clients include local community, tourists and upscale. 50% of sales are to corporate collectors. Overall price range: $300-15,000; most work sold at $2,500.
Media: Considers acrylic, ceramics, collage, drawing, fiber, glass, oil, paper, sculpture and watercolor. Most frequently exhibits paintings, drawings and pastels. Considers engravings, etchings, linocuts, lithographs, mezzotints, posters and serigraphs.
Style: Exhibits: impressionism and painterly abstraction. Genres include Americana, florals and landscapes.
Terms: Artwork is accepted on consignment and there is a 50% commission. Retail price set by the gallery. Gallery provides insurance, promotion and contract. Accepted work should be framed. Requires exclusive representation locally.
Submissions: Write to arrange a personal interview to show portfolio of photographs or slides. Mail portfolio for review. Send query letter with artist's statement, bio, résumé, SASE and slides. Responds in 2 months. Files slides and bio. Finds artists through word of mouth, submissions and portfolio reviews.
Tips: "Please include a cover letter, along with your most appealing creations. Archival-quality materials are everything—we are also a framing service whom museums use for framing."

JEAN STEPHEN GALLERIES, 917 Nicollet Mall, Minneapolis MN 55402. (612)338-4333. Fax: (612)337-8435. E-mail: jsgalleries@leodusa.net. Website: jeanstephengalleries.com. Directors: Steve or Jean Danko. Retail gallery. Estab. 1987. Represents 12 established artists. Interested in seeing the work of emerging artists. Exhibited artists include: Jiang, Hart and Max. Sponsors 2 shows/year. Average display time 4 months. Open all year; Monday-Saturday, 10-6. Located downtown; 2,300 sq. ft. 15% of space for special exhibitions; 85% of space for gallery artists. Clients include upper income. 90% of sales are to private collectors, 10% corporate collectors. Overall price range: $600-12,000; most work sold at $1,200-2,000.
Media: Considers oil, acrylic, pastel, pen & ink, drawing, mixed media, collage, paper, sculpture, ceramics, woodcuts, engravings, lithographs, wood engravings, mezzotints, serigraphs, linocuts and etchings. Most frequently exhibits serigraphs, stone lithographs and sculpture.
Style: Exhibits: expressionism, neo-expressionism, surrealism, minimalism, color field, postmodern works and impressionism. Genres include landscapes, southwestern, portraits and figurative work. Prefers Chinese contemporary, abstract and impressionism.
Terms: Accepts work on consignment (50% commission). Retail price set by the gallery. Gallery provides insurance and contract; artist pays shipping costs to and from gallery.
Submissions: Send query letter with résumé, slides and bio. Call for appointment to show portfolio of originals, photographs and slides. Responds in 2 months. Finds artists through art shows and visits.

N: TWEED MUSEUM OF ART, 1201 Ordean Court, Duluth MN 55812. (218)726-7823. Fax: (218)726-8503. E-mail: tma@d.umn.edu. Website: www.d.umn.edu/tma. **Contact:** Peter Spooner, curator/registrar. Museum and museum retail shop. Estab. 1950. Exhibits emerging, mid-career and established artists. Sponsors 10 exhibits/year. Average display time 2-3 months. Open Tuesday-Friday, 9-4:30; Saturday-Sunday, 1-5. Closed from late December to early January.
Media: Considers all media and all types of prints.
Style: Considers all styles and genres.
Submissions: Send query letter with artist's statement, bio, résumé and slides. Cannot return material.

FREDERICK R. WEISMAN ART MUSEUM, 333 East River Rd., Minneapolis MN 55455. (612)625-9494. Fax: (612)625-9630. Website: www.weisman.umn.edu. **Contact:** Lyndel King, director. Frederick R. Weisman Art Museum opened in November 1993; University of Minnesota Art Museum established in 1934. Represents 20,000 works in permanent collection. Represents established artists. 1,000 members. Sponsors 6-7 shows/year. Average display time 10 weeks. Open all year; Tuesday, Wednesday, Friday, 10-

5; Thursday, 10-8; Saturday-Sunday, 11-5. Located at the University of Minnesota, Minneapolis; 10,000 sq. ft.; designed by Frank O. Gehry. 40% of space for special exhibitions.

Media: Considers all media and all types of prints.

Style: Exhibits all styles, all genres.

Terms: Gallery provides insurance. Prefers artwork framed.

Submissions: "Generally we do not exhibit one-person shows. We prefer thematic exhibitions with a variety of artists. However, we welcome exhibition proposals. Exhibitions which are multi-disciplinary are preferred."

N WINGS 'N WILLOWS ART GALLERY & FRAME SHOP, 42 NW Fourth St., Grand Rapids MN 55744. (218)327-1649. **Owner:** Linda Budrow. Retail gallery, custom frame shop. Estab. 1976. Represents 30 established artists/year. Exhibited artists include Redlin and Bateman. Sponsors 1 show/year. Average display time 3 months. Open all year; Monday-Saturday, 10-5. Located downtown; 1,000 sq. ft. 5% of space for special exhibitions; 95% of space for gallery artists. Clientele: tourists, local community. 95% private collectors, 5% corporate collectors. Overall price range: $30-1,000; most work sold at $150-600.

Media: Considers paper, ceramics, glass, photography, wood carvings, lithographs and posters. Most frequently exhibits limited edition prints, posters and wood carvings.

Style: Genres include wildlife and landscapes. Prefers wildlife, landscape and nostalgic.

Terms: Buys outright for 50% of retail price (net 30 days). Retail price set by the artist. Gallery provides promotion. Gallery pays shipping costs. Prefers artwork unframed.

Submissions: Send query letter with bio, brochure and photographs. Write for appointment to show portfolio of photographs. Responds only if interested within 2 weeks. Finds artists through visiting art fairs and exhibitions, artist's submissions and publishers.

Mississippi

N HILLYER HOUSE, INC., 207 E. Scenic Dr., Pass Christian MS 39571. (228)452-4810. Fax: (228)452-3712. E-mail: hillyerhouse@yahoo.com. Website: www.hillyer-house.com. **Owners:** Katherine and Paige Reed. Retail gallery. Estab. 1970. Represents 200 emerging, mid-career and established artists including: 19 artists, 34 potters, 46 jewelers, 10 glass-blowers. Interested in seeing the work of emerging artists. Exhibited artists include: Kathie Calhoun and Ted Rose. Sponsors 12 shows/year. Average display time 2 months. Open all year; Monday-Saturday 10-5; Sunday 12-5. Located beachfront-middle of CBD historic district; 1,700 sq. ft. 50% of space for special exhibitions; 50% of space for gallery artists. Clients include visitors to the Mississippi Gulf Coast (80%), private collectors (20%). Overall price range: $25-700; most work sold at $30-150; paintings $250-700.

● Hillyer House has special exhibitions in all areas.

Media: Considers oil, watercolor, pastel, mixed media, sculpture (metal fountains), ceramic, craft and jewelry. Most frequently exhibits watercolor, pottery and jewelry.

Style: Exhibits: expressionism, imagism, realism and contemporary. Genres include aquatic/nautical. Prefers: realism, impressionism and expressionism.

Terms: Accepts work on consignment (35% commission); or artwork is bought outright for 50% of the retail price (net 30 days). Retail price set by gallery or artist. Gallery provides promotion and contract; artist pays for shipping. Prefers artwork framed.

Submissions: Send query letter with résumé, slides, bio, brochure and/or photographs, SASE and reviews. Call or write for appointment to show portfolio of originals and photographs. Responds only if interested within 3 weeks. Files photograph and bio. (Displays photo and bio with each person's art.)

Tips: "Work must be done in last nine months. Watercolors sell best. Make an appointment. Looking for artists with a professional attitude and approach to work. Be sure the work submitted is in keeping with the nature of our gallery."

MERIDIAN MUSEUM OF ART, 628 25th Ave., P.O. Box 5773, Meridian MS 39302. (601)693-1501. E-mail: MeridianMuseum@aol.com. **Director:** Terence Heder. Museum. Estab. 1970. Represents emerging, mid-career and established artists. Interested in seeing the work of emerging artists. Exhibited artists include Terry Cherry, Alex Loeb, Jere Allen, Patt Odom, James Conner, Joseph Gluhman, Bonnie Busbee and Hugh Williams. Sponsors 15 shows/year. Average display time 5 weeks. Open all year; Tuesday-Sunday, 1-5. Located downtown; 1,750 sq. ft.; housed in renovated Carnegie Library building, originally

constructed 1912-13. 50% of space for special exhibitions. Clientele: general public. Overall price range: $150-2,500; most work sold at $300-1,000.

● Sponsors annual Bi-State Art Competition for Mississippi and Alabama artists.

Media: Considers all media. Most frequently exhibits oils, watercolors and sculpture.

Style: Exhibits all styles, all genres.

Terms: Work available for sale during exhibitions (25% commission). Retail price set by the artist. Gallery provides insurance and promotion; shipping costs are shared. Prefers artwork framed.

Submissions: Prefers artists from Mississippi, Alabama and the Southeast. Send query letter with résumé, slides, bio and SASE. Responds in 3 months. Finds artists through submissions, referrals, work included in competitions and visiting exhibitions.

THE UNIVERSITY MUSEUMS, The University of Mississippi, P.O. Box 1848, University MS 38677. (662)915-7073. Fax: (662)915-7010. E-mail: museums@olemiss.edu. Website: olemiss.edu/depts/u_muse um. Museum. Estab. 1939. Approached by 5 artists/year. Represents 2 emerging, mid-career and established artists. Average display time 3 months. Open Tuesday-Saturday, 9:30-4:30; Sunday, 1-4. Closed 2 weeks at Christmas and major holidays. Clients include local community, students and tourists.

Media: Considers all media. Most frequently exhibits acrylic, oil and drawings. Considers all types of prints.

Style: Considers all styles. Genres include Americana, landscapes and wildlife.

Terms: Artwork is bought outright. Retail price set by the artist. Gallery provides insurance. Accepted work should be framed. Does not require exclusive representation locally. Accepts only artists from Mississippi, Tennessee, Alabama, Arkansas and Louisiana.

Submissions: Send query letter with artist's statement, bio, photographs and slides. Returns material with SASE. Responds in 3 months. Finds artists through word of mouth, submissions, and referrals by other artists.

Missouri

THE ASHBY-HODGE GALLERY OF AMERICAN ART, Central Methodist College, Fayette MO 65248. (660)248-6324 or (660)248-6304. Fax: (660)248-2622. E-mail: jgeistecoin.org. Website: www.cmc. edu. **Curator:** Joseph E. Geist. Nonprofit gallery, "Not primarily a sales gallery—only with special exhibits." Estab. 1993. Exhibits the work of 47 artists in permanent collection. Exhibited artists include Robert MacDonald Graham, Jr. and Birger Sandzén. Sponsors 5 shows/year. Average display time 2 months. Open all year; Tuesday-Thursday, 1:30-4:30. Located on campus of Central Methodist college. 1,400 sq. ft.; on lower level of campus library. 100% of gallery artists for special exhibitions. Clientele: local community and surrounding areas of Mid-America. Physically impaired accessible. Tours by reservation.

Media: Considers all media. Most frequently exhibits acrylic, lithographs and oil.

Style: Exhibits Midwestern regionalists. Genres include portraits and landscapes. Prefers: realism.

Terms: Accepts work on consignment (30% commission.) Retail price set by the gallery. Gallery provides insurance and promotion; shipping costs are shared. Prefers artwork framed.

Submissions: Accepts primarily Midwestern artists. Send query letter with résumé, slides, photographs and bio. Call for appointment to show portfolio of photographs, transparencies and slides. Finds artists through word of mouth and submissions.

N: BARUCCI'S ORIGINAL GALLERIES, 8101 Maryland Ave., St Louis MO 63105. (314)727-2020. Website: baruccis.com. **President:** Shirley Taxman Schwartz. Retail gallery and art consultancy specializing in hand-blown glass by national juried artists. Estab. 1977. Represents 40 artists. Interested in emerging and established artists. Sponsors 3-4 solo and 4 group shows/year. Average display time is 6 weeks. Located in "affluent county, a charming area." Clientele: affluent young area. 70% private collectors, 30% corporate clients. Overall price range: $100-10,000; most work sold at $500.

● This gallery has moved into a corner location featuring three large display windows. They specialize in hand blown glass by national juried artists.

Media: Considers oil, acrylic, watercolor, pastel, collage and works on paper. Most frequently exhibits watercolor, oil, acrylic and hand blown glass.

Style: Exhibits painterly abstraction, primitivism and impressionism. Genres include landscapes and florals. Currently seeking contemporary works: abstracts in acrylic and fiber, watercolors and some limited edition serigraphs.

Terms: Accepts work on consignment (50% commission). Retail price set by gallery or artist. Sometimes offers payment by installment. Gallery provides contract.
Submissions: Send query letter with résumé, slides and SASE. Portfolio review requested if interested in artist's work. Slides, bios and brochures are filed.
Tips: "More clients are requesting discounts or longer pay periods."

BOODY FINE ARTS, INC., 10734 Trenton Ave., St. Louis MO 63132. (314)423-2255. E-mail: boodyfin earts@earthlink.net. Website: www.boodyfinearts.com. Retail gallery and art consultancy. "Gallery territory is nationwide. Staff travels on a continual basis to develop collections within the region." Estab. 1978. Represents 200 mid-career and established artists. Clientele: 30% private collectors, 70% corporate clients. Overall price range: $500-1,000,000.
Media: Considers oil, acrylic, watercolor, pastel, drawings, mixed media, collage, sculpture, ceramic, fiber, metalworking, glass, works on handmade paper, neon and original handpulled prints.
Style: Exhibits color field, painterly abstraction, minimalism, impressionism and photorealism. Prefers non-objective, figurative work and landscapes.
Terms: Accepts work on consignment. Retail price is set by gallery and artist. Customer discounts and payment by installments available. Gallery provides insurance, promotion and contract; shipping costs are shared.
Submissions: Send query letter, résumé and slides. Write to schedule an appointment to show a portfolio, which should include originals, slides and transparencies. All material is filed. Finds artists by visiting exhibitions, word of mouth, artists' submissions and art collectors' referrals.
Tips: "I very seldom work with an artist until they have been out of college about ten years."

BYRON COHEN GALLERY FOR CONTEMPORARY ART, (formerly Byron Cohen Lennie Berkowitz), 2020 Baltimore, Kansas City MO 64108. (816)421-5665. Fax: (816)421-5775. E-mail: byroncohen @aol.com. Website: www.artnet.com/cohen.html. **Owner:** Byron Cohen. Retail gallery. Estab. 1994. Represents emerging and established artists. Exhibited artists include: Squeak Carnwath. Sponsors 6-7 shows/ year. Average display time 7 weeks. Open all year; Thursday-Saturday, 11-5. Located downtown; 1,500 sq. ft.; 100% of space for gallery artists. 90% of sales are to private collectors, 10% corporate collectors. Overall price range: $300-42,000; most work sold at $2,000-7,000.
Media: Considers all media. Most frequently exhibits painting, works on paper and sculpture.
Style: Exhibits: Considers all styles. Prefers contemporary painting and sculpture, contemporary prints, contemporary ceramics.
Terms: Accepts work on consignment (50% commission.) Retail price set by the gallery and the artist. Gallery provides insurance, promotion and contract; shipping costs are shared. Prefers artwork framed.
Submissions: Send query letter with résumé, slides, artist's statement and bio. Write for appointment to show portfolio of photographs, transparencies and slides. Files slides, bio and artist's statement. Finds artists through word of mouth, referrals by other artists, visiting art fairs and exhibitions.

N **CONTEMPORARY ART MUSEUM OF ST. LOUIS**, 3550 Washington St., St. Louis MO 63108. (314)535-4660. Fax: (314)535-1226. E-mail: info@contemporarystl.org. Website: www.contemporarystl. org. **Director:** Paul Ha. Nonprofit museum. Estab. 1980. Is a leading institution for contemporary art exhibitions in an innovative environment with community partnerships, education programs and outreach. Open Tuesday-Saturday, 10-5; Sunday, 12-5. Located mid-town, Grand Center; 27,200 sq. ft. building designed by Brad Cloepfil, Allied Works. This new facility is opening September 20, 2003.

N **MILDRED COX GALLERY AT WILLIAM WOODS UNIVERSITY**, One University Dr., Fulton MO 65251. (573)642-2251. Website: www.williamwoods.edu. **Contact:** Julie Gaddy, gallery coordinator. Nonprofit gallery. Estab. 1970. Approached by 20 artist/year; exhibits 8 emerging, mid-career and established artists/year. Exhibited artists include Elizabeth Ginsberg and Terry Martin. Average display time 2 months. Open Monday-Friday, 8-4:30; Saturday-Sunday, 1-4. Closed Christmas-January 20. Located within large moveable walls; 300 running feet. Clients include local community, students, upscale and foreign visitors. Overall price range: $1,000-10,000; most work sold at $800-1,000. Gallery takes no commission. "Our mission is education."
Media: Considers all media except installation. Most frequently exhibits drawing, painting and sculpture. Considers all prints except commercial off-set.
Style: Exhibits expressionism, geometric abstraction, impressionism, surrealism, painterly abstraction and

realism. Most frequently exhibits figurative and academic. Genres include Americana, figurative work, florals, landscapes and portraits.

Terms: Artists work directly with person interested in purchase. Retail price of the art set by the artist. Gallery provides insurance and contract. Accepted work should be framed and matted. Does not require exclusive representation locally. Artists are selected by a committee from slides or original presentation to faculty committee.

Submissions: Write to arrange a personal interview to show portfolio of slides or send query letter with artist's statement, résumé and slides. Returns material with SASE. Does not reply to queries. Artist should call. Files slides, statement and résumé until exhibit concludes. Finds artists through word-of-mouth.

Tips: To make your gallery submissions professional you should send "good quality slides! Masked with sliver opaque tape—no distracting backgrounds."

CRAFT ALLIANCE GALLERY, 6640 Delmar, St. Louis MO 63130. (314)725-1177, ext. 22. Fax: (314)725-2068. E-mail: gallery@craftalliance.org. Website: www.craftalliance.org. **Contact:** Randi Chervitz, gallery director. Nonprofit gallery with exhibition and retail galleries. Estab. 1964. Represents 500 emerging, mid-career and established artists. Exhibited artists include: Thomas Mann, Ellen Shankin and Randall Darwall. Exhibition space sponsors 10-12 exhibits/year. Average display time 4-6 weeks. Open all year. Located in the university area; storefront; adjacent to education center. Clients include local community, students, tourists and upscale. Retail gallery price range: $20 and up. Most work sold at $100.

Media: Considers ceramics, metal, fiber and glass. Most frequently exhibits jewelry, glass and clay. Doesn't consider prints.

Style: Exhibits contemporary craft.

Terms: Exhibition artwork is sold on consignment and there is a 50% commission. Artwork is bought outright. Retail price set by the gallery and the artist. Gallery provides insurance and promotion. Requires exclusive representation locally.

Submissions: Call or write to arrange a personal interview to show portfolio of slides or call first, then send slides or photographs. Returns material with SASE.

Tips: "Call and talk. Have professional slides and attitude."

GALERIE BONHEUR, 10046 Conway Rd., St. Louis MO 63124. (314)993-9851. Cell: (314)409-6057. Fax: (314)993-9260. E-mail: gbonheur@aol.com. Website: www.galeriebonheur.com. **Owner:** Laurie Griesedieck Carmody. Gallery Assistant: Sharon Ross. Private retail and wholesale gallery. Focus is on international folk art. Estab. 1980. Represents 60 emerging, mid-career and established artists/year. Exhibited artists include: Milton Bond and Justin McCarthy. Sponsors 6 shows/year. Average display time 1 year. Open all year; by appointment. Located in Ladue (a suburb of St. Louis); 3,000 sq. ft.; art is displayed all over very large private home. 75% of sales to private collectors. Overall price range: $25-25,000; most work sold at $50-1,000.

• Galerie Bonheur also has a location at 9243 Clayton Rd., Ladue, MO.

Media: Considers oil, acrylic, watercolor, pastel, pen & ink, drawing, mixed media, collage, paper, sculpture, ceramics and craft. Most frequently exhibits oil, acrylic and metal sculpture.

Style: Exhibits: expressionism, primitivism, impressionism, folk art, self-taught, outsider art. Genres include landscapes, florals, Americana and figurative work. Prefers genre scenes and figurative.

Terms: Accepts work on consignment (50% commission) or buys outright for 50% of retail price. Retail price set by the gallery and the artist. Gallery provides promotion; artist pays shipping costs to and from gallery. Prefers artwork framed.

Submissions: Prefers only self-taught artists. Send query letter with bio, photographs and business card. Write for appointment to show portfolio of photographs. Responds only if interested within 6 weeks. Finds artists through agents, visiting exhibitions, word of mouth, art publications and sourcebooks and submissions.

Tips: "Be true to your inspirations. Create from the heart and soul. Don't be influenced by what others are doing; do art that you believe in and love and are proud to say is an expression of yourself. Don't copy; don't get too sophisticated or you will lose your individuality!"

DANA GRAY & ASSOCIATES, P.O. Box 9244, St. Louis MO 63117. (314)589-4541. E-mail: info@danagray.com. Website: www.danagray.com. **Contact:** Dana Gray, president. Art consultancy. Estab. 2000. Represents over 12 mid-career and established artists/year. Exhibited artists include Miquel Berrocal (sculpture) and Salvador Dali (prints). Sponsors 1 exhibit/year. Average display time 3-6 weeks. Open by appointment only. Consultant works from home office and travels to client's location or does negotiations

by phone, e-mail and mail. Clients include local community and upscale. 5% of sales are to corporate collectors. Overall price range: $1,000-10,000; most work sold at $2,500.

Media: Considers collage, drawing, glass, mixed media, oil, paper, pastel, pen & ink, sculpture, watercolor. Most frequently exhibits paintings, prints and sculpture. Considers all types of prints except giclee.

Style: Exhibits impressionism, realism and surrealism. Considers all genres.

Terms: "Generally, I broker artworks and the percentage is agreed in advance between the artist/owner and the broker." Retail price of the art set by the artist/owner. Does not require exclusive representation locally.

Submissions; Responds to queries only if interested. Finds artists through art fairs and exhibits, referrals by other artists, word-of-mouth and periodicals.

MORTON J. MAY FOUNDATION GALLERY, Maryville University, 13550 Conway, St. Louis MO 63141. (314)576-9300. E-mail: nrice@maryville.edu. **Director:** Nancy N. Rice. Nonprofit gallery. Exhibits the work of 6 emerging, mid-career and established artists/year. Sponsors 10 shows/year. Average display time 1 month. Open all year. Located on college campus. 10% of space for special exhibitions. Clients include college community. Overall price range: $100-4,000.

● The gallery is long and somewhat narrow, therefore it is inappropriate for very large 2-D work. There is space in the lobby for large 2-D work but it is not as secure.

Media: Considers oil, acrylic, watercolor, pastel, pen & ink, drawings, mixed media, collage, works on paper, sculpture, ceramic, fiber, installation, photography, original handpulled prints, woodcuts, engravings, lithographs, wood engravings, mezzotints, linocuts and etchings. Exhibits all genres.

Terms: Artist receives all proceeds from sales. Retail price set by artist. Gallery provides insurance and promotion; artist pays for shipping. Prefers framed artwork.

Submissions: Prefers St. Louis area artists. Send query letter with résumé, slides, bio, brochure and SASE. Portfolio review requested if interested in artist's work. Portfolio should include slides, photographs and transparencies. Responds only if interested within 3 months. Finds artists through referrals by colleagues, dealers, collectors, etc. "I also visit group exhibits especially if the juror is someone I know and or respect."

Tips: Does not want "hobbyists/crafts fair art." Looks for "a body of work with thematic/aesthetic consistency."

MORGAN GALLERY, 114 Southwest Blvd., Kansas City MO 64108. (816)842-8755. Fax: (816)842-3376. E-mail: morgangallery@primary.net. Website: www.morgangallery.com. **Director:** Dennis Morgan. For profit gallery. Estab. 1969. Exhibits emerging, mid-career and established artists. Sponsors 6 exhibits/year. Average display time 6-8 weeks. Open all year; Tuesday-Friday, 10-5:30; Saturday 10-4. Closed Sundays. Clients include local community, students, tourists and upscale.

Media: Considers all media and all types of prints.

Style: Considers all styles.

Terms: Artwork is accepted on consignment and there is a 50% commission. Retail price set by the gallery and the artist. Gallery provides insurance, promotion and contract. Requires exclusive representation locally.

Submissions: Call or write to arrange a personal interview to show portfolio. Send query letter with artist's statement, bio, résumé, reviews, SASE and 20 slides. Returns material with SASE. Responds in 6 months. Files contact information. Finds artists through word of mouth, submissions, portfolio reviews, art exhibits, art fairs, and referrals by other artists.

WILLIAM SHEARBURN FINE ART, 4740-A McPherson, 2nd Floor, St. Louis MO 63108. (314)367-8020. E-mail: wshfineart@aol.com. **Owner/Director:** William Shearburn. Sponsors 5 shows/year. Average display time 6 weeks. Open all year; Tuesday-Saturday, 11-4. Located midtown; 1,200 sq. ft. "Has feel of a second floor New York space." 60% of space for special exhibitions; 40% of space for gallery artists. Overall price range: $500-50,000; most work sold at $2,500-5,000.

Media: Considers all media including drawings, paintings, prints and photography.

Style: Specializes in 20th Century American art.

Terms: Artwork is accepted on consignment (50% commission). Retail price set by the gallery. Gallery provides promotion and contract; shipping costs are shared. Prefers artwork framed.

Submissions: Prefers established artists only. Send query letter with résumé, slides, reviews and SASE. Call for appointment to show portfolio of photographs or transparencies.

Tips: "Please stop by the gallery first to see the kind of work we show and the artists we represent before you send us your slides."

THE SOURCE FINE ARTS, INC., 4137 Pennsylvania, Kansas City MO 64111. (816)931-8282. Fax: (816)931-8283. **Owner:** Denyse Ryan Johnson. Gallery Director: Penny Plotsky. Retail gallery. Estab. 1985. Represents/exhibits 50 mid-career artists/year. Exhibited artists include: Jack Roberts and John Gary Brown. Sponsors 3-4 openings, monthly shows/year. Open all year; Monday-Friday, 9-5; Saturday, 11-4. Located in midtown Westport Shopping District; 2,000 sq. ft. 50% of space for special exhibitions. Clients include tourists and upscale. 60% of sales are to private collectors, 40% corporate collectors. Overall price range: $200-6,500; most work sold at $1,000-4,500.

Media: Considers all media except photography. Most frequently exhibits oil, acrylic, mixed media, ceramics and glass.

Style: Exhibits: expressionism, minimalism, color field, hard-edge geometric abstraction, painterly abstraction and impressionism. Genres include landscapes. Prefers: non-objective, abstraction and impressionism.

Terms: Artwork is accepted on consignment (50% commission). Retail price set by the gallery. Gallery provides insurance, promotion and contract; show and shipping costs are shared.

Submissions: Prefers Midwest artists with exhibit, sales/gallery record. Send query letter with résumé, brochure, business card, 8-12 slides, photographs, reviews and SASE. Call for appointment to show portfolio of photographs, slides and transparencies. Responds in 1 month. Files slides and résumé. Finds artists through word of mouth, referrals by other artists, visiting art fairs and exhibitions and artists' submissions. Reviews submissions in January and July.

Tips: Advises artists who hope to gain gallery representation to "visit the gallery to see what media and level of expertise is represented. If unable to travel to a gallery outside your region, review gallery guides for area to find out what styles the gallery shows. Prior to approaching galleries, artists need to establish an exhibition record through group shows. When you are ready to approach galleries, present professional materials and make follow-up calls."

Montana

N ARTISTS' GALLERY, 111 S. Grand, #106, Bozeman MT 59715. (406)587-2127. **Chairperson:** Justine Heisel. Retail and cooperative gallery. Estab. 1992. Represents the work of 20 emerging and mid-career artists, 20 members. Sponsors 12 shows/year. Average display time 3 months. Open all year; Monday-Saturday, 10-5. Located near downtown; 900 sq. ft.; located in Emerson Cultural Center with other galleries, studios, etc. Clients include tourists, upscale, local community and students. 100% of sales are to private collectors. Overall price range: $35-600; most work sold at $100-300.

Media: Considers oil, acrylic, watercolor, pastel, pen & ink, drawing, mixed media, collage, paper, sculpture, ceramics and glass, woodcuts, engravings, linocuts and etchings. Most frequently exhibits oil, watercolor and ceramics.

Style: Exhibits: painterly abstraction, impressionism, photorealism and realism. Exhibits all genres. Prefers realism, impressionism and western.

Terms: Co-op membership fee plus donation of time (20% commission). Rental fee for space; covers 1 month. Retail price set by the artist. Gallery provides promotion; artist pays for shipping costs to gallery. Prefers artwork framed.

Submissions: Artists must be able to fulfill "sitting" time or pay someone to sit. Send query letter with résumé, slides, photographs, artist's statement and actual work. Write for appointment to show portfolio of photographs and slides. Responds in 2 weeks.

N THE BET ART & ANTIQUES, 416 Central Ave., Great Falls MT 59401. Phone/fax: (406)453-1151. **Partners:** D. Carter and E. Bowden. Retail gallery-antiques, old prints and art. Estab. 1955. Represents 12 mid-career and established artists/year. Interested in seeing the work of emerging artists. Exhibited artists include: Lisa Lorimer and King Kuka. Open all year; Monday-Saturday, 10-5:30. Located downtown; 140 sq. ft. 50% of space for gallery artists. Clientele: tourists and locals. 50% private collectors. Overall price range: $150-5,000; most work sold at $150-500.

Media: Considers oil, acrylic, watercolor, pastel, pen & ink, drawing, sculpture and photography; all types of prints. Most frequently exhibits oil paintings, watercolors and woodblock prints.

Style: Exhibits: expressionism and neo-expressionism. Exhibits all genres. Prefers: western, expressionism and landscapes.

Terms: Accepts work on consignment (30% commission) or buys outright for 50% of retail price. Retail price set by the gallery and artist. Gallery provides promotion; shipping costs are shared. Prefers artwork framed.

Submissions: Call or write for appointment to show portfolio of photographs. Responds in 1 month. Finds artists through word of mouth, local art shows and ads in phone book.

Tips: "Don't bring in work in bad condition or unframed. Don't set exaggerated and unrealistic prices."

N CUSTER COUNTY ART & HERITAGE CENTER, Box 1284, Water Plant Rd., Miles City MT 59301. (406)232-0635. Fax: (406)232-0637. Website: www.ccac.milescity.org. **Executive Director:** Mark Browning. Nonprofit gallery. Estab. 1977. Interested in emerging and established artists. 90% of sales are to private collectors, 10% corporate clients. Sponsors 8 group shows/year. Average display time is 6 weeks. Overall price range: $200-10,000; most artwork sold at $300-500.

- The galleries are located in the former water-holding tanks of the Miles City WaterWorks. The underground, poured concrete structure is listed on the National Register of Historic Places. It was constructed in 1910 and 1924 and converted to its current use in 1976-77. 2003 recipient of Governor's Award for the Arts.

Media: Considers all media and original handpulled prints. Most frequently exhibits painting, sculpture and photography.

Style: Exhibits: painterly abstraction, conceptualism, primitivism, impressionism, expressionism, neo-expressionism and realism. Genres include landscapes, western, portraits and figurative work. "Our gallery is seeking artists working with traditional and non-traditional Western subjects in new, contemporary ways." Specializes in western, contemporary and traditional painting and sculpture.

Terms: Accepts work on consignment (30% commission). Retail price is set by gallery and artist. Exclusive area representation not required. Gallery provides insurance, promotion and contract; shipping expenses are shared.

Submissions: Send query letter, résumé, brochure, slides, photographs and SASE. Write for appointment to show portfolio of originals, "a statement of why the artist does what he/she does" and slides. Slides and résumé are filed.

N FAR WEST GALLERY, 2817 Montana Ave., Billings MT 59101. (406)245-2334. Fax: (406)245-0935. E-mail: farwest@180com.net. Website: wwwfarwestgallery.com. **Manager:** Sondra Daly. Retail gallery. Estab. 1994. Represents emerging, mid-career and established artists. Exhibited artists include Joe Beeler, Dave Powell, Kevin Red Star and Stan Natchez. Sponsors 4 shows/year. Average display time 6-12 months. Open all year; 9-6. Located in downtown historic district in a building built in 1910. Clientele: tourists. Overall price range: $1-9,500; most work sold at $300-700.

Media: Considers all media and all types of prints. Most frequently exhibits Native American beadwork, oil and craft/handbuilt furniture.

Style: Exhibits all styles. Genres include western and Americana. Prefers: Native American beadwork, western bits, spurs, memorabilia, oil, watercolor and pen & ink.

Terms: Buys outright for 50% of retail price. Retail price set by the gallery and the artist. Gallery provides insurance and promotion.

HARRIETTE'S GALLERY OF ART, 510 First Ave. N., Great Falls MT 59405. (406)761-0881. E-mail: harriette@msn.net. **Owner:** Harriette Stewart. Retail gallery. Estab. 1970. Represents 20 artists. Exhibited artists include: Larry Zabel, Frank Miller, Arthur Kober, Richard Luce and Susan Guy. Sponsors 1 show/year. Average display time 6 months. Open all year. Located downtown; 1,000 sq. ft. 100% of space for special exhibitions. 90% of sales are to private collectors, 10% corporate collectors. Overall price range: $100-10,000; most artwork sold at $200-750.

Media: Considers oil, acrylic, watercolor, pastel, pencils, pen & ink, mixed media, sculpture, original handpulled prints, lithographs and etchings. Most frequently exhibits watercolor, oil and pastel.

Style: Exhibits: expressionism. Genres include wildlife, landscape, floral and western.

Terms: Accepts work on consignment (33⅓% commission); or outright for 50% of retail price. Retail price set by gallery and artist. Sometimes offers customer discounts and payment by installment. Gallery provides promotion; "buyer pays for shipping costs." Prefers artwork framed.

Submissions: Send query letter with résumé, slides, brochure and photographs. Portfolio review requested if interested in artist's work. "Have Montana Room in the largest Western Auction in U.S.—The Charles Russell Auction, in March every year—looking for new artists to display."

Tips: "Proper framing is important."

HOCKADAY MUSEUM OF ART, 302 Second Ave. E., Kalispell MT 59901. (406)755-5268. Fax: (406)755-2023. E-mail: hockaday@aboutmontana.net. Website: www.hockadayartmuseum.org. **Executive**

Director: Linda Engh-Grady. Museum. Estab. 1968. Exhibits emerging, mid-career and established artists. Interested in seeing the work of emerging artists. 500 members. Exhibited artists include: Jeannie Hamilton, Russell Chatham, Ace Powell, Bud Helbig and David Shaner. Sponsors approximately 15 shows/year. Average display time 2 months. Open year round. Located 2 blocks from downtown retail area; 2,650 sq. ft.; historic 1906 Carnegie Library Building with new (1989) addition; wheelchair access to all of building. 50% of space for special exhibitions. Overall price range $500-35,000.

Media: Considers all media, plus woodcuts, wood engravings, linocuts, engravings, mezzotints, etchings, lithographs and serigraphs. Most frequently exhibits painting (all media), sculpture/installations (all media), photography and original prints.

Style: Exhibits all styles and genres. Prefers: art of Montana and Montana artists, historical art with special focus on the art of Glacier National Park and photographs and traveling exhibits.

Terms: Accepts work on consignment (33⅓% commission). Also houses permanent collection: Montana and regional artists acquired through donations. Sometimes offers customer discounts and payment by installment to museum members. Gallery provides insurance, promotion and contract; shipping costs are shared. Artwork must be framed and ready to hang. Featured artists in Off the Wall Gallery and other exhibits must be members of the museum.

Submissions: Send query letter with résumé, slides, bio, reviews and SASE. Portfolio should include b&w photographs and slides (20 maximum). "We review *all* submitted portfolios once a year, in spring." Finds artists through submissions and self-promotions.

Tips: "Present yourself and your work in the best possible professional manner. Art is a business. Make personal contact with the director, by phone or in person. You have to have enough work of a style or theme to carry the space. This will vary from place to place. You must plan for the space. A good rule to follow is to present 20 completed works that are relative to the size of space you are submitting to. As a museum whose mission is education we choose artists whose work brings a learning experience to the community."

N **INDIAN UPRISING GALLERY**, 25 S. Teacy, Bozeman MT 59715. (406)586-5831. Fax: (406)582-9848. E-mail: indianuprisinggallery@msn.com. Website: www.indianuprisinggallery.com. Retail gallery. Estab. 1991. Represents 75 emerging, mid-career and established artists/year. Exhibited artists include: Sam English, Bruce Contway, Rance Hood, Frank Shortey and Gale Running Wolf. Open all year, Tuesday-Friday; 10:30-5:30.

Media: Considers all media. Most frequently exhibits fine, contemporary and traditional tribal.

Style: Exhibits all styles and genres.

Terms: Accepts work on consignment (20% commission) or buys outright for 50% of retail price (net 30 days). Retail price set by the gallery. Gallery provides insurance, promotion and contract; shipping costs are shared. Prefers artwork framed.

Submissions: Accepts only Native American artists from northern US. Send résumé, slides, bio and artist's statement. Write for appointment to show portfolio of photographs. Responds in 2 weeks. Finds artists through visiting museums and art shows for Indian art.

N **JAILHOUSE GALLERY**, 218 Center Ave., Hardin MT 59034. (406)665-3239. Fax: (406)665-3220.

Director: Terry Jeffers. Nonprofit gallery. Estab. 1978. Represents 25 emerging, mid-career and established artists/year. Exhibited artists include Gale Running Wolf, Sr. and Mary Blain. Sponsors 9 shows/year. Average display time 6 weeks. Open all year; January-April; Tuesday-Friday, 10-5 (winter); May-December; Monday-Saturday, 9:30-5:30. Located downtown; 1,440 sq. ft. 75% space for special exhibitions; 25% of space for gallery artists. Clientele: all types. 95% private collectors, 5% corporate collectors. Overall price range: $20-2,000; most work sold at $20-500.

Media: Considers all media and all types of prints. Most frequently exhibits mixed media, watercolor and pen & ink.

Style: Exhibits all styles and all genres. Prefers: western, Native American and landscapes.

Terms: Accepts work on consignment (30% commission). Retail price set by the gallery. Gallery provides insurance, promotion and contract. Artist pays shipping costs.

Submissions: Send query letter with résumé, business card, artist's statement and bio. Call for appointment to show portfolio of photographs. Responds in 3 weeks. Finds artists through word of mouth, referrals by other artists, visiting art fairs and exhibitions and artists' submissions.

N **LIBERTY VILLAGE ARTS CENTER**, 400 S. Main, Chester MT 59522. Phone/fax: (406)759-5652.

Contact: Director. Nonprofit gallery. Estab. 1976. Represents 12-20 emerging, mid-career and established

artists/year. Sponsors 6-12 shows/year. Average display time 6-8 weeks. Open all year; Tuesday-Friday, 12:30-4:30. Located near a school; 1,000 sq. ft.; former Catholic Church. Clients include tourists and local community. 100% of sales are to private collectors. Overall price range: $100-2,500; most work sold at $250-500

Media: Considers all media; types of prints include woodcuts, lithographs, mezzotints, serigraphs, linocuts and pottery. Most frequently exhibits paintings in oil, water, acrylic, b&w photos and sculpture assemblages.

Style: Exhibits: Considers all styles. Prefers: contemporary and historic

Terms: Accepts work on consignment (30% commission) or buys outright for 40% of retail price. Retail price set by the gallery. Gallery provides insurance and promotion; shipping costs are shared. Prefers artwork framed or unframed.

Submissions: Send query letter with slides, bio and brochure. Portfolio should include slides. Responds only if interested within 1 year. Artists should cross us off their list. Files everything. Finds artists through word of mouth and seeing work at shows.

Tips: "Artists make the mistake of not giving us enough information and permission to pass information on to other galleries."

YELLOWSTONE GALLERY, 216 W. Park St., P.O. Box 472, Gardiner MT 59030. (406)848-7306. E-mail: jckahrs@aol.com. Website: yellowstonegallery.com. **Owner:** Jerry Kahrs. Retail gallery. Estab. 1985. Represents 20 emerging and mid-career artists/year. Exhibited artists include: Mary Blain and Nancy Glazier. Sponsors 2 shows/year. Average display time 2 months. Open all year; seasonal 7 days; winter, Tuesday-Saturday, 10-6. Located downtown; 3,000 sq. ft. new building. 25% of space for special exhibitions; 50% of space for gallery artists. Clientele: tourist and regional. 90% private collectors, 10% corporate collectors. Overall price range: $25-8,000; most work sold at $75-600.

Media: Considers oil, acrylic, watercolor, ceramics, craft and photography; types of prints include wood engravings, serigraphs, etchings and posters. Most frequently exhibits watercolors, oils and limited edition, signed and numbered reproductions.

Style: Exhibits: impressionism, photorealism and realism. Genres include western, wildlife and landscapes. Prefers: wildlife realism, western and watercolor impressionism.

Terms: Accepts work on consignment (45% commission). Retail price set by the artist. Gallery provides contract; artist pays for shipping. Prefers artwork framed.

Submissions: Send query letter with brochure or 10 slides. Write for appointment to show portfolio of photographs. Responds in 1 month. Files brochure and biography. Finds artists through word of mouth, regional fairs and exhibits, mail and periodicals.

Tips: "Don't show up unannounced without an appointment."

Nebraska

N **CARNEGIE ARTS CENTER**, P.O. Box 375, 204 W. Fourth St., Alliance NE 69301. (308)762-4571. Fax: (308)762-4571. E-mail: carnegieartscenter@bbc.net. Website: www.carnegieartscenter.com. **Contact:** Gretchen Garwood, director or Peggy Weber, assistant gallery director. Nonprofit gallery. Estab. 1993. Represents 300 emerging, mid-career and established artists/year. 350 members. Exhibited artists include: Liz Enyeart (functional pottery), Silas Kern (handblown glass). Sponsors 12 shows/year. Average display time 6 weeks. Open all year; Tuesday-Saturday, 10-4; Sunday, 1-4. Located downtown; 2,346 sq. ft.; renovated Carnegie library built in 1911. Clients include tourists, upscale, local community and students. 90% of sales are to private collectors, 10% corporate collectors. Overall price range: $10-2,000; most work sold at $10-300.

Media: Considers all media and all types of prints. Most frequently exhibits pottery, blown glass, 2-dimensional, acrylics, bronze sculpture, watercolor, oil and silver jewelry.

Style: Exhibits all styles and genres. Most frequently exhibits realism, modern realism, geometric, abstraction.

Terms: Accepts work on consignment (35% commission). Retail price set by the artist. Gallery provides promotion. Shipping costs negotiated. Prefers artwork framed.

Submissions: Accepts only quality work. Send query. Write for appointment to show portfolio review of photographs, slides or transparencies. Responds only if interested within 1 month. Files résumé and contracts. Finds artists through word of mouth, referrals by other artists, visiting art fairs and exhibitions and artist's submissions.

Tips: "Presentations must be clean, "new" quality, that is, ready to meet the public. Two-dimensional

artwork must be nicely framed with wire attached for hanging. Unframed prints need protective wrapping in place."

GALLERY 72, 2709 Leavenworth, Omaha NE 68105-2399. (402)345-3347. Fax: (402)348-1203. Website: gallery72@novia.net. **Director:** Robert D. Rogers. Retail gallery and art consultancy. Estab. 1972. Interested in emerging, mid-career and established artists. Represents 10 artists. Sponsors 4 solo and 4 group shows/year. Average display time is 3 weeks. Clients include individuals, museums and corporations. 75% of sales are to private collectors, 25% corporate clients. Overall price range: $750 and up.
Media: Considers oil, acrylic, digital, watercolor, pastel, pen & ink, drawings, mixed media, collage, sculpture, ceramic, installation, photography, original handpulled prints and posters. Most frequently exhibits paintings, prints and sculpture.
Style: Exhibits: hard-edge geometric abstraction, color field, minimalism, impressionism and realism. Genres include landscapes and figurative work. Most frequently exhibits color field/geometric, impressionism and realism.
Terms: Accepts work on consignment (commission varies), or buys outright. Retail price is set by gallery or artist. Gallery provides insurance; shipping costs and promotion are shared.
Submissions: Send query letter with résumé, slides and photographs. Call to schedule an appointment to show a portfolio, which should include originals, slides and transparencies. Vitae and slides are filed.
Tips: "It is best to call ahead and discuss whether there is any point in sending your material."

N HAYDON GALLERY, 335 N. Eighth St., Suite A, Lincoln NE 68508. (402)475-5421. Fax: (402)472-9185. E-mail: HaydonGallery@alltel.net. Website: www.haydongallery.org. **Director:** Teliza V. Rodriguez. Nonprofit gallery in support of regional artists and educational unit for the community. Estab. 1984. Exhibits 100 mid-career and established artists. Exhibited artists include: Karen Kunc, Jim Bockelman, Ernest Ochsner, Jane Pronko and Susan Puelz. Sponsors 12 shows/year. Average display time 1 month. Open Tuesday-Saturday, 10-5. Closed 1 week in August and 1 week in December. Contact gallery for exact dates. Located in Historic Haymarket District (downtown); 2,500 sq. ft. of exhibition space. Clients include collectors, corporate, residential, architects and interior designers. 75% of sales are to private collectors, 25% corporate collectors. Overall price range: $75-20,000; most work sold at $500-3,000.
Media: Considers all media of original artwork and original prints. Most frequently exhibits paintings, mixed media and original prints.
Style: Considers most styles. Exhibits: solo, 2 and 3 person, and group exhibitions in all genres ranging from landscapes to abstracts, still lifes and figurative work. Prefers: contemporary realism, nonrepresentational work in all styles.
Terms: Accepts work on consignment. Retail price set by gallery and artist. Offers customer discounts and payment by installments, if artist agrees to an installment plan. Gallery provides insurance, promotion, contract; artist pays for all shipping costs to and from the gallery, not including to client.
Submissions: Accepts primarily midwest artists. Send query letter with résumé, slides, reviews and SASE. Gallery will respond only if interested. If there is no interest, will return slides only if SASE is enclosed. Finds artists through submissions, regional educational programs, visiting openings and exhibitions, and news media.
Tips: "Professionalism and seriousness of artist and probability of a long-term working relationship is a must."

NOYES ART GALLERY, 119 S. 9th St., Lincoln NE 68508. (402)475-1061. E-mail: rnoyes1348@aol.com. Website: www.noyesart.com. **Director:** Julia Noyes. Nonprofit gallery. Estab. 1992. Exhibits 150 emerging artists. 175 members. Average display time 1 month minimum. (If mutually agreeable this may be extended or work exchanged.) Open all year. Located downtown, "near historic Haymarket District; 3093 sq. ft.; renovated 100-year-old building." 25% of space for special exhibitions. Clientele: private collectors, interior designers and decorators. 90% private collectors, 10% corporate collectors. Overall price range: $100-5,000; most work sold at $200-750.
Media: Considers oil, acrylic, watercolor, pastel, pen & ink, drawings, mixed media, collage, paper, sculpture, ceramic, fiber, glass and photography; original handpulled prints, woodcuts, wood engravings, linocuts, engravings, mezzotints, etchings, lithographs and serigraphs. Most frequently exhibits oil, watercolor and mixed media.
Style: Exhibits expressionism, neo-expressionism, impressionism, realism, photorealism. Genres include landscapes, florals, Americana, wildlife, figurative work. Prefers realism, expressionism, photorealism.
Terms: Accepts work on consignment (10-35% commission). Retail price set by artist (sometimes in

conference with director). Gallery provides promotion and contract; artist pays for shipping. Prefers artwork framed.

Submissions: Send query letter with résumé, slides, bio, SASE; label slides concerning size, medium, price, top, etc. Submit at least 6-8 slides. Reviews submissions monthly. Responds in 1 month. Files résumé, bio and slides of work by accepted artists (unless artist requests return of slides). All materials are returned to artists whose work is declined.

PERIOD GALLERY, 5607 Howard, Omaha NE 68106. (402)553-3272. E-mail: shows@periodgaller y.com. Website: www.periodgallery.com. **Contact:** Larry Bradshaw, curator. For-profit internet gallery. Estab. 1998. Approached by 13,000 artists/year. Represents 1,300 mid-career, established artists. Sponsors 22 exhibits/year. Average display time 1-2 years. Clients include local community, students, tourists, upscale. 75% of sales are to corporate collectors. Overall price range: $100-20,000; most work sold at more than $300.

Media: Considers all media. Most frequently exhibits acrylic, oil, mixed media. Considers all types of prints.

Style: Considers all styles. Most frequently exhibits post modernism, neo-expressionism, realism. Considers all genres.

Terms: There is a 30% commission. There is a rental fee for cyberspace. The rental fee covers over 1 year. Retail price of the art set by the artist. Gallery provides promotion, contract, representation. Does not require exclusive representation locally. No copies of originals.

Submissions: Mail portfolio and/or entry form from website for review. Send query letter with artist's statement, bio, brochure, résumé, reviews, slides. Returns material with SASE. Responds to queries in 2 weeks. Files all submitted—selected slides. Finds artists through art exhibits, portfolio reviews, referrals by other artists, submissions, word of mouth, Internet.

Tips: "Have professional slides with labeling of TOP, FRONT, TITLE, MEDIA, FRAMED DIMENSIONS—Height 1st × width 2nd × depth 3rd, SALES PRICE, DATE CREATED."

WAREHOUSE GALLERY, 381 N. Walnut St., Grand Island NE 68801. (308)382-8589. **Contact:** Alan E. Lienert. Retail gallery and custom framing. Estab. 1971. Represents 25-30 emerging artists/year. Exhibited artists include: Doug Johnson and Cindy Duff. Sponsors 3 shows/year. Average display time 1 month. Open all year; Monday-Friday, 10-5; Saturday, 10-3. Located in old downtown; 900 sq. ft.; old tin ceilings and skylights. 50% of space for special exhibitions. Clients include upscale and local community. Overall price range: $150-2,000; most work sold at $200-300.

Media: Considers oil, acrylic, watercolor, pastel, pen & ink, mixed media, collage, sculpture, ceramics, fiber, glass and photography; types of prints include woodcuts, wood engravings, serigraphs and linocuts. Most frequently exhibits watercolor, oil, acrylic and pastel.

Style: Exhibits: realism. Genres include florals and landscapes. Prefers: landscapes, florals and experimental.

Terms: Accepts work on consignment (40% commission). Retail price set by the artist. Gallery provides insurance, promotion and contract; artist pays for shipping. Prefers artwork framed.

Submissions: Accepts only artists from the Midwest. Send query letter with résumé, slides, photographs and SASE. Write for appointment to show portfolio of photographs or slides. Responds only if interested within 3 weeks. Finds artists through referrals by other artists, art fairs and exhibitions.

ADAM WHITNEY GALLERY, 8725 Shamrock Rd., Omaha NE 68114. (402)393-1051. **Manager:** Linda Campbell. Retail gallery. Estab. 1986. Represents 350 emerging, mid-career and established artists. Exhibited artists include: Richard Murray, Debra May, Dan Boylan, Ken and Kate Andersen, Scott Potter, Phil Hershberger and Brian Hirst. Average display time 3 months. Open all year; Monday-Saturday, 10-5. Located in countryside village; 5,500 sq. ft. 40% of space for special exhibitions. Overall price range: $150-10,000.

Media: Considers oil, paper, fiber, acrylic, sculpture, glass, watercolor, mixed media, ceramic, installation, pastel, collage, craft, jewelry. Most frequently exhibits glass, jewelry, 2-dimensional works.

Style: Exhibits all styles and genres.

Terms: Accepts work on consignment (50% commission). Retail price set by gallery and artist. Gallery provides insurance, promotion and contract; shipping costs are shared. Prefers artwork framed.

Submissions: Send query letter with résumé, slides, photographs and reviews. Call or write for appoint-

ment to show portfolio of originals, photographs and slides. Files résumé, slides, reviews.

Nevada

ART ENCOUNTER, 3979 Spring Mountain Rd., Las Vegas NV 89102. (702)227-0220. Fax: (702)227-3353. E-mail: rod@artencounter.com. Website: www.artencounter.com. **Director:** Rod Maly. Retail gallery. Estab. 1992. Represents 100 emerging and established artists/year. Exhibited artists include: Jennifer Main, Jan Harrison and Vance Larson. Sponsors 4 shows/year. Open all year; Tuesday-Friday, 10-6; Saturday and Monday, 12-5. Located near the famous Las Vegas strip; 8,000 sq. ft. 20% of space for special exhibitions; 80% of space for gallery artists. Clients include upscale tourists and locals. 95% of sales are to private collectors, 5% corporate collectors. Overall price range: $200-20,000; most work sold at $500-2,500.
Media: Considers all media and all types of prints. Most frequently exhibits watercolor, oil and acrylic.
Style: Exhibits all styles and genres.
Terms: Rental fee for space; covers 6 months. Retail price set by the gallery and artist. Gallery provides promotion and contract; artist pays for shipping. Prefers artwork framed.
Submissions: Send 5-10 slides, photographs and SASE. Write for appointment to show portfolio of photographs or slides. Responds only if interested within 2 weeks. Files artist bio and résumé. Finds artists by advertising in the *Artist's Magazine, American Artist,* art shows and word of mouth.
Tips: "Poor visuals and no SASE are common mistakes."

N **ARTIST'S CO-OP OF RENO**, 627 Mill St., Reno NV 89502. (775)322-8896. Cooperative nonprofit gallery. Estab. 1966. 20 emerging, mid-career and established artists. Sponsors 6 shows/year. Average display time 6 months. Exhibits 12 feature shows/year and quarterly all-gallery change of show. Open all year; Monday-Sunday, 11-4. Located downtown; 1,000 sq. ft. in historic, turn of century "French laundry" building. 10% of space for special exhibitions; 90% of space for gallery artists. Clients include tourists, upscale and local community. 90% of sales are to private collectors, 10% corporate collectors. Overall price range: $50-2,000.
Media: Considers all media. Most frequently exhibits watercolor, oil, mixed media and pottery.
Style: Exhibits: conceptualism, photorealism, color field, realism and imagism. Genres include western, landscapes, florals, wildlife, Americana, portraits, southwestern and figurative work. Prefers Nevada landscapes and Americana.
Terms: There is co-op membership fee plus a donation of time. There is a 15% commission. Retail price set by the artist. Gallery provides promotion. Artist pays for shipping costs from gallery. Prefers art framed.
Submissions: Accepts only artists from northern Nevada. Send query letter with résumé, slides, photographs, reviews and bio. Call for appointment to show portfolio. Finds artists through word of mouth and artists' visits.
Tips: "We limit our membership to 20 local artists so that each artist has ample display space."

N **CONTEMPORARY ARTS COLLECTIVE**, 101 E. Charlesten Blvd., Suite 101, Las Vegas NV 89104. (702)382-3886. Website: www.cac-lasvegas.org. **Acting President:** Diane Bush. Alternative space, nonprofit gallery. Estab. 1989. Represents emerging and mid-career artists, 250 members. Exhibited artists include: Mary Warner, Eric Murphy, Andy Wallace and Almond Zigmund. Sponsors 9 shows/year. Average display time 5 weeks. Open all year; Tuesday-Saturday, 12-4. Located downtown; 800 sq. ft. Clients include tourists, local community and students. 75% of sales are to private collectors, 25% corporate collectors. Overall price range: $250-2,000; most work sold at $400.
Media: Considers all media and all types of prints. Most frequently exhibits painting, photography and mixed media.
Style: Exhibits: conceptualism, group shows of contemporary fine art. Genres include all contemporary art/all media. Artist pays shipping costs. Prefers artwork ready for display. Finds artists through entries.
Tips: "We prioritize group shows that are self curated, or curated by outside curators. Groups need to be three to four artists or more. Annual guidelines are sent out in January for next coming year. We are looking for experimental and innovative work."

N **NEVADA MUSEUM OF ART**, 160 W. Liberty St., Reno NV 89501. (775)329-3333. Fax: (775)329-1541. E-mail: art@nma.reno.nv.us. Website: nevadaart.org. **Curator:** Diane Deming. Museum. Estab. 1931. Hosts 8-12 exhibitions/year. Average display time: 6-8 weeks. Open all year. Located downtown in

business district. 80% of space for special exhibitions. "NMA is a nonprofit private art museum. Museum curates individual and group exhibitions and has active acquisition policy related to the mission of the institution."

Media: Considers all media.

Style: Exhibits all styles and genres.

Terms: Acquires art "by committee following strict acquisition guidelines per the mission of the institution."

Submissions: Send query letter with slides. Write to schedule an appointment to show a portfolio.

[N] [I] GENE SPECK'S SILVER STATE GALLERY, 719 Plumas St., Reno NV 89509. (702)324-2323. Fax: (702)324-5425. **Owner:** Carolyn Barnes Wolfe. Retail gallery. Estab. 1989. Represents 10-15 emerging, mid-career and established artists/year. Exhibited artists include: Gene Speck and Mary Lee Fulkerson. Sponsors 15-20 shows/year. Average display time 2-4 weeks. Closed for the month of January. Open Tuesday-Saturday, 11-6. Located within walking distance of downtown; 700 sq. ft.; refurbished brick house from 1911, charming garden patio. 50% of space for special exhibitions; 50% of space for gallery artists. Clients include tourists, upscale, local community and students. 80% of sales are to private collectors, 20% corporate collectors. Overall price range $20-5,500; most work sold at $100-2,000.

Media: Considers oil, acrylic, watercolor, pastel, pen & ink, paper, ceramics, fiber, jewelry and glass. Most frequently exhibits oils, fiber and watercolor.

Style: Exhibits: realism. Genres include western, wildlife, southwestern, landscapes and Americana.

Terms: Accepts work on consignment (30% commission). Retail price set by the artist. Gallery provides insurance, promotion and contract. Shipping costs are shared. Prefers artwork framed.

Submissions: Accepts only local artists. Send query letter with résumé, brochure, slides, photographs, artist's statement and bio. Call or write for appointment to show portfolio of photographs. Responds only if interested within 3 weeks. Finds artists through word of mouth and referrals by other artists.

New Hampshire

[N] [I] DOWNTOWN ARTWORKS, 67 Main St., Plymouth NH 03264. Phone/fax: (603)536-8946. E-mail: dtaw@worldpath.net. **Manager:** Ruth Preston. Retail and nonprofit gallery. Estab. 1991. Represents 30 emerging artists/year. 30 members. Exhibited artists include: Cam Sinclair. Sponsors 10 shows/year. Average display time 3 weeks. Open all year; Monday-Friday, 9-5; Saturday, 9-2. Located downtown Plymouth; 600 sq. ft. 25% of space for special exhibitions; 25% of space for gallery artists. Clients include tourists and locals. Overall price range: $50-2,000; most work sold at $150-250.

Media: Considers all media and all types of prints (limited edition). Most frequently exhibits oil, watercolor and mixed.

Style: Exhibits: photorealism. Genres include florals, wildlife and landscapes. Prefers: landscapes, florals and wildlife.

Terms: Accepts work on consignment (35% commission). Retail price set by the artist. Gallery provides insurance, promotion, contract, patron's list and tax information; artist pays for shipping. Prefers artwork framed.

Submissions: Accepts only artists from New Hampshire. Send business card and artist's statement. Call for appointment to show portfolio of photographs. Responds in 1 month. Finds artists by going to exhibitions and shows.

Tips: "Work should not be poorly framed and artists should not be unsure of price range. Frame all pieces with quality to match your work."

MCGOWAN FINE ART, INC., 10 Hills Ave., Concord NH 03301. (603)225-2515. Fax: (603)225-7791. E-mail: art@mcgowanfineart.com. Website: www.mcgowanfineart.com. **Gallery Director:** Sarah Chaffee. Owner/Art Consultant: Mary McGowan. Retail gallery and art consultancy. Estab. 1980. Represents emerging, mid-career and established artists. Sponsors 8 shows/year. Average display time 1 month. Located just off Main Street. 50% of space for special exhibitions. Clients include residential and corporate. Most work sold at $125-9,000.

Media: Considers oil, acrylic, watercolor, pastel, mixed media, collage, works on paper, sculpture, woodcuts, wood engravings, linocuts, engravings, mezzotints, etchings, lithographs and serigraphs. Most frequently exhibits sculpture, watercolor and oil/acrylic.

Style: Exhibits: painterly abstraction, landscapes, etc.

Terms: Accepts work on consignment (50% commission). Retail price set by artist. Gallery provides insurance and promotion; negotiates payment of shipping costs. Prefers artwork unframed.

Submissions: Send query letter with résumé, 5-10 slides and bio. Responds in 1 month. Files materials.

Tips: "I am interested in the number of years you have been devoted to art. Are you committed? Do you show growth in your work?"

MILL BROOK GALLERY & SCULPTURE GARDEN, 236 Hopkinton Rd., Concord NH 03301. (603)226-2046. Website: www.themillbrookgallery.com. For-profit gallery. Estab. 1996. Exhibits over 70 emerging, mid-career and established artists. Exhibited artists include: John Bott (painter), Laurence Young (painter), John Lee (sculptor) and Wendy Klemperer (sculptor). Sponsors 7 exhibits/year. Average display time 6 weeks. Open Tuesday-Saturday, 11-5; April 1-December 24th. Otherwise, by appointment. Located 3 miles west of The Concord NH Center; surrounding gardens, field and pond; outdoor juried sculpture exhibit. Three rooms inside for exhibitions, 1,800 sq. ft. Clients include local community, tourists and upscale, 10% of sales are to corporate collectors. Overall price range: $80-30,000; most work sold at $500-1,000.

Media: Considers acrylic, ceramics, collage, drawing, glass, mixed media, oil, pastel, sculpture, watercolor, etchings, mezzotints, serigraphs and woodcuts. Most frequently exhibits oil, acrylic and pastel.

Style: Considers all styles. Most frequently exhibits color field/conceptualism, expressionism. Genres include landscapes. Prefers more contemporary art.

Terms: Artwork is accepted on consignment and there is a 50% commission. Retail price set by the artist. Gallery provides insurance, promotion and contract. Accepted work should be framed and matted.

Submissions: Call or write to show portfolio of photographs and slides. Send query letter with artist's statement, bio, photocopies, photographs, résumé, SASE and slides. Returns material with SASE. Responds in 1 month. Finds artists through word of mouth, submissions, art exhibits and referrals by other artists.

THE OLD PRINT BARN—ART GALLERY, P.O. Box 978, Winona Rd., Meredith NH 03253-0978. (603)279-6479. Fax: (603)279-1337. Website: www.nhada.org/prints.htm. **Director:** Sophia Lane. Retail gallery. Estab. 1976. Represents 100-200 mid-career and established artists/year. May be interested in seeing the work of emerging artists in the future. Exhibited artists include: Michael McCurdy, Ryland Loos and Joop Vegter. Sponsors 3-4 shows/year. Average display time 3-4 months. Open daily 10-5 (except Thanksgiving and Christmas Day). Located in the country; over 4,000 sq. ft.; remodeled antique 19th century barn. 30% of space for special exhibitions; 70% of space for gallery artists. Clients include tourists and local. 99% of sales are to private collectors. Overall price range: $10-30,000; most work sold at $200-900.

Media: Considers watercolor, pastel and drawing; types of prints include woodcuts, engravings, lithographs, mezzotints, serigraphs, linocuts and etchings. Most frequently exhibits etchings, engravings (antique), watercolors.

Style: Exhibits: color field, expressionism, postmodernism, realism. Most frequently exhibits color field, realism, postmodernism. Genres include florals, wildlife, landscapes and Americana.

Terms: Accepts work on consignment. Retail price set by the gallery and artist. Gallery provides promotion; shipping costs are shared. Prefers artwork unframed but shrink-wrapped with 1 inch on top for clips so work can hang without damage to image or mat.

Submissions: Prefers only works of art on paper. No abstract art. Send query letter with résumé, brochure, 10-12 slides and artist's statement. Title, medium and size of artwork must be indicated clearly on slide label. Call or write for appointment to show portfolio or photographs. Responds in a few weeks. Files query letter, statements, etc. Finds artists through word of mouth, referrals of other artists, visiting art fairs and exhibitions and submissions.

Tips: "Show your work to gallery owners in as many different regions as possible. Most gallery owners have a feeling of what will sell in their area. I certainly let artists know if I feel their images are not what will move in this area."

N SHARON ARTS CENTER, 457 Route 123, Sharon NH 03458. (603)924-7256. Fax: (603)924-6074. E-mail: sharonarts@sharonarts.org. Website: www.sharonarts.org. **Curator of Exhibits:** Randall Hoel. Nonprofit exhibition galleries and fine craft shop, 30 Grove St., Peterborough NH. (603)924-7676. Estab. 1947. Represents 7-9 invitationals, 140 juried, 210 members emerging, mid-career and established artists/year. 1,100 members. Sponsors 10 shows/year. Average display time 6 weeks. Open all year; Monday-Saturday, 10-5; Sunday, 12-5. School of Art and Crafts located in a woodland setting; 2,500 sq. ft. 80% of space for special exhibitions; 20% of space for member artists. Clients include tourist, local and

regional. 85% of sales are to private collectors, 15% corporate collectors. Overall price range: $200-10,000; most work sold at $500-1,000.

Media: Considers all media and all types of prints including computer generated. Most frequently exhibits fine arts, crafts and historical.

Style: Exhibits: expressionism, primitivism, realism, impressionism, abstract, still life, portraiture, painting, sculpture, glass, wood, tapestry, textiles, photography, collage, monoprint, jewelry, book arts. Exhibits all genres. Prefers: representation, impressionism and abstractions.

Terms: Accepts work on consignment (40% commission). Retail price set by the artist. Gallery provides insurance, promotion and contract; artist pays for shipping. Prefers artwork framed.

Submissions: Send query letter with résumé, slides, bio, photographs and reviews. Call for appointment to show portfolio of photographs or slides. Responds in 2 months. Files résumé, sample slides or photos. Send copies. Finds artists through visiting exhibitions, submissions and word of mouth.

Tips: "Artists shouldn't expect to exhibit right away. We plan exhibits 18 months in advance."

THORNE-SAGENDORPH ART GALLERY, Keene State College, Wyman Way, Keene NH 03435-3501. (603)358-2720. Website: www.keene.edu/tsag. **Director:** Maureen Ahern. Nonprofit gallery. Estab. 1965. Represents emerging, mid-career and established artists. 600 members. Exhibited artists include: Jules Olitski and Fritz Scholder. Sponsors 5 shows/year. Average display time 4-6 weeks. Open Monday-Saturday, 12-4; Thursday and Friday evenings till 7. Follows college schedule. Located on campus; 4,000 sq. ft.; climate control, security. 50% of space for special exhibitions. Clients include local community and students.

Media: Considers all media and all types of prints.

Style: Exhibits: Considers all styles.

Terms: Accepts work on consignment (40% commission). Retail price set by the artist. Gallery provides insurance, promotion and contract; shipping costs are shared. Prefers artwork framed.

Submissions: Artist's portfolio should include photographs and transparencies. Responds only if interested within 2 months. Files all material.

New Jersey

BARRON ARTS CENTER, 582 Rahway Ave., Woodbridge NJ 07095. (908)634-0413. **Director:** Stephen J. Kager. Nonprofit gallery. Estab. 1977. Interested in emerging, mid-career and established artists. Sponsors several solo and group shows/year. Average display time is 1 month. Clients include culturally minded individuals mainly from the central New Jersey region. 80% of sales are to private collectors, 20% corporate clients. Overall price range: $200-5,000.

Media: Considers oil, acrylic, watercolor, pastel, pen & ink, drawings, mixed media, collage, works on paper, sculpture, ceramic, craft, fiber, glass, installation, photography, performance and original handpulled prints. Most frequently exhibits acrylic, photography and mixed media.

Style: Exhibits: painterly abstraction, impressionism, photorealism, realism and surrealism. Genres include landscapes and figurative work. Prefers painterly abstraction, photorealism and realism.

Terms: Accepts work on consignment. Retail price set by artist. Exclusive area representation not required. Gallery provides insurance, promotion and contract; artist pays for shipping.

Submissions: Send query letter, résumé and slides. Call for appointment to show portfolio. Résumés and slides are filed.

Tips: Most common mistakes artists make in presenting their work are "improper matting and framing and poor quality slides. There's a trend toward exhibition of more affordable pieces—pieces in the lower end of price range."

MARY H. DANA WOMEN ARTISTS SERIES, Mabel Smith Douglass Library, Douglass College, New Brunswick NJ 08901-8527. (732)932-9407, ext. 26. Fax: (732)932-6667. E-mail: olin@rci.rutgers.edu. Website: www.libraries.rutgers.edu/rulib/abtlib/dglsslib/gen/events/was.htm. **Curator:** Dr. Ferris Olin. Alternative exhibition space for juried exhibitions of works by women artists. Estab. 1971. Represents/exhibits 4 emerging, mid-career and established artists/year. Interested in seeing the work of emerging artists. Sponsors 4 shows/year. Average display time 5-6 weeks. Open September-June; Monday-Sunday approximately 12 hours a day. Located on college campus in urban area; lobby-area of library. Clients include students, faculty and community.

Media: Considers all media.

Style: Exhibits all styles and genres.

Terms: Retail price by the artist. Gallery provides insurance, promotion and arranges transportation. Prefers artwork framed.

Submissions: Exhibitions are curated by invitation. Portfolio should include 5 slides. Finds artists through referrals.

N EXTENSION GALLERY, 60 Sculptors Way Extension, Mercerville NJ 08619. (609)890-7777. Fax: (609) 890-1816. **Gallery Director:** Gyuri Hollósy. Nonprofit gallery/alternative space. Estab. 1984. Represents 60 emerging, mid-career, established artists/year. Sponsors 11 exhibitions/year. Average display time: 1 month. Open all year; Monday-Thursday 10-4 p.m. 1400 sq. ft.; attached to the Johnson Atelier Technical Institute of Sculpture. 90% of space devoted to showing the work of gallery artists.

● Extension Gallery is a service-oriented space for Johnson Atelier members; all work is done inhouse by Atelier members, apprentices and staff.

Media: Considers oils, acrylics, watercolor, pastels, drawings, mixed media, sculpture and all types of prints. Most frequently exhibits sculpture and drawing.

Style: Considers all styles. Prefers contemporary sculpture. Most frequently exhibits realism, expressionism, conceptualism.

GALMAN LEPOW ASSOCIATES, INC., 1879 Old Cuthbert Rd., #12, Cherry Hill NJ 08034. (856)354-0771. **Contact:** Judith Lepow. Art consultancy. Estab. 1979. Represents emerging, mid-career and established artists. Open all year. 1% of sales are to private collectors, 99% corporate collectors. Overall price range: $300-20,000; most work sold at $500-5,000.

Media: Considers oil, acrylic, watercolor, pastel, mixed media, collage, paper, sculpture, ceramic, craft, fiber, glass, photography, original handpulled prints, woodcuts, engravings, lithographs, pochoir, wood engravings, mezzotints, linocuts, etchings, and serigraphs.

Style: Exhibits: painterly abstraction, impressionism, realism, photorealism, pattern painting and hard-edge geometric abstraction. Genres include landscapes, florals and figurative work.

Terms: Accepts artwork on consignment (40-50% commission). Retail price set by artist. Gallery provides insurance; shipping costs are shared. Prefers artwork unframed.

Submissions: Send query letter with résumé, slides and SASE. Call for appointment to show portfolio of originals, slides and transparencies. Responds in 3 weeks. Files "anything we feel we might ultimately show to a client."

DAVID GARY LTD. FINE ART, 158 Spring St., Millburn NJ 07041. (973)467-9240. Fax: (973)467-2435. **Director:** Steve Suskauer. Retail and wholesale gallery. Estab. 1971. Represents 17-20 mid-career and established artists. Exhibited artists include: John Talbot and Theo Raucher. Sponsors 3 shows/year. Average display time 3 weeks. Open all year. Located in the suburbs; 2,000 sq. ft.; high ceilings with sky lights. Clients include "upper income." 70% of sales are to private collectors, 30% corporate collectors. Overall price range: $250-25,000; most work sold at $1,000-15,000.

Media: Considers oil, acrylic, watercolor, drawings, sculpture, pastel, woodcuts, engravings, lithographs, wood engravings, mezzotints, linocuts, etchings and serigraphs. Most frequently exhibits oil, original graphics and sculpture.

Style: Exhibits: primitivism, painterly abstraction, surrealism, impressionism, realism and collage. All genres. Prefers impressionism, painterly abstraction and realism.

Terms: Accepts artwork on consignment (50% commission). Retail price set by gallery and artist. Gallery services vary; artist pays for shipping. Prefers artwork unframed.

Submissions: Send query letter with résumé, photographs and reviews. Call for appointment to show portfolio of originals, photographs and transparencies. Responds in 2 weeks. Files "what is interesting to gallery."

Tips: "Have a basic knowledge of how a gallery works, and understand that the gallery is a business."

N GROUNDS FOR SCULPTURE, 18 Fairgrounds Rd., Hamilton NJ 08619. E-mail: info@groundsforsculpture.org. Website: www.groundsforsculpture.com. **Contact:** Brooke Barrie, director/curator. Museum. Estab. 1992. Exhibits emerging, mid-career and established artists. Exhibited artists in the museum include Dale Chihuly (glass) and Beverly Pepper (cast iron, stone). Exhibited artists in the sculpture park include George Segal and Isaac Witkin (bronze). Sponsors 5-8 exhibits/year. Average display time 2-7 months. Open all year; Tuesday-Sunday, 10-9. Located in an industrial area in Hamilton, New Jersey-

centrally located between New York City and Philadelphia. 2-10,000 square feet museum buildings and 35 acre sculpture park.

Media: Considers sculpture. Most frequently exhibits stone, bronze, metals and mixed media.

Style: Most frequently exhibits all styles of contemporary sculpture.

Submissions: Only sculpture is considered/reviewed. Send query letter with artist's statement, bio, reviews, slides and exhibition catalogues. Does not return material. Keeps materials in artist registry. Responds to queries in 2 months. Files all materials in artist registry unless artist requests their return. Finds artists through art exhibits, portfolio reviews and referrals by other artists and art reps.

N KEARON-HEMPENSTALL GALLERY, 536 Bergen Ave., Jersey City NJ 07304. (201)333-8855. Fax: (201)333-8488. E-mail: suzann@khgallery.com. Website: www.khgallery.com. **Director:** Suzann Anderson. Retail gallery. Estab. 1981. Represents emerging, mid-career and established artists. Exhibited artists include: Dong Sik-Lee, Mary Buondies, Jesus Rivera, Stan Mullins, Linda Marchand, Stephen McKenzie, Elizabeth Bisbing and Kamil Kubik. Sponsors 3 shows/year. Average display time 2 months. Open all year; Monday-Friday, 10-3; closed July and August. Located on a major commercial street; 150 sq. ft.; brownstone main floor, ribbon parquet floors, 14 ft. ceilings, ornate moldings, traditional. 100% of space for special exhibitions. Clients include local community and corporate. 60% of sales are to private collectors, 40% corporate collectors. Overall price range: $200-8,000; most work sold at $1,500-2,500.

Media: Considers oil, acrylic, watercolor, pastel, drawing, mixed media, collage, paper, sculpture, fiber, glass, installation, photography, engravings, lithographs, serigraphs, etchings and posters. Most frequently exhibits mixed media painting, photography and sculpture.

Style: Prefers figurative expressionism and realism.

Terms: Accepts work on consignment (50% commission). Retail price set by the gallery. Gallery provides promotion; artist pays for shipping. Prefers artwork framed.

Submissions: Send query letter with résumé, slides, bio, brochure, SASE, reviews, artist's statement, price list of sold work. Write for appointment to show portfolio of photographs and slides. Responds in 6 weeks. Files slides and résumés. Finds artists through art exhibitions, magazines (trade), submissions.

Tips: "View gallery website for artist requirements."

N KERYGMA GALLERY, 38 Oak St., Ridgewood NJ 07450. (201)444-5510. Gallery Directors: Ron and Vi Huse. Retail gallery. Estab. 1988. Represents 30 mid-career artists. Sponsors 9 shows/year. Average display time 4-6 weeks. Open all year. Located in downtown business district; 2,000 sq. ft.; "professionally designed contemporary interior with classical Greek motif accents." Clientele: primarily residential, some corporate. 80-85% private collectors, 15-20% corporate collectors. Most work sold at $2,000-5,000.

Media: Considers oil, acrylic, watercolor, pastel, mixed media, sculpture. Prefers oil or acrylic on canvas.

Style: Exhibits painterly abstraction, impressionism and realism. Genres include landscapes, florals, still life and figurative work. Prefers impressionism and realism.

Terms: Accepts artwork on consignment (50% commission). Retail price set by gallery and artist. Gallery provides insurance, promotion and in some cases, a contract; shipping costs are shared.

Submissions: Send query letter with résumé, slides, bio, photographs, reviews and SASE. Call for appointment to show portfolio originals, photographs and slides "only after interest is expressed by slide/photo review." Responds in 1 month. Files all written information, returns slides/photos.

Tips: "An appointment is essential—as is a slide register."

LIMITED EDITIONS & COLLECTIBLES, 697 Haddon, Collingswood NJ 08108. (856)869-5228. Fax: (856)933-2053. E-mail: fhotowiz@msn.com. Website: www.LTDeditions.net. **Owner:** John Daniel Lynch, Sr. For profit gallery. Estab. 1997. Approached by 24 artists/year. Exhibited artists include: Richard Montmurro, James Allen Flood and Gino Hollander. Open all year. Located in downtown Collingswood; 700 sq. ft. Overall price range: $190-20,000; most work sold at $450.

Media: Considers all media and all types of prints. Most frequently exhibits acrylic, watercolors and oil.

Style: Considers all styles and genres.

Terms: Artwork is accepted on consignment and there is a 30% commission. Retail price set by the artist. Gallery provides insurance, promotion and contract. Accepted work should be framed, mounted and matted. Does not require exclusive representation locally.

Submissions: Call or write to arrange a personal interview to show portfolio. Send query letter with bio, business card and résumé. Responds in 1 month. Finds artists through word of mouth, portfolio reviews, art exhibits, and referrals by other artists.

MARKEIM ART CENTER, Lincoln Ave. and Walnut St., Haddonfield NJ 08033. Phone/fax: (856)429-8585. E-mail: markeimartcenter@msn.com. Website: www.markeim.org. **Center Manager:** Lisa Hamill. Nonprofit gallery. Estab. 1956. Represents emerging, mid-career and established artists. 150 members. Exhibited artists include Ben Cohen and Steve Kuzma. Sponsors 8-10 shows/year, both on and off site. Average display time 1 month. Open all year; Monday-Thursday, 10-4; Friday-Saturday, 11-1. Located downtown; 600 sq. ft. 75% of space for special exhibitions; 20% of space for gallery artists. Overall price range: $100-2,000.
Media: Considers all media. Must be original. Most frequently exhibits paintings, photography and sculpture.
Style: Exhibits all styles and genres.
Terms: Work not required to be for sale (20% commission taken if sold.) Retail price set by the artist. Gallery provides promotion and contract. Artwork must be ready to hang.
Submissions: Send query letter with résumé, slides, bio/brochure, photographs, SASE, business card, reviews and artist's statement. Write for appointment to show portfolio of photographs and slides. Files slide registry.

THE NOYES MUSEUM OF ART, Lily Lake Rd., Oceanville NJ 08231. (609)652-8848. Fax: (609)652-6166. Website: www.noyesmuseum.org. **Curator of Collections and Exhibitions:** A.M. Weaver. Museum. Estab. 1983. Exhibits emerging, mid-career and established artists. Sponsors 9-12 shows/year. Average display time 6 weeks to 3 months. Open all year; Tuesday-Saturday, 10-4:30; Sunday, 12-5. 9,000 sq. ft.; "modern, window-filled building successfully integrating art and nature; terraced interior central space with glass wall at bottom overlooking Lily Lake." 75% of space for special exhibitions. Clients include rural, suburban, urban mix; high percentage of out-of-state vacationers during summer months.
Media: All types of American fine art, craft and folk art.
Style: Exhibits all styles and genres.
Submissions: Send query letter with résumé, slides, photographs and SASE. "Letter of inquiry must be sent; then museum will set up portfolio review if interested." Portfolio should include slides. "Materials only kept on premises if artist is from New Jersey and wishes to be included in New Jersey Artists Resource File or if artist is selected for inclusion in future exhibitions."

PIERRO GALLERY OF SOUTH ORANGE, (formerly The Gallery of South Orange), Baird Center, 5 Mead St., S. Orange NJ 07079. (973)378-7755, ext. 3. Fax: (973)378-7833. E-mail: goso1@aol.com. Website: community.nj.com/cc/sogallery. **Director:** Judy Wukitsch. Nonprofit gallery. Estab. 1994. Approached by 75-185 artists/year. Exhitits 75-100 emerging, mid-career and established artists. Sponsors 6 openings, number of exhibits within each time slot varies. Average display time 6 weeks. Open all year; Wednesday-Thursday, 10-2 and 4-6; weekends, 1-4. Closed Mid-December through mid-January; August. Located in park setting, 100 year old building; 3 rooms from intimate to large on second floor with wrap-around porch for receptions. Artists enjoy the quality of exhibition space and professionalism of staff. Visitors include students, upscale and artists. "As nonprofit we are not sales driven."
Media: Considers all media and prints, except posters–must be original works. Most frequently exhibits painting, mixed media/collage/sculpture.
Style: Considers all styles and genres.
Terms: Artwork is accepted on consignment and there is a 15% commission. Retail price set by the artist. Gallery provides insurance, promotion and contract. Accepted work should be framed. Does not require exclusive representation locally.
Submissions: Mail portfolio for review. PGOSO has 3 portfolio reviews per year: January, June and October. Send query letter with artist's statement, résumé, slides and any other items they choose. Returns material with SASE. Responds in 2 months from review date. Accepted portfolios go in active file from which all exhibitions are curated. Finds artists through word of mouth, submissions, portfolio reviews and referrals by other artists.
Tips: Send legible, clearly defined, properly identified slides.

N: POLO GALLERY, Fort Lee NJ 07020. (201)945-8200. Fax: (201)224-0150. **Director:** Mark A. Polo. Retail gallery, art consultancy. Estab. 1993. Represents 250 emerging, mid-career and established artists/year. Exhibited artists include: Christian Hal, Itzak Benshalom, Alice Harrison, Tobias Weissman, Judy Lyons Schneider, Jim Wilson and Ross Brown. Clients include tourists-passersby, private clientele, all economic strata. 90% of sales are to private collectors, 10% corporate collectors. Overall price range: $80-18,000; most work sold at $350-4,000.

Media: Considers all media and all types of prints. Most frequently exhibits oil, sculpture, works on paper.
Style: Exhibits all styles and genres. Prefers realism, painterly abstraction, conceptual.
Terms: Accepts work on consignment (50% commission). Retail price set by the gallery and the artist. Gallery provides promotion and contract; artist pays for shipping or costs are shared.
Submissions: Send query letter with résumé slides, bio, artist's statement, assumed price list. Call or write for appointment to show portfolio of slides and b&w prints for newspapers. Responds in 2 months. Artist should call if no contact. Files future show possibilities.
Tips: Common mistakes artists make are not labeling slides, not including price list, and sending slides of unavailable work.

☑ SERAPHIM FINE ARTS GALLERY, Dept. AM, 19 Engle St., Tenafly NJ 07670. (201)568-4432. **Directors:** E. Bruck and M. Lipton. Retail gallery. Represents 150 emerging, mid-career and established artists. 90% of sales are to private collectors, 10% corporate clients. Overall price range: $700-20,000; most work sold at $2,000-5,000.
Media: Considers oil, acrylic, watercolor, drawings, collage, sculpture and ceramic. Most frequently exhibits oil, acrylic and sculpture.
Style: Exhibits: impressionism, realism, painterly abstraction and conceptualism. Considers all genres. Prefers impressionism, realism and figure painting. "We are located in New Jersey, but we function as a New York gallery. We put together shows of artists who are unique. We represent fine contemporary artists and sculptors."
Terms: Accepts work on consignment. Retail price set by gallery and artist. Exclusive area representation required. Gallery provides insurance and promotion. Prefers framed artwork.
Submissions: Send query letter with résumé, slides and photographs. Portfolio should include originals, slides and photographs. Responds in 1 month. Files slides and bios.
Tips: Looking for "artistic integrity, creativity and an artistic ability to express self." Notices a "return to interest in figurative work."

BEN SHAHN GALLERIES, William Paterson University, 300 Pompton Rd, Wayne NJ 07470. (973)720-2654. E-mail: universitygalleries@wpunj.edu. Website: www.wpunj.edu. **Director:** Nancy Einreinhofer. Nonprofit gallery. Estab. 1968. Interested in emerging and established artists. Sponsors 5 solo and 10 group shows/year. Average display time is 6 weeks. Clients include college, local and New Jersey metropolitan-area community.
 ● The gallery specializes in contemporary art and encourages site-specific installations. They also have a significant public sculpture collection and welcome proposals.
Media: Considers all media.
Style: Specializes in contemporary and historic styles, but will consider all styles.
Terms: Accepts work for exhibition only. Gallery provides insurance, promotion and contract; shipping costs are shared.
Submissions: Send query letter with résumé, brochure, slides, photographs and SASE. Write for appointment to show portfolio. Finds artists through submissions, referrals and exhibits.

TRENTON CITY MUSEUM, 319 E. State St., Trenton NJ 08608. (609)989-3632. Fax: (609)989-3624. E-mail: bhill@ellarslie.org. Website: www.ellarslie.org. **Contact:** Brian O. Hill, director. Located in historic Cadwalader Park, a Frederick Law Olmsted Park, owned and maintained by City of Trenton, Douglas H. Palmer, Mayor. Museum and retail shop. Estab. 1974. Approached by 175 artists/year. Exhibits emerging, mid-career and established artists. Exhibited artists include: Tom Malloy (watercolor), Wendell Brooks (printmaker), Gabrielle Roos (sculpture) and Marge Chavooshian (watercolor). Sponsors 8 exhibits/year. Average display time 50 days. Open all year; Tuesday-Saturday, 11-3; Sunday, 1-4. Located in historic house (1848) with 4 galleries, 2,096 sq. ft. Clients include community, students and greater Trenton area. Overall price range: $5,000-12,000; most work sold at $400-2,000.
Media: Considers most media, NO installations, most types of prints and sculpture. Most frequently exhibits acrylic, oil, watercolor and sculpture.
Style: Considers all styles and genres.
Terms: Artwork is accepted on consignment and there is a 30% commission. Retail price set by the artist. Museum provides insurance, promotion and contract. Accepted work should be framed, mounted and matted where appropriate. Director reserves the right to refuse any work for any reason. Does not require exclusive representation locally.
Submissions: Mail portfolio for review. Send artist's statement, bio, photographs, SASE and slides.

Returns material with SASE. Responds only if interested within 2 months. Finds artists through annual Ellarslie Open which takes place in the spring of each year and word-of-mouth.

N WALKER-KORNBLUTH ART GALLERY, 7-21 Fair Lawn Ave., Fair Lawn NJ 07410. (201)791-3374. **Director:** Sally Walker. Retail gallery. Estab. 1965. Represents 20 mid-career and established artists/year. Exhibited artists include Stuart Shils, Larry Horowitz and Richard Segalman. Sponsors 8 shows/year. Open Tuesday-Saturday, 10-5:30; Sunday, 1-5; closed August. 2,000 sq. ft., 1920's building (brick), 2 very large display windows. 75% of space for special exhibitions; 25% of space for gallery artists. Clientele: mostly professional and business people. 85% private collectors, 15% corporate collectors. Overall price range: $400-45,000; most work sold at $1,000-4,000.
Media: Considers all media except installation. Considers all types of original prints (no limited edition prints). Most frequently exhibits oil, watercolor, pastel and monoprints.
Style: Exhibits: painterly abstraction, impressionism, realism, landscapes, figurative work. Prefers painterly realism, impressionism.
Terms: Accepts work on consignment (40-50% commission). Retail price set by the gallery and the artist. Gallery provides insurance and promotion; shipping costs are shared. Prefers artwork framed.
Submissions: "We don't usually show local artists." Send query letter with résumé, slides, reviews and SASE. Write for appointment to show portfolio of transparencies and slides. Files slides. Finds artists through word of mouth, referrals by other artists, visiting exhibitions and submissions.
Tips: "If you've never shown in a commercial gallery, please don't send slides. Have some idea of the kind of work we show; submitting inappropriate work is a waste of everyone's time."

New Mexico

THE ALBUQUERQUE MUSEUM, 2000 Mountain Rd. NW, Albuquerque NM 87104. (505)243-7255. **Curator of Art:** Ellen Landis. Nonprofit museum. Estab. 1967. Interested in emerging, mid-career and established artists. Sponsors mostly group shows. Average display time is 3-6 months. Located in Old Town (near downtown).
Media: Considers all media.
Style: Exhibits all styles. Genres include landscapes, florals, Americana, western, portraits, figurative and nonobjective work. "Our shows are from our permanent collection or are special traveling exhibitions originated by our staff. We also host special traveling exhibitions originated by other museums or exhibition services."
Submissions: Send query letter, résumé, slides, photographs and SASE. Call or write for appointment to show portfolio.
Tips: "Artists should leave slides and biographical information in order to give us a reference point for future work or to allow future consideration."

N ART CENTER AT FULLER LODGE, 2132 Central Ave., Los Alamos NM 87544. (505)662-9331. Website: www.artfulnm.org. **Director:** Gloria Gilmore-House. Nonprofit gallery and retail shop for members. Estab. 1977. 388 members. Sponsors 9 shows/year. Average display time 5 weeks. Open all year. Located downtown; 3,400 sq. ft. 90% of space for special exhibitions. Clients include local, regional and international visitors. 99% of sales are to private collectors, 1% corporate collectors. Overall price range: $50-1,200; most artwork sold at $30-300.
Media: Considers all media.
Style: Exhibits all styles and genres.
Terms: Accepts work by member artists on consignment (30% commission). Retail price set by the artist. Gallery provides insurance and promotion; artist pays for shipping. "Work should be in exhibition form (ready to hang)."
Submissions: "Prefer the unique." Send query letter with résumé, slides, bio, brochure, photographs, SASE and reviews. Files "résumés, etc.; slides returned only by SASE."
Tips: "We put on juried competitions, guild exhibitions and special shows throughout the year. Send SASE for prospectus and entry forms."

BENT GALLERY AND MUSEUM, 117 Bent St., Box 153, Taos NM 87571. (505)758-2376. **Owner:** Faye Noeding. Retail gallery and museum. Estab. 1961. Represents 15 emerging, mid-career and established artists. Exhibited artists include E. Martin Hennings, Charles Berninghaus, C.J. Chadwell and Leal Mack.

Open all year. Located 1 block off of the Plaza; "in the home of Charles Bent, the first territorial governor of New Mexico." 95% of sales are to private collectors, 5% corporate collectors. Overall price range: $100-10,000; most work sold at $500-1,000.

Media: Considers oil, acrylic, watercolor, pastel, pen & ink, drawings, sculpture, original handpulled prints, woodcuts, engravings and lithographs.

Style: Exhibits: impressionism and realism. Genres include traditional, landscapes, florals, southwestern and western. Prefers: impressionism, landscapes and western works. "We continue to be interested in collectors' art: deceased Taos artists and founders' works."

Terms: Accepts work on consignment (33⅓-50% commission). Retail price set by gallery and artist. Artist pays for shipping. Prefers artwork framed.

Submissions: Send query letter with brochure and photographs. Write for appointment to show portfolio of originals and photographs. Responds if applicable.

Tips: "It is best if the artist comes in person with examples of his or her work."

FENIX GALLERY, 228-B N. Pueblo Rd., Taos NM 87571. Phone/Fax: (505)758-9120. E-mail: jkendall@fenixgallery.com. Website: www.fenixgallery.com. **Director/Owner:** Judith B. Kendall. Retail gallery. Estab. 1989. Represents 18 emerging, mid-career and established artists/year. Exhibited artists include Alyce Frank and Earl Stroh. Sponsors 4 shows/year. Average display time 4-6 weeks. Open all year; daily, 10-5; Sunday, 12-5; closed Wednesday; by appointment only during winter months. Located on the main road through Taos; 2,000 sq. ft.; minimal hangings; clean, open space. 100% of space for special exhibitions during one-person shows; 50% of space for gallery artists during group exhibitions. Clientele: experienced and new collectors. 90% private collectors, 10% corporate collectors. Overall price range: $100-25,000; most work sold at $1,000-2,500.

• The Fenix Gallery has doubled its exhibition space.

Media: Considers all media; primarily non-representational, all types of prints except posters. Most frequently exhibits oil, sculpture and paper work/ceramics.

Style: Exhibits expressionism, painterly abstraction, conceptualism, minimalism and postmodern works. Prefers: conceptualism, expressionism and abstraction.

Terms: Accepts work on consignment (50% commission). Retail price set by the artist or a collaboration. Gallery provides insurance, promotion and contract; artist pays shipping costs to and from gallery. Prefers artwork framed.

Submissions: Prefers artists from area; "we do very little shipping of artist works." Send query letter with résumé, slides, bio, brochure, photographs, SASE, business card and reviews. Call for appointment to show portfolio of photographs. Responds in 3 weeks. Files "material I may wish to consider later—otherwise it is returned." Finds artists through personal contacts, exhibitions, studio visits, reputation regionally or nationally.

Tips: "I rely on my experience and whether I feel conviction for the art and whether sincerity is present."

516 MAGNIFICO ARTSPACE, 516 Central SW, Albuquerque NM 87102. (505)242-8244. Fax: (505)242-0174. E-mail: melody@magnifico.org. Website: www.magnifico.org. **Executive Director:** Suzanne Sbarge. Associate Director: Melody Mock. Alternative space, nonprofit. Estab. 1999. Approached by 100 artists/year. Sponsors 10 exhibits/year. Average display time 1 month. Open all year; Tuesday-Saturday, 12-5. Closed between exhibitions. Located in downtown Albuquerque; features track lighting, cement floors and is 3,000 sq. ft. total; handicap accessible; approximately 90 ft. deep and 22 ft. wide, the east wall has 3 divider panels which divide the space into 4 areas; the front section is 2 stories high and lit by north facing glasswall. Overall price range: $300-3,000.

Media: Considers all media. Most frequently exhibits painting, photography and sculpture. Considers all types of prints except posters.

Style: Considers all styles.

Terms: Retail price set by the artist. Gallery provides insurance and contract. Requests 50% commission of works sold.

Submissions: Call or visit website for proposal information and entry form. Exhibition proposals are reviewed by committee. Returns material with SASE. Responds in 1 month after the visual arts advisory committee meets. Files all selected materials; if not selected we will file the proposal and résumé. Finds artists through submissions, and proposals to gallery and referrals from our committee.

Tips: "Call for submission information and send only the required information. Write a specific and detailed proposal for the exhibition space. Do not send unsolicited materials, or portfolio, without the

application materials from the gallery. Please call if you have questions about the application or your proposal."

N GALLERY A, 105-107 Kit Carson, Taos NM 87571. (505)758-2343. E-mail: gallery@gallerya.com. Website: www.gallerya.com. **Owners:** Gene and Jules Sanchez. Director: Jules Sanchez. Retail gallery. Estab. 1960. Represents 40 emerging, mid-career and established artists. Exhibited artists include Gene Kloss and Fran Larsen. Sponsors 3-6 shows/year. Average display time 2 weeks. Open all year. Located one block from the plaza; 4,000 sq. ft. Clientele: "from all walks of life." 98% private collectors. Overall price range: $400-25,000; most artwork sold at $1,500-5,000.
Media: Considers oil, acrylic, watercolor, pastel, sculpture—bronze, stone or wood. Most frequently exhibits oil, pastels, watercolor and acrylic.
Style: Exhibits traditional and contemporary.
Terms: Accepts work on consignment (50% commission). Retail price set by artist. Sometimes offers customer discount and payment by installment. Gallery and artist provide promotion; artist pays for shipping. Expects artwork framed.
Submissions: Send query letter with bio and photographs. Responds only if interested. Portfolio review not required. Files bios. Finds artists through artists' submissions. Artist must include SASE for return of submitted material.

✓ THE HARWOOD MUSEUM OF ART, 238 Ledoux St., Taos NM 87571-6004. (505)758-9826. Fax: (505)758-1475. E-mail: harwood@unm.edu. **Contact:** Charles Lovell or David Witt, curator. Museum. Estab. 1923. Approached by 100 artists/year. Represents more than 200 emerging, mid-career and established artists. Exhibited artists include: Agnes Martin (painting) and Chuck Close (painting). Sponsors 10 exhibits/year. Average display time 2 months. Open all year; Tuesday-Saturday, 10-5; Sunday, 1-5. Consists of 7 galleries, 2 of changing exhibitions. Clients include local community, students and tourists. 1% of sales are to corporate collectors. Overall price range: $5,000-10,000; most work sold at $2,000.
Media: Considers all media and all types of prints.
Style: Considers all styles and genres.
Terms: Artwork is accepted on consignment and there is a 25% commission. Retail price set by the artist. Gallery provides insurance and contract. Accepted work should be framed, mounted and matted. Does not require exclusive representation locally.
Submissions: Mail portfolio for review. Send query letter with artist's statement, bio, brochure, résumé, reviews, SASE and slides. Responds in 3 months. Returns slides. Files everything else. Finds artists through word of mouth, submissions, art exhibits and referrals by other artists.
Tips: Professional presentation and quality work are imperative.

N IAC CONTEMPORARY ART, POB 21426, Albuquerque NM 87154-1426. (505)292-3675. E-mail: rs1@swcp.com. Website: www.iac1.freeservers.com. **Art Consultant/Broker:** Michael F. Herrmann. Estab. 1992. Represents emerging, mid-career and established local artists from website. Coordinates studio visits for small groups and individuals. Represented artists include Michelle Cook and Vincent Distasio. Overall price range: $250-40,000; most work sold at $800-7,000.
Media: Considers all media.
Style: Represents painterly abstraction, postmodern works and surrealism. Genres include figurative work.
Terms: Retail price set by collaborative agreement with artist.
Submissions: Send query letter with résumé, brochure, business card, slides, photographs, reviews, bio and SASE. Call or write for appointment to show portfolio. Responds in 1 month.
Tips: "I characterize the work we represent as Fine Art for the *Non*-McMainstream. We are always interested in seeing new work. We look for a strong body of work and when considering emerging artists we inquire about the artist's willingness to financially commit to their promotion. We prefer a website rather than slides. When sending slides, always include a SASE."

N CHARLOTTE JACKSON FINE ART, 200 W. Marcy St., #101, Santa Fe NM 87501. (505)989-8688. Fax: (505)989-9898. E-mail: cgjart@aol.com. Webiste: www.charlottejackson.com. **Contact:** Charlotte Jackson, director. For-profit gallery. Estab. 1989. Approached by 50 artists/year; exhibits 25 emerging, mid-career and established artists/year. Exhibited artists include Joseph Marioni and Florence Pierce. Sponsors 12 exhibits/year. Average display time 3-4 weeks. Open all year; Tuesday-Friday, 10-5:30; Saturday, 11-4. Located in 2 exhibition spaces and offices. Clients include local community and upscale.

Media: Considers acrylic, drawing, oil and watercolor. Reductive work only. Emphasis on monochrome painting.

Style: Exhibits reductive style.

Terms: Retail price of the art set by the artist. Gallery provides promotion. Requires exclusive representation locally. Prefers only reductive and monochrome.

Submissions: Mail portfolio for review or send query letter with bio, photographs, SASE and slides. Returns material with SASE. Responds to queries in 6 months.

JONSON GALLERY, UNIVERSITY OF NEW MEXICO, 1909 Las Lomas NE, Albuquerque NM 87131-1416. (505)277-4967. Fax: (505)277-3188. E-mail: jonsong@unm.edu. Website: www.unm.edu/~jonsong/. **Contact:** Robert Ware, curator. Alternative space, museum and nonprofit gallery. Estab. 1950. Approached by 20-30 artists/year. Represents emerging and mid-career artists. Exhibited artists include: Raymond Jonson (oil/acrylic on canvas/masonite). Sponsors 6-8 exhibits/year. Average display time 6 weeks. Open Tuesday-Friday, 9-4. Closed Christmas through New Years. Clients include local community, students and tourists. Overall price range: $150-15,000; most work sold at $3,000-4,000.

Media: Considers all media.

Style: Exhibits: conceptualism, geometric abstraction, minimalism and postmodernism. Most frequently exhibits conceptual, postmodernism and geometric abstraction.

Terms: Artwork is accepted on consignment and there is a 25% commission. Retail price set by dealer. Gallery provides insurance and promotion. Accepted work should be ready for display. Does not require exclusive representation locally.

Submissions: Write to arrange a personal interview to show portfolio of photographs, slides, transparencies and originals. Send query letter with artist's statement, bio, brochure, business card, photocopies, photographs, résumé, reviews, SASE and slides. Responds in 1 week. Files slides, bios, CVs, reviews of artists' works in exhibitions. Finds artists through word of mouth, submissions, art exhibits and referrals by other artists.

Tips: Submit a viable exhibition proposal.

[N] MARGEAUX KURTIE MODERN ART, 2865 State Hwy. 14, Madrid NM 87010. (505)473-2250. E-mail: mkmamadrid@att.net. Website: www.mkmamadrid.com. **Contact:** Jill Alikas St. Thomas, director. Art consultancy. Estab. 1996. Approached by 200 artists/year. Represents 13 emerging, mid-career and established artists. Exhibited artists include: Thomas St. Thomas, mixed media painting and sculpture; Gary Groves, color infrared film photography. Sponsors 8 exhibits/year. Average display time 5 weeks. Open Thursday-Tuesday, 11-5. Closed February. Located within a historical mining town 35 miles outside of Santa Fe NM, 1,020 sq. ft., 7 ft. ceilings, hardwood floors. Clients include local community, students and tourists. 5% of sales are to corporate collectors. Overall price range: $350-15,000; most work sold at $2,800.

Media: Considers acrylic, glass, mixed media, paper, sculpture. Most frequently exhibits acrylic on canvas, oil on canvas, photography.

Style: Exhibits: conceptualism, pattern painting. Most frequently exhibits narrative/whimsical, pattern painting, illussionistic. Genres include figurative work, florals.

Terms: Artwork is accepted on consignment and there is a 50% commission. Retail price set by the gallery. Gallery provides insurance. Accepted work should be framed, mounted or matted. Requires exclusive representation locally.

Submissions: Website lists criteria for review process. Send query letter with artist's statement, bio, résumé, reviews, SASE, slides, $25 review fee, check payable to gallery. Returns material with SASE. Responds to queries in 1 month. Finds artists through art fairs, art exhibits, portfolio reviews, referrals by other artists, submissions, word of mouth.

Tips: "Label all slides, medium, size, title and retail price, send only works that are available."

[N] RICHARD LEVY GALLERY, 514 Central Ave. SE, Albuquerque NM 87102. E-mail: info@levygallery.com Website: www.levygallery.com. **Contact:** Richard Levy, owner. Estab. 1992. Approached by 100 artists/year; exhibits 25 emerging and mid-career artists/year. Exhibited artists include Frederick Hammersley (oil on canvas) and Stuart Arends (mixed media). Sponsors 10 exhibits/year. Average display time 4-6 weeks. Open Tuesday-Saturday, 11-4. Closed during art fairs (always noted on voice message). Located on Central Ave. between 5th and 6th. Clients include upscale. 60% of sales are to corporate collectors. Overall price range $2,000-5,000; most work sold at $5,000.

Media: Considers all media. Most frequently exhibits paintings, prints and photography. Considers engravings, etchings, linocuts, lithographs and mezzotints.

Style: Exhibits conceptualim, geometric abstraction, minimalism and painterly abstraction. Most frequently exhibits contemporary, minimalism and geometric abstraction. Considers all genres.

Terms: Artwork is accepted on consignment and there is a 50% commission or artwork is bought outright for 50% of retail price. Retail price of the art set by the gallery and the artist. Gallery provides insurance and some promotion. Artwork should either be framed, mounted AND matted or presented without the same. Prefers exclusive representation locally.

Submissions: Write to arrange a personal interview to show portfolio or send query letter with artist's statement, bio, brochure, business card, photocopies, photographs, résumé, reviews, SASE and/or slides. Responds to queries only if interested within 6 months. Files artists that "we intend to watch or contact." Finds artists through art fairs and exhibits, portfolio reviews, referrals by other artists and word-of-mouth.

Tips: "Do not just show up with a portfolio. We are in the business of selling art and this is very disruptive."

N **LEWALLEN CONTEMPORARY**, 129 W. Palace Ave., Santa Fe NM 87501. (505)988-8997. Fax: (505)989-8702. **Director:** Geoffry Gorman. Retail gallery. Represents 75 emerging, mid-career and established artists/year. Exhibited artists include: John Fincher, Emmi Whitehorse, Roy DeForest and Robert Brady. Sponsors 7 shows/year. Average display time 3-4 weeks. Open all year; Monday-Saturday, 9:30-5:30; Sunday 12-5:30 (summer); Tuesday-Saturday, 9:30-5; (winter). Located downtown; 10,000 sq. ft.; varied gallery spaces; upstairs barrel-vaulted ceiling with hardwood floors. 25-30% of space for special exhibitions; 75-70% of space for gallery artists. Clients include a "broad range—from established well-known collectors to those who are just starting." 95% of sales are to private collectors, 5% corporate collectors. Overall price range: $650-350,000; most work sold at $1,500-15,000.

Media: Considers oil, acrylic, mixed media, sculpture and installation, lithograph and serigraphs. Most frequently exhibits oil, mixed media and acrylic/sculpture.

Style: Exhibits: surrealism, minimalism, postmodern works, photorealism, hard-edge geometric abstraction and realism. Genres include landscapes, southwestern and western. Prefers realism/photorealism, postmodern works and minimalism.

Terms: Accepts work on consignment (50% commission). Retail price set by the gallery and the artist. Gallery provides insurance, promotion, contract and shipping costs from gallery; artist pays shipping costs to gallery. Prefers artwork framed.

Submissions: Prefers only "artists from the western United States, but we consider all artists." Send query letter with résumé, slides or photographs, reviews and bio. "Artist must include self-addressed, stamped envelope if they want materials returned." Call for appointment to show portfolio of originals, photographs, slides or transparencies. Responds in 2 months. Finds artists through visiting exhibitions, various art magazines and art books, word of mouth, other artists and submissions.

NEDRA MATTEUCCI GALLERIES, 1075 Paseo De Peralta, Santa Fe NM 87501. (505)982-4631. Website: www.matteucci.com. **Director of Advertising/Public Relations:** Alex Hanna. For-profit gallery. Estab. 1972. Main focus of gallery is on deceased artists of Taos, Sante Fe and the West. Approached by 20 artists/year. Represents 100 established artists. Exhibited artists include: Dan Ostermiller and Glenna Goodacre. Sponsors 3-5 exhibits/year. Average display time 1 month. Open all year; Monday-Saturday, 8:30-5. Clients include upscale.

Media: Considers ceramics, drawing, oil, pen & ink, sculpture and watercolor. Most frequently exhibits oil, watercolor and bronze sculpture.

Style: Exhibits: impressionism. Most frequently exhibits impressionism, modernism and realism. Genres include Americana, figurative work, landscapes, portraits, Southwestern, Western and wildlife.

Terms: Artwork is accepted on consignment. Retail price set by the gallery and the artist. Requires exclusive representation within New Mexico.

Submissions: Write to arrange a personal interview to show portfolio of transparencies. Send query letter with bio, photographs, résumé and SASE.

MAYANS GALLERIES, LTD., 601 Canyon Rd., Santa Fe NM 87501; also at Box 1884, Santa Fe NM 87504. (505)983-8068. Fax: (505)982-1999. E-mail: arte4@aol.com. Website: www.artnet.com/mayans.html. **Contact:** Ernesto Mayans. Retail gallery and art consultancy. Estab. 1977. Represents 10 emerging, mid-career and established artists. Sponsors 2 solo and 2 group shows/year. Average display time 1 month. Clientele: 80% private collectors, 20% corporate clients. Overall price range: $350 and up; most work sold at $500-7,500.

Media: Considers oil, acrylic, watercolor, pastel, pen & ink, drawings, mixed media, sculpture, photography and original handpulled prints. Most frequently exhibits oil, photography, and lithographs.

Style: Exhibits 20th century American and Latin American art. Genres include landscapes and figurative work.

Terms: Accepts work on consignment. Retail price set by gallery and artist. Exclusive area representation required.

Submissions: Send query letter (or e-mail first), résumé, business card and SASE. Discourages the use of slides. Prefers 2 or 3 snapshots or color photocopies which are representative of body of work. Files résumé and business card.

Tips: "Currently seeking contemporary figurative work and still life with strong color and technique. Gallery space can accomodate small-scale work comfortably."

N: **MICHAEL McCORMICK GALLERIES**, 106-C Paseo del Pueblo Norte, Taos NM 87571. (505)758-1372. E-mail: michaelm@laplaza.org. Website: McCormickgallery.com. Retail gallery. Estab. 1983. Represents 10 emerging and established artists. Provides 3 solo and 1 group show/year. Average display time 6 weeks. 90% of sales are to private collectors, 10% corporate clients. Overall price range: $1,500-85,000; most work sold at $3,500-10,000.

Media: Considers oil, acrylic, watercolor, pastel, pen & ink, drawings, mixed media, collage, works on paper, sculpture, ceramic, photography, wood engravings, linocuts, engravings, mezzotints, etchings, lithographs, pochoir, serigraphs and posters. Most frequently exhibits oil, pottery and sculpture/stone.

Style: Exhibits: impressionism, neo-expressionism, surrealism, primitivism, painterly abstraction, conceptualism and postmodern works. Genres include landscapes and figurative work. Interested in work that is "classically, romantically, poetically, musically modern." Prefers figurative work, lyrical impressionism and abstraction.

Terms: Accepts work on adjusted consignment (approximately 50% commission). Retail price set by gallery and artist. Customer discounts and payment by installment are available. Exclusive area representation required. Gallery provides promotion and contract; artist pays for shipping. Prefers artwork framed.

Submissions: Send query letter with résumé, brochure, slides, photographs, bio and SASE. Portfolio review requested if interested in artist's work. Responds in 7 weeks. Finds artists usually through word of mouth and artists traveling through town.

Tips: "Send a brief, concise introduction with several color photos. During this last year there seem to be more art and more artists but fewer sales. The quality is declining based on a mad, frantic scramble to find something that will sell. Take some business courses. Try to be objective within your goals. If you want something you've never had, you have to do something you've never done."

N: **THE MUNSON GALLERY**, 225 Canyon Rd., Santa Fe NM 87501. (505)983-1657. Fax: (505)988-9867. E-mail: art@munsongallery.com. Website: www.munsongallery.com. **Contact:** Brendan Bullock, media coordinator. Retail gallery. Estab. 1860. Approached by 400 artists/year; exhibits 50 emerging, mid-career and established artists/year. Exhibited artists include Elmer Schooley (oils on canvas) and Richard Segalman (oils, watercolors and monoprints). Sponsors 9 shows/year. Average display time 3 weeks. Open all year; Monday-Friday, 9:30-5; weekends, 10-5. Located in a complex that houses about 10 contemporary art galleries. 100% of space for gallery artists. Clientele: upscale locals and tourists. Overall price range: $450-150,000; most work sold at $2,000.

Media: Considers all media. Considers engravings, etchings, linocuts, lithographs, monotypes, woodcuts and aquatints. Most frequently exhibits oils watercolor, pastel.

Style: Exhibits "contemporary representational, not too much abstract, except in sculpture." Genres include florals, southwestern, landscapes.

Terms: Accepts work on consignment (50% commission). Retail price set by the artist. Gallery provides promotion. Accepted work should be framed.

Submissions: Send query letter with artist's statement, bio, photographs, résumé, SASE and slides. Call or write for appointment to show portfolio of photographs, slides and transparencies. Responds as soon as possible. Finds artists through portfolio reviews, referrals by other artists, submissions and word-of-mouth. Files bios occasionally, announcements.

Tips: "At the moment, the gallery is not taking on any new artists, though portfolios will be reviewed. We will not actually be adding any new artists to our roster for at least a year. Submissions welcome, but with the understanding that this is the case."

N: **NEW MILLENNIUM ART/THE FOX GALLERY**, 217 W. Water, Santa Fe NM 87501. (505)983-2002. **Owner:** S.W. Fox. Retail gallery. Estab. 1980. Represents 12 mid-career artists. Exhibited artists

include R.C. Gorman and T.C. Cannon. Sponsors 4 shows/year. Average display time 1 month. Open all year. Located 3 blocks from plaza; 3,000 sq. ft.; "one large room with 19′ ceilings." 20% of space for special exhibitions. Clientele: "urban collectors interested in Indian art and contemporary Southwest landscapes." 90% private collectors; 10% corporate collectors.

Media: Considers oil, acrylic, watercolor, pastel, mixed media, sculpture, original handpulled prints, offset reproductions, woodcuts, lithographs, serigraphs and posters. Most frequently exhibits acrylic, woodblock prints and posters.

Style: Exhibits expressionism and impressionism. Genres include Southwestern.

Terms: Accepts artwork on consignment (40% commission). Retail price set by the gallery. Gallery provides insurance and promotion. Shipping costs are shared. Prefers artwork framed.

Submissions: Accepts only Native American artists from the Southwest. Send query letter with résumé, brochure, photographs and reviews. Write for appointment to show a portfolio of photographs. Responds in 2 weeks.

Tips: "We are primarily interested in art by American Indians; occasionally we take on a new landscapist."

N RUNNING RIDGE GALLERY, 640 Canyon Rd., Santa Fe NM 87501. **Contact:** Patt Abbott, director. For-profit gallery. Estab. 1979. Approached by 25 artists/year; exhibits 50 emerging, mid-career and established artists/year. Exhibited artists include Hiroshi Yamano (glass) and Peter Hayes (ceramics). Sponsors 6 exhibits/year. Average display time 3 weeks. Open all year; Monday-Friday, 10-5; Saturday-Sunday, 11-5. Located midway on historic Canyon Rd. 5 rooms (1,500 square feet) in an old house-lots of light. Clients include local community and tourists. 10% of sales are to corporate collectors. Overall price range: $55-12,000; most work sold at $1,000.

Media: Considers acrylic, ceramics, fiber, glass, oil, paper, watercolor. Most frequently exhibits glass, ceramics, jewelry. Considers engravings, etchings, linocuts, lithographs, mezzotints, serigraphs and woodcuts.

Style: Considers all styles.

Terms: Artwork is accepted on consignment and there is a 50% commission. Retail price of the art set by the artist. Gallery provides insurance, promotion and contract. Accepted work should be framed. Requires exclusive representation locally.

Submissions: Send e-mail images; then mail portfolio for review; then send query letter with artist's statement, bio, SASE and slides. Returns material with SASE. Responds to queries in 1 month. Finds artists through art fairs and exhibits, portfolio reviews, referrals by other artists, submissions and word-of-mouth.

Tips: "Have good quality slides."

LYNNE WHITE'S SHRIVER GALLERY, 401 Paseo Del Pueblo Norte, Taos NM 87571. (505)758-4994. Fax: (505)758-8996. E-mail: shriver@newmex.com. Website: www.shrivergallery.com. **Owner/Director:** Lynne White. Art consultancy and for-profit gallery. Estab. 1970. Approached by 15 artists/year. Exhibits 30 established artists. Exhibited artists include: Star Liana York, bronze sculpture; Walt Gonske, painting. Sponsors 4 exhibits/year. Average display time 3 weeks. Open all year; Monday-Saturday, 10-5, Clients include local community, tourists and upscale. Overall price range: $1,000-70,000; most work sold at $5,000.

 • Also has Brody & White Consulting, Inc., which serves as a back office for all tasks associated with the "business of art"—bios, artist's statements, inventory, mailings, research, press releases, marketing and PR plans, etc.

Media: Most frequently exhibits oils, bronze and watercolor.

Style: Exhibits: expressionism and impressionism. Most frequently exhibits representational, photorealistic, impressionistic. Genres include florals, landscapes and Southwestern.

Terms: Retail price set by the artist. Gallery provides insurance, promotion and contract. Accepted work should be framed. Does not require exclusive representation locally.

Submissions: Write to arrange a personal interview to show portfolio of photographs, slides and transparencies. Send query letter with artist's statement, bio, brochure, photographs, résumé, reviews, SASE and slides. Returns material with SASE. Responds in 1 week. Files bio, statement, and photocopies of photos (a few). Finds artists through word of mouth, portfolio reviews, art exhibits and referrals by other artists.

Tips: Do not just drop in! Any packet with all necessary components is professional.

New York

ADIRONDACK LAKES CENTER FOR THE ARTS, Route 28, Blue Mountain Lake NY 12812. (518)352-7715. E-mail: alca@telenet.net. **Director:** Ellen C. Butz. Nonprofit galleries in multi-arts center. Estab. 1967. Represents 107 emerging, mid-career and established artists/year. Sponsors 6-8 shows/year. Average display time 1 month. Open Monday-Friday, 10-4; July and August daily. Located on Main Street next to post office; 176 sq. ft.; "pedestals and walls are white, some wood and very versatile." Clients include tourists, summer owners and year-round residents. 90% of sales are to private collectors, 10% corporate collectors. Overall price range: $100-10,000; most work sold at $100-1,000.
Media: Considers all media and all types of prints. Most frequently exhibits paintings, sculpture, wood and fiber arts.
Style: Exhibits all styles. Genres include landscapes, Americana, wildlife and portraits.
Terms: Accepts work on consignment (30% commission). Retail price set by the artist. Gallery provides insurance, contract; shares promotion. Prefers artwork framed.
Submissions: Send query letter with slides or photos and bio. Annual submission deadline early November; selections complete by February 1. Files "slides, photos and bios on artists we're interested in." Reviews submissions once/year. Finds artists through word of mouth, art publications and artists' submissions.
Tips: "We love to feature artists who can also teach a class in their media for us. It increases interest in both the exhibit and the class."

KENISE BARNES FINE ART, 1955 Palmer Ave., Larchmont NY 10538. (914)834-8077. Fax: (914)833-7379. E-mail: Kenise@KBFA.com. Website: www.ArtNet.com. **Contact:** Kenise Barnes, director. For-profit gallery. Estab. 1995. Approached by 300 artists/year; exhibits 30 emerging and mid-career artists/year. Exhibited artists include David Collins (paintings and monotypes) and Henry Mandell (paintings and drawings). Sponsors 6 exhibits/year. Average display time 5-6 weeks. Open Wednesday-Saturday, 10-6. Closed for two weeks in August. Clients include local community and upscale. 10% of sales are to corporate collectors. Overall price range: $500-5,000; most work sold at $3,000.
Media: Considers acrylic, drawing, oil and paper. Also considers etchings.
Style: Exhibits color field and painterly abstraction.
Terms: Artwork is accepted on consignment and there is a 50% commission. Retail price of the art set by the gallery. Gallery provides insurance and promotion. Requires exclusive representation locally.
Submissions: Send query letter with artist's statement, bio, photocopies, résumé, reviews, SASE and slides. Returns material with SASE. Responds to queries in 1 month. Files letter and 1 image. Finds artists through referrals from other artists.

CEPA (CENTER FOR EXPLORATORY AND PERCEPTUAL ART), 617 Main St. #201, Buffalo NY 14203. (716)856-2717. Fax: (716)270-0184. E-mail: info@cepagallery.com. Website: www.cepagallery.com. **Director/Curator:** Lawrence Brose. Alternative space and nonprofit arts center. Interested in emerging, mid-career and established artists. Presents 3 major curated exhibitions and several solo installations. Average display time 4-6 weeks. Open all year. Office and underground hours are Monday-Saturday, 10-5. Passageway Gallery is open Monday-Sunday 9-9. Clients include artists, students, photographers and filmmakers. Prefers photographically related and digital media.
Media: Installation, photography, film, mixed media, computer imaging and digital photography.
Style: Contemporary photography. "CEPA provides a context for understanding the aesthetic, cultural and political intersections of photo-related art as it is produced in our diverse society." Interested in seeing "conceptual, installation, documentary and abstract work."
Terms: Accepts work on consignment (25% commission).
Submissions: Call first regarding suitability for this gallery. Send query letter with résumé, 20 numbered slides, SASE, brochure, slides, bio and artist's statement. Call or write for appointment to show portfolio of slides and photographs. Responds in 6 weeks. Residencies: CEPA Gallery awards 8 funded residencies/year, 4 to regional artists and 4 to national artists. Residencies range in length from 1-2 months and include budgets of $2,250-10,000 dependent on need. Submission guidelines same as exhibitions. Proposals are reviewed monthly.
Tips: "It is a policy to keep slides and information in our file for indefinite periods. Grant writing proce-

dures require us to project one and two years into the future. Provide a concise and clear statement to give staff an overview of your work."

CHAPMAN ART CENTER GALLERY, Cazenovia College, 22 Sullivan St., Cazenovia NY 13035. (315)655-7162. Fax: (315)655-2190. E-mail: jaistars@cazenovia.edu. Website: www.cazenovia.edu. **Director:** John Aistars. Nonprofit gallery. Estab. 1978. Interested in emerging, mid-career and established artists. Sponsors 8-9 shows/year. Average display time is 3 weeks. Clients include the greater Syracuse community. Overall price range: $50-3,000; most artwork sold at $100-200.
Media: Considers all media. Most frequently exhibits acrylic, oil and watercolor. Considers all types of prints.
Style: Exhibits all styles. "Exhibitions are scheduled for a whole academic year at once. The selection of artists is made by a committee of the art faculty in early spring. The criteria in the selection process is to schedule a variety of exhibitions every year to represent different media and different stylistic approaches; other than that, our primary concern is quality. Artists are to submit to the committee by March 1 a set of slides or photographs and a résumé listing exhibitions and other professional activity." Most frequently exhibits abstraction, realism.
Terms: Retail price set by artist. Exclusive area representation not required. Gallery provides insurance and promotion; works are usually not shipped.
Submissions: Send query letter, résumé, 10-12 slides or photographs.
Tips: A common mistake artists make in presenting their work is that the "overall quality is diluted by showing too many pieces. Call or write and we will mail you a statement of our gallery profiles."

☑ **COURTHOUSE GALLERY, LAKE GEORGE ARTS PROJECT**, 1 Amherst St., Lake George NY 12845. (518)668-2616. Fax: (518)668-3050. E-mail: mail@lakegeorgearts.org. **Gallery Director:** Laura Von Rosk. Nonprofit gallery. Estab. 1986. Approached by 200 artists/year. Exhibits 10-15 emerging, mid-career and established artists. Sponsors 5-8 exhibits/year. Average display time 5-6 weeks. Open all year; Tuesday-Friday, 12-5; Saturday, 12-4. Closed mid-December to mid-January. Clients include local community, tourists and upscale. Overall price range: $100-5,000; most work sold at $500.
Media: Considers all media and all types of prints. Most frequently exhibits painting, mixed media and sculpture.
Style: Considers all styles and genres.
Terms: Artwork is accepted on consignment and there is a 25% commission. Retail price set by the artist. Gallery provides insurance, promotion and contract. Accepted work should be framed, mounted and matted.
Submissions: Mail portfolio for review. Deadline always January 31st. Send query letter with artist's statement, bio, résumé, SASE and slides. Returns material with SASE. Responds in 2 months. Finds artists through word of mouth, submissions, portfolio reviews, art exhibits, art fairs and referrals by other artists.

N ✝ JAMES COX GALLERY AT WOODSTOCK, 4666 Rt. 212, Willow NY 12495. (845)679-7608. Fax: (845)679-7627. E-mail: jcoxgal@ulster.net. Website: www.jamescoxgallery.com. Retail gallery. Estab. 1990. Represents 30 mid-career and established artists. Exhibited artists include: Richard Segalman, Bruce North, Christie Scheele and Mary Anna Goetz. Represents estates of 7 artists including James Chapin, Margery Ryerson and Winold Reiss. Sponsors 5 shows/year. Average display time 1 month. Open all year; Monday-Friday, 10-5; weekends, by appointment. Elegantly restored Dutch barn. 50% of space for special exhibitions. Clients include New York City and tourists, residents of 50-mile radius. 95% of sales are to private collectors. Overall price range: $500-50,000; most work sold at $3,000-10,000.
Media: Considers oil, watercolor, pastel, drawing and sculpture. Considers "historic Woodstock, fine prints." Most frequently exhibits oil paintings, watercolors, sculpture.
Style: Exhibits: impressionism, realism. Genres include landscapes and figurative work. Prefers: expressive or evocative realism, painterly landscapes and stylized figurative work.
Terms: Accepts work on consignment (40% commission). Retail price set by the artist. Gallery provides promotion; artist pays shipping costs to and from gallery. Prefers artwork framed.
Submissions: Prefers only artists from New York region. Send query letter with résumé, slides, bio, brochure, photographs, SASE and business card. Responds in 3 months. Files material on artists for special, theme or group shows.
Tips: "Be sure to enclose SASE and be patient for response. Also, please include information on present pricing structure."

SAMUEL DORSKY MUSEUM OF ART, SUNY New Paltz 75, S. Manheim Blvd., New Paltz NY 12561. (845)257-3844. Fax: (845)257-3854. E-mail: dunganb@newpaltz.edu. Website: www.newpaltz.edu/

museum. **Contact:** Karl Emil Willers, curator. Museum. Estab. 1964. Exhibits established artists. Average display time 2 months. Open Wednesday, 1-8; Thursday-Sunday, 1-5. Closed holidays and school vacations (check website). Includes 9,000 sq. ft. of exhibition space in 6 galleries. Clients include local community, students, tourists and upscale.

Media: Considers all media and all types of original prints. Most frequently exhibits photographs, prints and paintings.

Style: Considers all styles.

Submissions: Send query letter with bio and SASE. Returns material with SASE. Responds only if interested within 3 months. Finds artists through art exhibits.

N **EAST END ARTS COUNCIL**, 133 E. Main St., Riverhead NY 11901. (631)727-0900. Fax: (631)727-0966. E-mail: gallery@eastendarts.org. Website: www.eastendarts.org. **Visual Arts Coordinator:** Elizabeth Malunowicz. Nonprofit gallery. Estab. 1971. Exhibits the work of artists of all media. Presents 10 shows annually—most of which are group exhibitions. Exhibits include approximately 600 artists/year, ranging from emerging to mid-career exhibitors of all ages. Average display time 4-5 weeks. Prefers regional artists. Clientele: small business and private collectors. Overall price range: $10-5,000; most work sold at $100-500.

Media: Considers all media including sculptures and installations. Considers posters and serigraphs for gift shop but not shows. Considers all types of prints.

Style: Exhibits contemporary, abstract, primitivism, non-representational, photorealism, realism, post-pop works, projected installations and assemblages. Genres include figurative, landscapes, portraits (social issues and concerns). "Being an organization relying strongly on community support, we walk a fine line between serving the artistic needs of our constituency and exposing them to current innovative trends within the art world. Therefore, there is not a particular area of specialization. We show photography, fine craft and all art media."

Terms: Accepts work on consignment (30% commission). Retail price set by gallery and artist. Exclusive area representation not required. Gallery provides insurance, promotion and contract; artist pays for shipping to and from gallery.

Submissions: Work is dropped off at gallery for open calls, no slides are accepted.

Tips: "Visit, become a member ($35/year individual) and you'll be sent all the mailings that inform you of shows, lectures, workshops, grants and more! All work must be framed with clean mats and glass/plexi and wired (or hooks) for hanging. Presentation of artwork is considered when selecting work for shows. Show you care about your work!"

GALLERY NORTH, 90 N. Country Rd., Setauket NY 11733. (516)751-2676. Fax: (516)751-0180. E-mail: gallerynorth@aol.com. Website: www.gallerynorth.org. **Director:** Colleen W. Hanson. Not-for-profit gallery. Estab. 1965. Exhibits the work of emerging, mid-career and established artists from Long Island. Sponsors 9 shows annually. Average display time 4-5 weeks. Open all year. Located 1 mile from the State University at Stony Brook; approximately 1,600 sq. ft.; "in a renovated Victorian house." 85% of space for special exhibitions. Clients include university faculty and staff, Long Island collectors and tourists. Overall price range: $100-25,000; most work sold at $1,500-2,500.

Media: Considers all media and original handpulled prints, frequent exhibits of paintings, prints and fine crafts, especially jewelry and ceramics.

Style: Prefers abstract and representational contemporary artists.

Terms: Accepts work on consignment (50% commission). Retail price set by gallery and artist. Gallery provides insurance, promotion and contract. Requires well-framed artwork.

Submissions: Send query letter with résumé, slides, bio, SASE and reviews. Portfolio review requested if interested in artist's work. Portfolio should include framed originals. Responds in 2 months. Files slides and résumés when considering work for exhibition. Finds artists from other exhibitions, slides and referrals.

Tips: "If possible artists should visit to determine whether their work is compatible with overall direction of the gallery. A common mistake artists make is that slides are not fully labeled as to size medium, top and price."

N **THE GRAPHIC EYE GALLERY OF LONG ISLAND**, 301 Main St., Port Washington NY 11050. (516)883-9668. Cooperative gallery. Estab. 1974. Represents 25 artists. Sponsors solo, 2-3 person and 4 group shows/year. Average display time: 1 month. Interested in emerging and established artists. Overall price range: $35-7,500; most artwork sold at $500-800.

Media: Considers mixed media, collage, works on paper, pastels, photography, paint on paper, woodcuts, wood engravings, linocuts, engravings, mezzotints, etchings, lithographs, serigraphs, and monoprints.
Style: Exhibits impressionism, expressionism, realism, primitivism and painterly abstraction. Considers all genres.
Terms: Co-op membership fee plus donation of time. Retail price set by artist. Offers payment by installments. Exclusive area representation not required. Prefers framed artwork.
Submissions: Send query letter with résumé, SASE, slides and bio. Portfolio should include originals and slides. "When submitting a portfolio, the artist should have a body of work, not a 'little of this, little of that.'" Files historical material. Finds artists through visiting exhibitions, word of mouth, artist's submissions and self-promotions.
Tips: "Artists must produce their *own* work and be actively involved. We have a competitive juried art exhibit annually. Open to all artists who work on paper."

GUILD HALL MUSEUM, 158 Main St., East Hampton NY 11937. (516)324-0806. Fax: (516)324-2722. **Contact:** Christina Mossaides Strassfield, curator. Farrin Cary, curatorial assistant. Museum. Estab. 1931. Represents emerging, mid-career and established artists. Sponsors 6-10 shows/year. Average display time 6-8 weeks. Open all year; Wednesday-Sunday, 11-5. 500 running feet; features artists who live and work on eastern Long Island. 85% of space for special exhibitions.
Media: Considers all media and all types of prints. Most frequently exhibits painting, prints and sculpture.
Style: Exhibits all styles and genres.
Terms: Artwork is donated or purchased. Gallery provides insurance and promotion. Prefers artwork framed.
Submissions: Accepts only artists from eastern Long Island. Send query letter with résumé, slides, bio, brochure, SASE and reviews. Write for appointment to show portfolio of originals and slides. Responds in 2 months.

CARRIE HADDAD GALLERY, 622 Warren St., Hudson NY 12534. (518)828-1915. Fax: (518)828-3341. E-mail: art@valstar.net. Website: www.carriehaddadgallery.com. **Owner:** Carrie Haddad. Art consultancy, nonprofit gallery. Estab. 1990. Approached by 50 artists/year. Exhibits 60 emerging, mid-career and established artists. Exhibited artists include: Jane Bloodgood-Abrams, oil; David Halliday, photography. Sponsors 8 exhibits/year. Average display time 5½ weeks. Open all year; Monday-Thursday, 11-5. Located on main street of Hudson; large, rambling space. Clients include local community, tourists and upscale. 10% of sales are to corporate collectors. Overall price range: $350-6,000; most work sold at $1,000.
Media: Considers all media except acrylic, oil and paper. Considers all types of prints except posters.
Style: Exhibits: expressionism, impressionism and postmodernism. Most frequently exhibits representational landscapes. Genres include figurative work, landscapes and abstract.
Terms: Artwork is accepted on consignment and there is a 50% commission. Retail price set by the artist. Gallery provides insurance and promotion. Requires exclusive representation locally.
Submissions: Send query letter with bio, photocopies, photographs, SASE and price list. Returns material with SASE. Responds in 2 months. Files all materials if interested. Finds artists through word of mouth, submissions, art exhibits and referrals by other artists.

IMPACT ARTIST GALLERY, INC., 2495 Main St., Suite 545, Tri Main Bldg., Buffalo NY 14214. Phone/fax: (716)835-6817. E-mail: impact@buffalo.com/impact. Website: www.buffalo.com/impact. Cooperative gallery, nonprofit gallery and rental gallery. Estab. 1993. Approached by 500 artists/year. Represents 310 emerging, mid-career and established artists. Sponsors 12 exhibits/year. Open all year; Tuesday-Friday, 11-4. Clients include local community, tourists and upscale.
Media: Considers all media except glass, installation and craft. Considers engravings, etchings, lithographs, serigraphs and woodcuts.
Style: Considers all styles. Most frequently exhibits expressionism, painterly abstraction, surrealism. Considers all genres.
Terms: Artwork is accepted on consignment and there is a 25% commission. Retail price set by the artist. Gallery provides promotion. Accepted work should be framed, matted and ready for hanging. Does not require exclusive representation locally. Women's art except for Fall National Show and Summer Statewide Show.
Submissions: Write to arrange a personal interview to show portfolio of slides. Mail portfolio for review. Send query letter with SASE and slides. Responds in 2 months. Files artist statement and résumé.

KIRKLAND ART CENTER, E. Park Row, P.O. Box 213 Clinton NY 13323-0213. (315)853-8871. Fax: (315)853-2076. E-mail: kacinc@dreamscape.com. **Contact:** Director. Nonprofit gallery. Estab. 1960. Interested in emerging, mid-career and established artists. Sponsors about 8 shows/year. Average display time is 7 weeks. Clients include general public and art lovers. 99% of sales are to private collectors, 1% corporate clients. Overall price range: $60-4,000; most artwork sold at $200-1,200.
Media: Considers oil, acrylic, watercolor, pastel, pen & ink, drawings, mixed media, collage, works on paper, sculpture, ceramic, craft, fiber, glass, installation, photography, performance art and original hand-pulled prints. Most frequently exhibits watercolor, oil/acrylic, prints, sculpture, drawings, photography and fine crafts.
Style: Exhibits: painterly abstraction, conceptualism, impressionism, photorealism, expressionism, realism and surrealism. Genres include landscapes, florals and figurative work.
Terms: Accepts work on consignment (25% commission). Retail price set by artist. Exclusive area representation not required. Gallery provides insurance, promotion and contract; artist pays for one-way shipping.
Submissions: Send query letter, résumé, slides, slide list and SASE.
Tips: "Shows are getting very competitive—artists should send us slides of their most challenging work, not just what is most saleable. We are looking for artists who take risks in their work and display a high degree of both skill and imagination. It is best to call or write for instructions and more information."

LEATHERSTOCKING GALLERY, 52 Pioneer St., P.O. Box 446, Cooperstown NY 13326. (607)547-5942. E-mail: drwells@hdpteam.com. (Gallery), (607)547-8044 (Publicity). **Publicity:** Dorothy V. Smith. Retail nonprofit cooperative gallery. Estab. 1968. Represents emerging, mid-career and established artists. 45 members. Sponsors 1 show/year. Average display time 3 months. Open in the summer (mid-June to Labor Day); daily 11-5. Located downtown Cooperstown; 300-400 sq. ft. 100% of space for gallery artists. Clients include varied locals and tourists. 100% of sales are to private collectors. Overall price range: $25-500; most work sold at $25-100.
Media: Considers oil, acrylic, watercolor, pastel, pen & ink, drawing, mixed media, collage, paper, sculpture, ceramics, craft, photography, handmade jewelry, woodcuts, engravings, lithographs, wood engravings, mezzotints, serigraphs, linocuts and etchings. Most frequently exhibits watercolor, oil and crafts.
Style: Exhibits: impressionism and realism, all genres. Prefers landscapes, florals and American decorative.
Terms: Co-op membership fee, a donation of time plus 10% commission. Retail price set by the artist. Gallery provides insurance, promotion and contract; artist pays shipping costs from gallery if sent to buyer. Prefers artwork framed.
Submissions: Accepts only artists from Otsego County; over 18 years of age; member of Leatherstocking Brush & Palette Club. Responds in 2 weeks. Finds artists through word of mouth locally; articles in local newspaper.
Tips: "We are basically non-judgmental (unjuried). You just have to live in the area!"

MAXWELL FINE ARTS, 1204 Main St., Peekskill NY 10566-2606. (914)737-8622. Fax: (914)788-5310. E-mail: devitomax@aol.com. **Partner/Co-Director:** W.C. Maxwell. For-profit gallery. Estab. 2000. Approached by 25 artists/year. Exhibits 18 emerging and established artists. Exhibited artists include: Nadine Gordon-Taylor and Ed Radford. Sponsors 5-6 exhibits/year. Average display time 6 weeks. Open all year; Friday-Saturday, 12-5. Closed July/August. Located in Peekskill, NY downtown artist district; 800 sq. ft. in 1850s carriage house. Clients include local community and upscale. 10% of sales are to corporate collectors. Overall price range: $100-1,000; most work sold at $300.
Media: Considers acrylic, ceramics, collage, drawing, glass, mixed media, oil, paper, pastel, pen & ink, sculpture and watercolor. Most frequently exhibits paintings, drawings and prints. Considers all types of prints.
Style: Considers all styles and genres. Most frequently exhibits abstract, conceptual and representational.
Terms: Artwork is accepted on consignment and there is a 40% commission. Retail price set by the gallery in consultation with the artist. Gallery provides promotion. Accepted work should be framed. Does not require exclusive representation locally.
Submissions: Mail portfolio for review. Send query letter with artist's statement, bio, photocopies, résumé, SASE and slides. Returns material with SASE. Responds in 1 month. Files résumé and photos. Finds artists through word of mouth, submissions, art exhibits and referrals by other artists.
Tips: "Take a workshop on Business of Art."

OXFORD GALLERY, 267 Oxford St., Rochester NY 14607. (585)271-5885. Fax: (585)271-2570. E-mail: info@oxfordgallery.com. Website: www.oxfordgallery.com. **Director:** Meghan M. Harrington. Retail

gallery. Estab. 1961. Represents 70 emerging, mid-career and established artists. Sponsors 10 shows/year. Average display time 1 month. Open all year; Tuesday-Friday, 12-5; Saturday, 10-5; and by appointment. Located "on the edge of downtown; 1,000 sq. ft.; large gallery in a beautiful 1910 building." Overall price range: $100-30,000; most work sold at $1,000-2,000.

Media: Considers oil, acrylic, watercolor, pastel, pen & ink, drawings, mixed media, collage, paper, sculpture, ceramic, fiber, original handpulled prints, woodcuts, engravings, lithographs, wood engravings, mezzotints, serigraphs, linocuts and etchings.

Styles: All styles.

Terms: Accepts artwork on consignment (50% commission). Retail price set by gallery and artist. Gallery provides promotion and contract.

Submissions: Send query letter with résumé, slides, bio and SASE. Responds in 3 months. Files résumés, bios and brochures.

Tips: "Have professional slides done of your artwork. Have a professional résumé and portfolio. Do not show up unannounced and expect to show your slides. Either send in your information or call to make an appointment. An artist should have enough work to have a one-person show (20-30 pieces). This allows an artist to be able to supply more than one gallery at a time, if necessary. It is important to maintain a strong body of available work."

N **PORT WASHINGTON PUBLIC LIBRARY**, One Library Dr., Port Washington NY 11050. (516)883-4400. Fax: (516)883-7927. **Chair, Art Advisory Council:** Eric Pick. Nonprofit gallery. Estab. 1970. Represents 10-12 emerging, mid-career and established artists/year. 23 members. Exhibited artists include: Frank Stella, Robert Dash. Sponsors 10-12 shows/year. Average display time 1 month. Open all year; Monday-Friday, 9-9; Saturday, 9-5; Sunday, 1-5. Located midtown, 972 sq. ft. Overall price range: up to $100,000.

Media: Considers all media and all types of prints.

Style: Exhibits all styles.

Terms: Price set by the artist. Gallery provides insurance and promotion.

Submissions: Send query letter with résumé, slides, bio, SASE. Responds in 1 month. Artist should call library. Finds artists through word of mouth, referrals by other artists, visiting art fairs and exhibitions and submissions.

N **PRINT CLUB OF ALBANY**, P.O. Box 6578, Albany NY 12206. (518)882-6884. E-mail: bolonda@ nycap.rr.com. Website: www.pcaprint.com. **President:** Donald Bolon. Nonprofit gallery and museum. Estab. 1933. Exhibits the work of 70 emerging, mid-career and established artists. Sponsors 1 show/year. Average display time 6 weeks. "We currently have a small space and hold exhibitions in other locations." 90% of sales are to private collectors, 10% corporate collectors.

Media: Considers engravings, etchings, linocuts, lithographs, mezzotints, serigraphs and woodcuts.

Style: Exhibits all styles and genres. "No reproductions."

Terms: Accepts work on consignment from members. Membership is open internationally. "We welcome donations (of artists' works) to the permanent collection." Retail price set by artist. Customer discounts and payment by installment are available. Gallery provides promotion. Artist pays for shipping. Prefers artwork framed.

Submissions: Prefers prints. Send query. Write for appointment to show portfolio of slides. Responds in 1 week.

Tips: "We are a nonprofit organization of artists, collectors and others. Artist members exhibit without jury. We hold member shows and the Triannual National Open Competitive Exhibitions. We commission an artist for an annual print each year. Our shows are held in various locations. We are planning a museum (The Museum of Prints and Printmaking) and building. We also collect artists' papers, etc. for our library. Send query."

■ **ROCHESTER CONTEMPORARY**, 137 East Ave., Rochester NY 14604. (585)461-2222. Fax: (585)461-2223. E-mail: info@rochestercontemporary.org. Website: www.rochestercontemporary.org. **Director:** Elizabeth McDade. Nonprofit gallery. Estab. 1977. Exhibits 200 emerging, mid-career and established artists/year. 400 members. Sponsors 12 shows/year. Average display time 2-6 weeks. Open 11 months. Business hours Monday-Friday, 10-5; gallery hours to be announced. Clients include artists, curators, collectors, dealers. 90% of sales are to private collectors, 10% corporate collectors. Overall price range: $25-15,000; most work sold at $40-500.

● Gallery strives to create a forum for challenging, innovative ideas and works.

Media: Considers all media, video, film, dance, music, performance art, computer media; all types of prints including computer, photo lithography.

Style: Exhibits all styles and genres.

Terms: During exhibition a 25% commission is taken on sold works. Retail price set by the artist. Gallery provides insurance, promotion and contract; shipping costs are shared, "depending upon exhibition, funding and contract." Prefers artwork framed.

Submissions: Includes regional national artists and alike in thematic solo/duo exhibitions. Send query letter with résumé and slides. Call for appointment to show portfolio of originals and slides. "We have a permanent artist archive for slides, bios, résumés and will keep slides in file if artist requests." Finds artists through national and local calls for work, portfolio reviews and studio visits.

Tips: "Present slides that clearly and accurately reflect your work. Label slides with name, title, medium and dimensions. Be sure to clarify intent and artistic endeavor. Proposals should simply state the artist's work. Documentation should be accompanied by clear, concise script."

N: THE SCHOOLHOUSE GALLERIES, Owens Rd., Croton Falls NY 10519. (914)277-3461. Fax: (914)277-2269. **Director:** Lee Pope. Retail gallery. Estab. 1979. Represents 30 emerging and mid-career artists/year. Exhibited artists include: Randell Reid and Jim Madden. Average display time 1 month. Open all year; Wednesday-Sunday, 1-5. Located in a suburban community of New York City; 1,200 sq. ft.; 70% of space for special exhibitions; 30% of space for gallery artists. Clients include residential, corporate, consultants. 50% of sales are to private collectors, 50% corporate collectors. Overall price range: $75-6,000; most work sold at $350-2,000.

Media: Considers oil, acrylic, watercolor, pastel, pen & ink, drawing, mixed media, collage, paper, sculpture, ceramics, fiber and photography, all types of prints. Most frequently exhibits paintings.

Style: Exhibits: expressionism, painterly abstraction, impressionism and realism. Genres include landscapes. Prefers: impressionism and painterly abstraction.

Terms: Accepts work on consignment (40% commission). Retail price set by the artist. Gallery provides insurance and promotion; shipping costs are shared.

Submissions: Send query letter with slides, photographs and SASE. "We will call for appointment to view portfolio of originals." Responds in 2 months. Files slides, bios if interested. Finds artists through visiting exhibitions and referrals.

BJ SPOKE GALLERY, 299 Main St., Huntington NY 11743. (631)549-5106. Website: www.quantumnow .com/bjspoke. **Contact:** Debbie LaMantia or Marilyn Lavi. Cooperative and nonprofit gallery. Estab. 1978. Exhibits the work of 24 emerging, mid-career and established artists. Sponsors 2-3 invitationals and juried shows/year. Average display time 1 month. Open all year. "Located in center of town; 1,400 sq. ft.; flexible use of space—3 separate gallery spaces." Generally, 66% of space for special exhibitions. Overall price range: $300-2,500; most work sold at $900-1,600. Artist is eligible for a 2-person show every 2 years. Entire membership has ability to exhibit work 11 months of the year.

 • Sponsors annual national juried show. Deadline December. Send SASE for prospectives.

Media: Considers all media except crafts, all types of printmaking. Most frequently exhibits paintings, prints and sculpture.

Style: Exhibits all styles and genres. Prefers painterly abstraction, realism and expressionism.

Terms: Co-op membership fee plus donation of time (25% commission). Monthly fee covers rent, other gallery expenses. Retail price set by artist. Payment by installment is available. Gallery provides promotion and publicity; artists pay for shipping. Prefers artwork framed; large format artwork can be tacked.

Submissions: For membership, send query letter with résumé, high-quality slides, bio, SASE and reviews. For national juried show send SASE for prospectus and deadline. Call or write for appointment to show portfolio of originals and slides. Files résumés; may retain slides for awhile if needed for upcoming exhibition.

Tips: "Send slides that represent depth and breadth in the exploration of a theme, subject or concept. They should represent a cohesive body of work."

N: STATE OF THE ART, 120 W. State St., Ithaca NY 14850. (607)272-8781. E-mail: Gallery@Lightlin k.com. Cooperative gallery. Estab. 1989. Represents emerging, mid-career and established artists. Exhibited artists include: Ralph Turtusso (mixed), Dede Hatch (photography). Sponsors 12 exhibits/year. Average display time 1 month. Open all year; Thursday-Sunday, 12-6; weekends, 12-8. Located in downtown Ithaca, 3 rooms about 13×25 each. Clients include local community, students, tourists, upscale. Overall price range: $250-6,000; most work sold at $350-500.

Media: Considers all media and all types of prints. Most frequently exhibits sculpture, paintings, mixed media.

Style: Considers all styles and genres.

Terms: There is a co-op membership fee plus a donation of time. There is a 10% commission. Retail price set by the artist. Gallery provides promotion and contract. Accepted work should be framed, mounted and matted. Does not require exclusive representation locally. "Our artist selection is through a jurying process of two-thirds minimum of the membership."

Submissions: Write to arrange a personal interview to show portfolio of photographs, slides and transparencies. Does not reply. Artist should personally stop by the gallery. Finds artists through word of mouth, submissions, portfolio reviews, art exhibits, referrals by other artists, regional and photography exhibition, international exhibition.

Tips: "Here we ask for more than ten pieces matted/framed professionally plus slides and other relevant material, i.e. statement and résumé. The presentation goes a long way to show the capacity for reliable quality of work. We judge according to composition, appeal, mastery of medium, uniqueness of style, consistent personal vision, variety. P.S. talent matters".

VISUAL STUDIES WORKSHOP GALLERIES, 31 Prince St., Rochester NY 14607. (716)442-8676. Fax: (716)442-1992. E-mail: gallery@vsw.org. Website: vsw.org. Alternative space, nonprofit gallery. Estab. 1971. Approached by 100 artists/year. Represents 20 emerging and mid-career artists. Sponsors 4-5 exhibits/year. Average display time 6-8 weeks. Open all year; Tuesday-Saturday, 12-5. Closed late summer/August. Located in a large old school building/third floor with 30-40 ft. cathedral ceilings; 2,300 sq. ft. in main gallery, 600 sq. ft. gallery 31. Clients include local community, students and national visitors. Overall price range: $200-3,000; most work sold at $500.

Media: Considers photography, mixed media and all digital media.

Style: Exhibits: conceptualism, installation, minimalism, multimedia, photography, postmodernism and conceptual.

Terms: Artwork is accepted on consignment and there is a 40% commission. Retail price set by the gallery and the artist. Gallery provides insurance. Accepted work should be framed, mounted and matted. Does not require exclusive representation locally.

Submissions: Write to arrange a personal interview to show portfolio of photographs. Mail portfolio for review. Send query letter with photographs, résumé and SASE. Returns material with SASE. Responds in 2 months. Finds artists through word of mouth, submissions, portfolio reviews, art exhibits and referrals by other artists.

Tips: Submit a letter explaining project, etc. copy prints, slides, résumé, and evidence that they have researched the gallery.

New York City

ADC GALLERY, (formerly Art Directors Club Gallery), 106 W. 29th St., New York NY 10001. (212)643-1440. Fax: (212)643-4266. Website: www.adcny.org. **Executive Director:** Myrna Davis. Nonprofit gallery. Exhibits groups in the field of visual communications (advertising, graphic design, publications, art schools). Estab. 1920. Exhibits emerging and professional work; 8-10 shows/year. Average display time 1 month. Closed August; Monday-Friday, 10-6. Located in Flower Market district; 4,500 sq. ft.; 1 gallery street level. 100% of space for special exhibitions. Clients include professionals, students.

Media: Considers all media and all types of prints. Most frequently exhibits posters, printed matter, photos, paintings, digital media and 3-D objects.

Style: Genres include advertising, graphic design, publications, packaging, photography, illustration and interactive media.

Terms: The space is available by invitation and/or approved rental.

Submissions: Submissions are through professional groups. Group rep should send reviews and printed work. Responds within a few months.

☑ **AGORA GALLERY**, 415 W. Broadway, Suite 5B, New York NY 10012. (212)226-4151, ext. 206. Fax: (212)966-4380. E-mail: Angela@Agora-Gallery.com. Website: www.Agora-Gallery.com. **Director:** Angela DiBello. For-profit gallery. Estab. 1984. Approached by 1,500 artists/year. Exhibits 100 emerging, mid-career and established artists. Sponsors 10 exhibits/year. Average display time 3 weeks. Open all year; Tuesday-Saturday, 12-6; weekends, 12-6. Closed national holidays. Located in Soho between Prince and

Spring; 2,000 sq. ft. of exhibition space, landmark building; elevator to gallery, exclusive gallery block. Clients include upscale. 10% of sales are to corporate collectors. Overall price range: $550-10,000; most work sold at $3,500-6,500.
Media: Considers acrylic, collage, digital, drawing, mixed media, oil, pastel, photography, sculpture, water-color.
Style: Considers all styles.
Terms: There is a representation fee. There is a 35% commission to the gallery; 65% to the artist. Retail price set by the gallery and the artist. Gallery provides insurance and promotion. Accepted work should be framed, mounted and matted. Does not require exclusive representation locally.
Submissions: Mail portfolio for review. Send artist's statement, bio, brochure, photographs, reviews if available, SASE. Responds in 3 weeks. Files bio, slides/photos and artist statement. Finds artists through word of mouth, submissions, portfolio reviews, art exhibits, referrals by other artists and website links.
Tips: "Follow instructions!"

N: ASIAN AMERICAN ARTS CENTRE, 26 Bowery, New York NY 10013. (212)233-2154. Fax: (212)766-1287. E-mail: aaartsctr@aol.com. **Executive Director:** Robert Lee. Nonprofit gallery. Estab. 1974. Exhibits the work of emerging and mid-career artists; 1,100 artists in archives file. Sponsors 5 shows/year. Average display time 5-6 weeks. Open September through June. Located in Chinatown; 1,800 sq. ft.; "a gallery and a research facility." 100% of space for special exhibitions. Overall price range: $500-10,000; most work sold at $500-3,000.
Media: Considers all media and all types of prints. Prefers paintings, installation and mixed media.
Style: Exhibits all styles and genres. Focuses on contemporary Asian, Asian American and American artists with strong Asian influences. Has a permanent historical archive of such.
Terms: Suggests a donation of 30% of the selling price. Retail price set by the artist. Gallery provides insurance and promotion. Shipping costs are shared. Prefers artwork framed.
Submissions: Send query letter with résumé and slides for permanent Asian American Artists Archive. Do not send original slides. Will call artists in summer if selected for Annual Show. Portfolio should include slides. Files slides.

ATLANTIC GALLERY, 40 Wooster St., 4th Floor, New York NY 10013. Phone/fax: (212)219-3183. Website: atlantic.artshost.com. Cooperative gallery. Estab. 1974. Approached by 50 artists/year. Represents 40 emerging, mid-career and established artists. Exhibited artists include: Carol Hamann (watercolor); Sally Brody (oil, acrylic); Richard Lincoln (oil). Average display time 3 weeks. Open Tuesday-Saturday, 12-6. Closed August. Located in Soho—has kitchenette. Clients include local community, tourists and upscale. 2% of sales are to corporate collectors. Overall price range: $100-13,000; most work sold at $1,500-5,000.
Media: Considers all media. Considers all types of prints. Most frequently exhibits watercolor, acrylic and oil.
Style: Considers all styles and genres. Most frequently exhibits impressionism, realism, imagism.
Terms: Artwork is accepted on consignment and there is a 20% commission. There is a co-op membership fee plus a donation of time. There is a 10% commission. Rental fee for space covers 3 weeks. Retail price set by the artist. Gallery provides promotion and contract. Accepted work should be framed. Does not require exclusive representation locally. Prefers only East Coast.
Submissions: Call or write to arrange a personal interview to show portfolio of slides. Send query letter with artist's statement, bio, brochure, SASE and slides. Returns material with SASE. Responds in 2 weeks. Files only accepted work. Finds artists through word of mouth, submissions, art exhibits and referrals by other artists.
Tips: Submit an organized folder with slides, bio, and 3 pieces of actual work; if we respond with interest, we then review again.

BLUE MOUNTAIN GALLERY, 530 W. 25th St., New York NY 10001. (646)486-4730. Fax: (646)486-4345. Website: www.artincontext.org/new_york/blue_mountain_gallery/. **Director:** Marcia Clark. Artist-run cooperative gallery. Estab. 1980. Exhibits 32 mid-career artists. Sponsors 13 solo and 1 group shows/year. Display time is 3 weeks. "We are located on the 4th floor of a building in Chelsea. We share our floor with two other well-established cooperative galleries. Each space has white partitioning walls and an individual floor-plan." Clients include art lovers, collectors and artists. 90% of sales are to private collectors, 10% corporate clients. Overall price range: $100-8,000; most work sold at $100-4,000.
Media: Considers painting, drawing and sculpture.

Style: "The base of the gallery is figurative but we show work that shows individuality, commitment and involvement with the medium."

Terms: Co-op membership fee plus donation of time. Retail price set by artist. Exclusive area representation not required. Gallery provides insurance, some promotion and contract; artist pays for shipping.

Submissions: Send name and address with intent of interest and sheet of 20 good slides. "We cannot be responsible for material return without SASE." Finds artists through artists' submissions and referrals.

Tips: "This is a cooperative gallery: it is important to represent artists who can contribute actively to the gallery. We look at artists who can be termed local or in-town more than out-of-town artists and would choose the former over the latter. The work should present a consistent point of view that shows individuality. Expressive use of the medium used is important also."

BROOKLYN BOTANIC GARDEN—STEINHARDT CONSERVATORY GALLERY, 1000 Washington Ave., Brooklyn NY 11225. (718)623-7200. Fax: (718)622-7839. E-mail: emilycarson@bbg.org. Website: www.bbg.org. **Contact:** Emily Carson, public programs associate. Nonprofit botanic garden gallery. Estab. 1988. Represents emerging, mid-career and established artists. 20,000 members. Sponsors 10-12 shows/year. Average display time 4-6 weeks. Open all year; Tuesday-Sunday, 10-4. Located near Prospect Park and Brooklyn Museum; 1,200 sq. ft.; part of a botanic garden, gallery adjacent to the tropical, desert and temperate houses. Clients include BBG members, tourists, collectors. 100% of sales are to private collectors. Overall price range: $75-7,500; most work sold at $75-500.

Media: Considers all media and all types of prints. Most frequently exhibits watercolor, oil and photography.

Style: Exhibits all styles. Genres include landscapes, florals and wildlife.

Terms: Accepts work on consignment (20% commission). Retail price set by the artist. Gallery provides insurance, promotion and contract; artist pays shipping costs to and from gallery. Artwork must be framed or ready to display unless otherwise arranged. Artists hang and remove their own shows.

Submissions: Work must reflect the natural world. Send query letter with résumé, slides, bio, brochure, photographs, SASE, business card and reviews for review.

Tips: "Artists' groups contact me by submitting résumé and slides of artists in their group. We favor seasonal art which echoes the natural events going on in the garden. Large format, colorful works show best in our multi-use space."

N CLAUDIA CARR GALLERY, 478 W. Broadway #2, New York NY 10012. (212)673-5518. Fax: (212)673-0123. E-mail: claudiacarr@erols.com. For profit gallery. Estab. 1995. Approached by 120 artists/year. Represents emerging, mid-career and established artists. Sponsors 10 exhibits/year. Average display time 4-6 weeks. Open Wednesday-Saturday, 11-5:30; closed Sunday, Christmas, New Year's and mid-July-August. "Soho gallery, second floor, small, intimate space." Clients include local community, tourists, upscale. 15% of sales are to corporate collectors. Overall price range: $300-6,000; most work sold at $1,500-2,000.

Media: Considers acrylic, paper, pastel, collage, pen & ink, mixed media, drawing, oil and watercolor. No prints. Most frequently exhibits drawing, painting on paper and monotype.

Style: Exhibits painterly abstraction, minimalism, geometric abstraction and other styles. Most frequently exhibits painterly abstraction and minimal. Genres include figurative work and landscapes.

Terms: Artwork is accepted on consignment (50% commission). Retail price set by the gallery and the artist. Gallery provides insurance and promotion. Accepted work should be framed, mounted or matted. Requires exclusive representation locally.

Submissions: Write to arrange a personal interview to show portfolio of photographs, transparencies, slides and other material or send query letter with bio, résumé, photocopies, photographs, slides and SASE. Returns material with SASE. Responds in 2 months. Files materials if interested. Finds artists through word of mouth and referrals by other artists.

Tips: "Write a cover letter, include biographical information, make certain to include a SASE. Be professional."

CERES, 584 Broadway, Room 306, New York NY 10012. (212)226-4725. E-mail: art@ceresgallery.org. Website: www.ceresgallery.org. **Administrator:** Olive H. Kelsey. Women's cooperative and nonprofit, alternative gallery. Estab. 1984. Exhibits the work of emerging, mid-career and established artists. 48 members. Sponsors 11-14 shows/year. Average display time 1 month. Open all year; Tuesday-Saturday, 12-6. Located in Soho, between Houston and Prince Streets; 2,000 sq. ft. 30% of space for special exhibitions; 70% of space for gallery artists. Clients include artists, collectors, tourists. 85% of sales are to private

collectors, 15% corporate collectors. Overall price range, $300-10,000; most work sold at $350-1,200.
Media: All media considered.
Style: "All genres and types of work are considered. Work dealing with women's politics and issues are particularly encouraged."
Terms: Co-op membership fee plus donation of time. Retail price set by artist. Gallery provides insurance; artists pays for shipping.
Submissions: Prefers women from tri-state area; "men may show in group/curated shows." Write with SASE for application. Responds in 3 weeks.
Tips: "Artist must have the ability to be a responsible gallery member and participant."

CITYARTS, INC., 525 Broadway, Suite 700, New York NY 10012. (212)966-0377. Fax: (212)966-0551. E-mail: tsipi@cityarts.org. Website: www.cityarts.org. **Executive Director:** Tsipi Ben-Haim. Art consultancy, nonprofit public art organization. Estab. 1968. Represents 1,000 emerging, mid-career and established artists. Produces 4-8 projects/year. Average display time varies. "A mural or public sculpture will last up to 15 years." Open all year; Monday-Friday, 10-5. Located in Soho; "the city is our gallery. CityArts's 200 murals are located in all 5 boroughs on NYC. We are funded by foundations, corporations, government and membership ('Friends of CityArts')."
Media: Considers oil, acrylic, drawing, sculpture, mosaic and installation. Most frequently exhibits murals (acrylic), mosaics and sculpture.
Style: Produces all styles and all genres depending on the site.
Terms: Artist receives a flat commission for producing the mural or public art work. Retail price set by the gallery. Gallery provides insurance, promotion, contract, shipping costs.
Submissions: "We prefer New York artists due to constant needs of a public art work created in the city." Send query letter with SASE. Call for appointment to show portfolio of originals, photographs and slides. Responds in 1 month. "We reply to original query with an artist application. Then it depends on commissions." Files application form, résumé, slides, photos, reviews. Finds artists through recommendations from other art professionals.
Tips: "We look for artists who are dedicated to making a difference in people's lives through art, working in collaboration with schools and community members."

CORPORATE ART PLANNING INC., 27 Union Square W., Suite 407, New York NY 10003. (212)242-8995. Fax: (212)242-9198. **Principal:** Maureen McGovern. Fine art exhibitors, virtual entities. Estab. 1986. Represents 2 illustrators, 2 photographers, 5 fine artists (includes 1 sculptor). Guidelines available for #10 SASE. Markets include: corporate collections; design firms; editorial/magazines; publishing/books; art publishers; private collections. Represents: Richard Rockwell, Suzanne Brookers, Michael Freidman and Barry Michlin.
 • Corporate Art Planning is not a physical art space, but requested to be in the Gallery section.
Handles: Fine art only.
Terms: Consultant receives 50%. For promotional purposes, prefers all artists have museum connections and auction profiles. Advertises in *The Workbook*, *Art in America*.
How to Contact: Will contact artist if artwork is requested by the corporate board. Portfolio should include color photocopies only (nonreturnable).

AMOS ENO GALLERY, 59 Franklin St., New York NY 10013. (212)226-5342. E-mail: amoseno@bway.net. Website: www.amosenogallery.org. **Director:** Deborah de Bruin. Nonprofit and cooperative gallery. Estab. 1973. Exhibits the work of 20 mid-career artists. Sponsors 12 shows/year. Average display time 3 weeks. Open all year. Located in Soho; about 1,000 sq. ft.; "excellent location."
Media: Considers oil, acrylic, watercolor, pastel, pen & ink, drawings, mixed media, collage, works on paper, sculpture, fiber, glass, installation and photography and video.
Style: Exhibits a range of styles.
Terms: Co-op membership fee (20% commission). Retail price set by the gallery and the artist. Artist pays for shipping.
Submissions: Send query letter with SASE for membership information.

THOMAS ERBEN GALLERY, 516 W. 20th St., New York NY 10011. (212)645-8701. Fax: (212)941-4158. E-mail: info@thomaserben.com. Website: www.thomaserben.com. For-profit gallery. Estab. 1996. Approached by 100 artists/year. Represents 15 emerging, mid-career and established artists. Exhibited artists include: Preston Scott Cohen (architecture) and Tom Wood (photography). Average display time 5-

6 weeks. Open all year; Tuesday-Saturday, 10-6. Closed Christmas/New Year's and August. Clients include local community, tourists and upscale.

Media: Considers all media. Most frequently exhibits photography, paintings and installation.

Style: Exhibits: contemporary art.

Submissions: Mail portfolio for review. Returns material with SASE. Responds in 1 month.

STEPHEN E. FEINMAN FINE ARTS LTD., 448 Broome St., New York NY 10012. (212)925-1313. E-mail: sef29@aol.com. **Contact:** S.E. Feinman. Retail/wholesale gallery. Estab. 1972. Represents 20 emerging, mid-career and established artists/year. Exhibited artists include: Mikio Watanabe, Johnny Friedlaender, Andre Masson, Felix Sherman, Nick Kosciuk, Robert Trondsen and Miljenko Bengez. Sponsors 4-6 shows/year. Average display time 10 days. Open all year; Monday-Sunday, 12-6. Located in Soho; 1,000 sq. ft. 100% of space for gallery artists. Clients include prosperous middle-aged professionals. 90% of sales are to private collectors, 10% corporate collectors. Overall price range, $300-20,000; most work sold at $1,000-3,500.

Media: Considers oil, acrylic, watercolor, pastel, pen & ink, drawing, mixed media, sculpture, woodcuts, engravings, lithographs, mezzotints, serigraphs, linocuts and etchings. Most frequently exhibits mezzotints, aquatints and oils. Looking for artists that tend toward abstract-expressionists (watercolor/oil or acrylic) in varying sizes.

Style: Exhibits representational, painterly abstraction and surrealism, all genres. Prefers abstract, figurative, representative and surrealist.

Terms: Consignment. Retail price set by the gallery. Gallery provides insurance, promotion, contract and shipping costs from gallery; artist pays shipping costs to gallery. Artwork must be unframed.

Submissions: Send query letter with résumé, slides and photographs. Responds in 3 weeks. No submissions by e-mail.

Tips: Currently seeking representative paintings and artists of quality who see a humorous bent in their works (sardonic, ironic) and are not pretentious. "Artists who show a confusing presentation drive me wild. Artists should remember that dealers and galleries are not critics. They are merchants who try to seduce their clients with aesthetics. Artists who have a chip on their shoulder or an 'attitude' are self-defeating. A sense of humor helps!"

FIRST STREET GALLERY, 526 W. 26th St., #915, New York NY 10001. (646)336-8053. Fax: (646)336-8054. E-mail: firststreetgallery@earthlink.net. Website: www.firststreetgallery.net. or www.artincontext.o rg. Contact: Members Meeting. Cooperative gallery. Estab. 1964. Represents emerging and mid-career artists. 30 members. Sponsors 10-13 shows/year. Average display time 1 month. Open Tuesday-Saturday, 11-6. Closed in August. 100% of space for gallery artists. Clients include collectors, consultants, retail. 50% of sales are to private collectors, 50% corporate collectors. Overall price range: $500-40,000; most work sold at $1,000-3,000.

Media: Considers oil, acrylic, watercolor, pastel, drawing, prints, sculpture. Considers prints "only in connection with paintings." Most frequently exhibits oil on canvas and works on paper.

Style: Exhibits: representational art. Genres include landscapes and figurative work. "First Street's reputation is based on showing representational art almost exclusively."

Terms: Co-op membership fee plus a donation of time (no commission). "We occasionally rent the space in August for $1,500-3,000." Retail price set by the artist. Artist pays shipping costs to and from gallery.

Submissions: Send query letter with résumé, slides, bio and SASE. "Artists' slides reviewed by membership at meetings once a month—call gallery for date in any month. We need to see original work to accept a new member." Responds in 1 month.

Tips: "Before approaching a gallery make sure they show your type of work. Physically examine the gallery if possible. Try to find out as much about the gallery's reputation in relation to its artists (many well-known galleries do not treat artists well). Show a cohesive body of work with as little paperwork as you can, no flowery statements, the work should speak for itself. You should have enough work completed in a professional manner to put on a cohesive-looking show."

FOCAL POINT GALLERY, 321 City Island, Bronx NY 10464. Phone/fax: (718)885-1403. E-mail: RonTerner@aol.com. Website: www.FocalPointGallery.com. **Contact:** Ron Terner. Retail gallery and alternative space. Estab. 1974. Interested in emerging and mid-career artists. Exhibited artists include Marguerite Chadwick-Juner (watercolor). Sponsors 2 solo and 6 group shows/year. Average display time 3-4 weeks. Clients include locals and tourists. Overall price range: $175-750; most work sold at $300-500.

Media: Considers all media. Most frequently exhibits photography, watercolor, oil. Also considers etchings, giclée, color prints, silver prints.

Style: Exhibits all styles. Most frequently exhibits painterly abstraction, conceptualism, expressionism. Genres include figurative work, florals, landscapes, portraits. Open to any use of photography.

Terms: Accepts work on consignment (30% commission). Exclusive area representation required. Customer discounts and payment by installment are available. Gallery provides promotion. Prefers artwork framed.

Submissions: "Please call for submission information. Do not include résumés. The work should stand by itself. Slides should be of high quality."

Tips: "Care about your work."

GALE-MARTIN FINE ART, 134 Tenth Ave., New York NY 10011. (646)638-2525. Fax: (646)486-7457. Website: www.gale-martinfineart.com. For-profit gallery. Estab. 1993. Exhibits mid-career and established artists. Exhibited artists include: D. Hamilton, Caranda-Martin and Francine Tint. Average display time 5 weeks. Open all year; Tuesday-Saturday, 11-6. Closed August and Christmas week. Located on ground floor space on Tenth Ave. in the Chelsea art district of Manhattan; 2,200 sq. ft./sky lights. Clients include upscale. Overall price range: $2,500-150,000; most work sold at $15,000.

Media: Considers acrylic, drawing, oil and paper. Most frequently exhibits paintings of all types.

Style: Exhibits: neo-expressionism and painterly abstraction.

Terms: Artwork is accepted on consignment and there is a 50% commission. Retail price set by the gallery and the artist. Gallery provides insurance. Accepted work should be framed according to our specifications. Requires exclusive representation locally. "We do not accept emerging artists, will consider artists with a strong following only."

Submissions: Cannot return material. Responds only if interested within 3 months. Finds artists through word of mouth and referrals by other artists.

GALLERY JUNO, 568 Broadway, Suite 604B, New York NY 10012. (212)431-1515. Fax: (212)431-1583. **Gallery Director:** June Ishihara. Retail gallery, art consultancy. Estab. 1992. Represents 18 emerging artists/year. Exhibited artists include: Pierre Jacquemon, Kenneth McIndoe and Otto Mjaanes. Sponsors 8 shows/year. Average display time 6 weeks. Open all year; Tuesday-Saturday, 11-6. Located in Soho; 1,000 sq. ft.; small, intimate space. 50% of space for special exhibitions; 50% of space for gallery artists. Clients include corporations, private, design. 20% of sales are to private collectors, 80% corporate collectors. Overall price range: $600-10,000; most work sold at $2,000-5,000.

Media: Considers oil, acrylic, watercolor, pastel, pen & ink, drawing, mixed media. Most frequently exhibits painting and works on paper.

Style: Exhibits: expressionism, neo-expressionism, painterly abstraction, pattern painting and abstraction. Genres include landscapes. Prefers: contemporary modernism and abstraction.

Terms: Accepts work on consignment (50% commission). Retail price set by the gallery and the artist. Gallery provides insurance and promotion; artist pays shipping costs. Prefers artwork framed.

Submissions: Send query letter with résumé, slides, bio, photographs, SASE, business card and reviews. Write for appointment to show portfolio of originals, photographs and slides. Responds in 3 weeks. Files slides, bio, photos, résumé. Finds artists through visiting exhibitions, word of mouth and submissions.

[N] GALLERY@49, 322 W. 49th St., New York NY 10019. (212)767-0855. Fax: (212)664-1534. E-mail: info@gallery49.com. Website: www.gallery49.com. **Contact:** Monica or Coca Rotaru. For-profit gallery. Estab. 1998. Approached by 800 artists/year; exhibits 15 emerging, mid-career and established artists. Exhibited artists include Librado Romero (painting) and Judith Wilde (painting). Sponsors 10 exhibits/year. Average display time is 1 month. Open all year; Tuesday-Saturday, 12-6. Located in Midtown Manhattan's Theater District, ground-floor, bi-level gallery, 1,200 square feet. Clients include local community and tourists. 5% of sales are to corporate collectors. Overall price range is $500-20,000; most work sold at $3,000.

Media: Considers all media. Most frequently exhibits painting, drawing and mixed media. Also considers engravings, etchings and lithographs.

Style: Exhibits conceptualism, neo-expressionism, postmodernism and painterly abstraction. Most frequently exhibits painterly abstraction.

Terms: Artwork is accepted on consignment and there is a 50% commission. Retail price of the art set by the gallery and the artist. Gallery provides insurance, promotion and contract. Accepted work should be framed. Does not require exclusive representation locally.

Submissions: Send query letter with artist's statement, bio, photographs, résumé, reviews and SASE. Returns material with SASE. Responds to queries only if interested in 6 months. Files photographs and resume. Finds artists through art fairs, portfolio reviews, referrals by other artists.

Tips: "Before submitting any material, artists should become familiar with the gallery and be sure their work is compatible with its aesthetic."

SANDRA GERING GALLERY, 534 W. 22nd St., New York NY 10011. (646)336-7183. Fax: (646)336-7185. E-mail: sandra@geringgallery.com. Website: www.geringgallery.com. **Associate Director:** Marianna Baer. For-profit gallery. Estab. 1991. Approached by 240 artists/year. Exhibits 12 emerging, mid-career and established artists. Exhibited artists include: John F. Simon, Jr., computer software panels; Xavier Veilhan, electronic sculpture and digital photography. Sponsors 9 exhibits/year. Average display time 5 weeks. Open all year; Tuesday-Saturday, 10-6; weekends, 10-6. Located on ground floor; 600 sq. ft. of storefront space.

Media: Considers mixed media, oil, sculpture and hightech/digital. Most frequently exhibits computer-based work, electric (light) sculpture and video/DVD.

Style: Exhibits: geometric abstraction. Most frequently exhibits cutting edge.

Terms: Artwork is accepted on consignment.

Submissions: Send query letter with bio and photocopies. Cannot return material. Responds only if interested within 6 months. Finds artists through word of mouth, art exhibits, art fairs and referrals by other artists.

Tips: Most important is to research the galleries and only submit to those that are appropriate. Visit websites if you don't have access to galleries. "We don't exhibit traditional, figurative painting or sculpture."

O.K. HARRIS WORKS OF ART, 383 W. Broadway, New York NY 10012. E-mail: okharris@okharris.com. Website: www.okharris.com. **Director:** Ivan C. Karp. Commercial exhibition gallery. Estab. 1969. Represents 55 emerging, mid-career and established artists. Sponsors 50 solo shows/year. Average display time 1 month. Open fall, winter, spring and early summer. "Four separate galleries for four separate one-person exhibitions. The back room features selected gallery artists which also change each month." 90% of sales are to private collectors, 10% corporate clients. Overall price range: $50-250,000; most work sold at $12,500-100,000.

Media: Considers all media. Most frequently exhibits painting, sculpture and photography.

Style: Exhibits: realism, photorealism, minimalism, abstraction, conceptualism, photography and collectibles. Genres include landscapes, Americana but little figurative work. "The gallery's main concern is to show the most significant artwork of our time. In its choice of works to exhibit, it demonstrates no prejudice as to style or materials employed. Its criteria demands originality of concept and maturity of technique. It believes that its exhibitions have proven the soundness of its judgment in identifying important artists and its pertinent contribution to the visual arts culture."

Terms: Accepts work on consignment (50% commission). Retail price set by gallery. Customer discounts and payment by installment are available. Exclusive area representation required. Gallery provides insurance and limited promotion. Prefers artwork ready to exhibit.

Submissions: Send query letter with 1 sheet of slides (20 slides) "labeled with size, medium, etc." and SASE. Responds in 1 week.

Tips: "We suggest the artist be familiar with the gallery's exhibitions and the kind of work we prefer to show. Visit us either in person or online at www.okharris.com. Always include SASE." Common mistakes artists make in presenting their work are "poor, unmarked photos (size, material, etc.), submissions without return envelope, inappropriate work. We affiliate about one out of 10,000 applicants."

N HELLER GALLERY, 420 W. 14th St., New York NY 10014. (212)414-4014. Fax: (212)414-2636. **Director:** Douglas Heller. Retail gallery. Estab. 1973. Represents/exhibits emerging, mid-career and established artists. Exhibited artists include: Bertil Vallien and Robin Grebe. Sponsors 11 shows/year. Average display time 3 weeks. Open all year; Tuesday-Saturday, 11-6; Sunday, 12-5. "For the past four years Heller Gallery has been located in Manhattan's Meat Packing District. The gallery is a bi-level 7,200 sq. ft. space." 60% of space for special exhibitions. Clients include serious private collectors and museums. 80% of sales are to private collectors, 10% corporate collectors and 10% museum collectors. Overall price range: $1,000-45,000; most work sold at $3,000-10,000.

Media: Glass and wood sculpture. Most frequently exhibits glass, glass and mixed media and wood.

Style: Geometric abstraction and figurative.

Terms: Artwork is accepted on consignment (50% commission). Retail price set by the artist. Gallery provides insurance and limited promotion; shipping costs are shared.

Submission: Send query letter with résumé, slides, photographs, reviews, bio and SASE. Call or write for appointment to show portfolio of photographs, slides and résumé. Responds in 1 month. Files information on artists represented by the gallery. Finds artists through word of mouth, referrals by other artists, visiting art fairs and exhibitions and submissions.

JEANETTE HENDLER, 55 E. 87th St., Suite 15E, New York NY 10128. (212)860-2555. Fax: (212)360-6492. Art consultancy. Exhibits established artists. Exhibited artists include: Warhol, Johns and Haring. Open all year by appointment. Located uptown. 50% of sales are to private collectors, 50% corporate collectors.

Media: Considers oil and acrylic. Most frequently exhibits oils, acrylics and mixed media.

Style: Exhibits: Considers all styles. Genres include landscapes, florals, figurative and Latin. Prefers: realism, classical, neo classical, pre-Raphaelite, still lifes and florals.

Terms: Artwork is accepted on consignment and there is a commission. Retail price set by the gallery and the artist. Gallery provides insurance, promotion and contract.

Submissions: Finds artists through word-of-mouth, referrals by other artists, visiting art fairs and exhibitions.

N MARTHA HENRY FINE ART, 400 E. 57th St., Suite 7L, New York NY 10019. (212)308-2759. Fax: (212)754-4419. E-mail: marthahenry@marthahenry.com. Website: www.marthahenry.com. **Contact:** Martha Henry, president. Estab. 1987. Art consultancy. Exhibits emerging, mid-career and established artists. Approached by over 200 artists/year; exhibits over 12 artists/year. Exhibited artists include Jay Milder (oil paintings) and Bob Thompson (oil paintings). Sponsors 2 exhibits/year. Average display time 4 days to 6 weeks. Open all year; Monday-Friday, 12-6; weekends by appointment only. Located in a private gallery in an apartment building. 5% of sales are to corporate collectors. Overall price range: $15,000-50,000; most work sold at $50,000.

Terms: Accepts only African-American artists.

Submissions: Mail portfolio for review or send query letter with artist's statement, bio, photocopies, photographs, SASE and slides. Returns material with SASE. Responds in 3 months. Files slides, bio or postcard. Finds artists through art fairs and exhibits, portfolio reviews, referrals by other artists, submissions, word-of-mouth and press.

MICHAEL INGBAR GALLERY OF ARCHITECTURAL ART, 568 Broadway, New York NY 10012. (212)334-1100. **Curator:** Millicent Hathaway. Retail gallery. Estab. 1977. Represents 145 emerging, mid-career and established artists. Exhibited artists include: Richard Haas and Judith Turner. Sponsors 6 shows/year. Average display time 6 weeks. Open all year; Tuesday-Saturday, 12-6. Located in Soho; 1,000 sq. ft. 60% of sales are to private collectors, 40% corporate clients. Overall price range: $500-10,000; most work sold at $5,000.

Media: Considers all media and all types of prints. Most frequently exhibits paintings, works on paper and b&w photography.

Style: Exhibits: photorealism, realism and impressionism. Specializes in New York City architecture. Prefers: New York City buildings, New York City structures (bridges, etc.) and New York City cityscapes.

Terms: Artwork accepted on consignment (50% commission). Artists pays shipping costs.

Submissions: Accepts artists only from New York City metro area. Send query letter with SASE to receive "how to submit" information sheet. Responds in 1 week.

Tips: "Study what the gallery sells before you go through lots of trouble and waste their time. Be professional in your presentation." The most common mistakes artists make in presenting their work are "coming in person, constantly calling, poor slide quality (or unmarked slides) and not understanding how to price their work."

JADITE GALLERIES, 413 W. 50th St., New York NY 10019. (212)315-2740. Fax: (212)315-2793. **Director:** Roland Sainz. Retail gallery. Estab. 1985. Represents 25 emerging and established, national and international artists. Sponsors 10 solo and 2 group shows/year. Average display time 3 weeks. Clientele: 80% private collectors, 20% corporate clients. Overall price range: $500-8,000; most artwork sold at $1,000-3,000.

Media: Considers oil, acrylic, watercolor, pastel, pen & ink, drawings, mixed media, collage, sculpture and original handpulled prints. Most frequently exhibits oils, acrylics, pastels and sculpture.

Style: Exhibits minimalism, postmodern works, impressionism, neo-expressionism, realism and surrealism. Genres include landscapes, florals, portraits, western collages and figurative work. Features mid-career and emerging international artists dealing with contemporary works.

Terms: Accepts work on consignment (40% commission). Retail price set by gallery and artist. Exclusive area representation not required. Gallery provides insurance, promotion and contract; exhibition costs are shared.

Submissions: Send query letter, résumé, brochure, slides, photographs and SASE. Call or write for appointment to show portfolio of originals, slides or photos. Resume, photographs or slides are filed.

N **CORTLAND JESSUP CJG PROJECTS INC.**, 135 W. 29th St, #500, New York NY 10012. **Director:** Cortland Jessup. Estab. 1990. Represents mid-career and established artists. Exhibited artists include Juliet Holland and Patrick Webb. Sponsors 12 shows/year. Average display time 4-6 weeks. Open all year; Wednesday-Saturday, 12-5:30. Located in East Chelsea; 900 sq. ft. 75% of space for special exhibitions; 25% of space for gallery artists. 90% private collectors, 10% corporate collectors. "We have a small curated competitive showcase space adjacent to our gallery where artists are selected annually for 1 or 2 person exhibition."

Media: Considers all media.

Style: Prefers mixed media painterly abstraction, conceptual neo-expressionism and periodically, traditional landscape, still life, figurative works by mid-career or established artists.

Terms: Accepts work on consignment. "Artist must support the expense. No gallery commissions on sales from artist supported exhibitions."

Submissions: Send résumé, slides, bio and SASE. Responds only if interested. Files material of interest or for consideration for future projects. Finds artists through word of mouth, referrals by other artists, travel and submissions.

Tips: "Don't walk in with slides and/or art under arm and expect to be seen. We will look only if sent by mail (or dropped off) with SASE—and we will never look at original art work carried in without appointment. We are highly selective and slides are reviewed twice a year for these spots."

N **JHB GALLERY**, 26 Grove St., 4C, New York NY 10014-5329. (212)255-9286. Fax: (212)229-8998. E-mail: info@jhbgallery.com. Art consultancy, for-profit gallery. Estab. 1982. Exhibited artists include: Ellen Carey and Don Freeman. Open by appointment only. Clients include upscale.

Media: Specializing in contemporary photography, new media and media related work.

Terms: Artwork is accepted on consignment and there is a 50% commission. Retail price set by the gallery. Gallery provides promotion. Does not require exclusive representation locally.

Submissions: Send query letter with artist's statement, bio, photocopies, photographs, résumé, reviews, SASE and slides. Returns material with SASE. Riles résumés. Finds artists through submissions, portfolio reviews, art exhibits, art fairs, and referrals by other artists.

MADELYN JORDON FINE ART, 40 Cushman Rd., Scarsdale NY 10583. (914)472-4748. E-mail: mrjart@aol.com. Website: www.madelynjordanfineart.com. **Contact:** Madelyn Jordon. Art consultancy, for-profit gallery. Estab. 1991. Approached by 50 artists/year. Exhibits 40 mid-career and established artists. Exhibited artists include: Ted Larsen and Derek Buckner. Clients include local community and upscale. 10% of sales are to corporate collectors. Overall price range: $500-20,000; most work sold at $3,000-5,000.

Media: Considers all media and all types of prints. Most frequently exhibits paintings, works on paper and sculpture.

Style: Considers all styles and genres.

Terms: Gallery provides insurance and promotion. Requires exclusive representation locally.

Submissions: Send artist's statement, bio, photographs, SASE or slides. Returns material with SASE.

N **LA MAMA LA GALLERIA**, 6 E. First St., New York NY 10003. (212)505-2476. **Curator:** Merry Geng. Nonprofit gallery. Estab. 1981. Exhibits the work of emerging, mid-career and established artists. Sponsors 14 shows/year. Average display time 3 weeks. Open September-June; Thursday-Sunday 1-6. Located in East Village; 2,500 sq. ft. "Large and versatile space." 20% of sales are to private collectors, 20% corporate clients. Overall price range: $500-1,000; most work sold at $500 or less.

Media: Considers oil, acrylic, watercolor, pastel, pen & ink, mixed media, collage, fiber, paper, craft. "No performance art." Prefer flat 2-D work. Most frequently exhibits acrylic, watercolor, installation.

Style: Considers all types of prints. Considers all styles. Most frequently exhibits postmodernism, expres-

sionism, primitive realism. Genres include pop-culture art, landscapes, cityscapes.

Terms: Accepts work on consignment (20% commission). Retail price set by artist, approved by gallery. Artist is responsible for delivery of sales. Artwork must be framed and ready to hang.

Submissions: "Call first to see if we are accepting slides at the time. Must include return mailer including postage."

Tips: "Most important is to call first to see if I'm currently looking at work. I sometimes make special acceptances. Try to have a clean and neat portfolio or book."

LIMNER GALLERY, 870 Avenue of the Americas, New York NY 10001. Phone/fax: (212)725-0999. E-mail: slowart@aol.com. Website: www.slowart.com. **Director:** Tim Slowinski. Limner Gallery is an artist-owned alternative retail (consignment) gallery. Estab. 1987. Represents emerging and mid-career artists. Hosts biannual exhibitions of emerging artists selected by competition, cash awards up to $1,000. Entry available for SASE or from website. Sponsors 6-8 shows/year. Average display time 3 weeks. Open Wednesday-Saturday, 12-6; August 30-June 15, by appointment. Located in Chelsea, 1,200 sq. ft.. 60-80% of space for special exhibitions; 20-40% of space for gallery artists. Clients include lawyers, real estate developers, doctors, architects. 95% of sales are to private collectors, 5% corporate collectors. Overall price range: $300-10,000.

Media: Considers all media, all types of prints except posters. Most frequently exhibits painting, sculpture and works on paper.

Style: Exhibits: primitivism, surrealism, political commentary, satire, all styles, postmodern works, all genres. "Gallery exhibits all styles but emphasis is on non-traditional figurative work."

Terms: Accepts work on consignment (50% commission). Retail price set by the gallery and the artist. Gallery provides promotion and contract; artist pays shipping costs to and from gallery. Prefers artwork framed.

Submissions: Send query letter with résumé, slides, bio and SASE. Call for appointment to show portfolio of originals, photographs, slides and transparencies. Responds in 3 weeks. Files slides, résumé. Finds artists through word of mouth, art publications and sourcebooks, submissions.

[N] THE JOE & EMILY LOWE ART GALLERY AT HUDSON GUILD, 441 W. 26th St., New York NY 10001. (212)760-9837. E-mail: jfurlong@hudsonguild.org. **Director:** Jim Furlong. Nonprofit gallery. Estab. 1948. Represents emerging, mid-career, community-based and established artists. Sponsors 8 shows/year. Average display time 6 weeks. Open all year. Located in West Chelsea; 1,200 sq. ft.; a community center gallery in a New York City neighborhood. 100% of space for special exhibitions. 100% of sales are to private collectors.

Media: Considers oil, acrylic, watercolor, pastel, pen & ink, drawings, mixed media, collage, paper, sculpture, original handpulled prints, woodcuts, wood engravings, linocuts, engravings, mezzotints, etchings, lithographs, pochoir and serigraphs. Most frequently exhibits paintings, sculpture and graphics. Looking for artist to do an environmental "installation."

Style: Exhibits all styles and genres.

Terms: Accepts work on consignment (20% commission). Retail price set by artist. Gallery provides insurance; artist pays for shipping. Prefers artwork framed.

Submissions: Send query letter, résumé, slides, bio and SASE. Portfolio should include photographs and slides. Responds in 1 month. Finds artists through visiting exhibitions, word of mouth, various art publications and sourcebooks, artists' submissions/self-promotions, art collectors' referrals.

Tips: "Medium or small works by emerging artists are more likely to be shown in group shows than large work."

THE MARBELLA GALLERY, INC., 28 E. 72nd St., New York NY 10021. (212)288-7809. **President:** Mildred Thaler Cohen. Retail gallery. Estab. 1971. Represents/exhibits established artists of the nineteenth century. Exhibited artists include: The Ten and The Eight. Sponsors 1 show/year. Average display time 6 weeks. Open all year; Tuesday-Saturday, 11-5:30. Located uptown; 750 sq. ft. 100% of space for special exhibitions. Clients include tourists and upscale. 50% of sales are to private collectors, 10% corporate collectors, 40% dealers. Overall price range: $1,000-60,000; most work sold at $2,000-4,000.

Style: Exhibits: expressionism, realism and impressionism. Genres include landscapes, florals, Americana and figurative work. Prefers Hudson River, "The Eight" and genre.

Terms: Artwork is bought outright. Retail price set by the gallery. Gallery provides insurance.

NURTUREART NON-PROFIT, INC., 160 Cabrini Blvd., Suite 134, New York NY 10033-1145. (212)795-5566. E-mail: nurtureart@nurtureart.org. Website: www.nurtureart.org. **Executive Director:**

George J. Robinson. All volunteer, tax-exempt charitable art services organization. Estab. 1997. Approached by and exhibits 400 emerging and mid-career artists/year. Exhibited artists include: Patrick Meagher, painting and works on paper. Sponsors 6 exhibits/year. Average display time 1 month. Open Monday-Friday, 10-6; Saturday, 11-5. Closed December 23-January 2; and July 1-August 31. Clients include local community, students, tourists and upscale. 25% of sales are to corporate collectors. Overall price range: $500-10,000; most work sold at $1,000-3,000.
Media: Considers all media except craft. Most frequently exhibits painting, work on paper and photography. Considers engravings, etchings, linocuts, lithographs, mezzotints and woodcuts.
Style: Considers all styles.
Terms: "Collector and artist are brought together for sale; if in commercial host venue, host acts as agent of sale for a commission. Retail price set by the artist. Gallery provides promotion and contract. Accepted work should be exhibition-ready per prior discussion, agreement. Does not require exclusive representation locally. Accepts only artists over 21 years of age, who do not have ongoing gallery representation.
Submissions: Send artist's statement, bio, color photocopies, résumé, reviews, SASE and slides (required). Artist should inquire first via website; also by phone if in New York City ("we cannot return long-distance phone calls.") Finds artists through word of mouth, website, portfolio submissions, jurors, curators, portfolio reviews, art exhibits, referrals by other artists.
Tips: "Solicit experience of professionals (for instance, peers and artist reps)."

BOSE PACIA MODERN, 508 W. 26th St., 11th Floor, New York NY 10001. (212)989-7074. Fax: (212)989-6982. E-mail: mail@bosepaciamodern.com. Website: www.bosepaciamodern.com. **Director:** Lisa Varghese. For-profit gallery. Estab. 1994. Approached by 100 artists/year. Exhibits 40 emerging and mid-career artists. Exhibited artists include: Jitish Kallat, mixed media/canvas; Arpita Singh, watercolor/paper, oil/canvas. Sponsors 5-6 exhibits/year. Average display time 5-6 weeks. Open all year; Tuesday-Saturday, 12-6. Large gallery in building in Chelsea district of New York. Clients include local community and upscale collectors. 5% of sales are to corporate collectors. Overall price range: $500-150,000; most work sold at $5,000-15,000.
Media: Considers acrylic, drawing, installation, mixed media, oil, paper, pastel, pen & ink, prints, sculpture and watercolor.
Style: Specializes in South Asian and international art. Considers all styles, primarily modern and contemporary work.
Terms: Artwork is accepted on consignment and there is a 50% commission. Retail price set by the gallery. Gallery provides promotion. Does not require exclusive representation locally. Typically accepts only artists from south Asia (India, Pakistan) and/or artists whose work is strongly influenced by South Asian region and culture.
Submissions: Mail portfolio for review. Returns material only with SASE. Responds only if interested within 1 month. Files portfolios. Finds artists through portfolio reviews and art exhibits.

THE PAINTING CENTER, 52 Greene St., New York NY 10013. Phone/fax: (212)343-1060. Website: www.thepaintingcenter.com. **Contact:** Christina Chow, administrative director. Nonprofit, cooperative gallery. Estab. 1993. Exhibits emerging mid-career and established artists. Open all year; Tuesday-Saturday, 11-6; weekends, 11-6. Closed Thanksgiving, Christmas/New Year's Day. Clients include artists, local community, students, tourists and upscale businessmen.
Media: Considers all media except: sculpture, photographs and some installations. Most frequently exhibits paintings in oil, acrylic and drawings.
Style: Considers all styles and genres.
Terms: There is a 20% commission. Retail price set by the artist. Accepted work should be framed and mounted. Does not require exclusive representation locally.
Submissions: Mail portfolio for review. Send artist's statement, bio, résumé, SASE and slides. Returns material with SASE. responds in 8 months. Finds artists through word of mouth, submissions, art exhibits and referrals by other artists and curators.
Tips: "Submit a letter addressed to the 'review committee,' a sheet of slides of your work, SASE, résumé, and publications/reviews about your work if you have any."

N: SCOTT PFAFFMAN GALLERY, 35 E. First St., New York NY 10003. **Contact:** Scott Pfaffman, director. Estab. 1996. Exhibits emerging, mid-career and established artists. Approached by 20 artists/year. Very small exhibition space. Clients include local community, collectors and artists. Overall price range: $100-5,000; most work sold at $300-500.

Media: Considers installation art, film, video, photography.

Style: Considers all styles.

Terms: Artwork is accepted on consignment and there is a 40% commission. Retail price of the art set by the the artist. Gallery provides promotion and contract. Does not require exclusive representation locally.

Submissions: Write to arrange a personal interview to show portfolio of photographs, slides and transparencies or send query letter with photographs, reviews and SASE. Returns material with SASE. Responds to queries only if interested within 2 months. Finds artists through referrals by other artists.

THE PHOENIX GALLERY, 568 Broadway, Suite 607, New York NY 10012. (212)226-8711. E-mail: info@phoenix-gallery.com. Website: www.phoenix-gallery.com. **Director:** Linda Handler. Nonprofit gallery. Estab. 1958. Exhibits the work of emerging, mid-career and established artists. 32 members. Exhibited artists include: Robert Blank and Steven Dono. Sponsors 10-12 shows/year. Average display time 1 month. Open fall, winter and spring. Located in Soho; 180 linear ft. "We are in a landmark building in Soho, the oldest co-op in New York. We have a movable wall which can divide the gallery into two large spaces." 100% of space for special exhibitions. 75% of sales are to private collectors, 25% corporate clients, also art consultants. Overall price range: $50-20,000; most work sold at $300-10,000.

- The Phoenix Gallery actively reaches out to the members of the local community, scheduling juried competitions, dance programs, poetry readings, book signings, plays, artists speaking on art panels and lectures. A special exhibition space, The Project Room, has been established for guest-artist exhibits.

Media: Considers oil, acrylic, watercolor, pastel, pen & ink, drawings, mixed media, collage, works on paper, sculpture, ceramic, photography, original handpulled prints, woodcuts, engravings, wood engravings, linocuts, etchings and photographs. Most frequently exhibits oil, acrylic and watercolor.

Style: Exhibits: painterly abstraction, minimalism, realism, photorealism, hard-edge geometric abstraction and all styles.

Terms: Co-op membership fee plus donation of time (25% commission). Retail price set by gallery. Offers customer discounts and payment by installment. Gallery provides promotion and contract; artist pays for shipping. Prefers artwork framed.

Submissions: Send query letter with résumé, slides and SASE. Call for appointment to show portfolio of slides. Responds in 1 month. Only files material of accepted artists. The most common mistakes artists make in presenting their work are "incomplete résumés, unlabeled slides and an application that is not filled out properly. We find new artists by advertising in art magazines and art newspapers, word of mouth, and inviting artists from our juried competition to be reviewed for membership."

Tips: "Come and see the gallery—meet the director."

QUEENS COLLEGE ART CENTER, Benjamin S. Rosenthal Library, Queens College/CUNY, Flushing NY 11367. (718)997-3770. Fax: (718)997-3753. E-mail: suzanna_simor@QC.edu. Website: www.qclibr ary/art/artlibrary.html. **Director:** Suzanna Simor. Curator: Alexandra de Luise. Nonprofit university gallery. Estab. 1955. Exhibits work of emerging, mid-career and established artists. Sponsors approximately 5 shows/year. Average display time 6 weeks. Open all year; when school is in session, hours are: Monday-Thursday, 9-8; Friday, 9-5. Call for summer and other hours. Located in borough of Queens; 1,000 sq. ft. The gallery is wrapped "Guggenheim Museum" style under a circular skylight in the library's atrium. 100% of space for special exhibitions. Clients include "college and community, some commuters." Nearly all sales are to private collectors. Overall price range: up to $10,000; most work sold at $300.

Media: Considers all media and all types of prints. Most frequently exhibits paintings, prints, drawings and photographs, smaller sculpture.

Style: Exhibits: Considers all styles.

Terms: Accepts work on consignment (40% commission). Retail price set by the artist. Gallery provides promotion. Artist pays for shipping costs, announcements and other materials. Prefers artwork framed.

Submissions: Cannot exhibit large 3-D objects. Send query letter with résumé, brochure, slides, photographs, reviews, bio and SASE. Responds in 3 weeks. Files all documentation.

Tips: "We are interested in high-quality original artwork by anyone. Please send sufficient information."

RAYDON GALLERY, 1091 Madison Ave., New York NY 10028. (212)288-3555. **Director:** Alexander R. Raydon. Retail gallery. Estab. 1962. Represents established artists. Sponsors 12 group shows/year. Clientele: tri-state collectors and institutions (museums). Overall price range: $100-100,000; most work sold at $1,800-4,800.

Media: Considers all media. Most frequently exhibits oil, prints and watercolor.

Style: Exhibits all styles and genres. "We show fine works of arts in all media, periods and schools from the Renaissance to the present with emphasis on American paintings, prints and sculpture." Interested in seeing mature works of art of established artists or artist's estates.

Terms: Accepts work on consignment or buys outright.

Tips: "Artists should present themselves in person with background back-up material (bios, catalogs, exhibit records and original work, slides or photos). Join local, regional and national art groups and associations for grants exposure, review, criticism and development of peers and collectors."

⚉ ST. MARK'S CHURCH, 131 E. Tenth St., New York NY 10003. (212)674-6377, ext. 12. Fax: (212)219-3588. E-mail: m.scheflen@verizon.net. Website: www.kiboko.org. **Director:** Mark Scheflen. Alternative space, nonprofit gallery. Estab. 1994. Approached by 100 artists/year. Represents 10-50 established artists. Sponsors 1 exhibit/year. Average display time 1-2 months. Open all year; Saturday-Sunday, 3:30-6:30. Closed Easter and Christmas. Located in downtown New York City; 40×60 wood floors; ideal lighting. Clients include local community and students.

Media: Considers all media. Most frequently exhibits multimedia exhibits. Considers engravings, etchings, linocuts, lithographs, mezzotints and woodcuts.

Style: Considers all styles and genres.

Terms: Artwork is accepted on consignment. Retail price set by the artist. Gallery provides insurance, promotion and contract. Accepted work should be framed and matted. Does not require exclusive representation locally. Professionals only.

Submissions: Write to arrange a personal interview to show portfolio. Send query letter with artist's statement, bio, photographs, résumé and slides. Returns material with SASE. Reponds only if interested within 2 months. Files résumé and statement. Finds artists through word of mouth, art exhibits, and referrals by other artists.

Tips: "Submit clear, concise artist and project statements."

SCULPTURECENTER, (formerly Sculpturecenter Gallery), 44-19 Purves St., Long Island City NY 11101. (718)361-1750. Fax: (718)786-9336. E-mail: info@sculpture-center.org. Website: www.sculpture-center.org. **Executive Director:** Mary Ceruti. Alternative space, nonprofit gallery. Estab. 1928. Exhibits emerging and mid-career artists. Sponsors 8-10 shows/year. Average display time 2-4 months. Open all year; Thursday-Monday, 11-6. Does not actively sell work.

Media: Considers drawing, mixed media, sculpture and installation. Most frequently exhibits sculpture, installations and video installations.

Terms: Accepts work on consignment (25% commission). Retail price set by the gallery and the artist. Gallery provides promotion; artist pays shipping costs.

Submissions: Send query letter with résumé, 10-20 slides, bio and SASE. Call for appointment to show portfolio of photographs, slides and transparencies. Responds in 2 months. Files bios and slides. Finds artists through artists' and curators' submissions (mostly) and word of mouth.

ANITA SHAPOLSKY GALLERY, 152 E. 65th St., (patio entrance), New York NY 10021. (212)452-1094. Fax: (212)452-1096. E-mail: ashapolsky@nyc.rr.com. Website: www.artincontext.org/anita-shapolsky-gallery.html. For-profit gallery. Estab. 1982. Exhibits established artists. Exhibited artists include: Ernest Briggs, painting; Michael Loew, painting. Open all year; Wednesday-Saturday, 11-6. Call for summer hours. Clients include local community and upscale.

Media: Considers acrylic, collage, drawing, mixed media, oil, paper, pen & ink, sculpture, engravings, etchings, lithographs, serigraphs and woodcuts. Most frequently exhibits oil, acrylic and sculpture.

Style: Exhibits: expressionism and geometric abstraction and painterly abstraction. Genres include 1950s abstract expressionism.

Terms: Prefers only 1950s abstract expressionism.

Submissions: Mail portfolio for review in May and October only. Send query letter with artist's statement, bio, SASE and slides. Returns material with SASE.

⚉ STEINHARDT CONSERVATORY GALLERY, 1000 Washington Ave., New York NY 11225. (718)623-7263. Fax: (718)622-7839. E-mail: emilycarson@bbg.org. Website: www.bbg.org. **Contact:** Emily Carson, curator, public programs associate. Nonprofit gallery. Estab. 1988. Approached by 75 artists/year. Represents 10-12 emerging, mid-career and established artists. Sponsors 10-12 exhibits/year. Average display time 4-6 weeks. Open all year; Thursday-Sunday, 10-4. Overall price range: $75-7,500; most work sold at $500.

Media: Considers all media and all types of prints.

Style: Considers all styles. Genres include the natural world.

Terms: Artwork is accepted on consignment and there is a 20% commission. Retail price set by the artist. Gallery provides insurance, promotion and contract. Accepted work should be framed. Does not require exclusive representation locally.

Submissions: Send query letter with artist's statement, bio, business card. Returns material with SASE. Responds to queries after 1st of January. Files application, résumé and statement. Finds artists through portfolio reviews, referrals by other artists, submissions and word of mouth.

Tips: "Quality, not quantity, with indication of total number of works to be hung if selected. Confirm that digital submissions are **fully functional** for consideration."

SYNCHRONICITY FINE ARTS, 106 W. 13th St., Ground Floor, New York NY 10011. (646)230-8199. Fax: (646)230-8198. E-mail: synchspa@bestweb.net. Website: www.synchronicityspace.com. Nonprofit gallery. Estab. 1989. Approached by several hundred artists/year. Exhibits 12-16 emerging and established artists. Exhibited artists include: Rosalyn Jacobs, oil on linen; Diana Postel, oil on linen; John Smith-Amato, oil on linen. Sponsors 6 exhibits/year. Average display time 1 month. Open all year; Tuesday-Saturday, 12-6. Closed in August for 2 weeks. Located in the heart of West Village—tree-lined street; 1,500 sq. ft; 8-9 ft. ceilings; all track/Halogen lighting. Clients include local community, students, tourists and upscale. 20% of sales are to corporate collectors. Overall price range: $1,500-10,000; most work sold at $3,000-5,000.

Media: Considers acrylic, collage, drawing, mixed media, oil, paper, pastel, pen & ink, sculpture, watercolor, engravings, etchings, mezzotints and woodcuts. Most frequently exhibits oil, sculpture and photography.

Style: Exhibits: color field, expressionism, impressionism, postmodernism and painterly abstraction. Most frequently exhibits semi-abstract and semi-representational abstract. Genres include figurative work, landscapes and portraits.

Terms: Alternative based upon existing funding resources. Retail price set by the gallery. Gallery provides insurance, promotion and contract. Accepted work should be framed, mounted and matted. Does not require exclusive representation locally. Only semi-abstract and semi-representational.

Submissions: Write to arrange a personal interview to show portfolio of photographs, slides and transparencies. Mail portfolio for review or make an appointment by phone. Send query letter with photocopies, photographs, résumé, SASE and slides. Returns material with SASE. Responds in 3 weeks. Files all unless artist requests return. Finds artists through submissions, portfolio reviews, art exhibits and referrals by other artists.

Tips: Include clear and accurate transparencies; cover letter; investigate gallery history to apply consistently with styles and type of work we show.

JOHN SZOKE EDITIONS, 591 Broadway, 3rd Floor, New York NY 10012. (212)219-8300. Fax: (212)966-3064. E-mail: info@johnszokeeditions.com. Website: www.johnszokeeditions.com. **President/Director:** John Szoke. Retail gallery and art publisher. Estab. 1974. Represents 30 mid-career artists. Exhibited artists include Jasper Johns, Picasso, Chagall. Publishes the work of Richard Haas, James Rizzi, Jeannette Pasin Sloan. Open all year. Located downtown in Soho. Clients include other dealers and collectors. 20% of sales are to private collectors.

● Not considering new artists at the present time.

Media: Exhibits works on paper, multiples in relief and intaglio and sculpture.

N **THROCKMORTON FINE ART**, 145 E. 57th St., 3rd Floor, New York NY 10022. (212)223-1059. Fax: (212)223-1937. E-mail: throckmorton@earthlink.net. Website: www.throckmorton-nyc.com. **Contact:** Kraige Block, director. For-profit gallery. Exhibits 15 emerging, mid-career and established artists/year. Exhibited artists include Ruven Afanador and Flor Garpuño. Average display time 1 month. Open all year; Tuesday-Saturday, 11-5. Located in the Hammacher Schlemmer Building; 4,000 square feet; 1,000 square feet exhibition space. Clients include local community and upscale. Overall price range $1,000-75,000; most work sold at $2,500.

Media: Most frequently exhibits photography, antiquities. Also considers gelatin, platinum and albumen prints.

Style: Exhibits expressionism. Genres include Latin American.

Terms: Retail price of art set by the gallery. Gallery provides insurance and promotion. Requires exclusive representation locally. Accepts only artists from Latin America. Prefers only b&w and color photography.

Submissions: Call or write to arrange personal interview to show portfolio of photographs. Returns material with SASE. Responds to queries only if interested within 2 weeks. Files bios and résumés. Finds artists through portfolio reviews, referrals by other artists and submissions.

TIBOR DE NAGY GALLERY, 724 Fifth Ave., New York NY 10019. (212)262-5050. Fax: (212)262-1841. **Owners:** Andrew H. Arnot and Eric Brown. Retail gallery. Estab. 1950. Represents emerging and mid-career artists. Exhibited artists include: Jane Freilicher, Estate of Nell Blaine, Robert Berlind, David Kapp and Rudy Burckhardt. Sponsors 12 shows/year. Average display time 1 month. Closed August. Located midtown; 3,500 sq. ft. 100% of space for work of gallery artists. 60% private collectors, 40% corporate collectors. Overall price range: $1,000-100,000; most work sold at $5,000-20,000.
　• The gallery focus is on painting within the New York school traditions and photography.
Media: Considers oil, pen & ink, paper, acrylic, drawings, sculpture, watercolor, mixed media, pastel, collage, etchings, and lithographs. Most frequently exhibits oil/acrylic, watercolor and sculpture.
Style: Exhibits representational work as well as abstract painting and sculpture. Genres include landscapes and figurative work. Prefers abstract, painterly realism and realism.
Submissions: Gallery is not looking for submissions at this time.

N. ALTHEA VIAFORA, 205 E. 72nd St., New York NY 10021. (212)628-2402. **Contact:** Althea Viafora-Kress. Private art dealer and art consultancy. Estab. 1981. Works with 10 emerging, mid-career and established artists/year. Exhibited artists include: Matthew Barney and Emil Lukas. Open by appointment. Clients include upscale. 100% of sales are to private collectors. Overall price range: $2,000-2,000,000; most work sold at $40,000-60,000.
Media: Considers oil, pen & ink, paper, acrylic, drawing, sculpture, watercolor, mixed media, installation, collage, murals, photography, mezzotint, etching, lithograph and serigraphs.
Style: Old masters, 19th century, modern, post-modern and contemporary.
Terms: Retail price set by the marketplace. Dealer provides insurance and promotion. Dealer pays for shipping costs. Prefers artwork framed.
Submissions: "Artists must be currently exhibiting in a commercial gallery." Send query letter with slides, reviews, bio and SASE. Contact through the mail. Responds in 1 month. Files bio. Finds artists through museums and commercial galleries.
Tips: "Go to galleries and museums to view your peers' work. Know the history of the dealer, curator, critic you are contacting."

The Vandals, oil on canvas, by May DeViney was shown at Viridian Artists in the heart of Chelsea in New York City. To see more work from this gallery, visit www.viridianartists.com.

N VIRIDIAN ARTISTS INC., 530 W. 25th St., Suite 407, New York NY 10001-5546. Phone/fax: (212)245-2882. E-mail: info@viridianartists.com. Website: www.viridianartists.com. **Director:** Vernita Nemec. Cooperative gallery. Estab. 1970. Exhibits the work of 35 emerging, mid-career and established artists. Sponsors 13 solo and 2 group shows/year. Average display time 3 weeks. Clients include consultants, corporations, private collectors. 50% of sales are to private collectors, 50% corporate clients. Overall price range: $500-20,000; most work sold at $1,000-8,000.

Media: Considers oil, acrylic, watercolor, pastel, pen & ink, drawings, mixed media, collage, works on paper, sculpture, installation, photography and limited edition prints. Most frequently exhibits works on canvas, sculpture, mixed media, works on paper and photography.

Style: Exhibits: hard-edge geometric abstraction, color field, painterly abstraction, conceptualism, post-modern works, primitivism, photorealism, abstract, expressionism, and realism. "Eclecticism is Viridian's policy. The only unifying factor is quality. Work must be of the highest technical and aesthetic standards."

Terms: Accepts work on consignment (30% commission). Retail price set by gallery and artist. Sometimes offers customer discounts and payment by installment. Exclusive area representation not required. Gallery provides promotion, contract and representation.

Submissions: Send query letter, slides or call ahead for information on procedure. Portfolio review requested if interested in artist's work.

Tips: "Artists often don't realize that they are presenting their work to an artist-owned gallery where they must pay each month to maintain their representation. We feel a need to demand more of artists who submit work. Because of the number of artists who submit work, our criteria for approval has increased as we receive stronger work than in past years, due to commercial gallery closings."

ELAINE WECHSLER P.D., 245 W. 104th St., Suite 5B, New York NY 10025. (212)222-4357. **Contact:** Elaine Wechsler. Art consultant, private dealer. Estab. 1985. Represents mid-career and established artists/year. Exhibited artists include John Hultberg (acrylic on canvas); Jacqueline R. Hud (oil/canvas). Open by appointment. Located uptown; 1,500 sq. ft.; pre-war suite—paintings hung as they would be in a home; art brokerage American painting: 1940s-1970s. Full catalog production/printing. Clientele: upscale. 80% private collectors. Overall price range: $800-50,000.

Media: Considers oil, acrylic, watercolor, mixed media, collage, paper, photography, lithograph and etching. Most frequently exhibits acrylic, oil, mixed media.

Style: Exhibits expressionism, painterly abstraction and surrealism. Genres include landscapes, florals and figurative work. Most frequently exhibits painterly abstraction, expressionism and surrealism. Finds appropriate New York venues for artists. Acts as career coach.

Terms: Charges 50% commission. Retail price set by the gallery and the artist. Gallery provides promotion and contract. Prefers artwork framed.

Submissions: Send query letter with résumé, slides, bio, brochure, SASE and reviews. Write for appointment to show portfolio of originals, photographs, slides and promotion material. Responds in 6 months. Files promotion brochures and bios. Finds artists through visiting exhibitions, slide files, referrals, artists' submissions.

Tips: Looks for "professional attitude, continuing production and own following of collectors."

N WIESNER GALLERY, Suite 4D, 730 57th St., Brooklyn NY 11220. (718)492-6123. **Director:** Nikola Vizner. Retail gallery and art consultancy. Estab. 1985. Represents 30 emerging and established artists. Sponsors 5 solo and 5 group shows/year. Average display time 1 month. Clientele: 50% private collectors, 50% corporate clients. Overall price range: $200-15,000; most artwork sold at $1,200.

Media: Considers oil, acrylic, watercolor, pastel, pen & ink, drawings, mixed media, collage, works on paper, sculpture, installations, photography and limited edition prints. Most frequently exhibits oil, acrylic and photography.

Style: Exhibits color field, painterly abstraction, minimalism, conceptualism, post-modernism, feminist/political, neo-expressionism, realism and surrealism. Genres include landscapes, Americana and figurative work. Seeks "strong contemporary works regardless of medium, with artist's statement about his viewpoint, philosophy, personal or universal message."

Terms: Accepts work on consignment (50% commission). Retail price set by gallery and artist. Exclusive area representation not required. Gallery provides insurance and promotion; artist pays for shipping.

Submissions: Send résumé, slides and SASE. Write for appointment to show portfolio of slides and transparencies. Files résumés, slides, photogrpahs, brochures and transparencies.

Tips: "Looks for high artistic knowledge and intelligence."

☑ **PHILIP WILLIAMS POSTERS**, 85 W. Broadway, New York NY 10007. (212)513-0313. E-mail: posters@mail.com. Website: www.postermuseum.com. **Contact:** Philip Williams. Retail and wholesale gallery. Represents/exhibits 40 emerging, mid-career and established artists. Open all year; Monday-Sunday, 11-7

Terms: Shipping costs are shared. Prefers artwork unframed.

Submissions: Prefers only vintage posters and outsider artist. Send query letter with photographs. Call for appointment to show portfolio of photographs.

North Carolina

[N] ARTS UNITED FOR DAVIDSON COUNTY, 220 S. Main St., Lexington NC 27292. (336)249-2742. Website: www.co.davidson.nc.us/arts. **Executive Director:** Erik Salzwedel. Nonprofit gallery. Estab. 1968. Exhibits 30 emerging, mid-career and established artists. Interested in seeing the work of emerging artists. 400 members. Exhibited artists include Bob Timberlake and Zoltan Szabo. Disney Animation Archives (1993), Ansel Adams (1994), P. Buckley Moss (1996). Sponsors 11 shows/year. Average display time 1 month. Open all year. 6,000 sq. ft; historic building, good location, marble foyer. 80% of space for special exhibitions; 10% of space for gallery artists. Clientele: 98% private collectors, 2% corporate collectors. Overall price range: $50-20,000; most work sold at $50-4,000.

Media: Considers all media and all types of prints. "Originals only for exhibition. Most frequently exhibits painting, photography and mixed media. "We try to provide diversity."

Style: Exhibits expressionism, painterly abstraction, postmodern works, expressionism, photorealism and realism. Genres include landscapes and Southern artists.

Terms: Accepts work on consignment (30% commission). Members can exhibit art for 2 months maximum per piece in our members gallery. 30% commission goes to Guild. Retail price set by gallery and artist. Gallery provides insurance, promotion and contract; artist pays for shipping. Prefers artwork framed for exhibition and unframed for sales of reproductions.

Submissions: Send query letter with résumé, slides, bio, brochure, photographs, business card, reviews and SASE. Write for appointment to show portfolio of originals, photographs and slides. Entries reviewed every May for following exhibition year.

[N] ARTSOURCE CONSULTANTS INC., 509-105 W. Whitaker Mill Rd., Raleigh NC 27608. (919)833-0013. Fax: (919)833-2210. E-mail: localart@bellsouth.net. Website: www.artsource-raleigh.com. **Contact:** Claire Ciardella or Sharon Tharrington. Retail gallery, art consultancy. Estab. 1990. Represents at least 60 emerging, mid-career and established artists/year. Exhibited artists include James P. Kerr, Patsy Howell, Kyle Highsmith, Victoria Josephson and Ted Jaslow. Sponsors 4 shows/year. Average display time 6 weeks; consignment period 6 months. Open all year; Monday-Saturday, 10-6. Located in Five Points area (1½ miles from downtown); 1,600 sq. ft. 50% of space for special exhibitions; 50% of space for gallery artists. Clientele: 40% private collectors, 60% corporate collectors. Overall price range: $100-7,500; most work sold at $500-2,000.

Media: Considers all media and all types of prints. Most frequently exhibits oils/acrylics and watercolors.

Style: Exhibits expressionism, painterly abstraction, impressionism, realism; Genres include landscapes, florals, wildlife, Americana and figurative work. Prefers landscapes/seascapes, florals/still lifes, abstraction (soft edge).

Terms: Accepts work on consignment (50% commission). Retail price set by the artist. Gallery provides insurance, promotion and shipping costs from gallery; artist pays shipping costs to gallery. Prefers artwork framed but "can be discussed."

Submissions: Prefers artists from Southeastern region. Send query letter with résumé, slides or photographs, bio and SASE. Call for appointment to show portfolio of originals, photographs, slides and transparencies. Responds in 6 weeks. Files résumé, bio info, reviews, photos (if possible). Finds artists through publications, sourcebooks, submissions.

Tips: To make gallery submissions professional, artists must have "a well put together artist package—including clear visuals, complete title/price list, impressive bio/résumé."

BLOUNT BRIDGERS HOUSE/HOBSON PITTMAN MEMORIAL GALLERY, 130 Bridgers St., Tarboro NC 27886. (252)823-4159. Fax: (252)823-6190. E-mail: edgecombearts@earthlink.net. Website: www.edgecombearts.org. Museum. Estab. 1982. Approached by 20 artists/year. Exhibits 6 emerging, mid-career and established artists. Sponsors 8 exhibits/year. Average display time 6 weeks. Open Monday-

Friday, 10-4; weekends 2-4. Closed major holidays, Christmas-New Year. Located in historic house in residential area of small town; gallery on 2nd floor is accessible by passenger elevator. Room is approximately 48′×20′. Clients include local community, students and tourists. Overall price range: $250-5,000; most work sold at $500.
Media: Considers acrylic, ceramics, collage, craft, drawing, fiber, glass, mixed media, oil, paper, pstel, pen & ink and watercolor. Most frequently exhibits oil, watercolor and ceramic. Considers all types of prints.
Style: Considers all styles and genres.
Terms: Artwork is accepted on consignment and there is a 30% commission. Retail price set by the artist. Gallery provides insurance and limited promotion. Accepted work should be framed. Does not require exclusive representation locally. Accepts artists from southeast and Pennsylvania.
Submissions: Send portfolio of photographs, slides or transparencies. Send query letter with artist's statement, bio, SASE and slides. Returns material with SASE. Responds in 3 months. Finds artists through word of mouth, submissions, art exhibits and referrals by other artists.

BLUE SPIRAL 1, 38 Biltmore Ave., Asheville NC 28801. (828)251-0202. Fax: (828)251-0884. E-mail: info@bluespiral1.com. Website: www.bluespiral1.com. **Director:** John Cram. Retail gallery. Estab. 1991. Represents emerging, mid-career and established artists living in the Southeast. Exhibited artists include Julyan Davis, Gary Beecham, Suzanne Stryk, Tommie Rush and D. Lanford Kühn. Sponsors 15-20 shows/year. Average display time 6-8 weeks. Open all year; Monday-Saturday, 10-6; Sundays (May-October), 12-5. Located downtown; 15,000 sq. ft.; historic building. 85% of space for special exhibitions; 15% of space for gallery artists. Clientele: "across the range." 90% private collectors, 10% corporate collectors. Overall price range: less than $100-50,000; most work sold at $100-2,500.
Media: Considers all media. Most frequently exhibits painting, clay, sculpture and glass.
Style: Exhibits all styles, all genres.
Terms: Accepts work on consignment (50% commission). Retail price set by the artist. Gallery provides insurance, promotion and contract; artist pays shipping costs to and from gallery. Prefers artwork framed.
Submissions: Accepts only artists from Southeast. Send query letter with résumé, slides, prices, statement and SASE. Responds in 3 months. Files slides, name and address. Finds artists through word of mouth, referrals and travel.
Tips: "Work must be technically well executed and properly presented."

BROADHURST GALLERY, 2212 Midland Rd., Pinehurst NC 28374. (910)295-4817. E-mail: Judy@broadhurst.com. Website: Broadhurstgallery.com. **Owner:** Judy Broadhurst. Retail gallery. Estab. 1990. Represents/exhibits 25 established artists/year. Sponsors about 4 large shows and lunch and Artist Gallery Talks on most Fridays. Average display time 1-3 months. Open all year; Tuesday-Friday, 11-5; Saturday, 1-4; and by appointment. Located on the main road between Pinehurst and Southern Pines; 3,000 sq. ft.; lots of space, ample light, large outdoor sculpture garden. 50% of space for special exhibitions; 50% of space for gallery artists. Clientele: people building homes and remodeling, also collectors. 80% private collectors, 20% corporate collectors. Overall price range: $5,000-40,000; most work sold at $5,000 and up.
Media: Considers oil, acrylic, watercolor, pastel, mixed media and collage. Most frequently exhibits oil and sculpture (stone and bronze).
Style: Exhibits all styles, all genres.
Terms: Retail price set by the artist. Gallery provides insurance, promotion and contract; shipping costs are shared. Prefers artwork framed.
Submissions: Send query letter with résumé, slides and/or photographs, and bio. Write for appointment to show portfolio of originals and slides. Responds only if interested within 3 weeks. Files résumé, bio, slides and/or photographs. Finds artists through agents, by visiting exhibitions, word of mouth, various art publications and sourcebooks and artists' submissions.
Tips: "Talent is always the most important factor, but professionalism is very helpful."

CHAPELLIER FINE ART, 105 Arlen Park Dr., Chapel Hill NC 27516. (919)967-9960. Fax: (919)969-7318. E-mail: chapellier@earthlink.net. Website: www.artnet.com/chapellier.html. **Director:** Shirley C. Lally. Retail gallery. Estab. 1916. Represents 3 established artists/year. Exhibited artists include Mary Louise Boehm, Elsie Dinsmore Popkin. Sponsors 3-4 shows/year. Average display time 6-8 weeks. Open all year; Monday-Saturday by appointment. 1,000 sq. ft. 75% of space for special exhibitions; 25% of space for gallery artists. Clientele: upscale. 90% private collectors, 10% corporate collectors. Overall price range: $500-90,000; most work sold at $3,000-10,000.
Media: Considers oil, acrylic, watercolor, pastel, pen & ink, drawing, mixed media, paper, sculpture

 insider report

Art in a tourist town:
Blue Spiral 1, Asheville, NC

While most people consider a tourist town the ideal place to *escape* from their work, getting your artwork *to* a hot vacation spot could be your best move yet. Case in point: Asheville, North Carolina.

John Cram

Framed with scenic mountain views, Asheville is conveniently situated along the spectacular Blue Ridge Parkway, the nation's most scenic thoroughfare, which is annually traveled by more than 22 million people. In addition to the views and mountain rail tours, visitors take to Asheville for other unique attractions, such as Chimney Rock Park, the Carl Sandburg Home National Historic Site, a heavy concentration of art deco architecture and the famed Biltmore Estate. This unusually high level of traffic offers terrific benefit to Asheville's businesses.

Capitalizing on the steady influx of potential patrons, dozens of artists and gallery owners have taken up residence, resulting in a convergence of more than two dozen art galleries within walking distance of each other in downtown Asheville. Collectively they create an attraction of their own.

Gallery owner John Cram knows firsthand of the advantages this unique situation presents to artists. In 1991 he opened Blue Spiral 1, a four-story, 15,000 square feet art gallery in the heart of historic Asheville. Since that time he has helped scores of artists, established and emerging, gain valuable exposure for their work. "The traffic here is nonstatic. There are always new and different people from all across the country coming through and seeing our artists' work," Cram says. "Asheville is truly diverse, and visited heavily." He points out that people on vacation tend to bring in more disposable income and often look to take a piece of art home with them, as a reminder of their travels. Because of these things, Cram says, shows in a tourist town gallery such as his Blue Spiral 1 can give artists enormous exposure and consequently help them establish higher prices for their work. And going the extra mile for their artists, Cram and Blue Spiral 1 distribute full-color brochures for upcoming shows, offer e-mail notification to returning patrons, showcase the artists on the Blue Spiral 1 website and link to each artist's own site. Additionally, they actively promote the gallery to ASID (American Society of Interior Designers) as a resource for interior decor.

Showing work from artists who specialize in "fine art and high craft, and cultural craft objects," Blue Spiral 1 has historically featured up to as many as 30 exhibitions per year, including their annual exhibition of new artists, and have included work from as many as 100 artists at a time. Many of the shows are designed around themes, for reasons of creating interest and promotion, as well as providing context for a wide range of art or a large number of artists at one time. Recent shows have included "Southeastern Fiber Invitational" featured in the spring of 2003, headlined: "Eighteen regional artisans display contemporary works with

a variety of colors, techniques and patterns." And earlier, an intriguing "For the Birds" show opened Halloween night 2002 as "a festive event and for all bird lovers . . . with painting, ceramics, glass, and sculpture by twenty-six Southeastern artists." In addition to new shows, another attraction for Blue Spiral 1 is the estate of Will Henry Stevens (1881-1949), which it has handled for over twenty years. Stevens was a master of early 20th century American art and created an exceptional body of abstract and representational work which reflected the mountain settings of Tennessee, North Carolina, and portions of southern Louisiana.

With recent decisions to simplify, Cram says he will focus on more singular exhibitions rather than so many large group shows. Even with this direction, he says, there is still prime opportunity for new artists to break in with Blue Spiral 1. The annual "New Artists, New Works, New Year" show is the best start. His selection process is straightforward. Selecting from southeastern artists only (covering about 14 states), and considering work in a range from color photography and painting to ceramic, wood, fiber arts, furniture, and more, Cram and his staff sit down about four times a year to review submissions. "Artists who knock our socks off may be incorporated immediately," he explains, "but typically we will contact them with some questions, then invite them to participate in the annual new artist's show." His advice to artists submitting work to a new venue? "Always visit the gallery and do your best to ascertain whether your art is a good fit."

© 2001 Daniel Nevins

Daniel Nevins was inspired to paint *The Generosity of Waters* after seeing a friend make a similar gesture with her hand to her chest. "I'm a gesture hound," confesses the artist. "I keep files on all kinds of gestures and recreate them in my work." Nevins sells much of his work through Blue Spiral 1 Gallery. He estimates 50% of the sales come from tourists coming to Asheville on vacation. "Asheville has a way of charming you. People come to Asheville and find it's this magical place, and want to take something back with them." It's easy to see why the magical, ethereal figures in Nevins's work might beckon a visitor to take home a painting.

In addition to Cram's development of Blue Spiral I, he established New Morning Gallery, featuring fine crafts or "Art for Living," Bellagio, purveying "wearable art" such as unique handmade clothing, accessories and shoes. As if those combined weren't challenge enough, he followed his passion for the visual arts one step further in 1997 to renovate and open an historic building now known as Asheville's Fine Arts Theatre in 1997, featuring independent and art films. All this motivation and success speaks volumes of John Cram, and also of Asheville—both are not only invested in but wholeheartedly committed to offering valuable support to a great diversity of artists.
—Terri See

To learn more about Blue Spiral I and John Cram's work, or about the arts in Asheville, visit www.bluespiral1.com, www.newmorninggallerync.com or www.ashevillechamber.org.

(limited to small pieces) and all types of prints. Most frequently exhibits oil, watercolor, pastel.
Style: Exhibits impressionism and realism. Exhibits all genres. Prefers realism and impressionism. Inventory is primarily 19th and early 20th century American art.
Terms: Accepts work on consignment (50% commission). Retail price set by the gallery. Gallery provides insurance, promotion and contract; shipping costs are shared. Prefers artwork framed.
Submissions: Accepts only artists from America. Send query letter with résumé, slides, bio or photographs, price list and description of works offered, exhibition record. Write for appointment to show portfolio of photographs, transparencies or slides. Responds in 1 month. Files material only if interested. Finds artists through word of mouth, visiting art fairs and exhibitions.
Tips: "Gallery owner and artist must be compatible and agree on terms of representation."

WELLINGTON B. GRAY GALLERY, EAST CAROLINA UNIVERSITY, Jenkins Fine Art Center, Greenville NC 27858. (919)757-6336. Fax: (919)757-6441. Website: ecuuax.cis.@cu.edu/academics/schdept/art/art.htm. **Director:** Gilbert W. Leebrick. Nonprofit university gallery. Estab. 1977. Represents emerging, mid-career and established artists. Sponsors 12 shows/year. Average display time 5-6 weeks. Open all year. Located downtown, in the university; 5,500 sq. ft.; "auditorium for lectures, sculpture garden." 100% of space for special exhibitions. Clientele: 25% private collectors, 10% corporate clients, 50% students, 15% general public. Overall price range: $1,000-10,000.
Media: Considers all media plus environmental design, architecture, crafts and commercial art, original prints, relief, intaglio, planography, stencil and offset reproductions. Most frequently exhibits paintings, printmaking and sculpture.
Style: Exhibits all styles and genres. Interested in seeing contemporary art in a variety of media.
Terms: 30% suggested donation on sales. Retail price set by artist. Gallery provides insurance and promotion; shipping costs are shared. Prefers artwork framed.
Submissions: Send query letter with résumé, slides, brochure and SASE. Write for appointment to show portfolio of originals, slides, photographs and transparencies. Responds in 6 months. Files "all mailed information for interesting artists. The rest is returned."

GREEN TARA GALLERY, 18 E. Franklin St., Chapel Hill NC 27514. (919)932-6400. Fax: (919)918-7542. E-mail: greentaragallery@mindspring.com. Website: www.greentaragallery.com. Retail gallery. Estab. 1998. Approached by 150 artists/year. Exhibits 150 established artists. Exhibited artists include: Scott Gibbs and Pam Calore. Sponsors 12 exhibits/year. Average display time 7-8 weeks. Open all year; Monday-Saturday, 10-6. Closed July 4th and New Years. 3,000 sq. ft. fine art and fine craft gallery located in the heart of Chapel Hill, NC featuring one of a kind art and art objects for your home, office and body. Clients include local community, tourists and upscale. 10% of sales are to corporate collectors. Overall price range: $25-3,000; most work sold at $1,000.
Media: Considers acrylic, ceramics, collage, drawing, glass, mixed media, oil, pastel, sculpture, watercolor and woodcuts. Most frequently exhibits oil, acrylic, mixed media. Considers only original art.
Style: Exhibits: conceptualism, expressionism, geometric abstraction, impressionism, minimalism, neo-

America's Best Small Art Towns

Throughout the last decade a virtual flood of artists and artisans have relocated from urban centers for the pace and economy of small town, rural life. Along with this trend, the country's tourism patterns have shifted from the well-traveled mainstream to destinations away from the beaten path; increasing numbers of tourists and lovers of the arts are finding unexpected quality art in rural places. From young artists looking for a launch, to retirees looking for a second career, a wide range of talent is finding eager audience and an increasing potential for earning a living in America's small art towns.

Here is a variety of art towns worth exploring. From well-established to up-and-coming, each has something unique to offer:

Fairhope, AL	Northampton, MA	Ithaca, NY
Northport, AL	Houghton, MI	Peekskill, NY
Bisbee, AZ	Lanesboro, MN	Woodstock, NY
San Jose, CA	New York Mills, MN	Henderson, NV
Creede, CO	Rochester, MN	Athens, OH
Ft. Collins, CO	Arrow Rock, MO	Yellow Springs, OH
Hartford, CT	Columbia, MO	Ashland, OR
Rehoboth Beach, DE	Ocean Springs, MS	Jim Thorpe, PA
Athens, GA	Bigfork, MT	Alpine, TX
Cape Coral, FL	Asheville, NC	Austin, TX
Naples, FL	Carrboro, NC	Round Top, TX
Athens, GA	Cary, NC	Abingdon, VA
Moscow, ID	Fargo, ND	Berkeley Springs, WV
Lafayette, IN	Keene, NH	Walla Walla, WA
Lawrence, KS	Nashua, NH	Casper, WY
Paducah, KY	Lambertville, NJ	Cody, WY
Provincetown, MA	Santa Fe, NM	

Additional Resources

The 100 Best Small Art Towns in America, John Villani
Art Now Gallery Guide, www.galleryguide.org

Many towns have art scene websites, or information on Chambers of Commerce websites. A few examples:
www.yellowspringsohio.org (Yellow Springs, OH)
www.roundtop.org (Roundtop, TX)
www.ashlandchamber.org (Ashland, OR)
www.portcity.org (Portsmouth, NH)
www.berkeleysprings.com (Berkeley Springs, WV)
www.prescott.org (Prescott, AZ)
www.paducaharts.com (Paducah, KY)
www.eurekachamber.com (Eureka, CA)
www.carrboro.com (Carrboro, NC)

expressionism, postmodernism, primitivism realism, surrealism and painterly abstraction. Most frequently exhibits impressionism, abstract expressionism and conceptualism. Genres include figurative work and landscapes.
Terms: Artwork is accepted on consignment and there is a 50% commission; or is bought outright for

40% of retail price. Retail price set by the gallery and the artist. Gallery provides insurance, promotion and contract. Accepted work should be framed, mounted and matted. Requires exclusive representation locally.

Submissions: Mail portfolio for review. Send query letter with artist's statement, bio, brochure, business card, photocopies, photographs, résumé, reviews, pricing, SASE and slides. Returns material with SASE. Files business card. Finds artists through word of mouth, submissions, portfolio reviews, art exhibits, art fairs, referrals by other artists and through other galleries.

Tips: "Include all the required information, and be reasonable in pricing and flexible. Act/behavior should be as if for any other job interview."

[N] LEE HANSLEY GALLERY, 225 Glenwood Ave., Raleigh NC 27603. (919)828-7557. **Proprietor:** Lee Hansley. Retail gallery, art consultancy. Estab. 1993. Represents 40 mid-career and established artists/year. Exhibited artists include Paul Hartley. Sponsors 10 shows/year. Average display time 5-7 weeks. Open all year; Monday-Thursday, 11-6; Friday, 11-9; Saturday, 11-5. Located in Glenwood South; 2,800 sq. ft.; 5 small, intimate exhibition galleries, one small hallway interior. 75% of space for special exhibitions; 25% of space for gallery artists. Clientele: local, state collectors. Overall price range: $250-18,000; most work sold at $500-2,500.

Media: Considers all media except large-scale sculpture. Considers all types of prints except poster. Most frequently exhibits painting/canvas, mixed media on paper.

Style: Exhibits expressionism, neo-expressionism, painterly abstraction, minimalism, color field, photorealism, pattern painting, hard-edge geometric abstraction. Genres include landscapes, figurative work. Prefers geometric abstraction, expressionism, minimalism.

Terms: Accepts work on consignment (50% commission). Retail price set by the gallery and the artist. Gallery provides insurance, promotion and verbal contract; shipping costs are shared. Prefers artwork framed.

Submissions: "Work must be strong, not political please." Send query letter with slides, bio and artist's statement. Write for appointment to show portfolio of photographs or slides. Responds in 2 months. Files slides, résumés.

RALEIGH CONTEMPORARY GALLERY, 323 Blake St., Raleigh NC 27601. (919)828-6500. E-mail: RCGallery@mindspring.com. Website: www.rcgallery.com. **Director:** Rory Parnell. Retail gallery. Estab. 1984. Represents 20-25 emerging and mid-career artists/year. Sponsors 6 shows/year. Average display time 1 month. Open all year; Monday-Saturday, 11-4. Located downtown; 1,300 sq. ft.; architect-designed; located in historic property in a revitalized downtown area. 30% of space for special exhibitions; 70% of space for gallery artists. Clients include corporate and private. 35% of sales are to private collectors, 65% corporate collectors. Overall price range: $500-5,000; most work sold at $1,200-2,500.

Media: Considers oil, acrylic, watercolor, pastel, pen & ink, drawing, woodcut, engraving and lithograph. Most frequently exhibits oil/acrylic paintings, drawings and lithograph.

Style: Exhibits all styles. Genres include landscapes and florals. Prefers landscapes, realistic and impressionistic; abstracts.

Terms: Accepts work on consignment (50% commission). Retail price set by the gallery and the artist. Gallery provides insurance, promotion and contract; shipping costs are shared.

Submissions: Send query letter with résumé, slides, bio, SASE and reviews. Call or write for appointment to show portfolio of slides. Responds in 1 month. Finds artists through exhibitions, word of mouth, referrals.

[N] SOMERHILL GALLERY, 3 Eastgate E. Franklin St., Chapel Hill NC 27514. (919)968-8868. Fax: (919)967-1879. **Director:** Joseph Rowand. Retail gallery. Estab. 1972. Represents emerging, mid-career and established artists. Sponsors 10 major shows/year, plus a varied number of smaller shows. Open all year. 10,000 sq. ft.; gallery features "architecturally significant spaces, pine floor, 18′ ceiling, 6 separate gallery areas, stable, photo, glass." 50% of space for special exhibitions.

Media: Considers all media, woodcuts, wood engravings, linocuts, engravings, mezzotints, etchings, lithographs and serigraphs. Does not consider installation. Most frequently exhibits painting, sculpture and glass.

Style: Exhibits all styles and genres.

Submissions: Focus is on contemporary art of the United States; however artists from all over the world

are exhibited. Send query letter with résumé, slides, bio, SASE and any relevant materials. Responds in 2 months. Files slides and biographical information of artists.

North Dakota

GANNON & ELSA FORDE GALLERIES, 1500 Edwards Ave., Bismarck ND 58501. (701)224-5520. Fax: (701)224-5550. E-mail: Michelle_Lindblom@bsc.nodak.com. Website: www.bismarckstate.com. **Gallery Director:** Michelle Lindblom. College gallery. Represents emerging, mid-career and established art exhibitions. Sponsors 6 shows/year. Average display time 6 weeks. Open all year; Monday-Thursday, 9-9; Friday, 9-4; Sunday, 6-9. Summer exhibit is college student work (May-August). Located on Bismarck State College campus; high traffic areas on campus. Clientele: all. 80% private collectors, 20% corporate collectors. Overall price range: $50-10,000; most work sold at $50-3,000.
Media: Considers oil, acrylic, watercolor, pastel, drawing, mixed media, collage, paper, sculpture, ceramics, fiber, photography, woodcut, engraving, lithograph, wood engraving, mezzotint, serigraphs, linocut and etching. Most frequently exhibits painting media (all), mixed media and sculpture.
Style: Exhibits expressionism, neo-expressionism, painterly abstraction, surrealism, impressionism, photorealism, hard-edge geometric abstraction and realism, all genres.
Terms: Accepts work on consignment (20% commission). Retail price set by the artist. Gallery provides insurance on premises, promotion, contract and shipping costs from gallery; artist pays shipping costs to gallery. Prefers artwork framed.
Submissions: Send query letter with résumé, slides, bio and SASE. Call or write for appointment to show portfolio of photographs and slides. Responds in 2 months. Files résumé, bio, photos if sent. Finds artists through word of mouth, art publications, artists' submissions, visiting exhibitions.
Tips: "Because our gallery is a university gallery, the main focus is to expose the public to art of all genres. However, we do sell work, occasionally."

HUGHES FINE ART CENTER ART GALLERY, Department of Visual Arts, University of North Dakota, Grand Forks ND 58202-7099. (701)777-2257. E-mail: mcelroye@badland.nodak.edu. Website: www.nodak.edu/dept/fac/visual_home.html. **Director:** Brian Paulsen. Nonprofit gallery. Estab. 1979. Exhibits emerging, mid-career and established artists. Sponsors 5 shows/year. Average display time 3 weeks. Open all year. Located on campus; 96 running ft. 100% of space for special exhibitions.
- Director states gallery is interested in "well-crafted, clever, sincere, fresh, inventive, meaningful, unique, well-designed compositions—surprising, a bit shocking, etc."

Media: Considers all media. Most frequently exhibits painting, photographs and jewelry/metal work.
Style: Exhibits all styles and genres.
Terms: Retail price set by artist. Gallery provides "space to exhibit work and some limited contact with the public and the local newspaper." Gallery pays for shipping costs. Prefers artwork framed.
Submissions: Send query letter with 10-20 slides and résumé. Portfolio review not required. Responds in 1 week. Files "duplicate slides, résumés." Finds artists from submissions through *Artist's & Graphic Designer's Market* listing, *Art in America* listing in their yearly museum compilation; as an art department listed in various sources as a school to inquire about; the gallery's own poster/ads.
Tips: "We are not a sales gallery. Send slides and approximate shipping costs."

NORTHWEST ART CENTER, Minot State University, 500 University Ave. W., Minot ND 58707. (701)858-3264. Fax: (701)858-3894. E-mail: nac@minotstateu.edu. **Director:** Zoe Spooner. Nonprofit gallery. Estab. 1970. Represents emerging, mid-career and established artists. Sponsors 18-20 shows/year. Average display time 4-6 weeks. Open all year. Two galleries: Hartnett Hall Gallery: Monday-Friday, 8-5; The Library Gallery: Sunday-Thursday, 8-9. Located on university campus; 1,000 sq. ft. 100% of space for special exhibitions. 100% private collectors. Overall price range: $100-40,000; most work sold at $100-4,000.
Media: Considers all media and all types of prints except posters.
Style: Exhibits all styles, all genres.
Terms: Retail price set by the artist. 30% commission. Gallery provides insurance, promotion and contract; shipping costs are shared. Prefers artwork framed.
Submissions: Send query letter with résumé, slides, bio, SASE and artist's statement. Call for appointment to show portfolio of originals, photographs, slides and transparencies. Responds in 4 months. Files all

material. Finds artists through submissions, visiting exhibitions, word of mouth.

Ohio

N ACME ART COMPANY, 1129 N. High St., Columbus OH 43201. (614)299-4003. **Contact:** Melesa A.C. Klosek, president. Volunteer and artist run nonprofit gallery. Estab. 1986. Represents 300 emerging and mid-career artists/year. 250 members. Sponsors 12 shows/year. Average display time 1 month. Open all year; Thursday-Sunday, 12-5. Located in Short North District; 1,400 sq. ft.; 3 gallery areas. 70% of space for special exhibitions; 70% of space for gallery artists. Clientele: avant-garde collectors, private and professional. 85% private collectors, 15% corporate collectors. Overall price range: $30-5,000; most work sold at $50-1,000.
Media: Considers all media and all types of prints except posters. Most frequently exhibits painting, installations and sculpture.
Style: Exhibits all styles. Most frequently exhibits contemporary, postmodernism, expressionism. Considers all genres.
Terms: Accepts work on consignment (30% commission). Retail price set by the gallery and the artist. Gallery provides promotion and contract; shipping costs are shared. Prefers artwork framed.
Submissions: Prefers only "artists who push the envelope, who explore new vision and materials of presentation." Send query letter with SASE for a call for entries prospectus. Call for following fiscal year line-up ("we work one year in advance"). Files bio, slides, résumé and other support materials sent by artists. A rotating exhibition panel selects work on a yearly basis from call-for-entries.

N ALAN GALLERY, 36 Park St., Berea OH 44017. (216)243-7794. Fax: (216)243-7772. **President:** Alan Boesger. Retail gallery and arts consultancy. Estab. 1983. Represents 25-30 emerging, mid-career and established artists. Sponsors 4 solo shows/year. Average display time 6-8 weeks. Clientele: 40% private collectors, 60% corporate clients. Overall price range: $700-6,000; most work sold at $1,500-2,000.
Media: Considers all media and limited edition prints. Most frequently exhibits watercolor, works on paper and mixed media.
Style: Exhibits color field, painterly abstraction and surrealism. Genres include landscapes, florals, western and figurative work.
Terms: Accepts work on consignment (40% commission). Retail price set by gallery and artist. Exclusive area representation not required. Gallery provides insurance, promotion and contract; shipping costs are shared.
Submissions: Send résumé, slides and SASE. Call or write for appointment to show portfolio of originals and slides. All material is filed.

N THE ART EXCHANGE, 539 E. Town St., Columbus OH 43215. (614)464-4611. Fax: (614)464-4619. E-mail: artexg@ix.netcom.com. Art consultancy. Estab. 1978. Represents 40 emerging, mid-career and established artists/year. Exhibited artists include Mary Beam, Carl Krabill. Open all year; Monday-Friday, 9-5. Located near downtown; historic neighborhood; 2,000 sq. ft.; showroom located in Victorian home. 100% of space for gallery artists. Clientele: corporate leaders. 20% private collectors; 80% corporate collectors. Overall price range: $150-6,000; most work sold at $1,000-1,500.
Media: Considers oil, acrylic, watercolor, pastel, mixed media, collage, sculpture, ceramics, fiber, glass, photography and all types of prints. Most frequently exhibits oil, acrylic, watercolor.
Style: Exhibits painterly abstraction, impressionism, realism, folk art. Genres include florals and landscapes. Prefers impressionism, painterly abstraction, realism.
Terms: Accepts work on consignment. Retail price set by the gallery and the artist.
Submissions: Send query letter with résumé and slides or photographs. Write for appointment to show portfolio. Responds in 2 weeks. Files slides or photos and artist information. Finds artists through word of mouth, referrals by other artists, visiting art fairs and exhibitions, submissions.
Tips: "Our focus is to provide high-quality artwork and consulting services to the corporate, design and architectural communities. Our works are represented in corporate offices, health care facilities, hotels, restaurants and private collections throughout the country."

ARTSPACE/LIMA, 65 Town Square, Lima OH 45801. (419)222-1721. Fax: (419)222-6587. E-mail: artspace@wcoil.com. Website: www.artspacelima.com. **Gallery Director:** David Cottrell. Nonprofit gallery. Exhibits 50-70 emerging and mid-career artists/year. Interested in seeing the work of emerging artists.

Sponsors 8-10 shows/year. Average display time 6-8 weeks. Open all year; Monday-Friday, 10-5; Saturday, 12-3; Sunday, 2-4. Located downtown; 286 running ft. 100% of space for special exhibitions. Clientele: local community. 80% private collectors, 5% corporate collectors. Overall price range: $300-6,000; most work sold at $500-1,000.

- Most shows are thematic and geared toward education. James H. Bassett: landscape architect reviewed in *Dialogue Magazine*, January 2002.

Media: Considers all media and all types of prints. Most frequently exhibits painting, sculpture, drawing.

Style: Exhibits all styles of contemporary and traditional work.

Terms: Accepts work on consignment (40% commission). Retail price set by the artist. Gallery provides insurance, promotion and contract. Artwork must be ready to hang.

Submissions: Send query letter with résumé, slides, artist's statement and SASE. Portfolio should include slides. Responds only if interested within 6 weeks. Files résumé.

N: THE CANTON MUSEUM OF ART, 1001 Market Ave. N., Canton OH 44702. (330)453-7666. **Executive Director:** M. Joseph Albacete. Nonprofit gallery. Estab. 1935. Represents emerging, mid-career and established artists. "Although primarily dedicated to large format touring and original exhibitions, the CMA occasionally sponsors solo shows by local and original artists, and one group show every 2 years featuring its own 'Artists League.' " Average display time is 6 weeks. Overall price range: $50-3,000; few sales above $300-500.

Media: Considers all media. Most frequently exhibits oil, watercolor and photography.

Style: Considers all styles. Most frequently exhibits painterly abstraction, post-modernism and realism.

Terms: "While every effort is made to publicize and promote works, we cannot guarantee sales, although from time to time sales are made, at which time a 25% charge is applied." One of the most common mistakes in presenting portfolios is "sending too many materials. Send only a few slides or photos, a brief bio and an SASE."

Tips: There seems to be "a move back to realism, conservatism and support of regional artists."

CHELSEA GALLERIES, 28120 Chagrin Blvd., Woodmere OH 44122. (216)591-1066. Fax: (216)591-1068. E-mail: info@chelseagalleries.com. **Director:** Jill T. Wieder. Retail gallery. Estab. 1975. Represents/exhibits 400 emerging and mid-career artists/year. Exhibited artists include Leonard Urso and Tom Seghi. Sponsors 5 shows/year. Average display time 6 months. Open all year; Monday-Friday, 10-6; Saturday, 10-5. Adjustable showroom; easy access, free parking, halogen lighting. 40% of space for special exhibitions; 100% of space for gallery artists. Clientele: upscale. 85% private collectors, 15% corporate collectors. Overall price range: $50-10,000; most work sold at $500-2,000.

Media: Considers all media and all types of prints. Most frequently exhibits painting, glass and ceramics.

Style: Exhibits all styles and all genres. Prefers: impressionism, realism and abstraction.

Terms: Artwork is accepted on consignment (50% commission). Retail price set by the gallery and the artist. Gallery provides insurance, promotion and contract; shipping costs are shared. Prefers artwork framed.

Submissions: Send query letter with résumé and slides. Must include information on size, media and retail price. Responds in 6 weeks. Files résumé and slides.

Tips: "Be realistic in pricing—know your market."

CINCINNATI ART MUSEUM, 953 Eden Park Dr., Cincinnati OH 45202. (513)639-2995. Fax: (513)639-2888. E-mail: information@cincyart.org. Website: www.cincinnatiartmuseum.org. Museum. Estab. 1881. Exhibits 6-10 emerging, mid-career and established artists. Sponsors 20 exhibits/year. Average display time 3 months. Open all year; Tuesday-Friday, 11-5; weekends from 10-5. General art museum with a collection spanning 6,000 years of world art. Over 100,000 objects in the collection with exhibitions on view annually. Clients include local community, students, tourists and upscale.

Media: Considers all media and all types of prints. Most frequently exhibits paper, mixed media and oil.

Style: Considers all styles and genres.

Submissions: Send query letter with artist's statement, photographs, reviews, SASE and slides.

CLEVELAND STATE UNIVERSITY ART GALLERY, 2121 Euclid Ave., AB 108, Cleveland OH 44115. (216)687-2103. Fax: (216)687-9340. E-mail: artgallery@csuohio.edu. Website: www.csuohio.edu/art/gallery. **Director:** Robert Thurmer. Assistant Director: Tim Knapp. University gallery. Exhibits 50 emerging, mid-career and established artists. Exhibited artists include Joel Peter Witkin and Buzz Spector. Sponsors 6 shows/year. Average display time 6 weeks. Open Monday-Friday, 10-5; Saturday, 12-4. Closed

Sunday and holidays. Located downtown: 4,500 sq. ft. (250 running ft. of wall space). 100% of space for special exhibitions. Clientele: students, faculty, general public. 85% private collectors, 15% corporate collectors. Overall price range: $250-50,000; most work sold at $300-1,000.

 ● This gallery's street address is 2307 Chester Ave., Cleveland OH 44114. Their mailing address is listed above.

Media: Considers all media.

Style: Exhibits all styles and genres. Prefers: contemporary. Looks for challenging work.

Terms: 25% commission. Sales are not a priority. Gallery provides insurance, promotion, shipping costs to and from gallery; artists handle crating. Prefers artwork framed.

Submissions: By invitation. Unsolicited inquiries may not be reviewed.

Tips: "Submissions recommended by galleries or institutions are preferred."

N EMILY DAVIS GALLERY, School of Art, University of Akron, Akron OH 44325-7801. (216)972-5950. E-mail: bengsto@uakron.edu. **Director:** Rod Bengston. Nonprofit gallery. Estab. 1974. Clientele: persons interested in contemporary/avant-garde art. 12 shows/year. Average display time is 3½ weeks. Interested in emerging and established artists. Overall price range: $100-65,000; "no substantial sales."

Media: Considers all media.

Style: Exhibits contemporary, abstract, figurative, non-representational, photorealistic, realistic, avant-garde and neo-expressionistic works.

Terms: Retail price is set by artist. Exclusive area representation not required. Gallery provides insurance, shipping costs, promotion and contract.

Submissions: Send query letter with 1-page résumé, brochure, 20 slides, photographs and SASE. Write for an appointment to show a portfolio. Résumés are filed. Finds artists through visiting exhibitions, word of mouth, various art publications, sourcebooks and artists' submissions/self-promotions.

Tips: "The gallery is a learning laboratory for our students. To that end, we exhibit contemporary and avant-garde artists drawn from the national level." Advice for artists looking for gallery representation: "Match the work to the gallery before approaching the gallery director or curator. Present the work in person, if possible."

THE DAYTON ART INSTITUTE, 456 Belmonte Park North, Dayton OH 45405-4700. (937)223-5277. Fax: (937)223-3140. E-mail: info@daytonartinstitute.org. Website: www.daytonartinstitute.org. Museum. Estab. 1919. Open all year; Monday-Wednesday, 10-4; Thursday, 10-8; Friday-Sunday, 10-4. Open 365 days of the year! Clients include local community, students and tourists.

Media: Considers all media.

Submissions: Send query letter with artist's statement, reviews and slides.

HILLEL JEWISH STUDENT CENTER GALLERY, 2615 Clifton Ave., Cincinnati OH 45220. (513)221-6728. Fax: (513)221-7134. E-mail: email@hillelcincinnati.org. Website: www.hillelcincinnati.org. **Director:** Rabbi Abie Ingber. Gallery Curator: Daniela Yovel. Nonprofit gallery, museum. Estab. 1982. Represents 5 emerging artists/academic year. Exhibited artists include Gordon Baer, Irving Amen and Lois Cohen. Sponsors 5 shows/year. Average display time 5-6 weeks. Open fall, winter, spring; Monday-Thursday, 9-5; Friday, 9-3; other hours in conjunction with scheduled programming. Located uptown (next to University of Cincinnati); 1,056 sq. ft.; features the work of Jewish artists in all media; listed in AAA Tourbook; has permanent collection of architectural and historic Judaica from synagogues. 20% of space for special exhibitions; 80% of space for gallery artists. Clientele: upscale, community, students. 90% private collectors, 10% corporate collectors. Overall price range: $150-3,000; most work sold at $150-800.

Media: Considers all media except installations. Considers all types of prints. Most frequently exhibits prints/mixed media, watercolor, photographs.

Style: Exhibits all styles. Genres include landscapes, figurative work and Jewish themes. Avoids minimalism and hard-edge geometric abstraction.

Terms: Artwork accepted for exhibit and there is a 30% commission. Retail price set by the artist. Gallery provides insurance, promotion, contract, opening reception; shipping costs are shared. Prefers artwork framed.

Submissions: "With rare exceptions, we feature Jewish artists." Send query letter with slides, bio or photographs, SASE. Call or write for appointment to show portfolio. Responds in 1 week. Files bios/résumés, description of work.

N KUSSMAUL GALLERY, 140 E. Broadway, P.O. Box 338, Granville OH 43023. (740)587-4640. E-mail: young@kussmaulgallery.com. Website: www.kussmaulgallery.com. **Owners:** James and Jennifer

Young. Retail gallery, custom framing. Estab. 1989. Represents 4-6 emerging and mid-career artists/year. Sponsors 1-2 shows/year. Average display time 30-100 days. Open all year; Tuesday-Saturday, 10-5; Sunday, 12-4. Located downtown; 3,200 sq. ft.; restored building erected 1830—emphasis on interior brick walls and restored tin ceilings. Gallery space upstairs has cathedral ceilings, exposed brick walls, skylights, approximately 1,600 sq. ft. devoted only to framed art and sculpture. 50% of space for art displays. Clients include upper-middle class. 75% of sales are to private collectors, 25% corporate collectors. Overall price range: $75-4,000; most work sold at $200-750.

Media: Considers oil, acrylic, watercolor, mixed media, sculpture, glass. "We are looking for hand-blown glass priced within reason! Also ceramics, wood carving, and any hand-crafted unique works. Our gallery has changed its focus to mostly 'contemporary American crafts.' We do still exhibit 2-D framed art." Also in need of primitive and outsider art.

Style: Exhibits: primitivism, impressionism, realism.

Terms: Accepts work on consignment (40% commission) or buys outright. Retail price set by the gallery. Gallery provides insurance on work purchased outright and promotion; artist pays shipping costs to and from gallery. Prefers artwork unframed.

Submissions: Send query letter with résumé, slides, bio and SASE. Responds only if interested within 1 month. Files slides, bio or returns them. Finds artists through networking, talking to emerging artists. E-mail with attached photos accepted.

Tips: "Don't overprice your work, be original. Have large body of work representing your overall talent and style."

N **LICKING COUNTY ART GALLERY**, P.O. Box 4277, Newark OH 43058-4277. (740)349-8031. Nonprofit gallery. Estab. 1959. Represents 30 artists; emerging, mid-career and established. Sponsors 12 shows/year. Average display time 3 months. Located 6 blocks north of downtown; 784 sq. ft.; in a Victorian brick building. 70% of space for special exhibitions. Clientele: 90% private collectors, 10% corporate clients. Overall price range: $30-6,000; most work sold at $50-200.

Media: Considers oil, acrylic, watercolor, pastel, pen & ink, drawings, mixed media, collage, works on paper, sculpture, ceramic, fiber, glass, installation, photography, original handpulled prints, woodcuts, engravings, lithographs, wood engravings, serigraphs and etchings. Most frequently exhibits watercolor, oil/acrylic and photography.

Style: Exhibits conceptualism, color field, impressionism, realism, photorealism and pattern painting. Genres include landscapes, florals, wildlife, portraits and all genres.

Terms: Artwork is accepted on consignment (30% commission.) Retail price set by artist. Gallery provides insurance, promotion and contract; artist pays for shipping. Prefers framed artwork.

Submissions: Send query letter with résumé, brochure and photographs. Write to schedule an appointment to show a portfolio, which should include originals and/or slides. Artists who submit must be members of the Licking County Art Association.

MALTON GALLERY, 2703 Observatory, Cincinnati OH 45208. (513)321-8614. E-mail: maltonartgallery @zoomtown.com. Website: www.maltonartgallery.com. **Director:** Sylvia Rombis. Retail gallery. Estab. 1974. Represents about 100 emerging, mid-career and established artists. Exhibits 20 artists/year. Exhibited artists include Carol Henry, Mark Chatterley, Terri Hallman and Esther Levy. Sponsors 7 shows/year. Average display time 1 month. Open all year; Tuesday-Friday, 11-5; Saturday, 12-5. Located in high-income neighborhood shopping district. 2,500 sq. ft. "Friendly, non-intimidating environment." 2-person shows alternate with display of gallery artists. Clientele: private and corporate. Overall price range: $250-10,000; most work sold at $400-2,500.

Media: Considers oil, acrylic, drawing, sculpture, watercolor, mixed media, pastel, collage and original handpulled prints.

Style: Exhibits all styles. Genres include contemporary landscapes, figurative and narrative and abstractions work.

Terms: Accepts work on consignment (50% commission). Retail price set by artist (sometimes in consultation with gallery). Gallery provides insurance, promotion, contract and shipping costs from gallery; artist pays shipping costs to gallery. Prefers framed works for canvas; unframed works for paper.

Submissions: Send query letter with résumé, slides or photographs, reviews, bio and SASE. Responds in 4 months. Files résumé, review or any printed material. Slides and photographs are returned.

Tips: "Never drop in without an appointment. Be prepared and professional in presentation. This is a business. Artists themselves should be aware of what is going on, not just in the 'art world,' but with everything."

N MARK PATSFALL GRAPHICS, INC., 1312 Clay St., Cincinnati OH 45202. (513)241-3232. E-mail: mpginc@iac.net. Website: www.patsfallgraphics.com. **Contact:** Mark Patsfall. Publisher/printer Fine Art editions. Estab. 1981. Exhibits emerging, mid-career and established artists. Exhibited artists include Nam June Paik and Kay Rosen (prints). Clients include local community, students and upscale. 25% of sales are to corporate collectors. Overall price range $350-2,500; most work sold at $1,000.
Media: Considers engravings, etchings, linocuts, lithographs, mezzotints, serigraphs and woodcuts.
Style: Exhibits conceptualism and postmodernism.
Terms: Gallery exhibits projects produced by the shop. Work is published by gallery or produced in collaboration with other publishers and/or artists.
Submissions: Call for submission information. Responds to queries in 1 week.

RUTLEDGE GALLERY, Kettering Tower Lobby, 40 N. Main St. Suite 60, Dayton OH 45423. (937)226-7335. Website: www.rutledge-art.com. **Director:** Jeff Rutledge. Retail gallery, art consultancy. Focus is on artists from the Midwest. Estab. 1991. Represents 45 emerging and mid-career artists/year. Sponsors 6 shows/year. Average display time 3 months. Exhibited artists include Natalya Romanovsky and Jeff Potter. Open all year; Tuesday-Friday, 11-6; Saturday, 11-5. "We specialize in sculpture and regional artists. We also offer commissioned work and custom framing." 70% of space for special exhibitions; 30% of space for gallery artists. Clientele: residential, corporate, private collectors, institutions. 65% private collectors, 35% corporate collectors.
Media: Considers oil, acrylic, watercolor, pastel, pen & ink, drawing, mixed media, paper, sculpture, ceramic, craft, glass, woodcuts, engravings, lithographs, linocuts, etchings and posters. Most frequently exhibits paintings, drawings, prints and sculpture.
Style: Exhibits expressionism, painterly abstraction, surrealism, color field, impressionism and realism. Considers all genres. Prefers: contemporary (modern), geometric and abstract.
Terms: Accepts work on consignment (50% commission). Retail price set by gallery. Gallery provides insurance, promotion and contract; artists pays shipping costs. Prefers artwork framed.
Submissions: Accepts mainly Midwest artists. Send query letter with résumé, brochure, 20 slides and 10 photographs. Call for appointment to show portfolio of originals, photographs, slides and transparencies. Responds only if interested within 1 month. Files "only material on artists we represent; others returned if SASE is sent or thrown away."
Tips: "Be well prepared, be professional, be flexible on price and listen."

SPACES, 2220 Superior Viaduct, Cleveland OH 44113. (216)621-2314. Website: www.spacesgallery.org. Alternative space. Estab. 1978. Represents emerging artists. Has 300 members. Sponsors 10 shows/year. Average display time 6 weeks. Open all year; Tuesday-Sunday. Located downtown Cleveland; 6,000 sq. ft.; "loft space with row of columns." 100% private collectors.
Media: Considers all media. Most frequently exhibits installation, painting, video and sculpture.
Style: Exhibits all styles. Prefers challenging new ideas.
Terms: Accepts work on consignment. 20% commission. Retail price set by the artist. Sometimes offers payment by installment. Gallery provides insurance, promotion and contract.
Submissions: Send query letter with résumé, 15 slides and SASE. Annual deadline in spring for submissions.
Tips: "Present yourself professionally and don't give up."

Oklahoma

N ♦ COLOR CONNECTION GALLERY, 2050 Utica Square, Tulsa OK 74114. (918)742-0515. Retail and cooperative gallery. Estab. 1991. Represents 9 established artists. Sponsors 12 shows/year. Average display time 1 month. Open all year; Tuesday-Saturday, 10-5:30. Located in midtown. Clientele: upscale, local community. 85% private collectors, 15% corporate collectors. Overall price range: $100-3,000; most work sold at $250-1,500.
Media: Considers oil, acrylic, watercolor, pastel, pen & ink, drawing, mixed media, collage, paper, sculpture, ceramics, glass, linocuts and etchings. Most frequently exhibits watercolor, oil, pastel and etchings.
Style: Exhibits expressionism, neo-expressionism, painterly abstraction, impressionism and realism. Genres include florals, portraits, southwestern, landscapes and Americana. Prefers impressionism, painterly abstraction and realism.

Terms: Co-op membership fee plus donation of time. Retail price set by the artist. Gallery provides promotion and contract.

Submissions: Accepts only artists from Oklahoma. Send query letter with résumé, slides and bio. Call for appointment to show portfolio of photographs, slides and sample of 3-D work. Does not reply. Artist should contact in person. Finds artists through word of mouth, referrals by other artists, visiting art fairs and exhibitions and artist's submissions.

M.A. DORAN GALLERY, 3509 S. Peoria, Tulsa OK 74105. (918)748-8700. Fax: (918)744-0501. E-mail: madgallery@aol.com. Retail gallery. Estab. 1979. Represents 45 emerging, mid-career and established artists/year. Exhibited artists include: P.S. Gordon and Otto Duecker. Sponsors 10 shows/year. Average display time 1 month. Open all year; Tuesday-Saturday, 10:30-6. Located central retail Tulsa; 2,000 sq. ft.; up and downstairs, Soho like interior. 50% of space for special exhibitions; 50% of space for gallery artists. Clients include upscale. 65% of sales are to private collectors; 35% corporate collectors. Overall price range: $500-40,000; most work sold at $5,000.

Media: Considers all media except pen & ink, paper, fiber and installation; types of prints include woodcuts, engravings, lithographs, wood engravings, mezzotints, serigraphs, linocuts and etchings. Most frequently exhibits oil paintings, watercolor and crafts.

Style: Exhibits: painterly abstraction, impressionism, photorealism, realism and imagism. Exhibits all genres. Prefers landscapes, still life and fine American crafts.

Terms: Accepts work on consignment (50% commission). Retail price set by the gallery and artist. Gallery provides insurance and promotion; shipping costs are shared. Prefers artwork framed.

Submissions: Send query letter with résumé, bio, SASE and artist's statement. Call for appointment. Responds in 1 month. Files any potential corporate artists.

N FIREHOUSE ART CENTER, 444 S. Flood, Norman OK 73069. (405)329-4523. **Contact:** Gallery Committee. Nonprofit gallery. Estab. 1971. Exhibits emerging, mid-career and established artists. 400 members. Sponsors 10-12 group and solo shows/year. Average display time 3-4 weeks. Open all year. Located in former fire station; 629.2 sq. ft. in gallery; consignment sales gallery has additional 620 sq. ft. display area; handicapped-accessible community art center offering fully equipped ceramics, painting, sculpture, jewelry and fiber studios plus b&w photography lab. Classes and workshops for children and adults are offered quarterly. Clientele: 99% private collectors, 1% corporate collectors.

Media: Most frequently exhibits functional and decorative ceramics and sculpture, jewelry, paintings and wood.

Style: All styles and fine crafts. All genres. Prefers: realism and impressionism.

Terms: Accepts work on consignment (35% commission). Offers discounts to gallery members. Gallery provides insurance and promotion for gallery exhibits and consignment sales; artist pays for shipping. Prefers artwork framed.

Submissions: Accepts only artists from south central US. Send query letter with résumé, bio, artist's statement, 20 slides of current work and SASE. Portfolio review required. Responds in 4 months. Finds artists through word of mouth, art publications, and art collectors' referrals.

Tips: "Develop a well-written statement and résumé. Send professional slides! Be aware that we are small and our price ranges for sales rarely exceed $1,000."

N ✦ LACHENMEYER ARTS CENTER, 700 S. Little, P.O. Box 586, Cushing OK 74023. (918)225-7525. **Director:** Rob Smith. Nonprofit. Estab. 1984. Exhibited artists include Darrell Maynard, Steve Childers and Dale Martin. Sponsors 3 shows/year. Average display time 2 weeks. Open in August, September, December; Monday, Wednesday, Friday, 9-5; Tuesday, Thursday, 6-9. Located inside the Cushing Youth and Community Center; 550 sq. ft. 80% of space for special exhibitions; 80% of space for gallery artists. 100% private collectors.

Media: Considers oil, acrylic, watercolor, pastel, pen & ink, drawing, mixed media, collage, paper, sculpture, ceramics, fiber, photography, woodcuts, engravings, lithographs, wood engravings, mezzotints, serigraphs, linocuts and etchings. Most frequently exhibits oil, acrylic and works on paper.

Style: Exhibits all styles. Prefers: landscapes, portraits and Americana.

Terms: Retail price set by the artist. Gallery provides promotion; shipping costs are shared. Prefers artwork framed.

Submissions: Send query letter with résumé, professional quality slides, SASE and reviews. Call or write for appointment to show portfolio of originals. Responds in 1 month. Files résumés. Finds artists through visiting exhibits, word of mouth, other art organizations.

Tips: "We prefer local and regional artists."

Ⓝ NO MAN'S LAND MUSEUM, P.O. Box 278, Goodwell OK 73939-0278. (580)349-2670. Fax: (580)349-2670. E-mail: nmlhs@ptsi.net. **Director:** Kenneth R. Turner. Museum. Estab. 1934. Represents emerging, mid-career and established artists. Sponsors 12 shows/year. Average display time 1 month. Open all year; Tuesday-Saturday, 9-12 and 1-5. Located adjacent to university campus. 10% of space for special exhibitions. Clientele: general, tourist. 100% private collectors. Overall price range: $20-1,500; most work sold at $20-500.
Media: Considers all media and all types of prints. Most frequently exhibits oils, watercolors and pastels.
Style: Exhibits primitivism, impressionism, photorealism and realism. Genres include landscapes, florals, Americana, southwestern, western and wildlife. Prefers realist, primitive and impressionist.
Terms: "Sales are between artist and buyer; museum does not act as middleman." Retail price set by the artist. Gallery provides promotion and shipping costs to and from gallery. Prefers artwork framed.
Submissions: Send query letter with résumé, brochure, photographs and reviews. Call or write for appointment to show portfolio of photographs. Responds only if interested within 3 weeks. Files all material. Finds artists through art publications, exhibitions, news items, word of mouth.

Ⓣ THE WINDMILL GALLERY, 3750 W. Robinson, Suite 103, Norman OK 73072. (405)321-7900. Website: www.windmillgallery.net. **Director:** Andy Denton. Retail gallery. Estab. 1987. Focus is on Oklahoma American Indian art. Represents 20 emerging, mid-career and established artists. Exhibited artists include Rance Hood, Gina Gray, Donald Vann, Darwin Tsoodle and others. Sponsors 4 shows/year. Average display time 1 month. Open all year. Located in northwest Norman (Brookhaven area); 900 sq. ft.; interior decorated Santa Fe style: stripped aspen, adobe brick, etc. 30% of space for special exhibitions. Clientele: "middle-class to upper middle-class professionals/housewives." 100% private collectors. Overall price range $50-15,000; most artwork sold at $100-2,000.
Media: Considers oil, acrylic, watercolor, pastel, pen & ink, drawings, mixed media, works on paper, sculpture, craft, original handpulled prints, offset reproductions, lithographs, posters, cast-paper and serigraphs. Most frequently exhibits watercolor, tempera and acrylic.
Style: Exhibits primitivism and realism. Genres include landscapes, southwestern, western, wildlife and portraits. Prefers Native American scenes (done by Native Americans), portraits and western-southwestern and desert subjects.
Terms: Artwork is accepted on consignment (40% commission). Retail price set by the artist. Customer discounts and payment by installments available. Gallery provides insurance and promotion. Shipping costs are shared. Prefers framed artwork.
Submissions: Send query letter with slides, bio, brochure, photographs, SASE, business card and reviews. Responds only if interested within 1 month. Portfolio review not required. Files brochures, slides, photos, etc. Finds artists through agents, visiting exhibitions, word of mouth, art publications and sourcebooks, artists' submissions/self-promotions and art collectors' referrals.
Tips: Accepts artists from Oklahoma area; Indian art done by Indians only. Director is impressed by artists who conduct business in a very professional manner, have written biographies, certificates of limited editions for prints, and who have honesty and integrity. "Call, tell me about yourself, try to set up appointment to view works or to hang your works as featured artist. Fairly casual—but must have bios and photos of works or works themselves! Please, no drop-ins!"

Oregon

Ⓝ Ⓣ BLACKFISH GALLERY, 420 NW Ninth Ave., Portland OR 97209. (503)224-2634. **Director:** Stephanie Wiarda. Retail cooperative gallery. Estab. 1979. Represents 24 emerging and mid-career artists. Exhibited artists include: Michael Knutson (oil paintings), Jonnel Covault (prints). Sponsors 12 shows/ year. Open all year. Located downtown, in the "Northwest Pearl District; 2,500 sq. ft.; street-level, 'garage-type' overhead wide door, long, open space (100′ deep)." 70% of space for feature exhibits, 15-20% for gallery artists. 80% of sales are to private collectors, 20% corporate clients. Overall price range: $250-12,000; most artwork sold at $900-1,400.
Media: Considers oil, acrylic, watercolor, pastel, pen & ink, drawings, mixed media, collage, sculpture, ceramic, photography, woodcuts, wood engravings, linocuts, engravings, mezzotints, etchings, lithographs, pochoir and serigraphs. Most frequently exhibits paintings, sculpture and prints.
Style: Exhibits: expressionism, neo-expressionism, painterly abstraction, surrealism, conceptualism, mini-

malism, color field, postmodern works, impressionism and realism. Prefers neo-expressionism, conceptualism and painterly abstraction.
Terms: Accepts work on consignment from invited artists (50% commission); co-op membership includes monthly dues plus donation of time (40% commission on sales). Retail price set by artist with assistance from gallery on request. Customer discounts and payment by installment are available. Gallery provides insurance, promotion and contract, and shipping costs from gallery. Prefers artwork framed.
Submissions: Accepts only artists from northwest Oregon and southwest Washington ("unique exceptions possible"); "must be willing to be an active cooperative member—write for details." Send query letter with résumé, slides, SASE, reviews and statement of intent. Write for appointment to show portfolio of photographs and slides. "We review throughout the year." Responds in 1 month. Files material only if exhibit invitation extended. Finds artists through agents, visiting exhibitions, word of mouth, various art publications and sourcebooks, submissions/self-promotions and art collectors' referrals.
Tips: "Understand—via research—what a cooperative gallery is. Call or write for information packet. Do not bring work or slides to us without first having contacted us by phone or mail."

N: BUSH BARN ART CENTER, 600 Mission St. SE, Salem OR 97302. Phone/fax: (503)581-2228. **Gallery Director:** Saralyn Hilde. Nonprofit gallery. Represents 125 emerging, mid-career and established artists/year. Sponsors 18 shows/year. Average display time 5 weeks. Open all year; Tuesday-Friday, 10-5; Saturday-Sunday, 1-5. Located near downtown in an historic park near Mission and High Streets in a renovated historic barn—the interior is very modern. 50% of space for special exhibitions; 50% of space for gallery artists. Overall price range: $10-2,500.
Media: Considers oil, acrylic, watercolor, pastel, pen & ink, drawing, mixed media, collage, paper, sculpture, ceramics, fiber, glass, installation, photography, all types of prints.
Style: Exhibits all styles.
Terms: Accepts work on consignment (40% commission). Gallery provides contract. Prefers artwork framed.
Submissions: Send query letter with résumé, 1 sheet of slides and bio. Write for appointment.
Tips: "Visit prospective galleries to insure your work would be compatible and appropriate to the space."

N: BUTTERS GALLERY, LTD., 223 NW Ninth Ave., Portland OR 97209. (503)248-9378. Fax: (503)248-9390. E-mail: bgl@teleport.com. **Director:** Jeffrey Butters. Retail gallery. Estab. 1987. Represents 50 emerging and mid-career artists/year. Exhibited artists include David Geiser, Ming Fay. Sponsors 12 shows/year. Average display time 1 month. Open all year; Tuesday-Friday, 10-5:30; Saturday, 11-5. Located in Northwest Triangle; 5,000 sq. ft.; concrete floors, large roll up garage doors. Clientele: tourists, upscale, local community, students. 70% private collectors, 30% corporate collectors. Overall price range: $500-40,000; most work sold at $500-10,000.
Media: Considers all media and all types of prints. Most frequently exhibits painting, sculpture, graphic works.
Style: Exhibits all styles and genres. Prefers painterly abstraction, expressionism, postmodern.
Terms: Accepts work on consignment (50% commission). Retail price set by the gallery and the artist. Gallery provides insurance, promotion and contract; shipping costs are shared.
Submissions: Send query letter with slides, bio and SASE. Write for appointment to show portfolio of photographs, transparencies and slides. Responds in 2 months. Finds artists through word of mouth, referrals by other artists, visiting art fairs and exhibitions, submissions.

N: THE MAUDE KERNS ART CENTER, 1910 E. 15th Ave., Eugene OR 97403. (541)345-1571. Fax: (541)343-3774. E-mail: mkart@efu.org. Website: www.mkartcenter.org. **Contact:** Tina Schrager. Nonprofit gallery and educational facility. Estab. 1963. Exhibits hundreds of emerging, mid-career and established artists. Exhibited artists include Mark Clarke (acrylic). Interested in seeing the work of emerging artists. 600 members. Sponsors 10 shows/year. Average display time 6 weeks. Open all year. Located in church building on Historic Register. 4 renovated galleries with over 2,500 sq. ft. of modern exhibit space. 100% of space for special exhibitions. Overall price range: $200-20,000; most work sold at $200-500.
Media: Considers all media. Most frequently exhibits oil/acrylic, mixed media, sculpture and photography.
Style: Contemporary artwork.
Terms: Accepts work on consignment (30% commission). Retail price set by artist. Gallery provides insurance and contract; artist pays for shipping. Artwork must be framed or ready to hang.
Submissions: Send query letter with résumé, slides, bio and SASE. Finds artists through calls to artists, word of mouth, and local arts council publications.

Tips: "Come visit to see exhibits and think about whether the gallery suits you. Include application form from call to artist/prospectus. Do not send more slides than requested. Send appropriate size SASE."

N LAWRENCE GALLERY, Box 187, Sheridan OR 97378 and 903 NW Davis St., Portland OR 97209. (503)228-1776. E-mail: info@lawrencegallery.net. Website: www.lawrencegallery.net. **Owners:** Gary and Signe Lawrence. Retail gallery and art consultancy. Estab. 1977. Represents more than 150 mid-career and established artists. Sponsors 15 shows/year. Open daily 10-5:30. "The gallery is surrounded by several acres of landscaping in which we feature sculpture, fountains and other outdoor art. Two locations: In the heart of Portland's Pearl District and in the heart of Oregon's Wine Country." Clientele: tourists, Portland and Salem residents. 80% private collectors, 20% corporate clients. Overall price range: $10-50,000; most work sold at $1,000-5,000.
Media: Considers oil, acrylic, watercolor, pastel, mixed media, collage, sculpture, clay, glass and jewelry. Always exhibits paintings, bronze sculpture, clay, glass and jewelry.
Style: Exhibits painterly abstraction, impressionism, photorealism and realism. Genres include landscapes and florals. "Our gallery features beautiful artworks that celebrate life."
Terms: Accepts work on consignment (50% commission). Retail price set by artist. Offers payment by installments. Exclusive area representation required. Gallery provides insurance, promotion and contract; artist pays for shipping.
Submissions: Send query letter, résumé, brochure, slides and photographs. Portfolio review required if interested in artists' work. Files résumés, photos of work, newspaper articles, other informative pieces and artist's statement. Finds artists through agents, visiting exhibitions, word of mouth, art publications and sourcebooks, submissions/self-promotions, art collectors' referrals.
Tips: "Artists seen by appointment only."

N LITTMAN GALLERY, Box 751, Portland OR 97207-0751. (503)725-5656. **Contact:** Nika Blasser, art exhibition committee co-coordinator. Nonprofit gallery. Estab. 1968. Represents emerging, mid-career and established artists. Sponsors 11 shows/year. Average display time 1 month. Closed December. Located downtown at Portland State University; 1,500 sq. ft.; wood floors, 18 ft. 11 in. running window space. 100% of space for special exhibitions.
Media: Considers acrylic, collage, drawing, installation, mixed media, oil, paper, pen & ink, sculpture; all types of prints. Most frequently exhibits mixed media, oil and installation.
Style: Exhibits all styles. Genres include fine art only.
Terms: Retail price set by the artist, gallery keeps 30%. Gallery provides insurance and promotion. Does not pay for shipping. Prefers artwork framed.
Submissions: Send query letter, résumé, slides and bio. "A common mistake of artists is not sending enough slides." Responds in 2 months. Files all information.
Tips: "We are a nonprofit university gallery which looks specifically for educational and innovative work."

N MINDPOWER GALLERY, 417 Fir Ave., Reedsport OR 97467. (800)644-2485 or (541)271-2485. Website: www.mindpowergallery.com. **Manager:** Tamara Szalewski. Retail gallery. Estab. 1989. Currently exhibiting over 100 artists. Exhibited artists include: John Stewart. Sponsors 6 shows/year. Average display time 2 months to continuous. Open all year; Tuesday-Saturday, 10-5. Located in "Oldtown" area—front street is Hwy. 38; 5,000 sq. ft.; 8 rooms with 500' of wall space. 20% of space for "Infinity" gift store (hand-crafted items up to $100 retail, New Age music, books); 10% for special exhibitions; 70% of space for gallery artists. Clients include ⅔ from state, ⅓ travelers. 90% of sales are to private collectors, 10% small business collectors. Overall price range: $100-20,000; most work sold at $500.
Media: Considers oil, acrylic, watercolor, pastel, mixed media, paper, batik, computer, sculpture: wood, metal, clay, glass; all types of prints. Most frequently exhibits sculpture, acrylic/oil, watercolor, pastel.
Style: Exhibits all styles and genres. "We have a visual computer catalog accessible to customers, showing work not currently at gallery."
Terms: Accepts work on consignment (40% commission). Retail price set by the artist. Gallery provides promotion, contract and insurance; artist pays shipping costs to and from gallery. Prefers artwork framed.
Submissions: Send query letter with typewritten résumé, slides, photographs and SASE. Responds within 1 month. Files résumés. Finds artists through artists' submissions, visiting exhibitions, word of mouth.
Tips: Please call between 9-9:30 and 5-5:30 to verify your submission was received.

ROGUE GALLERY & ART CENTER, 40 S. Bartlett, Medford OR 97501. (541)772-8118. Fax: (541)772-0294. E-mail: judy@roguegallery.org. Website: www.roguegallery.org. **Executive Director:** Judy

Barnes. Nonprofit sales rental gallery. Estab. 1961. Represents emerging, mid-career and established artists. Sponsors 8 shows/year. Average display time 6 weeks. Open all year; Tuesday-Friday, 10-5; Saturday, 11-3. Located downtown; main gallery 240 running ft. (2,000 sq. ft.); rental/sales and gallery shop, 1,800 sq. ft.; classroom facility, 1,700 sq. ft. "This is the only gallery/art center/exhibit space of its kind in the region, excellent facility, good lighting." 33% of space for special exhibitions; 33% of space for gallery artists. 95% of sales are to private collectors. Overall price range: $100-5,000; most work sold at $400-1,000.

Media: Considers all media and all types of prints. Most frequently exhibits mixed media, drawing, installation, painting, sculpture, watercolor.

Style: Exhibits all styles and genres. Prefers: figurative work, collage, landscape, florals, handpulled prints.

Terms: Accepts work on consignment (35% commission to members; 40% non-members). Retail price set by the artist. Gallery provides insurance, promotion and contract; in the case of main gallery exhibit.

Submissions: Send query letter with résumé, 10 slides, bio and SASE. Call or write for appointment. Responds in 1 month.

Tips: "The most important thing an artist needs to demonstrate to a prospective gallery is a cohesive, concise view of himself as a visual artist and as a person working with direction and passion."

Pennsylvania

[N] THE ART BANK, 7825 Winston Rd., Philadelphia PA 19118. Phone/fax: (215)753-0500. E-mail: theartbank@aol.com. **Director:** Phyllis Sunberg. Retail gallery, art consultancy, corporate art planning. Estab. 1985. Represents 40-50 emerging, mid-career and established artists/year. Exhibited artists include Lisa Fedon and John Spears. Average display time 3-6 months. Open all year; by appointment only. 1,000 sq. ft.; Clientele: corporate executives and their corporations. 20% private collectors, 80% corporate collectors. Overall price range: $300-35,000; most work sold at $500-1,000.

Media: Considers oil, acrylic, watercolor, pastel, mixed media, collage, sculpture, glass, installation, holography, exotic material, lithography, serigraphs. Most frequently exhibits acrylics, serigraphs and sculpture.

Style: Exhibits expressionism, painterly abstraction, color field and hard-edge geometric abstraction. Genres include landscapes. Prefers color field, hard edge abstract and impressionism.

Terms: Accepts work on consignment (40% commission). Shipping costs are shared. Prefers artwork unframed.

Submissions: Prefers artists from the region (PA, NJ, NY, DE). Send query letter with résumé, slides, brochure, SASE and prices. Write for appointment to show portfolio of originals (if appropriate), photographs and corporate installation photos. Responds only if interested within 2 weeks. Files "what I think I'll use—after talking to artist and seeing visuals." Finds artists through agents, by visiting exhibitions, word of mouth, art publications and sourcebooks, submissions.

ART FORMS, 106 Levering St., Philadelphia PA 19127. (215)483-3030. Fax: (215)483-8308. E-mail: artformsgallery@mac.com. **Gallery Manager:** Erin Bettejewski. Gallery Director: Marjie Lewis Quint. Cooperative gallery, nonprofit gallery. Estab. 1993. Exhibits emerging, mid-career and established artists. Average display time 1 month. Open all year; Wednesday-Sunday, 12-5; weekends, 12-9. Closed from December 24-January 2. Located in a block of Main St., in Manayunk Philadelphia; features 1 large main gallery, which the solo show is held and a smaller back gallery where 3 artists are displayed; huge storefront window.

Media: Considers all media and all types of prints. Most frequently exhibits paintings and sculpture.

Style: Considers all styles and genres.

Terms: There is a co-op membership fee plus a donation of time. There is a 30% commission. Retail price set by the artist. Accepted work should be framed, mounted and matted.

Submissions: Call or write to arrange a personal interview to show portfolio of slides. Mail portfolio for review. Send query letter with artist's statement, bio, brochure, business card, résumé, reviews, SASE and slides. Responds in 2 months. Finds artists through word of mouth, submissions, portfolio reviews and referrals by other aritsts.

Tips: "Type statement, and research who you're sending materials to. Know if the gallery is commercial/co-op."

[N] THE BINNEY & SMITH GALLERY, 25 W. Third St., Bethlehem PA 18015. (610)332-1300. Fax: (610)332-1312. E-mail: dlabelle@fest.org. Website: www.bananafactory.org. **Director:** Diane LaBelle.

Nonprofit gallery. Estab. 1997. Approached by 100 artists/year. Represents emerging, mid-career and established artists. Average display time 6 weeks. Open Wednesday-Sunday, 10-5. Closed the first week of August. Clients include local community, students, tourists, upscale. Overall price range: $75-15,000; most work sold at $300.

Media: Considers all media and all types of prints. Most frequently exhibits oil/acrylic paintings, sculpture and watercolor.

Style: Considers all styles and genres.

Terms: Artwork is accepted on consignment and there is a 35% commission. Retail price set by the artist. Gallery provides insurance, promotion and contract. Accepted work should be framed. Does not require exclusive representation locally.

Submissions: Mail portfolio for review. Send query letter with artist's statement, bio, brochure, photographs, résumé, reviews, SASE and slides. Responds only if interested within 6 months. Files artists approved by gallery committee. Finds artists through word of mouth, submissions, portfolio reviews, art exhibits, art fairs, and referrals by other artists.

Tips: "Have good slides, computer résumé and artist statement."

THE CLAY PLACE, 5416 Walnut St., Pittsburgh PA 15232. (412)682-3727. Fax: (412)682-3239. E-mail: clayplacel@aol.com. Website: www.clayplace.com. **Director:** Elvira Peake. Retail gallery. Estab. 1973. Represents 50 emerging, mid-career and established artists. Exhibited artists include Jack Troy and Kirk Mangus. Sponsors 12 shows/year. Open all year. Located in small shopping area; "second level modern building with atrium." 1,200 sq. ft. 50% of space for special exhibition. Overall price range: $10-2,000; most work sold at $40-100.

Media: Considers ceramic, sculpture, glass and pottery. Most frequently exhibits clay, glass and enamel.

Terms: Accepts artwork on consignment (50% commission) or buys outright for 50% of retail price (net 30 days). Retail price set by artist. Sometimes offers customer discounts and payment by installments. Gallery provides insurance, promotion and shipping costs from gallery.

Submissions: Prefers only clay, some glass and enamel. Send query letter with résumé, slides, photographs, bio and SASE. Write for appointment to show portfolio. Portfolio should include actual work rather than slides. Responds in 1 month. Does not reply when busy. Files résumé. Does not return slides. Finds artists through visiting exhibitions and art collectors' referrals.

Tips: "Functional pottery sells well. Emphasis on form, surface decoration. Some clay artists have lowered quality in order to lower prices. Clientele look for quality, not price."

N FLEISHER/OLLMAN GALLERY, 1616 Walnut St., Suite 100, Philadelphia PA 19103. (215)545-7562. Fax: (215)545-6140. **Director:** John Ollman. Retail gallery. Estab. 1952. Represents 12 emerging and established artists. Exhibited artists include Tony Fitzpatrick and Bill Traylor. Sponsors 10 shows/year. Average display time 5 weeks. Closed August. Located downtown; 3,000 sq. ft. 75% of space for special exhibitions. Clientele: primarily art collectors. 90% private collectors, 10% corporate collectors. Overall price range: $2,500-100,000; most work sold at $2,500-30,000.

Media: Considers oil, acrylic, watercolor, pastel, pen & ink, drawing, mixed media and collage. Most frequently exhibits drawing, painting and sculpture.

Style: Exhibits self-taught and contemporary works.

Terms: Accepts artwork on consignment (commission) or buys outright. Retail price set by the gallery. Gallery provides insurance and promotion; shipping costs are shared. Prefers artwork framed.

Submissions: Send query letter with résumé, slides, bio and SASE; gallery will call if interested within 1 month.

Tips: "Be familiar with our exhibitions and the artists we exhibit."

GALLERY JOE, 302 Arch St., Philadelphia PA 19106. (215)592-7752. Fax: (215)238-6923. **Director:** Becky Kerlin. Retail and commercial exhibition gallery. Estab. 1993. Represents/exhibits 15-20 emerging, mid-career and established artists. Exhibited artists include Wes Mills and Astrid Bowlby. Sponsors 6 shows/year. Average display time 6 weeks. Open all year; Wednesday-Saturday, 12-5:30. Located in Old City; 1,400 sq. ft. 100% of space for gallery artists. 80% private collectors, 20% corporate collectors. Overall price range: $500-25,000; most work sold at $2,000-10,000.

Media: Only exhibits sculpture and drawing.

Style: Exhibits representational/abstract.

Terms: Artwork is accepted on consignment (50% commission). Retail price set by the gallery and the artist. Gallery provides insurance and promotion. Artist pays for shipping costs. Prefers artwork framed.

Submissions: Send query letter with résumé, slides, reviews and SASE. Responds in 6 weeks. Finds artists mostly by visiting galleries and through artist referrals.

LANCASTER MUSEUM OF ART, 135 N. Lime St., Lancaster PA 17602. (717)394-3497. **Executive Director:** Cindi Morrison. Nonprofit organization. Estab. 1965. Represents over 100 emerging, mid-career and established artists/year. 700 members. Sponsors 12 shows/year. Average display time 6 weeks. Open all year; Monday-Saturday, 10-4; Sunday, 12-4. Located downtown Lancaster; 4,000 sq. ft.; neoclassical architecture. 100% of space for special exhibitions. 100% of space for gallery artists. Overall price range: $100-25,000; most work sold at $100-10,000.
Media: Considers all media.
Terms: Accepts work on consignment (30% commission). Retail price set by the artist. Gallery provides insurance; shipping costs are shared. Artwork must be ready for presentation.
Submissions: Send query letter with résumé, slides, photographs, SASE, and artist's statement for review by exhibitions committee. Annual deadline: February 1st.
Tips: Advises artists to submit quality slides and well-presented proposal. "No phone calls."

NEWMAN GALLERIES, 1625 Walnut St., Philadelphia PA 19103. (215)563-1779. Fax: (215)563-1614. E-mail: info@newmangalleries1865.com. Website: www.newmangalleries1865.com. **Owners:** Walter A. Newman, Jr., Walter A. Newman III, Terrence C. Newman. Retail gallery. Estab. 1865. Represents 10-20 emerging, mid-career and established artists/year. Exhibited artists include Timothy Barr, Randolph Bye, James Mcginley, Anthony J. Rudisill, Leonard Mizerek, Mary Anna Goetz, John Murray, George Gallo and John English. Sponsors 2-4 shows/year. Average display time 1 month. Open September through June, Monday-Friday, 9-5:30; Saturday, 10-4:30; July through August, Monday-Friday, 9-5. Located in Center City Philadelphia. 4,000 sq. ft. "We are the largest and oldest gallery in Philadelphia." 50% of space for special exhibitions; 100% of space for gallery artists. Clientele: traditional. 70% private collectors, 30% corporate collectors. Overall price range: $1,000-100,000; most work sold at $2,000-20,000.
Media: Considers oil, acrylic, watercolor, pastel, sculpture, engraving, mezzotint and etching. Most frequently exhibits watercolor, oil/acrylic, and pastel.
Style: Exhibits expressionism, impressionism, photorealism and realism. Genres include landscapes, florals, Americana, wildlife and figurative work. Prefers: landscapes, Americana, marines and still life.
Terms: Accepts work on consignment (45% commission). Retail price set by gallery and artist. Gallery provides insurance. Promotion and shipping costs are shared. Prefers oils framed; prints, pastels and watercolors unframed but matted.
Submissions: Send query letter with résumé, 12-24 slides, bio and SASE. Call for appointment to show portfolio of originals, photographs and transparencies. Responds in 1 month. Files "things we may be able to handle but not at the present time." Finds artists through agents, visiting exhibitions, word of mouth, art publications, sourcebooks and artists' submissions.

PENTIMENTI GALLERY, 133 N. Third St., Philadelphia PA 19106. (215)625-9990. Fax: (215)625-8488. E-mail: pentimen@earthlink.net. Website: www.pentimenti.com. **Contact:** Christine Pfister, director. Retail and commercial gallery. Estab. 1992. Represents 20-30 emerging, mid-career and established artists. Sponsors 7-9 exhibits/year. Average display time 4-6 weeks. Open all year; Wednesday-Friday, 12-5:30; weekends 12-5. Closed Sundays, August, Christmas and New Year. Located in the heart of Old City Cultural district in Philadelphia. Overall price range: $250-12,000; most work sold at $1,500-7,000.
Media: Considers all media. Most frequently exhibits paintings—all media except pastel/watercolor.
Style: Exhibits: conceptualism, minimalism, postmodernism and painterly abstraction. Most frequently exhibits postmodernism, minimalism and conceptualism.
Terms: Artwork is accepted on consignment and there is a 50% commission. Retail price set by the gallery and the artist. Gallery provides insurance and promotion. Requires exclusive representation locally.
Submissions: Call to arrange a personal interview to show portfolio of photographs, slides and transparencies. Send query letter with artist's statement, bio, brochure, photographs, résumé, SASE and slides. Returns material with SASE. Responds in 3 months. Finds artists through word of mouth, submissions, portfolio reviews, art exhibits, art fairs and referrals by other artists.

THE PRINT CENTER, 1614 Latimer St., Philadelphia PA 19103. (215)735-6090. Fax: (215)735-5511. E-mail: info@printcenter.org. Website: www.printcenter.org. Nonprofit gallery. Estab. 1915. Exhibits emerging, mid-career and established artists. Approached by 500 artists/year. Sponsors 11 exhibits/year. Average display time 2 months. Open all year; Tuesday-Saturday, 11-5:30. Closed December 21-January

3. Gallery houses 3 exhibit spaces as well as a separate Gallery Store. We are located in historic Rittenhouse area of Philadelphia. Clients include local community, students, tourists and high end collectors. 30% of sales are to corporate collectors. Overall price range: $15-15,000; most work sold at $200.

Media: Considers engravings, etchings, linocuts, lithographs, mezzotints, serigraphs and woodcuts. Send original artwork—no reproductions.

Style: Considers all styles and genres.

Terms: Artwork is accepted on consignment and there is a 50% commission. Retail price set by the artist. Gallery provides insurance, promotion and contract. Accepted work should be framed and matted for exhibitions; unframed for Gallery Store. Does not require exclusive representation locally. Only accepts prints and photos.

Submissions: Membership based—slides of members reviewed by Curator and Gallery Store Manager. Send membership. Finds artists through submissions, art exhibits and membership.

Tips: Be sure to send proper labeling and display of slides with attached slide sheet.

THE STATE MUSEUM OF PENNSYLVANIA, 300 North St., Harrisburg PA 17120-0024. (717)787-4980. **Contact:** Senior Curator, Art Collections. The State Museum of Pennsylvania is the official museum of the Commonwealth, which collects, preserves and exhibits Pennsylvania history, culture and natural heritage. The Museum maintains a collection of fine arts, dating from 1645 to present. Current collecting and exhibitions focus on works of art by contemporary Pennsylvania artists. The Archives of Pennsylvania Art includes records on Pennsylvania artists and continues to document artistic activity in the state by maintaining records for each exhibit space/gallery in the state. Estab. 1905. Sponsors 3 shows/year. Accepts only artists who are Pennsylvania natives or past or current residents. Interested in emerging and mid-career artists.

Media: Considers all media and all types of prints.

Style: Exhibits all styles and genres. Must be Pennsylvania artists and/or subject.

Submissions: Send query letter with résumé, slides, SASE and bio. Responds in 1-3 months. Retains résumé and bio for archives of Pennsylvania Art. Photos returned if requested. Finds artists through professional literature, word of mouth, Gallery Guide, exhibits, all media and unsolicited material.

Tips: "Have the best visuals possible. Make appointments. Remember most curators are also overworked, underpaid and on tight schedules."

THE WORKS GALLERY, Dept. AGDM, 303 Cherry St., Philadelphia PA 19106. (215)922-7775. Fax: (215)238-9351. E-mail: ruth@snyderman-works.com. Website: www.snyderman-works.com. **Owner:** Ruth Snyderman. Retail gallery. Estab. 1965. Represents 200 emerging, mid-career and established artists. Exhibited artists include Eileen Sutton and Patricia Sannit. Sponsors 10 shows/year. Average display time 1 month. Open all year; Tuesday-Saturday, 10-6. First Friday of each month hours extend to 9 p.m. as all galleries in this district have their openings together. Exhibitions usually change on a monthly basis except through the summer. Located downtown ("Old City"); 3,000 sq. ft. 65% of space for special exhibitions. Clientele: designers, lawyers, businessmen and women, students. 90% private collectors, 10% corporate collectors. Overall price range: $50-10,000; most work sold at $200-600.

Media: Considers ceramic, fiber, glass, photography and metal jewelry. Most frequently exhibits jewelry, ceramic and fiber.

Style: Exhibits all styles.

Terms: Accepts artwork on consignment (50% commission); some work is bought outright. Gallery provides insurance, promotion and contract; shipping costs are shared.

Submissions: Send query letter with résumé, 5-10 slides and SASE. Files résumé and slides, if interested.

Tips: "Most work shown is one-of-a-kind. We change the gallery totally for our exhibitions. In our gallery, someone has to have a track record so that we can see the consistency of the work. We would not be pleased to see work of one quality once and have the quality differ in subsequent orders, unless it improved. Always submit slides with descriptions and prices instead of walking in cold. Enclose an self-addressed, stamped return envelope. Follow up with a phone call. Try to have a sense of what the gallery's focus is so your work is not out of place. It would save everyone some time."

Rhode Island

ARNOLD ART, 210 Thames, Newport RI 02840. (401)847-2273. E-mail: info@arnoldart.com. Website: www.arnoldart.com. **President:** William Rommel. Retail gallery. Estab. 1870. Represents 40 emerging, mid-career and established artists. Exhibited artists include John Mecray, Willard Bond. Sponsors 4

exhibits/year. Average display time 1 month. Open Monday-Saturday, 9:30-5:30; Sunday, 12-5. Clientele: local community, students, tourists and Newport collectors. 1% of sales are to corporate clients. Overall price range: $100-35,000; most work sold at $300.

Media: Considers oil, acrylic, watercolor, pastel, pen & ink, drawings, mixed media. Most frequently exhibits oil and watercolor.

Style: Genres include marine sailing, classic yachts, America's cup, yachting/sailing.

Terms: Accepts work on consignment and there is a 40% commission. Retail price set by artist. Exclusive area representation not required. Gallery provides promotion.

Submissions: Send e-mail. Call or e-mail for appointment to show portfolio of originals. Returns materials with SASE.

Tips: To make your submissions professional you must "Frame them well."

ARTIST'S COOPERATIVE GALLERY OF WESTERLY, 12 High St., Westerly RI 02891. (401)596-2020. Cooperative gallery and nonprofit corporation. Estab. 1992. Represents 45-50 emerging, mid-career and established artists/year. Sponsors 12 shows/year. Average display time 1 month. Offers spring and fall open juried shows. Open all year; Tuesday-Saturday, 11-4. Located downtown on a main street; 30′ × 80′; ground level, store front, arcade entrance, easy parking. 80% of sales are to private collectors, 20% corporate collectors. Overall price range: $20-3,000; most work sold at $20-300.

Media: Considers all media and all types of prints. Most frequently exhibits oils, watercolors, ceramics, sculpture and jewelry.

Style: Exhibits: expressionism, primitivism, painterly abstraction, postmodern works, impressionism and realism.

Terms: Co-op membership fee of $120/year, plus donation of time and hanging/jurying fee of $10. Gallery takes no percentage. Regional juried shows each year. Retail price set by the artist. Gallery provides promotion; artist pays for shipping. Prefers artwork framed.

Submissions: Send query letter with 3-6 slides or photos and artist's statement. Call or write for appointment. Responds in 3 weeks. Membership flyer and application available on request.

Tips: "Take some good quality pictures of your work in person, if possible, to galleries showing the kind of work you want to be associated with. If rejected, reassess your work, presentation and the galleries you have selected. Adjust what you are doing appropriately. Try again. Be upbeat and positive."

CADEAUX DU MONDE, 26 Mary St., Newport RI 02835. (401)848-0550. Fax: (401)849-3225. E-mail: info@cadeauxdumonde.com. Website: www.cadeauxdumonde.com. **Owners:** Jane Perkins, Katie Dyer and Bill Perkins. Retail gallery. Estab. 1987. Represents emerging, mid-career and established artists. Exhibited artists include: John Lyimo and A.K. Paulin. Sponsors 7 changing shows and 1 ongoing show/year. Average display time 3-4 weeks. Open all year; daily, 10-6 and by appointment. Located in commercial district; 1,300 sq. ft. Located in historic district in "the Anna Pell House (circa 1840), recently restored with many original details intact including Chiswick tiles on the fireplace and an outstanding back stairway 'Galerie Escalier' (the servant's staircase), which has rotating exhibitions from June to December." 15% of space for special exhibitions; 85% of space for gallery artists. Clients include tourists, upscale, local community and students. 95% of sales are to private collectors, 5% corporate collectors. Overall price range: $20-5,000; most work sold at $100-300.

Media: Considers all media suitable for display in a stairway setting for special exhibitions. No prints.

Style: Exhibits: folk art. "Style is unimportant, quality of work is deciding factor—look for unusual, offbeat and eclectic."

Terms: Accepts work on consignment (30% commission). Retail price set by the artist. Gallery provides insurance. Artist pays shipping costs and promotional costs of opening. Prefers artwork framed.

Submissions: Send query letter with résumé, 10 slides, bio, photographs and business card. Call for appointment to show portfolio of photographs or slides. Responds only if interested within 2 weeks. Finds artists through word of mouth, referrals by other artists, visiting art fairs and exhibitions, artist's submissions.

Tips: Artists who want gallery representation should "present themselves professionally; treat their art and the showing of it like a small business; arrive on time and be prepared; and meet deadlines promptly."

N COMPLEMENTS ART GALLERY, Fine Art Investments, Ltd., 50 Lambert Lind Hwy., Warwick RI 02886. (401)739-9300. Fax: (401)739-7905. E-mail: fineartinv@aol.com. Website: www.complementsartgallery.com. **President:** Domenic B. Rignanese. Retail gallery. Estab. 1986. Represents hundreds of international and New England emerging, mid-career and established artists. Exhibited artists include

Fairchild and Hatfield. Sponsors 6 shows/year. Average display time 2-3 weeks. Open all year; Monday-Friday, 8:30-6; Saturday-Sunday, 9-5. 2,250 sq. ft.; "we have a piano and beautiful hardwood floors, also a great fireplace." 20% of space for special exhibitions; 60% of space for gallery artists. Clientele: upscale. 40% private collectors, 15% corporate collectors. Overall price range: $25-5,000; most work sold at $600-1,200.

Media: Considers all media except offset prints. Types of prints include engravings, lithographs, wood engravings, mezzotints, serigraphs and etchings. Most frequently exhibits serigraphs, oils and etchings.

Style: Exhibits expressionism, painterly abstraction, impressionism, photorealism, realism and imagism. Genres include florals, portraits and landscapes. Prefers realism, impressionism and abstract.

Terms: Accepts work on consignment (30% commission) or bought outright for 50% of retail price (90 days). Retail price set by the gallery. Gallery provides insurance, promotion and contract. Shipping costs are shared. Prefers artwork unframed.

Submissions: Size limitation due to wall space. Drawings no larger than 40×60, sculpture not heavier than 150 pounds. Send query letter with résumé, bio, 6 slides or photographs. Call for appointment to show portfolio of photographs and slides. Responds in 1 month. Files all materials from artists. Finds artists through word of mouth, referrals by other artists, visiting art fairs and all exhibitions and artist's submissions.

Tips: "Artists need to have an idea of the price range of their work and provide interesting information about themselves."

THE DONOVAN GALLERY, 3895 Main Rd., Tiverton Four Corners RI 02878. (401)624-4000. Fax: (401)624-4100. E-mail: kris@donovangallery.com. Website: www.donovangallery.com. **Owner:** Kris Donovan. Retail gallery. Estab. 1993. Represents 50 emerging, mid-career and established artists/year. Average display time 1 month. Open all year; Monday-Saturday, 10-5; Sunday, 12-5; shorter winter hours. Located in a rural shopping area; 2,000 sq. ft.; located in 1750s historical home. 100% of space for gallery artists. Clientele: tourists, upscale, local community and students. 90% private collectors, 10% corporate collectors. Overall price range: $80-6,500; most work sold at $250-800.

Media: Considers oil, acrylic, watercolor, pastel, mixed media, collage, paper, sculpture, ceramics, some craft, fiber and glass; and all types of prints. Most frequently exhibits watercolors, oils and pastels.

Style: Exhibits conceptualism, impressionism, photorealism and realism. Exhibits all genres. Prefers: realism, impressionism and representational.

Terms: Accepts work on consignment (45% commission). Retail price set by the artist. Gallery provides limited insurance, promotion and contract; artist pays for shipping. Prefers artwork framed.

Submissions: Accepts only artists from New England. Send query letter with résumé, 6 slides, bio, brochure, photographs, SASE, business card, reviews and artist's statement. Call or write for appointment to show portfolio of photographs or slides or transparencies. Responds in 1 week. Files material for possible future exhibition. Finds artists through networking and submissions.

Tips: "Do not appear without an appointment, especially on a weekend. Be professional, make appointments by telephone, be prepared with résumé, slides and (in my case) some originals to show. Don't give up. Join local art associations and take advantage of show opportunities there."

FINE ARTS CENTER GALLERIES/UNIVERSITY OF R.I., 105 Upper College Rd., Kingston RI 02881-0820. (401)874-2627. Fax: (401)874-2007. E-mail: shar@uri.edu. Website: www.uri.edu/artgalleries. Nonprofit gallery. Estab. 1968. Exhibits emerging, mid-career and established. Sponsors 15-20 exhibits/year. Average display time 1-3 months. Open all year; Tuesday-Friday, 12-4; weekends, 1-4. Reduced hours in summer. Composed of 3 galleries—main (largest space), photography and corridor (hallway) galleries. Clients include local community, students, tourists and upscale.

Media: Considers all types of prints.

Style: Considers all styles and genres.

Terms: Retail price set by the artist. Gallery provides insurance. Accepted work should be framed. Does not require exclusive representation locally.

Submissions: Mail portfolio for review. Returns material with SASE. Responds in 1 month. Finds artists through word of mouth, submissions, art exhibits and referrals by other artists.

HERA EDUCATIONAL FOUNDATION, HERA GALLERY, 327 Main St., P.O. Box 336, Wakefield RI 02880-0336. (401)789-1488. E-mail: info@heragallery.org. Website: www.heragallery.org. **Director:** Katherine Veneman. Nonprofit professional artist cooperative gallery. Estab. 1974. Located in downtown Wakefield, a Northeast area resort community (near beaches, Newport and Providence). Exhibits the work

of emerging and established artists who live in New England, Rhode Island and throughout the US. 30 members. Sponsors 9-10 shows/year. Average display time 4-5 weeks. Hours: Wednesday, Thursday and Friday, 1-5; Saturday, 10-4. Closed January. Located downtown; 1,200 sq. ft. 40% of space for special exhibitions.

Media: Considers all media and original handpulled prints.

Style: Exhibits installations, conceptual art, expressionism, neo-expressionism, painterly abstraction, surrealism, conceptualism, postmodern works, realism and photorealism, basically all styles. "We are interested in innovative, conceptually strong, contemporary works that employ a wide range of styles, materials and techniques." Prefers "a culturally diverse range of subject matter which explores contemporary social and artistic issues important to us all."

Terms: Co-op membership. Retail price set by artist. Sometimes offers customer discount and payment by installments. Gallery provides promotion; artist pays for shipping and shares expenses like printing and postage for announcements. Commission is 25%. No insurance.

Submissions: Send query letter with SASE. "After sending query letter and SASE, artists interested in membership receive membership guidelines with an application. Twenty slides or a CD-Rom are required for application review along with résumé, artist statement and slide list." Portfolio required for membership; slides for invitational/juried exhibits. Finds artists through word of mouth, advertising in art publications, and referrals from members.

Tips: "Please write for membership guidelines. We have two categories of membership, one of which is ideal for out of state artists."

South Carolina

CECELIA COKER BELL GALLERY, Coker College, 300 E. College Ave., Hartsville, SC 29550. (843)383-8156. E-mail: lmerriman@pascal.coker.edu. Website: www.coker.edu/art/gallery.html. **Director:** Larry Merriman. "A campus-located teaching gallery which exhibits a great diversity of media and style to expose students and the community to the breadth of possibility for expression in art. Exhibits include regional, national and international artists with an emphasis on quality. Features international shows of emerging artists and sponsors competitions." Estab. 1984. Interested in emerging and mid-career artists. Sponsors 5 solo shows/year. Average display time 1 month. "Gallery is 30×40, located in art department; grey carpeted walls, track lighting."

Media: Considers oil, acrylic, drawings, mixed media, collage, works on paper, sculpture, installation, photography, performance art, graphic design and printmaking. Most frequently exhibits painting, sculpture/installation and mixed media.

Style: Considers all styles. Not interested in conservative/commercial art.

Terms: Retail price set by artist (sales are not common). Exclusive area representation not required. Gallery provides insurance, promotion and contract; shipping costs are shared.

Submissions: Send résumé, 10-15 good-quality slides and SASE by October 15. Write for appointment to show portfolio of slides.

CHARLESTON CRAFTS, 87 Hasell St., Charleston SC 29401. (843)723-2938. Website: www.charlestoncrafts.org. Cooperative gallery. Estab. 1989. Represents 50 emerging, mid-career and established artists/year. 50-70 members. Sponsors 8 shows/year. Average display time 3-4 weeks. Open all year; Monday-Saturday 10-5. Located downtown. 5% of space for special exhibitions; 95% of space for gallery artists. Clientele: tourists and local community. 98% private collectors, 2% corporate collectors. Overall price range: $5-800; most work sold at $30-125.

Media: Considers basketry, paper, fiber, sculpture, glass, fine craft, fine photography, graphics, handpulled prints. Most frequently exhibits clay, glass, fiber and jewelry.

Terms: Co-op membership fee plus donation of time (35% commissions). Retail price set by the artist. Gallery provides promotion; shipping costs are shared. Prefers artwork either framed or unframed.

Submissions: Accepts only artists from South Carolina. Send query letter with SASE. Responds in 2 weeks. Files only applications to jury as member. Finds artists through word of mouth; jury twice a year, referrals and craft shows call for new member-press releases.

Tips: "Artists must realize we are a cooperative of juried members—all local South Carolina artists. We look at expertise in technique and finishing. Also how work is presented—professional display, packaging or tagging."

CITY ART GALLERY, 1224 Lincoln St., Columbia SC 29201. (803)252-3613. Fax: (803)252-3595. E-mail: gallerydirector@cityartonline.com. Website: www.cityartonline.com. **Contact:** Teri Tynes, gallery director. For-profit gallery. Estab. 1997. Approached by 400 artists/year. Represents 50 emerging, mid-career and established artists. Exhibited artists include: Tarleton Blackwell (oil, mixed media), Scotty Peek (charcoal) and Michael Brodeur (oil on canvas). Sponsors 5 exhibits/year. Average display time 6 weeks. Open all year; Monday-Friday, 10-6; weekends, 11-3. Located in the Vista, the gallery is housed in a spacious 19th century warehouse. City Art features a large main gallery, an adjacent small works gallery and a large second floor exhibition space. 2% of sales are to corporate collectors. Overall price range: $65-5,000; most work sold at $2,500.
Media: Considers all media. Most frequently exhibits oil on canvas, mixed media and photography.
Style: Considers contemporary. Most frequently exhibits abstraction, narrative, contemporary realism and expressionism,
Terms: Artwork is accepted on consignment and there is a 50% commission. Retail price set by the artist. Gallery provides insurance, promotion and contract. Accepted work should be framed. Requires exclusive representation locally.
Submissions: Mail portfolio for review. Returns material with SASE. Responds in 3 months. Files slides and biography. Finds artists through word of mouth, portfolio reviews, art exhibits and referrals by other artists.
Tips: Include full résumé with list of collectors; include digital images as well as slides. Specific list of solo and group shows.

N HAMPTON III GALLERY LTD., 3110 Wade Hampton Blvd., Taylors (Greenville) SC 29687. E-mail: hampton3gallery@mindspring.com. **Contact:** Sandra Rupp, director. Rental gallery. Estab. 1970. Approached by 20 artists/year; exhibits 25 mid-career and established artists/year. Exhibited artists include Carl Blair (oil paintings) and Darell Koons (acrylic paintings). Sponsors 8 exhibits/year. Average display time 4-6 weeks. Open all year; Tuesday-Friday, 1-5; Saturday and Sunday, 10-5. Located 3 miles outside of downtown Greenville, SC; one large exhibition room in center with 7 exhibition rooms around center gallery. Clients include local community and upscale. 5% of sales are to corporate collectors. Overall price range: $200-15,000; most work sold at $2,500.
Media: Considers acrylic, ceramics, collage, drawing, mixed media, oil, paper, pastel, pen & ink, sculpture and watercolor. Most frequently exhibits oil and watercolor. Also considers engravings, etchings, linocuts, lithographs, mezzotints, serigraphs and woodcuts.
Style: Exhibits color field, expressionism, geometric abstraction, imagism, impressionism and painterly abstraction. Most frequently exhibits painterly abstration and realism. Considers all genres.
Terms: Artwork is accepted on consignment and there is a 40% commission. Retail price of the art set by the artist. Gallery provides insurance, promotion and contract. Accepted work should be framed. Requires exclusive representation locally.
Submissions: Send query letter with artist's statement, bio, reviews, SASE and slides. Returns material with SASE. Responds to queries in 3 months. Finds artists through art exhibits, referrals by other artists and word-of-mouth.

N McCALLS, 111 W. Main, Union SC 29379. (864)427-8781. **Contact:** Bill McCall. Retail gallery. Estab. 1972. Represents 5-7 established artists/year. Exhibited artists include Betsy Humphries. Sponsors 2 shows and 1 competition/year. Average display time 9-12 weeks. Open all year; Tuesday-Friday, 10-5 (10 months); Monday-Saturday, 10-6 (2 months). Located downtown; 900 sq. ft. 10% of space for special exhibitions; 90% of space for gallery artists. Clientele: upscale. 60% private collectors, 40% corporate collectors. Overall price range: $150-2,500; most work sold at $150-850.
Media: Considers oil, pen & ink, acrylic, glass, craft (jewelry), watercolor, mixed media, pastel, collage; considers all types of prints. Most frequently exhibits jewelry, collage and watercolor.
Style: Exhibits painterly abstraction, primitivism, realism, geometric abstraction and impressionism. Genres include florals, western, southwestern, landscapes, wildlife and Americana. Prefers: southwestern, florals and landscapes.
Terms: Accepts work on consignment (negotiable commission). Retail price set by the gallery and the artist. Gallery provides insurance, promotion and contract.
Submissions: "I prefer to see actual work by appointment only."
Tips: "Present only professional quality slides and/or photographs."

PORTFOLIO ART GALLERY, 2007 Devine St., Columbia SC 29205. (803)256-2434. E-mail: portfolio @mindspring.com. Website: www.portfolioartgal.com. **Owner:** Judith Roberts. Retail gallery and art con-

sultancy. Estab. 1980. Represents 40-50 emerging, mid-career and established artists. Exhibited artists include Donald Holden, Sigmund Abeles and Joan Ward Elliott. Sponsors 4-6 shows/year. Average display time 3 months. Open all year. Located in a 1930s shopping village, 1 mile from downtown; 2,000 sq. ft.; features 12 foot ceilings. 100% of space for work of gallery artists. "A unique feature is glass shelves where matted and medium to small pieces can be displayed without hanging on the wall." Clientele: professionals, corporations and collectors. 40% private collectors, 40% corporate collectors. Overall price range: $150-12,500; most work sold at $300-3,000.

• Portfolio Art Gallery was selected by readers of the local entertainment weekly paper and by *Columbia Metropolitan* magazine as the best gallery in the area.

Media: Considers oil, acrylic, watercolor, pastel, mixed media, collage, works on paper, sculpture, ceramic, glass, original handpulled prints, woodcuts, wood engravings, linocuts, engravings, mezzotints, etchings, lithographs and serigraphs. Most frequently exhibits watercolor, oil and original prints.

Style: Exhibits neo-expressionism, painterly abstraction, imagism, minimalism, color field, impressionism, realism, photorealism and pattern painting. Genres include landscapes and figurative work. Prefers: landscapes/seascapes, painterly abstraction and figurative work. "I especially like mixed media pieces, original prints and oil paintings. Pastel medium and watercolors are also favorites. Kinetic sculpture and whimsical clay pieces."

Terms: Accepts work on consignment (40% commission). Retail price set by gallery and artist. Offers payment by installments. Gallery provides insurance, promotion and contract; artist pays for shipping. Artwork may be framed or unframed.

Submissions: Send query letter with slides, bio, brochure, photographs, SASE and reviews. Write for appointment to show portfolio of originals, slides, photographs and transparencies. Responds only if interested within 1 month. Files tearsheets, brochures and slides. Finds artists through visiting exhibitions and referrals.

Tips: "The most common mistake beginning artists make is showing all the work they have ever done. I want to see only examples of recent best work—unframed, originals (no copies)—at portfolio reviews."

[N] **SMITH GALLERIES**, The Village at Wexford, Suite 1-11, Hilton Head Island SC 29928. Phone/fax: (843)842-2280. E-mail: info@smithgalleries.com. Website: www.smithgalleries.com. **Owner:** Wally Smith. Retail gallery. Estab. 1988. Represents 300 emerging, mid-career and established artists. Exhibited artists include Mike Smith and Hessam. Sponsors 10 shows/year. Average display time 6 weeks. Open all year; Monday-Friday, 10-6; Saturday, 10-5. Located in upscale shopping center near town center; 3,600 sq. ft.; designed by Taliesan Architect Bennett Strahan and accompanied by custom fixtures. 30% of space for special exhibitions; 70% of space for gallery artists. Clientele: 95% private collectors, 5% corporate collectors. Overall price range: $200-4,000; most work sold at $400-1,200.

Media: Considers oil, acrylic, watercolor, pastel, paper, sculpture, ceramics, craft, fiber, glass, photography, woodcuts, engravings, lithographs, mezzotints, serigraphs, linocuts, etchings and posters. Most frequently exhibits serigraphs, oil and acrylic.

Style: Exhibits all styles. Genres include florals, wildlife, landscapes, Americana and figurative work. Prefers: realism, expressionism and primitivism.

Terms: Reviews artist's terms and evaluates whether they are appropriate for the gallery. Retail price set by the gallery. Gallery provides insurance and promotion; shipping costs are shared. Prefers consigned artwork framed; purchase artwork unframed.

Submissions: No restrictions. "Please review artist submission page on website." Send query letter with résumé, 6-10 slides, bio, brochure, photographs, SASE, business card, reviews, artist's statement, "no phone or walk in queries." Write for appointment to show portfolio or photographs. "No slides or transparencies." Responds only if interested within 6 weeks. Files résumé, photos, reviews and bio. Returns materials only with SASE.

Tips: "Know the retail value of your work. Don't skimp on framing. Learn to frame yourself if necessary. In short, make your work desirable and easy for the gallery to present. Don't wait until you are out of school to start developing a market. Give marketing a higher priority than your senior show or masters exhibition."

THE SPARTANBURG COUNTY MUSEUM OF ART, 385 S. Spring St., Spartanburg SC 29306. (803)583-2776. Fax: (803)948-5353. E-mail: museum@spartanarts.org. Website: www.sparklenet.com/museum-of-art. **Executive Director:** Theresa H. Mann. Nonprofit art museum. Estab. 1968. Museum shop carries original art, pottery, glass and jewelry by South Carolina artists. Represents emerging, mid-career and established artists. Sponsors 25 shows/year. Average display time 6-8 weeks. Open all year; Monday-

Friday, 9-5; Saturday, 10-2; Sunday, 2-5. Located downtown, in historic neighborhood; 2,500 sq. ft.; Overall price range: $150-20,000; most work sold at $150-800.

Media: Considers oil, acrylic, watercolor, pastel, pen & ink, drawings, mixed media, collage, works on paper, sculpture, ceramic, craft, fiber, glass, installation and photography.

Style: Exhibits all styles and genres.

Terms: Accepts artwork on consignment (40% commission). Retail price set by artist. The museum provides insurance and promotion; shipping costs are negotiable. Artwork must be framed.

Submissions: Send query letter with résumé, 10 slides, bio, brochure, SASE and reviews. Write for appointment to show portfolio of slides. Responds in 6 weeks. Files bio, résumé and brochure.

South Dakota

DAKOTA ART GALLERY, 902 Mt. Rushmore Rd., Rapid City SD 57701. (605)394-4108. **Director:** Marie Bachmeier. Retail gallery. Estab. 1971. Represents approximately 200 emerging, mid-career and established artists, approximately 180 members. Exhibited artists include James Van Nuys and Russell Norberg. Sponsors 8 shows/year. Average display time 6 weeks. Also sponsors 6-week-long spotlight exhibits—8 times a year. Average display time 6 weeks. Open all year; Monday-Saturday, 10-5. Located in downtown Rapid City; 1,800 sq. ft. 40% of space for special exhibitions; 60% of space for gallery artists. 80% private collectors, 20% corporate collectors. Overall price range: $25-7,500; most work sold at $25-400.

Media: Considers all media and all types of prints. Most frequently exhibits oil, acrylics, watercolors, pastels, jewelry, stained glass and ceramics.

Style: Exhibits expressionism, painterly abstraction and impressionism and all genres. Prefers: landscapes, western, regional, still lifes and traditional.

Terms: Accepts work on assignment (40% commission). Retail price set by the artist. Gallery provides insurance, promotion and contract. Artist pays shipping costs.

Submissions: "Our main focus is on artists from SD, ND, MN, WY, CO, MT and IA. We also show artwork from any state that has been juried in." Must be juried in by committee. Send query letter with résumé, 15-20 slides, bio and photographs. Call for appointment to show portfolio of photographs, slides, bio and résumé. Responds in 1 month. Files résumés and photographs. Finds artists through word of mouth, referrals by other artists, visiting art fairs and exhibitions, artist's submissions.

Tips: "Make a good presentation with professional résumé, biographical material, slides, etc. Know the gallery quality and direction in sales, including prices."

SOUTH DAKOTA ART MUSEUM, Medary Ave. at Harvey Dunn St., P.O. Box 2250, Brookings SD 57007. (605)688-5423. Fax: (605)688-4445. **Curator of Exhibits:** John Rychtarik. Museum. Estab. 1970. Exhibits 12-20 emerging, mid-career and established artists. Sponsors 17 exhibits/year. Average display time 2-4 months. Open all year; Monday-Saturday, 10-4; Sunday, 12-4. Closed state holidays. Consists of 6 galleries; 26,000 sq. ft. Clients include local community, students, tourists and collectors. Overall price range: $200-6,000; most work sold at $500.

Media: Considers all media and all types of prints. Most frequently exhibits painting, sculpture and fiber.

Style: Considers all styles.

Terms: Artwork is accepted on consignment and there is a 30% commission. Retail price set by the artist. Gallery provides insurance and promotion. Accepted work should be framed. Does not require exclusive representation locally.

Submissions: Send artist's statement, bio, résumé, SASE and slides. Returns material with SASE. Responds only if interested within 3 months. Finds artists through word of mouth, portfolio reviews, art exhibits and referrals by other artists.

VISUAL ARTS CENTER, WASHINGTON PAVILION OF ARTS & SCIENCE, 301 S. Main, Sioux Falls SD 57104. (605)367-7397. Fax: (605)367-7399. Website: washingtonpavilion.org. Nonprofit museum. Estab. 1961. Open Monday-Saturday, 10-5; Sundays 12-5.

Media: Considers all media.

Style: Exhibits local, regional and national artists.

Submissions: Send query letter with résumé and slides.

Tennessee

BENNETT GALLERIES, 5308 Kingston Pike, Knoxville TN 37919. (865)584-6791. Fax: (865)588-6130. Website: www.bennettgalleries.com. **Director:** Mary Morris. Owner: Rick Bennett. Retail gallery. Represents emerging and established artists. Exhibited artists include Richard Jolley, Carl Sublett, Scott Duce, Andrew Saftel and Tommie Rush. Sponsors 10 shows/year. Average display time 1 month. Open all year; Monday-Thursday, 10-6; Friday-Saturday, 10-5:30. Located in West Knoxville. Clientele: 70% private collectors, 30% corporate collectors. Overall price range: $200-20,000; most work sold at $2,000-8,000.
Media: Considers oil, acrylic, watercolor, pastel, drawing, mixed media, works on paper, sculpture, ceramic, craft, photography, glass, original handpulled prints. Most frequently exhibits painting, ceramic/clay, wood, glass and sculpture.
Style: Exhibits contemporary works in abstraction, figurative, non-objective, narrative, primitivism.
Terms: Accepts artwork on consignment (50% commission). Retail price set by the gallery and the artist. Sometimes offers customer discounts and payment by installments. Gallery provides insurance on works at the gallery, promotion and contract. Prefers artwork framed. Shipping to gallery to be paid by the artist.
Submissions: Send query letter with résumé, no more than 20 slides, bio, photographs, SASE and reviews. Portfolio review requested if interested in artist's work. Responds in 6 weeks. Files samples and résumé. Finds artists through agents, visiting exhibitions, word of mouth, various art publications, sourcebooks, submissions/self-promotions and referrals.
Tips: "When approaching a new gallery, do your research to determine if the establishment is the right venue for your work. Also make a professional presentation with clearly labeled slides and relevant reference material along with a self-addressed envelope."

N EATON GALLERY, 1401 Heistan Place, Memphis TN 38104. (901)274-0000. Fax: (901)274-4500. **Owner/Director:** Sandra Saunders. Retail gallery. Estab. 1984. Represents 25 emerging, mid-career and established artists. Exhibited artists include Marjorie Liebman, Jiaxian Hao, Taylor Lin, Weimin. 30% of space for special exhibitions. Clientele: 60% private collectors, 40% corporate clients. Overall price range: $350-10,000; most work sold at $700-4,500.
Media: Considers oil, acrylic, watercolor, pastel, drawings, mixed media, works on paper, sculpture, original handpulled prints, woodcuts, engravings, lithographs, mezzotints, serigraphs and etchings. Most frequently exhibits oil, acrylic and watercolor.
Style: Exhibits expressionism, painterly abstraction, color field, impressionism and realism. Genres include landscapes, florals, Americana, Southwestern, portraits and figurative work. Prefers impressionism, expressionism and realism.
Terms: Accepts work on consignment (50% commission). Retail price set by artist or both gallery and artist. Gallery provides insurance, promotion and contract; artist pays for shipping. Prefers artwork framed.
Submissions: Send query letter with résumé, bio, slides, photographs and reviews. Write for appointment to show portfolio of originals "so that we may see how the real work looks" and photographs. Responds in 1 week. Files photos and "anything else the artists will give us."
Tips: "Just contact us—we are here for you."

JAY ETKIN GALLERY, 409 S. Main St., Memphis TN 38103. (901)543-0035. E-mail: etkinart@hotmail.com. Website: www.jayetkingallery.com. **Owner:** Jay S. Etkin. Retail gallery. Estab. 1989. Represents/exhibits 20 emerging, mid-career and established artists/year. Exhibited artists include: Rob vander Schoor, Jeff Scott and Pamela Cobb. Sponsors 10 shows/year. Average display time 1 month. Open all year; Tuesday-Saturday, 11-5. Located in downtown Memphis; 10,000 sq. ft.; gallery features public viewing of works in progress. 30% of space for special exhibitions; 5% of space for gallery artists. Clientele: young upscale, corporate. 80% private collectors, 20% corporate collectors. Overall price range $200-12,000; most work sold at $1,000-3,000.
Media: Considers all media except craft, papermaking. Also considers kinetic sculpture and conceptual work. "We do very little with print work." Most frequently exhibits oil on paper canvas, mixed media and sculpture.
Style: Exhibits expressionism, conceptualism, neo-expressionism, painterly abstraction, postmodern

works, realism, surrealism. Genres include landscapes and figurative work. Prefers: figurative expressionism, abstraction, landscape.

Terms: Artwork is accepted on consignment (60% commission). Retail price set by the gallery and the artist. Gallery provides promotion. Artist pays for shipping or costs are shared at times.

Submissions: Accepts artists generally from mid-south. Prefers only original works. Looking for long-term committed artists. Send query letter with 6-10 sildes or photographs, bio and SASE. Write for appointment to show portfolio of photographs, slides and cibachromes. Responds only if interested within 1 month. Files bio/slides if interesting work. Finds artists through referrals, visiting area art schools and studios, occasional drop-ins.

Tips: "Be patient. The market in Memphis for quality contemporary art is only starting to develop. We choose artists whose work shows technical know-how and who have ideas about future development in their work. Make sure work shows good craftsmanship and good ideas before approaching gallery. Learn how to talk about your work."

N HANSON FINE ART & CRAFT GALLERY, INC., 5607 Kingston Pike, Knoxville TN 37919. (423)584-6097. Fax: (423)588-3789. **President:** Diane Hanson. Retail gallery. Estab. 1988. Represents 150 mid-career artists/year. Exhibited artists include: Thomas Pradzynsky. Sponsors 3 shows/year. Average display time 1 month. Open all year; Monday-Saturday, 10-5. Located in midtown; 3,500 sq. ft. showroom; features clean, contemporary organization of work. 33⅓% of space for special exhibitions; 33⅓% of space for gallery artists. Clients include upscale, professional. 70% of sales are to private collectors, 30% corporate collectors. Overall price range: $25-5,000; most work sold at $100-3,000.

Media: Considers oil, acrylic, watercolor, pastel, mixed media, collage, paper, sculpture, ceramics, craft, fiber, glass and all prints. Most frequently exhibits oil, acrylic, glass.

Style: Exhibits: expressionism, painterly abstraction, impressionism, realism. Prefers landscape, figurative, abstract.

Terms: Accepts work on consignment (50% commission). Buys outright for 50% of retail price (net 30 days). Retail price set by the gallery. Gallery provides insurance, promotion, selective contract.

Submissions: Send query letter with résumé, slides, bio, photographs, SASE, reviews and artist's statement. Call for appointment to show portfolio of photographs or slides. Responds in 1 month. Files only material from artists of interest.

Tips: "Have high quality of personal presentation of work—we need assurance of a business-like relationship."

N LISA KURTS GALLERY, 766 S. White Station Rd., Memphis TN 38117. (901)683-6200. Fax: (901)683-6265. E-mail: art@lisakurts.com. Website: www.lisakurts.com. **Contact:** Stephen Barker, communications. For-profit gallery. Estab. 1979. Approached by 500 artists/year; exhibits 20 mid-career and established nationnally and internationally known aritsts. Exhibited artists include Marcia Myers and Anita Huffington. Sponsors 9 total exhibitions/year. Average display time 4-6 weeks. Open all year; Tuesday-Friday, 10-5; Saturday, 11-4. "Lisa Kurts Gallery is Memphis' oldest gallery and is known to be one of the leading galleries in the USA. Exhibits nationally in International Art Fairs and is regularly reviewed in the national press. Publishes catalogues and works closely with serious collectors and museums. This gallery's sister company, Lisa Kurts Ltd. specializes in blue chip Impressionist and Early Modern paintings and sculpture." Clients include national and international. Overall price range: $5,000-100,000; most work sold at $7,500-15,000.

Media: Exhibits "80% oil painting, 18% sculpture, 2% photography."

Style: Most frequently exhibits "artists with individual vision and who create works of art that are well crafted or painted." Considers all genres.

Terms: Artwork is accepted on consignment and there is a 50% commission. Retail price of the art set by the artist and the market if the artist's career is mature; set by the gallery if the artist's career is young. Gallery provides insurance, promotion and contract. Accepted work should be "professionally framed or archively mounted as approved by gallery's standards." Requires exclusive representation in the South.

Submissions: Send query letter with artist's statement, résumé, reviews and slides. Returns materials with SASE. Responds to queries in 3 months. Files slides and complete information. Finds artists through art fairs and exhibits, portfolio reviews, referrals by other artists, submissions and word-of-mouth.

Tips: To make their gallery submissions professional artists must send "clearly labeled slides and a minimum of 1 sheet, with the total résumé, artist's statement, letter why they contacted our gallery reviews, etc. Do not call. E-mail if you've not heard from us in 3 months."

THE PARTHENON, Centennial Park, Nashville TN 37201. (615)862-8431. Fax: (615)880-2265. E-mail: susan@parthenon.org. Website: www.parthenon.org. **Curator:** Susan E. Shockley. Nonprofit gallery in a full-size replica of the Greek Parthenon. Estab. 1931. Exhibits the work of emerging to mid-career artists. Clientele: general public, tourists. Sponsors 10-12 shows/year. Average display time 3 months. Overall price range: $300-2,000. "We also house a permanent collection of American paintings (1765-1923)."
Media: Considers "nearly all" media.
Style: "Interested in both objective and non-objective work. Professional presentation is important."
Terms: "Sale requires a 20% commission." Retail price set by artist. Gallery provides a contract and limited promotion. The Parthenon does not represent artists on a continuing basis.
Submissions: Send 20 well-organized slides, résumé and artist's statement addressed to curator.
Tips: "We plan our gallery calendar at least one year in advance."

RIVER GALLERY, 400 E. Second St., Chattanooga TN 37403. (423)265-5033, ext. 5. Fax: (423)265-5944. E-mail: details@river-gallery.com. **Owner Director:** Mary R. Portera. Retail gallery. Estab. 1992. Represents 200 emerging and mid-career artists/year. Exhibited artists include: Leonard Baskin and Scott E. Hill. Sponsors 12 shows/year. Display time 1 month. Open all year; Monday-Saturday, 10-5; Sunday, 1-5. Located in Bluff View Art District in downtown area; 2,500 sq. ft.; restored early New Orleans-style 1900s home; arched openings into rooms. 30% of space for special exhibitions; 70% of space for gallery artists. Clients include upscale tourists, local community. 95% of sales are to private collectors, 5% corporate collectors. Overall price range: $5-5,000; most work sold at $200-1,000.
Media: Considers all media. Most frequently exhibits oil, original prints, photography, watercolor, mixed media, clay, jewelry, wood and glass.
Style: Exhibits all styles and genres. Prefers painterly abstraction, impressionism, photorealism.
Terms: Accepts work on consignment (50% commission). Retail price set by the gallery. Gallery provides insurance, promotion and contract; shipping costs are shared. Prefers artwork framed.
Submissions: Send query letter with résumé, slides, bio, photographs, SASE, reviews and artist's statement. Call or e-mail for appointment to show portfolio of photographs and slides. Files all material "unless we are not interested then we return all information to artist." Finds artists through word of mouth, referrals by other artists, visiting art fairs and exhibitions, submissions, ads in art publications.

Texas

N THE ART STUDIO, INC., 720 Franklin St., Beaumont TX 77701. (409)838-5393. E-mail: artstudio @artstudio.org. Website: www.artstudio.org. **Executive Director:** Greg Busceme. Assistant Director: Tracy Danna. Cooperative, nonprofit gallery and multicultural arts organization. Estab. 1983. Houses studios of 30 emerging, mid-career and established artists. Sponsors 10 exhibits/year. Average display time 1 month. No shows January, July, August. Artist space open and sales gallery open. Located in the downtown industrial district; 14,000 sq. ft.; 1946 brick 2-story warehouse with glass brick accents. Overall price range: $10-2,500; most work sold at $50-250.
 • Gallery publishes a monthly arts magazine called *Issue*, which is open for submissions of poetry, essays, opinions from public. The publication welcomes alternative views and controversial subjects. Sponsors monthly "band nights" featuring area musicians and monthly poetry nights called "Thoughtcrime: The Reading."
Media: Considers all media. Most frequently exhibits painting, ceramics and sculpture.
Style: Exhibits all styles. Prefers contemporary, painterly abstraction and photography.
Terms: Co-op membership fee of $20/year plus donation of 25% sales. Retail price set by artist. Gallery provides contract; artist pays for shipping. Prefers artwork framed.
Submissions: Send query letter with résumé and slides. Write for appointment to show portfolio of slides. Responds only if interested within 2 months. Files résumé and slides.
Tips: "Send résumé stating style and reason for choosing The Art Studio. It helps to live in the region."

N BARNARDS MILL ART MUSEUM, 307 SW. Barnard St., Glen Rose TX 76043. (817)897-2611.
Contact: Richard H. Moore, president. Museum. Estab. 1989. Represents 30 mid-career and established artists/year. Interested in seeing the work of emerging artists. Sponsors 2 shows/year. Open all year; Saturday, 10-5; Sunday, 1-5. Located 2 blocks from the square. "Barnards Mill is the oldest structure (rock exterior) in Glen Rose. 20% of space for special exhibitions; 80% of space for gallery artists.
Media: Considers oil, acrylic, watercolor, pastel, pen & ink, drawing, mixed media, collage, paper, sculp-

ture, ceramics, fiber, glass, installation, photography, woodcuts, engravings, lithographs, wood engravings, mezzotints, serigraphs, linocuts and etchings. Most frequently exhibits oil, pastel and watercolor.

Style: Exhibits experssionism, postmodern works, impressionism and realism, all genres. Prefers realism, impressionism and Western.

Terms: Gallery provides promotion. Prefers artwork framed.

Submissions: Send query letter with résumé, slides or photographs, bio and SASE. Write for appointment to show portfolio of photographs or slides. Responds only if interested within 3 months. Files résumés, photos, slides.

BLOSSOM STREET GALLERY & SCULPTURE GARDEN, 4809 Blossom, Houston TX 77007. Phone/fax: (713)869-1921. E-mail: Director@blossomstreetGallery.com. Website: www.blossomstreetgallery.com. **Contact:** Diane, director. For-profit gallery. Estab. 1997. Approached by 40 artists/year. Represents 20 emerging, mid-career and established artists. Exhibited artists include: Richard Roederer (painting and sculpture) and William Webman (photography). Average display time 1 month. Open all year; Tuesday-Sunday, 11-6. Located in inner city Houston; 3 exhibit spaces and 1 acre sculpture park and garden area. Clients include local community, tourists and upscale. 20% of sales are to corporate collectors. Overall price range: $200-20,000; most work sold at $1,000.

Media: Considers acrylic, collage, drawing, fiber, glass, installation, mixed media, oil, paper, pastel, pen & ink, sculpture, watercolor, etchings, linocuts, lithographs, mezzotints, serigraphs and woodcuts. Most frequently exhibits oil, collage and photography.

Style: Considers all styles. Genres include Americana, figurative work and landscapes.

Terms: Artwork is accepted on consignment and there is a 50% commission. Retail price set by the gallery and the artist. Gallery provides insurance, promotion and contract. Accepted work should be hangable. Requires exclusive representation locally—if a one-person exhibit.

Submissions: Send query letter with artist's statement, bio, brochure, business card, photocopies, photographs, résumé, reviews, SASE, slides or send web page. Returns material with SASE. Responds in 1 month. Finds artists through word of mouth, submissions, portfolio reviews, art exhibits and referrals by other artists.

JULIA C. BUTRIDGE GALLERY AT THE DOUGHERTY ARTS CENTER, 1110 Barton Springs Rd., Austin TX 78704. (512)397-1455. E-mail: megan.weiler@ci.austin.tx. Website: www.ci.austin.tx.us/dougherty/butridge.htm. **Gallery Coordinator:** Megan Weiler. Nonprofit gallery. Represents emerging, mid-career and established artists. Exhibited artists include John Christensen and T. Paul Hernandez. Sponsors 12 shows/year. Average display time 1 month. Open all year; Monday-Thursday, 9-9:30; Friday 9-5:30; Saturday 10-2. Located in downtown Austin; 1,800 sq. ft.; open to all artists. 100% of space for special exhibitions. Clientele: citizens of Austin and central Texas. Overall price range: $100-5,000.

Media: Considers all media, all types of prints.

Style: Exhibits all styles, all genres. Prefers: contemporary.

Terms: "Gallery does not handle sales or take commissions. Sales are encouraged but must be conducted by the artist or his/her affiliate." Rental fee for space; covers 1 month. Retail price set by the artist. Gallery provides insurance and promotion; artist pays shipping costs to and from gallery. Artwork must be framed.

Submissions: Accepts only regional artists, central Texas. Send query letter with résumé and 10-20 slides. Write for appointment to show portfolio of photographs and slides. Responds in 1 month. Files résumé, slides. Finds artists through visiting exhibitions, publications, submissions.

Tips: "Since most galleries will not initially see an artist via an interview, have fun and be creative in your paper presentations. Intrigue them!"

CARSON COUNTY SQUARE HOUSE MUSEUM, P.O. Box 276, Panhandle TX 79068. (806)537-3524. Fax: (806)537-5628. **Executive Director:** Viola Moore. Regional museum. Estab. 1967. Exhibits emerging, mid-career and established artists. Sponsors 12 shows/year (6 in each of 2 galleries). Average display time 2 months. Open all year. Purvines Gallery: 870 sq. ft (64.5 linear ft) in historic house; Brown Gallery: 1,728 sq. ft. (1,200 linear ft) in modern education building. Clientele: 100% private collectors. Overall price range: $50-1,200; most work sold at $150-500.

Media: Considers all media.

Style: All genres. No nudes.

Terms: Artwork accepted in exchange for a contributed piece at the end of the show. Artist and buyer make private arrangements; museum stays out of sale. Retail price set by artist. Gallery provides insurance, promotion and contract; artist pays shipping costs. Prefers artwork framed.

Submissions: Accepts only artists from Texas panhandle and adjacent states. Send query letter with résumé, slides, brochure, photographs, review and SASE. Write for appointment to show portfolio of photographs and slides. Responds only if interested within 1 month. Files all material.

CONTEMPORARY GALLERY, 4152 Shady Bend Dr., Dallas TX 75244. (972)247-5246. **Director:** Patsy C. Kahn. Private dealer. Estab. 1964. Interested in established artists. Clients include collectors and retail.
Media: Considers original handpulled prints.
Style: Contemporary, 20th-century art—graphics.
Terms: Accepts work on consignment or buys outright. Retail price set by gallery and artist; shipping costs are shared.
Submissions: Send query letter, résumé, slides and photographs. Write for appointment to show portfolio.

DALLAS MUSEUM OF ART, 1717 Harwood St., Dallas TX 75214. (214)922-1344. Fax: (214)922-1350. Website: www.DallasMuseumofArt.org. Museum. Estab. 1903. Exhibits emerging, mid-career and established: Exhibited artists include: Thomas Struth. Average display time 3 months. Open all year; Tuesday-Sunday, 11-5; open until 9 on Thursday. Closed New Year's Day, Thanksgiving and Christmas. Clients include local community, students, tourists and upscale.
 • Museum does not accept unsolicited submissions.
Media: Exhibits all media and all types of prints.
Style: Exhibits all styles and genres.

DIVERSEWORKS ARTSPACE, 1117 E. Freeway, Houston TX 77002. (713)223-8346. Fax: (713)223-4608. E-mail: info@diverseworks.org. **Visual Arts Director:** Diane Barber. Nonprofit gallery/performance space. Estab. 1982. Represents 1,400 members; emerging and mid-career artists. Sponsors 10-12 shows/ year. Average display time 6 weeks. Open all year. Located just north of downtown (warehouse district). Has 4,000 sq. ft. for exhibition, 3,000 sq. ft. for performance. "We are located in the warehouse district of Houston. The complex houses five artists's studios (20 artists), and a conservator/frame shop." 75% of space for special exhibition.
Style: Exhibits all contemporary styles and all genres.
Terms: "DiverseWorks does not sell artwork. If someone is interested in purchasing artwork in an exhibit we have, the artist contacts them." Gallery provides insurance, promotion and shipping costs. Accepts artwork framed or unframed, depending on the exhibit and artwork.
Submissions: All proposals are put before an advisory board made up of local artists. Send query letter with résumé, slides and reviews. Call or write to schedule an appointment to show a portfolio, which should include originals and slides. Responds in 3 months.
Tips: "Call first for proposal guidelines."

EL TALLER GALLERY-AUSTIN, 2438 W. Anderson Lane, #C-3, Austin TX 78757. (800)234-7362. Fax: (512)302-4895. **Owner:** Olga. Retail gallery, art consultancy. Estab. 1980. Represents 20 emerging, mid-career and established artists/year. Exhibited artists include R.C. Gorman and Amado Peña. Sponsors 3 shows/year. Average display time 2-4 weeks. Open all year; Tuesday-Saturday, 10-6. 1,850 sq. ft. 50% of space for special exhibitions; 100% of space for gallery artists. Clientele: tourists, upscale. 90% private collectors, 10% corporate collectors. Overall price range: $500-15,000; most work sold at $2,500-4,000.
Media: Considers all media and all types of prints. Most frequently exhibits mixed media, pastels and watercolors.
Style: Exhibits expressionism, primitivism, conceptualism, impressionism. Genres include florals, western, southwestern, landscapes. Prefers: southwestern, landscape, florals.
Terms: Accepts work on consignment (50% commission). Retail price set by the artist. Gallery provides promotion and contract; artist pays shipping costs. Prefers artwork framed.
Submissions: Send query letter with bio, photographs and reviews. Write for appointment to show portfolio of photographs and actual artwork. Responds only if interested within 2 months.

F8 FINE ART GALLERY, 211 Earl Garrett, Kerrville TX 78028. (830)895-0646. Fax: (830)895-0680. E-mail: fineart@ktc.com. Website: www.f8fineart.com. For-profit gallery. Estab. 2001. Approached by 200 artists/year. Exhibits 30 emerging and mid-career artists. Exhibited artists include: Ray Donley, Bruce Tinch and Burton Pritzker. Sponsors 6 exhibits/year. Average display time 2 months. Open all year; Tues-

day-Saturday, 11-4. Clients include local community and tourists. Overall price range: $400-10,000; most work sold at $2,500.

●	This gallery has a second location at 1137 W. Sixth St., Austin TX 78703. (512)480-0242. Fax: (572)480-0241. Open all year; Tuesday-Saturday, 10-6. "Both galleries are amont the premier galleries in their areas. Each has clean lines and is minimally decorated so that the focus is on the art."

Media: Considers acrylic, oil, mixed media and photography. Does not consider digital or reproduction work.

Style: Considers contemporary.

Terms: Artwork is accepted on consignment and there is a 50% commission. Retail price set by the gallery. Gallery provides insurance, promotion and contract. Accepted work should be framed and matted. Does not require exclusive representation locally.

Submissions: Send query letter with artist's statement, bio, images of work, résumé, reviews. Returns material with SASE. Responds only if interested within 6 weeks. Files all information that doesn't need to be returned on artists we're interested in only. Finds artists through submissions, portfolio reviews and art exhibits.

Tips: Give us all of the information you think we might need in a clean, well-organized form. Do not send original work. All art submissions should represent the original as closely as possible. Archival-quality is a must.

☑ **GREMILLION & CO. FINE ART, INC.,** 2501 Sunset Blvd., Houston TX 77005. (713)522-2701. E-mail: fineart@gremillion.com. Website: www.gremillion.com. **Director:** Christopher Skidmore. Sales/Marketing: Bob Russell. Retail gallery. Estab. 1980. Represents more than 80 mid-career and established artists. May be interested in seeing the work of emerging artists in the future. Exhibited artists include John Pavlicek and Robert Rector. Sponsors 12 shows/year. Average display time 4-6 weeks. Open all year. Located "West University" area; 12,000 sq. ft. 50% of space for special exhibitions. 60% private collectors; 40% corporate collectors. Overall price range: $500-300,000; most work sold at $3,000-10,000.

Media: Considers oil, acrylic, watercolor, pastel, pen & ink, drawing, mixed media, collage, works on paper, sculpture, original handpulled prints, woodcuts, engravings, lithographs, wood engravings, mezzotints, linocuts, etchings and serigraphs.

Style: Exhibits painterly abstraction, minimalism, color field and realism. Genres include landscapes and figurative work. Prefers abstraction, realism and color field.

Terms: Accepts artwork on consignment (varying commission). Retail price set by the gallery and artist. Gallery provides insurance and promotion; shipping costs are shared. Prefers artwork unframed.

Submissions: Call for appointment to show portfolio of slides, photographs and transparencies. Responds only if interested within 3 weeks. Files slides and bios. Finds artists through submissions and word of mouth.

CAROL HENDERSON GALLERY, 3409 W. Seventh, Ft. Worth TX 76107. (817)878-2711. Fax: (817)878-2722. E-mail: carolhgallery@cs.com. Website: www.carolhendersongallery.com. **Director:** Donna Craft. Retail gallery. Estab. 1989. Represents/exhibits 21 emerging, mid-career and established artists/year. Exhibited artists include Michael Bane, Art Werger and Cindi Holt. Sponsors 6 shows/year. Average display time 3-4 weeks. Open all year; Tuesday-Saturday, 10-5:30. Located in West Fort Worth; 2,100 sq. ft. 90% of space for gallery artists. Clientele: upscale, local community. 90% private collectors, 10% corporate collectors. Overall price range: $100-10,000.

Media: Considers all media, woodcut, mezzotint and etching. Most frequently exhibits oil, acrylic and glass.

Style: Exhibits expressionism, photorealism, primitivism, painterly abstraction and realism. Genres include landscapes, florals and figurative work. Prefers figurative, abstract and landscape.

Terms: Artwork is accepted on consignment (50% commission). Retail price set by the gallery and the artist. Gallery provides insurance, promotion and contract; shipping costs are shared. Prefers artwork framed.

Submissions: Send query letter with résumé, brochure, business card, slides, photographs, reviews, bio and SASE. Call for appointment to show portfolio of photographs, slides and transparencies. Responds in 2 weeks. Finds artists through referrals, artists' submissions.

IVÁNFFY & UHLER GALLERY, 4623 W. Lovers Lane, Dallas TX 75209. (214)350-3500. E-mail: info@ivanffyuhler.com. Website: www.ivanffyuhler.com. **Director:** Paul Uhler. Retail/wholesale gallery. Estab. 1990. Represents 20 mid-career and established artists/year. May be interested in seeing the work

of emerging artists in the future. Sponsors 3-4 shows/year. Average display time 1 month. Open all year; Tuesday-Saturday, 10-6; Sunday, 1-6. Located near Love Field Airport. 4,000 sq. ft. 100% of space for gallery artists. Clientele: upscale, local community. 85% private collectors, 15% corporate collectors. Overall price range: $1,000-20,000; most work sold at $1,500-4,000.

Media: Considers oil, acrylic, watercolor, pastel, pen & ink, drawing, mixed media, collage, paper, sculpture, woodcuts, engravings, lithographs, wood engravings, mezzotints, serigraphs, linocuts and etchings. Most frequently exhibits oils, mixed media, sculpture.

Style: Exhibits neo-expressionism, painterly abstraction, surrealism, postmodern works, impressionism, hard-edge geometric abstraction, postmodern European school. Genres include florals, landscapes, figurative work.

Terms: Gallery provides promotion; shipping costs are shared.

Submissions: Send query letter with résumé, photographs, bio and SASE. Write for appointment to show portfolio of photographs. Responds only if interested within 1 month.

Tips: "We prefer European-trained artists."

DEBORAH PEACOCK GALLERY, 1705 Guadalupe, #118, Austin TX 78701. (512)474-2235. Fax: (512)474-8188. E-mail: photo@art-n-music.com. Website: www.art-n-music.com. **Proprietor/Photographer:** Deborah Peacock. Alternative space, for-profit gallery and art consultancy. Estab. 1997. Approached by 100 artists/year. Represents 15 emerging, mid-career and established artists. Exhibited artists include: Nicolás Herrera and Ava Brooks. Sponsors 6-8 exhibits/year. Average display time 1 month. Open all year; first Thursday of the month and by appointment. Located in downtown Austin within The Art Guadalupe Arts Building. The studio/gallery photographs art, helps artists with promotional materials, portfolios, advertising and exhibits. Clients include local community and tourists. 20% of sales are to corporate collectors. Overall price range: $150-6,000; most work sold at $300.

 • Universal Photographics is also owned by Deborah Peacock. In addition to promoting artists, they also cater to businesses, actors and musicians; product photography and graphic/web design.

Media: Considers all media and all types of prints. Most frequently exhibits oil, sculpture and photography.

Style: Considers all styles and genres. Most frequently exhibits conceptualism, expressionism and surrealism.

Terms: Artwork is accepted on consignment and there is a 50% commission. There is a rental fee for space. The rental fee covers 1 month. Retail price set by the artist. Gallery provides insurance, promotion and contract. Accepted work should be framed and mounted. Does not require exclusive representation locally.

Submissions: Write to arrange a personal interview to show portfolio of photographs and slides; or mail portfolio for review; or send query letter with artist's statement, bio, photographs, résumé, SASE and slides. Returns material with SASE. Responds only if interested within 1 month. Files artists statements, bios, review, etc. Finds artists through portfolio reviews.

Tips: "Use of archival-quality materials is very important to collectors."

N SELECT ART, 4040 Avondale Ave., Dallas TX 75219. (214)521-6833. Fax: (214)521-6344. E-mail: selart@swbell.net. postoffice.swbell.net. **Owner:** Paul Adelson. Private art gallery. Estab. 1986. Represents 25 emerging, mid-career and established artists. Exhibited artists include Barbara Elam and Larry Oliverson. Open all year; Monday-Saturday, 9-5 by appointment only. Located in North Dallas; 2,500 sq. ft. "Mostly I do corporate art placement." Clientele: 15% private collectors, 85% corporate collectors. Overall price range: $200-7,500; most work sold at $500-1,500.

Media: Considers oil, fiber, acrylic, sculpture, glass, watercolor, mixed media, ceramic, pastel, collage, photography, woodcuts, linocuts, engravings, etchings and lithographs. Prefers monoprints, paintings on paper and photography.

Style: Exhibits photorealism, minimalism, painterly abstraction, realism and impressionism. Genres include landscapes. Prefers: abstraction, minimalism and impressionism.

Terms: Accepts work on consignment (50% commission). Retail price set by consultant and artist. Sometimes offers customer discounts. Provides contract (if the artist requests one). Consultant pays shipping costs from gallery; artist pays shipping to gallery. Prefers artwork unframed.

Submissions: "No florals or wildlife." Send query letter with résumé, slides, bio and SASE. Call for appointment to show portfolio of slides. Responds only if interested within 1 month. Files slides, bio, price list. Finds artists through word of mouth and referrals from other artists.

Tips: "Be timely when you say you are going to send slides, artwork, etc., and neatly label slides."

N: SICARDI GALLERY, 2246 Richmond Ave., Houston TX 77098. (713)529-1313. Fax: (713)529-0443. E-mail: sicardi@sicardi.com. Website: www.sicardi.com. For-profit gallery. Estab. 1994. Approached by 100s of artists/year. Represents 50 emerging, mid-career and established artists. Sponsors 10 exhibits/year. Average display time 1 month. Open all year; Tuesday-Friday, 10-6; Saturday, 11-5. Clients include local community, upscale, and international. Overall price range: $400-20,000; most work sold at $5,000.
Media: Considers acrylic, collage, drawing, installation, mixed media, oil, paper and sculpture. Most frequently exhibits acrylic, oil and photography. Considers engravings, etchings, linocuts, lithographs, serigraphs and woodcuts.
Style: Considers all styles. Most frequently exhibits painterly abstraction. Genres include contemporary.
Terms: Artwork is accepted on consignment and there is a 50% commission. Retail price set by the gallery. Gallery provides insurance and promotion. Accepted work should be framed. Requires exclusive representation locally. Accepts only artists from Latin America.
Submissions: Mail portfolio for review. Returns material with SASE. Responds only if interested within 2 months. Files artist statement, bio and slides/images. Finds artists through portfolio reviews and art exhibits.
Tips: "Include an organized portfolio with images of a body of work. Archival-quality materials must be used to sell fine art to collectors."

N: THE UPSTAIRS GALLERY, 1038 W. Abram, Arlington TX 76013. (817)277-6961. Website: upstair sartgallery.com. **Contact:** J.T. Martin, owner/director. Retail gallery. Estab. 1967. Represents 15 mid-career and established artists. Exhibited artists include Jessica Neary (oil); Maureen Brouillette (acrylic); and Darnell Jones. Average display time 1-3 months. Open all year. Located near downtown; 1,500 sq. ft. "An antique house, vintage 1930." 100% of space for special exhibitions. Clientele: homeowners, businesses/hospitals. 90% private collectors, 10% corporate collectors. Overall price range: $50-5,000; most work sold at $200-600.
Media: Considers oil, acrylic, watercolor, mixed media, ceramic, collage, original handpulled prints, etchings, lithographs and offset reproductions (few). Most frequently exhibits watercolor, oil and acrylic.
Style: Exhibits expressionism, conceptualism, impressionism and realism. All genres.
Terms: Accepts work on consignment (40-60% commission). Retail price set by the gallery and the artist. Artist pays for shipping. Prefers artwork framed.
Submissions: Send query letter with slides, photographs and SASE. Call for appointment to show portfolio of slides or photographs. Responds in 1 month.

WEST END GALLERY, 5425 Blossom, Houston TX 77007. (713)861-9544. E-mail: kpackl1346@aol.com. **Owner:** Kathleen Packlick. Retail gallery. Estab. 1991. Exhibits emerging and mid-career artists. Exhibited artists include Kathleen Packlick and Maria Merrill. Open all year; Saturday, 12-4. Located 5 mintues from downtown Houston; 800 sq. ft.; "The gallery shares the building (but not the space) with West End Bicycles." 75% of space for special exhibitions; 25% of space for gallery artists. Clientele: 100% private collectors. Overall price range: $30-2,200; most work sold at $300-600.
Media: Considers oil, pen & ink, acrylic, drawings, watercolor, mixed media, pastel, collage, woodcuts, wood engravings, linocuts, engravings, mezzotints, etchings, lithographs and serigraphs. Prefers collage, oil and mixed media.
Style: Exhibits conceptualism, minimalism, primitivism, postmodern works, realism and imagism. Genres include landscapes, florals, wildlife, Americana, portraits and figurative work.
Terms: Accepts work on consignment (40% commission). Retail price set by artist. Payment by installment is available. Gallery provides promotion; artist pays shipping costs. Prefers artwork framed.
Submissions: Accepts only artists from Houston area. Send query letter with slides and SASE. Portfolio review requested if interested in artist's work.

WOMEN & THEIR WORK GALLERY, 1710 Lavaca St., Austin TX 78701. (512)477-1064. Fax: (512)477-1090. E-mail: wtw@texas.net. Website: www.womenandtheirwork.org. **Associate Director:** Kathryn Davidson. Alternative space and nonprofit gallery. Estab. 1978. Approached by more than 200 artists/year. Represents 8-10 one person and seasonal juried shows of emerging and mid-career Texas women. Exhibited artists include: Margo Sawyer, Jill Bedgood and Connie Arismendi. Sponsors 12 exhibits/year. Average display time 5 weeks. Open Monday-Friday, 9-5; Saturday, 12-4. Closed Christmas holidays, December 24 through January 2. Located downtown; 2,000 sq. ft. Clients include local community, students, tourists and upscale. 10% of sales are to corporate collectors. Overall price range: $500-5,000; most work sold at $800-1,000.

Media: Considers all media and all types of prints. Most frequently exhibits photography, sculpture, installation and painting.

Style: Exhibits: contemporary. Most frequently exhibits minimalism, conceptualism and imagism.

Terms: Selects artists through a juried process and pays them to exhibit. Takes 25% commission if something is sold. Retail price set by the gallery and the artist. Gallery provides insurance, promotion and contract. Accepted work should be framed, mounted and matted. Does not require exclusive representation locally. Accepts Texas women-all media-in one person shows only. All other artists, male or female in juried show—once a year if member of W&TW organization.

Submissions: Call or e-mail to arrange a personal interview to show portfolio. Returns materials with SASE. Responds in 1 month. Filing of material depends on artist and if they are members. We have a slide registry for all our artists if they are members. Finds artists through submissions and annual juried process.

Tips: "Send quality slides, typed résumé, and clear statement with artistic intent. 100% archival material required for framed works. It's important for collectors to understand care of artwork."

Utah

BINGHAM GALLERY, 136 S. Main St., #210, Salt Lake City UT 84101. (801)832-9220 or (800)992-1066. Fax: (408)993-0735. Website: www.binggallery.com. Foundation Website: www.maynardd ixon.com. **Owners:** Susan and Paul Bingham. Retail and wholesale gallery. Also provides art by important living and deceased artists for collectors. Estab. 1974. Represents 8 established artists. Exhibited artists include Carolyn Ward, Patricia Smith, Kraig Kiedrowski and many others. "Nationally known for works by Maynard Dixon. Represents the Estate of John Stenvall and have exclusive representation of G. Russel Case. Gallery owns the Maynard Dixon home and studio in Mount Carmel, Utah and Founders of the Thunderbird Foundation for the Arts." Sponsors 4 shows/year. Average display time 5 weeks. Open all year. Located downtown; 2,500 sq. ft.; high ceiling/great lighting, open space. 60% of space for special exhibitions; 40% for gallery artists. Clientele: serious collectors. 100% private collectors. Overall price range: $1,000-300,000; most work sold at $1,800-5,000.

Media: Considers oil, acrylic, watercolor, pastel, pen & ink, drawing and sculpture; original handpulled prints and woodcut. Most frequently exhibits oil, acrylic and pencil.

Style: Exhibits painterly abstraction, impressionism and realism. Genres include landscapes, florals, southwestern, western, figurative work and all genres. Prefers California landscapes, Southwestern and impressionism.

Terms: Accepts work on consignment (50% commission), or buys outright for 30% of retail price (net 30 days). Retail price set by gallery and artist. Gallery provides insurance, promotion, contract and shipping costs from gallery. Prefers artwork unframed.

Submissions: Prefers artists be referred or present work in person. Call for appointment to show portfolio of originals. Responds in 1 week or gives an immediate yes or no on sight of work.

Tips: "Gallery has moved to downtown Salt Lake City." The most common mistake artists make in presenting their work is "failing to understand the market we are seeking."

C GALLERY, 466 S. Fifth E., Salt Lake City UT 84102-2705. (801)359-8625 or (801)865-5289. Fax: (801)359-8995. E-mail: constance@xmission.com. **Director:** Constance Theodore. Retail gallery. Estab. 1992. Represents 8 emerging, mid-career and established artists/year Exhibited artists include Joan Nelson and Michael Peglau. Sponsors 2 shows/year. Average display time 3 months. Open all year; Monday-Friday, 8-5. Located in downtown outskirts; 100 sq. ft.; attic loft of 1910 home converted to offices. 60% of space for special exhibitions; 40% of space for gallery artists. Clientele: upscale. 100% private collectors. Overall price range: $10-6,500; most work sold at $300.

Media: Considers bronze sculpture, landscape originals in oil, portraiture. Most frequently exhibits oil paintings on linen, acrylic on canvas, charcoal on paper portraits, cityscapes, interiors and soulscapes.

Style: Exhibits all styles. Genres include portraits, western contemporary, landscapes and Americana. Prefers: landscape, soulscapes, portraits and Americana. Shibusa aesthetics: simplicity, the implicit, modesty, silence, the natural, the everyday, the imperfect.

Terms: Accepts work on consignment (50% commission). Retail price set by the gallery. Gallery provides promotion. Shipping costs are shared. Prefers artwork framed.

Submissions: Accepts only artists with Utah heritage. Send query letter with résumé, 6 slides, bio, SASE, reviews and artist's statement. Call or write for appointment to show portfolio review of photographs and

slides. Responds in 1 week. Finds artists through word of mouth, referrals by other artists, visiting art fairs and exhibitions, artist's submissions.

Tips: "I like to see the originals. Call personally for an appointment with the director. At your meeting, present at least one original work and slides or photos. Have a résumé and artists' statement ready to leave as your calling card."

SERENIDAD GALLERY, 360 W. Main, P.O. Box 326, Escalante UT 84726. Phone/fax: (435)826-4720 and (888)826-4577. E-mail: hpriska@juno.com. Website: www.escalante-cc.com/serenidad/html. and www.escalanteretreat.com/gallery/html. **Co-owners:** Philip and Harriet Priska. Retail gallery. Estab. 1993. Represents 7 mid-career and established artists. Exhibited artists include Lynn Griffin, Rachel Bentley, Kipp Greene, Harriet Priska, Howard Hutchinson, Laurent Martres and Mary Kellog. All work is on continuous display. Open all year; Monday-Saturday, 8-8; Sunday, 1-8. Located on Highway 12 in Escalante; 1,700 sq. ft.; "rustic western decor with log walls." 50% of space for gallery artists. Clientele: tourists. 100% private collectors. Overall price range: $100-4,000; most work sold at $300-3,000.
Media: Considers oil, acrylic, watercolor, sculpture, fiber (Zapotec rugs), photography and china painting. Most frequently exhibits acrylics, watercolors, photography, pen & ink and oils.
Style: Exhibits realism. Genres include western, southwestern and landscapes. Prefers: Utah landscapes—prefer local area here, northern Arizona-Navajo reservation and California-Nevada landscapes.
Terms: Accepts work on consignment (commission set by artist) or buys outright (prices set by artist). Retail price set by the gallery. Gallery provides promotion.
Submissions: Finds artists "generally by artists coming into the gallery."
Tips: "Work must show professionalism and have quality. This is difficult to explain; you know it when you see it."

Vermont

[N] PARADE GALLERY, Box 245, Warren VT 05674. (802)496-5445. Fax: (802)496-4994. E-mail: jeff@paradegallery.com. Website: www.paradegallery.com. **Owner:** Jeffrey S. Burnett. Retail gallery. Estab. 1982. Represents 15-20 emerging, mid-career and established artists. Clients include tourist and upper middle class second-home owners. 98% of sales are to private collectors. Overall price range: $20-2,500; most work sold at $50-300.
Media: Considers oil, acrylic, watercolor, pastel, mixed media, collage, limited edition prints, fine arts posters, works on paper, sculpture and original handpulled prints. Most frequently exhibits etchings, silkscreen and watercolor. Currently looking for oil/acrylic and watercolor.
Style: Exhibits: primitivism, impressionistic and realism. "Parade Gallery deals primarily with representational works with country subject matter. The gallery is interested in unique contemporary pieces to a limited degree." Does not want to see "cutesy or very abstract art."
Terms: Accepts work on consignment (40% commission) or occasionally buys outright (net 30 days). Retail price set by gallery or artist. Sometimes offers customer discounts and payment by installment. Exclusive area representation required. Gallery provides insurance and promotion.
Submissions: Send query letter with résumé, slides and photographs. Portfolio review requested if interested in artist's work. A common mistake artists make in presenting their work is having "unprofessional presentation or poor framing." Biographies and background are filed. Finds artists through customer recommendations, shows, magazines or newspaper stories and photos.
Tips: "We need to broaden offerings in price ranges which seem to offer a good deal for the money."

WOODSTOCK FOLK ART PRINTS & ANTIQUITIES, P.O. Box 300, Woodstock VT 05091. (802)457-2012. E-mail: wfolkart@sover.net. Website: www.woodstockfolkart.com. **Art Director:** Gael Cantlin. Retail gallery. Estab. 1995. Represents 45 emerging, mid-career and established artists. Exhibited artists include Sabra Field, Anne Cady and Katie Upton. Sponsors 4 shows/year. Open all year; Monday-Saturday, 10-5; Sunday, 10-4. Located downtown in village; 900 sq. ft.. Clients include tourists, local. 20% of sales are to private collectors. Overall price range: $20-10,000; most work sold at $400-600.
Media: Considers oil, acrylic, watercolor, pastel, drawing, mixed media, sculpture, ceramics, glass, photography and woodcuts. Most frequently exhibits woodcuts (prints), oil and watercolor.
Style: Exhibits primitivism, color field, impressionism and photorealism. Genres include florals, landscapes and Americana. Prefers bold, colorful art.

Terms: Accepts work on consignment (50% commission). Retail price set by the artist. Gallery provides promotion. Prefers artwork framed.
Submissions: Send query letter with bio and photographs. Write for appointment to show portfolio of photographs. Responds only if interested within 1 month. Finds artists through word of mouth, referrals by other artists, visiting art fairs and exhibitions and artist's submissions.

Virginia

THE ART LEAGUE, INC., 105 N. Union St., Alexandria VA 22314. (703)683-1780. Website: www.theartleague.org. **Gallery Director:** Madalina Diaconu. Cooperative gallery. Estab. 1954. Interested in emerging, mid-career and established artists. 1,200-1,400 members. Sponsors 7-8 solo and 14 group shows/year. Average display time 1 month. Located in The Torpedo Factory Art Center. Accepts artists from metropolitan Washington area, northern Virginia and Maryland. 75% of sales are to private collectors, 25% corporate clients. Overall price range: $50-4,000; most work sold at $150-500.
Media: Considers all media. Most frequently exhibits watercolor, oil and photographs. Considers all types of prints.
Style: Exhibits all styles and genres. Prefers impressionism, painted abstraction and realism. "The Art League is a membership organization open to anyone interested."
Terms: Accepts work by jury on consignment (40% commission) and co-op membership fee plus donation of time. Retail price set by artist. Offers customer discounts (designers only) and payment by installments (if requested on long term). Exclusive area representation not required.
Submissions: Work juried monthly for each new show from actual work (not slides). Work received for jurying on first Monday evening/Tuesday morning of each month; pick-up non-selected work throughout rest of week.
Tips: "Artists find us and join/exhibit as they wish within framework of our selections jurying process. It is more important that work is of artistic merit rather than 'saleable. "

FINE ARTS CENTER FOR NEW RIVER VALLEY, P.O. Box 309, Pulaski VA 24301. Phone/fax: (540)980-7363. E-mail: facnrv@adelphia.net. **Contact:** Judy C. Ison. Nonprofit gallery. Estab. 1978. Represents 75 emerging, mid-career and established artists and craftspeople. Sponsors 10 solo and 2 group shows/year. Average display time is 1 month (gallery); 3-6 months (Art Mart). Clients include general public, corporate, schools. 80% of sales are to private collectors, 20% corporate clients. Overall price range: $20-500; most artwork sold at $20-100.
 • Downtown Pulaski has enjoyed a new growth in the arts, music and antiques areas thanks to an active and successful main street revitalization program.
Media: Considers all media and all types of prints. Most frequently exhibits oil, watercolor and ceramic.
Style: Considers all styles and genres.
Terms: Accepts work on consignment (30% commission). Retail price is set by gallery or artist. Sometimes offers payment by installments. Exclusive area representation not required. Gallery provides insurance (80% of value), promotion and contract.
Submissions: Send query letter with résumé, brochure, clearly labeled slides, photographs and SASE. Slides and résumés are filed. Portfolio review requested if interested in artist's work. "We do not want to see unmatted or unframed paintings and watercolors." Finds artists through visiting exhibitions and art collectors' referrals.
Tips: "In the selection process, preference is often (but not always) given to regional and Southeastern artists. This is in accordance with our size, mission and budget constraints."

GALLERY WEST, 205 S. Union St., Alexandria VA 22314. (703)549-7359. Fax: (703)549-8355. E-mail: gallerywest@starpower.net. Website: www.gallery-west.com. **President:** Wayne Guenther. Cooperative gallery and alternative space. Estab. 1979. Exhibits the work of 24 emerging, mid-career and established artists. Sponsors 12 shows/year. Average display time 1 month. Open all year. Located in Old Town; 1,000 sq. ft. 60% of space for special exhibitions. Clients include individual, corporate and decorators. 90% of sales are to private collectors, 10% corporate collectors. Overall price range: $100-3,500; most work sold at $500-700.
Media: Considers all media except video and film.
Style: All styles and genres.
Terms: Co-op membership fee plus a donation of time. (30% commission.) Retail price set by artist.

Sometimes offers customer discounts and payment by installments. Gallery assists promotion; artist pays for shipping. Prefers artwork framed.

Submissions: Send query letter with résumé, slides, bio and SASE. Call for appointment to show portfolio of slides. Responds in 1 month. Files résumés. Holds jury shows once/year open to all artists.

Tips: "High-quality slides are imperative."

HAMPTON UNIVERSITY MUSEUM, Huntington Building on Ogden Circle, Hampton VA 23668. (757)727-5308. Fax: (757)727-5170. Website: www.hamptonu.edu. **Director:** Ramona Austin. Curator of Exhibitions: Jeffrey Bruce. Museum. Estab. 1868. Represents/exhibits established artists. Exhibited artists include Elizabeth Catlett and Jacob Lawrence. Sponsors 4-5 shows/year. Average display time 6-8 weeks. Open all year; Monday-Friday, 8-5; Saturday, 12-4; closed on Sunday, major and campus holidays. Located on the campus of Hampton University.

Media: Considers all media and all types of prints. Most frequently exhibits oil or acrylic paintings, ceramics and mixed media.

Style: Exhibits African-American, African and/or Native American art.

Submissions: Send query letter with résumé and a dozen or more slides. Portfolio should include photographs and slides.

Tips: "Familiarize yourself with the type of exhibitions the Hampton University Museum typically mounts. Do not submit an exhibition request unless you have at least 35-45 pieces available for exhibition. Call and request to be placed on the Museum's mailing list so you will know what kind of exhibitions and special events we're planning for the upcoming year(s)."

MARSH ART GALLERY, University of Richmond Museums, Richmond VA 23173. (804)289-8276. Fax: (804)287-1894. E-mail: museums@richmond.edu. Website: oncampus.richmond.edu/museums. **Director:** Richard Waller. Museum. Estab. 1968. Represents emerging, mid-career and established artists. Sponsors 10 shows/year. Average display time 6 weeks. Open all year; with limited summer hours May-August. Located on University campus; 5,000 sq. ft. 100% of space for special exhibitions.

Media: Considers all media and all types of prints. Most frequently exhibits painting, sculpture, photography and drawing.

Style: Exhibits all styles and genres.

Terms: Work accepted on loan for duration of special exhibition. Retail price set by the artist. Gallery provides insurance, promotion, contract and shipping costs. Prefers artwork framed.

Submissions: Send query letter with résumé, 8-12 slides, brochure, SASE, reviews and printed material if available. Write for appointment to show portfolio of photographs, slides, transparencies or "whatever is appropriate to understanding the artist's work." Responds in 1 month. Files résumé and other materials the artist does not want returned (printed material, slides, reviews, etc.).

THE PRINCE ROYAL GALLERY, 204 S. Royal St., Alexandria VA 22314. (703)548-5151. E-mail: princeroyal@earthlink.net. Website: www.alexandriacity.com. **Director:** John Byers. Retail gallery. Estab. 1977. Interested in emerging, mid-career and established artists. Sponsors 6 shows/year. Average display time 3-4 weeks. Located in middle of Old Town Alexandria. "Gallery is the ballroom and adjacent rooms of historic hotel." Clientele: primarily Virginia, Maryland and Washington DC residents. 95% private collectors, 5% corporate clients. Overall price range: $75-8,000; most artwork sold at $700-1,200.

Media: Considers oil, acrylic, watercolor, mixed media, sculpture, egg tempera, engravings, etchings and lithographs. Most frequently exhibits oil, watercolor and bronze.

Style: Exhibits impressionism, expressionism, realism, primitivism and painterly abstraction. Genres include landscapes, florals, portraits and figurative work. "The gallery deals primarily in original, representational art. Abstracts are occasionally accepted but are hard to sell in northern Virginia. Limited edition prints are accepted only if the gallery carries the artist's original work."

Terms: Accepts work on consignment (40% commission). Retail price set by artist. Customer discounts and payment by installment are available, but only after checking with the artist involved and getting permission. Exclusive area representation required. Gallery provides insurance, promotion and contract. Requires framed artwork.

Submissions: Send query letter with résumé, brochure, slides and SASE. Call or write to schedule an appointment to show a portfolio, which should include originals, slides and transparencies. Responds in 1 week. Files résumés and brochures. All other material is returned.

Tips: "Write or call for an appointment before coming. Have at least six pieces ready to consign if accepted. Can't speak for the world, but in northern Virginia collectors are slowing down. Lower-priced items

continue okay, but sales over $3,000 are becoming rare. More people are buying representational rather than abstract art. Impressionist art is increasing. Get familiar with the type of art carried by the gallery and select a gallery that sells your style work. Study and practice until your work is as good as that in the gallery. Then call or write the gallery director to show photos or slides."

PRINCIPLE GALLERY, 208 King St., Alexandria VA 22314. (703)739-9326. Fax: (703)739-0528. E-mail: princga@erols.com. Website: www.principlegallery.com. **Contact:** Sue Hogan. For-profit gallery. Estab. 1994. Approached by 60 artists/year. Exhibits 70 mid-career and established artists. Sponsors 10 exhibits/year. Average display time 2-3 weeks. Open all year; Sunday-Monday, 12-5; Tuesday-Wednesday, 10-6; Thursday, 10-7; Friday-Saturday, 10-9. Located in historic building with large brightly lit rooms. Clients include local community, tourists and upscale. 10% of sales are to corporate collectors. Overall price range: $400-20,000; most work sold at $2,500.
Media: Considers acrylic, drawing, oil, pen & ink, sculpture, etchings and mezzotints. Most frequently exhibits painting, sculpture and drawing.
Style: Exhibits: impressionism and painterly abstraction. Most frequently exhibits realism. Genres include figurative work and landscapes.
Terms: Artwork is accepted on consignment. Retail price set by the gallery and the artist. Gallery provides insurance. Requires exclusive representation locally.
Submissions: Mail portfolio for review. Send query letter with artist's statement, bio, photographs, résumé, reviews, SASE and slides or send website address. Returns material with SASE. Responds only if interested within 1 month. Finds artists through word of mouth, portfolio reviews and referrals by other artists.

N ELIZABETH STONE GALLERY, 6726 W. Wakefield Dr., #2A, Alexandria VA 22307. Phone/fax:(703)765-3294. E-mail: elizabeth@elizabethstonegallery.com. Website: www.elizabethstonegallery. com. **Contact:** Elizabeth Stone, owner. Art consultancy. Estab. 1989. Approached by more than 50 artists/year; represents 100 established artists/year. Exhibited artists include Wendell Minor (watercolor/acrylic) and Lynn Munsinger (watercolor). Sponsors 12 exhibits/year. Average display time 1 month. Open all year; Monday-Friday, 10-5; Saturday-Sunday, 10-6. Showroom located at 2713 11th St., North Arlington, VA 22201. Clients include local community, tourists and upscale. 25% of sales are to corporate collectors. Overall price range: $100-7,500; most work sold at $500-1,000.
Media: Considers acrylic, ceramics, collage, fiber, mixed media, oil, paper, pastel, pen & ink, sculpture, watercolor. Most frequently exhibits watercolor, collage and mixed media. Considers limited edition prints by giclee reproduction and limited editions by off-set reproduction.
Style: Exhibits children's book illustration; specialist and consultant. Most frequently exhibits watercolor, collage and mixed media. Considers all genres.
Terms: Artwork is accepted on consignment and there is a 50% commission. Retail price of the art set by the gallery and the artist. Gallery provides insurance, promotion and contract. Accepted work should be framed, mounted and matted. Does not require exclusive representation locally. Accepts art only from children's book illustrators.
Submissions: Call or e-mail request. Cannot return material. Responds to queries in 1 month. Files children's books. Finds artists through referrals by other artists, word-of-mouth, children's book submissions.
Tips: "A phone call or e-mail with intent to me is enough. Provide quality book information of your published books."

Washington

THE AMERICAN ART COMPANY, 1126 Broadway Plaza, Tacoma WA 98402. (253)272-4327. E-mail: rickg@americanartco.com. Website: www.americanartco.com. **Director:** Rick Gottas. Retail gallery. Estab. 1889. Represents/exhibits 50 emerging, mid-career and established artists/year. Exhibited artists include Doug Granum, Oleg Koulikov, Yoko Hara and Warren Pope. Sponsors 10 shows/year. Open all year; Monday-Friday, 10-5:30; Saturday, 10-5. Located downtown; 3,500 sq. ft. 60% of space for special exhibitions; 40% of space for gallery artists. Clientele: local community. 95% private collectors, 5% corporate collectors. Overall price range: $500-15,000; most work sold at $1,800.
Media: Considers oil, fiber, acrylic, sculpture, glass, watercolor, mixed media, quilt art, pastel, collage, woodcuts, wood engravings, linocuts, engravings, mezzotints, etchings, lithographs, serigraphs, contemporary baskets, contemporary sculptural wood. Most frequently exhibits contemporary wood sculpture.

Style: Exhibits all styles. Genres include landscapes, Chinese and Japanese.

Terms: Artwork is accepted on consignment (50% commission) or bought outright for 50% of retail price; net 30 days. Retail price set by the gallery and the artist. Gallery provides insurance and promotion; shipping costs are shared. Prefers artwork unframed.

Submissions: Send query letter with résumé, slides, bio and SASE. Write for appointment to show portfolio of slides. Responds in 3 weeks. Finds artists through word of mouth, referrals by other artists, visiting art fairs and exhibitions, submissions.

ART SHOWS, P.O. Box 245, Spokane WA 99210-0245. (509)922-4545. E-mail: info@artshows.net. Website: www.artshows.net. **President:** Don Walsdorf. Major art show producer. Estab. 1988. Sponsors large group shows. Clientele: collectors, hotel guests and tourists. 70% private collectors, 30% corporate collectors. Overall price range $200-250,000; most work sold at $500-3,000.

Media: Considers all media except craft.

Style: Interested in all genres.

Submissions: Send query letter with bio, brochure and photographs. Portfolio review requested if interested in artist's work. Files biography and brochures.

Tips: Selecting quality art shows is important. Read all the prospectus materials. Then re-read the information to make certain you completely understand the requirements, costs and the importance of early responses. Respond well in advance of any suggested deadline dates. Producers cannot wait until 60 days in advance of a show, due to contractual requirements for space, advertising, programming etc. If you intend to participate in a quality event, seek applications a year in advance for existing events. Professional show producers are always seeking to upgrade the quality of their shows. Seek new marketing venues to expand your horizons and garner new collectors. List your fine art show events with info@artshow.net by providing name, date, physical location, full contact information of sponsor or producer. This is a free database at www.artshows.net. Any time you update a brochure, biography or other related materials, be certain to date the material. Outdated material in the hands of collectors works to the detriment of the artist.

DAVIDSON GALLERIES, 313 Occidental Ave. S., Seattle WA 98104. (206)624-7684. E-mail: info@davidsongalleries.com. Website: www.davidsongalleries.com. **Director:** Sam Davidson. Retail gallery. Estab. 1973. Represents 150 emerging, mid-career and established artists. Sponsors 36 shows/year. Average display time 3½ weeks. Open all year; Tuesday-Saturday, 11-5:30. Located in old, restored part of downtown: 3,200 sq. ft.; "beautiful antique space with columns and high ceilings built in 1890." 25% of space for special antique print exhibitions; 75% of space for gallery artists. Clientele: 90% private collectors, 10% corporate collectors. Overall price range: $50-70,000; most work sold at $250-5,000.

Media: Considers oil, acrylic, drawing (all types), sculpture, watercolor, mixed media, pastel, woodcuts, wood engravings, linocuts, engravings, mezzotints, etchings, lithographs, limited interest in photography, digital manipulation or collage.

Style: Exhibits expressionism, neo-expressionism, primitivism, painterly abstraction, postmodern works, realism, surrealism, impressionism.

Terms: Accepts work on consignment (50% commission). Retail price set by gallery and artist. Gallery provides insurance, promotion and contract; shipping costs are one way.

Submissions: Send query letter with résumé, 20 slides, bio and SASE. Responds in 6 weeks.

Tips: Impressed by "simple straight-forward presentation of properly labeled slides, résumé with SASE included. No videos."

FOSTER/WHITE GALLERY, 123 S. Jackson St., Seattle WA 98104. (206)622-2833. Fax: (206)622-7606. Website: www.fosterwhite.com. **Owner/Director:** Phen Huang. Retail gallery. Estab. 1973. Represents 90 emerging, mid-career and established artists/year. Interested in seeing the work of local emerging artists. Exhibited artists include Dale Chihuly, Mark Tobey, George Tsutakawa, Morris Graves, and William Morris. Average display time 1 month. Open all year; Monday-Saturday, 10-5:30; Sunday, 12-5. Located historic Pioneer Square; 5,800 sq. ft. Clientele: private, corporate and public collectors. Overall price range: $300-35,000; most work sold at $2,000-8,000.

• Gallery has additional spaces at 126 Central Way, Kirkland WA 98033 (425)822-2305. Fax: (425)828-2270, and Ranier Square, 1331 Fifth Ave., Seattle WA 98101, (206)583-0100. Fax (206)583-7188.

Media: Considers oil, acrylic, watercolor, pastel, pen & ink, drawing, mixed media, collage, paper, sculp-

ture, ceramics, craft, fiber, glass and installation. Most frequently exhibits glass sculpture, works on paper and canvas and ceramic and metal sculptures.

Style: Contemporary Northwest art. Prefers contemporary Northwest abstract, contemporary glass sculpture.

Terms: Gallery provides insurance, promotion and contract.

Submissions: Accepts only artists from Pacific Northwest. Send query letter with résumé, slides, bio and reviews. Write for appointment to show portfolio of slides. Responds in 3 weeks.

[N] [□] THE HENRY ART GALLERY, 15th Ave. NE and NE 41st St., Seattle WA 98195-1410. (206)543-2280. Fax: (206)685-3123. E-mail: hartg@u.washington.edu. Website: www.henryart.org. **Contact:** Jordan Howland, curatorial assistant. Museum. Estab. 1927. Exhibits emerging, mid-career and established artists. Sponsors 18 exhibits/year. Open Tuesday-Sunday, 11-5; Thursday, 11-8. Located "on the western edge of the University of Washington campus. Parking is often available in the underground Central Parking garage at NE 41st St. On Sundays, free parking is usually available. The Henry Art Gallery can be reached by over twenty bus routes. Call Metro at (206)553-3000 (http://transit.metroke.gov) or Community Transit at (425)778-2785 for additional information." Clients include local community, students, tourists and upscale.

Media: Considers all media. Most frequently exhibits painting, photography and video. Exhibits all types of prints.

Style: Exhibits all styles and genres.

Terms: Does not require exclusive representation locally.

Submissions: Send query letter with artist's statement, résumé, reviews, SASE, slides and transparencies. Returns material with SASE. Responds to queries quarterly. "If we are interested in an artist we will send them an informational letter and ask to keep their materials on file. The materials could include résumé, bio, reviews, slides, photographs, or transparencies." Finds artist's through art exhibits, exhibition announcements, individualized research, periodicals, portfolio reviews, referrals by other artists, submissions and word of mouth.

[N] MING'S ASIAN GALLERY, 10217 Main St., Old Bellevue WA 98004-6121. (206)462-4008. Fax: (206)453-8067. E-mail: mingsgallery@quest.net. **Contact:** Doreen Russell. Retail gallery. Estab. 1964. Represents/exhibits 3-8 mid-career and established artists/year. Exhibited artists include Kim Man Hee, Kai Wang and Kaneko Jonkoh. Sponsors 8 shows/year. Average display time 1 month. Open all year; Monday-Saturday, 10-6. Located downtown; 6,000 sq. ft.; exterior is Shanghai architecture circa 1930. 20% of space for special exhibitions. 35% private collectors, 20% corporate collectors. Overall price range: $350-10,000; most work sold at $1,500-3,500.

Media: Considers oil, acrylic, watercolor, sumi paintings, Japanese woodblock. Most frequently exhibits sumi paintings with woodblock and oil.

Style: Exhibits expressionism, primitivism, realism and imagism. Genres include Asian. Prefers: antique, sumi, watercolors, temple paintings and folk paintings.

Terms: Artwork is accepted on consignment (50% commission). Retail price set by the gallery and the artist. Gallery provides insurance, promotion and contract; shipping costs are shared. Prefers artwork framed.

Submissions: Send query letter with résumé, brochure, slides, photographs, reviews, bio and SASE. Write for appointment to show portfolio of photographs, slides and transparencies. Responds in 2 weeks. Finds artists by traveling to Asia, visiting art fairs, and through submissions.

PAINTERS ART GALLERY, 30517 S.R. 706 E., P.O. Box 106, Ashford WA 98304-0106. (360)569-2644. E-mail: mtwoman@mashell.com. Website: www.mashell.com/~mtwoman/. **Owner:** Joan Painter. Retail gallery. Estab. 1972. Represents 20 emerging, mid-career and established artists. Open all year. Located 5 miles from the entrance to Mt. Rainier National Park; 1,200 sq. ft. 50% of space for work of gallery artists. Clientele: collectors and tourists. Overall price range $10-7,500; most work sold at $300-2,500.

• The gallery has over 60 people on consignment. It is a very informal, outdoors atmosphere.

Media: Considers oil, acrylic, watercolor, pastel, mixed media, stained glass, reliefs, offset reproductions, lithographs and serigraphs. "I am seriously looking for totem poles and outdoor carvings." Most frequently exhibits oil, pastel and acrylic.

Style: Exhibits primitivism, surrealism, imagism, impressionism, realism and photorealism. All genres. Prefers: Mt. Rainier themes and wildlife. "Indians and mountain men are a strong sell."

Terms: Accepts artwork on consignment (30% commission on prints and sculpture; 40% on paintings). Retail price set by gallery and artist. Gallery provides promotion; artist pays for shipping. Prefers artwork framed.

Submissions: Send query letter or call. "I can usually tell over the phone if artwork will fit in here." Portfolio review requested if interested in artist's work. Does not file materials.

Tips: "Sell paintings and retail price items for the same price at mall and outdoor shows that you price them in galleries. I have seen artists underprice the same paintings/items, etc. when they sell at shows. Do not copy the style of other artists. To stand out, have your own style."

N **☆** **PHINNEY CENTER GALLERY**, 6532 Phinney Ave. N., Seattle WA 98103. (206)783-2244. Fax: (206)783-2246. E-mail: Ed@phinneycenter.org. Website: www.phinneycenter.org. **Arts Coordinator:** Ed Medeiros. Nonprofit gallery. Estab. 1982. Represents 10-12 emerging artists/year. Sponsors 10-12 shows/year. Average display time 1 month. Open all year; Monday-Friday, 9-9; Saturday, 9-2. Located in a residential area; 92 sq. ft.; in 1904 building—hardwood floors, high ceilings. 20% of space for special exhibitions; 80% of space for gallery artists. Overall price range: $50-4,000; most work sold at $300-1,000.

 • Phinney Center Gallery is open to Puget Sound artists only.

Media: Considers oil, acrylic, watercolor, pastel, pen & ink, drawing, mixed media, collage, paper, sculpture, ceramics, installation, photography, all types of prints. Most frequently exhibits painting, sculpture and photography.

Style: Exhibits painterly abstraction, all genres. Holds theme (fiber, sculpture, etc) calls twice a year (March and October). Juried show in September.

Terms: Accepts work on consignment (30% commission). Retail price set by the artist. Gallery provides promotion and contract; artist pays shipping costs to and from gallery. Prefers artwork framed. Artist pays for invitations and mailings.

Submissions: Send query letter with résumé, bio, 10 slides and SASE. Finds artists through calls for work in local publications.

Tips: "Do not send slides that show many styles of your work. Send a collection of slides that have a uniform feel—a theme—or a complete body of work."

West Virginia

THE ART STORE, 1013 Bridge Rd., Charleston WV 25314. (304)345-1038. Fax: (304)345-1858. **Director:** E. Schaul. Retail gallery. Estab. 1974. Represents 16 mid-career and established artists. Sponsors 6 shows/year. Average display time 3 weeks. Open all year. Located in a suburban shopping center; 2,000 sq. ft. 50% of space for special exhibitions. Clientele: professionals, executives, decorators. 80% private collectors, 20% corporate collectors. Overall price range: $200-8,000; most work sold at $2,000.

Media: Considers oil, acrylic, watercolor, pastel, mixed media, works on paper, ceramics, wood and metal.

Style: Exhibits expressionism, painterly abstraction, color field and impressionism.

Terms: Accepts artwork on consignment (50% commission). Retail price set by gallery and artist. Gallery provides insurance, promotion and shipping costs from gallery. Prefers artwork unframed.

Submissions: Send query letter with résumé, slides, SASE, announcements from other gallery shows and press coverage. Gallery makes the contact after review of these items; responds in 6 weeks.

Tips: "Do not send slides of old work."

Wisconsin

N **DAVID BARNETT GALLERY**, 1024 E. State St., Milwaukee WI 53202. (414)271-5058. Fax: (414)271-9132. Retail and rental gallery and art consultancy. Estab. 1966. Represents 300-400 emerging, mid-career and established artists. Exhibited artists include Claude Weisbuch and Carol Summers. Sponsors 12 shows/year. Average display time 1 month. Open all year. Located downtown at the corner of State and Prospect; 6,500 sq. ft.; "Victorian-Italianate mansion built in 1875, three floors of artwork displayed." 25% of space for special exhibitions. Clientele: retail, corporations, interior decorators, private collectors, consultants, museums and architects. 20% private collectors, 10% corporate collectors. Overall price range: $50-375,000; most work sold at $1,000-50,000.

Media: Considers oil, acrylic, watercolor, pastel, pen & ink, drawings, mixed media, collage, sculpture, ceramic, fiber, glass, photography, bronzes, marble, woodcuts, engravings, lithographs, wood engravings, serigraphs, linocuts, etchings and posters. Most frequently exhibits prints, drawings and oils.

Style: Exhibits expressionism, neo-expressionism, primitivism, painterly abstraction, surrealism, imagism, conceptualism, minimalism, postmodern works, impressionism, realism and photorealism. Genres include landscapes, florals, Southwestern, Western, wildlife, portraits and figurative work. Prefers old master graphics, contemporary and impressionistic.

Terms: Accepts artwork on consignment (50% commission). Retail price set by gallery and artist. Sometimes offers customer discounts and payment by installment. Gallery provides insurance and promotion; artist pays for shipping. Prefers artwork framed.

Submissions: Send query letter with slides, bio, brochure and SASE. "We return everything if we decide not to carry the artwork." Finds artists through agents, word of mouth, various art publications, sourcebooks, submissions and self-promotions.

GRACE CHOSY GALLERY, 1825 Monroe St., Madison WI 53711. (608)255-1211. Fax: (608)663-2032. E-mail: gchosy@chorus.net. **Director:** Grace Chosy. Retail gallery. Estab. 1979. Represents/exhibits 80 emerging, mid-career and established artists/year. Exhibited artists include Wendell Arneson and William Weege. Sponsors 11 shows/year. Average display time 3 weeks. Open all year; Tuesday-Saturday, 11-5. Located downtown; 2,000 sq. ft.; "open uncluttered look." 45% of space for special exhibitions; 55% of space for gallery artists. Clientele: primarily local community. 60% private collectors, 40% corporate collectors. Overall price range: $200-7,000; most work sold at $500-2,000.

Media: Considers all media except photography and fiber; all types of prints except posters. Most frequently exhibits paintings, drawings and sculpture.

Style: Exhibits all styles. Genres include landscapes, florals and figurative work. Prefers landscapes, still life and abstract.

Terms: Artwork is accepted on consignment. Retail price set by the gallery and the artist. Gallery provides insurance, promotion and contract. Artist pays for shipping costs.

Submissions: Send query letter with résumé, bio and SASE. Call or write for appointment to show portfolio. Responds in 3 months.

N̄ THE FLYING PIG, LLC, N6975 State Hwy. 42, Algoma WI 54201. E-mail: theflyingpig@charter.n et. Website: www.theflyingpig.biz. **Contact:** Susan Connor, owner/member. For-profit gallery. Estab. 2002. Exhibits 30 emerging artists. Exhibited artists include Kim Clayton and Eric Legge (acrylic on mixed media). Open Wednesday-Monday, 9-6. Closed January and February. Clients include local community, tourists and upscale. Overall price range: $5-3,000; most work sold at $300.

Media: Considers all media. Most frequently exhibits acrylic, mixed media and ceramics.

Style: Exhibits impressionism, minimalism, painterly abstraction and primitivism realism. Most frequently exhibits primitivism realism, impressionism and minimalism. Genres include outsider.

Terms: Artwork is accepted on consignment and there is a 40% commission or artwork is bought outright for 50% of retail price; net 15 days. Retail price set by the artist. Gallery provides insurance, promotion and contract. Accepted work should be framed. Does not require exclusive representation locally. Prefers only self-taught or outsider.

Submissions: Send query letter with artist's statement, bio and photographs. Returns material with SASE. Responds to queries in 3 weeks. Files artist's statement, bio and photographs if interested. Finds artist's through art fairs and exhibitions, referrals by other artsts, submissions, word-of-mouth and Online.

N̄ GALLERY 218, 218 S. Second St., Milwaukee WI 53204. (414)270-1043. E-mail: info@gallery218.c om. Website: www.gallery218.com. **President:** Judith Hooks. Nonprofit gallery, cooperative gallery, alternative space. "Gallery 218 is committed to providing exhibition opportunities to area artists. 218 sponsors exhibits, poetry readings, performances, recitals and other cultural events. 'The audience is the juror.'" Estab. 1990. Represents 200 emerging, mid-career and established artists/year. Exhibited artists include Mark Berson, Robert Ulrich, Veronica Ceci, Cathy Jean Clark, Steven Bleicher, Fred Stein, Judith Hooks. Sponsors 15 shows and 1 fair/year. Average display time 1 month. Open all year; Wednesday, 12-5; Friday, 1-9; Saturday and Sunday 12-5. Located just south of downtown; 1,500 sq. ft.; warehouse-type space— wooden floor, halogen lights; includes information area. 100% of space for gallery artists. 75% private collectors, 25% corporate collectors. Overall price range: $100-1,000; most work sold at $100-600.

• Gallery 218 has a "bricks and mortar" gallery as well as a great website, which provides lots of links to helpful art resources.

Media: Considers all media except crafts. Considers linocuts, monotypes, woodcuts, mezzotints, etchings, lithographs and serigraphs. Most frequently exhibits paintings/acrylic, photography, mixed media.
Style: Exhibits expressionism, conceptualism, photorealism, neo-expressionism, minimalism, hard-edge geometric abstraction, painterly abstraction, postmodern works, realism, surrealism, imagism, fantasy, comic book art. Exhibits all genres, portraits, figurative work; "anything with an edge." Prefers abstract expressionism, fine art photography, personal visions.
Terms: There is a yearly Co-op membership fee plus a monthly fee, and donation of time (25% commission.) Membership good 1 year. There is a rental fee for space; covers 1 month. Group shows at least 8 times a year (small entry fee). Retail price set by the artist. Gallery provides promotion; artist pays for shipping. Prefers artwork framed.
Submissions: Prefers only adults (21 years plus), no students (grad students OK), serious artists pursuing their careers. E-mail query letter with résumé, business card, slides, photographs, bio, SASE or request for application with SASE. E-mail for appointment to show portfolio of photographs, slides, résumé, bio. Responds in 1 month. Files all. Finds artists through referrals, visiting art fairs, submissions. "We advertise for new members on a regular basis."
Tips: "Don't wait to be 'discovered'. Get your work out there—not just once, but over and over again. Don't get distracted by material things, like houses, cars and real jobs. Be prepared to accept suggestions and/or criticism. Read entry forms carefully."

THE FANNY GARVER GALLERY, 230 State St., Madison WI 53703. (608)256-6755. E-mail: art@fannygarvergallery.com. Website: www.fannygarvergallery.com. **President:** Jack Garver. Retail Gallery. Estab. 1972. Represents 100 emerging, mid-career and established artists/year. Exhibited artists include Lee Weiss, Harold Altman and Josh Simpson. Sponsors 11 shows/year. Average display time 1 month. Open all year; Monday-Wednesday, 10-6; Thursday-Saturday, 10-8, Sunday, 12-4. Located downtown; 3,000 sq. ft.; older refurbished building in unique downtown setting. 33% of space for special exhibitions; 95% of space for gallery artists. Clientele: private collectors, gift-givers, tourists. 40% private collectors, 10% corporate collectors. Overall price range: $10-10,000; most work sold at $100-1,000.
Media: Considers oil, pen & ink, paper, fiber, acrylic, drawing, sculpture, glass, watercolor, mixed media, ceramics, pastel, collage, craft, woodcuts, wood engravings, linocuts, engravings, mezzotints, etchings, lithographs and serigraphs. Most frequently exhibits watercolor, oil and glass.
Style: Exhibits all styles. Prefers: landscapes, still lifes and abstraction.
Terms: Accepts work on consignment (50% commission) or buys outright for 50% of retail price (net 30 days). Retail price set by gallery. Gallery provides promotion and contract, artist pays shipping costs both ways. Prefers artwork framed.
Submissions: Send query letter with résumé, 8 slides, bio, brochure, photographs and SASE. Write for appointment to show portfolio, which should include originals, photographs and slides. Responds only if interested within 1 month. Files announcements and brochures.
Tips: "Don't take it personally if your work is not accepted in a gallery. Not all work is suitable for all venues."

LATINO ARTS, INC., 1028 S. Ninth, Milwaukee WI 53204. (414)384-3100 ext. 61. Fax: (414)649-4411. **Visual Artist Specialist:** Zulay Oszkay. Nonprofit gallery. Represents emerging, mid-career and established artists. Sponsors up to 5 individual to group exhibitions/year. Average display time 2 months. Open all year; Monday-Friday, 9-4. Located in the near southeast side of Milwaukee; 1,200 sq. ft.; one-time church. Clientele: the general Hispanic community. Overall price range: $100-2,000.
Media: Considers all media, all types of prints. Most frequently exhibits original 2- and 3-dimensional works and photo exhibitions.
Style: Exhibits all styles, all genres. Prefers artifacts of Hispanic cultural and educational interests.
Terms: "Our function is to promote cultural awareness (not to be a sales gallery)." Retail price set by the artist. Artist is encouraged to donate 15% of sales to help with operating costs. Gallery provides insurance, promotion, contract, shipping costs to gallery; artist pays shipping costs from gallery. Prefers artwork framed.
Submissions: Send query letter with résumé, slides, bio, business card and reviews. Call or write for appointment to show portfolio of photographs and slides. Responds in 2 weeks. Finds artists through recruiting, networking, advertising and word of mouth.

RAHR-WEST ART MUSEUM, 610 N. Eighth St., Manitowoc WI 54220. (920)683-4501. Fax: (920)683-5047. E-mail: rahrwest@manitowoc.org. Website: www.rahrwestartmuseum.org. **Contact:** Jan

Smith. Museum. Estab. 1950. Six exhibits, preferably groups of mid-career and established artists. Sponsors 8-10 shows/year. Average display time 6-8 weeks. Open all year; Monday-Friday, 10-4; Wednesday, 10-8; weekends, 11-4. Closed major holidays. Clients include local community and tourists. Overall price range: $50-2,200; most work sold at $150-200.

Media: Considers all media and all types of prints except posters. Most frequently exhibits painting, pastel and prints.

Style: Considers all styles. Most frequently exhibits impressionism, realism and various abstraction. Genres include figurative work, florals, landscapes and portraits.

Terms: Artwork is accepted on consignment and there is a 30% commission. Retail price set by the artist. Gallery provides insurance. Accepted work should be framed.

Submissions: Send query letter with artist's statement, bio, SASE and slides. Returns material with SASE if not considered. Responds only if interested. Files slides, contact and bio.

STATE STREET GALLERY, 1804 State St., La Crosse, WI 54601. (608)782-0101. E-mail: ssg1804@ya hoo.com. Website: www.statestreetartgallery.com. **President:** Ellen Kallies. Retail gallery. Estab. 2000. Approached by 15 artists/year. Represents 15 emerging, mid-career and established artists. Exhibited artists include: Diane French, Janet Miller, Robinson Scott and various local artists. Sponsors 6 exhibits/year. Average display time 4-6 months. Open all year; Tuesday-Saturday, 10-2; weekends by appointment. Located across from the University of Wisconsin/La Crosse on one of the main east/west streets. "We are next to a design studio, parking behind gallery." Clients include local community, tourists, upscale. 30% of sales are to corporate collectors, 70% to private collectors. Overall price range: $150-1,600; most work sold at $500-800.

Media: Considers acrylic, collage, drawing, glass, mixed media, oil, pastel, sculpture, watercolor and photography. Most frequently exhibits dry pigment, drawing, watercolor and mixed media collage. Considers all types of prints.

Style: Considers all styles and genres. Most frequently exhibits contemporary representational, realistic watercolor, collage.

Terms: Artwork is accepted on consignment and there is a 40% commission. Retail price set by the gallery and the artist. Gallery provides insurance, promotion, contract. Accepted work should be framed and matted.

Submissions: Call to arrange a personal interview or mail portfolio for review. Send query letter with artist's statement, photographs or slides. Returns material with SASE. Responds in 1 month. Finds artists through word of mouth, art exhibits, art fairs, and referrals by other artists.

Tips: "Be organized, be professional in presentation, be flexible! Most collectors today are savvy enough to want recent works on archival quality papers/boards, mattes etc. Have a strong and consistant body of work to present."

Wyoming

ARTISAN'S GALLERY, 215 S. Second, Laramie WY 82070. (307)745-3983. E-mail: brenda@artisa nsgallery.net. Website: www.artisansgallery.net. **Owners:** Scott & Brenda Hunter. Retail gallery. Estab. 1993. Represents emerging and mid-career artists varies. Exhibited artists include Paul Tweedy and John Werbelow. Sponsors 11 shows/year. Average display time 1 month. Open all year; Tuesday-Friday, 10:30-5; Saturday, 12-5. Located in historic downtown Laramie; 1,500 sq. ft. Clientele: tourists, upscale, local community and students. 90% private collectors, 10% corporate collectors. Overall price range: $150-3,800; most work sold at $300-1,000.

Media: Considers oil, acrylic, watercolor, pastel, mixed media, collage, sculpture, ceramics, fiber, glass, miniatures, photography; all types of prints. Most frequently exhibits pottery, watercolors and oil.

Style: Exhibits all styles and all genres. Prefers functional pottery, wildlife and realistic.

Terms: Accepts work on consignment (30% commission). Retail price set by the artist. Gallery provides promotion. Artwork must be framed.

Submissions: Accepts only artists from Wyoming. Prefers 3-D artwork, sculpture, pottery, blown and stained glass. Send query letter with brochure, photographs and artist's statement. Please include phone number. Call for appointment to show portfolio of photographs. Responds in 2 weeks, if interested within 1 week.

Tips: "It has often been said that sales are 98% presentation and 2% art itself. With this in mind, presentation (framing, mating, glazing etc.) should be as clean and clear-cut as possible. This always improves

sales as your customers, the art collectors, want to see a professional presentation for the art they are about to purchase, without framing hassles. If you value your artwork and think it's sellable, then frame it as such."

N COMMUNITY FINE ARTS CENTER, 400 C St., Rock Springs WY 82901. (307)362-6212. Fax: (307)352-6657. E-mail: cfac@rock.sw1.k12.wy.us. **Director:** Debora Thaxton Soulé. Nonprofit gallery. Estab. 1966. Represents 12 emerging, mid-career and established artists/year. Sponsors 8-10 shows/year. Average display time 1 month. Open all year; Monday and Wednesday, 10-9; Tuesday and Thursday, 10-6; alternating Friday and Saturday, 10-5; closed Sunday. Located downtown on the Rock Springs Historic Walking Tour route; 2,000 ground sq. ft. and 120 running sq. ft. of rotating exhibition space remodeled to accommodate painting and sculpture. 50% of space for special exhibitions; 50% of space for gallery artists. Clientele: community at large. 100% private collectors. Overall price range: $100-1,000; most work sold at $200-600.
Media: Considers all media, all types of prints. Most frequently exhibits oil/watercolor/acrylics, sculpture/ceramics, and installation.
Style: Exhibits all styles, all genres.
Terms: "We require a donation of a work." Retail price set by the artist. Gallery provides promotion; artist pays shipping costs to or from gallery. Prefers artwork framed.
Submissions: Send query letter with résumé, 15-30 slides, bio, brochure, photographs, SASE, business card, reviews, "whatever available." Call or write for appointment to show portfolio of slides. Responds only if interested within 1 month. Files all material sent. Finds artists through submissions.
Tips: "Prepare a professional portfolio."

N MANITOU GALLERY, 1715 Carey Ave., Cheyenne WY 82001. (307)635-0019. Fax: (307)778-3926. **President:** Robert L. Nelson. Retail, wholesale gallery and art consultancy. Estab. 1975. 50 emerging, mid-career and established artists/year. Exhibited artists include Jie Wei Zhou, Lyle Tayson and Santa Fe. Open all year; Monday-Friday, 8-5. Located downtown; 10,000 sq. ft. for gallery artists. Clients include tourists, upscale. 25% of sales are to collectors, 75% wholesale or other dealers. Overall price range: $100-75,000; most work sold at $300-5,000.
Media: Considers all media and types of prints. Most frequently exhibits oil, sculpture and watercolor.
Style: Exhibits all styles. Genres include florals, Western, wildlife, Southwestern and landscapes. Prefers Western, florals and landscapes.
Terms: Accepts work on consignment (50% commission) or buys outright for 40% of retail price. Retail price set by the gallery and the artist. Gallery provides insurance, promotion and contract; gallery pays shipping costs. Prefers artwork framed.
Submissions: Prefers only Western subject matter. Send query letter with slides, bio, brochure and photographs. Write for appointment to show portfolio of photographs and slides. Responds only if interested within 1 week.
Tips: "Many artists who contact our gallery are not ready to show in a gallery setting."

N NICOLAYSEN ART MUSEUM, 400 E. Collins Dr., Casper WY 82601. (307)235-5247. Fax: (307)235-0923. Website: www.thenic.org. **Director:** Holly Turner. Regional contemporary art museum. Estab. 1967. Average display time 3-4 months. Interested in emerging, mid-career and established artists. Sponsors 10 solo and 10 group shows/year. Open all year. Clientele: 90% private collectors, 10% corporate clients.
Media: Considers all media with special attention to regional art.
Style: Exhibits all subjects.
Terms: Accepts work on consignment (40% commission). Retail price set by artist. Exclusive area representation not required. Gallery provides insurance, promotion and shipping costs from gallery.
Submissions: Send query letter with slides. Write to schedule an appointment to show a portfolio, which should include originals or slides. Responds in 2 months.

WYOMING ARTS COUNCIL GALLERY, 2320 Capitol Ave., Cheyenne WY 82002. (307)777-7742. Fax: (307)777-5499. E-mail: lfranc@state.wy.us. Website: wyoarts.state.wy.us. **Visual Arts Program Manager:** Liliane Francuz. Nonprofit gallery. Estab. 1990. Sponsors up to 5 exhibitions/year. Average display time 6 ½ weeks. Open all year, Monday-Friday 8-5. Located downtown in capitol complex; 660 sq. ft.; in historical carriage house. 100% of space devoted to special exhibitions. Clientele: tourists,

upscale, local community. 98% private collectors. Overall price range $50-$1,500; most work sold at $100-250.

Media: Considers all media. Most frequently exhibits photography, paintings/drawings, mixed media and fine crafts.

Style: Exhibits all styles and all genres. Most frequently exhibits contemporary styles and craft.

Terms: Retail price set by the artist. Gallery provides insurance, promotion and contract. Shipping costs are shared. Prefers artwork framed.

Submissions: Accepts only artists from Wyoming. Send query letter with résumé, slides and bio. Call for portfolio review of photographs and slides. Responds in 2 weeks. Files résumé and slides. Finds artists through artist registry slide bank, word of mouth and studio visits.

Tips: "I appreciate artists letting me know what they are doing. Send me updated slides, show announcements, or e-mail to keep me current on your activities."

Puerto Rico

[N] GALERIA ATLAS ART INC., 208 Cristo St., Old San Juan Puerto Rico 00901. (787)723-9987. Fax: (787)724-6776. E-mail: atlasartos@yunque.net. Represents international and local artists. Sponsors several shows/year. Average display time 3 months. Clientele: 60% tourist and 40% local. 75% private collectors, 30% corporate clients. Overall price range: $500-30,000; most work sold at $1,000-5,000.

Media: Considers oil, acrylic, watercolor, pastel, drawings, mixed media, collage, sculpture, ceramic, woodcuts, wood engravings, linocuts, engravings, mezzotints, etchings, lithographs and serigraphs. Most frequently exhibits oil on canvas, mixed media and bronze sculpture. "The Atlas Art Gallery exhibits major contemporary artists. We prefer working with original paintings and sculpture."

Style: Exhibits expressionism, neo-expressionism and primitivism. Genres include Americana and figurative work. Prefers: expressionism and figurative work.

Terms: Accepts work on consignment or buys outright. Retail price set by artist. Exclusive area representation required. Gallery provides insurance and contract; artist pays for shipping. Prefers artwork framed.

Submissions: Send query letter with résumé, brochure, slides and photographs. Call for appointment to show portfolio of originals. Responds in 2 weeks. Files résumés.

[N] GALERÍAS PRINARDI, Condominio El Centro I 14-A Ave. Mūnoz Rivera #500, Hato Rey Puerto Rico 00198. (787)763-5727. Fax: (787)763-0643. E-mail: prinardi@prinardi.com. Website: www.prinardi.c om. **Contact:** Andrés Marrero, director. Art consultancy and for-profit gallery. Approached by many artists/year; represents with exclusivity 10 artists and exhibits many emerging, mid-career and established artists' works. Exhibited artists include Orlando Vallejo and Angélica Rivera (oil painting). Sponsors 24 exhibits/year. Average display time 2-3 weeks. Open all year; Monday-Friday, 10-6; Saturday, 11-4. Closed Sunday. Clients include upscale. 50% of sales are to corporate collectors. Overall price range: $3,000-25,000; most work sold at $8,000. "We also have serigraphs from $500-$1,500 and other works of art at different prices."

Media: Considers acrylic, ceramics, drawing, glass, installation, mixed media, oil, paper, pastel, pen & ink, sculpture and watercolor. Considers most media. Most frequently exhibits graphic art (serigraphs, engravings, etchings), oil and sculpture. Considers all types of prints, especially limited editions.

Style: Exhibits color field, expressionism, imagism, minimalism, neo-expressionism, postmodernism and painterly abstraction.

Terms: Artwork is accepted on consignment and there is a 40% or 50% commission, or artwork is bought outright for 100% of retail price; net 30 days. Retail price set by the gallery and the artist. Gallery provides promotion and contract. Sometimes requires exclusive representation locally. Accepts only fine artists.

Submissions: Mail portfolio for review or send query letter with artist's statement, bio, brochure, business card, photocopies, photographs, résumé, reviews and e-mail letter with digital photos. Cannot return material. Responds to queries in 1 month. If interested, files artist's statement, bio, brochure, photographs, resume and reviews. Finds artist's through portfolio reviews, referrals by other artists and submissions.

Tips: "Present an artist's portfolio which should include biography, artist's statement, curriculum and photos or slides of his/her work of art."

Canada

[Symbol] DALES GALLERY, 537 Fisgard St., Victoria, BC V8W 1R3 Canada. Fax: (250)383-1552. E-mail: dalesgallery@shaw.ca. Website: www.dalesgallery.ca. **Contact:** Sheila Watson. Museum retail shop. Estab. 1976. Approached by 6 artists/year; represents 40 emerging, mid-career and established artists/year. Exhib-

ited artists include: Grant Fuller and Graham Clarke. Sponsors 2-3 exhibits/year. Average display time 2 weeks. Open all year; Monday-Saturday, 10-5:30; Sunday, 12-4. Gallery situated in Chinatown (Old Town); approximately 650 sq. ft. of space—one side brick wall. Clients include: local community, students, tourists and upscale. Overall price range: $100-4,600; most work sold at $350.

Media: Considers most media except photography. Most frequently exhibits oils, etching and watercolor. Considers all types of prints.

Style: Exhibits: expressionism, impressionism, postmodernism, primitivism, realism and surrealism. Most frequently exhibits impressionism, realism and expressionism. Genres include figurative, florals, landscapes, humorous whimsical.

Terms: Accepts work on consignment (40% commission) or buys outright for 50% of retail price (net 30 days). Retail price set by both gallery and artist. Gallery provides promotion. Accepted work should be framed by professional picture framers. Does not require exclusive representation locally.

Submissions: Call to arrange a personal interview to show portfolio of photographs or slides or send query letter with photographs. Portfolio should include résumé, reviews, contact number and prices. Responds only if interested within 2 months. Finds artists through word of mouth, art exhibits, submissions, art fairs, portfolio reviews and referral by other artists.

GALERIE ART & CULTURE, 227 St. Paul W, Old Montreal, QC H2Y 2A2 Canada. Phone/fax: (514)843-5980. **President:** Helen Doucet. Retail gallery. Estab. 1989. Approached by 55 artists/year; represents 30 mid-career and established artists/year. Exhibited artists include: Louise Martineau and Pierre A. Raymond. Sponsors 6 exhibits/year. Average display time 13 days. Open all year; Tuesday-Friday, 10-6; weekends 10-5. Located in the historic area of Old Montreal. St. Paul is the oldest established commercial street in North America. Original brick work and high ceilings fit well for the exhibition of works of art. Clients include: local community, tourists and upscale. 15% corporate collectors. Overall price range: $700-2,500; most work sold at $1,200-1,500.

Media: Considers acrylic, oil, sculpture, watercolor. Most frequently exhibits oil, acrylic, sculpture.

Style: Exhibits: impressionism and postmodernism. Most frequently exhibits figurative works, landscapes, still lifes. Genres include figurative work, florals, landscapes, portraits.

Terms: Accepts work on consignment (50% commission). Retail price set by the gallery and the artist. Gallery provides promotion and contract. Accepted work should be unframed. Does not require exclusive representation locally. Accepts only artists from Canada, United States. Prefers only oils, acrylic.

Submissions: Mail portfolio for review. Send bio, photographs, résumé, reviews. Returns material with SASE. Responds in 1-2 months. Files dossiers of artists, exhibitions, portfolio reviews. Finds artists through submissions, portfolio reviews, referrals by other artists.

Tips: "Artists should present complete dossier of their works including photos of artworks, biographies, expositions, solo or group works, how they started, courses taken, number of years in the profession. As a gallery representative, it helps when selling a work of art that you have as much information on the artist, and when you present not just the work of art, but a complete dossier, it reassures the potential customer."

OPEN SPACE, 510 Fort St., Victoria BC V8W 1E6 Canada. (250)383-8833. Fax: (250)383-8841. E-mail: openspace@openspace.ca. Website: www.openspace.ca. **Director:** Todd Davis. Gallery Administrator: Jill Margo. Alternative space and nonprofit gallery. Estab. 1971. Represents emerging, mid-career and established artists. 150 members. Sponsors 8-10 shows/year. Average display time 3½ weeks. Open all year. Located downtown; 2,700 sq. ft.; "multi-disciplinary exhibition venue." 100% of space for gallery artists. Overall price range: $300-10,000.

Media: Considers oil, acrylic, watercolor, pastel, pen & ink, drawing, mixed media, collage, works on paper, sculpture, ceramic, installation, photography, video, performance art, original handpulled prints, woodcuts, wood engravings, linocuts, engravings, mezzotints and etchings.

Style: Exhibits conceptualism, postmodernism.

Terms: "No acquisition. Artists selected are paid exhibition fees for the right to exhibit their work." Retail price set by artist. Gallery provides insurance, promotion, contract and fees; shipping costs shared. Only artwork "ready for exhibition." Artists should be aware of the trend of "de-funding by governments at all levels."

Submissions: "Non-Canadian artists must submit by September 30 in order to be considered for visiting foreign artists' fees." Send query letter with recent curriculm vitae, 10-20 slides, bio, a list of any special equipment required, SASE (with IRC, if not Canadian), reviews and proposal outline. "No original work in submission." Responds in 3 months.

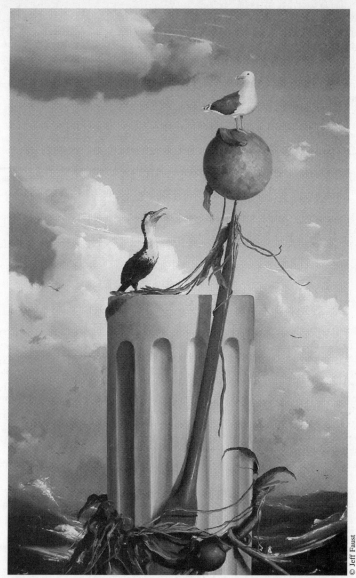

© Jeff Faust

Jeff Faust is an artist who likes to paint rather than promote himself, but his paintings keep selling as fast as he can paint them, says Robin Critelli, director of Gallery Bergelli in Larkspur, CA. "Sometimes they're sold before we even get them hung. While 2002 was not a good sales year for most artists, it was a very good year for Jeff," says Critelli. "People find his work meaningful—and sometimes spiritual—and that's what we need right now. Needless to say, I feel fortunate to have his work here." This painting is titled *Poem for the Storm*.

⚡ MARCIA RAFELMAN FINE ARTS, 10 Clarendon Ave., Toronto, ON M4V 1H9 Canada. (416)920-4468. Fax: (416)968-6715. E-mail: info@mrfinearts.com. Website: www.mrfinearts.com. **President:** Marcia Rafelman. Semi-private gallery. Estab. 1984. Approached by 100s of artists/year. Represents emerging and mid-career artists. Average display time 1 month. Open by appointment except the first 2 days of art openings which is open full days. Centrally located in Toronto's mid-town, 2,000 sq. ft. on 2 floors. Clients include local community, tourists and upscale. 40% of sales are to corporate collectors. Overall price range: $500-30,000; most work sold at $1,500-5,000.
Media: Considers all media. Most frequently exhibits photography, painting and graphics. Considers all types of prints.
Style: Exhibits: geometric abstraction, minimalism, neo-expressionism, primitivism and painterly abstraction. Most frequently exhibits high realism paintings. Considers all genres except southwestern, western and wildlife.
Terms: Artwork is accepted on consignment (50% commission); net 30 days. Retail price set by the gallery and the artist. Gallery provides insurance, promotion and contract. Requires exclusive representation locally.
Submissions: Prefer artists to send images by e-mail. Otherwise, mail portfolio of photographs, bio and reviews for review. Returns material with SASE if in Canada. Responds only if interested within 2 weeks. Files bios and visuals. Finds artists through word of mouth, submissions, art fairs and referrals by other artists.

International

Ⓝ ⊕ ARTEMPRESA GALLERY, San Jeronimo 448, 5000 Cordoba, Argentina. (54)351 4221290. Fax: (54)351 4271776. E-mail: artempresa@arnet.com.ar. Website: www.artempresagallery.com. **Contact:** Maria Elena Kravetz, director. For-profit gallery. Estab. 1998. Approached by 30 artists/year; exhibits 8 emerging and mid-career artists/year. Exhibited artists include Silvia Parmentier (glass-casting) and Alejandra Tolosa (carved wood, Xilographies). Average display time 20 days. Open Monday-Friday, 5-9; Saturday, 10-1. Closed Sunday. Closed January and February. Located in the main downtown of Cordoba city; 170 square meters, 50 spotlights and white walls. Clients include local community and tourists. Overall price range: $500-10,000; most work sold at $1,500-5,000.
Media: Considers all media. Most frequently exhibits glass sculpture and mixed media. Considers etchings, linocuts, lithographs and woodcuts.
Style: Considers all styles. Most frequently exhibits new-expressionism and painterly abstraction. Considers all genres.
Terms: Artwork is accepted on consignment and there is a 30% commission. Retail price set by the artist. Requires exclusive representation locally. Prefers only artists from South America and emphasizes sculptors.
Submissions: Mail portfolio for review. Cannot return material. Responds to queries in 1 month. Finds artist's through art fairs and exhibits, portfolio reviews, referrals by other artists, submissions and word-of-mouth.
Tips: Artists "must indicate a web page to make the first review of their works, then give an e-mail address to contact them if Artempresa in interested in their work."

Ⓝ ⊕ BLACKHEATH GALLERY, 34a Tranquil Vale, London SE3 0AX United Kingdom. Phone: 0181 8521802. Fax: 01580 291 321. **Contact:** Mrs. B. Simpson. Private retail gallery. Estab. 1975. Approached by 100 artists/year. Represents 74 emerging, mid-career and established artists. Exhibited artists include: John Sprakes, Alan Forneaux. Average display time 6 weeks. Open Monday-Friday, 10-6; closed Thursday. Located in center of thriving London village (ancient). Adjacent to Greenwich on 2 floors—can hang up to 150 pictures depending on size up to 6×6′. Aspect is modern and white walls. Clientele: local community, students and tourists. 5% corporate collectors. Overall price range: £150-8,000; most work sold at £700.
Media: Considers acrylic, ceramics, collage, drawing, fiber, glass, oil, pastel, pen & ink, photography, sculpture, watercolor. Most frequently exhibits painting, sculpture, glass. Considers engraving, etching, linocut, lithographs, mezzotint, serigraph, engraving and woodcut.
Style: Considers all styles. Most frequently exhibits expressionism, painterly abstraction, color field. Considers all genres.
Terms: Artwork is accepted on consignment (50% commission). Retail price set by the gallery or the

artist. Gallery provides burglary insurance, promotion and contract. Accepted work should be framed or mounted. Requires exclusive representation locally.

Submissions: Send artist's statement, photographs, résumé. Returns material with SASE. Responds in 2 weeks. Files biographies and slides (if not needed back). Finds artists through word of mouth, submissions, referrals by other artists, classified and magazine ads.

Tips: "Present good, clear photos or slides with additional information about each item—size, title, media, etc. and date executed. Good curriculum vitae or biography."

N ⬜ 🌐 **THE BRACKNELL GALLERY/THE MANSION SPACES**, South Hill Park Arts Centre, Ringmead, Bracknell Berkshire RG12-7PA, United Kingdom. (44)(0)1344-484858. Fax: (44)(0)1344-411427. E-mail: visual.art@southhillpark.org.uk. Website: www.southhillpark.org.uk. **Contact:** Elvned Myhre, head of visual arts. Alternative space/nonprofit gallery. Estab. 1991. Approached by at least 20 artists/year; exhibits 6-7 shows of emerging, mid-career and established artists. "For Mansion Spaces **very** many artists approach us. All applications are looked at." Exhibited artists include Anne-Marie Carroll (video) and Michael Porter (painting and photography). Average display time 1-2 months. Open all year; Wednesday-Friday, 7-9:30; Saturday and Sunday, 1-5. Located "within a large Arts centre, including theatre, studios, workshops, restaurants, etc.; one large room and one smaller with high ceilings, plus more exhibiting spaces around the centre." Clients include local community and students.

Media: Considers all media. Most frequently exhibits craftwork (ceramics, glasswork, jewelry, installations, group shows, video-digital works). Considers all types of prints.

Style: Considers all styles and genres.

Terms: Artwork is accepted on consignment and there is a 20% commission. Retail price set by the artist. Gallery provides insurance, promotion and contract. Does not require exclusive representation locally.

Submissions: Send query letter with artist's statement, bio, photographs and slides. Returns material with SASE. Responds to queries only if interested. Files all material "unless return of slides/photos is requested." Finds artist's through art exhibits, referrals by other artists, submissions and word-of-mouth.

Tips: "We have a great number of applications for exhibitions in The Mansion Spaces—make yours stand out! Exhibitions at The Bracknell Gallery are planned 2-3 years in advance."

N 🌐 **CHICHESTER GALLERY**, 8 The Hornet, Chichester, West Sussex PO19 4JG United Kingdom. Phone: 01243-779821. **Proprietor:** Thomas J.P. McHale. Cooperative period picture gallery/retail. Estab. 1997. Represents established artists. Exhibited artists include: Copley Fielding, George Leonard Lewis, Jessie Mellor. Located in Georgian period building. Interior has undergone careful and sympathetic restoration of cornices, ceiling and arches, shirting and other mouldings. Clientele: local, regional and national community. "Contemporary work now stocked and displayed by gifted local and nationally respected artists."

Media: Considers mixed media, oil, pastel, watercolor. Considers etching, engraving, mezzotint, lithographs, prints and woodcut. Representational painting only.

Style: Genres include costal scenes, landscapes, marines, portraits and still life.

Terms: Retail price set by the gallery.

Submissions: Replies promptly by fax or mail. Finds artists through art exhibits, art fairs, auctions, private buyers.

N 🌐 **GALLERÍA VÉRTICE**, Lerdo De Tejada, 2418 Col. Lafayette, Guadalajara Jalisco C.P. 44150, Mexico. (5233) 36160078. Fax: (5233) 33160079. E-mail: grjsls@mail.udg.mx. Website: www.verticegalleria.com. **Contact:** Luis García Jasso, director. Estab. 1988. Approached by 20 artists/year; exhibits 12 emerging, mid-career and established artists/year. Sponsors 10 exhibitions/year. Average display time 20 days. Open all year. Clients include local community, students and tourists. Overall price range: $5,000-100,000.

Media: Considers all media except installation. Considers all types of prints.

Style: Considers all styles. Most frequently exhibits abstraction, new-figurativism and realism. Considers all genres.

Terms: Artwork is accepted on consignment and there is a 40% commission. Retail price set by the gallery. Gallery provides insurance, promotion and contract. Accepted work should be framed. Requires exclusive representation locally.

Submissions: Mail portfolio for review or send artist's statement, bio, brochure, photocopies, photographs and resume. Responds to queries in 3 weeks. Finds artist's through art fairs, art exhibits and portfolio reviews.

☑ ⊕ **GOLDSMITHS FINE ART**, 9 High St., Lenham, Maidstone, Kent ME17 2QD United Kingdom. Phone: (01622)850011. E-mail: goldfineart@FSBDial.co.uk. Website: www.goldsmithandbate.com. **Partners:** Christine Goldsmith and Simon Bate. Retail gallery. Estab. 1987. Approached by 4 artists/year. Represents 15 emerging, mid-career and established artists. Exhibited artists include: Jane Ford, John Trickett, Nigel Hemming, Mackenzie Thorpe, Mark Spain and Martin Goode. Sponsors 2 exhibits/year. Open all year; Tuesday-Friday, 10-5; Saturday, 9:30-4:30. Located in a medieval village in Kent just off main village square in a 17th century building with timber and exposed fireplaces. 800 sq. ft. in 3 rooms. Clientele: local community, tourists aand upscale. 20% corporate collectors. Overall price range: £50-500. Most work sold at £100-200.

Media: Considers all media and all types of prints. Most frequently exhibits watercolor, mixed media and pen & ink.

Style: Exhibits contemporary original watercolors, etchings, mixed media and limited edition prints. Some abstracts and a few oils. Considers landscape, animals, still life and abstract.

Terms: Artwork is accepted on consignment (40% commission) or is bought outright for 100% of trade price; net 30 days. Retail price set by the gallery or the artist. Gallery provides insurance and promotion. Accepted work should be framed and mounted after discussion with gallery regarding style.

Submissions: Call or write to arrange a personal interview to show portfolio of photographs. Send query letter with artist's statement, bio, brochure, business card, photographs, résumé, reviews and SASE. Returns material with SASE. Responds in 2 weeks. Files catalogs/brochures. Finds artists through word of mouth, submissions, art exhibits and referrals by other artists.

Tips: "Please discuss framing and mounting with us if submitting work. Inexperienced artists often submit without an eye to the commercial implications of retailing the work."

▥ ⊕ **THE OCTOBER GALLERY**, 24 Old Gloucester St., London WC1N 3AL, United Kingdom. E-mail: octobergallery@compuserve.com. Website: www.theoctobergallery.com. **Contact:** Elisabeth Lacouschek, artistic director. Nonprofit gallery. Estab. 1979. Approached by 60 artist/year; exhibits 20 established artists/year. Exhibited artists include Ablade Glover (oil on canvas) and El Anatsui (mixed media). Average display time 1 month. Open Tuesday-Saturday, 12:30-5:30. Closed Christmas, Easter and August. Gallery is centrally located near the British Museum. Clients include local community and upscale. Overall price range: $80-18,000.

Media: Considers acrylic, ceramics, collage, drawing, mixed media, oil, paper, pen & ink, sculpture and watercolor. Most frequently exhibits mixed media, acrylic and collage. Also considers posters and woodcuts.

Style: Exhibits color field, conceptualism, expressionism, imagism, pattern painting, painterly abstraction, postmodernism and primitivism realism. Most frequently exhibits expressionism, painterly abstraction and primitivism realism. Genres include contemporary art from around the world.

Terms: Artwork is accepted on consignment and there is a 50% commission. Retail price set by the gallery and the artist. Gallery provides insurance, promotion and contract. Accepted work should be mounted. Does not require exclusive representation locally.

Submissions: Write to arrange a personal interview to show portfolio of photographs and slides. Send query letter with artist's statement, bio, brochure, business card, photocopies, photographs, résumé, SASE and slides. Returns material with SASE. Responds to queries in 3 months. Finds artists through referrals by other artists, submissions and word-of-mouth.

Tips: "Ensure all personal details are labeled clearly and correctly."

⊕ **PARK WALK GALLERY**, 20 Park Walk, London SW10 AQ United Kingdom. Phone/fax: (0207)351 0410. E-mail: mail@jonathancooper.co.uk. Website: www.jonathancooper.co.uk. **Gallery Owner:** Jonathan Cooper. Gallery. Estab. 1988. Approached by 5 artists/year. Represents 16 mid-career and established artists. Exhibited artists include: Kate Nessler. Sponsors 8 exhibits/year. Average display time 3 weeks. Open all year; Monday-Saturday, 10-6:30; Sunday, 11-4. Located in Park Walk which runs between Fulham Rd. to Kings Rd. Clientele: upscale. 10% corporate collectors. Overall price range: £500-50,000; most work sold at £4,500.

Media: Considers drawing, mixed media, oil, paper, pastel, pen & ink, photography, sculpture, watercolor. Most frequently exhibits watercolor, oil and sculpture.

Style: Exhibits: conceptualism, impressionism. Genres include florals, landscapes, wildlife, equestrian.

Terms: Artwork is accepted on consignment (50% commission). Retail price set by the gallery. Gallery provides promotion. Requires exclusive representation locally.

Submissions: Call to arrange a personal interview to show portfolio. Returns material with SASE. Re-

sponds in 1 week. Finds artists through submissions, portfolio reviews, art exhibits, art fairs, referrals by other artists.

Tips: "Include full curriculum vitae and photographs of work."

N ⊕ PRAXIS MÈXICO, Arquímedes 175, Colonia Polanco Mexico D.F. 11570, Mexico. (5255)5254-8813. Fax: (5255)5255-5690. E-mail: info@galeriapraxismexico.com.mx. For-profit gallery. Estab. 1998. Exhibits emerging, mid-career and established artists. Approached by 8 artists/year. Sponsors 4 exhibitions/year. Average display time 30 days. Open all year; Monday-Friday, 10-7:30, Saturday and Sunday, 10-3. Clients include local community, students and tourists. Overall price range: $5,000-100,000. Located in a basement with two separate rooms, a temporary room and the collective space. Clients include local community and tourists. 70% of sales are to corporate collectors. Overall price range: $5,000-100,000.

Media: Considers acrylic, craft, drawing, oil and sculpture. Also considers etchings, lithographs and serigraphs.

Style: Exhibits postmodernism. Genres include figurative work.

Terms: Artwork is accepted on consignment and there is a 50% commission or artwork is bought outright; net 30 days. There is a co-op membership fee plus a donation of time. There is a 10% commission. Retail price set by the gallery. Gallery provides promotion. Accepted work should be framed. Requires exclusive representation locally.

Submissions: Send e-mail. Returns material with SASE. Responds to queries in 1 month. Finds artists through art fairs and exhibits, portfolio reviews and referrals by other artists.

Syndicates & Cartoon Features

Barcley & Co.

HOW DISGUSTING! THERE'S A *HAIR* IN MY SPAGHETTI!

BIG DEAL! IT'S THE SPECIAL. WHAT?!

DIDN'T YOU ORDER THE ANGEL HAIR PASTA? WELL...YES.

I'M ANGEL.

© Todd Schowalter • Dist. by Plain Label Press

© 2002 Todd Schowalter for Plain Label Press

The syndicate Plain Label Press is a new listing to the book this year, but we're already laughing at the cartoons, particularly this one by Todd Schowalter. To see more of his work, and cartoons by other artists, visit www.plainlabelpress.com.

If you want to see your comic strip in the funny papers, you must first get the attention of a syndicate. Syndicates are agents who sell comic strips, panels and editorial cartoons to newspapers and magazines. They promote and distribute comic strips and other features in exchange for a cut of the profits.

The syndicate business is one of the hardest markets to break into. Newspapers are reluctant to drop long-established strips for new ones. Consequently spaces for new strips do not open up often. When they do, syndicates look for a "sure thing," a feature they'll feel comfortable investing more than $25,000 in for promotion and marketing. Even after syndication, much of your promotion will be up to you. Syndicated cartoonist Hilary Price, creator of *Rhymes with Orange*, talks about her experiences with King Features on page 514.

To crack this market, you have to be more than a fabulous cartoonist. The art won't sell if the idea isn't there in the first place. Work worthy of syndication must be original, salable and timely, and characters must have universal appeal to attract a diverse audience.

Although newspaper syndication is still the most popular and profitable method of getting your comic strip to a wide audience, the Web has become an exciting new venue for comic strips. There are hundreds of strips available on the Web. With the click of your mouse, you can be introduced to *The Norm*, by Michael Jantze; *Preteena*, by Allison Barrows; and *Cats with Hands*, by Joe Martin. (UComics.com provides a great list of online comics.)

Such sites may not make much money for cartoonists, but it's clear they are a great promotional tool. It is rumored that scouts for the major syndicates have been known to surf the more popular comic strip sites in search of fresh voices.

HOW TO SUBMIT TO SYNDICATES

Each syndicate has a preferred method for submissions, and most have guidelines you can send for or access on the syndicate's website. Availability is indicated in the listings.

To submit a strip idea, send a brief cover letter (50 words or less is ideal) summarizing your idea, along with a character sheet (the names and descriptions of your major characters), and

photocopies of 24 of your best strip samples on 8½ × 11 paper, six daily strips per page. Sending at least one month of samples, shows that you're capable of producing high-quality humor, consistent artwork and a long lasting idea. Never submit originals; always send photocopies of your work. Simultaneous submissions are acceptable. It is often possible to query syndicates online, attaching art files or links to your website. Response time can take several months. Syndicates understand it would be impractical for you to wait for replies before submitting your ideas to other syndicates.

Editorial cartoons

If you're an editorial cartoonist, you'll need to start out selling your cartoons to a base newspaper (probably in your hometown) and build up some clips before approaching a syndicate. Submitting published clips proves to the syndicate that you have a following and are able to produce cartoons on a regular basis. Once you've built up a good collection of clips, submit at least 12 photocopied samples of your published work along with a brief cover letter.

Payment and contracts

If you're one of the lucky few to be picked up by a syndicate, your earnings will depend on the number of publications in which your work appears. It takes a minimum of about 60 interested newspapers to make it profitable for a syndicate to distribute a strip. A top strip such as *Garfield* may be in as many as 2,000 papers worldwide.

Newspapers pay in the area of $10-15 a week for a daily feature. If that doesn't sound like much, multiply that figure by 100 or even 1,000 newspapers. Your payment will be a percentage of gross or net receipts. Contracts usually involve a 50/50 split between the syndicate and cartoonist. Check the listings for more specific payment information.

Before signing a contract, be sure you understand the terms and are comfortable with them.

Self-syndication

Self-syndicated cartoonists retain all rights to their work and keep all profits, but they also have to act as their own salespeople, sending packets to newspapers and other likely outlets. This requires developing a mailing list, promoting the strip (or panel) periodically, and developing a pricing, billing and collections structure. If you have a knack for business and the required time and energy, this might be the route for you. Weekly suburban or alternative newspapers are the best bet here (daily newspapers rarely buy from self-syndicated cartoonists).

For More Information

You'll get an excellent overview of the field by reading *Your Career in Comics*, by Lee Nordling (Andrews McMeel) a comprehensive review of syndication from the viewpoints of the cartoonist, the newspaper editor and the syndicate. *Successful Syndication: A Guide for Writers and Cartoonists* by Michael H. Sedge (Allworth Press) also offers concrete advice to aspiring cartoonists.

If you have access to a computer, another great source of information is Stu's Comic Strip Connection at www.stus.com. Here you'll find links to most syndicates and other essential sources including helpful books, courtesy of Stu Rees.

Cartoonist shares recipe for syndication success

In 1995, Hilary Price became the youngest woman ever to have a syndicated daily comic strip. Using a combination of wit and sarcasm, Price's *Rhymes with Orange* pokes fun of its creator, its readers and everyday life. Since the strip's syndication by King Features in 1995, *Rhymes with Orange* has made its home in newspapers across the country and even visited the pages of magazines such as *People*, *Forbes*, *Glamour* and *The Funny Times*.

Hilary Price

With her second book, *Reigning Cats and Dogs* out in June 2003, *Rhymes With Orange* greeting cards appearing on store shelves, talks of calendars, and nominations for Reuben Awards (not a sandwich, see page 516), Hilary Price shares her experiences in the world of syndication.

You got your start in *San Francisco Chronicle*, a local paper. How did you first approach them?
At the time, the *SF Chronicle* had a book review/opinion section on Sundays that featured a few gag cartoons. I met with the editor and showed her some cartoons. She liked them and agreed to place them where she had space. Unfortunately, the *Chronicle* no longer has that section, but my experience there gave me the confidence to send out the strips to syndicates, actually using *Artist's & Graphic Designer's Market* for contact information.

What were the differences between the way you approached the syndicates and your approach to the *Chronicle*?
Since I couldn't just walk in to the syndicate's office like I had at the *Chronicle*, I sent each syndicate a package according to what they specified they wanted. I sent them to all six, I believe, that there were at the time. I got a bunch of outright rejections and one letter that said, "What you've sent us isn't quite right, but keep at it and keep in touch." Then I got a call from Jay Kennedy at King Features Syndicate.

You went through a nine-month trial period at King before they launched *Rhymes with Orange*. What happened during the trial period?
I sent Jay seven pencilled strips a week. We would go over them on the phone and he would give them a check, a check-plus, or a check-minus. Originally, after the nine month period, King was going to launch *Rhymes with Orange*, but then *Baby Blues* jumped syndicates to King, so they put their efforts into that. Then Jay decided to bump my launch date again so they could launch Patrick McDonnell's *Mutts*. So it was at least a year and a half between the time Jay called me initially and when they launched the strip. Then three months after the launch before it appeared in the paper. Needless to say, my parents were in a swivet about the whole thing.

What happens when a syndicate launches your strip?

They put a package together with sample strips, a little biography of you, your characters (if you have them), some markety lingo about how hip and hilarious your strip is, and the phone number of the national sales director. Then the sales team goes out and meets with the editors and pitches it to them, maybe pointing to another syndicate's strip, and saying, " Why don't you give this strip a try in that spot?"

How do you get your magazine cameos?

The Funny Times I contribute to on my own, every couple of months. *Glamour* and *Forbes* contacted the syndicate, as did *People* magazine. In general, the syndicate doesn't usually initiate contact, and it will frustrate you if you depend on them to blitz the wider market with your strip. What they do best is sell the strip to newspapers. Any initiative you take to market your strip will be greeted with support, but unless you're high on the pecking order, you HAVE to take the initiative to market yourself the best you can.

You warn cartoonists that *The New Yorker* keeps its rejection slips on note pads that they just stick in your SASE. Did you learn this first hand?

I got lots of rejections from *The New Yorker*. I learned later that they were in pad form from my friend Sam Gross, who is a regular contributor to the magazine.

What lessons can one learn, if any, from rejections?

I don't have any Puritan, hair-shirt-type ideas of how rejections are good for you. They make success all the sweeter, but then they can make you feel like you should be grateful for anything you get, and that doesn't help you or the profession. All rejections do is separate the people who want it a little and will stop trying, from those who want it a whole lot and will keep trying.

Do you still get rejections?

I've gotten rejected for a calendar idea and for a story I pitched to the radio program *This American Life*. I get a paperless rejection whenever a newspaper decides to drop the strip. I'm usually depressed for a good 48 hours; then I get up and keep going.

© Hilary B. Price. Reprinted with Special Permission of King Features Syndicate.

Visit www.rhymeswithorange.com and start laughing. Price has archived and organized her cartoons into favorite categories. You can go to your category of choice, whether that's "cats," "dating," "dogs," "therapy," "work," "your parents" and more. This particular cartoon can be found under the section called "home." What's the meaning behind the title *Rhymes with Orange*? You can find the answer to that question on Price's website, too.

What would you say is the most important thing cartoonists can do to increase their chances of making this a career?

Two things:

1. READ! If you are not open to the world around you, how can you make pithy observations about it?

2. Try to establish a routine. This is very difficult and I still struggle with it, but having a deadline helps. Doing it every day, even if there are days when you come up with pure drivel, ultimately helps you. You don't know when that drivel might ferment into something tasty.

—*Mona Michael*

Reuben Awards

In the world of cartooning, nothing beats the prestige of the Reuben Awards. Sponsored by The National Cartoonists Society, the world's major organization of cartooning professionals, Reubens are awarded each year to the profession's finest.

While cartoonists can submit their work to be considered for an award, Reuben Awards jury members are also free to select work that hasn't been submitted. So you don't have to submit samples to be considered. And you don't have to be a member of The National Cartoonists Society either. What you must do is excel!

Scott Adams (creator of *Dilbert*), Will Eisner (graphic novelist), and Patrick McDonnell (creator of *Mutts*) are among the past winners of Cartoonist of the Year, the highest honor awarded. Divisional awards are also presented in the categories listed below. Each category carries its own submission requirements, which are outlined at the NCS website at www.reuben.org.

Reuben Awards Divisional Categories

Newspaper Panel Cartoons
Television Animation
Feature Animation
Newspaper Illustration
Gag Cartoons
Greeting Cards
Newspaper Comic Strips
Magazine Illustration
Book Illustration
Editorial Cartoons
Advertising and Illustration
Comic Books
New Media

N **AG FEATURES**, P.O. Box E, Fostoria IA 51340. E-mail: katie@agfeatures.com. Website: www.agfeatures.com. **Contact:** Katie Thompson, editor. Estab. 2001. Syndicate serving 35 weekly and daily newspapers. Guidelines not available.

Needs: Introduces 1 new strip/year. Considers single panel cartoons, puzzles/games. Will use agriculture or rural topics only.

First Contact & Terms: Sample package should include query letter. One sample should be included. Samples are not filed, but are returned by SASE if requested by artist. Company will contact artist for portfolio review if interested. Pays 67% of gross income. Pays on publication (monthly billing/payment cycle). Responds to submissions in 1 week. Buys first North American serial rights. Minimum length of contract is 1 month. Artist owns original art and characters.

Tips: "Be reliable and be willing to test the market—just like in any other competitive industry."

N **ARLINGTON CONNECTION**, 7913 W. Park Dr., McLean VA 22102. (703)917-6400. Fax: (703)917-0991. **Managing Editor:** Jim Silver. Estab. 1986. Publishes weekly newspapers covering Arlington.

Needs: Works with 2 paid established freelancers exclusively. Prefers local or Virginia artists. Prefers pen & ink with washes.

First Contact & Terms: Send query letter with brochure or résumé and tearsheets. Samples are filed or are returned by SASE. Responds only if interested. To show portfolio, mail tearsheets. Does not offer payment. Will send artist newspaper clipping upon publication for credits.

Tips: "We prefer local Northern Virginia freelancers who have local themes in their work."

ARTISTMARKET.COM (AKA A.D. KAHN, INC.), 35336 Spring Hill Rd., Farmington Hills MI 48331-2044. (248)661-8585. E-mail: editors@artistmarket.com. Website: www.artistmarket.com. **Publisher:** David Kahn. Website estab. 1996. Feature syndicate serving daily and weekly newspapers, monthly magazines.

• Artistmarket.com proactively invites newspaper and magazine editors, website designers and book publishers to use the Internet's largest resource of professional cartoonists, puzzle makers and writers. Sales have been generated worldwide.

Needs: Considers comic strips, editorial/political cartoons, gag cartoons, puzzles/games, written features for publication.

First Contact & Terms: E-mail or postal sample package should include material that best represents artist's work. Files samples of interest; others returned by SASE if requested by artist. Pays 50% of net proceeds. Negotiates rights purchased according to project. The artist owns original art and characters.

ARTIZANS.COM, (formerly Artizans Syndicate), 11149 65th St. NW, Edmonton, AB T5W 4K2 Canada. **Submission Editor:** Malcom Mayes. E-mail: submissions@artizans.com. Website: www.artizans.com. Estab. 1998. Artist agency and syndicate providing commissioned artwork, stock illustrations, political cartoons, gag cartoons, global caricatures, humorous illustrations to magazines, newspapers, Websites, corporate and trade publications and ad agencies. Submission guidelines available on website. Artists represented include Jan Op De Beeck and Dusan Petricic.

Needs: Works with 30-40 artists/year. Buys 30-40 features/year. Needs single panel cartoons, caricatures, illustrations, graphic and clip art. Prefers professional artists with a track records, who create artwork regularly and artists who have archived work or a series of existing cartoons, caricatures and/or illustrations.

First Contact & Terms: Send cover letter and copies of cartoons or illustrations. Send 6-20 examples if sending via e-mail; 24 if sending via snail mail. "In your cover letter tell us briefly about your career. This should inform us about your training, what materials you use and where you work has been published." Résumé and samples of published cartoons would be helpful but are not required. E-mail submission should include a link to other online examples of your work. Replies in 2 months. Artist receives 50-75%. Payment varies depending on artist's sales. Artists retain copyright. Our clients purchase a variety of rights from the artist.

Tips: We are only interested in professional artists with a track record. Link to our website for guidelines.

ATLANTIC SYNDICATION/EDITORS PRESS, 1970 Barber Rd., Sarasota FL 34240. (941)371-2252. Fax: (941)342-0999. E-mail: kslagle@atlanticsyndication.com. Website: www.atlanticsyndication.com. **President:** Mr. Kerry Slagle. Estab. 1933. Syndicate representative servicing 1,700 publications: daily and weekly newspapers and magazines. International, US and Canadian sales. Recent introductions include *Ginger Meggs* and *Mr. Potato Head.*

Needs: Buys from 1-2 freelancers/year. Introduces 1-2 new strips/year. Considers comic strips, gag cartoons, caricatures, editorial/political cartoons and illustrations. Considers single, double and multiple panel, pen & ink. Prefers non-American themes. Maximum size of artwork: 11×17. Does not accept unsolicited submissions.

First Contact & Terms: Send cover letter, finished cartoons, tearsheets and photocopies. Include 24-48 strips/panels. Does not want to see original artwork. Include SASE for return of materials. Pays 50% of gross income. Buys all rights. Minimum length of contract: 2 years. Artist owns original art and characters.

Tips: "Look for niches. Study, but do not copy the existing competition. Read the newspaper!" Looking for "well written gags and strong character development."

ASHLEIGH BRILLIANT ENTERPRISES, 117 W. Valerio St., Santa Barbara CA 93101. (805)682-0531. **Art Director:** Ashleigh Brilliant. Estab. 1967. Syndicate and publisher. Outlets vary. "We supply a catalog and samples for $2 plus SASE."

Needs: Considers illustrations and complete word and picture designs. Prefers single panel. Maximum size of artwork $5\frac{1}{2} \times 3\frac{1}{2}$, horizontal only.

First Contact & Terms: Samples are returned by SASE if requested by artist. Responds in 2 weeks. **Pays on acceptance**; minimum flat fee of $60. Buys all rights. Syndicate owns original art.

Tips: "Our product is so unusual that freelancers will be wasting their time and ours unless they first carefully study our catalog."

CELEBRATION: AN ECUMENICAL WORSHIP RESOURCE, (formerly Celebration: An Ecumenical Resource), Box 419493, Kansas City MO 64141-6493. (800)444-8910. Fax: (816)968-2291. E-mail: patmarrin@aol.com. Website: www.ncrpub.com/celebration/. **Editor:** Patrick Marrin. Syndicate serving churches, clergy and worship committees.

Needs: Buys 50 religious theme cartoons/year. Does not run an ongoing strip. Buys cartoons on church themes (worship, clergy, scripture, etc.) with a bit of the offbeat.

First Contact & Terms: Originals returned to artist at job's completion. Payment upon use, others returned. Send copies. Simultaneous submissions OK. Pays $30/cartoon. "We grant reprint permission to subscribers to use cartoons in parish bulletins, but request they send the artist an additional $5.

Tips: "We only use religious themes (black & white). The best cartoons tell the 'truth'—about human nature, organizations, by using humor."

N CITY NEWS SERVICE, Box 39, Willow Springs MO 65793. (417)469-2423. E-mail: cns@townsqr.com. **President:** Richard Weatherington. Estab. 1969. Editorial service providing editorial and graphic packages for magazines.

Needs: Buys from 12 or more freelance artists/year. Considers caricature, editorial and tax and business subjects as themes; considers b&w line drawings and shading film.

First Contact & Terms: Send query letter with résumé, tearsheets or photocopies. Samples should contain business subjects. "Send 5 or more b&w line drawings, color drawings, shading film or good line drawing editorial cartoons." Does not want to see comic strips. Samples not filed are returned by SASE. Responds in 4-6 weeks. To show a portfolio, mail tearsheets or photostats. Pays 50% of net proceeds; pays flat fee of $25 minimum. "We may buy art outright or split percentage of sales."

Tips: "We have the markets for multiple sales of editorial support art. We need talented artists to supply specific projects. We will work with beginning artists. Be honest about talent and artistic ability. If it isn't there then don't beat your head against the wall."

N COMMUNITY PRESS SERVICE, P.O. Box 717, Frankfort KY 40602. (502)223-1736. Fax: (502)223-0232. **Editor:** Judy Penn. Estab. 1990. Syndicate serving 200 weekly and monthly periodicals.

Needs: Approached by 15-20 cartoonists and 30-40 illustrators/year. Buys from 8-10 cartoonists and 4-5 illustrators/year. Introduces 1-2 new strips/year. Considers comic strips. Prefers single panel b&w line drawings with or without gagline. Maximum size of artwork $8\frac{1}{2} \times 11$; must be reducible to 50% of original size.

First Contact & Terms: Sample package should include cover letter, finished cartoons, photocopies. 5-10 samples should be included. Samples are filed. Responds in 2 months. Call for appointment to show portfolio of b&w final art. **Pays on acceptance**. Buys all rights. Offers automatic renewal. Syndicate owns original art; artist owns characters.

CONTINENTAL FEATURES/CONTINENTAL NEWS SERVICE, 501 W. Broadway, Plaza A, P.O. PMB 265, San Diego CA 92101. (858)492-8696. E-mail: continentalnewstime@lycos.com. Website:

www.mediafinder.com.cnstore. **Editor-in-Chief:** Gary P. Salamone. Parent firm established August, 1981. Syndicate serving 3 outlets: house publication, publishing business and the general public through the *Continental Newstime* magazine. Features include *Portfolio*, a collection of cartoon and caricature art.

Needs: Approached by 200 cartoonists/year. Number of new strips introduced each year varies. Considers comic strips and gag cartoons. Does not consider highly abstract, computer-produced or stick-figure art. Prefers single panel with gagline. Recent features include "FUSEBOX" by Greg Panneitz. Guidelines available for #10 SASE with first-class postage. Maximum size of artwork 8×10, must be reducible to 65% of original size.

First Contact & Terms: Sample package should include cover letter, photocopies (10-15 samples). Samples are filed or are returned by SASE if requested by artist. Responds in 1 month only if interested or if SASE is received. To show portfolio, mail photocopies and cover letter. Pays 70% of gross income on publication. Rights purchased vary according to project. Minimum length of contract is 1 year. The artist owns the original art and the characters.

Tips: "We need single-panel cartoons and comic strips appropriate for English-speaking, international audience. Do not send samples reflecting the highs and lows and different stages of your artistic development. CF/CNS wants to see consistency and quality, so you'll need to send your best samples."

CREATORS SYNDICATE, INC., 5777 W. Century Blvd., Suite 700, Los Angeles CA 90045. (310)337-7003. Fax: (310)337-7625. E-mail: cre8ors@aol.com. Website: www.creators.com. Address work to Editorial Review Board—Comics. **President:** Richard S. Newcombe. Director of Operations: Christina Lee. Estab. 1987. Serves 2,400 daily newspapers, weekly and monthly magazines worldwide. Guidelines on website.

Needs: Syndicates 100 writers and artists/year. Considers comic strips, caricatures, editorial or political cartoons and "all types of newspaper columns." Recent introductions: *One Big Happy*, by Rick Detorie and *Rubes*, by Leigh Rubin.

First Contact & Terms: Send query letter with brochure showing art style or résumé and "anything but originals." Samples are not filed and are returned by SASE. Responds in a minimum of 10 weeks. Considers salability of artwork and client's preferences when establishing payment. Negotiates rights purchased.

Tips: "If you have a cartoon or comic strip you would like us to consider, we will need to see at least four weeks of samples, but not more than six weeks of dailies and two Sundays. If you are submitting a comic strip, you should include a note about the characters in it and how they relate to each other. As a general rule, drawings are most easily reproduced if clearly drawn in black ink on white paper, with shading executed in ink wash or Benday® or other dot-transfer. However, we welcome any creative approach to a new comic strip or cartoon idea. Your name(s) and the title of the comic or cartoon should appear on every piece of artwork. If you are already syndicated elsewhere, or if someone else owns the copyright to the work, please indicate this."

N 🌐 DRAWN & QUARTERED LTD., 4 Godmersham Park, Canterbury, Kent CT4 7DT United Kingdom. Phone/fax: (44) 1227-730-565. E-mail: red@drawnandquartered.com. Website: www.drawnandquartered.com. **Contact:** Robert Edwards, chief executive. Estab. 2000. Syndicate serving over 100 weekly and monthly internet, magazines, newsletter, newspapers and tabloids. Guidelines available.

● This company operates similarly to a stock agency. See their website for extra details.

Needs: Considers caricatures, cartoons, single panel, line, pen & ink, spot drawings, editorial/political cartoons, illustrations, portrait art of politicians and celebrities. Prefers topical, timely, as-the-news-happens images; newspaper emphasis (i.e. political, sports, entertainment figures). Maximum size of artwork 7″ height; artwork must be reducible to 20% of original size. Prefers to receive CDs or Zips of work, JPEGs or PNGs; b&w or RGB color, resolution: 250-350dpi.

First Contact & Terms: Sample package should include cover letter, brochure, photocopies, résumé, contact information, tearsheets and self caricature/portrait if possible. 5-10 samples should be included. Samples are filed. Samples are returned by SASE if requested by artist. Portfolio not required. Pays 50% of net proceeds or gross income. Established average amount of payment US $20 per download. Pays on publication or downloads by client. Responds to submissions in 1 week. Minimum length of contract is 1 year. Offers automatic renewal. Artist owns copyright, original art and original characters.

Tips: "Identify and date" samples.

GRAPHIC ARTS COMMUNICATIONS, Box 421, Farrell PA 16121. (724)981-3571. **President:** Bill Murray. Estab. 1980. Syndicates to 200 newspapers and magazines.

Needs: Buys 400 pieces/year from artists. Humor through youth and family themes preferred for single

panel and multipanel cartoons and strips. Needs ideas for anagrams, editorial cartoons and puzzles, and for comic panel *Sugar & Spike*. Introductions include *No Whining*, by John Fragle and *Attach Cat*, by Dale Thompson; both similar to past work—general humor, family oriented.

First Contact & Terms: Query for guidelines. Sample package should contain 5 copies of work, résumé, SASE and cover letter. Responds in 6 weeks. No originals returned. Buys all rights. Pays flat fee, $8-50.

Tips: "Inter-racial material is being accepted more."

N **HISPANIC LINK NEWS SERVICE**, 1420 N St. NW, Washington DC 20005. (202)234-0280. Fax: (202)234-4090. E-mail: zapoteco@aol.com. **Editor:** Charles Ericksen. Syndicated column service to 70 newspapers and a newsletter serving 2,000 subscribers: "movers and shakers in the Hispanic community in U.S., plus others interested in Hispanics." Guidelines available.

Needs: Buys from 20 freelancers/year. Considers single panel cartoons; b&w, pen & ink line drawings. Work should have a Hispanic angle; "most are editorial cartoons, some straight humor."

First Contact & Terms: Send query letter with résumé and photocopies to be kept on file. Samples not filed are returned by SASE. Responds in 3 weeks. Portfolio review not required. **Pays on acceptance**; $25 flat fee (average). Considers clients' preferences when establishing payment. Buys reprint rights and negotiates rights purchased. "While we ask for reprint rights, we also allow the artist to sell later."

Tips: Interested in seeing more cultural humor. "While we accept work from all artists, we are particularly interested in helping Hispanic artists showcase their work. Cartoons should offer a Hispanic perspective on current events or a Hispanic view of life."

N **INTERPRESS OF LONDON AND NEW YORK**, 90 Riverside Dr., New York NY 10024. (212)873-0772. **Editor/Publisher:** Jeffrey Blyth. Syndicates to several dozen European magazines and newspapers.

Needs: Buys from 4-5 freelancers/year. Prefers material universal in appeal; no "American only."

First Contact & Terms: Send query letter and photographs; write for artists' guidelines. Samples not kept on file are returned by SASE. Responds in 3 weeks. Purchases European rights. Pays 60% of net proceeds on publication.

KING FEATURES SYNDICATE, 888 Seventh Ave., 2nd Floor, New York NY 10019. (212)455-4000. Website: www.Kingfeatures.com. **Editor-in-Chief:** Jay Kennedy. Estab. 1915. Syndicate servicing over 3,000 newspapers worldwide. Guidelines available for #10 SASE.

● This is one of the oldest, most established syndicates in the business. It runs such classics as *Blondie*, *Hagar*, *Dennis the Menace* and *Beetle Bailey* and such contemporary strips as *Zippy the Pinhead*, *Zits* and *Mutts*.

Needs: Approached by 6,000 freelancers/year. Introduces 3 new strips/year. Considers comic strips and single panel cartoons. Prefers humorous single or multiple panel, and b&w line drawings. Maximum size of artwork 8½×11. Comic strips must be reducible to 6½″ wide; single panel cartoons must be reducible to 3½″ wide.

First Contact & Terms: Sample package should include cover letter, character sheet that names and describes major characters and photocopies of finished cartoons. "Résumé optional but appreciated." 24 samples should be included. Returned by SASE. Full submission guidelines available on website. Responds in 2 months. Pays 50% of net proceeds. Rights purchased vary according to project. Artist owns original art and characters. Length of contract and other terms negotiated.

Tips: "We look for a uniqueness that reflects the cartoonist's own individual slant on the world and humor. If we see that slant, we look to see if the cartoonist is turning his attention to events other people can relate to. We also study a cartoonist's writing ability. Good writing helps weak art, better than good art helps weak writing."

MINORITY FEATURES SYNDICATE, INC., P.O. Box 421, Farrell PA 16121. (724)981-3751. Fax: (724)342-6244. **Editor:** Bill Murray. Estab. 1980. Syndicate serving 150 daily newspapers, school papers and regional and national publications. Art guidelines available for #10 SASE.

Needs: Approached by 800 freelance artists/year. Buys from 650 freelancers/year. Introduces 100 new strips/year. Considers comic strips, gag cartoons and editorial/political cartoons. Prefers multiple panel b&w line drawing with gagline. Prefers family-oriented, general humor featuring multicultural, especially Black characters. Maximum size of artwork 8½×11; must be reducible to 65%.

First Contact & Terms: Sample package should include cover letter, tearsheets and photocopies. 5 samples should be included. Samples are filed or returned by SASE. Responds in 3 months. To show

portfolio, mail b&w tearsheets. Pays flat fee of $50-150. Rights purchased vary according to project. No automatic renewal. Syndicate owns original art. Character ownership negotiable.

[N] PLAIN LABEL PRESS, P.O. Box 240331, Ballwin MO 63024. E-mail: mail@creativeon-line.com. Website: www.plainlabelpress.com. **Contact:** Laura Meyer, submissions editor. Estab. 1989. Syndicate serving over 100 weekly magazines, newspapers and internet sites. Guidelines available on website.

Needs: Approached by 500 cartoonists and 100 illustrators/year. Buys from 2-3 cartoonists/illustrators/year. Introduces 1-2 new strips/year. Strips introduced include *Barcley & Co.*, by Todd Schowalter and *The InterPETS!* Considers cartoons (single, double and multiple panel), comic strips, editorial/political cartoons and gag cartoons. Prefers comics with cutting edge humor, NOT mainstream. Maximum size of artwork 8½×11; artwork must be reducible to 25% of original size.

First Contact & Terms: Sample package should include an intro. letter, character descriptions, 3-4 weeks of material, photocopies or disk, no original art, SASE if you would like your materials returned. 18-24 samples should be included. Samples are not filed. If samples are not filed, samples are returned by SASE if requested by artist. Portfolio not required. Pays 60% of net proceeds, upon publication. Pays on publication. Responds to submissions in 2 months. Contract is open and may be cancelled at any time by the creator and/or by Plain Label Press. Artist owns original art and original characters.

Tips: "Be FUNNY! Remember readers read the comics as well as look at them. Don't be afraid to take risks. Plain Label Press does not wish to be the biggest syndicate, just the funniest. A large portion of our material is purchased for use online so a good knowledge of digital color and imaging puts a cartoonist at an advantage. Good luck!"

[N] TRIBUNE MEDIA SERVICES INTERNATIONAL, 202 W. First St., 10th Floor, Los Angeles CA 90012. (213)237-7987. Website: www.tmsinternational.com. **Contact:** Comics Editor.

Needs: Considers comic strips, panel cartoons and editorial cartoons. "We prefer humor to dramatic continuity and general illustrations for political commentary. We consider only cartoons that run six or seven days/week. Cartoons may be of any size, as long as they're to scale with cartoons running in newspapers." Strips usually run approximately 6⁷⁄₁₆×2; panel cartoons 3⅛×4; editorial cartoons vary.

First Contact & Terms: Submit photocopies or photostats of 24 dailies. Submitting Sunday cartoons is optional; if you choose to submit them, send at least 4. Responds in 2 months. Include SASE. Finds artists through word of mouth, submissions, newspapers.

Tips: "Don't imitate cartoons that are already in the paper. Avoid linework or details that might bleed together, fade out or reproduce too small to be seen clearly. We hardly ever match artists with writers or vice versa. We prefer people or teams who can do the entire job of creating a feature."

UNITED FEATURE SYNDICATE/NEWSPAPER ENTERPRISE ASSOCIATION, 200 Madison Ave., New York NY 10016. (212)293-8500. Website: www.unitedfeatures.com. **Contact:** Comics Editor. Syndicate serving 2500 daily/weekly newspapers. Guidelines available for #10 SASE and on website.

● This syndicate told *AGDM* they receive more than 4,000 submissions each year and only accept two or three new artists. Nevertheless, they are always interested in new ideas.

Needs: Approached by 5,000 cartoonists/year. Buys from 2-3 cartoonists/year. Introduces 2-3 new strips/year. Strips introduced include *Dilbert*, *Over the Hedge*. Considers comic strips, editorial political cartoons and panel cartoons.

First Contact & Terms: Sample package should include cover letter and nonreturnable photocopies of finished cartoons. 18-36 dailies. Color Sundays are not necessary with first submissions. Responds in 4 months. Does not purchase one shots. Does not accept submissions via fax or e-mail.

Tips: "No oversize packages, please."

UNITED MEDIA, 200 Madison Ave., New York NY 10016. (212)293-8500. Website: www.unitedfeatures.com. **Contact:** Editorial Submissions Editor or Comic Art Submissions Editor. Estab. 1978. Syndicate servicing US and international newspapers. Guidelines for SASE. "United Media consists of United Feature Syndicate and Newspaper Enterprise Association. Submissions are considered for both syndicates. Duplicate submissions are not needed." Guidelines available on website.

Needs: Introduces 2-4 new strips/year. Considers comic strips and single, double and multiple panels. Recent introductions include *Frazz*, by Jef Mallett. Prefers pen & ink.

First Contact & Terms: Send cover letter, résumé, finished cartoons and photocopies. Include 36 dailies; "Sundays not needed in first submissions." Do not send "oversize submissions or concepts without strips."

Samples are not filed and are returned by SASE. Responds in 3 months. "Does not view portfolios." Payment varies by contract. Buys all rights.

Tips: "Send copies, but not originals. Do not send mocked-up licensing concepts." Looks for "originality, art and humor writing. Be aware of long odds; don't quit your day job. Work on developing your own style and humor writing. Worry less about 'marketability'—that's our job."

UNIVERSAL PRESS SYNDICATE, 4520 Main St., Suite 700, Kansas City MO 64111. (816)932-6600. Website: www.uexpress.com. **Editorial Director:** Lee Salem. Syndicate serving 2,750 daily and weekly newspapers.

Needs: Considers single, double or multiple panel cartoons and strips; b&w and color. Requests photocopies of b&w, pen & ink, line drawings.

First Contact & Terms: Responds in 6 weeks. To show a portfolio, mail photostats. Send query letter with photocopies.

Tips: "Be original. Don't be afraid to try some new idea or technique. Don't be discouraged by rejection letters. Universal Press receives 100-150 comic submissions a week, and only takes on two or three a year, so keep plugging away. Talent has a way of rising to the top."

WHITEGATE FEATURES SYNDICATE, 71 Faunce Dr., Providence RI 02906. (401)274-2149. Website: www.whitegatefeatures.com. **Talent Manager:** Eve Green. Estab. 1988. Syndicate serving daily newspapers internationally, book publishers and magazines. Guidelines available on website.

● Send nonreturnable samples. This syndicate says they are not able to return samples "even with SASE" because of the large number of submissions they receive.

Needs: Introduced Dave Berg's *Roger Kaputnik*. Considers comic strips, gag cartoons, editorial/political cartoons, illustrations and spot drawings; single, double and multiple panel. Work must be reducible to strip size. Also needs artists for advertising and publicity. Looking for fine artists and illustrators for book publishing projects.

First Contact & Terms: Send cover letter, résumé, tearsheets, photostats and photocopies. Include about 12 strips. Does not return materials. To show portfolio, mail tearsheets, photostats, photographs and slides; include b&w. Pays 50% of net proceeds upon syndication. Negotiates rights purchased. Minimum length of contract 5 years (flexible). Artists owns original art; syndicate owns characters (negotiable).

Tips: Include in a sample package "info about yourself, tearsheets, notes about the strip and enough samples to tell what it is. Don't write asking if we want to see; just send samples." Looks for "good writing, strong characters, good taste in humor. No hostile comics. We like people who have cartooned for a while and are printed. Get published in local papers first."

Stock Illustration & Clip Art Firms

Stock illustration is a concept that has its origins in the photography market. Photographers have known that reselling photos can be profitable for both the photographers and publishers who purchase rights to reprint photos at reduced rates. Realizing that what works for photographers could work for illustrators, businesses began to broker illustrations the same way. They promoted the illustrations to art directors through catalogs, brochures, CD-ROMs and websites. The idea took off. Art directors (already accustomed to using stock photography) quickly adapted to flipping through stock illustration catalogs or browsing the Web for artwork at reduced prices, while firms split fees with illustrators.

There are those who maintain stock illustration hurts freelancers. They say it encourages art directors to choose ready-made artwork from catalogs at reduced rates instead of assigning illustrators for standard industry rates. Others maintain the practice gives freelancers a vehicle to resell their work. Marketing your work as stock allows you to sell an illustration again and again instead of filing it away in a drawer. That illustration can mean extra income every time someone chooses it from a stock catalog.

Stock vs. clip art

Stock illustration firms market images to book publishers, advertising agencies, magazines, corporations and other businesses through catalogs and websites. When most people think of clip art, they think of booklets of copyright-free graphics and cartoons, the kind used in church bulletins, high school newspapers, club newsletters and advertisments for small businesses. But these days, especially with some of the digital images available on disk and CD-ROMs, perceptions are changing. With the popularity of desktop publishing, newsletters that formerly looked homemade look more professional.

Copyright and payment

There is another crucial distinction between stock illustration and clip art. That distinction is copyright. Stock illustration firms do not sell illustrations. They license the right to reprint illustrations, working out a "pay-per-use" agreement. Fees charged depend on how many times and for what length of time their clients want to reproduce the artwork. Stock illustration firms generally split their fees 50-50 with artists, and pay the artist every time his image is used. You should be aware that some agencies offer better terms than others. So weigh your options before signing any contracts.

Clip art, on the other hand, generally implies buyers are granted a license to use the image as many times as they want, and furthermore, they can alter it, crop it or retouch it to fit their purposes. Some clip art firms repackage artwork created many years ago because it is in the public domain, and therefore, they don't have to pay an artist for the use of the work. But in the case of clip art created by living artists, firms either pay the artists an agreed-upon fee for all rights to the work, or will negotiate a royalty agreement. Keep in mind that if you sell all rights to your work, you will not be compensated each time it is used unless you also negotiate a royalty agreement. Once your work is sold as clip art, the buyer of that clip art can alter your work and resell it without giving you credit or compensation.

How to submit artwork

Companies are identified as either stock illustration or clip art firms in the first paragraph of each listing. Some firms, such as Metro Creative Graphics and Dynamic Graphics, seem to be

hybrids of clip art firms and stock illustration agencies. Read the information under "Needs" to find out what type of artwork each firm needs. Then check "First Contact & Terms" to find out what type of samples you should send. Most firms accept samples in the form of slides, photocopies and tearsheets. Increasingly, disk and e-mail submissions are encouraged in this market.

AFROCENTREX, P.O. Box 4375, Chicago IL 60680. (708)386-6122. E-mail: info@afrocentrex-softwar e.com. Website: www.afrocentrex.com. Chief Executive Officer: Keith Coleman. Estab. 1993. Clip art firm. Specializes in multicultural clip art. Recently introduced Hispanic clip art, Asian clip art, multicultural/ language websites. Distributes to over 20 outlets, including newspapers, schools and corporate accounts.
Needs: Approached by 2 cartoonists and 4-10 illustrators/year. Buys from 2-4 illustrators/year. Considers caricatures and illustrations. Prefers b&w line drawings and digital art.
First Contact & Terms: Send cover letter with résumé and photocopies or tearsheets and SASE. Include 3-5 samples. Samples are filed. Responds in 2 weeks. Write for appointment to show portfolio of final art. Pays flat fee; $25-150. **Pays on acceptance.** Negotiates rights purchased. Offers automatic renewal. Clip art firm owns original art and characters.
Tips: Looks for "persistence, professionalism and humbleness."

AGFA MONOTYPE TYPOGRAPHY, 200 Ballardvale St., Wilmington MA 01887. (978)284-5932. Fax: (978)657-8268. E-mail: allanhaley@agfamonotype.com. Website: www.fonts.com. **Director of Words & Letters:** Allan Haley. Estab. 1897. Font foundry. Specializes in high-quality Postscript and Truetype fonts for graphic design professionals and personal use. Clients include advertising agencies, magazines and desktop publishers.
• Does not want clip art or illustration—only fonts.
Needs: Approached by 10 designers/year. Works with 5 typeface designers/year. Prefers typeface and font designs. Freelance work demands knowledge of Illustrator, Photoshop, QuarkXPress.
First Contact & Terms: E-mail examples of font (PDF files or EPS or TIFF). Samples are not filed. Responds only if interested. Rights purchased vary according to project. Finds designers through word of mouth.

CUSTOM MEDICAL STOCK PHOTO, INC., The Custom Medical Building, 3660 W. Irving Park Rd., Chicago IL 60618-4132. (800)373-2677. Fax: (773)267-6071. E-mail: info@cmsp.com. Website: ww w.cmsp.com. Contact: Mike Fisher or Henry Schleichkorn. Estab. 1985. Medical and scientific stock image agency. Specializes in medical photography, illustration, medical cartoons and animation for the healthcare industry. Distributes to magazines, advertising agencies and design firms. Clients include textbook publishers, continuing medical education, movie producers. Guidelines available for #10 SASE.
Needs: Approached by 20 illustrators/year. Works with 50 illustrators and animators/year. Themes include healthcare. Knowledge of Photoshop, Illustrator and Aldus Freehand helpful.
First Contact & Terms: "Call first to discuss before shipping." Accepts disk submission compatible with Mac or PC; send "low res files for viewing." Responds in 1 month. Call or write for portfolio review. Pays royalties of 40%. Licenses non-exclusive rights to clients. Finds artists through word of mouth. "Our reputation precedes us among individuals who produce medical imagery. We also advertise in several medical and photographer's publications."
Tips: "Our industry is motivated by current events and issues that affect healthcare—new drug discoveries, advances and F.D.A. approval on drugs and medical devices."

⚏ DRAWN & QUARTERED LTD., 4 Godmersham Park, Canterbury Kent CT4-7DT United Kingdom. Phone/fax: (44)1227-730-565. E-mail: red@drawnandquartered.com. Website: www.drawnandquarte red.com. **Contact:** Robert Edwards, chief executive.
• See listing in Syndicates & Cartoon Features section.

SASE MEANS SELF-ADDRESSED, STAMPED ENVELOPE. Send SASEs when requesting return of your samples.

DREAM MAKER SOFTWARE, P.O. Box 260050, Highlands Ranch CO 80163-0050. (303)350-8557. Fax: (303)683-2646. E-mail: david@coolclipart.com. Website: www.coolclipart.com. Art Director: David Sutphin. Estab. 1986. Clip art firm, computer software publisher serving homes, schools and businesses. **Needs:** Approached by 20-30 freelancers/year. Considers a variety of work including cartoon type and realistic illustrations suitable for publication as clip art with a broad market appeal. Also interested in small watercolor illustrations in styles suitable for greeting cards. **First Contact & Terms:** Sample package should include cover letter. 8-12 samples should be included. Samples are not filed and are returned by SASE. Responds in 2 months only if interested. Considers both traditional and computer based (Illustrator) artwork. Does not accept initial samples on disk. Pays $10-50 flat fee on completion of contract. Typical contract includes artist doing 50-150 illustrations with full payment made upon completion and acceptance of work. Rights purchased include assignment of copyright from artist.

DYNAMIC GRAPHICS INC., 6000 N. Forest Park Dr., Peoria IL 61614-3592. (800)255-8800 or (309)688-8800. Fax: (309)688-8515. Website: www.dgusa.com. Art Director: Steve Justice. Distributes clip art, stock images and animation to thousands of magazines, newspapers, agencies, industries and educational institutions.
 • Dynamic Graphics is a stock image firm and publisher of *Step into Design*, *Digital Design newsletter*, and *Dynamic Graphics Magazine*. Uses illustrators from all over the world; 99% of all artwork sold as clip art is done by freelancers.
Needs: Works with more than 50 freelancers/year. Prefers illustration, symbols and elements; buying color and b&w, traditional or electronic images. "We are currently seeking to contact established illustrators capable of handling b&w or color stylized and representational illustrations of contemporary subjects and situations."
First Contact & Terms: Submit portfolio of at least 15 current samples with SASE. Responds in 2 weeks. **Pays on acceptance**. Negotiates payment. Buys all rights.
Tips: "We are interested in quality, variety and consistency. Illustrators contacting us should have top-notch samples that show consistency of style (repeatability) over a range of subject matter. We often work with artists who are getting started if their portfolios look promising. Because we publish a large volume of artwork monthly, deadlines are extremely important, but we do provide long lead time (4-6 weeks is typical). We are also interested in working with illustrators who would like an ongoing relationship. Not necessarily a guaranteed volume of work, but the potential exists for a considerable number of pieces each year for marketable styles."

GETTY IMAGES, 601 N. 34th St., Seattle WA 98103. (206)925-5000. Fax: (206)925-5600. Website: www.gettyimages.com. Visual content provider offering licensed and royalty-free images.
 • Getty Images offers the Artville Collection, Eyewire and many photographic images. Check their website to see the type of images they buy.
Needs: Approached by 1,500 artists/year. Buys from 100 freelancers/year. Considers illustrations, photos, typefaces and spot drawings.
First Contact & Terms: Sample package should include submission form (from website), tearsheets, slides, photocopies or digital files. 10 samples should be included. Samples are filed. Buys all rights or licenses image. Minimum length of contract is indefinite. Offers automatic renewal.

GRAPHIC CORP., a division of Corel Corporation, 1600 Carling Ave., Ottawa, ON K1Z 8R7 Canada. (613)728-0826. Fax: (613)728-9790. E-mail: janiesh@corel.com. Website: www.corel.com and www.creativeanywhere.com/clipart/.com. **Contact:** John Leblanc, senior creative manager. Estab. 1986. Software company specializing in clip art, animation, stock illustration, photos and fonts for use by computer hardware and software companies.
 • If you are adept at creating artwork using Corel software, attempt to submit work using a Corel graphic program.
Needs: Approached by 50 cartoonists and 50 illustrators/year. Buys from 20 cartoonists and 20 illustrators/year. Considers custom created clip art, software, photos, gag cartoons, caricature and illustrations. Prefers single panel. Also uses freelancers for computer illustration.
First Contact & Terms: Sample package should include cover letter, finished clip art in electronic samples. Maximum amount of samples possible should be included. "GraphicCorp recommends that image submissions: be provided in .WMF and/or .EPS format (preferably both); be provided on diskette; contain a *minimum* of 50 color images; (no black & white images, please); and contain the following subject-

matter: holidays, borders, greeting card-style, animals, religious, flowers, office and business imagery, family and educational subjects. ("See our website for the type of graphics we use.") Samples are not filed and are returned by SASE if requested by artist. Responds only if interested. Negotiates rights purchased.
Tips: "We prefer prolific artists or artists with large existing collections. Images must be in electronic format. We are not interested in expensive works of art. We buy simple, but detailed, images that can be used by anybody to convey an idea in one look. We are interested in quantity, with some quality."

IDEAS UNLIMITED FOR EDITORS, Omniprint Inc., 9700 Philadelphia Court, Lanham MD 20706. (301)731-5202. Fax: (301)731-5203. E-mail: editor@omniprint.net. Editorial Director: Rachel Brown. Stock illustration and editorial firm serving corporate in-house newsletters. Guidelines not available.
 • This new clip art firm is a division of Omni Print, Inc., which provides publishing services to corporate newsletter editors. Ideas Unlimited provides clip art in both hard copy and disk form.
Needs: Buys from 2 cartoonists and 5 illustrators/year. Prefers single panel with gagline.
First Contact & Terms: Sample package should include cover letter, tearsheets, résumé and finished cartoons or illustrations. 10 samples should be included. Samples are filed. Responds only if interested. Mail photocopies and tearsheets. Pays $50-100. **Pays on acceptance**. Buys all rights. Minimum length of contract is 6 months.

INDEX STOCKWORKS, 23 W. 18th St., 3rd Floor, New York NY 10011. (800)690-6979. Fax: (212)633-1914. E-mail: portfolio@indexstock.com. Website: www.indexstock.com. **Contact:** Desmond Powell. Estab. 1992. Stock illustration firm. Specializes in stock illustration for corporations, advertising agencies and design firms. Clients include Thomson Learning, Capital One, Ernst & Young and Draft Worldwide. Guidelines available on website.
Needs: Approached by 300 new artists/year. Themes include animals, business, education, healthcare, holidays, lifestyles, technology and computers, travel locations.
First Contact & Terms: Visit website. Click on link *For Artists Only*. Under **Submitting a Portfolio for review** click on link submitting a portfolio. Download and print the following documents: Appropriate guidelines based on the type of media you wish to submit, Pre-Portfolio Questionnaire Form and 2002 or current year PORTFOLIO SUBMISSION FORM. As instructed in guidelines sign and return forms with your images for review. Samples are filed or are returned through pre-paid return shipping via Federal Express, UPS or US Postal Services at artist's expense, depending on the outcome of the portfolio review. Responds only if interested. E-mail for portfolio review of available stock images and leave behinds. Pays royalties of 40%. Negotiates rights purchased. Finds artists through *Workbook*, *Showcase*, *Creative Illustration*, magazines, submissions.
Tips: "Index Stock Imagery likes to work with artists to create images specifically for stock. We provide 'Want' lists and concepts to aid in the process. We like to work with illustrators who are motivated to explore an avenue other than just assignment to sell their work."

☑ **INNOVATION MULTIMEDIA**, 31 Fairview Dr., Essex Junction VT 05452. (802)879-1164. Fax: (802)878-1768. E-mail: innovate@ad-art.com. Website: www.ad-art.com/innovation. Owner: David Dachs. Estab. 1985. Clip art publisher. Specializes in clip art for publishers, ad agencies, designers. Clients include US West, Disney, *Time* Magazine.
Needs: Prefers clip art, illustration, line drawing. Themes include animals, business, education, food/cooking, holidays, religion, restaurant, schools. 100% of design demands knowledge of Illustrator.
First Contact & Terms: Send samples and/or Macintosh disks (Illustrator files). Artwork should be saved as EPS files. Samples are filed. Responds only if interested. Pays by the project. Buys all rights.

METRO CREATIVE GRAPHICS, INC., 519 Eighth Ave., New York NY 10018. (212)947-5100. Fax: (212)714-9139. Website: www.metrocreativegraphics.com. Senior Art Director: Darrell Davis. Estab. 1910. Creative graphics/art firm. Distributes to 7,000 daily and weekly paid and free circulation newspapers,

schools, graphics and ad agencies and retail chains. Guidelines available (send letter with SASE or e-mail art director on website).

Needs: Buys from 100 freelancers/year. Considers all styles of illustrations and spot drawings; b&w and color. Editorial style art, cartoons for syndication not considered. Special emphasis on computer-generated art for Macintosh. Send floppy disk samples using Illustrator 5.0. or Photoshop. Prefers all categories of themes associated with newspaper advertising (retail promotional and classified). Also needs covers for special-interest newspaper, tabloid sections.

First Contact & Terms: Send query letter with non-returnable samples, such as photostats, photocopies, slides, photographs or tearsheets to be kept on file. Accepts submissions on disk compatible with Illustrator 5.0 and Photoshop. Send EPS or TIFF files. Samples returned by SASE if requested. Responds only if interested. Works on assignment only. **Pays on acceptance**; flat fee of $25-1,500 (buy out). Considers skill and experience of artist, saleability of artwork and clients' preferences when establishing payment.

Tips: This company is "very impressed with illustrators who can show a variety of styles." When creating electronic art, make sure all parts of the illustration are drawn completely, and then put together. "It makes the art more versatile to our customers."

MILESTONE GRAPHICS, 1093 A1A Beach Blvd., #388, St. Augustine FL 32080. Phone/fax: (904)823-9962. E-mail: miles@aug.com. Website: www.milestonegraphics.com. Owner: Jill O. Miles. Estab. 1993. Clip art firm providing targeted markets with electronic graphic images.

Needs: Buys from 20 illustrators/year. 50% of illustration demands knowledge of Illustrator.

First Contact & Terms: Sample package should include nonreturnable photocopies or samples on computer disk. Accepts submissions on disk compatible with Illustrator on the Macintosh. Send EPS files. Interested in b&w and some color illustrations. All styles and media are considered. Macintosh computer drawings accepted (Illustrator preferred). "Ability to draw people a plus, but many other subject matters needed as well. We currently have a need for golf and political illustrations." Reports back to the artist only if interested. Pays flat fee of $25 minimum/illustration, based on skill and experience. A series of illustrations is often needed.

ONE MILE UP, INC., 7011 Evergreen Court, Annandale VA 22003. (703)642-1177. Fax: (703)642-9088. E-mail: gene@onemileup.com. Website: www.onemileup.com. President: Gene Velazquez. Estab. 1988.
• Gene Velazquez told *AGDM* he is also looking for 3-D art and has a strong interest in aviation graphics. He does not use cartoons.

Needs: Approached by 10 illustrators and animators/year. Buys from 5 illustrators/year. Prefers illustration and animation.

First Contact & Terms: Send 3-5 samples via e-mail with résumé and/or link to your website. Pays flat fee; $30-120. **Pays on acceptance.** Negotiates rights purchased.

STOCK ILLUSTRATION SOURCE, 16 W. 19th St., 9th Floor, New York NY 10011. (212)849-2900, (800)4-IMAGES. Fax: (212)691-6609. E-mail: sis@images.com. Website: www.images.com. Acquisitions Manager: Barbara Preminger. Estab. 1992. Stock illustration agency. Specializes in illustration for corporate, advertising, editorial, publishing industries. Guidelines available.
• This agency is rebranding itself to Images.com—an umbrella agency which include S.I.S. and "spots on the spot."

Needs: "We deal with 500 illustrators." Prefers painterly, conceptual images, including collage and digital works, occasionally humorous illustrations. Themes include corporate, business, education, family life, healthcare, law and environment.

First Contact & Terms: Illustrators should scan sample work onto CD or disk and send that rather than e-mailing links to their sites. Will do portfolio review. Pays royalties of 50% for illustration sales. Negotiates rights purchased.

STOCKART.COM, 155 N. College Ave., Suite 225, Ft. Collins CO 80524. (970)493-0087 or (800)653-0087. Fax: (970)493-6997. E-mail: art@stockart.com. Website: www.stockart.com. Art Manager: Maile Fink. Estab. 1995. Stock illustration and representative. Specializes in b&w and color illustration for ad agencies, design firms and publishers. Clients include BBDO, Bozell, Pepsi, Chase, Saatchi & Saatchi.

Needs: Approached by 250 illustrators/year. Works with 150 illustrators/year. Themes include business, family life, financial, healthcare, holidays, religion and many more.

First Contact & Terms: Illustrators send at least 10 samples of work. Accepts hard copies, e-mail or disk submissions compatible with TIFF or EPS files less than 600k/image. Pays 50% stock royalty, 70%

commission royalty (commissioned work-artist retains rights) for illustration. Rights purchased vary according to project. Finds artists through sourcebooks, on-line, word of mouth. "Offers unprecedented easy out policy. Not 100% satisfied, will return artwork within 60 days."

Tips: "Stockart.com has many artists earning a substantial passive income from work that was otherwise in their file drawers collecting dust."

FOR EXPLANATIONS OF THESE SYMBOLS,
SEE THE INSIDE FRONT AND BACK COVERS OF THIS BOOK.

☑ **BASIC/BEDELL ADVERTISING & PUBLISHING**, P.O. Box 30571, Santa Barbara CA 93130. (805)695-0079. **President:** C. Barrie Bedell. Specializes in advertisements, direct mail, how-to books, direct response websites and manuals. Clients: publishers, direct response marketers, retail stores, software developers, web entrepreneurs, plus extensive self-promotion of proprietary advertising how-to manuals.

• This company's president is seeing "a glut of 'graphic designers,' and an acute shortage of 'direct response' designers."

Needs: Uses artists for publication and direct mail design, book covers and dust jackets, and camera-ready computer desktop production. Especially interested in hearing from professionals experienced in e-commerce and in converting printed training materials to electronic media, as well as designers of direct response websites.

First Contact & Terms: Portfolio review not required. Pays for design by the project, $100-2,500 and up and/or royalties based on sales.

Tips: "There has been a substantial increase in use of freelance talent and increasing need for true professionals with exceptional skills and responsible performance (delivery as promised and 'on target'). It is very difficult to locate freelance talent with expertise in design of advertising and direct mail with heavy use of type. Contact with personal letter and photocopy of one or more samples of work that needn't be returned."

■ **THE BASS GROUP**, Dept. AM, 102 Willow Ave., Fairfax CA 94930. (415)455-8090. **Producer:** Herbert Bass. Number of employees: 2. Approximate annual billing: $300,000. "A multimedia, full-service production company providing corporate communications to a wide range of clients. Specializes in multi-media presentations, video/film, and events productions for corporations."

Needs: Approached by 30 freelancers/year. Works with a variety of freelance illustrators and designers/year. Prefers solid experience in multimedia and film/video production. Works on assignment only. Uses freelancers for logos, charts/graphs and multimedia designs. Needs graphics, meeting theme logos, electronic speaker support and slide design. Needs computer-literate freelancers for design, illustration and production. 90% of freelance work demands skills in QuarkXPress, FreeHand, Illustrator and Photoshop.

First Contact & Terms: Send résumé and slides. Samples are filed and are not returned. Responds in 1 month if interested. Will contact artist for portfolio review if interested. Sometimes requests work on spec before assigning a job. Pays by the project. Considers turnaround time, skill and experience of artist and how work will be used when establishing payment. Rights purchased vary according to project. Finds illustrators and designers mainly through word-of-mouth recommendations.

Tips: "Send résumé, samples, rates. Highlight examples in speaker support—both slide and electronic media—and include meeting logo design."

☑ ■ **BERSON, DEAN, STEVENS**, 210 High Meadow St., Wood Ranch CA 91301. (818)713-0134. Fax: (818)713-0417. **Owner:** Lori Berson. Estab. 1981. Specializes in annual reports, brand and corporate identity, collateral, direct mail, trade show booths, promotions, websites, packaging, and publication design. Clients: manufacturers, ad agencies, corporations and movie studios. Professional affiliation: L.A. Ad Club.

Needs: Approached by 50 freelancers/year. Works with 10-20 illustrators and 5 designers/year. Works on assignment only. Uses illustrators mainly for brochures, packaging and comps. Also for catalog, P-O-P, ad and poster illustration, mechanicals retouching, airbrushing, lettering, logos and model-making. 90% of freelance work demands skills in Illustrator, QuarkXPress, Photoshop, as well as web authoring Dream-weaver, Flash/HTML, CGI, Java, etc.

First Contact & Terms: Send query letter with tearsheets and photocopies. Samples are filed. Will contact artist for portfolio review if interested. Pays for design and illustration by the project. Rights purchased vary according to project. Considers buying second rights (reprint rights) to previously published work. Finds artists through word of mouth, submissions/self-promotions, sourcebooks and agents.

BRAINWORKS DESIGN GROUP, INC., 2 Harris Court, #A7, Monterey CA 93940. (831)657-0650. Fax: (831)657-0750. E-mail: mail@brainwks.com. Website: www.brainwks.com. **Contact:** Alfred Kahn, president. Marketing Director: Michele Powers. Creative Services Coordinator: Monica O. Aguilar. Estab. 1970. Number of employees: 7. Specializes in ERC (Emotional Response Communications), graphic de-sign, corporate identity, direct mail and publication. Clients: colleges, universities, nonprofit organizations; majority are colleges and universities. Current clients include City College of New York, Loyola University Chicago, Manhattanville, University of South Carolina-Spartanburg.

Needs: Approached by 100 freelancers/year. Works with 4 freelance illustrators and 10 designers/year.

Prefers freelancers with experience in type, layout, grids, mechanicals, comps and creative visual thinking. Works on assignment only. Uses freelancers mainly for mechanicals and calligraphy. Also for brochure, direct mail and poster design; mechanicals; lettering; and logos. 100% of design work demands knowledge of QuarkXPress, Illustrator and Photoshop.

First Contact & Terms: Send brochure or résumé, photocopies, photographs, tearsheets and transparencies. Samples are filed. Artist should follow up with call and/or letter after initial query. Will contact artist for portfolio review if interested. Portfolio should include thumbnails, roughs, final reproduction/product and b&w and color tearsheets, photostats, photographs and transparencies. Pays for design by the project, $200-2,000. Considers complexity of project and client's budget when establishing payment. Rights purchased vary according to project. Finds artists through sourcebooks and self-promotions.

Tips: "Creative thinking and a positive attitude are a plus." The most common mistake freelancers make in presenting samples or portfolios is that the "work does not match up to the samples they show." Would like to see more roughs and thumbnails.

JANN CHURCH PARTNERS, INC. ADVERTISING & GRAPHIC DESIGN, INC., P.O. Box 9527, Newport Beach CA 92660. (949)640-6224. Fax: (949)640-1706. **President:** Jann Church. Estab. 1970. Specializes in annual reports, brand and corporate identity, display, interior, direct mail, package and publication design, and signage. Clients: real estate developers, medical/high technology corporations, private and public companies. Current clients include The Nichols Institute, The Anden Group, Institute for Biological Research & Development. Client list available upon request.

Needs: Approached by 100 freelance artists/year. Works with 3 illustrators and 5 designers/year. Works on assignment only. Needs technical illustration. 10% of freelance work demands computer literacy.

First Contact & Terms: Send query letter with résumé, photographs and photocopies. Samples are filed. Responds only if interested. To show a portfolio, mail appropriate materials. Portfolio should be "as complete as possible." Pays for design and illustration by the project. Rights purchased vary according to project.

CLIFF & ASSOCIATES, 715 Fremont Ave., South Pasadena CA 91030. (626)799-5906. Fax: (626)799-9809. E-mail: design@cliffassoc.com. **Owner:** Greg Cliff. Estab. 1984. Number of employees: 10. Approximate annual billing: $1 million. Specializes in annual reports, corporate identity, direct mail and publication design and signage. Clients: Fortune 500 corporations and performing arts companies. Current clients include BP, IXIA, WSPA, IABC, Capital Research and ING.

Needs: Approached by 50 freelancers/year. Works with 30 freelance illustrators and 10 designers/year. Prefers local freelancers and Art Center graduates. Uses freelancers mainly for brochures. Also for technical, "fresh" editorial and medical illustration; mechanicals; lettering; logos; catalog, book and magazine design; P-O-P and poster design and illustration; and model-making. Needs computer-literate freelancers for design and production. 90% of freelance work demands knowledge of QuarkXPress, FreeHand, Illustrator, Photoshop, etc.

First Contact & Terms: Send query letter with résumé and a nonreturnable sample of work. Samples are filed. Art director will contact artist for portfolio review if interested. Portfolio should include thumbnails, b&w photostats and printed samples. Pays for design by the hour, $25-35. Pays for illustration by the project, $50-3,000. Buys one-time rights. Finds artists through sourcebooks.

DENTON DESIGN ASSOCIATES, 491 Arbor St., Pasadena CA 91105. (626)792-7141. **President:** Margi Denton. Estab. 1975. Specializes in annual reports, corporate identity and publication design. Clients: nonprofit organizations and corporations. Current clients include California Institute of Technology, Huntington Memorial Hospital and University of Southern California.

Needs: Approached by 12 freelance graphic artists/year. Works with roughly 5 freelance illustrators and 4 freelance designers/year. Prefers local designers only. "We work with illustrators from anywhere." Works with designers and illustrators for brochure design and illustration, lettering, logos and charts/graphs. Demands knowledge of QuarkXPress, Photoshop and Illustrator.

First Contact & Terms: Send résumé, tearsheets and samples (illustrators just send samples). Samples

☑ **A CHECKMARK PRECEDING A LISTING** indicates a change in the mailing address since the 2003 edition.

are filed and are not returned. Responds only if interested. Art director will contact artist for portfolio review if interested. Portfolio should include color samples "doesn't matter what form." Pays for design by the hour, $20-25. Pays for illustration by the project, $250-6,500. Rights purchased vary according to project. Finds artists through sourcebooks, AIGA, *Print* and *CA*.

FREEASSOCIATES, 2800 28th St., Suite 305, Santa Monica CA 90405-2934. (310)399-2340. Fax: (310)399-4030. E-mail: jfreeman@freeassoc.com. Website: www.freeassoc.com. **President:** Josh Freeman. Estab. 1974. Number of employees: 4. Design firm. Specializes in marketing materials for corporate clients. Client list available upon request. Professional affiliations: AIGA.
Needs: Approached by 50 illustrators and 30 designers/year. Works with 5 illustrators and 5 designers/ year. Prefers freelancers with experience in top level design and advertising. Uses freelancers mainly for design, production, illustration. Also for airbrushing, brochure design and illustration, catalog design and illustration, lettering, logos, mechanicals, multimedia projects, posters, retouching, signage, storyboards, technical illustration and web page design. 10% of work is with print ads. 90% of design and 50% of illustration demand skills in Photoshop, QuarkXPress, Illustrator.
First Contact & Terms: Designers send query letter with photocopies, photographs, résumé, tearsheets and transparencies. Illustrators send postcard sample of work and/or photographs and tearsheets. Accepts Mac-compatible disk submissions to view in current version of major software or self-running presentations. CD-ROM OK. Samples are filed or returned by SASE. Will contact for portfolio review if interested. Pays for design and illustration by the project; negotiable. Rights purchased vary according to project. Finds artists through *LA Workbook*, *CA*, *Print*, *Graphis*, submissions and samples.
Tips: "Designers should have their own computer and high speed internet connection. Must have sensitivity to marketing requirements of projects they work on. Deadline commitments are critical."

DENNIS GILLASPY/BRANDON TAYLOR DESIGN, 6498 Weathers Place, Suite 100, San Diego CA 92121-2752. (858)623-9084. Fax: (858)452-6970. E-mail: dennis@brandontaylor.com. Website: brand ontaylor.com. **Owner:** Dennis Gillaspy. Co-Owner: Robert Hines. Estab. 1977. Specializes in corporate identity, displays, direct mail, package and publication design and signage. Clients: corporations and manufacturers. Client list available upon request.
Needs: Approached by 20 freelance artists/year. Works with 15 freelance illustrators and 10 freelance designers/year. Prefers local artists. Works on assignment only. Uses freelance illustrators mainly for technical and instructional spots. Uses freelance designers mainly for logo design, books and ad layouts. Also uses freelance artists for brochure, catalog, ad, P-O-P and poster design and illustration, retouching, airbrushing, logos, direct mail design and charts/graphs.
First Contact & Terms: Send query letter with brochure, résumé, photocopies and photostats. Samples are filed. Responds in 2 weeks. Write to schedule an appointment to show a portfolio or mail thumbnails, roughs, photostats, tearsheets, comps and printed samples. Pays for design by the assignment. Pays for illustration by the project, $400-1,500. Rights purchased vary according to project.

GRAPHIC DATA, 5111 Mission Blvd., P.O. Box 99991, San Diego CA 92169. Phone/fax: (619)274-4511 (call first before faxing). **President:** Carl Gerle. Estab. 1971. Number of employees: 3. Specializes in industrial design. Clients: industrial and publishing companies. Client list available upon request. Professional affiliations: IEEE, AGM, NCGA.
Needs: Works with 3 figurine (miniature) sculptors, 3 freelance illustrators and 3 designers/year. Needs sculptors and designers for miniature figurines. 80% of freelance work demands computer skills.
First Contact & Terms: Send query letter with brochure, résumé or photostats. Samples are returned if SASE included. Sometimes requests work on spec before assigning a job. Pays for design and sculpture by the project, $100-1,000 plus royalties. Rights purchased vary according to project.
Tips: "Know the fundamentals behind your craft. Be passionate about your work; care how it is used. Be professional and business-like."

HARTUNG & ASSOCIATES, LTD., 10279 Field Lane, Forestville CA 95436. (707)887-2825. Fax: (707)887-1214. Website: www.grafted1@sonic.net. **President:** Tim Hartung. Estab. 1976. Specializes in display, marketing and consulting, direct mail, package and publication design and corporate identity, web design and signage. Clients: corporations. Current clients include Marina Cove, Crown Transportation, Exigent. Client list available upon request.
Needs: Approached by 20 freelance graphic artists/year. Works with 5 freelance illustrators and 1 freelance designer/year. Prefers local artists "if possible." Works on assignment only. Uses illustrators and designers

mainly for brochures. Also uses freelance artists for brochure and package design and illustration, direct mail design, Web design, P-O-P illustration and design, mechanicals, retouching, airbrushing, audiovisual materials, lettering, logos and charts/graphs. 50% of freelance work demands skills in QuarkXPress or Illustrator.

First Contact & Terms: Send query letter with brochure, tearsheets and résumé. Samples are filed. Does not reply. Artist should follow up with call. Portfolio should include b&w and color thumbnails, roughs, final art, photostats and tearsheets. Pays for design by the hour or by the project. Pays for illustration by the project. "Rate depends on size, detail, etc. of project." Buys all rights. Finds artists through sourcebooks and artists' submissions.

■ **THE HITCHINS COMPANY**, 22756 Hartland St., Canoga Park CA 91307. (818)715-0150. Fax: (775)806-2687. E-mail: whitchins@socal.rr.com. **President:** W.E. Hitchins. Estab. 1985. Advertising agency. Full-service, multimedia firm.

Needs: Works with 1-2 illustrators and 3-4 designers/year. Works on assignment only. Uses freelance artists for brochure and print ad design and illustration, storyboards, mechanicals, retouching, TV/film graphics, lettering and logo. Needs editorial and technical illustration and animation. 60% of work is with print ads. 90% of design and 50% of illustration demand knowledge of PageMaker, Illustrator, QuarkXPress or FreeHand.

First Contact & Terms: Send postcard sample. Samples are filed if interested and are not returned. Responds only if interested. Call for appointment to show portfolio. Portfolio should include tearsheets. Pays for design and illustration by the project, according to project and client. Rights purchased vary according to project.

N ■ **IMPACT COMMUNICATIONS GROUP**, 18627 Brookhurst St., #4200, Fountain Valley CA 92708. Phone/fax: (714)963-0080. E-mail: info@impactgroup.com. Website: www.impactgroup.com. **Creative Director:** Brad Vinikow. Estab. 1983. Number of employees: 15. Marketing communications firm. Full-service, multimedia firm. Specializes in electronic media, business-to-business and print design. Current clients include Yamaha Corporation, Prudential, Isuzu. Professional affiliations: IICS, NCCC and ITVA.

Needs: Approached by 12 freelancers/year. Works with 12 freelance illustrators and 12 designers/year. Uses freelancers mainly for illustration, design and computer production. Also for brochure and catalog design and illustration, multimedia and logos. 10% of work is with print ads. 90% of design and 50% of illustration demands knowledge of Photoshop, QuarkXPress, Illustrator and Macro Mind Director.

First Contact & Terms: Designers send query letter with photocopies, photographs, résumé and tearsheets. Illustrators send postcard sample. Samples are filed and are not returned. Will contact artist for portfolio review if interested. Portfolio should include b&w and color final art, photographs, photostats, roughs, slides, tearsheets and thumbnails. Pays for design and illustration by the project, depending on budget. Rights purchased vary according to project. Finds artists through sourcebooks and self-promotion pieces received in mail.

Tips: "Be flexible."

■ **LEKASMILLER**, 1460 Maria Lane, Suite 260, Walnut Creek CA 94596. (925)934-3971. Fax: (925)934-3978. E-mail: jenna@lekasmiller.com. **Production Manager:** Jenna O'Neill. Estab. 1979. Specializes in annual reports, corporate identity, advertising, direct mail and brochure design. Clients: corporate and retail. Current clients include Cork Supply USA, California Cable & Telecommunications Association, Sun Valley Mall, Cost Plus World Market and Interhealth.

Needs: Approached by 80 freelance artists/year. Works with 1-3 illustrators and 5-7 designers/year. Prefers local artists only with experience in design and production. Works on assignment only. Uses artists for brochure design and illustration, mechanicals, direct mail design, logos, ad design and illustration. 100% of freelance work demands knowledge of QuarkXPress, Photoshop and Illustrator.

First Contact & Terms: Designers and illustrators should e-mail PDF or résumé and portfolio. Responds only if interested. Considers skill and experience of artist when establishing payment. Negotiates rights purchased.

■ **LINEAR CYCLE PRODUCTIONS**, P.O. Box 2608, San Fernando CA 91393-0608. **Producer:** Rich Brown. Production Manager: R. Borowy. Estab. 1980. Number of employees: 30. Approximate annual billing: $200,000. AV firm. Specializes in audiovisual sales and marketing programs and also in teleproduction for CATV. Current clients include Katz, Inc. and McDave and Associates.

Needs: Works with 7-10 freelance illustrators and 7-10 designers/year. Prefers freelancers with experience in teleproductions (broadcast/CATV/non-broadcast). Works on assignment only. Uses freelancers for story-boards, animation, TV/film graphics, editorial illustration, lettering and logos. 10% of work is with print ads. 25% of freelance work demands knowledge of FreeHand, Photoshop or Tobis IV.

First Contact & Terms: Send query letter with résumé, photocopies, photographs, slides, transparencies, video demo reel and SASE. Samples are filed or are returned by SASE if requested by artist. Responds only if interested. To show portfolio, mail audio/videotapes, photographs and slides; include color and b&w samples. Pays for design and illustration by the project, $100 minimum. Considers skill and experience of artist, how work will be used and rights purchased when establishing payment. Negotiates rights purchased. Finds artists through reviewing portfolios and published material.

Tips: "We see a lot of sloppy work and samples, portfolios in fields not requested or wanted, poor photos, photocopies, graphics, etc. Make sure your materials are presentable."

JACK LUCEY/ART & DESIGN, 84 Crestwood Dr., San Rafael CA 94901. (415)453-3172. **Contact:** Jack Lucey. Estab. 1960. Art agency. Specializes in annual reports, brand and corporate identity, publications, signage, technical illustration and illustrations/cover designs. Clients: businesses, ad agencies and book publishers. Current clients include U.S. Air Force, California Museum of Art & Industry, CNN. Client list available upon request. Professional affiliations: Art Directors Club, Academy of Art Alumni.

Needs: Approached by 20 freelancers/year. Works with 1-2 freelance illustrators/year. Uses mostly local freelancers. Uses freelancers mainly for type and airbrush. Also for lettering for newspaper work.

First Contact & Terms: Query. Prefers photostats and published work as samples. Provide brochures, business card and résumé to be kept on file. Portfolio review not required. Originals are not returned to artist at job's completion. Requests work on spec before assigning a job. Pays for design by the project.

Tips: "Show variety in your work. Many samples I see are too specialized in one subject, one technique, one style (such as air brush only, pen & ink only, etc.). Subjects are often all similar too."

MARKETING BY DESIGN, 2012 19th St., Suite 200, Sacramento CA 95818. (916)441-3050. **Creative Director:** Joel Stinghen. Estab. 1977. Specializes in corporate identity and brochure design, publications, direct mail, trade show, signage, display and packaging. Client: associations and corporations. Client list not available.

Needs: Approached by 50 freelance artists/year. Works with 6-7 freelance illustrators and 1-3 freelance designers/year. Works on assignment only. Uses illustrators mainly for editorial. Also uses freelance artists for brochure and catalog design and illustration, mechanicals, retouching, lettering, ad design and charts/graphs.

First Contact & Terms: Send query letter with brochure, résumé, tearsheets. Samples are filed or are not returned. Does not report back. Artist should follow up with call. Call for appointment to show portfolio of roughs, b&w photostats, color tearsheets, transparencies and photographs. Pays for design by the hour, $10-30; by the project, $50-5,000. Pays for illustration by the project, $50-4,500. Rights purchased vary according to project. Finds designers through word of mouth; illustrators through sourcebooks.

SUDI MCCOLLUM DESIGN, 3244 Cornwall Dr., Glendale CA 91206. (818)243-1345. Fax: (818)243-1345. E-mail: sudimccollum@earthlink.net. **Contact:** Sudi McCollum. Specializes in product design and illustration. Majority of clients are medium-to-large-size businesses. "No specialty in any one industry." Clients: home furnishing and giftware manufacturers, advertising agencies and graphic design studios.

Needs: Use freelance production people—either on computer or with painting and product design skills. Potential to develop into full-time job.

First Contact & Terms: Send query letter "with whatever you have that's convenient." Samples are filed. Responds only if interested.

✓ ▣ **SOFTMIRAGE, INC.**, 2900 Bristol St., Suite A102, Costa Mesa CA 92626. E-mail: contact@softmirage.com. Website: www.softmirage.com. **Design Director:** Steve Pollack. Estab. 1995. Number of employees: 12. Approximate annual billing: $2 million. Visual communications agency. Specializes in architecture, real estate and entertainment. Need people with strong spatial design skills, modeling and ability to work with computer graphics. Current clients include Four Seasons Hotels, UCLA, Ford, Richard Meier & Partners and various architectural firms.

Needs: Approached by 15 computer freelance illustrators and 5 designers/year. Works with 6 freelance 3D modelers, and 10 graphic designers/year. Prefers West coast designers with experience in architecture, engineering, technology. Uses freelancers mainly for concept, work in process computer modeling. Also

for animation, brochure design, mechanicals, multimedia projects, retouching, technical illustration, TV/film graphics. 50% of work is renderings. 100% of design and 30% of illustration demand skills in Photoshop, 3-D Studio Max, SoftImage, VRML, Flash and Director. Need Macromedia Flash developers.

First Contact & Terms: Designers send query letter or e-mail with samples. 3-D modelers send e-mail query letter with photocopies or link to website. Accepts disk and video submissions. Samples are filed or returned by SASE. Will contact for portfolio review if interested. Pays for design by the hour, $15-85. Pays for modeling by the project, $100-2,500. Rights purchased vary according to project. Finds artists through Internet, AIGA and referrals.

Tips: "Be innovative, push the creativity, understand the business rationale and accept technology. Check our website, as we do not use traditional illustrators, all our work is now digital. Send information electronically, making sure work is progressive and emphasizing types of projects you can assist with."

N SPLANE DESIGN ASSOCIATES, 10850 White Oak Ave., Granada Hills CA 91344. (818)366-2069. Fax: (818)831-0114. **President:** Robson Splane. Specializes in product design. Clients: small, medium and large companies. Current clients include Hanson Research, Accurida Corp., Hewlett Packard, Sunrise Corp. Client list available upon request.

Needs: Approached by 25-30 freelancers/year. Works with 1-2 freelance illustrators and 6-12 designers/year. Works on assignment only. Uses illustrators mainly for logos, mailings to clients, renderings. Uses designers mainly for sourcing, drawings, prototyping, modeling. Also uses freelancers for brochure design and illustration, ad design, mechanicals, retouching, airbrushing, model making, lettering and logos. 75% of freelance work demands skills in FreeHand, Ashlar Vellum, Solidworks and Excel.

First Contact & Terms: Send query letter with résumé and photocopies. Samples are filed or are returned. Responds only if interested. Will contact artist for portfolio review if interested. Portfolio should include color roughs, final art, photostats, slides and photographs. Pays for design and illustration by the hour, $7-25. Rights purchased vary according to project. Finds artists through submissions and contacts.

JULIA TAM DESIGN, 2216 Via La Brea, Palos Verdes CA 90274. (310)378-7583. Fax: (310)378-4589. E-mail: taandm888@earthlink.net. **Contact:** Julia Tam. Estab. 1986. Specializes in annual reports, corporate identity, brochures, promotional material, packaging and design. Clients: corporations. Current clients include Southern California Gas Co., *Los Angeles Times*, UCLA. Client list available upon request. Professional affiliations: AIGA.

●Julia Tam Design won numerous awards including American Graphic Design Award, Premier Print Award, *Creativity, American Corporate Identity* and work showcased in Rockport Madison Square Press and Northlight graphic books.

Needs: Approached by 10 freelancers/year. Works with 6-12 freelance illustrators 2 designers/year. "We look for special styles." Works on assignment only. Uses illustrators mainly for brochures. Also uses freelancers for brochure design and illustration; catalog and ad illustration; retouching; and lettering. 50-100% of freelance work demands knowledge of QuarkXPress, Illustrator or Photoshop.

First Contact & Terms: Designers send query letter with brochure and résumé. Illustrators send query letter with résumé and tearsheets. Samples are filed. Responds only if interested. Artist should follow up. Portfolio should include b&w and color final art, tearsheets and transparencies. Pays for design by the hour, $10-20. Pays for illustration by the project. Negotiates rights purchased. Finds artists through *LA Workbook*.

THARP DID IT, 50 University Ave., Loft 21, Los Gatos CA 95030. Website: www.TharpDidIt.com. **Art Director/Designer:** Mr. Tharp. Estab. 1975. Specializes in brand identity; corporate, non-corporate, and retail visual identity; packaging; and environmental graphic design. Clients: direct and through agencies. Current clients include Harmony Foods, Buckhorn Grill, Steven Kent Winery. Professional affiliations: American Institute of Graphic Arts (AIGA), Society for Environmental Graphic Design (SEGD), Western Art Directors Club (WADC), TDCTJHTBIPC (The Design Conference That Just Happens To Be In Park City).

●Tharp Did It won a gold medal in the International Packaging Competition at the 30th Vinitaly in Verona, Italy, for wine label design. Their posters for BRIO Toys are in the Smithsonian Institution's National Design Museum archives.

Needs: Approached by 150-300 freelancers/year. Works with 3-5 freelance illustrators each year.

First Contact & Terms: Send query letter with printed promotional material. Samples are filed or are returned by SASE. Will contact artist for portfolio review if interested. "No phone calls please. We'll call you." Pays for illustration by the project, $100-10,000. Considers client's budget and how work will be

THE BEST IN...

PRODUCT DESIGN: from cars to kitchen sinks, tires to televisions, we cover the new and notable

GRAPHIC DESIGN: breakout design in books, periodicals, brochures, annual reports, packaging, signage and more

INTERACTIVE DESIGN: the latest games, Web sites, CD-ROMs and software

ENVIRONMENTAL DESIGN: from restaurants and museums to schools, offices and boutiques, you'll take a tour of the world's best environmental design

I.D.® THE BEST IN DESIGN

used when establishing payment. Rights purchased vary according to project. Finds artists through awards annuals, sourcebooks, and submissions/self-promotions.

TRIBOTTI DESIGNS, 22907 Bluebird Dr., Calabasas CA 91302-1832. (818)591-7720. Fax: (818)591-7910. E-mail: bob4149@aol.com. Website: www.tribotti.com. **Contact:** Robert Tribotti. Estab. 1970. Number of employees: 2. Approximate annual billing: $200,000. Specializes in graphic design, annual reports, corporate identity, packaging, publications and signage. Clients: PR firms, ad agencies, educational institutions and corporations.

Needs: Approached by 8-10 freelancers/year. Works with 2-3 freelance illustrators and 1-2 designers/year. Prefers local freelancers only. Works on assignment only. Uses freelancers mainly for brochure illustration. Also for catalogs, charts/graphs, lettering and ads. Prefers computer illustration. 100% of freelance design and 50% of illustration demand knowledge of PageMaker, Illustrator, QuarkXPress, Photoshop, FreeHand. Needs illustration for annual reports/brochures.

First Contact & Terms: Send postcard sample or query letter with brochure, photocopies and résumé. Accepts submissions on disk compatible with PageMaker 6.5, Illustrator or Photoshop. Send EPS files. Will contact artist for portfolio review if interested. Portfolio should include thumbnails, roughs, original/final art, final reproduction/product and b&w and color tearsheets, photostats and photographs. Pays for design by the hour, $50-75. Pays for illustration by the project, $100-1,000. Rights purchased vary according to project. Finds artists through word of mouth and self-promotion mailings.

Tips: "We will consider experienced artists only. Must be able to meet deadlines. Send printed samples. We look for talent and a willingness to do a very good job."

THE VAN NOY GROUP, 3315 Westside Rd., Healdsburg CA 95448-9453. (707)433-3944. Fax: (707)433-0375. E-mail: jim@vannoygroup.com. Website: www.vannoygroup.com. **Vice President:** Ann Van Noy. Estab. 1972. Specializes in package design, brand and corporate identity, displays and package design. Clients: corporations. Current clients include Waterford, Wedgewood USA, Leiner Health Products, Pentel of America. Client list available upon request.

Needs: Approached by 1-10 freelance artists/year. Works with 2 illustrators and 3 designers/year. Prefers artists with experience in Macintosh design. Works on assignment only. Uses freelancers for packaging design and illustration, Quark and Photoshop production and lettering.

First Contact & Terms: Send query letter with résumé and photographs. Samples are filed. Will contact artist for portfolio review if interested. If no reply, artist should follow up. Pays for design by the hour, $35-100. Pays for illustration by the hour or by the project at a TBD fee. Finds artists through sourcebooks, self-promotions and primarily agents. Also have permanent positions available.

Tips: "I think more and more clients will be setting up internal art departments and relying less and less on outside designers and talent. The computer has made design accessible to the user who is not design-trained."

VISUAL AID/VISAID MARKETING, Box 4502, Inglewood CA 90309. (310)399-0696. **Manager:** Lee Clapp. Estab. 1961. Number of employees: 3. Distributor of promotion aids, marketing consultant service, "involved in all phases." Specializes in manufacturers, distributors, publishers and graphics firms (printing and promotion) in 23 SIC code areas.

Needs: Approached by 25-50 freelancers/year. Works with 1-2 freelance illustrators and 6-12 designers/year. Prefers freelancers with experience in animation, film/video production, multimedia. Uses freelancers for animation, billboards, brochure illustration, catalog design and illustration, direct mail, logos, posters, signage.

First Contact & Terms: Works on assignment only. Send postcard sample or query letter with brochure, photostats, duplicate photographs, photocopies and tearsheets to be kept on file. Responds if interested and has assignment. Write for appointment to show portfolio. Negotiates payment. $100-500. Considers skill and experience of artist and turnaround time when establishing payment.

Tips: "Do not say 'I can do anything.' We want to know the best media you work in (pen & ink, line drawing, illustration, layout, etc.)."

WESCO GRAPHICS, INC., 410 E. Grant Line Rd., #B, Tracy CA 95376. (209)832-1000. Fax: (209)832-7800. **Art Director:** Dawn Hill. Estab. 1977. Number of employees: 20. Service-related firm. Specializes in design, layout, typesetting, paste-up, ads and brochures. Clients: retailers. Current clients include Ben Franklin Crafts, Food 4 Less, Auto Deals.

Needs: Approached by 10 freelancers/year. Works with 2 freelance illustrators and 2 designers/year.

Prefers local freelancers with experience in paste-up and color. Works on assignment only. Uses freelancers mainly for overload. Also for ad and brochure layout. Needs computer-literate freelancers for production. 90% of freelance work demands skills in Illustrator, QuarkXPress, Photoshop and Multi Ad Creator.

First Contact & Terms: Send query letter with résumé. Samples are filed. Will contact artist for portfolio review if interested. Artist should follow up with call. Portfolio should include b&w thumbnails, roughs, photostats and tearsheets. Sometimes requests work on spec before assigning a job. Pays for design and illustration by the hour, $10-15. Buys all rights. Finds artists through word of mouth.

Tips: "Combine computer knowledge with traditional graphic skills."

■ ▓ **DANA WHITE PRODUCTIONS, INC.**, 2623 29th St., Santa Monica CA 90405. (310)450-9101. E-mail: dwprods@aol.com. **Owner/Producer:** Dana C. White. AV firm. "We are a full-service audiovisual production company, providing multi-image and slide-tape, video and audio presentations for training, marketing, awards, historical and public relations uses. We have complete inhouse production resources, including computer multimedia, photo digitizing, image manipulation, program assembly, slide-making, soundtrack production, photography and AV multi-image programming. We serve major industries such as US Forest Services, GTE; medical, such as Whittier Hospital, Florida Hospital; schools, such as University of Southern California, Pepperdine University; publishers, such as McGraw-Hill, West Publishing; and public service efforts, including fundraising."

Needs: Works with 8-10 freelancers/year. Prefers freelancers local to greater Los Angeles, "with timely turnaround, ability to keep elements in accurate registration, neatness, design quality, imagination and price." Uses freelancers for design, illustration, retouching, characterization/animation, lettering and charts. 50% of freelance work demands knowledge of Illustrator, FreeHand, Photoshop, Quark and Premier.

First Contact & Terms: Send query letter with brochure or tearsheets, photostats, photocopies, slides and photographs. Samples are filed or are returned only if requested. Responds in 2 weeks only if interested. Call or write for appointment to show portfolio. Pays by the project. Payment negotiable by job.

Tips: "These are tough times. Be flexible. Negotiate. Your work should show that you have spirit, enjoy what you do and that you can deliver high quality work on time"

■ **YAMAGUMA & ASSOCIATES**, YAD2M Creative, 255 N. Market St., #120, San Jose CA 95110-2409. (408)279-0500. Fax: (408)293-7819. E-mail: sayd2m@aol.com or info@yad2m.com. Website: www.yad2m.com. Estab. 1980. Specializes in corporate identity, displays, direct mail, publication design, signage and marketing. Clients: high technology, government and business-to-business. Current clients include Sun Microsystems, ASAT, BOPS and Xporta. Client list available upon request.

Needs: Approached by 6 freelancers/year. Works with 3 freelance illustrators and 2 designers/year. Works on assignment only. Uses illustrators mainly for 4-color, airbrush and technical work. Uses designers mainly for logos, layout and production. Also uses freelancers for brochure, catalog, ad, P-O-P and poster design and illustration; mechanicals; retouching; lettering; book, magazine, model-making; direct mail design; charts/graphs; and AV materials. Also for multimedia projects (Director SuperCard). Needs editorial and technical illustration. 100% of design and 75% of illustration demand knowledge of PageMaker, QuarkXPress, FreeHand, Illustrator, Model Shop, Strata, MMDir. or Photoshop.

First Contact & Terms: Send postcard sample or query letter with brochure and tearsheets. Accepts disk submissions compatible with Illustrator, QuarkXPress, Photoshop and Strata. Samples are filed. Will contact artist for portfolio review if interested. Portfolio should include thumbnails, roughs, b&w and color photostats, tearsheets, photographs, slides and transparencies. Sometimes requests work on spec before assigning a job. Pays for design by the hour, $15-50. Pays for illustration by the project, $300-3,000. Rights purchased vary according to project. Finds artists through self-promotions.

Tips: Would like to see more Macintosh-created illustrations.

Los Angeles

ASHCRAFT DESIGN, 11832 W. Pico Blvd., Los Angeles CA 90064. (310)479-8330. Fax: (310)473-7051. E-mail: information@ashcraftdesign.com. Website: www.ashcraftdesign.com. Estab. 1986. Specializes in corporate identity, display and package design and signage. Client list available upon request.

Needs: Approached by 2 freelance artists/year. Works with 1 freelance illustrator and 2 freelance designers/year. Works on assignment only. Uses freelance illustrators mainly for technical illustration. Uses freelance designers mainly for packaging and production. Also uses freelance artists for mechanicals and model making.

First Contact & Terms: Send query letter with tearsheets, résumé and photographs. Samples are filed and are not returned. Responds only if interested. To show a portfolio, e-mail samples or mail color copies. Pays for design and illustration by the project. Rights purchased vary according to project.

N ⚘ BRAMSON + ASSOCIATES, 7400 Beverly Blvd., Los Angeles CA 90036. (323)938-3595. Fax: (323)938-0852. E-mail: gbramson@aol.com. **Art Director:** Gene. Estab. 1970. Number of employees: 12. Approximate annual billing: more than $2 million. Advertising agency. Specializes in magazine ads, collateral, ID, signage, graphic design, imaging, campaigns. Product specialties are healthcare, consumer, business to business. Current clients include Johnson & Johnson, Chiron Vision, Lawry's and Surgin, Inc.
Needs: Approached by 150 freelancers/year. Works with 10 freelance illustrators, 2 animators and 5 designers/year. Prefers local freelancers. Works on assignment only. Uses freelancers for brochure and print ad design; brochure, technical, medical and print ad illustration, storyboards, mechanicals, retouching, lettering, logos. 30% of work is with print ads. 50% of freelance work "prefers" knowledge of Pagemaker, Illustrator, QuarkXPress, Photoshop, Freehand or 3-D Studio.
First Contact & Terms: Send query letter with brochure, photocopies, résumé, photographs, tearsheets, SASE. Samples are filed. Will contact artist for portfolio review if interested. Portfolio should include roughs, color tearsheets. Sometimes requests work on spec before assigning job. Pays for design by the hour, $15-25. Pays for illustration by the project, $250-2,000. Buys all rights or negotiates rights purchased. Finds artists through sourcebooks.
Tips: Looks for "very unique talent only." Price and availability are also important.

■ GRAPHIC DESIGN CONCEPTS, 15329 Yukon Ave., El Camino Village CA 90260-2452. (310)978-8922. **President:** C. Weinstein. Estab. 1980. Specializes in package, publication and industrial design, annual reports, corporate identity, displays and direct mail. Current clients include Trust Financial Financial Services (marketing materials). Current projects include new product development for electronic, hardware, cosmetic, toy and novelty companies.
Needs: Works with 15 illustrators and 25 designers/year. "Looking for highly creative idea people, all levels of experience." All styles considered. Uses illustrators mainly for commercial illustration. Uses designers mainly for product and graphic design. Also uses freelancers for brochure, P-O-P, poster and catalog design and illustration; book, magazine, direct mail and newspaper design; mechanicals; retouching; airbrushing; model-making; charts/graphs; lettering; logos. Also for multimedia design, program and content development. 50% of freelance work demands knowledge of PageMaker, Illustrator, QuarkXPress, Photoshop or FreeHand.
First Contact & Terms: Send query letter with brochure, résumé, tearsheets, photostats, photocopies, slides, photographs and/or transparencies. Accepts disk submissions compatible with Windows on the IBM. Samples are filed or are returned if accompanied by SASE. Responds in 10 days with SASE. Portfolio should include thumbnails, roughs, original/final art, final reproduction/product, tearsheets, transparencies and references from employers. Pays by the hour, $15-50. Considers complexity of project, client's budget, skill and experience of artist, how work will be used, turnaround time and rights purchased when establishing payment.
Tips: "Send a résumé if available. Send samples of recent work or *high quality* copies. Everything sent to us should have a professional look. After all, it is the first impression we will have of you. Selling artwork is a business. Conduct yourself in a business-like manner."

■ RHYTHMS PRODUCTIONS, P.O. Box 34485, Los Angeles CA 90034. (310)836-4678. **President:** Ruth White. Estab. 1955. AV firm. Specializes in CD-ROM and music production/publication. Product specialty is educational materials for children.
Needs: Works with 2 freelance illustrators and 2 designers/year. Prefers artists with experience in cartoon animation and graphic design. Works on assignment only. Uses freelancers artists mainly for cassette covers, books, character design. Also for catalog design, multimedia, animation and album covers. 2% of work is with print ads. 75% of design and 50% of illustration demands graphic design computer skills.
First Contact & Terms: Send query letter with photocopies and SASE (if you want material returned). Samples are returned by SASE if requested. Responds in 2 months only if interested. Will contact artist for portfolio review if interested. Pays for design and illustration by the project. Buys all rights. Finds artists through word of mouth and submissions.

N STUDIO WILKS, 2148-A Federal Ave., Los Angeles CA 90025. (310)478-4442. Fax: (310)478-0013. Estab. 1990. Specializes in print, collateral, packaging, editorial and environmental work. Clients:

ad agencies, architects, corporations and small business owners. Current clients include Walt Disney Co., Major League Soccer and Yoga Works.

Needs: Works with 6-10 freelance illustrators and 10-20 designers/year. Uses illustrators mainly for packaging illustration. Also for brochures, print ads, collateral, direct mail and promotions.

First Contact & Terms: Designers send query letter with brochure, résumé, photocopies and tearsheets. Illustrators send postcard sample or query letter with tearsheets. Samples are returned by SASE if requested by artist. Will contact artist for portfolio review if interested. Pays for design by the project. Buys all rights. Considers buying second rights (reprint rights) to previously published work. Finds artists through *The Workbook* and word of mouth.

San Francisco

◼ **THE AD AGENCY**, P.O. Box 470572, San Francisco CA 94147. **Creative Director:** Michael Carden. Estab. 1972. Ad agency. Full-service multimedia firm. Specializes in print, collateral, magazine ads. Client list available upon request.

Needs: Approached by 120 freelancers/year. Works with 120 freelance illustrators and designers/year. Uses freelancers mainly for collateral, magazine ads, print ads. Also for brochure, catalog and print ad design and illustration, mechanicals, billboards, posters, TV/film graphics, multimedia, lettering and logos. 60% of freelance work is with print ads. 50% of freelance design and 45% of illustration demand computer skills.

First Contact & Terms: Send query letter with brochure, photocopies and SASE. Samples are filed or returned by SASE. Responds in 1 month. Portfolio should include color final art, photostats and photographs. Buys first rights or negotiates rights purchased. Finds artists through word of mouth, referrals and submissions.

Tips: "We are an eclectic agency with a variety of artistic needs."

◫ **CAHAN & ASSOCIATES**, 171 Second St., 5th Floor, San Francisco CA 94105. (415)621-0915. Fax: (415)621-7642. E-mail: info@cahan.com. Website: www.cahanassociates.com. **President:** Bill Cahan. Estab. 1984. Specializes in annual reports, corporate identity, package design, signage, business and business collateral. Clients: public and private companies: real estate, finance and biotechnology. Client list available upon request.

Needs: Approached by 50 freelance artists/year. Works with 5-10 freelance illustrators and 3-5 freelance designers/year. Works on assignment only. Uses freelance illustrators mainly for annual reports. Uses freelance designers mainly for overload cases. Also uses freelance artists for brochure design.

First Contact & Terms: Send query letter with brochure, tearsheets, photostats, résumé, photographs, and photocopies. Samples are filed and are not returned. Responds only if interested. To show a portfolio, mail thumbnails, roughs, tearsheets, and transparencies. Pays for design or illustration by the hour or by the project. Negotiates rights purchased.

◪ **BRENT A. JONES DESIGN**, 328 Hayes St., San Francisco CA 94102. (415)626-8337. E-mail: jonesdes@pacbell.net. **Principal:** Brent Jones. Estab. 1983. Specializes in corporate identity and advertising design. Clients: corporations, museums, book publishers, retail establishments. Client list available upon request.

Needs: Approached by 1-3 freelancers/year. Works with 2 freelance illustrators and 1 designer/year. Prefers local freelancers only. Works on assignment only. Uses illustrators mainly for renderings. Uses designers mainly for production. Also uses freelancers for brochure and ad design and illustration, mechanicals, catalog illustration and charts/graphs. "Computer literacy a must." Needs computer-literate freelancers for production. 95% of freelance work demands knowledge of QuarkXPress, Illustrator and Photoshop.

First Contact & Terms: Send query letter with brochure and tearsheets. Samples are filed and are not returned. Responds in 2 weeks only if interested. Write for appointment to show portfolio of slides, tearsheets and transparencies. Payment for design is negotiable; or by the project. Pays for illustration by the project. Rights purchased vary according to project.

◫ **MEDIA SERVICES CORP.**, 10 Aladdin Terrace, San Francisco CA 94133. (415)928-3033. Fax: (415)928-1366. E-mail: msc94133@aol.com. **Design Director:** Betty Wilson. Estab. 1974. Number of employees: 4. Approximate annual billing: $750,000. Ad agency. Specializes in publishing and package design. Product specialties are publishing and consumer. Current clients include San Francisco Earthquake

Map and Guide, First Aid for the Urban Cat, First Aid for the Urban Dog.
Needs: Approached by 3 freelance artists/month. Works with 1-2 illustrators and 2 designers/month. Prefers artists with experience in package design with CAD. Works on assignment only. Uses freelancers mainly for support with mechanicals, retouching and lettering. 5% of work is with print ads.
First Contact & Terms: Designers send query letter with résumé. Illustrators send postcard sample. Samples are filed or are returned by SASE only if requested by artist. Responds only if interested. To show portfolio, mail tearsheets or 5×7 transparencies. Payment for design and illustration varies. Rights purchased vary according to project.
Tips: Wants to see "computer literacy and ownership."

TOKYO DESIGN CENTER, 703 Market St., Suite 252, San Francisco CA 94103. (415)543-4886. **Creative Director:** Kaoru Matsuda. Specializes in annual reports, brand identity, corporate identity, packaging and publications. Clients: consumer products, travel agencies and retailers.
Needs: Uses artists for design and editorial illustration.
First Contact & Terms: Send business card, slides, tearsheets and printed material to be kept on file. Samples not kept on file are returned by SASE only if requested. Will contact artist for portfolio review if interested. Pays for design and illustration by the project, $100-1,500 average. Sometimes requests work on spec before assigning job. Considers client's budget, skill and experience of artist, turnaround time and rights purchased when establishing payment. Interested in buying second rights (reprint rights) to previously published work. Finds artists through self-promotions and sourcebooks.

Colorado

BARNSTORM VISUAL COMMUNICATIONS, INC., (formerly Barnstorm Design/Creative), 530 E. Colorado Ave., Colorado Springs CO 80903. (719)630-7200. Fax: (719)630-3280. Website: www.barnstormdesign.com. **Owner:** Becky Houston. Estab. 1975. Specializes in corporate identity, brochure design, publications, web design and Internet marketing. Clients: high-tech corporations, nonprofit fundraising, business-to-business and restaurants. Current clients include Liberty Wire and Cable, Colorado Springs Visitors Bureau and Billiard Congress of America.
Needs: Works with 2-4 freelance artists/year. Prefers local, experienced (clean, fast and accurate) artists with experience in TV/film graphics and multimedia. Works on assignment only. Uses freelancers mainly for editorial and technical illustration and production. Needs computer-literate freelancers for production. 90% of freelance work demands knowledge of Illustrator, QuarkXPress, Photoshop and Macromedia FreeHand.
First Contact & Terms: Send query letter with résumé and samples to be kept on file. Prefers "good originals or reproductions, professionally presented in any form" as samples. Samples not filed are returned by SASE. Responds only if interested. Call or write for appointment to show portfolio. Pays for design by the hour/$15-40. Pays for illustration by the project, $500 minimum for b&w. Considers client's budget, skill and experience of artist, and turnaround time when establishing payment.
Tips: "Portfolios should reflect an awareness of current trends. We try to handle as much inhouse as we can, but we recognize our own limitations (particularly in illustration). Do not include too many samples in your portfolio."

JO CULBERTSON DESIGN, INC., 939 Pearl St., Denver CO 80203. (303)861-9046. E-mail: joculdes@aol.com. **President:** Jo Culbertson. Estab. 1976. Number of employees: 1. Approximate annual billing: $200,000. Specializes in direct mail, packaging, publication and marketing design, annual reports, corporate identity, and signage. Clients: corporations, not-for-profit organizations. Current clients include Love Publishing Company, American Cancer Society, Nurture Nature, Clarus Products Intl., Sun Gard Insurance Systems. Client list available upon request.
Needs: Approached by 15 freelancers/year. Works with 2 freelance illustrators/year. Prefers local freelancers only. Works on assignment only. Uses illustrators mainly for corporate collateral pieces, illustration and ad illustration. 50% of freelance work demands knowledge of QuarkXPress, Photoshop, CorelDraw.
First Contact & Terms: Send query letter with résumé, tearsheets and photocopies. Samples are filed. Reports back to the artist only if interested. Artist should follow up with call. Portfolio should include b&w and color thumbnails, roughs and final art. Pays for design by the project, $250 minimum. Pays for

illustration by the project, $100 minimum. Finds artists through file of résumés, samples, interviews.

Connecticut

■ COPLEY MEDIAWORKS, 18 Reef Rd., Fairfield CT 06430. Mailing address: P.O. Box 751, Fairfield CT 06430. (203)259-0525. Fax: (203)259-3321. E-mail: acopley@snet.net. **Production Director:** Alyce Kavanagh. Estab. 1987. Number of employees: 6. Approximate annual billing: $2,600,000. Integrated marketing communications agency. Specializes in television, business-to-business print. Product specialties are sports, publishing.
Needs: Approached by 12 freelance illustrators and 20 designers/year. Works with 2 freelance illustrators and 2 designers/year. Uses freelancers mainly for brochures and ads. Also for brochure illustration, catalog design, lettering, logos, mechanicals, storyboards, TV/film graphics. 25% of work is with print ads. 100% of freelance design demands skills in PageMaker, Photoshop, QuarkXPress, Illustrator. 50% of freelance illustration demands skills in Photoshop and Illustrator.
First Contact & Terms: Send query letter with brochure and résumé. Accepts disk submissions compatible with QuarkXPress. Samples are filed. Will contact for portfolio review if interested. Pays by project. Buys all rights. Finds artists through word of mouth, magazines, submissions.
Tips: "Bring overall business sense plus sense of humor. Must be punctual, trustworthy."

Ⓝ FORDESIGN GROUP, 87 Dayton Rd., Redding CT 06896. (203)938-0008. Fax: (203)938-3326. E-mail: steven@fordesign.net. Website: www.fordesign.net. **Principal:** Steve Ford. Estab. 1990. Specializes in brand and corporate identity, package and publication design and signage. Clients: corporations. Current clients include Sony, IBM, Cadbury Beverage, Carrs, MasterCard. Professional affiliations: AIGA, PDC.
Needs: Approached by 100 freelancers/year. Works with 4-6 freelance illustrators and 4-6 designers/year. Uses illustrators mainly for brochures, ads. Uses designers mainly for corporate identity, packaging, collateral. Also uses freelancers for ad and brochure design and illustration, logos. Needs bright, conceptual designers and illustrators. 90% of freelance work demands skills in Illustrator, Photoshop, FreeHand and QuarkXPress.
First Contact & Terms: Send postcard sample of work or send photostats, slides and transparencies. Samples are filed or returned by SASE if requested by artist. Will contact artist for portfolio review if interested. Portfolio should include b&w and color samples. Pays for design by the hour or by the project. Pays for illustration by the project.
Tips: "We are sent all *Showcase*, *Workbook*, etc." Impressed by "great work, simply presented." Advises freelancers entering the field to save money on promotional materials by partnering with printers. Create a joint project or tie-in. "Send out samples—good luck!"

■ FREELANCE EXCHANGE, INC., P.O. Box 1165, Glastonbury CT 06033-6165. (860)633-8116. Fax: (860)633-8106. E-mail: stella@freelance-exchange.com. Website: www.freelance-exchange.com. **President:** Stella Neves. Estab. 1983. Number of employees: 3. Approximate annual billing: $850,000. Specializes in annual reports, brand and corporate identity, direct mail, package and publication design, web page design, illustration (cartoon, realistic, technical, editorial, product and computer). Clients: corporations, nonprofit organizations, state and federal government agencies and ad agencies. Current clients include Lego Systems, PHS, Hartford Courant. Client list available upon request. Professional affiliations: GAIG, Connecticut Art Directors Club.
Needs: Approached by 350 freelancers/year. Works with 25-40 freelance illustrators and 30-50 designers/year. Prefers freelancers with experience in publications, website design, consumer products and desktop publishing. "Home page and website design are becoming more important and requested by clients." Works on assignment only. Uses illustrators mainly for editorial and computer illustration. Design projects vary. 100% of design and 50% of illustration demand knowledge of PageMaker, QuarkXPress, FreeHand, Illustrator, Photoshop, Persuasion, Powerpoint, Macromind Director, Page Mill or Hot Metal.
First Contact & Terms: Designers send postcard sample or query letter with résumé, SASE, brochure, tearsheets and photocopies. Illustrators send postcard sample or query letter with résumé, photocopies, photographs, SASE, slides and tearsheets. Samples are filed and are returned by SASE. Visit website for contact information. Pays for design by the project, $500 minimum. Pays for illustration by the project, $300 minimum. Rights purchased vary according to project.
Tips: "Send us one sample of your best work that is unique and special. All styles and media are OK, but

we're really interested in computer-generated illustration and websites. If you want to make money, learn to use the new technology. The 'New Media' is where our clients want to be, so adjust your portfolio accordingly. Your portfolio must be spectacular (I don't want to see student work). Having lots of variety and being well-organized will encourage us to take a chance on an unknown artist."

■ **MCKENZIE/HUBBELL CREATIVE SERVICES**, 5 Iris Lane, Westport CT 06880. (203)454-2443. Fax: (203)222-8462. E-mail: dmckenzie@mckenziehubbell.com or nhubbell@mckenziehubbell.com. Website: www.mckenziehubbell.com. **Principal:** Dona McKenzie. Specializes in business to business communications, annual reports, corporate identity, direct mail and publication design. Expanded services include: copywriting and editing, advertising and direct mail, marketing and public relations, website design and development, and multimedia and CD-ROM.

Needs: Approached by 100 freelance artists/year. Works with 5 freelance designers/year. Uses freelance designers mainly for computer design. Also uses freelance artists for brochure and catalog design. 100% of design and 50% of illustration demand knowledge of QuarkXPress 4.0, Illustrator 8.0 and Photoshop 5.5.

First Contact & Terms: Send query letter with brochure, résumé, photographs and photocopies. Samples are filed or are returned by SASE if requested by artist. Write to schedule an appointment to show a portfolio. Pays for design by the hour, $25-75. Pays for illustration by the project, $150-3,000. Rights purchased vary according to project.

N ■ **ULTITECH, INC.**, Foot of Broad St., Stratford CT 06615. (203)375-7300. Fax: (203)375-6699. E-mail: comcowic@meds.com. Website: www.meds.com. **President:** W.J. Comcowich. Estab. 1993. Number of employees: 3. Approximate annual billing: $1 million. Integrated marketing communications agency. Specializes in interactive multimedia, software, online services. Product specialties are medicine, science, technology. Current clients include Glaxo, Smithkline, Pharmacia, Baxter. Professional affiliation: IMA.

Needs: Approached by 10-20 freelance illustrators and 10-20 designers/year. Works with 2-3 freelance illustrators and 6-10 designers/year. Prefers freelancers with experience in interactive media design and online design. Uses freelancers mainly for interactive media—online design (WWW). Also for animation, brochure and web page design, medical illustration, multimedia projects, TV/film graphics. 10% of work is with print ads. 100% of freelance design demands skills in Photoshop, QuarkXPress, Illustrator, 3D packages.

First Contact & Terms: Designers send query letter with résumé. Illustrators send postcard sample and/or query letter with photocopies, résumé, tearsheets. Prefers e-mail submission. Samples are filed. Responds only if interested. Request portfolio review in original query. Pays for design by the project or by the day. Pays for illustration by the project. Buys all rights. Finds artists through sourcebooks, word of mouth.

Tips: "Learn design principles for interactive media."

Delaware

CUSTOM CRAFT STUDIO, 310 Edgewood St., Bridgeville DE 19933. (302)337-3347. Fax: (302)337-3444. **Vice President:** Eleanor H. Bennett. AV producer.

Needs: Works with 12 freelance illustrators and 12 designers/year. Works on assignment only. Uses freelancers mainly for work on filmstrips, slide sets, trade magazines and newspapers. Also for print finishing, color negative retouching and airbrush work. Prefers pen & ink, airbrush, watercolor and calligraphy. 10% of freelance work demands knowledge of Illustrator. Needs editorial and technical illustration.

First Contact & Terms: Send query letter with résumé, slides or photographs, brochure/flyer and tearsheets to be kept on file. Samples returned by SASE. Responds in 2 weeks. Originals not returned. Pays by the project, $25 minimum.

N ■ **GLYPHIX ADVERTISING**, 105 Second St., Lewes DE 19958. (302)645-0706. Fax: (302)645-2726. E-mail: rjundt@shore.intercom.net. Website: www.glyphixadv.com. **Creative Director:** Richard Jundt. Estab. 1981. Number of employees: 2. Approximate annual billing: $200,000. Ad agency. Specializes in collateral and advertising. Current clients include local colleges, ATR Galleries locally and New York City and Cytec Industries. Client list available upon request.

Needs: Approached by 10-20 freelancers/year. Works with 2-3 freelance illustrators and 2-3 designers/year. Prefers local artists only. Uses freelancers mainly for "work I can't do." Also for brochure and

catalog design and illustration and logos. 20% of work is with print ads. 100% of freelance work demands knowledge of Photoshop, QuarkXPress, Illustrator and Delta Graph.

First Contact & Terms: Send query letter with samples. Responds in 10 days if interested. Artist should follow-up with call. Portfolio should include b&w and color final art, photographs and roughs. Buys all rights. Finds artists through word of mouth and submissions.

Washington DC

LOMANGINO STUDIO INC., 1042 Wisconsin Ave., Washington DC 20007. (202)338-4110. Fax: (202)338-4111. Website: www.lomangino.com. **President:** Donna Lomangino. Estab. 1987. Number of employees: 6. Specializes in annual reports, corporate identity, website and publication design. Clients: corporations, nonprofit organizations. Client list available upon request. Professional affiliations: AIGA Washington DC.

Needs: Approached by 25-50 freelancers/year. Works with 1 freelance illustrator/year. Uses illustrators and production designers occasionally for publication. Also for multimedia projects. Accepts disk submissions, but not preferable. 99% of design work demands skills in Illustrator, Photoshop and QuarkXPress.

First Contact & Terms: Send postcard sample of work. Samples are filed. Will contact artist for portfolio review if interested. Pays for design and illustration by the project. Finds artists through sourcebooks, word of mouth and studio files.

Tips: "Please don't call. Send samples for consideration."

VISUAL CONCEPTS, 5410 Connecticut Ave., Washington DC 20015. (202)362-1521. **Owner:** John Jacobin. Estab. 1984. Service-related firm. Specializes in visual presentation, mostly for trade show exhibits and retail stores. Clients: retail stores, trade show industry, residential and commercial spaces. Current clients include Follies Paris, Moschino, White Rice.

Needs: Approached by 15 freelancers/year. Works with 2 freelance designers/year. Assigns 10-20 projects/year. Prefers local artists with experience in visual merchandising and 3-D exhibit building. Works on assignment only. Uses freelancers mainly for design and installation. Prefers contemporary, vintage or any classic styles. Also uses freelancers for editorial, brochure and catalog illustration, advertising design and layout, illustration, signage, and P-O-P displays.

First Contact & Terms: Contact through artist rep or send query letter with brochure showing art style or résumé and samples. Samples are filed. Call for appointment to show portfolio of thumbnails, roughs and color photographs or slides. Pays for design per job. Rights purchased vary according to project.

Florida

BUGDAL GROUP INC., 7314 SW 48th St., Miami FL 33155. (305)665-6686. Fax: (305)663-1387. E-mail: bugdal@bellsouth.net. **Vice President:** Margarita Spencer. Estab. 1971. Specializes in annual reports, brand and corporate identity, displays/signage design. Clients: corporations, public agencies. Current clients include Spillis Candella & Partners, Ampco Products, Arquitectonica, Camilo Office Furniture and Hellmuth, Obata and Kassabaum. Client list available upon request.

Needs: Approached by 50 freelancers/year. Works with 1 freelance illustrator/year. Prefers local freelancers with experience in signage and corporate. Works on assignment only. Uses illustrators mainly for print, brochure, catalog and ad illustration. Needs computer-literate freelancers for illustration and production. 100% of freelance work demands knowledge of PageMaker, FreeHand, Illustrator or Photoshop.

First Contact & Terms: Send query letter with brochure, résumé, photographs and transparencies. Samples are filed. Responds only if interested. Request portfolio review in original query. Portfolio should include roughs, tearsheets and slides. "Payment depends on the job."

EXHIBIT BUILDERS INC., 150 Wildwood Rd., Deland FL 32720. (386)734-3196. Fax: (386)734-9391. E-mail: art@exhibitbuilders.com. Website: exhibitbuilders.com. **President:** Penny D. Morford. Produces themed custom trade show exhibits and distributes modular and portable displays, and sales centers. Clients: museums, primarily manufacturers, government agencies, ad agencies, tourist attractions and trade show participants.

● Looking for freelance trade show designers.

Needs: Works on assignment only. Uses artists for exhibit/display design murals.

First Contact & Terms: Provide résumé, business card and brochure to be kept on file. Samples returned by SASE. Reports back for portfolio review. Considers complexity of project, skill and experience of artist, how work will be used, turnaround time and rights purchased when establishing payment.

Tips: "Wants to see examples of previous design work for other clients; not interested in seeing school-developed portfolios."

■ **GOLD & ASSOCIATES INC.**, 6000-C Sawgrass Village Circle, Ponte Vedra Beach FL 32082. (904)285-5669. Fax: (904)285-1579. **Creative Director/President:** Keith Gold. Incorporated in 1988. Full-service multimedia, marketing and communications firm. Specializes in graphic design and advertising. Product specialties are entertainment, medical, publishing, tourism and sports. Two locations.

Needs: Approached by over 50 freelancers/year. Works with approximately 15 freelance illustrators/year. Works primarily with artist reps. On basis assignment only. Uses freelancers for annual reports, books, brochures, editorial, technical, print ad illustration; storyboards, animatics, animation, music videos. 50% of work is in print. 50% of freelance work demands knowledge of Illustrator, QuarkXPress and Photoshop.

First Contact & Terms: Contact through artist rep or send query letter with photocopies, tearsheets and capabilities brochure. Samples are filed. Responds only if interested. Request portfolio review in original query. Will contact artists for portfolio review if interested. Follow up with letter after initial query. Portfolio should include tearsheets. "Maximum number of hours is negotiated up front." Pays for illustration by the project, $200-7,500. Buys all rights. Finds artists primarily through sourcebooks and reps.

TOM GRABOSKI ASSOCIATES, INC., 4649 Ponce de Leon Blvd., #401, Coral Gables FL 33146. (305)669-2550. Fax: (305)669-2539. E-mail: mail@tgadesign.com. **President:** Tom Graboski. Estab. 1980. Specializes in exterior/interior signage, environmental graphics, corporate identity, urban design and print graphics. Clients: corporations, cities, museums, a few ad agencies. Current clients include Universal Studios, Florida, Royal Caribbean Cruise Line, The Equity Group, Disney Development, The United States Lines, Delta Queen & American Classic Voyages.

Needs: Approached by 50-80 freelance artists/year. Works with approximately 4-8 designers/draftspersons/year. Prefers artists with a background in signage and knowledge of architecture. Freelance artists used in conjunction with signage projects, occasionally miscellaneous print graphics. 100% of design and 10% of illustration demand knowledge of PageMaker, Illustrator, QuarkXPress or FreeHand.

First Contact & Terms: Send query letter with brochure and résumé. "We will contact designer/artist to arrange appointment for portfolio review. Portfolio should be representative of artist's work and skills; presentation should be in a standard portfolio format." Pays by the project. Payment varies by experience and project. Rights purchased vary by project.

Tips: "Look at what type of work the firm does. Tailor presentation to that type of work." For this firm "knowledge of environmental graphics, detailing, a plus."

N ■ **MYERS, MYERS & ADAMS ADVERTISING, INC.**, 938 N. Victoria Park Rd., Fort Lauderdale FL 33304. (954)523-6262. Fax: (954)523-3517. E-mail: virginia@mmanda.com. Website: www.mmanda.com. **Creative Director:** Virginia Myers. Estab. 1986. Number of employees: 6. Approximate annual billing: $2 million. Ad agency. Full-service, multimedia firm. Specializes in magazines and newspaper ads; radio and TV; brochures; and various collateral. Product specialties are consumer and business-to-business. Current clients include Marine Industries Association and Embassy Suites. Professional affiliation: Advertising Federation.

Needs: Approached by 10-15 freelancers/year. Works with 3-5 freelance illustrators and 3-5 designers/year. Uses freelancers mainly for overflow. Also for animation, brochure and catalog illustration, model-making, posters, retouching and TV/film graphics. 55% of work is with print ads. Needs computer-literate freelancers for illustration and production. 20% of freelance work demands knowledge of PageMaker, Photoshop, QuarkXPress and Illustrator.

First Contact & Terms: Send postcard-size sample of work or send query letter with tearsheets. Samples are filed and are returned by SASE if requested by artist. Will contact artist for portfolio review if interested. Portfolio should include b&w and color final art, roughs, tearsheets and thumbnails. Pays for design and illustration by the project, $50-1,500. Buys all rights. Finds artists through *Creative Black Book*, *Workbook* and artists' submissions.

■ ▮ **ROBERTS COMMUNICATIONS & MARKETING, INC.**, 5405 Cypress Center Dr., Suite 250, Tampa FL 33609-1025. (813)281-0088. Fax: (813)281-0271. Website: www.robertscommunications.

insider report

Lettering artist offers clients a brush with greatness

What do suntan lotion, frozen vegetables, and tissues have in common? All three are products of companies that have relied on lettering artist Eliza S. Holliday for their packaging design needs. In her 25 years of experience as a hand lettering artist, Holliday has enjoyed success working on packaging for products like Coppertone™, Birdseye™, and Kleenex™.

What makes her work sell? She says the secret ingredient is adaptability. "I feel like I can chameleon to any request that's made of me. I can match a look or tone that I'm given, and the final product does not have an Eliza stamp on it." Understanding what clients want and accommodating their needs is what keeps the work coming. Nevertheless, originality and creativity are a large part of her satisfaction. "I'm more interested in creating work that is unique than work that is technically brilliant."

Eliza S. Holliday

While Holliday has always had an interest in art, English was her choice of majors in college. Eventually it was her love of writing and interest in a graphic presentation of her poems that turned her in the direction of the lettering arts. "To this date, I've only had one year of formal art training—in Chicago, in 1981. I went briefly to commercial art school." The larger portion of Holliday's education came from art and calligraphy seminars where she learned paste-up, typography and design, drawing, watercolor, acrylics and even bookbinding. This education in the field gave her the confidence and jumpstart she needed. "I started my own business right out of college, after going to a seminar in England where I met many working calligraphers and realized it was possible," she explains.

Working out of her apartment in Eugene, Oregon, Holliday started out modestly, approaching local print shops for piecework—filling out their certificates, wedding invitations, envelopes and small ads. "I built a small portfolio with this kind of work, along with additional invented samples, and gradually replaced them with better 'real' jobs. Soon, I had a numerous samples of different styles. " At the start, she supplemented her lettering jobs with other design work, such as one brief stint drawing baskets and wicker furniture for an import catalog in town.

Eventually she returned to Chicago in hopes of bigger opportunity. "I had a small professional portfolio to show; my classes at the American Academy added to that, and I made advertising contacts in Chicago. Many of these agencies did handlettering for layouts in the '50s and '60s and still appreciated the work done by hand. I was always well received. Each person I interviewed had someone else they referred me to. I was working right away. "

To keep the work coming in, enlisting a good art rep is a worthy effort, Holliday says, even at a substantial commission. "I have one talent firm in New York that has me on file and calls me for all their lettering jobs. They bid the job and take 25%, and it's totally worth it. I hate

dealing with the business end. I'd rather be doing calligraphy than spending so much time dealing with red tape." While Holliday acknowledges that many of her lettering artist friends look to reps for the bulk of their work, she prefers to primarily rely on old-fashioned word of mouth. "I started out building my business by referral—anyone I worked for learned of me from someone else, so I tended to get folks I liked dealing with." The jobs coming in from ad agencies and PR firms, she feels, often present her with clients more interested in a quick product rather than its quality. "Lots of deadlines, lots of changes, lots of hype. All transactions that transpire between you and customer have to be communicated to the agent, and all that takes time. But different things work for different artists," she says.

After many years in the business, Holliday witnessed the dramatic impact of computer designed fonts on the demand for handlettering. "I used to get asked to do catalog work all the time, and worked for Spiegel, Marshall Fields, and other stores in Chicago. Then there was a period where no calligraphy was used, and now I see computer generated 'handwriting' being used all the time. The same with print ads in magazines—a whole anti-technology look that mimics hand-lettered-looking copy, but when you take a closer look, you can see it's type." The same, she says, is true in packaging. She is reluctant to join the fold of her colleagues in developing a font of her own, feeling it will only further this turn.

While persistence, referrals and a little luck have led to some impressive work, Holliday says she does not earn her full income from lettering jobs alone. Half of her income from calligraphy has always been in teaching. And with a full schedule of workshop appearances

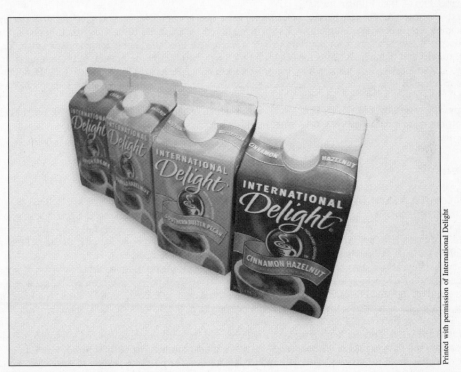

Printed with permission of International Delight

Eliza S. Holliday's calligraphy and lettering have graced many products we use everyday. A trip to your grocers will turn up lots of her work. For example, the word "Delight" on these non-dairy creamer products were penned by Holliday.

throughout the U.S. and Canada—not to mention a mail correspondence course of study in Brush Lettering and Design— she does keep busy.

In addition to acquiring work and building a fine portfolio, Holliday has taught at the Chicago Art Institute School of Design, at seven International Calligraphy Conferences and is co-author with Marilyn Reaves of the instructional manual, *Brush Lettering* (Design Books).

While she says she hasn't penned her way to riches, Holliday is content in her chosen vocation. "I am successful in that I do what I love," she says.

—*Terri See*

For more about Holliday, her current course offerings, or to see samples of her work, visit www.cains. com/eliza.

com. **Creative Director:** Amy Phillips. Art Directors: Chris Rocha and Greg Newcomb. Estab. 1986. Number of employees: 15. Ad agency, PR firm. Full-service multimedia firm. Specializes in integrated communications campaigns using multiple media and promotion. Professional affiliations: AIGA, PRSA, AAF, TBAF and AAAAS.

Needs: Approached by 50 freelancers/year. Works with 15 freelance illustrators and designers/year. Prefers local artists with experience in conceptualization and production knowledge. Uses freelancers for billboards, brochure design and illustration, lettering, logos, mechanicals, posters, retouching and website production. 60% of work is with print ads. 80% of freelance work demands knowledge of Photoshop 5.5, QuarkXPress 4.0 and Illustrator 8.0.

First Contact & Terms: Send postcard sample or query letter with photocopies, résumé and SASE. Samples are filed or are returned by SASE if requested by artist. Portfolios may be dropped off every Monday. Will contact artist for portfolio review if interested. Portfolio should include b&w and color final art, roughs and thumbnails. Pays for design by the hour, $40-80; by the project, $200 minimum; by the day, $200-600. Pays for illustration by the project, negotiable. Refers to Graphic Arts Guild Handbook for fee structure. Rights purchased vary according to project. Finds artists through agents, sourcebooks, seeing actual work done for others, annuals (*Communication Arts*, *Print*, *One Show*, etc.).

Tips: Impressed by "work that demonstrates knowledge of product, willingness to work within budget, contributing to creative process, delivering on-time."

Georgia

N DAUER ASSOCIATES, 1134 Warren Hall Lane, Atlanta GA 30319. (404)252-0248. Fax: (404)252-1018. **President/CEO:** Jacqueline M. Dauer. Estab. 1978. Number of employees: 2. Specialist in researching, concept designing, producing custom, world-class museum quality, digital, full-color, back-lit indoor medal of honor displays. Specializes in annual reports, brand and corporate identity; display, direct mail, fashion, package and publication design; technical illustration and signage.

● Has 50 years experience in the business. Only wants seasoned professionals.

Needs: Approached by hundreds of freelancers/year. Uses freelancers for ad, brochure, catalog, poster and P-O-P design and illustration; airbrushing; audiovisual materials; charts/graphs; direct mail and magazine design; lettering; logos; mechanicals; and model making. Freelancers should be familiar with Illustrator, Photoshop, FreeHand, PageMaker and QuarkXPress.

First Contact & Terms: Send postcard sample of work or send brochure, photocopies, résumé, slides, tearsheets and transparencies. Samples are filed and are not returned. Request portfolio review in original query. Artist should follow up with call. Will contact artist for portfolio review if interested. Portfolio should include "work produced on a professional basis." Pays for design and illustration by the project. Rights purchased vary according to project, most of the time buys all rights.

Tips: "Computer training isn't enough. The idea is the most important thing. Also, you must understand the basics of design. Be professional; be dedicated; be flexible. Learn how to make every art buyer who uses you once want to work with you again and again. Your reputation is at stake—every job counts."

☑ ▣ ▢ **EJW ASSOCIATES, INC.**, Crabapple Village Office Park, 1602 Abbey Court, Alpharetta GA 30004. (770)664-9322. Fax: (770)664-9324. E-mail: advertise@ejwassoc.com. Website: www.ejwasso c.com. **President:** Emil Walcek. Estab. 1982. Ad agency. Specializes in space ads, corporate ID, brochures, show graphics. Product specialty is business-to-business.

Needs: Works with 24 freelance illustrators and 12 designers/year. Prefers local freelancers with experience in Mac computer design and illustration and Photoshop expertise. Works on assignment only. Uses freelancers for brochure, website development, catalog and print ad design and illustration, editorial, technical illustration and logos. 50% of work is with print ads. Needs computer-literate freelancers for design, illustration, production and presentation. 75% of freelance work demands skills in FreeHand, Photoshop, web coding, FLASH.

First Contact & Terms: Send query letter with résumé, photostats, slides and website. Samples are filed or are returned by SASE if requested by artist. Responds only if interested. Write for appointment to show portfolio of thumbnails, roughs, final art, tearsheets. Pays for design by the hour, $40-80; by the day, $300-600; or by the project. Pays for illustration by the project. Buys all rights.

Tips: Looks for "experience in non-consumer, industrial or technology account work. Visit our website first—then e-mail or call. Do not send e-mail attachments."

LORENC & YOO DESIGN, INC., 109 Vickery St., Roswell GA 30075. (770)645-2828. Fax: (770)998-2452. E-mail: jan@lorencyoodesign.com. Website: www.lorencyoodesign.com. **President:** Mr. Jan Lorenc. Specializes in architectural signage design; environmental, exhibit, furniture and industrial design. Clients: corporate, developers, product manufacturers, architects, real estate and institutions. Current clients include Gerald D. Hines Interests, MCI, Georgia-Pacific, IBM, Urban Retail, Mayo Clinic. Client list available upon request.

Needs: Approached by 25 freelancers/year. Works with 5 illustrators and 10 designers/year. Local senior designers only. Uses freelancers for design, illustration, brochures, catalogs, books, P-O-P displays, mechanicals, retouching, airbrushing, posters, direct mail packages, model-making, charts/graphs, AV materials, lettering and logos. Needs editorial and technical illustration. Especially needs architectural signage and exhibit designers. 95% of freelance work demands knowledge of QuarkXPress, Illustrator or FreeHand.

First Contact & Terms: Send brochure, weblink, or CD, résumé and samples to be kept on file. Prefers digital files as samples. Samples are filed or are returned. Call or write for appointment to show portfolio of thumbnails, roughs, original/final art, final reproduction/product and color photostats and photographs. Pays for design by the hour, $40-100; by the project, $250-20,000; by the day, $80-400. Pays for illustration by the hour, $40-100; by the project, $100-2,000; by the day, $80-400. Considers complexity of project, client's budget, and skill and experience of artist when establishing payment.

Tips: "Sometimes it's more cost-effective to use freelancers in this economy, so we have scaled down permanent staff."

📋 ▣ ▢ **T-P DESIGN INC.**, 7007 Eagle Watch Court, Stone Mountain GA 30087. (770)413-8276. Fax: (770)413-9856. E-mail: tpdesign@mindspring.com. **Creative Director:** Charlie Palmer. Estab. 1991. Number of employees: 4. Approximate annual billing: $600,000. Specializes in brand identity, display, package and publication design. Clients: corporations. Current clients include Coca-Cola, Church's, Sprite, Powerade.

Needs: Approached by 4 freelancers/year. Works with 2 freelance illustrators and 2 designers/year. Prefers local artists with Mac systems, traditional background. Uses illustrators and designers mainly for comps and illustration on Mac. Also uses freelancers for ad, brochure, poster and P-O-P design and illustration; book design, charts/graphs, lettering, logos, mechanicals (important) and page layout. Also for multimedia projects. 75% of freelance work demands skills in Illustrator, Photoshop, FreeHand and QuarkXPress. "Knowledge of multimedia programs such as Director and Premier would also be desirable."

First Contact & Terms: Send query letter or photocopies, résumé and tearsheets. Accepts disk submissions compatible with Illustrator 5.5 or FreeHand. Samples are filed. Will contact artist for portfolio review if interested. Portfolio should include b&w and color final art, roughs (important) and thumbnails (important). Pays for design and illustration by the project. Rights purchased vary according to project. Finds artists through submissions and word of mouth.

Tips: "Be original, be creative and have a positive attitude. Need to show strength in illustration with a good design sense. A flair for typography would be desirable."

Hawaii

▣ **MILICI VALENTI NG PACK**, 999 Bishop St., 24th Floor, Honolulu HI 96813. (808)536-0881. Fax: (808)529-6208. Website: www.milici.com. **Creative Director:** George Chalekian. Ad agency. Number of employees: 74. Approximate annual billing: $40,000,000. Serves clients in travel and tourism, food, fi-

nance, utilities, entertainment and public service. Clients include First Hawaiian Bank, Aloha Airlines, Sheraton Hotels.

Needs: Works with 2-3 freelance illustrators/month. Artists must be familiar with advertising demands; used to working long distance through the mail and over the Internet; and be familiar with Hawaii. Uses freelance artists mainly for illustration, retouching and lettering for newspapers, multimedia kits, magazines, radio, TV and direct mail.

First Contact & Terms: Send brochure, flier and tearsheets or PDFs to be kept on file for future assignments. Pays $200-2,000.

■ **ERIC WOO DESIGN, INC.**, 733 Bishop St., Suite 1280, Honolulu HI 96813. (808)545-7442. Fax: (808)545-7445. E-mail: ericwoodesign@hawaii.rr.com. Website: www.ericwoodesign.com. **Principal:** Eric Woo. Estab. 1985. Number of employees: 3.5. Approximate annual billing: 500,000. Design firm. Specializes in image development, packaging, web and CD-ROM design, print. Specializes in state/corporate. Current clients include State of Hawaii and University of Hawaii. Client list available upon request.

Needs: Approached by 5-10 illustrators and 10 designers/year. Works with 1-2 illustrators/year. Prefers freelancers with experience in multimedia. Uses freelancers mainly for multimedia projects and lettering. 5% of work is with print ads. 90% of design demands skills in Photoshop, Illustrator, Quark, Flash, Go Live, Dreamweaver and Metropolis.

First Contact & Terms: Designers send query letter with brochure, photocopies, photographs, résumé and tearsheets. Illustrators send postcard sample of work or query letter with brochure, photocopies, photographs, résumé, tearsheets. Send follow-up postcard samples every 1-2 months. Accepts submissions on disk in above software. Samples are filed. Will call if interested. Will contact for portfolio review of final art, photographs, photostats, roughs, slides, tearsheets, thumbnails and transparencies. Pays for design by the hour, $15-50. Pays for illustration by the project. Rights purchased vary according to project.

Tips: "Design and draw constantly. Have a good sense of humor and enjoy life."

Idaho

■ ✦ **HNA IMPRESSION MANAGEMENT**, (formerly Hedden-Nicely & Assoc.), 1524 W. Hays St., Boise ID 83702. (208)344-4631. Fax: (208)344-2458. E-mail: tony@hedden-nicely.com. Website: www.hedden-nicely.com. **Production Coordinator:** Tony Uria. Estab. 1986. Number of employees: 7. Approximate annual billing: $600,000. Ad agency. Specializes in print materials—collateral, display, direct mail. Product specialties are industrial, manufacturing.

Needs: Approached by 5 illustrators and 10 designers/year. Works with 1 illustrator and 6 designers/year. Prefers local freelancers. Prefers that designers work electronically with own equipment. Uses freelancers mainly for logos, brochures. Also for airbrushing, animation, billboards, brochure, brochure illustration, lettering, model-making, posters, retouching, storyboards. 10% of work is with print ads. 90% of design demands knowledge of PageMaker, Photoshop, Illustrator 8.0. 40% of illustration demands knowledge of Photoshop 4.0, Illustrator 8.0.

First Contact & Terms: Designers send query letter with brochure and résumé. Illustrators send postcard sample of work. Accepts any Mac-compatible Photoshop or Adobe file on CD or e-mail. Samples are filed. Responds only if interested when an appropriate project arises. Art director will contact artists for portfolio review of color, final art, tearsheets if interested. Pays by the project. Rights purchased vary according to project, all rights preferred. "All of our freelancers have approached us through query letters or cold calls."

Illinois

N ■ **ARTONWEB**, 508 Bluffs Edge Dr., McHenry IL 60185. (815)578-9171. E-mail: sbastian@artonweb.com. Website: www.artonweb.com. **Owner:** Thomas Sebastian. Estab. 1996. Number of employees: 10. Integrated marketing communications agency and Internet service. Specializes in website design and marketing. Current clients include Design Strategies, Creative FX. Client list available upon request.

Needs: Approached by 12 illustrators and 12 designers/year. Works with 2-3 illustrators and 1-2 designers/year. Uses freelancers mainly for design and computer illustration. Also for humorous illustration, lettering,

logos and web page design. 5% of work is with print ads. 90% of design and 70% of illustration demands knowledge of Photoshop, Illustrator, QuarkXPress. **First Contact & Terms:** Send e-mail and follow-up postcard samples every 6 months. Accepts Mac-compatible disk submissions—floppy, Zip disk or CD-ROM. Samples are filed and are not returned. Does not reply. Artist should contact via e-mail. Will contact artist for portfolio review if interested. Pays by the project. Negotiates rights purchased. Finds freelancers through *Black Book*, creative sourcebooks, Web.

■ ▮ **BEDA DESIGN**, 38663 Thorndale Place, Lake Villa IL 60046. Phone/fax: (847)245-8939. **President:** Lynn Beda. Estab. 1971. Number of employees: 2-3. Approximate annual billing: $250,000. Design firm. Specializes in packaging, publishing, film and video documentaries. Current clients include business-to-business accounts, producers to writers, directors and artists.
Needs: Approached by 6-12 illustrators and 6-12 designers/year. Works with 6 illustrators and 6 designers/year. Prefers local freelancers. Also for retouching, technical illustration and production. 50% of work is with print ads. 75% of design demands skills in Photoshop, QuarkXPress, Illustrator, Premiere, Go Live.
First Contact & Terms: Designers send query letter with brochure, photocopies and résumé. Illustrators send postcard samples and/or photocopies. Samples are filed and are not returned. Will contact for portfolio review if interested. Payments are negotiable. Buys all rights. Finds artists through word of mouth.

■ **BENTKOVER'S DESIGN & MORE**, 1222 Cavell, Suite 3C, Highland Park IL 60035. (847)831-4437. Fax: (847)831-4462. **Creative Director:** Burt Bentkover. Estab. 1989. Number of employees: 2. Approximate annual billing: $200,000. Specializes in annual reports, ads, package and brochure design. Clients: business-to-business, foodservice.
Needs: Works with 3 freelance illustrators/year. Works with artist reps. Prefers freelancers with experience in computer graphics, multimedia, Macintosh. Uses freelancers for direct mail and brochure illustration. 80% of freelance work demands computer skills.
First Contact & Terms: Send brochure, photocopies and tearsheets. No original art—only disposable copies. Samples are filed. Responds in 1 week if interested. Request portfolio review in original query. Will contact artist for portfolio review if interested. Portfolio should include b&w and color photocopies. "No final art or photographs." Pays for design and illustration by the project. Rights purchased vary according to project. Finds artists through sourcebooks and agents.

☑ ■ ▮ **BRAGAW PUBLIC RELATIONS SERVICES**, 800 E. Northwest Hwy., Palatine IL 60074. (847)934-5580. Fax: (847)934-5596. **President:** Richard S. Bragaw. Vice President: Pattie Klein Vandenack. Number of employees: 3. PR firm. Specializes in newsletters and brochures. Clients: professional service firms, associations and industry. Current clients include Kaiser Precision Tooling, Inc. and Nykiel-Carlin and Co., Ltd.
Needs: Approached by 12 freelancers/year. Works with 2 freelance illustrators and 2 designers/year. Prefers local freelancers only. Works on assignment only. Uses freelancers for direct mail packages, brochures, signage, AV presentations and press releases. 90% of freelance work demands knowledge of Page-Maker. Needs editorial and medical illustration.
First Contact & Terms: Send query letter with brochure to be kept on file. Responds only if interested. Pays by the hour, $25-75 average. Considers complexity of project, skill and experience of artist and turnaround time when establishing payment. Buys all rights.
Tips: "We do not spend much time with portfolios."

■ **DeFOREST CREATIVE**, (formerly Lee DeForest Communications), 300 W. Lake St., Elmhurst IL 60126. (630)834-7200. Fax: (630)834-0908. E-mail: info@deforestgroup.com. **Art Director:** Wendy Engleking. Estab. 1965. Number of employees: 15. Marketing solutions, graphic design and digital photography firm.
Needs: Approached by 50 freelance artists/year. Works with 3-5 freelance designers/year. Prefers artists with experience in PhotoShop, Illustrator and Quark.
First Contact & Terms: Send query letter with résumé and samples. Samples are filed or returned by

● **SPECIAL COMMENTS** within listings by the editor of *Artist's & Graphic Designer's Market* are set off by a bullet.

SASE if requested by artist. To arrange for portfolio review artist should fax or e-mail. Pays for production by the hour, $25-75. Finds designers through word of mouth and artists' submissions.
Tips: "Be hardworking, honest, and good at your craft."

IDENTITY CENTER, 1110 Idaho St., Carol Stream IL 60188. E-mail: wk@identitycenter.com. Website: www.identitycenter.com. **President:** Wayne Kosterman. Number of employees: 3. Approximate annual billing: $250,000. Specializes in brand and corporate identity, print communications and signage. Clients: corporations, hospitals, manufacturers and banks. Professional affiliations: AIGA, American Center for Design, SEGD.
 • Seventeen corporate identity programs (before and after) appeared in *Design/Redesign*, a book by David Carter. More than 75 of their programs have appeared in his books over the past 18 years.
Needs: Approached by 40-50 freelancers/year. Works with 4 freelance illustrators and 4 designers/year. Prefers 3-5 years of experience minimum. Uses freelancers for editorial and technical illustration, mechanicals, retouching and lettering. 50% of freelance work demands knowledge of QuarkXPress, Photoshop, Illustrator and Dreamweaver.
First Contact & Terms: Designers send résumé and photocopies. Illustrators send postcard samples, color photocopies or other nonreturnable samples. To show a portfolio, send photocopies or e-mail. Do not send samples you need back without checking with us first. Pays for design by the hour, $20-50. Pays for illustration by the project, $200-5,000. Considers client's budget, skill and experience of artist and how work will be used when establishing payment. Rights purchased vary according to project.
Tips: "Not interested in amateurs or 'part-timers.' "

INNOVATIVE DESIGN & GRAPHICS, 1234 Sherman Ave., Suite 214, Evanston IL 60202-1375. (847)475-7772. E-mail: idgemail@sprintmail.com. **Contact:** Tim Sonder. Clients: corporate communication and marketing departments.
Needs: Works with 1-5 freelance artists/year. Prefers local artists only. Uses artists for editorial and technical illustration and desktop (CorelDraw, FreeHand, Illustrator).
First Contact & Terms: Send query letter with résumé or brochure showing art style, tearsheets, photostats, slides and photographs. Will contact artist for portfolio review if interested. Pays for design by the hour, $20-45. Pays for illustration by the project, $200-1,000 average. Considers complexity of project, client's budget and turnaround time when establishing payment. Interested in buying second rights (reprint rights) to previously published work.
Tips: "Interested in meeting new illustrators, but have a tight schedule. Looking for people who can grasp complex ideas and turn them into high-quality illustrations. Ability to draw people well is a must. Do not call for an appointment to show your portfolio. Send nonreturnable tearsheets or self-promos, and we will call you when we have an appropriate project for you."

QUALLY & COMPANY, INC., 1187 Willmette Ave., Suite 201, Willmette IL 60091-2719. (847)864-4154. **Creative Director:** Robert Qually. Specializes in integrated marketing/communication and new product development. Clients: major corporations, high net worth individuals and think tanks.
Needs: Works with 10-12 freelancers/year. "Freelancers must have talent and the right attitude." Works on assignment only. Uses freelancers for design, copywriting, illustration, retouching, and computer production.
First Contact & Terms: Send query letter with résumé, business card and samples that we can keep on file. Call or write for appointment to show portfolio.
Tips: Looking for "people with ideas, talent, point of view, style, craftsmanship, depth and innovation" in portfolio or samples. Sees "too many look-alikes, very little innovation."

JOHN STRIBIAK & ASSOCIATES, INC., 1266 Holiday Dr., Somonauk IL 60552. (815)498-4900. Fax: (815)498-4905. Website: www.jsa@stribiak.com. **President:** John Stribiak. Estab. 1981. Number of employees: 2. Approximate annual billing: $300,000. Specializes in corporate identity and package design. Clients: corporations. Professional affiliations: IOPP, PDC.
Needs: Approached by 75-100 freelancers/year. Works with 20 freelance illustrators and 2 designers/year. Prefers artists with experience in illustration, design, retouching and packaging. Uses illustrators mainly for packaging and brochures. Uses designers mainly for new products. Also uses freelancers for ad and catalog illustration, airbrushing, brochure design and illustration, lettering, model-making and retouching. Needs computer-literate freelancers for production. 70% of freelance work demands skills in Illustrator, Photoshop and QuarkXPress.

First Contact & Terms: Send postcard sample of work. Samples are filed. Will contact artist for portfolio review if interested. Portfolio should include b&w and color roughs and transparencies. Pays for design and illustration by the project. Rights purchased vary according to project. Finds artists through sourcebooks.

⌘ TEMKIN & TEMKIN, INC., 450 Skokie Blvd., Bldg. 800, Northbrook IL 60062. (847)498-1700. Fax: (847)498-3162. E-mail: steve@temkin.com. **President:** Steve Temkin. Estab. 1945. Number of employees: 10. Ad agency. Specializes in business-to-business collateral, consumer direct mail. Product specialties are food, gifts, electronics and professional services. Current clients include Chase Bank and HandGards.
Needs: Approached by 100 freelancers/year. Works with 5-10 freelance illustrators and 10 designers/year. Prefers local artists only. Uses freelancers mainly for design, concept and comps. Also for brochure and catalog design, mechanicals and retouching. 95% of work is with print ads. Needs computer-literate freelancers for design and production. 75% of freelance work demands knowledge of Photoshop, QuarkXPress, InDesign, Draw and Illustrator.
First Contact & Terms: Send query letter with photocopies and résumé. To arrange portfolio review artist should follow up with call or letter after initial query. Portfolio should include roughs, tearsheets and thumbnails. Pays for design by the project, $250-5,000. Rights purchased vary according to project.
Tips: "Present evidence of hands-on involvement with concept and project development.

Chicago

☑ THE CHESTNUT HOUSE GROUP INC., 2121 St. Johns Ave., Highland Park IL 60035. (847)432-3273. Fax: (847)432-3229. E-mail: mileszim@attbi.com. **Contact:** Miles Zimmerman. Clients: major educational publishers.
Needs: Illustration, layout and electronic page production. Needs computer-literate freelancers for production. Uses experienced freelancers only. Freelancers should be familiar with QuarkXPress and various drawing and painting programs for illustrators. Pays for production by the hour. Pays for illustration by the project.
First Contact & Terms: "Illustrators submit samples."

CLEARVUE, INC., 6465 N. Avondale, Chicago IL 60631. (773)775-9433. E-mail: custserv@clearvue.c om. Website: www.clearvue.com. **President:** Mark Ventling. Director: Jeffrey Kytta. Educational publishing and distribution.
Needs: Works with 1-2 freelance artists/year. Works on assignment only. Uses freelance artists mainly for catalog layout.
First Contact & Terms: Send query letter with SASE to be kept on file. Responds in 10 days. Write for appointment to show portfolio.
Tips: "Have previous layout skills."

Ⓝ ▣ DESIGN ASSOCIATES, 6117 N. Winthrop Ave., Chicago IL 60660. (773)338-4196. Fax: (773)338-4197. **Contact:** Paul Uhl. Estab. 1986. Number of employees: 3. Specializes in text and trade book design, annual reports, corporate identity, website development. Clients: corporations, publishers and museums. Client list available upon request.
Needs: Approached by 10-20 freelancers/year. Works with 100 freelance illustrators and 5 designers/year. Uses freelancers for design and production, illustration and photography, lettering. 100% of freelance work demands knowledge of Illustrator, Photoshop and QuarkXPress.
First Contact & Terms: Send query letter with samples that best represent work. Accepts disk submissions. Samples are filed. Will contact artist for portfolio review if interested. Portfolio should include b&w and color samples. Pays for design by the hour and by the project. Pays for illustration by the project. Buys all rights. Finds artists through sourcebooks, reps and word of mouth.

Ⓝ DESIGN MOVES, LTD., 660 LaSalle Place, Suite 202, Highland Park IL 60035. (847)433-4313. Fax: (847)433-4314. E-mail: laurie@designmoves.com. Website: www.designmoves.com. **Principal:** Laurie Medeiros Freed. Estab. 1988. Number of employees: 4. Specializes in design for annual reports, corporate literature, corporate identity, packaging, advertising and website design. Current clients include Baxter Healthcare, Microsoft Corp. and the Chicago Park District. Professional affiliations: AIGA, ACD, NAWBO.

Needs: Approached by 5-10 freelancers/year. Works with 3-5 freelance illustrators and 1-3 designers/year. Works on assignment only. Uses freelancers for lettering, internet design and programming, poster illustration and design, direct mail design and charts/graphs. Freelance work requires knowledge of HTML and Director, Illustrator, QuarkXPress and Photoshop.

First Contact & Terms: Send query letter with brochure, résumé and tearsheets. Samples are filed or are returned by SASE if requested. Request portfolio review in original query. Responds only if interested. Portfolio should include thumbnails, tearsheets, photographs and transparencies. Pays for design by the hour, $20-30. Pays for illustration by the project. Rights purchased vary according to project.

N ◪ **DAVE DILGER,** 1467 N. Elston, Suite 200, Chicago IL 60622. (773)772-3200. Fax: (773)772-3244. E-mail: paulsen@paulsenpartners.com. Website: www.paulsenpartners.com. **Contact:** Dave Dilger. Estab. 1951. Number of employees: 8. Ad agency. Full-service, multimedia firm. Specializes in print ads, collateral and other print material. Product specialty is industrial.

Needs: Approached by 5-10 freelancers/year. Works with 3-4 freelance illustrators and 10 designers/year. Prefers local artists only. Uses freelancers mainly for design and illustration. Also for brochure and catalog design; and retouching. 100% of work is with print ads. Needs computer-literate freelancers for design and production. 85% of freelance work demands knowledge of Photoshop 3.1, QuarkXPress 3.3 and Illustrator.

First Contact & Terms: Send query letter with résumé. Samples are filed or returned. Request portfolio review in original query. Portfolio should include b&w and color final art and roughs. Pays for design and illustration by the hour or by the project. "We work with the artist." Buys all rights or negotiates rights purchased.

◪ **HIRSCH O'CONNOR DESIGN INC.,** 205 W. Wacker Dr., Suite 622, Chicago IL 60606. (312)329-1500. E-mail: joconnor@hirschoconnor.com. Website: hirschoconnor.com. **Contact:** Joseph O'Connor. Number of employees: 8. Specializes in annual reports, corporate identity, publications, promotional literature, trade show design and web design. Current clients include ABN Amro, United Stationers, LaSalle Bank. Clients: manufacturing, PR, real estate, printing, associations, financial and industrial firms. Professional affiliations: AIGA, IABC and STA.

Needs: Approached by more than 100 freelancers/year. Works with 6-10 freelance illustrators and 3-5 designers/year. Prefers freelancers with experience in computer graphics, multimedia. Uses freelancers for computer needs, slide illustration, technical illustration. Freelancers should be familiar with Photoshop and Illustrator.

First Contact & Terms: Send query letter with promotional materials showing art style or samples. Samples not filed are returned by SASE. Responds only if interested. Call for appointment to show portfolio of roughs, final reproduction/product, tearsheets and photographs. Pays for design by the hour, $30-80. Pays for illustration by the project, $500-2,500. Interested in buying second rights (reprint rights) to previously published work. Finds artists primarily through sourcebooks and self-promotions.

Tips: "We're always looking for talent at fair prices."

◪ **HUTCHINSON ASSOCIATES, INC.,** 1147 W. Ohio, Suite 305, Chicago IL 60622. (312)455-9191. Fax: (312)455-9190. E-mail: hutch@hutchinson.com. Website: www.hutchinson.com. **Contact:** Jerry Hutchinson. Estab. 1988. Number of employees: 3. Specializes in annual reports, corporate identity, publication design and website design and development. Clients: corporations, associations and PR firms. Professional affiliations: AIGA, ACD.

● Work from Hutchinson Associates has been published in the design books *Work With Computer Type* Vols. 1-3 by Rob Carter (Rotovision) and *Graphic Design 97.*

Needs: Approached by 5-10 freelancers/year. Works with 3-4 freelance illustrators and 5-15 designers/year. Uses freelancers mainly for brochure design, annual reports, multimedia and web designs. Also uses freelancers for ad and direct mail design, catalog illustration, charts/graphs, logos, multimedia projects and mechanicals.

First Contact & Terms: Send postcard sample of work or send query letter with résumé, brochure, photocopies and photographs. Accepts disk submissions. Samples are filed. Request portfolio review in original query. Artist should follow up with call. Will contact artist for portfolio review if interested. Portfolio should include transparencies and printed pieces. Pays by the project, $100-10,000. Rights purchased vary according to project. Finds artists through sourcebooks, Illinois reps, submissions.

Tips: "Persistence pays off."

KAUFMAN RYAN STRAL INC., 650 N. Dearborn St., Suite 700, Chicago IL 60610. (312)467-9494. Fax: (312)467-0298. E-mail: lkaufman@bworld.com. Website: www.bworld.com. **President/Creative Director:** Laurence Kaufman. Production Manager: Marc Turner. Estab. 1993. Number of employees: 7. Ad agency. Specializes in all materials in print and website development. Product specialty is business-to-business. Client list available upon request. Professional affiliations: BMA, American Israel Chamber of Commerce.

Needs: Approached by 30 freelancers/year. Works with 6 freelance illustrators and 5 designers/year. Prefers local freelancers. Uses freelancers for design, production, illustration and computer work. Also for brochure, catalog and print ad design and illustration, animation, mechanicals, retouching, model-making, posters, lettering and logos. 30% of work is with print ads. 50% of freelance work demands knowledge of QuarkXPress, html programs FrontPage or Page Mill, Photoshop or Illustrator.

First Contact & Terms: Send query letter with résumé and photostats. Samples are filed or returned by SASE. Responds only if interested. Artist should follow up with call and/or letter after initial query. Will contact artist for portfolio review if interested. Portfolio should include b&w and color roughs and final art. Pays for design by the hour, $40-120; or by the project. Pays for illustration by the project, $75-8,000. Buys all rights. Finds artists through sourcebooks, word of mouth, submissions.

LUCY LESIAK DESIGN, 575 W. Madison St., Suite 2809, Chicago IL 60661. (312)902-4533. Fax: (312)775-7224. Current clients include Scott Foresman, McGraw-Hill, World Book. Client list available upon request.

Needs: Approached by 20 freelance artists/year. Works with 3-5 illustrators and 1-2 designers/year. Works on assignment only. Uses illustrators mainly for story or cover illustration, also editorial, technical and medical illustration. Uses designers mainly for text design. Also for book design, mechanicals and logos. 100% of design work demands knowledge of QuarkXPress, Illustrator or Photoshop.

First Contact & Terms: Send postcard sample or query letter with photocopies, brochure and résumé. Accepts disk submissions compatible with Mac Illustrator 7.0 and QuarkXPress 4.1. Samples are filed. Will contact artist for portfolio review if interested. Portfolio should include final art, color tearsheets and transparencies. Pays for design by the hour, $30-50. Pays for illustration by the project, $30-3,000. Rights purchased vary according to project. Finds artists through agents, sourcebooks and self-promotions.

MEYER/FREDERICKS & ASSOCIATES, 333 N. Michigan Ave., #1300, Chicago IL 60601. (312)782-9722. Fax: (312)782-1802. Estab. 1972. Number of employees: 15. Ad agency, PR firm. Full-service, multimedia firm.

Needs: Prefers local freelancers only. Freelancers should be familiar with Photoshop 7.0, QuarkXPress 4.1 and Illustrator 8.

First Contact & Terms: Send query letter with samples. Will contact artist for portfolio review if interested.

MSR ADVERTISING, INC., P.O. Box 10214, Chicago IL 60610-0214. (312)573-0001. Fax: (312)573-1907. E-mail: marc@msradv.com. Website: msradv.com. **President:** Marc S. Rosenbaum. Vice President: Peter Miller. Art Director: Linda Gits. Office Manager: Danielle Davidson. Estab. 1983. Number of employees: 6. Approximate annual billing: $2.5 million. Ad agency. Full-service multimedia firm. Specializes in medical, food, industrial and biotechnology. Current clients include AGCO Parts N.A., American Hospital Association, Illinois Biotechnology Industries Association.

 • MSR's Tampa, Florida office including similar SIC represented industries and professions, has added insurance agencies, law firms and engineering firms to their growing list of clients.

Needs: Approached by 6-10 freelancers/year. Works with 5-10 freelance illustrators and 5-10 designers/year. Prefers local artists who are "innovative, resourceful and hungry." Works on assignment only. Uses freelancers mainly for creative thought boards. Also for brochure, catalog and print ad design and illustration, multimedia, storyboards, mechanicals, billboards, posters, lettering and logos. 30% of work is with print ads. 75% of design and 25% of illustration demand computer skills.

First Contact & Terms: Send query letter with brochure, photographs, photocopies, slides, SASE and résumé. Accepts submissions on disk. Samples are filed or returned. Responds in 2 weeks. Write for appointment to show portfolio or mail appropriate materials: thumbnails, roughs, finished samples. Artist should follow up with call. Pays for design by the hour, $45-95. Buys all rights. Finds artists through submissions and agents.

Tips: "We maintain a relaxed environment designed to encourage creativity; however, work must be produced in a timely and accurate manner. Normally the best way for a freelancer to meet with us is

through an introductory letter and a follow-up phone call a week later. Repeat contact every 2-4 months. Be persistent and provide outstanding representation of your work."

TESSING DESIGN, INC., 3822 N. Seeley Ave., Chicago IL 60618-3912. (773)525-7704. Fax: (773)525-7756. E-mail: tess46@aol.com. **Principals:** Arvid V. Tessing and Louise S. Tessing. Estab. 1975. Number of employees: 2. Specializes in corporate identity, marketing promotions and publications. Clients: publishers, educational institutions and nonprofit groups. Majority of clients are publishers. Professional affiliation: Women in Design, Chicago Book Clinic, and the Society of Typographic Arts.
Needs: Approached by 30-80 freelancers/year. Works with 3 freelance illustrators and 2 designers/year. Works on assignment only. Uses freelancers mainly for publications. Also for book and magazine design and illustration, charts/graphs and lettering. 90% of design and 75% of illustration demand knowledge of QuarkXPress, Photoshop or Illustrator. Needs textbook, editorial and technical illustration.
First Contact & Terms: Designers send query letter with photocopies. Illustrators send postcard samples. Samples are filed and are not returned. Request portfolio review in original query. Artist should follow up with letter after initial query. Will contact artist for portfolio review if interested. Portfolio should include original/final art, final reproduction/product and photographs. Pays for design by the hour, $40-60. Pays for illustration by the project, $100 minimum. Rights purchased vary according to project. Finds artists through word of mouth, submissions/self-promotions and sourcebooks.
Tips: "We prefer to see original work or slides as samples. Work sent should always relate to the need expressed. Our advice for artists to break into the field is as always—call prospective clients, show work and follow up."

■ **L.C. WILLIAMS & ASSOCIATES**, 150 N. Michigan Ave., Suite 3800, Chicago IL 60601. (312)565-3900. Fax: (312)565-1770. E-mail: ccalvert@lcwa.com. **Creative Director:** Cindy Calvert. Estab. 2000. Number of employees: 8. Approximate annual billing: $3.5 million. PR firm. Specializes in marketing, communication, publicity, direct mail, brochures, newsletters, trade magazine ads, AV presentations. Product specialty is consumer home products. Current clients include Pergo, Ace Hardware, La-Z-Boy Inc. and Glidden. Promotional Products Association International. Professional affiliations: Chicago Direct Marketing Association, Sales & Marketing Executives of Chicago, Public Relations Society of America, Publicity Club of Chicago.
 ● LCWA is among the top 15 public relations agencies in Chicago. It maintains a satellite office in New York.
Needs: Approached by 50-100 freelancers/year. Works with 1-2 freelance illustrators and 2-5 designers/ year. Works on assignment only. Uses freelancers mainly for brochures, ads, newsletters. Also for print ad design and illustration, editorial and technical illustration, mechanicals, retouching and logos. 90% of freelance work demands computer skills.
First Contact & Terms: Send query letter with brochure and résumé. Samples are filed. Does not reply. Request portfolio review in original query. Artist should call within 1 week. Portfolio should include printed pieces. Pays for design and illustration by the project, fee varies. Rights purchased vary according to project. Finds artists through word of mouth and queries.
Tips: "Many new people are opening shop and you need to keep your name in front of your prospects."

☑ **ZÜNPARTNERS INCORPORATED**, 326 W. Chicago Ave., Chicago IL 60610. (312)951-5533. Fax: (312)951-5522. E-mail: request@zunpartners.com. Website: www.zunpartners.com. **Partners:** William Ferdinand and David Philmlee. Estab. 1991. Number of employees: 9. Specializes in annual reports, brand and corporate identity, capability brochures, package and publication design, electronic and interactive. Clients: from Fortune 500 to Internet startup companies. Current clients include Arthur Andersen, Unicom, B.P. and Sears. Client list available upon request. Professional affiliations: AIGA, ACD.
Needs: Approached by 30 freelancers/year. Works with 10-15 freelance illustrators and 15-20 designers/ year. Looks for strong personal style (local and national). Uses illustrators mainly for editorial. Uses designers mainly for design and layout. Also uses freelancers for collateral and identity design, illustration; web, video, audiovisual materials; direct mail, magazine design and lettering; logos; and retouching. Needs computer-literate freelancers for design, illustration, production and presentation. 90% of freelance work demands knowledge of Illustrator, Photoshop, QuarkXPress and Director, Flash, Dreamweaver and Go Live.
First Contact & Terms: Send postcard sample of work or send query letter with brochure or résumé. Samples are filed. Responds only if interested. Portfolios may be dropped off every Friday. Artist should follow up. Portfolio should include b&w and color samples. Pays for design by the hour and by the project.

Pays for illustration by the project. Rights purchased vary according to project. Finds artists through reference books and submissions.

Tips: Impressed by "to the point portfolios. Show me what you like to do and what you brought to the projects you worked on. Don't fill a book with extra items (samples) for sake of showing quantity."

Indiana

BOXFIRE, 400 Victoria Centre, 22 E. Washington St., Indianapolis IN 46204. (317)631-0260. E-mail: mark_gause@burnthatbox.com. Website: www.burnthatbox.com. **CEO/Creative Director:** Mark Gause. Creative Directors: Mary Hayes and Sean Cunat. Art Directors: Jim Collins, Kevin Nelson and Jason Cummings. Production Coordinator: Terry Tyler. Number of employees: 31. Approximate annual billing: $26 million. Marketing firm. Specializes in business-to-business, food service, transportation products and services, computer equipment, medical, life sciences and electronics.

Needs: Approached by 50 freelancers/year. Works with 15 freelance photographers, illustrators and 5 designers/year. Works on assignment only. Uses freelancers for technical line art, color illustrations and airbrushing. 100% of freelance design and 25% of illustration demand computer skills.

First Contact & Terms: Send query letter with résumé and photocopies. Accepts disk submissions. Samples not filed are returned. Responds only if interested. Call or write for appointment to show portfolio, or mail final reproduction/product and tearsheets. Pays by the project, $100 minimum. Buys all rights.

Tips: "Show samples of good creative talent."

◼ **GRIFFIN MARKETING SERVICES, INC.**, 802 Wabash Ave., Chesterton IN 46304-2250. (219)929-1616. Fax: (219)921-0388. E-mail: mgriffin45@aol.com. Website: www.griffinmarketingservice s.com. **President:** Michael J. Griffin. Estab. 1974. Number of employees: 20. Approximate annual billing: $4 million. Integrated marketing firm. Specializes in collateral, direct mail, multimedia. Product specialty is industrial. Current clients include Hyatt, USX, McDonalds.

Needs: Works with 20-30 freelance illustrators and 2-30 designers/year. Prefers artists with experience in computer graphics. Uses freelancers mainly for design and illustration. Also uses freelancers for animation, model making and TV/film graphics. 75% of work is with print ads. Needs computer-literate freelancers for design, illustration, production and presentation. 95% of freelance work demands knowledge of PageMaker, FreeHand, Photoshop, QuarkXPress and Illustrator.

First Contact & Terms: Send query letter with SASE or e-mail. Samples are not filed and are returned by SASE if requested by artist. Responds in 1 month. Will contact artist for portfolio review if interested. Pays for design and illustration by the hour, $20-150; or by the project.

Tips: Finds artists through *Creative Black Book*.

◼ **JMH CORPORATION**, 921 E. 66th St., Indianapolis IN 46220. (317)255-3400. E-mail: jmh@jmhde sign.com. Website: jmhdesign.com. **President:** J. Michael Hayes. Number of employees: 3. Specializes in annual reports, corporate identity, advertising, collateral, packaging, publications and website development. Clients: publishers, consumer product manufacturers, corporations and institutions. Professional affiliations: AIGA.

Needs: Approached by 30-40 freelancers/year. Works with 5 freelance illustrators and 2 designers/year. Prefers experienced, talented and responsible freelancers only. Works on assignment only. Uses freelancers for advertising, brochure and catalog design and illustration, P-O-P displays, retouching, charts/graphs and lettering. Needs editorial and medical illustration. 100% of design and 30% of illustration demand skills in QuarkXPress, Illustrator or Photoshop (latest versions).

First Contact & Terms: Send query letter with brochure/flyer, résumé, photocopies, photographs, tearsheets and slides. Accepts disk submissions compatible with QuarkXPress 4.0 and Illustrator 8.0. Send EPS files. Samples returned by SASE, "but we prefer to keep them." Response time "depends entirely on our needs." Write for appointment to show portfolio. Pays for design by the hour, $20-50, or by the project, $100-1,000. Pays for illustration by the project, $300-5,000.

Tips: "Prepare an outstanding mailing piece and 'leave-behind' that allows work to remain on file. Keep doing great work and stay in touch." Advises freelancers entering the field to "send samples regularly. Call to set a portfolio presentation. Do great work. Be persistent. Love what you do. Have a balanced life."

N ■ OMNI PRODUCTIONS, 12316 Brookshire Pkwy., Carmel IN 46082-0302. (317)848-3456. E-mail: winston@omniproductions.com. Website: omniproductions.com. **President:** Winston Long. Estab. 1984. AV firm. Full-service, multimedia firm. Specializes in video, Intranet, CD-ROM and Internet. Current clients include "a variety of industrial clients, international."

Needs: Works on assignment only. Uses freelancers for brochure design and illustration, storyboards, slide illustration, animation, and TV/film graphics. Needs computer-literate freelancers for design, illustration and production. Most of freelance work demands computer skills.

First Contact & Terms: Send résumé. Samples are filed and are not returned. Artist should follow up with call and/or letter after initial query. Pays be the project. Finds artists through agents, word of mouth and submissions.

Iowa

N ■ F.A.C. MARKETING, P.O. Box 782, Burlington IA 52601. (319)752-9422. Fax: (319)752-7091. Website: www.facmarketing.com. **President:** Roger Sheagren. Estab. 1952. Number of employees: 5. Approximate annual billing: $500,000. Ad agency. Full-service, multimedia firm. Specializes in newspaper, television, direct mail. Product specialty is funeral home to consumer.

Needs: Approached by 30 freelancers/year. Works with 1-2 freelance illustrators and 4-6 designers/year. Prefers freelancers with experience in newspaper and direct mail. Uses freelancers mainly for newspaper design. Also for brochure design and illustration, logos, signage and TV/film graphics. Freelance work demands knowledge of PageMaker, Photoshop, CorelDraw and QuarkXPress.

First Contact & Terms: Send query letter with brochure, photostats, SASE, tearsheets and photocopies. Samples are filed or returned by SASE if requested by artist. Request portfolio review in original query. Portfolio should include b&w photostats, tearsheets and thumbnails. Pays by the project, $100-500. Rights purchased vary according to project.

Kansas

👤 BRYANT, LAHEY & BARNES, INC., 5300 Foxridge Dr., Shawnee Mission KS 66202. (913)262-7075. **Art Director:** Libby Brockman. Ad agency. Clients: agriculture and veterinary firms.

Needs: Local freelancers only. Uses freelancers for illustration and production, via Mac format only; keyline and paste-up; consumer and trade magazines and brochures/flyers.

First Contact & Terms: Query by phone. Send business card and résumé to be kept on file for future assignments. Originals not returned. Negotiates payment.

👤 TASTEFUL IDEAS, INC., 5822 Nall Ave., Mission KS 66205. (913)722-3769. Fax: (913)722-3967. E-mail: one4ideas@aol.com. Website: www.tastefulideas.com. **President:** John Thomsen. Estab. 1986. Number of employees: 4. Approximate annual billing: $500,000. Design firm. Specializes in consumer packaging. Product specialties are largely, but not limited to, food and foodservice.

Needs: Approached by 15 illustrators and 15 designers/year. Works with 3 illustrators and 3 designers/year. Prefers local freelancers. Uses freelancers mainly for specialized graphics. Also for airbrushing, animation, humorous and technical illustration. 10% of work is with print ads. 75% of design and illustration demand skills in Photoshop and Illustrator.

First Conact & Terms: Designers send query letter with photocopies. Illustrators send query letter with photostats. Accepts disk submissions from designers and illustrators compatible with Illustrator, Photoshop—Mac based. Samples are filed. Responds only if interested. Art director will contact artist for portfolio review of final art of photostats if interested. Pays by the project. Finds artists through submissions.

✓ ■ WEST CREATIVE, INC., 9552 W. 116th Terrace, Overland Park KS 66210. (913)661-0561. Fax: (816)561-2688. E-mail: stan@westcreative.com. Website: www.westcreative.com. **Creative Director:** Stan Chrzanowski. Estab. 1974. Number of employees: 8. Approximate annual billing: $600,000. Design firm and agency. Full-service, multimedia firm. Client list available upon request. Professional affiliation: AIGA.

Needs: Approached by 50 freelancers/year. Works with 4-6 freelance illustrators and 1-2 designers/year. Uses freelancers mainly for illustration. Also for animation, lettering, mechanicals, model-making, retouch-

ing and TV/film graphics. 20% of work is with print ads. Needs computer-literate freelancers for design, illustration and production. 95% of freelance work demands knowledge of FreeHand, Photoshop, QuarkXPress and Illustrator. Full service web design capabilities.

First Contact & Terms: Send postcard-size sample of work or send query letter with brochure, photocopies, résumé, SASE, slides, tearsheets and transparencies. Samples are filed or returned by SASE if requested by artist. Responds only if interested. Portfolios may be dropped off every Monday-Thursday. Portfolios should include color photographs, roughs, slides and tearsheets. Pays for illustration by the project; pays for design by the hour, $25-60. "Each project is bid." Rights purchased vary according to project. Finds artists through *Creative Black Book* and *Workbook*.

N □ ♦ WP POST & GRAPHICS, 228 Pennsylvania, Wichita KS 67214-4149. (316)263-7212. Fax: (316)263-7539. E-mail: wppost@aol.com. Website: www.wponline.com. **Art Director:** Kelly Flack. Estab. 1968. Number of employees: 4. Ad agency, design firm, video production/animation. Specializes in TV commercials, print advertising, animation, web design, packaging. Product specialties are automative, broadcast, furniture, restaurants. Current clients include Adventure RV and Truck Center, The Wichita Eagle, Dick Edwards Auto Plaza, Turner Tax Wise. Client list available upon request. Professional affiliations: Advertising Federation of Wichita.

• Recognized by the American Advertising Federation of Wichita for excellence in advertising.

Needs: Approached by 2 illustrators and 10 designers/year. Works with 1 illustrator and 2 designers/year. Prefers local designers with experience in Macintosh production, video and print. Uses freelancers mainly for overflow work. Also for animation, brochure design and illustration, catalog design and illustration, logos, TV/film graphics, web page design and desktop production. 10% of work is with print ads. 100% of freelance work demands knowledge of Photoshop, FreeHand and QuarkXPress.

First Contact & Terms: Designers send query letter with résumé and self-promotional sheet. Illustrators send postcard sample of work or query letter with résumé. Send follow-up postcard samples every 3 months. Accepts disk submissions if compatible with Macintosh-formatted, Photoshop 4.0, FreeHand 7.0, or an EPS file. Samples are filed and are not returned. Responds only if interested. Art director will contact artist for portfolio review of b&w, color, final art, illustration if interested. Pays by the project. Rights purchased vary according to project and are negotiable. Finds artists through local friends and coworkers.

Tips: "Be creative, be original, and be able to work with different kinds of people."

Kentucky

MERIDIAN COMMUNICATIONS, 325 W. Main St., Suite 300, Lexington KY 40507. (859)252-3350. Fax: (859)281-5729. E-mail: mes@meridiancomm.com. Website: www.meridiancomm.com. **CEO:** Mary Ellen Slone. Estab. 1975. Number of employees: 58. Ad agency. Full-service, multimedia firm. Specializes in ads (magazine and newspaper), grocery store handbills, TV and radio spots, packaging, newsletters, etc. Current clients include Toyota/KY, Fazoli's, Three Chimneys Farm, Incredipet, Banfield Pet Hospitals, Slone's Signature Markets, Georgetown College, University of KY.

Needs: Approached by 6 artists/month. Works with 2 illustrators and 6 designers/month. Prefers regional/national artists. Works on assignment only. Uses freelancers for brochure and catalog design and illustration, print ad illustration, storyboards, animatics, animation, posters, TV/film graphics, logos.

First Contact & Terms: Send query letter with résumé, photocopies, photographs and tearsheets. Samples are filed. Responds in 2 weeks. To show portfolio, mail b&w and color tearsheets and photographs. Pays negotiable rates for design and illustration. Rights purchased vary according to project.

THE WILLIAMS McBRIDE GROUP, 344 E. Main St., Lexington KY 40507. (859)253-9319. Fax: (859)233-0180. Second location, 709 E. Market St., Louisville KY 40202. (502)583-9972. Fax: (502)583-7009. E-mail: mail@williamsmcbride.com. Website: www.williamsmcbride.com. **Partners:** Robin Williams Brohm and Kimberly McBride. Estab. 1988. Number of employees: 7. Design firm specializing in brand management, corporate identity and business-to-business marketing.

Needs: Approached by 10-20 freelance artists/year. Works with 4 illustrators and 3 designers/year. Prefers freelancers with experience in corporate design, branding. Works on assignment only. 100% of freelance design work demands knowledge of QuarkXPress, Photoshop and Illustrator. Will review résumés of web designers with knowledge of Director and Flash.

First Contact & Terms: Designers send query letter with résumé. Will review portfolios electronically or hardcopy samples. Illustrators send website or postcard sample of work. Samples are filed. Responds

only if interested. Pays for design by the hour, $50-65. Pays for illustration by the project. Rights purchased vary according to project. Finds artists through submissions, word of mouth, *Creative Black Book*, *Workbook* and *American Showcase*, artist's representatives.

Tips: "Keep our company on your mailing list; remind us that you are out there."

Louisiana

ANTHONY DI MARCO, 301 Aris Ave., Metairie LA 70005. (504)833-3122. **Creative Director:** Anthony Di Marco. Estab. 1972. Number of employees: 1. Specializes in illustration, sculpture, costume design, and art and photo restoration and retouching. Current clients include Audubon Institute, Louisiana Nature and Science Center, Fair Grounds Race Course. Client list available upon request. Professional affiliations: Art Directors Designers Association, Entergy Arts Council, Louisiana Crafts Council, Louisiana Alliance for Conservation of Arts.

• Anthony DiMarco recently completed the re-creation of a 19th-century painting, *Life on the Metairie*, for the Fair Grounds racetrack. The original painting was destroyed by fire in 1993.

Needs: Approached by 50 or more freelancers/year. Works with 5-10 freelance illustrators and 5-10 designers/year. Seeks "local freelancers with ambition. Freelancers should have substantial portfolios and an understanding of business requirements." Uses freelancers mainly for fill-in and finish: design, illustration, mechanicals, retouching, airbrushing, posters, model-making, charts/graphs. Prefers highly polished, finished art in pen & ink, airbrush, charcoal/pencil, colored pencil, watercolor, acrylic, oil, pastel, collage and marker. 25% of freelance work demands computer skills.

First Contact & Terms: Send query letter with résumé, business card, slides, brochure, photocopies, photographs, transparencies and tearsheets to be kept on file. Samples not filed are returned by SASE. Responds in 1 week if interested. Call or write for appointment to show portfolio. Pays for illustration by the hour or by the project, $100 minimum.

Tips: "Keep professionalism in mind at all times. Put forth your best effort. Apologizing for imperfect work is a common mistake freelancers make when presenting a portfolio. Include prices for completed works (avoid overpricing). Three-dimensional works comprise more of our total commissions than before."

THE O'CARROLL GROUP, 710 W. Prien Lake Rd., Suite 110, Lake Charles LA 70601. (337)478-7396. Fax: (337)478-0503. E-mail: info@ocarroll.com. Website: www.ocarroll.com. **Contact:** Art Director. Estab. 1978. Ad agency. Specializes in newspaper, magazine, outdoor, radio and TV ads. Product specialty is consumer. Client list available upon request.

Needs: Approached by 1 freelancer/month. Works with 1 illustrator every 3 months. Prefers freelancers with experience in computer graphics. Works on assignment only. Uses freelancers mainly for time-consuming computer graphics. Also for brochure and print ad illustration and storyboards. Needs website developers. 65% of work is with print ads. 50% of freelance work demands skills in Illustrator and Photoshop.

First Contact & Terms: Send query letter with résumé and paper or electronic samples. Samples are filed or returned by SASE if requested. Responds only if interested. Will contact artist for portfolio review if interested. Pays for design by the project. Pays for illustration by the project. Rights purchased vary according to project. Find artists through viewing portfolios, submissions, word of mouth, American Advertising Federation district conferences and conventions.

Maryland

SAM BLATE ASSOCIATES LLC, 10331 Watkins Mill Dr., Montgomery Village MD 20886-3950. (301)840-2248. Fax: (301)990-0707. Toll-Free: (877)821-6824. E-mail: info@writephotopro.com. Website: www.writephotopro.com. **President:** Sam Blate. Number of employees: 2. Approximate annual billing: $120,000. AV and editorial services firm. Clients: business/professional, US government, private.

Needs: Approached by 6-10 freelancers/year. Works with 1-5 freelance illustrators and 1-2 designers/year. Only works with freelancers in the Washington DC metropolitan area. Works on assignment only. Uses freelancers for cartoons (especially for certain types of audiovisual presentations), editorial and technical illustrations (graphs, etc.) for 35mm and digital slides, pamphlet and book design. Especially important are "technical and aesthetic excellence and ability to meet deadlines." 80% of freelance work demands knowledge of PageMaker, Photoshop, and/or Powerpoint for Windows.

First Contact & Terms: Send query letter with résumé and website, tearsheets, brochure, photocopies, slides, transparencies or photographs to be kept on file. Accepts disk submissions compatible with Photoshop and PageMaker. IBM format only. "No original art." Samples are returned only by SASE. Responds only if interested. Pays by the hour, $20-50. Rights purchased vary according to project, "but we prefer to purchase first rights only. This is sometimes not possible due to client demand, in which case we attempt to negotiate a financial adjustment for the artist."
Tips: "The demand for technically-oriented artwork has increased."

N **DEVER DESIGNS**, 1056 West St., Laurel MD 20707. (301)776-2812. Fax: (301)953-1196. E-mail: info@deverdesigns.com. Website: www.deverdesigns.com. **President:** Jeffrey Dever. Marketing Director: Holly Hagen. Estab. 1985. Number of employees: 8. Approximate annual billing: $750,000. Specializes in annual reports, corporate identity and publication design. Clients: corporations, museums, government agencies, associations, nonprofit organizations. Current clients include Carnegie Corporation of New York, US Department of Labor, National Air and Space Museum. Client list available upon request.
 ● Dever Designs won 13 awards for graphic design in 2001, including the 2001 American Graphic Design Award Competition, American Corporate I.D. and several awards in the *Creativity 31* competition.
Needs: Approached by 100 freelance illustrators/year. Works with 30-50 freelance illustrators and 1-2 designers/year. Prefers artists with experience in editorial illustration. Uses illustrators mainly for publications. Uses designers mainly for on-site help when there is a heavy workload. Also uses freelancers for brochure illustration, charts/graphs and in-house production. 100% of design demands knowledge of QuarkXPress.
First Contact & Terms: Send postcard, samples or query letter with photocopies, résumé and tearsheets. Accepts disk submissions compatible with Illustrator or QuarkXPress, but prefers hard copy samples which are filed. Will contact artist for portfolio review if interested. Portfolio should include b&w and/or color photocopies for files. Pays for design and illustration by the project. Rights purchased vary according to project. Finds artists through referrals.
Tips: Impressed by "uniqueness and consistent quality."

N **PICCIRILLI GROUP**, 502 Rock Spring Rd., Bel Air MD 21014. (410)879-6780. Fax: (410)879-6602. E-mail: info@picgroup.com. Website: www.picgroup.com. **President:** Charles Piccirilli. Executive Vice President: Micah Piccirilli. Estab. 1974. Specializes in design and advertising; also annual reports, advertising campaigns, direct mail, brand and corporate identity, displays, packaging, publications and signage. Clients: recreational sport industries, fleet leasing companies, technical product manufacturers, commercial packaging corporations, direct mail advertising firms, realty companies, banks, publishers and software companies.
Needs: Works with 4 freelance designers/year. Works on assignment only. Mainly uses freelancers for layout or production. Prefers local freelancers. 75% of design demands skills in Illustrator 5.5 and QuarkXPress 3.3.
First Contact & Terms: Send query letter with brochure, résumé and tearsheets; prefers originals as samples. Samples returned by SASE. Responds on whether to expect possible future assignments. To show a portfolio, mail roughs and finished art samples or call for an appointment. Pays for design and illustration by the hour, $20-45. Considers complexity of project, client's budget, and skill and experience of artist when establishing payment. Buys one-time or reprint rights; rights purchased vary according to project.
Tips: "Portfolios should include work from previous assignments. The most common mistake freelancers make is not being professional with their presentations. Send a cover letter with photocopies of work."

Massachusetts

RICHARD BERTUCCI/GRAPHIC COMMUNICATIONS, 3 Juniper Lane, Dover MA 02030-2146. (508)785-1301. Fax: (508)785-2072. E-mail: rich.bert@netzero.net. **Owner:** Richard Bertucci. Estab. 1970. Number of employees: 2. Approximate annual billing: $500,000. Specializes in annual reports, corporate identity, display, direct mail, package design, print advertising, collateral material. Clients: companies and corporations. Professional affiliations: AIGA.
Needs: Approached by 12-24 freelancers/year. Works with 6 freelance illustrators and 3 designers/year. Prefers local artists with experience in business-to-business advertising. Uses illustrators mainly for feature products. Uses designers mainly for fill-in projects, new promotions. Also uses freelancers for ad, brochure

and catalog design and illustration, direct mail, magazine and newspaper design and logos. 50% of design and 25% of illustration demand knowledge of Illustrator, Photoshop and QuarkXPress.
First Contact & Terms: Send postcard sample of work or send query letter with brochure and résumé. Samples are filed. Will contact artist for portfolio review if interested. Portfolio should include b&w and color roughs. Pays for design by the project, $500-5,000. Pays for illustration by the project, $250-2,500. Rights purchased vary according to project.
Tips: "Send more information, not just a postcard with no written information." Chooses freelancers based on "quality of samples, turn-around time, flexibility, price, location."

BODZIOCH DESIGN, 30 Robbins Farm Rd., Dunstable MA 01827. (978)649-2949. Website: www.bodziochdesign.com. Estab. 1986. Number of employees: 1. Specializes in annual reports, corporate identity and direct mail design. Clients: corporations. Current clients include New England Business Service, Analog Devices, Inc., Centra Software, Simpley Grinell/Tyco and Hybercom Corporation, Codem Systems. Client list available upon request.
Needs: Works with freelance illustrators and designers. Prefers local artists with experience in direct mail and corporate work. Uses illustrators mainly for charts, graphs and spot illustration. Uses designers mainly for concept, ad and logo design. Also uses freelancers for airbrushing, brochure and direct mail design, retouching. Needs computer-literate freelancers for design, illustration, production and presentation. 90% of freelance work demands knowledge of Illustrator, Photoshop, FreeHand and QuarkXPress.
First Contact & Terms: Send postcard sample of work. Samples are filed. Will contact artist for portfolio review if interested. Portfolio should include b&w and color final art and roughs. Pays for design by the hour, or project. Pays for illustration by the project (supply quote). Rights purchased as dictated by client (usually all rights). Finds artists through *American Showcase*, *Communication Arts*, *Workbook*, *Direct Stock*, mailings from reps, and websites such as www.monster.com and www.guru.com.

FLAGLER ADVERTISING/GRAPHIC DESIGN, Box 280, Brookline MA 02446. (617)566-6971. Fax: (617)566-0073. **President/Creative Director:** Sheri Flagler. Specializes in corporate identity, brochure design, ad campaigns and package design. Clients: finance, real estate, high-tech and direct mail agencies, infant/toddler manufacturers.
Needs: Works with 10-20 freelancers/year. Works on assignment only. Uses freelancers for illustration, photography, retouching, airbrushing, charts/graphs and lettering.
First Contact & Terms: Send résumé, business card, brochures, photocopies or tearsheets to be kept on file. Call or write for appointment to show portfolio. Samples filed and are not returned. Responds only if interested. Pays for design and illustration by the project, $150-2,500. Considers complexity of project, client's budget and turnaround time when establishing payment.
Tips: "Send a range and variety of styles showing clean, crisp and professional work."

McGRATHICS, 18 Chestnut St., Marblehead MA 01945. (781)631-7510. E-mail: www.mcgrathics.com. Website: www.mcgrathics.com. **Art Director:** Vaughn McGrath. Estab. 1978. Number of employees: 4-6. Specializes in corporate identity, annual reports, package and publication and web design. Clients: corporations and universities. Professional affiliations: AIGA, VUGB.
Needs: Approached by 30 freelancers/year. Works with 8-10 freelance illustrators/year. Uses illustrators mainly for advertising, corporate identity (both conventional and computer). Also for ad, brochure, catalog, poster and P-O-P illustration; charts/graphs. Computer and conventional art purchased.
First Contact & Terms: Send postcard sample of work or send brochure, photocopies, photographs, résumé, slides and transparencies. Samples are filed. Responds only if interested. Portfolio review not required. Pays for illustration by the hour or by the project. Rights purchased vary according to project. Finds artists through sourcebooks and mailings.
Tips: "Annually mail us updates for our review."

DONYA MELANSON ASSOCIATES, 5 Bisson Lane, Merrimac MA 01860. (978)346-9240. Fax: (978)346-8345. E-mail: dmelanson@dmelanson.com. Website: www.dmelanson.com. **Contact:** Donya Melanson. Advertising agency. Number of employees: 6. Clients: industries, institutions, education, associations, publishers, financial services and government. Current clients include: US Geological Survey, Mannesmann, Cambridge College, American Psychological Association, Brookings Institution Press and US Dept. of Agriculture. Client list available upon request.
Needs: Approached by 30 artists/year. Works with 3-4 illustrators/year. Most work is handled by staff, but may occasionally use illustrators and designers. Uses artists for stationery design, direct mail, brochures/

flyers, annual reports, charts/graphs and book illustration. Needs editorial and promotional illustration. 50% of freelance work demands skills in Illustrator, QuarkXPress or Photoshop.

First Contact & Terms: Query with brochure, résumé, photostats and photocopies. Provide materials (no originals) to be kept on file for future assignments. Originals returned to artist after use only when specified in advance. Call or write for appointment to show portfolio or mail thumbnails, roughs, final art, final reproduction/product and color and b&w tearsheets, photostats and photographs. Pays for design and illustration by the project, $100 minimum. Considers complexity of project, client's budget, skill and experience of artist and how work will be used when establishing payment.

Tips: "Be sure your work reflects concept development. We would like to see more electronic design and illustration capabilities."

RUTH MORRISON ASSOCIATES, INC., 246 Brattle St., Cambridge MA 02138. (617)354-4536. Fax: (617)354-6943. **Account Executive:** Cindy Simon. Estab. 1972. PR firm. Specializes in food, travel, design, education, non-profit. Assignments include logo/letterhead design, invitations and brochures.

Needs: Prefers local freelancers with experience in advertising and/or publishing. Other assignments include catalog, poster and print ad design. 5% of work is with print ads. 25% of freelance work demands computer skills.

First Contact & Terms: Send query letter with photocopies. Samples are filed or returned by SASE only if requested by artist. Does not reply. Pays for design and illustration by the project. Rights purchased vary according to project. Finds artists through word of mouth, magazines and advertising.

[N] [🖥] [🏛] PRECISION ARTS ADVERTISING INC., 57 Fitchburg Rd., Ashburnham MA 01430. (978)827-4927. Fax: (978)827-4928. E-mail: artistmarket@precisionarts.com. Website: www.precisionarts. com. **President:** Terri Adams. Estab. 1985. Number of employees: 2. Full-service web/print ad agency. Specializes in internet marketing strategy, website/print design, graphic design. Product specialty is manufacturing, including plastics, surgical and medical instruments, electronic equipment and instrumentation. Client list available upon request. Clients include: Northern Products, Safety Source Northeast, Ranor.

Needs: Approached by 5 freelance illustrators and 5 designers/year. Works with 1 freelance illustrator and 1 designer/year. Prefers local freelancers. 49% of work is with printing/marketing. 36% of work is web design. Freelance web skills required in Macintosh DreamWeaver and Photoshop; freelance print skills required in QuarkXPress, Photoshop, Illlustrator and Pre-Press.

First Contract & Terms: Send résumé with links to artwork and suggested hourly rate.

[🖥] [🏛] TR PRODUCTIONS, 1031 Commonwealth Ave., Boston MA 02215. (617)783-0200. Fax: (617)783-4844. Website: trprod.com. **Creative Director:** Cary M. Benjamin. Estab. 1947. Number of employees: 12. AV firm. Full-service multimedia firm. Specializes in FLASH, collateral, multimedia, web graphics and video.

Needs: Approached by 15 freelancers/year. Works with 5 freelance illustrators and 5 designers/year. Prefers local freelancers with experience in slides, web, multimedia, collateral and video graphics. Works on assignment only. Uses freelancers mainly for slides, web, multimedia, collateral and video graphics. Also for brochure and print ad design and illustration, slide illustration, animation and mechanicals. 25% of work is with print ads. Needs computer-literate freelancers for design, production and presentation. 95% of work demands skills in FreeHand, Photoshop, Premier, After Effects, Powerpoint, QuarkXPress, Illustrator, Flash and Front Page.

First Contact & Terms: Send query letter. Samples are filed. Does not reply. Artist should follow up with call. Will contact artist for portfolio review if interested. Rights purchased vary according to project.

Michigan

[🖥] BIGGS GILMORE COMMUNICATIONS, 261 E. Kalamazoo Ave., Suite 300, Kalamazoo MI 49007-3990. (269)349-7711. Fax: (269)349-3051. Website: www.biggs-gilmore.com. **Creative Department Office Manager:** Launa Rogers. Estab. 1973. Ad agency. Full-service, multimedia firm. Specializes in traditional advertising (print, collateral, TV, radio, outdoor), branding, strategic planning, e-business development, and media planning and buying. Product specialties are consumer, business-to-business, marine and healthcare.

● This is one of the largest southwestern Michigan. Clients include Baja Marine Corporation, Meridian Yachts, DuPont, Steelcase and Kellogg Company, US Marine, Armstrong, Zimmer, Machine

Works, Union Planters Bank and Proctor & Gamble Pharmaceuticals.

Needs: Approached by 10 artists/month. Works with 1-3 illustrators and designers/month. Works both with artist reps and directly with artist. Prefers artists with experience with client needs. Works on assignment only. Uses freelancers mainly for completion of projects needing specialties. Also for brochure, catalog and print ad design and illustration, storyboards, slide illustration, animatics, animation, mechanicals, retouching, billboards, posters, TV/film graphics, lettering and logos.

First Contact & Terms: Send query letter with brochure, photocopies and résumé. Samples are filed. Respondss only if interested. Call for appointment to show portfolio. Portfolio should include all samples the artist considers appropriate. Pays for design and illustration by the hour and by the project. Rights purchased vary according to project.

COMMUNICATIONS ELECTRONICS, INC., Dept AM, Box 2797, Ann Arbor MI 48106-2797. (734)996-8888. E-mail: cei@usascan.com. **Editor:** Ken Ascher. Estab. 1969. Number of employees: 38. Approximate annual billing: $5 million. Manufacturer, distributor and ad agency (13 company divisions). Specializes in marketing. Clients: electronics, computers.

Needs: Approached by 500 freelancers/year. Works with 40 freelance illustrators and 40 designers/year. Uses freelancers for brochure and catalog design, illustration and layout, advertising, product design, illustration on product, P-O-P displays, posters and renderings. Needs editorial and technical illustration. Prefers pen & ink, airbrush, charcoal/pencil, watercolor, acrylic, marker and computer illustration. 30% of freelance work demands skills in PageMaker or QuarkXPress.

First Contact & Terms: Send query letter with brochure, résumé, business card, samples and tearsheets to be kept on file. Samples not filed are returned by SASE. Responds in 1 month. Will contact artist for portfolio review if interested. Pays for design and illustration by the hour, $10-120; by the project, $10-15,000; by the day, $40-800.

■ PHOTO COMMUNICATION SERVICES, INC., 6055 Robert Dr., Traverse City MI 49864. (231)943-5050. E-mail: artists@UtopianEmpire.com. Website: www.UtopianEmpire.com. **Contact:** Ms. M'Lynn Hartwell. Estab. 1970. Full-service, multimedia firm. Specializes in corporate and industrial products, as well as radio spots.

Needs: Works on assignment. Uses freelancers mainly for internet web page, brochure, catalog and print ad design and illustration storyboards, animation, logos and more. 70% of work is with print ads.

First Contact & Term: Send query with brochure, SASE and tearsheets. Samples are filed or returned by SASE if requested by artist. Responds only if interested. To show portfolio, mail tearsheets and transparencies, CD-ROM. Pays for design and illustration by the project, negotiated rate. Rights purchased vary according to project.

Minnesota

▣ BUTWIN & ASSOCIATES ADVERTISING, (formerly Butwin & Associates Advertising, Inc.), 8700 Westmoreland Lane, Minneapolis MN 55426. Phone/fax: (952)545-3886. **President:** Ron Butwin. Estab. 1977. Ad agency. "We are a full-line ad agency working with both consumer and industrial accounts on advertising, marketing, public relations and meeting planning." Clients: banks, restaurants, clothing stores, food brokerage firms, corporations and a "full range of retail and service organizations."

● This agency offers some unique services to clients, including uniform design, interior design and display design.

Needs: Works with 10-15 illustrators and 10-12 designers/year. Prefers local artists when possible. Uses freelancers for design and illustration of brochures, catalogs, newspapers, consumer and trade magazines, P-O-P displays, retouching, animation, direct mail packages, motion pictures and lettering. 20% of work is with print ads. Prefers realistic pen & ink, airbrush, watercolor, marker, calligraphy, computer, editorial and medical illustration. Needs computer-literate freelancers for design and illustration. 40% of freelance work demands computer skills.

First Contact & Terms: Send brochure or résumé, tearsheets, photostats, photocopies, slides and photographs. Samples are filed or are returned only if SASE is enclosed. Responds only if interested. Call for appointment to show portfolio. Pays for design and illustration by the project; $25-3,000. Considers client's budget, skill and experience of artist and how work will be used when establishing payment. Buys all rights.

Tips: "Portfolios should include layouts and finished project." A problem with portfolios is that "samples are often too weak to arouse enough interest."

■ ✦ **UNO HISPANIC ADVERTISING AND DESIGN**, 2836 Lindale S., Suite 002, Minneapolis MN 55408. (612)874-1920. E-mail: unoonline.com. Website: www.unoonline.com. **Creative Director:** Luis Fitch. Marketing Director: Carolina Ornelas. Estab. 1990. Number of employees: 6. Approximate annual billing: $950,000. Specializes in brand and corporate identity, display, package and retail design and signage for the US Hispanic markets. Clients: Latin American corporations, retail. Current clients include MTV Latino, Target, Mervyn's, 3M, Dayton's, SamGoody, Univision, Wilson's. Client list available upon request. Professional affiliations: AIGA, GAG.

Needs: Approached by 33 freelancers/year. Works with 40 freelance illustrators and 20 designers/year. Works only with artists' reps. Prefers local artists with experience in retail design, graphics. Uses illustrators mainly for packaging. Uses designers mainly for retail graphics. Also uses freelancers for ad and book design, brochure, catalog and P-O-P design and illustration, audiovisual materials, logos and model making. Also for multimedia projects (Interactive Kiosk, CD-Educational for Hispanic Market). 60% of design demands computer skills in Illustrator, Photoshop, FreeHand and QuarkXPress.

First Contact & Terms: Designers send postcard sample, brochure, résumé, photographs, slides, tearsheets and transparencies. Illustrators send postcard sample, brochure, photographs, slides and tearsheets. Accepts disk submissions compatible with Illustrator, Photoshop, FreeHand. Send EPS files. Samples are filed. Will contact artist for portfolio review if interested. Portfolio should include color final art, photographs and slides. Pays for design by the project, $500-6,000. Pays for illustration by the project, $200-20,000. Rights purchased vary according to project. Finds artists through artist reps, *Creative Black Book* and *Workbook*.

Tips: "It helps to be bilingual and to have an understanding of Hispanic cultures."

Missouri

■ **MEDIA CONSULTANTS**, P.O. Box 130, Sikeston MO 63801. (573)472-1116. Fax: (573)472-3299. E-mail: rwrather@sbcglobal.net. **President:** Rich Wrather. Estab. 1981. Number of employees: 10. Ad agency, AV and PR firm. Full-service multimedia firm. Specializes in print, magazines, AV. Product specialty is business-to-business. Client list not available.

Needs: Appoached by 25 freelancers/year. Works with 10-15 freelance illustrators and 5-10 designers/year. Works on assignment only. Uses freelancers mainly for layout and final art. Also for brochure, catalog and print ad design and illustration, storyboards, animation, billboards, TV/film graphics and logos. 40% of work is with print ads. Needs computer-literate freelancers for design, illustration, production and presentation. 100% of freelance work demands knowledge of PageMaker, FreeHand or Photoshop.

First Contact & Terms: Send query letter with brochure, résumé, photocopies, photographs, SASE and tearsheets. Samples are filed. Will contact artist for portfolio review if interested. Portfolio should include b&w and color roughs, final art, tearsheets, photostats and photographs. Pays for design by the project, $150-1,000. Pays for illustration by the project, $25-250. Buys all rights. Finds artists through word of mouth.

Tips: Advises freelancers starting out to "accept low fees first few times to build a rapport. Put yourself on the buyer's side."

■ ✦ **PHOENIX LEARNING GROUP, INC.**, 2349 Chaffee Dr., St. Louis MO 63146. (314)569-0211. Website: phoenixlearninggroup.com. **President:** Heinz Gelles. Executive Vice President: Barbara Bryant. Vice President, Market Development: Kathy Longsworth. Number of employees: 50. Clients: libraries, museums, religious institutions, US government, schools, universities, film societies and businesses. Produces and distributes educational films.

Needs: Works with 1-2 freelance illustrators and 2-3 designers/year. Prefers local freelancers only. Uses artists for motion picture catalog sheets, direct mail brochures, posters and study guides. Also for multimedia projects. 85% of freelance work demands knowledge of PageMaker, QuarkXPress and Illustrator.

First Contact & Terms: Send postcard sample and query letter with brochure (if applicable). Send recent samples of artwork and rates to director of promotions. "No telephone calls please." Responds if need arises. Buys all rights. Keeps all original art "but will loan to artist for use as a sample." Pays for design and illustration by the hour or by the project. Rates negotiable. Free catalog upon written request.

N ⊡ ▣ SIGNATURE DESIGN, 2101 Locust, St. Louis MO 63103. (314)621-6333. Fax: (314)621-0179. E-mail: info@theresemckee.com. Website: www.theresemckee.com. **Owner:** Therese McKee. Estab. 1993. Interpretive graphic and exhibit design firm producing conceptual design, design development and project management for exhibits in museums, visitor centers and parks; interpretive signage for parks and gardens; and computer interactives and graphics for websites. Current clients include Bureau of Land Management, Missouri Botanical Garden, United States Post Office. Client list available upon request.
Needs: Approached by 15 freelancers/year. Works with 1-2 illustrators and 1-2 designers/year. Prefers local freelancers only. Works on assignment only. 50% of freelance work demands knowledge of QuarkXPress, FLASH animation, Illustrator or Photoshop.
First Contact & Terms: Send query letter with résumé, tearsheets and photocopies. Samples are filed. Responds only if interested. Artist should follow up with letter after initial query. Portfolio should include "whatever best represents your work." Pays for design by the hour. Pays for illustration by the project.

▣ STOBIE GROUP, LLC, 240 Sovereign Court, St. Louis MO 63011. (636)256-9400. Fax: (636)256-0943. E-mail: mtuttle@stobiegroup.com. Website: www.stobiegroup.com. **Creative Director:** Mary Tuttle. Estab. 1935. Number of employees: 10. Approximate annual billing: $8 million. Ad agency. Full-service, multimedia firm. Product specialties are business-to-business, industrial, healthcare and consumer services. Current clients include Star Manufacturing, RehabCare Group, Mallinckrodt.
Needs: Approached by 100-150 freelancers/year. Works with 12 freelance illustrators and 6 designers/year. Uses freelancers for art direction, design, illustration, photography, production. Also for brochure, catalog, print ad and slide illustration. 80% of work is with print. 75% of freelance work demands knowledge of QuarkXPress, Illustrator and Photoshop. Needs technical, medical and creative illustration.
First Contact & Terms: Send query letter with résumé, photostats, photocopies, and slides. Samples are filed or are returned by SASE if requested by artist. Will contact artist for portfolio review if interested. Portfolios should be e-mailed and should include thumbnails, roughs, original/final art and tearsheets. Sometimes requests work on spec before assigning a job. Pays for design by the project. Pays for illustration by the project. Negotiates rights purchased. Finds artists through word of mouth, reps and work samples.
Tips: Freelancers "must be well organized, meet deadlines, listen well and have a concise portfolio of abilities."

Montana

▣ WALKER DESIGN GROUP, 47 Dune Dr., Great Falls MT 59404. (406)727-8115. Fax: (406)791-9655. **President:** Duane Walker. Number of employees: 6. Design firm. Specializes in annual reports and corporate identity. Professional affiliations: AIGA and Ad Federation.
Needs: Uses freelancers for animation, annual reports, brochure, medical and technical illustration, catalog design, lettering, logos and TV/film graphics. 80% of design and 90% of illustration demand skills in PageMaker, Photoshop and Adobe Illustrator.
First Contact & Terms: Send query letter with brochure, photocopies, photographs, résumé, slides and/or tearsheets. Accepts disk submissions. Samples are filed and are not returned. Responds only if interested. To arrange portfolio review, artist should follow up with call or letter after initial query. Portfolio should include color photographs, photostats and tearsheets. Pays by the project; negotiable. Finds artists through *Workbook*.
Tips: "Stress customer service and be very aware of time lines."

Nebraska

MICHAEL EDHOLM DESIGN, 4201 Teri Lane, Lincoln NE 68502. (402)489-4314. **President:** Michael Edholm. Estab. 1989. Number of employees: 1. Approximate annual billing: $70,000. Specializes in annual reports; corporate identity; direct mail, package and publication design. Clients: ad agencies, insurance companies, universities and colleges, publishers, broadcasting. Professional affiliations: AIGA.
Needs: Approached by 20 freelancers/year. Also uses freelancers for ad, catalog and poster illustration; brochure design and illustration; direct mail design; logos; web design; and model-making. 20% of freelance work demands knowledge of Illustrator, Photoshop, FreeHand, PageMaker and QuarkXPress.
First Contact & Terms: Contact through telephone or mail. Send postcard sample of work or send

brochure, photocopies, SASE and tearsheets. Samples are filed. Will contact artist for portfolio review if interested. Portfolio should include b&w and color final art, photographs and slides. Pays for design and illustration by the project. Rights purchased vary according to project. Finds artists through *Workbook*, *Showcase*, direct mail pieces.

J. GREG SMITH, 1004 Farnam St., Burlington Place, Suite 102, Omaha NE 68102. (402)444-1600. **Senior Art Director:** Greg Smith. Estab. 1974. Number of employees: 8. Approximate annual billing: $1.5 million. Ad agency. Clients: financial, banking, associations, agricultural, travel and tourism, insurance. Professional affiliation: AAAA.
Needs: Approached by 1-10 freelancers/year. Works with 4-5 freelancers illustrators and 1-2 designers/year. Works on assignment only. Uses freelancers mainly for mailers, brochures and projects. Also for consumer and trade magazines, catalogs and AV presentations. Needs illustrations of farming, nature, travel.
First Contact & Terms: Send query letter with samples showing art style and/or photocopies. Responds only if interested. To show portfolio, mail final reproduction/product, color and b&w. Pays for design and illustration by the project, $500-5,000. Buys first, reprint or all rights.

New Hampshire

YASVIN DESIGNERS, 45 Peterborough Rd., Box 116, Hancock NH 03449. (603)525-3000. Fax: (603)525-3300. **Contact:** Creative Director. Estab. 1990. Number of employees: 3. Specializes in annual reports, brand and corporate identity, package design and advertising. Clients: corporations, colleges and institutions.
Needs: Approached by 10-15 freelancers/year. Works with 6 freelance illustrators and 2 designers/year. Uses freelancers for book production, brochure illustration, logos. 50% of freelance work demands knowledge of Illustrator, Photoshop, FreeHand and/or QuarkXPress.
First Contact & Terms: Send postcard sample of work or send query letter with photocopies, SASE and tearsheets. Samples are filed. Responds only if interested. Request portfolio review in original query. Portfolio should include b&w and color photocopies, roughs and tearsheets. Pays for design by the project and by the day. Pays for illustration by the project. Rights purchased vary according to project. Finds artists through sourcebooks and artists' submissions.

New Jersey

AM/PM ADVERTISING, INC., 345 Claremont Ave., Suite 26, Montclair NJ 07402. (973)824-8600. Fax: (973)824-6631. **President:** Bob Saks. Estab. 1962. Number of employees: 130. Approximate annual billing: $24 million. Ad agency. Full-service multimedia firm. Specializes in national TV commercials and print ads. Product specialties are health and beauty aids. Current clients include J&J, Bristol Myers, Colgate Palmolive. Client list available upon request. Professional affiliations: AIGA, Art Directors Club, Illustration Club.
Needs: Approached by 35 freelancers/year. Works with 3 freelance illustrators and designers/month. Agency prefers to work with local freelancers only with experience in animation, computer graphics, film/video production, multimedia, Macintosh. Works only with artist reps. Works on assignment only. Uses freelancers mainly for illustration and design. Also for brochure design and illustration, storyboards, slide illustration, animation, technical illustration, TV/film graphics, lettering and logos. 30% of work is with print ads. 50% of work demands knowledge of PageMaker, QuarkXPress, FreeHand, Illustrator or Photoshop.
First Contact & Terms: Send postcard sample and/or query letter with brochure, résumé and photocopies. Samples are filed or returned. Responds in 10 days. Portfolios may be dropped off every Friday. Artist should follow up after initial query. Portfolio should include b&w and color thumbnails, roughs, final art, tearsheets, photographs and transparencies. Pays by the hour, $35-100; by the project, $300-5,000; or with royalties (25%). Rights purchased vary according to project.
Tips: "When showing work, give time it took to do job and costs."

■ **NORMAN DIEGNAN & ASSOCIATES**, 3 Martens Rd., Lebanon NJ 08833. (908)832-7951. **President:** N. Diegnan. Estab. 1977. Number of employees: 5. Approximate annual billing: $1 million. PR firm. Specializes in magazine ads. Product specialty is industrial.

Needs: Approached by 10 freelancers/year. Works with 20 freelancers illustrators/year. Works on assignment only. Uses freelancers for brochure, catalog and print ad design and illustration, storyboards, slide illustration, animatics, animation, mechanicals, retouching and posters. 50% of work is with print ads. Needs editorial and technical illustration.

First Contact & Terms: Send query letter with brochure and tearsheets. Samples are filed and not returned. Responds in 1 week. To show portfolio, mail roughs. Pays for design and illustration by the project. Rights purchased vary according to project.

■ ■ **IRVING FREEMAN DESIGN CO.**, 10 Jay St., #2, Tenafly NJ 07670. (201)569-4949. Fax: (201)569-4979. E-mail: irv@freemanwolff.com. Website: www.freemanwolff.com. **CEO/CCO:** Irving Freeman. Estab. 1972. Approximate annual billing: $100,000. Specializes in Web design, corporate identity and collateral. Clients: corporations and publishers. Current clients include HarperCollins, Simon & Schuster and Warner Books. Client list available upon request. Professional affiliations: GAG.

Needs: Approached by 10 freelancers/year. Prefers local artists only. Uses designers mainly for book interiors. Needs computer-literate freelancers for design, production and presentation. 100% of freelance work demands knowlege of Illustrator, Photoshop, QuarkXPress and Flash/Dreamweaver.

First Contact & Terms: Send postcard sample of work or send brochure, photocopies, photographs and tearsheets. Samples are filed. Responds in 1 month. Will contact artist for portfolio review if interested. Portfolio should include final art. Pays for design by the hour, by the project and by the day. Rights purchased vary according to project. Finds artists through sourcebooks.

■ **JANUARY PRODUCTIONS, INC.**, 116 Washington Ave., Hawthorne NJ 07506. (201)423-4666. Fax: (201)423-5569. E-mail: awpeller@inetmail.att.net. Website: www.awpeller.com. **Art Director:** Karen Birchak. Estab. 1973. Number of employees: 12. AV producer. Serves clients in education. Produces children's educational materials—videos, sound filmstrips, read-along books, cassettes and CD-ROM.

Needs: Works with 1-2 freelance illustrators/year. "While not a requirement, a freelancer living in the same geographic area is a plus." Works on assignment only, "although if someone had a project already put together, we would consider it." Uses freelancers mainly for illustrating children's books. Also for artwork for filmstrips, sketches for books and layout work. 50% of freelance work demands knowledge of QuarkXPress and Photoshop.

First Contact & Terms: Send query letter with résumé, tearsheets, SASE, photocopies and photographs. Will contact artist for portfolio review if interested. "Include child-oriented drawings in your portfolio." Requests work on spec before assigning a job. Pays for design and illustration by the project, $20 minimum. Originals not returned. Buys all rights. Finds artists through submissions.

■ **LARRY KERBS STUDIOS**, 581 Mountain Ave., Gillette NJ 07433. (908)604-6137. Fax: (908)647-0543. E-mail: chlincoln@earthlink.net. **Contact:** Larry Kerbs. Specializes in sales promotion design, ad work and placement, annual reports, corporate identity, publications and technical illustration. Clients: industrial, chemical, medical devices, insurance, travel, PR, over-the-counter specialties.

 • Also has a western branch. See this company's listing in New Mexico for complete submission information.

■ **KJD TELEPRODUCTIONS**, 30 Whyte Dr., Voorhees NJ 08043. (856)751-3500. Fax: (856)751-7729. E-mail: kjdteleproductions.com. Website: www.kjdteleproductions.com. **President:** Larry Scott. Senior Editor: Kevin Alexander. Estab. 1989. Ad agency/AV firm. Full-service multimedia firm. Specializes in magazine, radio and television. Current clients include ICI America's and Taylors Nightclub.

Needs: Works with 20 freelance illustrators and 12 designers/year. Prefers freelancers with experience in TV. Works on assignment only. Uses freelancers for brochure and print ad design and illustration, storyboards, animatics, animation, TV/film graphics. 70% of work is with print ads. Also for multimedia projects. 90% of freelance work demands knowledge of QuarkXPress, Illustrator 6.0, PageMaker and FreeHand.

First Contact & Terms: Send query letter with brochure, photographs, slides, tearsheets or transparencies and SASE. Samples are filed or are returned by SASE. Accepts submissions on disk from all applications. Send EPS files. Responds only if interested. To show portfolio, mail roughs, photographs and slides. Pays for design and illustration by the project; rate varies. Buys first rights or all rights.

GET 2 FREE ISSUES of THE ARTIST'S MAGAZINE...

And Enjoy a Private Art Lesson!

The Artist's Magazine is your prime source of creative inspiration for all the major artistic disciplines. You get easy-to-understand, step-by-step instruction without having to pay for expensive art lessons!

Every month more than 200,000 fine artists rely on, and trust, *The Artist's Magazine* to bring them tips and techniques from today's hottest international artists.
You'll find expert advice on how to:

- Achieve stunning effects in watercolor, oil, acrylic, pastel, gouache, pen and ink, and many other mediums
- Choose and use supplies, and get the most mileage from all your materials
- Keep up to date on current seminars, workshops, competitions and exhibits
- And so much more!

Now, through this special trial offer in *Artist's and Graphic Designer's Market*, you can get 2 FREE ISSUES of *THE ARTIST'S MAGAZINE!*

Return the attached RISK-FREE RSVP card today!

SMITH DESIGN ASSSOCIATES, 205 Thomas St., Box 8278, Glen Ridge NJ 07028. (973)429-2177. Fax: (973)429-7119. E-mail: laraine@smithdesign.com. Website: www.smithdesign.com. **Vice President:** Laraine Blauvelt. Clients: cosmetics firms, toy manufacturers, life insurance companies, office consultants. Current clients: Popsicle, Good Humor, Motts. Client list available upon request.

Needs: Approached by more than 100 freelancers/year. Works with 10-20 freelance illustrators and 3-4 designers/year. Requires high level, experienced, talent, quality work and reliability. Uses freelancers for package design, concept boards, brochure design, print ads, newsletters illustration, POP display design, retail environments, web programming. 90% of freelance work demands knowledge of Illustrator, QuarkX-Press, 3-D rendering programs. Design style must be current to trends. Our work ranges from "classic brands" to "of the moment/cutting edge." Particularly when designing for KIDS and TEENS.

First Contact & Terms: Send query letter with brochure/samples showing work, style and experience. Include contact information. Samples are filed or are returned only if requested by artist. Responds in 1 week. Call for appointment to show portfolio. Pays for design by the hour, $25-100; or by the project, $175-5,000. Pays for illustration by the project, $175-5,000. Considers complexity of project and client's budget when establishing payment. Buys all rights. (For illustration work, rights may be limited to a particular use TBD). Also buys rights for use of existing non-commissioned art. Finds artists through word of mouth, self-promotions/sourcebooks and agents.

Tips: "Know who you're presenting to (visit our website to see our needs). Show work which is relevant to our business at the level and quality we require. We use more freelance designers and illustrators for diversity of style and talent."

☑ **THE STRONGTYPE**, 91 Prospect St., P.O. Box 1520, Dover NJ 07802-1520. (973)674-3727. Fax: (973)919-4265. E-mail: talentbank@strongtype.com. Website: www.strongtype.com. **Contact:** Richard Puder. Estab. 1985. Number of employees: 1. Approximate annual billing: $300,000. Specializes in marketing communications, direct mail and publication design, technical illustration. Client history includes Hewlett-Packard, Micron Electronics, R.R. Bowker, Scholastic, Simon & Schuster and Sony. Professional affiliation: Type Directors Club.

Needs: Approached by 100 freelancers/year. Uses designers mainly for corporate, publishing clients. Also uses freelancers or ad and brochure design and illustration, book, direct mail, magazine and poster design, charts/graphs, lettering, logos and retouching. 100% of freelance work demands skills in Illustrator, Photoshop, FreeHand, Acrobat, QuarkXPress, Director, Flash, Fireworks and Dreamweaver.

First Contact & Terms: E-mail with links and follow up again or send postcard sample, résumé or tearsheets. Samples are filed. Will contact artist for portfolio review if interested. Portfolio should include color photocopies, photographs, roughs and thumbnails. Pays for design and production by the hour, depending on skills, $10-100. Pays for illustration by the job. Buys first rights or rights purchased vary according to project. Finds artists through sourcebooks (e.g., *American Showcase* and *Workbook*) and by client referral.

Tips: Impressed by "listening, problem-solving, speed, technical competency and creativity."

New Mexico

BOOKMAKERS LTD., P.O. Box 1086, Taos NM 87571. (505)776-5435. Fax: (505)776-2762. E-mail: bookmakers@newmex.com. Website: www.bookmakersltd.com. **President:** Gayle Crump McNeil. "We are agents for children's book illustrators and provide design and product in services to the publishing industry."

First Contact & Terms: Send query letter with samples showing style and SASE if samples need returning. Responds in 1 month.

Tips: The most common mistake freelancers make in presenting samples or portfolios is "too much variety—not enough focus."

N̄ LARRY KERBS STUDIOS, 308 Read St., Santa Fe NM 87501. (505)989-9551, Fax: (505)989-9552. E-mail: kerbscreative@earthlink.net. **Contact:** Larry Kerbs. Specializes in sales promotion design, ad work and placement, annual reports, corporate identity, publications and technical illustration. Clients: industrial, chemical, medical devices, insurance, travel, PR, over-the-counter specialties.

- Eastern US **Contact:** Jim Lincoln, 581 Mountain Ave., Gillette NJ 07433. (908)604-6137. Fax: (908)647-0543. E-mail: chlincoln@earthlink.net.

Needs: Works with computer production people, 1 illustrator and 1 designer/month. Uses artists for direct

mail, layout, illustration, technical art, annual reports, trade magazine ads, product brochures and direct mail. Needs computer-literate freelancers, prefers those with strong design training. Needs editorial and technical illustration. Looks for realistic editorial illustration, montages, 2-color and 4-color.

First Contact & Terms: Mail samples or call for interview. Prefers b&w or color line drawings, renderings, layout roughs and previously published work as samples. Provide business card and résumé to be kept on file for future assignments. Negotiates payment by the project.

Tips: "Strengthen typographic knowledge and application; know computers, production and printing in depth to be of better service to yourself and to your clients."

■ **R H POWER AND ASSOCIATES, INC.**, 320 Osuna NE, Bldg. B, Albuquerque NM 87107. (505)761-3150. Fax: (503)761-3153. E-mail: rhpower@qwest.net. Website: www.rhpower.com. **Art Director:** Bruce Yager. Creative Director: Roger L. Vergara. Estab. 1989. Number of employees: 12. Ad agency. Full-service, multimedia firm. Specializes in TV, magazine, billboard, direct mail, newspaper, radio. Product specialties are recreational vehicles and automotive. Current clients include Kem Lite Corporation, RV Sales & Rentals of Albany, Ultra-Fab Products, Collier RV, Nichols RV, American RV and Marine. Client list available upon request.

Needs: Approached by 10-50 freelancers/year. Works with 5-10 freelance illustrators and 5-10 designers/year. Prefers freelancers with experience in retail automotive layout and design. Uses freelancers mainly for work overload, special projects and illustrations. Also for annual reports, billboards, brochure and catalog design and illustration, logos, mechanicals, posters and TV/film graphics. 50% of work is with print ads. 100% of design demands knowledge of Photoshop 6.0, QuarkXPress and Illustrator 8.0.

First Contact & Terms: Send query letter with photocopies or photographs and résumé. Accepts disk submissions in PC format compatible with CorelDraw, QuarkXPress or Illustrator 8.0. Send PC EPS files. Samples are filed and are not returned. Will contact artist for portfolio review if interested. Portfolio should include b&w and color final art, roughs and thumbnails. Pays for design and illustration by the hour, $12 minimum; by the project, $100 minimum. Buys all rights.

Tips: Impressed by work ethic and quality of finished product. "Deliver on time and within budget. Do it until it's right without charging for your own corrections."

New York

N **BOXER DESIGN**, 548 State St., Brooklyn NY 11216-1619. (718)802-9212. Fax: (718)802-9213. E-mail: eileen@boxerdesign.com. Website: www.boxerdesign.com. **Contact:** Eileen Boxer. Estab. 1986. Approximate annual billing: $250,000. Design firm. Specializes in books and catalogs for art institutions, announcements, conceptual, video, exhibits primarily, but not exclusively for cultural institutions. Current clients include Ubu Gallery, Guggenheim Museum, The American Federation of The Arts, Philadelphia Museum. AIGA award of excellence (Graphic Design USA) 1997.

Needs: 10% of work is with print ads. Design work demands intelligent and mature approach to design. Knowledge of Photoshop, Illustrator, QuarkXPress.

First Contact & Terms: Send e-mail with written and visual credentials. Accepts disk submissions compatible with Quark 4.0 or higher, Photoshop, Illustrator, all Mac, Zip. Samples are filed or returned on request. Responds in 3 weeks if interested in artist's work. Artist should follow-up with call after initial query. Pays by the project. Rights purchased vary according to project.

CARNASE, INC., 21 Dorset Rd., Scarsdale NY 10583. (212)777-1500. Fax: (914)725-9539. **President:** Tom Carnase. Estab. 1978. Specializes in annual reports, brand and corporate identity, display, landscape, interior, direct mail, package and publication design, signage and technical illustration. Clients: agencies, corporations, consultants. Current clients include: Clairol, Shiseido Cosmetics, Times Mirror, Lintas: New York. Client list not available.

• President Tom Carnase predicts "very active" years ahead for the design field.

Needs: Approached by 60 freelance artists/year. Works with 2 illustrators and 1 designer/year. Prefers artists with 5 years experience. Works on assignment only. Uses artists for brochure, catalog, book, magazine and direct mail design and brochure and collateral illustration. Needs computer-literate freelancers. 50% of freelance work demands skills in QuarkXPress or Illustrator.

First Contact & Terms: Send query letter with brochure, résumé and tearsheets. Samples are filed. Responds in 10 days. Will contact artist for portfolio review if interested. Portfolio should include photostats, slides and color tearsheets. Negotiates payment. Rights purchased vary according to project. Finds

artists through word of mouth, magazines, artists' submissions/self-promotions, sourcebooks and agents.

DESIGN CONCEPTS, 137 Main St., Unadilla NY 13849. (607)369-4709. **Owner:** Carla Schroeder Burchett. Estab. 1972. Specializes in annual reports, brand identity, design and package design. Clients: corporations, individuals. Current clients include American White Cross and Private & Natural.
Needs: Approached by 6 freelance graphic artists/year. Works with 2 freelance illustrators and designers/year. Prefers artists with experience in packaging, photography, interiors. Uses freelance artists for mechanicals, poster illustration, P-O-P design, lettering and logos.
First Contact & Terms: Send query letter with tearsheets, brochure, photographs, résumé and slides. Samples are filed or are returned by SASE if requested by artist. Responds. Artists should follow up with letter after initial query. Portfolio should include thumbnails and b&w and color slides. Pays for design by the hour, $30 minimum. Negotiates rights purchased.
Tips: "Artists and designers are used according to talent; team cooperation is very important. If a person is interested and has the professional qualification, he or she should never be afraid to approach us—small or large jobs."

McANDREW ADVERTISING, 210 Shields Rd., Red Hook NY 12571. Phone/fax: (845)756-2276. E-mail: robertrmca@aol.com. **Art/Creative Director:** Robert McAndrew. Estab. 1961. Number of employees: 3. Approximate annual billing: $200,000. Ad agency. Clients: industrial and technical firms. Current clients include chemical processing equipment, electrical components.
Needs: Approached by 20 freelancers/year. Works with 2 freelance illustrators and 2 designers/year. Uses mostly local freelancers. Uses freelancers mainly for design, direct mail, brochures/flyers and trade magazine ads. Needs technical illustration. Prefers realistic, precise style. Prefers pen & ink, airbrush and occasionally markers. 30% of work is with print ads. Freelance work demands computer skills.
First Contact & Terms: Query with business card and brochure/flier to be kept on file. Samples not returned. Responds in 1 month. Originals not returned. Will contact artist for portfolio review if interested. Portfolio should include roughs and final reproduction. Pays for illustration by the project, $35-300. Pays for design by the project. Considers complexity of project, client's budget and skill and experience of artist when establishing payment. Finds artists through sourcebooks, word of mouth and business cards in local commercial art supply stores.
Tips: Artist needs "an understanding of the product and the importance of selling it."

MITCHELL STUDIOS DESIGN CONSULTANTS, 1810-7 Front St., East Meadow NY 11554. (516)832-6230. Fax: (516)832-6232. E-mail: msdcdesign@aol.com. **Principals:** Steven E. Mitchell and E.M. Mitchell. Estab. 1922. Specializes in brand and corporate identity, displays, direct mail and packaging. Clients: major corporations.
Needs: Works with 5-10 freelance designers and 20 illustrators/year. "Most work is started in our studio." Uses freelancers for design, illustration, mechanicals, retouching, airbrushing, model-making, lettering and logos. 100% of design and 50% of illustration demands skills in Illustrator 5, Photoshop 5 and QuarkXPress 3.3. Needs technical illustration and illustration of food, people.
First Contact & Terms: Send query letter with brochure, résumé, business card, photographs and photocopies to be kept on file. Accepts nonreturnable disk submissions compatible with Illustrator, QuarkXPress, FreeHand and Photoshop. Responds only if interested. Call or write for appointment to show portfolio of roughs, original/final art, final reproduction/product and color photostats and photographs. Pays for design by the hour, $25 minimum; by the project, $250 minimum. Pays for illustration by the project, $250 minimum.
Tips: "Call first. Show actual samples, not only printed samples. Don't show student work. Our need has increased—we are very busy."

THE PHOTO LIBRARY INC., P.O. Box 691, Chappaqua NY 10514. (914)238-1076. Fax: (914)238-3177. **Vice President Marketing:** M. Berger. Estab. 1978. Number of employees: 3. Specializes in brand

N MARKETS NEW TO THIS EDITION

identity, package and publication design, photography and product design. Clients: corporations, design offices.

Needs: Approached by 6-12 freelancers/year. Works with 6-9 freelance illustrators and 3-6 designers/year. Uses designers mainly for product design. Also uses freelancers for magazine and poster design, mechanicals and model making. Needs computer-literate freelancers for design, presentation and mechanicals. 50% of freelance work demands knowledge of Illustrator 5.5, Photoshop 3.0, FreeHand, PageMaker and Form 2 Strata.

First Contact & Terms: Send brochure, photographs and résumé. Samples are not filed and are returned. Will contact artist for portfolio review if interested. Portfolio should include photographs and slides. Pays for design and illustration by the hour and by the project. Buys all rights. Finds artists through sourcebooks, other publications, agents and artists' submissions.

JACK SCHECTERSON ASSOCIATES, 5316 251 Place, Little Neck NY 11362. (718)225-3536. Fax: (718)423-3478. **Principal:** Jack Schecterson. Estab. 1967. Ad agency. Specializes in 2D and 3D visual marketing; new product introduction; product package graphic and corporate design.

Needs: Works direct and with artist reps. Prefers local freelancers. Works on assignment only. Uses freelancers for package, product and corporate design; illustration, brochures, catalogs, logos. 100% of design and 90% of graphic illustration demands skills in Illustrator, Photoshop and QuarkXPress.

First Contact & Terms: Send query letter with brochure, photocopies, tearsheets, résumé, photographs, slides, transparencies and SASE; "whatever best illustrates work." Samples not filed are returned by SASE only if requested by artist. Request portfolio review in original query. Will contact artist for portfolio review if interested. Portfolio should include roughs, b&w and color—"whatever best illustrates creative abilities/work." Pays for design and illustration by the project; depends on budget. Buys all rights.

SCHROEDER BURCHETT DESIGN CONCEPTS, 137 Main St. Route 7, Unadilla NY 13849-3303. (607)369-4709. **Designer & Owner:** Carla Schroeder Burchett. Estab. 1972. Specializes in packaging, marketing and restoration. Clients: manufacturers.

Needs: Works on assignment only. Uses freelancers for design, mechanicals, lettering and logos. 20% of freelance work demands knowledge of PageMaker or Illustrator. Needs technical and medical illustration.

First Contact & Terms: Send résumé. "If interested, we will contact artist or craftsperson and will negotiate." Write for appointment to show portfolio of thumbnails, final reproduction/product and photographs. Pays for design by the hour, $15 minimum. Pays for illustration by the project. "If it is excellent work, the person will receive what he asks for!" Considers skill and experience of artist when establishing payment. Finds artists through submissions and word of mouth.

Tips: "Creativity depends on each individual. Artists should have a sense of purpose and dependability and must work for long and short range plans. Have perseverance. Top people still get in any agency. Don't give up."

TOBOL GROUP, INC., 14 Vanderventer Ave., #L-2, Port Washington NY 11080. (516)767-8182. Fax: (516)767-8185. Estab. 1981. Ad agency. Product specialties are "50/50, business to business and business to consumer." Current clients include: Weight Watchers, Mainco, Lightalarms and Fiberall.

Needs: Approached by 2 freelance artists/month. Works with 1 freelance illustrator and 1 designer/month. Works on assignment only. Uses freelancers for brochure, catalog and print ad design and technical illustration, mechanicals, retouching, billboards, posters, TV/film graphics, lettering and logos. 45% of work is with print ads. 75% of freelance work demands knowledge of QuarkXPress or Illustrator.

First Contact & Terms: Send query letter with SASE and tearsheets. Samples are filed or are returned by SASE. Responds in 1 month. Call for appointment to show portfolio or mail thumbnails, roughs, b&w and color tearsheets and transparencies. Pays for design by the hour, $25 minimum; by the project, $100-800; by the day, $200 minimum. Pays for illustration by the project, $300-1,500 ($50 for spot illustrations). Negotiates rights purchased.

VISUAL HORIZONS, 180 Metro Park, Rochester NY 14623. (585)424-5300. Fax: (585)424-5313. E-mail: slides1@aol.com. or info@visualhorizons.com. Website: www.visualhorizons.com. Estab. 1971. AV firm. Full-service multimedia firm. Specializes in presentation products; digital imaging of 35mm slides. Current clients include US government agencies, corporations and universities.

Needs: Works on assignment only. Uses freelancers mainly for catalog design. 10% of work is with print ads. 100% of freelance work demands skills in PageMaker and Photoshop.

First Contact & Terms: Send query letter with tearsheets. Samples are not filed and are not returned.

Responds if interested. Portfolio review not required. Pays for design and illustration by the hour or project, negotiated. Buys all rights.

New York City

■ **AVANCÉ DESIGNS, INC.**, 1775 Broadway, Suite 419, New York NY 10019-1903. (212)420-1255. Fax: (212)876-3078. Website: www.avance-designs.com. Estab. 1986. "Avancé Designs are specialists in visual communication. We maintain our role by managing multiple design disciplines from print and information design and interactive media."
Needs: Designers, web designers, strong in Photoshop, Illustrator programmers in PHC, ASP, DHTML, Java-Script and Java.
First Contact & Terms: Send query letter. Samples of interest are filed and are not returned. Responds only if interested.

BARRY DAVID BERGER & ASSOCIATES, INC., 54 King St., New York NY 10014. (212)255-4100. **Art Director:** Barry Berger. Number of employees: 5. Approximate annual billing: $500,000. Specializes in brand and corporate identity, P-O-P displays, product and interior design, exhibits and shows, corporate capability brochures, advertising graphics, packaging, publications and signage. Clients: manufacturers and distributors of consumer products, office/stationery products, art materials, chemicals, healthcare, pharmaceuticals and cosmetics. Current clients include Dennison, Timex, Sheaffer, Bausch & Lomb and Kodak. Professional affiliations IDSA, AIGA, APDF.
Needs: Approached by 12 freelancers/year. Works with 5 freelance illustrators and 7 designers/year. Uses artists for advertising, editorial, medical, technical and fashion illustration, mechanicals, retouching, direct mail and package design, model-making, charts/graphs, photography, AV presentations and lettering. Needs computer-literate freelancers for illustration and production. 50% of freelance work demands computer skills.
First Contact & Terms: Send query letter, then call for appointment. Works on assignment only. Send "whatever samples are necessary to demonstrate competence" including multiple roughs for a few projects. Samples are filed or returned. Responds immediately. Provide brochure/flyer, résumé, business card, tearsheets and samples to be kept on file for possible future assignments. Pays for design by the project, $1,000-10,000. Pays for illustration by the project.
Tips: Looks for creativity and confidence.

DLS DESIGN, 156 Fifth Ave., New York NY 10010. (212)255-3464. E-mail: info@dlsdesign.com. Website: www.dlsdesign.com. **President:** David Schiffer. Estab. 1986. Number of employees: 4. Approximate annual billing: $150,000. Graphic design firm. Specializes in high-end print work; logo design; and implementation of graphically rich websites and other on-screen interfaces. Product specialties are corporate, publishing, nonprofit, entertainment, fashion, media and industrial companies. Current clients include The Foundation Center, Disney Magazine Publishing, American Management Association, Timex Watchbands, Newcastle/Acoustone Fabrics, CHIC Jeans and many others. Professional affiliation: WWWAC (World Wide Web Artists' Consortium).
 • Awards include: Award of Distinction and Honorable Mention (The Communicator Awards 2001); Bronze Award/Nonprofit Category (The Summit Creative Awards 2001).
Needs: "Over 50% of our work is high-end corporate websites. Work is clean, but can also be high in the 'delight factor.' " Requires designers and illustrators fluent in Photoshop, Image Ready, Dreamweaver and Flash for original website art, including splash screens, banners, GIF animations and interactive banners. Other essential programs include BBEdit, GIF Builder, DeBabelizer. Also uses freelancers fluent in clean, intermediate to advanced HTML, as well as an understanding of Javascript and CGI.
First Contact & Terms: E-mail is acceptable, but unsolicited attached files will be rejected. "Please wait until we say we are interested, or direct us to your URL to show samples." Uses some hourly freelance help in website authoring; rarely needs editorial illustrations in traditional media.

▣ **ERICKSEN ADVERTISING & DESIGN, INC.**, 12 W. 37th St., New York NY 10018. Fax: (212)239-3321. **Director:** Robert Ericksen. Full-service ad agency providing all promotional materials and commercial services for clients. Product specialties are promotional, commercial and advertising material for the entertainment industry. Current clients include BBC, National Geographic, Turner International.
Needs: Works with several freelancers/year. Assigns several jobs/year. Works on assignment only. Uses

freelancers mainly for advertising, packaging, brochures, catalogs, trade, P-O-P displays, posters, lettering and logos. Prefers composited and computer-generated artwork.

First Contact & Terms: Contact through artist's agent or send query letter with brochure or tearsheets and slides. Samples are filed and are not returned unless requested with SASE; unsolicited samples are not returned. Responds in 1 week if interested or when artist is needed for a project. Does not respond to all unsolicited samples. "Only on request should a portfolio be sent." Pays for illustration by the project, $500-5,000. Buys all rights and retains ownership of original. Finds artists through word of mouth, magazines, submissions and sourcebooks.

Tips: "Advertising artwork is becoming increasingly 'commercial' in response to very tightly targeted marketing (i.e., the artist has to respond to increased creative team input versus the fine art approach.)"

FREELANCE EXPRESS, INC., 111 E. 85th St., New York NY 10028. (212)427-0331. Multi-service company. Estab. 1988.

Needs: Uses freelancers for cartoons, charts, graphs, illustration, layout, lettering, logo design and mechanicals.

First Contact & Terms: Mail résumé and photocopied nonreturnable samples. "Say you saw the listing in *Artist's & Graphic Designer's Market.*" Provide materials to be kept on file. Originals are not returned.

JEWELITE SIGNS, LETTERS & DISPLAYS, INC., 106 Reade St., New York NY 10013. (212)233-1900. Fax: (212)233-1998. E-mail: jewelitesigns@aol.com. Website: www.jewelite.com. **Contact:** Jerry Samet. Produces signs, letters, silk screening, murals, handlettering, displays and graphics. Current clients include Transamerica, Steve Horn and MCI.

Needs: Approached by 15 freelancers/year. Works with 12 freelancers/year. Works on assignment only. Uses freelancers for handlettering, walls, murals, signs, interior design, architectural renderings, design consulting and model making. 80% of freelance work demands computer skills. Prefers airbrush, lettering and painting.

First Contact & Terms: Call or send query letter. Call for appointment to show portfolio of photographs. Pays for design and illustration by the project, $75 and up. Considers complexity of project and skill and experience of artist when establishing payment.

LEO ART STUDIO, INC., 276 Fifth Ave., Suite 610, New York NY 10001. (212)685-3174. Fax: (212)685-3170. E-mail: leoart2765@aol.com. Website: www.leoartstudio.com. **President:** Leopold Schein. Studio Manager and Art Director: Robert Schein. Number of employees: 3. Approximate annual billing: $500,000. Specializes in textile design for home furnishings. Clients: wallpaper manufacturers/stylists, glassware companies, furniture and upholstery manufacturers. Current clients include Burlington House, Blumenthal Printworks, Eisenhart Wallcoverings, Victoria's Secret, Town and Country, Culp, Inc. and Notra Trading. Client list available upon request.

Needs: Approached by 25-30 freelancers/year. Works with 3-4 freelance illustrators and 20-25 textile designers/year. Prefers freelancers trained in textile field, not fine arts. Must have a portfolio of original art designs. Should be able to be in NYC on a fairly regular basis. Works both on assignment and speculation. Prefers realistic and traditional styles. Uses freelancers for design, airbrushing, coloring and repeats. "We will look at any freelance portfolio to add to our variety of hands. Our recent conversion to CAD system may require future freelance assistance. Knowledge of Coreldraw, Photoshop or others is a plus."

First Contact & Terms: Send query letter with résumé. Do not send slides. Request portfolio review in original query. "We prefer to see portfolio in person. Contact via phone is OK—we can set up appointments with a day or two's notice." Samples are not filed and are returned. Responds in 5 days. Portfolio should include original/final art. Sometimes requests work on spec before assigning job. Pays for design by the project, $500-1,500. "Payment is generally a 60/40 split of what design sells for—slightly less if reference material, art material, or studio space is requested." Considers complexity of project, skill and experience of artist and how work will be used when establishing payment. Buys all rights.

Tips: "Stick to the field we are in (home furnishing textiles, upholstery, fabrics, wallcoverings). Understand manufacture and print methods. Walk the market; show that you are aware of current trends. Go to design shows before showing portfolio. We advise all potential textile designers and students to see the annual design show—Surtex—at the Jacob Javitz Center in New York, usually in spring. Also attend High Point Design Show in North Carolina and Heimtex America in Florida."

LUBELL BRODSKY INC., 21 E. 40th St., Suite 1806, New York NY 10016. (212)684-2600. **Art Directors:** Ed Brodsky and Ruth Lubell. Number of employees: 5. Specializes in corporate identity, direct

mail, promotion, consumer education and packaging. Clients: ad agencies and corporations. Professional affiliations: ADC, TDC.

Needs: Approached by 100 freelancers/year. Works with 10 freelance illustrators and photographers and 1-2 designers/year. Works on assignment only. Uses freelancers for illustration, retouching, charts/graphs, AV materials and lettering. 100% of design and 30% of illustration demands skills in Photoshop.

First Contact & Terms: Send postcard sample, brochure or tearsheets to be kept on file. Responds only if interested.

Tips: Looks for unique talent.

JODI LUBY & COMPANY, INC., 808 Broadway, New York NY 10003. (212)473-1922. E-mail: jluby@nyc.rr.com. **President:** Jodi Luby. Estab. 1983. Specializes in corporate identity, packaging, promotion and direct marketing design. Clients: magazines, corporations.

Needs: Approached by 10-20 freelance artists/year. Works with 5-10 illustrators/year. Uses freelancers for production and web production. 100% of freelance work demands computer skills.

First Contact & Terms: Send postcard sample or query letter with résumé and photocopies. Samples are not filed and are not returned. Will contact artist for portfolio review if interested. Portfolio should include thumbnails, roughs, b&w and color printed pieces. Pays for production by the hour, $25 minimum; by the project, $100 minimum. Pays for illustration by the project, $100 minimum. Rights purchased vary according to project. Finds artists through word of mouth.

MIZEREK DESIGN INC., 333 E. 14th St., New York NY 10003. (212)777-3344. E-mail: mizerek@aol. com. Website: www.mizerek.net. **President:** Leonard Mizerek. Estab. 1975. Specializes in catalogs, direct mail, jewelry, fashion and technical illustration. Clients: corporations—various product and service-oriented clientele. Current clients include: Rolex, Leslie's Jewelry, World Wildlife, The Baby Catalog, Time Life and Random House.

Needs: Approached by 20-30 freelancers/year. Works with 10 freelance designers/year. Works on assignment only. Uses freelancers for design, technical illustration, brochures, retouching and logos. 85% of freelance work demands skills in Illustrator, Photoshop and QuarkXPress.

First Contact & Terms: Send postcard sample or query letter with résumé, tearsheets and transparencies. Accepts disk submissions compatible with Illustrator and Photoshop 3.0. Will contact artist for portfolio review if interested. Portfolio should include original/final art and tearsheets. Pays for design by the project, $500-5,000. Pays for illustration by the project, $500-3,500. Considers client's budget and turnaround time when establishing payment. Finds artists through sourcebooks and self-promotions.

Tips: "Let the work speak for itself. Be creative. Show commercial product work, not only magazine editorial. Keep me on your mailing list!"

NAPOLEON ART STUDIO, 420 Lexington Ave., Suite 3020, New York NY 10170. (212)692-9200. Fax: (212)692-0309. **Studio Manager:** Scott Stein. Estab. 1985. Number of employees: 40. AV firm. Full-service, multimedia firm. Specializes in storyboards, magazine ads, computer graphic art animatics. Product specialty is consumer. Current clients include "all major New York City ad agencies." Client list not available.

Needs: Approached by 20 freelancers/year. Works with 15 freelance illustrators and 5 designers/year. Prefers local freelancers with experience in animation, computer graphics, film/video production, multimedia, Macintosh. Works on assignment only. Uses freelancers for airbrushing, animation, direct mail, logos and retouching. 10% of work is with print ads. Needs computer-literate freelancers for design, illustration, production and presentation. 80% of freelance work demands skills in Illustrator or Photoshop.

First Contact & Terms: Send query letter with photocopies, tearsheets and ¾″ or VHS tape. Samples are filed. Responds only if interested. Will contact artist for portfolio review if interested. Portfolio should include b&w and color thumbnails. Pays for design and illustration by the project. Rights purchased vary acording to project. Finds artists through word of mouth and submissions.

NICHOLSON NY L.L.C., 295 Lafayette St., Suite 805, New York NY 10012. (212)274-0470. Fax: (212)274-0380. Website: www.nny.com. President: Tom Nicholson. Manager of Design Department and Senior Art Director: Maya Kopytman. Contact: Wells Packard. Estab. 1987. Specializes in design of interactive computer programs. Clients: corporations, museums, government agencies and multimedia publishers. Client list available upon request.

Needs: Works with 3 freelance illustrators and 12 designers/year. Prefers local freelancers. Uses illustrators mainly for computer illustration and animation. Uses designers mainly for computer screen design and

concept development. Also for mechanicals, charts/graphs and AV materials. Needs editorial and technical illustration. Especially needs designers with interest (not necessarily experience) in computer screen design plus a strong interest in information design. 80% of freelance work demands computer skills.

First Contact & Terms: Send query letter with résumé; include tearsheets and slides if possible. Samples are filed or are returned if requested. Will contact artist for portfolio review if interested. Portfolio should include thumbnails, original/final art and tearsheets. Considers complexity of project, client's budget and skill and experience of artist when establishing payment. Rights purchased vary according to project. Interested in buying second rights (reprint rights) to previously published work. Finds artists through submissions/self-promotions and sourcebooks.

Tips: "I see tremendous demand for original content in electronic publishing."

NICOSIA CREATIVE EXPRESSO, LTD., 355 W. 52nd St., New York NY 10019. (212)515-6600. Fax: (212)265-5422. E-mail: info@niceltd.com. Website: www.niceltd.com. **President/Creative Director:** Davide Nicosia. Estab. 1993. Number of employees: 20. Specializes in graphic design, corporate/brand identity, brochures, promotional material, packaging, signage, marketing, website design and 3-D animations. Current clients include Calvin Klein, Victoria's Secret, Elizabeth Arden, Tiffany & Co., Bath & Body Works and *The New York Times*.

- NICE is an innovative graphic firm with offices in Madrid, Spain and New York. Their team of multicultural designers deliver design solutions for the global marketplace.

Needs: Approached by 70 freelancers/year. Works with 6 freelance illustrators and 8 designers/year. Works by assignment only. Uses illustrators, designers, 3-D computer artists and computer artists familiar with Illustrator, Photoshop, After Effects, Premiere, QuarkXPress, Macromedia Director, Flash and Maxon Cinema 4D.

First Contact & Terms: Send query letter and résumé. Responds for portfolio review only if interested. Pays for design by the hour. Pays for illustration by the project. Rights purchased vary according to project.

Tips: Looks for "promising talent and an adaptable attitude."

NOSTRADAMUS ADVERTISING, 884 West End Ave., Suite #2, New York NY 10025. Website: www.nostradamus.net. **Creative Director:** B.N. Sher. Specializes in book design, web design, fliers, advertising and direct mail. Clients: ad agencies, book publishers, nonprofit organizations and politicians.

Needs: Works with 5 artists/year. Needs computer-literate freelancers for design and production. Freelancers should know Quark, Photoshop, Dreamweaver.

First Contact & Terms: Send query letter with brochure, résumé, business card, samples and tearsheets. Do *not* send slides as samples; will accept "anything else that doesn't have to be returned." Samples not kept on file are not returned. Responds only if interested. Call for appointment to show portfolio. Pays for design and mechanicals by the hour, $30 average. Pays for illustration by the project, $100 minimum. Considers skill and experience of artist when establishing payment.

OUTSIDE THE BOX INTERACTIVE, 133 W. 19th, Suite 10B, New York NY 10011-4117. (212)463-7160. Fax: (212)463-9179. E-mail: theoffice@outboxin.com. Website: www.outboxin.com. **Vice President and Director of Multimedia:** Lauren Schwartz. Estab. 1995. Number of employees: 10. OTBI, a full service firm combining graphics, video, animation, text, music and sounds into effective interactive programs, with other media. Our product mix includes internet/intranet/extranet development and hosting, corporate presentations, disk-based direct mail, customer/product kiosks, games, interactive press kits, advertising, marketing and sales tools. We also offer web hosting for product launches, questionnaires and polls. Our talented staff consists of writers, designers and programmers.

Needs: Approached by 30-40 freelance illustrators and 30-40 designers/year. Works with 8-10 freelance illustrators and 8-10 designers/year. Prefers freelancers with experience in computer arts. Also for airbrushing, animation, brochure and humorous illustration, logos, model-making, multimedia projects, posters, retouching, storyboards, TV/film graphics, web page design. 90% of design demands skills in Photoshop 5, QuarkXPress 4, Illustrator 5, Director HTML, Java Script and any 3D program. 60% of illustration demands skills in Photoshop 3, QuarkXPress 4, Illustrator 8, any animation and 3D program.

First Contact & Terms: Send query letter with brochure, photocopies, photographs, photostats, résumé, SASE, slides, tearsheets, transparencies. Send follow-up postcard every 3 months. Accepts disk submissions compatible with Power PC. Samples are filed and are returned by SASE. Will contact if interested. Pays by project. Rights purchased vary according to project.

Tips: "Be able to think on your feet and to test your limits."

N **PRO/CREATIVES COMPANY**, 25 W. Burda Place, New York NY 10956-7116. **President:** D. Rapp. Estab. 1986. Ad agency and marketing/promotion PR firm. Specializes in direct mail, ads, collateral. Product specialties are consumer/trade, goods/services.

Needs: Works on assignment only. Uses freelancers for brochure and print ad design and illustration. 30% of work is with print ads.

First Contact & Terms: Samples are filed or are returned by SASE. Portfolio review not required. Pays for design and illustration by the project.

N **QUADRANT COMMUNICATIONS CO., INC.**, 137 Varick St., Third Floor, New York NY 10013. (212)352-1400. Fax: (212)352-1411. E-mail: quadcom@aol.com. **President:** Robert Eichinger. Number of employees: 4. Approximate annual billing: $850,000. Estab. 1973. Specializes in annual reports, corporate identity, direct mail, publication design and technical illustration. Clients: corporations. Current clients include AT&T, Citibank, Dean Witter Reynolds, Chase Manhattan Bank, Federal Reserve Bank and Polo/Ralph Lauren. Client list available upon request.

Needs: Approached by 100 freelancers/year. Works with 6 freelance illustrators and 4 designers/year. Prefers freelancers with experience in publication production. Works on assignment only. Uses freelancers mainly for publications, trade show collateral and direct mail design. Also for brochure, magazine Internet and intranet design; and charts/graphs. Needs computer-literate freelancers for design and production. 80% of freelance work demands knowledge of QuarkXPress, FreeHand or Illustrator and Photoshop.

First Contact & Terms: Send query letter with résumé. Samples are filed. Responds only if interested. Call for appointment to show portfolio of tearsheets and photographs. Pays for design by the hour, $25-35. Pays for illustration by the project, $400-1,200. Rights purchased vary according to project.

Tips: "We need skilled people. There's no time for training."

M **MIKE QUON/DESIGNATION INC.**, 53 Spring St., New York NY 10012. (212)226-6024. Fax: (212)219-0331. E-mail: mikequon@aol.com. Website: www.mikequondesign.com. **President:** Mike Quon. Estab. 1982. Number of employees: 3. Specializes in corporate identity, displays, direct mail, packaging, publications and web design. Clients: corporations (financial, healthcare, high technology) and ad agencies. Current clients include Pfizer, NBC, Bristol-Myers Squibb, American Express, JP Morgan Chase, Paine Webber, Hasbro, Verizon, AT&T. Client list available upon request. Professional affiliations: AIGA, Society of Illustrators, Graphic Artists Guild.

Needs: Approached by 50 illustrators and 50 designers/year. Works with 10 designers/year. Prefers local freelancers. Works on assignment only. Prefers graphic style. Uses artists for brochures, design and catalog illustration, P-O-P displays, logos, mechanicals, charts/graphs and lettering. Especially needs computer artists with skills in QuarkXPress, Illustrator, Photoshop.

First Contact & Terms: Send query letter with résumé and photocopies. Samples are filed or are returned if accompanied by SASE. Responds only if interested. No portfolio drop-offs. Mail only. Pays for design by the hour, $20-45. Pays for illustration by the project, $100-500. Buys first rights.

Tips: "Do good work and continually update art directors with mailed samples."

ARNOLD SAKS ASSOCIATES, 350 E. 81st St., New York NY 10028. (212)861-4300. Fax: (212)535-2590. E-mail: afiorillo@saksdesign.com. **Vice President:** Anita Fiorillo. Estab. 1967. Specializes in annual reports and corporate communications. Clients: Fortune 500 corporations. Current clients include Alcoa, Wyeth, Xerox and UBS. Client list available upon request.

Needs: Works with 1 or 2 mechanical artists and 1 designer/year. "Mechanical artists: accuracy and speed are important, as is a willingness to work late nights and some weekends." Uses illustrators for technical illustration and occasionally for annual reports. Uses designers mainly for in-season annual reports. Also uses artists for brochure design and illustration, mechanicals and charts/graphics. Needs computer-literate freelancers for production and presentation. 80% of freelance work demands knowledge of QuarkXPress, Illustrator or Photoshop.

First Contact & Terms: Send query letter with brochure and résumé. Samples are filed. Responds only if interested. Write for appointment to show portfolio. Portfolio should include finished pieces. Pays for design by the hour, $25-60. Pays for illustration by the project, $200 minimum. Payment depends on experience and terms and varies depending upon scope and complication of project. Rights purchased vary according to project.

N **STRATEGIC COMMUNICATIONS**, 45 W. 21st St., New York NY 10010. (212)727-9909. Fax: (212)727-9908. Website: www.stracom.com. Estab. 1981. PR firm. Specializes in corporate and

press materials, World Wide Web-based environments, VNRs, Quicktime and other DV, and presentation materials. Specializes in service businesses and online marketing.

Needs: Approached by 3-4 freelancers/month. Works with 3 illustrators and 4 designers/month. Prefers local freelancers only. Works on assignment only. Uses freelancers for brochure design and illustration, slide illustration, mechanicals, posters, web-based design, lettering, logos, corporate ID programs, annual reports, collateral and press materials.

First Contact & Terms: Send query letter with brochure, résumé, photographs and nonreturnable samples only. Include information about fee structure. Samples are filed. Does not reply, in which case the artist should send follow-up communication every 6-9 months to keep file active. Portfolio should include original, final art. Pays for design and illustration by the project. Rights purchased vary according to project.

Tips: "Send relevant work samples and pricing information based on 'needs.' When I receive irrelevant samples, I immediately assume the sender does not understand my business and would not be someone we are likely to engage. We toss all extraneous material and don't have time to separate a portfolio. We expect the artist to have some judgment. Do not deluge me with periodic postcards."

☑ ▣ ♿ **STROMBERG CONSULTING**, 711 Third Ave., 19th Floor, New York NY 10017. (646)935-4300. Fax: (646)935-4370. E-mail: clatz@stromberconsulting.com. Website: www.strombergconsulting.com. **Creative Director:** Chad Latz. Number of employees: 60. Product specialties are direct marketing, internal and corporate communication using traditional print base as well as Web and new media. Clients: industrial and corporate. Produces multimedia, presentations, videotapes and print materials.

Needs: Assigns 25-35 jobs/year. Prefers local designers only (Manhattan and its 5 burroughs) with experience in animation, computer graphics, multimedia and Macintosh. Uses freelancers for animation logos, posters, storyboards, training guides, Web Flash, application development, design catalogs, corporate brochures, presentations, annual reports, slide shows, layouts, mechanicals, illustrations, computer graphics and desk-top publishing web development, application development. Rarely uses illustrators.

First Contact & Terms: "Send note on availability and previous work." Responds only if interested. Provide materials to be kept on file for future assignments. Originals are not returned. Pays by the project.

Tips: Finds designers through word of mouth and submissions.

Ⓝ ▣ ♿ **TALCO PRODUCTIONS**, 279 E. 44th St., New York NY 10017. (212)697-4015. Fax: (212)697-4827. E-mail: alaw1@springmail.com. **President:** Alan Lawrence. Number of employees: 5. TV/film producer. Specializes in nonprofit organizations, industry, associations and PR firms. Produces videotapes, motion pictures. Professional affiliation: DGA.

Needs: Works with 1-2 freelance illustrators and 1-2 designers/year. Prefers local freelancers with professional experience. 15% of freelance work demands skills in FreeHand or Illustrator.

First Contact & Terms: Send query letter with résumé, brochure and SASE. Responds only if interested. Portfolio should include roughs, final reproduction/product, and color photostats and photographs. Payment varies according to assignment. Pays on production. Originals almost always returned at job's completion. Buys all rights. Considers complexity of project, client's budget and rights purchased when establishing payment.

North Carolina

BOB BOEBERITZ DESIGN, 247 Charlotte St., Asheville NC 28801. (828)258-0316. E-mail: bobb@main.nc.us. Website: www.bobboeberitzdesign.com. **Owner:** Bob Boeberitz. Estab. 1984. Number of employees: 1. Approximate annual billing: $80,000. Specializes in graphic design, corporate identity and package design. Clients: retail outlets, hotels and restaurants, textile manufacturers, record companies, publishers, professional services. Majority of clients are business-to-business. Current clients include Para Research Software, Blue Duck Music, Quality America, Owen Manufacturing Co., Cross Canvas Co. and High Windy Audio. Professional affiliations: AAF, Asheville Chamber, NARAS, Asheville Freelance Network, Asheville Creative Services Group.

- Owner Bob Boeberitz predicts "everything in art design will be done on computer; more electronic; more stock images; photo image editing and conversions will be used; there will be less commissioned artwork."

Needs: Approached by 50 freelancers/year. Works with 5 freelance illustrators/year. Works on assignment only. Uses freelancers primarily for technical illustration and comps. Prefers pen & ink, airbrush and acrylic. 50% of freelance work demands knowledge of PageMaker, Illustrator, Photoshop or CorelDraw.

First Contact & Terms: Send query letter with résumé, brochure, SASE, photographs, slides and tear-sheets. "Anything too large to fit in file" is discarded. Accepts disk submissions compatible with IBM PCs. Send AI-EPS, PDF, JPG, GIF, HTML and TIFF files. Samples are returned by SASE if requested. Responds only if interested. Will contact artist for portfolio review if interested. Portfolio should include thumbnails, roughs, final art, b&w and color slides and photographs. Sometimes requests work on spec before assigning a job. Pays for design and illustration, by the project, $50 minimum. Rights purchased vary according to project. Will consider buying second rights to previously published artwork. Finds artists through word of mouth, submissions/self-promotions, sourcebooks, agents.

Tips: "Show sketches—sketches help indicate how an artist thinks. The most common mistake freelancers make in presenting samples or portfolios is not showing how the concept was developed, what their role was in it. I always see the final solution, but never what went into it. In illustration, show both the art and how it was used. Portfolios should be neat, clean and flattering to your work. Show only the most memorable work, what you do best. Always have other stuff, but don't show everything. Be brief. Don't just toss a portfolio on my desk; guide me through it. A 'leave-behind' is helpful, along with a distinctive-looking résumé. Be persistent but polite. Call frequently. I don't recommend cold calls (you rarely ever get to see anyone) but it is an opportunity for a 'leave behind.' I recommend using the mail. E-mail is okay, but it isn't saved. Asking people to print out your samples to save in a file asking too much. I like postcards. They get noticed, maybe even kept. They're economical. And they show off your work. And you can do them more frequently. Plus you'll have a better chance to get an appointment. After you've had an appointment, send a thank you note. Say you'll keep in touch and do it!"

North Dakota

FLINT COMMUNICATIONS, 101 Tenth St. N., Fargo ND 58102. (701)237-4850. Fax: (701)234-9680. Website: www.flintcom.com. **Art Directors:** Gerri Lien and Dawn Koranda. Estab. 1947. Number of employees: 30. Approximate annual billing: $9 million. Ad agency. Full-service, multimedia firm. Product specialties are agriculture, manufacturing, healthcare, insurance and banking. Professional affiliations: AIGA.

Needs: Approached by 50 freelancers/year. Works with 6-10 freelance illustrators and 3-4 designers/year. Uses freelancers for annual reports, brochure design and illustration, lettering, logos and TV/film graphics. 40% of work is with print ads. 20% of freelance work demands knowledge of PageMaker, Photoshop, QuarkXPress and Illustrator.

First Contact & Terms: Send postcard-size or larger sample of work and query letter. Samples are filed. Will contact artist for portfolio review if interested. Pays for illustration by the project, $100-2,000. Rights purchased vary according to project.

Ohio

EVENTIV, 6790 Providence St., P.O. Box 2725, Whitehouse OH 43571. E-mail: jan@eventiv.com. Website: www.eventiv.com. **President/Creative Director:** Janice Robie. Ad agency specializing in graphics, promotions and electronic media. Product specialties are industrial, consumer.

Needs: Assigns 30 freelance jobs/year. Works with 5 illustrators/year and 20 designers/year. Works on assignment only. Uses freelancers for consumer and trade magazines, brochures, catalogs, P-O-P displays, AV presentations, posters and illustrations (technical and/or creative). 100% of design and 50% of illustration require computer skills. Also needs freelancers experienced in electronic authoring, animation, web design, programming and design.

First Contact & Terms: Send query letter with résumé and slides, photographs, photostats or printed samples. Accepts disk submissions compatible with Mac or Windows. Samples returned by SASE if not filed. Responds only if interested. Write for appointment to show portfolio, which should include roughs, finished art, final reproduction/product and tearsheets. Pays by the hour, $25-80 or by the project, $100-2,500. Considers client's budget and skill and experience of artist when establishing payment. Negotiates rights purchased.

Tips: "We are interested in knowing your specialty."

HOLLAND COMMUNICATIONS, 700 Walnut St., Suite 300, Cincinnati OH 45202-2011. (513)721-1310. Fax: (513)721-1269. E-mail: Mholland@hollandroi.com. Website: www.hollandROI.com.

Partner: Mark Holland. Estab. 1937. Number of employees: 17. Approximate annual billing: $12 million. Ad agency. Full-service, multimedia firm. Professional affiliation: AAAA.

Needs: Approached by 6-12 freelancers/year. Works with 5-10 freelance illustrators and 2-3 designers/year. Prefers artists with experience in Macintosh. Uses freelancers for brochure illustration, logos and TV/film graphics. 100% of freelance work demands knowledge of Photoshop, QuarkXPress and Illustrator.

First Contact & Terms: Send query letter with photocopies and résumé. Accepts submissions on disk. Samples are filed and are not returned. Will contact artist for portfolio review if interested. Portfolio should include b&w and color final art, photographs, roughs, tearsheets and thumbnails. Pays for design by the hour, by the project and by the day. Pays for illustration by the project. Rights purchased vary according to project.

■ ⚉ **ART MERIMS COMMUNICATIONS**, 600 Superior Ave., Suite 1300, Cleveland OH 44114-2650. (216)522-1909. Fax: (216)479-6801. E-mail: amerims@anational.com. **Creative Director:** Larry Hohman. Number of employees: 4. Approximate annual billing: $800,000. Ad agency/PR firm. Current clients include Ohio Pest Control Association, Woodruff Foundation, Associated Builders and Contractors, Inc.

Needs: Approached by 10 freelancers/year. Works with 1-2 freelance illustrators and 3 designers/year. Prefers local freelancers. Works on assignment only. Uses freelancers mainly for work on trade magazines, brochures, catalogs, signage, editorial illustrations and AV presentations. 20% of freelance work demands computer skills.

First Contact & Terms: Send query letter with samples to be kept on file. Call for appointment to show portfolio of "copies of any kind" as samples. Sometimes requests work on spec before assigning a job. Pays for design and illustration by the hour, $40-60, or by the project, $300-1,200. Considers complexity of project, client's budget and skill and experience of artist when establishing payment. Finds artists through contact by phone or mail.

Tips: When reviewing samples, makes decisions based on "subjective feeling about abilities and cost if budget is low."

⋈ STEVENS BARON COMMUNICATIONS, Hanna Bldg., Suite 645, 1422 Euclid Ave., Cleveland OH 44115-1900. (216)621-6800. Fax: (216)621-6806. Website: www.stevensbaron.com. **President:** Edward M. Stevens, Sr. Estab. 1956. Ad agency. Specializes in public relations, advertising, corporate communications, magazine ads and collateral. Product specialties are business-to-business, food, building products, technical products, industrial food service, healthcare, safety.

Needs: Approached by 30-40 freelance artists/month. Prefers artists with experience in food and technical equipment. Works on assignment only. Uses freelance artists mainly for specialized projects. Also uses freelance artists for brochure, catalog and print ad illustration and retouching. Freelancers should be familiar with PageMaker, QuarkXPress, FreeHand, Illustrator and Photoshop.

First Contact & Terms: Send query letter with résumé and photocopies. Samples are filed and are not returned. Does not reply back. "Artist should send only samples or copies that do not need to be returned." Will contact artist for portfolio review if interested. Portfolio should include final art and tearsheets. Pay for design depends on style. Pay for illustration depends on technique. Buys all rights. Finds artists through agents, sourcebooks, word of mouth and submissions.

Oklahoma

■ **THE FORD AGENCY**, P.O. Box 521180, Tulsa OK 74152-1180. (918)743-3673. Website: www.thefordagency.com. **Creative Director:** C.A. Ford. Estab. 1985. Design firm specializing in corporate identity and positioning in the fields of business, financial, food and retail.

Needs: Uses freelancers mainly for logo work, custom lettering, type design and technical illustration. Also for animation, medical and technical illustration, mechanicals, multimedia projects, retouching, storyboards, TV/film graphics and web page design.

First Contact & Terms: Designers send query letter with résumé. Illustrators send sample. Accepts disk submissions compatible with Macintosh format only. Samples are filed. Responds only if interested. Will contact artist for portfolio review of final art, roughs, tearsheets, thumbnails if interested. Pays $50-1,000. Finds artists through sourcebooks, graphics magazines and networking at speakers events and affiliated peer organizations.

N KIZER INC. PAGE ADVERTISING AND COMM.'S, 4513 Classen Blvd., Oklahoma City OK 73118. (405)858-4906. Fax: (405)840-4842. E-mail: bill@kizerincorporated.com. Website: www.kizerincorporated.com. **Principal:** William Kizer. Estab. 1995. Number of employees: 3. Ad agency. Specializes in magazine ads, annual reports, collateral material. Professional affiliations: OKC Ad Club, AMA, AIGA.

Needs: Approached by 10 illustrators/year. Works with 3 illustrators and 3 designers/year. 75% of work is with print ads. 100% of design demands knowledge of FreeHand, Photoshop. 50% of illustration demands knowledge of FreeHand, Photoshop.

First Contact & Terms: Designers send query letter. Illustrators send query letter with samples. Accepts disk submissions compatible with FreeHand 9.0 or Photoshop file. Samples are filed and are not returned. Responds only if interested. To show portfolio, artist should follow up with call. Portfolio should include "your best work." Pays by the project. Rights purchased vary according to project. Finds artists through agents, sourcebooks, on-line services, magazines, word of mouth, artist's submissions.

Oregon

C CREATIVE COMPANY, INC., 726 NE Fourth St., McMinnville OR 97128. (866)363-4433. Fax: (866)363-6817. E-mail: jlmorrow@creativeco.com. Website: www.creativeco.com. **President/Owner:** Jennifer Larsen Morrow. Specializes in marketing-driven corporate identity, collateral, direct mail, packaging and P-O-P displays. Product specialties are food, garden products, financial services, colleges, manufacturing, pharmaceutical, medical, transportation programs.

Needs: Works with 6-10 freelance designers and 3-7 illustrators/year. Prefers local artists. Works on assignment only. Uses freelancers for design, illustration, computer production (Mac), retouching and lettering. "Looking for clean, fresh designs!" 100% of design and 60% of illustration demand skills in QuarkXPress, Pagemaker, FreeHand, Illustrator and Photoshop.

First Contact & Terms: Send query letter with brochure, résumé, business card, photocopies and tearsheets to be kept on file. Samples returned by SASE only if requested. Will contact for portfolio review if interested. "We require a portfolio review. Years of experience not important if portfolio is good. We prefer one-on-one review to discuss individual projects/time/approach." Pays for design by the hour or project, $50-90. Pays for illustration by the project. Considers complexity of project and skill and experience of artist when establishing payment.

Tips: Common mistakes freelancers make in presenting samples or portfolios are: "1) poor presentation, samples not mounted or organized; 2) not knowing how long it took them to do a job to provide a budget figure; 3) not demonstrating an understanding of the audience, the problem or printing process and how their work will translate into a printed copy; 4) just dropping in without an appointment; 5) not following up periodically to update information or a résumé that might be on file."

OAKLEY DESIGN STUDIOS. 921 SW Morrison St., Suite 540, Portland OR 97205. (503)241-3705. Fax: (503)241-3812. E-mail: oakleyds@oakleydesign.com. **Creative Director:** Tim Oakley. Estab. 1992. Number of employees: 2. Specializes in brand and corporate identity, display, package and publication design and advertising. Clients: ad agencies, record companies, surf apparel manufacturers, mid-size businesses. Current clients include Restart Nutritional Bars, M3 Productions, Michael Allen Clothiers, Miller Nash, LLP, Hawaiian Isle, Judan Records, Amigo Records, Barran Liebman, Mira Mobile Television, Kink FM 102. Professional affiliations OMPA, AIGA, PDXAD and PAF.

Needs: Approached by 5-10 freelancers/year. Works with 3 freelance illustrators and 2 designers/year. Prefers local artists with experience in technical illustration, airbrush. Also for multimedia projects. Uses illustrators mainly for advertising. Uses designers mainly for logos. Also uses freelancers for ad and P-O-P illustration, airbrushing, catalog illustration, lettering and retouching. 60% of design and 30% of illustration demands skills in Illustrator, Photoshop and QuarkXPress.

First Contact & Terms: Contact through artist rep or send query letter with brochure, photocopies, photographs, résumé and tearsheets. Accepts disk submissions compatible with Illustrator 9.0. Send EPS files. Samples are filed or returned by SASE if requested by artist. Responds in 6 weeks. Request portfolio review in original query. Will contact artist for portfolio review if interested. Portfolio should include b&w and color final art, photocopies, photostats, roughs and slides. Pays for design by the project, $200 minimum. Pays for illustration by the project. Rights purchased vary according to project. Finds artists through design workbooks.

Tips: "Be yourself. No phonies. Be patient and have a good book ready."

WISNER ASSOCIATES, Advertising, Marketing & Design, 2237 NE Wasco, Portland OR 97232. (503)282-3929. Fax: (503)282-0325. **Creative Director:** Linda Wisner. Estab. 1979. Number of employees: 1. Specializes in brand and corporate identity, book design, direct mail, packaging, publications and exhibit design. Clients: small businesses, manufacturers, restaurants, service businesses and book publishers.
Needs: Works with 3-5 freelance illustrators/year. Prefers experienced freelancers and "fast, accurate work." Works on assignment only. Uses freelancers for technical and fashion illustration and graphic production. Knowledge of QuarkXPress, Photoshop, Illustrator and other software required.
First Contact & Terms: Send query letter with résumé and samples. Prefers "examples of completed pieces which show the fullest abilities of the artist." Samples not kept on file are returned by SASE only if requested. Will contact artist for portfolio review if interested. Pays for illustration by the hour, $20-45 average or by the project, by bid. Pays for computer work by the hour, $15-25.

Pennsylvania

⟨N⟩ BAILEY DESIGN GROUP, INC., 200 West Germantown Pike, Bldg. B, Plymouth Meeting PA 19462-1047. (610)940-9030. Fax: (610)940-2254. Website: www.baileydesigngroup.com. **Owners/Partners:** Christopher Bailey, Russ Napolitano. Creative Director: Dave Fiedler. Estab. 1985. Number of employees: 38. Specializes in package design, brand and corporate identity, sales promotion materials, corporate communications and signage systems. Clients: corporations (food, drug, health and beauty aids). Current clients include Johnson & Johnson Consumer Products Co., McNeil Consumer Specialty & Pharmaceutical, Welch's, Compass Group, Just Born Inc. and William Grant & Son. Professional affiliations: AIGA, PDC, APP, AMA, ADC.
Needs: Approached by 10 freelancers/year. Works with 3-6 freelance illustrators and 3-6 designers/year. Uses illustrators mainly for editorial, technical and medical illustration and final art, charts and airbrushing. Uses designers mainly for freelance production (*not* design), or computer only. Also uses freelancers for mechanicals, brochure and catalog design and illustration, P-O-P illustration and model-making.
First Contact & Terms: Send query letter with brochure, résumé, tearsheets and photographs. Samples are filed. Responds only if interested. Will contact for portfolio review if interested. Portfolio should include finished art samples, color tearsheets, transparencies and artist's choice of other materials. May pay for illustration by the hour, inhouse $10-15; by the project, $300-3,000. Rights purchased vary according to project.
Tips: Finds artists through word of mouth, self-promotions and sourcebooks.

⟨■⟩ PERCEPTIVE MARKETERS AGENCY, LTD., P.O. Box 408, Bala Cynwyd PA 19004-0408. (610)668-4699. Fax: (610)668-4698. E-mail: info@perceptivemarketers.com. Website: perceptivemarketers.com. **Creative Director:** Jason Solovitz. Estab. 1972. Number of employees: 8. Approximate annual billing: $4 million. Ad agency. Product specialties are communications, sports, hospitals, healthcare consulting, computers (software and hardware), environmental products, automotive, insurance, financial, food products and publishing. Professional Affiliation: Philadelphia Ad Club, Philadelphia Direct Marketing Association, AANI, Philadelphia Art Directors Club.
Needs: Approached by 50 freelancers/year. Works with 3 freelance illustrators and 5 designers/year. Uses 80% local talent. In order of priority, uses freelancers for computer production, photography, illustration, comps/layout and design/art direction. Also for multimedia. "Concepts, dynamic design, ability to follow instructions/layouts and precision/accuracy are important." 50% of work is with print ads. 100% of design and 50% of illustration demands skills in QuarkXPress, Illustrator or Photoshop.
First Contact & Terms: Send résumé and photostats, photographs and tearsheets to be kept on file. Accepts as samples "whatever best represents artist's work—but preferably not slides." Accepts submissions on CD. Samples not filed are returned by SASE only. Responds only if interested. Graphic designers call for appointment to show portfolio. Pays for design by the hour or by the project. Pays for illustration by the project, up to $3,500. Considers complexity of the project, client's budget and turnaround time when establishing payment. Buys all rights.
Tips: "Freelance artists should approach us with unique, creative and professional work. And it's especially helpful to follow up interviews with new samples of work (i.e., to send a month later a 'reminder' card or sample of current work to keep on file)."

⟨■⟩ SAI COMMUNICATIONS, 15 S. Bank St., Philadelphia PA 19106. (215)923-6466. Fax: (215)851-9410. AV firm. Full-service, multimedia firm.

Needs: Approached by 5 freelance artists/month. Works with 3 freelance designers/month. Uses freelance artists mainly for computer-generated slides. Also uses freelance artists for brochure and print ad design, storyboards, slide illustration and logos. 1% of work is with print ads.
First Contact & Terms: Send query letter with résumé. Samples are filed. Call to schedule an appointment to show a portfolio. Portfolio should include slides. Pays for design by the hour, $15-20. Pays for illustration by the project. Buys first rights.

WARKULWIZ DESIGN ASSOCIATES INC., 2218 Race St., Philadelphia PA 19103. (215)988-1777. Fax: (215)988-1780. E-mail: wda@warkulwiz.com. Website: www.warkulwiz.com. **President:** Bob Warkulwiz. Estab. 1985. Number of employees: 6. Approximate annual billing: $1 million. Specializes in annual reports, publication design and corporate communications. Clients: corporations and universities. Current clients include Citibank, Bell Atlantic and Wharton School. Client list available upon request. Professional affiliations: AIGA, 1ABC.
Needs: Approached by 100 freelancers/year. Works with 10 freelance illustrators and 5-10 photographers/year. Works on assignment only. Uses freelance illustrators mainly for editorial and corporate work. Also uses freelance artists for brochure and poster illustration and mechanicals. Freelancers should be familiar with most recent versions of QuarkXPress, Illustrator, Photoshop, FreeHand and Director.
First Contact & Terms: Send query letter with tearsheets and photostats. Samples are filed. Responds only if interested. Call for appointment to show portfolio of "best edited work—published or unpublished." Pays for illustration by the project, "depends upon usage and complexity." Rights purchased vary according to project.
Tips: "Be creative and professional."

Rhode Island

MANCINI MARKETING, 551 S. Main St., Providence RI 02903. (401)421-8490. Fax: (401)273-2808. E-mail: production@mancinimarketing.com. **President/Creative Director:** Stephen M. Mancini. Estab. 1980. Number of employees: 4. Ad agency. Full-service, multimedia firm. Product specialties are jewelry and consumer.
Needs: Approached by many freelancers/year. Works with several freelance illustrators and designers/year. Needs computer-literate freelancers for design, illustration and production. Most work demands computer skills.
First Contact & Terms: Send postcard-size sample of work. Samples are filed. Will contact artist for portfolio review if interested.

MARTIN THOMAS, INC., 334 County Rd., Barrington RI 02806-2410. (401)245-8500. Fax: (401)245-1242. E-mail: jshansky@cox.net. Website: www.martinthomas.com. **Creative Director:** Joe Shansky. Estab. 1987. Number of employees: 12. Approximate annual billing: $7 million. Ad agency, PR firm. Specializes in industrial, business-to-business. Product specialties are plastics, medical and automotive. Professional affiliations: American Association of Advertising Agencies, Boston Ad Club.
Needs: Approached by 10-15 freelancers/year. Works with 6 freelance illustrators and 10-15 designers/year. Prefers freelancers with experience in business-to-business/industrial. Uses freelancers mainly for design of ads, literature and direct mail. Also for brochure and catalog design and illustration. 85% of work is print ads. 70% of design and 40% of illustration demands skills in QuarkXPress.
First Contact & Terms: Send query letter with brochure and résumé. Samples are filed and are returned. Responds in 3 weeks. Will contact artist for portfolio review if interested. Portfolio should include b&w and color final art. Pays for design and illustration by the hour and by the project. Buys all rights. Finds artists through *Creative Black Book*.
Tips: Impress agency by "knowing industries we serve."

SILVER FOX ADVERTISING, 11 George St., Pawtucket RI 02860. (401)725-2161. Fax: (401)726-8270. E-mail: sfoxstudios@earthlink.net. Website: www.silverfoxstudios.com. **President:** Fred Marzocchi, Jr. Estab. 1979. Number of employees: 8. Approximate annual billing: $1 million. Specializes in annual reports; brand and corporate identity; display, package and publication design; and technical illustration. Clients: corporations, retail. Client list available upon request.
Needs: Approached by 16 freelancers/year. Works with 6 freelance illustrators and 12 designers/year. Works only with artist reps. Prefers local artists only. Uses illustrators mainly for cover designs. Also for

multimedia projects. 50% of freelance work demands knowledge of Illustrator, Photoshop, PageMaker and QuarkXPress.

First Contact & Terms: Send query letter with résumé and photocopies. Accepts disk submissions compatible with Photoshop 5.0 or Illustrator 8.0. Samples are filed. Does not reply. Artist should follow up with call and/or letter after initial query. Portfolio should include final art, photographs, roughs and slides.

Tennessee

N. McCLEAREN DESIGN, 3901 Brush Hill Rd., Nashville TN 37216. (615)226-8089. Fax: (615)226-9237. E-mail: mcclearen@comcast.net. **Owner:** Brenda McClearen. Estab. 1987. Number of employees: 3. Specializes in display, music, package and publication design, websites, photography.
Needs: Approached by 5-10 freelancers/year. Works with 5-7 freelance illustrators and designers/year. Uses freelancers for ad design and illustration, model-making and poster design. Needs computer-literate freelancers for design and illustration. 50% of freelance work demands knowledge of QuarkXPress and Macintosh.
First Contact & Terms: Samples are filed. Will contact artist for portfolio review if interested. Portfolio should include b&w and color final art, photographs and roughs. Pays by the project.

MEDIA GRAPHICS (division of Dev. Kinney/Media Graphics, Inc.), 717 Spring St., P.O. Box 820525, Memphis TN 38182-0525. (901)324-1658. Fax: (901)323-7214. E-mail: mediagraphics@devkinney.com. Website: www.devkinney.com. **CEO:** J.D. Kinney. Estab. 1973. Integrated marketing communications agency. Specializes in all visual communications. Product specialties are financial, fundraising, retail, business-to-business. Client list available upon request. Professional affiliations: Memphis Area chamber, B.B.B.
 • This firm reports they are looking for top illustrators only. When they find illustrators they like, they generally consider them associates and work with them on a continual basis.
First Contact & Terms: Send query letter with résumé and tearsheets. Accepts disk submissions compatible with Mac or PC. E-mail 1 sample JPEG, 65K maximum; prefer HTML reference or small PDF file. Samples are filed and are not returned. Will contact for portfolio review on web or via e-mail if interested. Rights purchased vary according to project.
Tips: Chooses illustrators based on "portfolio, availability, price, terms and compatibility with project."

ODEN MARKETING & DESIGN, 22 N. Front St., Suite 300, Memphis TN 38103-2162. (901)578-8055. Fax: (901)578-1911. Website: www.oden.com. **Creative Director:** Jess Blankenship. Estab. 1971. Specializes in annual reports, brand and corporate identity, design and package design. Clients: corporations. Current clients include International Paper, Maybelline, Federal Express.
Needs: Approached by 15-20 freelance graphic artists/year. Works with 5-8 freelance illustrators, photographers and 4-6 freelance designers/year. Works on assignment only. Uses illustrators, photographers and designers mainly for collateral. Also uses freelance artists for brochure design and illustration, mechanicals and ad illustration. Need computer-literate freelancers for design and production. 50% of freelance work demands knowledge of QuarkXPress or Photoshop.
First Contact & Terms: Send query letter with brochure, photographs, slides and transparencies. Samples are filed and are not returned. Responds only if interested. Portfolio review not required. Pays for illustration by the project, $500. Rights purchased vary according to project.
Tips: Finds artists through sourcebooks.

Texas

T. DYKEMAN ASSOCIATES INC., 4115 Rawlins, Dallas TX 75219. (214)528-2991. Fax: (214)528-0241. E-mail: adykeman@airmail.net. Website: dykemanassoc.com. **Contact:** Alice Dykeman. PR/marketing firm. Specializes in business, industry, hospitality, sports, environmental, energy, health.
Needs: Works with 12 illustrators and designers/year. Local freelancers only. Uses freelancers for editorial and technical illustration, brochure design, exhibits, corporate identification, POS, signs, posters, ads and all design and finished artwork for graphics and printed materials. PC or Mac.

First Contact & Terms: Request portfolio review in original query. Pays by the project, $250-3,000. "Artist makes an estimate; we approve or negotiate."

Tips: "Be enthusiastic. Present an organized portfolio with a variety of work. Portfolio should reflect all that an artist can do. Don't include examples of projects for which you only did a small part of the creative work. Have a price structure but be willing to negotiate per project. We prefer to use artists/designers/illustrators who will work with barter (trade) dollars and join one of our trade exchanges. We see steady growth ahead."

EGAN DESIGN ASSOCIATES, 18768 Wainsborough Lane, Dallas TX 75287. (972)931-7001. Fax: (972)931-7141. E-mail: abby-design@mindspring.com. **Art Director:** Abby Egan Smith. Estab. 1980. Number of employees: 6. Specializes in brand and corporate identity; display, direct mail and package design. Clients: corporations and manufacturers. Client list available upon request.

Needs: Uses designers mainly for computer production. Also uses freelancers for brochure and catalog design and illustration, lettering, logos, mechanicals and poster and P-O-P illustration. Needs computer-literate freelancers for illustration and production. 100% of freelance work demands knowledge of Illustrator, Photoshop and QuarkXPress.

First Contact & Terms: Send postcard sample of work, brochure, photocopies, photographs, photostats, résumé and tearsheets. Samples are filed. Will contact artist for portfolio review if interested. Rights purchased vary according to project.

THE EMERY GROUP, Dept. AM, 1519 Montana, El Paso TX 79902. (915)532-3636. Fax: (915)544-7789. E-mail: liza@emerygroup.com. **Contact:** Enrique Zarogoza, art director. Number of employees: 18. Ad agency. Specializes in automotive and retail firms, banks and restaurants. Current clients include Whataburger and Pepsi of El Paso.

Needs: Approached by 3-4 freelancers/year. Works with 2-3 freelance illustrators and 4-5 designers/year. Uses freelancers mainly for design, illustration and production. Needs technical illustration and cartoons.

First Contact & Terms: Works on assignment only. Send query letter with résumé and samples to be kept on file. Will contact artist for portfolio review if interested. Prefers tearsheets as samples. Samples not filed are returned by SASE. Replies. Sometimes requests work on spec before assigning a job. Pays for design by the hour, $15 minimum; by the project, $100 minimum; by the day, $300 minimum. Pays for illustration by the hour, $15 minimum; by the project, $100 minimum. Considers complexity of project, client's budget and turnaround time when establishing payment. Rights purchased vary according to project.

Tips: Especially looks for "consistency and dependability; high creativity; familiarity with retail, Southwestern and Southern California look."

☑ **ORIGIN DESIGN, INC.**, 1621 S. Jupiter Rd., Suite 103-J, Garland TX 75042. (214)341-4282. Fax: (214)341-4682. E-mail: origin@ont.com. Website: www.origin2000.net. **Owners:** Kathleen Zierhut and Clarence Zierhut. Estab. 1955. Specializes in display, product and package design and corporate identity. Clients: corporations, museums, individuals. Client list available.

Needs: Works with 1-2 freelance graphic artists and 3-4 freelance designers/year. Works on assignment only. Uses designers mainly for renderings and graphics. Also uses freelance artists for illustration, mechanicals, retouching, airbrushing and model-making. Needs computer-literate freelancers for design. 100% of freelance work demands knowledge of CAD and/or Pro-Engineering.

First Contact & Terms: Send query letter with résumé. Samples are filed. Responds only if interested. Will contact artist for portfolio review if interested. Porfolio should include b&w and color final art and photographs. Pays for design by the hour, $15-50, by the project or by direct quote. Buys all rights. Finds artists through sourcebooks and word of mouth.

Tips: "Be computer-literate and persistent."

STEVEN SESSIONS INC., 5177 Richmond, Suite 500, Houston TX 77056. (713)850-8450. Fax: (713)850-9324. E-mail: Steven@Sessionsgroup.com. Website: www.sessionsgroup.com. **President, Creative Director:** Steven Sessions. Estab. 1981. Number of employees: 8. Approximate annual billing: $2.5 million. Specializes in annual reports; brand and corporate identity; fashion, package and publication design. Clients: corporations and ad agencies. Current clients include Compaq Computer, Kellogg Foods, Texas Instruments. Client list available upon request. Professional affiliations: AIGA, Art Directors Club, American Ad Federation.

Needs: Approached by 50 freelancers/year. Works with 10 illustrators and 2 designers/year. Uses freelancers for brochure, catalog and ad design and illustration; poster illustration; lettering; and logos. 100% of

freelance work demands knowledge of Illustrator, QuarkXPress, Photoshop or FreeHand. Needs editorial, technical and medical illustration.

First Contact & Terms: Designers send query letter with brochure, tearsheets, slides and SASE. Illustrators send postcard sample or other nonreturnable samples. Samples are filed. Responds only if interested. To show portfolio, mail slides. Payment depends on project, ranging from $1,000-30,000/illustration. Rights purchased vary according to project.

■ EVANS WYATT ADVERTISING, P.O. Box 18958, Corpus Christi TX 78480-8958. (361)939-7200. Fax: (361)939-7999. E-mail: e-wyatt@hotmail.com. **Creative Director:** E. Wyatt. Estab. 1975. Ad agency. Full-service, multimedia firm. Specializes in general and industrial advertising, including electronic media.

Needs: Approached by 3-5 freelance artists/month. Works with 5-6 illustrators and 6-8 designers/month. Works on assignment only. Uses freelancers for ad design and illustration, brochure and catalog design and illustration, storyboards, retouching, billboards, posters, TV/film graphics, logos, industrial/technical art, websites and E-marketing. 60% of work is with print ads.

First Contact & Terms: Send a query letter with brochure, photocopies, SASE, résumé and photographs. Samples are filed or are returned by SASE if requested by artist. Responds in 1 month. Call for appointment to show portfolio or mail b&w and color copies, tearsheets and photographs. Pays by the hour, by the project or by arrangement. Buys all rights.

Tips: "Illustrators and graphic designers should be skilled, experienced and professional. Because of our market, size should also be reasonable in price and delivery."

Utah

ALAN FRANK & ASSOCIATES INC., Dept. AM, 1524 S. 1100 E., Salt Lake City UT 84105. (801)486-7455. **Art Director:** Kazuo Shiotani. Serves clients in travel, fast food chains and retailing. Clients include KFC, ProGolf.

Needs: Uses freelancers for illustrations, animation and retouching for annual reports, billboards, ads, letterheads, TV and packaging.

First Contract & Terms: Mail art with SASE. Responds in 2 weeks. Minimum payment: $500, animation; $100, illustrations; $200, brochure layout.

Vermont

HARRY SPRUYT DESIGN, P.O. Box 706, Putney VT 05346-0706. Specializes in design/invention of product, package and device, design counseling service shows "in-depth concern for environments and human factors with the use of materials, energy and time; product design evaluation and layout." Clients: product manufacturers, design firms, consultants, ad agencies, other professionals and individuals. Client list available.

Needs: Works on assignment only.

Virginia

EDDINS MADISON CREATIVE, 6121 Lincolnia Rd., #410 Alexandria VA 22312. (703)750-0030. Fax: (703)750-0990. E-mail: denise@emcreative.com. Website: www.em-creative.com. **Creative Director:** Marcia Eddins. Estab. 1983. Number of employees: 9. Specializes in brand and corporate identity and publication design. Clients: corporations, associations and nonprofit organizations. Current clients include Reuters, ABC, National Fire Protection Assoc., Nextel. Client list available upon request.

Needs: Approached by 20-25 freelancers/year. Works with 4-6 freelance illustrators and 2-4 designers/year. Uses only artists with experience in Macintosh. Uses illustrators mainly for publications and brochures. Uses designers mainly for simple design and Mac production. Also uses freelancers for airbrushing, brochure and poster design and illustration, catalog design, charts/graphs. Needs computer-literate freelancers for design, production and presentation. 100% of freelance work demands knowledge of Illustrator, Photoshop, FreeHand and QuarkXPress.

First Contact & Terms: Send postcard sample of work or send query letter with photocopies and rēsumē. Samples are filed. Will contact artist for portfolio review if interested. Rights purchased vary according to project. Finds artists through sourcebooks, design/illustration annuals and referrals.

Tips: Impressed by "great technical skills, nice cover letter, good/clean rēsumē and good work samples."

N: BERNARD HODES ADVERTISING, Dept. AM, 8270 Greensboro Dr., Suite 600, McLean VA 22102. (703)848-0810. Fax: (703)848-0895. **Creative Director:** Gregg Petermann. Estab. 1970. Ad agency. Full-service, multimedia firm. Specializes in recruitment advertising and employment communications. Current clients include Martin Marietta, Unysis, USF&G and Fairfax Hospital.

Needs: Prefers artists with experience in graphic design and high-tech corporate identity. Works on assignment only. Uses freelancers for illustration. 90% of work is with print ads. 99% of freelance work demands knowledge of QuarkXPress, Illustrator, Photoshop or PageMaker.

First Contact & Terms: Send query letter with brochure, photocopies, rēsumē and tearsheets. Samples are filed. Responds in 5 days only if interested. Write for an appointment to show a portfolio. Portfolio should include thumbnails, roughs, final art, tearsheets and 5×7 transparencies. Pays for design by the hour, $12-25. Pays for illustration by the project $200-5,000. Buys all rights.

N: ▣ WORK, INC., 111 Virginia St., Suite 500, Richmond VA 23219. (804)225-0100. Fax: (804)225-0369. E-mail: dbrooks@workadvertising.com. Website: www.workadvertising.com. **Contact:** Cabell Harris, president, chief creative director. Estab. 1994. Number of employees: 38. Approximate annual billing: $44 million. Ad agency. Specializes in strategic council, account management, creative and production services. Current clients include Virginia Tobacco Settlement Foundation, Virginia Tourism Corporation, Ogilvy and Mather, Great Valu, Super 8, Saxon Capital, Inc. Client list available upon request. Professional affiliations: Advertising Club of Richmond, AIGA.

Needs: Approached by 25 illustrators and 35-40 designers/year. Works with 2-3 illustrators and 6-7 designers/year. Works on assignment only. Prefers freelancers with experience in animation, computer graphics, Macintosh. Uses freelancers mainly for new business pitches and specialty projects. Also for logos, mechanicals, TV/film graphics, posters, print ads and storyboards. 40% of work is with print ads. 95% of design work demands knowledge of FreeHand, Illustrator, Photoshop and QuarkXPress. 20% of illustration work demands knowledge of FreeHand, Illustrator, Photoshop and QuarkXPress.

First Contact & Terms: Send query letter with photocopies, photographs, rēsumē, tearsheets, URL. Accepts e-mail submissions. Check website for formats. Samples are filed or returned. Responds only if interested. Request portfolio review in original query. Company will contact artist for portfolio review if interested. Portfolio should include b&w and color finished art, photographs, slides, tearsheets and transparencies. Pays freelancers usually a set budget with a buyout. Negotiates rights purchased. Finds freelancers through artists' submissions, sourcebooks and word-of-mouth.

Tips: "Send nonreturnable samples (lasers) of work with rēsumē. Follow up by e-mail."

Washington

▣ AUGUSTUS BARNETT ADVERTISING/DESIGN, P.O. Box 197, Fox Island WA 98333. (253)549-2396. Fax: (253)549-4707. E-mail: charlieb@augustusbarnett.com. **President/Creative Director:** Charlie Barnett. Estab. 1981. Approximate annual billing: $1.2 million. Specializes in food, beverages, mass merchandise, retail products, corporate identity, package design, business-to-business advertising, marketing, financial. Clients: corporations, manufacturers. Current clients include Tree Top, Inc., Vitamilk Dairy, Frank Russell Co., University of Washington, Gilbert Global, Washington State Fruit Commission/NW Cherry Growers. Client list available upon request. Professional affiliations: AAF and AIGA.

Needs: Approached by more than 50 freelancers/year. Works with 2-4 freelance illustrators and 2-3 designers/year. Prefers freelancers with experience in food/retail and Mac usage. Works on assignment only. Uses illustrators for product, theme and food illustration, some identity and business-to-business. Also uses freelancers for illustration, multimedia projects and lettering. 90% of freelance work demands skills in FreeHand 8.01 and Photoshop 4.01. Send query letter with samples, rēsumē and photocopies. Samples are filed. Responds in 1 month. Pays for design by the hour, negotiable. Pays for illustration by project/use and buyouts. Rights purchased vary according to project.

Tips: "Freelancers must understand design is a business, deadlines and budgets. Design for the sake of design alone is worthless if it doesn't meet or exceed clients' objectives. Communicate clearly. Be flexible."

BELYEA, 1809 Seventh Ave., Suite 1250, Seattle WA 98101. (206)682-4895. Fax: (206)623-8912. Website: www.belyea.com. Estab. 1988. Design firm. Specializes in brand and corporate identity, marketing collateral, in-store P-O-P, direct mail, package and publication design. Clients: corporate, manufacturers, retail. Current clients include Weyerhaeuser, K/P Corporation and Princess Tours. Client list available upon request.

Needs: Approached by 20-30 freelancers/year. Works with 10 freelance illustrators/photographers and 3-5 designers/year. Prefers local design freelancers only. Works on assignment only. Uses illustrators for "any type of project." Uses designers mainly for overflow. Also uses freelancers for brochure, catalog, poster and ad illustration; and lettering. 100% of design and 70% of illustration demands skills in QuarkX-Press, FreeHand or Photoshop.

First Contact & Terms: Send postcard sample and résumé. Accepts disk submissions. Samples are filed. Responds only if interested. Pays for illustration by the project. Rights purchased vary according to project. Finds artists through submissions by mail and referral by other professionals.

Tips: "Designers must be computer-skilled. Illustrators must develop some styles that make them unique in the marketplace. When pursuing potential clients, send something (one or more) distinctive. Follow up. Be persistent (it can take one or two years to get noticed) but not pesky. Get involved in local AIGA. Always do the best work you can—exceed everyone's expectations."

CREATIVE CONSULTANTS, 2608 W. Dell Dr., Spokane WA 99208-4428. (509)326-3604. Fax: (509)327-3974. E-mail: ebruneau@creativeconsultants.com. Website: www.creativeconsultants.com. **President:** Edmond A. Bruneau. Estab. 1980. Approximate annual billing: $300,000. Ad agency and design firm. Specializes in collateral, logos, ads, annual reports, radio and TV spots. Product specialties are business and consumer. Client list available upon request.

Needs: Approached by 20 illustrators and 25 designers/year. Works with 10 illustrators and 15 designers/year. Uses freelancers mainly for animation, brochure, catalog and technical illustration, model-making and TV/film graphics. 36% of work is with print ads. Designs and illustration demands skills in PageMaker 6.5, FreeHand 9.0, Photoshop and QuarkXPress 4.1.

First Contact & Terms: Designers send query letter. Illustrators send postcard sample of work and e-mail. Accepts disk submissions if compatible with Photoshop, QuarkXPress, PageMaker and FreeHand. Samples are filed. Responds only if interested. Pays by the project. Buys all rights. Finds artists through Internet, word of mouth, reference books and agents.

DAIGLE DESIGN INC., 180 Olympic Dr. SE, Bainbridge Island WA 98110. (206)842-5356. Fax: (206)780-2526. E-mail: candace@daigledesign.com. Website: www.daigledesign.com. **Creative Director:** Candace Daigle. Estab. 1987. Number of employees: 6. Approximate annual billing: $450,000. Design firm. Specializes in brochures, catalogs, logos, magazine ads, trade show display and websites. Product specialties are telecommunications, digital projectors, aviation, yachts, restaurant equipment and automotive. Professional affiliations: AIGA.

Needs: Approached by 10 illustrators and 20 designers/year. Works with 5 illustrators and 5 designers/year. Prefers local designers with experience in Photoshop, Illustrator, DreamWeaver, Flash and FreeHand. Uses freelancers mainly for concept and production. Also for airbrushing, brochure design and illustration, lettering, logos, multimedia projects, signage, technical illustration and web page design. 15% of work is with print. 90% of design demands skills in Photoshop, Illustrator and FreeHand. 50% of illustration demands skills in Photoshop, Illustrator and FreeHand. and DreamWeaver.

First Contact & Terms: Designers send query letter with résumé. Illustrators send query letter with photocopies. Accepts disk submissions compatible with Adobe pdf players. Send JPEG files. Samples are filed and are not returned. Responds only if interested. Will contact for portfolio review of b&w, color, final art, slides and tearsheets if interested. Pays for design by the hour, $25; pays for illustration by the project, $100-3,000. Buys all rights. Finds artists through submissions, reps, temp agencies and word of mouth.

DITTMANN DESIGN, P.O. Box 31387, Seattle WA 98103-1387. (206)523-4778. E-mail: dittdsgn@nwl ink.com. **Owner/Designer:** Martha Dittmann. Estab. 1981. Number of employess: 2. Specializes in brand and corporate identity, display and package design and signage. Clients: corporations. Client list available upon request. Professional affiliations: AIGA.

Needs: Approached by 50 freelancers/year. Works with 5 freelance illustrators and 2 designers/year. Uses illustrators mainly for corporate collateral and packaging. Uses designers mainly for color brochure layout and production. Also uses freelancers for brochure and P-O-P illustration, charts/graphs and lettering.

Needs computer-literate freelancers for design, illustration, production and presentation. 75% of freelance work demands knowledge of Illustrator, Photoshop, PageMaker, Persuasion, FreeHand and Painter.
First Contact & Terms: Send postcard sample of work or brochure and photocopies. Samples are filed. Will contact artist for portfolio review if interested. Portfolio should include final art, roughs and thumbnails. Pays for design by the hour, $35-100. Pays for illustration by the project, $250-5,000. Rights purchased vary according to project. Finds artists through sourcebooks, agents and submissions.
Tips: Looks for "enthusiasm and talent."

HORNALL ANDERSON DESIGN WORKS, INC., 1008 Western Ave., Suite 600, Seattle WA 98104. (206)467-5800. Fax: (206)467-6411. E-mail: info@hadw.com. Website: www.hadw.com. Estab. 1982. Number of employees: 70. Design firm. Specializes in full range brand and marketing strategy consultation; corporate, integrated brand and product identity systems; new media; interactive media websites; packaging; collateral; signage; trade show exhibits; environmental graphics and annual reports. Product specialties are large corporations to smaller businesses. Current clients include Microsoft, K2 Corporation, Weyerhaeuser, Seattle Sonics, Quantum, Leatherman Tools, Oneworld Challenge, Jack In The Box, Mahlum Architects, AT&T Wireless. Professional affiliations: AIGA, Society for Typographic Arts, Seattle Design Association, Art Directors Club.
● This firm has received numerous awards and honors, including the International Mobius Awards, National Calendar Awards, London International Advertising Awards, Northwest and National ADDY Awards, Industrial Designers Society of America IDEA Awards, Communication Arts, Los Angeles Advertising Women LULU Awards, Brand Design Association Gold Awards, AIGA, Clio Awards, Communicator Awards, Web Awards.
Needs: "Interested in all levels, from senior design personnel to interns with design experience. Additional illustrators and freelancers are used on an as needed basis in design and online media projects."
First Contact & Terms: Designers send query letter with photocopies and résumé. Illustrators send query letter with brochure and follow-up postcard. Accepts disk submissions compatible with QuarkXPress, FreeHand or Photoshop, "but the best is something that is platform/software independent (i.e., Director)." Samples are filed. Responds only if interested. Portfolios may be dropped off. Rights purchased vary according to project. Finds designers through word of mouth and submissions; illustrators through sourcebooks, reps and submissions.

HOWARD/FROST ADVERTISING COMMUNICATIONS, 3131 Western Ave., #520, Seattle WA 98121. (206)378-1909. Fax: (206)378-1910. E-mail: bruce@hofro.com. Website: www.hofro.com. **Creative Director:** Bruce Howard. Estab. 1994. Number of full-time employees: 4. Ad agency. Specializes in media advertising, collateral and direct mail. Client list is available upon request.
Needs: Approached by 20-30 illustrators and 10-15 designers/year. Works with 10 illustrators and 2 designers/year. Works only with artist reps. Uses freelancers mainly for illustration, design overload. Also for airbrushing, animation, billboards, brochure, humorous and technical illustration, lettering, logos, multimedia projects, retouching, storyboards, web page design. 60% of work is with print ads. 60% of freelance design demands knowledge of PageMaker, FreeHand and Photoshop.
First Contact & Terms: Designers send query letter with photocopies. Illustrators send postcard sample. Accepts disk submissions. Send files compatible with Acrobat, FreeHand, PageMaker or Photoshop. Samples are filed and not returned. Responds only if interested. Art director will contact artist for portfolio review if interested. Pays for design and illustration by the project. Negotiates rights purchased.
Tips: "Be patient."

Wisconsin

AGA CREATIVE COMMUNICATIONS, (formerly AGA Communications), 2400 E. Bradford Ave., Suite 206, Milwaukee WI 53211-4165. (414)962-9810. E-mail: greink@juno.com. **CEO:** Art Greinke. Estab. 1984. Number of employees: 4. Marketing communications agency (includes advertising and public relations). Full-service multimedia firm. Specializes in special events (large display and photo work), print ads, TV ads, radio, all types of printed material (T-shirts, newsletters, etc.). Clients include The Great Circus Parade, Clear Channel Radio, Circus World Museum, GGS, Inc., IBM, Universal Savings Bank and Landmark Theatre Chain. Also sports, music and entertainment personalities. Professional affiliations: PRSA, IABC, NARAS.
Needs: Approached by 125 freelancers/year. Works with 25 freelance illustrators and 25 designers/year.

Uses freelancers for "everything and anything"—brochure and print ad design and illustration, storyboards, slide illustration, retouching, model making, billboards, posters, TV/film graphics, lettering and logos. Also for multimedia projects. 40% of work is with print ads. 75% of freelance work demands skills in PageMaker, Illustrator, Quark, Photoshop, FreeHand or Powerpoint.

First Contact & Terms: Send postcard sample and/or query letter with brochure, résumé, photocopies, photographs, SASE, slides, tearsheets, transparencies. Samples are filed and are not returned. Responds only if interested. Will contact artists for portfolio review if interested. Portfolio should include b&w and color thumbnails, roughs, final art, tearsheets, photographs, transparencies, etc. Pays by personal contract. Rights purchased vary according to project. Finds artists through submissions and word of mouth.

Tips: "We look for stunning, eye-catching work—surprise us! Fun and exotic illustrations are key!"

IMAGINASIUM, INC., 321 St. George St., Green Bay WI 54302-1310. (920)431-7872. Fax: (920)431-7875. E-mail: joe@imaginasium.com. Website: www.imaginasium.com. **Creative Director:** Joe Bergner. Estab. 1991. Number of employees: 11. Approximate annual billing: $1.5 million. Advertising, graphic design, and marketing firm. Specializes in brand development, graphic design, advertising. Product specialties are business to business retail. Current clients include Wisconsin Public Service, Schneider Logistics, Shopko. Client list available upon request. Professional affiliation: Green Bay Advertising Federation, Second Wind Network.

Needs: Approached by 50 illustrators and 25 designers/year. Works with 5 illustrators and 2 designers/year. Prefers local designers. Uses freelancers mainly for overflow. Also for brochure illustration and lettering. 15-20% of work is with print ads. 100% of design and 50% of illustration demands skills in Photoshop, QuarkXPress and Illustrator.

First Contact & Terms: Designers send query letter with brochure, photographs and tearsheets. Illustrators send sample of work with follow-up every 6 months. Accepts Macintosh disk submissions of above programs. Samples are filed and are not returned. Will contact for portfolio review of color tearsheets, thumbnails and transparencies if interested. Pays for design by the hour, $50-75. Pays for illustration by the project. Rights purchased vary according to project. Finds artists through submissions, word of mouth, Internet.

UNICOM, 9470 N. Broadmoor Rd., Bayside WI 53217. (414)352-5070. Fax: (414)352-4755. **Senior Partner:** Ken Eichenbaum. Estab. 1974. Specializes in annual reports, brand and corporate identity, display, direct, package and publication design and signage. Clients: corporations, business-to-business communications, and consumer goods. Client list available upon request.

Needs: Approached by 5-10 freelancers/year. Works with 1-2 freelance illustrators/year. Works on assignment only. Uses freelancers for brochure, book and poster illustration, pre-press composition.

First Contact & Terms: Send query letter with brochure. Samples not filed or returned. Does not reply; send nonreturnable samples. Write for appointment to show portfolio of thumbnails, photostats, slides and tearsheets. Pays by the project, $200-3,000. Rights purchased vary according to project.

Wyoming

BRIDGER PRODUCTIONS, INC., P.O. Box 8131, Jackson WY 83001. (307)733-7871. Fax: (307)734-1947. E-mail: info@bridgerproductions.com. Website: www.bridgerproductions.com. **Director/Cameraman:** Michael J. Emmer. Estab. 1990. AV firm. Full-service, multimedia firm. Specializes in national TV sports programming, national commercials, marketing videos, documentaries. Product specialties are skiing, mountain biking, mountain scenery. Current clients include Life Link International, Crombies, JH Ski Corp., State of Wyoming. Client list available upon request.

Needs: Approached by 2 freelance artists/month. Works with 0-1 freelance illustrator and designer/month. Works on assignment only. Uses freelance artists for everything. Also uses freelance artists for storyboards, animation, model-making, billboards, TV/film graphics, lettering and logos. Needs computer-literate freelancers for design, illustration and production. 80% of freelance work demands knowledge of Amiga/Lightwave and other 3-D and paint programs.

First Contact & Terms: Send query letter with film and video work—animations, etc. Samples are filed and are not returned. Responds only if interested. Will contact artist for portfolio review if interested. Portfolio should include 16mm, 35mm, motion picture and video work. Pays for design by the project,

$150-20,000. Pays for illustration by the project, $150-1,500. Rights purchased vary according to project. Finds artists through word of mouth and submissions.

Canada

2 DIMENSIONS TORONTO INC., 88 Advance Rd., Toronto, ON M8Z 2T7 Canada. (416)234-0088. Fax: (416)234-8599. E-mail: kam@2dimensions.com. Website: www.2dimensions.com. Estab. 1989. Number of employees: 20. Specializes in image marketing, advertising, annual reports, brand and corporate identity; direct mail, package and publication design. Clients: Fortune 500 corporations (IBM, etc.), major distributors and manufacturers (Letraset), most government ministries (Canadian), television (Fox TV, CBC). Partial client list available (does not include confidential clients). Professional affiliations: GAG, GDAC

 ● 2 Dimensions has won over 500 international awards. The company was profiled in *Step by Step Graphics* in March 1998 and *Applied Arts Magazine* in February 1998.

Needs: Approached by 200 freelancers/year. Works with 35 freelance illustrators and 3 designers/year. Looks for unique and diverse signature styles. Designers must be local to either the Toronto or New York office, but not illustrators. Works on assignment only (illustrators mostly). Uses illustrators mainly for advertising, collateral. Uses designers mainly for special projects and overflow work. Designers must work under creative director. Also uses freelancers for brochure design and illustration, magazine design, catalog, P-O-P, poster and ad illustration, and charts/graphs. 100% of freelance design demands skills in QuarkXPress, FreeHand, Photoshop, Microsoft Word or Suitcase.

First Contact & Terms: Send query letter with brochure or tearsheets, résumé, SASE. Samples are filed or are returned by SASE if requested by artist. Responds in 2 weeks. Write for appointment to show portfolio. "Don't send portfolio unless we phone. Send tearsheets that we can file." Pays for design by the project, $300-10,000. Pays for illustration by the project, $300-8,000. Negotiates rights purchased.

Tips: "We look for diverse styles of illustration for specific projects. Send tearsheets for our files. Our creative director refers to these files and calls with assignment offers. We don't normally have time to view portfolios except relative to a specific job. Strong defined styles are what we notice. The economy has reduced some client budgets and increased demand for speculative work. Since we are emphatically opposed to spec work, we do not work this way. Generalist artists who adapt to different styles are not in demand. Unique illustrative styles are easier to sell."

WARNE MARKETING & COMMUNICATIONS, 1300 Yonge St., Suite 502, Toronto, Ontario M4T 1X3 Canada. (416)927-0881. Fax: (416)927-1676. E-mail: john@warne.com. Website: www.warne.com. **Graphics Studio Manager:** John Coljee. Number of employees: 11. Approximate annual billing: $4.5 million. Specializes in business-to-business promotion. Current clients: Johnston Equipment, Vitek Viscon, Butler Buildings. Professional affiliations: INBA, MIC, BMA, CCAB.

Needs: Approached by 5-6 freelancers/year. Works with 4-5 freelance illustrators and 1-2 designers/year. Works on assignment only. Uses freelancers for design and technical illustrations, brochures, catalogs, P-O-P displays, retouching, billboards, posters, direct mail packages, logos. Artists should have "creative concept thinking."

First Contact & Terms: Send query letter with résumé and photocopies. Samples are not returned. Responds only if interested. Pays for design by the hour, or by the project. Considers complexity of project, client's budget and skill and experience of artist when establishing payment. Buys all rights.

Record Labels

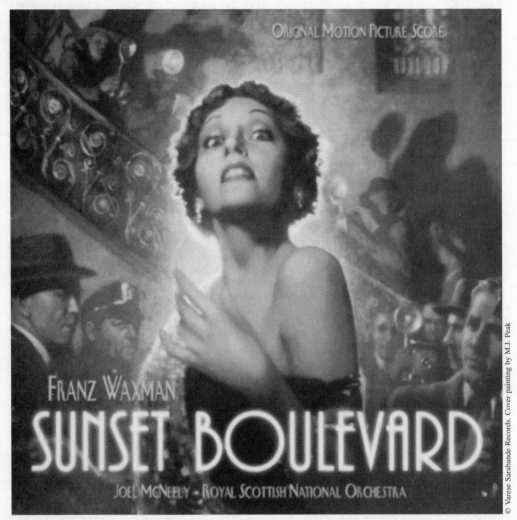

ORIGINAL MOTION PICTURE SCORE

FRANZ WAXMAN

SUNSET BOULEVARD

JOEL MCNEELY · ROYAL SCOTTISH NATIONAL ORCHESTRA

Varese Sarabande Records has carved out a very special niche in the recording industry. They produce soundtracks for motion pictures. This includes but is not limited to motion pictures made currently. Varese Sarabande also re-issues soundtracks for classic movies from past eras. For a series of CDs on classic Hollywood movies, the label chose artist Matthew Joseph Peak to capture the spooky glamour of Norma Desmond, *Sunset Boulevard*'s desperate aging film star. To see more of his work, visit Peak's website www.mjpeak.com which showcases his gallery work as well as the hundreds of CD and record covers he's created.

Record labels hire freelance artists for packaging, merchandising material, store displays, posters, and even T-shirts. But for the most part you'll be creating work for CD covers. Your greatest challenge in this market will be working within the size constraints of CD and cassette covers. The dimensions of a CD cover are 4¾ × 4¾ inches, packaged in a 5 × 5 inch jewel box. Inside each CD package is a 4-5 panel fold-out booklet, inlay card and CD. Photographs of the recording artist, illustrations, liner notes, titles, credit lines and lyrics all must be placed into that relatively small format.

LANDING THE ASSIGNMENT

Check the listings in the following section to see how each label prefers to be approached and what type of samples to send. Disk and e-mail submissions are encouraged by many of these listings. Check also to see what type of music they produce. Assemble a portfolio of your best work in case an art director wants to see more of your work.

Be sure your portfolio includes quality samples. It doesn't matter if the work is of a different genre—quality is key. If you don't have any experience in the industry, create your own CD package, featuring one of your favorite recording artists or groups.

Get the name of the art director or creative director from the listings in this section and send a cover letter with samples, asking for a portfolio review. If you are not contacted within a couple of months, send a follow-up postcard or sample to the art director or other contact person.

Once you nail down an assignment, get an advance and a contract. Independent labels usually provide an advance and payment in full when a project is done. When negotiating a contract, ask for a credit line on the finished piece and samples for your portfolio.

You don't have to live in one of the recording capitals to land an assignment, but it does help to familiarize yourself with the business. Visit record stores and study the releases of various labels. For further information about CD design read *Rock Art*, by Spencer Drate (PBC International) and *The Best Music CD Art & Design* (Rockport).

For More Information

Learn more about major labels and "indies" by reading industry trade magazines, like *Spin*, *Rolling Stone*, *Vibe*, *Revolver*, *Hit Parader* and *Billboard*. Each year around March, the Recording Industry Association of America releases sales figures for the industry. The RIAA's report also gives the latest trends on packaging and format, and music sales by genre. To request the most recent report, call the RIAA at (202)775-0101 or visit www.riaa.com.

ACTIVATE ENTERTAINMENT, 11328 Magnolia Blvd., Suite 3, North Hollywood CA 91601. (818)505-6573. Fax: (818)508-1101. **President:** James Warsinske. Estab. 2000. Produces CDs and tapes: rock & roll, R&B, soul, dance, rap and pop by solo artists and groups.
Needs: Produces 2-6 soloists and 2-6 groups/year. Uses 4-10 visual artists for CD and album/tape cover design and illustration; brochure design and illustration; catalog design, layout and illustration; direct mail packages; advertising design and illustration. 50% of freelancers work demands knowledge of PageMaker, Illustrator, QuarkXPress, Photoshop.
First Contact & Terms: Send query letter with SASE, tearsheets, photographs, photocopies, photostats, slides and transparencies. Samples are filed. Responds in 1 month. To show portfolio, mail roughs, printed samples, b&w and color photostats, tearsheets, photographs, slides and transparencies. Pays by the project, $100-1,000. Buys all rights.
Tips: "Get your art used commercially, regardless of compensation. It shows what applications your work has."

[N] AFTERSCHOOL PUBLISHING COMPANY, P.O. Box 14157, Detroit MI 48214. (313)894-8855. **President:** Herman Kelly. Estab. 1978. Produces CDs and tapes: rock, jazz, rap, R&B, soul, pop, classical, folk, educational, country/western, dance and new wave. Recent releases: *Enjoyment*, by H. Kelly on M.C.P.; and *Do You Remember What it Felt Like*, by M.C.P.

Needs: Produces 1 solo artist/year. Works with 10 freelance designers and 10 illustrators/year. Prefers professional artists with experience in all forms of the arts. Uses artists for CD cover design, tape cover and advertising design and illustration, brochure design, multimedia projects and posters. 10% of freelance work demands computer skills.

First Contact & Terms: Send query letter with brochure, résumé, SASE, bio, proposal and appropriate samples. Samples are filed or are returned by SASE. Responds in 1 month. Requests work on spec before assigning a job. To show portfolio, mail roughs, printed samples, b&w/color tearsheets, photographs, slides and transparencies. Pays by the project. Negotiates rights purchased. Interested in buying second rights (reprint rights) to previously published work. Finds artists through Michigan Artist Directory and Detroit Area.

Tips: "Be on a local or national artist roster to work outside your hometown."

[■] ALBATROSS RECORDS/R'N'D PRODUCTIONS, P.O. Box 540102, Houston TX 77254-0102. (713)521-2616. Fax: (713)529-4914. E-mail: rpds2405@aol.com. Website: www.rndproductions.com. **Art Director:** Victor Ivey. National Sales Director: Darin Dates. Estab. 1987. Produces CDs, cassettes: country, jazz, R&B, rap, rock and pop by solo artists and groups. Recent releases: *Mr. Mike*, by From tha Hood to tha Barrio; and *Suave House Greatest Hits Volume 1*, by 8 Ball and MJG.

Needs: Produces 22 releases/year. Works with 3 freelancers/year. Prefers freelancers with experience in QuarkXPress, Freelance. Uses freelancers for cassette cover design and illustration; CD booklet design; CD cover design and illustration; poster design; Web page design; advertising design/illustration. 50% of freelance work demands knowledge of QuarkXPress, FreeHand, Photoshop.

First Contact & Terms: Send postcard sample of work. Samples are filed and not returned. Will contact for portfolio review of b&w and color final art if interested. Pays for design by the project, $400 maximum. Pays for illustration by the project, $250 maximum. Buys all rights. Finds freelancers through word of mouth.

[●] ALPHABEAT, Box 12 01, D-97862 Wertheim/Main, West Germany. Phone/fax: 09342-841 55. E-mail: alphabeat@t-online.de. **Owner:** Stephan Dehn. A&R: Marga Zimmerman. Marketing: Alexandra Tagscherer. Sales: Katria Tagscherer. Produces CDs, tapes and albums: R&B, soul, dance, rap, pop, new wave, electronic and house; solo artists and groups.

Needs: Uses freelancers for CD/album/tape cover, brochure and advertising design and illustration; catalog design, illustration and layout; and direct mail packages.

First Contact & Terms: Send query letter with brochure, tearsheets, photostats, résumé, photographs, slides, SASE, photocopies and IRCs. Samples are returned by SAE with IRCs. To show portfolio, mail appropriate materials. Payment depends on product. Rights purchased vary according to project.

AMERICAN MUSIC NETWORK INC., P.O. Box 7018, Warner Robins GA 31095. (478)953-2800. Estab. 1986. Produces albums, CDs, cassettes, videos: country, folk, gospel, jazz, pop, progressive, R&B, rock, soul by solo artists and groups.

Needs: Produces 12 releases/year. Works with 6 freelancers/year. Uses freelancers for album cover design and illustration; cassette cover design and illustration; CD booklet design and illustration; CD cover design and illustration; poster design. 50% of freelance design and illustration demands knowledge of PageMaker, Illustrator, QuarkXPress, Photoshop or FreeHand.

First Contact & Terms: Send query letter with résumé. Samples are filed or returned by SASE if requested by artist. Responds in 4 months. Portfolio review not required. Pays by the project, $50-500. Negotiates rights purchased.

Tips: Looks for "originality."

[■] ARIANA RECORDS, 1312 S. Avenida Polar, #A-8, Tucson AZ 85710. (520)790-7324. E-mail: jgasper1596@earthlink.net. Website: www.arianarecords.com. **President:** Jim Gasper. Estab. 1980. Produces CDs: folk, spacefunk and rock, by solo artists and groups. Recent releases: *Porn Music*, by Buddy Love; *Songs of the 7 Seas*, by Baby Fish Mouth.

Needs: Produces 5 releases/year. Works with 2 freelancers/year. Prefers freelancers with experience in cover design. Uses freelancers for album cover design and illustration; cassette cover design and illustration;

CD cover design and illustration and multimedia projects. 70% of design and 50% of illustration demands computer skills. "We are looking at CD covers for the next two years."

First Contact & Terms: Send postcard sample of work. Samples are filed or returned by SASE if requested by artist. Responds in 1 month. Portfolio review not required. Pays by the project.

Tips: "We like simple, but we also like wild graphics! Give us your best shot!"

N ⚡ **ASTRALWERKS**, 104 W. 29th St., 4th Floor, New York NY 10001. (212)886-7510. Fax: (212)643-5562. E-mail: lisac@astralwerks.com. Website: www.astralwerks.com. **Contact:** Lisa Smith-Craig, director of production. Estab. 1993. Produces CDs, DVD and vinyl: alternative, progressive, rap, reggae, rock by solo artists and groups. Recent releases *Exit*, by KOS; *Clean*, by Cosmo Vitelli. Art guidelines available on website.

Needs: Produces 50 releases/year. Works with 2 freelancers/year. Prefers local freelancers. Uses freelancers for CD booklet illustration, CD cover design and illustration. 90% of design work demands knowledge of Illustrator, CD cover design and illustration. 90% of design work demands knowledge Illustrator, Photoshop and QuarkXPress. 10% of illustration work demands knowledge of FreeHand.

First Contact & Terms: Send postcard sample or query letter. Samples are filed. Responds only if interested. Request portfolio review in original query. Portfolio should include color finished and original art, photographs and roughs. Pays by the project; $100-500. Rights purchased vary according to project. Finds freelancers through word-of-mouth.

ATLAN-DEC/GROOVELINE RECORDS, 2529 Green Forest Ct., Snellville GA 30078-4183. (770)985-1686. E-mail: atlandec@prodigy.net. Website: www.atlan-dec.com. **Art Director:** Wileta J. Hatcher. Estab. 1994. Produces CDs and cassettes: gospel, jazz, pop, R&B, rap artists and groups. Recent releases: *Stepping Into the Light*, by Mark Cocker.

Needs: Produces 2-4 releases/year. Works with 1-2 freelancers/year. Prefers freelancers with experience in CD and cassette cover design. Uses freelancers for album cover, cassette cover, CD booklet and poster design. 80% of freelance work demands knowledge of Photoshop.

First Contact & Terms: Send postcard sample of work or query letter with brochure, photocopies, photographs and tearsheets. Samples are filed. Will contact for portfolio review of b&w, color, final art if interested. Pays for design by the project, negotiable. Negotiates rights purchased. Finds artists through submissions.

BAL RECORDS, Box 369, LaCanada CA 91012. (818)548-1116. E-mail: balmusic@pacbell.net. **President:** Adrian P. Bal. Secretary-Treasurer: Berdella Bal. Estab. 1965. Produces 1-2 CDs: rock & roll, jazz, R&B, pop, country/western and church/religious. Recent releases: *Travel With Me*, by Adrian Bal.

First Contact & Terms: Samples are not filed and are returned by SASE. Responds ASAP. Portfolio review requested if interested in artist's work. Sometimes requests work on spec before assigning a job. Finds new artists through submissions.

Tips: "I don't like the abstract designs."

BATOR & ASSOCIATES, 31 State St., Suite 44D, Monson MA 01057. **Art Director:** Joan Bator. Estab. 1969. Handles rock and country.

Needs: Buys 5,000 line drawings and logo designs/year. Illustrations, full-color and line for various advertising and books—adult and children.

First Contact & Terms: Slides and photostats welcome. Also have special need for top-notch calligraphy. Samples welcome. Works with freelancers on assignment only. Responds in 5 days with SASE. Pays by the project. Buys one-time rights; other rights negotiable. Send no originals, only your copies.

🌐 **BIG BEAR RECORDS**, P.O. Box, Birmingham B16 8UT England. (021)454-7020. Fax: (21)454-9996. E-mail: agency@bigbearmusic.com. Website: www.bigbearmusic.com. **Managing Director:** Jim Simpson. Produces CDs and tapes: jazz, R&B. Recent releases: *Let's Face the Music*, by Bruce Adams/Alan Barnes Quintet; *Blues & Rhythm, Volume One*, and *Smack Dab in the Middle*, by King Pleasure and The Biscuit Boys; *The Boss Is Home*, by Kenny Bakers Dozen.

Needs: Produces 4-6 records/year. Works with 2-3 illustrators/year. Uses freelancers for album cover design and illustration. Needs computer-literate freelancers for illustration.

First Contact & Terms: Works on assignment only. Send query letter with photographs or photocopies to be kept on file. Samples not filed are returned only by SAE (nonresidents include IRC). Negotiates payment. Considers complexity of project and how work will be used when establishing payment. Buys

all rights. Interested in buying second rights (reprint rights) to previously published work.

BLACK DIAMOND RECORDS INCORPORATED, P.O. Box 222, Pittsburg CA 94565. (510)980-0893. Fax: (925)432-4342. **Art Director:** Catrina Washington. Estab. 1988. Produces tapes, CDs and vinyl 12-inch and 7-inch records: jazz, pop, R&B, soul, urban hib hop by solo artists and groups. Recent releases: "X-Boyfriend," by Héye featuring Dashawn and "Simple and Easy," by Dean Gladney.
Needs: Produces 2 solo artists and 3 groups/year. Works with 2 freelancers/year. Prefers freelancers with experience in album cover and insert design. Uses freelancers for CD/tape cover and advertising design and illustration; direct mail packages; and posters. Needs computer-literate freelancers for production. 85% of freelance work demands knowledge of PageMaker, FreeHand.
First Contact & Terms: Send query letter with résumé. Samples are filed or returned. Responds in 3 months. Write for appointment to show portfolio of b&w roughs and photographs. Pays for design by the hour, $100; by the project, varies. Rights purchased vary according to project.
Tips: "Be unique, simple and patient. Most of the time success comes to those whose artistic design is unique and has endured rejection after rejection."

BLASTER BOXX HITS, 519 N. Halifax Ave., Daytona Beach FL 32118. (386)252-0381. Fax: (386)252-0381. E-mail: blasterboxxhits@aol.com. Website: blasterboxxhits.com. **C.E.O.:** Bobby Lee Cude. Estab. 1978. Produces CDs, tapes and albums: rock, R&B. Releases: *Blow Blow Stero*, by Zonky-Honky; and *Hootchie-Cootch Girl*.
Needs: Approached by 15 designers and 15 illustrators/year. Works with 3 designers and 3 illustrators/year. Produces 6 CDs and tapes/year. Works on assignment only. Uses freelancers for CD cover design and illustration.
First Contact & Terms: Send query letter with appropriate samples. Samples are filed. Responds in 1 week. To show portfolio, mail thumbnails. Sometimes requests work on spec before assigning a job. Pays by the project. Buys all rights.

BOUQUET-ORCHID ENTERPRISES, P.O. Box 1335, Norcross GA 30091. (770)814-2420. Website: www.bswrecords.com. **President:** Bill Bohannon. Estab. 1972. Produces CDs and tapes: rock, country, pop and contemporary Christian by solo artists and groups. Recent releases: *First Time Feeling*, by Adam Day; *Just Another Day*, by Bandoleers.
Needs: Produces 6 solo artists and 4 groups/year. Works with 5-6 freelancers/year. Works on assignment only. Uses freelancers for CD/tape cover and brochure design; direct mail packages; advertising illustration, logos, brochures. 60% of design work demands knowledge of PageMaker and QuarkXPress. 40% of illustration work demands knowledge of FreeHand.
First Contact & Terms: Send query letter with photocopies and sample CD booklet. "I prefer a brief but concise overview of an artist's background and works showing the range of his talents." Include SASE. Samples are not filed and are returned by SASE if requested by artist. Responds in 1 month. Company will contact artist for portfolio review if interested. Portfolio should include b&w and color photographs and tearsheets. Pays by the project, in line with industry standards for pay. Rights purchased vary according to project. Finds freelancers through agents, artists' submissions and word-of-mouth.
Tips: "Freelancers should be willing to work within guideline requested along with deadlines on material. They should be open to suggested changes and understand budgetary considerations. If we are pleased with artists' works, we are happy to give repeat business."

N **BROADLAND INTERNATIONAL**, 50 Music Sq. W., Suite 407, Nashville TN 37203. (615)327-3410. Fax: (615)327-3571. **A&R Director:** Gary Buck. Estab. 1975. Produces CDs, cassettes: country and gospel. Recent releases: "Again," by Johnny Duncan; "Can't Get Enough," by Gunslinger.
Needs: Produces 15-20 releases/year. Works with 3-4 freelancers/year. Prefers designers who own computers. Uses freelancers for album cover design and illustration; cassette cover design and illustration; CD booklet design and illustration; CD cover design and illustration; poster design. Also for in-store promotional posters. 80% of freelance work demands computer skills.
First Contact & Terms: Send query letter with brochure, résumé, photocopies, photographs, tearsheets. Accepts disk submissions (Windows). Samples are filed or returned by SASE if requested by artist. Will contact artist for portfolio review of b&w, color photocopies, photographs, tearsheets if interested. Pays by the project; negotiable. Rights purchased vary according to project.

N **C.L.R. RECORDS**, 14900 Croom Airport Rd., Upper Marlborough MD 20772. Phone/fax: (301)627-5996 (call before sending fax). E-mail: clrrecords@aol.com. **President of A&R:** Stephen Janis. Estab.

1992. Produces CDs, cassstettes, albums: dance and rap. Recent releases: *Lock Down*, by Sam "the Beast"; *Deep Marlin Funk*, by Mr. Muse.

Needs: Produces 4-5 groups/year. Approached by 25 designers and 25 illustrators/year. Works with 3 designers and 1 illustrator/year. Uses freelancers for CD cover design and illustration, album/tape cover and advertising design and posters.

First Contact & Terms: Send query letter with brochure, tearsheets, photostats, résumé, slides and transparencies. Samples are filed and are not returned. Call for appointment to show portfolio of roughs, original/final art, b&w tearsheets. Pays for design by the project, $500-1,000; pays for illustration by the project, $500-1,000. Buys all rights.

N CANTILENA RECORDS, 6548 Via Sereno, Rancho Murieta CA 95683-9226. **Contact:** Laurel Zucker. Estab. 1992. Produces CDs: classical by solo artists. Recent releases: *J.S. Bach Flute Sonatas* and *Telemann Fantasies*, by Laurel Zucker.

Needs: Produces 3 releases/year. Works with 2-3 freelancers/year. Prefers artists with experience in CD design. Uses freelancers for CD cover design. 100% of design work demands knowledge of Illustrator, PageMaker, Photoshop, QuarkXPress.

First Contact & Terms: Send query letter with sample CD booklets. Samples are not filed and not returned. Responds only if interested. Pays for design by the project. Buys all rights. Finds freelancers through artists' submissions and word-of-mouth.

CHATTAHOOCHEE RECORDS, P.O. 5754, Sherman Oaks CA 91413. (818)788-6863. Fax: (818)788-4229. **A&R:** Chris Yardum. Estab. 1958. Produces CDs and tapes: rock & roll, pop by groups. Recent releases: "Thanks for Nothing," by DNA.

Needs: Produces 1-2 groups/year. Works with 1 visual artist/year. Prefers local artists only. Works on assignment only. Uses artists for CD cover design and illustration; tape cover design and illustration; advertising design and illustration; posters. 50% of freelance work demands knowledge of Illustrator.

First Contact & Terms: Send query letter with brochure, résumé and photographs. Samples are filed and are not returned. Responds only if interested. To show portfolio, mail final art and photographs. Pays for design by the project. Rights purchased vary according to project.

N CLIO MUSIC, LLC, P.O. Box 3028, Palos Verdes Peninsula CA 90274. Phone/fax: (310)465-1824. **Contact:** Gene Davis. Estab. 1991. Produces albums, CDs, cassettes, videos: country, folk, jazz, big band by solo artists and groups. Releases: *Sweet Swing* (box set), *Rocky & Bullwinkle* (original cartoon cast album), albums by Max Weinberg 7, Sara Vaughan, Don Redman All Stars and children's Golden Records.
 ● Clio Music recently took over Drive Entertainment. They are currently in the process of licensing their library and are not accepting submissions. Artists should write for more information before submitting to this market.

N ▣ CORNELL ENTERTAINMENT GROUP (SUN DANCE RECORDS), 907 Baltimore St., Mobile AL 36605. (251)438-5756. E-mail: ceg4antoniop@hotmail.com. **Contact:** Antonio Pritchett. Estab. 1987. Produces CDs, CD-ROMs, cassettes: classical, country, folk, gospel, jazz, pop, R&B, rap, reggae, rock, soul by solo artists and groups. Recent releases: *Bringing It*, by Smoke Queen; *Luv of Money*, by Da Force. Art guidelines free with SASE.

Needs: Produces 37 releases/year. Works with 14 freelancers/year. Uses freelancers for animation, cover illustration and design, CD booklet illustration, CD cover design and illustration, CD-ROM packaging, poster and web design, spot illustration. Illustration demands knowledge of FreeHand, Illustrator, InDesign, PageMaker, Photoshop, QuarkXPress.

First Contact & Terms: Send query letter with brochure, photocopies, photographs, résumé, SASE, sample CD booklet. Samples are filed or returned by SASE. Does not reply. Artist should write a letter for an update on status. Company will contact artist for portfolio review if interested. Portfolio should include b&w and color finished art, original art, photographs, roughs, tearsheets. Pays by the hour, $8-19; by the project, $25-3,000. Rights purchased vary according to project. Finds freelancers through agents, artists' submissions, magazines, word-of-mouth.

Tips: "Your work is a statement of you, so put your best in everything you do."

▣ CRS ARTISTS, 724 Winchester Rd., Broomall PA 19008. (610)544-5920. Fax: (610)544-5921. E-mail: crsnews@erols.com. Website: www.erols.com/crsnews. **Administrative Assistant:** Caroline Hunt. Estab. 1981. Produces CDs, tapes and albums: jazz and classical by solo artists and compilations. Recent

releases: *Mostly French*, *Drama in Music* and *Tribute to German Leaders*.
 • Sponsors Competition for Performing Artists and National Competition for Composers Recording.
Needs: Produces 20 CDs/year. Works with 4 designers and 5 illustrators/year on assignment only. Also uses freelancers for multimedia projects. 50% of freelance work demands knowledge of Word Perfect and Wordstar.
First Contact & Terms: Send query letter with brochure, résumé, SASE and photocopies. Samples are filed or are returned by SASE if requested by artist. Responds in 1 month only if interested. Call for appointment to show portfolio or mail roughs, b&w tearsheets and photographs. Requests work on spec before assigning a job. Pays by the project. Buys all rights; negotiable. Finds new artists through *Artist's and Graphic Designer's Market*.

☑ **DAPMOR RECORDS**, (formerly Dapmor Publishing Company), 3031 Acron Ave., Kenner LA 70065. (504)468-9820. **Contact:** Mr. Kelly Jones, artist rep. Estab. 1996. Produces CDs, CD-ROMs: classical gospel, folk, progressive, reggae, country, jazz, pop, R&B, rap, rock and soul by solo artists. Recent releases include Sam Ridgley and King Floyd. Art guidelines available.
Needs: Produces 10 releases/year. Works with 5 visual artists/year. Uses freelancers for CD cover design.
First Contact & Terms: Send photographs and sample CD booklet. Samples are not filed and not returned. Responds in 1 month. Company will contact artist for portfolio review if interested. Portfolio should include finished art. Pays for design by the project. Pays for illustration by the day. Rights purchased vary according to project. Finds freelancers through agents.
Tips: "Must do good work. Never stop trying."

EARACHE RECORDS, 43 W. 38th St., New York NY 10018. (212)840-9090. Fax: (212)840-4033. E-mail: usaproduction@earache.com. Website: www.earache.com. **Product Manager:** Tim McVicker. UK estab. 1986, US estab. 1993. Produces albums, CDs, CD-ROMs, cassettes, 7″, 10″ and 12″ vinyl: rock, industrial, heavy metal techno, death metal, grind core. Recent releases: *The Haunted Made Me Do It*, by The Haunted; *Gateways to Annihilation*, by Morbid Angel.
Needs: Produces 18 releases/year. Works with 4-6 freelancers/year. Prefers designers with experience in music field who own Macs. Uses freelancers for album cover design; cassette cover illustration; CD booklet and cover design and illustration; CD-ROM design. Also for advertising and catalog design. 90% of freelance work demands knowledge of Illustrator 7.0, QuarkXPress 4.0, Photoshop 5.0, FreeHand 7.
First Contact & Terms: Send postcard sample of work. Samples are filed and not returned. Does not reply. Artist should follow-up with call and/or letter after initial query. Will contact artist for portfolio review of color, final art, photocopies, photographs if interested. Pays by the project. Buys all rights.
Tips: "Know the different packaging configurations and what they are called. You must have a background in music production/manufacturing."

THE ETERNAL SONG AGENCY, P.O. Box 121, Worthington OH 43085. E-mail: leopold@eternal-song.agency.com. Website: www.eternal-song-agency.com. **Art Director:** Leopold Crawford. Estab. 1986. Produces CDs, tapes and videos: rock, jazz, pop, R&B, soul, progressive, classical, gospel, country/western. Recent releases: *The Ultimate Answer*, by Jennifer Bates; and *Now I See the Truth*, by Laura Sanders.
Needs: Produces 6 releases/year. Works with 5-7 freelancers/year. Prefers freelancers with experience in illustration and layout. "Designers need to be computer-literate and aware of latest illustration technology." Uses freelancers for CD/tape cover, and advertising design and illustration, direct mail packages, posters, catalog design and layout.
First Contact & Terms: Send postcard sample of work or send query letter with brochure, photocopies, résumé, photographs. Samples are filed. Responds in 5 weeks. Art Director will contact artist for portfolio review if interested. Portfolio should include b&w and color final art and photocopies. Pays for design by the project, $300-5,000. Pays for illustration by the hour, $15-35; by the project, $300-5,000. Finds artists through word of mouth, seeing previously released albums and illustration, art colleges and universities. "Be persistent. Know your trade. Become familiar with technical advances as related to your chosen profession."

FOREFRONT RECORDS/EMI CHRISTIAN MUSIC GROUP, 230 Franklin Rd., Bldg. 21st Floor, Franklin TN 37067. (615)771-2900. Fax: (615)771-2901. E-mail: sparrish@forefrontrecords.com. Website: www.forefrontrecords.com. **Creative Services Manager:** Susannah Parrish. Estab. 1988. Produces CDs, CD-ROMs, cassettes: Christian alternative rock by solo artists and groups. Recent releases: *Lift*, by Audio Adrenaline; *Worship God*, by Rebecca St. James; *Momentum*, by Toby Mac; and *Genuine*, by Stacie Orrico.

Needs: Produces 15-20 releases/year. Works with 5-10 freelancers/year. Prefers designers who own Macs with experience in cutting edge graphics and font styles/layout, have the ability to send art over e-mail, and pay attention to detail and company spec requirements. Uses freelancers for cassette cover design and illustration; CD booklet design and illustration; CD cover design and illustration; CD-ROM design and packaging; poster design. 100% freelance design and 50% of illustration demands knowledge of Illustrator, QuarkXPress, Photoshop.

First Contact & Terms: Send postcard sample or query letter with résumé, photostats, transparencies, photocopies, photographs, slides, SASE, tearsheets. Accepts disk submissions compatible with Mac/Quark, Photoshop or Illustrator, EPS files. Samples are filed or returned by SASE if requested by artist. Responds only if interested. Portfolios may be dropped every Tuesday and Wednesday. Will contact artist for portfolio review if interested. Payment depends on each project's budgeting allowance. Negotiates rights purchased. Finds artists through artist's submissions, sourcebooks, web pages, reps, word-of-mouth.

Tips: "I look for cutting edge design and typography along with interesting use of color and photography. Illustrations must show individual style and ability to be conceptual."

✓ G2, (formerly Parallax Records), 14110 N. Dallas Pkwy., Suite 365, Dallas TX 75240. (972)726-9203. Fax: (972)726-7749. **Art Director:** Jason Abbott. Estab. 1995. Produces albums, CDs, cassettes: pop, R&B, rap, rock. by solo artists and groups.

Needs: Produces 2-3 releases/year. Works with 3 freelancers/year. Uses freelancers for album cover design and illustration; cassette cover design and illustration; CD booklet design and illustration; CD cover design and illustration; poster design. 75% of freelance work demands knowledge of PageMaker, Illustrator, QuarkXPress, Photoshop, FreeHand, Corel 7-8.

First Contact & Terms: Send query letter with brochure, résumé, photographs, tearsheets. Samples are filed. Portfolios may be dropped off every Tuesday. Will contact artist for portfolio review of final art, photocopies and photographs if interested. Pays for design by the project, $200-2,500. Pays for illustration by the hour. Buys all rights.

HARD HAT RECORDS AND CASSETTE TAPES, 519 N. Halifax Ave., Daytona Beach FL 32118-4017. (386)252-0381. Fax: (386)252-0381. E-mail: hardhatrecords@aol.com. Website: www.hardhatrecords.com. **CEO:** Bobby Lee Cude. Produces rock, country/western, folk and educational by group and solo artists. Publishes high school/college marching band arrangements. Recent releases: *Broadway USA* CD series (a 3-volume CD program of new and original music); and *Times-Square Fantasy Theatre* (CD release with 46 tracks of new and original Broadway style music).

 • Also owns Blaster Boxx Hits.

Needs: Produces 6-12 records/year. Works with 2 designers and 1 illustrator/year. Works on assignment only. Uses freelancers for album cover design and illustration; advertising design; and sheet music covers. Prefers "modern, up-to-date, on the cutting edge" promotional material and cover designs that fit the music style. 60% of freelance work demands knowledge of Photoshop.

First Contact & Terms: Send query letter with brochure to be kept on file one year. Samples not filed are returned by SASE. Responds in 2 weeks. Write for appointment to show portfolio. Sometimes requests work on spec before assigning a job. Pays by the project. Buys all rights.

◪ HICKORY LANE RECORDS, 19854 Butternut Lane, Pitt Meadows, BC V3Y 2S7 Canada. (604)465-1258. **President:** Chris Michaels. Estab. 1985. Produces CDs and tapes: country/western. Recent releases: *All Fired Up and Country*, by Chris Urbanski.

Needs: Produces 5 solo artists and 2 groups/year. Approached by 15 designers and 15 illustrators/year. Works with 2 designers and 2 illustrators/year. Works on assignment only. Uses freelancers for CD/tape cover, brochure and advertising design and illustration; and posters. 25% of freelance work demands knowledge of PageMaker, Illustrator, QuarkXPress, Photoshop, FreeHand.

First Contact & Terms: Send query letter with brochure, résumé, photostats, transparencies, photocopies, photographs, SASE and tearsheets. Samples are filed and are returned by SASE if requested by artist. Responds in 6 weeks. Call or write for appointment to show portfolio of b&w and color roughs, final art, tearsheets, photostats, photographs, transparencies and computer disks. Pays for design by the project, $250-650. Negotiates rights purchased.

Tips: "Keep ideas simple and original. If there is potential in the submission we will contact you. Be patient and accept criticism. Send us samples via email."

■ HOTTRAX RECORDS, 1957 Kilburn Dr., Atlanta GA 30324. (770)662-6661. E-mail: hotwax@hottrax.com. Website: www.hottrax.com. **Publicity and Promotion:** Teri Blackman. Estab. 1975. Produces

CDs and tapes: rock, R&B, country/western, jazz, pop and blues/novelties by solo and group artists. Recent releases: "Everythang & Mo'," by Sammy Blue; and *Lady That Digs The Blues*, by Big Al Jano & The Blues Mafia.

Needs: Produces 2 soloists and 4 groups/year. Approached by 90-100 designers and 60 illustrators/year. Works with 6 designers and 6 illustrators/year. Prefers freelancers with experience in multimedia—mixing art with photographs—and caricatures. Uses freelancers for CD/tape cover, catalog and advertising design and illustration; and posters. 25% of freelance work demands knowledge of PageMaker, Illustrator and Photoshop.

First Contact & Terms: Send postcard samples. Accepts disk submissions compatible with Illustrator and CorelDraw. Some samples are filed. If not filed, samples are not returned. Responds only if interested. Pays by the project, $150-1,250 for design and $1,000 maximum for illustration. Buys all rights.

Tips: "We file all samples that interest us even though we may not respond until the right project arises. We like simple designs for blues and jazz, including cartoon/caricatures, abstract for New Age and fantasy for heavy metal and hard rock."

HULA RECORDS, 99-139 Waiua Way, Unit #56, Aiea HI 96701. (808)485-2294. Fax: (808)485-2296. E-mail: hularecords@hawaii.rr.com. Website: www.hawaiian-music.com. **President:** Donald P. McDiarmid III. Produces educational and Hawaiian records; group and solo artists.

Needs: Produces 1-2 soloists and 3-4 groups/year. Works on assignment only. Uses artists for album cover design and illustration, brochure and catalog design, catalog layout, advertising design and posters.

First Contact & Terms: Send query letter with tearsheets and photocopies. Samples are filed or are returned only if requested. Responds in 2 weeks. Write for appointment to show portfolio. Pays by the project, $50-350. Considers available budget and rights purchased when establishing payment. Negotiates rights purchased.

N ☥ IDOL RECORDS, P.O. Box 720043, Dallas TX 75372. Fax: (214)370-5417. E-mail: info@idol-records.com. Website: www.idol-records.com. **Contact:** Miles. Estab. 1993. Produces CDs: rock by solo artists and groups. Recent releases: *The Day of the Ray*, by The Deathray Davies; *Onward Quirky Soldiers*, by Chomsky.

Needs: Produces 10-20 releases/year. Prefers local designers/illustrators. Uses freelancers for CD booklet illustration and cover design and poster design.

First Contact & Terms: Send photocopies, photographs, résumé and sample CD booklet. Samples are filed and not returned. Responds only if interested. Company will contact artist for portfolio review if interested. Pays by the project. Buys all rights. Finds freelancers through word-of-mouth.

IMAGINARY ENTERTAINMENT CORP., P.O. Box 66, Whites Creek TN 37189. (615)299-9237. E-mail: jazz@imaginaryrecords.com. Website: www.imaginaryrecords.com. **Proprietor:** Lloyd Townsend. Estab. 1982. Produces CDs, tapes and LP's: rock, jazz, classical, folk and spoken word. Releases include: *Kaki*, by S.P. Somtow; *Triologue*, by Stevens, Siegel and Ferguson; and *Fifth House*, by the New York Trio Project.

Needs: Produces 1-2 solo artists and 1-2 groups/year. Works with 1-2 freelancers/year. Works on assignment only. Uses artists for CD/LP/tape cover design and illustration.

First Contact & Terms: Send query letter with brochure, tearsheets, photographs and SASE if sample return desired. Samples are filed or returned by SASE if requested by artist. Responds in 3 months. To show portfolio, mail thumbnails, roughs and photographs. Pays by the project, $25-500. Negotiates rights purchased.

Tips: "I always need one or two dependable artists who can deliver appropriate artwork within a reasonable time frame."

N ☥ INTERSCOPE GEFFEN A&M RECORDS, 2220 Colorado Ave., Santa Monica CA 90404. (310)865-1000. **Contact:** Director of Creative Services. Produces CDs, cassettes, vinyl, DVD: a variety of music by solo artists and groups. Recent releases: *Red Letter Days*, by Wallflowers; *Sea Change*, by Beck. Art guidelines available with project.

Needs: Prefers local designers/illustrators with experience in music. Uses freelancers for cassette illustrations and design; CD booklet and cover illustration and design. 100% of design work demands knowledge of Illustrator, Photoshop and QuarkXpress. 100% of illustration work demands knowledge of FreeHand and Illustrator.

First Contact & Terms: Send postcard sample. Samples are filed. Responds only if interested. Portfolio

GET A FREE ISSUE OF HOW

From creativity crises to everyday technology, HOW covers every aspect of graphic design — so you have all the tools, techniques and resources you need for design success.

CREATIVITY idea-boosting tips from the experts and the inspiration behind some innovative new designs

BUSINESS how to promote your work, get paid what you're worth, find new clients and thrive in any economy

DESIGN an inside look at the hottest design workspaces, what's new in production and tips on designing for different disciplines

TECHNOLOGY what's happening with digital design, hardware and software reviews, plus how to upgrade on a budget

With this special introductory offer, you'll get a FREE issue of HOW. If you like what you see, you'll get a full year of HOW at our lowest available rate — a savings of 56% off the newsstand price.

I WANT TO TRY HOW.

Yes! Send my FREE issue and start my trial subscription. If I like what I see, I'll pay just $29.96 for 5 more issues (6 in all). If not, I'll write "cancel" on the invoice, return it and owe nothing. The FREE issue is mine to keep.

Name _____

Company _____

Address _____

City _____

State _____ZIP _____

SEND NO MONEY NOW.

Canadian orders will be billed an additional $15 (includes GST/HST). Overseas, add $22; airmail, add $65. Remit in U.S. funds. Allow 4-6 weeks for first issue delivery (12 weeks overseas). Annual newsstand rate $68.70.

Important! Please take a moment to complete the following information.

My business is best described as: (choose one)
○ 1 Advertising agency
○ 3 Design studio
○ 4 Graphic arts vendor
○ 2 Company
○ 7 Educational institution
○ 63 Other
(specify)_____

My job title/occupation is: (choose one)
○ 16 Owner/management
○ 22 Creative director
○ 12 Art director/designer
○ 13 Advertising/marketing staff
○ 25 Instructor
○ 19 Student
○ 63 Other
(specify)_____

TCAM2

You get three huge annuals:

SELF-PROMOTION — discover the keys to promoting your work and see the winners of our exclusive Self-Promotion Competition

INTERNATIONAL DESIGN — explore the latest design trends from around the world, plus the winning entries from the HOW International Design Competition

BUSINESS — get the scoop on protecting your work, building your business and your portfolio, and growing your career

Plus, get three acclaimed special issues — each focused on one aspect of design, so you'll get everything you need to know about Digital Design, Creativity and Trends & Type.

should include b&w and color finished art, original art and photographs. Pays by the project. Rights purchased vary according to project. Finds freelancers through magazines, sourcebooks and word-of-mouth.

IRISH MUSIC CORPORATION, 701 River St., Troy NY 12180. (518)266-0765. Fax: (518)266-0925. E-mail: info@regorecords.com. Website: www.regorecords.com. **Managing Director:** T. Julian McGrath. Estab. 1953. Produces CDs, video, DVD: Irish, Celtic, folk.
Needs: Produces 12 releases/year. Works with 2 freelancers/year. Prefers local designers. Uses freelancers for CD booklet and cover design and illustration; poster design. 100% of illustration demands computer skills.
First Contact & Terms: Send query letter with brochure, résumé, tearsheets. Samples are filed. Will contact artist for portfolio review of final art, tearsheets and transparencies. Pays by the project, $1,500 maximum. Assumes all rights.

JAY JAY RECORD, TAPE & VIDEO CO., P.O. Box 41-4156, Miami Beach FL 33141. Phone/fax: (305)758-0000. **President:** Walter Jagiello. Produces CDs and tapes: country/western, jazz and polkas. Recent releases: *Super Hits*, by Li'l Wally Jagiello; and *A Salute to Li'l Wally*, by Florida's Harmony Band with Joe Oberaitis (super polka man).
Needs: Produces 7 CDs, tapes and albums/year. Works with 3 freelance designers and 2 illustrators/year. Works on assignment only. Uses freelancers for album cover design and illustration; brochure design; catalog layout; advertising design, illustration and layout; and posters. Sometimes uses freelancers for newspaper ads. Knowledge of MIDI-music lead sheets helpful for freelancers.
First Contact & Terms: Send brochure and tearsheets to be kept on file. Call or write for appointment to show portfolio. Samples not filed are returned by SASE. Responds in 2 months. Requests work on spec before assigning a job. Pays for design by the project, $20-50. Considers skill and experience of artist when establishing payment. Buys all rights.

KALIFORNIA KILLER RECORDINGS (KKR), 1815 Garnet Ave., San Diego CA 92109. (858)539-3989. **President:** Mark Whitney Mehran. Produces albums and CDs: rock. Recent releases: "Know My Name" by Antie Pete and *HotRod Paradise* by The Green Leaf.
Needs: Produces 2-7 releases/year. Works with 3 freelancers/year. Prefers local artists. Uses freelancers for CD booklet design, CD cover illustration, poster design, negative prep and shooting.
First Contact & Terms: Send query letter and postcard with sample of work. Samples are not filed and are not returned. Responds only if interested. Art director will contact artist for portfolio review if interested. Pays by the project. Buys one-time rights.

K2B2 RECORDS, 1748 Roosevelt Ave., Los Angeles CA 90006-5219. (213)732-1602. Fax: (213)731-2758. E-mail: Marty@K2B2.com. Website: www.K2b2.com. **President:** Marv Moses. Art Director: Marty Krystall. Estab. 1979. Produces CDs: jazz, classical by solo artists. Recent releases: *Across the Tracks*, by Buellgrass; *Thelonious Atmosphere*, by Buell Neidlinger Quartet; *Marty Krystall Quartet*, by Marty Krystall.
Needs: Produces 1 release/year. Approached by 20 designers and 25 illustrators/year. Works with 2 designers and 1 illustrator/year. Uses freelancers for CD cover and catalog design and illustration; brochure and advertising design. Needs computer-literate freelancers for design, illustration. 100% of freelance work demands knowledge of Quark, Illustrator, Photoshop, FreeHand, Painter.
First Contact & Terms: Send query letter with brochure, résumé. Samples are filed and not returned. Responds only if interested. Artist should follow up with letter after initial query. Art Director will contact artist for portfolio review if interested. Portfolio should include color samples. Pays for design and illustration by the project, $500-1,500. Buys all rights.
Tips: "I prefer line drawings and oil painting—real art."

LCDM ENTERTAINMENT, Box 79564, 1995 Weston Rd., Toronto, ON M9N 3W9 Canada. E-mail: GuitarBabe@hotmail.com. Website: www.angelfire.com/ca3/liana and www.indie-music-toronto.ca. **Publisher:** L.C. DiMarco. Estab. 1991. Produces CDs, tapes, publications (quarterly): pop, folk, country/ western and original. Recent releases: "Amazon Trail," by LIANA; *Glitters & Tumbles*, by Liana; *Indie Tips & the Arts* (publication); and indie-music-toronto@yahoogroups.com (on-line newsletter).
Needs: Prefers local artists but open to others. Uses freelancers for CD cover design, brochure illustration, posters and publication artwork. Needs computer-literate freelancers for production, presentation and multimedia projects.

First Contact & Terms: Send query letter by snail mail with brochure, résumé, photocopies, photographs, SASE, tearsheets, terms of renumeration (i.e., pay/non-pay/alternative). No e-mail queries, submissions or solicitations. Samples are filed. Art director will contact artist for portfolio review if interested. Pays for design, illustration and film by the project. Rights purchased vary according to project.

Tips: "The best experience is attainable through indie labels. Ensure that the basics (phone/fax/address) are on all of your correspondence. Seldom do indie labels return long distance calls. Include SASE in your mailings always. Get involved and offer to do work on a volunteer or honorarium basis. We usually work with artists who have past volunteer experience first."

PATTY LEE RECORDS, 6034½ Graciosa Dr., Hollywood CA 90068. (323)469-5431. Website: www.Pat tyLeeRecords.com. **Contact:** Patty Lee. Estab. 1986. Produces CDs and tapes: New Orleans rock and roll, jazz, and eclectic by solo artists. Recent releases: *Sizzlin'*, by Armand St. Martin; *Magnetic Boots*, by Angelyne; *Return to Be Bop*, by Jim Sharpe.

Needs: Produces 2 soloists/year. Works with several designers and illustrators/year. Works on assignment only. Uses freelancers for CD/tape cover, sign and brochure design; and posters.

First Contact & Terms: Send postcard sample. Samples are filed or are returned by SASE. Responds only if interested. "Please do not send anything other than an introductory letter or card." Pays by the project; $100 minimum. Rights purchased vary according to project. Finds new artists through word of mouth, magazines, submissions/self-promotional material, sourcebooks, agents and reps and design studios.

Tips: "The postcard of their style and genre is the best indication to us as to what the artists have and what might fit into our needs. If the artist does not hear from us it is not due to a negative reflection on their art."

LEMATT MUSIC, (Pogo Records Ltd., Swoop Records, Grenouille Records, Zarg Records, Lee Sound Productions, R.T.F.M., Lee Music Ltd., Check Records, Value For Money Productions and X.R.L. Records), White House Farm, Shropshire TF9 4HA England. (01630) 647374. Fax: (01630)647612. **Producer:** Xavier Lee. Lawyer: Keith Phillips. Produces CDs, tapes and albums: rock, dance, country/western, pop, and R&B by group and solo artists. Recent releases: *Nightmare*, by Nightmare; *Fire*, by Nightmare; "Beautiful Sunday" and *Then and Now*, by Daniel Boone.

Needs: Produces 25 CDs, tapes/year. Works with 3-4 freelance designers and 3-4 illustrators/year. Works on assignment only. Uses a few cartoons and humorous and cartoon-style illustrations where applicable. Uses freelancers for album cover design and illustration; advertising design, illustration and layout; and posters. Needs computer-literate freelancers for design, illustration and presentation. 30% of freelance work demands computer skills.

First Contact & Terms: Send query letter with brochure, résumé, business card, slides, photographs and videos to be kept on file. Samples not filed are returned by SASE (nonresidents send IRCs). Responds in 3 weeks. To show portfolio, mail final reproduction/product and photographs. Original artwork sometimes returned to artist. Payment negotiated. Finds new artists through submissions and design studios.

LIVING MUSIC, P.O. Box 72, Litchfield CT 06759. (860)567-8796. Fax: (860)567-4276. E-mail: pwclmr @aol.com. Website: www.livingmusic.com. **Director of Communications:** Kathi Fragione. Estab. 1980. Produces CDs and tapes: classical, jazz, folk, progressive, world, New Age. Recent releases: *Celtic Solstice*, by Paul Winter & Friends; *Journey with the Sun*, by Paul Winter and the Earth Band; *Every Day is a New Life*, by Arto Tunchboyaciyan; and *Brazilian Days*, by Oscar Castro-Neves and Paul Winter.

Needs: Produces 1-3 releases/year. Works with 1-5 freelancers/year. Uses freelancers for CD/tape cover and brochure design and illustration; direct mail packages; advertising design; catalog design, illustration and layout; and posters. 70% of freelance work demands knowledge of PageMaker, Illustrator, QuarkXPress, Photoshop, FreeHand.

First Contact & Terms: Send postcard sample of work or query letter with brochure, transparencies, photographs, slides, SASE, tearsheets. Samples are filed or returned by SASE if requested by artist. Responds only if interested. Art director will contact artist for portfolio review of b&w and color roughs, photographs, slides, transparencies and tearsheets. Pays for design by the project. Rights purchased vary according to project.

Tips: "We look for distinct 'earthy' style." Prefers nature themes.

LUCIFER RECORDS, INC., Box 263, Brigantine NJ 08203. (609)266-2623. **President:** Ron Luciano. Produces pop, dance and rock.

Needs: Produces 2-12 records/year. Prefers experienced freelancers. Works on assignment only. Uses

freelancers for album cover and catalog design; brochure and advertising design, illustration and layout; direct mail packages; and posters.

First Contact & Terms: Send query letter with résumé, business card, tearsheets, photostats or photocopies. Responds only if interested. Original art sometimes returned to artist. Write for appointment to show portfolio, or mail tearsheets and photostats. Pays by the project. Negotiates pay and rights purchased.

MAGGIE'S MUSIC, INC., Box 490, Shady Side MD 20764. E-mail: mail@maggiesmusic.com. Website: www.maggiesmusic.com. **President:** Maggie Sansone. Estab. 1984. Produces CDs and tapes: contemporary acoustic, Christmas and Celtic. Recent releases: *Celtic Roots*, by Hesperus; *Scottish Fire*, by Bonnie Rideout; and *A Traveler's Dream*, by Maggie Sansone; and *Women of Ireland*, by Ceoltoiri Celtic Ensemble.

Needs: Produces 3-4 albums/year. Works with freelance graphic designers. Prefers freelancers with experience in CD covers and Celtic designs. Works on assignment only.

First Contact & Terms: Send query letter with color or b&w samples on 1 page only, or brochure. Samples are filed. Responds only if interested. Company will contact artist for portfolio review if interested. Requests work on spec before assigning a job. Pays for design and illustration by the project, $500-1,000. Sometimes interested in buying second rights (reprint rights) to previously published work, or as edited. Buys all rights.

Tips: This company asks that the artist request a catalog first "to see if their product is appropriate for our company, then send samples (nonreturnable for our files)."

MAGNOLIA MUSIC, 2606 Common St., Lake Charles LA 70601. (337)436-5917. Fax: (337)436-2970. E-mail: jiml@magnoliamusic.net. Website: www.magnoliamusic.com. **President:** Jim Levingston. Estab. 1988. Produces CDs and tapes: rock & roll, jazz, R&B, progressive, folk, gospel, country/western, cajun, zydeco.

Needs: Produces 3 groups/year. Uses artists for CD cover design and direct mail packages. Needs computer-literate freelancers for design.

First Contact & Terms: Send query letter with brochure and résumé. Samples are filed and are returned by SASE if requested by artist. Responds only if interested. Call to show portfolio of roughs and photographs. Pays for design by the project. Negotiates rights purchased.

METAL BLADE RECORDS, INC., 2828 Cochran St., Suite 302, Simi Valley CA 93065. (805)522-9111. Fax: (805)522-9380. E-mail: metalblade@metalblade.com. Website: www.metalblade.com. **Senior Vice President/General Manager:** Tracy Vera. Estab. 1982. Produces CDs and tapes: rock by solo artists and groups. Recent releases: *Revelation*, by Armored Saint; and *Maximum Violence*, by Six Feet Under.

Needs: Produces 30-50 releases/year. Approached by 10 designers and 10 illustrators/year. Works with 1 designer and 1 illustrator/year. Prefers freelancers with experience in album cover art. Uses freelancers for CD cover design and illustration. Needs computer-literate freelancers for design and illustration. 80% of freelance work demands knowledge of PageMaker, Illustrator, QuarkXPress, Photoshop.

First Contact & Terms: Send postcard sample of work or query letter with brochure, résumé, photostats, photocopies, photographs, SASE, tearsheets. Samples are filed or returned by SASE if requested by artist. Responds only if interested. Art director will contact artist for portfolio review if interested. Portfolio should include b&w and color, final art, photocopies, photographs, photostats, roughs, slides, tearsheets. Pays for design and illustration by the project. Buys all rights. Finds artists through *Black Book*, magazines and artists' submissions.

Tips: "Please send samples of work previously done. We are interested in any design."

MIA MIND MUSIC, 259 W. 30th St., 12th Floor, New York NY 10001. (212)564-4611. Fax: (212)564-4448. E-mail: mimimus@aol.com. Website: www.miamindmusic.com. **Contact:** Stevie B. "Mia Mind Music works with bands at the stage in their careers where they need CD artwork and promotional advertisements. The record label Mia Mind signs about 12 artists per year and accepts artwork through the mail or call for appointment." Recent releases: *Museum of Me*, by Chris Butler.

Needs: Approached by 40 designers and 50 illustrators/year. Works with 6 designers and 2 illustrators/year.

First Contact & Terms: Send query letter with résumé, photocopies, tearsheets. Samples are filed. Responds in 2 weeks. Call for appointment to show portfolio of b&w and color final art and photographs or mail appropriate materials. Pays for design by the project, $200 minimum; pays for illustration by the project, $200 minimum. Rights purchased vary according to project.

Tips: "Be willing to do mock-ups for samples to be added to company portfolio." Looks for "abstract,

conceptual art, the weirder, the better. 'Extreme' sells in the music market.''

MIGHTY RECORDS, BMI Music Publishing Co.—Corporate Music Publishing Co.—ASCAP, Stateside Music Publishing Co.—BMI, 150 West End Ave., Suite 6-D, New York NY 10023. (212)873-5968. **Manager:** Danny Darrow. Estab. 1958. Produces CDs and tapes: jazz, pop, country/western; by solo artists. Releases: *Falling In Love*, by Brian Dowen; and *A Part of You*, by Brian Dowen/Randy Lakeman.
Needs: Produces 1-2 solo artists/year. Works on assignment only. Uses freelancers for CD/tape cover, brochure and advertising design and illustration; catalog design and layout; and posters.
First Contact & Terms: Samples are not filed and are not returned. Rights purchased vary according to project.

N **⊕** **▣** **NERVOUS RECORDS**, 5 Sussex Crescent, Northolt, Middx. UB5 4DL, UK. 44(020)8423 7373. Fax: 44(020)8423 7773. E-mail: nervous@compuserve.com. Website: www.nervous.co.uk. **Contact:** R. Williams. Produces CDs, rockabilly and psychobilly. Recent releases: *Hot 'N Wild Rockabilly Cuts*, by Mystery Gang; and *Rockabillies Go Home*, by Blue Flame Combo.
Needs: Produces 9 albums/year. Approached by 4 designers and 5 illustrators/year. Works with 3 designers and 3 illustrators/year. Uses freelancers for album cover, brochure, catalog and advertising design and multimedia projects. 50% of design and 75% of illustration demand knowledge of Page Plus II and Microsoft Word 6.0.
First Contact & Terms: Send query letter with postcard samples; material may be kept on file. Write for appointment to show portfolio. Accepts disk submissions compatible with PagePlus and Microsoft Word. Samples not filed are returned by SAE (nonresidents include IRC). Responds only if interested. Original art returned at job's completion. Pays for design by the project, $50-200. Pays for illustration by the project, $10-100. Considers available budget and how work will be used when establishing payment. Buys first rights.
Tips: "We have noticed more imagery and caricatures in our field so fewer actual photographs are used.'' Wants to see "examples of previous album sleeves, keeping with the style of our music. Remember, we're a rockabilly label.''

NEURODISC RECORDS, INC., 3801 N. University Dr., Suite #403, Ft. Lauderdale FL 33351. (954)572-0289. Fax: (954)572-2874. E-mail: info@neurodisc.com. Website: www.neurodisc.com. **Contact:** John Wai and Tom O'Keefe. Estab. 1990. Produces albums, CDs: chillout, dance, electrobass, electronic lounge, New Age, progressive, rap, urban. Recent releases: *Progressive House Elements*, by DJ Andy Hughes; *Trance Vertigo*, by DJ Scott Stubbs.
Needs: Produces 10 releases/year. Works with 5 freelancers/year. Prefers designers with experience in designing covers. Uses freelancers for album cover design and illustration; animation; cassette cover design and illustration; CD booklet design and illustration; cover design and illustration; poster design; Web page design. Also for print ads. 100% of freelance work demands computer skills.
First Contact & Terms: Send postcard sample or query letter with brochure, photocopies and tearsheets. Samples are not filed and are returned by SASE if requested by artist. Will contact artist for portfolio review if interested. Pays by the project. Buys all rights.

ONE STEP TO HAPPINESS MUSIC, % Jacobson & Colfin, P.C., 19 W, 21st, #603A, New York NY 10010. (212)691-5630. Fax: (212)645-5038. E-mail: Bruce@thefirm.com. **Attorney:** Bruce E. Colfin. Produces CDs, tapes and albums: reggae group and solo artists. Release: *Make Place for the Youth*, by Andrew Tosh.
Needs: Produces 1-2 soloists and 1-2 groups/year. Works with 1-2 freelancers/year on assignment only. Uses artists for CD/album/tape cover design and illustration.
First Contact & Terms: Send query letter with brochure, résumé and SASE. Samples are filed or returned by SASE if requested by artist. Responds in 2 months. Call or write for appointment to show portfolio of tearsheets. Pays by the project. Rights purchased vary according to project.

N **ONEPLUS DESIGNS**, P.O. Box 3070, Lake Jackson TX 77566. (979)418-9015. Fax: (419)818-1935. E-mail: oneplusdesigns@hotmail.com. Website: www.aggravated.com/oneplusdesigns. **Contact:** John Hernandez. Estab. 1995. Produces CDs, cassettes: R&B and rap by solo artists and groups. Recent releases: "Aggravated State of Mind," and "Accept," by Agravated.
Needs: Produces 4 releases/year. Works with 2 freelancers/year. Works only with artist reps. Uses freelancers for album cover design and illustration; cassette cover design and illustration; CD booklet design and

illustration; CD cover design and illustration; poster design. 100% of freelance work demands knowledge of QuarkXPress 4, Photoshop 4.
First Contact & Terms: Send query letter brochure, résumé. Accepts disk subissions. Send EPS files. Samples are filed. Responds in 1 month. Will contact artist for portfolio review of b&w, color, final art. Pays by the hour. Buys first rights. Finds artists through World Wide Web.

OPUS ONE, Box 604, Greenville ME 04441. (207)997-3581. **President:** Max Schubel. Estab. 1966. Produces CDs, LPs, 78s, contemporary American concert and electronic music.
Needs: Produces 6 releases/year. Works with 1-2 freelancers/year. Prefers freelancers with experience in commercial graphics. Uses freelancers for CD cover design.
First Contact & Terms: Send postcard sample or query letter with rates and example of previous artwork. Samples are filed. Pays for design by the project. Buys all rights. Finds artists through meeting them in arts colonies, galleries or by chance.
Tips: "Contact record producer directly. Send samples of work that relate in size and subject matter to what Opus One produces. We want witty and dynamic work."

OREGON CATHOLIC PRESS, 5536 NE Hassalo, Portland OR 97213-3638. (503)281-1191. Fax: (503)282-3486. E-mail: jeang@ocp.org. Website: www.ocp.org/. **Art Director:** Jean Germano. Estab. 1934. Produces liturgical music CDs, cassettes, songbooks, missalettes, books.
Needs: Produces 10 collections/year. Works with 5 freelancers/year. Uses freelancers for cassette cover design and illustration; CD booklet illustration; CD cover design and illustration. Also for spot illustration.
First Contact & Terms: Send query letter with brochure, transparencies, photocopies, photographs, slides, tearsheets and SASE. Samples are filed or returned by SASE. Responds in 2 weeks. Will contact artist if interested. Pays for illustration by the project, $35-500. Finds artists through submissions and the Web.
Tips: Looks for attention to detail.

☐ **PALM PICTURES**, 601 W. 26th St., 11th Floor, New York NY 10001. (212)320-3600. Fax: (212)320-3609. E-mail: art@palmpictures.com. Website: www.palmpictures.com. **Studio/Creative Director:** Yuan Wu. Estab. 1959. Produces films, albums, CDs, CD-ROMs, cassettes, LPs: folk, gospel, pop, progressive, R&B, rap and rock by solo artists and groups.
Needs: Works with 15 freelancers/year. Prefers designers who own Mac computers. Uses freelancers for album, cassette, CD, DVD and VHS cover design and illustration; CD booklet design and illustration; and poster design; advertising; merchandising. 99% of design and 20% of illustration demand knowledge of Illustrator, QuarkXPress, Photoshop and FreeHand.
First Contact & Terms: Send postcard sample and or query letter with tearsheets. Accepts disk submissions. Samples are filed. Portfolios of b&w and color final art and tearsheets may be dropped off Monday through Friday. Pays for design by the project, $50-5,000; pays for illustration by the project, $500-5,000. Rights purchased vary according to project. Finds artists through submissions, word of mouth and sourcebooks.
Tips: "Have a diverse portfolio."

☑ ☐ **PPI ENTERTAINMENT GROUP**, 103 Eisenhower Pkwy., Roseland NJ 07105. (973)226-1234. **Creative Director:** Eric Lewandoski. Estab. 1923. Produces CDs, DVDs and tapes: educational, feature films; aerobics and self-help videos. Specializes in children's health and fitness. Recent releases: *The Method®*, *Quick Fix®* and *Peter Pan Records®*.
Needs: Produces 200 records and videos/year. Works with 10-15 freelance designers/year and 10-15 freelance illustrators/year. Uses artists for DVD menus and illustration; brochure, catalog and advertising design, illustration and layout; direct mail packages; posters; and packaging.
First Contact & Terms: Works on assignment only. Send query letter with samples to be kept on file; call or write for appointment to show portfolio. Prefers photocopies or tearsheets as samples. Samples not filed are returned only if requested. Responds only if interested. Original artwork returned to artist. Pays by the project. Considers complexity of project and turnaround time when establishing payment. Purchases all rights.

☐ **PPL ENTERTAINMENT GROUP**, P.O. Box 8442, Universal City CA 91618. (818)506-8533. Fax: (818)506-8534. E-mail: pplzmi@aol.com. Website: www.pplzmi.com. **Art Director:** Kaitland Diamond. Estab. 1979. Produces albums, CDs, cassettes: country, pop, R&B, rap, rock and soul by solo artists and

groups. Recent releases: "Destiny," by Buddy Wright; and *American Dream*, by Riki Hendrix.

Needs: Produces 12 releases/year. Works with 2 freelancers/year. Prefers designers who own Mac or IBM computers. Uses freelancers for album cover design and illustration; cassette cover design and illustration; CD booklet design and illustration; CD cover design and illustration; CD-ROM design and packaging; poster design; Web page design. Freelance work demands knowledge of PageMaker, Illustrator, Photoshop, QuarkXPress.

First Contact & Terms: Send query letter with brochure, photocopies, tearsheets, résumé, photographs, photostats, slides, transparencies and SASE. Accepts disk submissions. Samples are filed or returned by SASE if requested by artist. Responds in 2 months. Request portfolio review in original query. Pays by the project, monthly.

PRAVDA RECORDS, 6311 N. Neenah, Chicago IL 60631. (773)763-7509. Fax: (773)763-3252. E-mail: pravdausa@aol.com. Website: www.pravdamusic.com. **Contact:** Kenn Goodman. Estab. 1986. Produces CDs, tapes and posters: rock, progressive by solo artists and groups. Recent releases: *Vodka and Peroxide*, by Civiltones; *Dumb Ask*, by Cheer Accident.

Needs: Produce 1 solo artist and 3-6 groups/year. Works with 1-2 freelancers/year. Works on assignment only. Uses freelancers for CD/tape covers and advertising design and illustration; catalog design and layout; posters. Needs computer-literate freelancers for design and production. 100% of freelance work demands knowledge of Illustrator, QuarkXPress and Photoshop.

First Contact & Terms: Send query letter with résumé, photocopes, SASE. Samples are not filed and are returned by SASE if requested by artist. Responds in 2 months. Portfolio should include roughs, tearsheets, slides, photostats, photographs. Pays for design by the project, $250-1,000. Rights purchased vary according to project.

PUTUMAYO WORLD MUSIC, 324 Lafayette St., 7th Floor, New York NY 10012. (212)625-1400, ext. 214. Fax: (212)460-0095. E-mail: info@putumayo.com. Website: www.putumayo.com. **Production Manager:** Lisa Lee. Estab. 1993. Produces CDs, cassettes: folk, world. Recent releases: *Mississippi Blues*, by various artists; and *Carnival*, by various artists.

● All covers feature the distinctive naïve art of Nicola Heindl. Production says they rarely need freelancers, but visit the Putumayo website to see some great covers.

Needs: Produces 16 releases/year. Works with 1-4 freelancers/year. Prefers local designers who own computers with experience in digi-pak CDs. Uses freelancers for album and cassette design and World Wide Web page design. 90% of design demands knowledge of QuarkXPress, Photoshop.

First Contact & Terms: Send postcard sample. Samples are not filed and are returned by SASE if requested. Will contact for portfolio review of final art if interested. Pays by the project.

Tips: "We use a CD digi-pak rather than the standard jewel box. Designers should have experience working with illustrations as the primary graphic element."

R.E.F. RECORDING COMPANY/FRICK MUSIC PUBLISHING COMPANY, 404 Bluegrass Ave., Madison TN 37115. (615)865-6380. **Contact:** Bob Frick. Produces CDs and tapes: southern gospel, country gospel and contemporary Christian. Recent releases: *Seasonal Pickin*, by Bob Scott Frick; *Righteous Pair* and *Pray When I Want To*.

Needs: Produces 30 records/year. Works with 10 freelancers/year on assignment only.

First Contact & Terms: Send résumé and photocopies to be kept on file. Write for appointment to show portfolio. Samples not filed are returned by SASE. Responds in 10 days only if interested.

REDEMPTION RECORDING CO., P.O. Box 10238, Beverly Hills CA 90213. (323)651-0221. Fax: (323)651-5851. E-mail: info@redemption.net. Website: www.redemption.net. **Contact:** Ryan Kuper. Estab. 1990. Produces CD ROMs and cassettes: indie rock/punk and rock by groups. Recent releases: *s/t*, by Race For Titles.

Needs: Produces 5-10 releases/year. Works with 5 freelancers/year. Prefers artists with experience in CD design and associated layouts. Uses freelancers for cassette cover, CD booklet, cover and spot illustration; cassette cover, CD cover, poster and web design. 75% of design work demands knowledge of Illustrator and Photoshop.

First Contact & Terms: Send URL. Samples are filed and not returned. Responds only if interested. Portfolio not required. Rights purchased vary according to project. Finds freelancers through websites and examples currently in the market.

N ⊕ RED-EYE RECORDS, Wern Fawr Farm, Pencoed CF3 56NB Wales. 01656 860041. **Managing Director:** Mike Blanche. Estab. 1980. Produces albums, CDs, cassettes: gospel, pop, progressive, R&B, rock, soul by solo artists, groups. Recent releases: *Time is Ticking*, by Cadillacs; *Night Thoughts*, by Cadillacs.
Needs: Produces 3-4 releases/year.
First Contact & Terms: Send query letter with photocopies. Responds only if interested.

✓ 👤 RHINO ENTERTAINMENT/WARNER STRATEGIC MARKETING, (formerly Rhino Entertainment Company), 3400 W. Olive Ave., Burbank CA 91505. (818)238-6187. Fax: (818)562-9241. Website: www.rhino.com. **Creative Services:** Hugh Brown. Director, Creative Services: Lori Carfora. Estab. 1977. Produces albums, CDs, CD-ROMs, cassettes: country, folk, gospel, jazz, pop, progressive, R&B, rap, rock, soul. Recent releases: *Like Omigod! The 80's Pop Culture Box (Totally)*, Dwight Yoakum, *Reprise Please Baby: The Warner Bros. Years*, and *Ed Sullivan's Rock 'N' Roll Classics—Video Compilation*.
Needs: Produces 200 releases/year. Works with 10 freelancers/year. Prefers local designers and illustrators who own Mac computers. Uses freelancers for album, cassette and CD cover design and illustration; CD booklet design and illustration; and CD-ROM design and packaging. 100% of design demands knowledge of Illustrator, QuarkXPress, Photoshop, FreeHand.
First Contact & Terms: Send postcard sample. Accepts disk submissions compatible with Mac. Samples are filed. Does not reply. Artist should "keep us updated." Portfolios of tearsheets may be dropped off every Tuesday. Buys one-time rights. Rights purchased vary according to project. Finds artists through word-of-mouth, sourcebooks.

👤 RHYTHMS PRODUCTIONS/TOM THUMB MUSIC, Box 34485, Los Angeles CA 90034-0485. **President:** R.S. White. Estab. 1955. Produces CDs, cassettes of children's music.
Needs: Works on assignment only. Works with 3-4 freelance artists/year. Prefers Los Angeles artists who have experience in advertising, catalog development and cover illustration/design. Uses freelance artists for album, cassette and CD cover design and illustration; animation; CD booklet design and illustration; CD-ROM packaging. Also for catalog development. 95% of design and 50% of illustration demand knowledge of QuarkXPress and Photoshop.
First Contact & Terms: Send query letter photocopies and SASE. Samples are filed or are returned by SASE if requested. Responds in 6 weeks. "We do not review portfolios unless we have seen photocopies we like." Pays by the project. Buys all rights. Finds artists through submissions and recommendations.
Tips: "We like illustration that is suitable for children. We find that cartoonists have the look we prefer. However, we also like art that is finer and that reflects a 'quality look' for some of our more classical publications. Our albums are for children and are usually educational. We don't use any violent or extreme art which is complex and distorted."

■ ROCK DOG RECORDS, P.O. Box 3687, Hollywood CA 90078. (323)661-0259. E-mail: g.cannizzaro@att.net. Website: www.rockdogrecords.com. **Vice President of Production:** Gerry North Cannizzaro. CFO: Patt Connolly. Estab. 1987. Produces CDs and tapes: rock, R&B, dance, New Age, contemporary instrumental, ambient and music for film, TV and video productions. Recent releases: *This Brave New World*, by Brainstorm; *Fallen Angel*, by Iain Hersey; and *The Best of Brainstorm*, by Brainstorm.
 ● This company has a second location at P.O. Box 884, Syosset, NY 11791-0899. (516)544-9596. Fax: (516)364-1998. A&R, Promotion and Distribution: Maria Cuccia.
Needs: Produces 2-3 solo artists and 2-3 groups/year. Approached by 50 designers and 200 illustrators/year. Works with 5-6 designers and 25 illustrators/year. Prefers freelancers with experience in album art. Uses artists for CD album/tape cover design and illustration, direct mail packages, multimedia projects, ad design and posters. 95% of design and 75% of illustration demand knowledge of Print Shop or Photoshop.
First Contact & Terms: Send postcard sample or query letter with photographs, SASE and photocopies. Accepts disk submissions compatible with Windows '95. Send Bitmap, TIFF, GIF or JPG files. Samples are filed or are returned by SASE. Responds in 2 weeks. To show portfolio, mail photocopies. Sometimes requests work on spec before assigning a job. Pays for design by the project, $50-500. Pays for illustration by the project, $50-500. Interested in buying second rights (reprint rights) to previously published work. Finds new artists through submissions from artists who use *Artist's & Graphic Designer's Market*.
Tips: "Be open to suggestions; follow directions. Don't send us pictures, drawings (etc.) of people playing an instrument. Usually we are looking for something abstract or conceptual. We look for prints that we can license for limited use."

ROTTEN RECORDS, P.O. Box 56, Upland CA 91786. (909)920-4567. Fax: (909)920-4577. E-mail: rotten@rottenrecords.com. Website: www.rottenrecords.com. **President:** Ron Peterson. Estab. 1988. Produces CDs and tapes: rock by groups. Recent releases: *When the Kite String Pops*, by Acid Bath; *Do Not Spit*, by Damaged.
Needs: Produces 4-5 releases/year. Works with 3-4 freelancers/year. Uses freelancers for CD/tape cover design; and posters. Needs computer-literate freelancers for desigin, illustration, production.
First Contact & Terms: Send postcard sample of work or query letter with photocopies, tearsheets (any color copies samples). Samples are filed and not returned. Responds only if interested. Artist should follow up with call. Portfolio should include color photocopies. Pays for design and illustration by the project.

ROWENA RECORDS & TAPES, 195 S. 26th St., San Jose CA 95116. (408)286-9840. Fax: (408)286-9845. E-mail: jlo'neal@earthlink.com. **Owner:** Jeannine O'Neal. Estab. 1967. Produces CDs, tapes and albums: rock, rhythm and blues, country/western, soul, rap, pop and New Age; by groups. Recent releases: *Narrow Road*, by Jeannine O'Neal; and *Purple Jungle*, by Jerry Lee.
Needs: Produces 20 solo artists and 5 groups/year. Uses freelancers for CD/album/tape cover design and illustration and posters.
First Contact & Terms: Send query letter with brochure, résumé, SASE, tearsheets, photographs, photocopies and photostats. Samples are filed or are returned by SASE. Responds in 1 month. To show a portfolio, mail original/final art. "Artist should submit prices."

SAHARA RECORDS AND FILMWORKS ENTERTAINMENT, 28 E. Jackson Bldg., 10th Floor, #S627, Chicago IL 60604-2263. (773)509-6381. Fax: (312)922-6964. E-mail: edmsahara@yahoo.com. **Contact:** Dwayne Woolridge, marketing director. Estab. 1981. Produces CDs, cassettes: jazz, pop, R&B, rap, rock, soul, TV-film music by solo artists and groups. Recent releases: *Pay the Price* and *Rice Girl* film soundtracks and *Dance Wit Me*, by Steve Lynn.
Needs: Produces 25 releases/year. Works with 2 freelancers/year. Uses freelancers for CD booklet design and illustration; CD cover design and illustration; poster design and animation.
First Contact & Terms: Contact only through artist rep. Samples are filed. Responds only if interested. Payment negotiable. Buys all rights. Finds artists through agents, artist's submissions, *The Black Book* and *Directory of Illustration*.

SILVER WAVE RECORDS, 2475 Broadway, Suite 300, Boulder CO 80304. (303)443-5617. Fax: (303)443-0877. E-mail: valerie@silverwave.com. Website: www.silverwave.com. **Art Director:** Valerie Sanford. Estab. 1986. Produces CDs, cassettes: Native American and world music. Recent releases: *Beneath the Raven Moon*, by Mary Youngblood; *Music from A Painted Cave*, by Robert Mirabal; *Peace & Power: The Best of Joanne Shenandoah*; *Song For Humanity*, by Peter Kater and R. Carlos Naka.
Needs: Produces 4 releases/year. Works with 4-6 illustrators, artists, photographers a year. Uses illustrators for CD cover illustration.
First Contact & Terms: Send postcard sample or query letter with 2 or 3 samples. Samples are filed. Will contact for portfolio review if interested. Pays by the project. Rights purchased vary according to project.
Tips: "Develop some good samples and experience. I look in galleries, art magazines, *Workbook*, *The Black Book* and other trade publications. I visit artist's booths at Native American 'trade shows.' Word of mouth is effective. We will call if we like work or need someone." When hiring freelance illustrators, looks for a specific style for a particular project. "Currently we are producing contemporary Native American music and will look for art that expresses that."

◼ **SOMERSET ENTERTAINMENT**, 250 Ferrand Dr., Suite 1100, Don Mills, ON M3C 3G8 Canada. (416)510-2800. Fax: (416)510-3070. E-mail: elahman@somersetent.com. Website: www.somersetent.com. **Art Director:** Elliot Lahman. Estab. 1994. Produces CDs, cassettes and enhanced CDs: classical, country, folk, jazz, soul, children's music, solo artists and groups—some enhanced by nature sounds. Recent releases: *Jazz by Twilight*; *Shorelines-Classical Guitar*; *Spring Awakening*, by Dan Gibson and Joan Jerberman.

☑ ◼ **SONY MUSIC CANADA**, 1121 Leslie St., Toronto, ON M3C 2J9 Canada. (416)391-3311. Fax: (416)447-1823. E-mail: catherine_mcrae@sonymusic.ca. **Art Director:** Catherine McRae. Estab. 1962. Produces albums, CDs, cassettes: classical, country, folk, jazz, pop, progressive, R&B, rap, rock, soul. Recent releases: LPs by Celine Dion, Chantal Kreviazuk, Our Lady Peace.

Needs: Produces 40 domestic releases/year. Works with 10-15 freelancers/year. Prefers local designers who own Mac computers. Uses freelancers for album, cassette and CD cover design and illustration, CD booklet design and illustration, poster design. 80% of design and photography and 20% of illustration demand knowledge of Illustrator, Photoshop, QuarkXPress.

First Contact & Terms: E-mail website information. Accepts disk submissions compatible with Mac TIFF or EPS files. Responds only if interested. Will contact for portfolio review of b&w, color, photocopies, photographs, tearsheets if interested. Pays by the project. Buys all rights. Finds artists through other CD releases, magazines, art galleries, word of mouth.

Tips: "Know what is current musically and visually."

■ **SUGAR BEATS ENTERTAINMENT**, 48 W. 21st St., Suite 900, New York NY 10010. (212)604-0005. Fax: (212)604-0006. Website: www.sugarbeats.com. **Vice President Marketing:** Bonnie Gallanter. Estab. 1993. Produces CDs, cassettes: children's music by groups. Recent releases: "A Sugar Beats Christmas."

Needs: Produces 1 release/year. Works with 1-2 freelancers/year. Prefers local freelancers who own Macs with experience in QuarkXPress, Photoshop, Illustrator and web graphics. Uses freelancers for album cover design; cassette cover design and illustration; CD booklet design and illustration; CD cover design and illustration; poster design; Web page design. Also for ads, sell sheets and postcards. 100% of freelance design demands knowledge of Illustrator, QuarkXPress, Photoshop, FreeHand.

First Contact & Terms: Send postcard sample or query letter with brochure, tearsheets, résumé and photographs. Accepts Mac-compatible disk submissions. Will contact artist for portfolio review of b&w and color art. Pays by the project. Rights purchased vary according to project. Finds freelancers through referrals.

🌐 **SWOOP RECORDS**, White House Farm, Shropshire, TF9 4HA United Kingdom. Phone: 01630-647374. Fax: 01630-647612. **A&R International Manager:** Xavier Lee. International A&R: Tanya Woof. Estab. 1971. Produces albums, CDs, cassettes and video: classical, country, folk, gospel, jazz, pop, progressive, R&B, rap, rock, soul by solo artists and groups. Recent releases: *It's a Very Nice*, by Groucho; *New Orleans*, by Nightmare; "Sight 'n Sound;" and *Emmit Till.*

Needs: Produces 40 releases/year. Works with 6 freelancers/year. Prefers album cover design and illustration; cassette cover design and illustration; CD booklet design and illustration; CD cover design and illustration; poster design.

First Contact & Terms: Send sample of work with SASE (nonresidents send IRCs). Samples are filed for future reference. Responds in 6 weeks. Payment negotiated. Buys all rights. Finds artists through submissions.

🅽 ■ **TAESUE ENTERTAINMENT LTD.**, P.O. Box 803213, Chicago IL 60680. E-mail: Taesue1@aol.com and etaylor950@aol.com. **Contact:** Eric C. Taylor, CEO; Anthony Portee, vice president or Dyrol Washington, vice president. Estab. 1996. Produces CDs, cassettes, video: gospel, pop, R&B, rap by solo artists and groups. Recent releases: *In Time*, by Sacred Call; *Mama Say*, by The Fortress; *The Change*, by Rev. Patrick McCall and Praise and Anointed Needs.

Needs: Produces 6 releases/year. Works with 5 freelancers/year. Uses freelancers for album cover design and illustration; cassette cover design and illustration; CD booklet design and illustration; CD cover design and illustration; poster design; Web page design. 70% of design and 70% of illustration demands knowledge of Illustrator, Photoshop, FreeHand.

First Contact & Terms: Send query letter with brochure, résumé, photocopies, slides. Accepts disk submissions compatible with Mac or PC. Samples are filed or returned by SASE if requested by artist. Responds in 1 month. Art Director will contact artist for portfolio review of b&w, color, final art, photocopies, thumbnails if interested. Pays for design and illustration by the project; negotiable. Rights purchased vary according to project. Finds artists through *Black Book* and magazines.

Tips: "Record companies are always looking for a new hook so be creative. Keep your price negotiable. I look for creative and professional-looking portfolio."

☑ ■ 🕴 **TANGENT® RECORDS**, P.O. Box 383, Reynoldsburg OH 43068-0383. (614)751-1962. Fax: (614)751-6414. E-mail: info@tangentrecords.com. **President:** Andrew J. Batchelor. Estab. 1986. Produces CDs, DVDs, CD-ROMs, cassettes, videos: contemporary, classical, jazz, progressive, rock, electronic, world beat and New Age fusion. Recent releases: "Moments Edge," by Andrew Batchelor.

Needs: Produces 20 releases/year. Works with 5 freelancers/year. Prefers local illustrators and designers

who own computers. Uses freelancers for CD booklet design and illustration; CD cover design and illustration; CD-ROM design and packaging; poster design; Web page design. Also for advertising and brochure design/illustration and multimedia projects. Most freelance work demands knowledge of Illustrator, QuarkXPress, Photoshop, FreeHand and PageMaker.

First Contact & Terms: Send postcard sample or query letter with brochure, one-sheets, photocopies, tearsheets, résumé, photographs. Accepts both Macintosh and IBM-compatible disk submissions. Send JPG file and on 3.5″ diskette, CD-ROM or Superdisk 120MB. Samples are filed and not returned. Will contact artist for portfolio review of b&w, color, final art, photocopies, photographs, photostats, slides, tearsheets, thumbnails, transparencies if interested. Pays by the project. "Amount varies by the scope of the project." Negotiates rights purchased. Finds artists through college art programs and referrals.

Tips: Looks for "creativity and innovation."

TROPIKAL PRODUCTIONS/WORLD BEATNIK RECORDS, 20 Amity Lane, Rockwall TX 75087. Phone/fax: (972)771-3797. E-mail: tropikal@juno.com. Website: www.tropikalproductions.com. **Contact:** Jim Towry. Estab. 1981. Produces albums, CDs, cassettes: world beat, soca, jazz, reggae, hip-hop, latin, Hawaiian, gospel. Recent releases: *Cool Runner*; *Alive Montage*; *The Island*, by Watusi; and *Inna Dancehall*, by Ragga D.

Needs: Produces 5-10 releases/year. Works with 5-10 freelancers/year. Prefers freelancers with experience in CD/album covers, animation and photography. Uses freelancers for CD cover design and illustration; animation; cassette cover design and illustration; CD booklet design and illustration; CD cover design and illustration; poster design. 50% of freelance work demands knowledge of Illustrator, Photoshop.

First Contact & Terms: Send brochure, résumé, photostats, photocopies, photographs, tearsheets. Accepts Mac or IBM-compatible disk submissions. Send EPS files. "No X-rated material please." Samples are filed or returned by SASE if requested by artist. Responds in 15 days. Will contact for portfolio review of b&w, color, final art, photocopies, photographs, roughs if interested. Pays by the project; negotiable. Rights purchased vary according to project; negotiable. Finds artists through referrals, submissions.

Tips: "Show versatility; create theme connection to music."

■ **TRUE NORTH RECORDS/FINKELSTEIN MANAGEMENT CO. LTD.**, 260 Richmond St. W., Suite 501, Toronto, ON M5V 1W5 Canada. (416)596-8696. Fax: (416)596-6861. E-mail: truenorth@ca. inter.net. **Contact:** Dan Broome. Estab. 1969. Produces CDs, tapes and albums: rock and roll, folk and pop; solo and group artists. Recent releases: *The Charity of Night*, by Bruce Cockburn; *Industrial Lullaby*, by Stephen Fearing; *King of Love*, by Blackie and the Rodeo Kings; and *Raggle Taggle*, by John Bottomley.

Needs: Produces 2 soloist and 2 groups/year. Works with 4 designers and 1 illustrator/year. Prefers artists with experience in album cover design. Uses artists for CD cover design and illustration, album/tape cover design and illustration, posters and photography. 50% of freelance work demands computer skills.

First Contact & Terms: Send postcard sample, brochure, résumé, photocopies, photographs, slides, transparencies with SASE. Samples are filed or are returned by SASE if requested by artist. Responds only if interested. Pays by the project. Buys all rights.

UNIVERSAL RECORDS/MOTOWN RECORDS, 1755 Broadway, 7th Floor, New York NY 10019. (212)373-0600. **Creative Art Director:** Sandy Brummels. Produces CDs, video. Produces all genres of music.

Needs: Requires artists with experience in computer graphics (QuarkXPress, Illustrator and Photoshop). Uses artists for CD packaging and advertising design and illustration. 100% of freelance work demands computer skills.

First Contact & Terms: Designers send query letter with tearsheets, résumé, slides and photocopies. Illustrators send postcard sample or other nonreturnable sample. Samples are filed. Responds only if interested. Call for appointment to show portfolio of photographs and slides. Pays by the project. Buys all rights.

■ **VALARIEN PRODUCTIONS**, 15237 Sunset Blvd., Suite 105, Pacific Palisades CA 90272. (310)445-7737. Fax: (310)455-7735. E-mail: valarien@gte.net. Website: www.valerien.com. **Owner:** Eric Reyes. Estab. 1990. Produces CDs, cassettes: progressive, New Age, ambient, acoustic, film scores by solo artists. Recent releases: "In Paradise," by Valarien.

Needs: Produces 1-4 releases/year. Works with 1-2 freelancers/year. Prefers local freelancers who own Macs. Uses freelancers for album cover design and illustration; animation; cassette cover design and illustration; CD booklet design and illustration; CD cover design and illustration. Also for ads. 100% of freelance work demands knowledge of Illustrator, QuarkXPress.

First Contact & Terms: Send postcard sample of work. Samples are filed and not returned. Will contact artist for portfolio review of b&w, color, final art if interested. Pays by the project. Rights purchased vary according to project. Finds artists through word of mouth, submissions, sourcebooks.

VAN RICHTER RECORDS, 100 S. Sunrise Way, Suite 219, Palm Springs CA 92262. (760)320-5577. Fax: (760)320-4474. E-mail: vrichter@netcom.com. Website: vr.dv8.net. **Label Manager:** Paul Abramson. Estab. 1993. Produces CDs: rock, industrial. Recent releases: *Nightmare*, by Girls Under Glass.
Needs: Produces 3-4 releases/year. Works with 2-3 freelancers/year. Prefers freelancers with experience in production design. Uses freelancers for CD booklet and cover design and illustration; posters/pop. 100% of freelance work demands knowledge of Illustrator, QuarkXPress, Photoshop.
First Contact & Terms: Send postcard sample or query letter with brochure, tearsheets, photographs, print samples. Accepts Mac-compatible disk submissions. Samples are not filed and are returned by SASE if requested by artist. Will contact artist for portfolio review of final art if interested. Payment negotiable. Buys all rights. Finds artists through World Wide Web and submissions.
Tips: "You may have to work for free until you prove yourself/make a name."

VARESE SARABANDE RECORDS, 11846 Ventura Blvd., Suite 130, Studio City CA 91604. (818)753-4143. Fax: (818)753-7596. Website: www.varesesarabande.com. **Vice President:** Robert Townson. Estab. 1978. Produces CDs and tapes: film music soundtracks. Recent releases: "Sunset Boulevard," by Franz Waxman; *Star Trek/Nemesis*, by Jerry Goldsmith; and *Far From Heaven*, by Elmer Bernstein.
Needs: Works on assignment only. Uses artists for CD cover illustration and promotional material.
First Contact & Terms: Send query letter with photostats, slides and transparencies. Samples are filed. Responds only if interested. Pays by the project.
Tips: "Be familiar with the label's output before approaching them."

VERVE MUSIC GROUP, 1755 Broadway, 3rd Floor, New York NY 10019. (212)331-2000. Fax: (212)331-2065. Website: www.vervemusicgroup.com. Vice President Creative Services: Hollis King. **Associate Director:** Sherniece Smith. Produces albums, CDs: jazz, progressive by solo artists and groups. Recent releases: *The Look of Love*, by Diana Krall.
 • Verve Music Group houses the Verve, GRP, Impulse! and Blue Thumb Record labels.
Needs: Produces 120 releases/year. Works with 20 freelancers/year. Prefers designers with experience in CD cover design who own Macs. Uses freelancers for album cover design and illustration; CD booklet design and illustration; CD cover design and illustration. 100% of freelance design demands computer skills.
First Contact & Terms: Send nonreturnable postcard sample of work. Samples are filed. Does not reply. Portfolios may be dropped off Monday through Friday. Will contact artist for portfolio review if interested. Pays for design by the project, $1,500 minimum; pays for illustation by the project, $2,000 minimum.

WARLOCK RECORDS, INC., 133 W. 25th St., 9th Floor, New York NY 10001. (212)206-0800. Fax: (212)206-1966. E-mail: info@warlockrecords.com. Website: www.warlockrecords.com. **Art Director:** Amy Kwong. Estab. 1986. Produces CDs, tapes and albums: rhythm and blues, jazz, rap and dance. Recent releases: *No Nagging*, by Froggy Mit; *Lyrical Warfare*, by Chocolate Bandit; and *Just Be Free*, by Christina Aguilera.
Needs: Produces 5 soloists and 12-15 groups/year. Approached by 30 designers and 75 illustrators/year. Works with 3 designers and 4 illustrators/year. Prefers artists with experience in record industry graphic art and design. Works on assignment only. Uses artists for CD and album/cassette cover design; posters; and advertising design. Seeking artists who both design and produce graphic art, to "take care of everything, including typesetting, stats, etc." 99% of freelance work demands knowledge of Illustrator 6.0, Quark XPress 4.0, Photoshop 4,0, Flight Check 3.2.
First Contact & Terms: Send query letter with brochure, résumé, photocopies and photostats. Samples are filed and are not returned. "I keep information on file for months." Responds only if interested; as jobs come up. Call to schedule an appointment to show a portfolio, or drop off for a day or half-day. Portfolio should include photostats, slides and photographs. Pays for design by the project, $50-1,000; pays for illustration by the project, $50-1,000. Rights purchased vary according to project. Finds artists through submissions.
Tips: "Create better design than any you've ever seen and never miss a deadline—you'll be noticed. Specialize in excellence."

WARNER BROS. RECORDS, 3300 Warner Blvd., Burbank CA 91505. (818)953-3361. Fax: (818)953-3232. Website: www.wbr.com. **Art Dept. Assistant:** Michelle Barish. Produces the artwork for CDs, tapes and sometimes albums: rock, jazz, hip-hop, alternative, rap, R&B, soul, pop, folk, country/western by solo and group artists. Releases include: *Living Proof*, by Cher; *GHVZ*, by Madonna; and *Barricades and Brickwalls*, by Kasey Chambers. Releases approximately 200 total packages/year.
Needs: Works with freelance art directors, designers, photographers and illustrators on assignment only. Uses freelancers for CD and album tape cover design and illustration; brochure design and illustration; catalog design, illustration and layout; advertising design and illustration; and posters. 100% of freelance work demands knowledge of QuarkXPress, FreeHand, Illustrator or Photoshop.
First Contact & Terms: Send query letter with brochure, tearsheets, résumé, slides and photographs. Samples are filed or are returned by SASE if requested by artist. Responds only if interested. Submissions should include roughs, printed samples and b&w and color tearsheets, photographs, slides and transparencies. "Any of these are acceptable." Do not submit original artwork. Pays by the project.
Tips: "Send a portfolio—we tend to use artists or illustrators with distinct/stylized work—rarely do we call on the illustrators to render likenesses; more often we are looking for someone with a conceptual or humorous approach."

■ **WATCHESGRO MUSIC, BMI—INTERSTATE 40 RECORDS**, 9208 Spruce Mountain Way, Las Vegas NV 89134. (702)363-8506. **President:** Eddie Lee Carr. Estab. 1975. Produces CDs, tapes and albums: rock, country/western and country rock. Releases include: *The Baby*, by Blake Shelton; *Three Wooden Crosses*, by Randy Travis; *I Will*, by Chad Simmons; *Jude*, by Judy Willis; *Sonny*, by Sonny Marshall; *Deep in the South*, by Sean O'Brien.
● Watchesgro Music has placed songs in feature films: *Waitin' to Live*, *8 Mile*, *Die Another Day*, *DareDevil 2003*.
Needs: Produces 8 solo artists/year. Works with 3 freelancers/year for CD/album/tape cover design and illustration; and videos.
First Contact & Terms: Send query letter with photographs. Samples are filed or are returned by SASE. Responds in 1 week only if interested. To show portfolio, mail b&w samples. Pays by the project. Negotiates rights purchased.

WELK MUSIC GROUP, 2700 Pennsyvania Ave., Santa Monica CA 90404. (805)498-0197. Fax: (805)498-4297. E-mail: gcartwright@e-znet.com. **Contact:** Georgette Cartwright, creative services manager or Amy Von, director of new artist development. Estab. 1987. Produces CDs, tapes and albums; R&B, jazz, soul, folk, country/western, solo artists. Recent release: *Red-Luck*, by Patty Larkin.
● Contact information for Georgette Cartwright listed above; contact information for Amy Von is (310)829-9355; fax: (310)315-3006. This label acquired Sugar Hill Records. Sugar Hill will maintain its Durham NC headquarters. Welk Music Group, a division of The Welk Group encompasses Vanguard Records and Ranwood Records.
Needs: Produces almost 2 new artists and 2 catalog releases/month. Works with 4 designers/year. Prefers artists with experience in the music industry. Uses artists for CD cover design and illustration, album/tape cover design and illustration; catalog design, illustration and layout; direct mail packages; advertising design. 100% of freelance work demands knowledge of QuarkXPress, Illustrator and Photoshop.
First Contact & Terms: Send postcard sample with brochure, photocopies, photographs and tearsheets. Samples are filed. Responds only if interested. To show a portfolio, mail tearsheets and printed samples. Pays for design by the hour, $25-45; by the project, $800-2,000. Pays for illustration by the project, $200-500. Buys all rights.
Tips: "We need to have artwork for cover combined with CD booklet format."

WIND-UP ENTERTAINMENT, 72 Madison Ave., 8th Floor, New York NY 10016. (212)251-9665. Fax: (212)251-0779. E-mail: mdroescher@wind-uprecords.com. Website: www.wind-up.com. **Creative Director:** Mark Droescher. Estab. 1997. Produces CDs, cassettes, music videos and TV commercials: pop, R&B, rock by solo artists and groups. Recent releases: *Weathered*, by Creed; *Sinner*, by Drowning Pool; and *The Greyest of Blue Skies*, by Finger Eleven.
Needs: Produces 8 releases/year. Works with 8-10 freelancers/year. Prefers local freelancers who own Macs. Uses freelancers for album cover design and illustration; cassette cover design and illustration; CD booklet design and illustration; CD cover design and illustration; poster design and web page design. 100% of design and 50% of illustration demands knowledge of QuarkXPress 4, Photoshop 6.

First Contact & Terms: Send query letter with brochure, résumé, transparencies, photocopies, photographs, SASE, tearsheets or website link. Accepts disk submissions compatible with Mac. Samples are filed or returned by SASE if requested by artist. Will contact artist for portfolio review if interested. Pays for design by the hour, $25-50. Finds artists through word of mouth, magazines, reps, directories.
Tips: "Work should be as personal as possible."

Resources

Artists' Reps

Many artists find leaving promotion to a rep allows them more time for the creative process. In exchange for actively promoting an artist's career, the representative receives a percentage of sales (usually 25-30%). Reps concentrate on either the commercial or fine art markets, rarely both. Very few reps handle designers.

Fine art reps promote the work of fine artists, sculptors, craftspeople and fine art photographers to galleries, museums, corporate art collectors, interior designers and art publishers. Commercial reps help illustrators obtain assignments from advertising agencies, publishers, magazines and other art buyers. Some reps also act as licensing agents.

What reps do

Reps work with you to bring your portfolio up-to-speed and will work to get you some great clients. Usually a rep will recommend advertising in one of the many creative directories such as *American Showcase* or *Creative Illustration* so that your work will be seen by hundreds of art directors. (Expect to make an initial investment in costs for duplicate portfolios and mailings). Reps also negotiate contracts, handle billing and collect payments.

Getting representation isn't as easy as you might think. Reps are choosy about who they represent, not just in terms of talent, but in terms of marketability and professionalism. A rep will only take on talent she knows will sell.

What to send

Once you've narrowed down a few choices, contact them with a brief query letter and nonreturnable copies of your work. Check each listing for specific information.

I **For More Information**
The Society of Photographers and Artists Representatives (SPAR) is an organization for professional representatives. SPAR members are required to maintain certain standards and follow a code of ethics. For more information, write to SPAR, 60 E. 42nd St., Suite 1166, New York NY 10165, or visit their website www.spar.org.

☑ **ADMINISTRATIVE ARTS, INC.**, P.O. Box 547935, Orlando FL 32854-7935. (407)849-9744. Fax: (509)471-5278. E-mail: mangoarts@att.net. Website: www.mangoarts.com. **President:** Brenda B. Harris. Fine art advisor. Estab. 1983. Registry includes 1,000+ fine artists (includes fine art crafts). Markets include: architects, corporate collections, developers, private collections, public art.
● The software division of this company develops and distributes management software, Mango Arts Management System™, for artists, art festivals, art organizations, consultants and advisors that focus on project, inventory and marketing management (for artists) and presentation development. The advisory division assists corporations with art acquisitions. They analyze artistic growth, experi-

ence record and conduct an interview with the artist to determine the artist's professional management skills in order to advise artists on career growth.
Handles: Fine art. "We prefer artists with established regional and national credentials. We also review and encourage emerging talent."
Terms: "Trade discount requested varies from 15-50% depending on project and medium."
How to Contact: "For first contact, submissions must include: 1) complete résumé; 2) artist's statement or brief profile; 3) labeled slides (artist's name, title of work, date, medium, image size and *retail price*); 4) availability of works submitted. E-mail contact also acceptable." SASE. Responds in 1 month.
Tips: "Artists are generally referred by their business or art agent, another artist or art professional, educators, or art editors who know our firm. A good impression starts with a cover letter and a well organized, typed résumé. *Always place your name and slide identification on each slide*. Make sure that slides are good representations of your work. Know your retail and net pricing and the standard industry discounts. Invite the art professional to visit your studio. To get placements, be cooperative in getting art to the art professional when and where it's needed."

FRANCE ALINE ASSOCIATES, 1460 N. Mansfield Ave., Suite 319, Hollywood CA 90028. (323)933-2500. Fax: (323)467-0210. E-mail: franceealin@aol.com. **Owner:** France Aline. Commercial illustration, photography and digital artists representative. Specializes in logo design, advertising. Markets include: advertising, corporations, design firms, movie studios, record companies. Artists include: Jill Sabella, Bruce Wolfe, Craig Mullins, Ezra Tucker, Elisa Cohen and Todd White.
Handles: Illustration, photography.
Terms: Rep receives 25% commission. Exclusive area representation is required. Advertises in *American Showcase*, *The Workbook* and *Blackbook*.
How to Contact: For first contact, send tearsheets. Responds in a few days. Mail in appropriate materials. Portfolio should include tearsheets, photographs.
Tips: "Send promotions."

AMERICAN ARTISTS, REP. INC., 353 W. 53rd St., #1W, New York NY 10019. (212)582-0023. Fax: (212)582-0090. E-mail: amerart@aol.com. Commercial illustration representative. Estab. 1930. Member of SPAR. Represents 40 illustrators. Markets include: advertising agencies; corporations/client direct; design firms; editorial/magazines; paper products/greeting cards; publishing/books; sales/promotion firms.
Handles: Illustration, design.
Terms: Rep receives 30% commission. "All portfolio expenses billed to artist." Advertising costs are split: 70% paid by talent; 30% paid by representative. "Promotion is encouraged; portfolio must be presented in a professional manner—8×10, 4×5, tearsheets, etc." Advertises in *American Showcase*, *Black Book*, *RSVP*, *The Workbook*, medical and Graphic Artist Guild publications.
How to Contact: For first contact, send query letter, direct mail flier/brochure, tearsheets. Responds in 1 week if interested. After initial contact, drop off or mail appropriate materials for review. Portfolio should include tearsheets, slides.
Tips: Obtains new talent through recommendations from others, solicitation, conferences.

N THE ART AGENCY, 2405 N.W. Thurman St., Portland OR 97210. (503)203-8300. (503)203-8301.
Owner/Representative: Cindy Lommasson. Commercial illustration and photography representative. Estab. 1993. Member of the Society of Children's Book Writers and Illustrators and Graphic Artists Guild. Represents 15 illustrators, 1 photographer. Markets include advertising agencies, design firms, editorial/magazines and publishing/books.
Handles: Illustration and photography. "Styles created digitally are a big plus."
Terms: Agent receives 25% commission. Charges for postage, list purchase and direct mail. Requires exclusive area representation. Advertising costs are split; 75% paid by the talent, 25% paid by the representative. Artists must provide printed samples to leave with clients. Advertises in various online portfolios.
How to Contact: Send bio, direct mail flier/brochure, tearsheets, photocopies and SASE. Responds in 1 month if interested.
Tips: "Artist must have a minimum of five years professional experience. I prefer artists who have been self-representing at least three years. Style must be unique and consistent. Must work well with a wide range of clients. Prefers artists living in (or planning to move to) the Pacific Northwest."

ART LICENSING INTERNATIONAL, 1532 US 41 ByPass S #272, Venice FL 34293. (941)966-8912. Fax: (941)966-8914. E-mail: artlicensing@comcast.net. Website: www.artlicensinginc.com. **President:**

Michael Woodward, author of *Art Licensing 101*. Licensing agent. Estab. 1986. Licensing agents for artists, illustrators, photographers, concept designers and TV cartoon concepts. Handles collections of work submitted by artists for licensing across a range of product categories such as greeting cards, calendars, stationery and gift products, jigsaw puzzles, partyware, textiles, housewares, etc.

Needs: Prefers collections of art, illustrations of photography which have wide consumer appeal.

First Contact & Terms: Send examples on CD (TIF or JPEG files), color photocopies or slides/transparencies with SASE. Fine artists should send short bio. Terms are 50/50 with no expenses to artists "as long as artist can provide high resolution scans if we agree on representation. Our agency specializes in aiming to create a full licensing program so we can license art across a varied product range. We are therefore only interested in collections, or groups of artworks or concepts which have commercial appeal. Artists need to consider actual products when creating new art.

Tips: "Look at actual products in retail outlets and get a feel for what is selling well. Ask store owners or sales assistants what's 'hot.' Get to know the markets you are actually trying to sell your work to."

ART SOURCE L.A., INC., 2801 Ocean Park Blvd., PMB 7, Santa Monica CA 90405. (310)452-4411. Fax: (310)452-0300. E-mail: info@artsourcela.com. Website: www.artsourcela.com. **Contact:** Francine Ellman, president. Fine art representative. Estab. 1980. Represents artists in all media in fine art and accessories. Specializes in fine art consulting and curating worldwide. Markets include: architects; corporate collections; developers; hospitality public space; interior designers; private collections and government projects.

• Art Source has additional offices in Monterey, CA and Rockville, MD.

Handles: Fine art in all media, including works on paper/canvas, giclees, photography, sculpture, and other accessories handmade by American artists. Artists represented include Linda Adlestein, Betsy Bauer, Sandi Seltzer Bryant, Sarah Einstein, Phil Gallagher, Frances Hamilton, Sarah Hinckley, Aleah Kowry, Michael Ledet, Donna McGinnis, Michael Pauker, Livia Stein, Inez Storer, Jacqueline Warren and Cheryl Warrick.

Terms: Agent receives commission, amount varies. Exclusive area representation required in some cases. No geographic restrictions. "We request artists submit a minimum of 20 slides/visuals, résumé and SASE." Advertises in *Art News*, *Artscene*, *Art in America*, *Blue Book*, *Gallery Guide*, *Art Diary*, *Art & Auction*, *Guild*, and *Internet*.

How to Contact: For first contact, send résumé, bio, slides or photographs and SASE. Responds in 2 months. After initial contact, "we will call to schedule an appointment" to show portfolio of original art, slides, photographs. Obtains new talent through recommendations, artists' submissions and exhibitions.

Tips: "Be professional when submitting visuals. Remember—first impressions can be critical! Submit a body of work that is consistent and of the highest quality. Work should be in excellent condition and already photographed for your records. Framing does not enhance the presentation to the client. Please send all submissions to the Southern California Corporate Office."

ARTCO INCORPORATED, 3148 RFD Cuba Rd., Long Grove IL 60047-9606. (847)438-8420. Fax: (847)438-6464. E-mail: sybiltillman@msn.com. Website: www.e-Artco.com. **Contact:** Sybil Tillman. Fine art representative. Estab. 1970. Member of International Society of Appraisers and Appraisers Association of America Inc. Represents 60 fine artists. Specializes in contemporary artists' originals and limited edition graphics. Markets include: architects; art publishers; corporate collections; galleries; private collections.

Handles: Fine art.

Terms: "Each commission is determined mutually. For promotional purposes, I would like to see original work or transparencies." No geographic restrictions. Advertises in newspapers, magazines, etc.

How to Contact: For first contact, send query letter, résumé, bio, slides, SASE, photographs or transparencies. After initial contact, call for appointment to show portfolio of original art, slides, photographs. Obtains new talent through recommendations from others, solicitation, conferences, advertising.

N ARTINFORMS (A DIVISION OF MARTHA PRODUCTIONS). Website: www.artinforms.com. Commercial illustration representative. Estab. 2000. Represents 11 illustrators. Specializes in illustrators who do infographics work: charts, maps, cutaways, product and medical illustration. Artists include Marcia Staimer, Linda Ny, Tim Webb.

• See listing for Martha Productions.

Handles: Interested in illustration.

▨ ▣ **ARTISAN CREATIVE, INC.**, 1950 S. Sawtelle Blvd., Suite 320, Los Angeles CA 90025. (310)312-2062. Fax: (310)312-0670. E-mail: info@cre8art.com. Website: www.artisancreative.com. **Creative Contact:** Evan MacKenzie. Estab. 1996. Represents creative directors, art directors, graphic designers, illustrators, animators (3D and 2D), storyboarders, packaging designers, photographers, web designers, broadcast designers and multimedia designers. Markets include: advertising agencies, corporations/client direct, design firms, entertainment industry.
 • Artisan Creative has two other locations at 2805 Catherine Way, Santa Ana CA (2705. (949)260-1720. Fax: (949)252-7597. **Contact:** Lise Greenfield. 7736 Fay Ave., Suite 203, La Jolla CA 92093. (858)729-0003. Fax: (858)729-0005. **Contact:** Jennifer Karl.
Handles: Design web, multimedia, illustration, photography and production. Looking for web, packaging, traditional and multimedia-based graphic designers.
Terms: 100% of advertising costs paid by the representative. For promotional purposes, talent must provide 8½×11 color photocopies in a mini-portfolio and six samples scanned on disk. Advertises in magazines for the trade, direct mail and the Internet.
How to Contact: For first contact, send/fax résumé to Creative Staffing Department. "You will then be contacted if a portfolio review is needed." Portfolio should include roughs, tearsheets, photographs, or color photos of your best work.
Tips: "Have at least two years' working experience and a great portfolio."

▨ **ARTISTS ASSOCIATES**, 4416 La Jolla Dr., Bradenton FL 34210-3927. (941)756-8445. Fax: (941)727-8840. Contact: Bill Erlacher. Commercial illustration representative. Estab. 1964. Member of Society of Illustrators.
Handles: Illustration, fine art, design.
Terms: Rep receives 25% commission.
How to Contact: For first contact, send direct mail flier/brochure.

✔ **ARTVISIONS**, 12117 SE 26th St., Bellevue WA 98005-4118. E-mail: art@artvisions.com. Website: www.artvisions.com. **President:** Neil Miller. Estab. 1993. ArtVisions is a service of avidre, inc. Markets include publishers of limited edition prints, calendars, home decor, stationery, note cards, greeting cards, posters, manufacterers of giftware, home furnishings, textiles, puzzles and games.
Handles: Fine art licensing only.
Terms: Agent's commission varies. "We produce highly targeted direct marketing programs focused on opportunities to license art. We develop materials, including web and e-mail, especially for and partially funded by you. Requires exclusive world-wide representation for licensing (the artist is free to market original art—written contract provided).
How to Contact: Send slides/photos/tearsheets or brochures via mail, with SASE for return. Always label your materials. "We cannot respond to inquiries that do not include examples of your art."
Tips: "We do not buy art, we are a licensing agent for artists. Our income is derived from commissions from licensing fees we generate for you, so, we are very careful about selecting artists for our service. To gain an idea of the type of art we seek, please view our website: www.artvisions.com before submitting. Our way of doing business is very labor intensive and each artist's market plan is unique. Be prepared to invest in yourself including a share of your promotional costs."

▨ **ARTWORKS ILLUSTRATION**, 325 W. 38th St., New York NY 10018. (212)239-4946. Fax: (212)239-6106. E-mail: artworksillustration@earthlink.net. Website: www.artworksillustration.com. **Contact:** Betty Krichman, partner. Commercial illustration representative. Estab. 1990. Member of Society of Illustrators. Represents 30 illustrators. Specializes in publishing. Markets include advertising agencies, design firms, paper products/greeting cards, movie studios, publishing/books, sales/promotion firms, corporations/client direct, editorial/magazines. Artists include Dan Brown, Dennis Lyall, Jerry Vanderstelt.
Handles: Illustration. Looking for interesting juvenile.
Terms: Rep receives 25% commission; 30% for out of town artists (outside tri-state area). Exclusive area representation required. Advertising costs are split: 75% paid by artist; 25% paid by rep. Advertises in *American Showcase* and *ISPOT*.
How to Contact: For first contact, send e-mail samples. Responds only if interested. After initial contact, drop off or mail portfolio. Portfolio should include slides, tearsheets, transparencies.

ASCIUTTO ART REPS., INC., 1712 E. Butler Circle, Chandler AZ 85225. (480)899-0600. Fax: (480)899-3636. E-mail: aartreps@aol.com. **Contact:** Mary Anne Asciutto. Children's illustration represen-

tative. Estab. 1980. Member of SPAR, Society of Illustrators. Represents 20 illustrators. Specializes in children's illustration for books, magazines, posters, packaging, etc. Markets include: publishing/packaging/advertising.

Handles: Illustration only.

Terms: Rep receives 25% commission. No geographic restrictions. Advertising costs are split: 75% paid by talent; 25% paid by representative. For promotional purposes, talent should provide "prints (color) or originals within an 8½×11 size format."

How to Contact: Send a direct mail flier/brochure, tearsheets, photocopies and SASE. Responds in 2 weeks. After initial contact, send appropriate materials if requested. Portfolio should include original art on paper, tearsheets, photocopies or color prints of most recent work. If accepted, materials will remain for assembly.

Tips: In obtaining representation "be sure to connect with an agent who handles the kind of accounts you (the artist) *want*."

N] ATELIER KIMBERLEY BOEGE, P.O. Box 7544, Phoenix AZ 85011-7544. (602)265-4389. Fax: (602)265-8405. Owner: Kimberley Boege. Commercial illustration, photography representative. Estab. 1992. Represents 15 illustrators, 2 photographers. Markets include: advertising agencies, corporations/client direct, design firms, editorial/magazines. Represents: Robert Case, Gary Krejca, Susan Tolonen, Casey McKee, Jim McDonald, John Lambert, Paul Janovsky, Matt Foster, Dale Verzaal, Kevin Short, Howard Post, Tracy Hill, Adair Payne and JoAnn Daley.

Handles: Illustration and photography.

Terms: Rep receives 25% commission. Advertising costs are split: 75% paid by talent; 25% paid by representative. For promotional purposes, talent should provide 1-3 portfolios. Advertises in *The Workbook* and *Showcase*.

How to Contact: For first contact, send query letter, tearsheets, photocopies. Responds in 2 weeks. After initial contact, call to schedule an appointment for portfolio review. Portfolio should include 4×5 transparencies or laminated samples/printed pieces.

Tips: Wants artists with experience working in the freelance illustration/commercial illustration market.

CAROL BANCROFT & FRIENDS, 121 Dodgingtown Rd., P.O. Box 266, Bethel CT 06801. (203)748-4823. Fax: (203)748-4581. E-mail: artists@carolbancroft.com. Website: www.carolbancroft.com. **Owner:** Carol Bancroft. Illustration representative for children's publishing. Estab. 1972. Member of SPAR, Society of Illustrators, Graphic Artists Guild, SCBWI. Represents over 40 illustrators. Specializes in illustration for children's publishing—text, trade and any children's-related material. Clients include Scholastic, Holt, HarperCollins, Penguin USA. Artist list available upon request.

Handles: Illustration for children of all ages.

Terms: Rep receives 30% commission. Advertising costs are split: 75% paid by talent; 25% paid by representative. For promotional purposes, artist must provide "laser copies (not slides), tearsheets, promo pieces, books, good color photocopies, etc.; 6 pieces or more; narrative scenes with children and/or animals interacting." Advertises in *RSVP*, *Picture Book*, *Directory of Illustration*.

How to Contact: Send samples and SASE. "Artists must call no sooner than one month after sending samples."

Tips: "We look for artists who can draw animals and people with imagination and energy, depicting engaging characters with action in situational settings."

SAL BARRACCA ASSOC. INC., 96 Wood Creek Rd., Bethlehem CT 06751. (203)266-6750. Fax: (203)266-6751. **Contact:** Sal Barracca. Commercial illustration representative. Estab. 1988. Represents 23 illustrators. "90% of our assignments are book jackets." Markets include: advertising agencies; publishing/books. Clients include: Random House, HarperCollins, Harlequin Books. Artists include Al Slark, Dominick Finelle, Patrick Whelan and Roger Loveless.

Handles: Illustration.

Terms: Rep receives 25% commission. Exclusive area representation is required. Advertising costs are split: 75% paid by talent; 25% paid by representative. For promotional purposes "portfolios must be 8×10 chromes that are matted. We can shoot original art to that format at a cost to the artist. We produce our own promotion and mail out once a year to over 16,000 art directors."

How to Contact: For first contact, send direct mail flier/brochure, tearsheets and SASE. Responds in 1 week; 1 day if interested. After initial contact, drop off or mail in appropriate materials for review. Portfolio should include tearsheets, slides.

Tips: "Make sure you have at least three years of working on your own so that you don't have any false expectations from an agent."

BERENDSEN & ASSOCIATES, INC., 2233 Kemper Lane, Cincinnati OH 45206. (513)861-1400. Fax: (513)861-6420. E-mail: bob@illustratorsrep.com. Website: www.illustratorsrep.com and www.Stock ArtRep.com. President: Bob Berendsen. Commercial illustration, photography, artists' representative. Incorporated 1986. Represents 45 illustrators, 15 photographers. Specializes in "high-visibility consumer accounts." Markets include: advertising agencies; corporations/client direct; design firms; editorial/magazines; paper products/greeting cards; publishing/books; sales/promotion firms. Clients include Disney, CNN, Pentagram, F&W Publications. Client list available upon request. Represents: Jake Ellison, Bill Fox, George Hardebeck, Marcia Hartsock, Duff Orlemann, Jack Pennington, Dave Reed, Garry Richardson, Ursula Roma, Robert Schuster.

- This rep has four websites: illustratorsrep.com, photographersrep.com, designersrep.com and stock artrep.com. The fast-loading pages are easy for art directors to access—a great promotional tool for their talent.

Handles: Illustration, photography. "We are always looking for illustrators who can draw people, product and action well. Also, we look for styles that are metaphoric in content, and it's a plus if the stock rights are available."

Terms: Rep receives 30% commission. Charges "mostly for postage but figures not available." No geographic restrictions. Advertising costs are split: 70% paid by talent; 30% paid by representative. For promotional purposes, "artist must co-op in our direct mail promotions, and sourcebooks are recommended. Portfolios are updated regularly." Advertises in *RSVP*, *Creative Illustration Book*, *Directory of Illustration* and *American Showcase*.

How to Contact: For first contact, send an e-mail with no more than 6 jpegs attached or send query letter, résumé, and any nonreturnable tearsheets, slides, photographs or photocopies.

Tips: Artists should have a "proven style with at least ten samples of that style."

JOANIE BERNSTEIN, ART REP, 756-8 Aves, Naples FL 34102. (239)403-4393. Fax: (239)403-0066. E-mail: joanie@joaniebrep.com. Website: www.joaniebrep.com. **Contact:** Joanie. Commercial illustration representative. Estab. 1984. Represents 8 illustrators. Specializes in illustrations geared towards graphic design, advertising, editorial, books, music and product. Markets include advertising agencies, corporations/client direct, design firms, developers, editorial/magazines, movie studios, paper products/greeting cards, private collections, publishing/books, record companies and sales/promotion firms. Artists include Elvis Swift, Jack Molloy and Eric Hanson.

Handles: Illustration. Looking for an unusual, problem solving style.

Terms: Rep receives 25% commission. Exclusive representation required. Advertises in *Workbook*.

How to Contact: For first contact, send query letter with bio, direct mail flier/brochure or e-mail and web address. E-mails response to website queries and to mailed samples if e-mail address provided. After initial contact, call to schedule an appointment. Portfolio should include b&w and color finished art, original art, tearsheets.

Tips: "Current art (3-6 months old) is best to show—have a website. Don't mail a portfolio unless requested. Always include a stamped, return address slip."

SAM BRODY, ARTISTS & PHOTOGRAPHERS REPRESENTATIVE & CONSULTANT, 77 Winfield St., Apt. 4, E. Norwalk CT 06855-2138. Phone/fax: (203)854-0805 (for fax, add 999). **Contact:** Sam Brody. Commercial illustration and photography representative and broker. Estab. 1948. Member of SPAR. Consultant to illustrators, photographers, designers. Markets include: advertising agencies; corporations/client direct; design firms; editorial/magazines; publishing/books; sales/promotion firms.

Handles: Illustration, photography, design, "great writer and director talents."

Terms: Agent receives 30% commission. Exclusive area representation is required. For promotional purposes, talent must provide back-up advertising material, i.e., cards (reprints—*Workbook*, etc.), websites and self-promos.

How to Contact: For first contact, send bio, direct mail flier/brochure, tearsheets. Responds in 3 days or within 1 day if interested. After initial contact, call for appointment or drop off or mail in appropriate materials for review. Portfolio should include tearsheets, slides, photographs. Obtains new talent through recommendations from others, solicitation.

Tips: Considers "past performance for clients that I check with and whether I like the work performed."

SID BUCK SYDRA TECHNIQUES CORP., 998C Old Country Rd., Plainview NY 11803. (516)496-0953. Fax: (516)682-8153. E-mail: sydra@optonline.com. **President:** Sid Buck. Commercial illustration representative. Estab. 1964. Markets include: advertising agencies; corporations/client direct; design firms; editorial/magazines; paper products/greeting cards; publishing/books; fashion. Represents: Jerry Schurr, Ken Call and Glenn Iunstull, Robert Melendez, Robert Passantino, Howard Rose, Dee Densmore D'Amico.
Handles: Illustration, fashion and editorial.
Terms: Rep receives 25% commission. Exclusive area represention is required. Advertising costs are split: 75% paid by talent; 25% paid by representative.
How to Contact: For first contact, send photocopies, photostats. Responds in 1 week. After initial contact, call to schedule an appointment for portfolio review. Portfolio should include photostats, photocopies.

WOODY COLEMAN PRESENTS, INC., dba Portsort.com (artist-controlled cooperative). 490 Rockside Rd., Cleveland OH 44131. (216)661-4222. Fax: (216)661-2879. E-mail: woody@portsort.com. Website: www.portsort.com. **Contact:** Woody. Creative services representative. Estab. 1978. Member of Graphic Artists Guild. Specializes in illustration. Markets include: advertising agencies; corporations/client direct; design firms; editorial/magazines; paper products/greeting cards; publishing/books; sales/promotion firms; public relations firms.
Handles: Illustration.
Terms: Organization negotiates and invoices all projects and receives 25% commission. Selected professional illustrators—will receive free placement of 12-image portfolio on Internet Database (see www.portsort.com). For promotional purposes, talent must provide "all 12 or more image portfolios in 4×5 transparencies or high-quality prints, as well as 12-72 dpi scans." Advertises in *American Showcase*, *Black Book*, *The Workbook*, other publications.
How to Contact: For first contact, send query letter, tearsheets, slides, SASE or e-mail under 100K images. Responds in 1 month, only if interested. Portfolio should include tearsheets, 4×5 transparencies.
Tips: "Solicitations are made directly to our Cooperative. Concentrate on developing 12 specific examples of a single style exhibiting work aimed at a particular specialty (multiple 12-image portfolios allowed), such as fantasy, realism, Americana or a particular industry such as food, medical, architecture, transportation, film, etc."

DANIELE COLLIGNON, 200 W. 15th St., New York NY 10011. (212)243-4209. **Contact:** Daniele Collignon. Commercial illustration representative. Estab. 1981. Member of SPAR, Graphic Artists Guild, Art Director's Club. Represents 12 illustrators. Markets include: advertising agencies; corporations/client direct; design firms; editorial/magazines; publishing/books.
Handles: Illustration.
Terms: Rep receives 30% commission. Exclusive area representation is required. No geographic restrictions. Advertising costs are split: 75% paid by talent; 25% paid by representative. For promotional purposes, talent must provide 8×10 transparencies (for portfolio) to be mounted, printed samples, professional pieces. Advertises in *American Showcase*, *Black Book*, *The Workbook*.
How to Contact: For first contact, send direct mail flier/brochure, tearsheets. Responds in 5 days, only if interested. After initial contact, drop off or mail in appropriate materials for review. Portfolio should include tearsheets, transparencies.

N. CONTACT JUPITER, 124 McGill, Suite 300, Montreal QC H2Y 2E5. (514)572-0388. Fax: (450)491-3883. E-mail: info@contactjupiter.com. Website: www.contactjupiter.com. **Contact:** Oliver Mielenz, president. Commercial illustration representative. Estab. 1996. Member of Publicity Club of Montreal. Represents 1 fine artist, 10 illustrators, 8 photographers. Specializes in publishing, children's books, magazine, advertising. Licenses fine artists, illustrators, photographers. Markets include advertising agencies, paper products/greeting cards, record companies, publishing/books, corporations/client direct, editorial/magazines.
Handles: Illustration, multimedia, music, photography, design.
Terms: Reps receives 15-25% and rep fee. Promotion, sales services; $3,000-5,000. Advertising costs are split 50% paid by artist; 50% paid by rep. Exclusive representation required. For promotional purposes, talent must provide portfolio pieces (8½×11) and electronic art samples. Advertises in *Illustrators Directory*.
How to Contact: Send query letter with photocopies. Responds only if interested. After initial contact, e-mail to set up an interview or portfolio review. Portfolio should include b&w and color tearsheets.

Tips: "One specific style is easier to sell. Focus, focus, focus. Initiative, I find, is very important in an artist."

CORNELL & McCARTHY, LLC, 2-D Cross Hwy., Westport CT 06880. (203)454-4210. Fax: (203)454-4258. E-mail: cmartreps@aol.com. **Contact:** Merial Cornell. Children's book illustration representative. Estab. 1989. Member of SCBWI and Graphic Artists Guild. Represents 30 illustrators. Specializes in children's books: trade, mass market, educational.
Handles: Illustration.
Terms: Agent receives 25% commission. Advertising costs are split: 75% paid by talent; 25% paid by representative. For promotional purposes, talent must provide 10-12 strong portfolio pieces relating to children's publishing.
How to Contact: For first contact, send query letter, direct mail flier/brochure, tearsheets, photocopies and SASE. Responds in 1 month. Obtains new talent through recommendations, solicitation, conferences.
Tips: "Work hard on your portfolio."

CREATIVE FREELANCERS INC., 99 Park Ave., #210A, New York NY 10016. (800)398-9544. Fax: (203)532-2927. E-mail: cfonline@freelancers.com. Website: www.freelancers.com. **Contact:** Marilyn Howard. Commercial illustration and designers representative. Estab. 1988. Represents over 30 illustrators and designers. "Our staff members have art direction, art buying or illustration backgrounds." Specializes in children's books, advertising, architectural, conceptual. Markets include: advertising agencies; corporations/client direct; design firms; editorial/magazines; paper products/greeting cards; publishing/books; sales/promotion firms.
Handles: Illustration and design. Artists must have published work.
Terms: Rep receives 30% commission. Exclusive area representation is preferred. Advertising costs are split: 75% paid by talent; 25% paid by representative. For promotional purposes, talent should provide "JPEG or GIF images and be listed at our website. Transparency portfolio preferred if we take you on, but we are flexible." Advertises in *American Showcase*, *Workbook*.
How to Contact: For first contact, send tearsheets or file copies. Responds only if interested.
Tips: Looks for experience, professionalism and consistency of style. Obtains new talent through "word of mouth and website."

N CWC INTERNATIONAL, INC., 216 W. 18th St., Suite 1003, New York NY 10011. (646)486-6586. Fax: (646)486-7622. E-mail: agent@cwc-i.com. Website: www.cwc-i.com. **Contact:** Koko Nakano, senior creative agent. Commercial ilustration representative. Member of Graphic Artists Guild. Represents 2 fine artists, 19 illustrators. Specializes in advertising, fashion. Markets include advertising agencies, corporations/client direct, design firms, editorial/magazines, galleries, paper products/greeting cards, publishing/books, record companies. Artists include Tobie Giddio, Stina Persson, Chris Long, Furi Furi.
Handles: Fine art, illustration.
Terms: Exclusive area representation required.
How to Contact: For first contact, send query letter with direct mail flier/brochure, photocopies (3-4 images) and résumé via snail mail or e-mail. Responds only if interested.
Tips: "Please do not call. When sending any image samples by e-mail, be sure the entire file will not exceed 500K."

LINDA DE MORETA REPRESENTS, 1839 Ninth St., Alameda CA 94501. (510)769-1421. Fax: (510)521-1674. E-mail: ron@lindareps.com. Website: www.lindareps.com. **Contact:** Ron Lew. Commercial illustration and photography representative; also portfolio and career consultant. Estab. 1988. Represents 9 illustrators, 5 photographers. Markets include: advertising agencies; design firms; corporations/client direct; editorial/magazines; paper products/greeting cards; publishing/books; sales/promotion firms. Represents: Chuck Pyle, Pete McDonnell, Tina Healey, Barbara Callow, Janet Hyun, Craig Hannah, Monica Dengo, Tina Rachelle, James Chiang, Michael Cunningham, Tiffany Larsen, Susan Vogel, Ron Miller and John Branscombe.
Handles: Photography, illustration, lettering/title design.
Terms: Commission, exclusive representation requirements and advertising costs are according to individual agreements. Materials for promotional purposes vary with each artist. Advertises in *The Workbook*, *American Showcase*, *Directory of Illustration*, *Alternative Pick*.
How to Contact: For first contact, send direct mail flier/brochure, slides or photocopies and SASE. "Please do *not* send original art. SASE for any items you wish returned." Responds to any inquiry in

which there is an interest. Portfolios are individually developed for each artist and may include transparencies, prints or tearsheets.

Tips: Obtains new talent through client and artist referrals primarily, some solicitation. "I look for great creativity, a personal vision and style of photography or illustration combined with professionalism, maturity and passion."

FORTUNI, 2508 E. Belleview Place, Milwaukee WI 53211. (414)964-8088. Fax: (414)332-9629. **Contact:** Marian F. Deegan. Commercial illustration, photography representative. Estab. 1989. Member of Graphic Artists Guild. Represents 6 illustrators, 2 photographers. Markets include: advertising agencies; corporations/client direct; design firms; editorial/magazines; publishing/books. Artists include Peter Carter, Samantha Burton, Janet Drew, Dick Baker, Zelda Bean, Rijalynne Saari, Jody Winger and Kendra Shaw.
Handles: Illustration, photography. "I am interested in artists who have developed a consistent, distinctive style of illustration, and target the national advertising market."
Terms: Rep receives 30% commission. Advertising costs are split: 70% paid by talent; 30% paid by representative. For promotional purposes, talent must provide direct mail support, advertising, and a minimum of 4 duplicate transparency portfolios. "All promotional materials are developed and produced within my advertising specifications." Advertises in *Directory of Illustration*, *The Workbook*.
How to Contact: For first contact, send direct mail flier/brochure, slides, photographs, photocopies, SASE. Responds in 2 weeks if SASE is enclosed.

FREELANCE ADVANCERS, INC., 420 Lexington Ave., Suite 2007, New York NY 10170. (212)661-0900. Fax: (212)661-1883. E-mail: info@freelanceadvancers.com. Website: www.freelanceadvancers.com. President: Gary Glauber. Commercial illustration, graphic design, freelance artist representative. Estab. 1987. Member of Society of Illustrators. Represents 150 illustrators, 250 designers. Specializes in freelance project work. Markets include: advertising agencies; corporations/client direct; design firms; editorial/magazines; publishing/books.
Handles: Illustration, design. web design and art direction. Looks for artists with Macintosh software and multimedia expertise.
Terms: Rep receives 20% commission. 100% of advertising costs are paid by the representative. Advertises in *Art Direction, Adweek*.
How to Contact: For first contact, send query letter, résumé, tearsheets.
Tips: Looking for "talent, flexibility and reliability" in an artist. "Always learn, but realize you are good enough now."

ROBERT GALITZ FINE ART/ACCENT ART, 166 Hilltop Court, Sleepy Hollow IL 60118. (847)426-8842. Fax: (847)426-8846. **Contact:** Robert Galitz. Fine art representative. Estab. 1985. Represents 100 fine artists (includes 2 sculptors). Specializes in contemporary/abstract corporate art. Markets include: architects; corporate collections; galleries; interior decorators; private collections. Represents: Roland Poska, Jan Pozzi, Diane Bartz and Louis De Mayo.
Handles: Fine art.
Terms: Agent receives 25-40% commission. No geographic restrictions; sells mainly in Chicago, Illinois, Wisconsin, Indiana and Kentucky. For promotional purposes talent must provide "good photos and slides." Advertises in monthly art publications and guides.
How to Contact: For first contact, send query letter, slides, photographs. Responds in 2 weeks. After initial contact, call for appointment to show portfolio of original art. Obtains new talent through recommendations from others, solicitation, conferences.
Tips: "Be confident, persistent. Never give up or quit."

RITA GATLIN REPRESENTS INC., 83 Walnut Ave., Corte Madera CA 94925. (415)924-7881. Fax: (415)924-7891. E-mail: gatlin@ritareps.com. Website: www.ritareps.com. Agent: Rita Gatlin. Commercial illustration. Estab. 1991. Member of Society of Illustrators. Represents 12 illustrators. Markets include: advertising agencies; corporations/client direct; design firms; editorial/magazines; paper products/greeting cards; publishing/books. Artists include Sudi McCollum, Mary Ross and more. See our website.
Handles: Commercial illustrators only.
Terms: Rep receives 25% commission. Charges fees for portfolio materials (mounting and matting); postage for yearly direct mail divided among artists. Advertising costs are split: 75% paid by talent; 25% paid by representative. For promotional purposes, talent must provide at least one 8½×11 printed page.

Portfolios can be in transparency form or reflective art. Advertises in *American Showcase*, *The Workbook*, *Creative Illustration*, *Blackbook*.

How to Contact: For first contact, send query letter and tearsheets. Responds in 5 days. After initial contact, call to schedule an appointment for portfolio review.

Tips: "Artists must have a minimum of five years experience as commercial illustrators." When asked what their illustration style is, artists should never say they can do all styles—it's "a sign of a beginner. Choose a medium and excel."

DENNIS GODFREY REPRESENTING ARTISTS, 201 W. 21st St., Suite 10G, New York NY 10011. Phone/fax: (212)807-0840. E-mail: dengodfrey@aol.com. **Contact:** Dennis Godfrey. Commercial illustration representative. Estab. 1985. Represents 7 illustrators. Specializes in publishing and packaging. Markets include: advertising agencies; corporations/client direct; design firms; publishing/books. Clients include Putnam Berkley, Dell, Avon, Ogilvy & Mather, Oceanspray, Tropicana, Celestial Seasonings.

Handles: Illustration.

Terms: Rep receives 25% commission. Prefers exclusive area representation in NYC/Eastern US. Advertising costs are split: 75% paid by talent; 25% paid by representative. For promotional purposes, talent must provide mounted portfolio (at least 20 pieces), as well as promotional pieces. Advertises in *The Workbook*, *American Showcase*.

How to Contact: For first contact, send tearsheets. Responds in 2 weeks, only if interested. After initial contact, write for appointment to show portfolio of tearsheets, slides, photographs, photostats.

BARBARA GORDON ASSOCIATES, LTD., 165 E. 32nd St., New York NY 10016. (212)686-3514. Fax: (212)532-4302. **Contact:** Barbara Gordon. Commercial illustration and photography representative. Estab. 1969. Member of SPAR, Society of Illustrators, Graphic Artists Guild. Represents 9 illustrators, 1 photographer. "I represent only a small, select group of people and therefore give a great deal of personal time and attention to the people I represent."

Terms: No information provided. No geographic restrictions in continental US.

How to Contact: For first contact, send direct mail flier/brochure. Responds in 2 weeks. After initial contact, drop off or mail appropriate materials for review. Portfolio should include tearsheets, slides, photographs; "if the talent wants materials or promotion piece returned, include SASE." Obtains new talent through recommendations from others, solicitation, conferences, etc.

Tips: "I do not care if an artist or photographer has been published or is experienced. I am essentially interested in people with a good, commercial style. Don't send résumés and don't call to give me a verbal description of your work. Send promotion pieces. *Never* send original art. If you want something back, include a SASE. Always label your slides in case they get separated from your cover letter. And always include a phone number where you can be reached."

CAROL GUENZI AGENTS, INC., 865 Delaware St., Denver CO 80210. (303)820-2599. E-mail: art@artagent.com. Website: www.artagent.com. **Contact:** Carol Guenzi. Commercial illustration, film and animation representative. Estab. 1984. Member of Denver Advertising Federation and Art Directors Club of Denver. Represents 29 illustrators, 6 photographers and 3 multimedia developers. Specializes in a "wide selection of talent in all areas of visual communications." Markets include: advertising agencies; corporations/client direct; design firms; editorial/magazine, paper products/greeting cards, sales/promotions firms. Clients include Integer, BBDO, DDB Needham Dugan Valva Contess. Partial client list available upon request. Represents Christer Eriksson, Juan Alvarez, Shelly Bartek and Marc Brown.

Handles: Illustration, photography. Looking for "unique style application."

Terms: Rep receives 25% commission. Exclusive area representative is required. Advertising costs are split: 75% paid by talent; 25% paid by the representation. For promotional purposes, talent must provide "promotional material after six months, some restrictions on portfolios." Advertises in *American Showcase*, *Black Book*, *The Workbook*.

How to Contact: For first contact, send direct mail flier/brochure. Responds in 3 weeks, only if interested. Call or write for appointment to drop off or mail in appropriate materials for review, depending on artist's location. Portfolio should include tearsheets, slides, photographs. Obtains new talent through solicitation, art directors' referrals, an active pursuit by individual artist.

Tips: "Show your strongest style and have at least 12 samples of that style, before introducing all your capabilities. Be prepared to add additional work to your portfolio to help round out your style. Have a digital background."

GUIDED IMAGERY DESIGN & PRODUCTIONS, (formerly Guided Imagery Productions), 2995 Woodside Rd., #400, Woodside CA 94062. (650)324-0323. Fax: (650)324-9962. Owner/Director: Linda Hoffman. Fine art representative. Estab. 1978. Member of Hospitality Industry Association. Represents 3 illustrators, 12 fine artists. Specializes in large art production—perspective murals (trompe l'oiel); unusual painted furniture/screens. Markets include: design firms; interior decorators; hospitality industry.
Handles: Looking for "mural artists (realistic or trompe l'oiel) with good understanding of perspectives."
Terms: Rep receives 33-50% commission. 100% of advertising costs paid by representative. For promotional purposes, talent must provide a direct mail piece to preview work, along with color copies of work (SASE too). Advertises in *Hospitality Design*, *Traditional Building Magazine* and *Design Journal*.
How to Contact: For first contact, send query letter, résumé, photographs, photocopies and SASE. Responds in 1 month. After initial contact, drop off or mail appropriate materials. Portfolio should include photographs.
Tips: Wants artists with talent, references and follow-through. "Send color copies of original work that show your artistic style. Never send one-of-a-kind artwork. My focus is 3-D murals. References from previous clients very helpful." Please—no cold calls.

PAT HACKETT/ARTIST REPRESENTATIVE, 7014 N. Mercer Way, Mercer Island WA 98040. (206)447-1600. Fax: (206)447-0739. E-mail: pathackett@aol.com. Website: www.pathackett.com. **Contact:** Pat Hackett. Commercial illustration and photography representative. Estab. 1979. Represents 12 illustrators, 1 photographer. Markets include: advertising agencies; corporations/client direct; design firms; editorial/magazines.
Handles: Illustration.
Terms: Rep receives 25-33% commission. Exclusive representation is required. Advertising costs are split: 75% paid by talent; 25% paid by representative. For promotional purposes, talent must provide "standardized portfolio, i.e., all pieces within the book are the same format. Reprints are nice, but not absolutely required." Advertises in *Showcase*, *The Workbook*.
How to Contact: For first contact, send direct mail flier/brochure. Responds in 1 week, only if interested. After initial contact, drop off or mail in appropriate materials: tearsheets, slides, photographs, photostats, photocopies. Obtains new talent through "recommendations and calls/letters from artists moving to the area."
Tips: Looks for "experience in the *commercial* art world, professional presentation in both portfolio and person, cooperative attitude and enthusiasm."

HOLLY HAHN & CO., 837 W. Grand Ave., 3rd Floor, Chicago IL 60622. (312)633-0500. Fax: (312)633-0484. E-mail: holly@hollyhahn.com. Website: www.hollyhahn.com. Commercial illustration and photography representative. Estab. 1988. Member of CAR (Chicago Artists Representatives). Represents 3 illustrators, 3 photographers. Markets include: advertising agencies; corporations/client direct; design firms; editorial/magazines; publishing/books.
Handles: Illustration, photography.
Terms: Rep receives 30% commission. Advertises in *The Workbook*, *Black Book*, *Klik*, *Tilt* and *The Alternative Pick*.
How to Contact: To contact, send direct mail flier/brochure and tearsheets.
Tips: Wants artists with "professional attitudes and knowledge, unique abilities or application, interest and motivation and a strong commitment to the work and the imagery."

HANKINS & TEGENBORG, LTD., 11 E. St., 6th Floor, New York NY 10017. (212)755-6070. Fax: (212)755-6075. E-mail: dhlt@aol.com. Website: www.ht-ltd.com. Commercial illustration representative. Estab. 1980. Represents 50 illustrators. Specializes in realistic and digital illustration. Markets include: advertising agencies; publishing/book covers/promotion.
Handles: Illustration, computer illustration.
Terms: Rep receives 25% commission. "All additional fees are charged per job if applicable." Exclusive area representation is required. Advertising costs are split: 75% paid by talent; 25% paid by representative. For promotional purposes, talent must provide 8 × 10 transparencies or digital files. Advertises in *American Showcase* "and own promotion book."
How to Handle: For first contact, send query letter, direct mail flier/brochure, tearsheets and SASE. Responds if interested. Portfolio can be dropped off.

BARB HAUSER, ANOTHER GIRL REP, P.O. Box 421443, San Francisco CA 94142-1443. (415)647-5660. Fax: (415)546-4180. E-mail: barb@girlrep.com. Website: www.girlrep.com. Estab. 1980. Represents

8 illustrators. Markets include: primarily advertising agencies and design firms; corporations/client direct.
Handles: Illustration.
Terms: Rep receives 25-30% commission. Exclusive representation in the San Francisco area is required.
How to Contact: For first contact, send direct mail flier/brochure, tearsheets, slides, photographs, photocopies and SASE or e-mail without attachments. Responds in 1 month.

JOANNE HEDGE/ARTIST REPRESENTATIVE, 1415 Garden St., Glendale CA 91201. (818)244-0110. Fax: (818)244-0136. E-mail: hedgegraphics@earthlink.com. Website: www.hedgereps.com. **Contact:** J. Hedge. Commercial illustration representative. Estab. 1975. Represents 12 illustrators. Specializes in "high-quality, painterly and realistic illustration, digital art and lettering." Markets include advertising agencies, design firms, movie studios, package design firms and web/interactive clients.
Handles: Illustration. Seeks established realists in airbrush, painting and digital art.
Terms: Rep receives 30% commission. Artist pays quarterly portfolio maintenance expenses. Advertising costs are split: 75% paid by talent; 25% paid by representative. For promotional purposes, talent should provide "ad reprint flyer, 4×5 or 8×10 copy transparencies, matted on 11×14 laminate mattes." Advertises in *The Workbook*, *Directory of Illustration* and website.
How to Contact: Send query letter with direct mail flier/brochure or e-mail. Responds if interested. After initial contact, call or write for appointment to show portfolio of tearsheets (laminated), photocopies, 4×5 or 8×10 transparencies, or output.
Tips: Obtains new talent after talent sees *Workbook* directory ad, or through referrals from art directors or other talent. "Have as much experience as possible and zero or one other rep. That, and a good looking 8½×11 flier!"

HK PORTFOLIO, 666 Greenwich St., New York NY 10014. (212)675-5719. E-mail: harriet@hkportfolio.com. Website: www.hkportfolio.com. **Contact:** Harriet Kasak or Mela Bolinao. Commercial illustration representative. Estab. 1986. Member of SPAR, Society of Illustrators and Graphic Artists Guild. Represents 50 illustrators. Specializes in illustration for juvenile markets. Markets include: advertising agencies; editorial/magazines; publishing/books.
Handles: Illustration.
Terms: Rep receives 25% commission. No geographic restrictions. Advertising costs are split: 75% paid by talent; 25% paid by representative. Advertises in *Picture Book* and *Workbook*.
How to Contact: No geographic restrictions. For first contact, send query letter, direct mail flier/brochure, tearsheets, slides, photographs, photostats and SASE. Responds in 1 week. After initial contact, drop off or mail in appropriate materials for review. Portfolio should include tearsheets, slides, photographs, photostats, photocopies.
Tips: Leans toward "highly individual personal styles."

✅ **SCOTT HULL ASSOCIATES**, 303 E. Social Row Rd., Dayton OH 45458. (937)433-8383. Fax: (937)433-0434. E-mail: scott@scotthull.com. Website: www.scotthull.com. **Contact:** Scott Hull or Brienne McLaughlin. Commercial illustration representative. Estab. 1981. Represents 30 plus illustrators.
How to Contact: Contact by sending e-mail samples, tearsheets or appropriate materials for review. Follow up with phone call. Responds in 2 weeks.
Tips: Looks for "an interesting style and a desire to grow, as well as a marketable portfolio."

N INDUSTRY ARTS AGENCY, 67 Henry St., Suite 1, San Francisco CA 94114. (415)305-9040. Fax: (415)538-0118. E-mail: iacreative@industryarts.com. Website: www.industryarts.com. Agent/Broker: Marc Tocker. Commercial illustration, photography, graphic design representative and copywriters. Estab. 1997. Member of California Lawyers for the Arts. Represents 1 copywriter, 1 illustrator, 1 photographer, 1 designer. Specializes in clever cutting edge design. Markets include: advertising agencies, corporations/client direct, design firms.
Handles: Illustration, photography, design, Web design/programming. "We are looking for design mindful people who create cutting edge work that challenges dominant cultural paradigms."
Terms: Rep receives 20-25% commission. Exclusive area representation is required. Advertising costs are paid by talent. For promotional purposes, portfolio should be adapted to digital format for website presentation. Advertises in *The Workbook*.
How to Contact: For first contact, send query letter, bio, direct mail flier/brochure, tearsheets, photocopies and SASE. Responds in 2 weeks. Call to schedule an appointment. Portfolio should include original art, tearsheets, slides, photographs.

Tips: Looks for artists with an awareness of the cutting edge in contemporary design.

▦ INTERPRESS WORLDWIDE, P.O. Box 8374, Los Angeles CA 91618-8374. (323)876-7675. E-mail: email@interpressww.com. Website: www.interpressww.com. Rep Coordinator: Ellen Bow. Commercial and fashion illustration, photography, fine art, graphic design, actor, make-up artist, musicians, hairstylists; representative. Estab. 1989. Represents 8 illustrators, 10 photographers, 6 make-up artists, 4 hairstylists, 20 models, 15 musicians, 4 actors, 2 designers, 5 fine artists, 2 film directors. Specializes in subsidiaries worldwide. Markets include advertising agencies; corporations/client direct; editorial/magazines; movie industry; art publishers; galleries; private collections; publishing/books; music industry.
Handles: Illustration, photography, fine art, graphic arts; commercial, A/V productions; television, movie, music.
Terms: Rep receives 30% commission. Charges for postage and initial rep fee. Exclusive area representation is required. Advertising costs are split: 85% paid by talent; 15% paid by the representative. For promotional purposes, talent must provide 2 show portfolios, 6 traveling portfolios. Advertises in *Red Book*, *Production-Creation*.
How to Contact: For first contact, send query letter, résumé, bio, direct mail flier/brochure, tearsheets, slides, photographs and photostats. Responds in 2 months. After initial contact, write to schedule an appointment, mail in appropriate materials. No call-ins. Portfolio should include thumbnails, roughs, original art, tearsheets, slides, photographs, photostats, E-folio (Mac) audio/video clips VHS/DVD (PAL/NISC). Obtains new talent through recommendations from others and the extraordinary work, personality and talent of the artist.
Tips: "Try as hard as you can and don't take our 'no' as a 'no' to your talent."

THE IVY LEAGUE OF ARTISTS, 10 E. 39th St., 7th Floor, New York NY 10016. (212)545-7766. Fax: (212)545-9437. E-mail: ilartists@aol.com. **Contact:** Ivy Mindlin, president. Graphic design representative, illustration or photography broker. Commercial illustration, photography, fine art, graphic design representative. Estab. 1985. Represents 5 illustrators, 2 designers. Staff includes sales and graphic designers. Specializes in graphic design, illustration representatives. Markets include: advertising agencies, corporations/clients direct, publishing/books.
Will Handle: Interested in reviewing illustration, design.
Terms: Rep receives 30% commission.
How to Contact: For first contact, send tearsheets. Responds in 2 weeks. Portfolio should include prints, tearsheets.
Tips: "At this point, we are not looking for new talent."

KIRCHOFF/WOHLBERG, ARTISTS REPRESENTATION DIVISION, 866 United Nations Plaza, #525, New York NY 10017. (212)644-2020. Fax: (212)223-4387. Website: www.kirchoffwohlberg.com. **President:** Morris A. Kirchoff. Director of Operations: John R. Whitman. Artist's Representative: Elizabeth Ford. Estab. 1930. Member of SPAR, Society of Illustrators, AIGA, Associaton of American Publishers, Bookbuilders of Boston, New York Bookbinders' Guild. Represents over 50 illustrators. Specializes in juvenile and young adult trade books and textbooks. Markets include: publishing/books.
Handles: Illustration and photography (juvenile and young adult).
Terms: Rep receives 25% commission. Exclusive representation to book publishers is usually required. Advertising costs paid by representative ("for all Kirchoff/Wohlberg advertisements only"). "We will make transparencies from portfolio samples; keep some original work on file." Advertises in *American Showcase*, *Art Directors' Index*, *Society of Illustrators Annual*, *The Black Book*, children's book issues of *Publishers Weekly*.
How to Contact: Please send all correspondence to the attention of Elizabeth Ford. For first contact, send query letter, "any materials artists feel are appropriate." Responds in 6 weeks. "We will contact you for additional materials." Portfolios should include "whatever artists feel best represents their work. We like to see children's illustration in any style."

KLIMT REPRESENTS, 15 W. 72nd St., 7-U, New York NY 10023. (212)799-2231. E-mail: klimt@prodigy.net. Website: www.klimtreps.com. **Contact:** Bill or Maurine. Commercial illustration representative. Estab. 1978. Member of Society of Illustrators, Graphic Artists Guild. Represents 8 illustrators. Specializes in paperback covers, young adult, romance, science fiction, mystery, etc. Markets include: advertising agencies; corporations/client direct; design firms; editorial/magazines; paper products/greeting cards; publishing/books; sales/promotion firms. Represents: Blattel, Juan Moreno and Tom Roberts.

Handles: Illustration.
Terms: Rep receives 25% commission, 30% commission for "out of town if we do shoots." The artist is responsible for only his own portfolio. Exclusive area representation is required. Advertising costs are split: 75% paid by talent; 25% paid by representative. For promotional purposes, talent must provide 4×5 or 8×10 mounted transparencies. Advertises through direct mail.
How to Contact: For first contact, send direct mail flier/brochure, and "any image that doesn't have to be returned unless supplied with SASE." Responds in 5 days. After initial contact, call for appointment to show portfolio of professional, mounted transparencies.

N: ELLEN KNABLE & ASSOCIATES, INC., 1158 26th St., #552, Santa Monica CA 90403. (310)829-3269. (310)453-4053. E-mail: pearl2eka@aol.com. **Contact:** Ellen Knable. Commercial production representative. Estab. 1978. Markets include: advertising agencies; corporations/client direct; design firms. Clients include Chiat/Day, BBDO, J.W. Thompson/SF. Client list available upon request.
Terms: Rep receives 25-30% commission. Exclusive West Coast/Southern California representation is required. Advertising costs split varies. Advertises in *The Workbook*.
How to Contact: For first contact, send query letter, direct mail flier/brochure and tearsheets. Responds in 2 weeks. Call for appointment to show portfolio. Obtains new talent from creatives/artists.
Tips: "Have patience and persistence!"

CLIFF KNECHT–ARTIST REPRESENTATIVE, 309 Walnut Rd., Pittsburgh PA 15202. (412)761-5666. Fax: (412)761-4072. E-mail: cliff@artrep1.com. Website: www.artrep1.com. **Contact:** Cliff Knecht. Commercial illustration representative. Estab. 1972. Represents 20 illustrators. Markets include: advertising agencies; corporations/client direct; design firms; editorial/magazines; paper products/greeting cards; publishing/books; sales/promotion firms.
Handles: Illustration.
Terms: Rep receives 25% commission. No geographic restrictions. Advertising costs are split: 75% paid by the talent; 25% paid by representative. For promotional purposes, talent must provide a direct mail piece. Advertises in *Graphic Artists Guild Directory of Illustration*.
How to Contact: For first contact, send résumé, direct mail flier/brochure, tearsheets, slides. Responds in 1 week. After initial contact, call for appointment to show portfolio of original art, tearsheets, slides, photographs. Obtains new talent directly or through recommendations from others.

ANN KOEFFLER ARTIST REPRESENTATION, 1020 W. Riverside Dr., #45, Burbank CA 91506. (818)260-8980. Fax: (818)260-8990. E-mail: annartrep@aol.com. Website: www.annkoeffler.com. **Owner/Operator:** Ann Koeffler. Commercial illustration representative. Estab. 1984. Member of Society of Illustrators. Represents 20 illustrators. Markets include: advertising agencies, corporations/client direct, design firms, editorial/magazines, paper products/greeting cards, publishing/books, individual small business owners.
Will Handle: Interested in reviewing illustration. Looking for artists who are digitally adept.
Terms: Rep receives 25-30% commission. Advertising costs 100% paid by talent. For promotional purposes, talent must provide an initial supply of promotional pieces and a committment to advertise regularly. Advertises in *The Workbook*.
How to Contact: For first contact, send tearsheets or send images digitally. Responds in 1 week. Portfolio should include photocopies, 4×5 chromes.
Tips: "I only carry artists who are able to communicate clearly and in an upbeat and professional manner."

SHARON KURLANSKY ASSOCIATES, 192 Southville Rd., Southborough MA 01772. (508)460-0037. Fax: (508)480-9221. E-mail: lstock@charter.net. Website: www.laughing-stock.com. **Contact:** Sharon Kurlansky. Commercial illustration representative. Estab. 1978. Represents 9 illustrators. Markets include: advertising agencies; corporations/client direct; design firms; editorial/magazines; paper products/greeting cards; publishing/books; sales/promotion firms. Client list available upon request. Represents: Tim Lewis, Bruce Hutchison and Blair Thornley. Licenses stock illustration for all markets.
Handles: Illustration.
Terms: Rep receives 25% commission. Exclusive area representation is required. Advertising costs are split: 75% paid by talent; 25% paid by representative. "Will develop promotional materials with talent. Portfolio presentation formated and developed with talent also." Advertises in *American Showcase*, *The Creative Illustration Book*, under artist's name.
How to Contact: For first contact, send direct mail flier/brochure, tearsheets, slides and SASE. Responds

in 1 month if interested. After initial contact, call for appointment to show portfolio of tearsheets, photocopies. Obtains new talent through various means.

LANGLEY CREATIVE, 333 N. Michigan Ave., Suite 1322, Chicago IL 60601. (312)782-0244. Fax: (312)782-1535. E-mail: artrepsjl@aol.com. Website: www.sharonlangley.com. **Contact:** Sharon Langley. Commercial illustration representative. Estab. 1988. Member of CAR (Chicago Artists Representatives). Represents 23 illustrators. Markets include: advertising agencies; corporations; design firms; editorial/ magazines; publishing/books; promotion. Clients include Leo Burnett Launch Communications, Scott Foresman, BBDO. Represents: Michael Backus, Sheree Boyd, Ted Burn.
Handles: Illustration. Although representative prefers to work with established talent, "I am receptive to reviewing samples by enthusiastic up and coming artists."
Terms: Rep receives 25% commission. Exclusive area representation is preferred. Advertising costs are split: 75% paid by talent; 25% paid by representative. For promotional purposes, talent must provide printed promotional pieces, well organized, creative portfolio. Advertises in *The Workbook*. "If your book is not ready to show, be willing to invest in a 'zippy' new one."
How to Contact: For first contact, send "samples via e-mail or printed materials that do not have to be returned." Responds only if interested. Obtains new talent through recommendations from art directors, referrals and submissions.
Tips: "You need to be focused in your direction and style. Be willing to create new samples. Be a 'team player.' The agent and artist form a bond and the goal is success. Don't let your ego get in the way. Be open to constructive criticism and if one agent turns you down quickly move to the next name on your list."

LESLI ART, INC., Box 6693, Woodland Hills CA 91364. (818)999-9228. Fax: (818)999-0833. E-mail: artlesli@aol.com. Website: www.LesliArt.com. **Contact:** Stan Shevrin. Fine art agent, publisher and advisor. Estab. 1965. Represents emerging, mid-career and established artists. Specializes in artists painting in oil or acrylic, in traditional subject matter in realistic or impressionist style. Also represents illustrators who want to establish themselves in the fine art market. Sells to leading art galleries throughout the US. Represents: Tom Darro, Greg Harris, Christa Kieffer, Roger LaManna, Dick Pionk, Rick Peterson and John Stephens. Licenses period costumed figures and landscapes for prints, calendars and greeting cards.
Terms: Receives 50% commission. Pays all expenses including advertising and promotion. Artist pays one-way shipping. All artwork accepted unframed. Exclusives preferred. Contract provided.
How to Contact: For first contact, send either color prints or slides with short bio and SASE if material is to be returned. Material will be filed if SASE is not included. Responds in 1 month. Obtains new talent through "reviewing portfolios."
Tips: "Artists should show their most current works and state a preference for subject matter and medium. Know what subject you're best at and focus on that."

LINDGREN & SMITH, 250 W. 57th St., #521, New York NY 10107. (212)397-7330. Fax: (212)397-7334. E-mail: inquiry@lindgrensmith.com. Website: www.lindgrensmith.com. Website: www.stock.lindgrensmith.com. **Assistant:** Pamela Wilson. Commercial illustration representative. Estab. 1984. Member of SPAR. Markets include advertising agencies; corporations/client direct; design firms; editorial/magazines; paper products/greeting cards; publishing/books, children's books. Represents: Cynthia von Buhler, Lori Lohstoeter, Joseph Daniel Fiedler, Martin Hoake, Joe and Kathy Heiner, Kim Johnson, Francis Livingston, Robert Rodriquez, Robert Gantt Steele, Robert Wagt.
Handles: Illustration and picture books.
Terms: Exclusive representation is required. Advertises in *Workbook*, *Black Book* and *Picture Book*.
How to Contact: For first contact, send direct mail flier/brochure, tearsheets, photocopies. "We will respond by mail."
Tips: "Check to see if your work seems appropriate for the group. We only represent experienced artists who have been professionals for some time."

LONDON CONTEMPORARY ART, 6950 Phillips Hwy., Suite 51, Jacksonville FL 32216. (904)296-4982. E-mail: lcausa@mindspring.com. Website: www.lcausa.com. **Contact:** Marketing Manager. Fine art representative and publisher. Estab. 1977. Represents 45 fine artists. Specializes in "selling to art galleries." Markets include: galleries; corporate collections; interior designers.
Handles: Fine art.
Terms: Publisher of original art. Exclusive representation is required. For promotional purposes talent

must provide biography, slides, color prints, "any visuals." Advertises in *Art Business News*, *Art & Antiques*, *Preview* and *Art World News*.

How to Contact: For first contact, send tearsheets, slides, photographs and SASE. LCA will respond in 1 month, only if interested. "If interested, we will call you." Portfolio should include slides, photographs. Obtains new talent through recommendations from others and word of mouth.

MAGNET REPS, 3450 Vinton Ave., Los Angeles CA 90034. (310)876-7111. Fax: (310)876-7199. Website: http://magnetreps.com. **Contact:** Paolo Rizzi, director. Commercial illustration representative. Estab. 1999. Member of Graphic Artists Guild. Represents 10 illustrators. Markets include advertising agencies, corporations/client direct, design firms, editorial/magazines, movie studios, paper products/greeting cards, publishing/books, record companies, character development. Artists include Ben Shannon, Red Nose Studio, Gordon Wiebe.

Handles: Illustration. Looking for artists with the passion to illustrate every day, an awareness of cultural trends in the world we live in, and a basic understanding of the business of illustration.

Terms: Charges a website setup fee. Exclusive representation required. Advertising costs are split. For promotional purposes, talent must provide a well-developed consistent portfolio. Advertises in *Workbook* and *Alternative Pick*.

How to Contact: For first contact, submit a web link to portfolio, or 2 sample JPEGs for review via e-mail only. Responds in 1 month. We will contact artist via e-mail if we are interested. Portfolio should include color print outs, good quality.

Tips: "Be realistic about how your style matches our agency. We do not represent scientific, technical, medical, sci-fi, hyper-realistic, story boarding, landscape, pin-up, cartoon or cutesy styles. We will not represent artists that imitate the style of one of our existing artists."

MARLENA AGENCY, 145 Witherspoon St., Princeton NJ 08542. (609)252-9405. Fax: (609)252-1949. E-mail: marzena@bellatlantic.net. Website: marlenaagency.com. **Artist Reps:** Marlena Torzecka, Ella Lupo, Greta T'Jonck. Commercial illustration representative. Estab. 1990. Member of Art Directors Club of New York, Society of Illustrators. Represents 28 illustrators from France, Poland, Germany, Hungary, Italy, Spain, Canada and US. Specializes in conceptual illustration. Markets include: advertising agencies; corporations/client direct; design firms; editorial/magazines; publishing/books; theaters. Represents: Cyril Cabry, Linda Helton and Waldemar Shierzy.

● This agency produces promotional materials for artists such as wrapping paper, calendars, brochures.

Handles: Illustration, fine art and prints.

Terms: Rep receives 30% commission; 35% if translation needed. Costs are shared by all artists. Exclusive area representation is required. Advertising costs are split: 70% paid by talent; 30% paid by representative. For promotional purposes, talent must provide slides (preferably 8×10 framed); direct mail pieces, 3-4 portfolios. Advertises in *American Showcase*, *Black Book*, *Illustrators 35* (New York City), *Workbook*, *Alternative Pick*. Many of the artists are regularly featured in CA Annuals, The Society of Illustrators Annuals, American Illustration Annuals.

How to Contact: For first contact send tearsheets or e-mail low resolution images. Responds in 1 week only if interested. After initial contact, drop off or mail appropriate materials. Portfolio should include tearsheets.

Tips: Wants artists with "talent, good concepts—intelligent illustration, promptness in keeping up with projects, deadlines, etc."

MARTHA PRODUCTIONS, INC., 7550 W. 82nd St., Playa Del Rey CA 90293. (310)670-5300. Fax: (310)670-3644. E-mail: marthaprod@earthlink.net. Website: www.marthaproductions.com. **Contact:** Martha Spelman, president. Commercial illustration representative. Estab. 1978. Represents 40 illustrators. Licenses illustrators. Specializes in illustration in various styles and media. Markets include: advertising agencies; corporations/client direct; design firms; developers; editorial/magazines; paper products/greeting cards; publishing/books; record companies; sales/promotion firms. Represents: Steve Vance, Allen Garns, Bruce Seretta.

Handles: Illustration, retro, infographics.

Terms: Rep receives 30% commission. Advertising costs are split: 70% paid by talent; 30% paid by representative. For promotional purposes, talent must "have existing promotional pieces. Also need to be on our website." Advertises in *The Workbook* and *RSVP*.

How to Contact: For first contact, send query letter, direct mail flier/brochure and SASE. Can e-mail a

few small JPEG files. Responds only if interested. After initial contact, drop off or mail portfolio. Portfolio should include b&w and color tearsheets. Obtains new talent through recommendations and solicitation.
Tips: "An artist seeking representation should have a strong portfolio with pieces relevant to advertising, corporate collateral or publishing markets. Check the rep's website or ads to see the other talent they represent to determine whether the artist could be an asset to that rep's group or if there may be a conflict. Reps are looking for new talent that already has a portfolio of salable pieces, some existing promos and hopefully some experience."

[N] MENDOLA ARTISTS, 420 Lexington Ave., New York NY 10170. (212)986-5680. Fax: (212)818-1246. **Contact:** Tim Mendola. Commercial illustration representative. Estab. 1961. Member of Society of Illustrators, Graphic Artists Guild. Represents 60 or more illustrators, 3 photographers. Markets include: advertising agencies; corporations/client direct; design firms; editorial/magazines; sales/promotion firms.
Handles: Illustration. "We work with the top agencies and publishers. The calibre of talent must be in the top 5%."
Terms: Rep receives 25% commission. Artist pays for all shipping not covered by client and 75% of promotion costs. Exclusive area representation is sometimes required. Advertising costs are split: 75% paid by talent; 25% paid by representative. For promotional purposes, talent must provide 8×10 transparencies and usually promotion in at least one sourcebook. Advertises in *American Showcase*, *Black Book*, *RSVP*, *The Workbook*.
How to Contact: For first contact, send direct mail flier/brochure, tearsheets, slides. Responds in 1 week. After initial contact, drop off or mail in appropriate materials for review. Portfolio should include original art, tearsheets, slides, photographs.

MONTAGANO & ASSOCIATES, 211 E. Ohio, #2006, Chicago IL 60611. (312)527-3283. Fax: (312)527-2108. E-mail: dm@davidmontagano.com. Website: davidmontagano.com. **Contact:** David Montagano. Commercial illustration, photography and television production representative and broker. Estab. 1983. Represents 8 illustrators, 3 photographers. Markets include: advertising agencies; corporations/client direct; design firms; editorial/magazines; paper products.
Handles: Illustration, photography, design, marker and storyboard illustration.
Terms: Rep receives 30% commission. No geographic restrictions. Advertises in *American Showcase*, *The Workbook*, *CIB*.
How to Contact: For first contact, send direct mail flier/brochure, tearsheets, photographs. Portfolio should include original art, tearsheets, photographs.

MORGAN GAYNIN INC., 194 Third Ave., New York NY 10003. (212)475-0440. Fax: (212)353-8538. E-mail: info@morgangaynin.com. Website: www.morgangaynin.com. **Partners:** Vicki Morgan and Gail Gaynin. Commercial illustration representative. Estab. 1974. Member of SPAR, Graphic Artists Guild, Society of Illustrators, AIGA. Markets include: advertising agencies; corporations/client direct; design firms; magazines; books; sales/promotion firms.
Handles: Illustration. "Fulltime illustrators only."
Terms: Rep receives 30% commission. Exclusive area representation is required. No geographic restrictions. Advertising costs are split: 70% paid by talent; 30% paid by representative. "We require samples for three duplicate portfolios; the presentation form is flexible." Advertises in directories, on the Web, direct mail.
How to Contact: For first contact, send any of the following: direct mail flier/brochure, tearsheets, slides with SASE. "If interested, we keep on file and consult these samples first when considering additional artists. No drop-off policy." Obtains new talent through "recommendations from artists we represent and from artists' samples on file."

[N] MUNRO CAMPAGNA, 630 N. State St., Chicago IL 60610. (312)321-1336. Fax: (312)321-1350. E-mail: steve@munrocampagna.com. Website: www.munrocampagna.com. **President:** Steve Munro. Commercial illustration, photography representative. Estab. 1987. Member of SPAR, CAR (Chicago Artists Representatives). Represents 22 illustrators, 2 photographers. Markets include advertising agencies; corporations/client direct; design firms; publishing/books. Represents: Pat Dypold and Douglas Klauba.
Handles: Illustration.
Terms: Rep receives 25-30% commission. Exclusive area representation is required. Advertising costs are split: 75% paid by talent; 25% paid by representative. For promotional purposes, talent must provide 2 portfolios. Advertises in *American Showcase*, *Black Book*, *The Workbook*.

How to Contact: For first contact, send query letter, bio, tearsheets and SASE. Responds in 2 weeks. After initial contact, write to schedule an appointment. Portfolio should include 4×5 or 8×10 transparencies.

THE NEWBORN GROUP, INC., 115 W. 23rd St., Suite 43A, New York NY 10011. (212)989-4600. Fax: (212)989-8998. Website: www.newborngroup.com. **Owner:** Joan Sigman. Commercial illustration representative. Estab. 1964. Member of SPAR, Society of Illustrators, Graphic Artists Guild. Represents 12 illustrators. Markets include: advertising agencies; design firms; editorial/magazines; publishing/books. Clients include Leo Burnett, Berkley Publishing, Weschler Inc.
Handles: Illustration.
Terms: Rep receives 25% commission. Exclusive area representation is required. Advertising costs are split: 75% paid by talent; 25% paid by representative. Advertises in *American Showcase*, *The Workbook*, *Directory of Illustration*.
How to Contact: "Not reviewing new talent."
Tips: Obtains new talent through recommendations from other talent or art directors.

LORI NOWICKI AND ASSOCIATES, 310 W. 97th St., #24, New York NY 10025. E-mail: lori@lorinowicki.com. Website: www.lorinowicki.com. Estab. 1993. Represents 20 illustrators. Markets include: advertising agencies; design firms; editorial/magazines; publishing/books; children's publishing.
Handles: Illustration.
Terms: Rep receives 25-30% commission. Cost for direct mail promotional pieces is paid by illustrator. Exclusive area representation is required. Advertising costs are split: 75% paid by talent; 25% paid by representative. Advertises in *The Workbook*, *Black Book*, *Showcase*, *Directory of Illustration*.
How to Contact: For first contact, send query letter, résumé, tearsheets or e-mail a link to your website. Samples are not returned. "Do not phone, do not e-mail attachments, will contact if interested." Wants artists with consistent style. "We are aspiring to build a larger children's publishing division."

N **CAROLYN POTTS & ASSOC. INC.**, 848 Dodge Ave., #236, Evanston IL 60202. (847)864-7644. E-mail: carolyn@cpotts.com. **President:** Carolyn Potts. Commercial photography, illustration representative. Estab. 1976. Member of SPAR, CAR (Chicago Artists Reps). Represents photographers and illustrators. Specializes in contemporary advertising and design. Markets include: advertising agencies; corporations/client direct; design firms; publishing/books. Artists include Julia La Pine, John Craig, Rhonda Voo and Karen Bell.
Handles: Illustration, photography. Looking for "artists able to work with new technologies (interactive, computer, etc.)."
Terms: Rep receives 30-35% commission. Artists share cost of their direct mail postage and preparation. Exclusive area representation is required. Advertising costs are split: 70% paid by the talent; 30% paid by the representative after initial trial period wherein artist pays 100%. For promotional purposes, talent must provide direct mail piece and multiple portfolios. Advertises in *American Showcase*, *Black Book*, *The Workbook*, *Single Image*.
How to Contact: For first contact, send direct mail flier/brochure and SASE. Responds in 3 days. After initial contact, write to schedule an appointment. Portfolio should include tearsheets, slides, photographs.
Tips: Looking for artists with high level of professionalism, awareness of current advertising market, professional presentation materials (that includes a digital portfolio) and positive attitude.

CHRISTINE PRAPAS/ARTIST REPRESENTATIVE, 12480 SE Wiese Rd., Boring OR 97009. (503)658-7070. Fax: (503)658-3960. E-mail: cprapas@teleport.com. Website: www.christineprapas.com. **Contact:** Christine Prapas. Commercial illustration and photography representative. Estab. 1978. Member of AIGA and Graphic Artists Guild. "Promotional material welcome."

GERALD & CULLEN RAPP, INC., 108 E. 35th St., New York NY 10016. (212)889-3337. Fax: (212)889-3341. E-mail: lara@rappart.com. Website: www.theispot.com/rep/rapp. **Contact:** Lara Tomlin. Commercial illustration representative. Estab. 1944. Member of SPAR, Society of Illustrators, Graphic Artists Guild. Represents 50 illustrators. Markets include: advertising agencies; corporations/client direct; design firms; editorial/magazines; paper products/greeting cards; publishing/books; sales/promotion firms. Represents: Jonathan Carlson, Mark Rosenthal, Seth and James Steinberg.
Handles: Illustration.
Terms: Rep receives 25-30% commission. Exclusive area representation is required. No geographic restrictions. Split of advertising costs is negotiated. Advertises in *American Showcase*, *The Workbook*,

Graphic Artists Guild Directory and *CA*, *Print* magazines. "Conducts active direct mail program and advertises on the Internet."

How to Contact: For first contact, send query letter, direct mail flier/brochure or e-mail with no more than 1 image attached. Responds in 1 week. After initial contact, call for appointment to show portfolio of tearsheets, slides. Obtains new talent through recommendations from others, solicitations.

N̄ THE RAPPAPORT AGENCY, 1812 Ivar Ave., Bungalow 8, Hollywood CA 90028. (323)464-4481. Fax: (323)464-5030. Website: www.rappagency.com. **Contact:** Jodi Rappaport or Del Martin. Commercial photography, graphic design, stylist and art director representative. Estab. 1987. Member of SPAR. Represents 3 photographers, 2 designers. Markets include: advertising agencies; corporations/client direct; design firms; editorial/magazines; sales/promotion firms. Clients include galleries.

Handles: Photography, design.

Terms: Rep receives 25% commission. Charges for messengers and air courier per charges incurred. Exclusive area representation is required. Advertising costs are paid by talent. For promotional purposes, talent must provide direct mail pieces, professional portfolio presentation.

How to Contact: For first contact, send direct mail flier/brochure. Responds in 1 week, only if interested. After initial contact, drop off portfolio for review. "If interested, I will call to set up meeting. Portfolio content depends upon the client and what presentation form is appropriate for the work."

Tips: "I generally only take meeting with photographers who are recommended to me. Otherwise, I keep promos on file. Books are seen on a drop-off basis only. Any photographer interested in seeking representation should research the talent the rep is working with so they have an idea if the rep is appropriate for their needs. They should be clear about their focus and direction, and know what venues they would like to explore. They should have a great, strong presentation."

REPERTOIRE, 2029 Custer Pkwy., Richardson TX 75080. (972)761-0500. Fax: (972)761-0501. E-mail: info@repertoireart.com. Website: www.repertoireart.com. **Contact:** Andrea Lynch (illustration). Commercial illustration and photography representative and broker. Estab. 1974. Member of SPAR. Represents 3 illustrators and 10 photographers. Specializes in "importing specialized talent into the Southwest." Markets include advertising agencies, corporations/client direct, design firms, editorial/magazines. Artists include Marc Hauser, Gary John Norman and Gary Parker.

Handles: Illustration, photography, design.

Terms: Rep receives 25-30% commission. Exclusive area representation is required. Advertising costs are split; printing costs are paid by talent; distribution costs are paid by representative. Talent must provide promotion, both direct mail and a national directory. Advertises in *The Workbook* and *Black Book*.

How to Contact: For first contact, send direct mail flier/brochure, tearsheets. Responds in 1 month. After initial contact, write for appointment or drop off or mail portfolio of tearsheets, slides, photographs. Obtains new talent through referrals, solicitations.

Tips: Looks for "sense of humor, honesty, maturity of style, ability to communicate clearly and relevance of work to our clients."

N̄ REPFILE, 837 E. 17th Ave., Suite 3C, Denver CO 80218. (303)504-0805. E-mail: michelle@repfile.c om. Website: www.repfile.com. **Contact:** Michelle Desloge, president/owner. Commercial/fine art talent rep. Estab. 1998. Member of ADCD/AIGA. Represents 1 fine artist, 3 illustrators, 10 photographers, 1 animator. Markets include advertising agencies, design firms, galleries, corporations/client direct, private collections. Artists include Yasmin Adl-Esfandiary, Doug Applegate.

Handles: Fine art, photography, illustration.

Terms: Rep receives variable commission. Advertising costs are paid by artist. For promotional purposes, talent must provide portfolios, direct mail campaign (active), rational ad in sourcebooks, *Creative Black Book*, *Directory of Illustration*.

How to Contact: Send query letter with bio, direct mail flier/brochure, e-mail portfolio. Responds only if interested. Portfolio should include slides (that do not need to be returned to talent), e-mail samples.

Tips: "Do not approach a rep without first sending samples of work. My pet peeve is receiving a phone call/message wanting to set-up an appointment before I even know the caliber of work. Always send samples with introduction."

N̄ RETROREPS (A DIVISION OF MARTHA PRODUCTIONS), 7550 W. 82nd St., Playa Del Rey CA 90293. (310)670-5300. Fax: (310)670-3644. E-mail: marthaprod@earthlink.net. Website: www.ret roreps.com. **Contact:** Martha Spelman. Commercial illustration representative. Estab. 1998. Represents

\mathcal{G}et a **FREE ISSUE** of *Watercolor Magic!*

From the Publishers of *The Artist's Magazine* and *Artist's and Graphic Designer's Market*

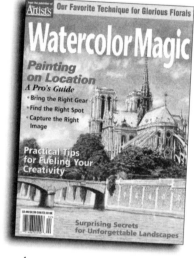

\mathcal{P}acked with innovative ideas, creative inspiration, and detailed demonstrations from the best watermedia artists in the world, *Watercolor Magic* will offer you everything you need to take your art to the next level. You'll learn how to:

- Choose a great subject every time

- Capture light and shadows to add depth and drama

- Experiment by combining media

- Master shape, detail, texture and color

- Explore cutting-edge techniques and materials

- Get inspired and create breathtaking art!

See for yourself how *Watercolor Magic* will help you turn ordinary works into extraordinary art. Mail the card below for your FREE TRIAL ISSUE!

PROCESS IMMEDIATELY!

19 illustrators, 1 photographer. Specializes in artists and a photographer working in retro styles from the 1920s through 1970s. Licenses illustrators and photographers. Artists include Bruce Sereta, John Kachik, Tom Nikosey.

• See listing for Martha Productions.

Handles: Interested in illustration and photography.

THE ROLAND GROUP, 4948 St. Elmo Ave., Suite #201, Bethesda MD 20814. (301)718-7955. Fax: (301)718-7958. E-mail: info@therolandgroup.com. Website: www.therolandgroup.com. Commercial illustration and photography representative. Estab. 1988. Member of SPAR, Society of Illustrators, Ad Club, Production Club. Represents 20 illustrators and over 200 photographers. Markets include: advertising agencies; corporations/client direct; design firms; editorial/magazines; paper products/greeting cards; publishing books.

Handles: Illustration and photography.

Terms: Rep receives 35% commission. Exclusive and non-exclusive representation available. Also work with artists on a project-by-project basis. For promotional purposes, talent must provide 8½×11 promo sheet. Advertises in *American Showcase*, *The Workbook*, *International Creative Handbook*, *Black Book* and *KLIK*.

How to Contact: For first contact, send query letter, tearsheets and photocopies. Responds only if interested. Portfolio should include nonreturnable tearsheets, photocopies.

ROSENTHAL REPRESENTS, 3850 Eddingham Ave., Calabasas CA 91302. (818)222-5445. Fax: (818)222-5650. E-mail: eliselicenses@hotmail.com. Commercial illustration representative and licensing agent for artists who do advertising, entertainment, action/sports, children's books, giftware, collectibles, figurines, children's humorous, storyboard, animal, graphic, floral, realistic, impressionistic and game packaging art. Estab. 1979. Member of SPAR, Society of Illustrators, Graphic Artists Guild, Women in Design and Art Directors Club. Represents 100 illustrators, 2 designers and 5 fine artists. Specializes in game packaging, personalities, licensing, merchandising art and storyboard artists. Markets include: advertising agencies; corporations/client direct; paper products/greeting cards; sales/promotion firms; licensees and manufacturers.

Handles: Illustration.

Terms: Rep receives 30% as a rep; 50% as a licensing agent. Exclusive area representation is required. No geographic restrictions. Advertising costs are paid by talent. For promotion purposes, talent must provide 1-2 sets of transparencies (mounted and labeled). Also include 1-3 promos. Advertises in *American Showcase* and *The Workbook*.

How to Contact: For first contact, send direct mail flier/brochure, tearsheets, slides, photocopies, photostats and SASE. Responds in 1 week. After initial contact, call for appointment to show portfolio of tearsheets, slides, photographs, photocopies.

Tips: Obtains new talent through seeing their work in an advertising book or at award shows, *Art Decor*, *Art Business News* and by referrals.

⊞ S.I. INTERNATIONAL, 43 E. 19th St., New York NY 10003. (212)254-4996. Fax: (212)995-0911. E-mail: hspiers@si-i.com. Website: www.si-i.com. **Artists Relations:** Donald Bruckstein. Commercial illustration representative. Estab. 1983. Member of SPAR, Graphic Artists Guild. Represents 50 illustrators. Specializes in license characters, educational publishing and children's illustration, digital art and design, mass market paperbacks. Markets include design firms; publishing/books; sales/promotion firms; licensing firms; digital art and design firms.

Handles: Illustration. Looking for artists "who have the ability to do children's illustration and to do license characters either digitally or reflectively."

Terms: Rep receives 25-30% commission. Advertising costs are split: 70% paid by talent; 30% paid by representative. "Contact agency for details. Must have mailer." Advertises in *Picture Book*.

How to Contact: For first contact, send query letter, tearsheets. Responds in 3 weeks. After initial contact, write for appointment to show portfolio of tearsheets, slides.

⊞ LIZ SANDERS AGENCY, 2415 E. Hangman Creek Lane, Spokane WA 99224. (509)993-6400. Fax: (509)466-5400. E-mail: liz@lizsanders.com. Website: http://lizsanders.com. **Contact:** Liz Sanders, owner. Commercial illustration representative. Estab. 1985. Represents 10 illustrators. Specializes in marketing of individual artists within an ever-evolving illustration world. Markets include advertising agencies,

corporations/client direct, design firms, editorial/magazines, juvenile markets, paper products/greeting cards, publishing/books, record companies, sales/promotion firms.

Handles: Interested in illustration. Looking for fresh, unique talent committed to long term careers whereby the agent/talent relationship is mutually respectful, responsive and measurably successful.

Terms: Rep receives 25-30% commission. Exclusive representation required. Advertises in *Picturebook*, *American Showcase*, *Workbook*, *Directory of Illustration*, direct mail material, traditional/electronic portfolio for agent's personal presentations, means to advertise if not substantially, then consistently.

How to Contact: For first contact, send direct mail flier/brochure, nonreturnables, photocopies and tearsheets. Responds only if interested. After initial contact, call to schedule an appointment, depending on geographic criteria. Portfolio should include tearsheets, photocopies and digital output.

Tips: "Concisely present a single, focused style supported by 8-12 strong samples. Only send a true portfolio upon request."

✔ **JOAN SAPIRO ART CONSULTANTS**, 4750 E. Belleview Ave., Greenwood Village CO 80121. (303)793-0792. Fax: (303)290-9204. E-mail: jsac@qwest.net. **Contact:** Laura Hohlfield or Joan Sapiro. Estab. 1980. Specializes in "corporate art with other emphasis on hospitality, health care and art consulting/advising to private collectors."

Handles: All mediums of artwork and all prices if applicable for clientele.

Terms: Artist must be flexible and willing to ship work on consignment. Also must be able to provide sketches, etc. if commission piece involved. No geographic restrictions.

How to Contact: For first contact, send résumé, bio, direct mail flier/brochure, tearsheets, slides, photographs, price list—net (wholesale) and SASE. After initial contact, drop off or mail in appropriate materials for review.

Tips: Obtains new talent through recommendations, publications, travel, research, university faculty.

N **THE SCHUNA GROUP INC.**, 1503 Briarknoll Dr., Arden Hills MN 55112. (651)631-8480. Fax: (651)631-8426. E-mail: joanne@schunagroup.com. Website: www.schunagroup.com. **Contact:** JoAnne Schuna, owner. Commercial illustration representative. Represents 15 illustrators. Specializes in illustration. Markets include advertising agencies, corporations/client direct, design firms, editorial/magazines, paper products/greeting cards, publishing/books, record companies, sales/promotion firms. Artists include Cathy Gendron, Jim Dryden.

Handles: Interesting in receiving illustration.

Terms: Rep receives 25% commission. Exclusive representation required. Advertising costs are split: 75% paid by artist; 25% paid by rep. Advertises in *Workbook* and by direct mail.

How to Contact: For first contact, send query letter with photocopies, SASE and tearsheets. Responds in 2 weeks. After initial contact, wait for response. Portfolio should include finished art, tearsheets, transparencies.

Tips: "Send (either by mail or e-mail) a couple of tearsheets with a brief note initially. If the rep is interested, she will respond and arrange a scenario where she can look at additional work."

FREDA SCOTT, INC., 383 Missouri St., San Francisco CA 94107. (415)550-9121. Fax: (415)550-9120. E-mail: freda@fredascott.com. Website: www.fredascott.com. **Contact:** Freda Scott. Commercial illustration and photography representative. Estab. 1980. Member of SPAR. Represents 10 illustrators, 15 photographers. Markets include: advertising agencies; corporations/client direct; design firms; editorial/magazines; paper products/greeting cards; publishing/books; sales/promotion firms. Clients include J. Walter Thompson, Anderson & Lembke, Oracle Corp., Sun Microsystems. Client list available upon request.

Handles: Illustration, photography.

Terms: Rep receives 25% commission. No geographic restrictions. Advertising costs are split: 75% paid by talent; 25% paid by representative. For promotional purposes, talent must provide "promotion piece and ad in a directory. I also need at least three portfolios." Advertises in *American Showcase*, *Black Book*, *The Workbook*.

How to Contact: For first contact, send direct mail flier/brochure, tearsheets and SASE. If you send transparencies, responds in 1 week, if interested. "You need to make follow-up calls." After initial contact, call for appointment to show portfolio of tearsheets, photographs, 4×5 or 8×10.

Tips: Obtains new talent sometimes through recommendations, sometimes solicitation. "If you are seriously interested in getting repped, keep sending promos—once every six months or so. Do it yourself a year or two until you know what you need a rep to do."

FRAN SEIGEL, ARTISTS AND LICENSING, (formerly Fran Seigel, Artist Representative), 160 W. End Ave., #23-S, New York NY 10023. (212)712-0830. Fax: (212)712-0857. Website: www.fsartists.com. Commercial illustration. Estab. 1982. Member of SPAR. Represents 6 illustrators. Specializes in stylized realism leaning toward the conceptual or fantasy direction. Markets include advertising agencies; client direct; design firms; magazines; paper products/greeting cards; book jackets; licensing.
Handles: Illustration, fine art. "Artists in my group must have work applicable to my key markets: book jackets and a high level unique style. Themed groups of works and/or multicultural subjects is also a plus."
Terms: Rep receives 30% commission. Exclusive national representation is required. Advertising costs are split: 70% paid paid by talent; 30% paid by representative. "First promotion is designed by both of us, paid for by talent; subsequent promotion costs are split." Advertises in *Graphic Artists Guild Directory of Illustration.*
How to Contact: For first contact, send 12-20 images, direct mail flier/brochure, tearsheets, slides and SASE. Responds in 2 weeks only if SASE is included.
Tips: Looking for artists with " 'uniquely wonderful' artwork, vision and energy, market-oriented portfolio, and absolute reliability and professionalism. Prefer talent with a minimum of three to five years freelance experience. Artists with high level work in the fantasy genre or in ethnic or multicultural markets may forward a selection of prints for consideration. Excellent figure work and artwork in themed groups are very important. Reply sent only if SASE included."

N SIMPATICO ART & STONE, 1221 Demaret Lane, Houston TX 77055-6115. (713)467-7123. **Contact:** Billie Blake Fant. Fine art broker/consultant/exhibitor. Estab. 1973. Specializes in unique fine art, sculpture and Texas domestic stone furniture, carvings, architectural elements. Market includes: corporate; institutional and residential clients.
Handles: Unique fine art and sculpture not presently represented in Houston, Texas.
Terms: Standard commission. Exclusive area representation required.
How to Contact: For first contact, send query letter, résumé, slides. Obtains new talent through travel, publications, exhibits and referrals.

SUSAN AND CO., 5002 92nd Ave. SE, Mercer Island WA 98040. (206)232-7873. Fax: (206)232-7908. E-mail: susan@susanandco.com. Website: www.susanandco.com. **Owner:** Susan Trimpe. Commercial illustration, photography representative. Estab. 1979. Member of SPGA. Represents 19 illustrators, 2 photographers. Specializes in commercial illustrators. Markets include advertising agencies; corporations/client direct; design firms; publishing/books. Artists include: Bryn Barnard, Linda Ayriss and Larry Jost.
Handles: Looks for "current illustration styles."
Terms: Rep receives 30% commission. Charges postage if portfolios are shipped out of town. National representation is required. Advertising costs are split: 70% paid by talent; 30% paid by representative. "Artists must take out a page in a publication, i.e., *American Showcase*, and *The Workbook* with rep."
How to Contact: For first contact, send query letter and direct mail flier/brochure. Responds in 2 weeks only if interested. After initial contact, call to schedule an appointment. Portfolio should "be representative of unique style."
Tips: Wants artists with "unique well-defined style and experience."

✓ THOSE 3 REPS, 2909 Cole, Suite #333, Dallas TX 75204. (214)871-1316. Fax: (214)880-0337. **Contact:** Debbie Bozeman, Carol Considine, Lisa Button. Artist representative. Estab. 1989. Member of Dallas Society of Visual Community, ASMP, SPAR and Dallas Society of Illustrators. Represents 15 illustrators, 8 photographers. Specializes in commercial art. Markets include: advertising agencies; corporations/client direct; design firms; editorial/magazines.
Handles: Illustration, photography (including digital).
Terms: Rep receives 30% commission; 30% for out-of-town jobs. Exclusive area representation is required. Advertising costs are split: 70% paid by talent; 30% paid by representative. For promotional purposes, talent must provide 2 new pieces every 2 months, national advertising in sourcebooks and at least 1 mailer. Advertises in *Workbook*, own book.
How to Contact: For first contact, send query letter and tearsheets. Responds in days or weeks only if interested. After initial contact, call to schedule an appointment, drop off or mail in appropriate materials. Portfolio should include tearsheets, photostats, transparencies, digital prints.
Tips: Wants artists with "strong unique consistent style."

N THREE IN A BOX INC., 468 Queen St. E, Suite 104, Toronto, ON M5A 1T7 Canada. (416)367-2446. Fax: (416)367-3362. E-mail: info@threeinabox.com. Website: threeinabox.com. **Contact:** Holly

Venable, managing director. Commercial illustration representative. Estab. 1990. Member of Graphic Artists Guild. Represents 53 illustrators, 2 photographers. Specializes in illustration. Licenses illustrators and photographers. Markets include advertising agencies, corporations/client direct, design firms, editorial/magazines, paper products/greeting cards, publishing/books, record companies, sales/promotion firms. Artists include Otto Steininger, Martin O'Neill and Peter Ferguson.

Handles: Illustration. Looking for advertising, infographic specialists and illustrators with a solid portfolio of editorial work in one style.

Terms: Rep receives 30% commission. Exclusive representation required. Advertising costs are split: 70% paid by artist; 30% paid by rep. Contact (UK).

How to Contact: For first contact, send query letter to info@threeinabox.com, URL. Responds in 1 week. After initial contact, we'll call if interested. Portfolio should include digital.

Tips: "Try to specialize/you can't do everything well."

T-SQUARE, ETC., 1426 Main St., Venice CA 90291. (310)581-2200. Fax: (310)581-2204. E-mail: diane@t-squareetc.com. Website: www.t-squareetc.com. **Managing Director:** Diane Pirritino. Graphic design representative. Estab. 1990. Member of Advertising Production Association of California, Ad Club of LA. Represents 50 illustrators, 100 designers. Specializes in computer graphics. Markets include advertising agencies; corporations/client direct; design firms; editorial/magazines.

Handles: Design.

Terms: Rep receives 25% commission. Advertising costs are split: 25% paid by talent; 75% paid by representative. For promotional purposes, talent must provide samples from their portfolio (their choice).

How to Contact: For first contact, send résumé. Responds in 5 days. After initial contact, call to schedule an appointment. Portfolio should include thumbnails, roughs, original art, tearsheets, slides.

Tips: Artists must possess "good design, computer skills, flexibility, professionalism."

CHRISTINA A. TUGEAU: ARTIST AGENT, 110 Rising Ridge Rd., Ridgefield CT 06877. (203)438-7307. Fax: (203)894-1993. E-mail: catartrep@aol.com. Website: www.catugeau.com. **Owner:** Chris Tugeau. Children's publishing market illustration representative K-12. Estab. 1994. Member of Graphic Artists Guild, SPAR, SCBWI. Represents 40 illustrators. Specializes in children's book publishing and educational market and related areas. Represents: Stacey Schuett, Larry Day, Bill Farnsworth, Melissa Iwai, Keiko Motoyama, Teri Sloat, Jason Wolff, Jeremy Tugeau, Priscilla Burris, John Kanzler, Ann Barrow, Lisa Carlson, Heather Maione and others.

Handles: Illustration. Must be proficient at illustrating children and animals in a variety of interactive situations, backgrounds, full color/b&w, and with a strong narrative sense.

Terms: Rep receives 25% commission. Exclusive USA representation is required. For promotional purposes, talent must provide a direct mail promo piece, 8-10 good "back up" samples (multiples), 3 strong portfolio pieces. Advertises in *RSVP* and *GAG Directory of Illustration* and *Picturebook*.

How to Contact: For first contact, send direct mail flier/brochure, tearsheets, photocopies, books, SASE, "prefer no slides! No originals." Responds by 2 weeks. No initial e-mailed samples, please.

Tips: "You should have a style uniquely and comfortably your own and be great with deadlines. Will consider young, new artists to the market with great potential and desire, as well as published, more experienced illustrators. Best to study and learn the market standards and expectations by representing yourself for a while when new to the market."

☑ **JAE WAGONER, ARTIST REPRESENTATIVE**, P.O. Box 1259, Alta CA 95701. Website: www.jaewagoner.com. **Contact:** Jae Wagoner "by mail only—send copies or tear sheets only for us to keep—do not call!" Commercial illustration representative. Estab. 1975. Represents 20 illustrators and FLASH artists. Markets include: advertising agencies; corporations/client direct; design firms; editorial/magazines; paper products/greeting cards; publishing/books; sales/promotion firms.

 • This rep's street address is 33885 Nary Red Rd., Alta CA 95701. However, all mail should go to the P.O. Box.

Handles: Illustration, FLASH web animation.

Terms: Agent receives 30% commission. Exclusive area representation required. Advertising costs depend. For promotional purposes talent must advertise once a year in major promotional book (ex: Workbook) exclusively with us. "Specifications and details are handled privately." Advertises in *The Workbook*.

How to Contact: When making first contact, send: query letter (with other reps mentioned), photocopies ("examples to keep only. No unsolicited work returned.") Responds in weeks only if interested. After initial contact, talent should wait to hear from us.

Tips: "We select first from 'keepable' samples mailed to us. The actual work determines our interest, not verbal recommendation or résumés. Sometimes we search for style we are lacking. It is *not* a good idea to call a rep out of the blue. You are just another voice on the phone. What is important is your work, *not* who you know, where you went to school, etc. Unsolicited work that needs to be returned creates a negative situation for the agent. It can get lost, and the volume can get horrendous. Also—do your homework—do not call and expect to be given the address by phone. It's a waste of the rep's time and shows a lack of effort. Be brief and professional." Sometimes, even if an artist can't be represented, Jae Wagoner provides portfolio reviews, career counseling and advice for an hourly fee (with a 5 hour minimum fee). If you are interested in this service, please request this in your cover letter.

☑ **GWEN WALTERS**, 269 Ridgeview Dr., Palm Beach FL 33480. (561)848-3362. E-mail: Artincgw@ aol.com. Website: www.GwenWaltersartrep.com. Commercial illustration representative. Estab. 1976. Member of Graphic Artists Guild. Represents 17 illustrators. "I lean more toward book publishing." Markets include: advertising agencies; corporations/client direct; editorial/magazines; paper products/greeting cards; publishing/books; sales/promotion firms. Represents: Gerardo Suzan, Fabricio Vanden Broeck, Resario Valderrama, Lave Gregory, Susan Spellman, Sally Schaedler, Judith Pfeiffer, Yvonne Gilbert, Gary Torrisi, Larry Johnson, Pat Davis and Linda Pierce.
Handles: Illustration.
Terms: Rep receives 30% commission. Charges for color photocopies. Advertising costs are split; 50% paid by talent; 50% paid by representative. For promotional purposes, talent must provide direct mail pieces. Advertises in *RSVP*, *Directory of Illustration* and *Picture Book*.
How to Contact: For first contact, send résumé bio, direct mail flier/brochure. After initial contact, representative will call. Portfolio should include "as much as possible."
Tips: "You need to pound the pavement for a couple of years to get some experience under your belt. Don't forget to sign all artwork. So many artists forget to stamp their samples."

[N] **WATSON & SPIERMAN PRODUCTIONS**, 636 Broadway, Suite 708, New York NY 10012. (212)431-4480. Fax: (212)253-9996. E-mail: email@watsonspierman.com. Website: www.watsonspierman .com. Commercial illustration/photography representataive, Estab. 1992. Member of SPAR. Represents 4 fine artists, 8 illustrators, 8 photographers. Specializes in general illustration, photography. Markets include advertising agencies, design firms, galleries, paper products/greeting cards, record companies, publishing/ books, sales/promotion firms, corporations/client direct, editorial/magazines. Artists include Kan, Monica Lind, Daniel Arsenault, Ian Bradshaw, Adam Brown, Bryan Helm, Joseph Ilan, Frank Siteman, North Sullivan, Kim Harlow, Annabelle Verhoye.
Handles: Fine art, illustration, photography.
Terms: Rep receives 30% commission. Exclusive representation required. Advertising costs are paid by artist. Artist must publish every year in a sourcebook with all Watson & Spierman talent. Advertises in *American Showcase*, *Workbook*.
How to Contact: For first contact, send link to website. Responds only if interested. After initial contact, drop off or mail portfolio. Portfolio should include b&w, color, finished art, original art, photographs, tearsheets.
Tips: "We love to hear if an artist has an ad out or recently booked a job. Those are the updates that are most important to us."

[N] **WILEY ART GROUP**, 1535 Green St., Suite 301, San Francisco CA 94123. (415)441-3055. Fax: (415)441-6200. E-mail: david@wileyartgroup.com. Website: www.wileyartgroup.com. **Contact:** David Wiley. Commercial and fine art illustration and photography representative. Estab. 1984. Member of AIP (Artists in Print). Society of Illustrators, Graphic Artists Guild, Bay Area Lawyers for the Arts. Represents 6 illustrators and 1 photographer. Specializes in "being different and effective!" Clients include Coke, Pepsi, Robert Mondavi. Client list available upon request.
Terms: Agent receives 30% commission. No geographical restriction. Artist is responsible for all portfolio costs. Artist pays for sourcebook ads, postcard, tearsheet mailing. Agent will reimburse artist for 30% of page costs through commissioned jobs. Each year the artists are promoted in *American Showcase*, *Black Book* and *Workbook*, *Directory of Illustration*, and through direct mail (tearsheets and quarterly postcard mailings).
How to Contact: For first contact, send tearsheets or copies of your work accompanied by SASE. If interested, agent will call back to review portfolio, which should include commissioned and non-commissioned work.

Tips: "The bottom line is that a good agent will get you *more* work at *better rates* of pay. More work because clients come to us knowing that we only represent serious professionals. Better rates because our clients know that we have a keen understanding of what the market will bear and what the art is truly worth."

DEBORAH WOLFE LTD., 731 N. 24th St., Philadelphia PA 19130. (215)232-6666. Fax: (215)232-6585. Website: www.illustrationOnLine.com. **Contact:** Deborah Wolfe. Commercial illustration representative. Estab. 1978. Represents 25 illustrators. Markets include: advertising agencies; corporations/client direct; design firms; editorial/magazines; publishing/books.
Handles: Illustration.
Terms: Rep receives 25% commission. Advertises in *American Showcase*, *Black Book*, *The Workbook*, *Directory of Illustration* and *Picturebook*.
How to Contact: For first contact, send direct mail flier/brochure, tearsheets, slides. Responds in 3 weeks.

Organizations, Publications & Websites for Art Professionals

There are literally millions of artist- and designer-related websites out there. Here are just a few that we at *Artist's & Graphic Designer's Market* think are particularly useful.

BUSINESS

ARTS BUSINESS EXCHANGE: www.artsbusiness.com. *Sign up for the free e-mail newsletter and get updates on trends, Canadian art news, sales data and art law and policy.*

STARVING ARTISTS LAW: www.starvingartistslaw.com. *Start here for answers to your legal questions.*

TERA'S WISH: wwww.teras-wish.com/marketing
Tera Leigh, author of How to Be Creative If You Never Thought You Could *(North Light Books) shares tips and ideas for marketing, promotion, P.R. and more.*

ILLUSTRATORS

ALTPICK.COM: The Source for Creative Talent & Imagination: www.altpick.com. *News, competition deadlines, artist listings and much more. Check out the wealth of information listed.*

ASSOCIATION OF MEDICAL ILLUSTRATORS: www.ami.org. *A must visit for anyone interested in the highly specialized niche of medical illustration.*

CANADIAN ASSOCIATION OF PHOTOGRAPHERS, ILLUSTRATORS IN COMMUNICATIONS (CAPIC): www.capic.org. *There's a ton of copyright and industry news and articles on this site, also help with insurance, lawyers, etc.*

CANADIAN SOCIETY OF CHILDREN'S AUTHORS, ILLUSTRATORS AND PERFORMERS: www.canscaip.org. *This organization promotes all aspects of Children's writing, illustration and performance.*

THE DRAWING BOARD: members.aol.com/thedrawing. *Get everything here from pricing guidelines to events, tips to technique.*

GREETING CARD ASSOCIATION: www.greetingcard.org. *A great place for learning about and networking in the greeting card industry.*

MAGATOPIA: www.magatopia.com. *Online magazine articles, web searches for art jobs, weekly columns on freelancing. . . . there's a lot to explore at this site.*

MAGAZINES A-Z: www.magazinesatoz.com. *This is a straightforward listing to a bunch of magazines.*

THE MEDICAL ILLUSTRATORS HOME PAGE: www.medartist.com. *A site for medical illustrators who want to post their work for stock imagery or view others work.*

SOCIETY OF CHILDREN'S BOOK WRITERS AND ILLUSTRATORS: www.scbwi.org. *With chapters all over the world, SCBWI is the premier organization for professionals in children's publishing.*

THE SOCIETY OF ILLUSTRATORS: www.societyillustrators.org. *Since 1901, this organization has been working to promote the interest of professional illustrators. Information on exhibitions, career advice, and many other links provided.*

WRITERS WRITE: GREETING CARDS: www.writerswrite.com/greetingcards. *This site has links for artists with greeting card companies and submission information.*

FINE ARTISTS

ART DEADLINES LIST: www.artdeadlineslist.com. *The e-mail version of this list is free. It's a great source for deadlines for calls for entries, competitions, scholarships, festivals and more.*

ART DEALERS ASSOCIATION OF AMERICA: www.artdealers.org. *Opportunities and information on marketing your work, galleries and dealers.*

ARTDEADLINE.COM: artdeadline.com. *Called the "Art Professional's Resource," this site lists information for funding, grants, commissions for art in public places, representation. . . . the list goes on and on.*

ARTIST HELP NETWORK: www.artisthelpnetwork.com. *Find career, legal, money advice along with multiple regional, national and international resources.*

ARTIST REGISTRY: www.artistregistry.com. *A registry where you can post art, get updates on calls for entries throughout the United States and much more.*

THE ARTIST'S NETWORK: www.artistsnetwork.com. *Get articles, excerpts and tips from* The Artist Magazine, Watercolor Magic, *and* Decorative Artist's Workbook.

ARTLINE: www.artline.com. *Artline is comprised of 7 dealer associations, Art Dealers Association of America, Art Dealers Association of Greater Washington, Association of International Photography Art Dealers, Chicago Art Dealers Association, International Fine Print Dealers Association, San Francisco Art Dealers Association, and Society of London Art Dealers. The website has information about exhibits and artists worldwide.*

NEW YORK FOUNDATION FOR THE ARTS: www.nyfa.org. *With news, searchable database of opportunities for artists, links to other useful sites such as databases of galleries and the Artist's Community Federal Credit Union-this site is loaded!*

CARTOONISTS & COMIC BOOK ARTISTS

CARTOONISTS ASSOCIATION: www.cartoonistsassociation.com. *A website/organization for cartoonists, by cartoonists.*

NATIONAL CARTOONISTS SOCIETY: www.reuben.org. *Home and birthplace of the famed Reuben Awards, this organization holds something for cartoonists interested in everything from caricature to animation.*

ADVERTISING, DESIGN & GRAPHIC ART

ADVERTISING AGE: www.adage.com. *This site is a database of advertising agencies.*

AMERICAN INSTITUTE OF GRAPHIC ARTS: www.aiga.org. *Whether or not you join the organization, this site is a must for designers! From inspiration to insurance the AIGA is the designer's spot.*

THE ART DIRECTORS CLUB: www.adcny.org. *Founded in 1920, this international not-for-profit organization features job listings, educational opportunities, annual awards in advertising, graphic design, new media and illustration.*

ASSOCIATION TYPOGRAPHIQUE INTERNATIONALE (ATYPI): www.atypi.org. *Dedicated entirely to typography and type, if fonts are your specialty, make sure this site is on your favorites list.*

GRAPHIC ARTISTS GUILD: www.gag.org. *The art and design industry standard.*

HOW MAGAZINE: www.howdesign.com. *One of the premier publications dedicated to design, the website features jobs, business resources, inspiration and news, as well as conference information.*

SOCIETY OF GRAPHIC DESIGNERS OF CANADA: www.gdc.net. *Great site for Canadian designers with industry news, job postings and forums.*

TYPE DIRECTORS CLUB: www.tdc.org. *Events, news, awards, scholarships are all here for "those interested in excellence in typography."*

OTHER USEFUL SITES

ANIMATION WORLD NETWORK: www.awn.com. *Animation industry database, job postings, resume database, education resources, discussion forums, links, newsletters and a host of other resources cover everything animation.*

ART SCHOOLS: www.artschools.com. *A free online directory with a searchable database of art schools all over the world. They also have information on financial aid, majors and lots more.*

ARTBUSINESS.COM: www.artbusiness.com. *Contains art business related articles, reviews on business of art books and sells classes on marketing for artists.*

THE ARTIST MAGAZINE: www.artistmagazine.com. *Archives of articles covering everything from the newest type of colored pencil to techniques in waterolors.*

ARTLEX ART DICTIONARY: www.artlex.com. *Art dictionary with more than 3,200 terms.*

COMMUNICATION ARTS MAGAZINE: www.commarts.com. *Publication and website covering all aspects of creatives from illustrators to designers to typography.*

IMAGESITE: www.imagesite.com. *Lists searchable databases of advertising agencies, art reps, competitions, galleries and printers.*

INTERNATIONAL ANIMATION ASSOCIATION: asifa.net. *ASIFA or Association Internationale du Film d'Animation is an international group dedicated to the art of animation. They list worldwide news, information on chapters of the group, as well as conferences, contests and workshops.*

MUSIC CONNECTION: www.musicconnection.com. *If you're working hard to get your art on CD covers, you'll want to keep up with the ever-changing world of the music industry.*

PORTFOLIOS.COM: www.portfolios.com. *Serving both artists and clients looking for artists-portfolios.com offers a variety of services for everyone. This is a really nice site; you can post up to a five-image portfolio for free.*

Glossary

Acceptance (payment on). An artist is paid for his work as soon as a buyer decides to use it.

Adobe Illustrator®. Drawing and painting computer software.

Adobe PageMaker. Illustration software (formerly Aldus PageMaker).

Adobe Photoshop®. Photo manipulation computer program.

Advance. Amount paid to an artist before beginning work on an assigned project. Often paid to cover preliminary expenses.

Airbrush. Small pencil-shaped pressure gun used to spray ink, paint or dye to obtain gradated tonal effects.

Aldus FreeHand. Illustration software (see Macromedia FreeHand).

Aldus PageMaker. Page layout software (see Adobe PageMaker).

Anime. Japanese word for animation.

Art director. In commercial markets, the person responsible for choosing and purchasing artwork and supervising the design process.

Biannually. Occurring twice a year.

Biennially. Occurring once every two years.

Bimonthly. Occurring once every two months.

Biweekly. Occurring once every two weeks.

Book. Another term for a portfolio.

Buy-out. The sale of all reproduction rights (and sometimes the original work) by the artist; also subcontracted portions of a job resold at a cost or profit to the end client by the artist.

Calligraphy. The art of fine handwriting.

Camera-ready. Art that is completely prepared for copy camera platemaking.

Capabilities brochure. A brochure, similar to an annual report, outlining for prospective clients the nature of a company's business and the range of products or services it provides.

Caption. See gagline.

Carriage trade. Wealthy clients or customers of a business.

CD-ROM. Compact disc read-only memory; non-erasable electronic medium used for digitized image and document storage and retrieval on computers.

Collateral. Accompanying or auxiliary pieces, such as brochures, especially used in advertising.

Color separation. Photographic process of separating any multi-color image into its primary component parts (cyan, magenta, yellow and black) for printing.

Commission. 1) Percentage of retail price taken by a sponsor/salesman on artwork sold. 2) Assignment given to an artist.

Comprehensive. Complete sketch of layout showing how a finished illustration will look when printed; also called a comp.

Copyright. The exclusive legal right to reproduce, publish and sell the matter and form of a literary or artistic work.

Consignment. Arrangement by which items are sent by an artist to a sales agent (gallery, shop, sales rep, etc.) for sale with the understanding the artist will not receive payment until work is sold. A commission is almost always charged for this service.

Direct-mail package. Sales or promotional material that is distributed by mail. Usually consists of an outer envelope, a cover letter, brochure or flier, SASE, and postpaid reply card, or order form with business reply envelope.

Dummy. A rough model of a book or multi-page piece, created as a preliminary step in determining page layout and length. Also, a rough model of a card with an unusual fold or die cut.

Edition. The total number of prints published of one piece of art.

Elhi. Abbreviation for elementary/high school used by publishers to describe young audiences.

Environmental graphic design (EGD). The planning, designing and specifying of graphic elements in the built and natural environment; signage.

EPS files. Encapsulated PostScript—a computer format used for saving or creating graphics.

Estimate. A ballpark figure given to a client by a designer anticipating the final cost of a project.

Etching. A print made by the intaglio process, creating a design in the surface of a metal or other plate with a needle and using a mordant to bite out the design.

Exclusive area representation. Requirement that an artist's work appear in only one outlet within a defined geographical area.

Finished art. A completed illustration, mechanical, photo, or combination of the three that is ready to go to the printer. Also called camera-ready art.

Gagline. The words printed with a cartoon (usually directly beneath); also called a caption.

Giclée Method of creating limited and unlimited edition prints using computer technology in place of traditional methods of reproducing artwork. Original artwork or transparency is digitally scanned, and the stored information is manipulated on screen using computer software (usually Photoshop). Once the image is refined on screen, it is printed on an Iris printer, a specialized ink-jet printer designed for making giclée prints.

Gouache. Opaque watercolor with definite, appreciable film thickness and an actual paint layer.

Halftone. Reproduction of a continuous tone illustration with the image formed by dots produced by a camera lens screen.

Informational graphics. Information, especially numerical data, visually represented with illustration and text; charts/graphs.

IRC. International Reply Coupon; purchased at the post office to enclose with artwork sent to a foreign buyer to cover his postage cost when replying.

Iris print. Limited and unlimited edition print or giclée output on an Iris or ink-jet printer (named after Iris Graphics of Bedford, Massachusetts, a leading supplier of ink-jet printers).

JPEG files. Joint Photographic Experts Group—a computer format used for saving or creating graphics.

Keyline. Identification of the positions of illustrations and copy for the printer.

Kill fee. Portion of an agreed-upon payment an artist receives for a job that was assigned, started, but then canceled.

Layout. Arrangement of photographs, illustrations, text and headlines for printed material.

Licensing. The process whereby an artist who owns the rights to his or her artwork permits (through a written contract) another party to use the artwork for a specific purpose for a specified time in return for a fee and/or royalty.

Lithography. Printing process based on a design made with a greasy substance on a limestone slab or metal plate and chemically treated so image areas take ink and non-image areas repel ink.

Logo. Name or design of a company or product used as a trademark on letterhead, direct mail packages, in advertising, etc., to establish visual identity.

Mechanicals. Preparation of work for printing.

Multimedia. A generic term used by advertising, public relations and audiovisual firms to describe productions involving animation, video, web graphics or other visual effects. Also, a term used to reflect the varied inhouse capabilities of an agency.

Naif. Native art of such cultures as African, Eskimo, Native American, etc., usually associated with daily life.

Offset. Printing process in which a flat printing plate is treated to be ink-receptive in image areas and ink-repellent in non-image areas. Ink is transferred from the printing plate to a rubber plate, and then to the paper.

Overlay. Transparent cover over copy, on which instruction, corrections or color location directions are given.

Panel. In cartooning, the boxed-in illustration; can be single panel, double panel or multiple panel.

PMT. Photomechanical transfer; photostat produced without a negative.

P-O-P. Point-of-purchase; in-store marketing display that promotes a product.

Prima facie. Evidence based on the first impression.

Print. An impression pulled from an original plate, stone, block screen or negative; also a positive made from a photographic negative.

Production artist. In the final phases of the design process, the artist responsible for mechanicals and sometimes the overseeing of printing.

QuarkXPress. Page layout computer program.

Query. Letter to an art director or buyer eliciting interest in a work an artist wants to illustrate or sell.

Quotation. Set fee proposed to a client prior to commencing work on a project.

Rendering. A drawn representation of a building, interior, etc., in perspective.

Retail. The sale of goods in small quantities directly to the consumer.

Roughs. Preliminary sketches or drawings.

Royalty. An agreed percentage paid by a publisher to an artist for each copy of a work sold.

SASE. Self-addressed, stamped envelope.

Self-publishing. In this arrangement, an artist coordinates and pays for printing, distribution and marketing of his/her own artwork and in turn keeps all ensuing profits.

Semiannual. Occurring twice a year.

Semimonthly. Occurring twice a month.

Semiweekly. Occurring twice a week.

Serigraph. Silkscreen; method of printing in which a stencil is adhered to a fine mesh cloth stretched over a wooden frame. Paint is forced through the area not blocked by the stencil.

Speculation. Creating artwork with no assurance that a potential buyer will purchase it or reimburse expenses in any way; referred to as work on spec.

Spot illustration. Small illustration used to decorate a page of type, or to serve as a column ending.

Storyboard. Series of panels that illustrate a progressive sequence or graphics and story copy of a TV commercial, film or filmstrip. Serves as a guide for the eventual finished product.

Tabloid. Publication whose format is an ordinary newspaper page turned sideways.

Tearsheet. Published page containing an artist's illustration, cartoon, design or photograph.

Thumbnail. A rough layout in miniature.

TIFF files. Tagged Image File Format—a computer format used for saving or creating graphics.

Transparency. A photographic positive film such as a color slide.

Type spec. Type specification; determination of the size and style of type to be used in a layout.

Velox. Photoprint of a continuous tone subject that has been transformed into line art by means of a halftone screen.

VHS. Video Home System; a standard videotape format for recording consumer-quality videotape, most commonly used in home videocassette recording and portable camcorders.

Video. General category comprised of videocassettes and videotapes.

Wash. Thin application of transparent color or watercolor black for a pastel or gray tonal effect.

Wholesale. The sale of commodities in large quantities usually for resale (as by a retail merchant).

Niche Marketing Index

The following indexes can help you find the most appropriate listings for the kind of artwork you create. Check the individual listings for specific information about submission requirements.

Children's Publications/Products

Collectibles

Fashion

Humorous Illustration

print

Subscribe now and save 64% off the newsstand price.

You'll get...

Print's Regional Design Annual
The most comprehensive yearly profile of graphic design in America, packed with the best, most current work in the country.

Print's European Design Annual
A portfolio of the finest work being created across the Continent, with commentary on national styles and international trends.

Print's Digital Design Annual
An annual showcase of the most cutting-edge digital art being created in the areas of animation, Web sites, television ads, kiosks and more.

Plus 3 regular issues — a full year of *Print* at the introductory rate of just $37. (Annual newsstand rate $102.)

NICHE MARKETING INDEX

Informational Graphics

Multimedia

Religious/Spiritual

General Index

Companies or galleries that appeared in the 2003 edition but do not appear in this edition are identified by a two-letter code explaining why the market was omitted: (**ED**)—Editorial Decision, (**NS**)—Not Accepting Submissions, (**NR**)—No (or late) Response to Listing Request, (**OB**)—Out of Business, (**RR**)—Removed by listing's Request.

Companies that appeared in the 2003 edition of *Artist's & Graphic Designer's Market,* **but do not appear this year, are listed in this General Index with the following codes explaining why these markets were omitted: (ED)—Editorial Decision, (NS)—Not Accepting Submissions, (NR)—No (or late) Response to Listing Request, (OB)—Out of Business, (RR)—Removed by Listing's Request.**